Architecture and Interior Design
from the 19th Century
An Integrated History

Volume 2

Buie Harwood
FIDEC, Hon. FASID, Certified Interior Designer, Virginia
Professor Emeritus, Virginia Commonwealth University

Bridget May, Ph.D.
IDEC, Allied Member ASID
Professor, Marymount University

Curt Sherman
FIDEC, Allied Member ASID
Professor Emeritus, Winthrop University

PEARSON

Prentice
Hall

Upper Saddle River, New Jersey
Columbus, Ohio

Library of Congress Cataloging-in-Publication Data

Harwood, Buie.
 Architecture and interior design from the 19th century : an integrated history, v. 2 / Buie
Harwood, Bridget May, Curt Sherman. — 1st ed.
 p. cm.
 Includes bibliographical references and index.
 ISBN 0-13-098538-4 (alk. paper)
 1. Interior decoration—History—19th century. 2. Interior architecture—History—19th century.
3. Decorative arts—History—19th century.
 I. May, Bridget. II. Sherman, Curt. III. Title.

 NK1960.H37 2009
 729.09'034—dc22

 2007045346

Editor in Chief: Vernon R. Anthony
Acquisitions Editor: Jill Jones-Renger
Editorial Assistant: Doug Greive
Production Coordination: Linda Zuk, WordCraft LLC
Project Manager: Louise Sette
AV Project Manager: Janet Portisch
Operations Specialist: Deidra Schwartz
Art Director: Diane Ernsberger
Cover Designer: Carey Davies
Cover photos:
Photo 1: © Historical Picture Archive/CORBIS
Photo 2: James McNeill Whistler (American, 1834-1903), "Harmony in Blue & Gold" (The Peacock Room, northeast corner, from a house owned by Frederick Leyland, London). Oil & metal leaf on Canvas. Leather & Wood. Place of origin: London, 1876-1977. Courtesy of the Freer Gallery of Art, Smithsonian Institution, Washington, D.C. F1904.61.
Photo 3: Art Resource/The Museum of Modern Art
Photo 4: Eric Samper/Terre Sauvage Magazine
Photo 5: Dorling Kindersley © Sean Hunter
Photo 6: © Judith Miller/Dorling Kindersley/Lyon and Turnbull Ltd.

Director, Image Resource Center: Melinda Patelli
Manager, Rights and Permissions: Zina Arabia
Manager, Visual Research: Beth Brenzel
Manager, Cover Visual Research and Permissions: Karen Sanatar
Image Permissions Coordinator: Angelique Sharps
Director of Marketing: David Gesell
Marketing Manager: Thomas Hayward
Marketing Assistant: Les Roberts

Text photo credits appear on page 1008.

This book was set in Goudy by S4Carlisle Publishing Services. It was printed and bound by Courier Kendallville, Inc. The cover was printed by Phoenix Color Corp.

Pearson Prentice Hall™ is a trademark of Pearson Education, Inc.
Pearson® is a registered trademark of Pearson plc
Prentice Hall® is a registered trademark of Pearson Education, Inc.

Pearson Education Ltd., London
Pearson Education Singapore, Pte. Ltd.
Pearson Education Canada, Inc.
Pearson Education—Japan

Pearson Education Australia Pty. Limited
Pearson Education North Asia Ltd., Hong Kong
Pearson Educacion de Mexico, S.A. de C.V.
Pearson Education Malaysia, Pte. Ltd.

10 9 8 7 6 5 4 3 2 1
ISBN-13: 978-0-13-098538-5
ISBN-10: 0-13-098538-4

Contents

This book is dedicated
to our families, mentors, and students.

Preface

This book will be useful to students of design history, architects interior designers, furniture designers, design consultants, design manufacturers, and theater/film set designers, as well as students and professionals in the related fields of art history, material culture, museum studies, and history. It will also be of interest to historical/preservation specialists and societies, craftspeople, design journalists, and others with an interest in design history.

It was written to fulfill a need in interior design education and related design disciplines. We are not aware of another book that provides the scope included herein, which allows the reader to compare and contrast architecture, interiors, furniture, and decorative arts during the 19th century to the present. We have tried to interweave a design analysis language with that of art and architectural history. Our intent is to provide a flexible, easy-to-use, and well-organized resource for those with a variety of interests. Included herein are an extensive bibliography, glossary, and index.

The concept of this book evolved over a number of years through our university teaching experiences. We, and our colleagues, were continually frustrated by the lack of adequate resources to support the desired content, context, and comprehensiveness of design history. All of our shared ideas have been realized here as we worked on the scope, organization, and presentation of this material. We hope that this effort fulfills a need for you and future generations who find the study of design history exciting.

ACKNOWLEDGMENTS

This book, like Volume 1, has been an enormous endeavor and a formidable challenge. We would like to gratefully acknowledge those who provided valuable assistance through its development. Special thanks to each of you for all of your wonderful contributions!

To our Prentice Hall/Pearson Education support team who had faith in us and made the book happen: Vern Anthony, Linda Zuk, Ann Brunner, Michelle Churma, ReeAnne Davies, Jill Jones-Renger, Susan Watkins, Louise Sette, Janet Portisch, and their many associates.

To our many students who inspired us to undertake this project: those who had courses with Buie at Virginia Commonwealth University, the University of Texas at Austin, and North Texas State University; and with Bridget at Marymount University, the University of Georgia at Athens, and Mississippi University for Women; and with Curt at Winthrop University, San Diego State University, and Washington State University.

To the institutions who supported our efforts: Virginia Commonwealth University and Marymount University.

To our friends who offered their expertise, support, resources, interest, and listening ears, particularly Paul Best, Becky Sweet, and Allan Hing.

To our special library resource friends: Suzanne Freeman at the Virginia Museum of Fine Arts in Richmond, who provided a wealth of information; Carl Vuncannon and his staff at the Bernice Bienenstock Furniture Library in High Point, North Carolina; and to Ray Bonis in Special Collections, Cabell Library at Virginia Commonwealth University.

To our reviewers: Cindy Cook, Appalachian State University; Richard Joncas, Harrington College of Design; Margaret S. Bateman, Mississippi State University; and John Turpin, Washington State University.

To our individual family members and friends who offered ongoing support, listened to complaints, and provided expertise when needed.

To the illustrators and photographers who recorded their environments from the 19th century through the present. As shown herein, their depictions of architecture, interiors, furnishings, and costumes were of enormous value in providing a resource archive.

To our wonderful and talented artist, Chris Good. You did a great job again!

Introduction

The true poets of the twentieth century are the designers, the architects and engineers who glimpse some inner vision and then translate it into valid actuality for the world to enjoy.

<div align="right">

"The Lost Worlds of the Fair,"
from Official Guide Book, 1939, p. 169.

</div>

We shape our buildings, thereafter they shape us.

<div align="right">

Winston Churchill, as quoted in *Time* magazine, 1960

</div>

INTEGRATING ARCHITECTURE, INTERIOR DESIGN, FURNITURE, AND DECORATIVE ARTS

This book, Volume 2, provides a survey of architecture, interiors, furniture, and decorative arts during the 19th century to the present. (Volume 1, published in 2002, covers the same material from the earliest cultural precedents through the 18th century.) Our intent is to provide a completely integrated and interdisciplinary reference for studying the built environment, interior design, interior architectural features, design details, motifs, furniture, space planning, color, lighting, textiles, interior surface treatments, and decorative accessories. Each period is placed within a cultural, historical, social, and conceptual context so that the reader can make connections between all aspects of the aesthetic development. Examples depict high-style (Fig. I-1) and vernacular (Fig. I-2) buildings, interiors, and furnishings from residential, commercial, and institutional projects. Later interpretations (Fig. I-3) illustrate the application of each stylistic influence during later periods, including products currently available and projects recently completed.

People provide our travelogue through history and our understanding of architecture and design. They shape and define our architecture, interiors, furniture, and decorative arts. Their tastes, ideas, knowledge, activities, and perceptions define the macro and micro environments. The environments discussed herein emphasize aesthetic and functional considerations—spaces that have been made by people in which to live, work, and play. The study of architecture stresses the exterior built environment—buildings within a site, structures that form shelter, forms articulating a design language—a macro view of space. The study of

interior design parallels this concept but focuses on interior environments where people go about their daily activities—areas within the building, rooms and their relationship in a structure, envelopes displaying a design vocabulary—a micro view of space. The study of furniture and decorative arts offers a more detailed view of the objects and materials within interiors. This aesthetic and functional language and vocabulary become our road map for understanding design history.

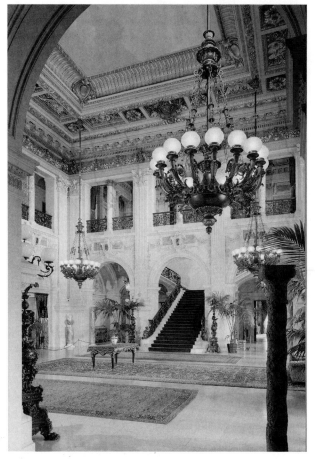

▲ I-1. Stair hall, The Breakers (Cornelius Vanderbilt House), 1892–1895; Newport, Rhode Island; Richard Morris Hunt. Classical Eclecticism/Neo-Renaissance.

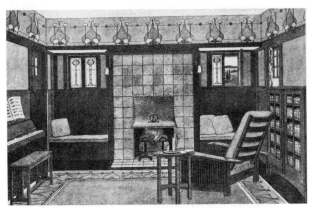

▲ I-2. Living room and dining room; published in *The Craftsman*, 1905–1906; Gustav Stickley and Harvey Ellis. American Arts and Crafts/Craftsman Style.

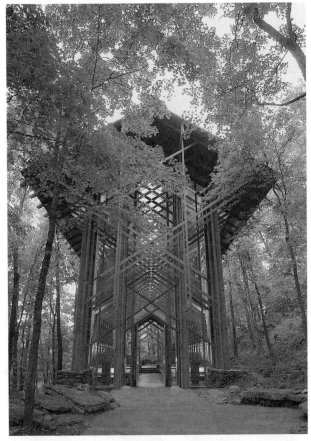

▲ I-3. Thorncrown Chapel, 1978–1980; Eureka Springs, Arkansas; E. Fay Jones and Maurice Jennings. Environmental Modern. (This is a Later Interpretation for Chapter 6, "Gothic Revival.")

APPROACHES TO DESIGN HISTORY

There are various approaches to the study of design history, whether architecture, interior design and furniture, or a combination. Art history uses works of art such as painting,

sculpture, architecture, furniture, ceramics, and metals to study the past. Its formalistic method follows chronology and stylistic development to grasp the meaning of works of art and, by extension, a society or people. Architectural history follows a similar pattern through its study of buildings. Its method specifically addresses buildings primarily through their individual histories, functions, owners, architects, styles, sitings, materials, construction methods, and contextual environments. Material culture looks specifically at man-made objects as transmitters of ideas and values of a society or group. Objects made and used by a society may include tools, furniture, textiles, and lighting that may be high style or vernacular. Design history studies artifacts and their contexts with a focus on their design and designers, materials, form, and function. Interior design historians bring a unique approach to design history by integrating the relationship of architecture and interiors in the context of history and design analysis. To accomplish this, the art history, architectural history, material culture, and design history approaches are merged and used as they relate to considerations of research, programming, concept, function, overall aesthetic, principles, and elements, as well as meaning and intent. As interior design educators, we have taken this last approach.

A stylistic approach to design history identifies forms, function, and visual features. This method, which is typically chronological, can be as simple as codifying visual characteristics with little definition of the roles of form and/or function. In a broader view, such as that of art history or material culture, style can assume that groups of people during particular times prefer particular forms and motifs as a reflection of their cultural and social qualities or particular design theories, as in the case of many modern designers. Therefore, objects, such as architecture, interiors, furnishings, and decorative arts can embody the values and/or beliefs of a society, group, or individual. In this sense, objects become historical documents or visual records. As primary documents, they can tell us much about an individual or group. Objects survive much longer than written records do and often derive from a broader spectrum of society. But the most complete picture exists when objects and written records are integrated.

Styles evolve from social, cultural, economic, and/or political factors of a given time. Available materials, climate, location, technology, and historical events affect the visual image. Until the middle of the 19th century, styles originate with political or religious leaders, the wealthy, other important people, or the design elite, and then filter to the middle class through an increasing range of media as time passes. Mass production and communication make it possible for many to emulate high-style design. Style or movement beginnings and endings vary. Consequently, dates provided herein should be considered guidelines because resources deviate in identifying exact dates, and transitions are common as stylistic periods change.

Additionally, personal preferences affect or determine the form and appearance of buildings and objects. Some people choose older styles over newer ones, especially in early periods when fashion is less important and visual resources, such as books, periodicals, or photographs, are limited.

USING DESIGN ANALYSIS

An important skill for architects and interior designers is the ability to read and understand existing exterior and interior environments. This is accomplished through design analysis—a visual language of design evaluation. This process affects aesthetic decisions and functional considerations and is most critical when evaluating historical structures and interiors and their contents. Studying these structures and interiors as historical records helps designers understand the evolution of a building, build visual literacy, and assess the appropriate design direction. Understanding historical design can also provide a wealth of design ideas for contemporary projects. A designer may enhance the original visual image, choose to reproduce it, or provide an adaptation.

Design analysis incorporates a specific language based on integrating the principles and elements of design and the architectural and interior components of a building. The principles of design include proportion, scale, balance; harmony, unity/variety/contrast; rhythm; and emphasis. The elements of design are size/space, line, color, light, texture, and shape/form (see Principles and Elements of Design definitions, page xviii). As identified in this book, architectural components of a building embrace site orientation, floor plan, materials, construction systems, color, facades, windows, doors, roof, architectural details, and unique features. Interior components generally encompass the relationship of the interior to the exterior, materials, color, lighting, floors, walls, windows, doors, textiles, ceilings, interior details, special treatments, and unique features. Furnishings and decorative arts address specific relationships; furniture arrangements; materials; seating; tables; storage; beds; upholstery; special decorative arts such as ceramics, metalwork, or mirrors; and unique features. The overall appearance of the exterior and interior derives from the integration of this design analysis language as applied to a three-dimensional form.

Design analysis also addresses ordering systems used to articulate buildings and interiors. The most common ordering systems are spatial definition, proportion, geometry, scale, and visual perception. Spatial definition involves wall planes enclosing space and the spatial elasticity of the surrounding space. In 1823, Sir John Soane interprets Roman influences in the Bank of England, London, where he experiments with geometric shapes, spatial interplay, vaults and curved ceiling surfaces, and lighting to accentuate form (Fig. I-4; see Chapter 4, "English Regency, British

Greek Revival"). In 1929, Ludwig Mies van der Rohe creates the German Pavilion at the International Exposition in Barcelona. Its open, flowing spaces penetrate from one to another with a few carefully positioned walls, panels, and marble screens in an ordered, asymmetrical relationship (Fig. I-5; see Chapter 24, "The Bauhaus"). Behavioral design specialists also refer to personal and social space related to the concept of proxemics (the physical distance between people in space). These considerations can define the experience of space as being confined, tight, and restricted or spacious, expanding, and flexible.

Proportion recognizes dimensions and relationships within objects. The Greeks codify the Golden Section (Fig. I-6), clarifying the specific relationship between the whole and its parts. In 1910, the architectural firm of McKim, Mead, and White use a Beaux Arts proportional vocabulary in the Pennsylvania Railroad Terminal Station in New York City using classical models such as the Roman baths, symmetry, large columns, huge vaults, high ceilings, and grand scale to create a monumental concourse interpreted in contemporary materials and construction (Fig. I-7; see Chapter 12, "Classical Eclecticism"). In 1992, Donald Chadwick and William Stumpf articulate contemporary ideas of proportion in the Aeron chair by addressing ergonomics, anthropometrics, functionality, form, materials, and movement to create a new icon in office seating (Fig. I-8; see Chapter 33, "Late Modern · 2").

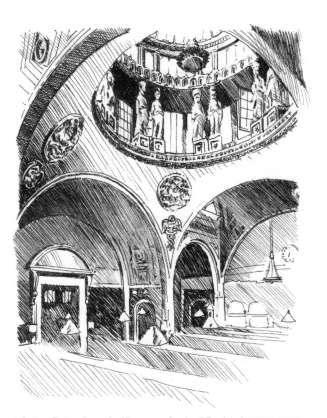

▲ I-4. Rotunda and office area, Bank of England, 1788–1823; London, England; Sir John Soane. English Regency.

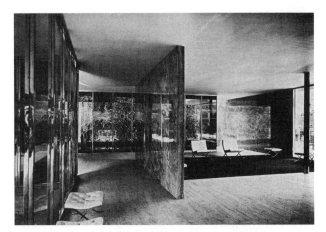

▲ **I-5.** Interiors, German Pavilion, International Exposition, 1929; Barcelona, Spain; Ludwig Mies van der Rohe. The Bauhaus.

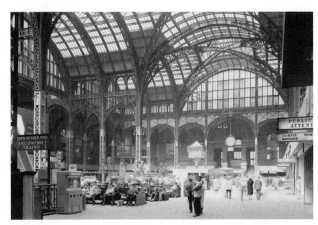

▲ **I-7.** Concourse showing steel frame support system, Pennsylvania Railroad Terminal Station, 1906–1910; New York City, New York; McKim, Mead, and White. Classical Eclecticism/ Beaux Arts.

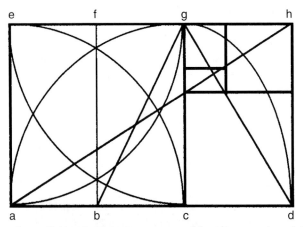

▲ **I-6.** Golden Section: aceg = square; bf = 1/2 square; bg = bd and determines smaller Golden Mean; adhe = Golden Mean.

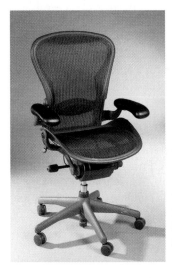

◄ **I-8.** Aeron chair, 1992; Donald Chadwick and William Stumpf, manufactured by Herman Miller. Late Modern • 2.

Geometry describes three-dimensional forms in terms of standard geometric shapes to include a triangle, square, circle, rectangle, and pentagon integrated with lines. In 1924, Gerrit Rietveld favors a machine vocabulary, one stressing flat geometric shapes, unadorned surfaces, asymmetry, and the purity of the graphic language as illustrated in the Schröder House in Utrecht, Holland (Fig. I-9; see Chapter 23, "De Stijl"). In 1983, Richard Meier envisions a language of structural geometry in Atlanta's High Museum of Art, as illustrated in the building composition, modular surface materials, architectural details, circulation patterns, and room proportions (Fig. I-10; see Chapter 31, "Late Modern • 1"). In the 1990s, flexible office systems display geometry through the use of modular parts composed of panel partitions, work surfaces, storage areas, filing components, and integrated lighting (Fig. I-11; see Chapter 33, "Late Modern • 2").

Scale refers to the size relationship of one thing to another, such as a building to its site or a piece of furniture to an interior, based on a comparison and human dimensions. In 1949, Philip Johnson conceives his famous Glass House in Connecticut as a small building placed in a natural environment, one that emphasizes the interplay of exterior and interior space and the relationship of interior space to the scale of the furnishings (Fig. I-12; see Chapter 28, "Geometric Modern"). In 1997, innovative architect Frank Gehry creates a unique setting for the Guggenheim Museum in Spain by placing a large-scale sculptural structure of curved and bent forms on direct axis and proximity to the city center of Bilbao (Fig. I-13; see Chapter 35, "Neo-Modern").

Visual perception pertains to the way one views a space and the person's position within the space. In 1875, Jean-Louis-Charles Garnier establishes grandeur, opulence,

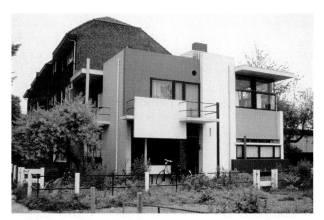

▲ I-9. Schröder House, 1924; Utrecht, Netherlands; Gerrit Thomas Rietveld in association with owner Truus Schröder-Schräder. De Stijl.

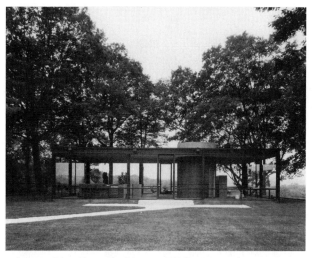

▲ I-12. Glass House (residence of Philip Johnson), 1949; New Canaan, Connecticut; Philip Johnson. Geometric Modern.

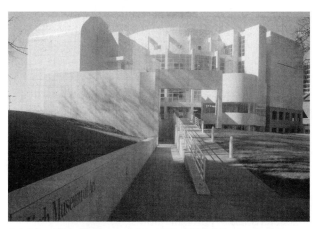

▲ I-10. High Museum of Art, 1980–1983; Atlanta, Georgia; Richard Meier. Late Modern • 1.

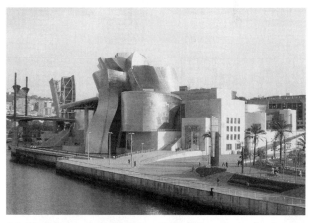

▲ I-13. Guggenheim Museum, 1997; Bilbao, Spain; Frank Gehry and Partners. Neo-Modern.

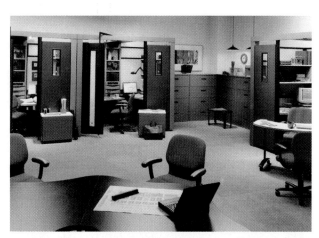

▲ I-11. Personal Harbor office furniture, c. 1992; United States; Paul Siebert, Mark Baloga, and Steve Eriksson; manufactured by Steelcase. Late Modern • 2.

formality, and procession in his articulation of the grand stair hall at the Paris Opera (Fig. I-14; see Chapter 8, "Second Empire, Rococo Revival"). In 1936, Frank Lloyd Wright creates Fallingwater, his residential masterpiece in Pennsylvania that fuses the terraced building to the natural landscape, articulates the interplay of exterior and interior space, creates procession and movement, and addresses a contextual human scale (Fig. I-15; see Chapter 29, "Organic and Sculptural Modern"). In 1955, Le Corbusier expresses solitude and serenity in his creation of Nôtre-Dame-du-Haut at Ronchamp in France by siting the bold, sculptural church on a high, terraced landscape similar to the Acropolis. The interiors evoke intimacy, simplicity, and meditation with an engaging interplay of light from various shaped windows (Fig. I-16; see Chapter 29, "Organic and Sculptural Modern").

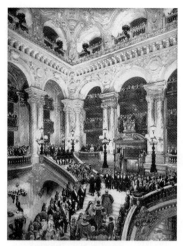

▲ **I-14.** Grand staircase, Opera House, 1862–1875; Paris, France; Jean-Louis-Charles Garnier. Second Empire.

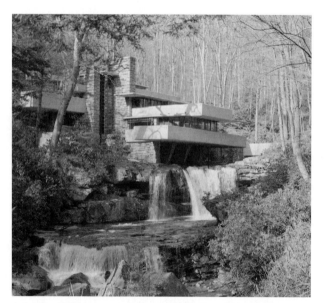

▲ **I-15.** Fallingwater, 1935–1937; Bear Run, Pennsylvania; Frank Lloyd Wright. Organic and Sculptural Modern.

USING THE BOOK

Within the book, the interrelationship of written narrative and graphic illustrations is considered a guiding principle. This material is integrated and carefully weighted throughout the book so that the reader can make connections between the written and visual content. One can, therefore, read the text or view the images and grasp the basic concepts of the period. An historical vocabulary and design analysis language are interwoven throughout the text.

Basic art movement sections provide a comprehensive introduction to subsequent chapters that address particular historical styles. These sections feature a timeline of important events and inventions and the creation of major works

of art, music, and literature. Wherever possible, authentic graphic typefaces related to individual periods highlight chapter titles and timelines to reinforce stylistic design connections. Maps help to illustrate changes that relate to the text. Chapters use a consistent footprint composed of headings and subheadings that provide an organized format for the presentation and sequencing of design content. This arrangement supports the idea of reviewing the content chronologically or topically. Chapter 1 provides an overview of the Industrial Revolution (Fig. I-17) in many countries to establish a foundation for the subsequent development of the historical styles. Because the book is intended to be a general survey of these periods, supplementary references such as those in the bibliography may assist in providing more detailed historical explanations.

The written narrative is descriptive and concise, with a combination of paragraphs and bullet point lists to aid in the easy retrieval of information. Paragraphs present general information and bullet point lists identify distinct design features. Design Characteristics, including specific motifs, are noted in each chapter. The Architecture and Interiors categories are sequenced as one would build a structure, from bottom (foundation or floor) to top (roof or ceiling). The Furnishings and Decorative Arts category provides an overview of the most important furniture, textiles, and decorative accessories. Boxed features provide lists of Important Buildings and Interiors as well as important Design Practitioners to assist in additional study. The Design Spotlight focuses on individual examples of architecture, interiors, and furniture to illustrate specific characteristics important to a particular period, with graphic illustrations included for reference and identification of characteristics, details, and motifs.

The text synthesizes information from many sources. Primary sources (those created during the period under study), such as treatises and books, are noted where possible so that the reader can explore them individually for design ideas. Secondary sources (those describing the period under study) are numerous, and the Bibliography includes

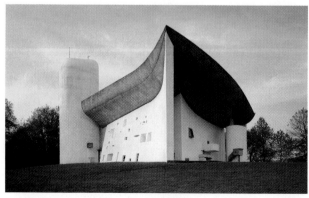

▲ **I-16.** Nôtre-Dame-du-Haut (Pilgrimage Chapel), 1950–1955; Ronchamp, France; Le Corbusier. Organic and Sculptural Modern.

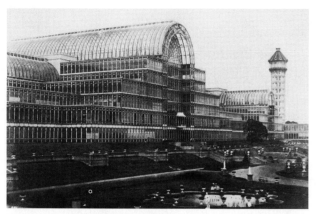

▲ I-17. Crystal Palace, 1851; London, England; gardener Sir Joseph Paxton. Industrial Revolution.

a large selection for further reading. References are grouped alphabetically by general information and by basic movement to facilitate use. A Glossary defines terms with which the reader may not be familiar.

The graphic illustrations feature a wide diversity of images, some common to the period and some less known. They include examples in black and white and color, line drawings, and material from trade catalogs, magazines, books, and journals from more recent sources and from original sources or older publications. Images are selected to convey the best representation of the place or item as it was built or used. Often this results in an illustration from drawings or photographs that may be more contemporary with the date of construction. Our preference has been to show the place or item as it looked when first developed rather than when it was first publicized or at a later point in time. This helps make clear the influence that the structure or object had on other architects or designers. Costume images reinforce the important relationship of clothing and the near environment. Design diagramming points out major design features and characteristics of a particular style of architecture, interiors, and furniture so that the reader can make visual connections between the content.

For greater historical accuracy, some images have been slightly modified digitally from their original appearance to represent more accurately the building or object as it would have appeared upon completion or in its appropriate time frame. These actions include removing automobiles, electrical or telephone wires, and signage that are not of the original period. Older prints and negatives have also had their foxing or spotting removed. These actions have not been taken on images obtained from museums or commercial photographers.

PRINCIPLES OF DESIGN

Principles of design are the vocabulary used to measure and define design, and they are often described using the elements of design.

- **Proportion.** The relationship of parts of a design to each other and to the whole, such as between large and small windows in a house.

- **Scale.** A contextual relationship comparing dimensional objects, such as the proportional size of a door to all other doors, to human beings, and to the space in which it belongs.

- **Balance.** A result when forces opposing each other achieve equilibrium. Examples include symmetrical/formal balance developing from a central axis, asymmetrical/informal balance with an irregular axis, and radial balance developing from a central core.

- **Harmony.** The relationship of parts to each other through similarity and to an overall theme of design, such as the consistency in size and color of architectural trim on a house.

- **Unity, Variety, Contrast.** Unity is the collection of elements seen as a visually related whole. Variety is the tension between opposing elements, such as between straight and curved lines. Contrast refers to the means of accenting a composition as through light, color, texture, pattern, scale, and/or configuration.

- **Rhythm.** The relationship of visual elements together in a regular pattern through repetition, alternation, or progression, such as the repetition of lines and shapes in a textile pattern.

- **Emphasis.** The importance of an item in its space that thereby makes other items less important, such as the focal point created by placing a large oil painting at the end of a narrow hallway.

ELEMENTS OF DESIGN

The elements of design are the tools for working in space.

- **Space.** The area in which objects and people exist and move as well as a period of time, thereby establishing relationships, such as between man and his environment. Space may be arranged through a linear, nucleus, modular, or grid pattern.

- **Line.** The connection of two points in space, which may be straight or curved as well as directional, such as vertical, horizontal, or diagonal.

- **Color.** Described by hue (the color name), value (its change from light to dark), and intensity (its brightness or chroma). The gradation of color indicates a transition from light to dark, such as from pink to rose to burgundy.

- **Light.** Light defines and shapes forms and spaces so that people can view them. It typically emits bright spots and shadows that create contrast between light and dark through natural or artificial sources.

- **Texture.** The visual or tactile quality of natural and man-made objects, such as brick, velvet, or paint.

- **Shape and Form.** Shape is two dimensional, such as squares, circles, and triangles. Form is three dimensional, such as cubes, spheres, and pyramids.

Reference: Kilmer, Rosemary, and W. Otie Kilmer. *Designing Interiors*. Ft. Worth and New York: Harcourt, Brace, Jovanovich and Holt, Rinehart and Winston, 1992.

Architecture Profession: A Timeline

"The practice of architecture, for the purposes of the licensing statute, should be defined as performing, offering to perform, or directly supervising the performance of certain services, hereafter described, in connection with the design, construction, enlargement, or alteration of a building or group of buildings and the space within and surrounding such buildings that have as their principal purpose human occupancy, habitation, or use."

—Virginia licensing bill for architecture #645,
Code of Virginia, March 1990

Early 1800s Architects design buildings, interiors, and furniture for their buildings and oversee the creation of them by local artisans, crafts guilds, or commercial firms. Robert Mills, who apprentices with Benjamin Henry Latrobe, is one of the first professionally trained native-born American architects.

1818 John Haviland publishes the *Builder's Assistant*, one of the first publications written and published in America. It is probably the first to illustrate the Greek and Roman orders.

1819 L'École des Beaux-Arts (School of Fine Arts) opens in Paris and replaces the French Academy. It becomes the world's premier architectural school during the 19th century.

1829 Town and Davis forms in Massachusetts as one of the earliest architectural partnerships in America.

1837 The Royal Institute of British Architects (RIBA) forms to promote the progression and expansion of architecture in Britain.

1857 The American Institute of Architects (AIA) forms as the voice of the architectural profession to promote its members and advance the standing of the profession. Prior to this, masons, carpenters, bricklayers, and other building trades members could call themselves architects.

1866 The Massachusetts Institute of Technology (MIT) begins an architecture program, the first in the United States, one year after the school opens. Developed by William Robert Ware, the course outline indicates that the apprenticeship model has disappeared. Subsequent programs, all Beaux-Arts based, are developed at Cornell (1871), the University of Illinois (1873), Columbia University (1881), and Tuskegee (1881).

1880s Architects become more professional as training moves from apprenticeships to formal, academic education in North America and Europe. Many go to Paris to study at L'École des Beaux-Arts, often as post-graduates. Those unable to go to Paris study with Beaux-Arts-trained mentors or professors in universities. In Britain, some schools offer architectural instruction, which is supplemented with apprentice training.

1884 The Western Association of Architects (WAA) is founded in Chicago. Five years later it merges with the AIA. In this same year the Art Worker's Guild, a professional group of architects, designers, and artisans, forms in England.

1890 The first architectural registration law in Canada is enacted in the province of Ontario, followed within a year by one in Québec. Various states develop model laws regulating the practice of architecture in the United States. These laws include, among other things, an architectural practice definition and qualifications for practice. Early architectural registration examinations are developed and evaluated by each individual state board in the United States.

1897 Illinois becomes the first state in the United States to adopt legal registration/licensing for architects to

regulate their practice. Within 50 years, all states have licensing laws. The Vienna Secession (Wiener Secession), a society of avant-garde architects, designers, sculptors, and painters, forms in Vienna, Austria.

1904 RIBA establishes a Board of Architectural Education that values formal, academic instruction, thus ending architectural education by apprenticeship.

1907 The Deutscher Werkbund, a government-sponsored organization, forms in Munich, Germany, as an association of architects, designers, craftsmen, manufacturers, and writers.

1908 The Architectural Institute of Canada is incorporated to promote architecture and its practice in Canada. Within a year, it is renamed the Royal Architectural Institute of Canada (RAIC).

1912 The Association of Collegiate Schools of Architecture (ACSA) is founded in the United States to advance the quality of architectural education.

1919 The National Council of Architectural Registration Boards (NCARB) forms in the United States as a council of Member Boards with an emphasis on protecting the health, safety, and welfare of the public.

The Bauhaus, a new school that merges the Grand Ducal School of Arts and Crafts with the Academy of Fine Arts, is established in Weimar, Germany. The school strives to unite all the arts (architecture is included) with craft and technology, to elevate crafts disciplines to the level of the fine arts, and to establish connections with industry.

1920 The AIA publishes *A Handbook of Architectural Practice* in the United States, which is regularly updated and currently called *The Architect's Handbook of Professional Practice.*

1932 "Modern Architecture: An International Exhibition" opens at the Museum of Modern Art (MOMA) in New York City. The exhibit is a seminal event for modern architecture in America because it identifies the International Style and its architects.

1937 Walter Gropius, former director of the Bauhaus, moves to the architecture department in the College of Design at Harvard University in Boston. Mies van der Rohe, another former director of the Bauhaus, becomes director of architecture at the Armour Institute, later the Illinois Institute of Technology (IIT) in Chicago.

1940 The National Architectural Accrediting Board (NAAB) is founded in the United States to accredit professional degree programs in architecture.

1945 Following World War II, more practitioners have formal architecture and/or design schooling, unlike their predecessors, and more universities and schools offer courses and degree programs in design that are heavily based on the history of architecture, interiors, furniture, and the decorative arts, a reflection of the Beaux-Arts methods of education.

1948 The International Union of Architects (Union Internationale des Architects, or UIA) is founded to unite the architects of all countries worldwide into a unified federation of their national organizations so they are represented as one voice. Shortly after it forms, the UIA begins holding a regular international Congress and Assembly in major cities around the world.

1963 NCARB administers its first uniform multiple-choice examination for all member boards.

1967 NCARB adopts the professional degree in architecture from NAAB-accredited programs as the educational standard, but the decision is reversed one year later.

1968 NCARB evaluates the standards, criteria, and direction for education, experience, and examination standards, which is reflected in a revised examination emphasizing the application of knowledge and judgment to practice situations.

1973 NCARB administers for the first time a uniform examination in a two-test format made up of the Equivalency Examination (renamed Qualifying Test in 1976) and the Professional Examination. It tests knowledge, skills, and ability for practice.

1976 The Canadian Architectural Certification Board (CACB) is formed to evaluate the academic qualifications of those who apply for registration.

Mid 1970s Committees of NCARB and the AIA jointly develop the Intern Development Program (IDP), a monitored work experience program for beginning architects. A pilot test of the program is administered during 1976–1977. In 1978, Mississippi is the first state to adopt IDP. By 2006, 49 states in the United States stipulate participation in IDP to meet requirements for legal registration.

1978 The RAIC Syllabus Program, established by the RAIC Certification Board, is formalized as a work experience program for intern architects in Canada.

1979 Architect Philip Johnson is the first to receive the prestigious Pritzker Prize in Architecture. The Canadian Centre for Architecture (CCA) is founded in Canada to serve as an advocate for the promotion of architecture in society with an emphasis on design practice and research in the field.

Late 1970s–early 1980s The Committee of Canadian Architectural Councils (CCAC), which is similar to NCARB in the United States, forms to represent the voice of the provincial licensing associations in Canada. The Council of Canadian University Schools of Architecture (CCUSA), which is similar to ACSA in the United States, is formed as an advocate for accredited architectural programs in Canada. There is more specialization in design projects in North America based on the major categories of offices, hospitality, retail, health care, and institutional. This complexity leads to a greater separation in the disciplines of architecture and interior design based on more specific project knowledge. Larger architectural firms are capable of site planning, architectural design, and the design of interiors and furnishings. Some firms hire specialists to address particular needs.

1980 The RAIC becomes a voluntary national professional association of architects in Canada.

1983 NCARB reorganizes its examination to more adequately emphasize practice requirements and professional competency. The first Architect Registration Examination (ARE) is administered in June of this year and is adopted by member boards.

1984 NCARB formally accepts the educational requirement of a professional degree in architecture from NAAB-accredited programs as the educational standard, recognizing the growing complexity of both architectural education and practice. Subsequently it offers the Broadly Experienced Architect (BEA) process as an alternate for architects who do not hold an accredited degree to achieve NCARB certification.

1989 NCARB and CCAC study education, examination, and training standards for architects in the United States and Canada, which leads to a mutual recognition of architectural qualifications for registration.

1990s Architects continue to respond to the increased complexity of the built environment. Specialty areas continue, with greater specialization within areas, such as an emphasis on medical centers, not just health care in general. Instantaneous communication in a global community enables design teams to work together on architectural projects. Architects, contractors, interior designers, engineers, and project managers are from different countries. Many firms have offices across the globe.

1991 CACB begins to oversee accreditation for professional architectural degree programs in Canada. All English-speaking Canadian provinces use the ARE to test professional competency. In 1995, a French edition of the examination is administered in Quebec.

1993 NCARB publishes its first continuing education monograph for architects to support continuing professional development. By 2004, 28 NCARB member boards require continuing education units (CEUs) for registration renewal.

1994 The UIA establishes the Professional Practice Commission to address international standards of professionalism in architectural practice due to the increasing globalization of the profession. NCARB and CCAC agree that candidates for licensure must have a professional degree in architecture accredited by NAAB or CACB.

1997	The ARE is updated and all nine portions are administered using computerized delivery and scoring methods.
1998	The Internship in Architecture Program (IAP) in Canada is implemented as a structured work experience program that provides a transition from formal education to architectural registration/licensure.
1999	At the UIA Congress and Assembly in Beijing, China, the Assembly unanimously approves the "UIA Accord on Recommended International Standards of Professionalism in Architectural Practice," which becomes the first global standard in the profession of architecture. With this standard in place, the UIA begins to take the lead in implementing worldwide the inter-recognition standards of architectural professionalsim and

| 2000s | competence and in facilitating the portability of professional credentials. Architects are involved with strategic planning, branding, and facilities management as they strive to further assist their clients. Professional design organizations move to have sustainable concepts become a part of education, standard practice, professional ethics, and social responsibility. |
| 2006 | NCARB works with legal registration authorities from various countries concerning mutual recognition of qualifications for education, experience, and examination standards to meet practice guidelines. Architectural students in North America and England come from around the world, and many return to their home countries to practice, which affects the direction and quality of architecture around the world. |

Interior Design Profession: A Timeline

"An Interior Decorator is one who, by training and experience, is qualified to plan, design and execute structural interiors and their furnishings and to supervise the various arts and crafts essential to their completion."

—Official Definition, American Institute of Interior Decorators, 1931

"The professional interior designer is a person qualified by education, experience and examination who
I - identifies, researches, and, creatively solves problems pertaining to the function and quality of the interior environment;
II - performs services relative to interior spaces, including programming, design analysis, space planning, and aesthetics, using specialized knowledge of interior construction, building codes, equipment, materials, and furnishings; and
III - prepares all drawings and documents relative to the design of interior spaces in order to enhance and protect the health, safety, and welfare of the public."

—Official Definition, National Council for Interior Design Qualification, 1982

1850s–1880s	In North America, cabinetmaking and decorating firms, upholsterers, artists, and craftsmen guilds decorate interiors and produce furniture. Department stores and firms, such as L.C. Tiffany's Associated Artists, also provide interior decoration services. By the end of the century, the interior decorator begins to emerge as separate from tradespersons, craftsmen, painters, wallpaper hangers, or large furniture firms. Nearly all decorators are men, but some advocacy of the profession for women begins in the late 19th century. Women begin decorating outside the home.
1882–1888	The Century Guild, founded in England by Arthur Heygate Mackmurdo, brings crafts and fine arts together through architecture.
1898	Elsie de Wolfe redecorates her dining room at Irving Place in New York City. Recognition leads to the establishment of her own decorating firm, the interior design of the Colony Club in 1905, and her self-described title as "America's first woman professional decorator."
1899	The British Institute of Interior Design forms in England.
1900	The new discipline of Domestic Science, or Home Economics, formulates functional planning concepts for kitchens and baths.
1901	A group of artist-designers organizes the Société des Artistes Décorateurs (SAD; Society of Decorative Artists) in France. The group wants to promote its work as well as to distinguish it from that of artisans or craftsmen.
1904	The New York School of Fine and Applied Arts initiates courses in interior decoration under the guidance of Frank Alvah Parsons. In 1940, the school becomes Parsons School of Design.
1914	The Decorators Club of New York forms as an association for interior decorators.
1916	Sherrill Whiton creates a home study course for the decorative arts in the United States.
1924	The New York School of Interior Decoration begins under the direction of Sherrill Whiton as the first school in the United States emphasizing interior decoration education.
1928	At the Bauhaus in Germany, director Hermann Meyer combines mural painting with metal and furniture workshops to create an interior design department.
1930	Designers form the Union des Artistes Modernes (UAM) in France with an emphasis on rejecting excessive ornament, adopting new or industrial materials, and promoting mass production.
1931	The American Institute of Interior Decorators (AIID) forms in Grand Rapids, Michigan. One of its goals is to separate interior decorators from the many people who decorate interiors and call themselves decorators, including painters and wallpaper hangers. It creates a definition for *interior decorator*.

1920s–1940s	Interior decorators work individually, in partnerships, in design firms or department stores, and decorating becomes a big business. Expansion of design education spreads throughout the United States and Canada with the establishment of design programs in areas such as New York, Michigan, Washington, Virginia, and Manitoba. In 1923, 60 schools, including colleges, offer study in interior decoration.
1936	AIID changes its name to the American Institute of Decorators (AID) and moves its headquarters to New York City.
1938	The first Canadian interior design registration law is passed in Quebec restricting the use of the title Certified Interior Designer.
1941	Nancy Vincent McClelland becomes the first woman national president of AID. She serves until 1944.
1944	The Council of Industrial Design forms in England to promote well-designed British products. In the early 1970s, the name is changed to the Design Council, with an additional focus to expand design awareness.
1945	After World War II, residential suburbs increase and commercial office buildings multiply across the United States, leading to an expansion in residential and commercial interior design. More practitioners have architecture and/or design schooling, unlike their predecessors, and more universities and schools offer courses and degree programs in design.
1947	The Home Fashions League (HFL), composed solely of women, is established in New York to facilitate discussions in the home fashions field.
1950s	Commercial interior design becomes more important in North America as interior planning grows more complex and specialized. Architectural firms such as Skidmore, Ownings and Merrill (SOM) in New York City establish interiors units. The Knoll Planning Unit, directed by Florence Knoll, becomes a leader in the design and furnishing of modern commercial interiors. She is the one of the first recognized commercial interior designers. Knoll

	emphasizes that she is not an interior decorator.
1955	The AID Professional Practice Manual is the first manual published on interior decoration and design practice in the United States.
1957	The National Society of Interior Designers (NSID) forms in the United States as an alternative association to AID. The HFL expands to become the National Home Fashions League (NHFL) in the United States, with a focus on furnishings and design.
1960s	Specialization increases in design projects based on the major categories of offices, hospitality, retail, health care, and institutional. This complexity leads to a greater separation in the disciplines of architecture and interior design based on the knowledge required to do a job. As a result, more architectural firms have more interior design departments. Research and programming become more important and begin to inform the development of projects.
1960	The Inchbald School of Design opens in London, England, and offers one of the first programs in interior design in that country, subsequently followed by Kingston Polytechnic (now Kingston University) and Brighton Polytechnic (now Brighton University).
1961	AID renames itself the American Institute of Interior Designers. The Institute of Store Planners (ISP) is founded in the United States to represent designers involved in the design of retail spaces. The National Council for Diplomas in Art and Design (NCDAD) is established in England. It merges with the Council for National Academic Awards in 1974. This organization is responsible for validating almost all art and design degree-level courses in the United Kingdom.
1963	The Interior Design Educators Council (IDEC) is founded. Its goal is to strengthen lines of communication among interior design educators in North America, educational institutions, and interior design organizations, and to increase professionalism.
	The International Federation of Interior Architects/Interior Designers (IFI) forms in

Denmark with the purpose of uniting and providing discussion on interior design issues within European countries.

1966 The Interior Decorators and Designers Association (IDDA) forms in Great Britain to promote the interior design profession throughout the kingdom.

1968 IDEC publishes the first *Directory of Institutions Offering Interior Design Education* and *A Critical Study of Interior Design Education,* which is a comprehensive study of interior design education in North America, under the direction of Arnold Friedmann.

1969 The Institute of Business Designers (IBD) organizes in the United States to advance the profession of commercial interior design through advocacy, education, networking, and public relations. Interior design education increasingly emphasizes problem-solving projects with more practical applications.

1970 The Foundation for Interior Design Education Research (FIDER) forms to promote excellence in interior design through research and the accreditation of interior design programs in North America. It is formalized as an accrediting organization in 1971.

1970–1973 AID administers a qualifying examination for those who want to be corporate members.

1972 The Interior Designers of Canada (IDC) forms with a goal to foster design communication across the Canadian provinces.

1973 FIDER accredits the first six interior design programs that include the University of Cincinnati, University of Texas at Austin, Virginia Commonwealth University, University of Georgia, University of Missouri, and Texas Tech University.

1974 The National Council for Interior Design Qualification (NCIDQ) is incorporated, administers its first qualifying examination for interior designers in North America, and develops guidelines for model legislation/licensing in interior design.

1975 The American Society of Interior Designers (ASID) forms from the merger of AID and NSID. The ASID Internship Task Force

proposes a post-graduate internship program. NCIDQ finalizes a proposal for a model licensing statute for the profession, which includes A *Definition of an Interior Designer.* The definition addresses education, experience, and examination and recognizes a professional's responsibility to protect the health, safety, and welfare of the public. It is subsequently distributed to professional interior design organizations. During this same year, the Interior Design Society (IDS), an arm of NHFL, is organized primarily to support decorators in department stores. Additionally, IDEC publishes the first interior design research journal, the *Journal of Interior Design Education and Research,* later changed to the *Journal of Interior Design.*

1979 The International Society of Interior Designers (ISID) is established to foster design communication internationally with an emphasis on residential design.

1982 Alabama passes the first Interior Design Title Act in the United States. It restricts the use of the title *Interior Designer* to those with specific qualifications. Subsequently, Connecticut (1983) and Louisiana (1984) pass similar legislation.

1984 *The 1995 Hypothesis* is the first prediction of the future of interior design as articulated by the leaders of the major interior design organizations in North America. It addresses requirements for education, experience, examination, licensing, and continuing education.

1985 *Interior Design* magazine initiates the Hall of Fame event in New York to recognize significant contributions by noteworthy interior designers.

1986 The Council of Federal Interior Designers (CFID) incorporates in Washington, D.C. to establish a communication network among federal designers in the United States. Its most important goal is to get the U.S. Office of Personnel and Management to recognize interior design as a profession requiring education and examination. The first Practice Act for Interior Designers passes in Washington, D.C. It restricts the practice of interior design to those who are licensed.

1988	Canada boasts 8 out of 10 provinces with interior design legislation in place. The International Furnishings and Design Association (IFDA) evolves as a result of NHFL expansion and the addition of male members.
1989	Leaders of ASID, IBD, and the American Institute of Architects (AIA) sign the first Accord Agreement on interior design title registration. It addresses career path requirements and legal registration of interior designers. At the same time, NCIDQ activates its new exam eligibility requirements stipulating a minimum of two years of education and two years of practice for a combination of 6 to 7 years of education and practice. And FIDER activates its standards for the first professional degree level of interior design education, leading to a 4–5 year degree.
late 1980s	In response to the increasing complexity of interior design and the specific knowledge required for some projects, interior designers begin to specialize, even more than previously, in particular types of interiors within the broad categories of offices, hospitality, retail, health care, and institutional. For example, some may specialize solely in the interior design of showrooms, legal offices, nursing homes, retail boutiques, restaurants, schools, or hotels and casinos.
1990	FIDER publishes the recognized Common Body of Knowledge in interior design. NCIDQ publishes the updated international Definition of an Interior Designer on behalf of the profession. The Interior Design Continuing Education Council (IDCEC) is formalized from the previous IDEC Continuing Education Forum. The organization's purpose is to review continuing education courses sponsored by the interior design associations in North America.
1992	The IDEC Task Force on two-year interior design programs evaluates educational directions for preprofessional level interior design programs. The *ASID Professional Practice Manual*, the first comprehensive guide for the interior design profession, is published by ASID.
1994	The International Interior Design Association (IIDA) forms in the United States from the merger of IBD, the International Society of Interior Designers (ISID), and the Council of Federal Interior Designers (CFID). Its goal is to represent interior designers worldwide.
1996	The Interior Design Experience Program (IDEP), an entry-level monitored work experience program, is activated by NCIDQ in North America. It supports the career path connection between the accreditation of interior design educational programs by FIDER and the qualifying examination administered by NCIDQ.
2000s	Interior designers become involved with strategic planning, branding, and facilities management as they strive to further assist their clients. Research in design areas expands significantly. Conducted by educators, manufacturers, industry, psychologists, and many others, developments are disseminated by books, journals, and websites.
2002	The British Interior Design Association (BIDA) forms from the amalgamation of the Interior Decorators and Designers Association (IDDA) and the United Kingdom chapter of the International Interior Design Association (IIDA).
2003	FIDER ceases to accredit preprofessional programs in interior design. ASID and the Unversity of Minnesota launch Informe Design, a searchable Internet database for designers of research abstracts on human behavior and the built environment.
2005	Major interior design associations and organizations in North America jointly publish *The Interior Design Profession's Body of Knowledge* by Denise Guerin and Caren Martin. It is the first comprehensive documentation of the profession's evolving knowledge base.
2006	FIDER changes its name to the Council for Interior Design Accreditation (CIDA) to further clarify its mission as the accrediting agency for interior design programs.
2008	NCIDQ begins to require exam candidates to complete all experience under the direct supervision of an NCIDQ Certificate holder, a licensed/registered interior designer, or an architect who offers interior design services.

Architecture
and Interior Design
from the 19th Century
An Integrated History

	
1752	Benjamin Franklin flies a kite
1773	Boston Tea Party is held
1775	American Revolution begins
1776	Declaration of Independence signed in United States
1782	James Watt patents the steam engine
	Argand lamps invented
1783	American Revolutionary War ends
1785	James Cartwright patents power loom
1789	The first use of interchangeable parts is for firearms
1790	England has first steam-powered textile factory
	A machine is invented to cut nails
1800	United States population nears 5,300,000
	Federal government spends $12,500,000 to run country
1807	Robert Fulton builds first steam-powered boat
1810	Metal cans for canning patented
1813	Waltham, MA, is site of first power loom
1815	Vincent Figgins designs Egyptian typeface
1819	First United States oil well in Titusville, PA
1825	Erie Canal opens
1833	Balloon frame construction invented
1836	Numbered patent system begins in United States
	First railroads operate in Canada
1840	Gaslight begins to appear in homes
	Steam-powered circular saw in use
1844	Bigelow invents power carpet loom
	Wallpaper printing machine imported to United States
1854	Otis passenger elevator arrives
1855	Bessemer invents process for mass-produced steel
1865	John Mayo of NYC patents plywood
1869	Thomas Edison invents a printing telegraph
	98,459 patents have been granted in the United States
1870	Margaret Knight invents square bottom paper grocery bags
1871	Portland cement patented in United States
1874	Barbed wire begins to fence in the United States
	Isaac Cole patents a one-piece plywood chair
	Typewriter introduced in the United States
1876	Mechanical calculators start clicking
	Alexander Graham Bell patents telephone
1879	Thomas Edison invents an electric motor
1881	Electric light bulb lights up
1886	Aluminum first produced
1888	First trolley car starts up
1889	First hydroelectric dam constructed
	Gasoline-powered automobiles introduced
1890	Scott Paper puts toilet tissue on a roll
1894	Guglielmo Marconi invents wireless telegraphy
1900	Thomas Edison invents a storage battery
	United States has about 8,000 cars and less than 10 miles of concrete roads
	United States population stands at 76 million
	125,000,000,000 matches sold in the United States
	An item that costs $1.00 would cost $19.95 in 2000

E e

A. REVOLUTION

Almost from its beginning in the mid-18th century, the Industrial Revolution transforms economies, societies, and cultures as well as business, industry, and technology. Industrialization profoundly affects architecture, interiors, furniture, and the decorative arts in form, materials, and technologies. It also changes the way that the creators and consumers think about and produce or use them. The relationship or lack thereof to mechanization colors design over the next century and a half.

One of the most significant effects of industrialization is the democratization of design, style, and fashion as more goods become more available to all levels of society. Individuals learn about the newest fashions and products through World's Fairs, exhibitions, and the media. Eventually, a consumer culture arises to which designers, producers, and retailers must respond. By the mid-20th century, consumerism increasingly drives design in both creation and production.

The spread of mechanization raises questions about the design of buildings and objects, both in terms of their appearance and their effects on people. Artists, artisans, architects, designers, and others will grapple with these issues for many decades. They first ponder whether to accept or reject the machine, and then debate about how to counter its effects on both design and society. Some concentrate on the negative changes in society from industrialization and prescribe transformations in design to bring reforms. Others want to improve the quality and design of goods as well as the taste and discernment of the consumer. Through their writings and/or work, architects, designers, and theorists strive to define a design language for the machine and seek to identify what it means to be modern—how buildings and products should express their own time. Results are numerous, varied, and change over time with new theories and ideas, new art and design movements, and as mechanization is accepted and, even, embraced.

By altering the way that people live and work, the Industrial Revolution affects the appearance and planning of communities and public and private buildings, ushering in new types, new construction methods, new technologies, and new materials that increase comfort and convenience for all levels of society. Architecture and interior types develop or evolve in response to changes in social patterns, business, and industry. Numbers and types of commercial interiors multiply and focus more upon the needs of workers, users, productivity, and function. In residences, people generally live less formally and have fewer social rituals, which inspires new types of rooms and modifications in planning. Although taste and fashion continue to drive the design of most spaces, function becomes an important design concept particularly for kitchens and baths. In both public and private buildings, new types of furnishings develop or older ones evolve in response to changes in working methods, different lifestyles, new technologies, such as the automobile, television, the computer, and the accumulation of goods.

Because of rapidly changing fashions and the sheer number of goods available, people need help in making choices. Books and periodicals giving decorating advice proliferate. Interior decoration services spread beyond architects and artists to include large furniture firms, department stores, individual decorators, and, ultimately, interior designers and design firms. With the increased importance of specialization and professionalization throughout the 19th and early 20th centuries, architecture raises its standards for education and practice and increasingly separates itself from engineering, artisans, and builders. Interior decoration breaks away from architecture and furniture making in the second half of the 19th century. By the mid-20th century, the interior designer with education and training emerges in response to increased emphasis on commercial design and improvements in technology. Additionally, the new professions of furniture and industrial design develop in the early 20th century. By the beginning of the 21st century, architecture, interior design, furniture design, and industrial design are recognized, separate professions. Additionally, the practice of architecture and interior design requires rigorous professional standards with a strong emphasis on the health, safety, and welfare of the public. Legal recognition and licensing become common practice.

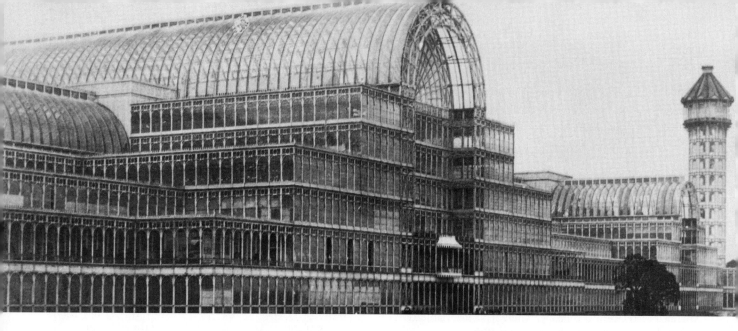

CHAPTER 1

Industrial Revolution

1750–1900s

The Industrial Revolution begins in England in the second half of the 18th century and spreads throughout Europe, North America, and British territories worldwide. Continuing through the 19th century with rapid growth and significant urban expansion, societies are transformed from agrarian economies to industrial ones. New developments in transportation, engineering methods, industrial mechanization, factory production, and construction materials create a new integration of art and technology. Changes in ideas, tastes, and attitudes fostered by the Industrial Revolution lead to innovations in the aesthetics of architecture, interiors, and furnishings—initiating dramatic changes.

HISTORICAL AND SOCIAL

Industrialization gradually, but profoundly, alters economies and societies. Major centers of production such as England, France, and North America feel the impact most significantly.

Today [circa 1900] in the United States alone there are 185,000 miles of railroad, or more than a third of the mileage of the entire world. In 1833, there were but sixteen passenger locomotives in the United States; today there are 10,000.

George B. Waldron, "The Marvels We Have Wrought in One Hundred Years," *The Ladies Home Journal*, 1900

In contrast to German, the modern American house is built entirely from the inside out. It not only corresponds to particular individual demands but above all to the peculiarities, customs, and needs of the Americans. That these customs are pronounced and distinctly marked gives domestic architecture in the United States a great advantage over our own German architecture.

Wilhelm Bode upon visiting the Chicago World's Fair in 1893; *Moderne Kunst in der Vereinigten Staaten*, 1894

Buildings, as things made by man, as artifacts, are conditioned by their designer's knowledge and inspiration and by prevailing trends in construction techniques and in aesthetics.

Dennis Sharp, *Twentieth Century Architecture: A Visual History*, 1991

Improvements in transportation including expanding railway systems and changes in marketing, decrease regionalism, promote homogeneity, and support cultural communication. Urban growth gives rise to larger commercial buildings with more varying types of use. Factories increase in number, size, and complexity, and mass-produced products become more diverse in number and decrease in price. Townhouses and apartment buildings multiply in cities.

The wealthy elites (Fig. 1-1) continue as the tastemakers, but society is no longer governed by aristocratic ideals. Old class divisions begin to disappear. Members of the newly rich, rapidly expanding middle class who are avid consumers become the trendsetters. They direct more attention to their work and home environments, creating a greater demand for goods and services. At the same time, improvements in industrialization and transportation help distribute manufactured products to wider segments of society. Consequently, shopping through catalogs, popular magazines, retail boutiques, and department stores becomes more common as the century progresses. Greater availability tends to make goods disposable; most people no longer have to reuse or make do.

Society continues to be male dominated, and family units remain important. But, as members move to cities seeking employment, families change. Distinct role separations are evident in public and private arenas. Men go out to work daily and encounter social, economic, political, and industrial issues. As in the past, they control government, guard customs, shape policy, determine acceptable standards, and serve as heads of households. Legally, the sole authority for decisions rests with them.

Women remain subservient in the workplace and at home. Regarded as nurturers of the family and guardians of domesticity, they are expected to create homes that are shelters and refuges from the negative effects of industrialization and urbanization. Ideas of home as the expression of the wife's creativity and artistic nature, as well as the culture and character of the family, help organize society, create its rituals, and legitimize shopping. As a consequence, most families are consumers instead of producers, and the wife is responsible for the appearance and management of the home. These ideas continue through the early 20th century.

CONCEPTS

Besides profoundly changing the economy and society, the Industrial Revolution introduces new materials, techniques, and forms to architecture, interiors, and furnishings. It fosters novelty, innovation, and alteration. Although industrialization makes more goods available, it does not ensure that they are well made or well designed. This engenders a century-long debate among critics, designers, and consumers about how manufactured goods should look and who should determine this.

Throughout the 19th century, exhibitions and expositions are innovative testing grounds for new design ideas and the introduction of new products. They also are fresh sources for the introduction of new concepts in interior decoration and furnishings. Manufacturers create their finest, most innovative pieces for these exhibitions and architects design impressive new buildings that affect architectural development. In 1851, the Great Exhibition of the Works of Industry of All Nations held at the Crystal Palace (referred to as the Great Exhibition, and herein as the Crystal Palace Exhibition) in London becomes the largest international exhibition ever held to display machine-made goods as well as handcrafted products. The Great Exhibition establishes Great Britain's industrial supremacy in the world. More exhibitions follow in prominent European and American cities. In 1876, the International Exhibition of Arts, Manufactures, and Products of Soil and Mine (popularly known as the Centennial Exhibition) held in Fairmount Park in Philadelphia celebrates the American centennial and showcases products of art and industry from all over the world. In 1889, the Paris Exposition Universelle (also called the Paris Exposition), featuring the Eiffel Tower, celebrates the centennial of the French Revolution with a spectacular exhibit of products from many countries. These exhibitions help introduce new styles and trends, which are important to consumers who want to be up-to-date and fashionable.

Consumer tastes, speed of production, and distribution dictate the look of manufactured goods. Customers want comfort or, at least, its appearance. Objects must look expensive, which demands visual complexity. Uncertain in matters of taste, the newly wealthy and middle class desire historicism, believing that references to the past indicate taste, gentility, and a liberal arts education. Stylistic

▲ 1-1. "Shilling day at the International Exhibition"; published in the *London News,* July and December 1862.

associations are very important because homes and their decoration reveal the culture and character of the inhabitants. Most people are proud of technological advances and regard them as evidence of progress. They admire the machine and favor machine-carved ornament because it can look handmade but is fashioned in less time and with less expense. Materials that imitate the appearance of other materials also are esteemed, particularly those associated with wealth.

Ultimately, a reaction begins as those who recognize the poor design and quality of manufactured goods look for ways to improve them and reform taste. They also seek to resolve the social problems that industrialization creates and improve the life of workers through better factories and housing. Throughout the 19th century, many reformers advocate rejecting the machine and returning to handmade techniques.

DESIGN CHARACTERISTICS

During most of the 19th century, buildings, interiors, and furnishings look backward in design instead of forward, almost an antithesis of progress. They rarely incorporate new materials and products, but instead rely on those of earlier periods. Old forms, designs, and construction techniques are familiar and therefore less threatening, so new technology may be largely ignored. Historical features from past styles shape the visual language from the mid-18th century well into the 20th century. In some of these periods, classical elements and attributes such as symmetry, regularity, unity, and harmony continue to be important design principles, particularly in facades and plans. In contrast, others seek asymmetry and variety in design.

As the 19th century progresses, the integration of art and technology begins to determine the visual complexity and character of buildings, interiors, and furnishings. Machine production encourages greater variety of aesthetics, resulting in a wider diversity of design images. As time passes, a better understanding of the machine and its possibilities produce recognizable changes in the character of the exterior and interior built environment. Historical references continue but are interpreted in new materials. Elements of past styles may merge with new construction technology and materials. For example, intricate historical details in iron or other materials may contrast with simpler cast iron forms (Fig. 1-2). Period elements appear on iron front buildings, glass and iron ceilings

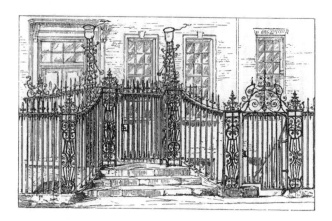

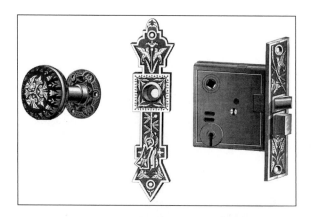

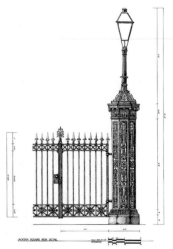

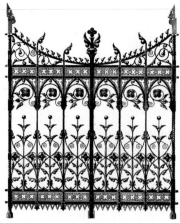

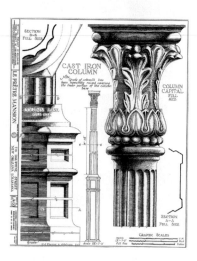

▲ **1-2.** Iron gates, porches, and architectural details.

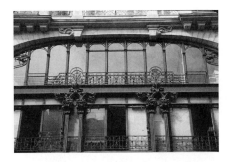
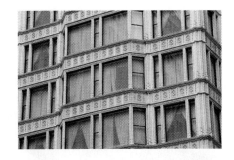
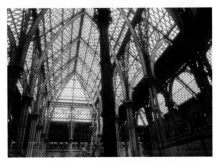
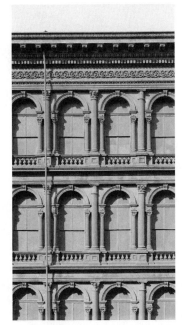
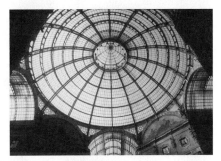

▲ **1-3.** Details of windows from Paris, New York, and Chicago and skylights from Oxford, England, and Milan, Italy.

and canopies, columns and arches, stairways, elevators, heating devices, kitchen stoves, lighting, and office, garden, and bedroom furniture. A recognizable change in the character of the exterior and interior environment illustrates a better understanding of the machine and its possibilities.

As a result of reforms and innovations later in the century, some architecture, interiors, and furnishings begin to display new materials, structural honesty, engineering changes, and mechanical improvements. They may reveal few or no references to past styles, little or no ornamentation, simpler facades and interior decoration, and fewer variations in color. Often there is no specific aesthetic vocabulary derived from the past; instead compositions have unique variations in character, proportion, form, and emphasis, particularly in commercial buildings. Designers carefully articulate parts, which relate to each other and the whole, in proportional and often geometric relationships that emphasize technology and materials. These changes lead to a new visual language that transforms the image of the 20th century.

■ *Motifs.* Motifs generally relate to the period influences and vary within developments and countries. Details that emphasize technology appear later in architecture and interiors, as illustrated on gates, porches, balconies, columns, hardware, chimneypieces, and furnishings (Fig. 1-2, 1-12, 1-22, 1-23, 1-30, 1-33, 1-42, 1-43, 1-44, 1-45, 1-46).

ARCHITECTURE

Social, economic, and technical changes in the 19th century lead to new building types, such as railway stations, shopping arcades, office buildings, and factories. These progressive commercial environments require new materials and construction methods and demand the expertise of engineers to achieve the necessary wide expanses of free open space. A split emerges between engineering and architecture as the century evolves. Engineers focus on the new, functional, and innovative structures, whereas most architects continue designing with traditional styles, materials, and techniques.

Engineering feats provide landmarks and set the stage for significant changes in the direction of design throughout the 19th century. Reflecting improvements in transportation and new construction materials, England leads the transformation. In 1779, the country announces the first iron bridge at Coalbrookdale (Fig. 1-4), and this accomplishment is followed by the Clifton suspension bridge near Bristol, and later the Brooklyn Bridge in New York City. In 1825, railway systems begin in England and expand rapidly there and in other countries as the century progresses. In 1851, gardener Joseph Paxton, using his knowledge of greenhouse construction, designs the Crystal Palace Exhibition building (Fig. 1-7) in London with prefabricated parts for construction, standardized sections of iron and glass, and large expanses of open space. In 1889, Gustav Eiffel leaves his mark through the design of the Eiffel Tower for the Paris Exposition (Fig. 1-11). Continuing the use of prefabricated parts, the tower boasts an early use of the Otis elevator.

Throughout the century, new building types and techniques gradually transform the appearance of architecture into one that integrates engineering technology as a part of the built form. Within this evolution, architects design monumental commercial building facades with embellishments of past styles while creating interiors with innovations in structural form and space but continuing references to the past. Notable European examples include the Bibliothèque

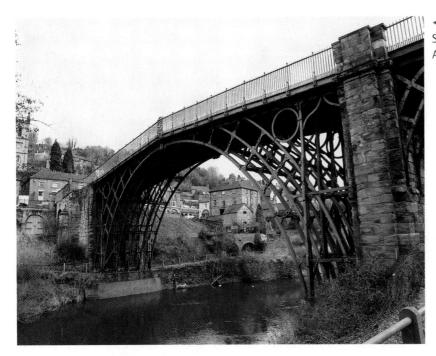

▲**1-4.** Iron bridge, 1779; Coalbrookdale, Shropshire, England; Thomas F. Pritchard and Abraham Darby III.

Nationale (Fig. 1-23), Gare de Nord railway station, and the Bon Marché Department Store in Paris; S. Pancras Station train shed (Fig. 1-24) in London; University Museum in Oxford; and Galleria Vittorio Emanuele II (Fig. 1-25) in Milan. In the United States, important examples include the Concourse of the 1910 Pennsylvania Station (Fig. 1-32) in New York City and the Bradbury Building (Fig. 1-30) in Los Angeles.

Toward the end of the 19th century, commercial buildings appear with little or no reference to past styles and traditional imagery. Often designed by architects, these structures integrate engineering technology, exhibit simplicity in design, emphasize structure and construction,

and display extreme verticality. Many of these buildings have iron or steel-frame construction. Important projects include Les Halles Centrales (Fig. 1-8) and Le Parisien Office (Fig. 1-15) in Paris; Oriel Chambers (Fig. 1-9) in Liverpool; the Fuller Building (Flatiron Building; Fig. 1-14) in New York City; and the Reliance Building (Fig. 1-13) in Chicago. As icons of architectural innovation, they are pioneering examples of modern design that lead to the design movements of the 20th century.

Changes brought by the Industrial Revolution also transform residential construction, most specifically in the invention of balloon frame construction in 1833 by Augustine Taylor in Chicago, Illinois, and prefabricated, mail-order houses later in the century. Balloon framing (Fig. 1-17) reduces housing costs and speeds construction so that home building becomes an industry after midcentury. Eventually, prefabricated housing comes into being. Both balloon framing and prefabricated housing require standardized parts, but use wood construction rather than iron or steel. They offer inexpensive housing alternatives, can be ordered from catalogs, cater to the expanding middle classes, and require no architect for implementation. Both help expansion in Canada and the United States, particularly as settlements move westward.

Public Buildings

■ *Types.* New commercial building types include railway stations, exhibition halls, shopping arcades, department stores, office buildings, factories, warehouses, and industrial buildings, many with large expanses of glass (Fig. 1-5, 1-6, 1-8, 1-9, 1-10, 1-12, 1-13, 1-14, 1-15, 1-24, 1-25, 1-26, 1-29, 1-32).

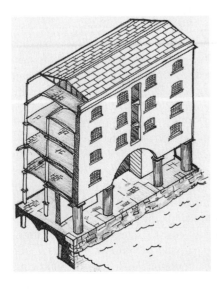

◄**1-5.** Albert (Stanley) Dock, mid-19th century; Liverpool, England.

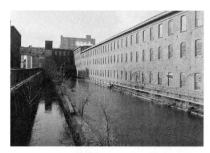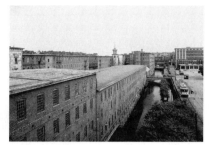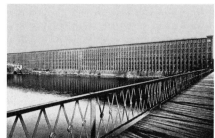

▲ **1-6.** Textile mills, 1821–1836; Massachusetts.

DESIGN SPOTLIGHT

Architecture: Crystal Palace, 1851; London, England; gardener Sir Joseph Paxton. The design concept is new, innovative, and derives from greenhouses and conservatories of the time. As the largest building ever constructed of cast iron and glass, its modular design and prefabricated parts allow factories easily to mass-produce the quantity of components needed. Parts arrive at the site preassembled allowing the construction at an unprecedented rate of months instead of years. Promoted by Prince Albert, the structure showcases the first international exhibition for the display of machine-made goods and handcrafted products. The Exhibition features more than 10,000 exhibits on display from many countries. Interior space encompasses the enormous area of 770,000 square feet. Successful,

fast construction and public acclaim open the door for more buildings like it. After the fair closes, the Crystal Palace is reassembled in a park outside of London. Fire destroys it in 1936.

Architect and designer, Owen Jones decorates the interiors with red, blue, yellow, and white. The vast interiors are filled with displays of industry, machinery, manufactured products such as furniture, fabrics, wallpapers, and numerous consumer goods from England, Europe, and other parts of the world. A series of courts exhibit art and architecture from ancient Egypt to the Renaissance. Among them are the Medieval Court by A. W. N. Pugin (see Chapter 6, "Gothic Revival"), and Alhambra Court by Owen Jones (see Chapter 9, "Exoticism").

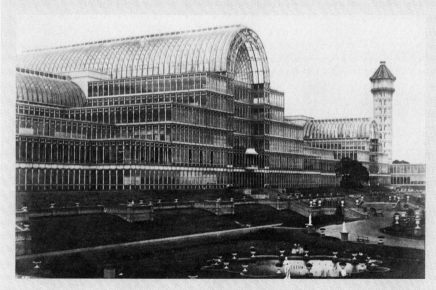

◄ **1-7.** Crystal Palace, 1851; London, England.

■ *Site Orientation.* As a result of the new building types, public structures are sited on urban streets to achieve advantageous locations in the heart of a city (Fig. 1-13, 1-14).
■ *Relationships.* Public and government buildings are large, monumental, and prominent. Consequently, they often dwarf

other surrounding buildings. The design intent is for them to stand out and be noticed (Fig. 1-7, 1-11, 1-13, 1-14).
■ *Floor Plans.* Plans for factories, railway stations, shopping arcades, and other building types grow out of function. Most buildings continue in traditional planning

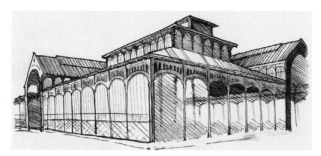

▲ **1-8.** Les Halles Centrales, begun 1853; Paris, France; Victor Baltard and Félix-Emmanuel Callet.

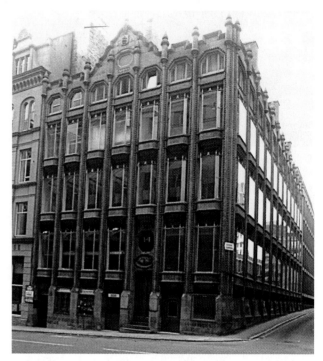

▲ **1-9.** Oriel Chambers, 1864; Liverpool, England; Peter Ellis.

patterns with central vertical circulation cores and partitioned walls, but large public areas change noticeably to encompass huge open areas of space delineated with iron columns (Fig. 1-7, 1-13, 1-22, 1-23,1-29). Offices perhaps evidence the most change as the century progresses, with more attention given to individual work requirements, general storage needs, and better illumination (Fig. 1-31).

■ *Materials.* New materials include brick in more colors and artificial stone. Improved manufacturing processes increase the use of wrought and cast iron decoratively and structurally for columns, balustrades, stair rails, roof trusses, window frames, stairs, and cemetery fences (Fig. 1-12, 1-15, 1-22, 1-23, 1-24, 1-26, 1-27, 1-30, 1-32). New manufacturing techniques, developed in France, increase the availability of glass in many forms, particularly in large sheets.

■ *Construction.* Commercial buildings borrow from engineering innovations. They may exhibit the use of iron and glass for the entire structure or only for roofs and walls. Prefabricated standardized parts derived from concepts of the Crystal Palace (Fig. 1-7, 1-22) are more commonplace as the century progresses. In the 1840s, the cast-iron skeleton essential for tall buildings is used in New York City. By 1853, skyscraper elements are in place with the introduction of the

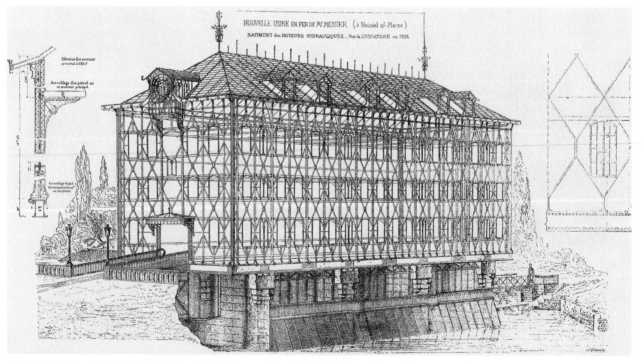

▲ **1-10.** Turbine Building, Menier Chocolate Factory, 1871–1872; Noisiel-sur-Marne, France; Jules Saulnier.

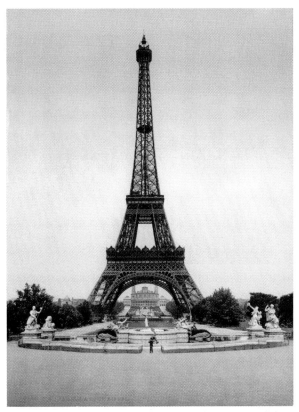

▲ **1-11.** Eiffel Tower, 1889; Paris, France; A. Gustav Eiffel, with elevators by Elisha Graves Otis.

safety elevator in New York by Elisha Graves Otis. Toward the end of the 19th century, the Chicago School architects introduce iron and steel structural skeletons covered by masonry facades, and French architects experiment with load-bearing brick exteriors with reinforced concrete columns on the interiors (Fig. 1-13, 1-27). These new systems will lead to further innovations in the early 20th century.

■ *Paint.* Paint is made up of pigment for color; binder, such as oil or water, to hold it together; and various thinners for application. Some pigments, such as ultramarine, are expensive, and their use is a statement of affluence. Oil paint also is more expensive than water-based paint, so many exterior and interior surfaces are unpainted or simply whitewashed, sometimes with color mixed into the whitewash. Until the late 19th century, individuals mix their own paint, either from pastes or dry pigments supplied by manufacturers. Ready-made paint generally is not available until the third quarter of the 19th century because manufacturing, storing, and shipping paint presents many difficulties that must be overcome. Additionally, a great deal of capital is required to make and supply mixed paint.

As the residential and commercial construction markets grow and capital increases, manufacturers respond with new paint formulas that do not separate and come in resealable containers. In the mid-19th century, green is the earliest successful ready-mixed paint color in the

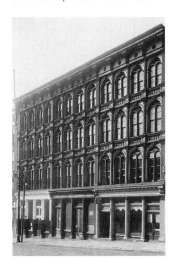

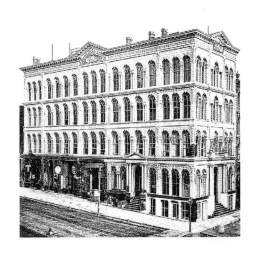

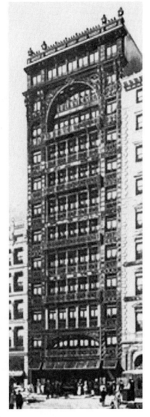

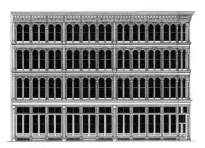

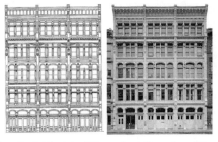

▲ **1-12.** Iron-front buildings, 1870s–1890s; New York, Virginia, Wisconsin, Missouri, and Kentucky.

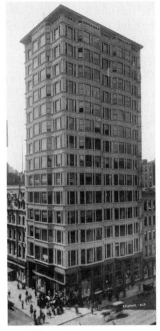

▲ 1-13. Reliance Building and floor plan, 1890–1894; Chicago, Illinois; Daniel H. Burnham, John W. Root.

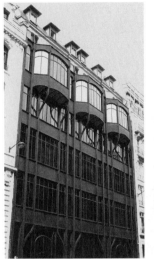

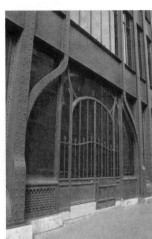

▲ 1-15. Le Parisien Office, 1903–1905; Paris, France; Georges Chedanne.

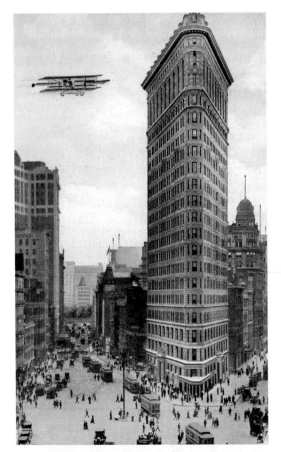

▲ 1-14. Fuller Building (Flatiron Building), 1901–1903; New York City, New York; Daniel H. Burnham. This building was the first steel frame skyscraper in the United States.

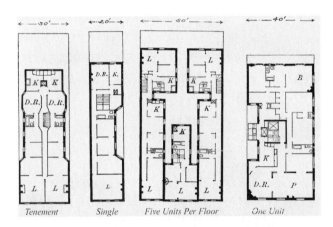

Tenement Single Five Units Per Floor One Unit

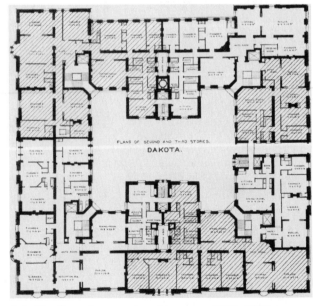

▲ 1-16 Floor plans, apartment houses, c. 1880s–1890s.

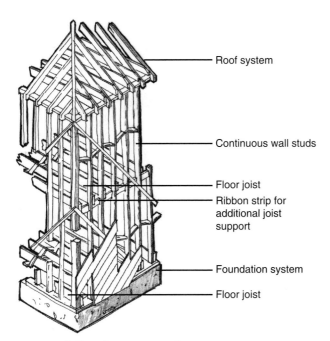

▲ **1-17.** Balloon frame construction.

United States; hence its recommendation by critics and its use for shutters and trim on exteriors. By the late 1860s, manufacturers offer ready-mixed paint in a variety of colors, including earth and stone colors and sanded finishes. Expanded transportation systems bring these products to more consumers. Consequently, color schemes for exteriors and interiors become complex with a multiplicity of colors, and paint makers begin to advertise their products with colorful paint sample cards.

■ *Facades.* Facades of large commercial buildings exhibit architectural features from past styles, classical ordering, design regularity, and monumental scale (Fig. 1-9, 1-12, 1-14). Those that arise primarily from engineering concepts reflect diversity in appearance, form, and scale and often lack ornamentation (Fig. 1-5, 1-10, 1-15).

■ *Windows.* Large expanses of glass in standard sizes become common on all types of buildings. Windows generally are symmetral in scale, shape, and placement (Fig. 1-3, 1-6, 1-13, 1-15).

■ *Doors.* Grand, prominent entry doors define the front facade and announce the public circulation path (Fig. 1-15). Additional doors that repeat this architectural character support entry and exits on various sides of a building.

■ *Roofs.* Roof types and heights vary based on the particular building type and location. Office structures have flatter rooflines with cornices and railway stations display multiple roof heights and forms.

■ *Later Interpretations.* As the 20th century progresses, architecture and engineering technology integrate fully in various types of structures, such as office buildings, hotels, museums, concert halls, shopping malls, and airport terminals. Noteworthy examples include the Seagram Building in New York City; Hyatt Hotel in Atlanta; Pompidou

DESIGN SPOTLIGHT

Architecture: Albert Trinler House; New Albany, Indiana; house and plans published in *American Cottage Homes,* 1878; George and Charles Palliser. This example represents the mail-order house, a type of new residential construction prevalent during the late 19th and early 20th centuries. Illustrated in paperback booklets, they appeal to an expanding middle class seeking inexpensive homes. The Palliser brothers begin their business in Bridgeport, Connecticut, in the 1870s building speculative housing. Their catalogs provide plans, elevations, details, and specifications for a set fee. After purchasing, clients then hire a local builder to construct their new houses. This process becomes common throughout the United States for numerous (and documented) houses in suburb developments (see Chapter 10, "Stick, Queen Anne"). The Industrial Revolution permits the middle class to decorate the interiors of their homes with fashionable and affordable finishes and furnishings that emulate high styles.

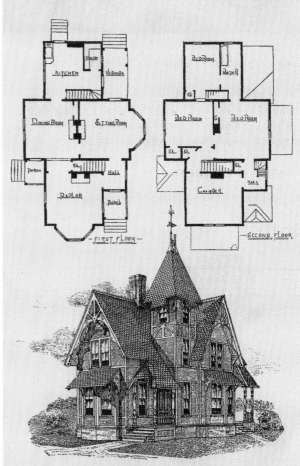

▲ **1-18.** Albert Trinler House.

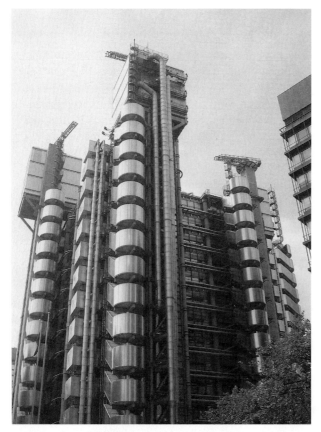

▲ **1-19.** Later Interpretation: Lloyd's Building, 1978–1986; London, England; Richard Rogers. Late Modern.

Center in Paris; Opera House in Sydney, Australia; Lloyd's Building in London (Fig. 1-19); United Airlines Terminal in Chicago; and the Ronald Reagan Washington National Airport (Fig. 1-37) in Washington, D.C.

Private Buildings

■ *Types*. Apartment buildings and residential construction expand everywhere to support the developing middle class (Fig. 1-16, 1-18).

■ *Mail-Order Houses*. House designs copied or ordered by mail from pattern books, trade catalogs, architectural journals, and manufacturing companies become more common as the 19th century progresses (Fig. 1-18). Popular books and sources in the United States include *Rural Residences* (1837), *The Architecture of Country Houses* (1851), *Palliser's American Cottage Homes* (1878), and *The American Architect and Building News* (1876–1890). Publications feature exterior and interior designs, floor plans, and architectural details. Construction materials to build a complete house can be ordered from a variety of catalogs or companies, including Sears, Roebuck & Company.

■ *Site Orientation*. Architects and builders site apartment buildings in urban areas where population expansion is the greatest. They often are in groups arranged around or by a city park, prominent street, and/or waterways. Individual houses may also be located in these areas, but usually have a yard surrounding them. In the 1840s and 1850s, as city centers become overcrowded and overdeveloped, new housing spreads to the suburbs where houses are grouped along smaller streets to create self-contained residential neighborhoods, often with picturesque or romantic-sounding names such as Brook Farm near West Roxbury, Massachusetts, and Kensington and Notting Hill in London. Mail-order houses often appear similarly grouped. Rail lines and the new streetcars support access to these suburbs. As the 20th century evolves, these suburbs become even more common.

■ *Floor Plans*. Dwellings often have more and differentiated spaces with public and private areas more carefully separated. Large houses frequently have new rooms such as double parlors and a conservatory. As the century progresses, kitchens reflect greater attention to appliances, better storage, and functional planning (Fig. 1-34). Bathrooms, which become more common throughout the century, incorporate a sink, tub, toilet, and possibly a bidet, and shower to add convenience and comfort (Fig. 1-35). Although fireplaces remain, other types of heating sources appear, including central heat with radiators (Fig. 1-33).

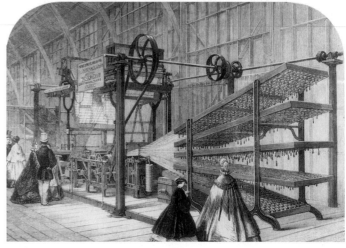

▲ **1-20.** Sewing machine and textile machine looms, mid-19th century.

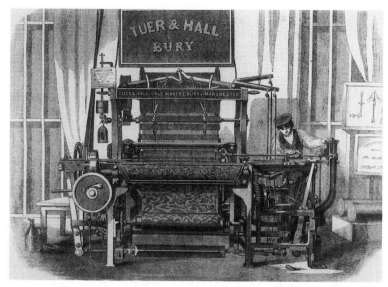
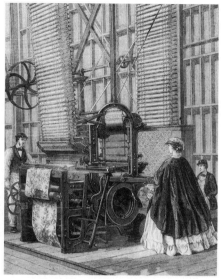

▲ **1-21.** Carpet power looms for producing jacquard, Brussels, and velvet pile carpets and for weaving tufted pile carpets; published in *The Illustrated London News* in 1861–1862.

Elevators gradually supplant stairs as the main source of vertical circulation in multistory apartment complexes.

■ *Balloon Frame Construction*. Residential construction methods, primarily in North America, change during the second half of the 19th century from timber framing with mortise and tenon joints or stacked brick methods to balloon frame construction with prefabricated parts. The new technique incorporates a frame of wooden studs that extends the height of the building, rests on floor joists, and is secured in place with nails (Fig. 1-17). The studs are produced cheaply, in standardized sizes, and delivered inexpensively to a site.

■ *Facades*. Flats or apartments in larger cities such as Paris, London, and New York City boast greater heights, stepped balconies, large windows, and interior space innovations (Fig. 1-16). These facades often illustrate a traditional image based on architectural features of past styles, but plainer, less ornamented buildings emerge toward the end of the 19th century. Houses vary in design concept, but generally represent the popular historical revival styles and influences common to a period, whether they are architect or builder designed or ordered by mail (Fig. 1-18). Consequently, the 19th century is noteworthy for its wide array of styles and compositions including Victorian Revivals, Academic Historicism, and Reform Movements (see these sections for examples).

■ *Later Interpretations*. Apartment buildings and houses of the 19th century serve as excellent sources of reference for residential developments into the 21st century. Designers and consumers then and later draw inspiration from past styles to establish cultural identities, character, and human scale. Examples may closely replicate an original period image or interpret it in a more contemporary manner. As technology continues to improve, exteriors and interiors

integrate new construction methods, building forms, and architectural details.

INTERIORS

The Industrial Revolution supplies new technology that significantly improves the quality of life for many and revolutionizes both work and home environments. Interiors increasingly emphasize function, efficiency, and comfort—considerations that become standard for appearance and beauty in the 20th century. Conveniences derived from

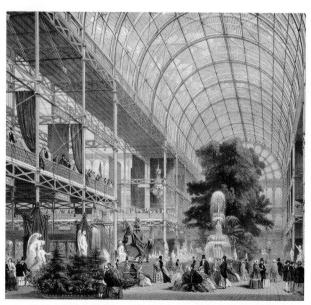

▲ **1-22.** Exhibit Hall, Crystal Palace, 1851; London, England; Sir Joseph Paxton.

IMPORTANT BUILDINGS AND INTERIORS

- **Buffalo, New York:**
 - Guaranty Building, 1895; Dankmar Adler and Louis H. Sullivan.
- **Chicago, Illinois:**
 - Auditorium Building (Roosevelt University), 1887–1889; Dankmar Adler and Louis H. Sullivan.
 - Home Insurance Company Building, 1883–1885; William Le Baron Jenney.
 - Monadnock Building, 1889–1891, 1893; Daniel H. Burnham of Burnham & Root (north half), and William Holabird and Martin Roche (south half).
 - Reliance Building, 1890–1891, 1894–1895; Daniel H. Burnham and John W. Root.
 - Rookery Building, 1885–1888; Chicago, Illinois; Daniel H. Burnham and John W. Root.
- **Glasgow, Scotland:**
 - Firth of Forth Bridge, 1884–1889; John Fowler and Benjamin Baker.
 - Gardner's Warehouse, 1855–1856; John Baird I.
- **Los Angeles, California:**
 - Bradbury Building, 1889–1893; George Herbert Wyman.
- **Liverpool, England:**
 - Albert (Stanley) Dock, 1845; Jesse Hartley.
 - Oriel Chambers, 1864; Peter Ellis.
- **London, England:**
 - Crystal Palace, 1851; Sir Joseph Paxton with interiors by Owen Jones.
 - Leadenhall Market, 1881.
 - Palm House, Kew Gardens, London, 1845–1847; Decimus Burton and Richard Turner.
 - Train shed, S. Pancras Station, 1864–1868; William Henry Barlow and R. M. Ordish.
- **Lowell, Massachusetts:**
 - Boott Cotton Mill, 1821–1836.
- **Milan, Italy:**
 - Galleria Vittorio Emmanuele II, 1865–1867, 1877; Giuseppe Mengoni.
- **New York City, New York:**
 - Brooklyn Bridge, 1869–1883; James A. Roebling.
 - Equitable Life Insurance Company, 1868–1870; Arthur Gilman and Edward Kendall.
 - Fuller Building (Flatiron Building), 1901–1903; Daniel H. Burnham.
 - Grand Central Railroad Terminal Station, 1871, 1903–1913; Reed and Stem, Warren and Wetmore.
 - Harper and Brothers Building, 1884; James Bogardus.
 - Pennsylvania Railroad Terminal Station, 1906–1911; McKim, Mead, and White.
 - Statue of Liberty, 1886; A. Gustav Eiffel.
- **Noisiel-sur-Marne, France:**
 - Turbine Building, Menier Chocolate Factory, 1871–1872; Jules Saulnier.
- **Oxford, England:**
 - University Museum, central court; 1854–1860; Benjamin Woodward.
- **Paris, France:**
 - Bibliothèque Nationale, Main Reading Room, 1858; Pierre-François-Henri Labrouste.
 - Bibliothèque Ste.-Geneviève, 1838–1850; Pierre-François-Henri Labrouste.
 - Magasin au Bon Marchè Department Store, 1876; A. Gustav Eiffel and L. A. Boileau.
 - Eiffel Tower, 1889; A. Gustav Eiffel, with elevators by Elisha Graves Otis.
 - Gallerie des Machines, Exposition Universelle, 1889; Ferdinand Dutert and Victor Contamin.
 - Gare de l'Est, 1847–1852; François-Alexandre Duquesney.
 - Gare du Nord, 1861–1865; Jacques Ignace Hittorff.
 - Les Halles Centrales, begun 1853; Victor Baltard and Félix-Emmanuel Callet.
 - Le Parisien Office, 1903–1905; Georges Chedanne.
 - S. Jean-de-Montmarte, 1897–1904; Anatole de Baudot and Paul Cattacin.

better lighting, heating, and plumbing increase throughout the century. Manufacturers produce more furniture, decorative objects, textiles, and wallpaper for an expanding consumer market. Improvements in rail and ship transportation make products that result in comfortable interiors available to more people. Consequently, rooms have more upholstered seating, carpeting, and practical conveniences.

Commercial interiors evidence technological innovations that integrate historic revival influences or new and later reform design ideas. Most feature at least one or two prominent, large-scaled spaces conveying the overall character and richness of the interior design. In these spaces, architectural details, surface applications, furnishings, and lighting often merge as a unified whole, attesting to the

DESIGN SPOTLIGHT

Interiors: Main Reading Room, Bibliothèque Nationale, 1858; Paris, France; Pierre-François-Henri Labrouste. This important architectural interior illustrates an early use of iron, an innovative structural design, meticulous planning, and large scale. Slender iron columns and arches support nine domes of terra-cotta, each pierced with a glass oculus (skylight). For the first time, modern structural materials are given a decorative and functional role in a significant interior. The vaults and wall surfaces above the built-in bookcases display elaborate Pompeian wall decorations, which offer colorful accents to a generally monochromatic color scheme. Natural lighting penetrates downward from the skylights, and task-oriented lamps on table surfaces provide artificial lighting. The impressive interior maintains a sense of order and organization through its simplicity and lack of clutter.

In contrast, the exterior is not as innovative. The composition utilizes Renaissance forms and details and traditional masonry building materials. Pilasters divide the multistory facade into bays with large rectangular windows, and a prominent entrance highlights the center.

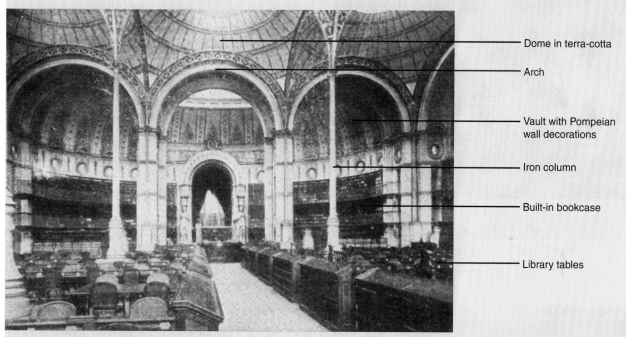

Dome in terra-cotta

Arch

Vault with Pompeian wall decorations

Iron column

Built-in bookcase

Library tables

▲ **1–23.** Reading Room, Bibliothèque Nationale.

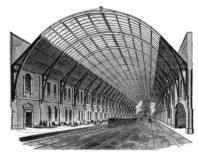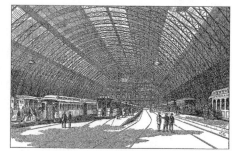

▲ **1–24.** Train sheds, Kings Cross Railway Station, 1852; S. Pancras Station, 1864–1868; and Grand Central Depot (Grand Central Railroad Terminal Station), 1871; London, England, and New York City, New York; Lewis Cubitt, architect for Kings Cross; William Henry Barlow and R. M. Ordish, architects for S. Pancras.

abilities of the designer. Some of these interiors become noteworthy because of their prominence in the community, popularity with the public, individual impressiveness, technological advances, and/or the recognition given the architect or designer. Commercial interiors reflecting new concepts and historic revival influences include the Opera House in Paris; Houses of Parliament in London; and Grand Central Station main concourse in New York City. Commercial interiors exhibiting reform ideas are the Crystal Palace Exhibition building in London (Fig. 1-22); Guaranty Trust in Buffalo; and Carson Pirie Scott in

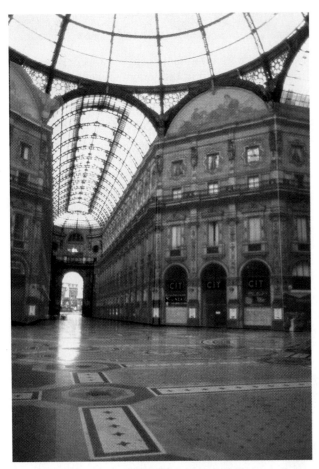

▲ **1-25.** Central concourse, Galleria Vittorio Emmanuele II, 1865–1877; Milan, Italy; Giuseppe Mengoni.

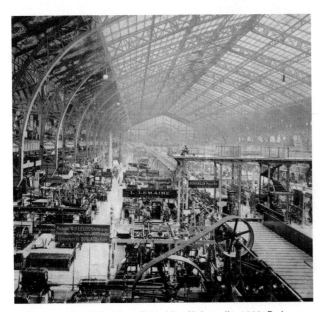

▲ **1-26.** Hall of Machines, Exposition Universelle, 1889; Paris, France.

DESIGN PRACTITIONERS

- **Alexandre Gustav Eiffel** (1832–1923) is a French engineer known for his good craftsmanship and graceful designs for bridges and viaducts. Eiffel casts the Statue of Liberty, which France gives to the United States in 1886. His best-known work is the Eiffel Tower, created to celebrate the Centennial of the French Revolution.

- **Pierre-François-Henri Labrouste** (1801–1875) is an architect who champions the use of modern materials in architecture. Trained at the L'École des Beaux Arts in Paris, he approaches architecture with the concerns of an engineer and opposes a traditional academic approach. His own work is Neo Grec in style and represents a fusion of functionalism with Neoclassicism. One of his most important projects is Bibliothèque Ste.-Geneviève in Paris, which has a masonry facade and interiors with cast-iron columns and skylights. This is the first time modern structural materials are given a decorative and functional role in a significant interior. He later exploits this idea in the Bibliothèque Nationale.

- **Sir Joseph Paxton** (1801–1865), a landscape gardener, designs the Crystal Palace in London to house the Great Exhibition. Based upon his experience with greenhouse construction, he creates a prefabricated cast-iron and glass design that eventually revolutionizes architecture.

- **Michael Thonet**, an innovative designer from Austria, pioneers mass-produced bentwood furniture without complex carved joints and contours and ships it unassembled.

- **Important North American Factories** Berkey and Gay, 1859, and Phoenix Furniture Company, 1870, Grand Rapids, Michigan; Mitchell and Rammelsberg, 1849–1930s, Cincinnati, Ohio; and Paine Furniture Company, 1835, Boston, Massachusetts.

▲ **1-27.** Main lobby, Rookery Building, 1885–1888; Chicago, Illinois; Daniel H. Burnham and John W. Root, with interiors modified or redesigned by Frank Lloyd Wright.

▲ **1-28.** G. G. Elmore, Wholesale and Retail Druggist, 1876; Batavia, New York.

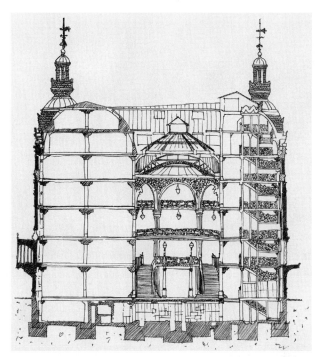

▲ **1-29.** Section, Printemps Department Store, 1881–1889; Paris, France.

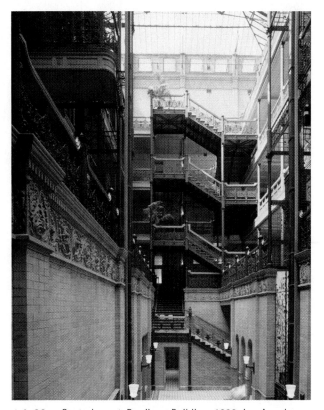

▲ **1-30.** Central court, Bradbury Building, 1893; Los Angeles, California; George H. Wyman. This office interior illustrates an extensive use of wrought iron in the central court and open elevator cages.

Chicago. As icons to architectural and interior innovation, these latter examples have a significant impact on modern design in the 20th century.

Less important commercial interiors may not show as much attention to design but do incorporate the functional aspects required to provide service, convenience, and efficiency for the users (Fig. 1-28). As the 20th century progresses, offices exhibit significant improvements with better work areas, furnishings, equipment, and lighting (Fig. 1-31). Factories and industrial complexes also focus on function over design and improved production systems.

Residential interiors usually follow references to past historical periods. Some interiors feature new materials, such as iron and glass, but forms and motifs generally remain historical until the late 19th century. Some interiors reflecting historic revival influences include those in the Osborne House in southern England and Marble House in Newport, Rhode Island. Residential interiors exhibiting reform concepts are those in the Red House in southern

▲ **1-31.** Offices, *New York Dramatic Mirror* newspaper, 1899, and American Type Founders Company, 1902; New York City, New York.

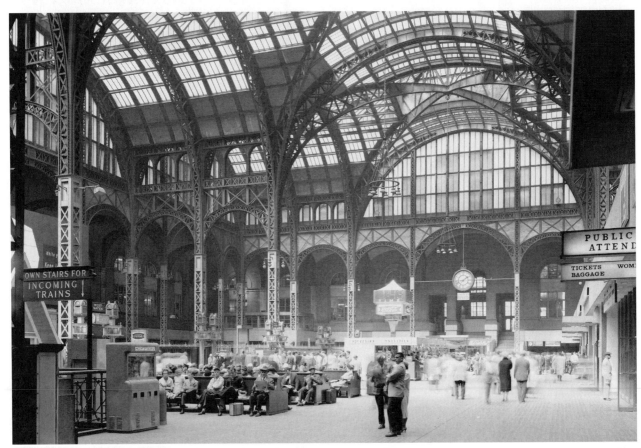

▲ **1-32.** Concourse showing steel frame support system, Pennsylvania Railroad Terminal Station, 1906–1910; New York City, New York; McKim, Mead, and White.

England; Hôtel Tassel in Brussels; and the Isaac Bell House in Newport, Rhode Island. Each of these, as well as others, affects the evolution of residential interiors well into the 20th century.

Throughout the 19th century, architects and designers create residential interiors for wealthy clients who want to convey their status to society. This is also true for design intellectuals who see themselves as innovators in taste and messengers of reform. The expanding middle class, however, looks to other sources for help and advice in decorating. As a result, books related to the design of interiors and their furnishings increase dramatically, especially after midcentury. Written by architects, artists, and dilettantes, these volumes help in the quest for

GOLD'S PATENT "HEALTH" HEATER.

▲ **1-33.** Heating Sources: Chimneypieces, coal grates, Franklin stove, furnace mid- to late 19th century; England and the United States.

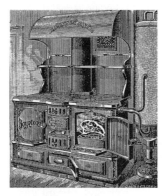

FOR COAL OR WOOD.

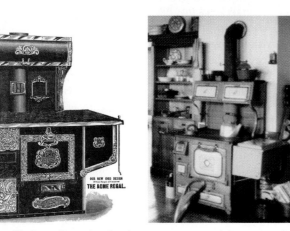

THE ACME REGAL.

▲ **1-34.** Kitchens: Examples showing stoves, ranges, sinks, preparation areas, and storage; late 19th century.

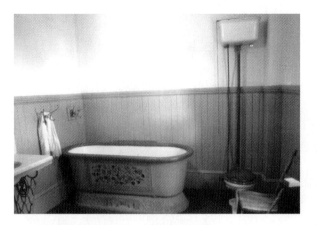

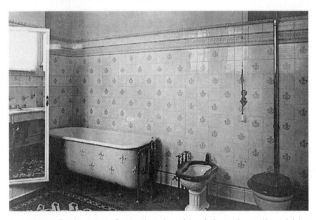
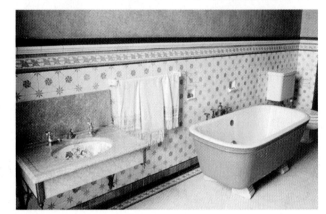

▲ **1-35.** Bathrooms: Examples showing sinks, tubs, toilets, bidets, and storage, late 19th century; United States.

correct home decoration. Kitchens and bathrooms gain importance in the house as more attention is given to function, comfort, and appearance.

Public Buildings

■ *Types*. The most important public spaces are grand rooms designed to impress and garner attention. They usually appear in railway stations as main concourses; exhibition halls as main display areas; shopping arcades as central concourses or retail streets; department stores as central stairwells or retail atriums with balconies; office buildings as main lobbies and central stairwells; hotels as lobbies, ballrooms, and restaurants; and in factories and industrial buildings as entries (Fig. 1-22, 1-25, 1-26, 1-27, 1-29, 1-30, 1-32).

■ *Relationships*. Large, important spaces are on a central axis that defines the major circulation path from outside to inside (Fig. 1-22, 1-30). Sometimes users must go through small vestibules, up grand staircases, or through long corridors to access the space. This process of procession, which is a component of historical influence, adds to the awareness of arrival and may be similar to entering a grand space such as a Gothic cathedral. The desired effect is to impress.

■ *Materials*. The interior materials may repeat the exterior materials in architectural form and details. Interior surface treatments, however, vary depending on the type of structure, with expensive, impressive materials used for important and/or public spaces such as hotel and office building lobbies and less expensive, plainer materials reserved for factories and industrial complexes.

■ *Lighting*. Commercial interiors incorporate natural light through windows and skylights. Industrialization, however, brings significant improvements in artificial lighting in the form of kerosene, oil, gas, and electric lighting fixtures for public and private interiors (Fig. 1-36, 1-39). Whale-oil lamps are more common at the beginning of the 19th century, but by midcentury they diminish in use because whaling ceases to be profitable. The Argand lamp, invented by François-Pierre Ami Argand in 1781, is a tubular wick lamp with an oil reservoir. It greatly enhances overall illumination, but its reservoir casts a shadow. So, Argands soon are followed by lamps with improved designs, such as the astral lamp, and lamps that use alternative fuels, such as lard oil. The portability of oil lamps gives greater flexibility, and they also offer greater illumination than candles do. Plain or embellished with crystal prisms, oil lamps come as chandeliers, lanterns, sconces, or individual fixtures or as pairs for the mantel.

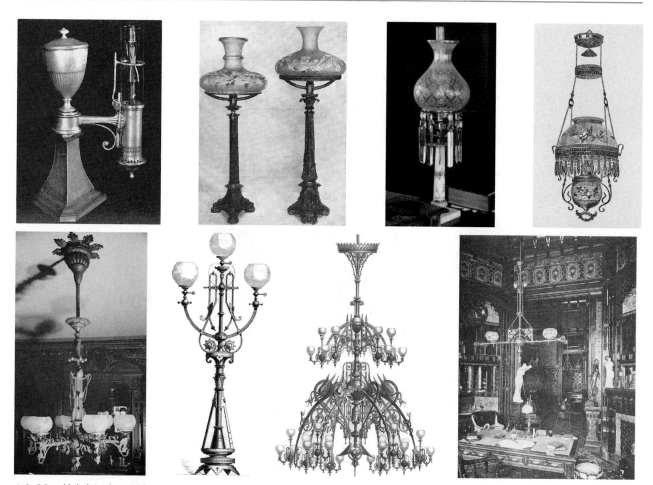

▲ **1-36.** Lighting: Argand lamp, astral lamps, hanging oil lamp, gasolier, hall lamp, chandeliers, late 18th to 19th centuries.

Gas and kerosene revolutionize lighting after midcentury. They are cheaper and seem inexhaustible. During the Regency period, Lord Dundonald introduces gas lighting into his home in 1787. It later is used as street lighting in the Pall Mall area of London in 1807 and Boston in 1817. Created mainly for factories and public buildings, gas lighting is slowly adopted for residences, particularly after midcentury when means to lessen smoke and odors are invented. Gasoliers and gas wall brackets provide even brighter illumination but have limited flexibility because of the rigid stem that houses the gas pipe. Variations of the gasolier may have elaborate stems, two to eight branching arms, etched glass globes, and crystal prisms. Tubes attached to a gas source and a table lamp permit limited portability. Kerosene, a hydrocarbon lamp fuel patented in 1854, replaces oil. Plain or decorated with painted flowers and embellished with crystal prisms, these lamps can be ordered through catalogs such as Sears, Roebuck and Company and often are rewired for electricity at a later date. The electric lamp, invented in 1879, does not come into general use until the early 20th century. Early fixtures combine gas and electricity, a reflection of the uncertainty of consumer acceptance and the early unreliability of these power sources.

■ *Floors*. Floors are of wood, tile, stone, and masonry in simple or complex patterns in both public and private spaces. Wall-to-wall carpeting increases in use with the need for acoustical control and as consumer taste demands it. Industrialization reduces its price and makes less-expensive forms, such as ingrains, more widely available. Carpet's popularity waxes and wanes over the century, especially in homes. After midcentury, for example, design reforms promote wood floors and area rugs over carpet.

■ *Heating*. Although wood-burning fireplaces remain common, other types of heating appear, such as coal grates, Franklin stoves, and central heating (Fig. 1-33). They are also common in residences. Although stoves provide heat from the middle of the 18th century onward, they do not supplant fireplaces because of the associated smells. Central heating systems, in which a wood or coal furnace heats several rooms, are invented in the 1830s. They come into general use toward the end of the 19th century with open floor plan arrangements. Steam heat emerges in the 1850s. Critics favor fireplaces throughout the century, however, believing that stoves and furnaces create bad air.

■ *Later Interpretations*. Public interiors of the 20th century clearly illustrate continuing technological advancements through construction, materials, furnishings, heating and ventilating, and lighting. As the century progresses, even more and varied spaces develop to support user needs, behavioral issues, and environmental considerations. Grand spaces in important buildings continue to command attention because of their design innovations and impressive character (Fig. 1-37).

Private Buildings

■ *Types*. In larger homes, new rooms include double parlors, music and ballrooms, a library, breakfast room, and conservatory. Toward the end of the 19th century, small houses eliminate parlors and other superfluous spaces to reduce costs, to accommodate heating and plumbing, and to make housekeeping easier in an era with few, if any, servants. Kitchens and bathrooms in all levels of housing show significant improvements and design changes.

■ *Kitchens*. Kitchens inside houses are standard during the latter half of the 19th century (Fig. 1-34). In large houses and mansions, servants assist in the ongoing duties whereas in smaller homes, the wife labors alone. Kitchens gradually evolve from multiuse spaces dominated by a fireplace in which meal preparation requires backbreaking labor to smaller spaces with labor-saving appliances that emphasize function, organization, and domestic economy. Although a few early writers attempt to specify efficient kitchens, the new discipline of Home Economics researches principles of kitchen planning during the late 19th century. Widespread adoption of kitchen planning primarily is a 20th-century development.

New appliances, better storage, and efficient planning increasingly define the kitchen floor plan as the 19th century progresses. Cast-iron cooking ranges, introduced in the 1840s, improve in design. Refrigeration remains primitive throughout the 19th century with iceboxes placed in convenient locations for ice delivery instead of in consideration of cooks. The first commercial freezing machine appears in Europe in the 1860s, but practical, compact units for the home are not available until the 20th century. Until municipal waterworks bring running water into the home, servants or housewives either carry water into the kitchen in buckets or use a hand pump. Metal or cast-iron sinks materialize in the second half of the 18th century and become more evident throughout the 19th century. Built-in kitchen cabinets arrive in the 1920s.

■ *Bathrooms*. Concerns for health, sanitation, and convenience provide the impetus for bathrooms to be incorporated into the house (Fig. 1-35). Throughout the 19th century, people use outdoor privies and bathe at washstands or in small tubs brought into the house for that purpose. Bathrooms require an adequate water supply and sewerage, which do not become common until municipal waterworks supply them. Hotels begin to have water closets and bathtubs, beginning in the late 1820s.

Primitive types of water closets have existed since ancient times, but the first patent for a water closet that empties the bowl is given in 1772 to Alexander Cumming, an English watchmaker. Improvements continue, but water closets remain expensive, and people distrust having them inside their homes. The early built-in bathtub is of wood lined with tin or copper and is rare until the mid-19th century. Cast-iron tubs with plain or enameled finishes and faucets appear in catalogs during the 1870s. Lavatories or sinks are uncommon because people perform these ablutions in their bedrooms with bowls and pitchers. Although some appear in the late 19th century, bathrooms with toilets, tubs, and sinks are largely a 20th-century development. It is not until the 1920s that bathrooms assume the appearances and multiple functions, such as shaving, applying makeup, and brushing teeth, that are common today.

■ *Color*. Hues are brighter and come from synthetic pigments. Artificial dyes offer a wider range of colors than earlier. New hues include chrome yellow, ultramarine blue, and bright green. Colors also reflect changes in lighting, so with dim light in earlier periods, colors are intense.

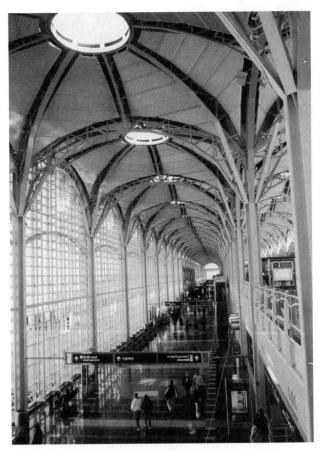

▲ **1-37.** Later Interpretation: Airline Terminal, Ronald Reagan Washington National Airport, 1997; Washington, D.C.; Cesar Pelli.

As illumination increases with the introduction of electric lighting, colors become paler. This also reflects an increasing emphasis on health and sanitation concerns because white is regarded as sanitary. Customs change too, with more social activities in the home at night, so there is a preference for rich, cheerful colors that are attractive at all times. Various publications promote the use of certain colors for particular spaces and to replicate historical styles.

■ *Lighting.* As with commercial spaces, domestic interiors use kerosene, oil, gas, and electric lighting fixtures (Fig. 1-36). Types of lighting and specific features common to commercial spaces repeat in residential interiors.

■ *Wallpaper.* With the introduction of continuous rolls of machine-made paper and roller printing in the first quarter of the 19th century, wallpaper becomes cheaper and more readily available than earlier hand-blocked papers are. Machine-made papers have smaller repeats printed with thinner inks on standard sizes of paper. Decorating and advice books promote wallpaper, so its use increases throughout the 19th century. Each historical or revival style has its own colors and patterns.

■ *Textiles.* Mechanization of textile production begins in the second half of the 18th century. By the first half of the 19th century, power looms and improvements in cylinder printing and dye technology are producing a greater variety of cheaper textiles, so their use increases (Fig. 1-20, 1-21). Textiles are block printed until about 1818 when roller printing begins to take over. About midcentury, wall-to-wall carpeting becomes common for important rooms, opulent window treatments are more universal, upholstered furniture increases, and a variety of textiles appear in a room. After the second half of the century, interiors are filled with doilies, antimacassars, mantel and shelf lambrequins, lamp mats, and table covers often made by the ladies of the house.

FURNISHINGS AND DECORATIVE ARTS

The furniture industry gradually mechanizes during the 19th century. Standardized parts and machine-carved ornament replace much handwork. By midcentury, large

Furniture: Chairs, rocker, and table, mid- to late 19th century; Vienna, Austria; published in *The Illustrated London News*, 1862, and exhibited at the Centennial International Exhibition in 1876; Michael Thonet. In the 1830s, Thonet patents a method for mass-producing bentwood furniture made of beech rods in standardized parts. The curved, contoured frames have no complicated carved joints, so they are easy to assemble. Variations of the main chair design include the popular Vienna Café chair, bentwood rocker, and several tables. Chairs are shipped all over the world and frequently used in restaurants because they were light, strong, and portable. In 1851, Thonet shows his furniture at the Crystal Palace Exhibition and later at the Centennial International Exhibition in 1876. Both exhibitions help popularize his furniture throughout Europe and North America.

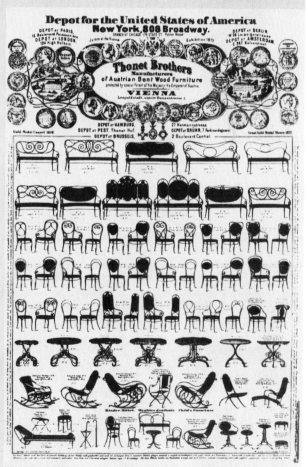

▲ **1-38.** Chairs, rocker, and table, mid- to late 19th century.

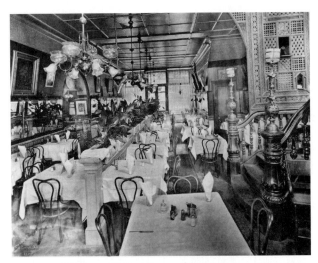

▲ 1–39. O'Neill and Bristol Oyster and Chop House, 1906; New York City, New York.

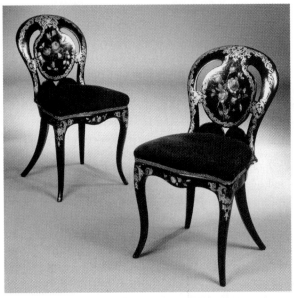

▲ 1–41. Chairs in papier-mâché, mid-19th century; England.

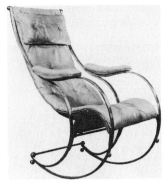

◀ 1–40. Rocker, mid-19th century; Peter Cooper.

manufacturers begin to replace small shops. Workshops of individual craftspersons making furniture at customers' requests manage to survive into the 20th century by adopting labor-saving devices. Factories, located near large stands of timber, water, and railways, produce quantities of furniture and ship them to retailers, furniture shops, and department stores that sell them to consumers.

Catalogs become a popular source of furnishings for the middle class to support a growing interest in selection, quality, and price. Through books and periodicals, the middle and working classes see the latest fashions and attempt to copy them in less expensive ways such as do-it-yourself instructions. Following the Crystal Palace Exhibition of 1851, almost yearly international expositions promote the latest styles. Manufacturers create their finest, most innovative pieces for the exhibitions and people flock to see them.

Furniture for the home, the workplace, and the garden illustrate many changes resulting from the Industrial Revolution. Office furniture (Fig. 1-31, 1-42, 1-43) becomes more diverse in function, type, selection, and materials—this diversity and the exponential growth of industry lead eventually to the rise of major office furniture manufacturers in the 20th century. Furniture for the home offers more

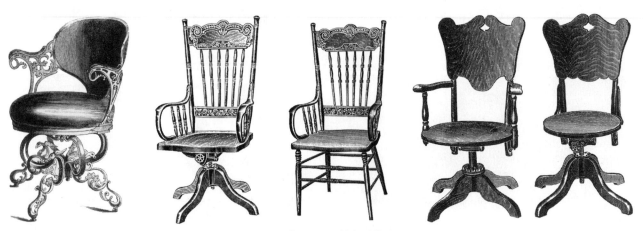

▲ 1–42. Office Furniture: Chairs and desks, mid- to late 19th century; United States.

flexibility, and new and various types increase throughout the 19th century. Built-in furniture becomes more common later in the century in some reform developments. During the reign of Queen Victoria (1837–1901) in England, gardens are important, so garden furniture (Fig. 1-44) appears in formal settings outdoors as well as in conservatories. Cast-iron garden furniture often incorporates traditional motifs from nature, such as a fern pattern.

Our Special $12.75 Roll Top Desk.

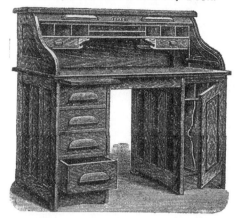
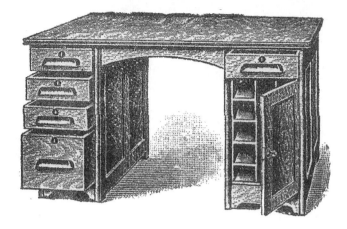

▲ **1–42.** *(continued)*

DESIGN SPOTLIGHT

Furniture: Cabinet secretary (Wooten desk), Centennial International Exhibition, 1876; Philadelphia, Pennsylvania; manufactured by the Wooten Desk Company in Indianapolis, Indiana. Renaissance Revival. The Wooten desk, an example of ingenious patent furniture, is wildly popular in the 1870s and 1880s. Shown in the Centennial International Exhibition in 1876, the Wooten desk, with its numerous drawers, files, and pigeonholes inside to assist with paper organization, becomes a symbol of status and orderliness for the prosperous businessman. The functional design emphasizes efficiency, flexibility, and practicality. Made in four models with varying prices, custom forms are also available. The invention of the typewriter and other forms of office equipment renders Wooten desks less functional.

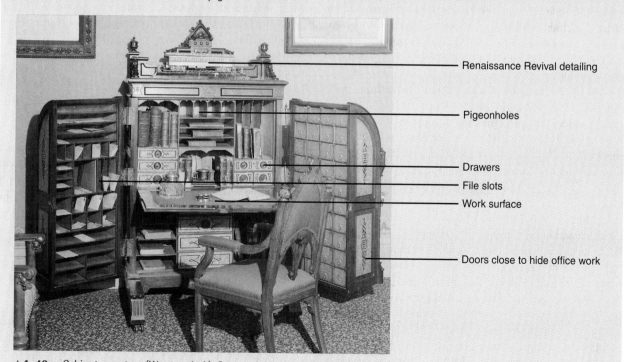

— Renaissance Revival detailing

— Pigeonholes

— Drawers
— File slots
— Work surface

— Doors close to hide office work

▲ **1–43.** Cabinet secretary (Wooten desk), Centennial International Exhibition, 1876.

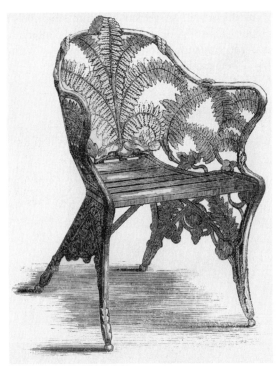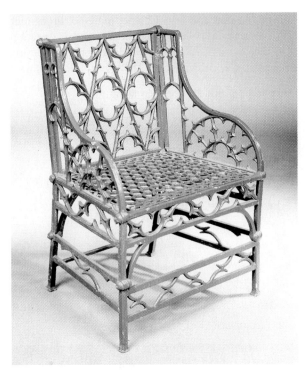

▲ **1-44.** Garden Furniture: Chair and bench in cast iron, mid-19th century; United States and England.

Public and Private Buildings

■ *Types*. Victorians are fascinated with furnishings that accommodate a multiplicity of functions or support new functions and use new materials such as iron, spring steel, and papier-mâché (Fig. 1-41). New types of furniture for offices include multicompartmented desks and filing cabinets. In gardens (Fig. 1-44), iron seating and plant stands appear. Cabinets with folding beds, sofas, or chairs are available.

■ *Mail-Order Furniture*. In the late 19th century, mail-order furniture allows the middle class to be stylish at reasonable prices. In North America, companies such as Sears, Roebuck and Company; Montgomery Ward and Company; the Hudson Bay Company; and manufacturers in Grand Rapids, Michigan, market their goods through catalogs that feature all types of furniture for both the office and home (Fig. 1-45). These catalogs provide the foundation for a major furniture industry that flourishes throughout North America and Europe in the 20th century.

■ *Relationships*. Furnishings become more movable, reflecting changes in lifestyles and in lighting. Formal, static furniture groupings evolve to less formal and more flexible ones. Arrangements continue to take advantage of natural lighting, but new, portable sources of illumination permit greater placement variety. Gas lighting causes furniture to assume a more fixed location to garner the most illumination possible. This may be in the center of a room or around the perimeter. For example, in offices,

desks are next to a gas wall sconce or window and in a parlor, a table with chairs may center directly under a gasolier while other chairs are located by the windows. Aided by new artificial lighting, furniture arrangements later migrate to various locations in a room. With the advent of electric lighting, furnishings group near electrical outlets.

■ *Materials*. New materials include papier-mâché, coal, iron, zinc, steel, and rubber. Cane, rattan, and wicker furnishings, although not new, are fashionable. Cast iron is popular for garden furniture, beds, umbrella stands, and hallstands. Metal becomes common for use in furniture parts, such as the coil spring.

■ *Papier-Mâché*. Composed of molded paper pulp with glue and other additives, this material is applied to a metal frame and lacquered black. Decoration consists of inlaid mother-of-pearl, painted flowers, and gilded scrolls in Rococo or Renaissance Revival styles. Popular after the 1850s, examples of papier-mâché furniture most often include chairs, sofas, tables, and beds (Fig. 1-41).

■ *Construction*. Machine-made furniture gradually replaces handmade throughout the 19th century. Patents for new inventions such as planers, band and circular saws, lathes, carving and boring machines facilitate the process. In the 1830s, Michael Thonet in Austria pioneers mass-produced bentwood furniture that is shipped unassembled (see Design Spotlight; Fig. 1-38, 1-39). Exhibited widely, his furniture becomes popular throughout Europe and North America.

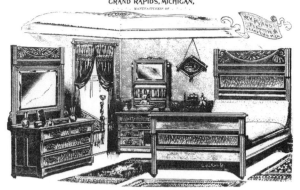

New England Furniture Company,
GRAND RAPIDS, MICHIGAN,

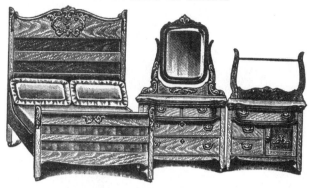

One of Our Handsomest and Latest Design Bedroom Suites for $16.95.

▲ **1–45.** Mail-Order Furniture: Bedroom suites, c.1890s; Grand Rapids, Michigan, and Chicago, Illinois.

John Henry Belter, a Rococo Revival cabinetmaker (see Chapter 8, "Second Empire, Rococo Revival"), perfects a process of laminating and bending woods that can be elaborately carved. His name becomes synonymous with high-quality furniture that integrates machine and hand-crafted production methods. The invention of coil springs in 1822, by George Junigl of Vienna, gives rise to overstuffed furniture with rounded edges and deep tufting, which is fashionable during the Victorian period and into the 20th century.

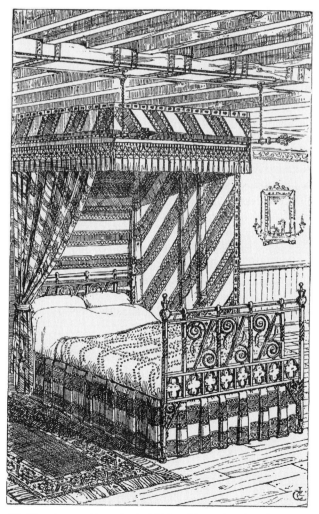

▲ **1–46.** Iron and brass beds, 1864 and 1897; London, England, and Chicago, Illinois; examples from *Hints on Household Tastes* and mail-order beds from Chicago manufactured by Montgomery Ward and Company and Sears, Roebuck and Company.

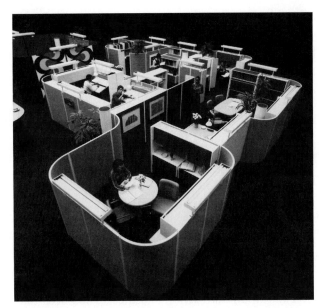

▲1-47. Later Interpretation: Systems furniture, 1990s; Zeeland, Michigan; manufactured by Herman Miller Inc. Late Modern.

IMPORTANT TREATISES AND CATALOGS

- ***The American Woman's Home,*** 1869; Catherine E. Stowe and Harriet Beecher Stowe.
- ***Bicknell's Village Builder,*** 1872; Amos J. Bicknell.
- ***Cast Iron Buildings,*** 1856; James Bogardus.
- ***The Model Architect,*** 1852–1873; Samuel Sloan.
- ***Palliser's Model Homes,*** 1878; George Palliser.
- ***The Scientific American Architects and Builders Edition,*** 1885–1905.
- **Periodicals:**
 - *The American Architect and Building News,* beginning in 1870s.
 - *Godey's Lady's Book and Lady's Magazine,* 1830–1898.
 - *House Beautiful,* beginning in 1896.
- **Catalogs:**
 Thonet Company; Sears, Roebuck and Company; and Montgomery Ward and Company are a few of the many available.

■ *Seating.* New types of seating emerge throughout the 19th century, reflecting the new types of interior spaces for work, play, and home. For example, Thonet's numerous bentwood chairs become symbols of the Vienna café society. Exhibitions and mail-order catalogs carry iron garden furniture with decorative scrolls and foliage (Fig. 1-44). Multipurpose furniture, auditorium seating, ice cream parlor chairs, metal rockers, and barber chairs become more commonplace (Fig. 1-40). Designs feature various historic revival styles as well as more modern interpretations with no evident style.

■ *Office Furniture.* New, expanding offices have large desks, swivel office chairs, stationary and revolving bookcases, and portable and/or built-in storage units (Fig. 1-42). Functional considerations are paramount as a result of an increase in paperwork. Introduced in the 1870s, the Wooten desk with its numerous drawers, files, and pigeonholes, helps businessmen organize their papers (Fig. 1-43).

■ *Beds.* Exhibitions and catalogs have a wide diversity of choices, some plain and others more elaborate. Suites of bedchamber furniture in wood increase in popularity with middle-class consumers as manufacturing processes expand (Fig. 1-45). Critics promote beds of iron or brass in prevailing styles as more sanitary than wood (Fig. 1-46).

■ *Later Interpretations.* As specialized interiors increase in the 20th century, furniture designs change to support different aesthetic movements, functional needs, production methods, and consumer tastes. One of the most significant changes is the development of office systems furniture in the late 1960s. Building on precursors, office systems designs of the late 1990s promote a machine aesthetic, advanced technology, functional needs, integrated lighting, and human behavioral considerations (Fig. 1-47).

1751	Denis Diderot begins publishing the first encyclopedia
1778	La Scala opens in Milan with Salieri's *L'Europa riconosciuta*
1789	George Washington becomes president
	French Revolution begins
1791	U.S. Bill of Rights ratified
1792	France declared a republic and heads roll
	United States Capitol begun
1793	First powered textile mill in Pawtucket, RI
1796	Asher Benjamin writes first U.S. pattern book,
	The Country Builder's Assistant
1797	Hannah Foster writes first American best-seller, *The Coquette.*
1800	Thomas Jefferson elected president of United States
1803	Louisiana Purchase dramatically increases
	size of United States
1804	Napoleon becomes emperor in France
1807	Industrial employment overtakes agriculture in England
1808	Beethoven composes the *Fifth Symphony*
1812	Greece loses the Elgin Marbles to England
	War of 1812 begins between United States and Britain
	First gas company starts in London
1813	The waltz is performed in ballrooms
	around the world
1815	Napoleon defeated at Waterloo
	East Indies Mount Tambora casts a pall everywhere
	Congress accepts Thomas Jefferson library to begin the Library of Congress
1817	Baltimore adopts gas street lighting
1819	L' École des Beaux-Arts opens in France
1822	First steam railways serve Britain
1824	British stone mason Joseph Aspdin
	patents Portland cement
1830	First U.S. locomotive goes into service in South Carolina
1832	Mrs. Trollope notes the *Domestic Manners of Americans*
	Luman Reed builds the first gallery for art
	in the United States
1837	The Commission for Historic Monuments begins in France
	Victoria becomes queen of the United Kingdom
1840	Thomas Cole, *The Architect's Dream*
1842	First Christmas cards are printed in England
1845	**Robert Besley designs Caslon typeface**
	Frederick Douglass, *Narrative of the Life of Frederick Douglass*
1846	U.S. Congress declares war on Mexico
	Richard Morris Hunt, first American to enroll in L' École des Beaux-Arts
	A. Gesner distills kerosene for lamps
1848	Karl Marx, *Communist Manifesto*
	First major operation under anesthesia
1850	Issac Singer patents his sewing machine
1853	S. Nicholas, first million-dollar hotel, opens in NYC
1854	Duncan Phyfe dies at 86
	Henry David Thoreau, *Walden*
1856	State of Tennessee purchases President Jackson's Hermitage
1857	First mass-produced portable sewing machine made in United States

B. LATE NEOCLASSICAL

Neoclassicism is an international movement, beginning in Rome and France in the 1740s, that strives to imitate or evoke images of classical antiquity in art, architecture, interiors, furniture, decorative arts, landscapes, literature, dress, and behavior. Although continuing the classical traditions of the Renaissance (15th and 16th centuries) and Baroque (17th century), Neoclassicism draws from a wider range of prototypes and cultures, including Egypt, Greece, Rome, and the Etruscans. Archaeology and studies and publications of ancient structures by scholars, architects, designers, and artists provide images and information about these ancient cultures. Early Neoclassical manifestations can be plain and monumental or express lightness, grace, and refinement. Classical forms and motifs are always evident.

Late Neoclassical begins about 1790 when the style sheds its Roman complexity and ornament for an image that is simpler, often more political, and more inspired by ancient Greece than ancient Rome. By this time, scholarship indicates that Greece influenced Roman art to a far greater extent than was previously thought. Increased admiration and appreciation for ancient Greece leads to a preference for the simplicity of its art and architecture. Drawing from scholarship and archaeology, architects and designers emphasize archaeological correctness and often copy or adapt antique examples for architecture, interiors, furniture, and decorative arts. Following the French and American Revolutions, Neoclassicism aligns with the new, more democratic forms of government and becomes a favored style for government buildings and artistic propaganda. By the 1820s (earlier in England), designers begin to tire of the limitations of classicism and seek inspiration in other periods, such as the Middle Ages, and different cultures, such as that of China.

Late Neoclassical France, under Napoleon I, resumes her leadership in art and design. Like previous monarchs, Napoleon recognizes the importance of art to the state. His principal architects, Charles Percier and Pierre-François-Léonard Fontaine, create the Empire style to glorify the emperor and help legitimize his reign. The Empire style in France largely manifests in interiors and furniture because little noteworthy building takes place. In imitation of Napoleon I, other European sovereigns and nobles adopt Empire for their surroundings. The middle classes in Germany and Austria follow a simplified Empire style known as Biedermeier. Lacking an emperor to glorify, neither England nor America develops a strong Empire interior style, but French Empire furniture is fashionable in both countries.

Greek Revival originates in England as the first of the great architectural revival styles of the 19th century. It is more popular and lasts longer in Scotland, Germany, and America. The style in all countries is associated with new building types, such as museums that are regarded as temples of art. In Germany and America, Greek Revival acquires political overtones. In the United States, it becomes a visual metaphor for the democratic government (temples of democracy), whereas Greek Revival represents the German spirit in Germany. In contrast, the Picturesque or Romantic Movement in England promotes a greater taste for other cultures and modes. Empire or classical is but one aspect of England's Regency period, which shows, as well, influences from Greece, Rome, Egypt, China, India, and Gothic.

During the early 19th century, the changes brought on by the Industrial Revolution increase, making its influence felt more than ever before. New technology and inventions facilitate mass production, which makes an increasing array of goods available to more people. Periodicals join books as the means of spreading the newest styles and fashions. Revivalism begins to take hold in all countries.

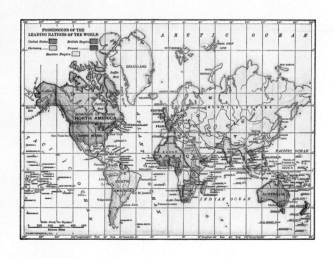

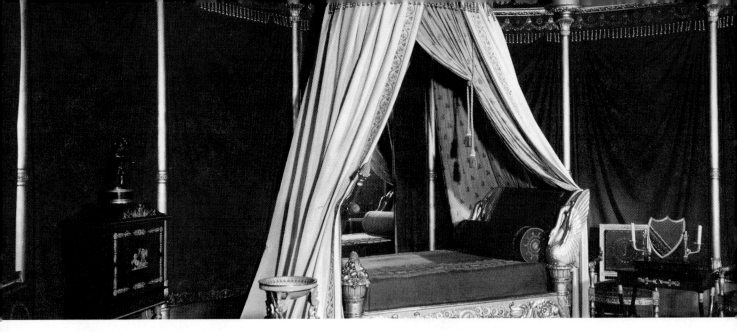

CHAPTER 2

Directoire, French Empire

1789–1815

I sealed the yawning abyss of anarchy, and thwarted chaos. I cleansed the Revolution, raised up peoples and strengthened monarchy. I inspired all forms of ambition, rewarded merit on every occasion, and stretched the bounds of fame. All that surely amounts to something! On what grounds could I be accused that would make it impossible for any historian to defend me?

Napoleon Bonaparte, Mémorial de Sainte-Hélène, 1823.
Conversation with General Las Cases, Saint Helena, May 1, 1816

Persuaded as we are that this sickness, which is that of modern taste . . . , must find its treatment and cure in the examples and models of antiquity— followed not blindly but with the discernment suitable to modern manners, customs, and materials—we have striven to imitate the antique in its spirit, principles, and maxims, which are timeless.

Percier and Fontaine,
Discours préliminaire, Recueil de décorations intérieures, 1801

Neoclassicism dominates the period, although it changes in response to political and social developments. Little important building takes place, so interiors and furniture manifest stylistic developments. In interiors and furniture, the simple, plainer Directoire defines the beginning of the post-Revolutionary period and evolves into the heavier, more majestic Empire. Architect–designers Charles Percier and Pierre-François-Léonard Fontaine create the style, as dictated by Napoleon Bonaparte as Emperor of France. The image glorifies the Emperor and creates a heroic vision through grandeur, military images, and Roman Imperial motifs, which reinforces the historic references of Napoleon's Empire.

HISTORICAL AND SOCIAL

The French Revolution, which begins with great hopes of changing injustices in the political and social systems, deteriorates into terror, violence, and random destruction. Ultimately, for real and trumped-up crimes against the people, members of all classes are executed, including King Louis XVI and his queen. Between 1789 and 1795, new regimes rise and fall quickly, leaving the country in shambles—its political, economic, and social systems all but destroyed.

A five-person Directory, as stipulated by the new constitution, governs France during the period of 1795 to 1799.

Although it makes some progress in restoring the country economically and socially, its incompetence and dishonesty limit its effectiveness. Additionally, conflicts between the Royalists, determined to restore the monarchy, and the Jacobins, who want a democratic republic, threaten the fragile peace. Hoping to increase financial stability, the Directory authorizes military aggression abroad and appoints Napoleon Bonaparte as commander-in-chief. Military victories reap some success while earning Napoleon recognition and helping to restore French confidence.

During the years of the Directory, a different social life and structure evolve in France. A nouveau riche class of businessmen, financiers, and speculators begins to display its wealth in newly purchased and refurbished townhouses that once belonged to the aristocracy. Times that are more settled foster tastes for luxury and pleasure, and fashionable society once again attends concerts, plays, games, and fireworks. Dress becomes more colorful and increasingly emulates the Classic Greek and Rome of antiquity (Fig. 2-1). The middle class assumes a new and greater importance.

By 1799, the power and influence of the Directory are so deteriorated that Napoleon, along with others, easily seizes power in a coup d'etat. Napoleon sets up the Consulate, with himself as Premier Consul, and strives to unify France, heal the wounds of the Revolution, and create a stable government. Gradually, he increases the powers of the Consulate, while decreasing those of the various legislative bodies. In 1802, he revises the constitution to declare himself Consul for life. In 1804, Napoleon declares himself Emperor, and thereby dissolves the Consulate and establishes a hereditary monarchical regime in France (Fig. 2-2).

Although he presents himself as a man of peace and defender of the Republic, Napoleon believes that the way to peace is through military might. In 1805, he renews aggression against the nations of Europe. To ensure his continued influence in the lands that he conquers, he installs members of his family as rulers. However, his efforts to enforce a blockade against Britain and to invade Spain and Russia lead to the Empire's downfall. Napoleon abdicates in 1814, and Louis XVIII, younger brother of Louis XVI, becomes king.

Despite his tyranny and dictatorship, Napoleon's enlightened policies are good for France. He sets up the *Code Napoleon* to preserve political and social advances made during the Revolution and reestablishes the Catholic Church as state church. He promotes the arts and industries of France, strives for greater opportunities in education, and supports universal suffrage for men.

French society during the time of the Empire is as glittering and magnificent as when the Bourbons reigned. Realizing the advantages to the Empire and society as a whole, Napoleon requires brilliant entertainments, although he rarely participates himself. Court etiquette and dress again become as rigid and codified as in the days of the French monarchy. Following the lead of Empress Josephine, Empress Marie Louis, Madame Récamier, and other noble women who are aware of the latest innovations in design commission the finest of furnishings for their homes. They host *salons*, which are once again fashionable. As the period progresses, women's freedoms, acquired during the Directoire period, diminish. Napoleon opens more schools for women, but their learning is restricted to such things as painting, dance, and sewing. The *Code Napoleon* reestablishes the husband as head of the house, so women again take a secondary role and are expected to remain at home.

CONCEPTS

Neoclassicism characterizes French architecture throughout the period. In contrast three styles—Directoire, Consulate, and Empire—define interiors and furniture. Like architecture, they stem from Neoclassicism, but each has a different focus and appearance that reflects the political and social climate of its day. Nevertheless, architecture, interiors, and furniture reveal symmetry, horizontality, proportions evolving from slender to heavier, classical details, and an emphasis upon archaeological correctness or accuracy in design.

▲ **2-1.** Women's costumes, Directoire and French Empire, c. early 19th century.

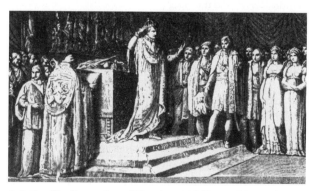

▲ **2-2.** The Coronation of Napoleon at Milan on May 23, 1805.

IMPORTANT TREATISES

- *Choix de plus célèbres Maisons de plaisance de Rome et des environs,* 1804; Charles Percier and Pierre-François-Léonard Fontaine.

- *L'Architecture Considérée sous le rapport de l'art, des mœurs et de la législation,* 1804; Claude-Nicolas Ledoux.

- *Meubles et Objets de Goût,* 1802–1835; Pierre de la Mésangère. (Periodical)

- *Palais, maisons, et autres édifices modernes dessinés à Rome,* 1798; Charles Percier and Pierre-François-Léonard Fontaine.

- *Précis des leçons d'architecture données à l'Ecole royale polytechnique,* 1802–1805; Jean-Nicolas-Louis Durand.

- *Recueil de décorations intérieures,* 1801, 1812, 1827; Charles Percier and Pierre-François-Léonard Fontaine.

- *Traité théorétique et pratique de l'art de bâtir,* 1802–1803; Jean-Baptiste Rondelet.

Directoire, or *Le Style Républicain,* is named for the Directory that rules France from 1789 to 1799. A transition style, it links Louis XVI and Empire and reflects a more spare and Grecian classicism. Directoire heightens the simpler forms, smaller scale, greater severity, and reduced ornament evident in the last years of Louis XVI's reign. These changes result from the Revolution's destructive and disruptive effects on French society and economy and a reaction to aristocratic rule and taste.

During the time of the Consulate (1799–1804), the early years of Napoleon's rule, designers interpret classicism by emphasizing Imperial Roman and Egyptian influences over Grecian ones. During this period, increased formality, monumentality, and ornamentation reflect France's increasing stability, wealth, and confidence. Roman, Egyptian, and military forms and motifs appear in response to the military victories and exploits of Napoleon and his armies.

The fully developed Empire style, coinciding with the reign of Napoleon Bonaparte as Napoleon I (1804–1815), glorifies him and his empire. Recognizing the value of art to educate people of his greatness and legitimize his rule, very early in his reign Napoleon calls for writers and artists to create an image of him as a man of destiny, a modern Caesar, a hero who has earned the right to rule France. Paintings and images of the Emperor present a heroic character to reinforce the military origins of the empire. He demands an appropriate style to promote this image and establish a suitable setting for his empire. His architect–designers Charles Percier and Pierre-François-Léonard Fontaine turn to the grandeur of Imperial Rome, surrounding him with forms and motifs from the ancient world power and those reminiscent of his military victories. Their design ideas are documented in their book *Recueil de décorations intérieures,* published in 1801, 1812, and 1827.

DESIGN CHARACTERISTICS

Classical forms and motifs dominate architecture, interiors, furniture, and decorative arts during the early 19th century in France. Common to the entire period is a desire to emulate ancient forms. Scale evolves from small and light to larger, bolder, and more monumental.

- *Directoire.* Design characteristics generally reflect the charm and grace of Louis XVI. Forms and motifs are simple and originate in symbols of the Revolution and ancient Greece and Rome. Designers eliminate all references to the former Bourbon kings and strive to emulate more closely antique (primarily ancient Greek) concepts and designs. During the time of the Consulate, designs become more formal, scale becomes heavier, and Egyptian and Roman motifs appear.
- *Empire.* Characteristics and prototypes derive from the grandeur of Egypt and Rome. Interiors and furniture become pompous, formal, and more masculine, and these forms reveal this change more than architecture does. Publications of interiors and furnishings spread the Empire style and assert France's continued dominance in design.
- *Motifs.* Classical motifs (Fig. 2-3, 2-4, 2-5, 2-6, 2-7, 2-16, 2-17) appear extensively throughout the period as embellishment and include the classical figure, acanthus leaf, swag, rinceau, rosette, anthemion, scroll, arabesque, cartouche, vase, and lyre. Common during Directoire are lozenges, rosettes, spirals, and symbols of the Revolution,

▲ 2-3. *Détails et adjustements tirés de l'Atélier de Peinture du C. I.,* c. 1827; Charles Percier and Pierre-François-Léonard Fontaine.

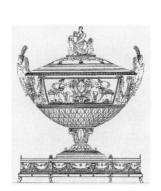

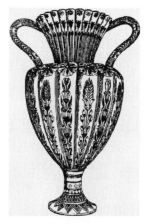

▲ **2-6.** *Pot-à-Oille, éxecuté à Paris, pour S. M. l'Imperatrice,* c. 1827; Charles Percier and Pierre-François-Léonard Fontaine; and vase in Grand Trianon; Sèvres.

▲ **2-4.** *Development de la Voule du Cabinet du Roi d' Espangne,* c. 1827; Charles Percier and Pierre-François-Léonard Fontaine.

such as the oak leaf and clasped hands. During the Consulate years, Roman motifs emerge (Fig. 2-3, 2-4, 2-7, 2-18, 2-31, 2-37), such as animal legs, swans, caryatids, chimeras, and monopodia. They are joined by military

◄ **2-7.** Octagon, lozenge, fruit, and foliage motif in fabric; Directoire.

symbols, such as stars, swords, spears, helmets, and X shapes. In 1798, after Napoleon's Egyptian campaign, Egyptian motifs, sphinxes, obelisks, pyramids, and head-dresses of pharaohs, come into vogue. Additional Empire motifs (Fig. 2-4, 2-15, 2-19, 2-20, 2-28, 2-33, 2-40) are military icons, swords, and symbols associated with Napoleon and Josephine, such as the honeybee, laurel wreath, letter N, eagle, rose, and swan.

ARCHITECTURE

Most building activity occurs after the 1790s because earlier times are too uncertain and prominently displaying one's wealth is unwise. As the period becomes more stable, the new rich begin to purchase and renovate the *hôtels* that once belonged to the aristocracy. Newly formed governments remodel older structures to accommodate their changed use. Designers and architects study, measure, draw, and publish information on ancient structures, which subsequently become the models for new buildings. The assembling of forms is more deliberate than it was before.

▲ **2-5.** Panel details, c. early 1800s; Charles Normand.

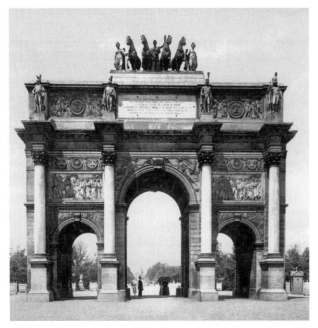

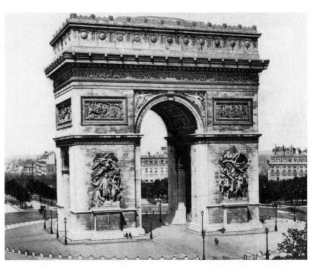

▲ **2-9.** Arc de Triomphe de l'Etoile, c. 1808–1836; Paris, France; J.-F.-T. Chalgrin.

▲ **2-8.** Arc de Triomphe du Carrousel, 1806–1808; Paris, France; Charles Percier and Pierre-François-Léonard Fontaine.

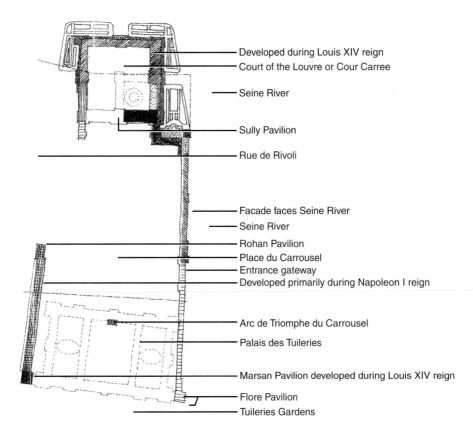

Developed during Louis XIV reign
Court of the Louvre or Cour Carree

Seine River

Sully Pavilion

Rue de Rivoli

Facade faces Seine River
Seine River
Rohan Pavilion
Place du Carrousel
Entrance gateway
Developed primarily during Napoleon I reign

Arc de Triomphe du Carrousel

Palais des Tuileries

Marsan Pavilion developed during Louis XIV reign

Flore Pavilion
Tuileries Gardens

◀ **2-10.** Site plan, Louvre and the Palais des Tuileries, begun c. 1200 with many later additions; c.1790s–1820s additions include the Cour Carrée, wing linking Rohan and Marsan Pavilions, and enlargement of Place du Carrousel; Paris, France; c. 1800 additions Charles Percier and Pierre-François-Léonard Fontaine.

Architectural theory emphasizes form and structure over ornament, and education continues to center on ancient models. The Académie Royale d'Architecture closes in 1793, but its successor, L'École des Beaux-Arts, opens in 1819.

Unique to France, the school strives to prepare architects to design monumental public buildings. This education system makes France a center for theory development and architectural debate in the 18th and 19th centuries.

DESIGN SPOTLIGHT

Architecture: La Madeleine, 1804–1849; Paris, France; Pierre Vignon and interiors by J.-J.-M. Huvé in 1825–1845. Imitating a Roman temple and originally intended as a church, this structure had a short life as a Temple of Glory before returning to use as a place of worship. The open site and podium convey monumentality and significance. Corinthian columns surround the exterior and form the portico. A sculptured pediment announces the entry, which is approached from the front in the Roman manner. Contrasting with the relatively plain exterior, the opulent interior derives its character from Roman baths. The Corinthian columns carrying round arches and a sequence of three coffered domes are reminiscent of Byzantine and some Romanesque structures. The design of the exterior and interior serves as a visual link between the Napoleonic and Roman Empires.

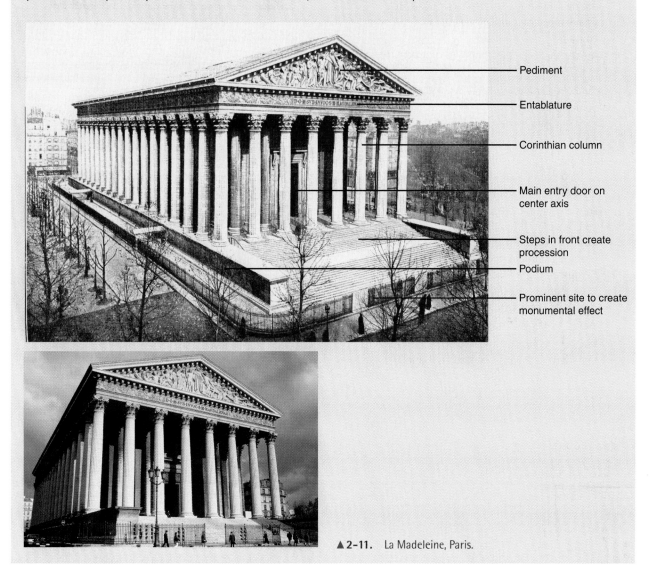

Pediment

Entablature

Corinthian column

Main entry door on center axis

Steps in front create procession

Podium

Prominent site to create monumental effect

▲ **2-11.** La Madeleine, Paris.

Architecture, bold but stylistically unadventurous, continues the plain, geometric, and classical trends of the late 18th century. Greek influence is particularly evident in severity or plainness, but exteriors also may exhibit Roman or Egyptian attributes and motifs. New state architecture under Napoleon is monumental in scale and sited in open space or in prominent vistas to emphasize its monumentality.

To create jobs, counter social unrest, and alleviate the costs of wars, Napoleon calls for an impressive building campaign and extensive urban renewal program for Paris. However, monetary difficulties and an abbreviated reign prevent him from accomplishing much of it. Some of his plans continue after he abdicates the throne. Most of his personal commissions are for the restoration and enlarging

IMPORTANT BUILDINGS AND INTERIORS

- **Compiègne, France:**
 - Chateau de Compiègne (Palais Royale during reign of Napoleon I; interiors in French Empire style), 1738–1751, and later; Ange-Jacques Gabriel, completed by le Dreux de la Chatre, with décor by Dubois and Redouté.

- **Paris and nearby area, France:**
 - Arc de Triomphe du Carrousel, 1806–1808; Charles Percier and Pierre-François-Léonard Fontaine.
 - Arc de Triomphe de l'Etoile, c. 1808–1836; J.-F.-T. Chalgrin.
 - Chapelle Expiatoire, 1816–1824; Pierre-François-Léonard Fontaine.
 - Château de la Malmaison, c. 1625, redone in c.1800; Charles Percier and Pierre-François-Léonard Fontaine.
 - La Madeleine, 1804–1849; Pierre Vignon and interiors by J.-J.-M. Huvé.
 - Louvre, begun c. 1200 with many later additions; c.1790s–1820s. Additions include the Cour Carrée, wing linking Rohan and Marsan Pavilions, and enlargement of Place du Caroussel; c. 1800 additions Charles Percier and Pierre-François-Léonard Fontaine.
 - Rue de Rivoli, 1802–1855; Charles Percier and Pierre-François-Léonard Fontaine.
 - Rue des Pyramides, 1802–1855; Charles Percier and Pierre-François-Léonard Fontaine.

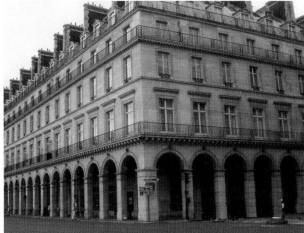

▲ **2-13.** Rue de Rivoli, 1802–1855; Paris, France; Charles Percier and Pierre-François-Léonard Fontaine.

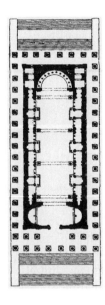

◄ **2-12.** Floor plan, La Madeleine, 1804–1849; Paris, France; Pierre Vignon.

of palaces, *châteaux*, and *hôtels* for himself, his family, and government dignitaries.

Public Buildings and Private Buildings

- *Types.* The most common building is some form of monument to Napoleon that emulates ancient models, such as the Arc de Triomphe de l'Etoile (Fig. 2-9). New building types are not introduced.
- *Site Orientation.* To create a more imperial Paris, Napoleon commands that the areas around the Louvre and the Tuileries palaces be cleared to open space. This effort extends the size of the Louvre (Fig. 2-10) and initiates new buildings along the Rue de Rivoli (Fig. 2-13). To enhance the settings of public buildings and palaces, Napoleon also orders the restoration of public gardens. State buildings and monuments (Fig. 2-8, 2-9) to the Empire are set in large open spaces or in prominent vistas to accentuate their significance. One innovation of

the period is the roofed passages between blocks of luxury shops, such as on the Rue de Rivoli.

■ *Floor Plans*. Most public and private building plans are rectangular in form with rooms symmetrically distributed at least along one axis (Fig. 2-12). In residences, the orientation and layout of rooms follow earlier patterns, continuing the emphasis on formality, rank, and status as was common during the Louis XIV period. Plans are organized around public and private *appartements*. Doorways to connecting rooms in state apartments are aligned on the same side of the wall to create an *enfilade,* with each space more ornately decorated than the last one.

■ *Materials*. Most new buildings are of stone with iron balconies at windows. Napoleon promotes new materials in architecture such as cast iron, which is used for bridges, domes, and structural support.

■ *Facades*. Grecian severity defines monumental buildings (Fig. 2-9, 2-11), which means that these buildings have little ornament and few details. Scale is monumental. Most buildings are raised on podia to emphasize their importance. Arcades or columns may completely surround the building or only articulate the facade. Columns, engaged columns, or pilasters combine with other details to form repeating units. Lesser buildings often have Palladian proportions. However, like buildings of state, they feature columns and/or pilasters and minimal ornament. Facades of shops may be as elegant as other buildings or whimsical with creative use of color and ornament.

■ *Windows*. Rectangular windows, large and small, delineate facades of both state and lesser buildings (Fig. 2-13). French windows allow access to porches or balconies. As during previous periods, their use on important floors marks that floor on the exterior, enhances inside illumination, and adds to the magnificence of the interior spaces. Palladian windows appear on less-important buildings.

■ *Doors*. Doorways are imposing for all buildings with columns or pilasters and pediments identifying them. Some entrances have a monumental portico. Arcaded walkways are common (Fig. 2-13).

■ *Roofs*. Roofs are flat with balustrades, pyramidal, or gabled with a low pitch in the antique or Grecian manner.

■ *Later Interpretations*. There are few later interpretations in architecture because there is no definitive Empire architectural style.

INTERIORS

Classical attributes and motifs drawn from Greek, Roman, and Egyptian sources characterize interiors from the Directoire years through those of the Empire. The image changes from one of lightness and delicacy to majesty and

DESIGN PRACTITIONERS

■ **Georges Jacob** (1739–1814), a former *ébéniste* to Marie-Antoinette and the Royal family, continues working during Directoire. During the 1780s, he introduces the saber leg and scrolled back and also pioneers the use of mahogany, particularly for furniture in the Etruscan style. Jacob makes antique-style furniture for the prominent Neoclassical painter, Jacques-Louis David, and helps promote the antique style.

■ **Charles Percier** (1764–1838) and **Pierre-François-Léonard Fontaine** (1762–1853) are architects and interior and furniture designers who create the Empire style for Napoleon. While studying in Rome, they examine ancient monuments and Renaissance structures. Consequently, their designs emphasize archaeological correctness over fantasy and charm. Their book, *Recueil de décorations intérieures*, sets forth their design philosophy. Its two main precepts of designs are forms and decoration derived from ancient models adapted for contemporary use and unity, reason, and function over fashion. As a handbook intended for the middle class, it spreads the Empire style all over Europe. They execute numerous commissions for Napoleon, especially remodeling and retrofitting palaces for him and his relatives.

■ **François-Honoré-Georges Jacob-Desmalter** (1770–1841), son of Georges Jacob, is a cabinetmaker in his own right. As the firm Jacob Frères, he and his brother Georges become leading cabinetmakers during the Directoire period. Following the death of his brother, he forms a partnership with his father in 1802 under the name Jacob-Desmalter et Cie. The firm provides Empire-style furniture in designs by Percier and Fontaine for Napoleon and others.

■ **Jean Zuber** (1773–1835) and **Joseph Dufour** (1752–1827) produce well-designed and artistic wallpaper in lavish colors in the early 19th century. Both head wallpaper firms that are known for their gorgeous *papiers panoramiques* (scenic papers). Zuber develops the technique of graduated colors for skies. His firm's hand-blocked scenic papers are still produced using the original blocks.

pompousness. Common to the entire period are wall decorations based upon those uncovered in ancient Pompeii.

Directoire interiors continue the scale and treatments of the last years of Louis XVI's reign but with noticeable simplicity, muted colors, more delicate decoration, and

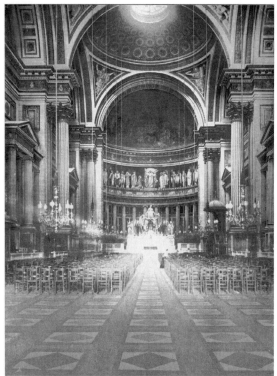

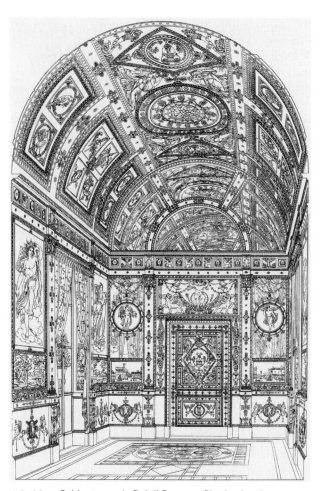

▲ 2-14. Nave, La Madeleine, 1804–1849; Paris, France; Pierre Vignon and interiors by J.-J.-M. Huvé in 1825–1845.

▲ 2-16. *Cabinet pour le Roi d' Espagne*, Placé a Aranjuez, c. 1800; Paris, France; Charles Percier and Pierre-François-Léonard Fontaine; published in *Recueil de décorations intérieures*, Paris, 1812, 1827.

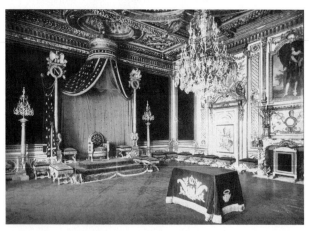

▲ 2-15. Le Salle du Trone a Napoleon (throne room of Napoleon), Palais de Fontainebleau, c. 1800; Fontainebleau, France.

▲ 2-17. *Cheminée du Grand Cabinet de l' Empereur* (chimneypiece in the emperor's cabinet room), Palais des Tuileries, c. early 1800s; Paris, France; Charles Percier and Pierre-François-Léonard Fontaine; published in *Recueil de décorations intérieures*, 1812, 1827.

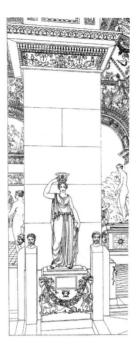

▲ **2-18.** Caryatids.

additional antique details. In the 1790s under the Consulate, a new richness and formality begin to permeate interiors as an outgrowth of increasing prosperity. Scale and color grow bolder. Imperial Roman and Egyptian motifs, reflecting Napoleon's military victories in Italy and his campaign in Egypt, appear as wall decorations and on chimneypieces, fabrics, furniture, and porcelains.

Empire interiors are masculine, formal, and richly detailed. The charm and intimacy of earlier Neoclassical rooms disappear. Classical decorations, rich colors, and large, formal furniture arranged stiffly around the walls characterize interiors. Court architects Charles Percier and Pierre-François-Léonard Fontaine create the style for Napoleon using the forms and motifs from ancient Roman

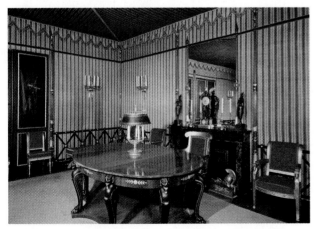

▲ **2-19.** Salle de Conseil (Council Chamber), Château de la Malmaison, c.1800; near Paris, France; Charles Percier and Pierre-François-Léonard Fontaine.

models. They design all elements in the magnificent, masculine settings that glorify the Emperor and reinforce his heroic image.

Public and Private Buildings

■ *Types*. Floor plans and room types change little during the period because modes of living do not vary from earlier times. Rooms of state and private *appartements* dominate residences (Fig. 2-15, 2-20, 2-21, 2-22), and the trend of the previous period toward smaller, less formal rooms continues. Dining rooms are slightly more common than they were before. Fewer people receive guests in their bedroom.

■ *Relationships*. Rectilinear spaces arranged symmetrically reflect the organization of facades and emphasize the integration between the exterior and interior. Both exteriors and interiors derive from classical modes and have similar attributes, but interiors are more colorful, lively, and richly treated than exteriors are.

■ *Color*. Directoire colors are softer with more muted blues, grays, and greens than those of Louis XVI. During the Consulate years, colors move toward richer reds, blues, and greens. Empire colors are highly saturated and include deep red, magenta, blue, green, yellow, and purple. Some have poetic names such as fawn or lemon wood (Fig. 2-19, 2-20).

■ *Lighting*. Lighting fixtures of the period (Fig. 2-19, 2-20, 2-22, 2-27) include candlesticks, candelabra, *appliqué*, *lustre*, lanterns, *guéridon*, and oil lamps. Classical motifs embellish the surfaces repeating interior ornamentation. Chandeliers are luxury items for formal spaces and rooms of state. After 1810, they are pear shaped with long chains of glittering crystals hanging from a smaller upper bronze ring to another lower and larger bronze ring that holds the candles. Hanging fixtures may imitate ancient oil lamps. Cylindrical lanterns illuminate entries and dining rooms. In progressive, wealthy homes, oil lamps begin to replace candles. Argand and astral lamps are made of painted sheet metal or have Japanned designs that imitate marble or porcelain. Like other fixtures, *candelabra* imitate antique prototypes. Most are of gilded bronze with darker bronze figures. *Guéridons* with candelabra enhance illumination and create decorative visual elements against walls.

■ *Floors*. Floors are wooden boards or parquet (Fig. 2-20, 2-22). Entrances, bathrooms, and dining rooms are sometimes black and white marble. Middle-class homes commonly use small, usually red, tiles. In most rooms, Savonnerie and Aubusson carpets and rugs in bold, bright colors with classical and Empire motifs lie on wood and masonry floors (Fig. 2-15, 2-28). Borders are added or removed to adjust width. *Moquette*, a less expensive narrow-width carpet in repeating patterns, often is used in less-important rooms in wealthy homes and most rooms in middle-class homes.

DESIGN SPOTLIGHT

Interiors: *Cabinet de travail-bibliothéque* (Library), Château de la Malmaison, c.1800; near Paris, France; Charles Percier and Pierre-François-Léonard Fontaine; published in *Recueil de décorations intérieures*, 1812, 1827. While Napoleon is fighting in Egypt, Josephine purchases Malmaison, a rundown early-18th-century chateau, and directs Percier and Fontaine to refurbish it in the opulent Empire style, which contrasts with the

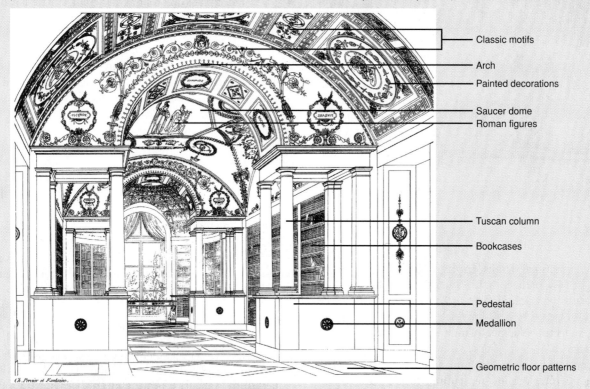

Classic motifs
Arch
Painted decorations
Saucer dome
Roman figures
Tuscan column
Bookcases
Pedestal
Medallion
Geometric floor patterns

plain, simple three-story exterior with a slate roof. Revealing a strong masculine image, the library's design emphasizes the large scale, symmetry, geometric forms, crisp lines, and classical details that define Empire. The room features mahogany Tuscan columns on pedestals, saucer (shallow) domes, round arches, and painted ceiling decorations composed of portraits of the Roman emperors, a reminder of the link between the Roman Empire and Napoleon. Mahogany bookcases by the firm Jacob Frères line the walls. Rich colors of red, blue, and gold enrich the interiors and complement the furnishings. As a reflection of his tastes and demand for a heroic image, this room is typical of the interiors with which Napoleon surrounds himself—masculine, sober, and replete with classical details and reminders of the historic nature of the empire.

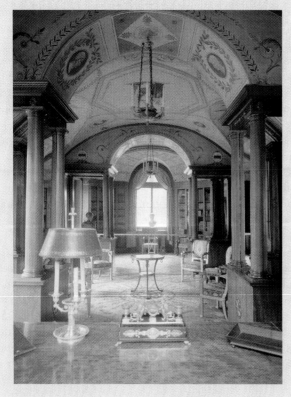

▲ **2-20.** Library, Château de la Malmaison, near Paris.

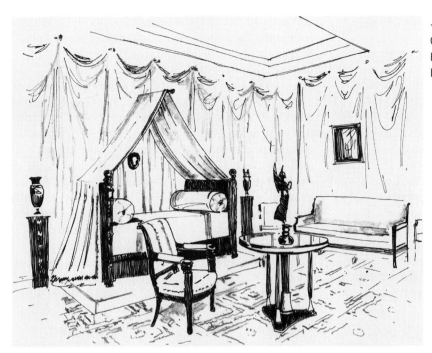

◄**2-21.** *Appartement de l'Empereur*, Château de la Malmaison, c.1800; near Paris, France; Charles Percier and Pierre-François-Léonard Fontaine.

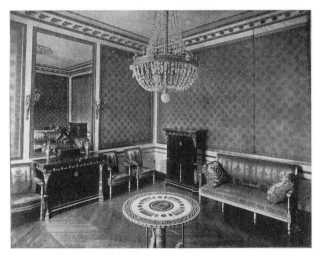

▲**2-22.** Salon, Grand Trianon, c. early 1800s; France.

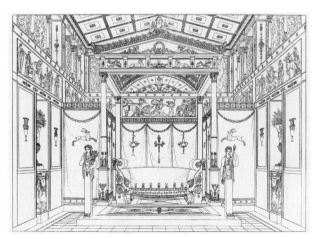

▲**2-23.** *Lit éxécuté à Paris*, c. 1827; Paris, France; Charles Percier and Pierre-François-Léonard Fontaine; published in *Recueil de décorations intérieures*, 1812, 1827.

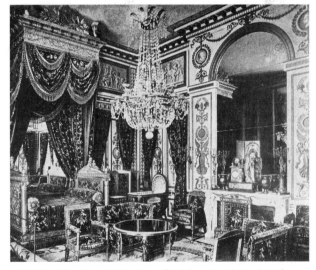

▲**2-24.** Chambre de Napoleon (bedchamber of Napoleon), Palais de Fontainebleau, c.1800s; Fontainebleau, France.

■ *Walls.* Walls retain classical proportions and details with an emphasis on the chimneypiece (Fig. 2-15, 2-16, 2-17, 2-23). Symmetrical compositions of paneling in classical proportions with plain or decorated centers are typical. A dado forms the base, and the wall is capped by a frieze and cornice. During the Directoire, walls display painted Pompeian decorations arranged in panels or friezes that are composed of light-scale grotesques, arabesques, foliage, flowers, or figures in brighter colors against softly colored backgrounds. Rooms of this time usually display a simple geometric rhythm, whereas richer decoration and materials characterize later Empire-style rooms. Characteristics, such as Egyptian motifs,

common in Empire, make their appearance during the Consulate years.

Official or important Empire rooms display greater formality and majesty through architectural details, such as pilasters, columns, and pediments in marble or stone (Fig. 2-14). These details in lesser rooms may be of stucco or wood or trompe l'oeil. Graining and marbling are also common treatments for walls, dados, moldings, or baseboards. Wall paneling may have large mirrors, painted or gilded stucco ornament depicting classical motifs, or painted decorations in the centers. Heavy moldings or pilasters outline the panels. Painted classical compositions resemble those of earlier times but are even bolder and more colorful. In middle-class houses, decoration often resists symmetry and careful organization to accommodate personal tastes.

Textile wall treatments (Fig. 2-22) become opulent during Empire, helping to soften stiffness and increase richness and majesty. Walls loosely draped with fabrics and/or valances are thought to look antique (Fig. 2-21, 2-23). Tent rooms, reminiscent of the military origins of the Empire, are fashionable during the period (Fig. 2-19). Percier and Fontaine are among the first to use them at Malmaison.

■ *Wallpaper.* During the period, the use of wallpaper increases, particularly in public buildings and in the homes of those who cannot afford more expensive treatments. Nevertheless, wallpaper is not considered appropriate for the most formal rooms. Patterns include small repeating designs, stripes, borders, architectural details, imitations of textiles and drapery, flocked papers, and *irisé* or shaded papers. Introduced in the first decade of the 19th century, *papiers panoramiques* (Fig. 2-25) feature exotic themes or idealized worlds block printed in lavish detail and numerous, rich colors. Those produced by Dufour and Zuber are especially favored for their quality and beauty. Scenic papers soon become fashionable for sitting and dining rooms. French wallpapers dominate European markets despite the Napoleonic Wars.

■ *Chimneypieces.* Mantels (Fig. 2-24) usually are of white, black, red, or brown marble with a shelf supported by columns, pilasters, consoles, caryatids, or winged lions.

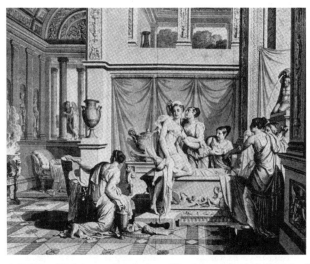 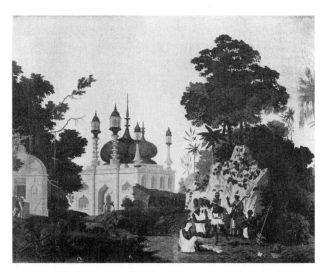

▲ **2-25.** Wallpapers: Panels from "Psyche and Cupid," 1814, by Dufour; "Vues D'Indostan," c. 1820s by Zuber; and detail from *Meubles et Objets de Goût,* 1802–1835.

▲ **2-26.** Window Treatments: Wallpaper showing drapery treatment and actual drapery examples, c. 1815–1820s.

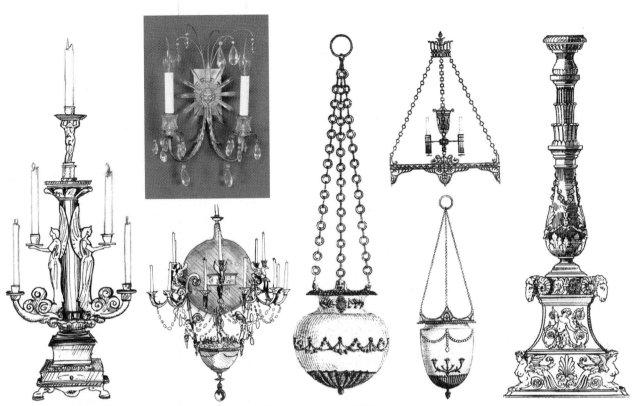

▲ **2-27.** Lighting: *Candelabra, appliqué, cristeaux,* and *guéridon,* c. early 1800s.

▲ **2-28.** Rugs: Savonnerie rugs at Malmaison, c. early 1800s.

Simpler mantels are rectangular forms with applied gilded bronze or stucco classical motifs such as swags, draped figures, or sphinxes adorning them in the manner of Empire furniture. Above the mantel, there is a large painting, mirror, or window. Objects on the mantelshelf, such as clocks or candelabra, are large and showy.

■ *Window Treatments.* Like other decorative details, window treatments become more opulent during the period, featuring elaborate fringed and tasseled swags and festoons draped over rods or attached to decorative cornices (Fig. 2-26). Rods shaped like spears, lances, or other similar forms terminate in large finials. Pairs of windows may be treated as one with continuous drapery composed of multiple swags and festoons. Beneath drapery are curtain panels that may puddle on the floor. Muslin or other thin fabrics hang next to the glass. Some treatments consist of two contrasting colors of fabric, one for the face and another for the lining. Curtains may open and close using the new French draw rod introduced in 1790, or they can be tied back with ropes and tassels or looped over holdbacks during the day.

■ *Doors.* Doors are paneled in mahogany often with gilded moldings. Those leading to important rooms may be painted or inlaid with classical details to match the interiors (Fig. 2-16). A complete entablature typically surmounts doorways.

■ *Ceilings.* Ceilings in rooms of state and important residential areas are the most heavily decorated with carved wood or stuccowork enhanced with paintings or gilding (Fig. 2-16, 2-20, 2-23). Sometimes, the carpet repeats the ceiling decorations. Lesser rooms have plain ceilings with a central rosette. Some may be painted to look like the sky.

■ *Later Interpretations.* Empire interiors are revived briefly in the late 19th century (Fig. 2-29). Designers closely copy the original interiors with paneled or painted walls. Scenic wallpapers are also common. Tent rooms reappear at various times in the 20th century.

FURNISHINGS AND DECORATIVE ARTS

Classical attributes, forms, and motifs define furniture from Directoire to Empire. For inspiration, designers rely on surviving examples from Pompeii, ancient vase paintings, and stucco reliefs. Copying and adapting ancient Greek and Roman furniture continue during all periods. Directoire advances trends evident in the last years of Louis XVI's reign, such as slender proportions, greater severity, and angularity. During the Consulate period, furniture becomes heavier in scale, gilding and ornament increase, and Egyptian motifs are more evident. Empire furniture continues classical emphasis, but becomes masculine, stiff, and majestic as design supercedes comfort. Pieces are intended to be seen primarily from the front and to support formal living. Symmetry is an important design principle in all periods.

The break up of guilds following the Revolution allows greater freedom and opportunities for individual *ébénistes.* Many who had worked for the Crown continue working for the remaining aristocracy and the wealthy throughout Directoire and into the Empire period, and design and quality remain as excellent as before. However, by the end of Napoleon's reign, industrialization is affecting furniture making. Individual cabinetmakers begin to disappear, replaced by large firms. Overall design quality begins to deteriorate as furniture becomes larger, bulkier, and more curvilinear. Newly invented saws can make larger and thinner veneers, so nearly all pieces are veneered.

Public and Private Buildings

■ *Types.* New to the period are sofa or center tables, round tables with basins and pitchers derived from antique tripods, and toilette tables with attached mirrors and matching *psychés.*

■ *Distinctive Features.* Although much of Directoire closely resembles Louis XVI, distinguishing characteristics in seating include the rolled-over back, saber leg (Fig. 2-30), greater emphasis on Grecian prototypes, and motifs associated with the Revolution. During the Consulate years, furniture begins to assume characteristic Empire features

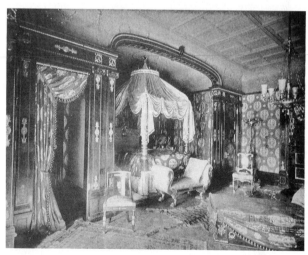

▲ **2-29** Later Interpretation: Bedroom; published in *The Room Beautiful,* 1916.

▲ **2-30** *Fauteuil* and *Bergère,* c. 1790s; France. Directoire.

DESIGN SPOTLIGHT

Furniture: *Fauteuil et Siege à deux places* c. 1800; Paris area, France; Charles Percier and Pierre-François-Léonard Fontaine; published in *Recueil de décorations intérieures*, 1812, 1827. This armchair repeats the large scale of Empire interiors. Its rolled-over back and continuous line of back and legs are reminiscent of the Greek klismos, while the turned front legs resemble those of Roman thrones. Sphinxes, common after Napoleon's Egyptian campaign in 1799, form the arm supports. The upholstery and carvings highlight classical motifs and geometric shapes common to the period. The trim and tassels under the seat add further opulence.

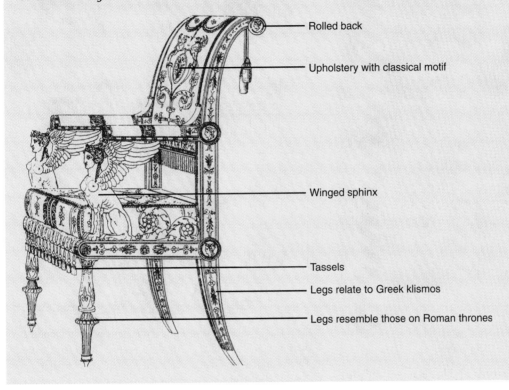

◀ **2-31.** *Fauteuil et Siege à duex places* c. 1800, Paris.

Rolled back

Upholstery with classical motif

Winged sphinx

Tassels

Legs relate to Greek klismos

Legs resemble those on Roman thrones

such as heavier scale, frontality, and Roman and Egyptian motifs (Fig. 2-34). A clean, simple silhouette with sharp corners and no attempts to soften them distinguishes Empire furniture. Large areas of flat mahogany veneer with little carving, few moldings, and heavy bases enhance the blocky appearance. Makers leave off door handles and keyholes to achieve an unbroken surface. Applied ornamentation featuring motifs of the period may appear on large flat surfaces, such as those of commodes and beds (Fig. 2-40, 2-42).

■ *Relationships.* Although furniture still lines the walls when not in use, toward the end of the period it begins to migrate from the perimeter, centering on the fireplace in less-formal rooms. The introduction of *chaises volantes*, seating with casters and decorated backs, coincides with this development. Most Empire furniture has an architectonic feeling because it is regarded as part of the interior architecture.

■ *Materials.* Directoire furniture is of wood native to France because imported materials are impossible to obtain. Often a painted finish disguises common woods and coordinates with interior colors and decoration; there is little marquetry, inlay, or applied embellishment. During the Consulate and Empire, both solid and veneer mahogany dominate furniture until 1806, when a naval blockade imposed by France's enemies prevents its importation. After that, most furniture is made of native woods, such as walnut, beech, pear, ash, and elm. Darker woods rule before 1806; after that lighter-colored woods replace them. After 1810, white paint with gilding or gray paint with white details is typical for furniture. Important or official rooms have gilded furnishings, while plain or painted pieces fill lesser rooms. Tables and case pieces throughout the period have marble tops in black, gray, blue, dark green, purple, brown, or white. Pewter, ebony, or ivory inlay in bands and/or gilded bronze or brass mounts in classical motifs characterize Consulate or Empire casepieces.

■ *Seating.* Sets of upholstered chairs and sofas are very fashionable. Directoire seating closely resembles Louis XVI. Chairs are light in scale, often painted, and reveal delicate classical decoration (Fig. 2-30). Legs are tapered and quadrangular, turned, or baluster-shaped. Backs may feature trellises or lyre splats. A rosette in a square accentuates the junction of leg and seat rail.

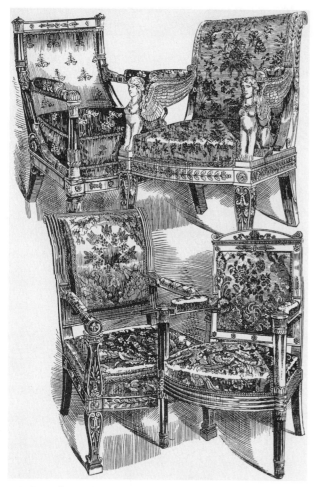

▲ **2-32.** *Fauteuils*, c. 1800–1820; France.

Designed to be sat in erectly and be seen primarily from the front, Empire *chaises* and *fauteuils* are stiffly rectilinear with some curves in backs, legs, or seats (Fig. 2-30, 2-31, 2-32, 2-34). Backs may be flat and rectangular or rolled-over. Front legs are straight and fluted, turned, sabers, or flat and reminiscent of Greek rectangular leg designs. Back legs most often are sabers. Arm supports may be flat, turned, or animal shaped (Fig. 2-33). The boxy upholstery has sharp corners. Gondola chairs are the most graceful Empire

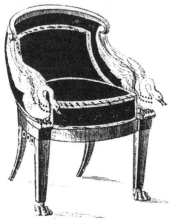

◄ **2-33.** *Bergère* with swans, c. early 1800s; France.

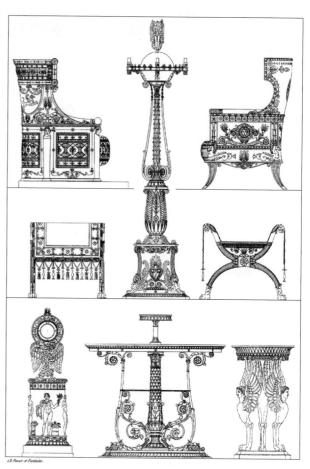

▲ **2-34.** *Fauteuils, tabourets, candelabra, côté du tabouret, petit pendule,* and table, c. 1800; Paris area, France; by Charles Percier and Pierre-François-Léonard Fontaine; published in *Recueil de décorations intérieures,* 1812, 1827.

chairs with curving backs, saber legs, and animal- or sphinx-shaped arm stumps. Curule or X-shaped chairs and stools copy antique examples (Fig. 2-15, 2-34). *Canapés* (Fig. 2-22, 2-35), beginning in Consulate, closely follow antique forms with outward scrolled arms equal or unequal in height and either turned or outwardly curved legs. A variation is the *méridienne.* Sofas or chairs often have matching footstools.

■ *Tables.* Empire rooms boast a variety of tables, many of which copy or emulate antique prototypes (Fig. 2-36, 2-37, 2-38). All of the table types and stands of the 18th century continue in this period. Pier tables stand between windows (Fig. 2-39). Their front legs may be columns with gilded capitals, caryatids, terms, or animal legs. Mirrored backs double the apparent size of the table and reflect light as well as the Empire-style carpeting on the floor. Consoles, made in pairs to display vases, statuettes, or candleholders, may be semicircular or rectangular with columns, caryatids, terms, or turned legs. Tops of pier tables and consoles are marble, and inlay and applied classical motifs embellish the aprons. Large tables, even for dining, remain rare. Most

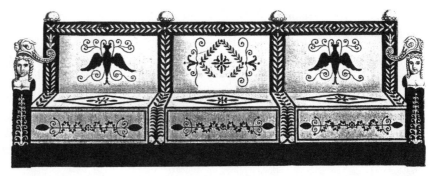

▲ **2-35.** *Canapés*, c. 1790s–1810s; France.

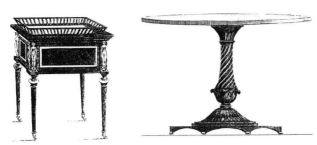

▲ **2-36.** Small tables, 1800s–1820s; France.

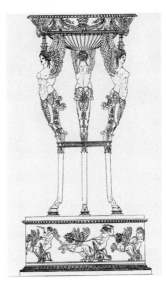

◄ **2-38.** *Trépied vases et frise, exécutés à Paris* (tripod vase and frieze copied from Roman forms), c. 1801; France; Charles Percier and Pierre-François-Léonard Fontaine; published in *Recueil de décorations intérieures*, 1812, 1827.

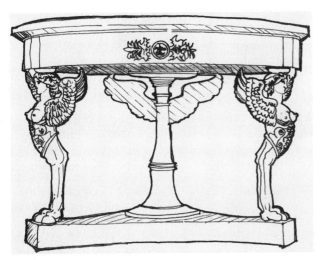

▲ **2-37.** Round tables with pedestal base and quadruped legs, c. early 1800s; France.

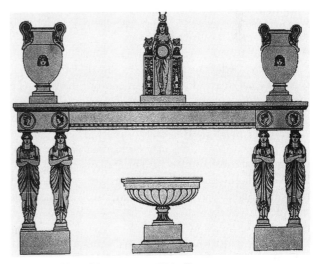

▲ **2-39.** Pier table, c. 1800s–1820s; France.

dining tables are round with drop leaves in the English manner. Particularly fashionable are small round or polygonal tables with single center supports or three or four columns on a concave-sided base. Large *bureau plats* (Fig. 2-19) are more common than rolltop desks.

■ *Storage*. Directoire commodes are rectangular and severely plain. Simple moldings define drawers, and the pulls are plain, metal rectangles. The short, tapered legs are fluted. Tops may have stringing or cross banding. Empire case and storage pieces are massive and architectural in form with large expanses of mahogany veneer and bronze mounts

depicting classical motifs and figures. Corners may have columns, caryatids, or terms. Commodes, used in nearly all rooms, have three drawers in the main body, a fourth in the apron, and a marble top (Fig. 2-40). An alternative form has drawers behind doors, which are covered with mythological

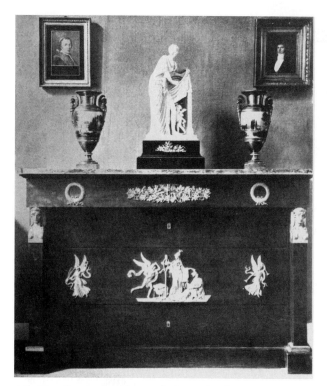

▲ **2-40.** *Commode* with *ormolu* decoration; France.

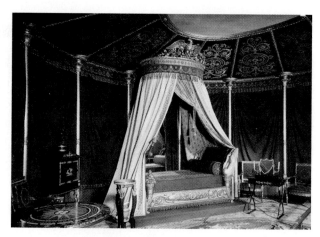

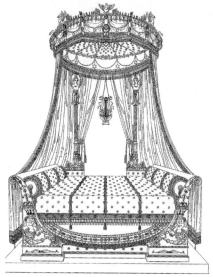

▲ **2-41.** *Lit,* Chambre a Coucher de l'Impératrice (Josephine's bedroom), Château de la Malmaison, c. 1800; near Paris, France; and lit (drawing) published in *Recueil de décorations intérieures,* 1812, 1827; Charles Percier and Pierre-François-Léonard Fontaine.

scenes. The corners of either type may have columns, caryatids, or *égyptiennes en gaine* in gilded bronze or wood that is painted green (*à l'antique*) or gilded. Often a *secrétaire à abattant* matches the commode. Tall and rectangular, the *secrétaire à abattant* has drawers beneath the large front panel. Drawers and doors inside are usually a lighter wood than that of the exterior. A tall chest with seven drawers, one for each day of the week, is called a *semainier.*

■ *Beds.* Directoire beds, simple in form and design, feature low pediments carried by fluted columns and geometric carving in low relief. In contrast, beds are the most creative designs of the Empire period (Fig. 2-41, 2-42). The *lit droit* is usually mahogany with caryatid supports or straight posts topped with carved heads painted black or green. Variations may be painted gray or white with minimal carved ornament. The *lit en bateau* (Fig. 2-23, 2-41) commonly has scrolled or animal-shaped ends and rests on a solid dais with bronze mounts in classical or military designs. Beds are placed in alcoves or lengthwise on the wall with a canopy above and heavy silk and muslin hangings draping over the ends. *Somnos* resembling classical pedestal tables flank either side of the bed.

■ *Upholstery.* Napoleon's large commissions revive France's silk and cotton industries, which almost completely disappear during the Revolution. By the end of the period, industrialization increases production and lowers prices. Typical furnishing fabrics are brocades, damasks, velvets, moirés, lampas, and printed cottons. Printing methods include hand-blocks, copper plates, and cylinders. Patterns (Fig. 2-44) are numerous, but most come from classical

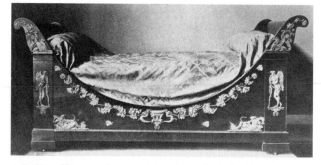

▲ **2-42.** *Lit en acajou garni de cuivres dorés* (bed in mahogany with gilded bronze appliqués), c. early 1800s; France.

◄ **2-43.** Daybed, c. early 1800s; France.

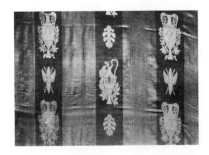
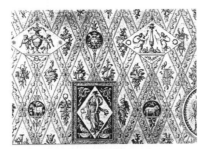

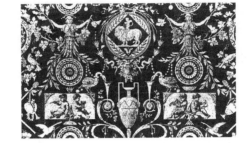

▲ **2-44.** Upholstery: Cottons and damasks.

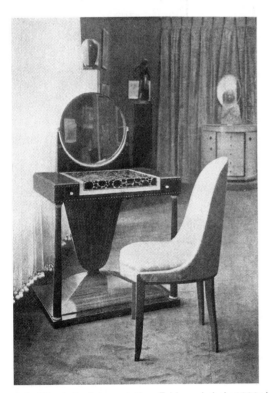

▲ **2-45.** Later Interpretation: Table and chair, 1926; Jacques Ruhlmann. Art Deco.

sources. Ensembles consisting of *fauteuils, chaises, canapés,* and stools are upholstered alike in tapestry, silk, satin, or damasks in vivid colors or horsehair in black, red, green, plum, and light blue.

Bands of contrasting color, fabric, or braid outline seats and backs. Rosettes, medallions, and other motifs woven in contrasting colors or gold on solid fabric are centered on seats and backs. Similar or matching designs in strips adorn the front edge of the seat. Sofas, stools, and chairs occasionally have heavy fringe or tassels beneath the seat or arms.

■ *Decorative Arts.* Napoleon's commissions also revive the decorative arts. Porcelain becomes large, monumental, and completely covered with applied or painted decoration. Classical scenes, cities, sites important to the Empire, classical figures, and scenes from the Renaissance and Middle Ages embellish table services, tea and coffee services, centerpieces, vases, and other porcelain objects. Fancy gilded borders frame the decoration. Vases in classical shapes are mounted in gilded bronze, and other pieces often have gilded bronze handles. In 1804, Sèvres discontinues making soft paste, or artificial porcelain, in favor of hard paste, or true porcelain. Numerous private porcelain factories spring up after the Revolution. Their creative designs appeal to a wider audience, including Americans. Contrasts of matte and shiny surfaces and plain or sculpted areas are characteristic of silver and gold tea and coffee services, implements for the dressing table, centerpieces, lighting fixtures, and tableware. Like porcelains, the forms and decorations of metalware derive from classical sources. Similarly, mantel clocks and other *objets d'art* become larger and more majestic. Designs feature classical or exotic figures of dark or gilded bronze on marble pedestals.

■ *Later Interpretations.* Empire furnishings are revived in the 19th century during Second Empire and in the 20th century during Art Deco (Fig. 2-45), and interpretations continue today.

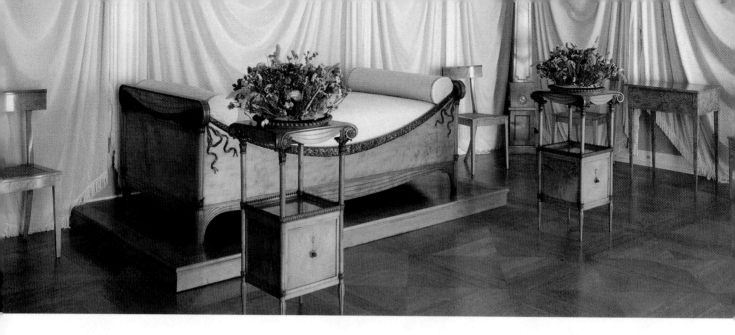

CHAPTER 3

German Greek Revival, Biedermeier

1815-1848

The term Biedermeier, first used in 1853, was given to a political caricature appearing in the "Fleigende Blätter" who typified a well-to-do middle-class man without culture. Biedermeier furniture, marked by its commonplace forms, is a potpourri of early nineteenth-century classicism—Sheraton, Regency, Directoire, and especially French Empire—with certain traits of its own.

Louise Ade Boger, *Furniture Past and Present*, 1966

HISTORICAL AND SOCIAL

The German states, including Austria and Prussia, wage war against France for nearly 18 years before defeating Napoleon in 1813. In 1814, the Congress of Vienna convenes to decide the fate of Napoleon's empire. To help alleviate Germany's social, political, and economic problems, the Congress establishes the German Confederation to replace the Holy Roman Empire and Napoleon's Confederation of the Rhine. The German Confederation unites 39 German states and Prussia under Austrian rule. Each state retains its independence and government.

As Minister of Foreign Affairs, Prince Clemens von Metternich of Austria strives to preserve the alliance by suppressing liberalism and nationalism. He institutes strong censorship and authoritarian rule, maintained by surveillance and repression. At the same time, he brings about economic recovery, which sustains his political stranglehold. Eventually, the growth of the middle class and the prosperity brought by the Industrial Revolution bring change in the form of revolutions beginning in 1848.

With political activism prohibited, people turn inward, focusing on their homes and families (Fig. 3-1). They pursue

Early-19th-century architecture in Germany and Austria continues the Neoclassical development first in the Greek Revival style, which is followed by a more eclectic approach that encompasses the Italian Renaissance, Byzantine, Early Christian, and Romanesque. The term *Biedermeier* applies mainly to middle-class interiors and furniture in Austria and Germany during the period of 1815 to 1848. This style, an adaptation of French Empire, replaces formality and majesty with comfort and function.

tranquil, informal lifestyles in which visiting and entertaining friends are commonplace activities. Family members engage in hobbies and pastimes, such as reading, needlework, letter writing, or making scrapbooks. Practicality and coziness are more important than display and opulence are.

The period is a golden age for music and literature. Particularly admired are the musical accomplishments of Franz Schubert, Ludwig van Beethoven, and Franz Joseph Haydn. Opera houses and music halls are filled to capacity. Those who can afford it own a clavichord and/or other type of musical instrument. Germans also highly esteem literature, owning numerous books and/or borrowing from local libraries. However, censorship and repression extend even to favored musicians, writers, and their works. To avoid government censors, authors and writers often attend the newly fashionable literary salons held in individual homes.

CONCEPTS

As elsewhere in Europe, Neoclassicism is the style of choice in the German states during the first decades of the 19th century. Architecture and furniture sometimes show strong French influence because German designers study in France, read French theorists, and emulate French designs despite wars between the two countries and Napoleon's domination. Princes and aristocrats often hire French designers for their palaces and other structures.

In the early years of the 19th century, most buildings are Greek Revival style. German architects favor Greek architecture over Roman because of the honesty of structure they believe it exhibits. They and their patrons also think that the German spirit is embodied in Greek architecture; thus, architecture fulfills a political and social role as in France. During the 1830s, architects adopt a more eclectic approach, choosing attributes and details from Italian Renaissance, Romanesque, and Byzantine. Following other countries, by midcentury German architecture displays a multiplicity of styles.

IMPORTANT TREATISES

■ *Gadanken über die Nachahmung griechischer Werke inder Malerei und Bildhauerkunst.* (Thoughts on the Imitation of Greek Works of Art in Painting and Sculpture), 1759; Johann Johachim Winckelmann.

■ *Ideen zu Zimmerverzierungen.* (Ideas for Room Decorations), 1795–1800; Friedrich August Leo.

■ *Sammlung Architektonischer Entwürfe.* (Collection of Architectural Drawings), 1819–1843; Karl Friedrich Schinkel.

■ *Theory of Color.* 1810; Johann Wolfgang Goethe.

■ *Vorbilder für Fabrikanten und Handwerker* (Models from Manufacturers and Craftsmen), 1819; Karl Friedrich Schinkel.

German nobility prefers the formal and majestic Empire for important interiors to express rank, status, majesty, and grandeur. In contrast, the middle class adopts a simpler style for their homes that becomes known as *Biedermeier*. Originally pejorative, the term is first applied to furniture in the late 19th century. The expression combines *bieder*, meaning plain or unpretentious, and *meier*, a common German last name.

Biedermeier interior planning centers on function and comfort instead of rank and display. Rooms accommodate a variety of family activities within a warm, inviting atmosphere. Similarly, furniture designs strive for use and practicality in contrast to the grandiose spirit of Empire. Middle-class values, such as the importance of family, modesty, and simplicity, are common themes in rooms and furnishings.

DESIGN CHARACTERISTICS

As in other European countries, classicism in form, proportion, and details dominate German architecture, high-style interiors, and furniture. Architecture and interiors in middle-class homes especially favor simplicity and function.

■ *German Greek Revival.* Greek Revival architecture in Germany, like that of other countries, derives its details primarily from ancient Greek and its forms mainly from Roman architecture. The style features Greek and Roman temple forms, the Greek orders, plain walls, and minimal, classically derived ornament. It also reveals such classical attributes as symmetry, repose, and a concern for proportion. Geometric solids—cubes, rectangles, or cylinders—compose buildings as well as furniture. Reproductions and

◄ **3-1.** Costumes of a man and woman.

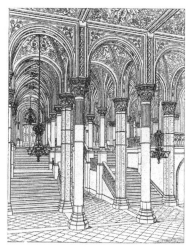

▲ 3-2. Architectural and interior details.

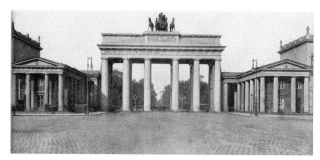

▲ 3-3. Brandenburg Gate, 1789–1793; Berlin, Germany; by C. G. Langhans.

adaptations of Grecian and Roman prototypes, such as the Parthenon and Pantheon, frequently characterize monuments and important buildings. As time progresses, more ornament and a broader spectrum of prototypes overcome the plainer Grecian style.

▪ *Biedermeier.* Biedermeier interiors display bright colors, good lighting, warm woods, plants, and flowers, contributing to an inviting atmosphere. Rooms and furnishings are small in scale. Drawing rooms often have a lot of furniture, especially chairs, to support numerous activities. Families personalize their homes with portraits, silhouettes, pictures, and collections. Biedermeier furniture, a pared-down version of French Empire, features light woods, minimal embellishment, and geometric forms. Designed by craftsmen, examples reveal the concern of the artisan for enhancing the materials. As in France, some pieces derive from classical prototypes. Biedermeier also reveals influences from Sheraton and Regency of England.

▪ *Motifs.* Architecture and furniture exhibit classical motifs (Fig. 3-2, 3-12, 3-13, 3-18) including columns, Egyptian terms, pediments, Greek key or fret, acanthus leaves, palmettes, lyres, urns, hearts, arrows, and a stylized Prince of Wales motif.

ARCHITECTURE

Neoclassicism, which begins in the second half of the 18th century in Germany, continues to define architecture during the first decades of the 19th century. German architects are not stylistic innovators, neither are they mere copyists of the work of others. Their genius lies in the ability to synthesize ancient Greek and Roman, French, and English influences and their own past styles into a unique German vision. French inspiration is evident in rationalism, geometric forms, Gothic-type structures, and visionary architecture. An underlying Romanticism stems from England, particularly in gardens and settings.

IMPORTANT BUILDINGS AND INTERIORS

▪ **Berlin, Germany:**

—Altes Museum, 1823–1830; Karl Friedrich Schinkel.

—Bauakademie, 1831–1836; Karl Friedrich Schinkel.

—Brandenburg Gate, 1789–1793; C. G. Langhans.

—Hauptwache, 1840s; Karl Friedrich Schinkel.

—Neue Wache (New Guard House), 1816–1818; Karl Friedrich Schinkel.

—Schauspielhaus (Royal Theater; now called Konzerthaus), 1821; Karl Friedrich Schinkel.

▪ **Munich, Germany:**

—The Glyptothek (sculpture gallery), 1816–1830; Leo von Klenze.

—Propylaea, 1846–1860; Leo von Klenze.

—Ruhmes-Halle, early 19th century, Leo von Klenze.

▪ **Potsdam, Germany:**

—Schloss Charlottenhof, 1826–1827; Karl Friedrich Schinkel.

▪ **Regensburg area, Germany:**

—The Walhalla, 1830–1842; Leo von Klenze.

Buildings exhibit the hallmarks of Neoclassicism: clean lines, plain walls, smooth or slightly rusticated surfaces, geometric forms, and entire structures or just the details derived from antique prototypes. The geometric forms that make up buildings retain their individuality instead of blending into a whole. Some structures copy ancient edifices, while others exhibit an antique flavor. Greek Revival is favored for the first two decades of the 19th century. After that, an increase in ornament and number of styles signals a move away from the single classical vision toward a broader, more eclectic approach that is inspired by the Italian Renaissance, Romanesque, or Byzantine.

Architecture: Schauspielhaus (Royal Theater, now called Konzerthaus), 1821; Berlin, Germany; Karl Friedrich Schinkel. An important early building by Schinkel, he receives a commission from the king to design a new theater to replace an earlier one that burned. The king requires that Schinkel follow the footprint of the previous theater and reuse some elements, such as the Ionic columns. Schinkel devises a three-part structure with a prominent main center façade approached by processional front steps and crowned by a temple front using the Ionic columns. He further articulates the image of Neoclassicism with classic ordering, rustication, straight lines, rectangular windows, and plain walls. The front vertical planes are layered to achieve depth and movement. Additional classical motifs highlight the prominent points of the roof and reiterate the classical language. Because of its frequent use and its location in an important Berlin square, the building becomes a symbolic statement of German Greek Revival architecture. A Greek amphitheater plan inspires the form of the auditorium.

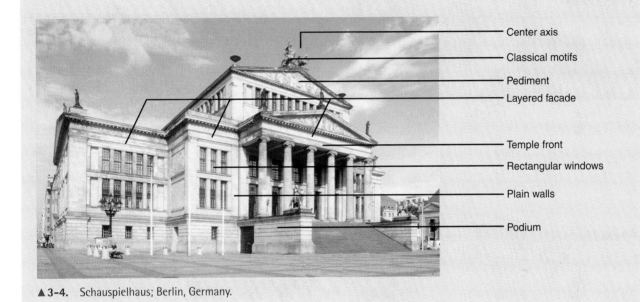

Center axis
Classical motifs
Pediment
Layered facade
Temple front
Rectangular windows
Plain walls
Podium

▲ **3-4.** Schauspielhaus; Berlin, Germany.

In Germany, architects develop the first of the Greek Revival ceremonial gateways, the Brandenburg Gate in Berlin (1789–1793; Fig. 3-3), and the first museum designed for sculpture, Glyptothek, Munich (1816–1830). Of the numerous excellent architects, Karl Friedrich Schinkel and Leo von Klenze are the most outstanding. Schinkel in Berlin and von Klenze in Munich design a variety of building types in the Neoclassical style, transforming those cities and affecting architectural design of their day and with continued influence, even to the Modern Movements in the early 20th century.

Public and Private Buildings

■ *Types.* Building types include museums (Fig. 3-5), monuments, gateways, galleries, theaters (Fig. 3-4), prisons, factories, markets, squares, row houses, apartments, and palaces.

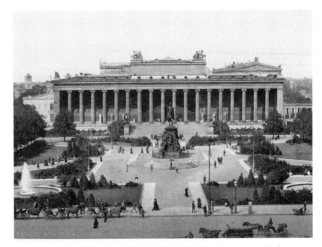

▲ **3-5.** Altes Museum, 1823–1830; Berlin, Germany; Karl Friedrich Schinkel.

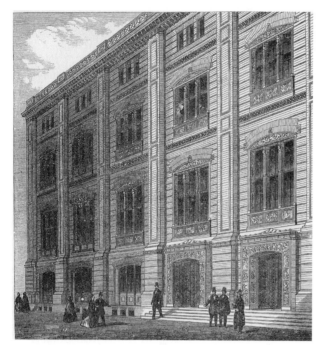

▲ **3-6.** Bauakademie, 1831–1836; Berlin, Germany; Karl Friedrich Schinkel.

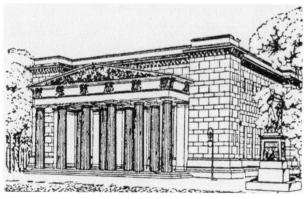

▲ **3-7.** Hauptwache, 1840s; Berlin, Germany; Karl Friedrich Schinkel.

▲ **3-8.** Ruhmes-Halle, early 19th century; Munich, Germany; Leo von Klenze.

▲ **3-9.** Propylaea, 1846–1860; Munich, Germany; Leo von Klenze.

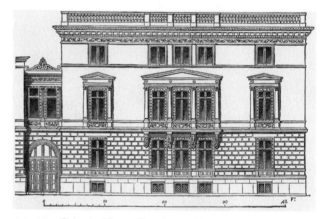

▲ **3-10.** Palace of Count Portales, early 19th century; Berlin, Germany.

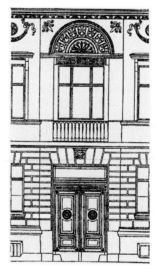

◄ **3-11.** Façade detail, Wohnhaus, early 19th century; Berlin, Germany.

■ *Site Orientation.* Monuments and important buildings sit in open spaces to enhance their importance (Fig. 3-3, 3-4, 3-5, 3-8). Further emphasizing them are ceremonial entrances composed of staircases and gateways modeled on those of the Acropolis in Athens. Museums, even though

- **Josef Ulrich Danhauser** (1780–1829) is the best-known Biedermeier cabinetmaker in Vienna. He designs all types of furniture, accessories, upholstery, and window treatments. Beginning in 1804, his factory, Danhausersche Möbelfabric, supplies furnishings to both the nobility and middle class.

- **Leo von Klenze** (1784–1864), an architect and furniture designer, works mostly in Munich. After studying with Percier and Fontaine in Paris, he develops a passion for antiquity that is reflected in his work. Like others, he designs many different building types and works mostly in the Greek Revival and Neoclassical styles. Klenze and his great patron, the Crown Prince of Bavaria, strive to transform Munich into a modern capital.

- **Karl Friedrich Schinkel** (1781–1841) is the foremost and most prolific German architect of the period. Schinkel designs many different building types in a variety of styles from Greek Revival to a more eclectic classicism to Gothic. His later work reveals concern for picturesque environments, informality, and asymmetry, and he introduces cast iron for structures, details, and furniture. Later designers admire the unity, functionality, and what they perceive as the German character of his work.

located in more crowded urban settings, maintain ceremonial entrances. Other structures locate along streets or in squares that are carefully planned. Palaces are situated in picturesque gardens.

- *Floor Plans.* Most plans are symmetrical and composed of rectangular, square, and/or round or apsidal spaces. For palaces and monuments, progression, ceremony, and status are important concepts in space planning. Museums require spaces in a variety of shapes and sizes to display their collections more effectively.

- *Materials.* Northern Germany favors brick, while other areas use local building stone. Schinkel introduces colored brick, terra-cotta, and cast iron.

- *Facades.* Podia with front or angled staircases, porticoes, temple fronts, or colonnades announce important buildings (Fig. 3-4, 3-5, 3-7, 3-8). Greek prototypes, such as the Parthenon or the stoa, inspire the designs of these porticoes and colonnades. Greek Doric is the most common order followed by Corinthian. Alternatively, some facades have round arches instead of columns. Pilasters or engaged columns create bays on lesser buildings or the side walls of important ones (Fig. 3-6). Stringcourses may separate stories, and friezes or cornices accentuate the junction of wall

and roof (Fig. 3-10). In keeping with Neoclassical design, walls tend to be blank and smoothly finished or lightly rusticated (Fig. 3-7, 3-9, 3-10, 3-11).

- *Windows.* Columns, pilasters, or plain lintels may accentuate rectangular windows and form a rectangular grid across the façade. Arched or round windows are uncommon until the third decade of the 19th century when Renaissance prototypes, particularly those by Andrea Palladio and Guilio Romano, become design sources.

- *Doors.* Porticoes, temple fronts, or aedicula define and emphasize entrances (Fig. 3-4, 3-7, 3-9).

- *Roofs.* Low-pitched gabled roofs in keeping with Greek architecture are typical. Some structures, such as museums and churches, may have domes.

- *Later Interpretations.* As in other countries, Germany participates in the Classical Revival at the end of the 19th century. The simplicity and geometry of Neoclassical design affect early modern architects.

INTERIORS

Following the lead of the French, German and Austrian nobility choose the Empire style especially for ceremonial spaces in their homes, palaces, theaters, and museums (Fig. 3-12, 3-13). Middle class members, however, find it too opulent and expensive. They do not share the Empire vision of grandeur. Instead, they want rooms that focus on comfort and simplicity. They find these ideals in the Biedermeier style.

In middle-class homes, human-scale rooms have a warm, comfortable, and inviting feeling created and enhanced by good lighting, bright colors, and modest furnishings. Collections of glassware, needlework, or other prized possessions, and family silhouettes or portraits attest to the importance of the family and personalize the spaces. Floral patterns, plants, flowers, birds, and fish bring in the natural world. Numerous watercolors and paintings of domestic interiors from the period indicate the significance of domestic spaces.

Private Buildings

- *Types.* Most middle-class apartments are small. Typical spaces are the drawing room, dining room, bedrooms, one or two dressing rooms, and a study or library, service areas, and servants' quarters.

- *Relationships.* Attention focuses on the drawing room as the center of family life (Fig. 3-14, 3-15, 3-16). Space planning requires zones for activities such as reading, hobbies, or letter writing. Furniture lines the walls and fills corners, leaving the center of the space open, but pieces can be moved where needed. Bedrooms are sparsely furnished with a bed, bedside table, chair, couch, and wardrobe.

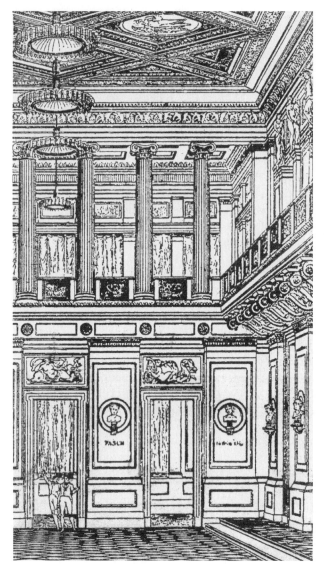

▲ **3-12.** Interior, Schauspielhaus (Royal Theater), 1821; Berlin; Karl Friedrich Schinkel.

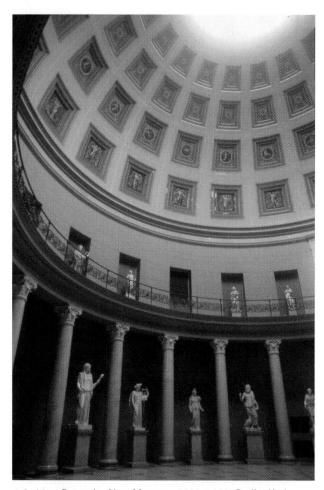

▲ **3-13.** Rotunda, Altes Museum, 1823–1830; Berlin; Karl Friedrich Schinkel.

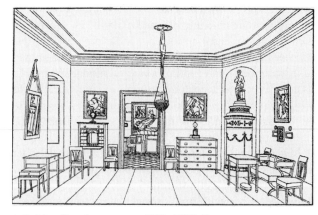

▲ **3-14.** Drawing room, c. 1820–1830; Germany.

■ *Color.* Colors are light and bright. The typical palette contains green, blue, yellow, gray, or brown.

■ *Lighting.* Most rooms have good natural lighting from large windows. Artificial lighting comes from ceiling fixtures, such as lanterns or small chandeliers, sconces, and candlesticks (Fig. 3-14, 3-15). A few people can afford oil lamps.

■ *Floors.* Floors are wood planks or, occasionally, parquet. Wall-to-wall machine-made carpet or area rugs in brightly colored geometric or floral patterns are common floor coverings. Oriental rugs are not affordable for most people.

■ *Walls.* Typical treatments are paint or wallpaper (Fig. 3-14, 3-15, 3-16). Painted walls usually are a solid, light color. The use of wallpaper increases during the period because industrialization reduces the cost and increases availability. Patterns include stripes, geometrics, florals, or imitations of textiles. Both papered and painted walls may have borders in complementary colors and patterns. Baseboards, cornice moldings, and trim around doors and windows usually contrast with the wall color.

■ *Window Treatments.* Window treatments vary from simple white muslin swags with fringe to multiple swags in brightly

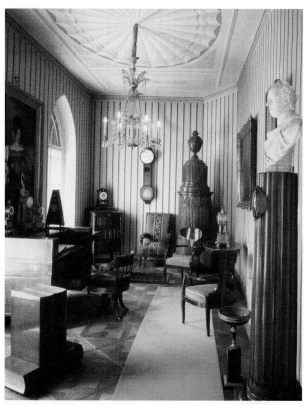

▲ **3-15.** Drawing room, Greymuller Schlossl House, c. 1820s–1830s; Germany.

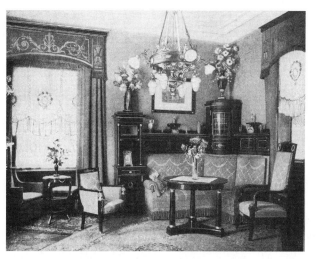

▲ **3-17.** Later Interpretation: Living room; published in *The Room Beautiful*, 1916. Biedermeier interpretation.

■ *Ceilings.* Ceilings are usually plain gray or white. Some have painted decorations, wallpaper borders, plasterwork, or plaster rosettes (Fig. 3-14, 3-15).
■ *Later Interpretations.* The simple, sparsely furnished Biedermeier interior appeals to designers of the late 19th and 20th centuries (Fig. 3-17).

FURNISHINGS AND DECORATIVE ARTS

Like the interiors, Biedermeier furniture is human scaled, comfortable, and simple in design. Designers are influenced by French Empire, English Regency, Sheraton, Louis XVI, and Rococo. Mostly made by artisans, it reflects a high degree of craftsmanship and concern for the material. Function supercedes display as a design goal. Like architecture, furniture is composed of geometric solids and may display classical attributes or copy or adapt antique prototypes.

Early examples (1815–1830) are rectangular in form with minimal decoration. Beauty and interest lie in the grain of the wood and the geometric or curvilinear composition. Classical restraint defines the image. Nevertheless, some furniture displays eccentricity with odd shapes and unusual decoration. Later furniture (1830–1848) moves away from classical restraint to greater exaggeration with more ornament, curves, and bulges. Innovation and fashion replace function and simplicity as industrialization takes hold. Machines make more and more furniture, providing consumers with many types of furniture in numerous styles.

Public and Private Buildings

■ *Types.* New furniture pieces include plant stands, tables for birdcages, magazine racks, and vitrines to display treasured objects.

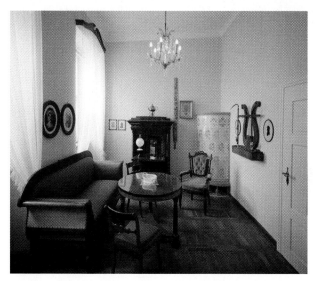

▲ **3-16.** Drawing room, c. 1820s–1840s; Germany.

colored fabrics trimmed with braid, fringe, and tassels. Floor-length curtains and glass curtains may hang beneath the swags. Sometimes unpatterned window treatments offer the only respite from pattern in the Biedermeier room.
■ *Doors.* Doors are plain, paneled, dark wood with simple, painted surrounds.

DESIGN SPOTLIGHT

Furniture: *Designs for Fifteen Side Chairs*, c. 1805; Germany and other chairs from Austria. These side chairs illustrate the variety, simplicity, and elegance of Biedermeier furniture, with rectangular forms minimal decoration, and Classical restraint. Curved open backs are inspired by French Empire and English Regency examples. Front legs are straight and tapered, while the rear legs are a delicate saber style. Beauty and interest lie in the grain of the wood and the geometric or curvilinear composition. Fruitwood and mahogany are the most used woods. Seats are upholstered in textiles fashionable at the time, with patterns having classical motifs.

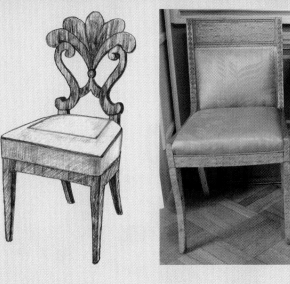

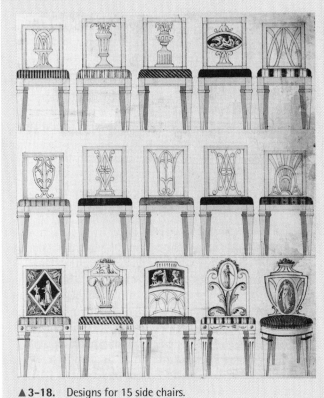

▲ **3-18.** Designs for 15 side chairs.

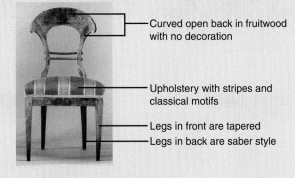

Curved open back in fruitwood with no decoration

Upholstery with stripes and classical motifs

Legs in front are tapered
Legs in back are saber style

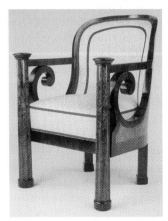

◀ **3-19.** Armchair, c. 1825; Austria.

■ *Distinctive Features.* Large areas of veneer that emphasize the grain of the wood characterize most Biedermeier furniture (Fig. 3-18, 3-20, 3-21, 3-22). Pieces are composed of geometric solids that do not blend or unify, but assert themselves as in architecture. Although the furniture is volumetric, it maintains a planar appearance. Like French Empire furniture, Biedermeier has an angular silhouette with sharp corners, smooth surfaces, and frontal appearance. Unlike Empire, there is little gilding, few bronze mounts, and no feeling of pompousness or majesty.

■ *Relationships.* Furniture is light in scale and often multipurpose to suit small spaces.

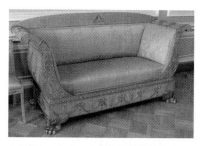 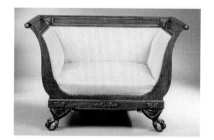 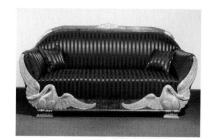

▲ **3-20.** Sofas, c. 1820–1840s; Germany and New York.

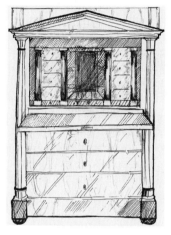

◀ **3-21.** *Secrétaire*, from Castle Zeil, 1830; Germany.

▲ **3-23.** Later Interpretation: Bureau, c. 1850s–1860s; Texas.

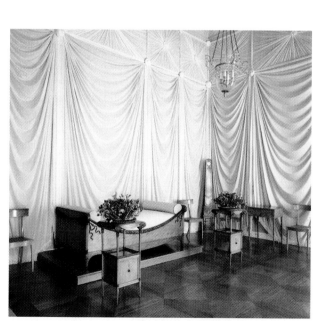

◀ **3-24.** Later Interpretation: Side chair of molded lucite, 1939; United States; Elsie de Wolfe.

▲ **3-22.** Pearwood furniture, bedroom for Queen Louise, Charlottenburg Castle; Germany; Karl Friedrich Schinkel.

■ *Materials.* Cabinetmakers use local woods, predominately light-colored fruitwoods, maple, birch, ash, or cherry. Imported or exotic woods are too expensive for most people. Some pieces have inlay; marquetry; porcelain or glass plaques; or painted, stenciled, or transfer-printed decorations. Inlay and stringing in ebony or other dark woods outline or accentuate legs, backs, drawers, and doors.

■ *Seating.* Unlike Empire, Biedermeier seating looks comfortable and inviting with its curves and deep, overstuffed seats. Seating comes in many forms with numerous details. Side chairs (Fig. 3-18) outnumber armchairs (Fig. 3-19) because they are more easily moved. Legs may be turned, sabers, or straight and tapered with or without a slight

▲ **3-25.** Later Interpretation: DG dining chair, walnut and blackened steel, 2003; United States; Gulassa & Co., Inc.

outward curve near the floor. Rear legs are sabers. Trapezoid or round seats are upholstered, whereas backs usually are not. Backs exhibit the greatest variety of design from ladderbacks to interpretations of the Greek klismos, shield shapes, fan shapes, splats, trellises, lyres, balloons, rectangles, and other geometric shapes (Fig. 3-18). Sofas (Fig. 3-20) often correspond in design to chairs. Corner banquettes are a Biedermeier innovation. Later seating may be highly imaginative interpretations of classicism or even breaks with it.

■ *Tables*. Biedermeier drawing rooms or libraries are filled with many tables for work, games, writing, and display (Fig. 3-14, 3-16). Also common are sofa tables and pier or console tables. Tables display infinite variety in shape, form, and leg styles. Geometric solids, like architecture, or curvilinear shapes define the form and silhouette. Round and rectangular tops have inlay, stringing, or veneer patterns such as stars or sunbursts. Tables may have a single center support or three or four scroll-shaped, turned, straight, or tapered legs.

■ *Storage*. Storage pieces are important in drawing rooms and bedrooms. Nearly every drawing room has a secretary or drop-front desk (Fig. 3-21). Most desks are tall and

rectangular, but some, particularly later, exhibit great creativity in form and shape. Inside the drop front are numerous drawers, secret drawers, and pigeonholes. Tops may have pediments or rectangular boxes diminishing in size. Corners may have columns in contrasting colors. Some secretaries have matching wardrobes. Doors of secretaries and wardrobes may have veneer patterns such as sunbursts. Other wardrobes have two doors, sometimes mirrored, with columns on the corners. Chests with three or four drawers also store possessions in drawing rooms and bedrooms. Vitrines or display cabinets show off prized possessions of the family. They have glass on three sides and a mirrored back. *Étagères* hold books and/or display collections.

■ *Beds*. Like other furniture, beds display great variety in design (Fig. 3-22). Poster or French beds with equal-height head- and footboards are common, but four-posters are most favored. Beds are usually draped. They may have matching night tables.

■ *Upholstery*. Local textiles dominate Biedermeier furnishings because imported ones are too expensive. Common upholstery textiles include horsehair, needlework, velvet, printed cotton, linen, or wool. Only the nobility can afford silk. Abstract patterns in strong colors are favored. Sometimes chairs and sofas have lengths of fabrics draped over them or furniture covers in garish colors with contrasting edge bands.

■ *Decorative Arts*. Mirrors, numerous pictures, family portraits, or silhouettes hang on walls. Screens may divide spaces or hide beds in drawing rooms and washstands in bedrooms. Proudly displayed, porcelain has classical or urn shapes with naturalistic plants and flowers in colored panels or surrounded by borders. Blown and cut glass, plain or colored, is particularly prized. Bavaria is an important and well-known center for glassmaking.

■ *Later Interpretations*. Vernacular interpretations of Biedermeier occur throughout the United States in the mid to late 19th century particularly where Germans settle and crafts production flourishes, such as in Texas (Fig. 3-23). The light-colored woods; simple, planar forms; functionality; minimal ornament; and unpretentiousness of Biedermeier influence subsequent modern movements, including Art Nouveau (called *Jugendstil* in Germany) and Art Deco. Designers who adapt the basic forms of Biedermeier include Josef Hoffman, Peter Behrens, and Elsie de Wolfe (Fig. 3-24). Because of its basic simplicity, today's manufacturers market furniture based upon Biedermeier (Fig. 3-25).

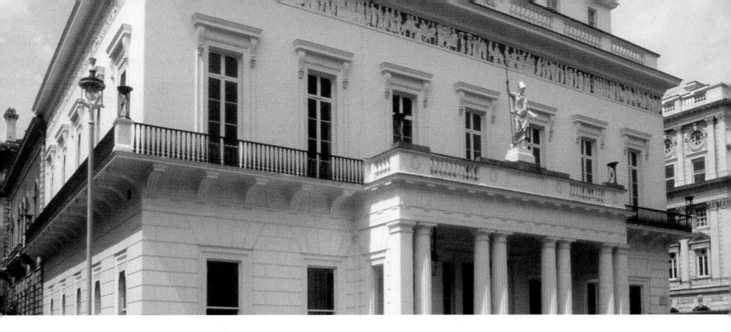

English Regency, British Greek Revival

1790s-1840s

Whether the house be Grecian or gothic, large or small, it will require the same rooms for the present habits of life, viz. a dining-room and two others, one of which may be called a drawing-room, and the other a book-room, if small, or the library, if large: to these is sometimes added a breakfast room, but of late, especially since the central hall, or vestibule, has been in some degree given up, these rooms have been opened into each other, "en suite," by large folding doors; the effect of this enfilade, or "visto," through a modern house, is occasionally increased by a conservatory at one end, and repeated by a large mirror at the opposite end.

Humphry Repton, 1816 from *Regency Style*, 1996, p. 29 by Steve Parissien

England's Regency is a creative and productive period for both architecture and the decorative arts. Designers borrow and synthesize forms and influences from classical, medieval, and exotic sources. Neoclassicism continues to dominate the arts and architecture, but the Romantic and Picturesque Movements also affect design. Consequently, formality and symmetry through classicism shape the main character, and eclecticism and asymmetry enliven the building context. This mixing of influences contributes to a unique and distinctive design image, one that offers more variety than is evident in earlier periods.

HISTORICAL AND SOCIAL

The term *Regency* can refer to several periods. Politically, it designates the time between 1811 and 1820 when George, Prince of Wales, serves as Prince Regent for his father who is too ill to reign. Artistically, Regency covers the years between 1790 and 1830, although characteristics of this style appear as early as the 1780s and continue well past 1830.

George, Prince of Wales and eldest son of George III and Queen Charlotte, is a great patron and collector of art and architecture. Unlike his forebears, he sees himself as an arbiter of taste. He gives numerous commissions to architects and designers, including the remodeling of Carleton House in London and the Royal Pavilion at Brighton. Hugely unpopular, he becomes one of the most despised English monarchs because of his excessive spending and dissolute, immoral lifestyle. His marriage to Caroline of Brunswick produces one daughter, Princess Charlotte.

The period is largely one of luxury, prosperity, and growth despite social unrest, violence, and injustice. Following the loss of the American colonies, Great Britain looks to the south (Africa) and east (India) for colonization to increase trade and commerce and enhance prosperity. The British victories over Napoleon stimulate nationalism and patriotism. The Congress of Vienna, which meets in 1814 to bring order back to Europe following the defeat of Napoleon, increases Britain's territorial holdings by adding former Dutch holdings, such as Ceylon (today's Sri Lanka).

The Industrial Revolution, which begins in the textile industry, boosts economic prosperity. New inventions help Britain become the largest exporter of cotton textiles in the world by 1830 and increase her production of iron and coal. Towns and cities grow as people move to them to take factory jobs. London, the largest city, is a center for trade and commerce. People are living longer, marrying younger, and having larger families.

The nobility become wealthier as does the larger middle class (Fig. 4-1), whose demand for houses and furnishings creates a building boom. Fashion begins to surpass taste as the driving force in art and design, and fashions change quickly. Consumers of the new commercial classes face a vast array of stylistic choices. Numerous books and periodicals assist them in furnishing their homes with the latest fashions. The seeds of revivalism that will characterize the Victorian era are sown during this period.

CONCEPTS

During the Regency period, classicism dominates architecture, interiors, and furniture and follows two paths. One thread maintains the flow of the Neoclassical, continuing its lightness and advocating stylistic purity and archaeological correctness. A second, later trend, adopts elements

IMPORTANT TREATISES

- **The Cabinet Dictionary,** 1803; Thomas Sheraton.
- **The Cabinet-maker, Upholsterer and General Artist's Encyclopaedia,** 1804–1806; Thomas Sheraton.
- **The Cabinet-maker and Upholsterer's Guide,** 1826; George Smith.
- **A Collection of Designs for Household Furniture and Interior Decoration,** 1808; George Smith.
- **A Collection of Ornamental Designs,** 1812; George Smith.
- **Household Furniture and Interior Decoration,** 1807; Thomas Hope.
- **The Laws of Harmonious Colouring,** 1821; David Ramsay Hay.
- **Plans of Buildings,** 1788; Sir John Soane.
- **Periodicals:** *The Repository of Arts, Literature, Commerce, Manufactures, Fashions and Politics (Ackerman's Repository),* 1809–1828; Rudolph Ackerman.

from other classical sources, such as the Italian Renaissance. Although often at war with France, French influences are strong in England.

The Romantic and the Picturesque Movements influence design thinking throughout the period. Romantics believe in the unity of reason, nature, and antiquity, and they rigorously seek the beautiful and the sublime or the awe-inspiring or terror-filled experience of nature. Because feelings are supreme, Romantics esteem past styles for their visual and symbolic associations, and they evoke an emotional response. They regard medieval styles as equal counterparts to classical ones. The Picturesque Movement also admires nature and the visual qualities of landscapes, such as asymmetry. These two movements open the door for a broader range of design resources and greater eclecticism. Their reliance upon links and relationships leads eventually to designing in a particular style based upon that style's historical associations, which characterizes design throughout the Victorian period. Known as associationism, this manner of thought values a work of art beyond beauty, which may be shown by intrinsic qualities such as form, to the images, memories, and thoughts that it may conjure up in the viewer's mind.

Unlike European designers, the English freely borrow from many sources besides classical, producing a unique expression. Forms remain the same, but the details

◄ 4-1. Costumes of women.

denote a particular style or design source. The Industrial Revolution produces new materials, makes existing materials more available, and helps to bring about less-formal living patterns. In this period, interior decoration advice books and periodicals begin their ascent in popularity. Two important ones are *Household Furniture and Interior Decoration* (1807) by Thomas Hope and *A Collection of Designs for Household Furniture and Interior Decoration* (1808) by George Smith.

DESIGN CHARACTERISTICS

Although classicism dominates, Regency architecture, interiors, and furniture exhibit great variety and eclecticism through classical (Greek, Roman, Egyptian, and Italian Renaissance), medieval (Norman, Gothic, Tudor, and Elizabethan), and exotic (Chinese, Turkish, and Indian) influences and characteristics. Some designers working in the classical mode strive for archaeological correctness and use the vast array of treatises portraying works of ancient Greece, Rome, and Egypt as resources. Others are more

eclectic, receiving inspiration from contemporary France and Renaissance Italy. In general, symmetry, concern for proportion, monumentality, and antique forms and details characterize the classical styles. The medieval and exotic modes are evocative, freely mixing elements and details from their sources with contemporary forms. Asymmetry and irregularity are more common with these influences. Emblems and associations become important during the period.

■ *Greek Revival.* Originating in the early 19th century in England, examples portray a stark, Grecian image that derives from studies of antiquity in the late 18th century. Buildings feature bold, simple massing; flat, unbroken walls; minimal, refined, and flat ornament; the Greek orders, particularly the Doric; heavy proportions; porticoes; colonnades; and Greek or Roman temple forms.

■ *Motifs.* Motifs include pediments, columns, arabesques, grotesques, urns, classical figures, trellises, fretwork, bamboo, foliage, pagodas, pointed arches, fan vaulting, rose windows, sphinxes, sun disk and vulture, Egyptian heads, and stars (Fig. 4-2, 4-6, 4-13, 4-22, 4-24, 4-29, 4-30, 4-31, 4-34, 4-36, 4-40).

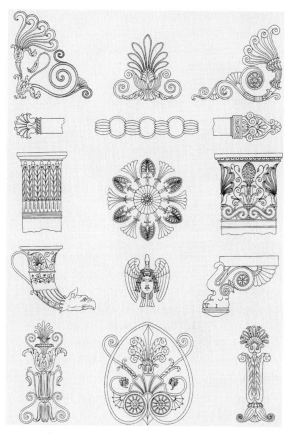

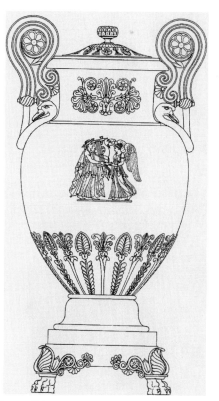

▲ **4-2.** Ornamental motifs and vase; published in *Household Furniture and Interior Decoration*, 1807; Thomas Hope.

ARCHITECTURE

Regency architecture follows two paths, Neoclassicism and the Picturesque Movement, with each producing many variations. Architects possess a large body of architectural theory, the classical being the best understood. Consequently, most public buildings are Neoclassical and feature typical classical elements, such as columns and pediments, and attributes like symmetry, order, and balance.

During the 18th century, classical Greek buildings become objects of scrutiny by architects, dilettantes, and others who measure, draw, and publish them. The most famous treatise is Stuart and Revett's *Antiquities of Athens*, published beginning in 1762. Although interpretations of temple ruins are common in picturesque landscapes, tastes do not run to the Grecian, so few buildings are constructed in the style during the period.

By 1800, appreciation for things Greek has increased. Abbé Marc Laugier's theories of simplicity and architectural purity deriving from the primitive hut are finding greater acceptance among English architects, and Lord Elgin's importation into England of the Parthenon sculptures focuses popular attention on Greece. Thomas Hope, who prefers Greek designs to Roman, issues a strong call for buildings of pure Greek design. Designers respond with

▲ **4-3.** Dulwich Picture Gallery, 1811–1814; London, England; John Soane. English Regency.

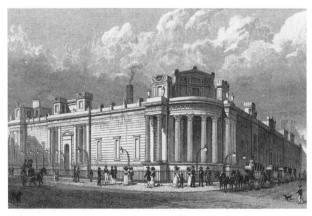

▲ **4-4.** Bank of England, 1788–1823; London, England; Sir John Soane. English Regency.

▲ **4-6.** Hyde Park Corner, arch and screen, 1825; London, England; Decimus Burton. British Greek Revival.

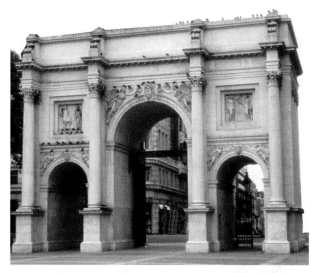

▲ **4-5.** S. Pancras Church, 1818–1824; London, England; H. W. Inwood. British Greek Revival.

▲ **4-7.** Marble Arch, 1828; London, England; John Nash. English Regency.

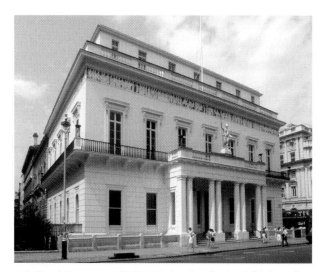

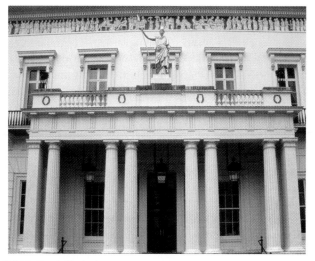

▲ **4-8.** Athenaeum, 1829-1830; London, England; Decimus Burton. British Greek Revival.

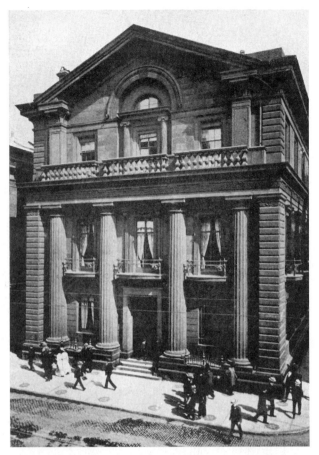

▲ 4-9. Branch Bank of England, 1845; Liverpool, England; C. R. Cockerell. British Greek Revival.

Greek Revival buildings. Many museums, libraries, art galleries, and university buildings are Greek Revival and stand as Temples of Learning or Temples of Art, structures created for educating humankind about the accomplishments of the ancients. Largely supplanted by Gothic Revival by midcentury in England, Greek Revival continues well into the 1860s in Scotland.

Beginning in the 1820s, designers, having reached what they believe are the limitations of the Greek Revival, turn to the Italian Renaissance, Italian vernacular, and Andrea Palladio for inspiration. Thus, they develop the Renaissance Revival, which continues into the Victorian period. Renaissance Revival, adopted first for gentlemen's clubs, copies and adapts forms and details from Italian Renaissance palaces (see Chapter 7, "Italianate, Renaissance Revival").

The Picturesque Movement in architecture develops from landscapes designed in the second half of the 18th century. These landscapes feature asymmetry, meandering paths, ponds with irregular shapes, and ruins or small buildings for contemplation as designers strive to create a series of views or pictures reminiscent of ancient history, literature, or lyrical paintings. In architecture, this translates to unity with the landscape, asymmetry in plan and form as well as

the integration of nature inside and outside. These attributes contrast with Neoclassical and for the most part characterize domestic structures.

Medieval sources, important to the Picturesque, lead to the appearance of Gothic characteristics, such as pointed arches and tracery, applied to contemporary buildings (see Chapter 6, "Gothic Revival"). Late in the period, the Tudor and Elizabethan styles join Gothic. Elements from such exotic sources as China, India, and Islam also appear, although rarely are entire structures designed in these modes. An exception is the Royal Pavilion at Brighton, which features onion domes, foliated arches, and latticework. The Italianate style also develops from Italian vernacular buildings during this period. It features asymmetry, towers, round arches, and large overhanging eaves on roofs (see Chapter 7, "Italianate, Renaissance Revival").

Public Buildings

■ *Types.* The period produces a variety of building types such as monuments, banks, museums, gentlemen's clubs, markets, churches, factories, and warehouses (Fig. 4-3, 4-4, 4-5, 4-6, 4-7, 4-8, 4-9, 4-10). Most important buildings are classical or Greek Revival in style. Beginning in this period, architects make a distinction between architecture and engineering. They do not consider utilitarian buildings, such as factories, as architecture. Nevertheless, many of these buildings have classical design compositions.

■ *Site Orientation.* Some public buildings are part of Picturesque urban developments and their relationship to each other and the street is carefully considered to create focal points (Fig. 4-6, 4-7, 4-8, 4-10, 4-11).

■ *Floor Plans.* Plans do not change a great deal. Symmetry continues to govern the disposition of spaces. Important buildings often have a variety of sized and shaped spaces suitable to their functions.

■ *Materials.* Stucco as facing for other materials dominates the period (Fig. 4-3, 4-6). It usually is colored and scored to resemble stone. Brick and stone also are used (Fig. 4-4, 4-8) and ironwork is especially characteristic. Because iron can easily reproduce ornament in any style, balconies, verandas, some interior columns, windows, and roofs are made of cast iron.

■ *Façades.* Usual classical characteristics include temple fronts, porticoes, colonnades, pediments, clean lines, smooth or rusticated walls, geometric forms, and symmetrically disposed wings. Greek Revival (Fig. 4-6, 4-10, 4-11) strives to create a Grecian image using the Doric, Ionic, or Corinthian orders, minimal ornament, and compositions of geometric solids derived from ancient Greek prototypes such as the Parthenon (448–432 B.C.E.), the Choragic Monument of Lysicrates (c. 334 B.C.E.), and the Tower of the Winds (c. C.E. 40). During the 1820s, architects begin to add elements from the Italian Renaissance and Andrea Palladio. The Italian palazzo

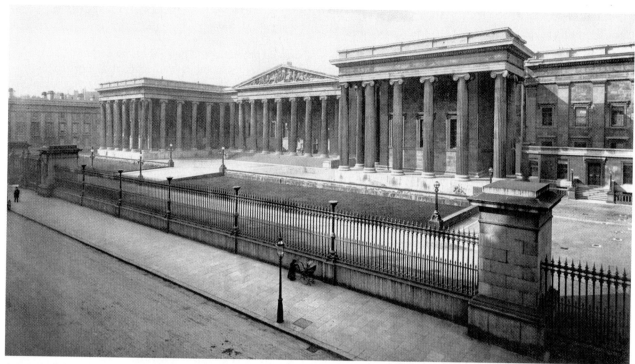

▲ 4-10. British Museum, 1823–1846; London, England; Sir Robert Smirke. British Greek Revival.

becomes the model for gentlemen's clubs and banks (Fig. 4-8). Most churches maintain the 18th-century Georgian or classical tradition with portico or temple front and steeple behind (Fig. 4-5). Some follow medieval or Gothic prototypes.

■ *Windows.* Windows may be rectangular or square, small or large (Fig. 4-8, 4-9). Typical sash and French windows are arranged symmetrically across the façade usually with blank walls in between. Some have rounded tops, lintels, or pediments. A few buildings have Palladian windows.

■ *Doors.* Doors are wood paneled with surrounds appropriate to the style, including columns, pilasters, porticoes, pointed arches, and foliated arches.

■ *Roofs.* Roofs may be flat, gabled with pitch dependent upon the style, hipped, vaulted, or domed.

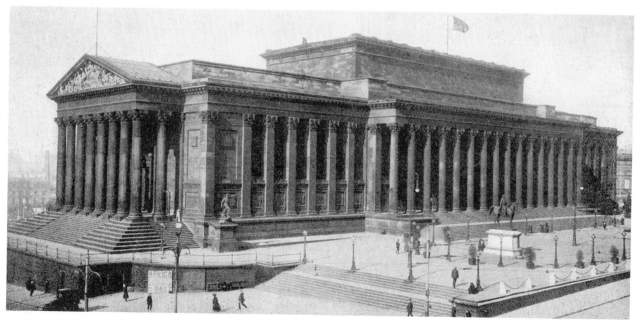

▲ 4-11. St. George's Hall, c. 1840–1854; Liverpool, England; by Harvey Lonsdale Elmes. British Greek Revival.

DESIGN SPOTLIGHT

Architecture: Park Crescent, begun 1812; Regent's Quadrant, 1819–1820; Cumberland Terrace, 1825; in Regent's Park, London, England; John Nash. English Regency. These row houses are centerpieces in Regent's Park. The design of Cumberland Terrace treats the terrace as a single unit. The building has triumphal arches in the center joined by two wings on either side. Although Grecian details embellish the building, its long wall is broken by a series of projections that create repetitive movement and visual interest, vital ingredients in the Picturesque. Projecting pavilions with balustrades carried by pairs of Ionic columns define the ends of the wings and middle section. A large two-step projection distinguishes the building's center. This pavilion is composed of a central portico with a pediment flanked by smaller stepped-back Ionic porticoes. The tympanum has terra-cotta figures of Britannia flanked by the arts and sciences. Ionic pilasters divide the recessed portions of the building into bays. The entire lower story is rusticated and has sash windows. French windows highlight the middle story, and smaller square sashes define the third and fourth stories. Nash places the main entrances and service buildings at the rear so as not to disturb his composition and to further the illusion of one long building.

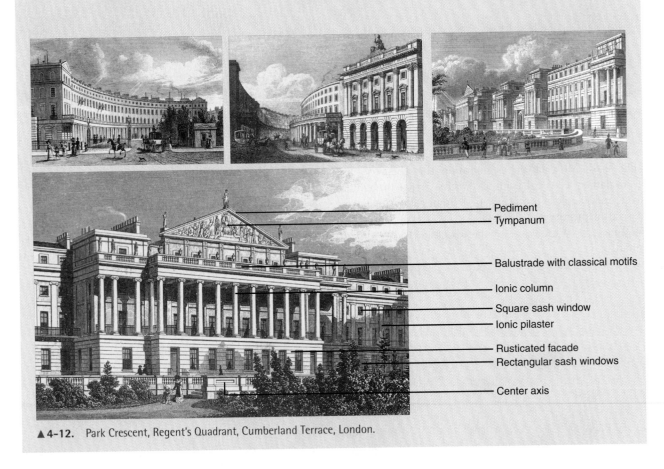

- Pediment
- Tympanum
- Balustrade with classical motifs
- Ionic column
- Square sash window
- Ionic pilaster
- Rusticated facade
- Rectangular sash windows
- Center axis

▲ **4-12.** Park Crescent, Regent's Quadrant, Cumberland Terrace, London.

■ *Later Interpretations*. A second Neoclassical Revival begins in the late 19th century. Architectural expressions are even more monumental and larger than earlier ones, although they may look similar to one another.

Private Buildings

■ *Types*. Villas, which are somewhere between a mansion and a cottage in size, and townhouses are common in the period (Fig. 4-12). The few large country houses built may be rectangular blocks or have wings in the Palladian manner. The villa and cottage are more likely to exhibit medieval or exotic characteristics. Townhouses, often called terraces in England, are tall and narrow in width and exhibit classical characteristics.

■ *Site Orientation*. Some private apartment buildings are part of urban developments, and their relationship to each other and the street is carefully considered to create a

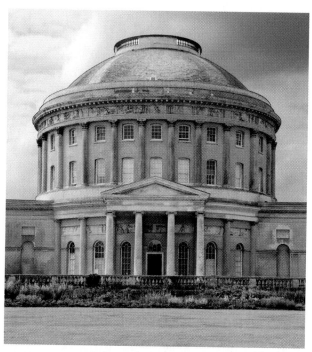

▲ **4-13.** Ickworth, 1795–1829; Suffolk, England; Mario Asprucci the Younger. English Regency.

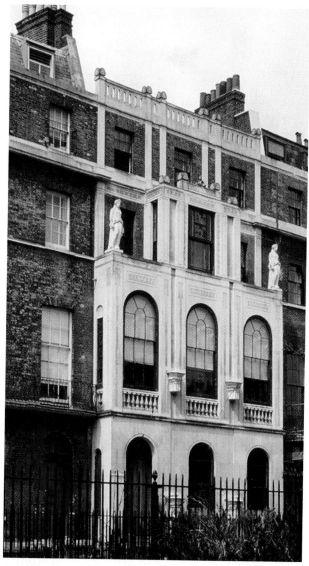

▲ **4-14.** No. 13, Lincoln's Inn Fields (Soane's house, now the Soane Museum), 1812–1813; London, England; Sir John Soane. English Regency.

series of scenic views. John Nash's design for Regent Street and Regent's Park in London is an example (Fig. 4-12). Nature and the landscape are important, so country houses and villas are set in gardens of formal and informal or wild areas enhanced with ancient "ruins" and statuary (Fig. 4-13). Picturesque structures attempt to blend with the landscape instead of contrasting with it as in the 18th century. Nature is brought into the house with conservatories, greenhouses, verandas, and with plants and flowers.

■ *Floor Plans.* Neoclassical house plans, with the exception of terraces, are symmetrical (Fig. 4-23). Picturesque plans are asymmetrical and may have angled wings and/or center on verandas or towers. Plans are less likely than before to be disposed around suites of apartments and more likely to be arranged in circular patterns around the staircase. Rooms of state begin to disappear as rank and ceremony decline in importance. The library evolves from a singularly masculine domain to a room used by the entire family. The dining room, however, remains masculine in atmosphere, whereas the parlor, where guests are received, has a feminine air. New additions to the plan may include the breakfast room, adjoining parlors with sliding doors to create a more open plan, and the conservatory to bring nature into the house (Fig. 4-15). Somewhat more common are bathrooms, although the vast majority of houses have no running water, at least on upper floors.

■ *Materials.* Brick is the dominant building material followed by local stone, which is used primarily by the wealthy (Fig. 4-13). New methods of firing give a greater

range of colors for brick. Yellow, gray, cream, and white brick replace red in popularity. In the 1830s, new machinery ensures consistency in brick sizes. As in public buildings, stucco often covers brick and is colored and scored to resemble ashlar masonry. However, stucco is not very durable, so builders develop Portland cement in 1814 as a substitute. Its name comes from its resemblance to Portland stone. Ceramic tiles in similar colors to brick are a less common building material. Cast iron is used for balcony railings, glazing bars in windows, balustrades, and staircases. Iron is usually painted green to resemble bronze.

■ *Façades.* Newer characteristics include wider and taller sash windows, bow and bay windows, simpler door cases,

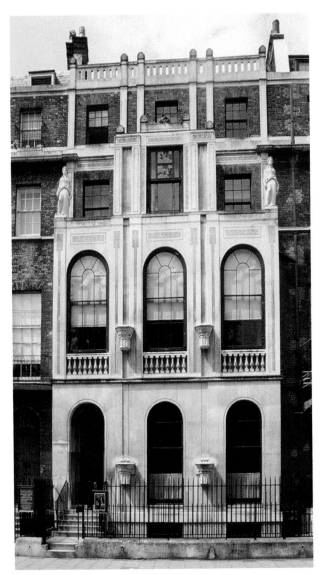

▲ **4-14.** *(continued)*

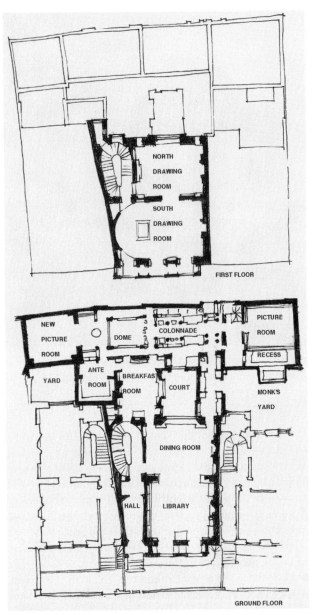

▲ **4-15.** Floor plan, No. 13, Lincoln's Inn Fields, 1812–1813; London, England; Sir John Soane. English Regency.

and/or stucco. Classical façades in town and country are symmetrical with temple fronts, porticoes, blank walls, columns, and/or pilasters (Fig. 4-12, 4-14). Compositions develop from geometric forms derived from classical sources. Townhouses occasionally show medieval or exotic details, such as trellis balcony supports or pointed arches. Asymmetry, irregular massing, and freely mixed elements from a variety of sources often characterize medieval- and exotic-style country houses, castles, villas, and cottages. Indian-style buildings, which are few, feature cupolas, lacy arches, and onion domes. Verandas, arriving from India, may surround a medieval- or exotic-style house or be integrated into one or more façades, giving a Picturesque image and taking advantage of light and views. French windows often open to verandas and balconies. With the exception of garden buildings, there are few purely Chinese structures. Some buildings freely mix Indian and/or Chinese details (Fig. 4-16).

■ *Windows.* Sash windows are the most typical (Fig. 4-12, 4-13, 4-14). New methods of glassmaking increase sizes of the panes. Floor-length windows, usually leading to balconies, verandas, or conservatories, are more evident. Dark colors, such as chocolate brown, may highlight window frames. Exterior shutters may be brown, black, or green. Some windows have fabric awnings or canopies over them.
■ *Doors.* Door surrounds are plainer than before with light reeding preferred over columns or pilasters. Fanlights are smaller with simpler glazing patterns. Doors are wood with two or three large panels. Some have circular or diamond shapes in the panels. In the 1830s, doors with glass panes

DESIGN SPOTLIGHT

Architecture: Royal Pavilion, 1786-1787, remodeled 1815-1821; Brighton, England; Henry Holland, remodeled by John Nash. English Regency. Originally classical in style, the Royal Pavilion represents the exotic, eclectic aspects of Regency as envisioned by John Nash for the Prince of Wales. Nash creates a building without parallel in Europe that sets the standard for fantasy resort architecture. Taking advantage of new materials, he enlarges the building with a cast-iron frame. Highly irregular in form, the Pavilion combines Chinese, Islamic, medieval, and Indian details and motifs. Curving and rectangular forms create a picturesque outline. Chinese-style lattice in a Gothic pattern fills Islamic horseshoe arches and edges the balconies. French windows with curving tops allow access to the outside or the balconies. Minarets, onion domes, chimneys, and pointed battlements punctuate the roofline. The minarets and domes are iron covered in stucco.

The Pavilion's interiors are equally exotic and ostentatious in design. Exterior influences repeat inside, but Chinese details predominate. Lavish materials, rich colors, gilding, bamboo, fretwork, flowers, foliage, and dragons characterize wall, floor, and ceiling treatments as well as furnishings throughout the Pavilion. The most magnificent of the rooms are the Banqueting Room by artist Robert Jones and the Music Room decorated by Frederick Crace.

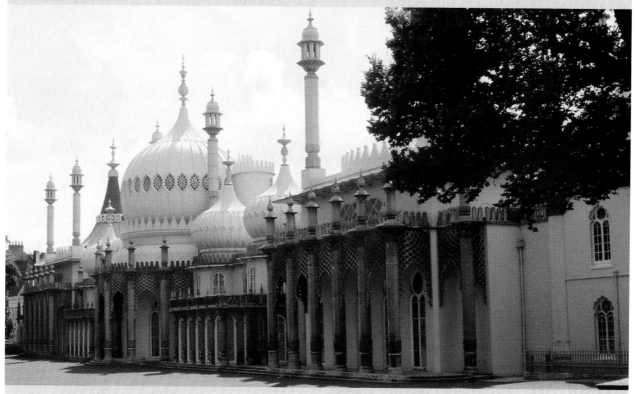

▲ **4-16.** Royal Pavilion; Brighton, England.

emerge. Glass is usually in the upper half of the door or only in the top two panels. Doors are painted dark colors unless they are made of mahogany or oak. Cast-iron knobs and hinges are usually painted black. Door knockers, such as lion heads, sphinxes, or crocodiles, are fashionable, but bells begin to replace them in the 1830s.

■ *Roofs*. Roofs may be flat, gabled, hipped, or battlemented. Roofs of classical styles are likely to be flat or gabled. Medieval and exotic styles may be battlemented, parapeted, or domed in exotic shapes (Fig. 4-16). Italian villa roofs may have overhanging eaves.

■ *Later Interpretations*. Some variations of the English Regency style filter to the United States in the early 19th century through the work of a few architects, such as William Jay (Fig. 4-17). In approximately 1904, interest in Regency brickwork and ironwork revives, so many Regency Revival terraces are constructed in London and other English cities.

DESIGN PRACTITIONERS

Breaking with the 18th-century tradition of Robert Adam and others, Regency architects rarely design domestic interiors and furniture. These tasks are left to upholsterers, cabinetmakers, and other designers often with the help of patrons. Pattern books for furniture and interiors assist patrons and consumers in designing their homes.

- **Crace and Son** is one of the best-known furniture-making, upholstery, and interior decoration firms of the Regency. Frederick, a son, creates the interiors of the Royal Pavilion at Brighton. The father, John C. Crace, makes the furniture for the Pavilion. Another son, John G. Crace, collaborates with A. W. N. Pugin on the interiors of the Houses of Parliament.

- **Gillow and Company** designs interiors and furniture for wealthy patrons from the mid-18th through the 19th centuries. Robert Gillow opens the London branch as a cabinetmaking firm in 1769. By 1800, the firm furnishes entire houses. Innovations include the whatnot and pieces named for wealthy patrons.

- **Thomas Hope** (1769–1811) is a wealthy connoisseur and collector who designs the furniture and interiors of his homes around his collection of ancient artifacts. Influences include classical antiquity and Napoleon's architects and his friends, Percier and Fontaine. Hope's correct application of forms and motifs reflects his careful study of antique sources. His book, *Household Furniture and Interior Decoration*, introduces the term *interior decoration* to the English public and also features the interiors of his Duchess Street house.

- **John Nash** (1752–1835) is the leading architect of the Picturesque in England. His partnership with landscape designer Humphry Repton produces many country houses, villas, and cottages that exemplify Picturesque characteristics. Nash becomes the principal architect of the Prince Regent in 1811. He creates plans for Regent Street and Regent's Park, thus bringing the Picturesque into the city. Nash designs in many styles and introduces cast iron for various parts of his buildings.

- **George Smith** (c. 1786–1826) promotes eclecticism with less concern for archaeological correctness than Hope does. Smith popularizes Hope's ideas. Unlike Hope, he includes a few Norman or Gothic and Chinese designs in his book. Because he is a cabinetmaker, his designs assume a more practical approach. His first book, *A Collection of Designs for Household Furniture and Interior Decoration*, contains color plates and is a guide to furnishing all rooms in a house.

- **Sir John Soane** (1753–1837), one of England's great architects, creates a unique and personal style in architecture and interiors that synthesizes Neoclassicism and Picturesque. His Neoclassical style is one of reduction—eliminating details. Thus, fluting in his hands becomes incised lines. Picturesque characteristics include antique allusions, changes in level, and implied movement. His interiors have slender proportions, spare details, unusual lighting, rich colors, and unusual vaults and domes.

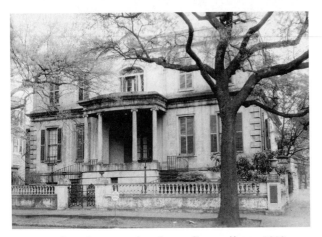

▲ **4-17.** Later Interpretation: Owens-Thomas House, 1816–1819; Savannah, Georgia; William Jay. American Regency.

INTERIORS

Like architecture, Regency interiors are eclectic and borrow from the same sources—classical, medieval, Italian, French Empire, Chinese, and Indian. Classically inspired rooms are the most common, followed by medieval examples. Entirely Chinese or Indian interiors are rare as in architecture. Public interiors and important domestic rooms have more ambitious treatments that include architectural details such as moldings, the orders, or fan vaulting. Other rooms have flat, decorative treatments such as paint, fabric, or wallpaper. Each room typically is treated as a unit with its own color scheme or theme and is usually designated as such (Chinese Room or Yellow Room). Inherited rank becomes less important than wealth, which must be

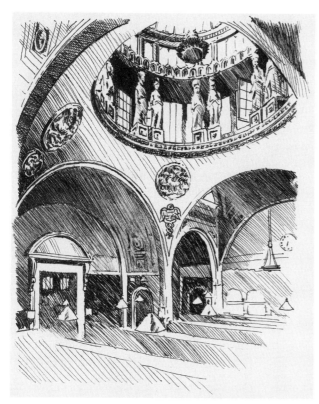

▲ **4-18.** Rotunda and office area, Bank of England, 1788–1823; London, England; Sir John Soane. English Regency.

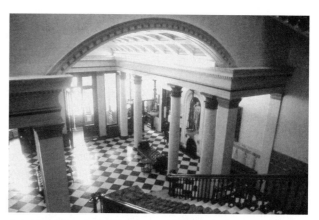

▲ **4-19.** Entry hall, Athenaeum, 1829–1830; London, England; Decimus Burton. British Greek Revival.

displayed. Consequently, many rooms are ostentatious or sometimes even garish.

The Industrial Revolution greatly affects interiors and their decoration. The use of textiles increases because they are more readily available and cost less. Cast-iron balustrades, fire grates, and stoves become more universal. Advancements in the manufacture of glass and the development of plate glass allow larger windows to provide more natural light. Artificial lighting improves with

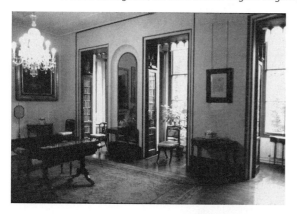

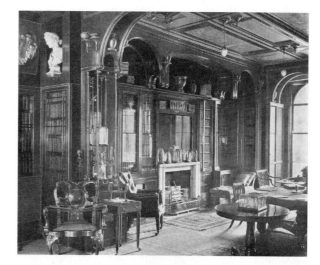

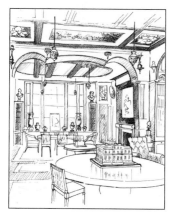

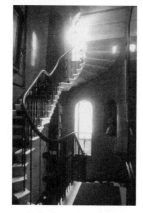

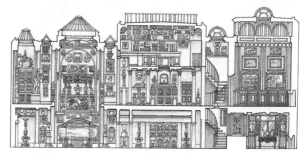

▲ **4-20.** Drawing room, dining room, stair hall, and section at No. 13, Lincoln's Inn Fields, 1812–1813; London, England; Sir John Soane. English Regency.

DESIGN SPOTLIGHT

Interiors: Breakfast room, No. 13, Lincoln's Inn Fields; London, England; Sir John Soane. English Regency. This engaging room in Soane's second house shows his personal style that includes Neoclassical as well as Picturesque design elements. The room's location creates a series of vistas common to the Picturesque that draw the eye into the dome, across the space, and into the Monument Courtyard outside. The shallow canopy dome seems to float lightly above the space, making it appear more intimate in scale. Contributing to this effect, natural and artificial light from light wells illuminate the room perimeter, making the walls brighter than the dome is. Hundreds of small mirrors in the dome, the pendentives, and underneath the arches multiply light and views to enhance the feeling of Neoclassical lightness. The incised lines and Greek key motifs that embellish the dome are typical of Soane's style. The house showcases his interior architecture and vast collection of artifacts, books, and artwork.

Remodeled by Soane, the cream-colored exterior of the house features a projecting façade on the first two stories with triple arches and classical details (Fig. 4-14). A single projecting arch and statues define the third story, while the fourth story has square windows separated by pilasters. A balustrade caps the composition and hides the roof.

Skylight

Shallow canopy dome

Incised lines and Greek key motifs on dome

Pendentive

Light well above illuminates perimeter of room

Classical artifacts are accented throughout the space to create vistas

Lightweight furnishings contribute to Neoclassical character

◄**4-21.** Breakfast room, No. 13, Lincoln's Inn Fields, London.

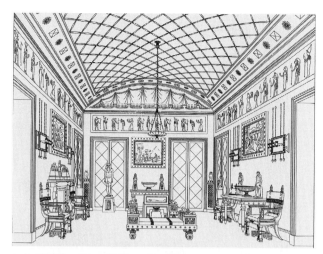

▲ 4-22. Interior with Egyptian influence; published in *Household Furniture and Interior Decoration*, 1807; London, England; Thomas Hope. English Regency.

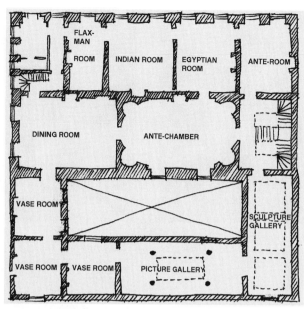

▲ 4-23. Floor plan, Thomas Hope House, Duchess Street, c. early 19th century; London, England. English Regency.

advances in the fishing industry that provide more oil and the development of gas lighting.

During this period, room use and associations become more prescribed as family and business relationships change in response to the Industrial Revolution and etiquette and manners increasingly define roles and interactions. Residential entry halls regulate social status as friends, acquaintances, beaux, and social climbers leave their calling cards to be reviewed by the family. In addition, business associates and less important persons wait in the hall for the gentleman or lady of the house. Parlors, where guests are received and entertained, give impressions of status and culture through formal, usually feminine, décor. An important symbol of wealth and hospitality is the dining room, which is found in more middle-class homes. The family gathers for formal, elaborate meals in which acquaintances and friends are entertained in lavishly appointed, masculine spaces. Although private, bedrooms have richly embellished suites of furniture as an expression of wealth and taste. These specific room uses and connotations continue throughout the 19th century.

Completely architect-designed interiors decline as many people begin decorating their own rooms aided by furniture and interior pattern books. Some call in upholsterers or furniture-making firms. A few antiquarians conduct more scholarly restorations of homes.

Public and Private Buildings

■ *Types*. Commercial buildings generally continue to use the same types of room spaces, but business offices become more important and increase in number. New in houses are conservatories and breakfast rooms (Fig. 4-21). Galleries for paintings and sculpture are important in museums and the homes of the wealthy.

■ *Relationships*. Interiors may or may not repeat exterior architectural details. In commercial structures, there is more design integration between exterior and interior architectural features, whereas there is usually more variety in residential buildings (Fig. 4-22, 4-24). Styles are often mixed in houses; not all room styles reflect the exterior style. For example, some Picturesque houses have classically inspired interiors and some classically inspired houses have halls and libraries rendered in other styles.

■ *Color*. Color inside public buildings comes from the materials, such as stone or marble. Wallpaper and fabric are not commonly used in public spaces. Walls are painted white, gray, or a rich red or blue.

Regency colors tend to be rich and vivid. Usual colors include crimson, saffron yellow, blue, and gold. Color schemes come from many sources, including a motif or pattern used in the room. Scholarship discovers the colors of the ancients, which form Etruscan or Pompeian color plans of terra-cotta, red, and black, sometimes mixed with blue or green (Fig. 4-21). Chinese color schemes, such as those at Brighton Pavilion, may be based on the blue or green backgrounds of imported Chinese wallpapers or the red, black, and yellow of imported Chinese lacquer (Fig. 4-24).

Pattern books and periodicals promote rooms that are coordinated in color. Authors insist that walls, curtains, and upholstery should match. Newly developed color theories, such as those of David Ramsay Hay, advocate color schemes based upon the use of the room (gaiety for drawing rooms) or orientation (blue for south rooms and red for rooms facing north). Most rooms have at least two colors that may be either matching or contrasting. Many

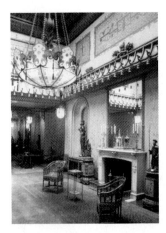
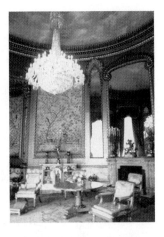
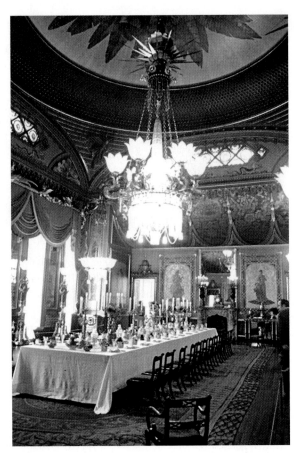
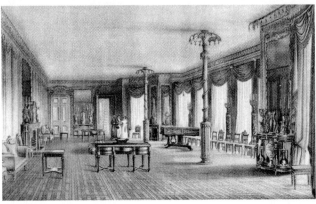

▲ **4-24.** Entry hall, Music Gallery, Banqueting Room, Saloon in the Royal Pavilion, 1786–1787, remodeled 1815–1821; Brighton, England; Henry Holland, remodeled by John Nash. English Regency.

more colors are available to consumers than ever before, but crimson and red remain the most used colors, particularly for dining rooms and libraries. Drawing rooms are often green, while bedrooms are frequently blue. By the 1830s, lighter hues, such as French gray, lilac, or light blue, are fashionable. White rooms are rare, and yellow is considered a daring color. Marbling and graining are common. As before, baseboards or skirting are painted or grained a dark color.

■ *Lighting.* Interiors are more light-filled than ever before. Larger windows allow more natural light to enter. Advancements in artificial lighting brighten rooms after dark. The Argand lamp is in common use during Regency (Fig. 4-25). Argands and other oil lamps may be made of silver, brass, bronze, glass, and crystal in many shapes and sizes, including multiarmed hanging fixtures. Crystal chandeliers with candles continue in important spaces, along with decorative wall sconces and torchères (Fig. 4-25). The Sinumbra lamp, invented in 1809, begins to rival the Argand in popularity because it has no reservoir to cast a shadow. Throughout the period, gas lighting increases in use, but it is hazardous and causes explosions. Despite lighting improvements, candles still predominate in most homes.

■ *Floors.* Most floors are wood boards cut in random lengths and widths (Fig. 4-21). The best woods, such as oak and mahogany, are left uncovered. Other woods are painted, stenciled, or covered with carpet or rugs. Parquet floors, especially those that imitate Roman flooring patterns, briefly return to fashion. Stone, scagliola, and marble cover only lower floors because of the weight of the materials (Fig. 4-19). Black and white are the most fashionable color choices.

■ *Floor Coverings.* Industrialization makes machine-made rugs and carpets more readily available for the middle class, although some types, such as Brussels and Wilton, remain beyond the reach of many. A less expensive alternative is ingrain, a reversible woven pileless carpet that is also called Kidderminster or Scotch carpet. Ingrains typically cover hallways, staircases, servants' rooms, sitting rooms, and parlors of those unable to afford more expensive carpet. Brussels and Wilton are made in 27″ strips, whereas ingrains come in widths up to 54″ with 36″ as standard. Strips are sewn together so that carpet can be laid wall to wall, although some leave a 1″ to 2″ border of wood floor. Usual patterns include designs after Roman pavements, stone, tile, geometric, or floral patterns in three or more colors with or without

▲ **4-25.** Lighting: Argand lamp, torchère, and chandeliers mainly from Brighton Pavilion, c. 1775–1790; England.

borders. Gothic motifs are more evident after 1820. Although Oriental rugs are largely out of fashion, Turkish and Persian patterned carpets are used in libraries and dining rooms (Fig. 4-20, 4-21). Axminster, a knotted carpet, remains expensive and so is not common. Grass matting, plain and patterned, is especially popular for Chinese rooms and summer use in all rooms.

People carefully safeguard their carpets from wear and dirt by using strips or pieces of drugget, green or brown baize, serge, haircloth, and other long-wearing materials. Drugget remains in place unless important personages are being entertained. Hearth rugs in matching or contrasting designs protect the carpet in front of the fireplace. Crumb cloths of drugget cover carpets beneath dining tables.

Floor cloths are still used, but they are not cheap or durable. Composed of heavy canvas or similar tightly woven fabric and several layers of paint, patterns include black-and-white marble, stone, tile, flowers, and Turkish or Persian patterns.

■ *Walls.* In public buildings, architectural details, such as columns, pilasters, and pediments, articulate the walls (Fig. 4-18, 4-19). Most have a dado, fill, and cornice or frieze. Spaces between details are often painted or

paneled. Architectural details in the average Regency interior are lighter in scale, more restrained in design, and simpler in detail than before because they are designed to show off furnishings and fabrics, not the moldings. In some grand houses, the more impressive the room, the more profuse the ornament, whether carved or molded (Fig. 4-20).

In all houses, important rooms have more ambitious wall schemes. Each style has its own appropriate treatments. Dadoes are largely out of fashion, so walls are treated as a single entity. Plaster, papier-mâché, or stucco decorations may adorn walls. In wealthy homes, gilding highlights these details.

Paneling adapts to any style. Oak and pine are the most common woods. Pine usually is painted or grained to imitate more expensive woods. Very wealthy people choose mahogany for paneling. Centers of panels may be grained, marbleized, painted a solid color, or painted with classical, medieval, or Chinese motifs; trellises; foliage; or landscapes (Fig. 4-20, 4-24). Alternatively, fabrics may fill panels or be draped in folds with valances on walls. Panel moldings, panel centers, and the walls contrast in color. Following French Empire fashion, tent rooms with fabric-draped walls and ceilings are fashionable. Some rooms

▲ **4-26.** Wallpapers: Papers in vogue include ones with architectural designs of stone blocks, swag or small floral patterns finished with matching borders, as well as those with Chinese decorative patterns.

have painted landscapes or outdoor views, an outgrowth of Romanticism.

■ *Wallpaper.* With improvements in its manufacture, the use of wallpaper increases (Fig. 4-24, 4-26). Early in the period, it is block printed in rolls (called pieces) about 11′-6″ long. By the 1830s, most wallpaper is roller printed. With so many patterns available, advice books recommend certain types for certain rooms. They suggest papers imitating stone or marble for entrance halls and hallways. The pattern gives an architectonic feel, is easy to repair, and the colors do not rival those in other rooms. Flock papers are particularly prized for drawing rooms. Sometimes matching plain papers adorn adjoining rooms. Also in vogue are architectural papers, papers that imitate textiles or drapery, sprig papers with small floral patterns, and small prints. The latter commonly cover walls in servants' rooms or service areas. Many papers have matching borders.

Papers from China, although expensive, remain highly fashionable. European chinoiserie papers are a less-expensive choice. French scenic or landscape papers, though highly esteemed, have little appeal in Britain. Most likely this is because the many paintings and artworks collected on Grand Tours look better on simpler backgrounds.

■ *Chimneypieces.* Rectangular chimneypieces are simply treated with reeding instead of columns, brackets, or caryatids. Mantels are made of colored marble, scagliola, stone with or without ormolu or bronze details, or, for simpler ones, painted pine or plaster. The Regency fireplace is smaller than before and is fitted with a coal grate decorated with classical or Gothic motifs. A large mirror or painting usually hangs over the fireplace.

■ *Staircases.* Staircases in Regency houses are impressive, revealing great delicacy and ingeniousness (Fig. 4-20). Using iron framing and cantilevering, designers create gracefully curving forms that appear to have no structural support. Some even have no soffits beneath and appear as risers and treads in a sweeping curve ascending from floor to floor. Individual steps and balusters may be of cast iron or wood. Iron balusters are particularly fine. They may be simple columnar forms or have classical details, such as rosettes or acanthus leaves, and be painted black or bright green. Handrails are mahogany, oak, or a grained pine referred to as deal.

■ *Windows.* Most windows have simple molding surrounds. Many continue to have folding interior shutters.

■ *Window Treatments.* Curtains become universal during the period (Fig. 4-27). Fabrics for curtains include velvet (reserved for dining rooms and libraries), silks, satins, damasks, moreen, moiré, and calicoes or other printed cottons. Treatments, especially in important

▲ **4-27.** Window Treatments: Designs for draperies with fringe, c. 1820s–1830s.

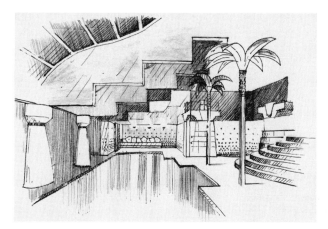

▲ **4-28.** Later Interpretation: Pool House, c. 1981; Llwellyn Park, New Jersey; Robert A. M. Stern.

rooms, are composed of layers of fabric. Swags or valances (called drapery) hang from or drape over wooden or brass rods or carved and gilded cornices. Contrasting linings and a variety of trims add interest and richness. Floor-length or longer curtains hang beneath the swags with sheer white or tinted muslin curtains behind them. Blinds or shades hang next to the glass to block light and protect furnishings from fading. Both sets of curtains may be tied or looped back over cloak pins during the day. Multiple windows may be treated as one for unity.

Swagged drapery predominates until about 1820, when valances or pelmets and valance boards come into vogue. Designs and shapes of valances harmonize with the style of the room. Throughout the period, fringe, braid, or tape in contrasting colors embellish swags, valances, curtains, and glass curtains. Blinds or shades include roller blinds, Venetian blinds, or fabric or paper shades. Interior shutters may be painted green or to match the room.

■ *Doors.* Interior doors are paneled. Mahogany doors have a clear finish, while other woods are painted to match the rest of the decoration. Double doorways signal important rooms.

■ *Ceilings.* Ceilings are important areas for design in both public and private buildings. In public buildings, ceilings may be compartmentalized, beamed, vaulted, or domed with coffers, in essence more architecturally significant (Fig. 4-18, 4-19). In houses, ceilings may be plain white or a paler version of the walls. Some are treated in the Adam manner or have a plaster rosette in the center. Thomas Hope publishes barrel or groin vaulted ceilings with classical features in frieze area below (Fig. 4-22). Following a fashion set by the Prince Regent, some ceilings are painted with clouds and other heavenly details. Ceilings in Gothic- or Tudor-style rooms may have real or imitation beams or brackets.

■ *Later Interpretations.* Regency interiors briefly are revived as an additional classical style at the end of the 19th century continuing into the early 20th century. Some rooms revive only one aspect or component of the original. Other rooms focus upon Regency refinement and simplicity, thereby rejecting the opulence of the previous Victorian period. Individual characteristics of Regency interiors, such as architectural concepts or window treatments, still appear in some interiors today (Fig. 4-28).

FURNISHINGS AND DECORATIVE ARTS

Eclecticism, large areas of veneer with applied or inlaid decoration, and a shiny finish characterize furniture throughout the period. Dark and exotic woods dominate, and many pieces have metal parts, ornament, details, and/or casters to facilitate mobility. Regency designers synthesize forms and motifs from classical (Egypt, Greece, Rome), French Empire, medieval (Gothic, Tudor, and Elizabethan), and exotic sources (Turkey, India, and China). As in architecture, classicism is the dominant influence.

Early Regency furniture is graceful, movable, and light in scale as in the previous period. Sheraton and Hepplewhite forms continue from before. Forms are rectangular and symmetrical with restrained ornament. Exceptions are sideboards and couches, which tend toward massiveness. Many classical pieces copy or adapt from ancient sources. Medieval and exotic designs apply motifs to contemporary forms rather than copy earlier pieces. About

Furniture: Armchairs; published in *Household Furniture and Interior Decoration*, 1807; London, England; Thomas Hope. These chairs showcase Hope's main ideas of furniture design: to design in a close imitation of the antique. Emulating his friends Charles Percier and Pierre-François-Léonard Fontaine in Empire France, Hope copies extant ancient furniture or illustrations from vase paintings and relief sculpture. The upper left chair resembles the ancient Roman curule, the X-form stools for the highest officials. Form and design are simple. Reeding on the frame, finials, and wavy incising on the back are the only embellishment. The lower left chair derives from the Greek klismos and closely resembles a design by Percier and Fontaine. Massive in scale, the front supports on the chair at right are monopodia (head and chest of a lion attached to a paw), a Roman form. The back legs are saber. The solid curvilinear back is embellished with Greek frets and a laurel wreath. Decorative fringe hangs beneath the seat as is common during the period.

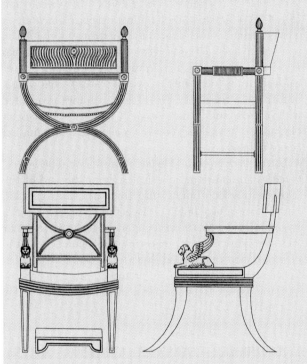

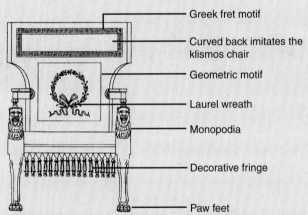

Greek fret motif

Curved back imitates the klismos chair

Geometric motif

Laurel wreath

Monopodia

Decorative fringe

Paw feet

▲ **4–29.** Armchairs, published in *Household Furniture and Interior Decoration*, 1801, London.

1810, furniture becomes heavier, more eclectic, and more embellished as form becomes subordinate to decoration. Toward the end of the period, much more furniture is machine-made and the dominance of classicism declines in favor of other styles.

Furniture pattern books and treatises, important during Regency, show the scores of resources, styles, and approaches to design available. Two books by Thomas Sheraton forecast Regency furniture trends. His first one, *Cabinet Dictionary* (1803), introduces the Grecian couch and French Empire, and later *The Cabinet-maker, Upholsterer and General Artist's Encyclopaedia* (1806) illustrates Egyptian taste for the first time. Thomas Hope introduces archaeological eclecticism to England in his book *Household Furniture and Interior Decoration* (1807). It showcases his ideas, as does his London home (which he opens to the public). During the next year, George Smith's *A Collection of Designs for Household Furniture and Interior Decoration* (1808) also promotes eclecticism and includes designs for entire rooms. Ackerman's *Repository* (published between 1806 and 1828) also features Regency furniture and, more rarely, interiors. Classicism dominates the *Repository* until about 1825 when other styles prevail.

Public and Private Buildings

■ *Types.* New pieces of furniture include sofa tables, Grecian couches, X-form stools, nesting tables, work tables, chiffoniers, and dwarf bookcases (Fig. 4-33, 4-36). Also

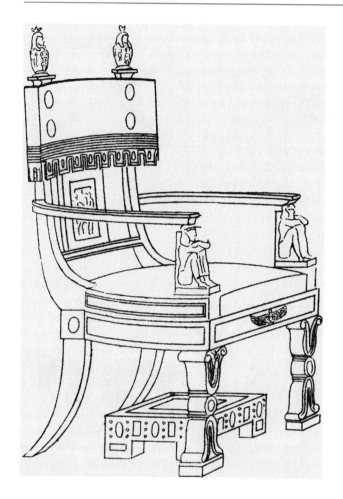

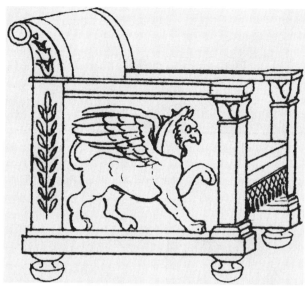

▲ **4-30.** Armchairs with Egyptian influences; published in *Household Furniture and Interior Decoration*, 1807; England; Thomas Hope.

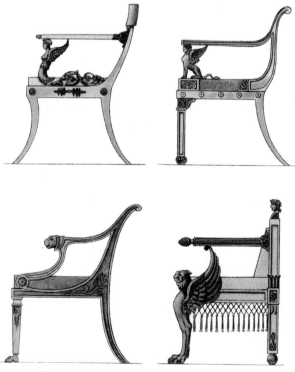

▲ **4-31.** Drawing room chairs; published in *A Collection of Designs for Household Furniture and Interior Decoration*, 1808; London, England; George Smith.

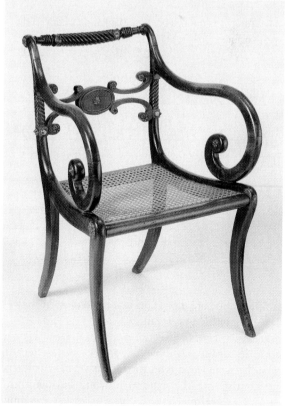

▲ **4-32.** Elbow chair with saber legs, c. 1810; England.

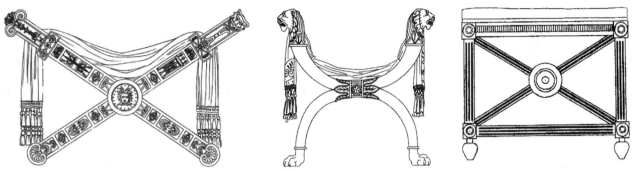

▲ **4-33.** X-form stools; published in *Household Furniture and Interior Decoration*, 1807; London, England; Thomas Hope.

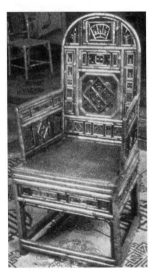 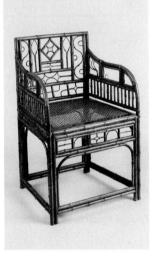 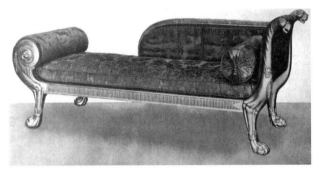

▲ **4-34.** Armchairs of bamboo, Brighton Pavilion, early 19th century; England.

▲ **4-35.** Scrolled-end sofa with representative leg detail, c. 1805–1810; England.

◄ **4-36.** Grecian-style couch; published in *Household Furniture and Interior Decoration*, 1807; London, England; Thomas Hope.

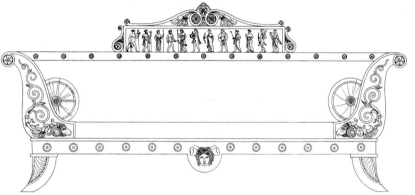

new to the period are the whatnot, a stand of open shelves for display, and the flower stand.

■ *Distinctive Features.* Eclecticism distinguishes Regency furniture in totality. Although there is great variety in designs, classical elements and attributes are most evident. Forms often remain the same with details distinguishing the style. Classical pieces often have saber legs, reeding,

and/or brass paw feet with or without casters. Classical details come from antique architecture as well as furniture. Unlike classical, medieval or exotic furniture does not attempt to copy extant examples but, like architecture, strives to be evocative. Chinese examples, which are more prevalent among the exotic styles, have fretwork, pagodas, or lacquered finishes (Fig. 4-34).

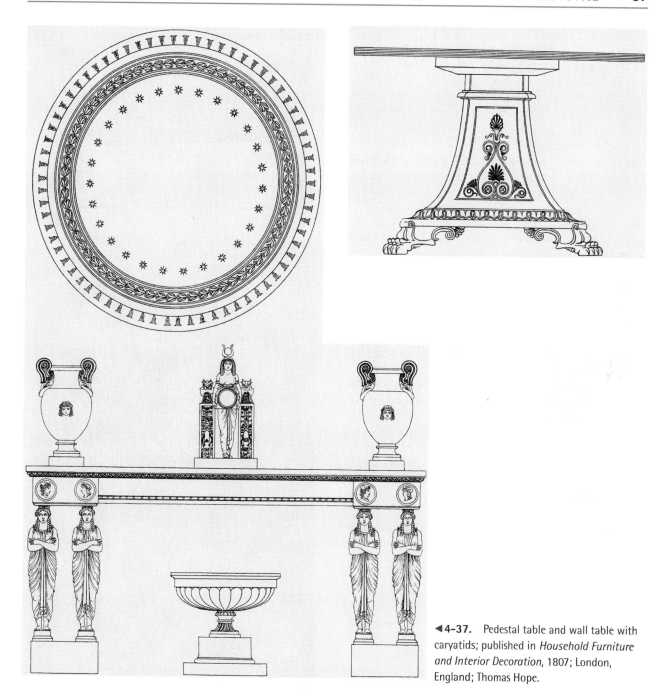

◄ **4-37.** Pedestal table and wall table with caryatids; published in *Household Furniture and Interior Decoration*, 1807; London, England; Thomas Hope.

■ *Relationships.* Less-formal living patterns bring about modern space planning for use and convenience. Furniture no longer lines the perimeter of the room when not in use, except in important rooms. Sofas sit at right angles to or in front of the fireplace. Many have sofa tables in front of them. Center tables, introduced from France, become a gathering place for the family. Unique to Regency are the many additional small tables placed around the room for a variety of functions. Comfort becomes increasingly important, and furniture makers experiment with different types of stuffing and springs. Furniture variety indicates wealth instead of position in society.

■ *Materials.* Expensive furniture is made of mahogany or oak. Highly prized are exotic woods, such as rosewood, tulipwood, or zebrawood, which are often used as veneers. Less expensive woods are grained or stained to imitate more expensive ones. Pieces may be painted green to imitate bronze, be painted like bamboo, or feature classical or Chinoiserie scenes (Fig. 4-39). Much furniture is simply painted with gilded highlights; black is particularly fashionable. Also fashionable are Boullework and *églomisé*. Japanning in red, green, or black revives. Beginning in the 1820s, cast-iron garden furniture, hall furniture, and beds emerge. Especially

distinctive in Regency furniture are brass and other metals used as furniture mounts, inlay, trellises or grilles, or paw feet. Stringing or cross-banding highlights drawers, doors, and plain legs.

■ *Seating*. Much of the seating is classical in design. Some chairs imitate the earlier work of Sheraton or copy the Greek klismos (Fig.4-29, 4-30, 4-31, 4-32). Others adapt the classical language with saber front and back legs, caned seat, and back and legs in a continuous curve. Arms are graceful scrolls. The horizontal back-boards may be painted or gilded. Alternatively, the front legs may be turned or in the form of Roman monopodia (Fig. 4-31). Paw feet are common. Another much imitated ancient form is the X-shaped or Roman curule chair or stool popularized by Hope (Fig. 4-29, 4-33). Windsor chairs are found in the garden, hall, and family drawing rooms. Toward the end of the period, bizarre or highly exaggerated ornament or forms materialize on seating.

Sofas and couches inspired by antiquity or French Empire are very fashionable during the Regency (Fig. 4-35, 4-36). Most drawing and dining rooms have at least one, if not two. Sofas have outward-scrolled arms and legs ending in paw feet. Cornucopia-shaped legs are common. Backs may be rectangular, curved, or have an asymmetrical panel not as long as the back. Seats have a bolster on each end and, sometimes, cushions across the back. Stools and window seats follow designs of sofas.

■ *Tables*. Numerous tables fill Regency rooms. Pier tables, circular tables, and stands frequently copy antique examples in wood or metal (Fig. 4-37). Supports may be turned, columnar, or monopodia. Most terminate in paw feet. Nests of tables, usually slender, may have three (trio tables) or four (quartetto tables) small tables that slide into one another. Worktables, often for sewing, are small with drawers and a silk pouch for scraps and threads. Some small tables open to reveal game boards. Sofa tables, placed in front of the sofa, are oblong and supported by trestles that are usually lyre shaped. They often have drop leaves and drawers. Dining tables may be in several parts as in earlier periods or may be extension tables with several pedestals or claws, as they are called. Pedestals have a single center support and outward-curving legs ending in metal paws. Sideboards are long, have tapered pedestals, and may resemble an Egyptian gateway.

■ *Storage*. Fashionable commodes are massive with eclectic designs and marble tops (Fig. 4-38). Painting, veneers, and metalwork are common embellishments. Chiffoniers, introduced in the late 18th century, have open shelves for books with drawers or cupboards below. Low or dwarf bookcases of elbow height are also fashionable because paintings can be hung over them. Tall bookcases and secretary bookcases are often classical in design, but Smith illustrates bookcase doors in several styles, including Chinese and Egyptian. Instead of glass,

▲ **4-38.** Commode, mahogany, c. 1820; England.

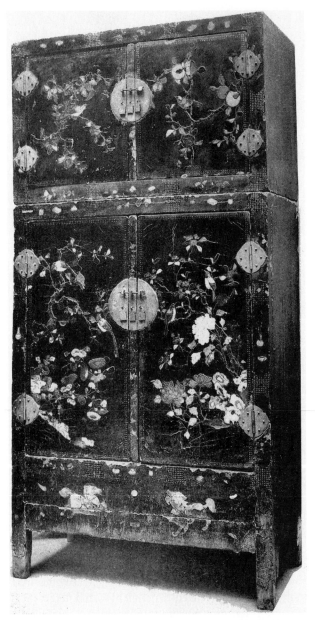

▲ **4-39.** Chinoiserie cabinet, early 19th century; England.

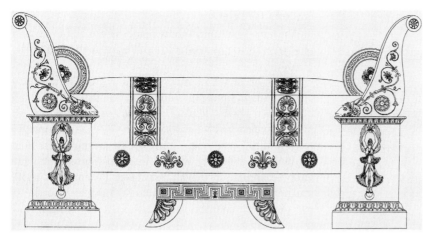

◄**4-40.** Bed; published in *Household Furniture and Interior Decoration*, 1807; London, England; Thomas Hope.

◄**4-41.** Convex mirror, gilded wood with eagle, c. 1800; England.

▲**4-42.** Upholstery: Printed cottons and damasks, c. early 1800s.

many have brass trellises with silk curtains behind them to protect the books. Double chests with Chinoiserie decoration are popular and bring the exotic influence into a room (Fig. 4-39).

■ *Beds*. Several types of beds are fashionable, including the four-poster, the half-tester, and the French bed or *lit en bateau* (Fig. 4-40). All have carved and applied details. The four-poster with complex hangings is most fashionable, but all types of beds display opulent hangings with rich trims. Like window treatments, bed hangings sometimes have contrasting linings. Sunburst patterns often form the head cloth or line the canopy ceiling.

■ *Upholstery*. Upholstery fabrics include velvet, silk, damask, chintz, and leather for dining rooms and libraries. Braid, tape, tassels, or fringe embellishes many pieces. Also, festoons of fabric with eye-catching trim hang between furniture legs or arms, across backs, under seats or rails, and over tables and beds. Loose slipcovers to protect expensive fabrics or tabletops are more common and elaborate than ever before. Made of chintz, gingham, calico, or baize, furniture covers may have contrasting trims.

Plain-woven machine-made fabrics become increasingly common throughout the period in contrast to the handwoven silks of earlier (Fig. 4-42). Printed textiles are

highly prized. During the first decade of the 19th century, drab-style furniture prints in dull brown with yellow or green and no red are fashionable. Superseding these are brightly colored chintzes in a full range of patterns, including architectural motifs, flowers, game birds, panels with borders, and large-scale botanical plants. Stripes begin to appear in pattern books in the mid-1820s.

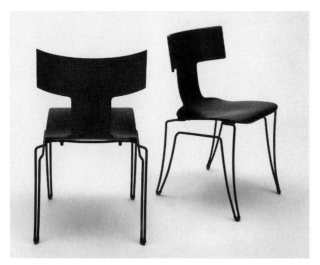

▲ **4-43.** Later Interpretation: Anziano klismos chair, 2004; New York; John Hutton, manufactured by Donghia. Modern Historicism.

■ *Decorative Arts.* Most rooms contain at least one looking glass or pier glass, which is carefully placed with an eye to their reflections in and among rooms. Chimney glasses, low, horizontal, and narrow, feature classical moldings, colonnettes, or figures. Pier glasses may extend to the ceiling. Newly fashionable for Regency is the convex mirror with a heavy circular frame that is usually gilded (Fig. 4-41). Paintings, prints, and silhouettes hang on walls, usually in gilded frames. Accessories, such as silverware, clocks, and vases,

usually reflect the style or theme of the space. Also fashionable are porcelain figures made in sets. The number of objects in rooms begins to proliferate at the end of the period.

Meals are lavish so tables and sideboards display many pieces of silver, silver plate, china, and cut glass. Bone china begins to replace soft paste porcelain in the 1790s. Most pieces are elaborately decorated with classical, Chinese, or floral motifs. Lesser houses continue to use transfer-printed earthenware primarily in blue and red. Patterns include Chinese, Indian, medieval, and classical themes. By 1830, the popular Willow pattern features birds in the sky, a pagoda, water, boat, bridge, Chinese figures, and a willow tree.

Nature, so valued by the Romantic Movement, enters the house through the plants, flowers, and caged birds that often decorate Regency rooms. Naturalistically arranged flowers, real and artificial, sit on stands or hang on walls.

■ *Later Interpretations.* The scale and simplicity of some Regency furniture appeal to followers of the Aesthetic Movement in the 1860s and 1870s. Dante Gabriel Rossetti, for example, uses Regency seating furniture in his own home. Regency furniture revives along with interiors at the end of the 19th century. In 1917, the sale of Thomas Hope's personal furniture prompts a continued revival of Regency furniture in the 20th century. The form, scale, and curving lines of Regency chairs and sofas continue to appeal to designers and clients today. Some manufacturers reproduce Regency sofas and chairs; others adapt Regency designs (Fig. 4-43).

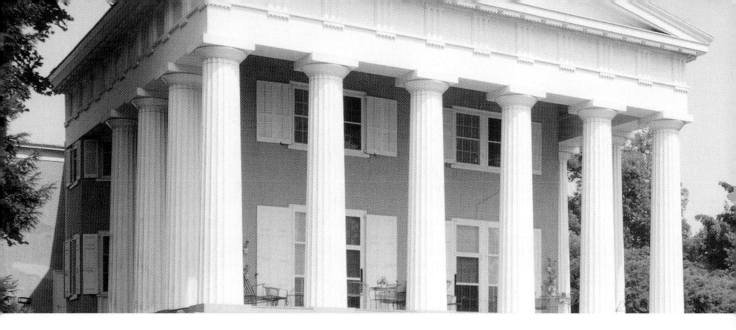

CHAPTER 5

American Greek Revival, American Empire

1820s–1860s

The public sentiment just now runs almost exclusively and popularly into the Grecian school. We build little besides temples for our churches, our banks, our taverns, our court houses and our dwellings. A friend of mine has just built a brewery on the model of the Temple of the Winds in Athens.

James Fenimore Cooper, as stated by
Aristabulus Bragg, *Home as Found*, 1828

Regarding it as an expression of democracy and national culture, America wholeheartedly embraces Greek Revival for numerous structures ranging from banks to courthouses, cottages to mansions. The most common interpretation is a temple form with portico in masonry for public buildings and white-painted wood for houses. Architectural details derived from Greece, Rome, and Egypt and simple wall treatments signal Grecian interiors. American Empire furniture is characterized by classically derived ornament and wood-grain patterns, often of veneer. It is heavier proportioned and more archaeologically correct than was Federal, the previous style.

HISTORICAL AND SOCIAL

A great wave of nationalist feelings follows the War of 1812 with Great Britain. This period of strong national unity precedes four decades of strife between parts of the country that will culminate in the Civil War beginning in 1860. The northern, southern, and western sections have very different outlooks, societies, and economics, so each wants to control and determine national policies to its own benefit. They argue over banking, tariffs, annexation of territory, and, ultimately, slavery.

Stimulated by the Industrial Revolution and the westward migration of farmers, manufacturing dominates the Northeast. Factories using steam or water power to manufacture goods spring up throughout the region, transforming quiet farm towns into bustling industrial cities. New roads, canals, and railroads help move goods to the western territories and abroad. Boston, New York, Philadelphia, and Baltimore rapidly increase in size and population.

The South remains agrarian with cotton as its chief crop. Consequently, states' rights and slavery are important

issues there. Because cotton is most often grown on large plantations using slave labor, the movement to abolish slavery that arises in the North angers Southerners. Slavery becomes a major issue in the annexation of western states and settlement of western territories such as Texas, Oregon, California, and New Mexico. Southerners also greatly resent the tariffs that protect northern manufactured goods.

Migration westward accelerates, caused in part by manifest destiny, the notion that expansion is not only inevitable, but divinely ordained. However, most settlers simply desire to own their own land or to explore new territory. Although bringing benefits to the nation, expansion also increases disputes and controversy, particularly over slavery. Further complicating the western expansion, the United States clashes with Mexico over the annexation of Texas.

Despite difficulties, the country prospers as a whole. Gold is discovered in California in 1848. Greater production of wheat, cotton, and manufactured goods increases wealth in the Midwest, South, and North, respectively. Affluent northern businessmen, manufacturers, and southern plantation owners live in large, well-furnished mansions. Slaves and settlers who live in one-room hovels, log cabins, and sod houses are at the opposite end of the scale. In between these groups is the sizable middle class, which has become sufficiently large and wealthy that merchants and manufacturers begin to provide goods and services for it.

Schooling in the United States is local and traditional, which means that the extent (length and/or number of schools) depends on the resources of towns and cities and the ambitions of churches and other public and private groups. Members of the common-school movement advocate reform through systematic elementary education. The Industrial Revolution helps bring about a movement for women's rights as working-class women begin to earn wages in factories, thereby gaining some independence. However, reforms are slow, and middle- and upper-class women see little change. They still are expected to be responsible for the home and child rearing and remain at home.

CONCEPTS

In America, the adoption of Greek Revival in architecture and American Empire in furniture coincides with a period of nationalistic fervor and enthusiasm for progress and personal liberty. Following the American Revolution, leaders, such as Thomas Jefferson, see classical antiquity as the source of ideal beauty and regard its citizens as models of civic virtue and morality. Thus, they choose classical-style architecture and furniture for themselves and for the architecture of the new nation and its model civilization.

By the turn of the 19th century, Greek Revival assimilation of Greek modes is easy because many Americans are

◀**5-1.** Portrait of Dolly Madison.

already familiar with Neoclassicism through the Federal style. Furthermore, classical studies form the basis for liberal arts education, and many see the Greek struggle for independence as a parallel to America's ongoing fights with Great Britain. As a visual metaphor for beauty, democracy, republican government, liberty, and civic virtue, Greek Revival defines numerous buildings, both rural and urban, high style and vernacular across the nation. It is America's first national style.

Sources of influence include archaeological books, such as *The Antiquities of Athens* (5 volumes, 1762–1816) by Stuart and Revett, and builders' manuals, such as Asher Benjamin's *American Builder's Companion* in which the 6th edition of

IMPORTANT TREATISES

- *The American Builder's Companion,* 6th edition, 1827; Asher Benjamin.

- *The Architecture of Country Houses,* 1850; Andrew Jackson Downing.

- *The Builder's Assistant,* 3 volumes, 1818–1821; John Haviland.

- *The Cabinet Maker's Assistant,* 1840; John Hall.

- *An Encyclopedia of Cottage, Farm, and Villa Architecture and Furniture,* 1830; John Claudius Loudon.

- *The Modern Builder's Guide,* 1833; Minard Lafever.

- *The Practical House Carpenter,* 1830–1857; Asher Benjamin.

- *The Young Builder's General Instructor,* 1829; Minard Lafever.

- *Workwoman's Guide,* 1838; A Lady.

1827 features Greek details. Few Americans travel to Greece to see original models, although many professional architects either emigrate from Europe or are trained there. America has no schools of architecture at this time.

Continuing the Neoclassical mode, American Empire furniture develops from French Empire and English Regency influences. Americans (Fig. 5-1) learn of European designs through widely circulated pattern books and pamphlets, when they travel abroad, or when they import furniture from England and France. New settlers often bring furniture with them, while cabinetmakers and

pattern books depict Europe's latest fashions. French and English designers particularly important to the development of American Empire are Percier and Fontaine, Thomas Hope, and George Smith.

DESIGN CHARACTERISTICS

Although influenced by Europe, Americans adapt English Greek Revival and French Empire to their needs, tastes, and situations. They create a unique classical expression

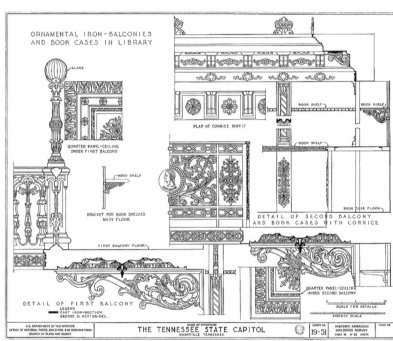

▲ **5-2.** Architectural details from Alabama, Mississippi, and Tennessee.

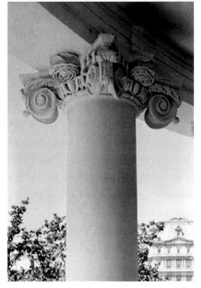
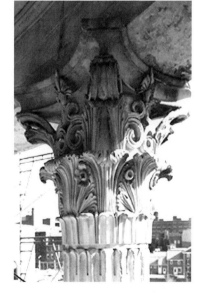

▲ **5-3.** Column details from Pennsylvania and Washington, D.C.

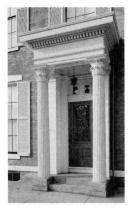 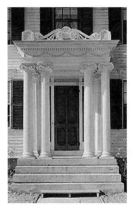 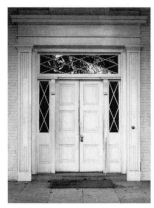 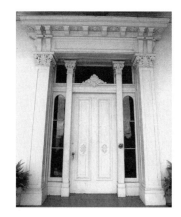

▲ **5-4.** Door details from Indiana, Vermont, Tennessee, and Louisiana.

that is often symmetrical and horizontal, but does not necessarily follow rules of classicism or reflect classical proportions. Liberties are taken frequently, either as a result of a lack of awareness, more concern for a classical look than correct use of classical forms and details, or simply as a way of adapting classicism to America.

■ *Greek Revival.* Temple forms, the Greek orders, and simple white exteriors define American Greek Revival buildings. Structures, particularly domestic, often are wood, and there are far more vernacular buildings than there are in Europe. Grecian-style interiors in America are plainer and simpler than are those of Europe. Bolder architectural details and walls treated as one expanse mark the style. Americans are less likely to imitate Etruscan or Pompeian modes than are the English and French, and they do not have an emperor to glorify like France.

■ *American Empire.* American Empire furniture tends toward greater simplicity than does European, although forms and ornament derive from classical prototypes as in Europe. A late variation composed of broad flat areas, columns, and bold scrolls covered with plain or figured veneer is called Pillar and Scroll or Late Classical. Developing from inventions of the Industrial Revolution, the style follows furniture changes after the restoration of

the Bourbon monarchy in France. Unlike English Regency interiors and furniture, exotic or medieval styles and influences are rare in America.

■ *Motifs.* Architectural details and motifs come primarily from Greece, but also from Rome and Egypt. They include egg and dart, bead, and dentil moldings, triglyphs and metopes, honeysuckles, anthemions, acanthus leaves, and the fret or key (Fig. 5-2, 5-25, 5-38). Interiors, furniture, and decorative arts exhibit a greater range of motifs from more sources, including Egyptian, Greek, Roman, and Renaissance. These include sphinxes, battered or pylon forms, paw feet, Egyptian or classical figures, lyres, harps, swans, dolphins, eagles, caryatids, serpents, arabesques, and columns (Fig. 5-26, 5-28, 5-39, 5-44, 5-45, 5-49).

ARCHITECTURE

As in other countries, American Greek Revival architecture relies on forms and elements derived from a few classical models adapted to contemporary requirements and ornament taken chiefly from Greece, but also Rome. Inspired by English buildings and publications, America adapts the style to its national consciousness. Nationalist expressions

IMPORTANT BUILDINGS AND INTERIORS

■ **Austin, Texas:**
—Governor's Mansion, 1855; Abner Cook.

■ **Athens, Georgia:**
—A. P. Dearing House, 1850–1856.
—Grant-Hill-White-Bradshaw House, c. 1850s.
—Joseph E. Lumpkin House, 1842.

■ **Boston, Massachusetts:**
—Quincy Market, 1825; Alexander Parris.

■ **Bucks County, Pennsylvania:**
—Andalusia, 1833; Thomas U. Walter and Nicholas Biddle.

■ **Camden, South Carolina:**
—Bethesda Presbyterian Church, 1820; Robert Mills.
—Bishop Davis House, 1820.

■ **Charleston, South Carolina:**
—First Baptist Church, 1822; Robert Mills.
—Old Market Hall, early 19th century.

IMPORTANT BUILDINGS AND INTERIORS

—S. Phillips Church, 1835–1838; Joseph Hyde; steeple added in 1848–1850; E. B. White.

■ **Columbia, South Carolina:**

—Mills Building, State Hospital, 1821–1827; Robert Mills.

■ **Columbus, Ohio:**

—Ohio State Capitol, 1838–1861; Thomas Cole.

—Old Courthouse, 1850; Howard Daniels.

■ **Demopolis, Alabama:**

—Gaineswood, 1843–1861; General Nathan Bryan Whitfield.

■ **Harwington, Connecticut:**

—Congregational Church, 1806.

■ **Madison, Indiana:**

—Costigan House, 1846–1849; Francis Costigan.

■ **Marshall, Michigan:**

—Harold Craig Brooks House, c.1840; architect possibly Richard Upjohn.

■ **Memphis, Tennessee:**

—Hunt-Phelan House, 1828–1840; Robert Mills.

■ **Nashville, Tennessee, area:**

—Belle Meade, 1854; Adolphus Heimann (?).

—Hermitage, 1819, rebuilt 1836; David Morrison, later possibly Robert Mills.

—Tennessee State Capitol, 1845–1859; William Strickland.

■ **Natchez, Mississippi:**

—D'Evereux, 1836–1840; James Hardie.

—Dunleith, 1856.

—Stanton Hall, 1857; Thomas Rose and Lewis Reynolds.

■ **New Haven, Connecticut:**

—First Church of Christ, Congregational, 1814; Ithiel Town.

■ **New Iberia, Louisiana:**

—Shadows-on-the-Teche, 1834.

■ **New Orleans, Louisiana:**

—Louisiana State Bank, 1820; Benjamin Henry Latrobe.

—Old City Hall (Gallier Hall), 1845–1850; James Gallier, Sr.

■ **New York City, New York:**

—Customs House (now known as the Federal Hall National Memorial), 1833–1844; Ithiel Town and Alexander Jackson Davis with James Frazee.

■ **Philadelphia, Pennsylvania:**

—Andalusia, 1798, remodeled 1836; Thomas U. Walter and Nicholas Biddle.

—Girard College, Founders Hall, 1833–1847; Thomas U. Walter and Nicholas Biddle.

—Fairmount Waterworks, 1812–1822; Frederick C. Graff.

—Merchant's Exchange, 1832–1834; William Strickland.

—Second Bank of the United States (later known as the Customs House), 1817–1824; William Strickland.

■ **Pinewood, South Carolina:**

—Milford, 1838–1841; Charles Reichardt and Russell Warren (?).

■ **Quincy, Massachusetts:**

—Unitarian Church, 1828; Alexander Parris.

■ **Raleigh, North Carolina:**

—North Carolina State Capitol, 1833–1840; William Nichols, Jr., Ithiel Town and Alexander Jackson Davis, David Paton.

■ **Richmond, Virginia:**

—Linden Row, 1847, 1853; Otis Manson (builder).

—Monumental Church, 1812; Robert Mills.

—S. Paul's Episcopal Church, 1843–1845; Thomas S. Stewart.

—White House of the Confederacy (John Brockenbrough House), 1818; Robert Mills.

■ **Savannah, Georgia:**

—Trinity Church, 1848; John B. Hogg.

■ **Vacherie, Louisiana:**

—Oak Alley, 1832; attributed to Joseph Pilié.

■ **Washington, D.C., and nearby area:**

—National Patent Office (National Portrait Gallery), 1836–1840; Robert Mills, William D. Elliot, and Ithiel Town.

—The White House, Oval Portico and South Elevation, 1824; James Hoban.

—Treasury Building, 1836–1842; Robert Mills.

—Washington City Hall (U.S. District Court Building), 1817–1825; George Hadfield.

■ **Williamsburg, Massachusetts:**

—Josiah Hayden House, 1839.

■ **Winnsboro, South Carolina:**

—Fairfield County Courthouse, 1823; Robert Mills.

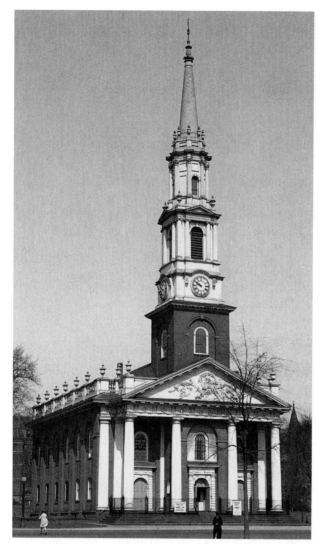

▲ **5-5.** First Church of Christ, Congregational, 1814; New Haven, Connecticut; Ithiel Town.

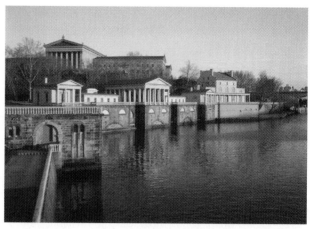

▲ **5-6.** Fairmount Waterworks, 1812–1822; Philadelphia, Pennsylvania.

and cultural symbolism unique to America aid in the adoption of Greek Revival. Various building types adapt temple forms, often in wood. This design variety sets the American Greek Revival apart from its European counterparts.

In egalitarian America, everyone can be a patron. Consequently, the Greek Revival temple form becomes the most common architectural icon for high-style government, commercial, and institutional buildings designed by architects and builders. It serves as a symbol of order, repose, and stability. Many Americans live in temple-form houses, believing them to be the only proper dwelling for citizens of revived classical governments. High-style, vernacular, or folk interpretations of white temple-form houses dot the landscape, creating an image of Greek simplicity. In towns named for Greek cities, such as Athens, Syracuse, or Troy, temple fronts often line quiet, tree-shaded streets. Because the style's inception coincides with the population explosion and territorial expansion,

◄ **5-7.** First Baptist Church, 1822; Charleston, South Carolina; Robert Mills.

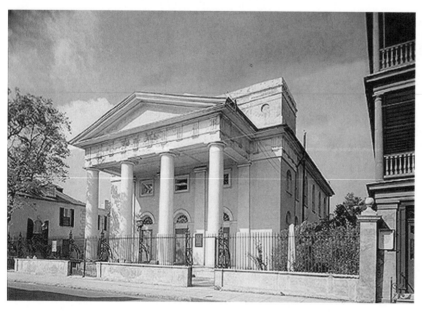

DESIGN SPOTLIGHT

Architecture: Second Bank of the United States (later known as the Customs House), 1817–1824; Philadelphia, Pennsylvania; William Strickland. The Second Bank of the United States is the first major example of Greek Revival architecture in the United States. William Strickland's design, which derives from the Parthenon for the first time in America, wins the competition held by the bank's directors. Because he has not been to Greece, Strickland uses the restored views of the Parthenon from Stuart and Revett's book as the model for the Doric porticoes on each end of the rectangular structure. In order to accommodate the windows, the design does not repeat the columns on the sides of the building. Marble veneer faces the entire structure. The gable roof conceals the barrel-vaulted banking room in the center of the plan. The building is very influential because the bank is one of the most important financial institutions in the country until the 1830s.

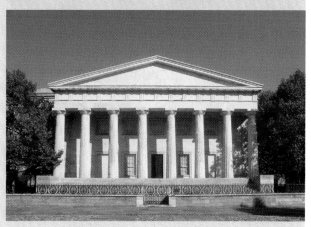

▲ 5-8. Second Bank of the United States, Philadelphia.

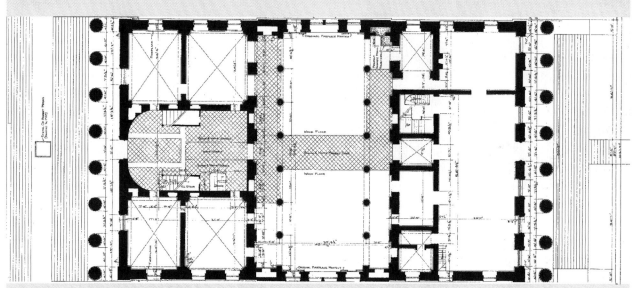

▲ 5-9. Floor plan, first floor, Second Bank of the United States; Philadelphia, Pennsylvania.

vernacular examples are far more numerous in America than they are in Europe.

Public Buildings

■ *Types.* Numerous Greek Revival banks, retail establishments, government and public works buildings, offices, institutions, colleges, bridges, monuments, and memorials proclaim the uniqueness of the new nation (Fig. 5-6, 5-8, 5-13, 5-14). Some states such as Tennessee (Fig. 5-14), Connecticut, Kentucky, Indiana, North Carolina, and Ohio build Greek Revival capitol buildings. Pagan associations render the style inappropriate for churches, so only a few are built, mostly for reformed denominations.

■ *Site Orientation.* Designers strive to isolate public buildings in the manner of the Greek acropolis instead of

▲ **5-10.** Quincy Market, 1825; Boston, Massachusetts; Alexander Parris.

▲ **5-12.** Old Market Hall, 1841; Charleston, South Carolina.

▲ **5-11.** Merchant's Exchange, 1832–1834; Philadelphia, Pennsylvania; William Strickland.

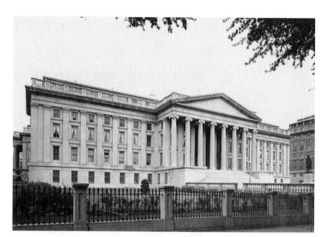

▲**5-13.** Treasury Building, 1836–1842; Washington, D.C.; Robert Mills.

the Roman manner of relating buildings to each other. Although buildings in complexes relate to each other visually, they assert their individual character, as shown in the Fairmount Waterworks in Philadelphia (Fig. 5-6). Structures in cities often front important streets or parks.

■ *Floor Plans.* Plans are generally rectangular and suitable to building function (Fig. 5-9). Most are symmetrical and oriented around important circulation spaces. Rooms vary in shape from square to round. Designers use great ingenuity in creating functional plans within the temple form but generally do not try to adapt ancient plans to contemporary needs.

■ *Materials.* Building materials are usually local stone, granite, marble, and brick. Examples in wood may appear in more rural areas, particularly in southern states. Some are painted white, while others are left the color of the material. Public buildings often combine trabeated and

arcuated construction by using columns along with vaults and domes.

■ *Façades.* Temple fronts depicting the classical image and the Greek orders define Greek Revival façades (Fig. 5-6, 5-7, 5-8, 5-10, 5-12, 5-14). Most buildings have porticos on one if not both ends, thereby emulating the Roman temple form. Few are peripteral. Some may give that impression with pilasters that continue the column rhythm, divide walls into bays, and simulate the post and lintel building system. Walls are flat with few projections other than porticoes. Basements sometimes are rusticated. Scale may be larger than that of the originals. Like their prototypes, structures are horizontal, symmetrical, and reflect clarity, repose, and stability.

Some buildings closely imitate specific prototypes, such as Strickland's Second Bank of the United States (Fig. 5-8), which emulates the Parthenon (447–436 B.C.E.; Athens,

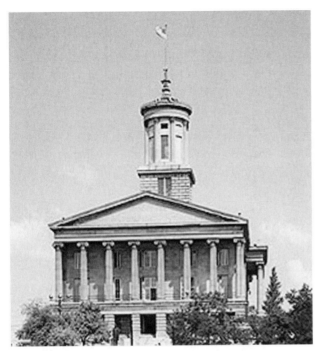

▲ **5-14.** Tennessee State Capitol, 1845–1859; Nashville, Tennessee; William Strickland.

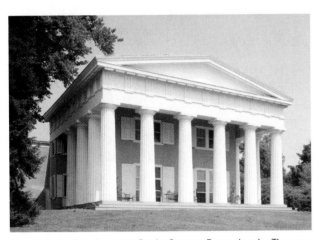

▲ **5-15.** Andalusia, 1833; Bucks County, Pennsylvania; Thomas U. Walter and Nicholas Biddle.

Greece). Others do not copy earlier structures, so they vary greatly from the original Greek ones or display strong Roman influences. Designers may deviate from classical canons for creativity, individuality, or to distinguish American buildings. A few structures, particularly those designed by architects, have cylindrical ends or projections, such as Merchant's Exchange (Fig. 5-11), in the manner of Greek *tholos* or Hellenistic monuments. Some public structures, notably courthouses and state capitols, have domes and/or cupolas. Because there are no Grecian prototypes for domes or cupolas, designers look to the Choragic Monument of Lysicrates (c. 334 B.C.E.; Athens, Greece) or the octagonal Tower of the Winds (c. 40 C.E.; Athens, Greece)

DESIGN PRACTITIONERS

- **Charles-Honoré Lannuier** (1779–1819), a cabinetmaker, trains in Paris and immigrates to New York City in 1803. His early work is Directoire, but he soon adopts the Empire mode, becoming a leading exponent of the style. Lighter in scale than French, his furniture is often elaborately decorated and features caryatids.

- **Robert Mills** (1781–1855) studies with Benjamin Henry Latrobe and is one of the first professionally trained architects in America. He provides practical, if somewhat unimaginative, designs for many different building types, such as the first fireproof American building in Charleston, South Carolina. A leading exponent of Greek Revival, he is appointed official architect of government buildings. He designs the Treasury Building and Washington Monument in Washington, D.C.

- **Duncan Phyfe** (1768–1854) emigrates from Scotland and opens a shop in New York City in 1792, soon becoming the city's leading cabinetmaker. He is one of the principal creators of the American Empire style. The Grecian cross form is his innovation, and Phyfe characteristics include lyres for chair backs or table pedestals.

- **Anthony Quervelle** (1789–1856) develops a local version of American Empire in Philadelphia. His elegant furniture often displays exquisitely carved architectural motifs and foliage.

- **William Strickland** (1788–1854), like Robert Mills, studies with Benjamin Henry Latrobe and sets up an architectural practice in Philadelphia. A creative designer, he is known for his Greek Revival designs, many of which he derives from *Antiquities of Athens* by Stuart and Revett. He also designs in Egyptian Revival and other styles. His Second Bank of the United States is the first fully Greek Revival structure in the country.

- **Town and Davis** is one of the earliest architectural partnerships in America. Founded in 1829 in New York City by Ithiel Town and Alexander Jackson Davis, the firm executes commissions in Greek Revival and other styles. Lasting until 1835, the firm of Town and Davis produces influential designs for many different building types.

for inspiration. The cupola of the Tennessee State Capitol in Nashville (Fig. 5-14) is modeled after the Choragic Monument of Lysicrates. Ornament on all building types is minimal and Grecian, most commonly a Doric frieze, the

DESIGN SPOTLIGHT

Architecture: Rose Hill, 1835; Geneva, New York. Built in 1835 for the Swan family, Rose Hill illustrates common Greek Revival characteristics for residences. A graceful Ionic portico with pediment creates a temple image. Symmetrical, floor-length sash windows on the first floor allow access to the porch. The center doorway features small Ionic columns carrying an entablature with trabeated lights and sidelights over the single door.

Flanking wings also have Ionic porches. The entire building is painted white. Inside, bold classical details around doors and windows and chimneypieces connect interior and exterior. Together with prominent cornices, plain ceilings, unarticulated painted or wallpapered walls, and Empire or Rococo Revival furniture, they provide formal settings for the rituals of entertaining guests and family.

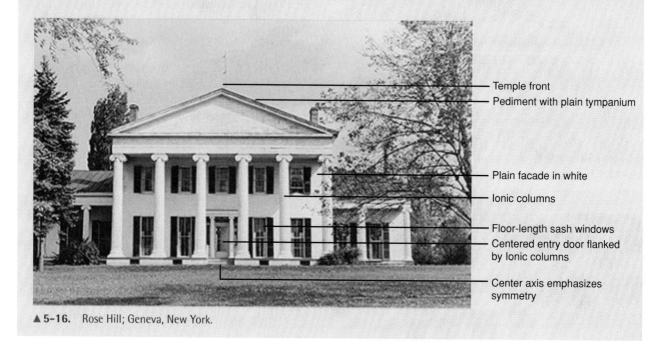

Temple front
Pediment with plain tympanium

Plain facade in white
Ionic columns

Floor-length sash windows
Centered entry door flanked by Ionic columns

Center axis emphasizes symmetry

▲ **5-16.** Rose Hill; Geneva, New York.

anthemion, or Greek key. Architectural details are larger and bolder than Federal ones are.

Churches continue the traditional form of porch with a tall steeple behind it, but with Grecian columns and other details (Fig. 5-5, 5-7). Steeples, which combine rectangular and cylindrical shapes, are modern creations because vertical Grecian prototypes are rare.

- *Windows.* Windows are rectangular and double hung. Arched, round, or Palladian examples are extremely rare because arches do not characterize Greek architecture. Decorative surrounds include pilasters, lintels, or pediments.
- *Doors.* Entrances are important and may be grandly treated with pilasters or columns (Fig. 5-3). Tops may be flat or may have pediments. Surrounds may be further embellished with classical moldings, such as egg and dart, triglyphs, Greek key, acanthus leaves, or palmettes.
- *Roofs.* Roofs are usually low-pitched gables resembling ancient temples (Fig. 5-6, 5-12). Some structures have flat roofs with balustrades. Domes with cupolas and cupolas alone often denote important spaces (Fig. 5-14).

- *Later Interpretations.* During the Neoclassical Revival of the late 19th and early 20th centuries, structures in the Greek Revival style are built. They are larger in scale than their predecessors were and more likely to be of brick or stone. Greek Revival is common for state and county courthouses in the first quarter of the 20th century. In the late 20th century, interpretations of Greek Revival continue, but they may illustrate significant variations in image or materials.

Private Buildings

- *Types.* Common house types include the temple form with or without wings, the gable end, and peripteral forms that are common on Southern plantations and mansions (Fig. 5-18, 5-22). Numerous classical porches, pilasters, and columns are added to existing houses for an updated Grecian appearance. Row houses and shotgun houses also feature Greek details (Fig. 5-21).
- *Site Orientation.* Houses may be sited in rural landscapes, along tree-lined streets in cities or towns, or as urban row

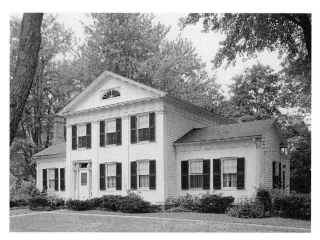

▲ **5-17.** Dr. John H. Matthews House, 1839; Painesville, Ohio; Jonathan Goldsmith.

houses (Fig. 5-15, 5-16, 5-17, 5-21). A typical image for many today, but uncommon during the period, is a long double row of trees leading to the large columned plantation house.

■ *Floor Plans*. Rectangular spaces again define floor plans (Fig. 5-19). Residences have few circular or apsidal rooms. The symmetrical, double-pile or Georgian plan of central hall with flanking rectangular rooms, common in the 18th century, remains typical for larger houses. To accommodate entrances on one side, plans of gable-end houses are often asymmetrical. Floor plans for temple forms with wings are the most functional and show the greatest variation. Most large homes have double parlors separated by sliding pocket doors.

■ *Materials*. Unlike public buildings, most houses are of wood that is painted white (Fig. 5-20). Some examples, particularly in the Northeast, are of brick, stone, or granite. Brick is sometimes painted white or covered with stucco and scored to resemble stone. Cast iron may be used for details or handrails of steps.

■ *Façades*. Houses, to a greater extent than public buildings, re-create the ancient image by adopting temple forms and details. Temple fronts are definitive with columns on fronts only, front and sides, or surrounding the house (Fig. 5-15, 5-16, 5-18, 5-22). Doric is the most common column, followed by Ionic and Corinthian. Peripteral and other types may have no pediments (Fig. 5-20). Rectangular porches and porticoes may be full or partial width and have single or double stories. Fenestration may be symmetrical or asymmetrical. Walls, rarely divided into bays, are smooth. Gable-end or other vernacular house types may have corner pilasters to simulate a portico.

Proportions often are very different from those of ancient structures. Because the classical idea is more important than archaeological correctness is, many liberties are taken whether resulting from ignorance, creativity, or individuality. Quadrangular pillars, unclassical treatments such as Doric columns with bases or plain shafts, or cupolas appear in both high-style and vernacular houses. Wide bands of trim, some with narrow horizontal windows, are common at the roofline. Trim may be in three parts, reflecting the classical entablature. Ornament is rare and found at doors and windows, beneath the cornice, and on columns and pilasters. Row houses sometimes have cast-iron handrails with palmettes, acanthus leaves, and other classical details.

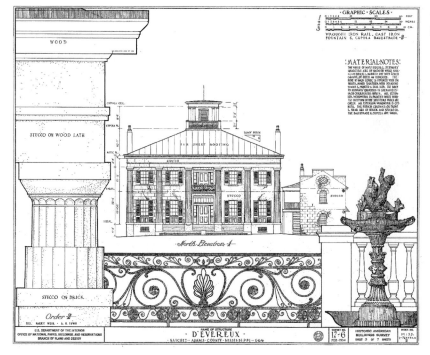

◄ **5-18.** D'Evereux, 1840; Natchez, Mississippi.

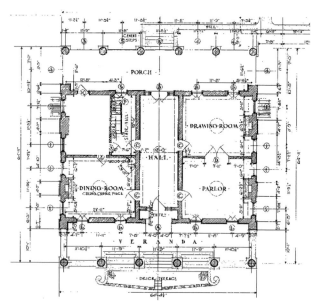

▲ **5-19.** Floor plan, first floor, D'Evereux, 1840; Natchez, Mississippi.

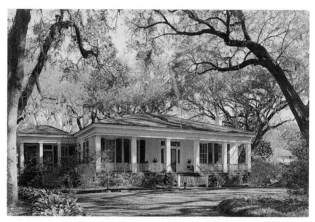

▲ **5-20.** Hardaway-Evans-Wilson-Sledge House, 1840; Mobile, Alabama.

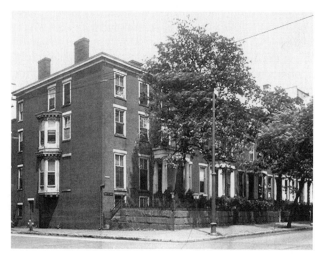

▲ **5-21.** Linden Row, 1847, 1853; Richmond, Virginia.

■ *Windows*. Rectangular windows may have double or triple sashes (Fig. 5-15, 5-16, 5-17, 5-18). Those with triple sashes allow access to verandas. Exterior shutters are typical. The window surround may be plain and rectangular or have a pediment or ears. Elaborate ones have pilasters or decorative cresting. Tall windows may have decorative panels beneath. Windows on masonry examples may have lintels over them. Some houses have small rectangular frieze windows often with metal grilles near the roofline. Some houses have tripartite windows in the Palladian manner, but without the arched central window.

■ *Doors*. Like windows, doors reflect the trabeated construction system in shape and ornament (Fig. 5-4). Columns or pilasters carrying a small entablature may flank entrances. A more typical treatment is a rectangular light above the door with flanking sidelights. Glass may be plain or have etched designs. The surround may have an entablature, pediment, or ears with and without decorative cresting. Classical moldings, the Greek key,

◀ **5-22.** Governor's Mansion, 1855; Austin, Texas; Abner Cook.

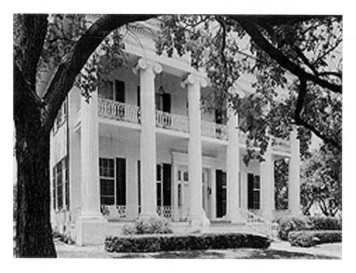

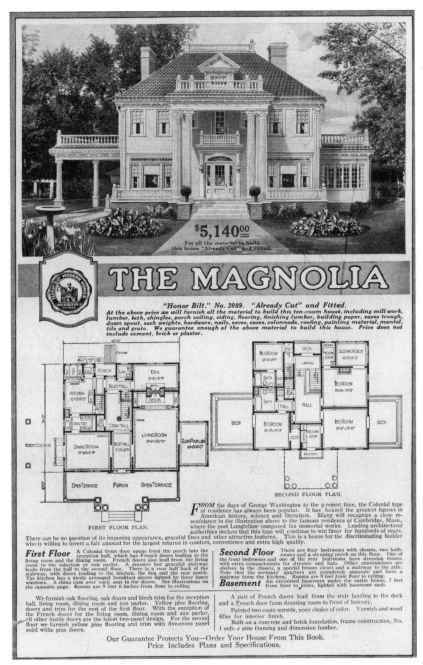

acanthus leaves, honeysuckles, or triglyphs may embellish the surround. Many affluent houses have a balcony above the entrance. Doors themselves are wood paneled and may be single or double.

■ *Roofs.* Roofs may be flat without balustrades or low-pitched gables to resemble the temple (Fig. 5-15, 5-16, 5-18). Some gables are steeper than the prototypes to allow for rain or snow. A few are hipped. Some have rectangular or cylindrical cupolas.

■ *Later Interpretations.* As in public buildings, Neoclassical Revival houses sometimes replicate Greek Revival forms and details, but with larger scale and different materials (Fig. 5-23).

INTERIORS

Greek Revival interiors do not replicate those of the past because few examples survive. Public interiors have large and bold classical details rather than purely classical forms and treatments. Important rooms are grandly treated with columns, pilasters, moldings, and coffered ceilings. Spaces are generally rectangular, and those with

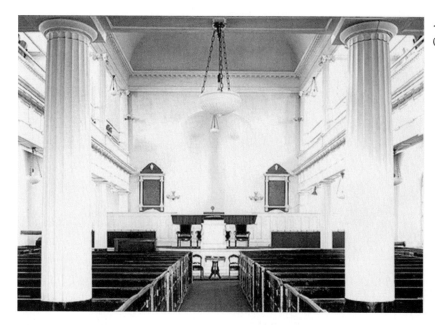

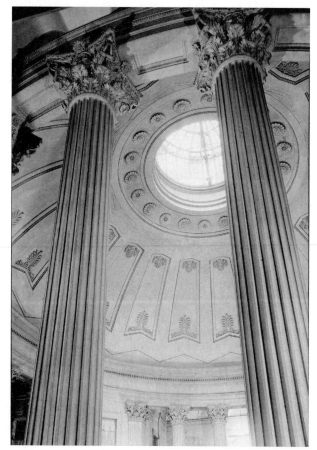

◄**5-24.** Nave, First Baptist Church, 1822; Charleston, South Carolina; Robert Mills.

domes may be round or octagonal. A few spaces feature apsidal ends with a screen of columns separating the curving portions from the rest of the space. Domestic rooms are mostly rectangular spaces, but usually with an overall simpler character than is evident in public interiors. Furnishings may or may not be classical because the Rococo and Gothic Revivals gain popularity toward the middle of the century.

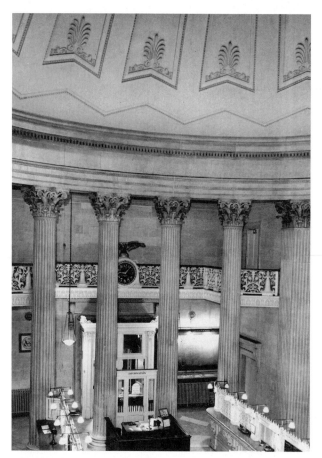

▲ **5-25.** Rotunda, Customs House, New York City, 1834–1841; Town and Davis.

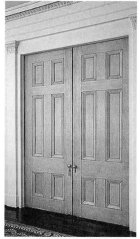
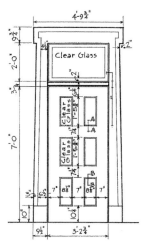
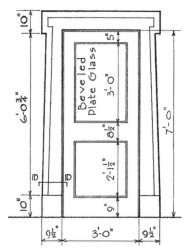

▲ **5-26.** Doors from South Carolina, Pennsylvania, and Texas, c. 1830s–1850s.

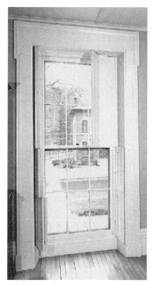
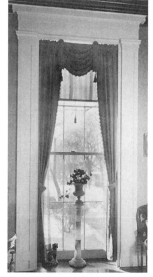

▲ **5-27.** Windows from Massachusetts and Michigan, c. 1840s–1850s.

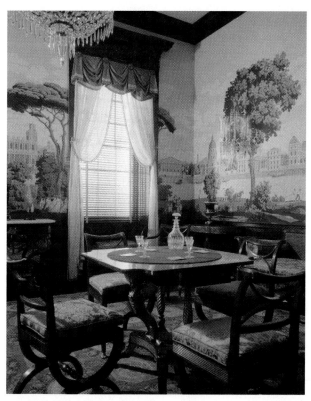

▲ **5-28.** Parlor, William C. Williams House, 1810; Richmond, Virginia (Richmond Room, Metropolitan Museum of Art, New York); house possibly by Alexander Parris.

Public Buildings

■ *Relationships.* Symmetry and regularity are important design principles. Interiors often have bold architectural details and display more embellishment and color than exteriors while maintaining a dignified and somber feeling.

■ *Color.* Most color comes from materials such as the whites and grays of marble or stone. Somber colors for walls, such as stone, gray, or drab (gray-brown), are common. Many walls are marbleized. Doors and trim often are grained. Important rooms may have gilding on details. Drapery, upholstery, and carpets provide accents of stronger, saturated colors in deep reds, blues, greens, and golds (Fig. 5-25).

■ *Lighting.* Interiors are lit with a combination of candlesticks, Argand lamps, astral lamps, lanterns, and hanging lamps (Fig. 5-39). Large windows admit natural light, and fireplaces also may provide illumination.

■ *Floors.* Floors may be masonry, marble, or wood. Some important spaces have wall-to-wall carpets in bold geometric patterns with classical motifs and saturated colors of deep reds, blues, greens, or golds.

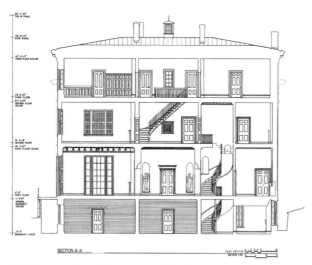

▲ **5-29.** Section, White House of the Confederacy (John Brockenbrough House), 1818; Robert Mills.

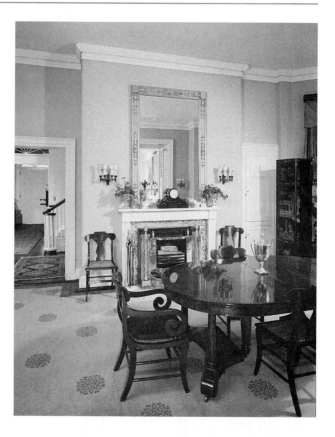

■ *Walls*. Bold architectural details articulate walls, particularly in important spaces (Fig. 5-24). Some walls are treated as one broad expanse with paint or wallpaper, whereas others are divided by a dado, fill, and cornice or are divided into bays with engaged columns or pilasters.

■ *Windows and Window Treatments*. Plain or complicated moldings surround rectangular windows. Those in important rooms have lintels or pediments surmounting them. Window treatments (Fig. 5-27, 5-31, 5-35), when present, are composed of swags and festoons suspended from a gilded classical cornice, under-curtains of damask or velvet tied back, and a thinner material such as muslin next to the glass. Simpler treatments consist of panels hanging from rings on wooden rods.

■ *Doors*. Doorways into important spaces have grand treatments with columns or pilasters or larger moldings with entablatures above. Doors may be single or double in paneled wood painted to match moldings, grained to imitate other woods, or sealed with a clear finish.

■ *Ceilings*. Whereas some ceilings are plain with a plaster rosette, others may have coffers or may be compartmentalized combinations of circles, ellipses, and rectangles. Paint or gilding may highlight details.

■ *Later Interpretations*. Classical-style interiors characterize Neoclassical Revival buildings, but they do not necessarily replicate Greek Revival characteristics.

Private Buildings

■ *Types*. Halls or passages (Fig. 5-32, 5-34) remain summer living spaces early in the period, but eventually become service areas or spaces for regulating social relationships. Many homes have double parlors, separated by sliding or pocket doors when needed or accented by

▲ **5-30.** Dining room and graining details, Andalusia, 1833; Bucks County, Pennsylvania; Thomas U. Walter and Nicholas Biddle.

DESIGN SPOTLIGHT

Interiors: Parlor, Shadows-on-the-Teche, 1834; New Iberia, Louisiana. Constructed between 1831 and 1834, Shadows-on-the-Teche is owned by sugarcane planter David Weeks. The two-story gable-roofed house has a symmetrical façade of brick with double-hung windows. Colossal Tuscan columns carrying a Roman Doric frieze create the gallery or porch that runs across both stories, and an exterior stair on one side provides vertical circulation. Originally, the house was painted white with green shutters.

This interior museum installation reproduces the parlor of an upper-middle-class house where guests are received and various rites and ceremonies take place. Fresco paper, in which borders form a paneled or compartmentalized design, in buff damask adorns the walls. On the floor is a multicolored wool Brussels carpet in a geometric-floral pattern. The window treatments are green damask with shaped valance and are tied back under curtains. A center table with an astral lamp and American Empire-style gondola chairs provide a place for people to gather. Additional furniture includes American Empire pier tables, side chairs, armchairs, and a sofa. The bold cornice, door surrounds, and rectangular marble with ormolu mantel clock and girandoles are common details in Greek Revival houses.

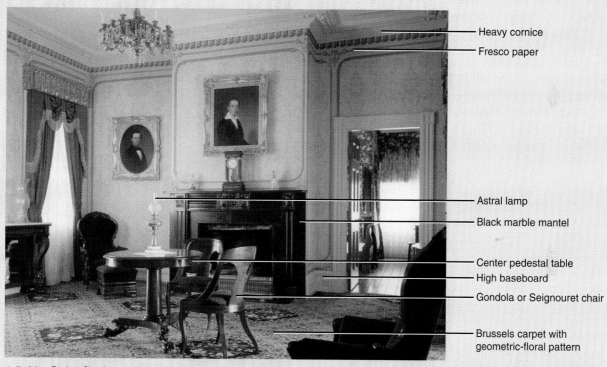

Heavy cornice
Fresco paper
Astral lamp
Black marble mantel
Center pedestal table
High baseboard
Gondola or Seignouret chair
Brussels carpet with geometric-floral pattern

▲ **5-31** Parlor, Shadows-on-the-Teche; New Iberia, Louisiana.

columns (Fig. 5-26). The front parlor, used for entertaining, displays a feminine, elegant manner to impress visitors (Fig. 5-28, 5-31, 5-32). The rear or family parlor is less elegantly decorated and serves as a repository for older furnishings. Dining rooms are more common than they were before (Fig. 5-30, 5-33). Considered masculine spaces, they are somber in tone or rich and warm. Service areas are at the rear, in the basement, or completely separated from the house. The best chambers, located on the ground or second floor, often have elaborate, four-poster beds and large wardrobes (Fig. 5-37) to display wealth and prosperity.

■ *Relationships.* Classical details unite interior with exterior. Symmetry and regularity are important design principles, as in public buildings. Interiors display more embellishment and color than do exteriors.

■ *Color.* The Romantic interest in nature appears in colors with names like moss green, fawn brown, or stone gray. Early in the period, light values and neutral tones predominate. By midcentury, colors such as lilac, peach, bronze green, sage, and salmon are fashionable. Writers of pattern books specify colors based upon color theories. They recommend cool colors for south rooms and warm for north; sober tones, such as gray, buff, or drab for halls;

and light, elegant colors for parlors. Dining rooms may be red or green. Emphasizing the importance of placement, writers call for light ceilings, darker walls, and woodwork that is lighter or darker than the walls. They consider cornices especially important and recommend emphasizing them by contrasting colors to walls and ceilings. Graining and marbling are common on doors, woodwork, and fireplaces. Critics believe that bedrooms should be cheerful with light-colored walls and simple patterns.

■ *Lighting*. Most people use a combination of firelight with candles and lamps for illumination, often choosing candles, which are less expensive and more portable than lamps. As in previous periods, levels of artificial illumination are low, but for entertaining, additional lighting signals hospitality. Candlesticks, candelabra, wall sconces, and lamps may be of glass, silver, bronze, and brass (Fig. 5-31, 5-39). Lead glass prisms embellishing the fixtures enhance light. Affluent and high-style parlors and dining rooms may have elegant cut-glass chandeliers suspended from carved ceiling medallions (Fig. 5-31, 5-32, 5-35). Argand lamps, tubular wick lamps with a reservoir to hold fuel, are more common than they were before (Fig. 5-39). They have single or double arms and are made in pairs or sets of three for use on a mantel. People substitute sinumbra or annular lamps for reading or on center tables.

■ *Floors*. Wood floors predominate throughout the period, although more affluent homes sometimes have marble or other masonry flooring. Floors may be sealed with varnish, painted, or covered with floor cloths or carpets. Painted floors have solid colors or patterns, such as stripes or imitations of marble. Floor cloths in solid colors and patterns also remain popular, but not inexpensive.

■ *Floor Coverings*. The use of carpets (Fig. 5-30, 5-31, 5-32, 5-33) increases dramatically as a result of industrialization. Carpets usually are installed in narrow strips that are pieced together. Wall-to-wall carpets include Brussels, Wilton, ingrain, tapestry, and list. Brussels and Wilton remain expensive, but more Americans than ever before can afford ingrain, list, tapestry, and Venetian carpets. Early in the period, carpets have geometric designs and classical motifs in several colors of which combinations of red and green are especially fashionable. Later patterns include trellises and stripes with flowers, imitations of Oriental rugs, and realistically shaded flowers. Hearth rugs in complementary patterns protect the carpet in front of fireplaces. Many still use crumb cloths to shield carpet beneath dining tables. In summer, carpet is taken up and replaced with grass matting. Matting is usually laid wall to wall with edges abutting. Easily cleaned and inexpensive, it comes in plain and patterned versions, but does not wear well.

■ *Walls*. Walls are usually treated in one large expanse with paint or paper (Fig. 5-28, 5-29, 5-30, 5-31, 5-32, 5-34, 5-36). Bold, decorative moldings, often with foliage or leaves, may compose cornices (Fig. 5-38). Baseboards are deeper than before. Rectangular, stone mantels, usually

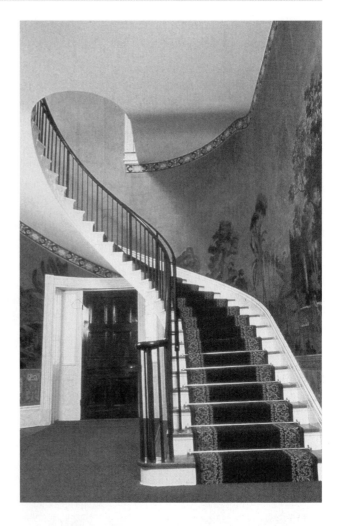

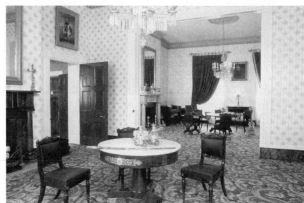

▲ **5-32.** Entrance hall and parlors, Hermitage, 1819, rebuilt 1836; Nashville, Tennessee; David Morrison, later possibly Robert Mills.

black or white, resemble exterior door surrounds (Fig. 5-30, 5-31, 5-35). Columns, brackets, or caryatids may support the shelf.

■ *Wallpaper*. As in Europe, wallpaper use increases in American homes. Continuous rolls are common after 1830; machine-made paper becomes available about 1820

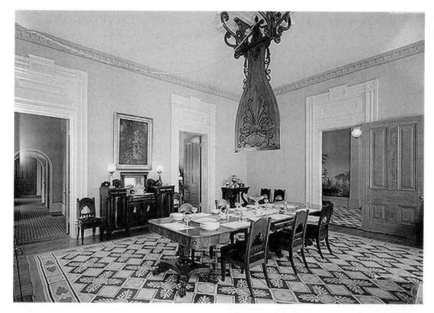

◄ **5-33.** Dining room, Melrose, c. 1840s; Natchez, Mississippi; John Byers.

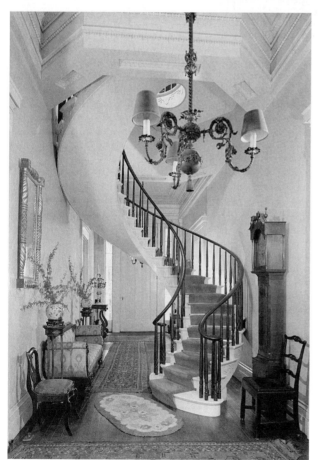

▲ **5-34.** Stair hall, Charles L. Shrewsbury House, c.1849; Madison, Indiana.

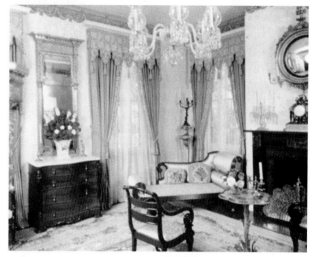

▲ **5-35.** Music room, Rosedown Plantation, c. 1834–1859; St. Francisville, Louisiana.

but does not dominate the market until the 1840s. Most papers continue to be hand-block printed, although roller print examples increase. New colors for papers include chrome yellow, French blue, and bright green.

Wallpaper in many patterns comes from England, France, China, and America (Fig. 5-28, 5-32). French papers dominate the American market because Americans favor their designs and colors. Landscape or scenic papers from France, particularly, are fashionable. Designed to cover the wall from dado to ceiling, landscape views have 20 to 30 panels per pattern. Panels are about 20' wide and 8' to 10' tall. The upper portion is sky with or without clouds and can be cut to fit the height of any room. The images depicted consist of numerous flat, opaque colors built up by printing individually with wooden blocks.

Other patterns include architectural, ashlar, fresco, landscape, and textile or drapery imitations. Architectural papers imitate architectural details such as columns, coffered

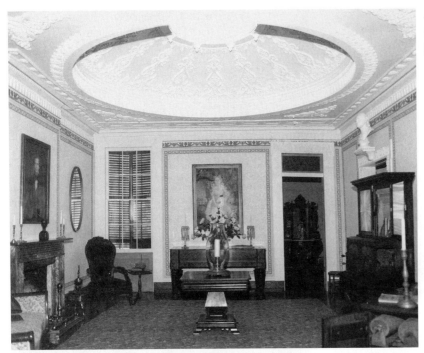

◀5-36. Parlor and library, Gaineswood, 1843–1861; Demopolis, Alabama; General Nathan Bryan Whitfield.

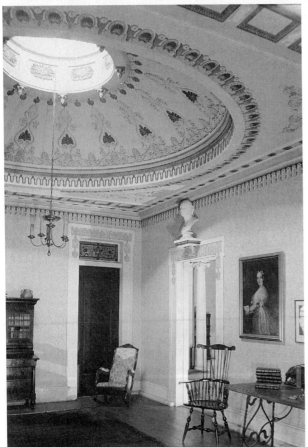

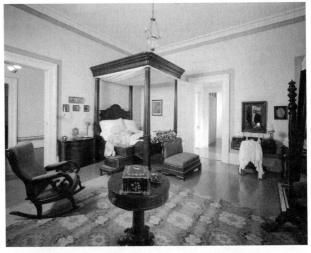

▲ 5-37. Master bedroom, General Phineas Banning Residence, c. 1850s–1860s; Wilmington, California.

ceilings, cornice moldings, or dadoes. Ashlar papers, simulating masonry or stone in appropriate colors, are recommended for passages and hallways. Fresco papers consist of vertical panels with flowers or foliage combined with columns and/or architectural moldings. Paper imitations of textiles or drapery substitute for the real thing in many homes. Also fashionable are rainbow (shaded) papers from France and small repeating flowers or geometric shapes. Borders complement all patterns.

■ *Windows*. Plain or complicated moldings surround large rectangular windows. Some have lintels or pediments surmounting them (Fig. 5-27).

■ *Window Treatments*. Many rooms continue to have interior shutters that fold into a shutter box in the window jamb when not in use. Shutters block light and provide

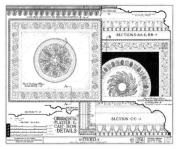

▲ **5-38.** Ceiling details from Virginia, Mississippi, and Louisiana, c. 1830s–1860.

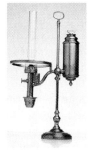

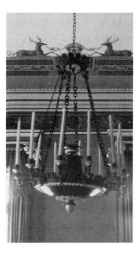

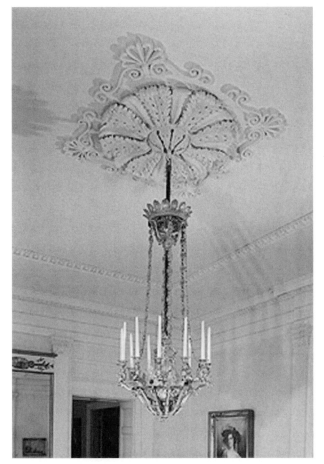

▲ **5-39.** Lighting: Dolphin candlesticks, Argand lamps, urn chandelier, and glass chandelier, c. 1830s–1860s.

privacy. Parlors, dining rooms, and other important spaces usually have textile window treatments, which become more common during the period (Fig. 5-27, 5-31, 5-35). These treatments typically include swags and cascades or a shaped valance with trim and tassels, heavy trimmed side curtains tied back, sheer under-curtains, and a roller shade or blinds. As in Europe, swags and cascades, often with contrast linings and elaborate trims, are usual. Americans also increasingly use the newly introduced French draw rod for curtains. Roller blinds made of white cotton or unbleached linen (called Holland cloth) debut in about 1825. Windows in less important rooms have simple panels, sometimes with a valance. Rural houses often have no window treatments, as before.

■ *Doors*. Doorways to important rooms have complex surrounds composed of architectural details such as pilasters carrying an entablature or battered moldings reminiscent of Egyptian gateways (Fig. 5-26). Other doorways have simpler surrounds. Doors are mahogany, walnut, or rosewood. Less expensive woods are grained to resemble the more expensive ones.

■ *Textiles*. People increasingly use more fabrics than they did previously. However, textile wall treatments or tent rooms are less common in America than they are in Europe. Curtain fabrics and upholstery may be silk or chintz in the parlor, moreen in the dining room, and cottons for bedrooms. Fashionable rooms may have several

patterns of textiles instead of only one, as in earlier periods.

■ *Ceilings.* Carved or cast plaster medallions or rosettes embellish the centers of some ceilings, while other ceilings are plain (Fig. 5-36, 5-38, 5-39, 5-43).

FURNISHINGS AND DECORATIVE ARTS

American Empire is heavier, plainer, and more sculptural than the earlier Federal. Carving, gilding, and classically inspired forms, such as the klismos and curule, define the image. The *style antique*, as it is called, borrows heavily from, but does not copy, French Empire and English Regency. Pillar and Scroll or Late Classical is a late version of American Empire that is characterized by simple forms, massive pillars, scrolls, and large expanses of mahogany veneer with no ormolu or gilding. Both American Empire and Pillar and Scroll pieces are heavy and solid looking with good proportions. Case pieces tend to be rectangular, while chairs and sofas are more curvilinear. Regional variations evident in American Empire disappear in Pillar and Scroll, which is usually machine-made. Furniture maintains a relationship with archi-tecture because many cabinetmakers learn proportion, scale, and relationships using the classical orders as models.

Technology and industrialization influence both styles. The new circular veneer saw slices veneers much thinner than before, enabling cabinetmakers to use rare exotic woods such as rosewood and apply veneers to curved surfaces without it splitting. The steam-drive lathe, introduced in the 1820s, contributes to the popularity of turned Roman legs. Cabinetmakers also adopt the French polish, a high-gloss and more quickly applied lacquer-based finish. At the end of the 1830s, the steam-driven band saw that can cut intricate curves in any thickness of wood comes into general use. The period also marks the beginning of mass-produced furniture. People continue purchasing custom furniture from small cabinetmaking shops but

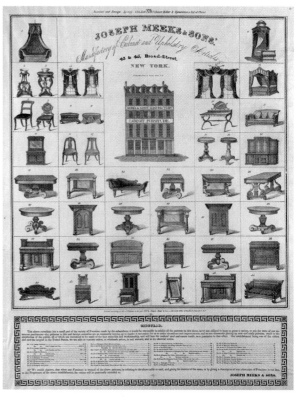

▲ **5-41** Cabinet and upholstery articles, c. 1833; New York City, New York; manufactured by Joseph Meeks and Sons.

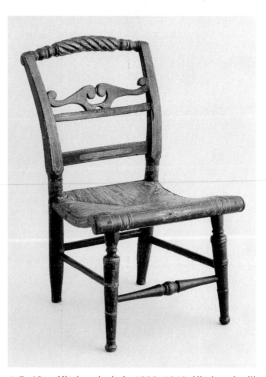

▲ **5-42.** Hitchcock chair, 1826–1843; Hitchcocksville, Connecticut; Lambert Hitchcock.

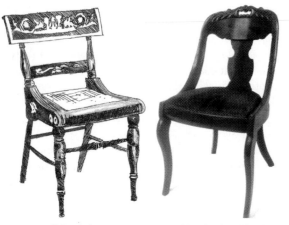

▲ **5-40.** Side chairs, c. 1810s–1850s; Maryland and Louisiana.

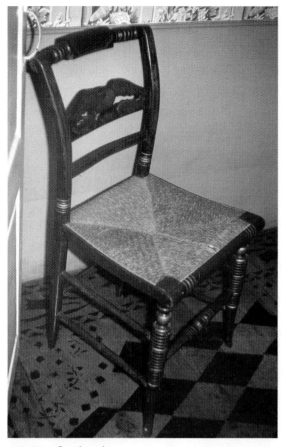

▲ **5-42.** Continued.

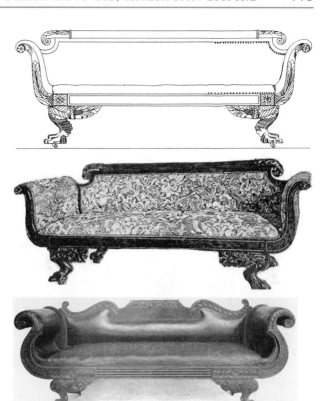

▲ **5-44.** Plain sofas, c. 1820s–1840s.

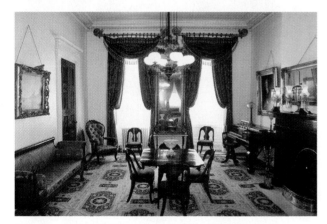

▲ **5-43.** Parlor, Old Merchant's House, 1830s; New York
(Furniture Museum, East Village, New York City).

now can buy other furniture from auction houses, merchants, upholsterers, and large retail establishments.

Public and Private Buildings

■ *Types.* Furniture types from earlier periods continue. Innovative forms include the klismos and curule for seating, the Grecian couch, and sleigh or French bed (Fig. 5-35, 5-40, 5-48). Also, new to the period are the center table and the pianoforte, both of which commonly grace parlors (Fig. 5-31, 5-32, 5-41, 5-43).

■ *Distinctive Features.* Dark wood, carving, and brass mounts distinguish American Empire, while veneers, minimal embellishment, and scrolls define Pillar and Scroll or Late Classical (Fig. 5-44, 5-45, 5-46). Both styles, with the exception of pillar and scroll chairs, tend toward rectilinear forms and sharp corners. Case pieces rest on solid bases or paw feet. Classical motifs are common.

■ *Relationships.* Furniture maintains its perimeter location, but chairs increasingly move to the center when not in use. Sofas may be at right angles to the fireplace, and center tables are common.

■ *Materials.* Mahogany is the most popular wood followed by cherry, maple, and exotic woods, such as rosewood. Many pieces are veneered; others are painted or grained to imitate marble, ebony, or rosewood. Brass mounts and other details are common on Empire examples, but rare on Late Classical or Pillar and Scroll, which is very plain and relies on line for interest. Between 1807 and 1815, brass mounts from Europe are unobtainable because of import restrictions, so stenciled decorations and inlay are substituted. Painted furniture remains fashionable. Pieces may be painted completely or have color or ebonizing accentuating feet, drawers, or column supports. Typical colors include yellow ochre, red, green, blue, and black. Pressed glass knobs appear on furniture soon after patents for them are awarded in 1825 and 1826.

DESIGN SPOTLIGHT

Furniture: Sideboards, c. 1820s–1840s. The sideboard is the most impressive piece in the Greek Revival dining room. Intended to proclaim wealth and to display objects, silver and glass are carefully arranged on its top. Most have drawers and cupboards for storage of items associated with dining. Broad expanses of mahogany, classical details, and large scale define the American Empire sideboard. These examples illustrate the variety in form and design.

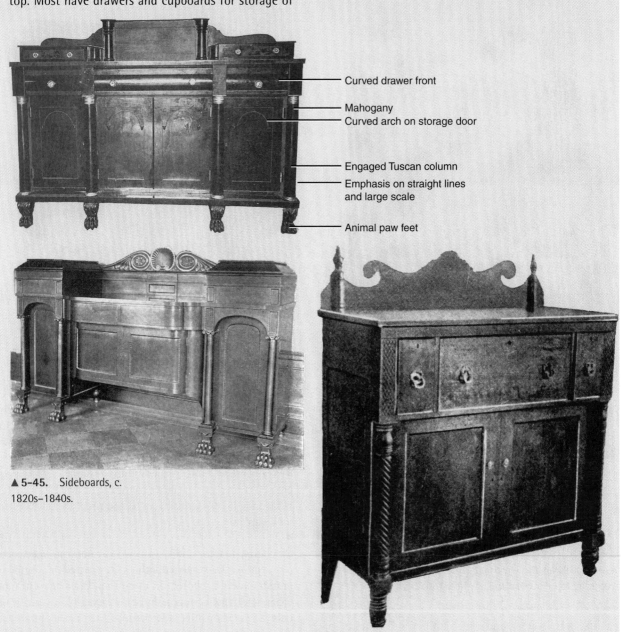

Curved drawer front

Mahogany
Curved arch on storage door

Engaged Tuscan column
Emphasis on straight lines and large scale

Animal paw feet

▲ **5-45.** Sideboards, c. 1820s–1840s.

■ *Seating.* Seating furniture often is part of suites of furnishings that include chairs, sofas, window seats, card tables, and pier tables in matching designs (Fig. 5-30, 5-31, 5-32, 5-41, 5-43). Most rooms have numerous chairs of which the Greek klismos is the most common antique form. Examples may closely or loosely follow the klismos form (Fig. 5-28, 5-40). Leg types include turned, X-shaped, cornucopia, saber, and quadrangular. Chair backs may have horizontal, vase, eagle, or lyre splats. Animal feet, brass-paw toecaps, and casters are common. Reeding and carved or painted classical motifs may highlight backs and rails. Chairs with caned seats

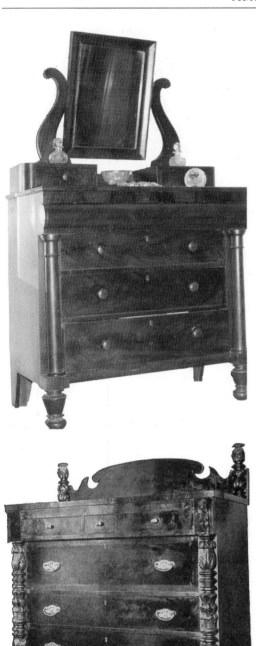

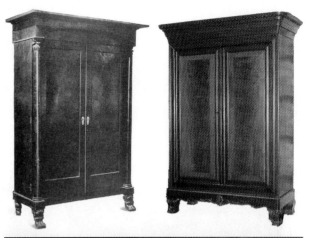

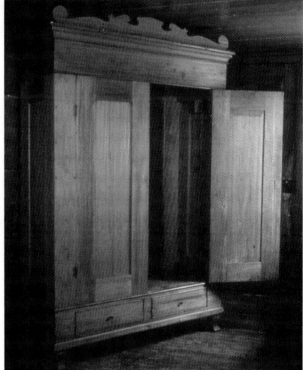

▲ **5-47.** Wardrobes, c. 1820s–1850s; New York, Louisiana, and Texas.

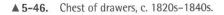

▲ **5-46.** Chest of drawers, c. 1820s–1840s.

usually have cushions with tassels for comfort. Gondola chairs (Fig.5-31, 5-40) derived from French Empire forms are also fashionable. Grecian cross-legged chairs and sofas have X-shaped or curule legs that may face either the front or sides.

Fancy chairs are popular versions of klismos or Sheraton styles. They have rush seats, turned legs, and stenciled decorations and may be painted black, yellow, or green. To simulate gilding, bronze dust may be sprinkled onto still-wet varnish. Although many firms make them, those by Lambert Hitchcock in Connecticut are the best known (Fig. 5-42). They are especially popular in New England. Stools or *tabourets* become increasingly popular throughout the period and sometimes are used as window seats.

Every elegant parlor has at least one sofa (Fig. 5-43, 5-44). Plain sofas, as they are called, have identical

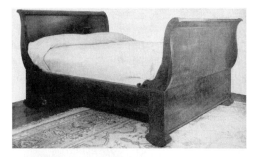

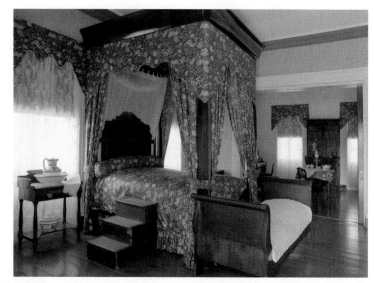

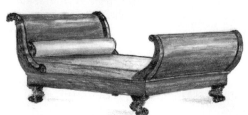

▲ **5-48.** Sleigh beds and four-poster bed, c. 1820s–1850s; Louisiana and Washington, D.C.

▲ **5-49.** Textiles: Cotton and wool, and quilt, c. 1820s–1860s.

scrolled ends, a long wooden crest, and lion's paw or cornucopia feet. Expensive examples feature carving, reeding or fluting, and veneer. Box types are rectangular with heavy turned legs and feet. Grecian sofas (Fig. 5-35), derived from Greek prototypes, have complex scrolls, backs often not as long as the seat, and saber legs. They often appear in pairs. Ottoman sofas are benches without arms that are commonly used as window seats.

Toward the end of the period, elaborate and carved forms in seating gradually give way to simple veneered and scrolled forms in the Pillar and Scroll style. Especially popular in America is the Pillar and Scroll rocker with curving arms and upholstered seat and back (Fig. 5-37). It is sometimes referred to as a Lincoln rocker because President Abraham Lincoln is depicted in one.

■ *Tables.* Center tables with round wooden tops often have central pedestals that may be carved or fluted, resting on a circular, triangular, or a rectangular base with paw or rounded feet (Fig. 5-31, 5-32, 5-41). Some center tables have caryatid, dolphin, scrolled, or bracket supports. Card tables have pedestals that may be fluted or shaped into lyres, eagles, or caryatids. Dining tables continue to be made in pieces so that they can be taken apart when not in use (Fig. 5-30, 5-33). Pedestals (called pillar and claw) are heavier than before and may have richly carved or brass paw feet. Rectangular pier tables used for serving food or holding dishes, decorative objects, or lighting are placed symmetrically, usually between windows, in the parlor and dining room (Fig. 5-32). Heavy columns or scrolls support the marble tops. Mirrored backs double the apparent size and reflect light. Below the shelf are rounded or paw feet that may be ebonized or painted green with inlaid brass rings.

■ *Storage.* The sideboard, which dominates the dining room, is one of the most impressive pieces in the house

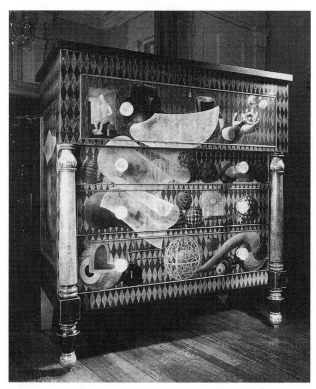

▲ **5-50.** Later Interpretation: "Phrenology," decorated chest of drawers, 1991; Rob Womack. Modern Historicism.

(Fig. 5-33, 5-45). Used for display and storage, it has drawers and doors on the sides and a long drawer in the center with pediment above. Some sideboards have columns or pilasters on the corners and paw feet. Chests of drawers in bedchambers, or bureaus as Americans call them, have three or four drawers with an overhanging top and columns on each side (Fig. 5-46). The piece may rest on paw feet. Desks and bookcases have flat tops, glass doors, and a rectangular base with a drop front that reveals the writing surface. Pleated yellow or green silk behind doors protect books from sunlight. The less popular *secrétaire à abattant* is rectangular with a pediment and drop front. Wardrobes are tall and massive with two doors (Fig. 5-47). Columns and/or paw feet may embellish them.

■ *Beds.* Four-poster beds continue in use, but posts are heavier and carved with classical ornament and other motifs (Fig. 5-37, 5-48). A heavy canopy with curved moldings often rests on the posts. A tall, carved headboard and/or pediment adds to the grandeur. Bed hangings remain opulent with swags or other complicated designs forming valances. French or sleigh beds have head- and footboards of equal height (Fig. 5-48). They are of dark wood with bright brass mounts. Over the bed, a rounded canopy may attach to the wall and support draped hangings of richly trimmed silk, cottons, or wool, sometimes with a contrast lining.

■ *Textiles.* The most common upholstery fabrics are horsehair, plush, silk, wool, and leather. Some covers have a central medallion for the back and seat and running decorative details for edges. Sometimes, sofas and chairs are further embellished with heavy shawl fringe. Furniture covers protect fabrics both in the summer and winter. Quilt-making becomes popular for women, with designs pieced together or embroidered on a fabric surface (Fig. 5-49). Flowers and eagles are popular motifs. Quilts usually cover beds.

■ *Decorative Arts.* More accessories and pictures appear in interiors during the period. Pictures and paintings hang symmetrically by slender cords from picture moldings mounted below the cornice. Mirrors reflect Empire design characteristics such as heavier proportions and rich carving. The round mirror in a heavy frame with a convex glass and an eagle motif remains very fashionable (Fig. 5-28, 5-35). English, American, and Chinese export porcelains, large in scale and classical in form, decorate mantels and pier tables and form large dinner sets. English transfer-printed ceramic wares are especially popular. Made specifically for the American market, pieces feature engraved images of American buildings or landscapes, portraits of American heroes, or other designs with an American theme.

During the 1830s, pressed glass dinnerware, candlesticks (Fig. 5-39), and lamps begin to be produced in a wide range of patterns, colors, and at reasonable prices. An American invention, pressed glass competes with more expensive domestic and imported cut glass and has a significant impact upon glass making in America and Europe. Forms and motifs may be classical. Most patterns feature densely packed flowers, foliage, volutes, and scrolls, a result of the manufacturing process. Silver is large in scale with classical forms, such as urns or columns, and classical decoration such as acanthus leaves. The wealthy have ormolu mantel clocks, and many Americans can now afford wooden wall and mantel clocks.

■ *Later Interpretations.* Reproductions and adaptations of American Empire and Pillar and Scroll furniture are introduced during the late 20th century as Americans restore old houses with period-style furnishings (Fig. 5-50). The newer interpretations are often desired because of improved functional considerations, such as wider beds and more storage compartments or places for televisions or computers in wardrobes.

Year	Event
1800	Philadelphia is the largest U.S. city
1804	Jacquard introduces simplified patterned weaving
1806	Webster starts his dictionary
1807	Robert Fulton builds first steam-powered boat
	Electric battery invented in England
1814	Star Spangled Banner starts waving
	Glass is first pressed into shapes by machine
1834	Currier and Ives start printing
	Braille writing system first used
1835	Mark Twain born
1836	Ralph Waldo Emerson, *Nature*
1837	Queen Victoria begins reign in Great Britain
	The Royal Institute of British Architects (RIBA) forms in England
1838	The Trail of Tears begins for 60,000 Cherokees
1841	Catherine Beecher, *Treatise on Domestic Economy*
1842	The New York Philharmonic Orchestra founded
1844	Morse sends his first telegram
1847	Hiram Powers's *The Greek Slave* first exhibited
1848	Erastus Bigelow invents loom for Brussels and tapestry carpets
1850	A. J. Downing, *The Architecture of Country Houses*
1851	Crystal Palace Exhibition is a gem in London
	Herman Melville, *Moby Dick*
1856	The first aniline dye, mauveine (purple), is discovered by W. H. Perkin
1857	American Institute of Architects (AIA) forms in the United States
	Electric arc lamps in use
1860	Pennysylvania site of first oil refinery
	John Rogers begins selling sculpture groups in NYC
	Alexander Phemister designs Bookman typeface
1861	U.S. Civil War begins
1865	U.S. Civil War ends
1867	Dominion of Canada founded
1869	Suez Canal opens
1873	C. Dresser, *Principles of Design*
1876	Centennial Exhibition in Philadelphia displays Japanese decorative arts
1886	Sears, Roebuck and Company begins as a catalog retailer
	First electric washing machine cleans up
1893	World's Columbian Exposition opens in Chicago
1894	The American Academy in Rome founded
1897	Wharton and Codman, *The Decoration of Houses*
1899	London's South Kensington Museum becomes the Victoria and Albert Museum
1900	Sigmund Freud, *Interpretation of Dreams*
1901	First transatlantic radio telegraphic transmission
	Theodore Roosevelt becomes president
	Queen Victoria dies
	U.S. Bureau of Standards established
1903	First transcontinental automobile trip across the United States
	Chicago's Iroquois Theater 15-minute fire kills 602
	Teddy Roosevelt authorizes construction of the Panama Canal

C. VICTORIAN REVIVALS

The period between 1830 and 1900 is named for Queen Victoria of the British Empire who ascends the throne in 1837. She rules until 1901, longer than any other monarch before her. Her reign sees a transformation of life and society as the Industrial Revolution completely changes how people live, work, play, build, and decorate. Class structure now depends on work and wealth instead of rank. Family and gender roles change as men work away from home and women remain at home. Leisure activities such as shopping, traveling, and going to the theater, clubs, and pubs increase substantially. Consequently, numerous new building types must be designed, built, decorated, and furnished.

Until the 19th century, people, even the wealthy, own few objects and keep the ones they have for generations. Leisured, cultured aristocrats patronize individual craftsmen or guilds. Both makers and customers have generations of cultivated tastes and notions of excellence in design behind them. Styles develop slowly and continue for years.

In contrast, the Victorian period is characterized by numerous European and non-European styles swiftly succeeding one another and an explosion of goods. Numerous styles or revivals demanding attention rapidly appear throughout the period. Industrialization creates a consumer class by introducing choice, both of style and quantity. With factories producing so many new goods, outmoded objects no longer appeal, giving rise to the notion of the disposable. Furnishings are imbued with social and cultural messages that change quickly, so middle-class Victorians, who have unprecedented spending power, continually strive to be up-to-date and keep up appearances. Signals of middle-class affluence include carpet, curtains, carved furniture, large mirrors, and a variety of accessories from wax flowers to Parian-ware busts.

Victorians take great pride in the machine and new materials, which they see as modern and progressive. They admire the scientific knowledge and technical achievements that produce these items. Machine-carved ornament is favored because it resembles hand carving but is done faster, more perfectly, and, presumably, more cheaply. New materials often are more durable, colorful, and cleanable than older ones are. Particularly admired are new materials that imitate other materials, especially those associated with wealth, objects made of previously unknown materials, or old materials used in new ways, such as papier-mâché furniture. New manufacturing techniques and new materials also inspire novelty and innovation, which are highly

esteemed. Manufacturers and sellers respond with a plethora of goods and styles, which increases their sales and profits.

Also characterizing the period is historicism, which stresses history as a standard of value. This arises from the belief that age and longevity sanctify certain characteristics, making them respectable, and ascribe an education and taste to the owner and maker. This, in turn, suggests gentility and acceptability, qualities that are especially important to the Victorians. So, as evidence of their culture, status, and good taste, they seek to surround themselves with historical styles or revivals, such as Grecian, Gothic, Rococo, Renaissance, or Egyptian. These revivals rarely are historically correct. The romantic view of history and stylistic associations or images are more important than imitation. Although past styles become more clearly understood as the century progresses, stylistic distinctions and designations for material culture remain unclear. Nevertheless, the era is one of specialization with Rococo Revival in the parlor, Gothic Revival in the library, and Renaissance Revival in the dining room. Similarly, styles for public buildings convey their purpose or their associations. For example, some regard Gothic Revival as a Christian style that is more appropriate for churches than pagan classical temples are. Exotic styles, such as Egyptian, identify cemeteries, prisons, and libraries to give a sense of eternity, permanence, security, or superior intellect.

Women's roles change during the period. As husbands are working away from the home or farm, they no longer assume the role of decorator. This task, which now falls to the wife, is a particularly difficult one because she must choose among an abundance of styles, each with its own historical and cultural associations and correct uses. In addition,

reformers who are concerned with the effects of industrialization on the home and family insist that the home is the antidote to mechanization's negative effects. Women, they insist, are best suited to create homes that are refuges and places of culture, taste, and education. The notion of domestic environmentalism assumes that the home affects the inhabitants positively or negatively; this pervades writing and thinking during the entire 19th century.

Additionally, the home represents the family to visitors and business associates and is the setting for life's social rituals. The objects with which people surround themselves display the culture and taste of the family, and each object also serves as a learning experience for the children. Consequently, what a woman buys reflects who she is and what her family becomes. Not only is what she buys important, but where she buys it and how she displays it are vital because they can affect her social status, her husband's advancement, and the moral health of her children. The Victorian period is the first to ascribe moral attributes to the style of objects and buildings. The prevailing notion is that good design represents good morals.

Gothic Revival strives to emulate the Gothic style of the Middle Ages. Elements of Gothic architecture are applied to contemporary forms in architecture, interiors, and furniture beginning in the middle of the 18th century. Throughout the 19th and 20th centuries, expressions vary in response to scholarship, associations, and reform movements.

In contrast to other revivals, Second Empire is a contemporary architectural style in France that becomes fashionable in England and North America because of its associations with culture and cosmopolitanism. Also associated with culture, Rococo Revival strives to evoke the French Rococo of the 18th century. Its curvilinear compositions are bolder than the original and adopt new materials and construction methods. It is one of the most popular revival styles.

Italianate and Renaissance Revival architecture look back to the high style and vernacular architecture of Italy to create formal and informal compositions in masonry in Europe and North America, and wood in the United States. Interiors and furniture are among the most eclectic of the revivals and borrow from the Renaissance in Italy, France, Germany, and England.

Exoticism looks to non-Western sources for inspiration, including Egypt, the Middle East, and the Far East. Styles include Egyptian, Turkish, Moorish, and Indian Revivals. Although manifest in architecture, interiors, and decorative arts, complete expressions are rarer than other revivals. Often people choose a room or furnishings over an entire house.

Stick, a unique American style, looks to the Middle Ages and half timbering for inspiration. Queen Anne architecture originates in England as an attempt to avoid creating a style by adopting vernacular elements from the 16th through the 18th centuries. Appearing most in architecture, interiors follow fashionable styles, and furniture may show some elements from the 18th century. The United States interprets Queen Anne in wood.

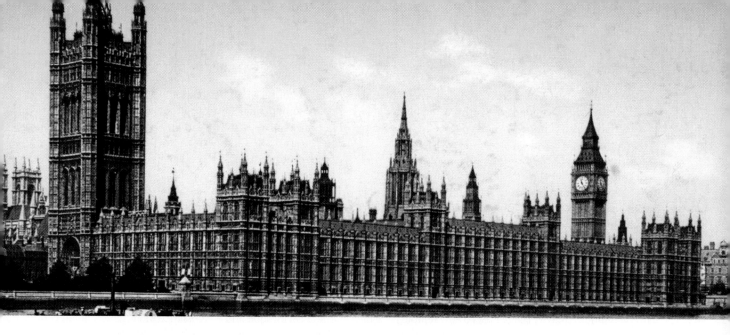

CHAPTER 6
Gothic Revival
1830s-1880s

Gothic Revival consciously revives Gothic and other aspects of the Middle Ages. Beginning in England about the middle of the 18th century, it challenges the supremacy of Neoclassicism within 50 years. In its earliest manifestations, Gothic Revival applies ecclesiastical architectural motifs to contemporary forms. Following the growth of scholarship, the style begins to develop from medieval prototypes, eventually forming a unique expression indicative of its time. Elements of Gothic Revival theories become foundations for later design reform movements.

HISTORICAL AND SOCIAL

Developing in France about 1100, Gothic architecture reflects a period in which religion is extremely important. As an outgrowth of thought about what constitutes the form of a noble church building, Gothic cathedrals seek to awe and inspire. Physical elements, such as pointed arches, ribbed vaults, and stained glass, come together in the great cathedrals to create soaring spaces with softly colored lighting that dwarf people, inspire faith, and glorify the God or saints to which they are dedicated. Decoration and structure are one in the same. Although primarily ecclesiastical, Gothic architectural details appear in some secular public and private buildings, interiors, furniture, and decorative arts.

Gothic Revival idealizes a period that is extremely difficult for most people. Many live in squalor, and disease is rampant. Food, clothing, and essential goods remain scarce. Few, even among the nobility, can read. Servitude governs the lives of most people, and nobles move frequently to oversee their properties or take part in or avoid wars and conflicts. Monasteries and universities are centers for learning and preserving culture, and crafts guilds oversee quality of goods produced.

Gothic survives as a style for churches and in renovations and additions to medieval structures until the 1700s, especially in England and Germany. Gothic Revival develops as a style after the mid-18th century, when European designers, influenced by the Romantic and Picturesque Movements, turn to the Middle Ages as a source of inspiration. Influenced by literary themes, they find appealing the gloom, melancholy, and the supernatural linked to Gothic. Redefining beauty to include not only form but

the images conjured in the viewer's mind, they come to regard the medieval period as worthy of emulation like classical antiquity. Thus, Gothic becomes an alternative style to classicism.

By the early 19th century, the times increasingly favor a return to the medieval past as industrialization and political changes interrupt lives and transform countries. People seeking stability, meaning, and continuity begin to look longingly toward an idealized past. At the same time, in reaction to the Enlightenment of the 18th century, religious fervor increases, which in turn promotes renewed church construction and discussions of what should constitute a model church building. Architects, theorists, and believers see Gothic as more fitting for the Christian church building than a classical (or pagan) temple is. Some denominations and religious groups adopt the Gothic Revival as a visual metaphor for their faith. Continuing the tradition of earlier Romance novels, 19th-century writers, such as Victor Hugo and Sir Walter Scott, write stories set in the Middle Ages, which capture the imaginations of readers in England, France, and North America.

■ *England.* The Gothic Revival in England begins earlier than in other countries and continues a sustained development throughout the 19th century. Interest in Gothic as a style for modern buildings and furnishings arises in the mid-18th century with manifestations that are fanciful and lighthearted and appeal mostly to the affluent (Fig. 6-1). By the early 19th century, serious scholarship, investigations of medieval buildings, and a religious revival bring a more accurate Gothic Revival to the forefront of stylistic choices for numerous new and remodeled churches and their interiors, furnishings, and priestly vestments.

About 1850, finding that re-created medieval prototypes cannot meet contemporary functional requirements, designers cease copying originals and move toward greater eclecticism, more boldness, and an emphasis on color and surface decoration. During this same period, Gothic becomes firmly aligned with design reform movements as adherents strive to design in the spirit of the medieval instead of relying upon Gothic forms or details as before. During the same period, the writings of art critic John Ruskin inspire a colorful expression derived from Venetian Gothic, which becomes known as High Victorian Gothic.

■ *France.* In the 18th century, French Neoclassicists are interested in Gothic as a method of construction. Jacques-Germain Soufflot uses a form of Gothic construction in S. Geneviève (Panthéon, 1757–1790) in Paris, although the exterior displays the purity of Greek classicism. Although he is applauded for his integration of Gothic and classicism, there is little popular interest in Gothic beyond "ruins" in picturesque landscapes and gardens.

In the early 19th century, scholarship indicates that Gothic had originated in France, and French nationalistic pride in the style swells, especially among the clergy and aristocrats. Gothic Revival begins to convey an image of

French heritage and nationalism. With the restoration of the Bourbon (and Catholic) monarchy in 1815, Gothic becomes an antidote to earlier Napoleonic imperialism. Between 1830 and 1845, the Flamboyant Gothic (14th–16th centuries) forms the basis for a more Romantic Gothic Revival that is visually complex and asymmetrical. By 1845, French designers, like the English, are producing a more correct Gothic Revival derived from earlier examples.

■ *Germany.* As in England and France, early German manifestations of Gothic Revival are picturesque and irregular. Although more greatly influenced by classicism, Gothic Revival innovations in Germany are the Romantic castles along the Rhine River. Unlike England and France, the Romanesque and Renaissance modes exert greater influence on German architects than Gothic does.

■ *United States.* The United States has little Gothic architecture to study, restore, or emulate. Consequently, there is little interest in the style and few manifestations of Gothic Revival before the 1830s. In the 1840s, Americans begin to interpret Gothic Revival in modest wooden cottages and villas. The style is not as pervasive as in England partly because of the dominance of Greek Revival. As in Europe, American designers strive for a more archaeologically correct Gothic, particularly in churches during the 1850s. Following the Civil War, High Victorian Gothic is primarily used for public and collegiate buildings and a few churches throughout the 1870s. Gothic Revival is never as popular or pervasive as in England.

CONCEPTS

Nationalism as well as religious, literary, and historical associations interweave with the ascent of Gothic Revival in architecture and design in the late 18th and early 19th centuries. England, France, and Germany all claim to have

◄ **6-1.** Women's costumes from *Godey's Lady's Book and Lady's Magazine,* c. mid-19th century.

originated the medieval Gothic, in contrast to classical antiquity, which clearly comes from Greece and Rome. Each country regards it as a national style and expressive of its heritage and traditions. Largely a style for churches and castles at first, the visual complexity and fanciful image of the Early Gothic Revival appeal to the senses and contrast with the rationality of classicism. Rarely is there any emphasis upon correct use of forms and motifs, proper context, and structure because image is more important than accuracy.

Stimulated by their interest in the medieval period and realizing that little is known about the period, antiquarian and other learned societies begin to research a variety of medieval structures from cathedrals to cottages and other medieval sources such as illuminated manuscripts. Soon, books with histories of buildings and picturesque illustrations intensify public interest while providing architects and designers with images for inspiration. As a result, Gothic Revival becomes more sober and archaeologically correct as designers strive for correct use of the original forms and motifs. They begin to distinguish between the various styles of the Middle Ages, often choosing one over others for personal and patron preferences or for particular associations. No longer do they limit themselves to the medieval styles of their own countries. By the 1850s, Gothic Revival has become increasingly eclectic and less directly dependent upon precedents.

■ *England*. The greatest designer and theorist of Gothic Revival in England is Augustus Welby Northmore Pugin. Passionately believing in the superiority of Gothic, Pugin's writings form a theoretical base for Gothic Revival, and his design work is a model for others. Many of his defining principles for Gothic Revival significantly affect subsequent reform movements. Unlike others, Pugin uses primary resources as the model for his designs and strives to design in the Gothic manner instead of merely copying or applying architectural details to contemporary forms, as in his earlier work. His insistence upon correctness coupled with the newly developed stylistic chronology and scholarship leads to designs and details derived from the various English medieval, pre- and postmedieval styles.

In the 1850s, the views and writings of John Ruskin, an art historian and art critic, create the theoretical basis for High Victorian Gothic. Ruskin is mostly interested in the liveliness created by surface decoration and colorful building materials. He promotes as ideal the buildings of Venice, particularly the Ducal Palace with its Roman, Italian, and Moorish influences. In addition, English designers exchange ideas with those in France and Germany, thus increasing the range of design resources beyond Italy during the period.

Also during the mid-19th century, Gothic Revival becomes a tool of the design reform movements. Recognizing the lack of taste and discrimination of the majority of contemporary society, the emphasis upon materialism, and the poor designs of most machine-made goods, reformers call for change. Like Ruskin and Pugin, reformers regard the architecture and goods of medieval or preindustrial times as honest in material and construction and suitable for their purpose, unlike contemporary ones.

■ *France*. Eugène-Emmanuel Viollet-le-Duc is the primary theorist and designer of Gothic Revival in France.

IMPORTANT TREATISES

England

■ *An Attempt to Discriminate the Styles of English Architecture*, 1817; Thomas Rickman.

■ *Contrasts; or a Parallel between the Noble Edifices of the Fourteenth and Fifteenth Centuries and Similar Buildings of the Present Day*, 1836; Augustus Welby Northmore Pugin.

■ *Gothic Architecture, Improved by Rules and Proportions, in Many Grand Designs of Columns, Doors, Windows, Chimney-pieces, Arcades, Colonnades, Porticos, Umbrellos, Temples, and Pavilions etc.*, 1742; Batty Langley.

■ *Gothic Forms*, 1867; Bruce Talbert.

■ *Gothic Furniture in the Style of the Fifteenth Century*, 1835; Augustus Welby Northmore Pugin.

■ *Hints on Household Taste*, 1868; Charles L. Eastlake.

■ *A History of the Gothic Revival*, 1872; Charles L. Eastlake.

■ *Specimens of Gothic Architecture*, 1821; Augustus Charles Pugin.

■ *Stones of Venice*, 1851–1853; John Ruskin.

■ *The Seven Lamps of Architecture*, 1849; John Ruskin.

■ *The True Principles of Pointed or Christian Architecture*, 1841; Augustus Welby Northmore Pugin.

France

■ *Dictionnaire raisonné de l'architecture française*, 1854–1868; Eugène-Emmanuel Viollet-le-Duc.

United States

■ *The Architecture of Country Houses; Including Designs for Cottages, Farm Houses, and Villas . . .*, 1850; Andrew Jackson Downing.

■ *Cottage Residences*, 1842; Andrew Jackson Downing.

■ *Rural Residences*, 1837; Alexander Jackson Davis.

An architect and restorer, his ideas grow out of his restorations and re-creations of numerous medieval buildings. He favors Gothic over classicism as a universal architectural language. With the hope of developing a style for his own time, he strives to design in a medieval manner instead of copying and applying Gothic details.

■ *United States*. In the United States, two men advance Gothic Revival, Alexander Jackson Davis in practice and Andrew Jackson Downing, primarily through his writings. Both men downsize and simplify European architecture to create modest, practical Gothic Revival designs, often in wood, that they believe are more suitable for Americans.

DESIGN CHARACTERISTICS

Attributes, such as verticality, and details, such as pointed arches, from Gothic architecture characterize Gothic Revival buildings, interiors, furniture, and decorative arts in all periods. The expression varies, however, in accuracy and intention.

■ *Early or Picturesque Gothic Revival (mid-18th–mid-19th centuries)*. The expression is visually complex, asymmetrical, irregular, linear, thin, and light in scale. Compositions consist of architectural motifs applied to contemporary forms, whether a building, an interior, or furniture, and those forms and/or details may be used in ways that are different from the originals or unintended. Most examples reveal little concern for historical accuracy, although some show references to parts of or entire medieval sources or monuments. Gothic Revival in interiors and furniture often ties to the Rococo of the 18th century.

■ *Gothic Revival (1830s–1880s)*. In the 1830s, Gothic Revival sheds its lighthearted approach as accuracy in form and detail becomes the main design goal. Some designers strive to re-create Gothic buildings and furnishings, particularly churches that adapt to contemporary usage. Pugin himself advocates late-13th- and early-14th-century manifestations of Gothic. Asymmetry, irregularity, and details derived from Gothic architecture remain characteristic.

■ *High Victorian Gothic (1850s–1880s)*. In England and America and later Gothic Revival elsewhere, architecture becomes heavier in scale with plain or patterned surfaces and larger and bolder details. Structural polychrome, or color coming from materials, is characteristic. Historical accuracy is often evident, although designers draw from many medieval periods from their own and other countries. There is not a corresponding style in interiors, but many pieces of furniture have colorful inlay, tiles, or paintings.

■ *Gothic Revival and Design Reform (1850s–1920s)*. After becoming associated with various design reform movements in the mid-19th century, Gothic Revival architecture and furnishings show the application of principles that

designers believe are evident in medieval artifacts, such as honest construction and ornament derived from structure. A furniture variation known as Reformed Gothic is created. Less overtly Gothic Revival, it nevertheless uses medieval details and simplified forms and is often polychromatic.

▲ **6-2.** Iron railings and cast-iron hinges, mid- to late-19th century; Augustus W. N. Pugin.

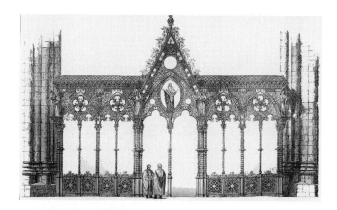

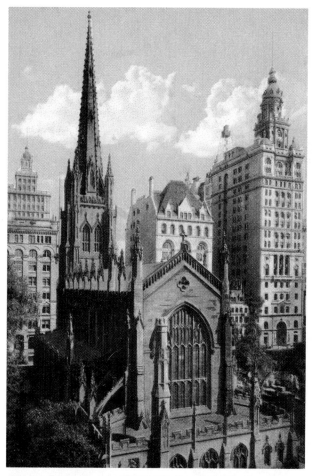

▲ **6-3.** Cast-iron church screen and column; published in *The Illustrated London News*, July–December 1862; by Sir George Gilbert Scott, manufactured by Skidmore's Art-Manufacturers' Company.

■ *Motifs*. Motifs derive from medieval precedents. They include pointed arches, pinnacles, battlements, crockets, stained glass, tracery, rose windows, trefoils, quatrefoils, cinquefoils, cluster columns, oak leaves, and heraldic devices (Fig. 6-2, 6-3, 6-4, 6-6, 6-11, 6-15, 6-20, 6-29, 6-33, 6-34, 6-42, 6-46). Early buildings may have Tudor or ogee arches, while later ones may combine round arches and details from other medieval styles.

ARCHITECTURE

Gothic forms and motifs adapted from medieval churches, houses, and castles characterize Gothic Revival architecture in all phases and all countries. The extent, intent, and accuracy of borrowings vary throughout its long history.

■ *Early or Picturesque Gothic Revival (mid-18th–mid-19th centuries)*. In the first decades of the 18th century, Gothic (or Gothick until the 1750s) "ruins" set in irregular and contrasting landscapes are the earliest evidence of Gothic Revival in England. By the 1750s, the style is part of the architect's repertoire, although used only occasionally. From that time through the early 19th century, buildings are asymmetrical assemblages of Gothic architectural

▲ **6-4.** Trinity Church, 1841–1846; New York City, New York; Richard Upjohn.

elements intended to convey a picturesque or Romantic image. The few Gothic Revival homes belong to wealthy antiquarians who wish to make a particular design statement about themselves or proclaim a religious or ancient heritage.

■ *Gothic Revival (1830s–1880s)*. In the early 19th century, scholarship and theory broaden the appeal and advance the development of Gothic Revival. Assisted by publications and a stylistic chronology of the Middle Ages, designers attempt to capture accuracy in Gothic design. This is particularly true in England where Pugin and the Ecclesiologists, a reform group, attempt to define the form and quality of religious architecture. They push for English medieval prototypes, such as the 14th-century local parish church, which becomes the model for numerous English and American churches. The rebuilding of the Palace of Westminster (Houses of Parliament) beginning in 1840 moves Gothic Revival from primarily an ecclesiastical and domestic style to one considered appropriate for government and commercial buildings. During this time, Pugin and others begin to promote Gothic Revival as a moral

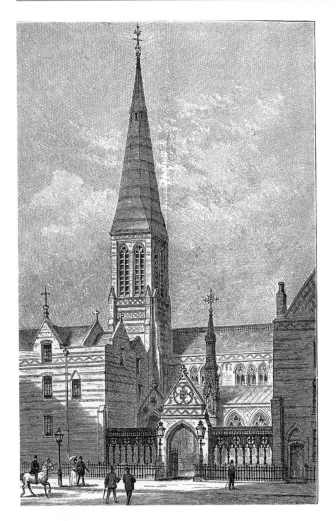

▲ **6-5.** All Saints Church, Margaret Street, 1849–1859; London, England; William Butterfield.

style and an antidote to industrialization and its negative effects on design and society.

Gothic Revival churches and public buildings always outnumber domestic examples because the style is difficult to adapt to residences. Some early residences derive from castles with battlements, towers, and asymmetrical massing. Others resemble medieval abbeys or simply have Gothic details and asymmetry. Only a few examples try to re-create a medieval house because Gothic was rarely used domestically, and medieval houses no longer suit contemporary lifestyles.

American innovations during this period are wooden versions of Gothic in country churches and modest villas or cottages. Unlike in England, wood is plentiful, so American designers become adept in adapting Gothic form and details to the material. Following the lead of Davis and Downing, American architects and builders freely interpret Gothic form and details in wood in numerous unpretentious houses, giving rise to the so-called Carpenter's Gothic. Gothic-style wooden ornament becomes easier to make following the invention of the scroll saw. Promoters of the style believe that the vertical board and batten expresses honest construction advocated by Pugin.

■ *High Victorian Gothic (1850s–1880s).* By the second half of the century, Gothic Revival enters a new phase in which bold geometric forms, simpler outlines, structural polychrome, and elements from Italian, French, German, or other medieval styles characterize structures. Architects now use Gothic on a wider range of building types, including commercial and civic. They may directly quote parts of earlier buildings or use them as a point of departure for their own designs. French architects, unlike the English, begin to use cast iron in Gothic Revival and restorations of earlier buildings. Roofs of iron to prevent fires are the most common use for the material, but cast and flat iron structural and decorative components are used increasingly.

Public Buildings

■ *Types.* Early Gothic Revival buildings are mostly churches (Fig. 6-4, 6-5, 6-13, 6-16). By the mid-19th century, Gothic becomes an accepted style for museums, national monuments, university buildings, town halls, hotels, train stations, and commercial buildings (Fig. 6-6, 6-8, 6-9, 6-10, 6-11, 6-12, 6-14, 6-15). In North America, Gothic Revival, rare for government and commercial buildings, is commonly adopted for churches, prisons, and cemeteries.

■ *Site Orientation.* Rural churches in England strive for what theorists declare is the ideal church, one modeled after the 14th-century parish church building that is surrounded by a churchyard with a graveyard nearby. American rural churches are similar. Urban examples in all countries sit on streets with little or no surrounding yards.

■ *Floor Plans.* Plans vary with structure. Most churches have the basilica or Latin cross plans, which adapt well for worship and liturgical functions. For other building types,

IMPORTANT BUILDINGS AND INTERIORS

- **Baton Rouge, Louisiana:**
 - Old State Capitol, 1847–1849, 1880–1882; James H. Dakin.
- **Berlin, Germany:**
 - Friedrich Werdersche Kirche, 1824; Karl Friedrich Schinkel.
- **Cardiff, Wales:**
 - Cardiff Castle, 1868–1881; William Burges.
 - Castell Coch, 1875–1881; William Burges.
- **Cheadle, Staffordshire, England:**
 - S. Giles Church, 1839–1844; Augustus Welby Northmore Pugin.
- **Chicago, Illinois:**
 - Old Water Tower, 1867–1869; William W. Boyington.
- **Devon, England:**
 - Knightshayes Court, 1869–1871; William Burges.
- **Kennybunk, Maine:**
 - Wedding Cake House, 1820–1845.
- **Lexington, Virginia:**
 - Virginia Military Institute, Barracks, 1848; Alexander Jackson Davis.
- **London, England:**
 - Albert Memorial, Kensington Gardens, 1863–1872; Sir George Gilbert Scott.
 - All Saints Church, Margaret Street, 1849–1859; William Butterfield.
 - Natural History Museum, 1868–1880; Alfred Waterhouse.
 - New Palace of Westminster (Houses of Parliament), 1835–1865; Sir Charles Barry and Augustus Welby Northmore Pugin.
 - Midland Grand Hotel at S. Pancras Station, 1868–1874; Sir George Gilbert Scott.
 - Royal Courts of Justice (Law Courts), 1874–1882; George Edmund Street.
- **Manchester, England:**
 - Town Hall, 1868–1877; Alfred Waterhouse.
- **Montreal, Quebec, Canada:**
 - Christ Church Cathedral, 1857–1860; Frank Wills.
 - Basilique Notre-Dame, 1823–1843, 1872–1880; James O'Donnell with interior renovations later by Victor Bourgeau.

- **Newport, Rhode Island:**
 - Kingscote, 1841; Richard Upjohn.
- **New York City, New York:**
 - Grace Church, 1843–1846; James Renwick, Jr.
 - National Academy of Design, 1862–1865; P. B. Wight.
 - S. Patrick's Cathedral, 1853–1888; James Renwick, Jr.
 - Trinity Church, 1841–1846; Richard Upjohn.
- **Norfolk, England:**
 - Costessey Hall, 1825; John Chessel Buckler.
- **Ottawa, Ontario, Canada:**
 - Dominion Parliament Buildings, 1861–1867; Thomas Fuller.
- **Oxford, England:**
 - University Museum, 1854–1860; Benjamin Woodward.
- **Paris, France:**
 - Cathedral of Notre Dame, 1163–1250, 1845–1856 (restoration); Eugène-Emmanuel Viollet-le-Duc.
 - S. Chapelle, 1840 (restoration); Eugène-Emmanuel Viollet-le-Duc.
 - S. Eugène-Ste-Cécile, 1854–1855; Louis-Auguste Boileau.
- **Richmond, Virginia:**
 - Old City Hall, 1887–1894; Elijah E. Myers.
- **San Francisco, California:**
 - Howard Street Methodist Church; 1881.
- **Savannah, Georgia:**
 - Green-Meldrin House, 1853; John S. Norris.
- **Sydney, Australia:**
 - Houses of Parliament, late 19th century.
- **Tarrytown, New York:**
 - Lyndhurst, 1838–1865; Alexander Jackson Davis.
- **Toronto, Ontario, Canada:**
 - Holland House, 1831–1833; John Howard.
- **Vienna, Austria:**
 - Neuss Rathaus (City Hall), 1872–1873; Friedrich von Schmidt.
 - Votivkirche, 1879; H. von Ferstel.

DESIGN SPOTLIGHT

Architecture: New Palace of Westminster (Houses of Parliament), 1835-1865; London, England; Sir Charles Barry and Augustus W. N. Pugin. This complex of buildings is the first major public architectural statement in Gothic Revival. It unites the Gothic style with British history and heritage and establishes it as a proper style for government buildings in England and abroad. In October 1834, fire almost completely destroys the original complex, which is composed of buildings dating from the late 11th century. The competition held for the design of the new complex stipulates Gothic or Elizabethan as the style to harmonize with nearby Westminster Abbey. Charles Barry's design featuring Perpendicular-style details and an overall grand scale wins the competition. The building's river side is symmetrical with buttresses, tracery, pointed arches, and pinnacles for details. Short towers or pavilions mark the ends and middle of the composition. Surviving buildings that include Westminster Hall and the Jewel Tower with buttresses and pinnacles dictate the asymmetrical, tall towers. A. W. N. Pugin assists Barry with the design and completes the working drawings for exterior details. He is completely responsible for the interiors, which are designed after the fashion of a medieval residence. Pugin designs all parts to create a coherent whole. The interiors are far more influential than is the building itself.

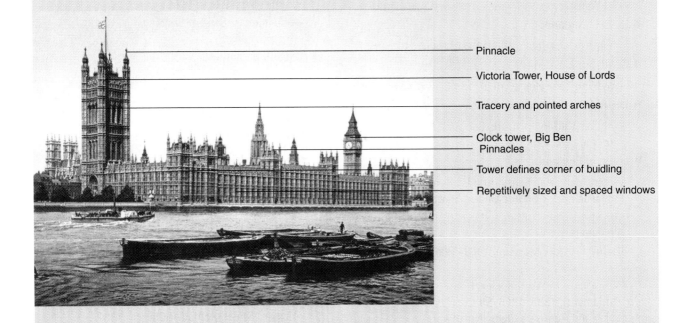

Pinnacle

Victoria Tower, House of Lords

Tracery and pointed arches

Clock tower, Big Ben
Pinnacles

Tower defines corner of buidling

Repetitively sized and spaced windows

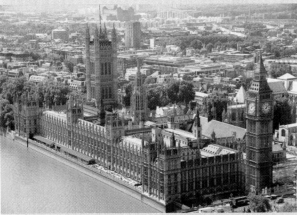

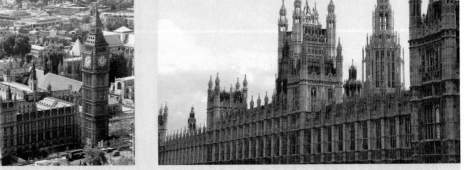

▲ **6-6.** New Palace of Westminster, London.

◀ **6-6.** *(continued)*

windows, and other elements may contrast in color with walls. After 1850, Gothic Revival buildings, particularly in England and North America, feature structural polychrome in which stone, terra-cotta, brick, and other materials form stripes, horizontal or oblique bands, diapers, or other patterns (Fig. 6-5, 6-8). Details that contrast with walls contribute to the colorful appearance. Red, black, white, and yellow are common colors. Also during this period, architects begin to incorporate cast-iron and glass interiors, which are often concealed behind masonry exteriors (Fig. 6-11, 6-15). French architects are more likely to use cast iron than are the English.

■ *Façades.* There is great variety in design throughout the period (Fig. 6-4, 6-5, 6-6, 6-8, 6-9, 6-11, 6-14, 6-15, 6-16). Medieval forms and/or details are typical in all expressions. Earlier examples seek to evoke a Gothic image by using Gothic details, lightness in scale, and asymmetry. During the mid-19th century, greater accuracy is desired. Forms and details may come from Early Gothic, Decorated Gothic, Perpendicular Gothic, Romanesque, Norman, or Tudor. High Victorian Gothic examples are more colorful, bolder, and more forceful, even brutal at times.

Pointed arches, battlements, pinnacles, and one or more towers characterize Gothic Revival structures other than churches (Fig. 6-6, 6-8, 6-11, 6-15). Round or square towers with pinnacles or dormers may highlight corners or centers of buildings. Ground floors may have an arcade of pointed arches. Pointed-arch lancet windows form rows on

Gothic Revival enables architects to design functional, asymmetrical plans (Fig. 6-7). There are few, if any, attempts to re-create medieval plans.

■ *Materials.* Designers use many building materials from stone to brick to cast iron. Structures before 1850 are monochromatic, although stone detailing around doors,

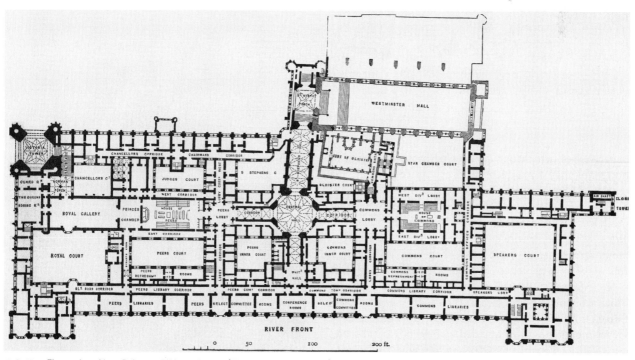

▲ **6-7.** Floor plan, New Palace of Westminster (Houses of Parliament), 1835–1865; London, England; Sir Charles Barry and Augustus W. N. Pugin.

▲ **6-8.** National Academy of Design, 1862–1865; New York City, New York; P. B. Wight.

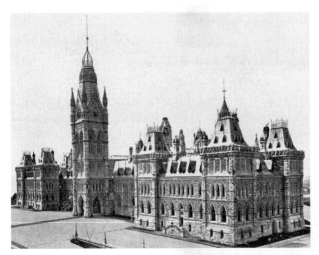

▲ **6-9.** Dominion Parliament Buildings, 1861–1867; Ottawa, Ontario, Canada; Thomas Fuller.

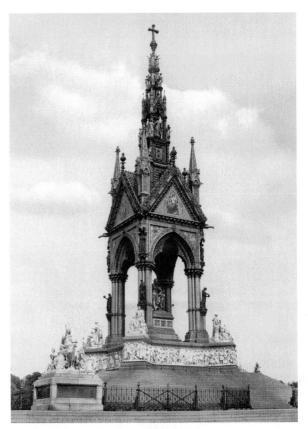

▲ **6-10.** Albert Memorial, Kensington Gardens, 1863–1872; London, England; Sir George Gilbert Scott.

▲ **6-11.** Midland Grand Hotel and S. Pancras Station, 1868–1874; London, England; Sir George Gilbert Scott.

upper stories, which may be divided by stringcourses or hood moldings. Portions of walls may project, creating a regular rhythm across the façade.

■ *Church Façades.* Some church façades resemble earlier precedents with three doorways marking the nave and aisles, central rose window, and two towers with battlements and pinnacles (Fig. 6-13). Others have a single, central doorway with a tower or steeple behind (Fig. 6-5, 6-16). A tower and steeple define the crossing or a wing in other examples. Some façades are triangular in shape, formed from the gable end of the building. Some French or German churches have rounded arches and corbel tables derived from Romanesque. Horizontal rows of niches with pointed arches may stretch across upper areas. Buttresses and flying buttresses may divide fronts and sides into

▲ 6-11. *(continued)*

▲ 6-13. Basilique Notre-Dame, 1823–1843, 1872–1880; Montreal, Quebec, Canada; James O'Donnell with interior renovations later by Victor Bourgeau.

▲ 6-12. Town Hall, 1867–1877; Manchester, England; Alfred Waterhouse.

bays. Gothic Revival churches usually do not have the educational sculpture and stained glass programs of the prototypes. Following Pugin's advice, elevations usually develop from the plan to provide clarity. Consequently, significant parts, such as the choir and presbytery, are denoted on the façade. High Victorian Gothic façades are bold, muscular, and colorful. Lacking the complex silhouettes and lacey appearance of earlier examples, they reveal fewer details and more patterns.

■ *Windows.* Windows, which are large and numerous, may be bay, oriel, lancet, rose, or pointed arches (Fig. 6-6, 6-8, 6-14, 6-15). They may have pinnacles or hood moldings. Tracery and stained or painted glass are common. In High Victorian Gothic, the size and number of windows sometimes are reduced, giving more wall space.

Window tracery varies from simple to complex and derives its appearance from earlier Gothic styles. Tracery that multiplies as it approaches the top of the window signals the English Perpendicular (c. 1330–1530) style, while geometric or curvilinear tracery comes from English Decorated style (c. 1240–1330). Lancet windows denote Early

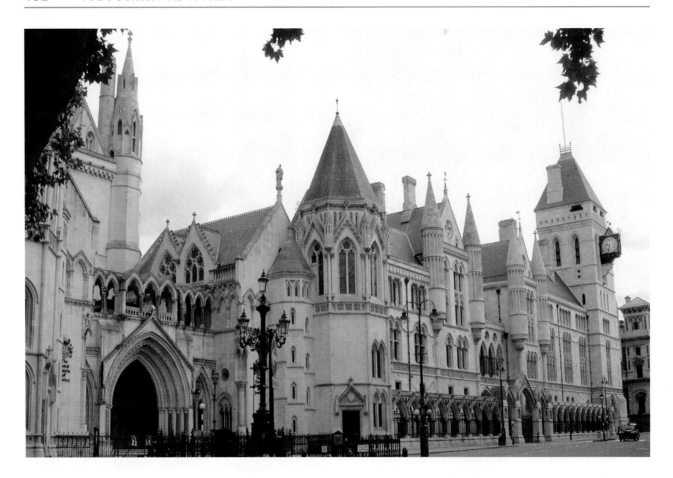

▲ **6-14.** Royal Courts of Justice (Law Courts), 1874–1882; London, England; George Edmund Street.

English Gothic (before 1240). Tracery in flame-like forms derives from the French Flamboyant style (14th–16th centuries).

■ *Doors.* Doorways may be recessed as in Gothic churches, have Gothic-style surrounds with pointed arches, or have Gothic-style porches (Fig. 6-11). Doors are wood and plain or carved with Gothic details and elaborate strap-metal hinges and locks (Fig. 6-2).

■ *Roofs.* Steeply pitched gable roofs with slate tiles are definitive (Fig. 6-9, 6-11, 6-12). Some roofs have battlements

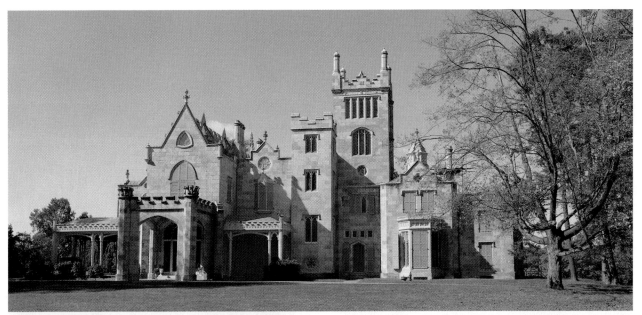

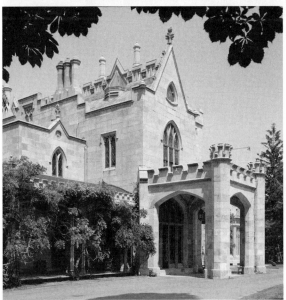

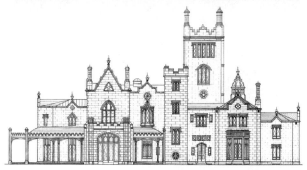

◄**6-20.** Lyndhurst, 1838–1865; Tarrytown, New York; Alexander Jackson Davis.

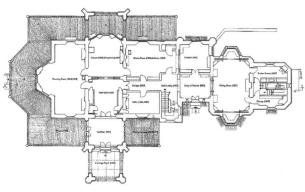

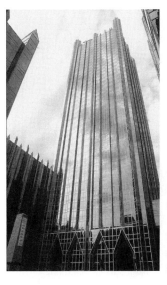

◄**6-22.** Later Interpretation: Pittsburgh Plate Glass Building, 1979–1984; Pittsburgh, Pennsylvania; Philip Johnson and John Burgee. Modern Historicism.

▲ **6-21.** Floor plan, Lyndhurst, 1838–1865; Tarrytown, New York.

INTERIORS

Gothic Revival interiors feature Gothic elements and motifs with verticality, asymmetry, pointed arches, and deep moldings defining the style. Gothic may appear architecturally as in fan vaulting or decoratively as in wallpaper. Furniture and decorative objects display Gothic details. Gothic Revival interiors rarely emulate the originals, which are little understood. So, only a few are vaulted or of stone

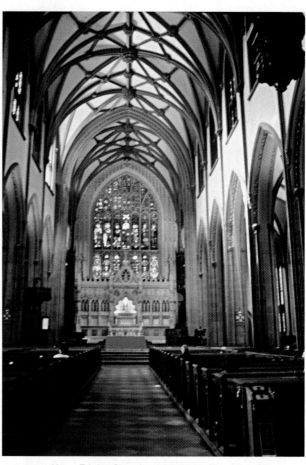

▲ **6-24.** Nave, Trinity Church, 1839–1846; New York City, New York; Richard Upjohn.

▲ **6-23.** Wall details, S. Giles Church, 1839–1844; Cheadle, Staffordshire, England; Augustus W. N. Pugin.

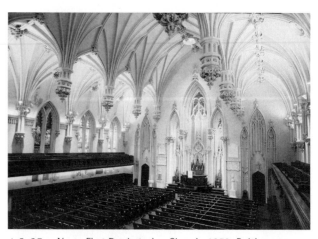

▲ **6-25.** Nave, First Presbyterian Church, 1859; Baltimore, Maryland; Nathan G. Starkweather.

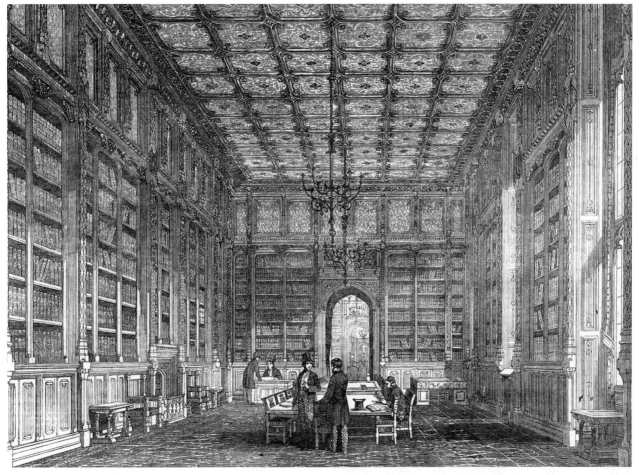

▲ **6-26.** Library, House of Lords, Houses of Parliament, 1835–1865; London, England; Augustus W. N. Pugin.

in the medieval manner. Unlike medieval examples, contemporary rooms rely on fixed decorative details and furniture instead of movable hangings and furnishings. In homes that are not completely Gothic Revival, the style is considered appropriate for certain interiors such as libraries.

■ *Early or Picturesque Gothic Revival (mid-18th–mid-19th centuries).* In the 18th century, Gothic motifs are arranged

▲ **6-27.** Chancel, S. John's Church, 1869; Torquay, England; G. E. Street.

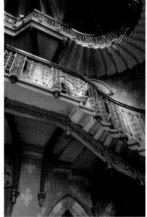

▲ **6-28.** Stair hall, Midlands Hotel, S. Pancras Station, 1868–1874; London, England; Sir George Gilbert Scott.

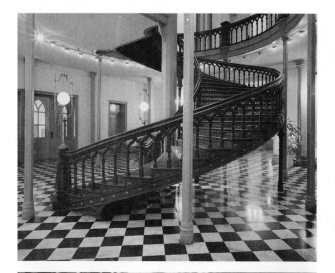

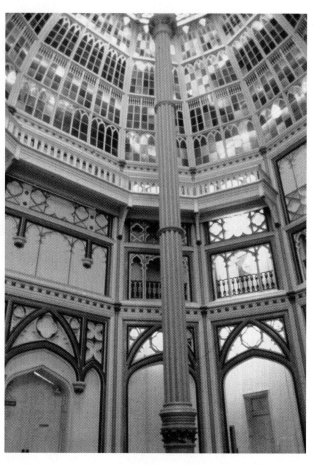

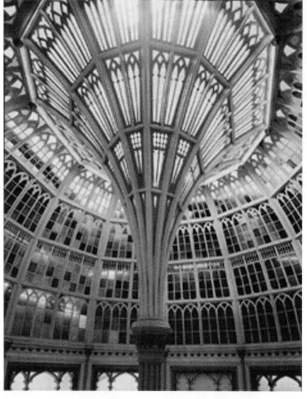

◀ **6-29.** Stair hall, Old State Capitol, 1847–1849, 1880–1882; Baton Rouge, Louisiana; James H. Dakin.

in a classical fashion or combined with Rococo in a lighthearted or fanciful manner. Some interiors have details derived from medieval prototypes. In the Regency period, Gothic Revival is one of several stylistic choices for interiors along with Chinese, Grecian, Roman, or Egyptian. Picturesque Gothic continues throughout the century.

■ *Gothic Revival (1830s–1880s).* A concern for accuracy in interiors arises with the same concern in architecture. Forms and details often come from one of the styles of medieval Gothic such as the French Flamboyant style (14th–16th centuries), Early English Gothic (before 1240), English Perpendicular (c. 1330–1530), or English Decorated style

(c. 1240–1330). Following Pugin's examples, Gothic Revival rooms become polychromatic and richly detailed. Like exteriors, interiors in High Victorian Gothic buildings feature structural polychrome and numerous patterns. Details are bolder than previously.

■ *Gothic Revival and Design Reform (1850s–1920s).* At midcentury, the Reformed Gothic interior appears. Like architecture, it may be more accurate, borrowing 14th- or 15th-century elements. However, these interiors often have more discrete references to medieval sources as designers move away from literal Gothic details, striving for a fresh interpretation. Decoration is simpler with less ornament.

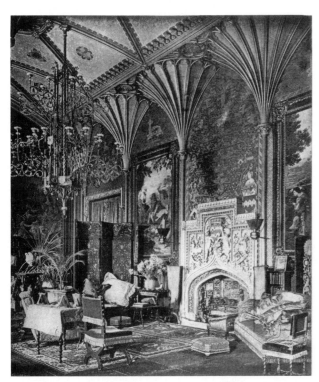

▲ **6-30.** Interior, Eastnor Castle, c. 1840s; Herefordshire, England; interiors by Augustus W. N. Pugin.

▲ **6-31.** Main entry hall, Kingscote, 1841; Newport, Rhode Island; Richard Upjohn.

Public Buildings

■ *Types.* New spaces include rooms with specific functions related to the building's use, such as art galleries, conference rooms, offices, and public spaces in hotels. Entry and stair halls frequently convey the Gothic image (Fig. 6-28, 6-29) with more architectural expressions.

■ *Relationships.* Interiors maintain a strong relationship to exteriors because forms and motifs come from Gothic architecture.

▲ **6-32.** Interior; published in *The Architecture of Country Houses; Including Designs for Cottages, Farm Houses, and Villas . . .* , 1850; Andrew Jackson Downing.

▲ **6-33.** Entrance hall, Green-Meldrin House, 1853; Savannah, Georgia; John S. Norris.

■ *Color.* Crimson, blue, and gold dominate until the 19th century. Highly saturated primary colors mixed with white, brown, green, or gold define the later Gothic Revival (Fig. 6-23). Contrasting colors, borders, and stenciling may articulate architectural details. Marbling and graining remain fashionable.

■ *Lighting.* Interiors are not lit with torches, candles, or fires as the originals were. Contemporary hanging lanterns, chandeliers, and wall sconces, which may be oil, gas, or electric, employ Gothic forms and motifs as do candlesticks (Fig. 6-39).

■ *Floors.* Floors may be wood or masonry. Tiles in rich colors and medieval patterns are common in public buildings (Fig. 6-37). Carpet with Gothic or medieval motifs in blue, crimson, green, yellow, or black may cover floors.

■ *Walls.* Walls receive a variety of treatments including paneling, painting, wallpaper, and structural polychrome (Fig. 6-23, 6-27, 6-28, 6-38). Wood paneling, often of oak, may cover the wall completely, partially, or serve as a dado.

Interior: Dining room, library, and section, Lyndhurst, 1838–1865; Tarrytown, New York; Alexander Jackson Davis. Architect Davis designs the original house or villa, called Knoll, in 1838 for William Paulding and enlarges it in 1864 for George Merritt who renames it Lyndhurst. It is a magnificent example of Gothic Revival. Influenced by English sources, such as Pugin, characteristics include asymmetry, battlements, pointed arches, pinnacles, quatrefoils, rose windows, and stained glass. The veranda is an American detail.

The dining room is part of the 1864 addition. As previously, Davis designs the architecture, interiors, and some of the furniture to integrate the interior with the exterior design. The interiors reflect the more opulent, robust yet sober Gothic of the post–Civil War period. Pointed arches, crockets, tracery, and cluster columns, typical of Gothic and Gothic Revival, abound throughout the space and are reminiscent of the exterior. The heavy ceiling beams terminate in corbels and cluster columns flanking the doorways and fireplace. The red wall color is common for Gothic and in dining rooms. The doorways have Tudor arches and panels with tracery. Davis designs the chairs, which are heavier and less fanciful than his earlier chairs.

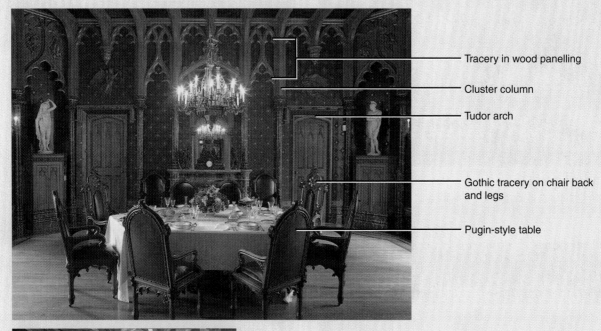

Tracery in wood panelling

Cluster column

Tudor arch

Gothic tracery on chair back and legs

Pugin-style table

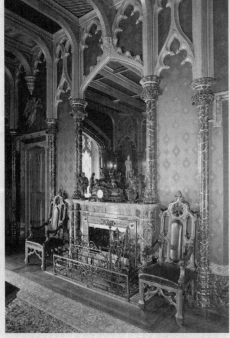

▲ 6–34. Dining room, library, and section, Lyndhurst; Tarrytown, New York.

▲ **6-34.** *(continued)*

Panels are stained dark to look old and may be carved with pointed arches, tracery, quatrefoils, linenfold, oak leaves, heraldic devices, or other medieval motifs. Centers of panels may have painted decorations or wallpaper. Cluster or compound columns may divide walls and rise to fan vaulting. Columns contrast in color to walls. Pugin sets the fashion for layers or rows of patterns painted, stenciled, or in wallpaper in rich colors. Some plaster walls are painted and scored to resemble stone.

Church walls often resemble originals with tripartite compositions of pointed arches carried by compound columns, a triforium above, and stained glass clerestory windows (Fig. 6-25, 6-27). The nave may terminate in a semicircular apse with stained glass windows or, in Protestant churches, an altar and pulpit.

Like exteriors, High Victorian Gothic interiors are very colorful with structural and applied colors in layers or bands. Reformed Gothic rooms may have simple wallpaper or painted stylized patterns. Paneling is dark and reveals its construction. Hangings, considered more medieval, are preferred.

■ *Chimneypieces.* Some rooms have large or hooded chimneypieces in the medieval manner. Smaller chimneypieces feature Gothic details such as pinnacles, pointed or Tudor arches, quatrefoils, or rosettes. Some American rooms have rectangular mantels with a flat shelf. The cast-iron grate inside often has a Tudor arch.

■ *Window Treatments.* Window treatments are usually cloth panels hanging from rings and rods. A cornice with crockets or cusps sometimes hides rods. Pelmets or valances in pointed or other Gothic shapes may cover the tops.

■ *Doors.* Doors are wooden and may have carved or painted Gothic motifs. Surrounds may be elaborate with pointed or Tudor arches carried by slender cluster columns and surmounted by pinnacles. Others have hood moldings or battlements above them.

■ *Ceilings.* Two types of ceilings are found: timber ceilings in the medieval manner or flat ceilings with beams or

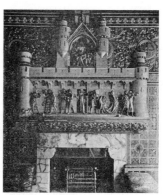

◀**6-36.** Chimneypiece, William Burges House, late 19th century; Kensington, London, England; William Burges.

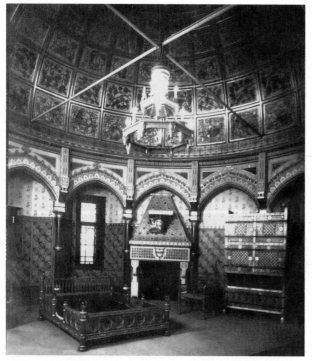

▲ **6-35.** Lady's bedroom, Castell Coch, 1875–1881; Cardiff, Wales; William Burges.

▲ **6-37.** Tile floors, 1860s–1880s; England; William Butterfield, Augustus W. N. Pugin, and Charles Eastlake.

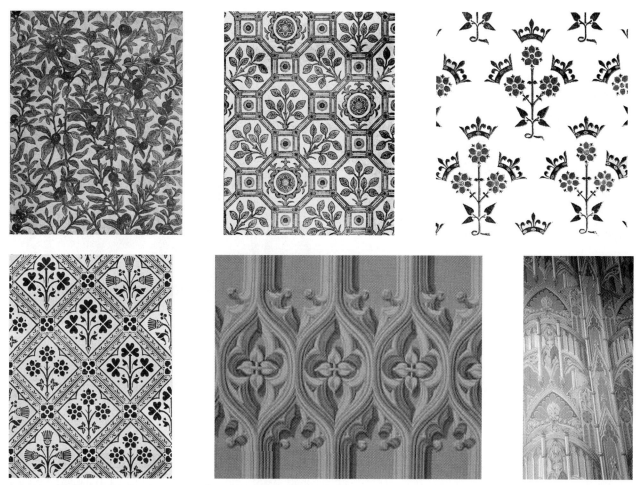

▲ **6–38.** Wallpapers: Various patterns and motifs related to the period, mid- to late 19th century; England and the United States; designed by Charles L. Eastlake, B. Binyon, Augustus W. N. Pugin, and others.

compartments (Fig. 6-24, 6-25, 6-26). Timber ceilings are more common in England than America. Timbers, bracket supports, beams, and the spaces between them may be carved or painted and stenciled in rich colors. In compartmented ceilings the point of junction typically has a pendant or rosette. Ceilings in important rooms may have wood or plaster fan vaulting. Spaces between the ribs in vaulted ceilings usually are painted blue with gold stars.

■ *Later Interpretations*. Large public spaces in ecclesiastical and collegiate buildings of the early 20th century are later interpretations of Gothic Revival. The revival influences fade as the 20th century progresses.

Private Buildings

■ *Types*. Most large English Gothic Revival houses have a great hall as in the Middle Ages. Decorated in a medieval manner, the space, which serves as a living room, is usually two stories with a large fireplace (Fig. 6-35). However, it is rarely used because it is difficult to heat. Like other houses, Gothic Revival ones may have libraries or studies, billiard rooms, conservatories, smoking rooms, art galleries, or chapels.

■ *Relationships*. Interiors relate to exteriors through Gothic architectural motifs. Rooms are often more colorful and richly detailed and/or patterned than exteriors are. Designers, such as Pugin, abhor patterns that look three-dimensional. They use two-dimensional, stylized patterns with no shading, which they believe are appropriate for flat surfaces such as walls or floors.

■ *Color*. As in public buildings, colors of Gothic Revival rooms are typical of their period. Details are white and gold in the 18th century. Crimson, blue, and gold is a common color scheme in the early 19th century. Colors increase in variety throughout the century but remain rich and glowing. Highly saturated red, blue, green, and yellow mixed with white, brown, or gold appear in patterns and articulate architectural details (Fig. 6-35). Marbling and graining are fashionable in Gothic Revival houses at midcentury and later.

■ *Lighting*. Oil, gas, and electric lamps and chandeliers, sconces, and candleholders feature Gothic motifs and designs. Fixtures resemble those used in public buildings but are domestic in scale (Fig. 6-39).

■ *Floors*. Floors may be wood or masonry. Tiles in rich colors and medieval patterns are common in England (Fig. 6-37). Those in residential buildings are similar in

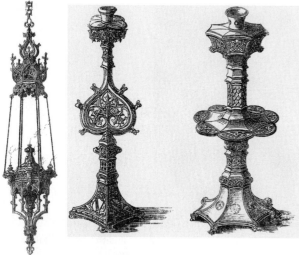

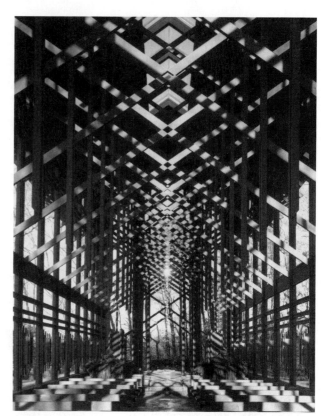

▲ **6-40.** Later Interpretation: Nave, Thorncrown Chapel, 1979–1980, 1989; Eureka Springs, Arkansas; E. Fay Jones. Environmental Modern.

▲ **6-39.** Lighting: Branch lights, chandelier, candlesticks, and wall sconces.

design to ones in commercial structures. Some floors have ingrain, Wilton, or Brussels carpet. Patterns may be Gothic motifs, small repeating motifs, or florals in blue, crimson, green, yellow, or black.

■ *Walls*. Wall treatments include paneling in dark colors, paint, wallpaper, and textile hangings (Fig. 6-30, 6-34,

6-36, 6-38). Some rooms incorporate antique architectural fragments such as paneling. Pugin popularizes dark paneling with centers of rich, glowingly colored patterns. Paneling may be carved with pointed arches, oak leaves, linenfold, or other similar motifs. William Burges continues Pugin's fashion for layers or rows of patterns painted or stenciled in rich colors but draws from more sources than Pugin does (Fig. 6-35, 6-36). Common wallpaper patterns include Gothic windows or pointed arches or castles in imaginary landscapes. Leather and textile hangings adorn walls in some rooms.

■ *Window Treatments*. Simple curtains hanging from rods are most common. They usually are tied or looped back during the day. Pelmets or valances with Gothic points replace earlier complicated types. Many windows have roller blinds painted with medieval scenes. In America, only important rooms have curtains.

■ *Doors*. Like paneling, doors are stained dark to look old. Some have Gothic carving or paintings. Heavy moldings often surround doors (Fig. 6-31, 6-33, 6-34).

■ *Ceilings*. As in public buildings, large two-storied interiors often have timber ceilings. Other ceilings are flat with applied beams and ribs to achieve a medieval effect (Fig. 6-30, 6-32, 6-35). A cornice with pointed arches or other Gothic details may separate the wall and ceiling.

■ *Later Interpretations*. Late-19th- and early-20th-century interiors continue to offer examples of Gothic Revival, but

they generally are limited to specific rooms in large estates, such as some in Newport, Rhode Island. During the late 20th century, architects experiment with contemporary interiors inspired by Gothic designs, such as the Thorncrown Chapel in Arkansas by Fay Jones (Fig. 6-40; see Chapter 34, "Environmental Modern").

FURNISHINGS AND DECORATIVE ARTS

As in architecture and interiors, most Gothic Revival furniture has Gothic and other medieval architectural details applied to contemporary furniture forms. There is less Gothic Revival furniture than architecture or, even, interiors. Few original Gothic pieces survive, so not much is known about medieval furniture, and there is little to copy. A great deal of Gothic Revival furniture is custom designed and made for specific rooms in Gothic Revival houses. Not all furniture in a Gothic Revival room is Gothic Revival. Many rooms have only one or two pieces of Gothic-style furniture.

Early Gothic-style furnishings often combine Gothic with Rococo, but Rococo characteristics disappear in the 19th century. During the 1830s, following his study of primary resources, Pugin tries to design in a true Gothic manner instead of merely using Gothic motifs. He strives for medieval forms and details, honest and visible construction, and truth to materials. Only a few furniture designers adopt his ideas; most continue using Gothic architectural details on contemporary forms and pieces

During the 1850s, reform designers begin to follow Pugin's lead and create a simpler, less obvious style derived from Gothic. Reform or Modern Gothic furniture, as illustrated in the designs of Bruce Talbert (Fig. 6-48), is rectangular with turned or chamfered legs. Incising and naturalistic carvings embellish the frame. Some furniture after 1850 has inlaid or applied color, tiles, or painting, reflecting the High Victorian preference for structural polychrome.

Public and Private Buildings

■ *Types*. There are no specific types for Gothic Revival because the style appears on all typical pieces of the time.
■ *Distinctive Features*. As in interiors, architectural details from Gothic and other medieval buildings and monuments, such as tracery or pointed arches, distinguish Gothic Revival furniture. Reformed or Modern Gothic relies more on form than architectural details. Its characteristics include simplicity, rectangular outline, chamfering, incised or shallow-relief carving, spindles, painted or inlaid geometric or naturalistic decoration or painted scenes with medieval themes (Fig. 6-41, 6-43, 6-46, 6-47).
■ *Relationships*. Architectural details convey the style's relationship to architecture. There is less built-in furniture than in the Middle Ages.

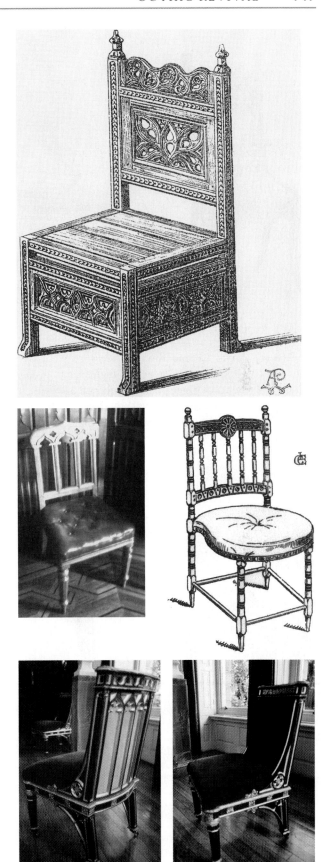

▲ **6-41.** Side chairs, c. 1840s–1870s; England and the United States.

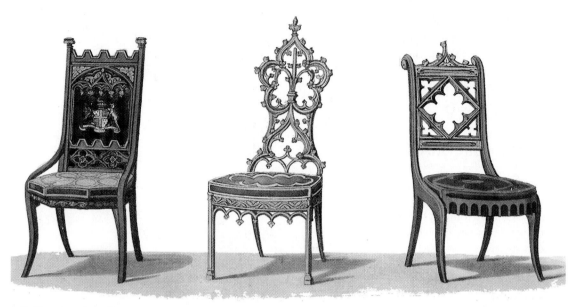

▲ **6-41.** *(continued)*

■ *Materials.* Much Gothic Revival furniture is of oak following the originals. Other woods include mahogany, walnut, and rosewood. Some pieces are ebonzied because it is thought ebonizing was a medieval practice. Painting, inlay, or gilding highlights or embellishs details or surfaces.

Pugin, Burges, and later reform designers reject veneers and marquetry, declaring them dishonest.

■ *Seating.* Backs of chairs and settees, with or without upholstery, often resemble rose windows, windows with tracery, or have pinnacles or quatrefoils (Fig. 6-41, 6-42,

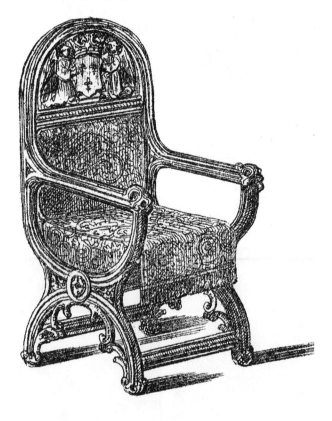

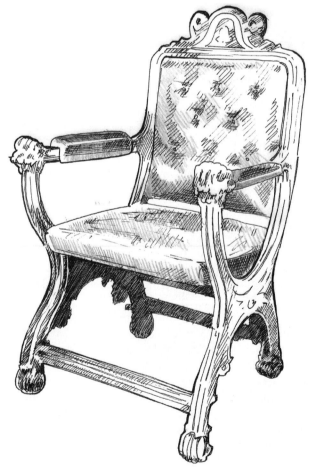

▲ **6-42.** Carver chair and armchairs, c. 1820s–1870s; England and the United States.

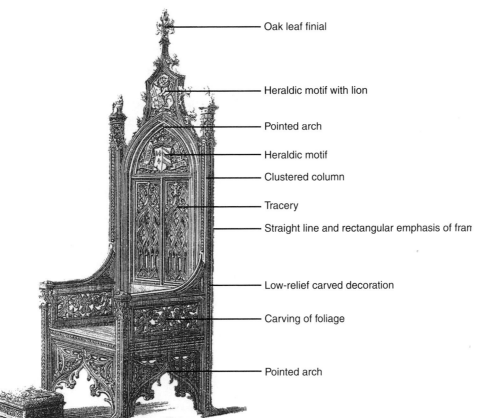

Oak leaf finial

Heraldic motif with lion

Pointed arch

Heraldic motif

Clustered column

Tracery

Straight line and rectangular emphasis of fram

Low-relief carved decoration

Carving of foliage

Pointed arch

▲ **6-43.** Drawing room sofa, c. 1868; England; Charles L. Eastlake.

▲ **6-42.** *(continued)*

▲ **6-44.** Bench and stools, c. 1820s–1870s; England; Augustus W. N. Pugin.

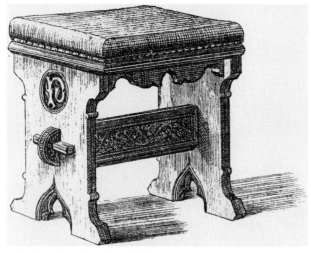

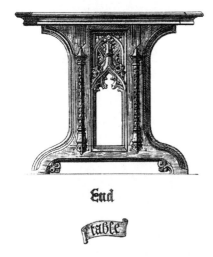

End

Table

Side

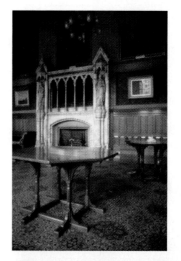

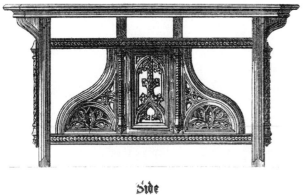

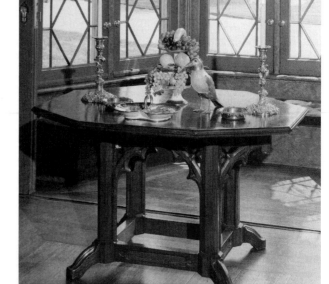

▲ 6-44. (continued)

▲ 6-45. Tables, c. 1870s; United States and England; Augustus W. N. Pugin and from Lyndhurst.

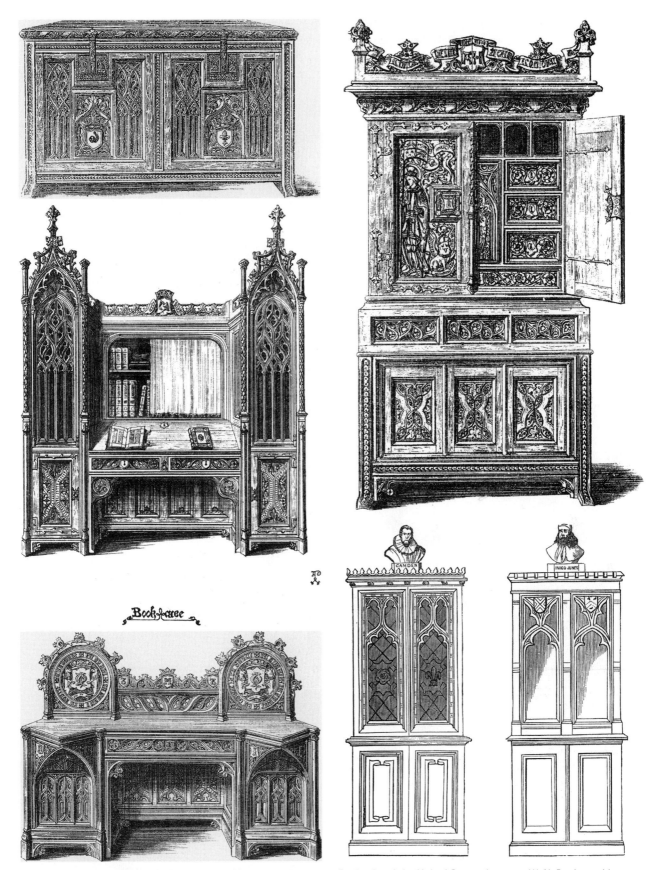

▲ **6–46.** Chest, bookcases, sideboard, and cabinet, c. 1850s–1870s; England and the United States; Augustus W. N. Pugin, and by Andrew Jackson Downing (lower right).

DESIGN SPOTLIGHT

Furniture: Washstand, c. 1880; London, England; William Burges. Burges designs this washstand for the guest bedroom in Tower House, his personal interpretation of a medieval house. The washstand of painted and gilded oak has a simple rectangular outline with Gothic details such as *quatrefoils* and long, strap hinges. The top, wash basin, and soap dishes are of alabaster. The inlaid silver fishes in the basin appear to swim when the basin is filled with water. The tap copies a bronze medieval *aquamanile*, a ewer and basin, used by priests for ceremonial handwashing, a detail derived from Burges's scholarship. Mirrors embellish the back and lower portions of the washstand, a very unmedieval feature also typical of Burges.

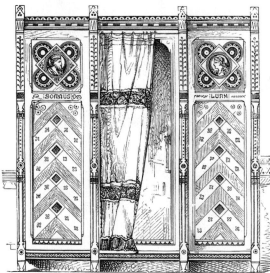

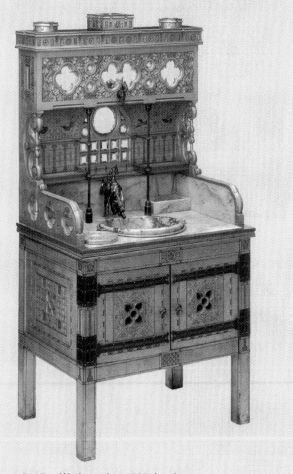

▲ **6-47.** Washstand, c. 1880; London.

▲ **6-48.** Bed and wardrobe, c. 1870s; England; Bruce Talbert.

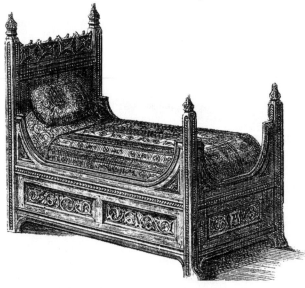

6-43, 6-44). Legs are cluster columns, turned, spirals, or balusters. The earlier 19th-century gondola chair continues with quatrefoils and pointed arches in its back and saber legs. Pugin introduces an X-form chair with curving Xs on the sides and a rectangular back (Fig. 6-42). Shallow carving highlights the wood frame. Reformed Gothic seating

▲ **6-49.** Beds, c. mid-19th century; England and the United States.

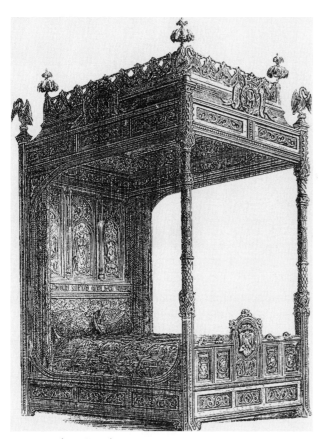

▲ **6-49.** (continued)

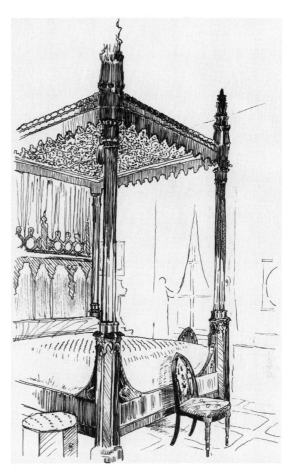

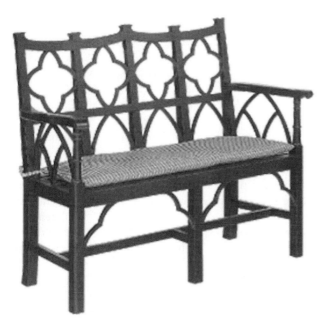

▲ **6-50.** Later Interpretation: Gothic bench, 2004; manufactured by Hickory Chair. Modern Historicism.

is rectangular with turned or chamfered legs. Incising and naturalistic carvings embellish the frame.

■ *Tables*. Tables vary in size and shape (Fig. 6-45) according to their function. Tops may be round, octagonal, or rectangular. Legs are usually cluster or compound columns, but baluster turned or spirals may be substituted. Pointed arches, crockets, or cusps may appear on aprons. Pugin designs trestle tables with crossing ogee arches as supports.

■ *Storage*. Forms are rectangular and decidedly vertical and vary in size and overall design. Pieces include chests, bookcases, cabinets, secretaries, wardrobes, and sideboards (Fig. 6-46, 6-47, 6-48). Façades often have tracery, linenfold, rose windows, and/or quatrefoils in panels. Tops may have steeply pitched gables or pinnacles. Cresting, when present, has oak leaves or pointed arches. Glazing bars in glass doors form pointed arches and/or tracery. Some pieces, such as those by Burges, have painted decorations with complex medieval iconographies (Fig. 6-47).

■ *Beds*. Bed types include four-posters, often with cluster-column posts, half-testers, or full canopies (or testers; Fig. 6-48, 6-49) and may have pointed arches or crockets. Headboards and footboards may have carved Gothic decoration.

■ *Upholstery*. Gothic Revival textiles have Gothic details in literal to loose interpretations in prints and wovens. Some prints mix traceried windows with flowers and foliage, while others have geometric medieval motifs in rich colors.

■ *Decorative Arts*. Gothic Revival pervades all decorative arts from ceramics to silver to clocks to fireplace furniture.

■ *Later Interpretations*. Gothic-style furniture is designed for Gothic Revival buildings into the 20th century. Historical, antiquarian, or other contexts continue to inspire Gothic Revival furnishings today (Fig. 6-50).

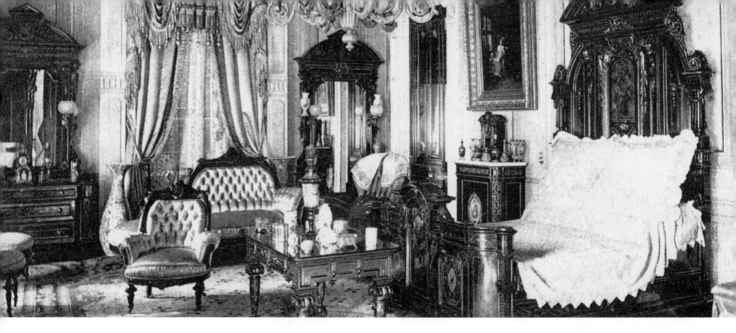

Italianate, Renaissance Revival

1830s–1870s

There is also far greater latitude and variety in the ornaments of the different modes of the Italian architecture . . . than in the purely classical style. It addresses itself more to the feelings and the senses, and less to the reason or judgment, than the Grecian style, and it is also capable of a variety of expression quite unknown to the architecture of the five orders. Hence, we think it far better suited to symbolize the variety of refined culture and accomplishment which belongs to modern civilization than almost any other style.

Andrew Jackson Downing,
The Architecture of Country Houses, 1850

HISTORICAL AND SOCIAL

■ *Italian Renaissance (14th–16th centuries).* Italianate and Renaissance Revival of the 19th century look back to the Renaissance, the rebirth of interest in classical antiquity that appears first in Italian literature, and then in culture and art in the 14th century. Arising from the study of ancient texts and structures, Greek and Roman forms and details reappear in architecture during the 1420s in Florence, Italy. Writers, architects, artists, and sculptors create the style for powerful, prosperous families in Florence that possess the wealth and leisure to commission fine homes and great works of art. Italian Renaissance compositions derive from but do not copy classical antiquity. Designers, seeking a classical approach in their work, adopt the elements, forms, and attributes of the art and architecture of ancient Greece and Rome. Classical elements and attributes are less evident in interiors and furniture because little is known about them. However, the Renaissance establishes the principle of unity in decoration and furnishings in interiors. Renaissance furniture exhibits architectural details and proportions instead of copying

Italy provides the models for Italianate and Renaissance Revival architecture, interiors, and furnishings beginning in the 1830s. Various titles describe this architectural style, including Italianate, Renaissance Revival, Palazzo Style, and Italian Villa Style. Public and private buildings rely on two Italian building types: formal, classical urban palaces; and picturesque, asymmetrical farmhouses or other vernacular structures. Renaissance Revival interiors and furniture are highly eclectic, mixing characteristics from various periods and countries in addition to Renaissance Italy. The style goes by many names, such as Henri IV, Louis XIII, François I, Tudor, and Free Renaissance, the latter in Great Britain.

ancient examples. Warfare, travel, and books spread Italian concepts to France, Spain, and England where they first appear as decorative elements grafted onto Gothic and indigenous forms. Each country gradually assimilates Renaissance design principles, but its interpretation of them is unique.

■ *Italianate or Italian Villa Style*. In the early 19th century, the Picturesque Movement inspires English designers to explore alternatives to classicism, Gothic, and other styles of the Middle Ages. Some turn to Italian vernacular farmhouses whose asymmetry, irregularity, and rambling forms are appealing and picturesque, yet Italian. By the 1830s, Italian Villa–style country houses and train stations become more common in England. In the 1840s, the style is given royal approval by Osbourne House (Fig. 7-12), a seaside home for Queen Victoria and Prince Albert enlarged in the style beginning in 1845.

Publications spread the Italianate style to North America, with the first examples appearing in the late 1830s. During the early 1840s, its use increases after writer and design critic Andrew Jackson Downing begins to advocate the style as a rural alternative to classical and Gothic. He publishes examples by Alexander Jackson Davis of what he calls Italian Villas, Italianate, Tuscan Villas, Lombard Style, or the Bracketed style in several of his books beginning with *Cottage Residences* (1842). Although he regards Italianate as somewhat inferior to Gothic, Downing nevertheless praises it for its interesting appearance, freedom in planning, and refined cultural ties.

■ *Renaissance Revival*. In the early 1830s, Sir Charles Barry initiates the Renaissance Revival (or Palazzo Style) in England by turning to Italian Renaissance urban palaces for inspiration. By the end of the decade, High Renaissance palaces define gentlemen's clubs, a few country houses, banks, and commercial buildings across England. The style spreads to North America during the 1840s where it soon is used mainly for public buildings and commercial structures.

CONCEPTS

The Italian Renaissance offers new inspiration for designers, who are weary of the Neoclassical columns and porticoes and are searching for a richer, more plastic alternative to the spare Greek Revival. High Renaissance Roman, Florentine, and Venetian urban palaces become models for the Italianate or Palazzo Style in England and Renaissance Revival in America, collectively known as Renaissance Revival. In contrast to earlier, architects are not primarily interested in the order, harmony, and proportions of Italian examples. Instead, they view the style as an expression of Italian refinement and culture as well as wealth and luxury. Renaissance Italy further appeals because it is nearer to their homelands and time than the remote, somewhat obscure, classical antiquity.

◄ **7-1.** Man and woman; published in the *London Illustrated News*, July–December 1862.

IMPORTANT TREATISES

■ *Édifices de la Rome moderne,* 1840–1857; Paul Letarouilly.

■ *An Encyclopedia of Cottage, Farm, and Villa Architecture and Furniture,* 1833; John Claudius Loudon.

■ *An Essay on the Present State of Architectural Study and the Revival of the Italian Style,* 1839; W. H. Leeds.

■ *History of the Modern Styles of Architecture,* 1862; James Fergusson.

■ *Rudimentary Treatise on the Principles of Design in Architecture,* 1850; Edward Lacy Garbett.

In contrast to the more formal and classical Renaissance Revival, the Italianate and the Italian Villa styles derive from vernacular Italian farmhouses, villas, and churches. Primarily residential, this picturesque style is an alternative to Gothic Revival, offering asymmetry and freedom in design without the religious or moral overtones of Gothic.

Renaissance Revival interiors and furniture draw upon Italian, French, German, English, and Northern European Renaissance and Mannerist forms and motifs. Like architecture, they express refinement and culture. Designers adapt and reuse forms and motifs, not to replicate past glories, but to create something new and uniquely of the period.

DESIGN CHARACTERISTICS

Although both are derived from Italian models, Italianate is asymmetrical and picturesque, whereas Renaissance Revival is classical, symmetrical, and refined. Both

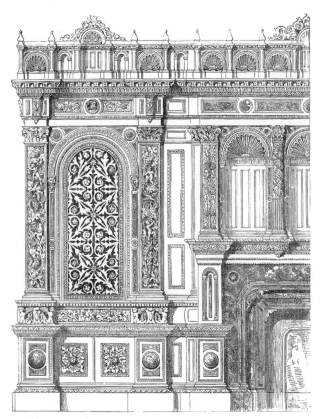

▲ **7-2.** Bookcase and chimneypiece detail, Great Exhibition, Crystal Palace, 1851; London, England; T. A. Macquoid.

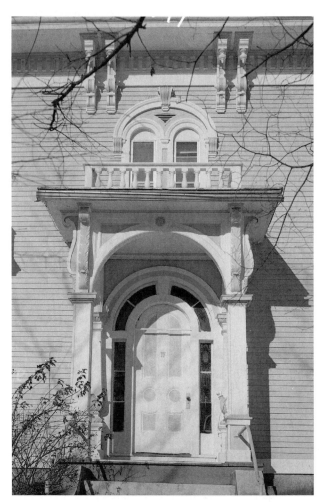

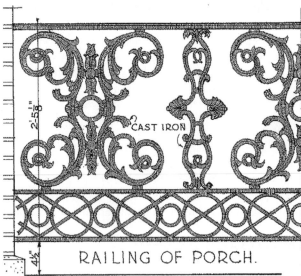

▲ **7-3.** Doorway, railing, and hardware, mid-19th century; United States.

have associations of Italian culture and sophistication in design.

■ *Italianate or Italian Villa Style*. Definitive characteristics for Italianate and the Italian Villa style include brackets beneath the low-pitched roof and individual and/or groups of round arched windows surmounted with pediments or hood moldings. Also common is a tower, usually asymmetrically placed. Other characteristics include asymmetrical massing, bay windows, balconies, porches or verandas, and round arched doorways. Interiors usually are revival styles, such as Rococo Revival and Renaissance Revival.

■ *Renaissance Revival*. Structures closely resemble Italian urban palaces, particularly those of the High Renaissance. The rectangular block-like forms usually have no columns or protruding porticoes, porches, or bay windows. Lower stories may be rusticated, and quoins are common. Windows have pediments, lintels, or aedicula. A prominent cornice defines the roofline. Interiors often have bold classical details and may be Renaissance Revival or other revival styles.

Renaissance Revival interiors exhibit classical or Mannerist architectural details, deep moldings, beamed or compartmented ceilings, rich and warm colors, numerous heavy textures, and fashionable patterns on walls, floors,

and window treatments. Similarly, ornament comes from Renaissance and Mannerist sources. Interiors are highly eclectic, drawing from many sources. Renaissance Revival furniture has massive proportions, a rectangular or jagged

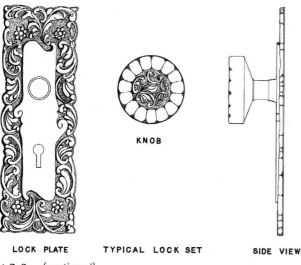

LOCK PLATE TYPICAL LOCK SET SIDE VIEW

KNOB

▲ **7-3.** *(continued)*

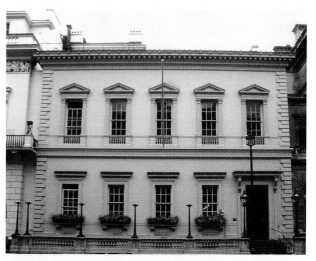

▲ **7-4.** Travellers Club, Pall Mall, 1829–1832; London, England; Sir Charles Barry. Renaissance Revival.

outline, architectural details, dark woods, rich carving, and contrasts of form and materials.

■ *Motifs.* Classical motifs in architecture and interiors include pediments, stringcourses, quoins, hood moldings, brackets, columns on porches or verandas, swags, acanthus, arabesques, and round arches (Fig. 7-3, 7-4, 7-5, 7-7, 7-11, 7-14, 7-15, 7-20, 7-22). Additional motifs (Fig. 7-2, 7-26) for interiors and furniture are fruit, game, animals, masks, strapwork, Greek key, sphinxes, lotus blossoms, palmettes, urns, roundels, cabochons, pendants, and applied bosses or lozenges.

ARCHITECTURE

As an outgrowth of a search for alternatives to classicism and Gothic, the Italianate or Italian Villa style originates in England with John Nash's Cronkhill in Shropshire (1802). Evoking images of Italian vernacular buildings, Cronkhill's picturesque, rambling forms highlight an asymmetry in which additions are added where needed with little thought to symmetry or overall design. The style soon defines other country houses as well as public buildings.

During the 1830s and 1840s, the Italianate Style spreads across England, and then to North America. The first Italian Villa in the United States is a residence designed in 1837 by John Notman for Rt. Rev. George Washington Doane in New Jersey. After A. J. Downing praises the style for country residences, American examples interpret the Italian Villa style in wood like the Greek Revival or Gothic Revival. There are a few urban examples in masonry. By the 1860s and 1870s, the robust, highly embellished masonry of Italian Villa expresses wealth for the newly arrived captains of industry. Italianate is enormously popular in the United States because of its adaptability. Variations are endless.

The first example of Renaissance Revival in England is the Travellers Club in London (1831; Fig. 7-4) which is modeled after the Palazzo Farnese (1517–1589) in Rome. Barry chooses it as a sophisticated and cultured alternative to Neoclassical and a more embellished image than the plain Greek Revival. Thus, he maintains a classical style but a different, novel appearance. A gathering place for those returning from Grand Tours, the choice of Italian Renaissance carries associations of Italy, culture, wealth, and leisure, highly appropriate for a men's club. Barry continues to design in the style as do others for banks and commercial buildings. As the 19th century progresses and tastes change, architects turn to the more embellished and three-dimensional Northern Italian and Venetian examples, such as the Library of Saint Mark's (begun 1537; Venice). Publications spread the style.

As in England, the Renaissance Revival in North America recalls Italian Renaissance palaces and defines gentlemen's clubs, and government and commercial buildings. In the 1830s, the United States introduces Renaissance Revival cast-iron façades modeled on Venetian palaces for commercial buildings and department stores. Units are individually cast and bolted together to form entire front façades. Inside, a structural cast-iron skeleton eliminates the need for thick masonry walls and allows larger windows. (See Chapter 1, "Industrial Revolution.") This commercial image expresses Italian culture, wealth, taste, and a regard for the past yet a modern, progressive attitude. The Venetian style rarely affects houses until the 1890s.

Public Buildings

■ *Types.* First used for gentlemen's clubs (Fig. 7-4, 7-5), Renaissance Revival delineates many building types, including offices, department stores, warehouses, mills, factories, post offices, custom houses, city halls, train

DESIGN SPOTLIGHT

Architecture: Reform Club and door detail, Pall Mall, 1837–1841; London, England; Sir Charles Barry. Palazzo style or Renaissance Revival. Inspired by the High Renaissance Palazzo Farnese (begun 1517; redesigned 1534, 1541, 1546; completed 1589) in Rome, the Reform Club is a rectangular block with three stories separated by bold stringcourses. Quoins highlight the building's corners. Smooth stone walls form backgrounds for the crisp details. Lower-story windows have lintels, while those on the second story have aedicula to identify the piano nobile or main floor. Attic windows are small rectangles framed with astragal moldings. A bold frieze and cornice cap the composition. The symmetrical floor plan centers on a central two-story saloon instead of the typical Italian cortile. This building and the Travellers Club are the first buildings of the Renaissance Revival in England and inspire similar examples in other countries.

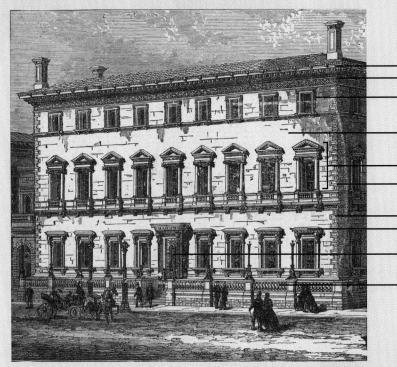

Bold cornice
Frieze
Astragal molding frames window

Plain smooth walls

Aedicula
Second level defined as a piano nobile (main floor)
Quoins at building corners
Lintels

Entry door framed with classical detailing

Classical balustrade

▲ **7-5.** Reform Club and door detail, Pall Mall; London.

IMPORTANT BUILDINGS AND INTERIORS

- **Baden, Ontario, Canada:**
 - —Castle Kilbride, 1877. Italianate.
- **Bristol, England:**
 - —Bristol Branch, Bank of England, 1844–1846; C. R. Cockerell. Renaissance Revival.
- **Buckinghamshire, England:**
 - —Cliveden House, 1850; Sir Charles Barry. Renaissance Revival.
- **Dresden, Germany:**
 - —Art Gallery, 1847–1854; Gottfried Semper.
- **Dublin, Ireland:**
 - —Trinity College Museum, 1852–1857; Thomas Deane and Benjamin Woodward. Renaissance Revival.
- **Isle of Wight, England:**
 - —Osborne House, 1845–1851; Thomas Cubitt with Prince Albert. Italianate.
- **Janesville, Wisconsin:**
 - —Lincoln-Tallman House, 1855–1857.
- **Jim Thorpe, Pennsylvania:**
 - —Asa Packer Mansion, 1861. Italianate.
- **London, England:**
 - —Carlton Club, 1854–1856; Sidney Smirk. Renaissance Revival.
 - —Foreign Office, 1861–1873; Sir George Gilbert Scott. Renaissance Revival.
 - —King's Cross Station, 1850–1852; Lewis Cubitt.
 - —Reform Club, Pall Mall, 1837–1841; Sir Charles Barry. Palazzo or Renaissance Revival.
 - —Royal Albert Hall, c. 1871. Renaissance Revival.
 - —Travellers Club, Pall Mall, 1829–1831; Sir Charles Barry. Renaissance Revival.
- **Macon, Georgia:**
 - —Johnston-Felton-Hay House, 1855–1860; Thomas Thomas and Son. Italianate or Palazzo Style.
- **Manchester, England:**
 - —Free Trade Hall, 1853–1854; Edward Walters. Palazzo Style.
- **Memphis, Tennessee:**
 - —Mallory-Neely House, c. 1852, 1883.

- **New York City, New York:**
 - —Tiffany and Company, c. 1870s. Northern Renaissance Revival or Venetian Style.
- **Paris, France:**
 - —Palais des Études, École des Beaux-Arts, designed in 1832–1834, built 1834–1839; Félix Louis Jacques Duban.
 - —Bibliothéque Sainte-Geneviéve, designed 1842, built 1843–1850; Henri Labrouste.
- **Philadelphia, Pennsylvania:**
 - —Athenaeum, 1845–1847; John Notman. Renaissance Revival.
- **Portland, Maine:**
 - —Morse-Libby House (Victoria Mansion), 1858–1860; Henry Austin. Italian Villa.
- **Potsdam, Germany:**
 - —Persius Court, Gardner's House, 1829–1833; Karl Friedrich Schinkel. Renaissance Revival.
- **Providence, Rhode Island:**
 - —Gov. Henry Lippitt House, 1862–1875; Henry Childs. Renaissance Revival.
- **San Francisco, California:**
 - —Evans House, 1883. Italianate.
- **Savannah, Georgia:**
 - —Mercer House, 1860–1866; plans by Muller and Bruyn. Italianate.
- **Shrewsbury, England:**
 - —Cronkhill, 1802; John Nash. Italian Villa.
- **Springfield, Massachusetts:**
 - —Henry A. Sykes House, 1849. Italian Villa.
- **Staffordshire, England:**
 - —Trentham Hall, 1834–1849; Sir Charles Barry. Palazzo Style or Renaissance Revival.
- **Vienna, Austria:**
 - —Museum of Applied Art, 1871; Vienna, Austria; Heinrich Ferstel. Renaissance Revival.
- **Washington, D.C.:**
 - —Custom House, 1857; Ammi B. Young. Renaissance Revival.

stations, and theaters (Fig. 7-8). Some commercial buildings in the United States are Italianate (Fig. 7-9). A few train stations and town halls display the towers, round arches, and bracketed roofs of the Italian Villa style (Fig. 7-10).

- *Site Orientation.* Most buildings occupy large portions of a city block and seldom are a part of a city plan. They appear as large rectangular blocks with no protrusions such as porches or entryways.

DESIGN PRACTITIONERS

- **Sir Charles Barry** (1795–1860) initiates the Renaissance Revival style in England with his designs for gentlemen's clubs. His Grand Tour, in which he studies in Florence and Rome, helps solidify his preference of working in a classical mode, although he designs in various styles. However, his best-known building and the one that earns him his knighthood is the New Palace of Westminster that is in a picturesque Gothic Revival style.

- **John Notman** (1810–1865) designs the first Italianate residence in the United States, Riverside in New Jersey in 1839. Probably inspired by Barry, he also designs the Renaissance style Athenaeum in Philadelphia. Born in Scotland, he emigrates to the United States in 1831. In addition to the Italian styles, Notman works in the Greek, Gothic, and Egyptian Revivals.

- **Alexander Roux** (1813–1886) is a French cabinetmaker in New York City who works in Rococo, Gothic, and Renaissance Revival styles. He also decorates interiors and sells mantels and interior architectural details. After opening his own shop in 1837, he capitalizes on the popularity of French taste in America and soon has a very successful business.

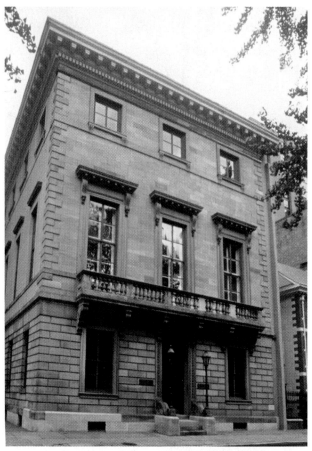

▲ **7-7.** Athenaeum, 1845–1847; Philadelphia, Pennsylvania; John Notman. Renaissance Revival.

- *Floor Plans.* Barry's plan for the Reform Club in London (Fig. 7-6), derived from Italian precedents, is the model for many subsequent buildings. In these cases, symmetry and an open central courtyard or cortile are characteristic.

Other plans are symmetrical, developing from the function of the building.

- *Materials.* Materials are chosen to emphasize heaviness and give rich texture and contrast. Structures are of brick,

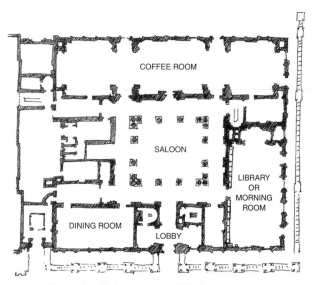

▲ **7-6.** Floor plan, Reform Club, Pall Mall, 1837–1841; London, England; Sir Charles Barry. Palazzo or Renaissance Revival.

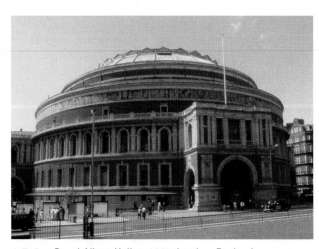

▲ **7-8.** Royal Albert Hall, c. 1871; London, England. Renaissance Revival.

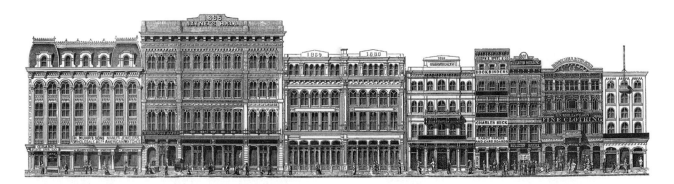

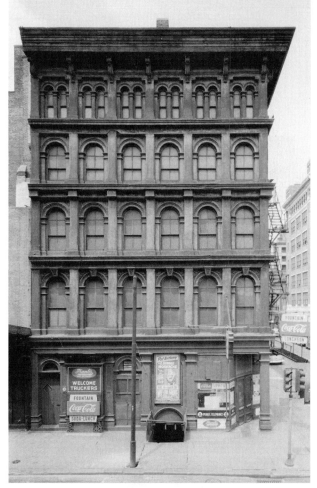

▲ **7-9.** Commercial buildings, c. 1870s–1880s; Pennsylvania and Tennessee. Renaissance Revival.

modillions, separates walls and roof. Walls typically serve as backgrounds for windows, doors, and other details. Balconies or *loggias* are common. In commercial structures, wall space is greatly reduced to allow larger windows for display and more light in the interiors. Façades based on Northern Italian or Venetian models are more embellished. Round arches, pilasters or engaged columns, swags, acanthus leaves, arabesques, and other classical ornament define these façades. Italian Villa style buildings have one or two towers, individual or groups of fenestration with round arches, and brackets beneath the roof (Fig. 7-10).

■ *Windows.* Bold details surrounding windows and doors give three-dimensionality, contrast, and a richness not found in Greek Revival (Fig. 7-8). Windows may diminish in size on each story and have simpler treatments on successive stories (Fig. 7-5, 7-7). Lintels, pediments, or aedicula demarcate windows, depending on the story. Second-story windows usually are the largest and have the boldest surrounds. Stringcourses often form bases for windows, which alternatively may rest on brackets or consoles. Earlier examples feature the rectangular windows of Roman palaces, while later ones exhibit the

stone, or cast iron. Because smooth wall surfaces are desirable, façades may be stuccoed for a flat appearance (Fig. 7-4, 7-5). Details may be of different materials.

■ *Façades.* Façades resemble or directly imitate Italian High Renaissance palaces (Fig. 7-4, 7-5, 7-7, 7-11). Lower stories may be rusticated. Quoins delineate corners. As in the prototypes, the most important floor is the largest and usually on the second level, while on successive stories the room height may diminish. A large cornice, usually with

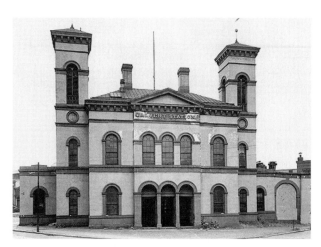

▲ **7-10.** Pennsylvania Railroad, Calvert Station, c. 1860s; Baltimore, Maryland. Italian Villa.

▲ **7-11.** Hotel Kummer, c. 1840s–1870s; Vienna, Austria.

▲ **7-13** "Design for a Small Classical Villa," published in *The Architecture of Country Houses* by Andrew Jackson Downing, 1853; Alexander Jackson Davis. Italian Villa.

▲ **7-12.** Osborne House, 1845–1851; Isle of Wight, England; Thomas Cubitt with Prince Albert. Italianate.

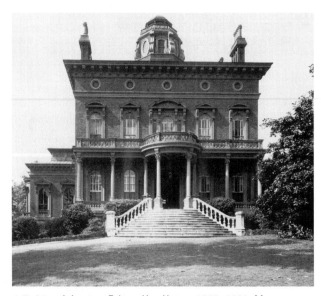

▲ **7-14.** Johnston-Felton-Hay House, 1855–1860; Macon, Georgia; Thomas Thomas and Son. Italianate or Palazzo Style.

round-topped windows typical of Northern Italian or Venetian modes. Italian Villa buildings usually have hood moldings or pediments over the windows, which may be round or rectangular (Fig. 7-10).

DESIGN SPOTLIGHT

Architecture: Morse-Libby House (Victoria Mansion), 1858–1860; Portland, Maine; Henry Austin. Italian Villa. In contrast to earlier and simpler examples, this house expresses richness and wealth with its masonry building materials, abundance of textures, and robust details. The asymmetrical façade is composed of geometric forms and has a marked verticality that is emphasized by the tower. Rusticated quoins and deep hood moldings and pediments stand out against the smooth walls and create strong light and dark contrasts. Large ornamental brackets beneath the roof

and round-arched windows and doorway complete the Italian Villa motifs.

As is typical in many homes, the interiors display several styles, including Renaissance Revival in the parlor, Rococo Revival in the music room (see Chapter 8, "Second Empire, Rococo Revival"), and Gothic Revival in the library (see Chapter 6, "Gothic Revival"). Like the exteriors, the owner's wealth is evident in the bold architectural details, painted and gilded wall and ceiling decorations, costly materials, lavish textiles, and furniture in rich finishes.

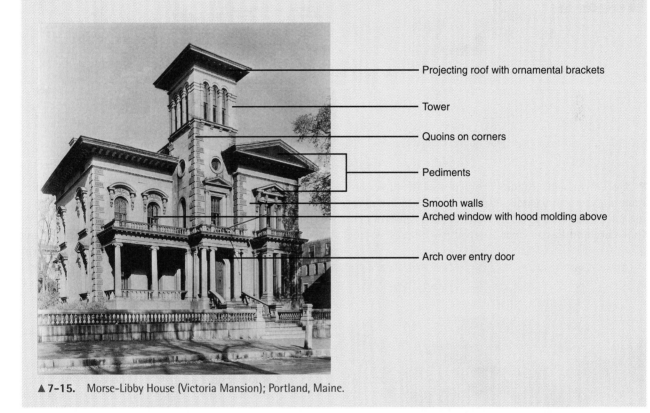

Projecting roof with ornamental brackets

Tower

Quoins on corners

Pediments

Smooth walls
Arched window with hood molding above

Arch over entry door

▲ **7-15.** Morse-Libby House (Victoria Mansion); Portland, Maine.

■ *Doors*. Doors, of paneled wood, are often centered on the main façade to signal their importance. They usually have rounded tops. Doorway surrounds may include pilasters or engaged columns carrying an entablature or pediment (Fig. 7-4).

■ *Roofs*. Downplayed as in the originals, roofs may be flat or low pitched. Some examples have balustrades (Fig. 7-11). Tower roofs are hipped or gabled and low pitched. Brackets beneath the roof identify the Italian Villa style.

■ *Later Interpretations*. In the late 19th century, Italian Renaissance palaces again become models for contemporary

public and private buildings, particularly for the wealthy. Although both derive from similar models, the scale of the NeoRenaissance buildings is far larger than the earlier ones (See Chapter 12, "Classical Eclecticism.")

Private Buildings

■ *Types*. Mansions, row houses, and urban villas are usually Renaissance Revival in both England and the United States, whereas villas, country houses, and cottages may be Italian Villa style or Italianate (Fig. 7-12, 7-13, 7-15).

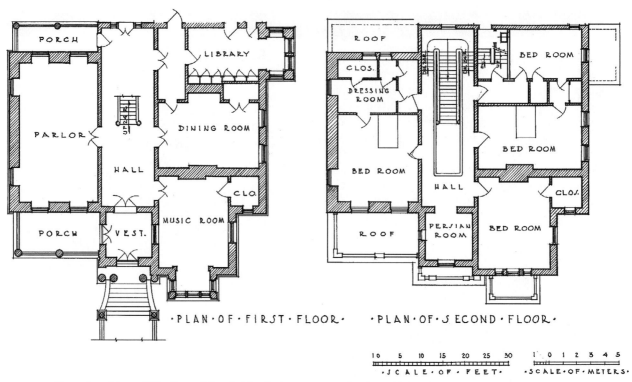

·PLAN·OF·FIRST·FLOOR· ·PLAN·OF·SECOND·FLOOR·

·SCALE·OF·FEET· ·SCALE·OF·METERS·

▲ **7-16.** Floor plans, Morse-Libby House (Victoria Mansion), 1858–1860; Portland, Maine; Henry Austin. Italian Villa.

■ *Site Orientation*. Rural examples usually have surrounding lawns and gardens that combine formal and informal areas. In the 1840s, architects begin to plan Italianate and Renaissance Revival row houses as long

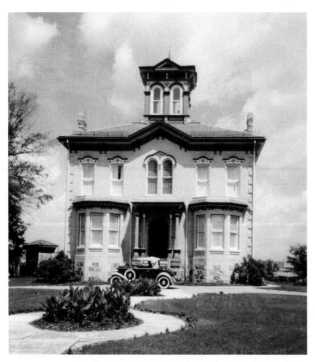

▲ **7-17.** Castle Kilbride, 1877; Baden, Ontario, Canada. Italianate.

units of repetitive and uniform designs that form streetscapes (Fig. 7-18).

■ *Floor Plans*. Floor plans do not change much with the style, although some asymmetry may be evident. Many houses maintain the traditional double-pile or Georgian plan of a central hall flanked by two rooms on each floor. Square, formal plans are typical for Renaissance Revival, but projecting rooms, porches, and verandas help break up strict symmetry in Italianate or Italian Villas (Fig. 7-13). Townhouses have side hall plans (Fig. 7-18). Staircases often are curvilinear.

■ *Materials*. Houses are built of stone, brick, brownstone, or wood (Fig. 7-12, 7-13). Wood and brick may be stuccoed and scored to resemble stone. A cheaper substitute is a painted finish mixed with sand, which suggests stone. In the United States, polychrome of three or more colors is common with a lighter body and darker details. The individual components within architectural details also may contrast in color to create highlights and shadows for more three-dimensionality. Typical colors include buff, straw, or stone, brown, red, olive, gold, green, and blue. One often recommended color scheme includes a buff body, light olive trim, reddish-brown sashes, and green shutters. Some residences have painted cast-iron hood moldings, brackets, porches, and other details.

■ *Façades*. Façade design varies from close depictions of Italian High Renaissance palaces to asymmetrical examples that are boldly decorated with classical and nonclassical

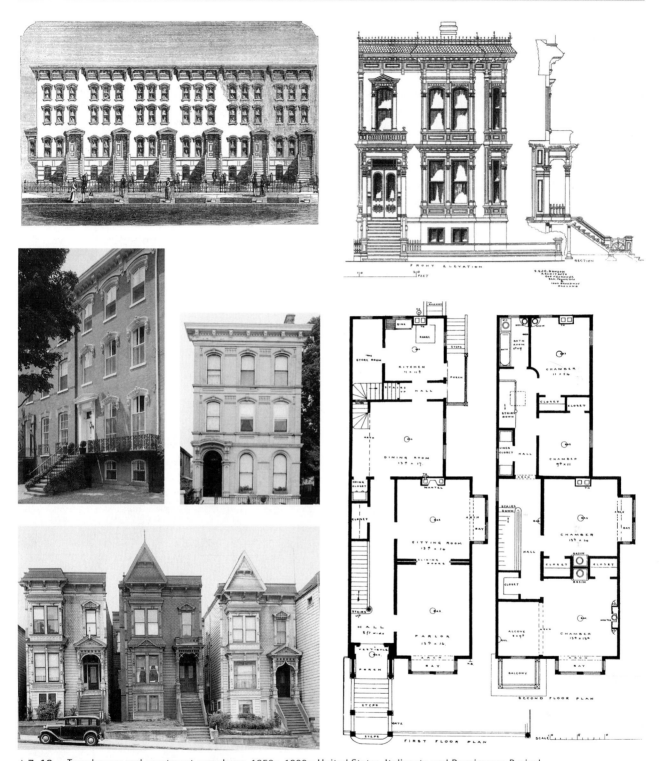

▲ **7-18.** Townhouses and apartment complexes, 1850s–1880s; United States. Italianate and Renaissance Revival.

details. Renaissance Revival examples in England or Germany closely resemble Italian prototypes and are formal, symmetrical rectangular blocks (Fig. 7-18). Heights of stories diminish. Rustication, when present, is confined to lower stories and quoins. Bold details, such as lintels or triangular or segmental pediments, emphasize rectangular windows and doorways. In both England and America, Italianate houses may have a centered gable or

be a rectangular block with a cupola (Fig. 7-14). Italian Villas have a tall, rectangular tower on one corner or occasionally two corners to emphasize verticality (Fig. 7-15). In both versions, wall surfaces are smooth to provide a neutral background for windows and doors, and there may be *loggias* or balconies. Verandas or porches are common. A large cornice and heavy brackets emphasize the roofline. Italianate row houses have rounded windows with or without hood moldings, rounded doorways, and bracketed cornices (Fig. 7-18).

■ *Windows*. Rectangular windows with lintels or triangular and/or segmental pediments above them characterize Renaissance Revival houses. Some windows have stained glass in them. Italianate and Italian Villa styles feature round-arched two-over-two windows; some homes may have only rectangular windows or mix round-arched windows (Fig. 7-15, 7-17). Some residences have bay windows. Windows may be single or in groups with and without shutters or blinds. Hood moldings or pediments over windows are a definitive characteristic of the Italianate and Italian Villa styles.

■ *Doors*. Like windows, doors often have round-arched tops. Surrounds may have pilasters or engaged columns carrying a lintel or pediment or boldly carved surrounds (Fig. 7-18). Doors are wooden with panels and may be single or double. Some may be grained to imitate more expensive woods. A few have glass in the upper portions.

■ *Roofs*. Low-pitched gable or hipped roofs are most used. Grand houses may have a cupola instead of a tower (Fig. 7-14).

■ *Later Interpretations*. In the late 19th century, the Renaissance again defines some residences (see Chapter 12, "Classical Eclecticism"). Some early-20th-century homes,

such as four-squares, reflect Italianate characteristics, such as brackets beneath the roof or hood moldings. In the late 20th century, contemporary townhouses in some historic areas of European cities imitate the character of commercial and residential buildings nearby (Fig. 7-19).

INTERIORS

Italianate or Renaissance Revival public buildings feature interiors with Renaissance or classical architectural details. Following Barry's design of the Reform Club, many English public buildings center on two-story halls with superimposed columns defining floors and with skylights above. Renaissance Revival rooms, particularly important or public ones, have bold architectural details, rich textures, a variety of materials, and lavish classical and naturalistic ornament derived from Renaissance and

◄ **7-19.** Later Interpretation: Townhouses, 45–47 Pall Mall, c. 1990s; London, England. Modern Historicism.

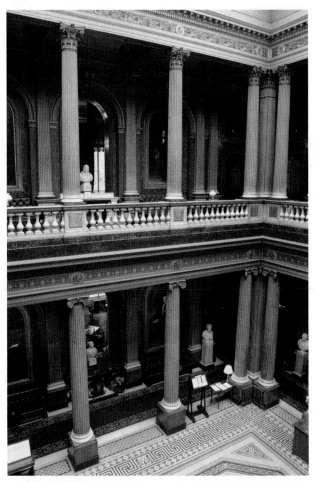

▲**7-20.** Central saloon, Reform Club, Pall Mall, 1837–1841; London, England; Sir Charles Barry. Palazzo or Renaissance.

Mannerist sources. In contrast, houses may have rooms decorated in Rococo Revival, Gothic Revival, and/or Renaissance Revival.

Although the Renaissance heritage of a country often defines the style of that country, eclecticism prevails. Interior decoration and furnishings are chosen as symbols of wealth, taste, and civilization, and the Renaissance styles imply a long, genteel, sophisticated heritage. Displays of wealth frequently characterize Renaissance Revival interiors in public and private buildings.

Public and Private Buildings

■ *Types*. Renaissance Revival defines a wide variety of public rooms, usually those of importance such as entry halls, atriums, courtrooms, or legislative chambers (Fig. 7-20, 7-21, 7-22). In residential buildings, entry halls, parlors, dining rooms, and bedrooms may display Renaissance Revival or Italianate characteristics (Fig. 7-27, 7-28, 7-29, 7-30, 7-31).

▲ **7-21.** Atrium hall, Museum of Applied Art, 1871; Vienna, Austria; Heinrich Ferstel. Renaissance Revival.

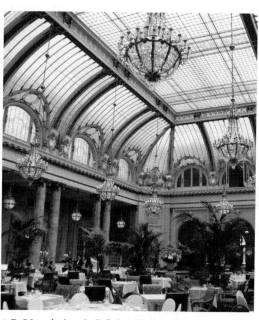

▲ **7-22.** Atrium hall, Palace Hotel, view as of 1906; San Francisco, California; Carleton E. Watkins.

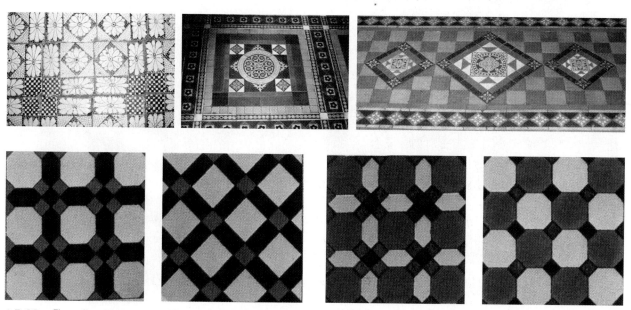

▲ **7-23.** Floor tiles, 1860s–1880s; Virginta (top row) and from *Homestead Architecture* by Samuel Sloan (bottom row).

▲ **7-24.** Library; published in *The Architecture of Country Houses* by Andrew Jackson Downing, 1853.

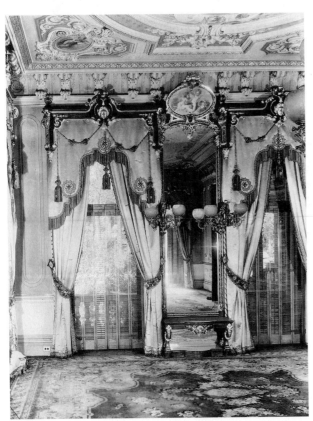

▲ **7-25.** Window Treatments: Examples from *Beautiful Homes*, 1878 (top right); Morse-Libby House, 1860s (bottom left); and *Godey's Lady's Book*, 1870–1890 (bottom right).

 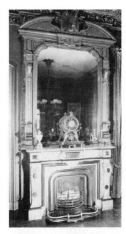 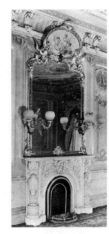 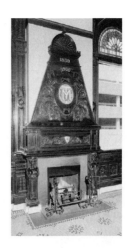

▲ 7-26.　Chimneypieces, c. 1870s–1880s; England, Rhode Island, Maine, and Missouri.

DESIGN SPOTLIGHT

Interiors: Renaissance Revival parlor, Jedediah Wilcox House, 1870; Meriden, Connecticut (now located in the Metropolitan Museum of Art). Like the other rooms in the Wilcox mansion, the rear parlor is designed en suite, that is, the mantel, over-mantel mirror, window cornices, light fixtures, and furniture match. The white marble mantel has paneled columns, acanthus leaf carving, rosettes, and a cartouche in the center. The mirror above the mantel and the door surrounds have similar details. The carpet is typical of the period in color and its scrolling geometric motifs recall Renaissance arabesques. It is a reproduction of a carpet from Paris found in a New York City house. Window treatments of boldly shaped lambrequins hang from ebonized cornices that match the mirror. The painted ceiling has flowers and rosettes. Made by John Jelliff and Co. of Newark, New Jersey, the Renaissance Revival parlor suite features similar details to the room's architecture. It is made of rosewood with mother-of-pearl medallions.

The exterior of the house is Second Empire and displays the style's characteristics of mansard roofs on the house and its tower, brackets supporting the roof, dormers, and round-arched windows with hood moldings (see Chapter 8, "Second Empire, Rococo Revival"). An 1870 newspaper description of the house called the style Franco-Italian and noted that the architect was Augustus Truesdell.

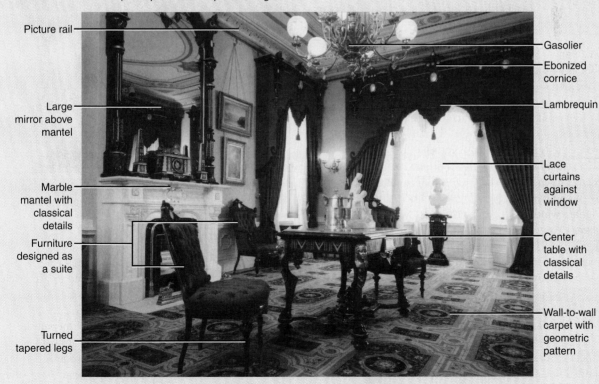

Picture rail

Large mirror above mantel

Marble mantel with classical details

Furniture designed as a suite

Turned tapered legs

Gasolier

Ebonized cornice

Lambrequin

Lace curtains against window

Center table with classical details

Wall-to-wall carpet with geometric pattern

▲ 7-27.　Renaissance Revival parlor, Jedediah Wilcox House; Meriden, Connecticut.

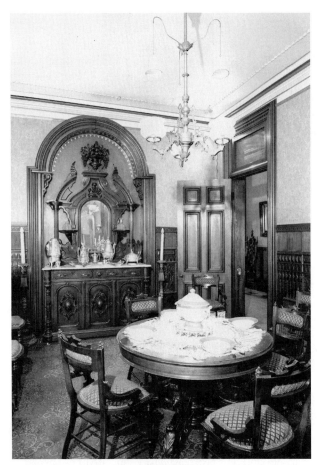

▲ **7-28.** Dining room, James Whitcomb Riley House, 1872; Indianapolis, Indiana. Italianate.

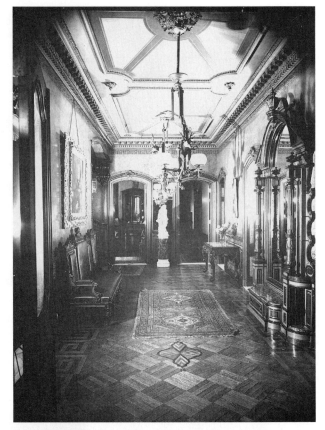

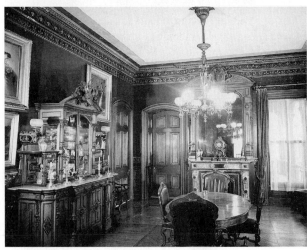

▲**7-29** Entry hall and dining room, Gov. Henry Lippitt House, 1862–1875; Providence, Rhode Island; Henry Childs. Italianate.

■ *Relationships*. Furniture may still line the walls in rooms in public buildings as well as the entry hall and important rooms in homes. A particularly impressive piece of furniture may dominate a room, such as the center table in the parlor, the hallstand in the entry hall, and the sideboard in the dining room.

■ *Color*. Renaissance Revival palettes are warm and rich. Crimson is favored, particularly for dining rooms, followed by green, brown, gold, and blue. Gilding may highlight details. Wood trim and paneling are stained a rich brown. Ceilings are white or a lighter tint of the wall color.

■ *Lighting*. As in other styles of the period, candles, oil lamps, and gas fixtures light both Renaissance Revival and Italianate interiors (Fig. 7-28, 7-29, 7-30, 7-32, 7-34). Unlike Gothic Revival or Rococo Revival, only a few feature distinctive Renaissance forms or motifs. Some forms copy ancient Greek vases or have classical motifs.

■ *Floors*. Floors may be of wood planks, parquet, marble, terrazzo, or tiles in colorful patterns (Fig. 7-20, 7-23, 7-29, 7-31). Masonry floors are common in public buildings and domestic entry halls. Carpets and rugs cover floors in both public and private buildings (Fig. 7-27). Floor cloths or oil cloths, as they are called in America, still appear in less-formal rooms. Patterns imitate carpet or masonry.

■ *Carpets*. Brussels, Wilton, or tapestry carpets in large-scale floral or geometric patterns with naturalistic shading are common in Renaissance style rooms. Typical colors are maroon, red, olive, brown, cream, and blue.

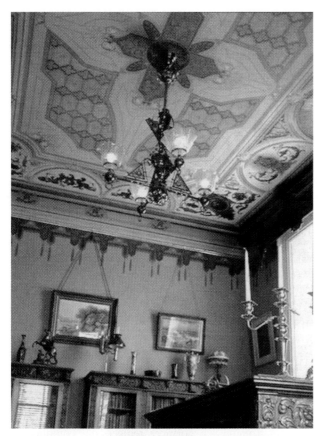

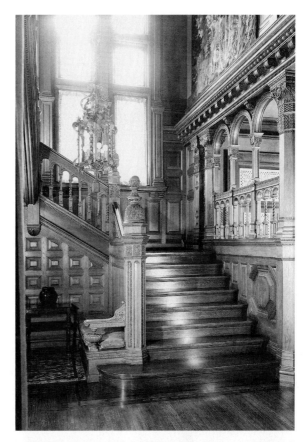

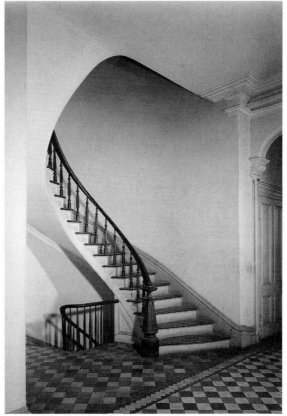

▲ **7-30.** Interior and ceiling details, Castle Kilbride, 1877; Baden, Ontario, Canada. Italianate.

▲ **7-31.** Stair halls and details, 1860s–1870s; Minnesota, Georgia, and Maine. Renaissance Revival and Italianate.

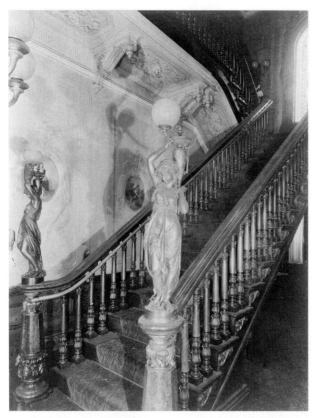

▲ **7-31.** *(continued)*

Although the jacquard mechanism and steam-powered loom increase carpet production, Brussels and Wilton remain expensive because their construction methods demand a great deal of wool yarn. Less expensive tapestry carpets use preprinted wool warp threads on the surface and less expensive threads for the body. Because an unlimited number of colors can be printed onto surface threads, tapestry carpets exhibit great details and realistic shading. Ingrain carpets, used in less important rooms, have large scrolled or circular patterns in green, red, brown, and white. Plain and patterned grass matting usually replaces carpet in summer.

■ *Walls.* Common wall treatments include architectural details, paneling, paint, and wallpaper (Fig. 7-30). Pilasters, engaged columns, brackets, niches, and other architectural details define important rooms in public and private buildings (Fig. 7-20). Plaster or papiermâché strapwork, roundels, cabochons, bosses, and other Renaissance or Mannerist details may embellish paneling or walls. Panels may have Renaissance motifs carved or painted in the center or may be composed of contrasting colors of wood. Deep cornices exhibit brackets, leaves, foliage, or flowers (Fig. 7-20, 7-25, 7-29, 7-32).

■ *Wallpapers.* Wallpapers with Renaissance motifs may cover walls although there are fewer Renaissance patterns than other styles. Patterns include textile imitations, flock designs, fresco styles that imitate moldings, and gilded elements and motifs. Leather in embossed and gilded designs often is used in dining rooms because it is thought that leather will not absorb smells.

■ *Chimneypieces.* Mantels are commonly of slate or marble, with white the preferred color. Other colors are black, gray, rose, brown, dark green, or two colors such as black and white. Most mantels are rectangular with an arched opening and a shaped shelf above (Fig. 7-24, 7-26, 7-27). Heavy or decorative moldings surround the opening, and a centered keystone carved with shells, fruit, acanthus leaves, or scrolls accents it. Moldings and carvings may decorate the spaces over the opening and the sides. Rectangular mantels may be carved with cartouches, tablets, brackets, caryatids, or columns. Plainer mantels are used in less important rooms.

■ *Staircases.* Staircases may be straight, rectangular, or curved with a mahogany handrail (Fig. 7-31). The large and prominent newel post may be polygonal or baluster shaped. In wealthy homes, staircases may have niches for sculpture. Some staircases are lit from above with skylights.

■ *Window Treatments.* Deep lambrequins or pelmets hanging from gilded cornices replace the complicated swagged drapery of earlier (Fig. 7-24, 7-25, 7-27, 7-32). Lambrequins often have complex shapes and fringe trim. Beneath them hang symmetrical fabric panels and muslin or lace curtains next to the glass. Curtains may be tied or looped back over cloak or curtain pins during the day. Plain panels hanging from rings on rods are a simpler treatment for less important rooms. Heavy plain or patterned fabrics are usual for lambrequins and curtains. Also common are roller blinds in linen or brown Holland cloth painted with scenes or designs.

■ *Doors.* Doors may be arched or rectangular and are generally paneled in dark mahogany, walnut, or rosewood (Fig. 7-28, 7-29). Sliding or pocket doors in double parlors may have frosted or etched glass panels. Robust moldings, pediments, or entablatures surmount doors in public buildings or important rooms in homes. Doorknobs may be white or decorated porcelain, glass, silver plate, or solid silver.

■ *Ceilings.* Flat ceilings may be plain with a plaster rosette, have beams, or be compartmentalized with strapwork, pendants, bosses, or other patterns inside them (Fig. 7-24, 7-29, 7-32, 7-33). Some ceilings are painted to imitate compartments (Fig. 7-30). Gas fixtures hang from plaster rosettes (Fig. 7-33, 7-34).

■ *Later Interpretations.* In the late 19th century, Renaissance architectural details, paneling, and other elements again define interiors in wealthy homes (see Chapter 12, "Classical Eclecticism," and Chapter 30, "Modern Historicism.") These

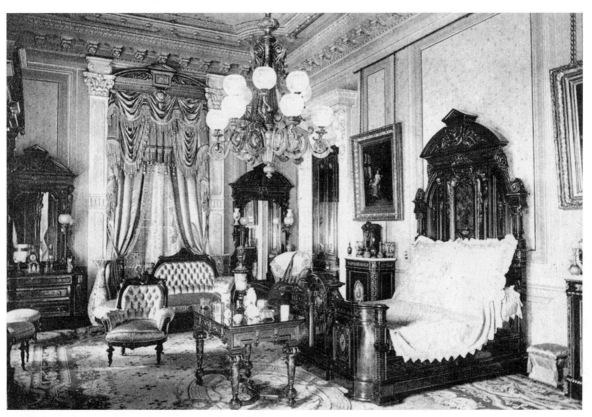

▲ **7-32.** Mrs. A. T. Stewart's bedroom, c. 1870s–1880s; published in *Artistic Houses*, 1883. Renaissance Revival.

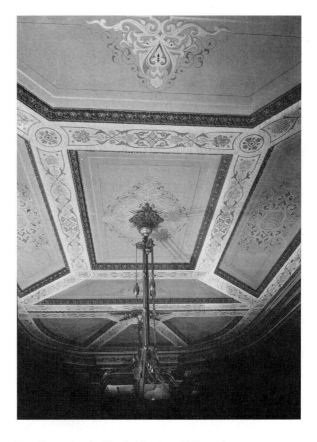

▲ **7-33.** Ceiling details, 1860s–1870s; Pennsylvania, Rhode Island, and Missouri.

versions are more correct because the Renaissance is better understood in the previous revival styles. Wealthy Americans import entire Renaissance rooms or specific architectural details from Europe and install them in their homes (Fig. 7-35). In the 20th century, there is less direct importation of rooms and more reinvention of stylistic features. As an example, various hotels incorporate designs based on Renaissance Revival influences (Fig. 7-36).

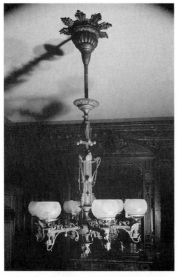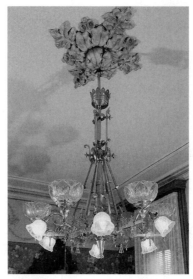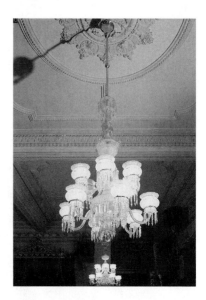

▲ **7-34.** Lighting: Gasoliers from Rhode Island, Indiana, Hawaii.

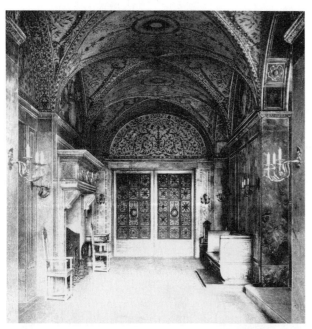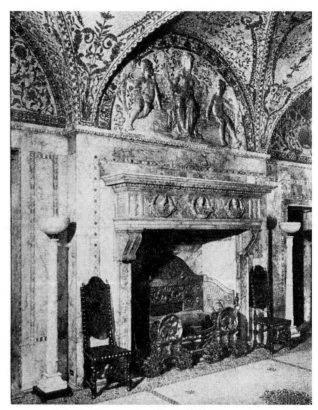

▲ **7-35.** Later Interpretation: Entrance hall, Villard Houses, 1882–1885; New York City, New York; McKim, Mead, and White. Neo-Renaissance.

▲ **7-36.** Later Interpretation: Grand Hall, Venetian Hotel, 1999; Las Vegas, Nevada. Modern Historicism.

FURNISHINGS AND DECORATIVE ARTS

Renaissance Revival furniture gains popularity in nearly all European countries and North America beginning in the 1860s. Nationalist motivations are particularly strong in Germany and Italy, but less so in England and North America. Each country interprets the style in light of its own past. Nevertheless, certain features are common, including massive proportions, an irregular silhouette, architectural motifs, opulence, and Renaissance or Baroque motifs from the 15th, 16th, and 17th centuries. The style does not seek to copy Renaissance forms or motifs, but instead adapts and reinvents them to create a new style in keeping with contemporary tastes that are suitable for contemporary rooms. Renaissance Revival furniture is common in gentlemen's clubs, smoking rooms, dining rooms, libraries, and entrance halls as well as the parlors and bedrooms of wealthier homes.

Neo-Grec, New Greek, or Modern Greek is a variation of Renaissance Revival that the French introduce in the Great London Exposition in 1862. More two-dimensional than its counterpart, Neo-Grec features less carving, more incising, and Greek, Roman, and especially Egyptian motifs (Fig. 7-27).

Public and Private Buildings

■ *Types.* All types of furniture may be Renaissance Revival. Particularly characteristic are sideboards, pedestals, easels, wall pockets, and hanging cabinets.

■ *Distinctive Features.* Distinctive to Renaissance Revival is an uneven outline, competing elements instead of a unified whole, architectural details, heavy cresting often in the form of a pediment, tapered legs, and carved or applied ornament (Fig. 7-28, 7-32, 7-38, 7-43). Finials, drops, or pendants highlight tops, legs, and other features.

■ *Relationships.* Architectural motifs establish a relationship with exteriors and some interiors.

■ *Materials.* Walnut, mahogany, and oak are the most common woods. Veneer, marquetry, inlay, ormolu, gilding, or porcelain may embellish pieces. Burl veneer contrasting with plainer veneer is a frequent characteristic. Neo-Grec pieces usually are ebonized and have incising highlighted with gilding. Carving on more expensive pieces may be excessive and in high relief. Applied ornament, such as bosses, is common on cheaper furniture. Drawer pulls may be turned or teardrop pendants. More expensive pieces have large brass and ebony pendants for pulls. Cabinet tops are often marble or scagliola.

■ *Seating.* Like other styles, Renaissance Revival seating comes in sets and shows great variety in form and details (Fig. 7-27, 7-28, 7-37). Some seating is large and richly carved and ornamented, while other examples have simple forms with turned legs, ladder backs, and caned seats. Legs are usually turned with a large ring at the top that tapers to a smaller ring. Most have casters. Some legs are modified cabriole shapes. Back legs are commonly reversed cabrioles like Rococo Revival. Neo-Grec pieces may have saber, *klismos*, or curule legs and hoof or paw feet. The round or trapezoidal seats of parlor or dining chairs are upholstered, whereas hall chairs have wooden seats suitable for their less important users. Backs are rectangular with a wooden frame that flares out at the top, forming ears and a large crest, usually in a pediment shape. Common embellishments include incising, carving, finials, and applied ornament such as pendants. Sofas may have double or tripartite backs. Unlike Rococo Revival, each part is treated separately and does not blend into a unified whole. Backs and seats often are deeply tufted to add to the opulence and appearance of comfort.

■ *Tables.* Like seating, Renaissance Revival tables take many forms (Fig. 7-27, 7-28, 7-32). Tops may be round, oval, oblong, or rectangular. Most tops are of marble, but expensive tables may have inlay or marquetry. Bases and legs form complicated shapes and silhouettes. Turning, animal forms, lyres, urns, brackets, or a combination are typical for legs and bases. Pendants, finials, drops, incising, and carving add interest and complexity. Extension dining tables with one or more pedestals replace the drop-leaf tables of earlier. In the hall or parlor, large pedestals

DESIGN SPOTLIGHT

Furniture: Suites of seating furniture; published in *McDonough, Price & Company* catalog, Chicago, 1878. These offerings from the McDonough Company exhibit the variety of form and details in Renaissance Revival parlor suites. Common characteristics include the turned legs, rectangular forms, and jagged, complex outlines. Deep tufting and added embellishments create an image of comfort and opulence.

▲ **7-37.** Suites of seating furniture, 1878.

and plant stands resembling columns decorated with Renaissance motifs hold sculpture, flowers, or plants.

■ *Storage.* Hallstands dominate the hall. Their form and embellishment are designed to create an impression of wealth and refinement for visitors. Formal and massive, they may be 6 to 10 feet tall. Characterized by a complicated silhouette topped by a pediment, the hallstand has knobs for hanging outwear, a mirror to check one's appearance before entering the parlor, an umbrella stand, and a marble top on which to leave calling cards, a common social ritual.

Similarly, the massive sideboard dominates the dining room and is lavishly embellished with carving, ormolu, porcelain, marble, marquetry, inlay, and gilding (Fig. 7-28, 7-29, 7-38). Its main function is to display the family's wealth, culture, and good taste. The basic form features a plinth or block base with three or four doors or drawers above, a marble top, and a large wooden back with shelves and a mirror. Capped by a large pediment with finials, the sideboard may have realistic carvings of food, game, or hunting motifs. Cabinetmaking firms commission impressive Renaissance Revival sideboards,

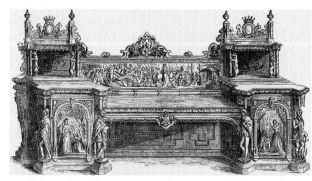

▲ **7-38.** Sideboards and cabinets, c. 1850s–1870s; England, United States, Germany, Belgium, and Italy. Renaissance Revival.

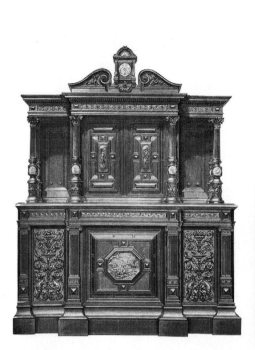
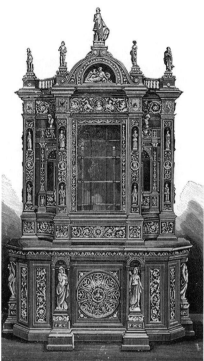
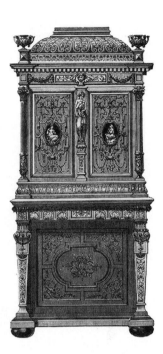

▲ **7-38.** *(continued)*

large cabinets, and pianofortes with much carving and complex iconographies as exhibition pieces for expositions (Fig. 7-38, 7-42). Dressers and wardrobes for smaller houses may imitate these concepts, but are often simpler in design (Fig. 7-39, 7-40). Renaissance Revival *étagères* show marked verticality, undulating forms, unusual cutouts, mirrors, shelves, pediments, cartouches, and other embellishment.

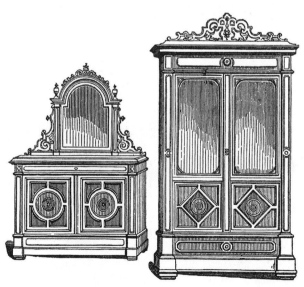

▲ **7-39.** Storage pieces; published in *The Architecture of Country Houses* by Andrew Jackson Downing, 1853.

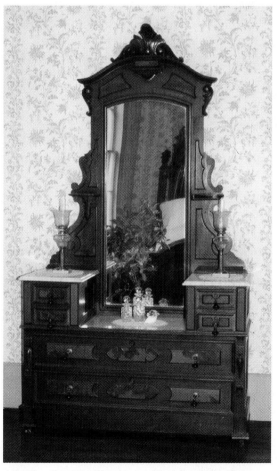

▲ **7-40.** Dresser with mirror, mid-19th century; Texas.

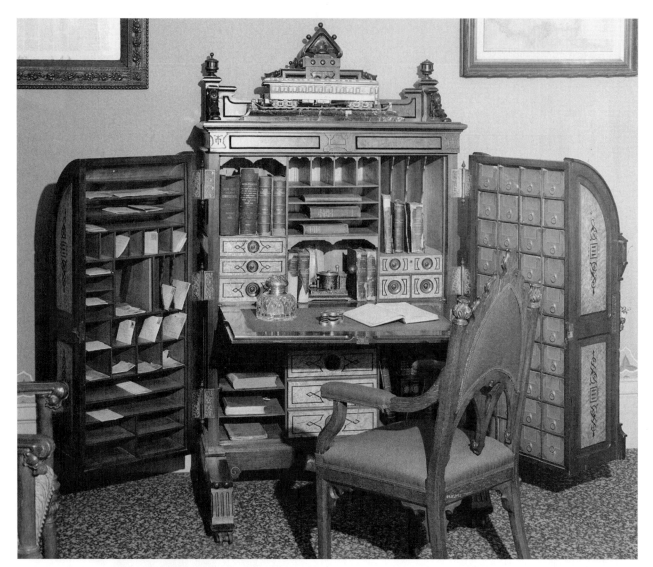

▲ **7-41.** Cabinet secretary (Wooten desk), Centennial International Exhibition, 1876; Philadelphia, Pennsylvania; manufactured by the Wooten Desk Company in Indianapolis, Indiana (see Chapter 1, "Industrial Revolution"). Renaissance Revival.

■ *Wooten Desk*. The Centennial International Exhibition of 1876 in Philadelphia featured a new cabinet secretary called a Wooten desk (Fig. 7-41; see also Chapter 1, "Industrial Revolution"). An example of ingenious patent furniture, it becomes a symbol of status and orderliness for the prosperous businessman. It features numerous drawers, files, and pigeonholes inside to assist with paper organization. The functional design emphasizes efficiency, flexibility, and practicality. The doors can be closed when not in use. Made in four models with varying prices, customs forms are also available. The invention of the typewriter and other forms of office equipment render Wooten desks less functional.

■ *Beds*. Renaissance Revival beds also have massive proportions (Fig. 7-32, 7-43). Headboards may be up to eight feet

▲ **7-42.** Grand pianoforte with ebony inlay and gold relief decoration, Great Exhibition, Crystal Palace, 1851; London, England; manufactured by Messrs. Broadwood in London. Renaissance Revival.

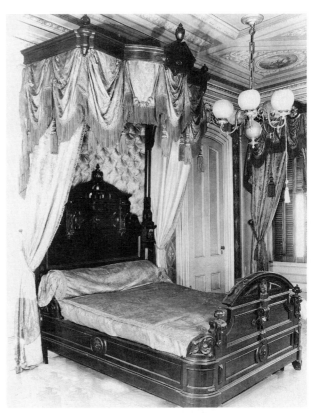

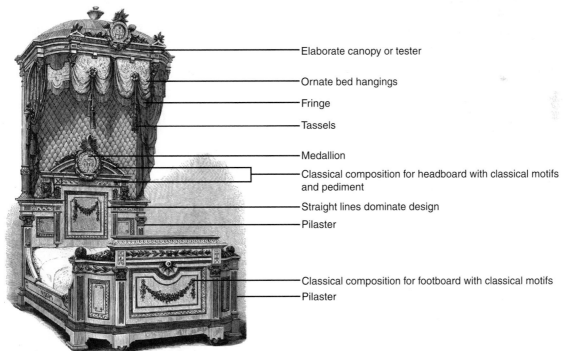

Elaborate canopy or tester

Ornate bed hangings

Fringe

Tassels

Medallion

Classical composition for headboard with classical motifs and pediment

Straight lines dominate design

Pilaster

Classical composition for footboard with classical motifs

Pilaster

▲ **7–43.** Beds, 1850s–1870s; Belgium, England, and the United States. Renaissance Revival.

tall and often resemble Renaissance church façades or are capped with a tall pediment. Panels have carvings of fruit, flowers, and Renaissance motifs. Not to be outdone, the lower footboards also have carved panels. Canopies are largely out of fashion, but when present, they have deep moldings and applied ornament. Bed drapery is complicated in form and lavishly trimmed with fringe and tassels. Matching night tables, dressers, gentleman's chests, wardrobes, wash stands, shaving stands, boot jacks, and towel racks complete the bedroom suite. All match the bed in size and details.

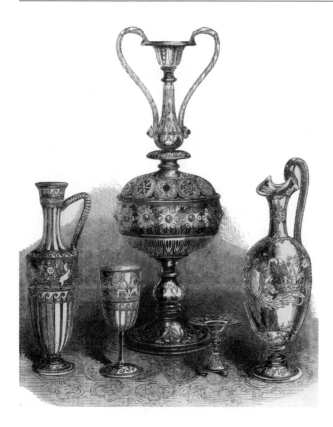

▲ 7-45. Later Interpretation: "Giovanni" dining room suite, 1920s; Minneapolis, Minnesota; manufactured by William A. French Furniture Company. Modern Historicism.

■ *Upholstery.* There are few distinctive Renaissance Revival textiles, although damasks may have large repeats in undulating patterns with naturalistic flowers and leaves. In the 1850s, textiles emulate the arabesques and grotesques of Rome and the Renaissance. Upholstery fabrics include damasks, moreen, horsehair, leather, and velvet, plain and patterned. Bed drapery may be of damask, velvet, satin, or moreen.

■ *Decorative Arts.* Classical figures, busts, and urns stand on pedestals, mantels, and in niches in Renaissance Revival interiors (Fig. 7-20, 7-29). Pictures are important. Rarely from the Renaissance, subjects vary from classical to contemporary themes. Revived Italian *maiolica* with Italian, French, and Flemish motifs is especially popular. Glass and porcelain objects may decorate mantels and tables (Fig. 7-32, 7-44). Large mirrors hang over fireplaces or between windows (Fig. 7-25). Frames may be stained, ebonized, and gilded wood and are carved with Renaissance motifs. Wall pockets, hanging cabinets, canterburies to hold magazines, all in Renaissance forms, commonly accessorize interiors.

■ *Later Interpretations.* There are very few interpretations of Renaissance Revival furniture in later developments. Some furniture manufacturers produce variations called Italian or Tuscan for residential furniture during the 1920s (Fig. 7-45) and again in the late 20th century. (see Chapter 30, "Modern Historicism.")

▲ 7-44. Decorative arts: Glass and porcelain, International Exhibition, 1862; London, England.

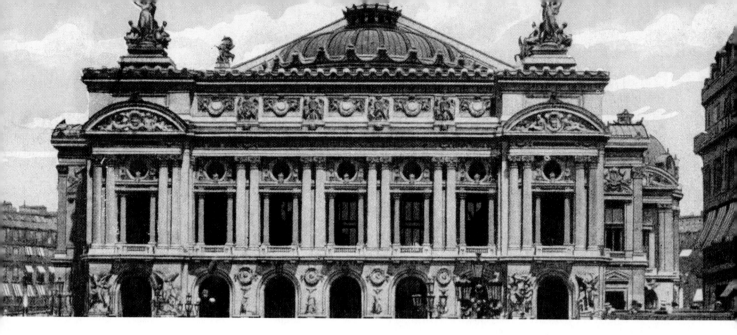

CHAPTER 8

Second Empire, Rococo Revival

Second Empire

1855–1885,

Rococo Revival

1845–1870s

Developing in France, Second Empire is an international architectural style characterized by a mansard roof, pavilions, and bold details. Although evident in earlier buildings, these elements come together in the New Louvre in Paris built during the reign of Napoleon III (1852–1871).

> *Modern French furniture . . . stands much higher in general estimation in this country than any other. Its union of lightness, elegance, and grace renders it especially the favorite of the ladies.*
>
> Andrew Jackson Downing, *The Architecture of Country Houses,* 1850

> *This style is exemplified in the new portions of the Louvre at Paris, at once the most extensive and elegant of the public works with which the genius of the present emperor has enriched that attractive city. From the great intrinsic beauty of this style not less than from its extreme readiness of adaptation to the wants and uses of the present day it has attained universal popularity in Europe and in the chief cities of our own country.*
>
> *Report of the Committee on Public Buildings, City Document No. 44, Boston, 1880, pp. 15–16*

In Europe and America, the style carries associations of elegance, sophistication, and cosmopolitanism.

Rococo Revival, based upon the 18th-century French Rococo, is the most popular of all revival styles for both interiors and furniture in the 19th century, particularly in England and North America. Its curving forms and feminine grace make it suitable for parlors, drawing rooms, and boudoirs. As a style of the Industrial Revolution, Rococo Revival uses interior surface treatments, textiles, furniture, and decorative arts that often are machine-made and utilize newly developed and patented techniques.

HISTORICAL AND SOCIAL

Following the defeat of Napoleon I in 1812, France remains unsettled. A series of governments, beginning with Louis XVI's brother, neither solves problems nor resolves conflicts.

181

More importantly, with the exception of the first five years of the reign of Louis Philippe (1830–1848), the new regimes do not aid the country in industrializing like the rest of Europe. Finally, in November 1848, Charles Louis Napoleon Bonaparte, nephew of Napoleon I, wins the presidency by a landslide vote. In 1851, he secures dictatorial power by a coup d'etat. A year later, following in the footsteps of his uncle, he takes the name Napoleon III and establishes what he calls the Second Empire (for the first Empire, see Chapter 2, "Directoire, French Empire"). He maintains a dictatorship, suppresses freedoms, and censors news until 1860 when intense opposition forces him to begin reforms. Ultimately, he sets up a limited monarchy. Nevertheless, Napoleon III has a positive effect on the country by encouraging industrialization, attempting to help the poor, and modernizing Paris.

One of his most enduring achievements is the reconstruction of Paris directed by Baron Haussman. Well acquainted with the glories of the first Empire under his uncle Napoleon I, Napoleon III and his wife, Eugénie, lead a glittering society with lavish entertainments that take place in opulent surroundings. Thus, France again becomes the model for wealth and luxury throughout the world. Despite domestic improvements, Napoleon III's foreign policies and wars ultimately lead to his downfall, like his uncle. He is overthrown following France's defeat in the Franco-Prussian war in 1870.

The Rococo or Louis XV style appears about 1700, in part as a reaction to the formal, majestic Baroque style in France. Primarily an interior and furniture style for the aristocracy, Rococo is asymmetrical and light in scale with curves dominating both form and decoration. Naturalistic ornament with numerous small parts replaces the orders, pediments, and other classical details of earlier periods. For the first time since the Renaissance, a style does not model itself on classical antiquity. Themes and motifs include romance, the pastoral life, the exotic, fantasy, and gaiety. The style's finest and most complete expression is in interiors where it achieves total unity between decoration and furnishings. Although known as Louis XV or *Louis Quinze*, Rococo appears before Louis XV takes the throne, and Neoclassical largely supplants it before Louis's death in 1774.

Initiated as a reaction to the simplicity of Neoclassicism, Rococo Revival first appears in Regency England where eclecticism demands new sources of inspiration. Despite war with Napoleon, the English remain captivated by French design and decoration. The Prince of Wales, an early advocate of French antiques, collects furniture and architectural elements from French *hôtels* and *châteaux* destroyed in the Revolution. English cabinetmakers copy pieces of imported French furniture. By the 1820s, a French style called (incorrectly) *Louis Quatorze* has emerged. Confusion exists because the style, which is based largely upon Louis XV or Rococo, depicts some elements of Louis XIV or Baroque, such as symmetry and bold carving. Consequently, literature of the period may refer to Rococo

Revival as Louis XIV, Louis XV or *Louis Quinze*, Neo-Louis, Modern French, or Old French.

Queen Victoria signals her approval of the style when she commissions *Louis Quatorze* furniture for Osborne House on the Isle of Wight and for Balmoral Castle in Scotland. Capitalizing on her influence, publications and pattern books popularize the new look for the expanding middle classes. Uncertain in matters of taste, they desire styles with references to the past, believing that these elements indicate a liberal education, taste, and gentility. Stylistic associations are extremely important because people believe that their homes display their family's culture and character.

In France, Rococo Revival gains popularity during the reign of Louis Philippe (1830–1848) and becomes known as *le style Pompadour*. It remains fashionable in the reign of Napoleon III (1850–1870) where it shares the limelight with a revival of Louis XVI (1760–1789). Rococo Revival is fashionable in the German-speaking countries from the 1840s. First grafted onto Biedermeier forms, a full-blown Rococo Revival soon arises and is eagerly adopted by the prosperous middle class. Like the British, Americans are enamored with things French, so Rococo Revival enjoys its greatest success in the United States beginning in the 1840s.

CONCEPTS

An international architectural style, Second Empire is inspired by the New Louvre in Paris (1852–1857) which connects the old Louvre and the Tuileries palaces. Although some elements have precedents in French architecture, the boldness and richness presented by the façades reflect mid-19th-century architectural preferences. Because its elements are already familiar in France, the Second Empire style has minimal influence there. Elsewhere, however, it becomes an important expression of sophistication, cosmopolitanism, and French culture. The adoption of Second Empire in England and North

▲ **8-1.** Ladies' costumes from *Godey's Lady's Book and Lady's Magazine*, c. 1860s.

IMPORTANT TREATISES

- *The Cabinet-Maker's Assistant,* 1853; Blackie and Son.
- *An Encyclopaedia of Domestic Economy,* 1844; Thomas Webster and Mrs. Parkes.
- *Godey's Lady's Book,* 1830–1878; Louis A. Godey and Sarah Josepha Hale.
- *The House Decorator and Painter's Guide,* 1840; H. W. and A. Arrowsmith.
- *The Practical Cabinetmaker & Upholsterer's Treasury of Designs, House-Furnishings & Decorators Assistant,* 1847; Henry Whitaker.

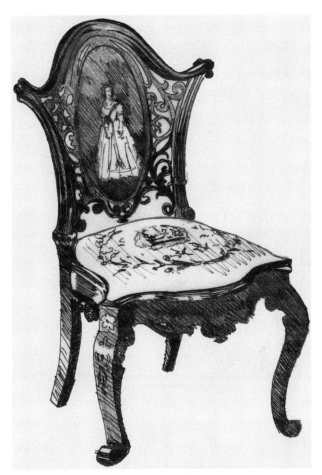

▲ **8-2.** Drawing room chair with the image of Queen Victoria; exhibited at the Great Exhibition, Crystal Palace, 1851; London, England; manufactured by Henry Eyles firm in Bath. Rococo Revival.

America coincides with building booms and economic prosperity, so the style comes to symbolize affluence, elegance, sophisticated taste, authority, and power. Similarly, interiors decorated for Napoleon III and Empress Eugénie are models for the affluent or nobility in Europe and America. There is no corresponding furniture style called Second Empire.

Reflecting the prosperity of the aristocratic and middle classes, Rococo Revival depicts a French look associated with noble tastes, which becomes extremely popular for home decoration in all Western countries between the 1830s and the 1860s. Rococo Revival also portrays the feminine character advanced by critics for public and private parlors and other spaces associated with women (Fig. 8-1) or those requiring elegance. Rococo's curving forms and visual complexity also communicate comfort and prosperity, which are equally desirable in the mid-19th century. Designers adapt elements of 18th-century Rococo to all 19th-century interior trappings. Rococo Revival has no corresponding architectural style, like its 18th-century counterpart.

Upholsterers and cabinetmakers, instead of architects and progressive designers, purvey Rococo Revival interiors and furnishings to create an image of respectability, taste, gentility, luxury, and refinement. Individuals rely on books, such as *An Encyclopedia of Cottage, Farm and Villa Architecture and Furniture* (1833) by Englishman J. C. Loudon, and periodicals, such as *Godey's Lady's Book* in the United States, to decorate their Rococo Revival rooms. Their approach emphasizes image and use, which appeals to a broad segment of society.

DESIGN CHARACTERISTICS

Past styles inspire Second Empire and Rococo Revival. Second Empire adopts a bold, three-dimensional classicism along with elements of French Renaissance. Rococo

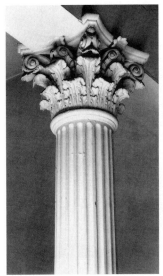

◄ **8-3.** Capital and columned entrance, Old City Hall, 1862–1865; Boston, Massachusetts; G. J. F. Bryant. Second Empire.

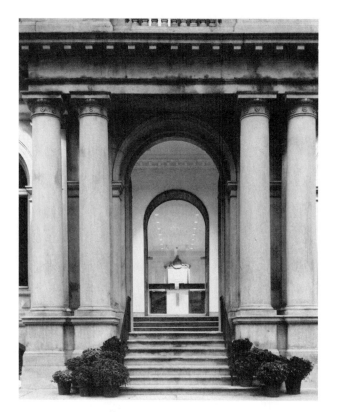

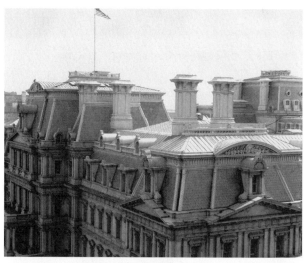

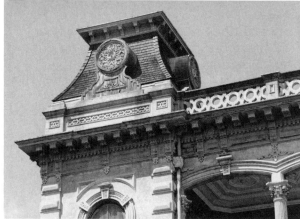

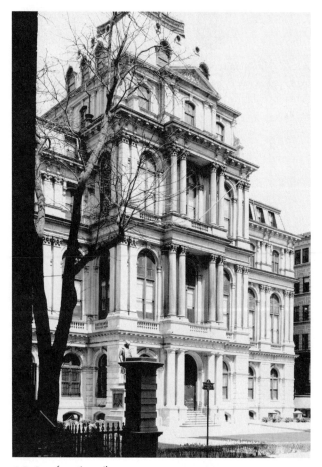

▲ 8-3. *(continued)*

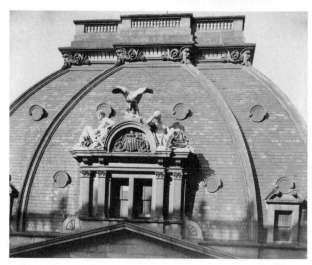

▲ **8-4.** Roof details, c. 1870s–1880s; Washington, D.C.; Hawaii; and Missouri.

Revival uses French Baroque of the 17th century and French Rococo of the 18th century as models. Although curvilinear, the revival style is bolder, more symmetrical, and more sculptural than its predecessor.

- *Second Empire (1855–1885).* In architecture, the definitive characteristic is a mansard roof, which is combined with other elements. These common architectural components include wall and/or roof dormers, stringcourses, columns, sculpture in high relief, and classical details. Pavilions characterize public buildings but are rare in private ones. Buildings project an air of grandeur and formality and often exhibit elements of other styles, especially Italianate or Renaissance Revival. Second Empire interiors, created for Napoleon III, are opulent and grand. Monumental scale, heavy architectural details, lavish materials, and a mixture of previous styles of French furniture are characteristic.
- *Rococo Revival (1845–1870s).* Like its 18th-century predecessor, curves and naturalistic ornament characterize Rococo Revival furniture, finishes, and decorative accessories, as well as wallpapers and carpets. The style attempts to capture the spirit of Rococo instead of mirroring its image. Rococo Revival interiors, unlike those of the 18th century, have wall-to-wall carpet, layers of drapery, heavy moldings, and large patterned wallpapers. Although curvilinear, Revival furniture is heavier, more lavishly carved, and evidences deeper upholstery than does the original Rococo. Naturalistic motifs characterize both the original style and its revival, but Rococo Revival ornament usually is symmetrical, higher in relief, and more profuse than that of its predecessor.
- *Motifs.* Motifs common in Second Empire are columns, swags, cartouches, pediments, and relief sculpture (Fig. 8-3, 8-4, 8-8, 8-9, 8-28). Rococo Revival motifs include C and S scrolls, female masks, vines, shells, grapes, roses, flowers, leaves, acorns, nuts, and birds (Fig. 8-2, 8-39, 8-41, 8-45).

ARCHITECTURE

Unlike other 19th-century revival styles, Second Empire reflects contemporary architectural developments in France in the 1850s and 1860s when Napoleon III undertakes a major rejuvenation of Paris. Wide boulevards and grand buildings transform the city into a modern, elegant metropolis. The world soon strives to emulate Paris, particularly the most famous of its buildings, the New Louvre (Fig. 8-6). Its mansard roof, pavilions, and classical details have appeared on French buildings since the 17th century. The richness, three-dimensionality, and plasticity these elements now exhibit are new in the 19th century.

International Expositions in Paris in 1855 and 1867 acquaint visitors with the new style. Images in numerous professional and popular periodicals inspire Second Empire buildings in Great Britain, her territories, North America, Germany, Austria, Australia, and Latin America. In Great Britain, designers find that Second Empire is eminently suitable for new railway stations, office buildings, and grand hotels, to create an image of refinement and affluence. Following the Civil War in the United States, Second Empire defines numerous government buildings. Because this period coincides with the administration of Ulysses Grant, the style is sometimes called the General Grant style. The ornate Second Empire particularly appeals to the newly affluent and powerful American leaders of commerce and industry who choose it for their offices and homes. Because it is an expensive style in which to build, Second Empire dies out following world economic reverses in the 1870s.

Public Buildings

- *Types.* Buildings include commercial offices, government offices (Fig. 8-13, 8-15, 8-16, 8-17), town halls (Fig. 8-9, 8-14), art galleries (Fig. 8-8), retail structures, theaters (Fig. 8-11), railway stations, and grand hotels (Fig. 8-5).
- *Site Orientation.* As parts of urban settings, buildings sit along streets in prominent locations in cities. Sometimes they are part of large urban developments as in Paris (Fig. 8-6, 8-7).
- *Floor Plans.* Floor plans are usually symmetrical with formal planning reflecting the function of the building (Fig. 8-7, 8-10, 8-12).
- *Materials.* Stone, granite, marble, brownstone (in the United States), brick, and iron details are common building materials (Fig. 8-6, 8-8, 8-15). Sometimes walls and details contrast in material and color, or the building may exhibit structural polychrome. Some Second Empire buildings, particularly multistory ones, have cast-iron façades. Shingles may be polychrome slate, tin, or wood.

▲ **8-5.** Great Western Hotel, 1851–1853; Paddington, London, England; P. C. Hardwick. Second Empire.

DESIGN SPOTLIGHT

Architecture: New Louvre, 1852–1857; Paris, France; L. T. J. Visconti and H. M. Lefuel. Second Empire. The New Louvre initiates and embodies the Second Empire style. Napoleon III calls for the addition of two wings, one on the end of the west front of the Old Louvre, to accommodate elements of his new government. Built around two internal courtyards, they are designed by Ludovico Tullio Johachim Visconti and completed by Hector Martin Lefuel on Visconti's death. The mansard roofs, pavilions, arched lower stories, classical details, and rounded pediments with relief sculpture are reminiscent of the work of Renaissance designer–architects Pierre Lescot

and Jean Goujon, and they tie old and new buildings together. The bold three-dimensional elements, columns, figural sculpture, and profuse decoration are new.

Interior decoration reflects ties with the first empire of Napoleon as well as earlier French monarchs. Room treatments embody the magnificence of the Second Empire with bold classical architectural details, rich finishes and materials, lavish gilding, and a mix of old and new furniture in the Empire and Louis styles. Despite their expensive materials, splendid decoration, and rich colors, the interiors are cold, uninviting, and overly grand.

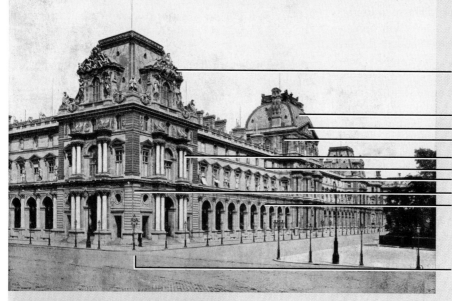

Rounded pediments with relief sculpture over dormer window

Mansard roof
Pediment
Arched window

Paired columns
Stringcourse
Projecting cornice
Quoins define corners
Arched lower story

Corner pavilion

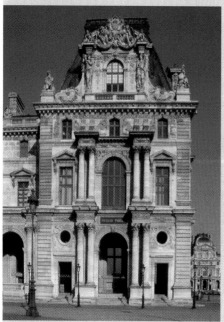

▲ **8-6.** New Louvre, 1852–1857; Paris.

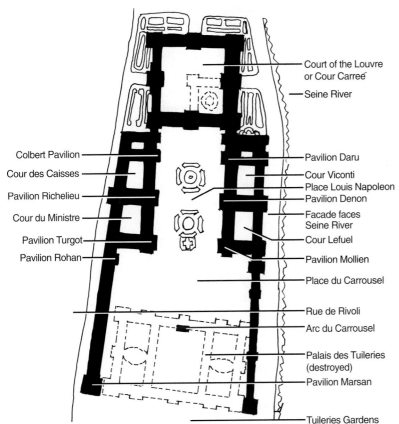

Court of the Louvre or Cour Carreé

Seine River

Colbert Pavilion

Cour des Caisses

Pavilion Richelieu

Cour du Ministre

Pavilion Turgot

Pavilion Rohan

Pavilion Daru

Cour Viconti

Place Louis Napoleon

Pavilion Denon

Facade faces Seine River

Cour Lefuel

Pavilion Mollien

Place du Carrousel

Rue de Rivoli

Arc du Carrousel

Palais des Tuileries (destroyed)

Pavilion Marsan

Tuileries Gardens

◄ **8-7.** Site plan, New Louvre, 1852–1857; Paris, France; L. T. J. Visconti and H. M. Lefuel. Second Empire.

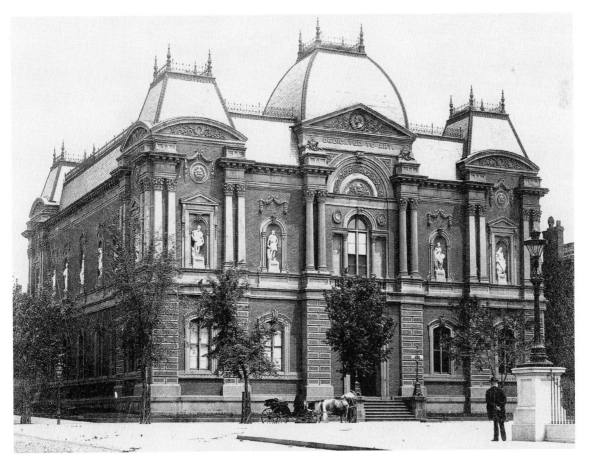

▲ **8-8.** Corcoran Gallery of Art (now the Renwick Gallery), 1859–1871; Washington, D.C.; James Renwick, Jr. Second Empire.

IMPORTANT BUILDINGS AND INTERIORS

■ **Boston, Massachusetts:**

—Old City Hall, 1862–1865; Arthur Gilman and Gridley J. F. Bryant. Second Empire.

■ **Cape May, New Jersey:**

—Colonial Hotel, 1894–1895; William and Charles Church. Second Empire.

—Queen Victoria Inn, c. 1881. Second Empire.

■ **Columbia, Tennessee:**

—Rattle and Snap, 1845; furniture by John Henry Belter. Rococo Revival interiors.

■ **Des Moines, Iowa:**

—Terrace Hill (Allen-Hubbell House, now Governor's Mansion), 1867–1869; William W. Boyington. Second Empire.

■ **Honolulu, Hawaii:**

—Iolani Palace, 1879–1882; T. J. Baker, C. J. Wall, and Isaac Moore. Second Empire.

■ **Indianapolis, Indiana:**

—Morris-Butler House, 1864; possibly by Dietrich Bohlen. Rococo Revival interiors.

■ **Isle of Wight, England:**

—Osborne House, 1845–1851; Thomas Cubitt, under the direction of Prince Albert. Rococo Revival interiors (Italianate Villa).

■ **Jefferson City, Missouri:**

—Governor's Mansion, 1871; George Inham Barnott. Second Empire.

■ **London, England:**

—Great Western Hotel, 1851–1853; P. C. Hardwick. Second Empire.

—Lancaster House, 1825; Benjamin Wyatt. Rococo Revival interiors.

—National Discount Offices, 1857; James Knowles, Sr., and James Knowles, Jr. Second Empire.

■ **Montreal, Canada:**

—Hôtel de Ville (City Hall), late 19th century. Second Empire.

■ **Natchez, Mississippi:**

—Dunleith, 1847. Rococo Revival interiors.

—Landsdowne, 1853. Rococo Revival interiors.

—Melrose, c. 1845; Jacob Byers. Rococo Revival interiors.

—Monmouth, c. 1818. Rococo Revival interiors.

—Rosalie, 1820. Rococo Revival interiors.

—Stanton Hall, 1850–1858. Rococo Revival interiors.

■ **New Haven, Connecticut:**

—John M. Davies House, 1867–1868; Henry Austin and David R. Brown. Second Empire.

■ **Newport, Rhode Island:**

—Chateau-sur-Mer, 1852, remodeled 1872; Richard Morris Hunt. Second Empire.

■ **New York City, New York:**

—Waldorf Astoria Hotel, c. 1880s. Second Empire.

■ **Paris, France:**

—Opera House, 1862–1875; Jean-Louis-Charles Garnier. Second Empire.

—New Louvre, 1852–1857; L. T. J. Visconti and H. M. Lefuel. Second Empire.

■ **Philadelphia, Pennsylvania:**

—Philadelphia City Hall, 1871–1881; John MacArthur, Jr., and Thomas U. Walter. Second Empire.

■ **Providence, Rhode Island:**

—City Hall, 1874–1878; Samuel J. F. Thayer. Second Empire.

■ **Quebec City, Quebec, Canada:**

—Hôtel du Parliament, 1876–1877. Second Empire.

■ **Saratoga, New York:**

—Colonel Robert Milligan House, c. 1853. Rococo Revival interiors.

■ **Sacramento, California:**

—Albert Gallatin House (Governor's Mansion), 1877–1880; Nathaniel Goodell. Second Empire.

—Gov. Leland Stanford House, 1857–1874; Seth Babson. Second Empire.

■ **Scarborough, England:**

—Grand Hotel, 1863–1867; Cuthbert Brodrick. Second Empire.

■ **St. Louis, Missouri:**

—Post Office, 1873–1884; Alfred B. Mullett. Second Empire.

■ **Washington, D.C.:**

—State, Navy, and War Building (Old Executive Office Building), 1871–1888; Alfred B. Mullett. Second Empire.

—Cocoran Gallery of Art (now the Renwick Gallery), 1859–1871; James Renwick, Jr. Second Empire.

▲ **8-9.** Old City Hall, 1862–1865; Boston, Massachusetts; Arthur Gilman and Gridley J. F. Bryant. Second Empire.

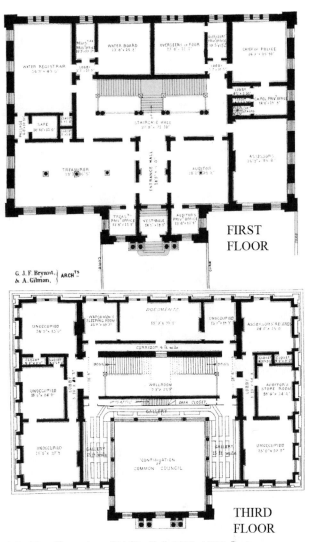

▲ **8-10.** Floor plans, Old City Hall, 1862–1865; Boston, Massachusetts; Arthur Gilman and Gridley J. F. Bryant. Second Empire.

■ *Façades.* Façades are formal and majestic with projecting centers and ends defined by paired columns or pilasters in the traditional French manner. (Fig. 8-6, 8-8, 8-9). Multiple forms, architectural elements, and details, particularly on pavilions, give a plastic or layered appearance, enhancing the three-dimensionality of the façade. Superimposed orders may organize façades with prominent stringcourses providing horizontal emphasis. Some façades have numerous bays defined by single or paired columns or pilasters (Fig. 8-8, 8-9, 8-11, 8-14, 8-16, 8-17). Quoins may accentuate corners, and lower stories may be rusticated (Fig. 8-5, 8-13, 8-15). Bold relief sculpture with complex or symbolic iconographies highlights important buildings. Tall, ornamented chimneys emphasize verticality.

■ *Windows.* Two-over-two windows are common. They may be rectangular or arched and have pediments, lintels, hood moldings, or a combination (Fig. 8-6, 8-8, 8-9, 8-16, 8-17). Windows may diminish in size, with attic or top-story windows being the smallest. Small circular windows may light rectangular spaces or towers. Wall and/or roof dormers are a defining feature and may have circular tops, pediments, or lintels (Fig. 8-4).

■ *Doors.* Columns, porches, pediments, and changes in shape emphasize major doorways, particularly those located in the center of the building (Fig. 8-9, 8-13, 8-14).

■ *Roofs.* The distinctive mansard roof, named for 17th-century French architect François Mansart, defines the style. Its tall, full shape allows another story when legal restrictions do not, so mansards become common in both remodeling and new construction. Each portion of the building or pavilion may have its own roof. Roofs exhibit several profiles: straight, straight with a flare, concave, convex, or S-shaped; these may be combined in one building (Fig. 8-5, 8-6, 8-9, 8-14, 8-16, 8-17). Iron cresting or curbing often tops the roofs. Rooflines may have a picturesque appearance with a multiplicity of shapes, layers, forms, and details. Shingles may be polychrome.

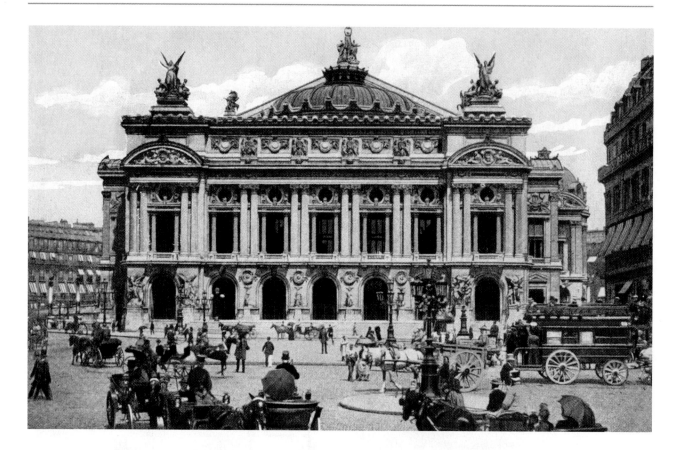

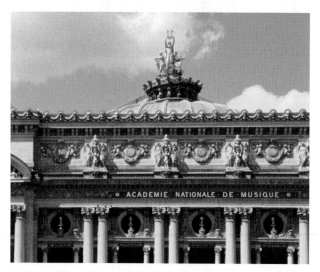

▲ 8-11. Opera House, 1862–1875; Paris, France; Jean-Louis-Charles Garnier. Second Empire.

■ *Later Interpretations.* Some Beaux-Arts buildings at the end of the 19th century and continuing into the 20th century feature mansard roofs and similar characteristics to those of Second Empire. The Post-Modern movement explores the mansard roof in a variety of contexts. Some buildings of the late 20th century interpret the scale and form of Second Empire, but illustrate the character in a far more contemporary manner (Fig. 8-26; see Chapter 12,

"Classical Eclecticism," and Chapter 30, "Modern Historicism.").

Private Buildings

■ *Types.* Second Empire is largely an urban style for mansions (Fig. 8-18, 8-20, 8-21, 8-22), apartment buildings (Fig. 8-25), and row houses. A few smaller

▲ **8-12.** Floor plan, Opera House, 1862–1875; Paris, France; Jean-Louis-Charles Garnier. Second Empire.

▲ **8-13.** Hôtel du Parliament, 1876–1877; Quebec City, Quebec, Canada. Second Empire.

suburban or rural examples exist in the United States (Fig. 8-19, 8-24).

■ *Site Orientation.* As an urban style, houses sit upon streets with surrounding lawns in the United States (Fig. 8-18, 8-20, 8-22, 8-24). Row houses may be treated as single units with each house uniform in design or they may vary.

■ *Floor Plans.* Plans for residences are formal and may be symmetrical or asymmetrical (Fig. 8-23). Room shapes are typically rectangular, with or without bay windows. Upper floors generally repeat the plan of the first floor, so support walls and mechanical connections line up vertically. Important room spaces include the entrance hall, stair hall, parlor, and dining room. Located near the dining room, the kitchen usually has a rear entrance, a pantry flanking it, and sometimes a servant's room nearby.

■ *Materials.* Local stone, brownstone, marble, granite, and brick are typical building materials (Fig. 8-18, 8-20, 8-21). Some interpret the style in wood (Fig. 8-24). Polychrome schemes of three or more colors are typical. A frequent color scheme is a body in fawn or straw, brown quoins, olive windows and porch, and Indian red sashes. A stone or gray painted body that creates the impression of stone is

also common. Details may be green, red, gold, or blue. Shutters, when present, are dark green or brown. Cresting and row house stair rails may be of cast iron.

■ *Façades.* Façades of one to four stories may be symmetrical or asymmetrical (Fig. 8-18, 8-19, 8-20, 8-21, 8-22, 8-25). Irregular massing and rectangular or angular projections create the three-dimensional appearance found on public buildings. Houses of the affluent have more projections and bolder architectural details. The center may project forward like the pavilion on a public building. Containing the entrance, the central bay often has a tower (Fig. 8-18, 8-22). Elements in common with Italianate or the Italian Villa styles include brackets at the roofline, hood moldings, single and groups of rectangular and round-arched windows, quoins, and prominent stringcourses. A few examples exhibit stick work like the Stick style or a mixture of textures and materials like Queen Anne. Porches, usually smaller than Italianate, may be full or partial width of the façade. Rectangular

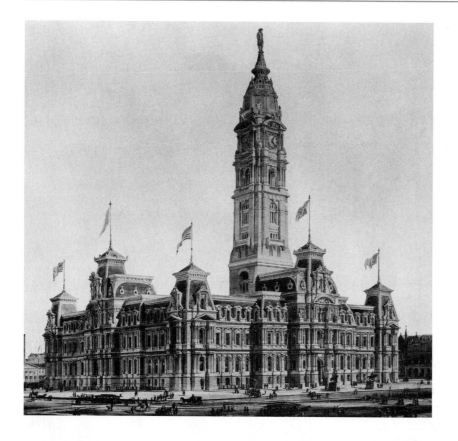

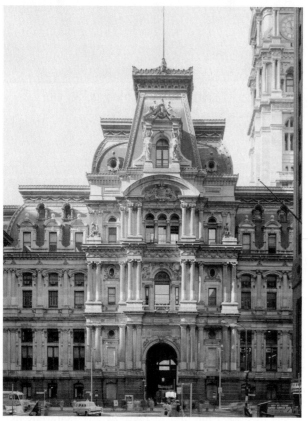

▲ **8-14.** Philadelphia City Hall, 1871–1881; Philadelphia, Pennsylvania; John MacArthur, Jr., and Thomas U. Walter. Second Empire.

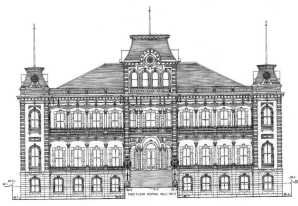

▲ **8-15.** Iolani Palace, 1879–1882; Honolulu, Hawaii; T. J. Baker, C. J. Wall, and Isaac Moore. Second Empire.

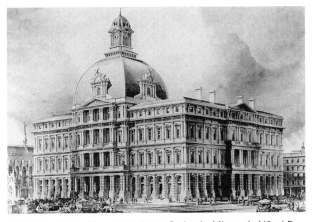

▲ **8-16.** Post Office, 1873–1884; St. Louis, Missouri; Alfred B. Mullett. Second Empire.

porch supports have scrollwork banisters and brackets. Towers and tall, decorated chimneys emphasize verticality.

■ *Windows.* Second Empire residences exhibit a variety of windows (Fig. 8-18, 8-19, 8-22, 8-24, 8-25). Two-over-two

DESIGN PRACTITIONERS

■ **John Henry Belter** (1804–1863), who emigrates from Germany to New York City in 1840, opens a cabinetmaking shop where he creates some of the most ornate Rococo Revival furniture in the United States. Belter furniture is made of laminated wood, a process he brings from Germany. Six to eight layers of wood are glued together with the grain at right angles to each other. Belter invents a special saw to carve and pierce the laminate. He receives several other furniture patents in the 1850s and 1860s. One is for bending wood in two directions using heat and molds. From these, he creates his famous dished backs.

■ **Prudent Mallard** (1806–1879) becomes a prominent furniture maker in New Orleans after arriving there in the 1830s. He is known for his enormous beds with silk-lined half canopies. Mallard's firm makes furniture in the Rococo, American Empire, Renaissance, and Gothic Revival styles. He also imports furniture and luxury items from France.

■ **Joseph Meeks (1771–1868) and Sons,** a firm in New York City, makes laminated Rococo Revival furniture that rivals Belter's in exuberance and lavish ornament, but the form and details are different. The firm also works in other styles.

■ **Alfred B. Mullet** (1834–1890), born in England, is a prominent Federal architect who designs many Second Empire governmental buildings in Washington, D.C., and other cities. He also designs in other styles. His buildings include the State, Navy, and War Building (1871–1888) in Washington, D.C.; the San Francisco Mint (1874) in San Francisco, California; and Pioneer Courthouse and Square (1875) in Portland, Oregon.

■ **James Renwick** (1818–1895) practices architecture mainly in New York. Not formally trained as an architect, Renwick learns architectural principles from his father, an engineer, and possesses a broad cultural education. Like most architects of his day, he works in many different styles. The first two major buildings of Second Empire are Renwick's: the Main Hall at Vassar College (1861–1865) in Poughkeepsie, New York, and the Renwick Gallery (Old Corcoran Gallery; 1859–1861) in Washington, D.C.

■ **François Seignouret** (1768–?), who emigrates from France, is a prominent furniture maker in New Orleans who opens his shop in 1822. Although he works in several styles, Seignouret is known for his American Empire furniture, inspired by French Restauration furniture, which follows French Empire.

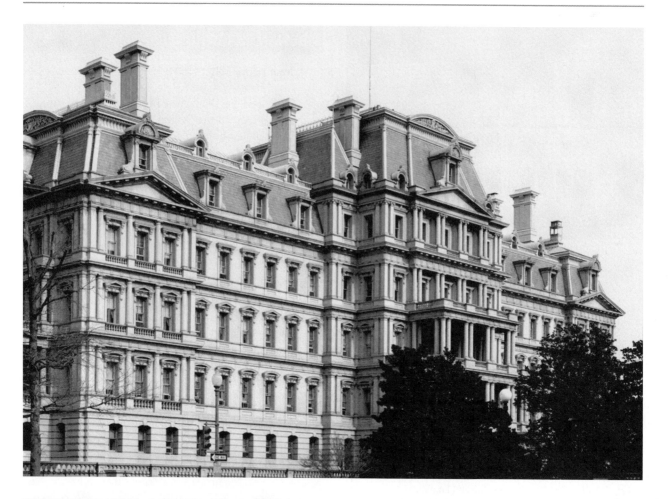

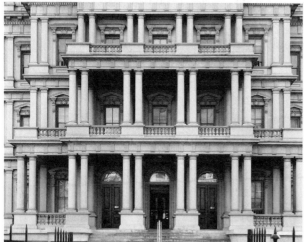

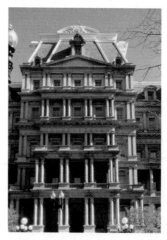

▲ **8-17.** State, Navy, and War Building (Old Executive Office Building), 1871–1888; Washington, D.C.; Alfred B. Mullett. Second Empire.

windows may be round arched as in Italianate or rectangular, single or grouped. Some have decorative surrounds such as triangular or segmental pediments or hood moldings. Some have shutters or blinds. Small round windows may accentuate towers or other areas.

A few residences have bay or oriel windows. Dormers take many shapes from circular to triangular.

■ *Doors.* Doorways are emphasized by their location within projecting centers or porticoes (Fig. 8-18, 8-20, 8-22, 8-24). Moldings, pilasters, and columns form the

DESIGN SPOTLIGHT

Architecture: Terrace Hill (Allen-Hubbell House, now Governor's Mansion), 1867–1869; Des Moines, Iowa; William W. Boyington. Terrace Hill is one of America's finest Second Empire houses with its mansard roof, tall tower, and bold details. Richness characterizes the composition and conveys the sophistication and culture of French design. Other Second Empire characteristics include the bracketed cornice separating roof from wall, variety of windows with hood moldings, bold dormer windows, and polychrome slate roof. Inside, the mansion was opulently furnished in a variety of fashionable styles including Rococo Revival.

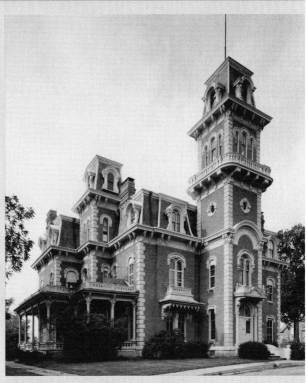

▲ **8-18.** Terrace Hill; Des Moines, Iowa.

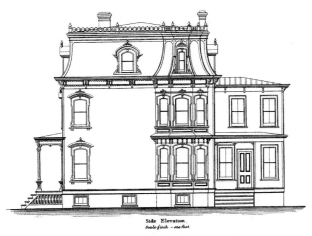

▲ **8-19.** House; published in *Bicknell's Village Builder: Elevations and Plans for Cottages, Villas, Suburban Residences, Farm Houses . . . Also Exterior and Interior Details . . . with Approved Forms of Contracts and Specifications* by Amos J. Bicknell, 1872. Second Empire.

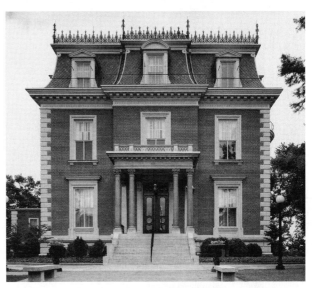

▲ **8-20.** Governor's Mansion, 1871; Jefferson City, Missouri; George Inham Barnott. Second Empire.

surrounds and stress importance. Doors may be rectangular or round arched with glass panels. Grand entrances have double doors.

■ *Roofs*. Mansard roofs define Second Empire residences like public buildings (Fig. 8-18, 8-19, 8-20, 8-21). Roof profiles may be straight (most common), straight with flare, concave, convex, or S-shaped and often vary on different parts of the house. Some houses have a cupola instead of or in addition to a tower. Shingles of slate, tin, or wood may form colorful patterns in red, green, blue, tan,

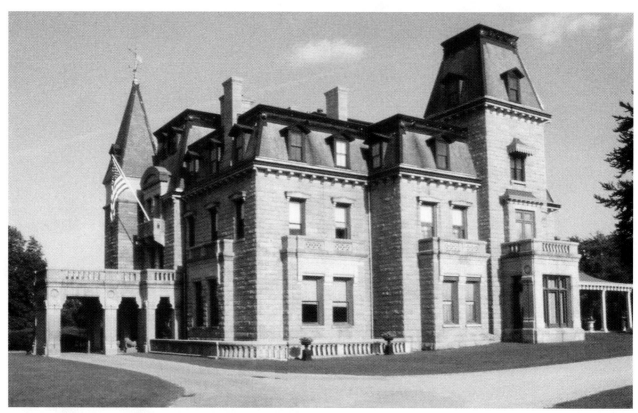

▲ **8-21.** Chateau-sur-Mer, 1852, remodeled 1872; Newport, Rhode Island; Richard Morris Hunt. Second Empire.

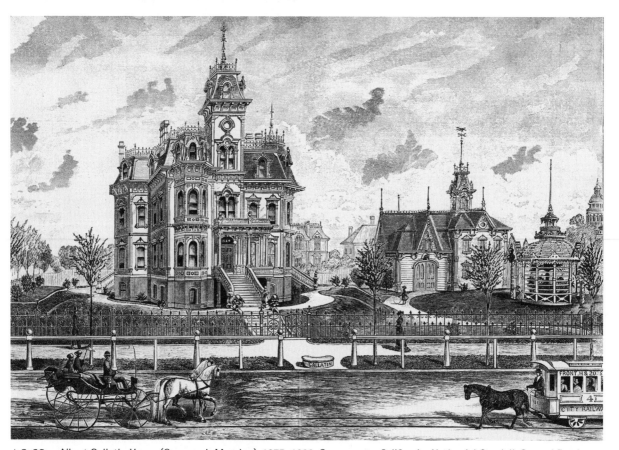

▲ **8-22.** Albert Gallatin House (Governor's Mansion), 1877–1880; Sacramento, California; Nathaniel Goodell. Second Empire.

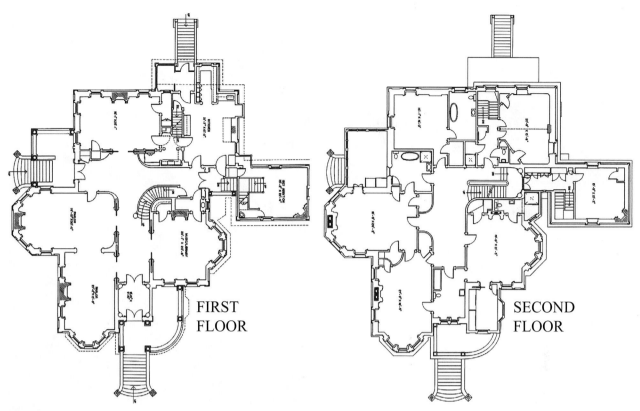

▲ 8–23. Floor plans, Albert Gallatin House (Governor's Mansion), 1877–1880; Sacramento, California; Nathaniel Goodell. Second Empire.

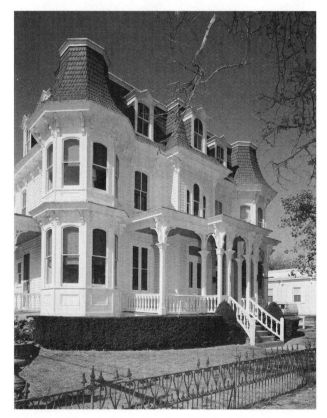

▲ 8–24. House on Ocean Street, c. 1881; Cape May, New Jersey. Second Empire.

and/or gray. Roofs nearly always contrast in color to the rest of the house. Brackets emphasize the roofline as in Italianate but are smaller, and the eaves do not project as much as Italianate ones do.

■ *Later Interpretations.* Houses in the Beaux-Arts style sometimes have mansard roofs with symmetrical and classical details (see Chapter 12, "Classical Eclecticism").

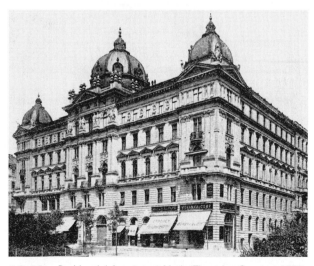

▲ 8–25. Residential Apartment Marie-Theresien Court, c. 1890; Vienna, Austria.

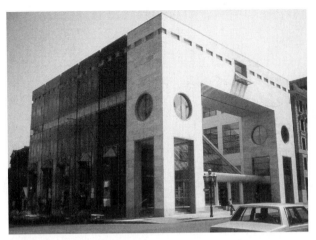

▲ **8-26.** Later Interpretation: Musée des Beaux Arts, 1991; Montreal, Quebec, Canada; Moshe Safdie.

INTERIORS

True Second Empire interiors are those created for Napoleon III in the Louvre and Tuileries. Like the first empire of Napoleon I, they are opulent, showy, and in keeping with the majestic Second Empire image. These rooms usually mix old and new furniture in Louis XIV, XV, and XVI styles as a visible tie to earlier French monarchs. Like the first empire, their grandeur often makes them cold and uninviting despite expensive materials, splendid decoration, and rich colors. And, like their predecessors, they are generally considered too grand for the rest of the world.

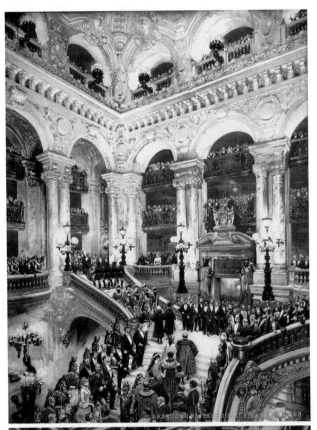

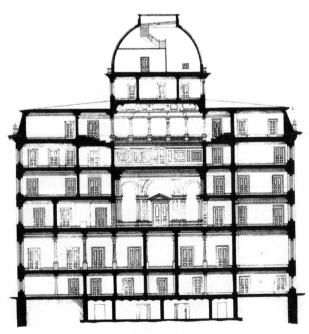

▲ **8-27.** Section, Old City Hall, 1862–1865; Boston, Massachusetts; G. J. F. Bryant. Second Empire.

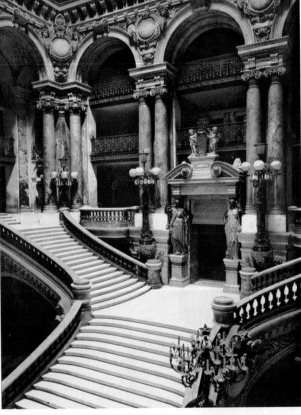

▲ **8-28.** Grand staircase and building section, Opera House, 1862–1875; Paris, France; Jean-Louis-Charles Garnier. Second Empire.

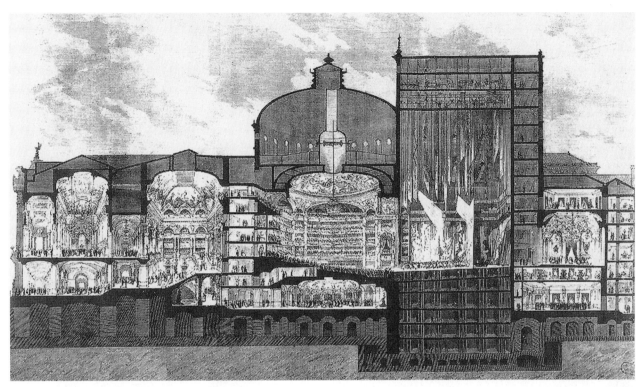

▲ **8-28.** *(continued)*

▲ **8-29.** Pennsylvania Supreme Court Chamber and City Council Caucus Room, Philadelphia City Hall, 1871–1881; Philadelphia, Pennsylvania; John MacArthur, Jr., and Thomas U. Walter. Second Empire.

In other countries, interiors in Second Empire buildings are Rococo Revival, Renaissance Revival, Gothic Revival (more rarely), or a combination. However, many public rooms feature the bold classical details, prominent chimney-pieces, and rich colors characteristic of Second Empire regardless of their architectural styles. For residences, new technology facilitates replication of the opulence, if not the elegance, of Rococo and Second Empire with plaster moldings, wallpapers, carpets, textiles, and richly carved furniture. Enormously popular in most countries, Rococo Revival

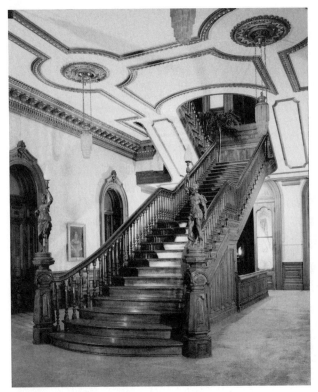

▲ **8-30.** Grand staircase, Iolani Palace, 1879–1882; Honolulu, Hawaii; T. J. Baker, C. J. Wall, and Isaac Moore. Second Empire. (Light fixtures date to c. 1920.)

▲ **8-31.** Parlor, Monmouth; c. 1818; Natchez, Mississippi. Rococo Revival.

rooms convey an image of French culture. Renaissance Revival, Rococo Revival, or Louis XVI Revival furniture fills these rooms. Despite its great public esteem, design reformers in England and North America despise Rococo Revival for its air of artificiality, fussiness, and naturalistic patterns, particularly in carpets and wallpapers. By the mid-1860s, taste for Rococo Revival declines in favor of new styles.

Public and Private Buildings

■ *Types.* No particular room types are associated with Second Empire. In contrast, Rococo Revival is the most fashionable and common style for parlors, both public and private, bedrooms, boudoirs, and ladies' retiring rooms in public buildings (Fig. 8-31, 8-32, 8-33, 8-34). The style is

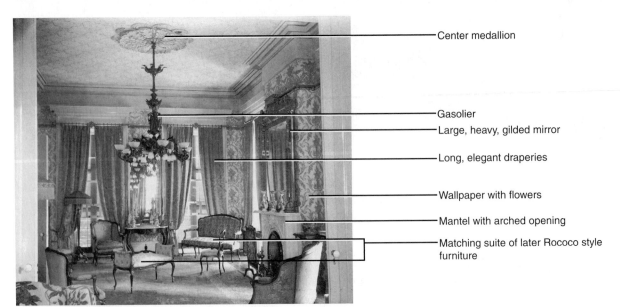

Center medallion

Gasolier
Large, heavy, gilded mirror

Long, elegant draperies

Wallpaper with flowers

Mantel with arched opening

Matching suite of later Rococo style furniture

▲ **8-32.** Parlor, Dunleith, 1847; Natchez, Mississippi. Rococo Revival.

DESIGN SPOTLIGHT

Interiors: Parlor, Colonel Robert Milligan House, c. 1853 (period room in the Brooklyn Museum); Saratoga, New York. Rococo Revival. Parlors of the 19th century are designed to impress the guests who are entertained there. The elegance and grace of the room's furnishings reflect its use by the lady of the house, who likely plans its decoration and the activities that take place there. Furnished in the latest French taste, the parlor reflects wealth and culture. From curving, gilded cornices, hang long, elegant draperies trimmed with braid and tassels. Shutters cover the windows to block the sun. Brussels carpet with flowers and scrolls covers the floor. The mantel with its arched opening is of Carrara marble. A large gold-framed mirror accents the wall above. The rosewood Rococo-style parlor set with its curving backs clearly is among the most expensive. A floral damask covers the sofa and chairs.

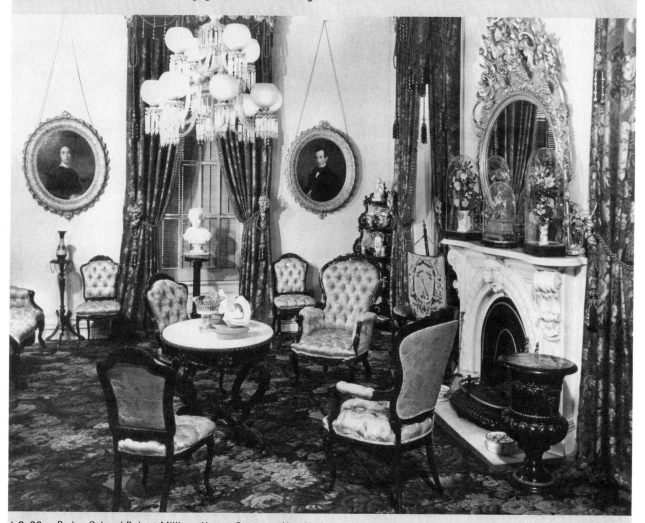

▲ **8-33.** Parlor, Colonel Robert Milligan House; Saratoga, New York.

rare in dining rooms and libraries, which are considered masculine spaces.

■ *Relationships.* Interiors in Second Empire buildings often display bold classical architectural details (Fig. 8-27, 8-28, 8-29, 8-30). Those in public buildings or homes of the wealthy have rich textures and lavish materials. Fussy, unclassical Rococo Revival interiors contrast with Greek Revival, Renaissance Revival, Italianate, and Second Empire exteriors.

■ *Color.* Second Empire adopts colors of the period, which are highly saturated and rich. Crimson, green, blue, and gold are most common. Parlors or drawing rooms may

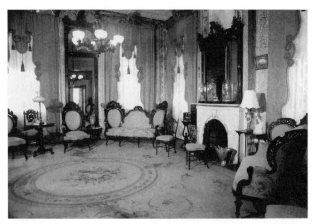

▲ **8-34.** Parlor, Lansdowne, 1853; Natchez, Mississippi. Rococo Revival.

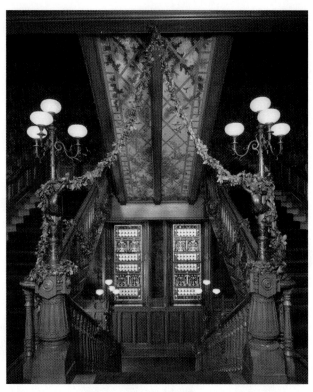

▲ **8-36.** Stair hall, Chateau-sur-Mer, 1852, remodeled 1872; Newport, Rhode Island; Richard Morris Hunt. Second Empire.

be white and gold with furniture covered in blue, red, or green.

Rococo Revival parlors before 1850, often have color schemes of white and gold, pearly white, or lavender. After 1850 and in contrast to its Rococo predecessor, colors become highly saturated blues, crimsons, greens, and golds (Fig. 8-33). Shades of red, relating to roses and the Louis XV period, are very fashionable (Fig. 8-34). Carpet, wallpaper, drapery, and upholstery have numerous colors and patterns.

■ *Lighting.* Chandeliers and candelabra in Second Empire rooms are large to suit the scale of the space and may be of polished metal or cut glass with hundreds of crystals (Fig. 8-28, 8-29, 8-36, 8-38). Candelabra sit in front of mirrors to reflect and intensify the light.

Candles, oil lamps, gas lamps, sconces, and chandeliers (Fig. 8-31, 8-32, 8-33, 8-38) have C and S scrolls, curving outlines, and naturalistic ornament. They are among the most elaborate of all styles. Lamps and candleholders often

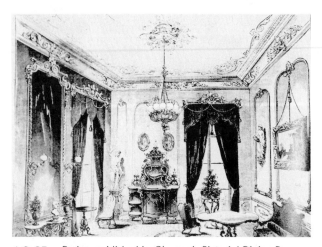

▲ **8-35.** Parlor; published in *Gleason's Pictorial Dining Room Companion*, 1854. Rococo Revival.

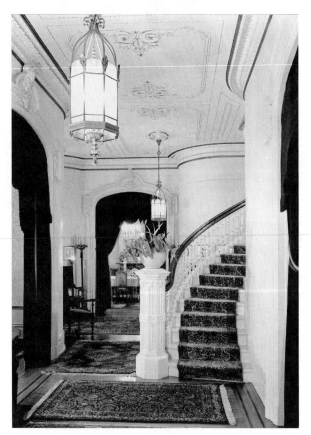

▲ **8-37.** Stair hall, Gov. Leland Stanford House, 1857–1872; Sacramento, California. Second Empire.

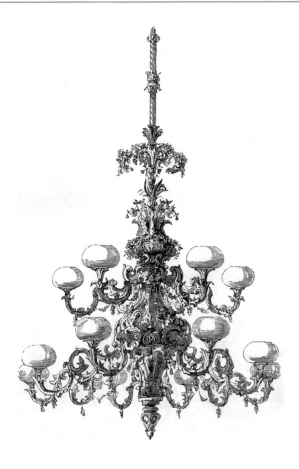

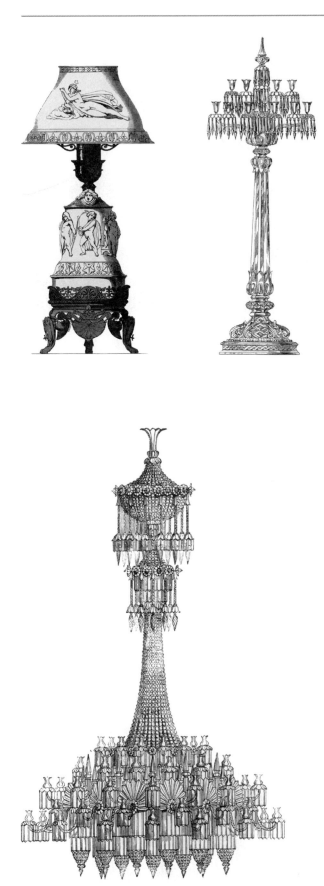

▲ **8-38.** Lighting: Lamp, candelabra, crystal chandeliers, and gasolier, mid-19th century; England and the United States.

have glass prisms to reflect light and add to the air of opulence and wealth.

■ *Floors*. Floors are marble or tiles in Second Empire public buildings and wood or parquet with rugs in residences. Both use wall-to-wall carpet in important rooms. Second Empire carpets have bold classical and other motifs in rich colors (Fig. 8-37). They often feature black, which intensifies colors, and realistically shaded flowers and foliage.

■ *Carpets*. Wall-to-wall carpets cover the floors in most Rococo Revival public and private parlors, drawing rooms, and bedrooms (Fig. 8-33, 8-41). Public buildings and wealthy homes use Brussels, Wilton, and tapestry carpets, whereas ingrains are more common in middle-class residences. Much to the distaste of design critics and reformers, the public favors patterns that are three-dimensional with naturalistically shaded flowers, foliage, ferns, and/or leaves in a profusion of colors. (Critics dislike these patterns because they believe that flat patterns are more appropriate for flat surfaces.) Some carpets used in Rococo Revival rooms have geometric patterns in red, green, black, and white.

■ *Walls*. Prominent architectural details and deep cornices typify Second Empire interiors (Fig. 8-28, 8-29). Some rooms have paneled dadoes or paneled walls. Walls may be painted or wallpapered in Renaissance or Neoclassical patterns. Second Empire rooms in Napoleon III's various palaces often have rectangular paneling. Panel

▲ **8-39.** Wallpapers: Patterns with roses (adaptation) and other various motifs; England, France, and the United States.

▲ **8-40.** Window Treatments: Single and double window draperies, and lace curtains, 1850s–1870s; England and the United States.

▲ **8-40.** *(continued)*

moldings are gilded or painted a contrasting color to the centers.

Walls in Rococo Revival interiors are treated as a single unit with no dado, unlike those of the earlier Rococo or Louis XV style that were paneled with dado, fill, and frieze. Between the cornice moldings and baseboards, walls may be painted or papered (Fig. 8-31, 8-32, 8-33). Mass-produced or hand-blocked wallpapers are nearly universal, with French papers the most highly prized. Types include fresco papers, large florals interspersed with scrolls, satin (shiny) papers, flock papers, and imitations of textiles (Fig. 8-39). Like carpet, flowers and foliage are realistically rendered and shaded.

Mantels, which are focal points in Rococo Revival rooms, are usually of white or black marble and often have curving shapes similar to those of the 18th century. However, the most common mantel form, rectangular with a shaped shelf and round arched opening, has no earlier precedent (Fig. 8-32, 8-33, 8-34). A heavy molding surrounds the opening, the center of which may feature a scroll, shell, or cartouche. The perimeter of the molding and/or face of the mantel may be carved with flowers, fruit, leaves, and/or female masks. The mantel shelf holds an array of decorative objects and candlesticks with prisms. Large, heavy gilded mirrors, which reflect the light, often accent the wall area above the mantel.

■ *Window Treatments.* Windows in Second Empire rooms have prominent surrounds and opulent layered, trimmed, and tasseled drapery. From richly molded and gilded cornices hang trimmed valances, curtains, and glass (lace) curtains (Fig. 8-40).

The typical window treatment for Rococo Revival parlors and other important rooms consists of a lambrequin with an intricate, curving shape (Fig. 8-31, 8-34, 8-35, 8-40). It hangs from a gilded cornice that is composed of scrolls. Under-curtains usually tied back, lace or muslin beneath them, and a roller blind next to the glass complete the ensemble. Trims, fringe, and tassels embellish

▲ **8-41.** Rugs: Floral rugs, mid-19th century; England and the United States.

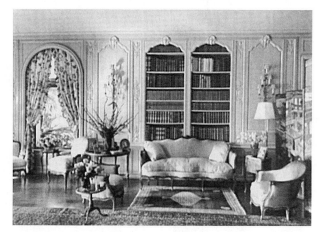

▲ **8-42.** Later Interpretation: Living room, c. 1930–1940; Palm Beach, Florida. Neo-Rococo.

lambrequins and curtains alike. Simpler treatments of panels hanging from rings are found in other rooms or lesser houses. Drapery fabrics, usually patterned, include damask, satin, brocatelle, brocade, velvet, and plush.

■ *Doors.* Doorway surrounds in both Second Empire and Rococo Revival rooms are impressive combinations of moldings with doors in dark stained or grained woods (Fig. 8-30, 8-31, 8-37). Double doors indicate important rooms. Unlike its precedent, the Rococo Revival door does not have a painting or panel with an asymmetrical frame above it.

■ *Ceilings.* Ceilings may be plain, painted, or compartmentalized in Second Empire public buildings and wealthy homes (Fig. 8-28, 8-29, 8-30, 8-36).

Most ceilings in Rococo Revival rooms are flat with a plaster rosette or medallion in the center from which a chandelier or gasolier hangs (Fig. 8-32, 8-33, 8-35, 8-38). Where wall and ceiling join are deep, cast-plaster moldings are composed of repeating designs, foliage, and/or flowers. The 18th century cove ceiling with abundant curvilinear forms and foliage repeats in some rooms.

■ *Later Interpretations.* Second Empire rooms are rarely reinterpreted. Around 1900, Rococo is again fashionable. However, rooms in this period assume a more authentic appearance with curvilinear paneling in white and gold or pastels, area rugs in curving floral patterns, Rococo-style furniture, and fewer accessories. Popularized by fashionable interior decorators, Rococo decoration continues with some accuracy into the 1930s (Fig. 8-42). In the late 20th century, along with the popular trend of renovating old homes, modern adaptations of Rococo Revival interiors appear again. The overall design represents a more or less authentic character. Rooms are generally less fussy with fewer curvilinear patterns, furniture, and decorative objects than the originals. Modern interpretations have much more natural and artificial light than the originals (see Chapter 30, "Modern Historicism").

FURNISHINGS AND DECORATIVE ARTS

Like its prototype, Rococo Revival furniture has a curving silhouette, cabriole legs, and naturalistic ornament, but in contrast to its predecessor, it is larger and heavier with symmetrical, carved decoration and pierced work. With coil springs for comfort, upholstery is sumptuous. The revival style introduces furniture that is unknown in the 18th century, such as the *étagère* or *tête-à-tête*.

Rococo Revival in the United States is more flamboyant and embellished than in Europe. American cabinetmakers develop new methods for shaping wood for backs and beds. Designers and manufacturers find that Rococo Revival is infinitely adaptable, suiting many tastes and price ranges. Expensive furniture is made of costly wood and has abundant carving, often executed by hand. Cheaper furniture resembles the expensive, but is simpler in shape, often machine produced, and made of inexpensive woods with less carving.

Public and Private Buildings

■ *Types.* Because Rococo Revival is highly recommended for parlors and bedrooms, parlor sets and bedroom suites are typical; dining tables and sideboards are less common (Fig. 8-32, 8-33, 8-34, 8-45). New to the period are balloon-back chairs and the *tête-à-tête* (Fig. 8-46). An important status symbol in every parlor is the *étagère*. It displays accessories and decorative objects that are most often carefully selected by the lady of the house to portray her family's taste and culture.

■ *Distinctive Features.* Curves, C and S scrolls, cabriole legs, and carved, naturalistic ornament distinguish Rococo Revival from other styles (Fig. 8-43, 8-45, 8-47). Particularly

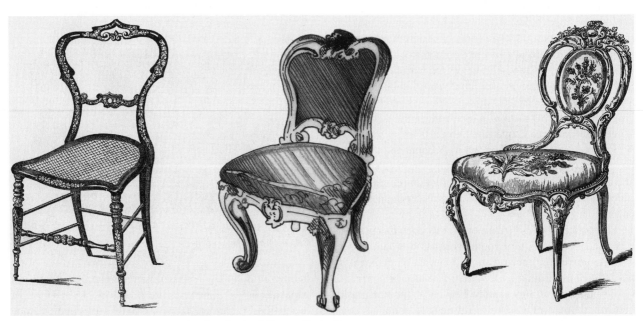

▲ **8-43.** Parlor chairs, 1830s–1850s; London, England. Rococo Revival.

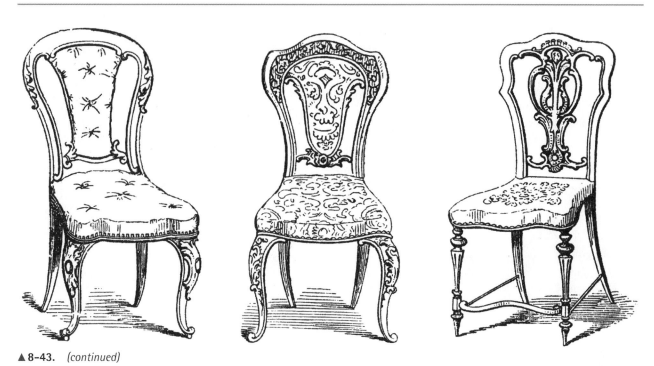

▲ **8-43.** *(continued)*

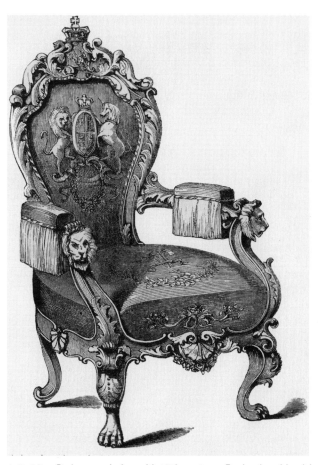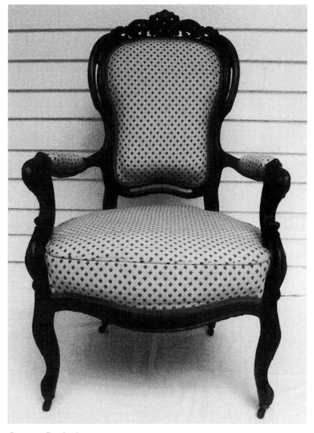

▲ **8-44.** Parlor armchairs, mid-19th century; England and Louisiana. Rococo Revival.

DESIGN SPOTLIGHT

Furniture: Parlor chair, parlor suite, and center table, c. 1850s–1860s; New York; John Henry Belter. These furniture pieces represent examples found in a typical Rococo Revival parlor suite consisting of a sofa, two armchairs, two side chairs, a *tête-à-tête*, and often a table. John Henry Belter, a German immigrant, perfects a method of bending laminated wood that allows it to be curved in shape and carved and pierced, as on these examples. The chair, like its 18th-century predecessor, has cabriole legs and a wooden frame composed of C and S scrolls. The resemblance ends with the heavy scale, reverse cabriole rear legs, and the profuse carving and piercing of roses, flowers, leaves, and scrolls. The upholstery is a reproduction of a blue and gold brocatelle from the mid 19th century. Belter's furniture adorns the homes of America's wealthiest families.

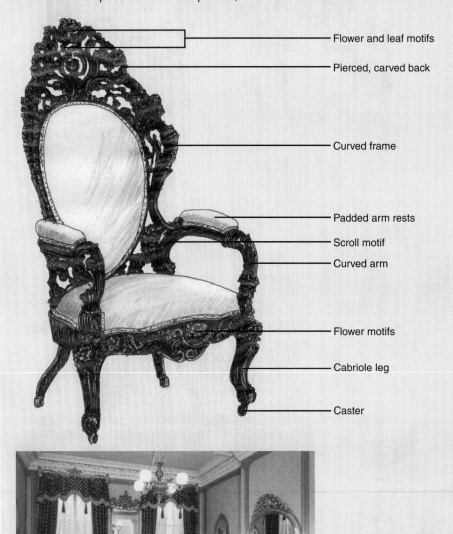

- Flower and leaf motifs
- Pierced, carved back
- Curved frame
- Padded arm rests
- Scroll motif
- Curved arm
- Flower motifs
- Cabriole leg
- Caster

◀**8-45.** Parlor chair, parlor suite, and center table, c. 1850s–1860s; New York.

characteristic of chairs is the English balloon-back or wasp-waist, which is composed of a single curve that flares out at the top and tapers inward near the seat (Fig. 8-43). Curving and carved silhouettes are complicated, often flamboyant.

■ *Relationships.* Furniture migrates outward from its earlier position lining the walls and, in contrast to earlier times, remains there when not in use. The center table in nearly every parlor and family drawing room displays prized family books or decorative objects and is a gathering place for the family and guests (Fig. 8-33, 8-47). Sofas sometimes flank the fireplace or the center table.

■ *Materials.* Dark woods are characteristic. Costly pieces are of rosewood and mahogany, while other furniture is of walnut or maple. In the most expensive rosewood furniture, the grain emphasizes the sense of movement. Veneers are used often. In America, cabinetmakers apply veneers of costly woods to laminated backs, the tops of which may be carved, pierced, or have applied ornament. Wood furniture has a high-gloss finish known as French polish. English and French furniture has gilding, ormolu, or porcelain plaques unlike in the United States.

▲ **8-46.** *Tête-à-tête* in black walnut; exhibited at the Crystal Palace Exhibition in 1851; manufactured in Montreal by J & W Hilton. Rococo Revival.

New to the period is papier-mâché furniture (see Chapter 1, "Industrial Revolution"). Although papier-mâché has been known in Europe since the 17th century, the manufacturing process improves in the late 1830s. Thus, it becomes suitable for furniture, although structural parts are made of wood or metal. Papier-mâché furniture, which enjoys great popularity in Great Britain, is often lacquered or japanned in black with painted decoration or mother-of-pearl inlay.

Elaborate upholstery supports the cultural vision of comfort and expensiveness. Particularly suited to Rococo Revival is the typical deep tufting in diamond or star patterns that characterizes both seats and backs (Fig. 8-33, 8-46). Tufting, piping, and puffing add visual complexity and enhance the prized expensive look. More and deeper tufts indicate a more expensive piece. Long, heavy bullion fringe may adorn the skirt, and tassels may decorate the back.

■ *Seating.* Parlor sets have a sofa; a gentleman's chair that is larger, more throne-like; a smaller lady's chair with a wider seat; and three or more wall or side chairs (Fig. 8-33, 8-43, 8-44, 8-45). Rococo-style chairs take many forms. Most have balloon backs, are usually upholstered, and feature cabriole legs ending in a whorl foot or cone (Fig. 8-43). Some dining or parlor chairs have a wooden back with a splat or cross rail. Dining chairs sometimes have turned legs. All back legs are reverse cabrioles, and most have casters to facilitate moving.

Sofa backs have three forms: triple arches, serpentine, and double or tripartite backs composed of three separate curvilinear medallions (Fig. 8-31, 8-32, 8-34, 8-45). The most fashionable Rococo Revival parlors have a *tête-à-tête* (Fig. 8-46) and a *méridienne*. The pouf or *pouffe*, a stool with deeply tufted coil spring upholstery, is introduced from France about 1830.

The most ornate and expensive chairs and sofas have laminated backs that curve in two planes with hand-carved, pierced flowers, fruit, birds, and foliage along the back edges and forming the crest. Like the prototype, seat

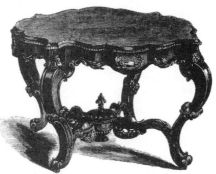
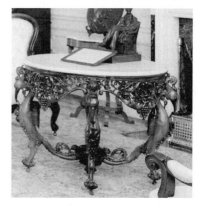

▲ **8-47.** Tables with marble and wood tops; mid-19th century. Rococo Revival.

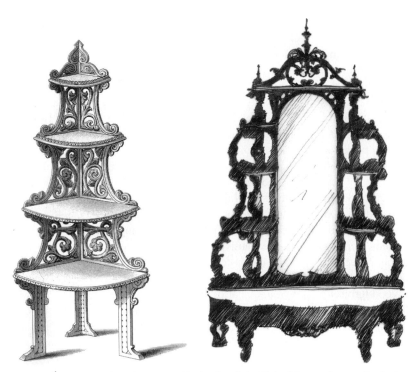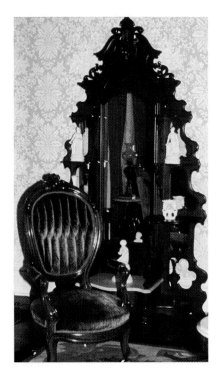

▲ **8-48.** *Étagères*, mid-19th century; England and the United States. Rococo Revival.

and back rails undulate, and knees of cabriole legs are heavily carved. John Henry Belter of New York City, one of the best known cabinetmakers of the period, creates parlor sets with lavish carving, laminated veneer surfaces, and complicated, curving forms (Fig. 8-45). His costly furniture is highly prized and often imitated.

■ *Tables.* Convoluted shapes and lavishly carved naturalistic motifs are common on expensive tables, whereas cheaper ones have undulating shapes and less profuse carving. Center tables are oval, round, or oblong in shape with marble tops and heavily carved aprons with Rococo Revival motifs (Fig. 8-33, 8-47). Many have four cabriole legs that are joined by arched, curving stretchers with a finial in the center. Instead of a single curve, legs may be composed of several C or S scrolls. In contrast to their 18th-century prototypes, consoles often have four legs instead of two and may be joined to a monumental pier glass with carved embellishment. Like other tables, consoles usually have shaped marble tops and heavily carved aprons.

■ *Storage.* The *étagère* features a complex curvilinear outline, pierced and solid carving, shelves, mirrored back, and marble top (Fig. 8-31, 8-48). As a showy focal point for the parlor, it displays all available contemporary techniques for ornamentation. The dresser, usually serpentine or kidney shaped, has three to four large drawers surmounted by a marble or wood top with small drawers or shelves, above which is attached a tall mirror with carved crests. Moldings outline the drawers, and, on expensive pieces, drawer pulls

are hand-carved flowers, fruit, or leaves. Chests of drawers are similar in form and decoration to dressers.

■ *Beds.* Rococo Revival beds have tall headboards, low footboards, and rounded ends (Fig. 8-49). Footboards on very expensive beds undulate. Carving of flowers, leaves, and foliage adorns head- and footboards. Some beds have half or full testers with hangings. The underside of the canopy is upholstered in complicated patterns. In warm climates in the United States, lightweight mosquito netting hangs around the perimeter of the canopy for protection. The use of bed drapery declines during the period because people begin to regard it as unhealthy. In addition, central heating is more prevalent, so hangings are no longer needed for warmth or protection from drafts. Bedroom suites include the bed, night table, dresser, gentleman's chest, and washstand. Less common pieces are a shaving stand, towel rack, and wardrobe.

■ *Upholstery.* Textiles in a variety of patterns characterize Rococo Revival furniture. Some pieces are upholstered in two different fabrics: one covers the inside arms, back, and seat; another covers the outside of the back and arms. Typical textiles for upholstery include damask, velvet or plush, brocatelle, satin, silk, and horsehair (Fig. 8-33, 8-44, 8-46). Common patterns have naturalistic flowers, birds, fruit, and foliage in scrolling surrounds or foliage only. Flowers and leaves usually are realistically shaded. Sometimes Renaissance or Gothic-style patterns, especially when combined with flowers or scrolls, appear in Rococo Revival rooms and on furniture. Interiors are filled with doilies,

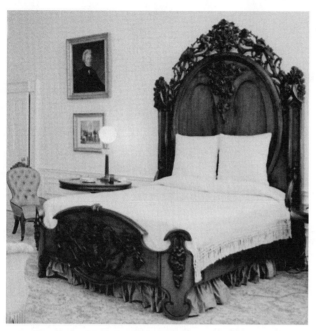

▲ **8-49.** Bed, mid-19th century; United States. Rococo Revival.

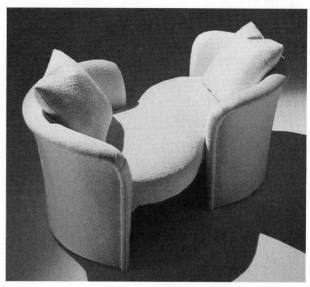

▲ **8-50.** Later Interpretation: *Tête-à-tête*, 2004; manufactured by Thayer Coggin, High Point, North Carolina. Modern Historicism.

antimacassars, mantel and shelf lambrequins, lamp mats, and table covers made by the ladies of the house. Embroidery often embellishes smaller chairs and ottomans. Cotton or chintz in floral patterns covers furniture and hangs at windows in summer.

■ *Decorative Arts*. Rococo Revival interiors have many accessories. Sitting on mantels or shelves of the *étagère* are Parian ware busts, allegorical figures, and classical sculpture; porcelain figurines and vases with curving forms and embellishment; boxes; jars; clocks; candlesticks; and girandoles (Fig. 8-33). Vases or dried flowers under tall glass domes highlight consoles and tabletops. Numerous etchings, engravings, lithographs, chromolithographs, and/or paintings hang on walls suspended by decorative

ropes from picture moldings below the cornice. Large mirrors with carved and gilded frames hang over the mantel and on the piers between windows (Fig. 8-31, 8-32, 8-33, 8-34). Many parlors have a stereopticon to examine views (images) of unusual scenes or exotic lands. Decorative screens, plants, and flowers fill corners.

■ *Later Interpretations*. In the late 19th century, Rococo furniture is again fashionable. As with interiors, examples more closely follow the18th-century predecessors. Cheaper adaptations appear in mail-order catalogues. In the second half of the 20th century, Victorian Rococo furniture revives in simpler form and may appear as an inexpensive suite of furniture with traditional upholstery or as a single chair or sofa covered in an updated textile. In the early 21st century, various manufacturers experiment with old forms in new designs, some created with connecting parts (Fig. 8-50).

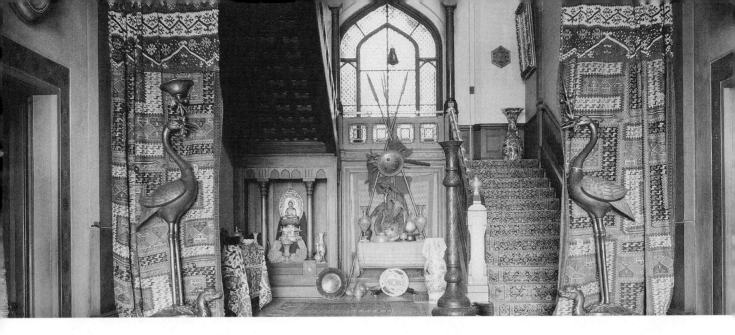

CHAPTER 9

Exoticism

1830s–1920s

Inspired by revivalism, eclecticism, and a quest for novelty in the second half of the 19th century, Exoticism looks to non-Western cultures for inspiration and borrows their forms, colors, and motifs. International expositions, books, periodicals, travel, and advances in technology acquaint Europeans and Americans with other cultures while creating a romantic image of faraway lands and people. Egyptian Revival, Moorish or Islamic, Turkish, and Indian join, yet never completely surpass other fashionable styles.

In this room Messrs. Louis C. Tiffany and Co. have made an elaborate attempt to assimilate the Moresque idea to modern requirements, and no expense has been spared to attain the most prefect result in every respect, even the grand piano being made to assume a Moresque garb. . . . The fireplace is lined with old Persian tile in blue, blue-greens, and dark purplish-red on a white ground, making a valuable sensation in the surrounding opal tile, of which the hearth is composed. . . . All the woodwork above [the floor] is executed in white holly, the panels in which are filled with various incrustations of stucco in delicate Moresque patterns re-enforced with pale tints, gold, and silver. Such portions of the walls as are not otherwise occupied are covered with stamped cut and uncut velvet on satin ground, in tones of pale buff, red, and blue. . . . The furniture is all of white holly, carved, turned, and inlaid with mother-of-pearl, making rich effects with the olive plush coverings embroidered in cream and gold-colored floss.

A. F. Oakley, *Harper's New Monthly Magazine*, April 1882, describing the salon in the George Kemp House, New York City

HISTORICAL AND SOCIAL

By the middle of the 19th century, Europeans and Americans (Fig. 9-1) begin to lose interest in the prevailing styles, such as Greek Revival and Gothic Revival. Their desire for new and novel styles opens the door for exotic influences. At the same time, designers are looking for new sources of inspiration apart from the rampant historicism. Eclecticism, a dominant force in design during the time, encourages the exploration and appreciation of the architecture and decorative arts of other cultures. Although exotic-style public and private buildings, interiors, and furnishings appear in both Europe and North America, they are not overridingly popular.

Exotic influences are not new in Europe or even North America because they have been present in varying degrees since the Middle Ages. What is new is the widespread fascination, arising from art, travel, literature (such as guidebooks, novels, and travelogues), international expositions, trade with other countries, colonialism (particularly in France and England). Equally important are archaeology, scholarship, and publications, which increase interest in and create design resources for exotic

cultures. This intense scrutiny engenders myths about the lives, people, customs, architecture, and objects in other countries. Exotic styles arise mainly from the Egyptian and Islamic cultures, which have centuries of artistic traditions that are largely unknown to Westerners until the 19th century.

■ *Egyptian Revival.* The art and architecture of ancient Egypt project a timeless, formal, and ordered appearance arising from a hierarchal society immersed in religion. The most significant structures—pyramids, tombs, and temples—are associated with spirituality, death, and rebirth. Noteworthy introductions include the column, capital, pylon, and obelisk. Egyptians are known for achievements in medicine, astronomy, and geometry.

Characteristics of Egyptian architecture appear in and influence art and architecture as early as classical antiquity and continue in varying degrees through the Renaissance, the Baroque, and into the 18th century. In the middle of the 18th century, some interest in Egypt arises following Giovanni Battista Piranesi's creation and publication of Egyptian style interiors in the Caffeè degli Inglese (English Coffee House) in Rome and his prints of Egyptian style details. At the same time, Neoclassical architects, influenced by French theories, adopt the forms, geometric volumes, and some details of Egyptian architecture to express clarity, severity, and integrity. Subsequent interest in Egyptian art and architecture usually corresponds to events that bring attention to it.

The earliest widespread adoption of Egyptian forms and motifs in architecture and the decorative arts begins following Napoleon's conquest of Egypt in 1798–1799. Napoleon's scientists, cartographers, engineers, and artists study and record tombs, temples, and other buildings, and the newly established Insitut d'Egypte examines all aspects of Egyptian civilization. These sources provide a wealth of information about Egypt, ancient and modern, and acquaint people with the land, about which little is known in the West. A few Egyptian-style buildings and interiors occur, and Egyptian details are applied to furniture.

A larger Egyptian Revival begins at midcentury aided by new technology, which makes emulation of ancient artifacts easier, faster, and more practical. Knowledge of Egyptian and other cultures increases through developments in communications that make the world seem smaller and allow almost anyone to visit faraway lands through photographs and stereo views. Museums and individuals collect and exhibit artifacts unearthed in numerous archaeological sites, further acquainting and stirring more interest. The successful Egyptian Court at the Crystal Palace Exhibition of 1851 leads to similar displays at later expositions. Egypt even finds a place in the design reform movements of the mid-19th century as the adherents admire the stylized forms of its ornament and sturdy and honest construction of its furniture.

A new wave of Egyptian Revival begins in the 1870s, inspired by the opening of the Suez Canal in 1869, Giuseppe Verdi's opera *Aida* of 1871 with its colorful Egyptian-style sets, and the installation of Egyptian obelisks in London in 1878 and New York's Central Park in 1879. The revival continues until the end of the 19th century when interest begins to wane, although use of Egyptian forms and motifs never completely ceases. In 1922, the discovery of the tomb of Tutankhamen immediately stirs renewed interest in and emulation of ancient Egypt.

■ *Turkish, Arab, Saracenic, or Moorish and Indian Styles.* Like Egypt, religion is a significant influence on Islamic art and architecture. The design traditions of its various peoples and the aesthetic sensibilities of its artists and builders contribute to its unique form and decoration. Common to all arts are dense, flat patterns composed of geometric forms and curving tendrils, which dematerialize form and create visual complexity. Also unique is calligraphy that is integrated into decoration of nearly all objects and structures.

Europeans are somewhat acquainted with Turkey, Persia, Syria, Morocco, Moorish Spain, and India before the mid-19th century. In the 1830s, a religious revival in England focuses attention on Palestine where Christ had lived. Painters, artists, and architects go to the Middle East to study, paint, and sketch. Upon their return, many publish their work. Design reformers admire the intricate, stylized, and colorful designs and motifs of the Middle East and promote them in their work and publications. Panoramas, a popular form of entertainment; photographs; travel books; and stereo views depict Cairo, Jerusalem, Paestum, Karnak, and Pompeii along with other exotic sights.

◄ 9-1. Woman's costume showing paisley underskirt; published in Bloomingdale's catalog, 1886.

Like Egyptian Revival, expositions acquaint people with the Islamic art and decoration. The Alhambra Court at the Crystal Palace Exhibition of 1851 is also very successful as is a smaller version in the New Crystal Palace four years later in London. Both are important models for designers. At the Centennial International Exposition of 1876 in Philadelphia, several buildings are Islamic in form if not visual character. Turkish bazaars, cafés, and entertainment pavilions at successive expositions provide places for shopping, eating, and amusement. Not to be outdone, department stores and warehouses, such as Macy's in New York and Liberty's in London, import goods from the Middle East and display them in bazaars or use them in tearooms throughout the 1870s and 1880s. This inspires a domestic craze for Turkish or Cozy corners.

Closely aligned with the Turkish, Moorish, Saracenic or Arab (as it is called) in Britain is the Indian or Mogul style, a Victorian interpretation of Indian art and life. The English colonists and military returning home bring ideas, architecture, and objects from India, an important British possession. India also exports many goods to the mother country. Displays of Indian wares are well attended at the Crystal Palace Exhibition of 1851. The style is limited to a few examples in Great Britain.

CONCEPTS

Fascination with non-Western cultures gives rise to Egyptian Revival, Turkish or Islamic styles, and the Indian or Mogul style with various intensities throughout the 19th century and into the 20th. Common among them is the adaptation of characteristics of the cultures to Western tastes and needs. By the mid-19th century, associations and symbolism strongly influence stylistic choices and the visual image. Each style is associated with particular building types, rooms, and furniture, and conveys a particular image, such as timelessness, monumentality, or a touch of the exotic in an otherwise ordinary Victorian house.

DESIGN CHARACTERISTICS

Non-Western cultures during the 19th and early 20th centuries inspire several Exotic revivals, including Egyptian Revival and Turkish or Moorish Revival. Each is an assemblage of motifs applied to contemporary forms. Few, if any, attempts are made to live as other cultures do because associations and evoking an image are more important. The forms and motifs of the culture define the style.

■ *Egyptian Revival.* Although Egyptian forms and motifs appear in architecture beginning in antiquity, the first conscious revival occurs about 1810. Egyptian Revival architecture adopts the monumentality, simplicity, column forms, battered sides, and other architectural details and motifs of the surviving buildings of ancient Egypt. The small number of examples is limited to a few buildings types. Interiors, furniture, and decorative arts adopt the details and motifs more than the forms of Egyptian architecture. Eclecticism is characteristic in interiors and furniture. Most often, Egyptian details are applied to contemporary forms, but in the second half of the 19th century, Egyptian chairs and stools are copied.

■ *Turkish, Arab, Saracenic, Moorish, and Indian Styles.* Often evident in these styles are the architectural details and complex layered ornament of Islamic art and architecture. European and American designers sometimes strive to use forms and motifs more correctly, although still copying and reinterpreting them. Access to more information enables them to develop greater archaeological correctness. In architecture, fully Turkish or Moorish expressions are extremely rare, but many buildings display some architectural details. Similarly, interiors also have Moorish architectural details combined with other styles. Mostly limited to particular types, such as smoking rooms, interiors may be filled with rugs, furniture, and decorative arts from the Middle East as well as Western interpretations. Overstuffed, deeply tufted upholstery is the most common example of Turkish-style furniture.

■ *Motifs.* Characteristic motifs are geometric forms typical of Egyptian architecture, columns and other architectural details, as well as real and fake hieroglyphs, scarabs, Egyptian figures or heads, Egyptian gods and goddesses, lotus, papyrus, crocodiles, cobra, sphinxes, and sun disk (Fig. 9-2, 9-4, 9-5, 9-6, 9-7, 9-19, 9-23, 9-24, 9-41). Islamic or Turkish motifs include onion domes, minarets, lattice, horseshoe arches, multifoil arches, ogee arches, peacocks, carnations, vases, arabesques, and flat and intricate patterns (Fig. 9-2, 9-3, 9-13, 9-17, 9-20, 9-25, 9-34).

IMPORTANT TREATISES

■ *L'art arabe d'après les monuments du Caire,* 1869; Emile Prisse d'Avennes.

■ *Atlas de l'histoire de l'art égyptien,* 1870; Emile Prisse d'Avennes.

■ *Domestic Architecture,* 1841; Richard Brown.

■ *Grammar of Ornament,* 1856; Owen Jones.

■ *Manners and Customs of the Ancient Egyptians,* 1837; John Gardner Wilkinson.

■ *Plans, Elevations, Sections and Details of the Alhambra,* 1824–1825; Owen Jones.

■ *Voyage dans la basse et la haute égypte,* 1802; Baron de Denon.

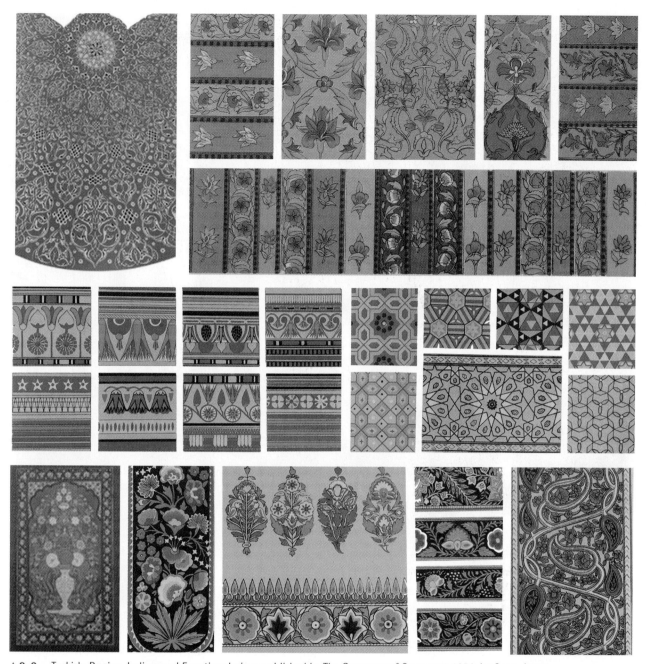

▲ **9-2.** Turkish, Persian, Indian, and Egyptian designs published in *The Grammar of Ornament*, 1856, by Owen Jones.

ARCHITECTURE

Examples of Exoticism in architecture are uncommon when compared to other styles. Rare in residences, designers apply exotic styles to particular public building types. In the 19th century, the idea that a building's design should convey its purpose governs stylistic choices, making certain styles appropriate for particular types of buildings. Symbolism, acknowledged through form and motifs, is an important design context and characteristic. Thus, the ancient Egyptians' strong belief in life after death makes their art and architecture appropriate for cemeteries and funerary buildings. Themes of justice, solidity, and security give rise to Egyptian Revival courthouses and prisons. The perceived superior knowledge of the ancient Egyptians deems the style appropriate for libraries and centers of learning. Medical buildings often feature the style because of the 19th century's belief in Egypt's advanced medical knowledge and practices. Freemasons, secret societies, and fraternal lodges see Egypt's mysterious image and wisdom as ample reason for choosing its style. For bridges and train stations, Egyptian Revival symbolizes advancements in technology. Less obvious is the choice of Egyptian Revival for churches and synagogues.

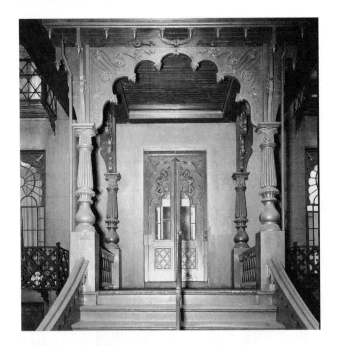

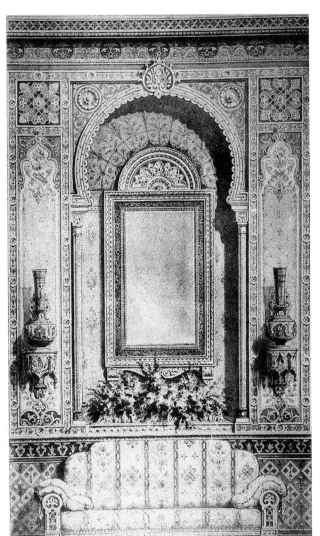

▲ 9-3. Porch, wall elevation, and door detail, mid-19th century. Islamic influence.

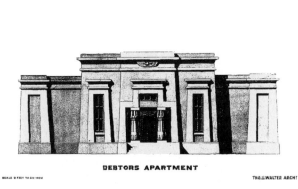

DEBTORS APARTMENT

SCALE 9 FEET TO AN INCH THO.U.WALTER ARCHT

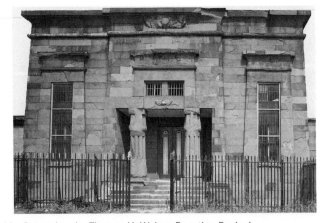

▲ 9-4. Philadelphia County Prison, Debtors' Wing, 1836; Philadelphia, Pennsylvania; Thomas U. Walter. Egyptian Revival.

IMPORTANT BUILDINGS AND INTERIORS

■ **Antwerp, Belgium:**

—Elephant Pavilion, Antwerp Zoo, 1855–1856; Charles Servais. Egyptian Revival.

■ **Atlanta, Georgia:**

—Yaarab Temple Shrine Mosque (Fox Theater), 1927–1929; Marye, Alger, and Vinour. Islamic Revival.

■ **Boise, Idaho:**

—Ada Theater, 1926; Frederick C. Hummel. Egyptian Revival.

■ **Cincinnati, Ohio:**

—Isaac M. Wise Temple, 1866; James K. Wilson. Turkish/Exotic Revival.

■ **Devonport, England:**

—Egyptian Library, 1823; John Foulston. Egyptian Revival.

■ **Glasgow, Scotland:**

—Templeton's Carpet Factory, 1889–1892. Exotic/Byzantine Revival.

■ **Hudson, New York:**

—Olana, 1870–1872 house, 1888–1891 studio wing; Frederic E. Church, consulting architect Calvert Vaux. Exotic/Moorish Revival.

■ **Leeds, England:**

—Temple Mill, 1842; Joseph Bonomi, Jr. Egyptian Revival.

■ **London, England:**

—Arab Hall, Lord Leighton House, c. 1865; George Aitchison. Exotic/Islamic Revival.

—The Egyptian Hall, Piccadilly, 1812; P. F. Robinson. Egyptian Revival.

■ **Los Angeles, California:**

—Egyptian Theater, 1922; Meyer and Holler. Egyptian Revival.

—Los Angeles Public Library, 1922–1926; Bertram G. Goodhue and Carlton M. Winslow. Egyptian/Islamic Revival.

—Sampson Tyre and Rubber Company Building, 1929; Morgan, Walls, and Clements. Exotic.

■ **Mitchell, South Dakota:**

—Corn Palace, 1921; Rapp and Rapp. Turkish/Exotic Revival.

■ **Nashville, Tennessee:**

—First Presbyterian Church, 1848–1851; William Strickland. Egyptian Revival.

■ **New Haven, Connecticut:**

—Grove Street Cemetery Entrance, 1845; Henry Austin. Egyptian Revival.

—Willis Bristol House, 1846; Henry Austin. Exotic/Islamic Revival.

■ **New York City, New York:**

—New York City Halls of Justice and House of Detention (The Tombs), 1835–1838; John Haviland. Egyptian Revival.

■ **Paris, France:**

—Palais de Justice, 1857–1868; Joseph-Louis Duc. Egyptian Revival.

■ **Philadelphia, Pennsylvania:**

—Pennsylvania Academy of Fine Arts, 1871–1876; Frank Furness and George W. Hewitt. Exotic Revival.

—Pennsylvania Fire Insurance Company, c. 1839, John Haviland, and 1902, Theophilus Parsons Chandler, Jr. Egyptian Revival.

—Philadelphia County Prison, Debtors' Wing, 1836; Thomas U. Walter. Egyptian Revival.

■ **Richmond, Virginia:**

—Egyptian Building, Medical College of Virginia (now a part of Virginia Commonwealth University), 1844–1845; Thomas S. Stewart. Egyptian Revival.

—Millhiser House, 1891–1894; William M. Poindexter. Turkish/Exotic Revival.

■ **Sag Harbor, Long Island, New York:**

—First Presbyterian Church, 1843–1844; to the design of Minard LaFever. Egyptian Revival.

■ **San Francisco, California:**

—Fine Arts Building, California Midwinter International Exposition, 1894. Egyptian Revival.

—Hindu Society, late 19th century. Turkish/Exotic Revival.

■ **Santa Fe, New Mexico:**

—Scottish Rite Cathedral, c. 1912; C. H. Martindale. Moorish Revival.

■ **Washington, D.C.:**

—Washington Monument, 1833 (designed), 1848–1884 (built); Robert Mills. Egyptian Revival.

Architecture: New York City Halls of Justice and House of Detention (The Tombs), 1835–1838; New York City, New York; John Haviland. Egyptian Revival. This building is one of the most significant Egyptian Revival structures in the United States. The attributes and visual characteristics of ancient Egyptian buildings are intended to convey security, monumentality, terror, and the misery awaiting those to be incarcerated there. Reminiscent of the massive gateways at the entrances of Egyptian tombs, the façade emphasizes symmetry, volume, simple geometric forms, and minimal ornament. Two wings with battered walls and a center entrance portico carried by Egyptian-style columns compose the facade. Slanted moldings carrying a lintel form the window surrounds. A plain or half-circle molding emphasizes the corners and the cavetto cornice that caps the composition. Haviland derives the architectural vocabulary from several scholarly books on ancient Egypt that he owns. The building also is a model prison for its day, incorporating fireproofing, natural light and air, sanitary facilities, a hospital, and individual cells for inmates.

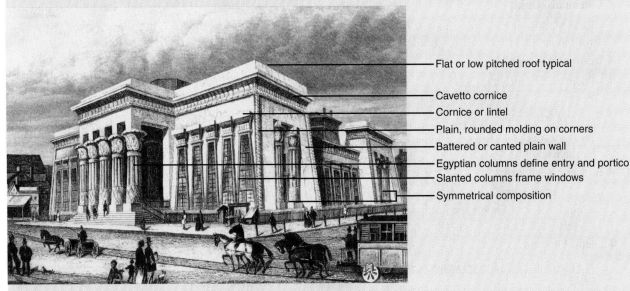

Flat or low pitched roof typical
Cavetto cornice
Cornice or lintel
Plain, rounded molding on corners
Battered or canted plain wall
Egyptian columns define entry and portico
Slanted columns frame windows
Symmetrical composition

▲ **9-5.** New York City Halls of Justice and House of Detention (The Tombs); New York City.

Architects rarely try to re-create authentic Egyptian or Middle Eastern buildings, preferring instead to apply forms and motifs to contemporary forms. These details may mix with other styles. The belief that Egypt influences Greece prompts Egyptian details in Greek Revival. Islamic patterns sometimes mix with Gothic Revival in the work of some designers, such as William Burges, and the Queen Anne style in the late 19th century.

Never achieving a full revival, Turkish or Moorish details may define homes and a wide range of public buildings from the 1860s onward. Picturesque, hedonistic, and erotic allusions limit the Turkish context for use to those building types possessing romantic ideals, some tie to the Middle East, amusement, or entertainment.

Public and Private Buildings

■ *Types*. Appropriate building types for Egyptian Revival include cemetery gates and other funerary structures, prisons, courthouses, commercial buildings, fraternal lodges, and occasionally a church or train station (Fig. 9-4, 9-5, 9-6, 9-7, 9-8, 9-9). In the early 20th century, Egyptian movie theaters are common (Fig. 9-15). Entire houses in the Egyptian style are rare, but Egyptian details such as columns or slanted window surrounds combine with other styles. Turkish or Moorish defines a variety of building types, including synagogues, fraternal temples, pubs, clubs, theaters, music halls, and a few commercial buildings (Fig. 9-11, 9-12). Moorish-style houses (Fig. 9-17) are exceedingly eclectic with elements from several styles applied to contemporary forms.

■ *Site Orientation*. No particular site orientation is associated with exotic buildings. Designers do not re-create the processional entrances to Egyptian temples.

■ *Floor Plans*. There is no typical Egyptian Revival or Turkish floor plan. Designers do not re-create accurate floor plans of any exotic style, but instead develop the plan from function or an attribute such as symmetry.

■ *Materials*. Materials include stone, brick, or wood, particularly in America. Brick may be stuccoed to render the

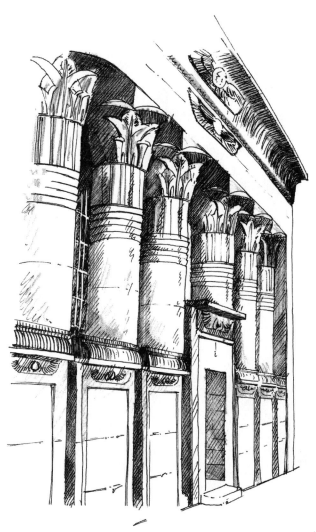

▲ **9-6.** Temple Mill, 1842; Leeds, England; Joseph Bonomi, Jr. Egyptian Revival.

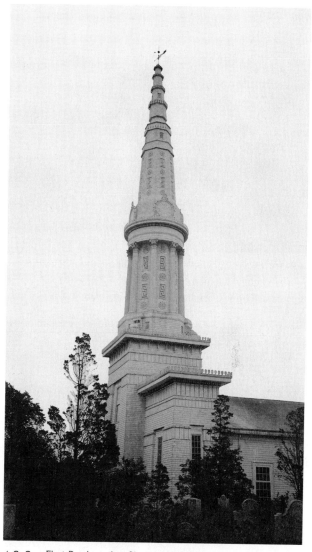

▲ **9-8.** First Presbyterian Church, 1843–1844; Sag Harbor, Long Island, New York; to the design of Minard LaFever. Egyptian Revival.

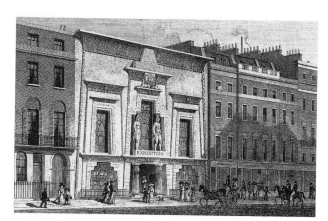

▲ **9-7.** Egyptian Hall, c. 1840s; Picadilly, London, England. Egyptian Revival.

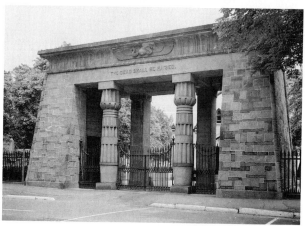

▲ **9-9.** Grove Street Cemetery Entrance, 1845; New Haven, Connecticut; Henry Austin. Egyptian Revival.

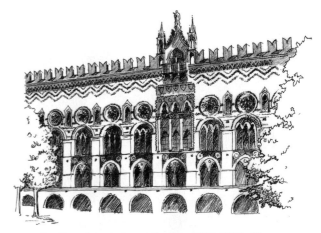

▲ **9-12.** Templeton's Carpet Factory, 1889–1892; Glasgow, Scotland. Byzantine and Exotic Revival.

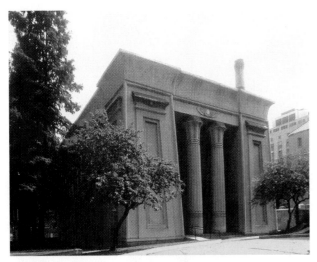

▲ **9-10.** Egyptian Building, Medical College of Virginia (now a part of Virginia Commonwealth University), 1844–1845; Richmond, Virginia; Thomas S. Stewart. Egyptian Revival.

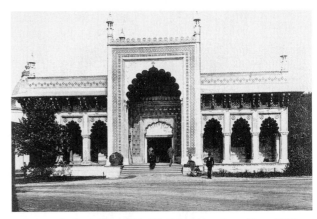

▲ **9-13.** India Building, World's Columbian Exposition, 1893; Chicago, Illinois; construction by Henry Ives Cobb.

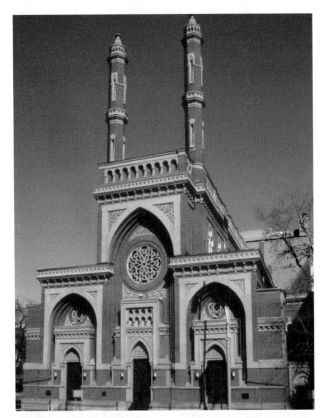

▲ **9-11.** Isaac M. Wise Temple, 1866; Cincinnati, Ohio; James K. Wilson. Turkish/Exotic Revival.

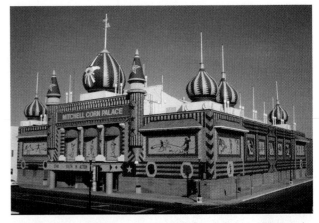

▲ **9-14.** Corn Palace, 1921; Mitchell, South Dakota; Rapp and Rapp. Turkish/Exotic Revival.

smooth walls desirable in Egyptian Revival. Details such as columns or domes may be in cast iron, terra-cotta, or ceramic tiles. Turkish or Moorish structures have brightly colored tiles, details, and intricate patterning composed of stars, flowers, or arabesques (Fig. 9-17). Common colors include neutrals, blues, turquoises, greens, purples, oranges, and reds.

■ *Façades.* Façades reveal Egyptian influence through such visual characteristics as geometric forms, smooth wall treatments, battered walls, Egyptian reed-bundle or papyrus columns, cavetto cornices, round moldings, and

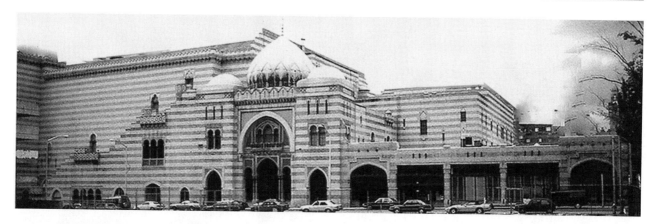

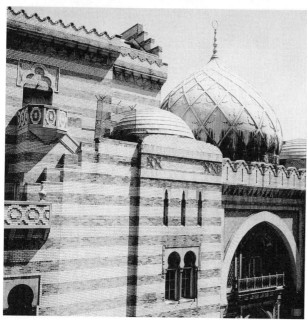

▲ **9-15.** Yaarab Temple Shrine Mosque (Fox Theater), 1928–1929; Atlanta, Georgia; Marye, Alger, and Vinour. Art Deco/Egyptian Revival.

▲ **9-16.** Willis Bristol House, 1846; New Haven, Connecticut; Henry Austin. Exotic/Islamic Revival.

Egyptian motifs (Fig. 9-4, 9-5, 9-6, 9-7, 9-8, 9-9, 9-10). Characteristic attributes include massiveness, solemnity, solidity, and timeless or eternal feeling. The Egyptian gateway or pylon is a common form for entrances or entire

DESIGN PRACTITIONERS

- **Joseph Bonomi, Jr.** (1796–1878) is the curator of Sir John Soane's Museum. Bonomi also is a distinguished Egyptologist who creates many Egyptian Revival buildings in England. He is best known for Temple Mills in Leeds and the Egyptian Court (with Owen Jones) at the New Crystal Palace in 1854.

- **John Haviland** (1792–1852) comes to the United States from England in 1816. He designs many Greek Revival buildings as well as the first prison in the United States to center on reform ideals from Europe. Haviland is best known for his Egyptian Revival buildings, including the New York City Halls of Justice and House of Detention. He publishes the *Builder's Assistant* in 1818, which is the first American publication to illustrate the Greek orders.

- **Owen Jones** (1809–1874) is a noted designer and architect, and an authority on color and ornament. Following extended travels to Spain and the Middle East, he publishes works that establish him as an authority on Islamic art and architecture. As Superintendent of the Works for the Great Exhibition of 1851, Jones decorates the interiors of the Crystal Palace. At the new Crystal Palace, he designs historical interiors in various styles, including Islamic. His *Grammar of Ornament* illustrates ornament in color of historical styles and works of Islamic, Chinese, and other non-Western cultures.

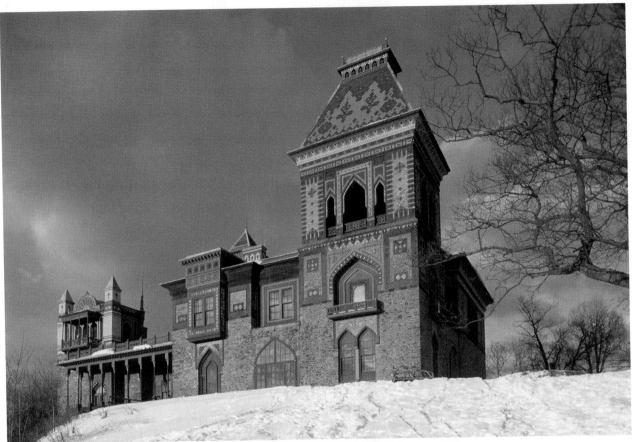

▲ **9-17.** Olana, 1870–1872 house, 1888–1891 studio wing; Hudson, New York; Frederic E. Church, consulting architect Calvert Vaux. Exotic/Moorish Revival.

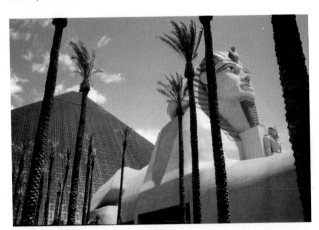

▲ **9-18.** Later Interpretation: Luxor Hotel, 1993; Las Vegas, Nevada; Veldon Simpson. Modern Historicism with Egyptian influences.

façades. Domes, Moorish arches, minarets, and colorful tiles define Moorish-style buildings (Fig. 9-11, 9-13, 9-14, 9-15, 9-16, 9-17). Islamic arches may create bays across the façade and be superimposed on each story.

■ *Windows.* Windows have slanted sides or surrounds on Egyptian Revival buildings (Fig. 9-5, 9-7, 9-8). Islamic-style arches may frame or form windows (Fig. 9-11, 9-15). Some have colored glass panes.

■ *Doors.* Doorways feature slanted sides and Egyptian columns (Fig. 9-6). Doors in Islamic-style structures may be located within horseshoe, multifoil, or ogee arches carried by piers or columns (Fig. 9-3, 9-11, 9-13).

■ *Roofs.* Roofs usually are flat or low pitched on Egyptian Revival structures (Fig. 9-7). Islamic buildings may have multiple roofs with onion domes and minarets (Fig. 9-14).

■ *Later Interpretations.* Egyptian and Turkish design features are not used frequently in later periods, except in countries of, or influenced by, the Middle East. In the late 20th century, the most common application in Europe and America appears in buildings emphasizing entertainment, such as hotels, theaters, casinos, and theme parks in places like Las Vegas (Fig. 9-18) or Disneyworld. Structures in the Middle East reflect their Arabic or Islamic heritage, using a more contemporary vocabulary.

INTERIORS

Exotic interiors often are the most eclectic, combining architectural details, motifs, furniture, or decorative arts of several cultures or styles. Although this enhances their

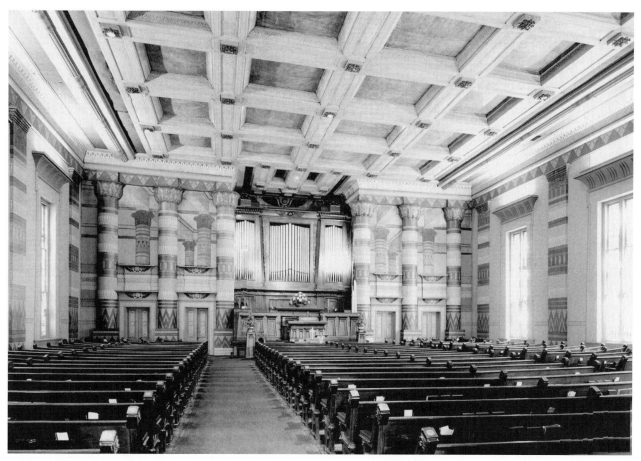

▲ **9-19.** Nave, First Presbyterian Church, 1848–1851; Nashville, Tennessee; William Strickland. Egyptian Revival.

appeal, they usually represent only a room or two within houses or a particular building type. As in architecture, associations are important for choosing an exotic interior style, and particular rooms are deemed appropriate for a particular style. Egyptian Revival interiors are far less common in residences but typify rooms in public buildings of the style. Museums, zoos, and collectors decorate interiors housing their Egyptian or Middle Eastern artifacts and animals in the appropriate style. Billiard or smoking rooms, reserved for males, are most likely to be Turkish, Islamic, or Indian. Turkish corners, derived from Turkish bazaars, and extremely popular in the late 19th century in England and North America, are seen as exotic and somewhat promiscuous.

Public and Private Buildings

■ *Types*. Egyptian Revival buildings usually have an interior or interiors in the same style, particularly in fraternal temples and early-20th-century movie theaters. Smoking rooms, billiard rooms, Turkish bathrooms, male-related spaces in hotels and houses, tea rooms, and conservatories may exhibit Turkish designs and details (Fig. 9-22, 9-28, 9-30). Turkish or cozy corners are a

craze in American and English homes during the 1870s through the 1890s (Fig. 9-31, 9-32). Occupying a corner or small portion of the room, the Turkish corner is identified by curtains and/or a canopy of Turkish fabrics or rugs, divans or built-in seating with piles of pillows, Oriental rugs, and numerous accessories such as potted palms, ceramics, spears, swords, pipes, small tables, lamps, and candlesticks. Periodicals carry instructions for making cozy corners to aid owners of modest houses in following the fashion.

■ *Relationships*. Often, there is little or no relationship between exterior style and interior character. Room associations and fashion are more likely to influence style choices.

■ *Color*. Rich, highly saturated colors (Fig. 9-2) are associated with exotic styles. Blue, green, gold, yellow, red, and black are common for Egyptian. Turkish colors include blues, greens, purples, turquoises, reds, oranges, white, and black (Fig. 9-25, 9-26). Bold colors are usually seen against a neutral, often beige or earth-toned background.

■ *Lighting*. Lighting fixtures exhibit forms and motifs common to exotic styles (Fig. 9-22, 9-27). Often fixtures acquired

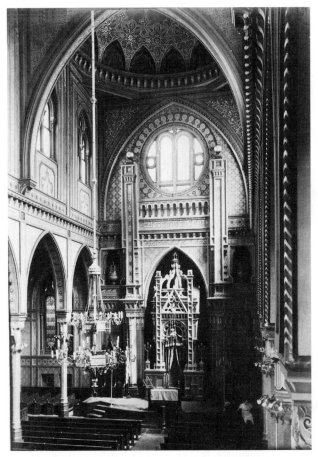

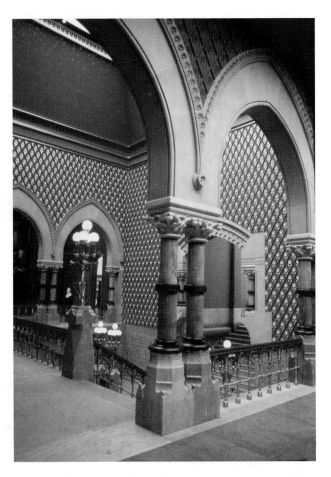

▲ **9-20.** Nave, Isaac M. Wise Temple, 1866; Cincinnati, Ohio; James K. Wilson. Turkish/Exotic Revival.

on foreign travels are adapted to contemporary use. Mosque lamps may illuminate Turkish interiors.

■ *Floors.* Wood floors with Oriental rugs are common in Turkish and Egyptian Revival interiors (Fig. 9-22, 9-26, 9-29, 9-30, 9-34). Alternative floor coverings include animal skins and furs. Decorative tiles in various patterns may embellish vestibules, large halls, and conservatories (Fig. 9-25).

■ *Walls.* Walls feature motifs of the style chosen. In public spaces, Egyptian architectural details, such as columns or relief sculpture, may articulate walls (Fig. 9-19, 9-23, 9-24). Spaces between architectural details may be decorated with colorful Egyptian motifs or figures. Bands of Egyptian patterning, figures, or hieroglyphs may decorate walls and columns. Wallpaper and borders with Egyptian figures and motifs are available but not common. A few landscape wallpapers in the early 19th century depict Egyptian architecture.

Islamic-style arches in plaster or paneling may articulate walls or divide spaces in Turkish rooms (Fig. 9-21, 9-22, 9-23, 9-26, 9-29). An alternative is ceramic tiles with flat, intricate, stylized Islamic patterns, which cover

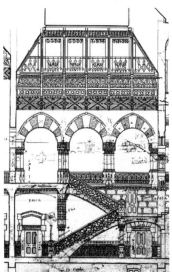

▲ **9-21.** Stair hall and elevation, Pennsylvania Academy of Fine Arts, 1872–1876; Philadelphia, Pennsylvania; Frank Furness and George W. Hewitt.

walls or embellish fireplace openings (Fig. 9-25). Flat or draped textiles, such as shawls, kelims, or carpets, adorn walls of Turkish interiors (Fig. 9-26, 9-32). Wallpapers and borders with Islamic patterns are an alternative for

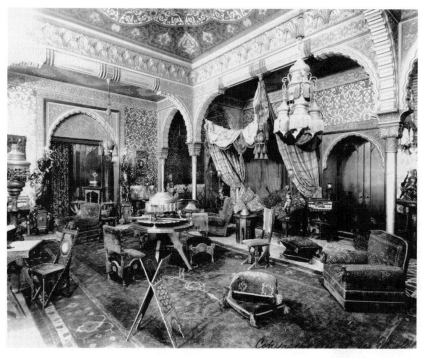

◀ **9-22.** Hotel lobby, 1902; United States.

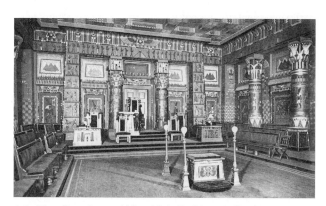 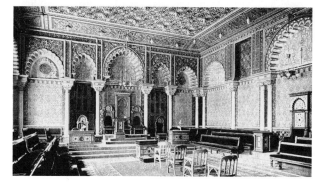

▲ **9-23.** Egyptian and Moorish halls, Masonic Temple, c. 1890; Philadelphia, Pennsylvania. Egyptian and Moorish Revival.

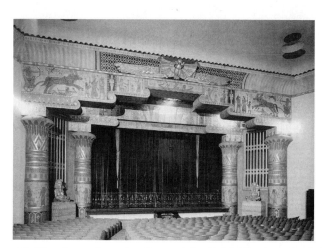 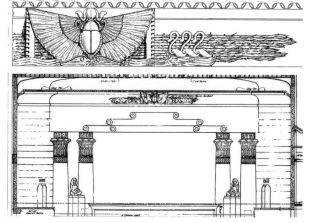

▲ **9-24.** Proscenium, elevation, and detail, Ada Theater, 1926; Boise, Idaho; Frederick C. Hummel. Egyptian Revival.

textiles. Islamic patterns used on walls (Fig. 9-3) influence reform wallpaper designers, such as William Morris, who adopt their flat, colorful, and curvilinear patterns in the second half of the 19th century (see Chapter 17, "English Arts and Crafts"). Fabrics in complicated

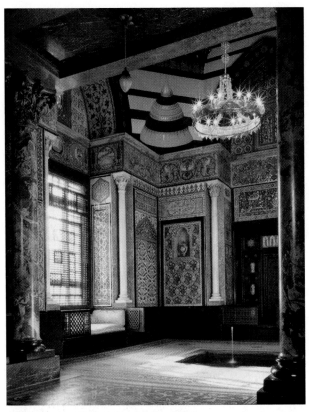

▲ **9-25.** Arab Hall, Lord Leighton House, c. 1865; London, England; George Aitchison. Islamic Revival.

patterns or rugs hanging from fretwork, Moorish-style arches, or spears frequently define the Turkish or cozy corner (Fig. 9-22, 9-31, 9-32). Niches, called Damascus niches, are a common Islamic characteristic for displaying ceramics or sculpture. Rooms often appear crowded with objects collected from many exotic locations.

- *Windows Treatments.* Lavish, layered window treatments are characteristic of exotic rooms (Fig. 9-32). Some are of Turkish textiles, such as kelims, or European imitations of them.
- *Doors.* Egyptian doorways (Fig. 9-19) may have slanted surrounds or be painted with Egyptian motifs. Islamic-style doors may have stenciled or inlaid decoration in geometric patterns or arabesques. Some have panels shaped like horseshoe or pointed arches. Interior doorways have portieres made of rugs, fabrics with Turkish motifs, or bands of fabrics hanging from rings (Fig. 9-28). Above may be fretwork with Moorish-style arches.
- *Textiles.* Egyptian motifs mixed with flowers and foliage typify Egyptian revival fabrics. The flat patterns of Indian chintzes and embroideries influence European textile and wallpaper designers from the 17th century onward. The European reinterpretation of the Indian elongated leaf pattern becomes known as paisley (Fig. 9-33). Islamic patterns especially appeal to reform textile designers who advocate flat, stylized patterns (Fig. 9-25). Textiles are important in Turkish style interiors where Oriental carpets and rugs cover floors, pillows, or seating, or hang on walls or at doorways (Fig. 9-22, 9-26, 9-31, 9-34). Turkish style interiors, like Egyptian and Islamic ones, use European textiles with Turkish patterns.
- *Ceilings.* Ceilings may have wallpapers or painted or plaster decorations in highly saturated colors and Egyptian or Turkish motifs, arches, and/or patterning (Fig. 9-20,

DESIGN SPOTLIGHT

Interiors: Stair hall and chimneypieces, Olana, 1870–1872 house, 1888–1891 studio wing; Hudson, New York; Frederic E. Church, with consulting architect Calvert Vaux. Exotic/Moorish Revival. Home of the Hudson River School painter, Frederic Edwin Church, Olana's Islamic design results from Church's extended visit to the Middle East in 1867. Church designs the exterior and interiors with the help of architect Calvert Vaux. He makes numerous sketches for the exterior, each room, and its architectural details and decoration. The asymmetrical exterior is constructed of multicolored brick with tile accents. Islamic pointed arches, a tower, porches, balconies, and numerous windows to take advantage of the magnificent surrounding countryside. The house adapts

Middle Eastern forms and elements to an American 19th-century lifestyle.

In the stair hall, Oriental rugs cover the stairs and floors and form the drapery at the first landing. A small columned niche holds a golden Buddha. At the second landing, pointed arches are accented above with stenciling in rich colors derived from a book of Eastern designs. Light from a window with yellow glass behind the arches illuminates the staircase. The stairhall contains some of Church's finest objects, including Persian ceramics, brasswares, and sculpture. He uses them to direct attention to great past civilizations.

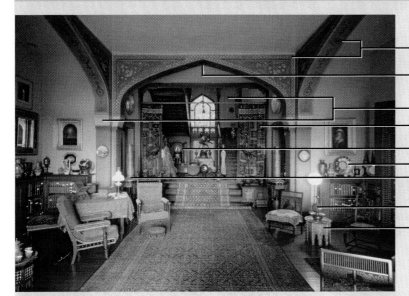

- Stenciling with exotic motifs
- Pointed arches
- Moorish style colors
- Oriental rugs form drapery
- Niche with Buddha
- Persian ceramics
- Exotic floor candlestick
- Brassware used throughout as decorative accents
- Moorish style table with ivory inlay

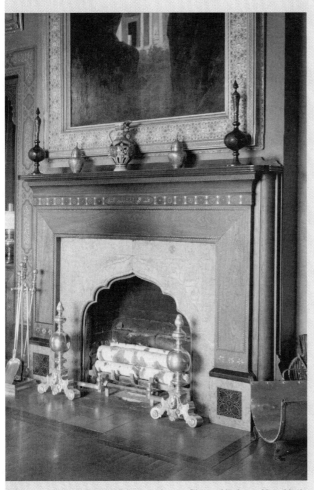

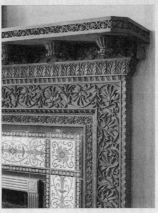

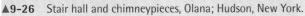

▲9-26 Stair hall and chimneypieces, Olana; Hudson, New York.

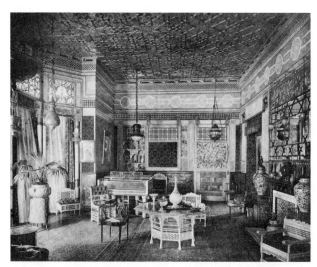

▲ **9-27.** Salon, George Kemp House; published in *Artistic Houses*, 1882; Louis Comfort Tiffany and Company. Exotic/Moorish Revival.

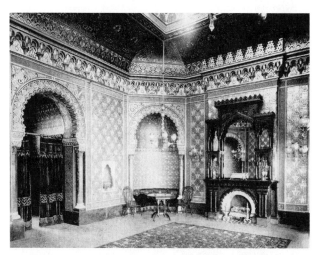

▲ **9-28.** Oswald Ottendorfer's Moorish Pavilion; Manhattanville, New York; published in *Artistic Homes*, Vol. 1, 1883. Turkish Revival.

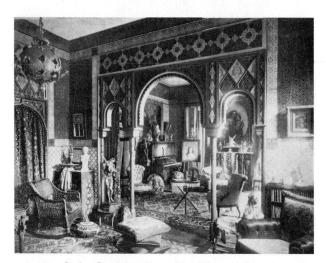

▲ **9-29.** Parlor, Sarah Ives Hurtt; New York; published in *Artistic Homes*, Vol. 1, 1883. Turkish Revival.

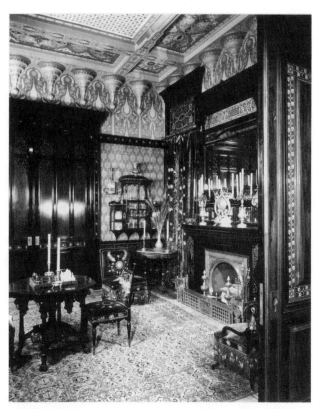

▲ **9-30.** Smoking room, John D. Rockefeller House, c. 1885; New York City, New York. Turkish Revival.

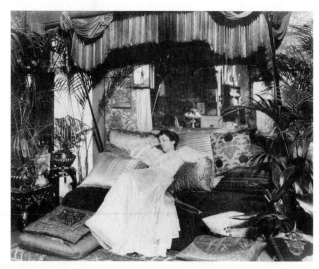

▲ **9-31.** Elsie de Wolfe in her cozy corner, Irving House, 1896; New York. Turkish/Exotic Revival.

9-25, 9-27). Ceilings in public spaces may be compartmentalized and decorated with colorful Egyptian motifs or Islamic patterning.

■ *Later Interpretations*. Occasional examples of Exotic influences appear in interiors during the late 20th century. Most examples are within entertainment facilities focused on fantasy, romance, and mystery (Fig. 9-35; see Chapter 30, "Modern Historicism").

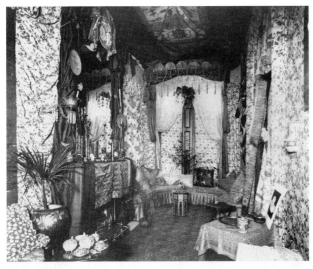

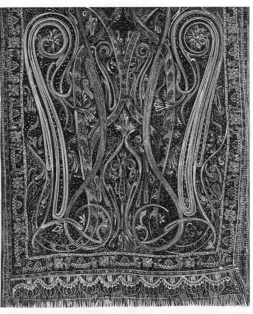

◄ **9-32.** Reception room, Hall House, 1896; New York City, New York. Turkish/Exotic Revival.

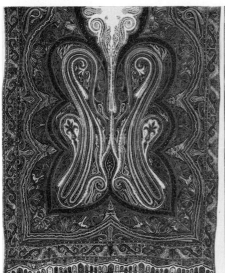

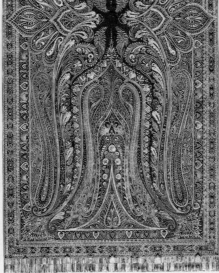

▲ **9-33.** Textiles: Paisley patterns, mid to late 19th century; England and the United States. Islamic/Exotic Revival.

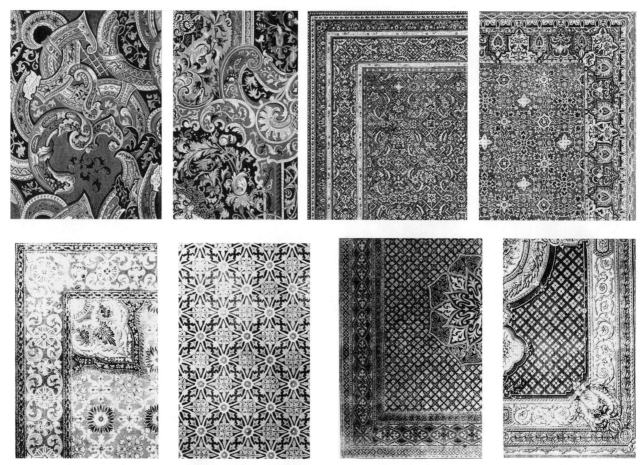

▲ 9-34. Rugs: Examples from the mid to late 19th century; Turkish, Persian, and Caucasian. Islamic/Exotic Revival.

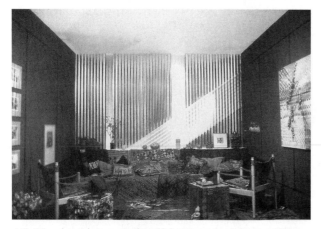

▲ 9-35. Later Interpretation: Living room cozy corner, 1993; Charlotte, North Carolina; Huston/Sherman. Modern Historicism.

FURNISHINGS AND DECORATIVE ARTS

Egyptian character manifests in furniture as motifs in classical styles, as a deliberate revival, or as copies of extant ancient pieces. Early in the 19th century, Egyptian motifs appear in French Empire, Regency, and Biedermeier (see Chapter 2, "Directoire, French Empire," Chapter 3, "German Greek Revival, Beidermeier," Chapter 4, "English Regency, British Greek Revival"). The later Neo-Grec (see Chapter 7, "Italianate, Renaissance Revival"), a substyle of Renaissance Revival, mixes Greek, Roman, and Egyptian. Mid-19th century design reformers adopt the slanted back with double bracing of Egyptian chairs as a sturdy and honest method of construction. Egyptian Revival furniture applies Egyptian motifs to contemporary forms with varying accuracy. Beginning in the 1880s, the Egyptian collections at the British Museum inspire English copies of stools and chairs.

Moorish- or Turkish-style furnishings appear beginning in the 1870s. Some are imported; some are made in England and North America. Imports include screens, small tables, and Koran stands. In the United States, the most common manifestation of Turkish style is in upholstery or built-in seating. Seating adopts Turkish names such as divan or ottoman. Imported furniture, rugs, and decorative arts from the Middle East easily add a touch of the exotic to any interior.

Furniture: Turkish parlor chairs and sofa, late 19th century; United States; by S. Karpen Brothers and Sears, Roebuck and Company. Turkish/Exotic Revival. Manufactured by S. Karpen Brothers and exhibited at the World's Columbian Exposition in 1893, these chairs exemplify the appearance of opulence and comfort desired during the period. The deeply tufted back and seat, puffing on the edges of the cushions, a fringed and tasseled skirt, rounded corners, and additional padding on seat and arms create the overstuffed Turkish upholstery that is fashionable in the 1880s and 1890s. Sears, Roebuck and Company, other companies, and manufacturers distributed similar versions.

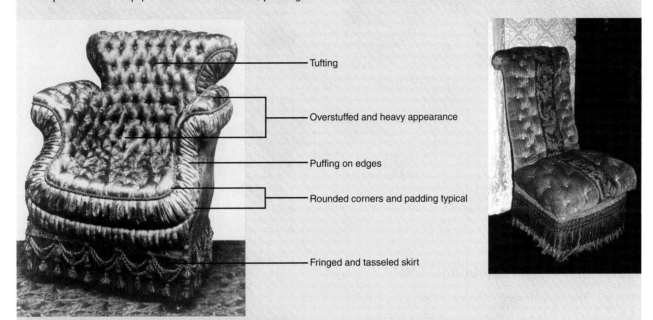

Tufting

Overstuffed and heavy appearance

Puffing on edges

Rounded corners and padding typical

Fringed and tasseled skirt

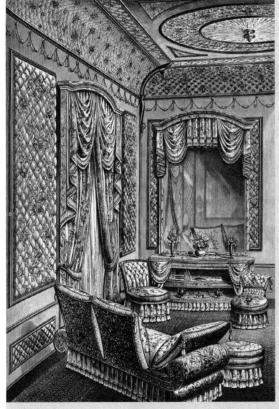

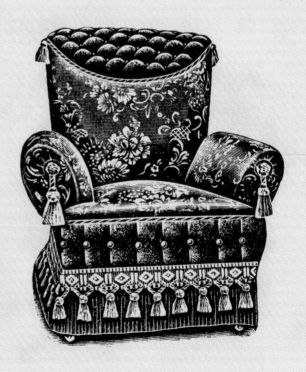

▲ **9–36** Turkish parlor chairs, late 19th century.

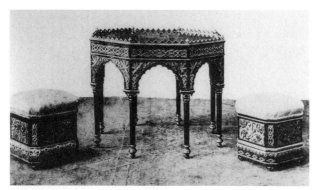

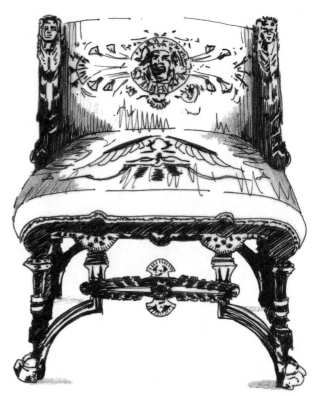

▲ **9-37.** Moorish stools and table, c. 1890; Florence, Italy; Andre Bacceti.

Wicker, which carries associations with Exoticism, becomes extremely fashionable in the second half of the 19th century. Known since antiquity, manufacturers experiment with forms, materials, colors, and motifs from China, Japan, and Moorish Spain. Wicker has numerous patterns, including Egyptian.

Public and Private Buildings

■ *Types.* The Turkish-style overstuffed upholstery has no prototype in the Middle East as do many Egyptian Revival pieces, such as pianos and wardrobes. All types of furniture

▲ **9-38.** Slipper chair, c. 1875. Egyptian Revival.

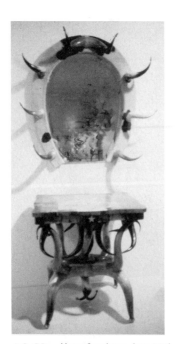

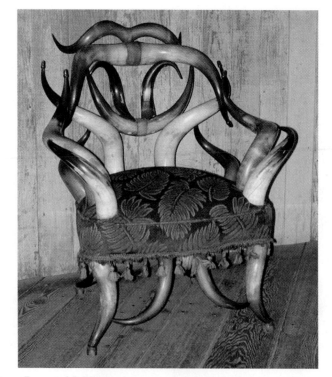

▲ **9-39.** Horn furniture, late 19th century; Texas and California.

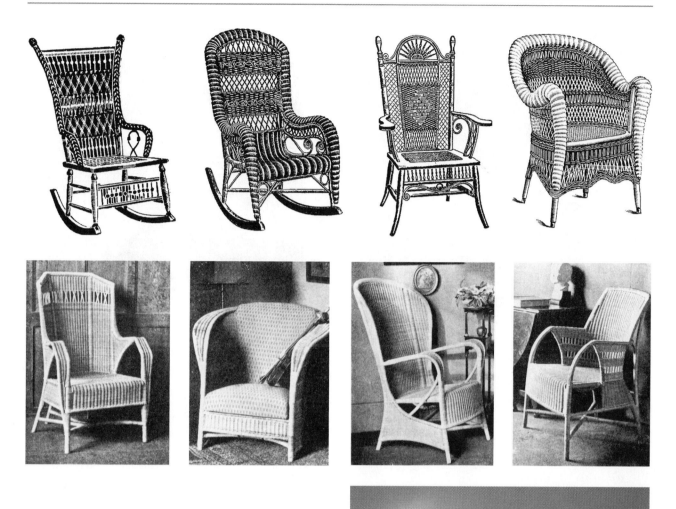

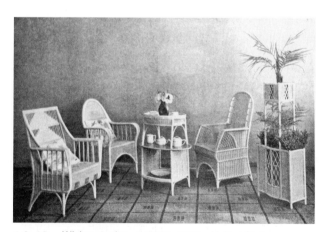

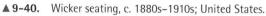

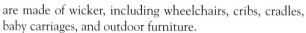

▲ **9-40.** Wicker seating, c. 1880s–1910s; United States.

are made of wicker, including wheelchairs, cribs, cradles, baby carriages, and outdoor furniture.

■ *Distinctive Features.* Egyptian Revival furniture displays the forms and motifs of ancient Egyptian architecture,

with slanted sides, columns, obelisks, and hieroglyphs (Fig. 9-38). Some pieces are gilded or ebonized with incising. Deep tufting and fancy trims distinguish Turkish upholstery and give the impression of comfort and opulence

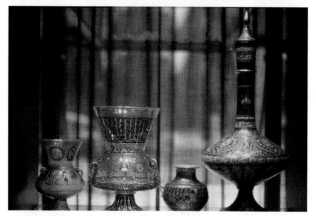

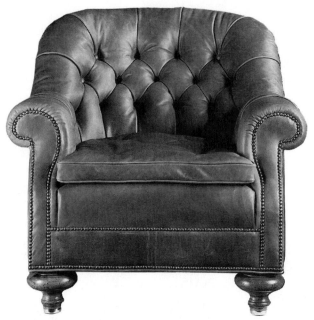

▲ **9-42.** Later Interpretation: Turkish chair, 2003; available from Marco Fine Furniture. Modern Historicism.

▲ **9-41.** Decorative Arts: Clock, vases, and glassware; clocks and vases exhibited at the Centennial International Exposition of 1876 in Philadelphia; United States, and Austria. Egyptian Revival.

(Fig. 9-22, 9-36). Other Turkish-style furniture is light in scale and often has fretwork in typical patterns. Wicker varies from very plain to highly decorative with curlicues, beadwork, and various patterning (Fig. 9-29, 9-40).

■ *Relationships.* Exotic rooms have the same style of furniture with the exception of Turkish upholstery, which mixes with other styles. Wicker is used on porches and conservatories and may appear in other rooms.

■ *Materials.* Egyptian Revival and Turkish furniture usually is of dark woods, such as mahogany or rosewood. Less exotic woods are grained to imitate other woods. Embellishments consist of inlay, gilding, ebonizing, incising, ormolu mounts, or painted decorations. Inlay in Turkish furniture is of bone or ivory. Wicker is made of straw, willow, rattan, and other fibers, although most is of rattan (Fig. 9-40). It is painted red, yellow, brown, black, green, or white. Some pieces have gilding or combinations of colors.

■ *Seating.* Egyptian Revival chairs and parlor sets have wooden frames with carved and sometimes stylized Egyptian details and upholstered backs and seats (Fig. 9-38). Legs may be animal shaped with paw feet or hooves or tapered with Egyptian-style capitals. Turkish-style overstuffed upholstery has deep tufting, fringe, and/or trim that covers the legs. Chairs and sofas often have an extra roll of stuffing around the arms and backs

(Fig. 9-36). Cording, puffing, and pleating add visual complexity and give an impression of comfort. Turkish *divans* or *lounges* refer to deeply tufted couches without backs or arms. Turkish ottomans are large and round with tufted backs and a space for a potted palm or sculpture in the raised center. Often used in grand spaces, they are intended as a momentary seat rather than a place of relaxation. Variations of the Turkish style include chairs or sofas with round or oval backs not attached to the seats and round or oval seats. Often small and fragile, these chairs upholstered in silk or satin are used in parlors. Americans love Turkish-style rocking chairs. Some Turkish interiors use pillows on the floor for seating (Fig. 9-29, 9-31). Others, particularly men's smoking rooms and libraries, incorporate horn chairs upholstered in exotic skins or other similar horn furniture (Fig. 9-39). Usually made in western areas of the United States such as Texas, examples convey a rugged, manly character.

Indoor and outdoor seating in public and private buildings, including parlor sets, often is of wicker (Fig. 9-40). Solid portions may be plainly woven or have patterns, such as stars or dippers. Cresting, backs, legs, and arms often have curving forms of fans, lattice, strapwork, arabesques, ogees, or curlicues. Some wicker seating has upholstered backs and seats, although most rely on added cushions for comfort. Ladies add their own decorative touches, such as ribbon threaded through openwork, bows, or tassels.

■ *Tables.* Egyptian Revival tables exhibit Egyptian motifs, such as figures, heads, or sphinxes. Some have slender tapered legs with incising and stylized carving. Obelisks or pylon-shaped pedestals display sculpture

or plants. Hexagonal or octagonal occasional tables imported from the Middle East are of dark woods with ivory or mother-of-pearl inlay in geometric patterns (Fig. 9-27, 9-37). Small stands, originally designed to hold the Koran, rest upon tables and hold books. Wicker tables and stands may match seating.

■ *Storage*. Wardrobes, cupboards, and commodes may have the slanted sides and fronts of Egyptian gateways, Egyptian columns or figures, and other Egyptian motifs. Tops may have cavetto cornices or rounded moldings. Some pieces are ebonized with gilding, incising, and painted decorations. Wicker cupboards or chests of drawers are not as common as wicker seating is.

■ *Beds*. Egyptian-style beds are very rare. Beds for children, cribs, and cradles may be in plain or fancy wicker.

■ *Upholstery*. Textiles for upholstery include damasks, velvets, cut velvets, brocades, satins, silks, Oriental rugs, cottons or other fabrics either plain or with Egyptian and Turkish motifs or patterns, and leather. In the 1880s, Liberty and Company in London sells hugely popular silk textiles with anglicized Middle Eastern patterns in pastel blues, greens, corals, yellows, and golds.

■ *Decorative Arts*. Egyptian Revival decorative arts, such as clocks, porcelains, or vases, feature Egyptian architectural details, including obelisks, and motifs, such as sphinxes. Sevres and other porcelain factories make dinner sets painted with Egyptian motifs and architecture. Egyptian mantel sets consisting of a clock and vases or obelisks are common in the second half of the 19th century (Fig. 9-41). Imported brass objects, ceramics, folding screens, spears, daggers, plates, tiles, and potted palms define Turkish or Moorish interiors. Ceramics from India and the Middle East inspire tiles and other ceramics with intricate flat patterns in turquoise, blue, green, and red. The glass of Louis Comfort Tiffany and others draws inspiration from the shapes, forms, and colors of Egyptian, Islamic, and Oriental glass and ceramics. Wicker mirrors, plant stands, birdcages, and the like add a touch of exoticism to many rooms.

■ *Later Interpretations*. Furnishings and decorative arts reflecting an Exotic influence rarely appear in later periods, unless in concert with custom-designed Exotic interiors, such as those in entertainment facilities or libraries of the late 20th century (Fig. 9-42). Art Deco in the 1920s and 1930s adapts Egyptian motifs and colors.

CHAPTER 10

Stick Style, Queen Anne

Stick Style

1860s–1880s,

Queen Anne

1880s–1910s

Uniquely American, the Stick Style in architecture reinterprets medieval half-timbered buildings and the new balloon framing construction method with wooden planks or sticks that form decorative surface patterns on exteriors. Queen Anne originates in England as an attempt to create an image of home, tradition, and middle-class comfort. Highly eclectic, the style combines elements from the 16th, 17th, and 18th centuries. Queen Anne appeals to Americans also, who translate it into wood instead of the brick of England. Neither Stick Style nor Queen Anne has a corresponding interior or furniture style, but some interiors and furniture in Queen Anne buildings vaguely recall 18th-century prototypes.

Ah, to build to build! That is the noblest art of all the arts. Painting and Sculpture are but images, are merely shadows, cast by outward things. On stone or canvas, having in themselves no separate existence. Architecture, existing in itself, and not in seeming a something it is not, surpasses them as substance shadow.

Henry Wadsworth Longfellow, from *Palliser's New Cottage Homes and Details*, 1887, by George and Charles Palliser

HISTORICAL AND SOCIAL

Queen Anne rules Great Britain from 1702 to 1714. She has little interest in government and as a result rules through advisors. During this time, English architecture and interiors are classical in feeling. Large-scale buildings and complexes display restrained Baroque (17th century) characteristics, including center emphasis, advancing and receding planes, some curves, and bold classical details. The period sees the spreading of the rectangular block manor house, developed earlier, with symmetrical façade, sash windows, classical details such as quoins, and a hipped roof. The Neo-Palladian style begins during Queen Anne's reign and is based on the writings of Vitruvius and the work of Andrea Palladio, a 16th-century Italian Renaissance architect, and Inigo Jones, a 17th-century English architect. Interiors during the early 18th century are restrained, sober, and classical in details. Furniture continues the earlier Dutch William and Mary style but becomes simpler, more attenuated, and more curvilinear.

After the 1850s, a second generation of the middle class comes into its own. These individuals are from moneyed households and possess the advantages of education and culture. They regard the creation of beauty as important as well as the cultivation of classical Greek virtues, refinement, and

manners to create a gentlemanly or lady-like image. This group leads sophisticated lives, traveling, attending plays and cultural events, and socializing with friends and family in well-appointed houses. During the 1860s, these English socialites begin to look back to their Stuart (late 17th century) and Georgian heritages (18th century) for the desirable attributes of refinement and gentility. This interest in a later past rather than the popular Gothic Revival helps contribute to the development of the Queen Anne architectural style.

Although American architects are aware of English architectural developments through publications and travel in England, they do not wholeheartedly follow them. However, the 1876 Philadelphia Centennial Exhibition acquaints the American public with both the Stick Style and English Queen Anne, and they soon become popular styles for residences. Americans (Fig. 10-1) look back to their own 17th- and 18th-century pasts more as an antidote to contemporary industrial life than an ideal of gentility (see Chapter 13, "Colonial Revival"). This nostalgia opens the way for wider acceptance of Stick and Queen Anne. Rejecting the shady values demonstrated in contemporary politics, the middle class flees the corrupt, scandalous cities of the present and escapes to the purer, simpler rural life and imagined past. Summer resorts filled with picturesque Stick and Queen Anne structures amid tranquil landscapes become popular travel destinations.

CONCEPTS

■ *Stick Style.* Applied to American buildings as a half-timbered appearance rendered in wood, the Stick Style develops during the 1850s from concepts of the Picturesque,

▲ **10-1.** Mark Twain (above, center), Molly Brown, and a carpenter, c. 1865–1880; United States.

historicism, and Gothic Revival theory. Early-19th-century Picturesque suburban architecture in England and late Gothic vernacular buildings in England, France, and Germany form the model for this uniquely American style. Also influential are Swiss cottages and the board and batten cottages of A. J. Davis and A. J. Downing published in *Rural Residences* (1837) and *The Architecture of Country Houses* (1850).

■ *English Queen Anne.* Arising in the 1860s, English Queen Anne is the style of choice for the middle class. Although its name suggests the early 18th century, highly eclectic Queen Anne includes characteristics from English vernacular, Elizabethan, Tudor, and Japanese architecture as well as that of the 17th and early 18th centuries. Unlike

the Greek and Gothic Revivals, Queen Anne strives, through eclecticism, not to revive a past style or to create a new historical style. Consequently, there is confusion, even among practitioners, about what exactly constitutes Queen Anne. By the 1890s, Queen Anne is applied to almost anything that is not Gothic Revival.

■ *American Queen Anne.* Americans translate elements of English Queen Anne into wood and use it primarily for residences. Its image of home and ancestry appeals to both the middle class and design critics who urge the style's immediate adoption. A variation is Victorian Vernacular. It translates Queen Anne, Stick, and other styles into common or folk versions of architecture, interiors, and furniture for the American middle and working classes. Often, builders, artisans, or cabinetmakers simply add details of high styles to folk or traditional forms (Fig. 10-3).

DESIGN CHARACTERISTICS

Primarily architectural styles, Stick and English and American Queen Anne look back to the Middle Ages, English Renaissance, and vernacular buildings for inspiration.

Highly eclectic, they adopt asymmetry, irregularity, verticality, forms, and details of earlier buildings

■ *Stick Style.* Structures in this style feature stickwork forming panels and framing windows and doors. Additional stickwork appears in the bracket supports beneath the roof, decorative trusses in the gables, and ornamental cresting. Full- and partial-width porches have supports with diagonal stickwork braces. Mostly residential, the style conveys a half-timbered, medieval feeling. The Stick Style has no corresponding style in interiors or furniture, although some rooms may reflect a general exterior character in paneling with stick-like patterns.

■ *English Queen Anne.* Architecture of this style features elements from Stuart, Georgian, medieval, Early Renaissance, and vernacular English buildings. Human scale and the visual language speak of refinement, simplicity, comfort, and hominess, qualities appealing to the middle class instead of the wealthy or landed gentry. Characteristics include brown and red brick, white-painted sash or casement windows, oriel or bay windows, Flemish or straight gables, tall and prominent chimneys, hipped or gable roofs, cupolas, pediments, pilasters, and columns. Interiors in Queen Anne buildings may follow revival styles, Aesthetic

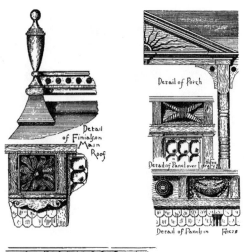

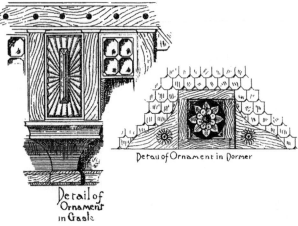

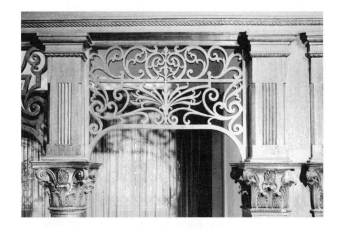

▲ **10–2.** Architectural details, 1870s–1880s; United States.

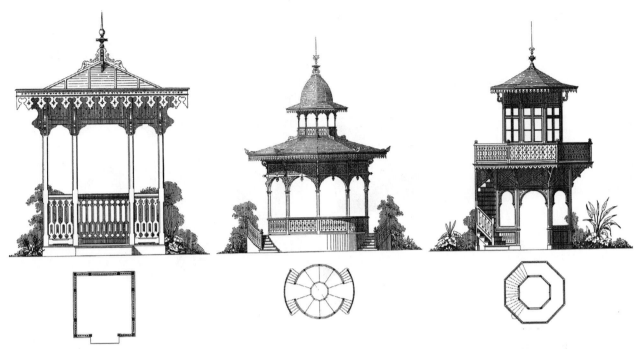

▲ **10-3.** Gazebos (summer houses), 1870s–1890s; United States.

principles, or be 19th-century interpretations of Queen Anne. The latter bear little resemblance to the originals, although characteristics include pediments (usually broken), swags, urns, ceiling medallions, and other qualities of 18th-century interiors. Colors, textures, and furnishings are typical of the 19th century instead of the prototypes. Like architecture, Queen Anne interiors and furniture are eclectic and loosely resemble the corresponding 18th-century styles, but distinctions are not clear.

■ *American Queen Anne*. This style evidences variety as a key characteristic. Houses are large, asymmetrical, and rambling with full- or partial-width porches. A variety of window types, materials, textures, and colors is typical—anything to avoid a plain or flat wall surface. Towers or turrets, prominent chimneys that are usually decorated, and a multiplicity of roofs and roof types are also characteristic. Interiors and furnishings may be in a revival style or follow Aesthetic Movement or Arts and Crafts principles. The latter is contemporary with the Queen Anne style's height of popularity in the United States. Although the first examples are architect designed and closely resemble English models, the style proves so popular that builders and artisans produce many examples across the nation, and it frequently appears in home plan books. In the United States, there are fewer Queen Anne interiors and furniture.

■ *Motifs*. Motifs include sunflowers, pediments, columns, spindles, scrollwork, quoins, Flemish gables, strapwork, swags, cherubs, flowers, and foliage (Fig. 10-2, 10-8, 10-16, 10-19, 10-23, 10-32, 10-34, 10-36, 10-37, 10-43).

ARCHITECTURE

Primarily residential, the Stick Style emerges on the East Coast of the United States during the 1850s and is more popular in pattern books than in practice, according to the actual number of buildings built. The first example of the mature style and a prototype for others is the John N. A. Griswold House (Fig. 10-8) designed by Richard Morris Hunt and built in Newport during the Civil War. Other examples are mostly located in summer resorts, such as Newport, Rhode Island, where the style's light and rustic appearance is appealing. An exception is San Francisco, where the style continues well into the 1880s, corresponding to the city's rapid growth during the period. The so-called Painted Ladies (which may be Stick, Queen Anne, or Italianate) form a colorful regional style for row houses with stickwork, brackets, and other wood decoration (Fig. 10-18).

English Queen Anne does not have a strong theoretical or scholarly base but adopts the irregularity, open planning, truth in construction, and honesty of material of Gothic Revival without its moral or religious overtones. Striving for freedom in planning, design, and decoration, the style derives its red brick, sash windows, cupolas, shutters, and fanlights from 18th-century architecture. Gables, pediments, white trim, and prominent coves come from 17th-century buildings. Traditional earlier English buildings contribute a homey, friendly appearance, half-timbering, tiled façades, pargework, overhangs, casement windows, and plans and elevations

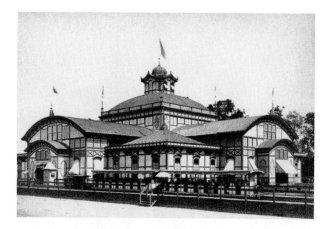

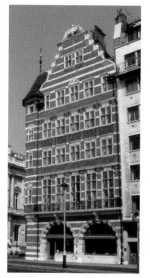

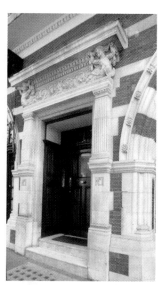

▲ **10–5.** Allied Assurance Company, 1–2 St. James Street, c. 1882; Pall Mall, London, England; Richard Norman Shaw. Queen Anne.

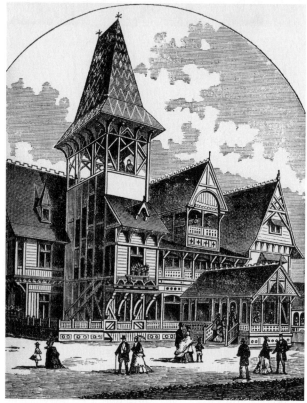

▲ **10–4.** Women's Pavilion, and New Jersey State Building, International Centennial Exhibition, 1876; Philadelphia, Pennsylvania. Stick Style.

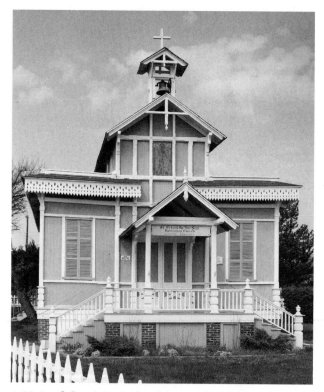

▲ **10–6.** S. Peter's by the Sea Episcopal Church, late 19th century; Cape May, New Jersey. Stick Style.

that appear to have evolved over time with additions as needed. Some buildings reveal elements of the Aesthetic Movement and Japanese design.

The foundation for Queen Anne is laid during the 1850s and 1860s by renewed interest in the Stuart and Georgian periods, a rejection by some architects of the moral and religious nature of Gothic Revival, and a move toward a less literal interpretation of Gothic evident in the work of some architect–designers such as Philip Webb. Believing that buildings during Queen Anne's reign were basically medieval in form with classical ornament applied, designers

turn to the pre-Georgian period. The style coalesces in the work of William Eden Nesfield and Richard Norman Shaw following their study of vernacular Elizabethan and Jacobean architecture. By the 1870s, the visual language has fully developed as more Queen Anne buildings are built and published in architectural and building

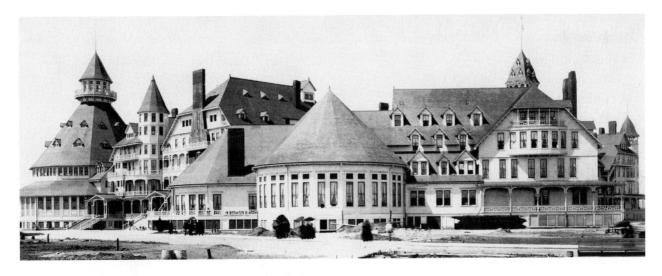

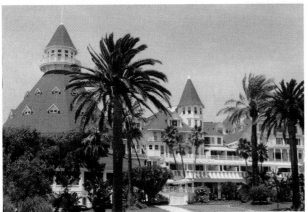

▲ **10-7.** Hotel del Coronado, 1886–1888; Coronado, California. Queen Anne.

magazines. Queen Anne is very popular in England during the second half of the 19th century for all types of buildings and, to a lesser degree, interiors and furniture, where it is even more eclectic than in architecture. Three of the most influential buildings are Leys Wood (Fig. 10-9), a large country house in Sussex resembling Elizabethan mansions; New Zealand Chambers, an office building in London,

both by Richard Norman Shaw; and the Red House (demolished) in London by J. J. Stevenson.

The first American example of Queen Anne, the Watts Sherman House (Fig. 10-15) in Newport, Rhode Island, by H. H. Richardson, closely follows Shaw's Leys Wood. It sets the stage for other early architect-designed structures, which tend to be more horizontal and differently massed than English examples are. Other American differences include more open space planning, varying room heights and floor levels, and greater integration of exterior and interiors through porches, larger windows, and use of exterior materials inside. This early version of Queen Anne evolves into the Shingle Style, but the variety, eclecticism, and quasi-medievalism of English Queen Anne continue in numerous wooden residences across America. House pattern books, the expanding railroad system, balloon framing, standardized lumber sizes, and factory-made precut architectural parts quickly spread the style, enabling thousands of Americans to have small and large houses in the latest Queen Anne fashion.

Public and Private Buildings • Stick Style

■ *Types.* Although primarily a residential development (Fig. 10-8, 10-11, 10-13), there are a few Stick Style state

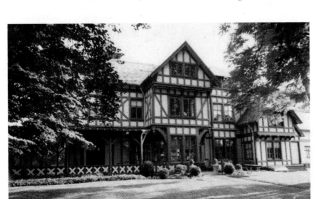

WEST ELEVATION

▲ **10-8.** John N. A. Griswold House, 1862–1864; Newport, Rhode Island; Richard Morris Hunt. Stick Style.

IMPORTANT BUILDINGS AND INTERIORS

■ **Arcadia, California:**

—Queen Anne cottage, 1881; A. A. Bennett.

■ **Cambridge, England:**

—Dining Hall, Newnham College, Cambridge University, 1874–1910; Basil Champneys. Queen Anne.

■ **Cape May, New Jersey:**

—Elridge Johnson House (Pink House), 1882. Queen Anne.

—Emlen Physick House, 1879; attributed to Frank Furness. Stick Style.

—S. Peter's by the Sea Episcopal Church, late 19th century. Stick Style.

■ **Denver, Colorado:**

—George Schleier Mansion, late 1880s; E. F. Edbrooke.

—Molly Brown House, c. 1880s; William Lang. Queen Anne.

■ **Eureka, California:**

—Carson House, 1884–1886; Samuel and Joseph C. Newsom. Stick Style/Queen Anne.

■ **Galveston, Texas:**

—Sonnenthiel House, c. 1887. Queen Anne.

■ **London, England:**

—Allied Assurance Company, 1–2 St. James Street, Pall Mall, c. 1882; Richard Norman Shaw. Queen Anne.

—Bedford Park (Queen Anne village), 1877–1880; Richard Norman Shaw. Queen Anne.

—Linley Sanbourne House, c. 1870s; Kensington.

—Lowther Lodge (Royal Geographic Society), 1873–1875; Kensington Gore, Richard Norman Shaw. Queen Anne.

—New Scotland Yard, 1887–1890; Richard Norman Shaw.

—New Zealand Chambers, 1871–1873; Richard Norman Shaw. Queen Anne.

—Palace Gate, No. 8, 1873–1875; Kensington; J. J. Stevenson. Queen Anne.

■ **Los Angeles, California:**

—Hale House, c. 1885; Joseph Cather Newson.

—Lewis House, 1889; Joseph Cather Newson.

■ **Newport, Rhode Island:**

—John N. A. Griswold House, 1862–1864; Richard Morris Hunt. Stick Style.

—Watts Sherman House, 1874–1875; Henry Hobson Richardson. Queen Anne.

■ **Northumberland, England:**

—Craigside, 1869–1884; Richard Norman Shaw. Queen Anne.

■ **Philadelphia, Pennsylvania:**

—Women's Pavilion, New Jersey State Building, Michigan State Building, and the Pennsylvania State Building, International Centennial Exhibition, 1876. Stick Style.

■ **San Diego area, California:**

—Hotel del Coronado, 1886–1888; Coronado. Queen Anne.

—Sherman-Gilbert House, 1887–1889; Comstock and Trotsche. Stick Style.

—Villa Montezuma, Jesse Shepard House, 1887. Comstock and Trotsche; Queen Anne.

■ **San Francisco, California:**

—Haas-Lilenthal House, c. 1886. Queen Anne.

■ **Surrey, England:**

—Lodge at Kew Gardens, 1866; W. E. Nesfield. Queen Anne.

■ **Sussex, England:**

—Leys Wood, 1866–1869; Richard Norman Shaw. Queen Anne.

pavilions at the International Centennial Exhibition (Fig. 10-4) and some churches (Fig. 10-6) and resort hotels elsewhere.

■ *Materials.* Wood is the primary building material for all building types. A few examples may mix brick, stone, or masonry with wood.

■ *Façades.* Stickwork, composed of flat boards, creates panels that organize the façade and emphasize the structure (Fig. 10-4, 10-6, 10-8, 10-13). Applied over wall surfaces (usually upper stories), stickwork may be horizontal, vertical, and/or diagonal. The pattern of sticks may reflect the balloon framing beneath or simply decorate the surface. Although resembling half-timbering, the wall beneath the stickwork is covered with traditional American clapboards instead of plaster. The verticality, asymmetrical massing, and irregular silhouette of medieval buildings

▲ **10-9.** Leys Wood, 1866–1869; Sussex, England; Richard Norman Shaw. Queen Anne.

are common. Additional characteristics include square or rectangular towers and rectangular bay windows. Single-story porches, which lighten the mass of the structure, may be partial or full width and extend on one, two, or three sides. Porch supports have diagonal brackets. Some houses may be polychrome with colors emphasizing stickwork. Some display elements from other styles or cultures (Fig. 10-11).

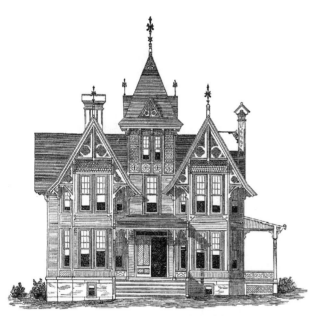

▲ **10-10.** Model house; published in *Details of Cottage and Constructive Architecture . . . Showing a Great Variety of Designs for Cornices, Brackets, Window Caps, Doors, Piazzas . . .*, 1873; by Amos J. Bicknell. Queen Anne.

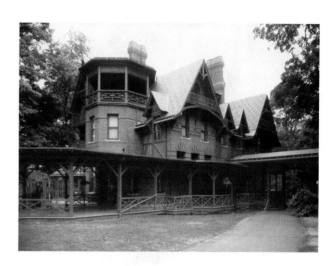

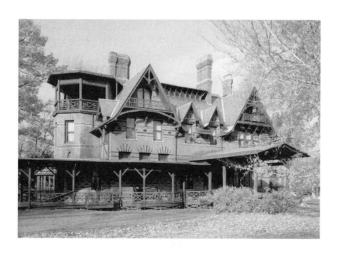

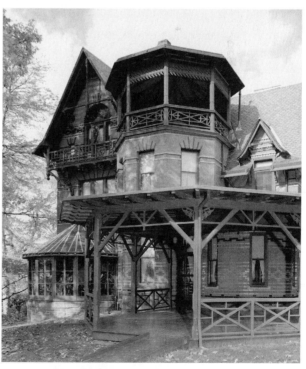

▲ **10-11.** Mark Twain House, c. 1874; Hartford, Connecticut; Edward Tucker Potter. Stick Style.

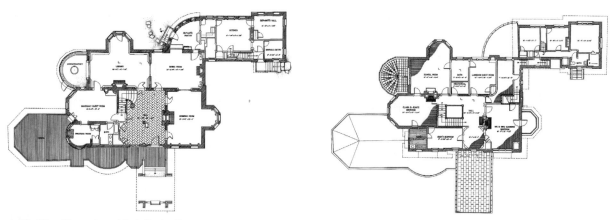

▲ **10-12.** Floor plans, Mark Twain House, c. 1874; Hartford, Connecticut; Edward Tucker Potter. Stick Style.

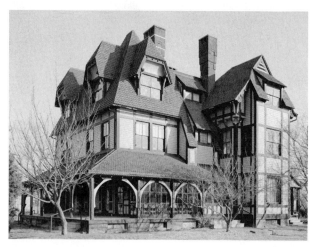

▲ **10-13.** Emlen Physick House, 1879; Cape May, New Jersey; attributed to Frank Furness. Stick Style.

▲ **10-14.** Craigside, 1869–1884; Northumberland, England; Richard Norman Shaw. Old English style, Queen Anne.

■ *Windows.* One-over-one or two-over-two sash windows are most common although some have bay windows (Fig. 10-7, 10-8, 10-11, 10-13). A few examples have casements or triple sash windows. Shutters are not used.

■ *Roofs.* Multiple steeply pitched roofs may be gabled, cross gabled, or hipped with wide eaves and large brackets beneath to support them (Fig. 10-4, 10-7, 10-8, 10-11, 10-13, 10-16). Ends of rafters may be exposed in gables. Also typical is a decorative truss in the apex of the roof that repeats stickwork on the facade. Dormers, cresting, and pendants are common. Slate or wooden shingled roofs may be polychrome.

Public and Private Buildings • Queen Anne

■ *Types.* English Queen Anne defines many public building types, including offices (Fig. 10-5), schools, colleges, shops, pubs, coffee houses, hospitals, hotels, and even a few churches. Private building types include manor houses, town houses or terraces, flats, and worker housing (Fig. 10-9, 10-14, 10-20). Only a few country houses adopt the style because it is not pretentious enough for the wealthy.

In the United States, Queen Anne is primarily a residential style, usually for single-family dwellings or townhouses (Fig. 10-10, 10-15, 10-16, 10-18, 10-19). Queen Anne's large rambling forms and residential appearance make it suitable for hotels (Fig. 10-7) and a few commercial buildings.

■ *Site Orientation.* Houses in England may be rural or urban with appropriate sites (Fig. 10-9). England's Bedford Park, one of the first garden cities, features green settings for its small and large, single or duplex simplified, Queen Anne houses, schools, shops, pubs, and church. Some buildings, such as schools, have lawns surrounding them. In the United States, Queen Anne houses fill newly developed suburbs or large lots in cities (Fig. 10-15, 10-17, 10-19).

■ *Floor Plans.* Commercial structures have no typical floor plans but develop from space allowances and functional needs.

English and American houses usually have irregular floor plans centered on living halls, large spaces with stairs, a fireplace, and often an inglenook or area with built-in seating around the fireplace (Fig. 10-12). American plans have tall and broad openings between the living hall and

DESIGN SPOTLIGHT

Architecture: Watts Sherman House, 1874–1875; Newport, Rhode Island; Henry Hobson Richardson. Queen Anne. The Watts Sherman House is considered the first American example of Queen Anne. Richardson models Shaw's work, which he is familiar with through publications of it. However, he creates something new and uniquely American. More horizontal than British examples, the house masses around the central open floor plan with monumental living hall. Horizontal bands of windows highlight the hall on the exterior and form a glass wall. Richardson rejects the red brick and white paint of England for a combination of granite, brownstone, stucco, and shingles in various shapes. Tall chimneys, leaded casement windows, and half-timbering recall English medieval examples. Although lacking the ample porches characteristic of later examples, Richardson's design greatly influences the Queen Anne, Colonial Revival, and Shingle styles. The house has had several additions since its initial construction, the earliest by Stanford White in 1881. The open plan centers on a large staircase and living hall from which space flows through broad openings into the dining room, library, and drawing room. Details from the Middle Ages define the stair and hall and include beamed ceilings, wainscoting, a large hooded fireplace, and stained glass windows.

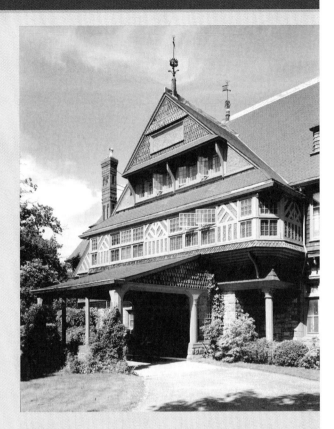

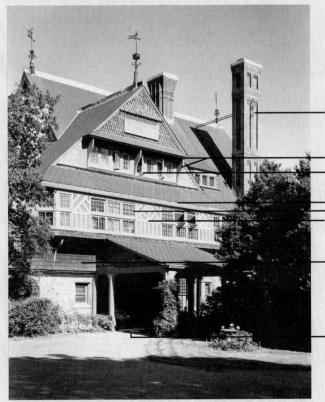

— Tall chimney

— Variety in roof design
— Horizontal band of windows

— Horizontal emphasis
— Small window panes
— Half-timbering

— Shingles accent facade

— Partial-width porch for entry

◄ **10-15.** Watts Sherman House; Newport, Rhode Island.

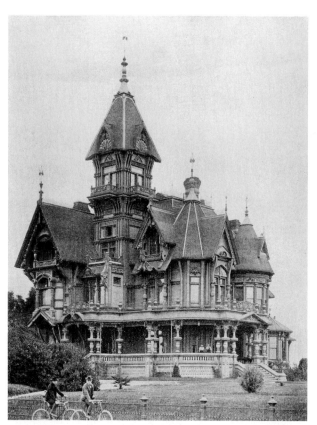

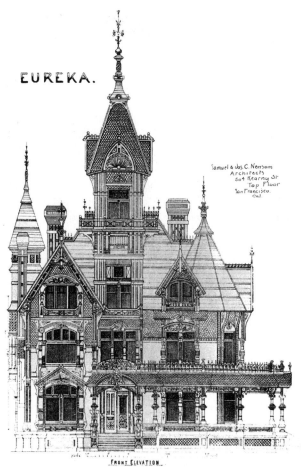

EUREKA.

▲ **10-16.** Carson House, 1884–1886; Eureka, California; Samuel Newsom and Joseph C. Newsom. Stick Style/Queen Anne.

DESIGN PRACTITIONERS AND FURNITURE MANUFACTURERS

- **Richard Morris Hunt** (1827–1895) is known for his buildings in classical styles and grand manor houses for the wealthy, but his Griswold House is the first example of Stick style in the United States. Hunt is influenced by French half-timber structures he saw while studying abroad (see Chapter 12, "Classical Eclecticism").

- **William Eden Nesfield** (1835–1888), along with Shaw, inaugurates the Queen Anne and Old English styles in England. Nesfield's Lodge at Kew Gardens in Surrey is considered the first manifestation of Queen Anne.

- **Richard Norman Shaw** (1831–1912) creates the Queen Anne and Old English architectural styles and becomes their leading practitioner in England during the 1870s. He regards them as secular, domestic, and English in contrast to the Gothic Revival. Shaw soon tires of Queen Anne and moves on to Renaissance and Georgian

Revival. Through publication, his work is well known on both sides of the Atlantic. Shaw also designs interiors and furniture, of which little survives.

- **John James Stevenson** (1831–1908) is the leading designer of Queen Anne residences in London. His own house, called the Red House and now demolished, showcases his ideas and is widely imitated.

- **Berkey and Gay** (1861–1948) is one of the three largest furniture manufacturers in Grand Rapids, Michigan, in the second half of the 19th century. Known for its excellent quality, the company produces furniture in many revival styles, particularly dining room and bedroom suites of Renaissance Revival, Eastlake, and Gothic Revival. In the early 20th century, it adds an upholstery division and is a leading producer of Colonial Revival furniture.

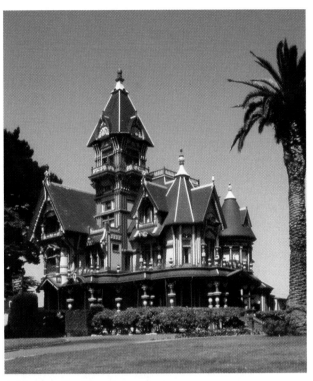

▲ **10–16.** *(continued)*

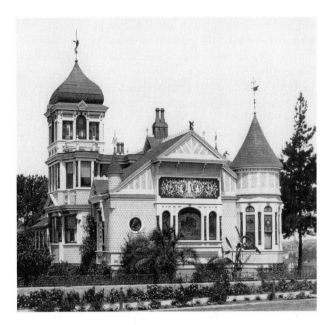

DESIGN PRACTITIONERS

- **Grand Rapids Chair Company** (1872–1973) produces caned chairs and frames for upholstery suites until the early 20th century when it begins making living and dining room furniture in revival styles. Its best-known line is Castle Oak, a Tudor Revival style. During the 1950s, the company produces a line of modular furniture for the home. It becomes a subsidiary of Sligh Furniture in 1945 and is fully integrated into Baker Furniture in 1973.

- **Mitchell and Rammelsberg** (1849–1930s), Cincinnati, Ohio, uses interchangeable parts and ornament to produce many types of furniture in a plethora of styles for home, office, and saloon. One of the largest furniture manufacturers in the United States, the company stocks less expensive furniture in showrooms in New Orleans, St. Louis, and Memphis. The firm also makes custom furniture to order for wealthy clients.

- **Sligh Furniture Company** (1880–present) of Grand Rapids, Michigan, manufactures bedroom furniture exclusively until the 1930s when it adds a line of desks and moves to Holland, Michigan. The company produces a range of residential furniture and clocks.

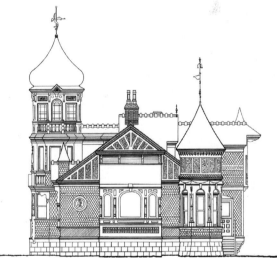

EAST ELEVATION

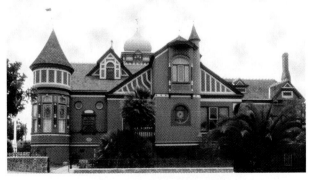

▲ **10–17.** Villa Montezuma, Jesse Shepard House, 1887; San Diego, California; Comstock & Troitsebe. Queen Anne.

surrounding spaces, which gives a more open feeling and allows space to flow between and among rooms. Also evident in the Stick Style, balloon framing and central heating make these new, open plans feasible. The large windows and ample porches characteristic of American houses help bring the outside into the house.

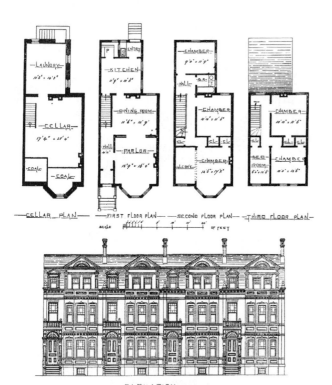

■ *Materials*. English Queen Anne buildings most often are of brown brick with red brick trim or only red brick (Fig. 10-5). Windows and other details are painted white. Ornament may consist of terra-cotta plaques with naturalistic motifs, tiles, and pargework. Balcony supports may be of wood painted white, stone, or wrought iron. Roofs usually are slate.

Wood is the dominant building material for American Queen Anne houses and hotels (Fig. 10-7, 10-18, 10-19). Timber is plentiful, and the scroll saw and balloon framing make wooden buildings cheaper, easier, and faster to construct. Some homes have a mixture of materials such as terra-cotta, brick, or stone, and wood. Board and batten, clapboards, or shingles may cover wall surfaces (Fig. 10-17). On roofs are wooden or slate shingles and, sometimes, iron cresting (Fig. 10-16, 10-17).

American color schemes are composed of several colors that contrast the body of the house with structural details, such as windows, brackets, and eaves. Multiple contrasting colors cause elements to apparently advance and recede, creating highlights and shadows. Dark, rich colors from nature are popular, including brown, terra-cotta, and olive green.

■ *Façades*. Queen Anne buildings in both England and the United States are asymmetrical and varied in form and design but convey a similar feeling to late medieval, 17th- and 18th-century, and/or rural houses of the past (Fig. 10-9, 10-13, 10-14). Both English and American public and private buildings may be self-contained or rambling depending upon the site and function. Façades, rarely flat, have a variety of projections, protrusions, and volumes. Although larger in scale than residences, public buildings have a similar character to residences.

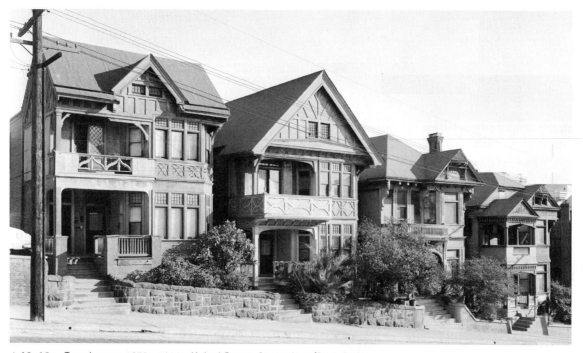

▲ **10-18.** Townhouses, 1870s–1880s; United States. Queen Anne/Stick Style.

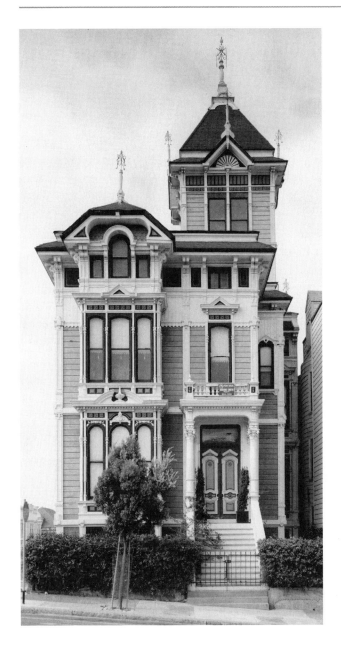

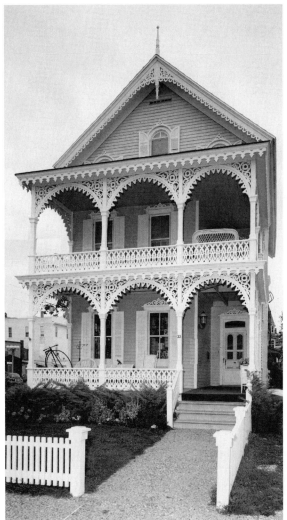

English structures, particularly commercial buildings, usually have brick pilasters often dividing fronts into bays. Common characteristics of both public and private buildings are straight and Flemish gables, tall and decorated chimneys, half-timbering, tile work, jetties, combinations of windows (Fig. 10-5). Somewhat less typical are quoins, stringcourses, columns, pediments, and arched lower stories. Houses sometimes have niches to display blue and white porcelain or other decorative objects. Important buildings, such as town halls, may have centerpieces, clock towers, or a cupola. Following Shaw, some buildings have a large cove, often with patterned pargework, joining wall and roof.

American Queen Anne houses have round, polygonal, or angled towers, usually on corners, half-timbering, decorative stone or terra-cotta panels, and wooden scrollwork

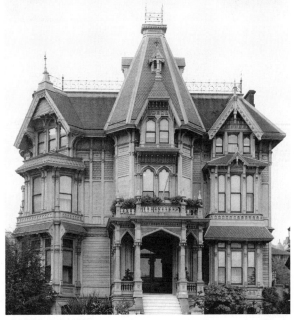

▲ **10-19.** Houses, c. 1880s–1900s; United States. Queen Anne/Victorian vernacular.

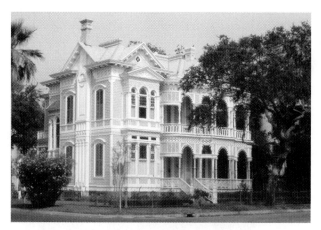

▲ **10-19.** *(continued)*

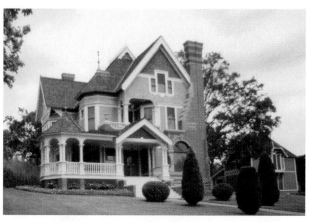

▲ **10-19.** *(continued)*

highlighting porches, walls, gables, and windows (Fig. 10-10, 10-17, 10-19). Rooms, balconies, walls, and roofs interlock. Rooms may project over porches or bay windows. Spindles embellish gables, porch supports, and cornices.

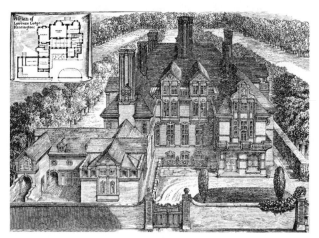

▲ **10-20.** Lowther Lodge, c. 1873–1875; Kensington Gore, London, England; Richard Norman Shaw. Queen Anne.

A variety of colors, textures, and materials is common. In the 1890s, a version of Queen Anne called Free Classic appears in the United States with classical columns, colonnettes, pediments, and Palladian windows. Like the Stick Style, Queen Anne houses have single-story full- or partial-width porches surrounding them. Some have additional smaller porches on their upper stories. Some examples have the latticework and/or horseshoe arches of Islamic architecture. Townhouses or flats have similarly designed details usually organized in multiple components for unity (Fig. 10-18). American Queen Anne hotels resemble large-scale houses with bays, towers, prominent chimneys, and porches (Fig. 10-7).

■ *Windows.* Use of a variety of windows is characteristic of all Queen Anne structures in England and the United States (Fig. 10-19, 10-21). Casements with leaded panes or sash windows with small panes painted white are frequent. Other types include round, square, Palladian, and arched. Some sashes have a single pane below with small panes above. Shop windows often have a single pane of glass to display merchandise more effectively. Windows

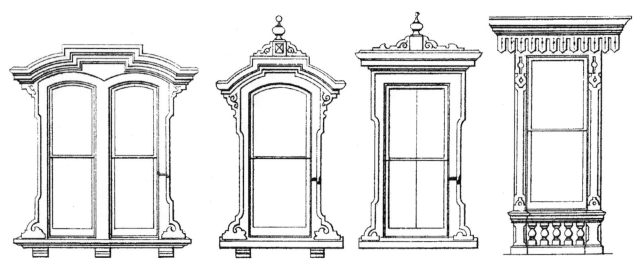

▲ **10-21.** Decorative glass windows, c. 1870s, 1880s; United States.

▲ **10-21.** *(continued)*

American Queen Anne. To restrict as little light as possible, colored glass often is limited to transoms or borders.

■ *Doors.* Entries may be prominent or unobtrusive, centered, or on one side. Formal porches with pediments and columns or simple surrounds composed of columns or pilasters carrying lintels, a pediment, or fanlight may define the entry (Fig. 10-16, 10-19). Doors are wood paneled painted dark green or black. Doorways in American buildings usually have simple or less complicated surrounds than those in England do. Doors may be single or double and have plain, etched, or stained glass in the upper portions.

■ *Roofs.* Most buildings have a multiplicity of steeply pitched roofs that may be gabled or hipped (Fig. 10-14, 10-15, 10-16, 10-17, 10-19). Townhouses usually have flat roofs, sometimes with a false gable. Dormers, usually embellished, are common in all styles in both countries. Flemish or straight gables are common in English Queen Anne. Jerkinhead roofs may appear in American Queen Anne. Towers may have angled or conical roofs or onion domes. Starbursts, shingles, tiles, flowers, or foliage may decorate the apex of roofs in American Queen Anne. Bargeboards and decorative trusses are common adornments. Towers and gables may have finials or pinnacles. Large chimneys may resemble Elizabethan or Tudor examples.

■ *Later Interpretations.* In the late 20th century, Queen Anne Style houses adapted for modern living appear in upscale American housing developments. Often clad in vinyl siding, the contemporary versions have a tower and a porch but fewer decorative details and colors than their predecessors did. A keeping room or great room replaces the earlier living hall. Hotels also exhibit Queen Anne and Stick Style characteristics, particularly those located near water (Fig. 10-22).

(Fig. 10-21) may be single, double, or triple, and one, two, or three stories tall. Some are small and unobtrusive, while others dominate the facade. Bay and oriel windows may be angled with three to five sides, curved, or curved with flat fronts, and exhibit endless variations. Details for bays are numerous, including arches, pediments, and pargework. Glazing bars may be of wood, lead, or stone. Bays may project beneath overhangs or have balconies above them. Stained, leaded, etched, and colored glass is common in

INTERIORS

Stick Style buildings do not have corresponding interior styles, so their rooms feature fashionable revivals such as Rococo, Renaissance, Medieval, or Gothic. Like architecture, interiors in Queen Anne houses do not replicate those of the 18th century. Most follow revival styles or the Aesthetic Movement (see Chapter 16, "Aesthetic Movement") or Arts and Crafts Movement (see Chapters 17, "English Arts and Crafts," and 18, "American Arts and Crafts"). A few recall 18th-century interiors with classical columns, pediments, low relief plasterwork in classical motifs, or wall paneling (Fig. 10-26, 10-27). As is typical of the time, each room may depict a different style with masculine styles, such as Jacobean, defining dining rooms and halls and feminine styles, such as Adam, in the parlor and morning room.

Public and Private Buildings

■ *Types.* Living halls become characteristic during this period as formal living begins to give way to informality. They serve as living rooms, entrance halls, and circulation spaces

▲ **10-22.** Later Interpretation: Grand Floridian Resort and Spa, c. 1990; Lake Buena Vista, Florida; Wimberly, Allison, Tong, & Goo.

DESIGN SPOTLIGHT

Interiors: Stair hall, John N. A. Griswold House, 1863–1864; Newport, Rhode Island; Richard Morris Hunt. Stick Style. The stair hall is reminiscent of medieval interiors with its high ceilings and walls highlighted with dark wood brackets, panels, and flat trim. Carving in the stair rails recalls Gothic tracery. The flat wood trim and X shapes in the panels unite with the stickwork on the exterior and call attention to the decorative wall surface. The medieval character of the exterior and architectural details define the Stick Style. Definitive characteristics are the stickwork, porch supports with diagonal braces, bracket supports beneath the roof, decorative trusses in the gables, and ornamental cresting.

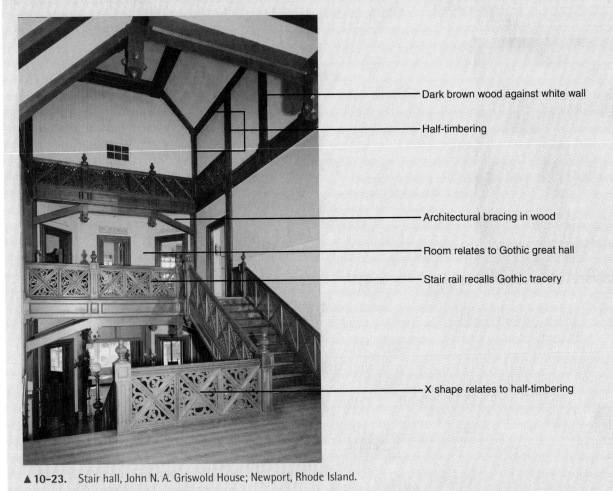

Dark brown wood against white wall

Half-timbering

Architectural bracing in wood

Room relates to Gothic great hall

Stair rail recalls Gothic tracery

X shape relates to half-timbering

▲ **10-23.** Stair hall, John N. A. Griswold House; Newport, Rhode Island.

◄ **10-24.** Stair hall, Watts Sherman House, 1874–1875; Newport, Rhode Island; Henry Hobson Richardson. Queen Anne.

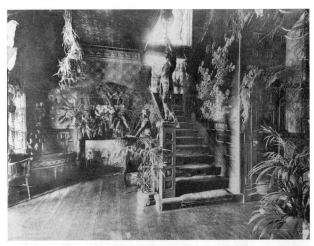

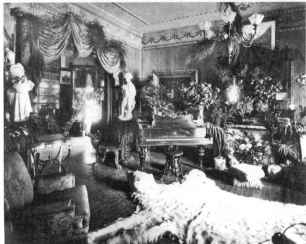

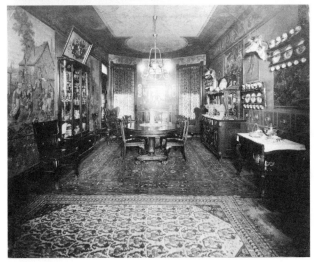

▲ **10–25.** Entry hall, parlor, and dining room, Molly Brown House, c. 1880s; Denver, Colorado; William Lang. Queen Anne.

▲ **10–26.** Wall elevation with chimneypiece; published in *Suggestions for Home Decoration*, 1880; England; by T. Knight, design by J. D. Sedding. Queen Anne.

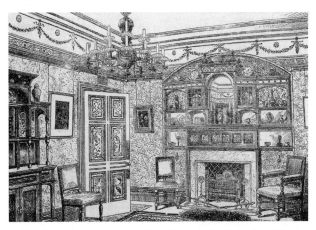

▲ **10–27.** Dining room; published in *How to Build, Furnish, and Decorate*, 1883; by Robert W. Shoppell, New York.

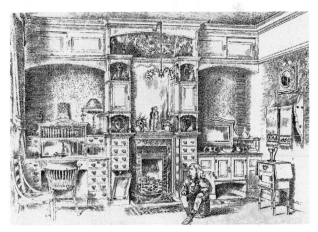

▲ **10–28.** Model bedroom, shown at the International Health Exhibition, 1884; England; published in *British Architect*, June 1884; designed by R. W. Edis for Jackson and Graham. Queen Anne.

(Fig. 10-24, 10-29). Many homes still retain the parlor, which varies from comfortable family rooms to carefully decorated, maintained, and seldom-used monuments to formal living (Fig. 10-25).

■ *Relationships.* Often there is little relationship between exterior and interior because no similar vocabulary exists in either Queen Anne or Stick. However, houses and interiors later may reveal elements of the Aesthetic Movement and Japanese influence (see Chapter 16, "Aesthetic Movement") and Arts and Crafts Movement.

■ *Color.* Colors vary with the interior style chosen. Revival-style colors tend to be more saturated or dark and

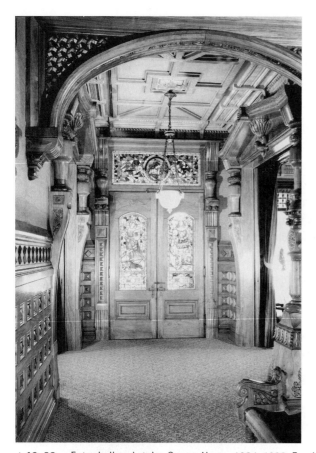

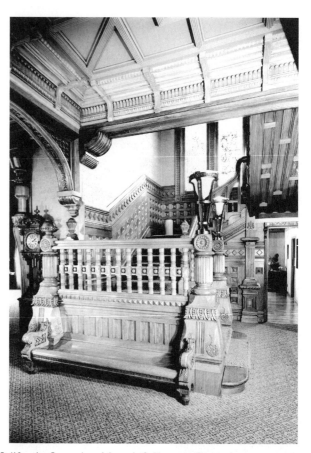

▲ **10-29.** Entry hall and stairs, Carson House, 1884–1886; Eureka, California; Samuel and Joseph C. Newson. Queen Anne.

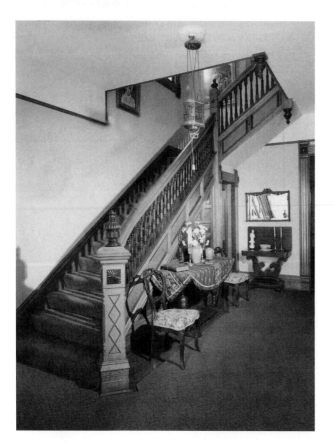

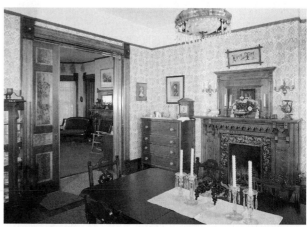

▲ **10-30.** Stair hall and dining room, Jeremiah Nunan House, 1892; Jacksonville, Oregon; architect George Franklin Barber, from his architectural pattern book mail-order catalog *The Cottage Souvenir*. Queen Anne.

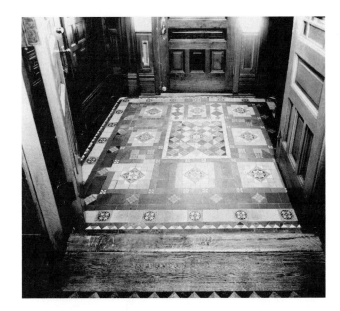

▲ **10-31.** Floor tiles, and oilcloths and linoleum (patterns imitate decorative tiles, wood planks, and ingrain carpets); Colorado and Virginia.

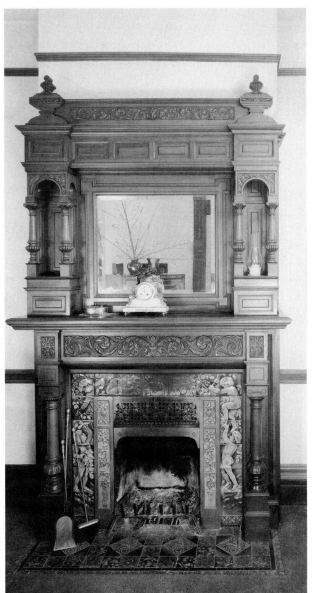

▲ **10-32.** Mantels, late 19th century; United States and England. Queen Anne.

▲ **10-32.** *(continued)*

rich especially after midcentury. Aesthetic Movement colors follow tertiary hues. Queen Anne colors lean toward those of the Neoclassical (late 18th, early 19th century) and as such may be saturated lighter tints. Arts and Crafts interiors use colors of nature.

■ *Lighting.* Most homes have gas light in gasoliers, sconces, and portable lamps in brass or wrought iron (Fig. 10-28, 10-29). Americans also use kerosene or oil lamps. Electric fixtures come into use late in the period. Designs for fixtures may adapt characteristics of Neoclassical, the Aesthetic Movement, Arts and Crafts, or Revival styles.

■ *Floors.* Most floors are wood with rugs following the admonitions of design critics. Middle and lower middle classes cling to carpeting, which they can more readily afford. Some continue replacing carpet with grass matting in the summer. Other types of floors include decorative tile and linoleum (Fig. 10-31). Oilcloths cover some floors.

■ *Walls.* Walls are decorated according to the interior style chosen. In revival interiors, wallpaper and paint are the most common wall treatments. Using wallpapers, the working classes can easily imitate more sophisticated and expensive treatments. Those influenced by the Aesthetic Movement favor tripartite painted, paneled, or papered

▲ **10-33.** Wall designs and color schemes; published in *Painting and Decorating*, c. 1898; by Walter Pierce, London.

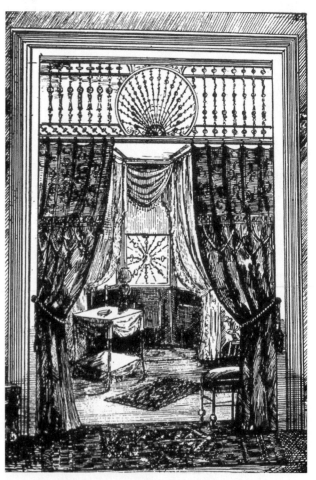

▲ **10-34.** Wood screen and portières; published in the *Practical Handbook on Cutting Draperies*, by N. W. Jacobs, 1890.

▲ **10-35.** Lace curtain patterns; c. 1880s–1900s.

walls (Fig. 10-25, 10-26, 10-29, 10-33). British houses sometimes have tiled dadoes in the hallway, bathrooms, and kitchens. Plate rails high on the wall display collections of china. As earlier, fireplaces are focal points (Fig. 10-26, 10-27, 10-28, 10-32). Queen Anne chimneypieces usually have broken pediments surmounting shelves for display. Tiles, usually blue and white, surround the fireplace opening. A cove or delicate cornice molding with a wallpaper border below separates the wall and ceiling.

■ *Window Treatments.* Window treatments vary from simple panels hanging from rings on plain rods to layers of treatments typical of revival styles. Lace curtains continue to be fashionable (Fig. 10-35).

■ *Doors.* Doors have simple surrounds, are paneled and stained a dark color. Doorways and openings to public rooms usually have portières that match the room's décor and sometimes the window treatments (Fig. 10-34). Upper portions of openings may have spindle grilles (Fig. 10-2, 10-34).

■ *Textiles.* Rooms boast a variety of textiles embellishing mantels and shelves and covering windows, pianos, and/or backs and arms of upholstery. Pillows, shelf lambrequins, and antimacassars made by the lady of the house are proudly on display.

■ *Ceilings.* Ceilings in revival-style interiors are usually a lighter tint than are the walls. Those influenced by the Aesthetic Movement have painted decorations or wallpapers (Fig. 10-36). Queen Anne ceilings may have low-relief plaster decorations in white or other colors.

▲ **10-36.** Ceiling patterns in paint (top) and metal, late 19th to early 20th centuries; Pennsylvania, Texas, and Illinois.

▲ **10–36.** *(continued)*

■ *Later Interpretations*. In the late 20th century, increased awareness of the economic benefits of reusing older buildings for commercial or residential purposes in England and the United States leads to the preservation, restoration, rehabilitation, and adaptive use of numerous structures (see Chapter 30, "Modern Historicism"). However, often only the original exteriors remain, while earlier interiors are destroyed or severely modified. Like other Victorian styles, rooms within Stick and Queen Anne houses usually reflect a period flavor instead of an accurate depiction of the period.

FURNISHINGS AND DECORATIVE ARTS

As in interiors, no similar vocabulary to architecture develops in furniture and, as a result, eclecticism rules. Use of new and old furnishings in various styles characterizes

DESIGN SPOTLIGHT

Furniture: Mail-order furniture: Side chairs; published in F. E. Stuart; Sears, Roebuck and Company; and Montgomery Ward and Company catalogs, c. 1900; United States. These chairs illustrate the many stylistic choices for dining chairs available to consumers at the end of the 19th century. Turning, spindle work, and caned seats are common features. Incising and pressed and applied wood decoration embellish some models.

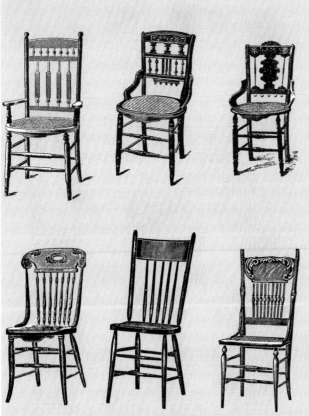

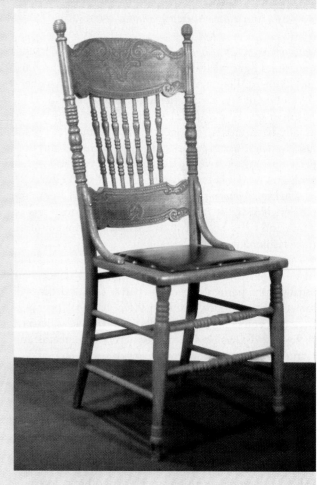

▲ **10–37.** Mail-order-furniture. Sears, Roebuck and Company and Montgomery Ward and Company catalogs.

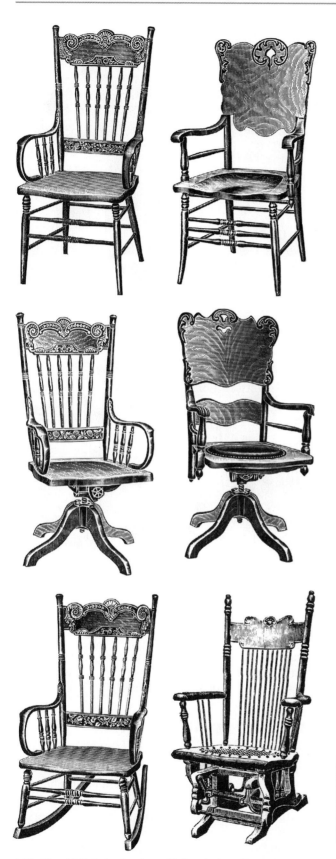

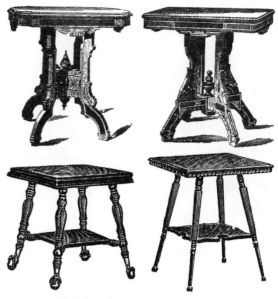

▲ **10-39.** Mail-Order Furniture: Tables; published in F. E. Stuart and Sears, Roebuck and Company catalogs, c. 1900; United States.

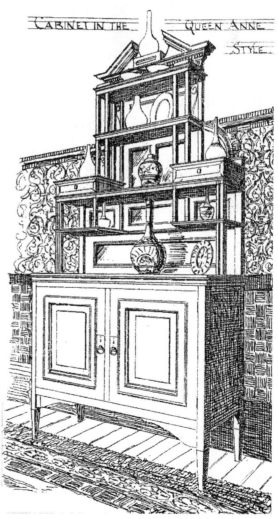

▲ **10-38.** Mail-Order Furniture: Dining chairs, office chairs, and rockers; published in Montgomery Ward and Company and Sears, Roebuck and Company catalogs, c. 1895, 1902; United States.

▲ **10-40.** Cabinet in the Queen Anne style; published in *Art Furniture*, c. 1877; England; designed by Edward W. Godwin.

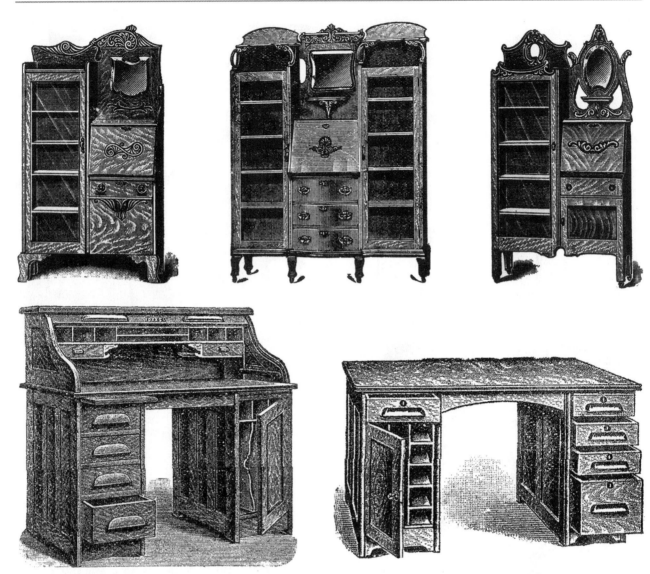

▲ **10–41.** Mail-Order Furniture: Desks; published in the Sears, Roebuck and Company catalog, c. 1900; United States.

rooms, which may have Japanese prints, English porcelain, Oriental or Middle Eastern folding screens, Art Furniture (see Chapter 16, "Aesthetic Movement"), cottage furniture, and Sheraton, Chippendale, Jacobean pieces, and/or overstuffed upholstery.

A few architects and others design furniture inspired by English traditional styles. This so-called Queen Anne furniture displays a range of forms and motifs from the 17th, 18th, and 19th centuries (Fig. 10-40). Designers pay little heed to correct use of forms and motifs. Characteristic of many pieces are shelves and brackets to display objects and collections.

In the United States, Victorian vernacular furniture interpretations are cheaper, machine-made versions of high styles such as Renaissance or Rococo Revivals. Americans can purchase furniture in department stores or through the mail.

Because much of the country remains rural, many furnish their homes through mail order using Sears or other catalogs (see Chapter 1, "Industrial Revolution").

Public and Private Buildings

■ *Types.* Factory-made office furniture of flat or rolltop desks and chairs is readily available and affordable (Fig. 10-38, 10-41; see Chapter 1, "Industrial Revolution"). For homes of people less enamored with eclecticism, suites of furniture for the parlor, the dining room, and bedrooms are most popular (Fig. 10-44). For the parlor, factories make affordable three-piece suites consisting of a sofa or settee, an armchair, and a rocker. Dining room suites have extension tables, chairs, and a china cabinet. Typical for bedrooms are beds, dressers, night stands, and wash stands.

◄**10-42.** Mail-order furniture: Wardrobes, china cabinets, and cupboard; published in Sears, Roebuck and Company and J. Shoolbred and Company catalogs, c. 1895, c. 1889; United States and England (see Chapter 1, "Industrial Revolution").

■ *Distinctive Features.* Queen Anne furniture (Fig. 10-40) features broken pediments, fretwork, turned balusters, columns, and pilasters. Characteristics of Sheraton, Adam, and Chippendale may mix together. Light-scale furniture may appear spindly. The use of gold-finished oak, applied carving, and embossed decoration characterizes middle-class factory-made furniture.

■ *Relationships.* Furniture has completed its migration from the perimeter of the room and is arranged near lighting and for use. Sizes for manufactured furniture are standardized by this period.

■ *Materials.* Mahogany and fruitwoods in a dark finish are favored for Queen Anne style furniture. Much factory-made furniture is oak or walnut. Oak is cheaper, more readily available, and strong enough to withstand packing and shipping.

■ *Seating.* Manufactured oak chairs follow many styles (Fig. 10-37, 10-38). Details such as curving legs and carved flowers signal Rococo Revival. Renaissance Revival chairs and rockers have baluster legs, spindle backs, and applied moldings. No matter what the style, seats may be solid wood, leather, or caned. Most common are pressed back chairs and rockers. A metal die, heat, and pressure apply designs to backs, giving the impression of hand-carved embellishment. Made in several price levels, they have turned legs, solid seats and backs with designs that are usually curvilinear with flowers and foliage on the crest or splat. Windsor chairs also are a popular choice for consumers.

■ *Tables.* American furniture manufacturers produce many different types, styles, and price levels of tables. Dining tables in oak usually are monumental in scale with

▲ **10-43.** Sideboards, c. 1890s–1900s; United States.

▲ **10-44.** Mail-Order Furniture: Chamber suites; published in Montgomery Ward and Company; Sears, Roebuck and Company; and New England Furniture Company catalogs, c. 1895, c. 1902; United States.

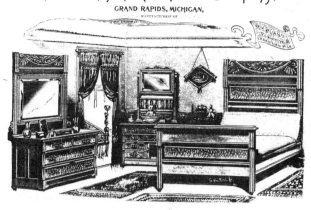

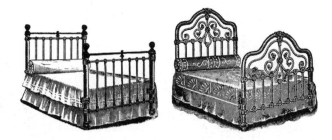

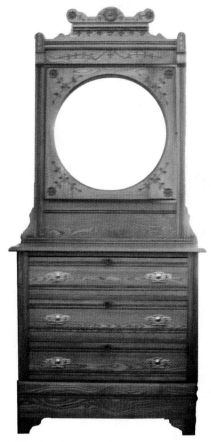

▲ **10-44.** *(continued)*

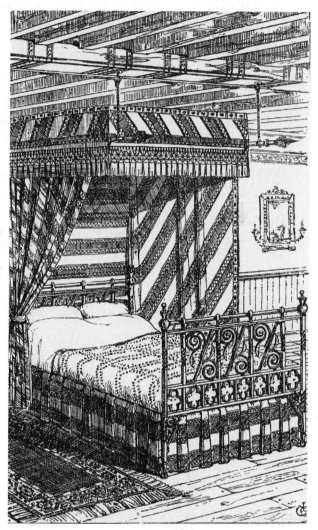

▲ **10-45.** Mail-Order Furniture: Iron and brass beds, c. 1860s–1900s; United States and England; manufactured by George Heyman and Sears, Roebuck and Company; and published in *Hints on Household Taste* by Charles L. Eastlake (bottom view; see Chapter 1, "Industrial Revolution").

a single center support that is turned or rectangular. Four legs with paw feet or rounded ends provide support and embellishment. Round tables usually have several leaves. Fancier tables have four turned legs or melon supports with paw feet. The bowed stretcher and apron feature pressed decorations. The most expensive parlor tables have marble tops and a center support composed of three or four legs and a central member (Fig. 10-39). Legs are rectilinear in form with incised or pressed decoration. Other parlor tables have rectangular wooden tops, turned splayed legs

connected to a lower shelf, and ball and claw feet in wood or glass. Fancier tables have pressed decoration on their aprons.

■ *Storage*. Queen Anne–style desks, bookcases, and sideboards with cabinets on top have broken pediments and brackets to display *objets d'art* (Fig. 10-40, 10-42, 10-43). The bases have slender, straight, tapered legs in the Late Neoclassic manner. A lower shelf provides additional display space. Swags, paterae, urns, arabesques, husks, and stringing decorate the drawers, doors, and legs.

Factory-made oak storage pieces include sideboards, china cabinets, desks, bookcases, desk and bookcase combinations, and kitchen cabinets (Fig. 10-41, 10-42). They are rectangular in form with wood, brass, or glass pulls and pressed, applied, or carved decoration on the crest. China cabinets have high, mirrored backs with shelves and lower drawer and doors. Fancier examples have applied or pressed decoration.

■ *Beds*. Wooden beds have tall solid backs with pressed or applied decorations (Fig. 10-44). Tops may be flat, arched, curved, or pedimented. Solid footboards repeat the headboard design but are shorter. Iron or brass beds (see Chapter 1, "Industrial Revolution") may be composed of plain, round, and turned rods topped with balls or curving rods (Fig. 10-45). Bedroom suites include matching dressers, chiffoniers, washstands, wardrobes, and night stands (Fig. 10-44).

■ *Upholstery*. Common upholstery fabrics are damask, velvet, leather, horsehair, and tapestry. Upholstery displays many different types and patterns of fabrics in contrast to ensuite rooms of the earlier 19th century.

■ *Decorative Arts*. Numerous brackets and shelves on furniture, the mantel, and wall shelves display blue and white porcelain and other ceramics. Japanese fans and peacock feathers may add an exotic touch. Stands hold plants and flowers. Mirrors, paintings, and prints may cover walls.

	
1820	Physicist Hans Oerstead discovers electromagnetism
1822	Charles Wilson Peale paints *The Artist in His Studio*
1825	Erie Canal opens
1827	Steam-powered rotary press invented
	Friction match invented
1829	Tremont House, first real hotel in U.S. opens in Boston
1847	First U.S. postage stamps issued
1848	Gold discovered in California
1849	Cast-iron building façades become popular
1850	First bathtub installed in the White House
1851	Crystal Palace Exhibition opens in London
	Gas ranges for the home introduced
1853	Crystal Palace Exhibition, New York
	First illustrated hardware catalog issued, U.S.
1854	Bessemer steel-making process developed
1856	NYC Central Park opens
1858	Mount Vernon Ladies Association purchases Mount Vernon
1863	Lincoln gives his Gettysburg Address
	Frederick Walton invents linoleum
	Regular home delivery of mail becomes popular
	13th Amendment abolishes slavery
	George Pullman builds first *Pullman Palace Car*
1865	Ku Klux Klan (KKK) founded
	Lincoln assassinated
	Salvation Army gets its start
	Scotsman Joseph Lister promotes antiseptic surgery
1866	Massachusetts Institute of Technology (MIT) begins first U.S. architecture program
1867	Strauss likes the *Blue Danube*
1870	African-American men gain vote in U.S.
1871	Architectural terra-cotta first used in U.S. on a large scale
	Great Chicago Fire opens many opportunities
	Metropolitan Museum of Art, New York, founded
1876	Germany starts the refrigeration revolution
1881	Columbia University begins an architecture program
	Electric streetcars begin to travel
1886	Construction begins on the Library of Congress in Washington, D.C.
	Geronimo, the Apache, captured
1890	Hendrik Isben completes *Hedda Gabler*
1893	World's Columbian Exhibition held in Chicago
	Cracker Jack and Aunt Jemima are a hit with kids and in the kitchen
	550 banks fail in U.S. depression
1897	C. A. Parsons patents a steam turbine used to power ships
	Illinois becomes the first state in the United States to adopt architectural licensing
1898	Library of Congress moves into its new building
	Spanish American War breaks out
1902	Morris Benton designs Franklin Gothic typeface
1916	San Diego Exposition introduces Spanish Revival architecture

D. ACADEMIC HISTORICISM

The term *Academic Historicism* refers to a more studied method of design that is usually acquired in an academic or educational setting as opposed to learning through an apprenticeship or work experience. This characterizes the late 19th and early 20th centuries in Europe and North America. Reacting to the rampant eclecticism, vagaries, and licentiousness of design in the earlier part of the century, designers return to a more disciplined and sober design approach that derives from and uses elements of classical antiquity and the Renaissance. Many of these participating designers study at *L'École des Beaux-Arts* in France, which emphasizes study and emulation of the best examples of the past. Consequently, they reintroduce the classical idiom as a means of bringing order, unity, and restraint to design. Although eclecticism still dominates design, it becomes more thoughtful and carefully considered or more scientific and systematic. Overt connections to the past replace the loose, haphazard borrowings of earlier.

Study of the best examples of the past becomes easier in the second half of the 19th century because past styles are better understood and designers have greater access to ancient and Renaissance buildings and their images. The disciplines of art and architectural history have classified past styles and trends according to the scientific method. Museums and individuals collect and display artifacts and art works. With easier travel, more designers and their clients visit important sites. New developments in publishing and photography provide images and information for both those who travel and those who do not.

Classical eclecticism is the unifying element among late-19th-century and early-20th-century architecture, interiors, and furniture despite a large number of individual styles, such as Romanesque Revival, Chateauesque, Beaux-Arts, Neo-Renaissance, and Neoclassical Revival. Designs reveal clear and, sometimes, discrete references to earlier buildings. The period is one of grandiose scale and monumentality, which express prosperity, culture, and nationalism in buildings and furnishing for nations and the affluent. Beaux-Arts-trained designers are readily able to produce works that communicate these qualities. Collaboration among architects, artists, sculptors, landscape architects, and others to create monumental works of architecture is at an all-time high. Trained in a classical vocabulary, they create classical and, often, restrained exteriors and lavish interiors of which many rooms feature period designs in expensive materials and finishes.

Academic Historicism, the Arts and Crafts Movement, and other factors help inspire renewed interest in local or regional styles. In the United States, this gives rise to the Colonial Revival, which is based upon English Colonial and dominates the eastern part of the country, and the Spanish Colonial Revivals that derive from Spanish and Mediterranean architecture and are immensely fashionable in the southwestern United States.

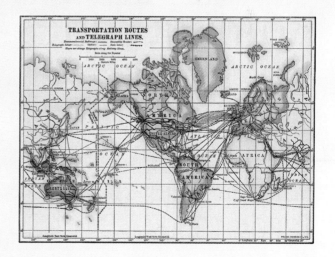

Romanesque Revival, Richardsonian Romanesque

Romanesque Revival 1820s–1860s
Richardsonian Romanesque 1860s–1900s

Corbel tables and round arches distinguish buildings in the Romanesque Revival or the Round-arched Style, which originates in Germany in the early 19th century. Developing from similar medieval impulses as the Gothic Revival, Romanesque Revival is a less popular alternative to Gothic Revival in England, Europe, and North America. Its use diminishes by the 1860s. During the 1870s, American

The manner of Richardson is worthy of the name of an original American style if the Americans are pleased to say so. Its primary elements are these: rough rustic stonework for the wall facing wherever eligible; exceedingly bold and massive Romanesque detail, Italian, French or Spanish at pleasure; the wide, heavy, low-browed, semicircular-arched doorway, as a specially favourite feature, with its deep voussoirs strongly emphasized and its dark shadowy porch within—the focus of the composition and the foundation of its motive; then the arcade to correspond; the campanile rising like a cliff in unbroken breadth and stern repose.

James Fergusson, *Modern Styles of Architecture*, 1899

architect Henry Hobson Richardson creates a personal style that becomes known as Richardsonian Romanesque. Based upon Romanesque structures and other sources, massiveness, round arches, and rough-faced stone define the style, which is the first American style to be taken up in Europe. Neither the German nor American versions of Romanesque Revival have a corresponding interior or furniture style.

HISTORICAL AND SOCIAL

An international ecclesiastical architectural style, Romanesque flourishes in Europe from the 8th century until about 1150. The style arises in response to a need for more and larger fireproof churches for the numerous pilgrims seeking a religious experience or to view religious artifacts. The name comes from the round or Roman arches that characterize it, and each European region adapts Roman vaulted construction to its own liturgical

and practical needs. Common Romanesque characteristics include the round arch, repeated modules, ribbed vaults, towers, corbel tables, and articulation of design features through massing, repetition, moldings, and sculpture. Romanesque construction techniques using groin vaults and buttresses become the foundation for Gothic architecture.

In late-1820s Germany, Romanesque Revival develops out of discussions about selecting an appropriate national style from among medieval alternatives to classicism, a resurgence of religious fervor, and the study and publication of medieval and Romanesque architecture. Consequently, in their quest for a national style that expresses their move toward unification, the Germans investigate Romanesque with great intensity and depth. Not only do scholars and architects scrutinize Germany's medieval buildings, but they study those of Byzantium and Italy, which gives a strong Italian flavor to the revival.

Rulers Ludwig I of Germany and Friedrich Wilhelm IV of Prussia see religion as essential in the revitalization of their countries following the Napoleonic wars. Both advocate a strong church–state system and support the restoration of medieval churches and the building of new churches many of which are Romanesque Revival. New social institutions develop from the universal church movement, which strives to support contemporary life and confront problems of progress and modernization. Within the movement is a general push for a return to the simplicity in faith of early Christianity, which in turn, supports simpler, less expensive church buildings. Religious revivals prompt a return to doctrinal simplification based upon models of Early Christianity, of which the use of Early Christian and medieval models for contemporary churches is a visual expression.

Royal family ties, visits by German architects and theorists, prints, and pattern books bring the Romanesque Revival to England. Queen Victoria's marriage to the German Prince Albert aligns the two families and creates trade and diplomatic exchanges. As in Germany, a Protestant Revival and subsequent turn toward simplicity in doctrines and buildings focuses some attention on Romanesque Revival over Gothic Revival. Nevertheless, Gothic Revival dominates English architecture, interiors, and furniture (see Chapter 6, "Gothic Revival").

A similar pattern prompts the rise of Romanesque Revival in North America. The style's inception coincides with the immigration of thousands of Germans during the 1830s and 1840s, which creates an atmosphere receptive to German culture. Royal patronage plays a role in the transmission of Romanesque Revival because Ludwig I and Friedrich Wilhelm IV fund the building of churches and monasteries in America for German immigrants. Immigrant architects and architectural treatises from Germany also help advance the revival, which briefly surpasses Gothic Revival in popularity in the 1850s. In both England and North America, Romanesque Revival inspires a picturesque image that is not so tainted by associations of Catholicism or elitism as is Gothic Revival.

In the second half of the 19th century, one of the foremost architects interpreting Romanesque in the United States is Henry Hobson Richardson (Fig. 11-1), who studies at L'École des Beaux-Arts in France beginning in 1860. While there, he travels in England, France, Italy, and the Mediterranean regions. When he returns to Boston in 1865, he is familiar with contemporary architectural developments in France, early medieval churches in England and France (particularly Normandy), and recently discovered Early Christian churches (c. 500–1500 C.E.) in Syria. Drawing from these and other influences, Richardson works out his own personal interpretation of Romanesque and contemporary European design. By adapting the vocabulary of Romanesque, including the round arch, to many building types and using load-bearing masonry walls, Richardson gives them a signature weightiness and monumental scale, while maintaining delicacy of ornament and attention to detail. Most noteworthy Richardsonian Romanesque examples come from his office until his death in 1886. Afterward, the style as interpreted by other architects becomes especially strong in Chicago and the Midwest.

CONCEPTS

German architect Heinrich Hübsch lays the theoretical foundation for Romanesque Revival in his 1828 work *In welchem Style sollen wir bauen? (In What Style Shall We Build?)*. Advancing Romanesque as superior to Gothic, he declares that it is simpler to construct and more economical than Gothic Revival. He also notes that the style is rational like classicism, can use German building materials, and suits the German climate. Hübsch probably coins the term *Rundbogenstil* or Round-arched Style by which Romanesque Revival is known in Germany. His writing sets the stage for the development and

IMPORTANT TREATISES

- ***Denkmale der Baukunst vom 7ten bis zum 13ten Jahrhundert am Nieder-Rhein** (Monuments of Architecture from the 7th to the 13th Centuries on the Lower Rhine)*, 1830-1833; Sulpiz Boisserée.

- ***Designs for Rural Churches**, 1836; G. E. Hamilton.

- ***Ecclesiastical Architecture of Italy from the Time of Constantine to the Fifteenth Century**, 1843; Henry Gally Knight.

- ***In welchem Style sollen wir bauen? (In What Style Shall We Build?)**, 1828; Heinrich Hübsch.

adoption of *Rundbogenstil* in Germany and later in other countries.

Richardsonian Romanesque draws from Spanish and southern French Romanesque, Norman, and Syrian Early Christian sources instead of the German *Rundbogenstil*.

Although eclectic in inspiration, Richardson does more than copy forms and motifs from medieval buildings. He absorbs their character and personalizes the details of Romanesque, and creates an individual style so distinctive that it bears his name. Defining grand public buildings and residences of the affluent, Richardsonian Romanesque conveys a majestic, strong, powerful, and enduring appearance.

DESIGN CHARACTERISTICS

Romanesque Revival and Richarsonian Romanesque look to the past for inspiration. Deriving from several styles, including Romanesque, expressions are largely limited to architecture and feature masonry walls, symmetry, columns, round arches, and towers.

◄ **11–1.** Henry Hobson Richardson posed as a monk, c. 1880s.

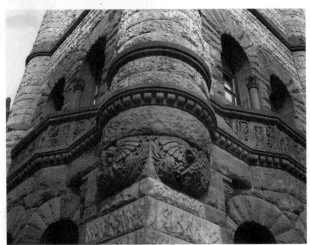

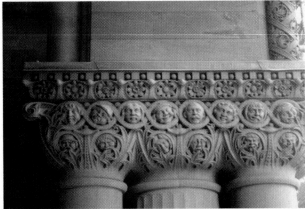

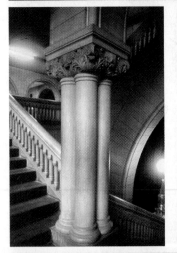

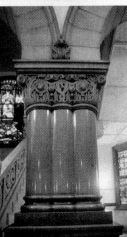

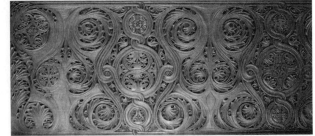

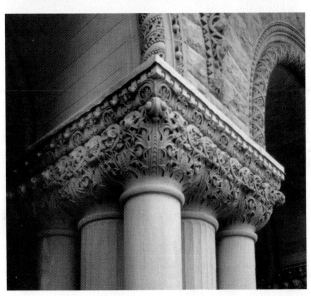

▲ **11–2.** Architectural details, mid- to late 19th century; Ohio, Toronto, Pennsylvania, and Minnesota.

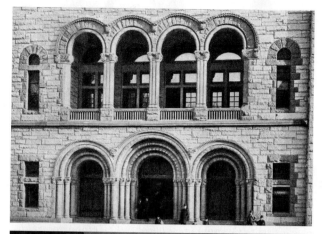

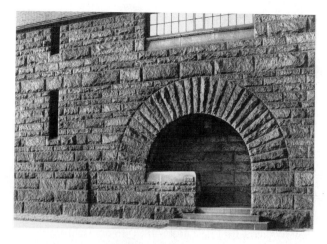

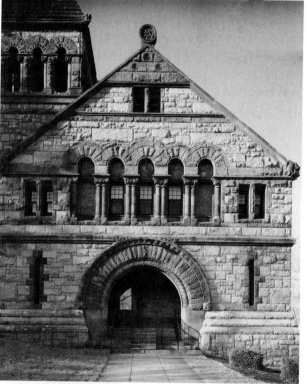

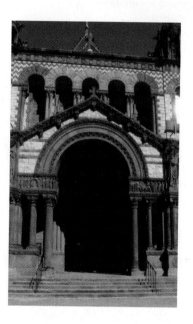

▲ **11-3.** Arch and column details, mid- to late 19th century; New York, Massachusetts, and Illinois, Henry Hobson Richardson and others.

■ *Romanesque Revival.* Definitive characteristics of Romanesque Revival are round arches and corbel tables used as stringcourses or to define rooflines. Additional characteristics include smooth walls, round doorways and windows, a gabled façade on churches, deeply recessed doorways with layered colonnettes, and towers. *Rundbogenstil* and Romanesque Revival borrow forms or details from Early Christian (c. 500–1500), Byzantine (330–1453), Italian Romanesque (8th century to 1150; especially in Lombardy), or Early Italian Renaissance (1420–1500; especially in Florence). Buildings often exhibit structural polychrome, color that is inherent in the materials, delineating important elements.

■ *Richardsonian Romanesque.* Buildings are of rough-faced stone that gives a weighty, massive appearance.

Voussoirs, lintels, capitals, ornament, and other details are often a different color from the walls. Also characteristic are round arches for doors, windows, and other openings; Syrian arches; and arches carried by squatty columns. Façades usually are asymmetrical with one or more towers and bands or groups of windows. Embellishment is derived from medieval sources and includes foliage capitals, carved moldings, and terra-cotta panels of flowers and other details.

■ *Motifs.* Common motifs include round arches, corbel tables, hood moldings, battlements, and rose windows for Romanesque Revival (Fig. 11-3, 11-5, 11-6, 11-7). Round arches, Syrian arches, floral capitals, lozenges, chevrons, and terra-cotta panels of floral ornament identify Richardsonian Romanesque (Fig. 11- 2, 11-3, 11-9).

ARCHITECTURE

Like Romanesque, Romanesque Revival originates as an ecclesiastical style. In Germany, *Rundbogenstil* first appears in less affluent Protestant suburban churches in Munich and Berlin. As the two cities grow, architects also easily adapt the style to other building types, particularly schools, hospitals, and other structures associated with social reform.

▲ **11-4.** Staabibliothek (State Library), 1827–1843; Munich, Germany; Friedrich von Gärtner. *Rundbogenstil.*

IMPORTANT BUILDINGS AND INTERIORS

- **Albany, New York:**
 - Albany City Hall, 1880–1881; Henry Hobson Richardson. Richardsonian Romanesque.
- **Berlin, Germany:**
 - Heilandskirche, Sacrow, 1841–1844; Ludwig Persius. *Rundbogenstil.*
 - Nazarenthkirche, 1831–1832; Karl Friedrich Schinkel. *Rundbogenstil.*
 - Werdersche Kirche, mid-19th century; Karl Friedrich Schinkel. *Rundbogenstil.*
- **Boston, Massachusetts:**
 - Ames Building, 1886–1887; Henry Hobson Richardson. Richardsonian Romanesque.
 - Trinity Church, 1873–1877; Henry Hobson Richardson. Richardsonian Romanesque.
- **Brooklyn, New York:**
 - Church of the Pilgrims, 1844–1846; Richard Upjohn. Romanesque Revival.
- **Brunswick, Maine:**
 - Bowdoin College Chapel, 1844–1855; Richard Upjohn. Romanesque Revival.
- **Cambridge, Massachusetts:**
 - Sever Hall, Harvard University, 1878–1880; Henry Hobson Richardson. Richardsonian Romanesque.
- **Chicago, Illinois:**
 - American Academy of Fine Arts, 1887–1888; Daniel H. Burnham and John W. Root. Richardsonian Romanesque.
 - Chicago Historical Society, 1892; Henry Ives Cobb. Richardsonian Romanesque.
 - Edward E. Ayer House, 1885; John W. Root of Burnham and Root. Richardsonian Romanesque.
 - J. J. Glessner House, 1885–1887; Henry Hobson Richardson. Richardsonian Romanesque.
 - Marshall Field Wholesale Store, 1885–1887; Henry Hobson Richardson. Richardsonian Romanesque.
- **Cincinnati, Ohio:**
 - City Hall, 1888–1893; Samuel Hannaford.

- **Dallas, Texas:**
 - Dallas County Courthouse, 1893; Orlopp and Kusener. Richardsonian Romanesque.
- **Galveston, Texas:**
 - Col. Walter Gresham House, 1887–1893; Nicholas J. Clayton. Richardsonian Romanesque.
- **London, England:**
 - Bloomsbury Baptist Chapel, 1847–1848; John Gibson.
 - Natural History Museum, 1860s; Alfred Waterhouse. Romanesque Revival.
 - S. Philip Church, Bethnal Green, 1841–1842; T. L. Walker. Romanesque Revival.
 - Westminster Chapel, Buckingham Gate, 1864–1865; W. F. Poulton. Romanesque Revival.
- **Milwaukee, Wisconsin:**
 - Elizabeth Plankinton House, 1886–1888. Attributed to Edward Townsend Mix. Richardsonian Romanesque.
- **Minneapolis/St. Paul, Minnesota:**
 - Pillsbury Hall, University of Minnesota, 1887–1889; Leroy S. Buffington and Harvey Ellis. Richardsonian Romanesque.
 - James J. Hill House, 1889–1891; Peabody and Stearns. Richardsonian Romanesque.
- **Munich, Germany:**
 - Staabibliothek (State Library), 1827–1843; Friedrich von Gärtner. *Rundbogenstil.*
 - Allerheiligenhofkirche (Court Church of All Saints), 1826–1837; Leo von Klenze. *Rundbogenstil.*
- **New York City, New York:**
 - S. George's Episcopal Church, 1846–1848; Leopold Edilitz and Otto Blesch. Romanesque Revival.
- **Newark, New Jersey:**
 - Benedictine Abbey Church of S. Mary's, 1857.

IMPORTANT BUILDINGS AND INTERIORS

- **Nîmes, France:**
 - —S. Paul Church, designed 1835 and built 1838–1850; Charles-Auguste Questel. Romanesque Revival.
- **North Easton, Massachusetts:**
 - —F. L. Ames Gate Lodge, 1880–1881; Henry Hobson Richardson. Richardsonian Romanesque.
 - —Oliver Ames Free Library, 1877–1883; Henry Hobson Richardson. Richardsonian Romanesque.
 - —Town Hall, 1879; Henry Hobson Richardson. Richardsonian Romanesque.
- **Pittsburgh, Pennsylvania:**
 - —Allegheny County Court House, 1884–1888; Henry Hobson Richardson. Richardsonian Romanesque.
- **Quincy, Massachusetts:**
 - —Crane Memorial Library, 1880–1883; Henry Hobson Richardson. Richardsonian Romanesque.
- **Santa Fe, New Mexico:**
 - —S. Francis Cathedral, c. 1869; designed by Bishop Jean Baptiste Lamy. Romanesque Revival.
- **St. Louis, Missouri:**
 - —Union Station, 1892–1894; Theodore C. Link. Richardsonian Romanesque.
- **Stanford, California:**
 - —Quadrangle, Stanford University, 1892; Shepley, Rutan, and Coolidge. Richardsonian Romanesque.
- **Syracuse, New York:**
 - —Syracuse City Hall, 1892; Charles Erastus Colton. Richardsonian Romanesque.
- **Toronto, Canada:**
 - —Ontario Parliament Building, 1886–1892; R. A. Waite. Richardsonian Romanesque.
- **Washington, D.C.:**
 - —Smithsonian Institution, 1846–1848; James Renwick, Jr. Romanesque Revival.
- **Wilton, England:**
 - —S. Mary and S. Nicholas, 1841–1845; Thomas H. Wyatt and David Brandon. Romanesque Revival.

As in Germany, Romanesque Revival in other countries, including England, is largely ecclesiastical and Protestant. In America, Romanesque Revival–style schools arise from the Americans' study of German educational methods and schools. Although Andrew Jackson Downing depicts an example called a Norman villa in *The Architecture of Country Houses* (1850), few American residences

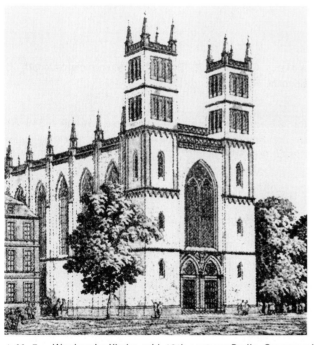

▲ **11–5.** Werdersche Kirche, mid-19th century; Berlin, Germany; Karl Friedrich Schinkel. *Rundbogenstil.*

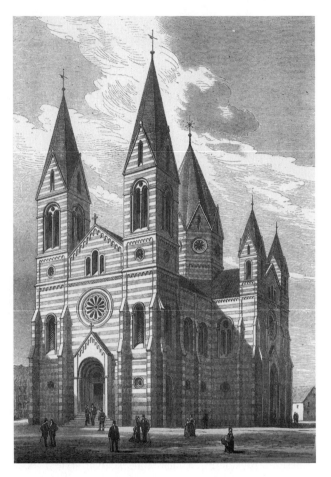

▲ **11-6.** Churches, mid-19th century; Munich and Stuggart, Germany; *Rundbogenstil.*

are influenced by the German Romanesque Revival style. Alternative names for Romanesque Revival include Norman (as a precursor to Gothic) or Lombard.

H. H. Richardson's Trinity Church [1873–1877; (Fig. 11-9, 11-24)] in Boston is the building that transforms the Romanesque concept from German prototypes to French and Mediterranean sources as interpreted by Richardson. Over the next 15 years, Richardson's public and private buildings reveal a move away from direct quotations from medieval structures to a more simplified, unique style. An impenetrable and fortress-like character makes Richardsonian Romanesque a suitable choice for state houses, courthouses, and prisons. Following Richardson's death, other architects take up the style, which becomes fashionable for affluent residences. Often the style is not as successful in the hands of Richardson's followers. Interest fades during the1890s.

Public Buildings • Romanesque Revival

■ *Types.* Romanesque Revival characterizes churches (Fig. 11-5, 11-6), schools, libraries (Fig. 11-4), museums (Fig. 11-7, 11-8), hospitals, train stations, courthouses, and city halls in the various countries.

■ *Site Orientation.* Public structures usually are located outside of city centers as a part of newly developing suburbs (Fig. 11-8). In suburban Munich, Friedrich von Gärtner designs several Romanesque Revival buildings

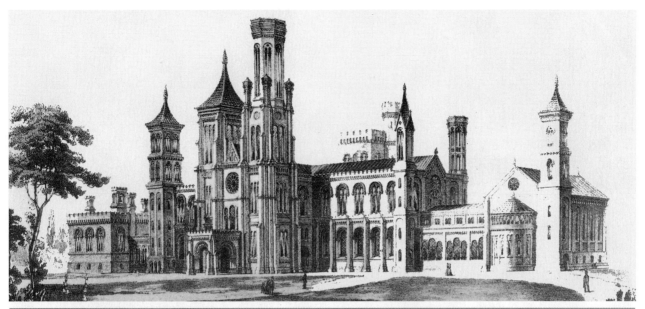

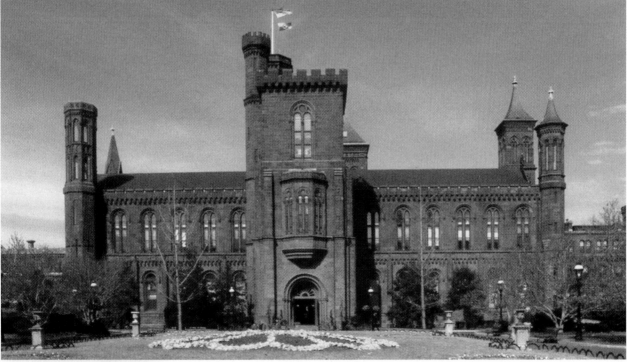

▲ **11–7.** Smithsonian Institution, 1847–1855; Washington, D.C.; James Renwick, Sr. Romanesque Revival.

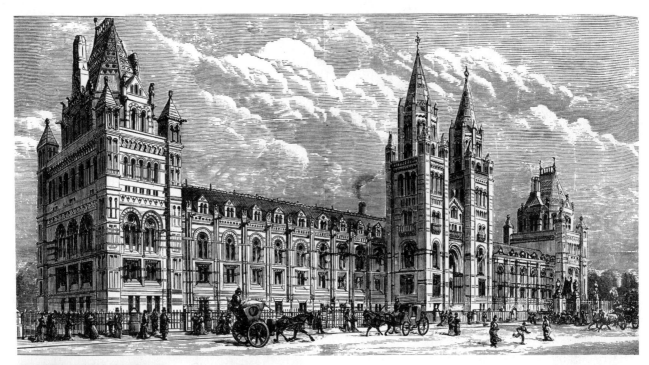

▲ **11-8.** Natural History Museum, 1860s; London, England; Alfred Waterhouse. Romanesque Revival.

for Ludwig I on a street called *Ludwigstraße* (*Ludwigstrasse*). They include a state library (Fig. 11-4), salt works, university, and girls' school. Prussian churches in the style sometimes are part of picturesque complexes of supporting buildings such as rectories, parish houses, schools, and bell towers.

■ *Floor Plans.* Floor plans serve the function of the building. Churches may exhibit one of three different plans: basilica, Latin cross, or Greek cross. A few have open auditoriums with pulpit and altar on one end to facilitate Protestant preaching. Hospitals and schools usually have long corridors with rooms on either side.

■ *Materials.* Romanesque Revival structures are most often of brick in various colors for economy and ease of construction. Details and ornament may be of different colored brick than walls or of stone, terra-cotta, or ceramic tiles (Fig. 11-6).

■ *Façades.* Churches usually have one or two towers flanking a central portion, which is crowned by a triangular shape created by the gable roof (Fig. 11-5, 11-6). Arched or rose windows often extend into the gable. Contrary to the earlier Romanesque, each tower often has a different design. Plain wall surfaces may be articulated with buttresses, windows, hood moldings, and corbel tables. A few churches in Germany replicate the colonnaded forecourt of Early Christian churches. Public buildings usually have symmetrical façades composed of rows of round-arched windows with a central entrance (Fig. 11-4, 11-7). Some are very plain with little or no articulation, while others have stringcourses, occasionally with corbel tables, to separate stories and/or quoins highlighting corners. Larger structures, such as schools or hospitals, often have towers flanking the entrance and/or on the corners (Fig. 11-7, 11-8).

■ *Windows.* Most windows are composed of round arches, but a few are rectangular or pointed (Fig. 11-4, 11-6, 11-7, 11-8). Windows may be single or grouped in doubles, triples, or more. Some are bifora, and others have hood moldings. Churches often have a rose window or a row of arched windows highlighting the main façade above the doorway (Fig. 11-6).

■ *Doors.* Plain and carved wooden doors, like windows, usually are set within round arches. Some churches have the three traditional entrances corresponding to the nave and aisles, while others have a single center entrance. Doorways may be deeply recessed with layers of

DESIGN PRACTITIONERS

■ **Heinrich Hübsch** (1795–1863) is a main theorist and practitioner for the *Rundbogenstil*. His arguments for structural rationality, careful consideration of costs, and brick as an economical building material help break the hold of classicism in Germany while promoting the round-arched style. His best work is the Pump Room at the spa at Baden Baden.

■ **Leopold Eidlitz** (1823–1908) comes from Prague to America and works in the Romanesque Revival and High Victorian Gothic styles. Influenced by Gärtner, his Romanesque-style S. George's in New York City has a large galleried auditorium. His work influences Frank Furness and Henry Hobson Richardson.

■ **Henry Hobson Richardson** (1838–1886) introduces the Queen Anne style to America (see Chapter 10, "Stick Style, Queen Anne") and is instrumental in the development of the Shingle style (see Chapter 18, "Shingle and American Arts and Crafts"). His work related to Romanesque Revival is called Richardsonian Romanesque because of its unique personal nature. Despite his abbreviated life, he significantly influences American architecture and architects, such as Louis Sullivan and Frank Lloyd Wright.

■ **Friedrich von Gärtner** (1792–1847) is one of the most distinguished architects working in Munich. His most notable and influential work is the *Ludwigstrasse*, an urban street of buildings of disparate functions in the *Rundbogenstil* style. A Roman triumphal arch terminates one end of the street, while a Florentine loggia caps the other. Between these are discrete references to the history of the round arch and symbolic references to Ludwig I as Roman emperor and Renaissance prince.

■ **Shepley, Rutan, and Coolidge** is an architectural firm composed of George Shepley, Charles Rutan, and Charles Coolidge. Following Richardson's death, the firm takes over his practice and completes work in progress, including the Glessner House. The firm opens a Chicago branch after receiving several important commissions such as the Chicago Public Library and Art Institute of Chicago.

colonnettes as in Romanesque (Fig. 11-6, 11-7). Entrances may be in a series of three or four round arches carried by pilasters or engaged columns. On public structures, larger, more prominent arches announce the entrance. Some have towers flanking the entrances to give them additional significance.

■ *Roofs.* Roofs are usually flat or low-pitched gables and/or cross gables (Fig. 11-4, 11-6). Church domes are rare. As a defining feature on churches and other structures, a corbel table emphasizes the roof line. Some, particularly large structures designed to resemble castles, have battlements. Towers may have conical or pyramidal roofs with spires and/or gables and spires (Fig. 11-7, 11-8).

■ *Later Interpretations.* Very few interpretive examples of Romanesque Revival appear in later periods. In the late 20th century, some commercial buildings exhibit large round arches with new materials reminiscent of the revival character (Fig. 11-21).

Public and Private Buildings • Richardsonian Romanesque

■ *Types.* Richardsonian Romanesque defines more building types than Romanesque Revival does, including state capitols, offices, courthouses (Fig. 11-12, 11-14), department stores (Fig. 11-11), warehouses, train stations, libraries (Fig. 11-10), churches (Fig. 11-9), and bridges. Residences may be architect-designed single-family and row houses or speculatively built row houses (Fig. 11-18, 11-19). Because the style is expensive, it does not become part of the builder's repertoire.

■ *Site Orientation.* Public buildings usually are located in an urban setting near city centers or on avenues for transportation (Fig. 11-9, 11-11, 11-12, 11-13). Urban residences front on streets but may have gardens on the side or in the rear. Lawns surround those in the suburbs (Fig. 11-17). Some examples reveal a direct connection to the landscape through horizontal orientation, rugged textures, and natural building materials, such as rocks or boulders.

■ *Floor Plans.* Richardson's plans have a new and original openness and fluidity of space. Plans of some large public buildings show his assimilation of Beaux-Arts planning concepts of modules or units arranged along main and subsidiary axes and façades developing from the ground plan. Residential floor plans are usually asymmetrical with rooms arranged around the stair hall (Fig. 11-20). Some have the living hall with fireplace introduced by Richardson in the Watts Sherman house (see Chapter 10, "Stick Style, Queen Anne," Fig. 10-13).

■ *Materials.* Although Richardson is aware of developments in the use of cast iron for structure, he favors load-bearing masonry walls and chooses rusticated or heavily textured stone or boulders to give signature heaviness to his buildings (Fig. 11-9, 11-10, 11-11, 11-12). Veneering techniques have not yet been developed, so walls are as

DESIGN SPOTLIGHT

Architecture: Trinity Church, 1873–1877; Boston, Massachusetts; Henry Hobson Richardson. Richardsonian Romanesque. Considered the first full example of Richardsonian Romanesque, Richardson wins the competition for Trinity Church in 1872, although the final design is very different from the competition drawings. Richardson draws inspiration from French, English, Spanish Romanesque, and Norman examples. In the Beaux-Arts manner, the exterior design articulates the plan with its rounded apse and short nave and transept. A large porch with twin towers and pyramidal roofs defines the entrance façade, but the heavy tower marking the crossing dominates the composition and recalls the tower of Salamanca Cathedral, Spain.

In the 1890s, Sheply, Rutan, and Coolidge add the arched entry and picturesque spires and windows of the towers that are derived from English sources. Trinity's walls are of ashlar-faced granite in a light color with darker sandstone highlighting such architectural details as voussoirs and capitals and forming stripes and geometric patterns

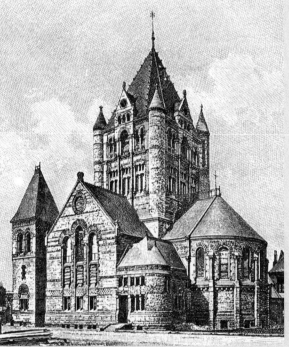

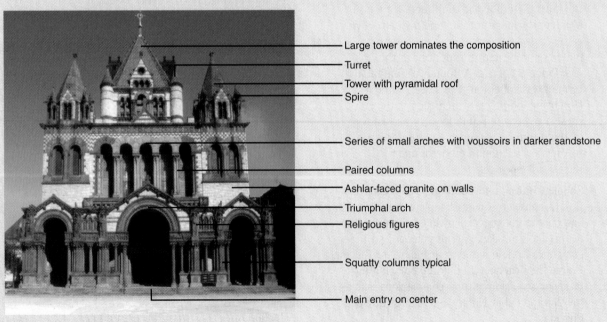

- Large tower dominates the composition
- Turret
- Tower with pyramidal roof
- Spire
- Series of small arches with voussoirs in darker sandstone
- Paired columns
- Ashlar-faced granite on walls
- Triumphal arch
- Religious figures
- Squatty columns typical
- Main entry on center

▲ **11-9.** Trinity Church; Boston.

across the façade to emphasize horizontality. Roofs of orange clay tiles cap the towers. Carved ornament in foliage and naturalistic patterns reveal Richardson's creativity, while recalling English sources of the period. Phillip Brooks, rector of Trinity, may have had a large part in its design and choice of Romanesque. Brooks is a major exponent of the larger movement to return Protestantism to its earlier roots and away from ritualistic, Catholic practices. Romanesque, with its primitive simplicity, expresses the goals of the movement. Numerous important designers contribute to the building, including future architects Charles F. McKim and Stanford White; artist John LaFarge; and sculptor Augustus Saint-Gaudens. Trinity brings Richardson to the forefront of American architecture.

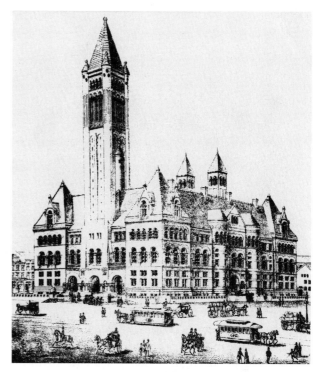

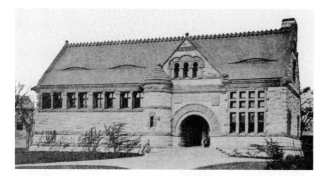

▲ **11-10.** Crane Memorial Library, 1880–1883; Quincy, Massachusetts; Henry Hobson Richardson. Richardsonian Romanesque.

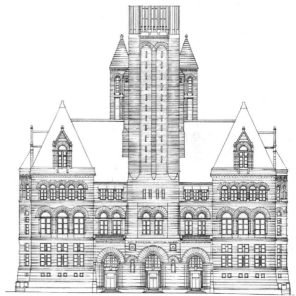

▲ **11-12.** Allegheny County Court House, 1884–1888; Pittsburgh, Pennsylvania; Henry Hobson Richardson. Richardsonian Romanesque.

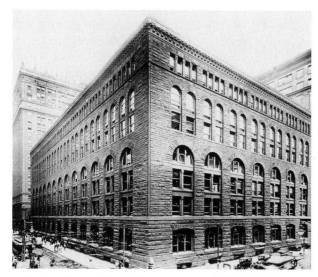

▲ **11-11.** Marshall Field Wholesale Store, 1885–1887; Chicago, Illinois; Henry Hobson Richardson. Richardsonian Romanesque.

thick and solid as they appear. Ashlar masonry, fieldstone, brownstone, rocks, boulders, and granite are used for both public and private buildings. A few examples are brick, usually to blend with surrounding structures. Contrasts of color, material, or texture are common because lintels, voussoirs, and other architectural details are of different colors or materials. Decorative plaques in terra-cotta or stone add embellishment. Other architects follow Richardson's lead.

▲ **11-13.** Erie County Savings Bank, 1890–1893; Buffalo, New York; George Post. Richardsonian Romanesque.

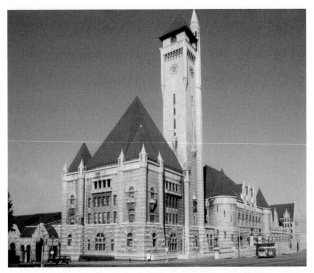

▲ **11-15.** Union Station, 1892–1894; St. Louis, Missouri; Theodore C. Link. Richardsonian Romanesque.

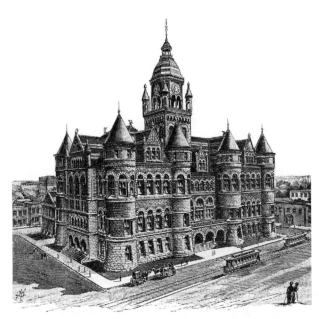

▲ **11-14.** Dallas County Courthouse, 1893; Dallas, Texas; Orlopp and Kusener. Richardsonian Romanesque.

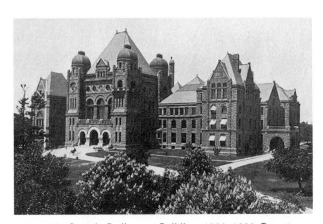

▲ **11-16.** Ontario Parliament Building, 1886–1892; Toronto, Ontario, Canada; R. A. Waite. Richardsonian Romanesque.

■ *Façades*. Façades of public buildings are usually asymmetrical with a horizontal emphasis (Fig. 11-10). Rustication, rough textures, bold details, and deep reveals in windows and doorways convey massiveness (Fig. 11-10 through 11-15). Interest comes from the structural polychrome, contrasts of texture, rhythms of windows, and carved ornament. Compositions range from picturesque and embellished to severely plain. Walls may be flat or have projections such as windows, bays, pavilions, or towers (Fig. 11-16). On tall buildings, stringcourses may separate several rows of windows. Structures often have a water table, a slanted projection forming a base, or battered base, which adds to the weighty appearance. State buildings, courthouses, and city halls usually have asymmetrically placed tall towers to signify civic authority as in the Middle Ages. Towers, which may be circular or rectangular, sometimes resemble Italian campaniles or bell towers (Fig. 11-12, 11-14, 11-15). Columns, which vary from tall and slender to the more typical short and heavy, carry arches. Shafts may be unfluted, and capitals feature lacy foliage derived from Byzantine or Romanesque examples. Chimneys are usually simply treated. A heavy cornice, corbel table, or corbelling defines the roofline.

Like public buildings, residences range from the severely plain to more picturesque compositions with lavish embellishment, and walls are rusticated stone with contrasts of color or material to emphasize architectural details

▲ **11-17.** F. L. Ames Gate Lodge, 1880–1881; North Easton, Massachusetts; Henry Hobson Richardson. Richardsonian Romanesque.

(Fig. 11-18, 11-19). Rectangular or round towers are common on suburban examples, whereas row houses substitute bay or oriel windows. Porches with Syrian or round arches may define the entrance or extend on one or more sides of a house. *Port-cochères* are common. Stringcourses may separate stories, and a heavy cornice or corbelling defines the roofline. Some examples have battlements.

■ *Windows.* Windows on both public and private buildings may be round-arched or rectangular or a combination of the two (Fig. 11-10, 11-11, 11-12, 11-18). On both types of buildings, windows with deep reveals, often in bands, form a regular and horizontal rhythm across the façade. Single or multiple columns with foliage capitals

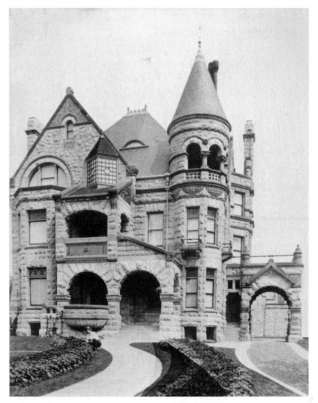

▲ **11-19.** Elizabeth Plankinton House and elevation, 1886–1888; Milwaukee, Wisconsin; attributed to Edward Townsend Mix. Richardsonian Romanesque.

▲ **11-18.** J. J. Glessner House, 1885–1887; Chicago, Illinois; Henry Hobson Richardson. Richardsonian Romanesque.

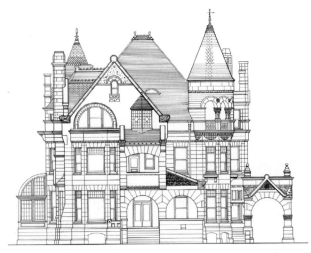

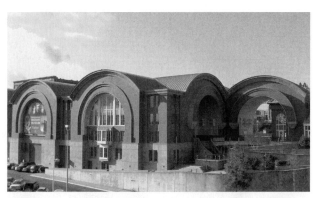

▲ **11-21.** Later Interpretation: Washington State History Museum, 1996; Tacoma, Washington; Charles Moore and Arthur Anderson. Modern Historicism.

▲ **11-19.** (Continued)

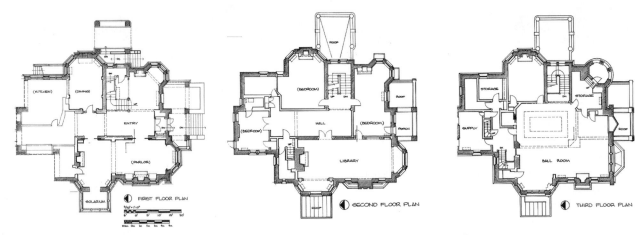

▲ **11-20.** Floor plans, Elizabeth Plankinton House, 1886–1888; Milwaukee, Wisconsin; attributed to Edward Townsend Mix.

sometimes separate windows. Deep reveals give a punched-out appearance to rectangular windows, which are usually tall and narrow with stone mullions. Many have quoins or smaller transoms, square windows, or lintels above them. The moldings surrounding arched windows may have carved ornament derived from medieval sources, such as lozenges, zigzags, or foliage. Wall dormers, common on large public and private buildings, often have parapets with patterned brick or stonework, carved ornament and finials, or they may be severely plain. Residences have stained or colored glass windows. Most residential windows have a single-pane lower sash with either a single-pane or multipaned upper sash.

■ *Doors.* A large Syrian arch or triple arches often announce the entrance on public and private buildings. Some entries are recessed within arches, or as on residences, an arcade may form a porch or portico (Fig. 11-9, 11-10, 11-12, 11-17, 11-18). Others have three arched doors with deep reveals and colonnettes like a Romanesque church. Doorway arches have carved ornament

on public buildings to add to their importance. Doors are wood and may be carved or plain with a window.

■ *Roofs.* Gable roofs with side parapets define most Richardsonian Romanesque public buildings (Fig. 11-10, 11-12, 11-18). A few examples have pyramidal roofs. Gable roofs may have decorative cresting, while pyramid roofs have finials. For residences, gable roofs are most common and may be front or side gables with or without cross gables. Urban row houses may have hipped or mansard roofs. Round towers have conical roofs with finials and rectangular towers have pyramidal roofs (Fig. 11-19). Some have rectangular or circular buttresses. Slate or clay tiles cover roofs, which are steeply pitched in the medieval manner. Some roofs have eyebrow dormers.

INTERIORS

Romanesque Revival interiors often have a medieval appearance created by architectural elements and ornament

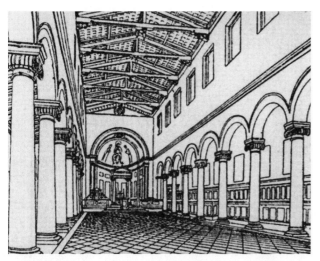

▲ **11-22.** Nave, Frieden Church, mid-19th century; Potsdam, Germany; L. Persius. Romanesque Revival.

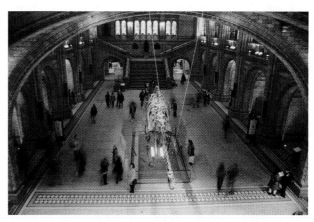

▲ **11-23.** Central hall, Natural History Museum, 1860s; London, England; Alfred Waterhouse. Romanesque Revival.

DESIGN SPOTLIGHT

Interiors: Nave, Trinity Church, 1873–1877; Boston, Massachusetts; Henry Hobson Richardson. Richardsonian Romanesque. Richardson designs the space to support the eloquent preaching of Phillip Brooks, Trinity's rector. The triple vaults with tie beams and colorful decoration come from English sources, particularly William Burges whom Richardson admires. Although the design provides little wall space for paintings, Old and New Testament figures highlight the spandrels of the arches in the crossing. Along the nave are biblical murals within frames. Daring in a nonresidential context, the rich terra-cotta red walls unify the space. Painted and stenciled decorations in blue, green, brown, and gold emphasize architectural details. Ceilings are gilded and richly painted in similar fashion to the walls. The gilding now dominating the chancel is added in a 1937 renovation, and it separates the chancel from the rest of the space in a way the designers did not intend. The plain windows allow in too much light, which interferes with the color scheme. Later, John Lafarge adds the large stained glass windows, and William Morris and Edward Burne-Jones provide smaller windows. The pews feature simple spiral turning, reeding, and foliage carving in a medieval manner.

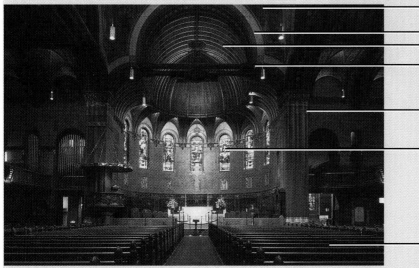

Old and New Testament figures highlight the spandrels

Triumphal arch distinguishes apse

Barrel vault ceiling

Large, dark wood beams

Stencil decoration

Stained glass window

Pews feature spiral turning, reeding, and foliage carving in a Medieval manner

▲ **11-24.** Nave Trinity Church; Boston.

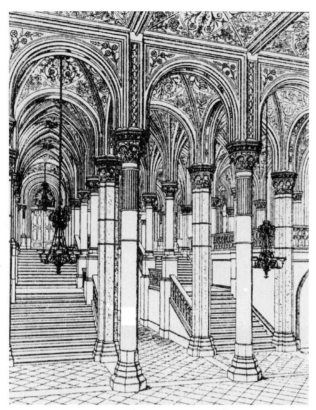

▲ **11-25.** Stairway, North Railway Station, mid- to late 19th century; Vienna, Austria. Romanesque Revival.

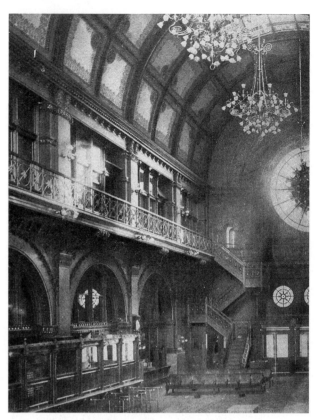

▲ **11-27.** Waiting room, Union Station, 1888; Indianapolis, Indiana; Thomas Rudd. Richardsonian Romanesque.

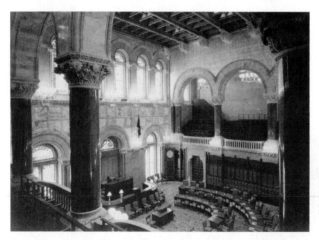

▲ **11-26.** Senate Chamber, New York State Capitol, 1881; Albany, New York; Henry Hobson Richardson. Richardsonian Romanesque.

derived from Early Christian, Romanesque, or Byzantine sources. Many public building types, such as courthouses, and/or their interiors, such as governmental chambers, were unknown in the Middle Ages, so have no exact prototype. Churches come closer to replicating the prototypes than do other public buildings or residences.

Interiors in Richardsonian Romanesque public buildings usually have a medieval appearance with characteristics similar to the exteriors. Syrian or round arches carried by squatty columns and Medieval-style carved ornament define stair halls and important spaces. Some rooms have large, hooded fireplaces recalling those of the Middle Ages. Private interiors often feature revival styles or characteristics of the Aesthetic Movement (see Chapter 16, "Aesthetic Movement").

Public and Private Buildings

■ *Types.* Romanesque Revival church interiors often replicate Early Christian (c. 500–1500) or Romanesque prototypes with a large nave with a tall trussed and coffered wooden ceiling (Fig. 11-22). Separating the aisles from the nave is an arcade composed of round arches. Clerestory windows above allow light into the nave. A triumphal arch may define the apse. A large open space with pews facing an altar and pulpit is common for Protestant churches where preaching is more important than rituals are.

■ *Relationships.* Interiors often have a vaguely medieval character similar to exteriors that is defined in details. Typical details include round or Syrian arches, heavy columns with foliage capitals, and Romanesque- or Byzantine-style ornament (Fig. 11-24, 11-25, 11-26, 11-27, 11-29). Like

▲ **11–28.** Stair halls, Syracuse City Hall, 1892; Syracuse, New York; by Charles Erastus Colton.

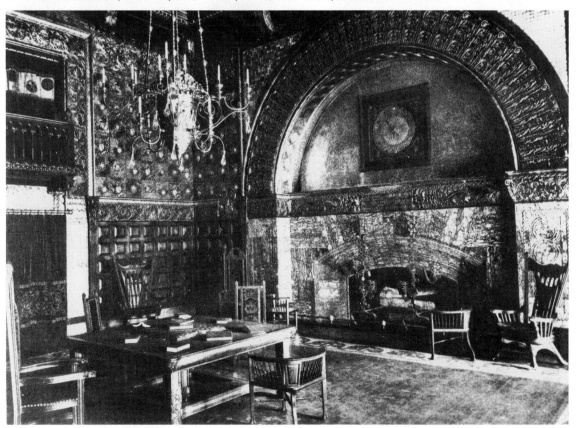

▲ **11–29.** Parlor, R. H. White House; Boston, Massachusetts; published in *Artistic Houses*, 1883; Peabody and Stearns.

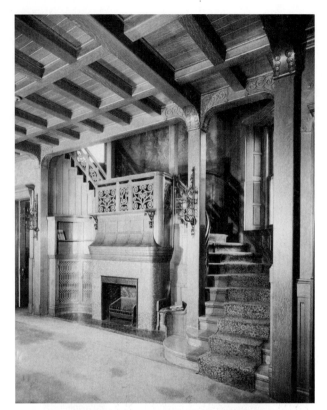

▲ **11-30.** Entry hall, Edward E. Ayer House, 1885; Chicago, Illinois; John W. Root of Burnham and Root. Richardsonian Romanesque.

exteriors, interior architectural details often contrast in color and material to walls. Voussoirs, for example, may be of stone with Romanesque carved ornament and contrast to walls, which may be painted.

■ *Color.* The palette for public and private interiors includes terra-cotta reds, greens, blues, golds, and browns in both Romanesque styles (Fig. 11-24). Gilding emphasizes important elements.

■ *Lighting.* Medieval-style lighting fixtures in brass, iron, or copper are used.

■ *Floors.* Floors may be stone, polished marble, encaustic tiles in colorful patterns, or wood (Fig. 11-22, 11-28). Carpet in period colors and patterns often covers floors in important spaces in both public and private buildings.

■ *Walls.* Wall treatments include stone, marble, tile, dark wood paneling, wallpaper in medieval patterns, and embossed leather (Fig. 11-28, 11-29, 11-30, 11-31). In Germany, *Rundbogenstil* initiates a revival of the art of mural painting, so in many German churches and some later

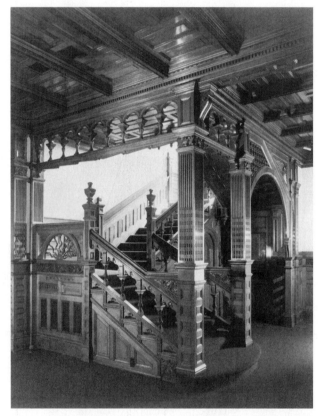

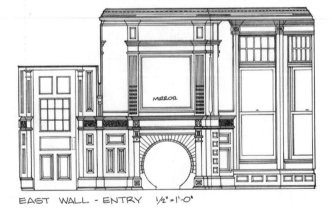

NORTH WALL - ENTRY / MAIN STAIR

EAST WALL - ENTRY ½"-1'-0"

▲ **11-31.** Stair hall and elevations, Elizabeth Plankinton House, 1886–1888; Milwaukee, Wisconsin; attributed to Edward Townsend Mix. Richardsonian Romanesque.

American ones, murals of religious scenes embellish the walls. Additionally, ornamental painting composed of geometric and naturalistic interlaced shapes may articulate architectural details. Forms, motifs, and colors are derived from medieval and Romanesque sources. Decorative balustrades in wood and iron are typical (Fig. 11-27, 11-28, 11-30, 11-31).

■ *Windows*. Round-arched windows may have stained or colored glass in all building types (Fig. 11-24). Curtains follow related period styles with heavy under-curtains and fancy valances.

■ *Doors*. Doors are carved wood. They may often feature columns on the sides and carved lintels above.

■ *Ceilings*. Ceilings may be beamed, trussed in the medieval manner, coffered, vaulted, or flat (Fig. 11-22, 11-23, 11-24, 11-25, 11-26, 11-27, 11-30, 11-31). Dark wood beams may be carved and painted with gilding highlighting details. Heavy corbels with carved medieval ornament may support ceiling beams. Residences may have painted ceiling decorations.

FURNISHINGS AND DECORATIVE ARTS

Romanesque Revival and Richardsonian Romanesque rooms feature medieval-style furniture, although there is no exactly corresponding furniture style for either. Richardson is one of the few American architects of his day to design furniture (Fig. 11-32). Like others before him, Richardson believes that no detail is too small for the architect's attention. So he and/or members of his office design furnishings for many of his public buildings and residences. It is not known how much actually came from his hand. Richardsonian furniture varies in design from a heavy, rugged appearance like the exteriors of his buildings to a slender form with spindles recalling early vernacular pieces. Designed to suit particular spaces, the furniture repeats the form and elements of the architecture. Designs are eclectic and medieval in character. Mostly of oak, carving is its main form of decoration. Little furniture remains in its original context, so its design relationship to the architecture is lost.

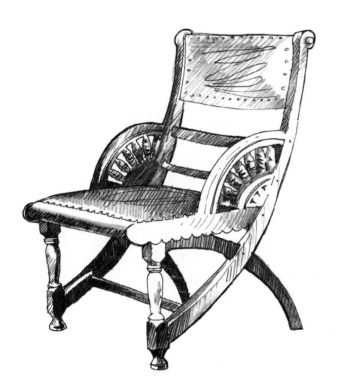

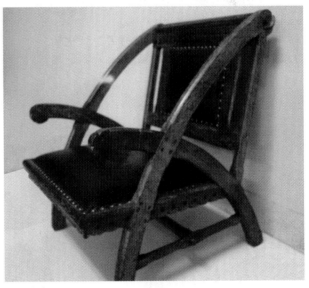

▲ **11-32.** Armchairs, c. 1870s–1880s; Henry Hobson Richardson.

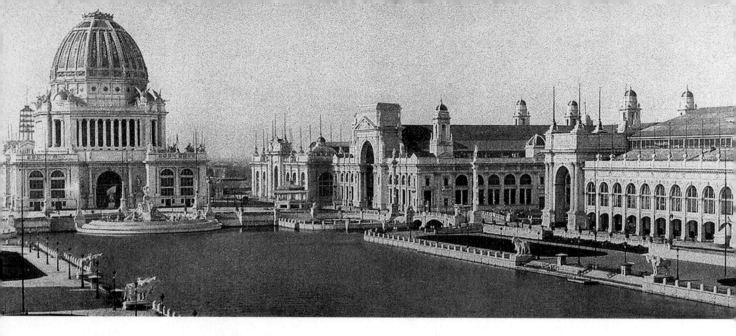

Classical Eclecticism

Beaux-Arts, Neo-Renaissance, Châteauesque, and Neoclassical Revival 1880s–1940s

It is therefore all the more encouraging to note the steady advance in taste and knowledge . . . [that] is chiefly due to the fact that American architects are beginning to perceive two things . . . first that architecture and decoration, having wandered since 1800 in a labyrinth of dubious eclecticism, can be set right only by a close study of the best models; and secondly, that . . . these models are chiefly to be found in buildings erected in Italy after the beginning of the 16th century, and in other European countries after the full assimilation of the Italian influence.

Edith Wharton and Ogden Codman,
The Decoration of Houses, 1897

Renaissance, and/or the Baroque, the architectural compositions declare a classical or cosmopolitan European heritage, civic or national pride, or personal culture and prosperity. Inside, a team of designers creates richly decorated, often authentic, period rooms. In keeping with the period's emphasis upon professionalism, interior decoration becomes known as a profession.

HISTORICAL AND SOCIAL

The end of the 19th and beginning of the 20th century is a period of relative peace and prosperity for Europe and North America. The Industrial Revolution continues to transform lives and societies. Capitalism creates enormously wealthy persons and nations that, among other things, undertake large building campaigns. Governments and individuals alike seek to create an image of prosperity, culture, and national pride. At the same time, increased specialization within industry and business demands a

During the late 19th century, Classical Eclecticism, as interpreted by *Beaux-Arts*-trained architects and designers, begins to dominate the design of public buildings and the mansions of the well-to-do in Europe and the United States. Four stylistic variations emerge: Beaux-Arts, Neo-Renaissance, Châteauesque, and Neoclassical Revival. Relying on forms and motifs from classical antiquity, the

more skilled approach for each. Consequently, the era sees further development of architecture as a profession and the beginnings of interior decoration (Fig. 12-2) as separate from architecture and a design specialty and profession in its own right.

L'École des Beaux-Arts (School of Fine Arts), which replaces the French Academy in 1819, is the world's premier architectural school during the 19th century. Graduates, who are trained in monumental planning and comprehensive design, return home to continue these practices. Cognizant of the classical vocabulary, architects and artists collaborate on the grand-scale designs that define the period. This marks a general return to classical modes in architecture and design in most countries at the end of the 19th century, signaling a rejection of the Victorian styles. By 1900, Beaux-Arts and Neoclassical Revival are the fashion in North America, Great Britain, and Europe as designers return to order and rationale in reaction to the curvilinear irregularities of Art Nouveau (see Chapter 19, "Art Nouveau").

The World's Columbian Exposition of 1893 in Chicago, Illinois, introduces the world to Classical Eclecticism on its grandest scale. The layout and buildings surrounding the Court of Honor exemplify Beaux-Art planning principles, and the buildings' gleaming white classical façades (Fig. 12-10) fascinate visitors and designers from all over the world. The exposition establishes Classical Eclecticism as the standard for subsequent international exhibitions and large-scale governmental and commercial projects. The layout of the fair inspires the City Beautiful Movement, which affects city and civic centers in the United States and Europe.

The patrons of Classical Eclecticism are wealthy industrialists and businessmen, such as Americans John D. Rockefeller, Andrew Carnegie, and Henry Clay Frick, who build enormous, lavish homes like the "cottages" in Newport, Rhode Island, and sponsor museums and other public institutions. In England, wealthy landowners, aristocrats, and industrialists, such as Samuel Courtauld and Sir Joseph Whitworth, build or acquire large country houses and found galleries and similar institutions. Although the middle classes (Fig. 12-1) cannot emulate the scale and demonstration of wealth of these examples, many follow the principles of classicism and the notion of careful choices based upon the best examples of the past in their own homes.

CONCEPTS

Rejecting High Victorian picturesque irregularity, polychrome, and loose borrowings from and interpretations of the past, Classical Eclecticism seeks to restore order, unity, and restraint to architecture and interiors. To accomplish this, architects and designers study and model the finest examples of history. Stylistic associations remain important as before, but compositions are more archaeologically correct and reveal specific borrowings of form or details

◄ **12-1.** People gathering at the opening of the World's Columbian Exposition (White City), 1893; Chicago, Illinois.

▲ **12-2.** Elsie de Wolfe; as published in *The House in Good Taste*, 1913.

IMPORTANT TREATISES

- *Artistic Houses: Being a Series of Interior Views of a Number of the Most Beautiful and Celebrated Homes in the United States, with a Description of the Art Treasures Contained Therein,* 4 parts in 2 vols., 1883–1884.

- *The Decoration of Houses,* 1897; Edith Wharton and Ogden Codman.

- *The House in Good Taste,* 1913; Elsie de Wolfe.

- *Interior Decoration: Its Principles and Practice,* 1915; Frank Alvah Parsons.

- *Mr. Vanderbilt's House and Collection,* 4 vols., 1883–1884; Edward Strahan (Earl Shinn).

- *The Practical Book of Period Furniture,* 1914; Harold Donaldson Eberlein and Abbot McClure.

- *Principles of Home Decoration,* 1903; Candace Wheeler.

from particular prototypes. The Beaux-Arts education encourages unity of appearance within classical traditions but allows for individual interpretations. Using a specific idiom of classical vocabulary from antiquity to the 17th century, Beaux-Arts, Neo-Renaissance, Châteauesque, and Neoclassical Revival emulate past examples and display monumental planning while using contemporary materials. Architects, designers, artists, sculptors, and landscape designers work together in the Renaissance manner to create comprehensive solutions, grand scale, and lavish interiors that proclaim a classical and/or European heritage. The middle classes strive to copy them in a much reduced manner.

DESIGN CHARACTERISTICS

All examples are monumental in scale and reveal an academic spirit, while drawing upon various classical traditions, either a specific prototype, a variety of prototypes, or a particular style. Some buildings and interiors reveal no specific prototypes in favor of the designer's or client's personal attitudes or individuality. Large, often richly ornamented buildings and opulent, lavishly furnished interiors demonstrate wealth and status. Four architectural styles develop based upon the prototypes chosen.

- *Beaux-Arts.* Beaux-Arts in all countries aspires to emulate the classical traditions of ancient Rome, the Italian Renaissance, the Baroque, and 17th- and 18th-century France. Examples are more exuberant and highly embellished than other styles. Definitive characteristics include symmetry, a five-part façade with center emphasis, rusticated ground story, smooth stone upper stories, advancing and receding planes, layers of elements especially on corners, paired columns, dramatic skylines, roof balustrades, grand staircases, and lavish ornament that highlights important parts.

During the 1880s in Great Britain and North America, Beaux-Arts town halls, state capitols, libraries, and museums begin to define city centers as architects trained at L'École des Beaux-Arts apply their knowledge. The style is largely limited to the East Coast of the United States until popularized by the World's Columbian Exposition of 1893. During the last decade of the 19th century, Beaux-Arts defines numerous town, country, and resort houses of the very rich.

- *Neo-Renaissance.* Like the earlier Renaissance Revival (see Chapter 7, "Italianate, Renaissance Revival"), Neo-Renaissance emulates Italian 16th-century palaces or villas. However, late 19th-century structures are larger in scale and more strongly identified with the originals. Typical characteristics include rectangular block forms, rusticated lower stories, arched or rectangular openings, quoins, modillioned cornice, and a flat or low-pitched roof.

Architects McKim, Mead, and White initiate the Neo-Renaissance in the United States with the design of the Villard houses (Fig. 12-24), six speculative townhouses in New York City. Based on the Palazzo della Cancelleria in Rome, a 16th-century palace, the individual townhouses look like a single house. The firm, seeking a style that unifies urban ensembles, finds it in Italian Renaissance palaces.

- *Châteauesque.* In England, despite the popularity of French interiors and furniture, there are few buildings in the so-called French Châteaux style that copy from the French Renaissance style. In contrast, in the United States, Richard Morris Hunt derives Châteauesque from his sketches of numerous French *châteaux,* such as Blois and Chambord, in the transitional François I style in which Gothic and Renaissance intermingle. Vertical and picturesque, the style features asymmetry, smooth stone walls, towers or turrets, pointed- or ogee-arched openings, bay or oriel windows, tracery, hood moldings, multiple wall or roof dormers, and tall and steeply pitched roofs with cresting or spires or pinnacles. Most examples are architect-designed urban or suburban affluent residences; Châteauesque is a more expensive alternative to Queen Anne.

- *Neoclassical Revival.* The Neoclassical Revival emulates either Neoclassical prototypes of the 18th and early 19th centuries or the Grecian idiom in the spirit of Greek Revival. A quieter alternative to the more embellished and baroque Beaux-Arts, Neoclassical Revival characteristics include symmetry, the Greek orders, rusticated basements, smooth upper stories, flat roofs, porticoes with and without pediments, a balanced rhythm between walls and openings or walls and columns or pilasters, and limited ornament.

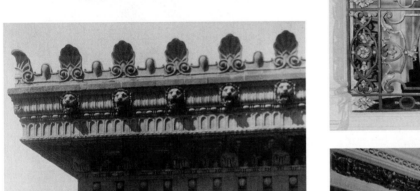

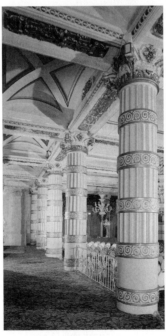

▲ **12–3.** Architectural details, c. 1880s–1910s; Illinois; Kansas; Rhode Island; Washington, D.C.; and Pennsylvania.

Some examples closely resemble early Greek Revival types but are grander in scale with a more monumental feeling. Like Beaux-Arts, the World's Columbian Exposition initiates the Neoclassical or Classical Revival, particularly in the United States, because many state pavilions are in the style.

Like exteriors, interiors are monumental in scale and inspired by a variety of classical and past traditions. Interior concepts often more closely replicate past styles than earlier interior revivals do. The Louis styles of France (Louis XIV, XV, and XVI), regarded by many as high culture, are often copied. Architecture, furnishings,

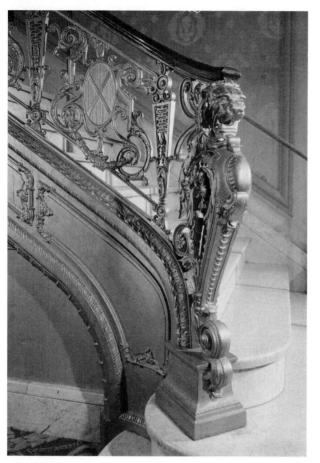

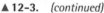
▲ **12-3.** *(continued)*

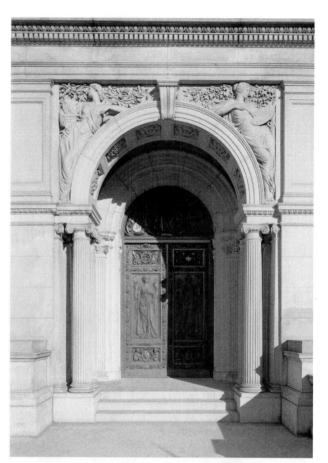

painting, and sculpture combine for grand effects. Lavish and expensive materials and finishes demonstrate prosperity, wealth, and culture. In North America, houses of the wealthy incorporate entire rooms or parts of rooms from Europe. Similarly, furniture is large scale, formal, majestic, and replicates French styles of Rococo, Neoclassic, and Empire and the English styles of Georgian, Adam, Hepplewhite, and Sheraton. Collections of art are proudly displayed. Classical Eclecticism gives rise to period styles that will dominate popular interior design throughout the early 20th century.

■ *Motifs*. Beaux-Arts motifs include swags, acanthus leaves, cartouches, figural and relief sculpture, flowers, cherubs, shells, C and S scrolls, and wreaths (Fig. 12-3, 12-4, 12-10, 12-15). Neo-Renaissance features egg and dart, bead, and dentil moldings; cartouches; roundels; and classical motifs such as pilasters, lintels, and stringcourses (Fig. 12-3, 12-8, 12-26, 12-32, 12-33, 12-34, 12-38, 12-40, 12-51). Typical Châteauesque motifs are tracery, pointed arches, pinnacles, fireplace hood moldings, floral panels, griffins, and gargoyles (Fig. 12-27). Neoclassical Revival motifs include egg and dart, bead, and dentil moldings;

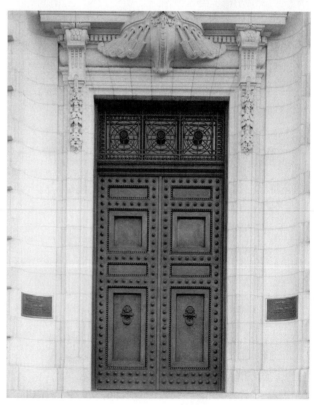
▲ **12-4.** Door details, c. 1890s–1900s; Washington, D.C., and Maryland. Beaux-Arts.

triglyphs and metopes; cartouches; honeysuckles; anthemions; acanthus leaves; the fret or key; swags; lyres; vases; drapery; and classical figures (Fig. 12-3, 12-21, 12-28).

ARCHITECTURE

Education at L'École des Beaux-Arts emphasizes the study of the classical traditions, especially of ancient Greece and Rome, axial design, and formal, monumental planning. Students analyze functions of the building according to the program and organize them in units along a main circulation axis with minor cross axes. Plans show a clear ranking of axes, functions, and distinctions within the building. The façade develops from the plan, and parts of the composition are articulated with a distinct hierarchy like the ground plan. Location and site also are methodically designed with the relationships between and among structures considered.

Students at L'École des Beaux-Arts work in *ateliers* or studios under the direction of a practicing architect or *patron* who teaches design principles as exemplified in the best examples of classical design. The school hosts lectures in history, art, and construction and competitions in which students progress through the program of study. Presentation drawings, a hallmark of the Beaux-Arts training, are beautifully and artistically rendered plans and elevations. These drawings lead to Modernist criticism that structure and construction are ignored at the expense of creating pretty presentations. However, drawings are important to the process of developing, explaining, and completing the design solution. Architects strive to integrate architecture of the past with contemporary needs, materials, and technology.

▲ **12-6.** Galleria Vittorio Emanuele II, 1865–1867; Milan, Italy; Giuseppe Mengoni. Neo-Renaissance.

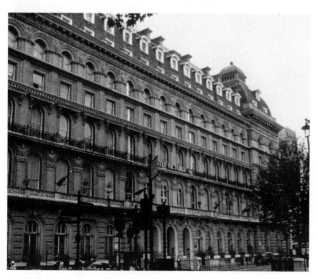

▲ **12-5.** Grosvenor Hotel, 1860–1861; London, England; J. T. Knowles. Neo-Renaissance.

▲ **12-7.** Civic Theater, c. 1880s–1900s; Amsterdam, Holland. Neo-Renaissance.

DESIGN SPOTLIGHT

Architecture: Boston Public Library, 1888–1892; Boston, Massachusetts; McKim, Mead, and White. Neo-Renaissance. McKim, Mead, and White's success with the Villard Houses wins the firm the commission for the Boston Public Library. To dominate and help unify Copley Square with its colorful Gothic buildings and Richardson's Trinity Church (see Chapter 11, "Romanesque Revival") and to express Boston's cultural heritage, McKim, Mead, and White choose a classical Italian Renaissance style. There are few models for a structure that houses the largest circulating collection in the world. The building is a rectangular block with an open central courtyard. The arched façade of

Milford granite recalls S. Geneviève (1844–1850) in Paris by Henri Labrouste and San Francesco (c. 1450) in Remini, Italy, by Alberti. Above a rusticated basement, arched windows emphasize horizontality and create a regular rhythm across the façade. Patrons enter through one of three arched doorways. A deep cornice and low-pitched hipped tile roof cap the composition. Many artists collaborate for the interiors, including sculpture by Augustus Saint-Gaudens, bronze doors by Daniel Chester French, mosaics in the vestibule by Maitland Armstrong, and murals by Puvis de Chavannes and Edwin Austin Abbey.

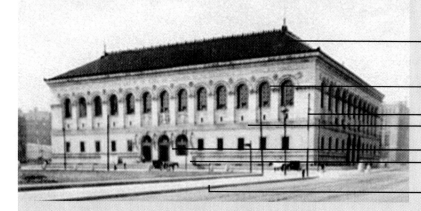

Low-pitched, hipped tile roof like ones in Italy

Arched windows create a regular rhythm across facade

Granite facade; larger story recalls piano nobile

Stringcourse emphasizes horizontal movement

Entry doors

Rectangular building with central courtyard

Symmetrical emphasis

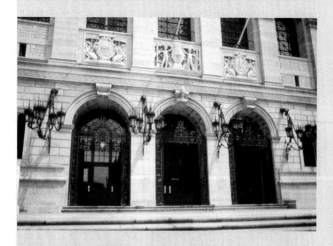

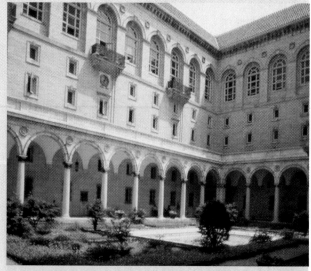

▲ 12-8. Boston Public Library; Boston.

▲ **12-9.** Château Frontenac (hotel), 1893; Quebec City, Quebec, Canada; Bruce Price. Châteauesque.

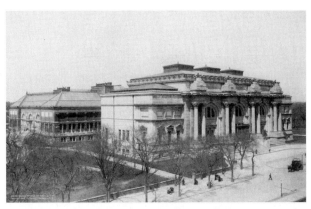

▲ **12-11.** Metropolitan Museum of Art, 1894–1895; New York City, New York; Richard Morris Hunt. Beaux-Arts.

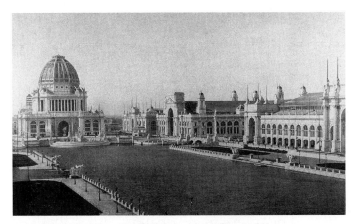

▲ **12-10.** Administration Building and the Court of Honor, World's Columbian Exposition (White City), 1893; Chicago, Illinois; Richard Morris Hunt. Beaux-Arts.

▲ **12-12.** L' Hotel de Ville de Quebec (city hall), 1895–1896; Quebec City, Quebec, Canada; Tanguay and Vallée. Neo-Renaissance.

Public and Private Buildings

■ *Types.* Classical Eclecticism in its various manifestations, with the exception of Châteauesque, defines numerous building types including capitols, courthouses, town halls (Fig. 12-12), government buildings (Fig. 12-20, 12-22), libraries (Fig. 12-8, 12-18), museums (Fig. 12-11), hotels (Fig. 12-5, 12-9, 12-14), symphony halls, clubs, university buildings, memorials (Fig. 12-23), and monuments (Fig. 12-16). Although a few grand hotels are Châteauesque, it is primarily a residential style (Fig. 12-27). Dwellings in all four styles may be town homes, row houses, apartment buildings, residential hotels, or country houses (Fig. 12-24, 12-26, 12-29).

■ *Site Orientation.* Context, grand scale, and comprehensive planning are important to all styles of public and private structures. Large public buildings with gleaming classical façades become part of urban ensembles that line boulevards or define civic or city centers.

A formal, ceremonial approach is important and often characterized by a monumental staircase. Similarly, many residences have ceremonial entries created by curving drives and/or *porte cochères*. Formal gardens with engaging vistas, fountains, *parterres*, sculpture, monuments, and memorials surround both public and private structures.

IMPORTANT BUILDINGS AND INTERIORS

■ **Amsterdam, Holland:**

—Civic Theater, c. 1880s–1900s. Neo-Renaissance.

—Rijksmuseum, 1876–1885; Petrus Josephus Hubertus Cuypers. Neo-Renaissance.

■ **Asheville, North Carolina:**

—Biltmore Estate, 1888–1895; Richard Morris Hunt. Châteauesque.

■ **Austin, Texas:**

—Texas State Capitol, 1882–1888; Elijah E. Myers. Neo-Renaissance.

■ **Boston, Massachusetts:**

—Boston Public Library, 1888–1892; McKim, Mead, and White. Neo-Renaissance.

■ **London, England:**

—British Museum, 1937–1938; John Russell Pope. Neoclassical Revival.

—Grosvenor Hotel, 1860–1861; J. T. Knowles. Neo-Renaissance.

—Lloyd's Building, 1928–1929; Sir Edwin Cooper (?). Neoclassical Revival.

—Ritz Hotel, 1906. Neo-Renaissance.

—Royal Automobile Club, 1908–1911; Charles Mewes and Arthur B. Davis. Neo-Renaissance.

■ **Miami, Florida:**

—Viscaya, 1916; F. Burrall Hoffman and Paul Chalfin. Neo-Renaissance.

■ **Milan, Italy:**

—Galleria Vittorio Emanuele II, 1865–1867; Giuseppe Mengoni. Neo-Renaissance.

■ **Montreal, Canada:**

—Banque de Montreal, 1904; McKim, Mead, and White. Beaux-Arts.

—Oratoire Saint-Joseph, 1924–1937. Neoclassical Revival.

■ **Nashville, Tennessee:**

—Parthenon, 1897, reconstructed 1921–1931; Colonial William Smith. Neoclassical Revival.

■ **Newport, Rhode Island:**

—Marble House, 1888–1892; Richard Morris Hunt. Beaux-Arts.

—Ochre Court, 1888–1891; Richard Morris Hunt. Châteauesque.

—Rosecliff, 1901–1902; McKim, Mead, and White. Beaux-Arts.

—The Breakers (Cornelius Vanderbilt house), 1892–1895; Richard Morris Hunt. Neo-Renaissance.

■ **New York City, New York:**

—Carnegie Hall, 1891; William B. Tuthill and William Morris Hunt, Dankmar Adler. Neo-Renaissance.

—Columbia University, 1893; McKim, Mead, and White. Beaux-Arts.

—Grand Central Railroad Terminal Station, 1903–1913; Reed and Stem, and Warren and Wetmore. Beaux-Arts.

—Library of J. P. Morgan, 1906; McKim, Mead, and White. Neo-Renaissance.

—Metropolitan Museum of Art, 1894–1902; Richard Morris Hunt. Beaux-Arts.

—New York Public Library, 1902–1911; Carrère and Hastings. Beaux-Arts.

—Pennsylvania Railroad Terminal Station, 1906–1910; McKim, Mead, and White. Beaux-Arts.

—Villard Houses, 1882–1885; McKim, Mead, and White. Neo-Renaissance.

■ **Palm Beach, Florida:**

—Whitehall (Henry Flagler Mansion), 1900–1902; John Merven Carrère and Thomas Hastings. Beaux-Arts.

■ **Providence, Rhode Island:**

—Rhode Island State Capitol, 1895–1904; McKim, Mead, and White. Beaux-Arts.

■ **Quebec City, Quebec, Canada:**

—Château Frontenac (hotel), 1893; Bruce Price. Châteauesque.

—L'Hotel de Ville de Quebec (city hall), 1895–1896; Tanguay and Vallée. Neo-Renaissance.

■ **Rome, Italy:**

—American Academy in Rome, 1913; McKim, Mead, and White. Neo-Renaissance.

—Monument to Victor Emmanuel II, 1885–1911; Giuseppe Sacconi. *Stile Umberto*/Neo-Renaissance.

■ **San Francisco, California:**

—City Hall, c. 1920s; Bakewell and Brown. Neoclassical Revival.

—Palace of Fine Arts, Panama Pacific International Exposition, 1913–1915; Bernard Maybeck. Beaux-Arts.

■ **San Simeon, California:**

—Neptune Pool, Hearst Castle (home of William Randolph Hearst), 1935–1936; Julia Morgan. Neoclassical Revival.

IMPORTANT BUILDINGS AND INTERIORS

- **Springfield, Illinois:**
 - Illinois Capitol Building, 1889. Neoclassical Revival.
- **Washington, D.C.:**
 - Jefferson Memorial, 1934–1943; John Russell Pope. Neoclassical Revival.
 - Library of Congress Building (Jefferson Building), 1897; John L. Smithmeyer and Paul J. Pelz. Neo-Renaissance.
 - Lincoln Memorial, 1922; Henry Bacon. Beaux-Arts.
 - National Gallery of Art, 1937–1941; John Russell Pope. Neoclassical Revival.
 - Union Station, 1908; Daniel Burham. Beaux-Arts.
 - United States Supreme Court, 1935; Cass Gilbert. Neoclassical Revival.
- **White Sulphur Springs, West Virginia:**
 - Greenbriar Hotel, 1922. Neoclassical Revival.

▲ **12-13.** Banque de Montreal, 1904; Montreal, Canada; McKim, Mead, and White. Beaux-Arts.

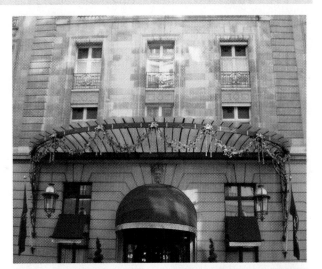

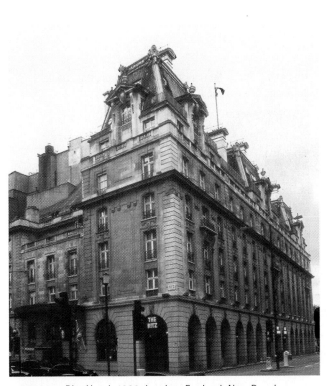

▲ **12-14.** Ritz Hotel, 1906; London, England. Neo-Renaissance.

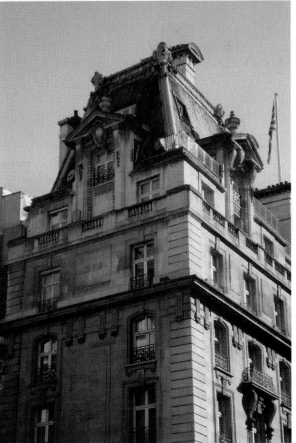

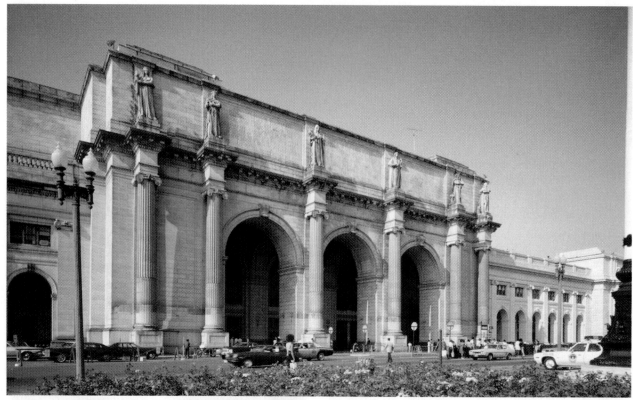

◄**12-15.** Union Station, 1908; Washington, D.C.; Daniel Burnham. Beaux-Arts.

▲ **12-16.** Monument to Victor Emmanuel II, 1885–1911; Rome, Italy; Giuseppe Sacconi. *Stile Umberto*/Neo-Renaissance.

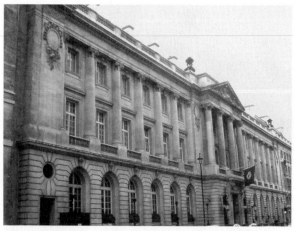

▲ **12-17.** Royal Automobile Club, 1908–1911; London, England; Charles Mewes and Arthur B. Davis. Neo-Renaissance.

■ *Floor Plans*. Floor plans in both public and private buildings are usually symmetrical and organized along axes with clearly defined, hierarchical spaces (Fig. 12-25, 12-28). Sequencing is important, and spaces may have various shapes such as circular or elliptical. Circulation spaces also are important, so staircases are prominently located. Types of rooms in residences include imposing public spaces especially drawing and dining rooms; clearly defined masculine spaces, such as billiard, smoking, or reading rooms; and feminine spaces, such as morning rooms, boudoirs, or

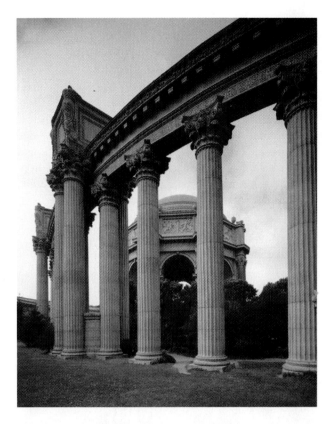

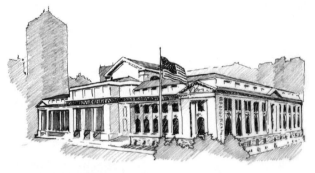

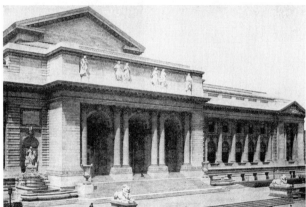

▲ **12-18.** New York Public Library, 1902–1911; New York City, New York; Carrère and Hastings. Beaux-Arts.

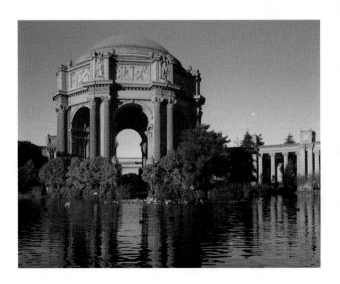

▲ **12-19.** Palace of Fine Arts, Panama Pacific International Exposition, 1913–1915; San Francisco, California; Bernard Maybeck. Beaux-Arts.

drawing rooms. Gendered spaces visually portray the prevailing idea of separate roles for men and women. Servants' quarters are relegated to separate wings or floors. Affluent clients demand the latest technology, such as elevators and central heat, and recreational spaces, like bowling alleys and swimming pools.

■ *Materials*. Buildings are of light-colored masonry such as marble, limestone, or sandstone. Some Châteauesque structures are of darker-colored masonry. A few public and private buildings are of brick. Decorative wrought iron, copper, aluminum, or bronze grilles and other details add embellishment.

■ *Façades*. Beaux-Arts public buildings usually have five-part façades composed of pavilions, joining units, and frontispiece (Fig. 12-10, 12-11, 12-13, 12-15, 12-18, 12-19).

▲ **12-20.** Missouri State Capitol, 1913–1918; Jefferson City, Missouri; Tracy and Swartwout. Neoclassical Revival.

▲ **12-21.** Parthenon, 1897, reconstructed 1921–1931; Nashville, Tennessee; 1897 by William C. Smith; 1921–1931 by William B. Dinsmoor and Russell E. Hart. Neoclassical Revival.

Temple front with pediment and Corinthian columns

Large columns

Emphasis on symmetry

Light-colored masonry

Pilasters divide facade into small bays

Figures on podia appear as guardians of power

Prominent stairway emphasizes procession in the Roman manner

▲ **12-22.** United States Supreme Court, 1935; Washington, D.C.; Cass Gilbert. Neoclassical Revival.

As the climax of the composition, the center or frontispiece is emphasized, often with a dome. Basements, or ground floors, of public and private structures usually are rusticated and upper stories are smooth. Planes may curve or advance and recede, elements may be layered, and corners may feature multiple angles, pilasters, or quoins. Openings are round, rectangular, or a combination of the two. Pairs of columns or pilasters (a defining feature), balconies, and balustrades are common. Sometimes a complete entablature separates stories. Figural sculpture sometimes accents rooflines. Relief sculpture, flowers, foliage, cartouches, swags, and other carved ornament decorate façades and surround or surmount fenestration. Prominent cornices with modillions or balustrades may cap compositions. The image is one of classical, formal exuberance.

Urbane and dignified, Neo-Renaissance public and private façades present an image of stately authority through

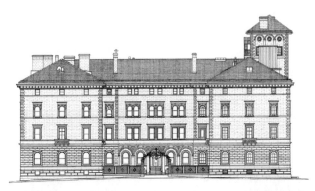

▲ **12-23.** Jefferson Memorial, 1934–1943; Washington, D.C.; John Russell Pope. Neoclassical Revival.

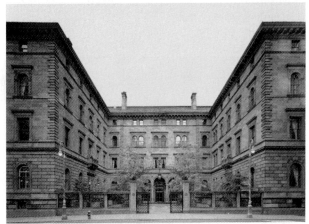

▲ **12-24.** Villard Houses, 1882–1885; New York City, New York; McKim, Mead, and White. Neo-Renaissance.

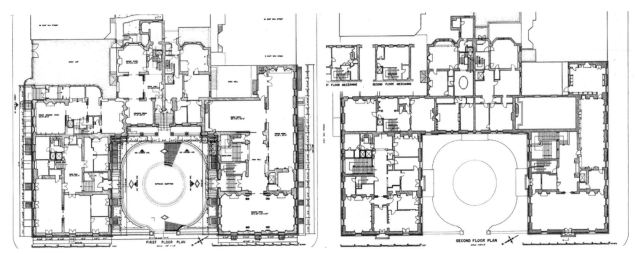

▲ **12-25.** Floor plans, Villard Houses, 1882–1885; New York City, New York; McKim, Mead, and White. Neo-Renaissance.

DESIGN SPOTLIGHT

Architecture: The Breakers (Cornelius Vanderbilt House), 1892–1895; Newport, Rhode Island; Richard Morris Hunt. Neo-Renaissance. Designed by Richard Morris Hunt, the new Breakers replaces an earlier wood-framed house that burns in 1892. Hunt's models are 16th-century palazzos in Genoa and Turin. Cruciform in shape with projecting porches on each end, the plan centers on a two-story hall. Monumental in scale and richly detailed, the façade facing the sea has arched loggias between two pavilions. Engaged columns articulate the pavilions and loggias. Other Renaissance details are the arched and rectangular windows, richly detailed friezes, stringcourses, and quoins. Supported by brackets, a low-pitched hipped roof crowns the composition. This 70-room mansion is the epitome of Beaux-Arts monumental and elegant design. The Vanderbilts use it about six weeks a year, during which time it is a center of life and entertainment for the wealthiest of the wealthy.

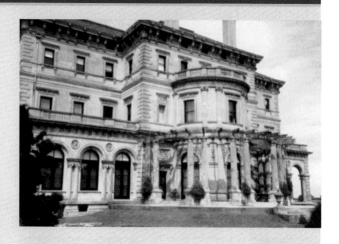

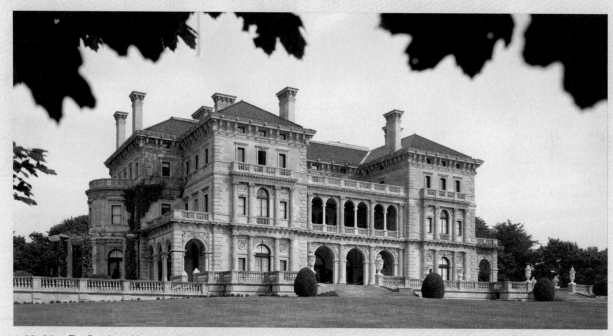

▲ **12-26.** The Breakers; Newport, Rhode Island.

symmetry, horizontality, and classical details (Fig. 12-5, 12-6, 12-7, 12-8, 12-12, 12-14, 12-17, 12-24, 12-26). Like their Renaissance models, forms generally are rectangular blocks with few projections, although residences may be U-shaped like Italian villas. Basements or ground stories usually are rusticated. Upper stories are smooth and may diminish in height. The main floor or *piano nobile*, usually the tallest, has the largest windows and carries the greatest detail, including pediments, pilasters, aedicula, and stringcourses. Bold details give three-dimensionality to façades like the prototypes and earlier Renaissance Revival. Openings may be round, rectangular, or a combination, and

quoins define corners. A prominent cornice caps the composition. On residences, second-story *loggias* and side porches provide outdoor living spaces.

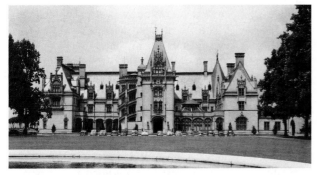

▲ **12-27.** Biltmore Estate, 1890–1895; Asheville, North Carolina; Richard Morris Hunt. Châteauesque.

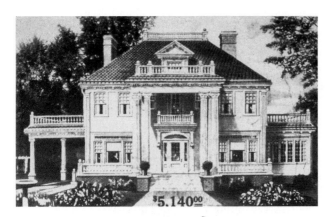

Châteauesque façades are asymmetrical, picturesque compositions defined by verticality, complexity, pointed or ogee arched openings, oriel or bay windows, balconies, towers, wall dormers, parapets, and tall chimneys (Fig. 12-9, 12-27). Some exhibit a nearly classical symmetry and horizontal emphasis with a picturesque roofline. Hunt usually places a tower on the corner of his town homes for decorative interest and to provide diagonal views.

Neoclassical Revival façades are plainer with far less ornament and fewer arches than the other styles (Fig. 12-20, 12-21, 12-22, 12-23, 12-28, 12-29, 12-30). Façades exhibit a balance of rhythms in the relationship of wall to window or wall to column or to pilaster. Symmetry, center emphasis, porticos, pediments, temple fronts, and relief sculpture are characteristic. Façades may present an image of heavy solidity if Grecian or lightness and delicacy when reflecting Roman or French or English Neoclassical influence.

■ *Windows.* Beaux-Arts windows, whether round or rectangular, are usually lavishly embellished with quoins, lintels, shells, or foliage (Fig. 12-13). In contrast, Neo-Renaissance and Neoclassical windows have triangular segmental pediments or lintels over them. Round-arched windows are typical on Neo-Renaissance buildings (Fig. 12-8). Palladian, round, or fan windows may highlight Neo-Renaissance and those Neoclassical Revival buildings influenced by France and England. Some Neoclassical Revival residences have triple sashes like their Greek Revival prototypes. Others have bay windows. Châteauesque windows often have pointed or ogee

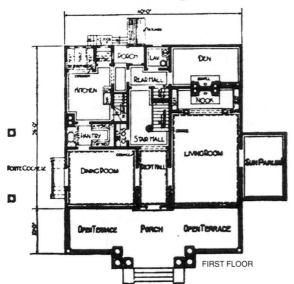

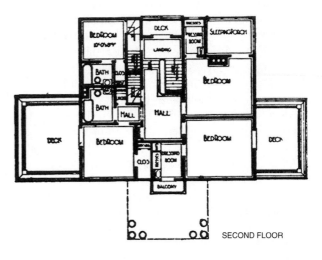

▲ **12-28.** "The Magnolia" house and floor plan, c. 1918–1921; model house available through Sears, Roebuck and Company catalog. Neoclassical Revival.

DESIGN PRACTITIONERS

This period marks the increasing professionalism of the architect as training moves from apprenticeships to formal, academic education in North America and Europe. Many go to Paris to study at L'École des Beaux-Arts, often as postgraduates. Those unable to go to Paris study with Beaux-Arts-trained mentors or professors in universities. In Britain, Royal Academy schools offer architectural instruction, which is supplemented with apprentice training. In 1904, the Royal Institute of British Architects (RIBA) establishes a Board of Architectural Education that values formal, academic instruction, thus ending architectural education by apprenticeship. The first school of architecture in the United States opens at Massachusetts Institute of Technology in 1865. Others soon follow.

Also during the period, the interior decorator emerges as separate from the tradesman, painter, or wallpaper hanger. The decorator selects, procures, and arranges furniture and finishes. Following the examples of Candace Wheeler and Elsie de Wolfe, more women become decorators, although males still dominate.

By the mid-19th century, the term *interior decorator* may refer to painters, wallpaper hangers, upholsterers, tradesmen, craftsmen, or large furniture firms, such as Herter Brothers or Pottier and Stymus in New York City or Gillows in London, that provide decoration and furnishings for public and private interiors. During the second half of the 19th century, department stores and firms, such as Tiffany and Associates, also provide interior decoration services.

In the late 19th century, women begin seeking more ways to achieve economic independence from their fathers and husbands. Some turn to art, design, or interior decoration as an outgrowth of the mid-Victorian notion that women can and should decorate their homes because they are biologically suited to do so. Women form arts and crafts societies and author numerous advice books and decorating manuals beginning in the 1870s. In 1895, Candace Wheeler publishes an article in *The Outlook Magazine* titled "Interior Decoration as a Profession for Women," which encourages women to enter the field after training and work experience, both of which are extremely difficult to do. She and her firm, Associated Artists, model a successful career in design and decoration for other women. Other women follow her lead, including Alice G. Durham, Wheeler's daughter-in-law.

In the early 20th century, Elsie de Wolfe (Fig. 12-2) is credited with being the first woman to call herself a professional decorator. Possessing good taste and appropriate social status, de Wolfe provides advice and services. She establishes the manner of work for the early profession by developing the concept, going to Europe to seek furniture and textiles, and overseeing the completion of the work. These early interior decorators, many of whom increasingly are women, work in historical French, English, and American styles for affluent, high-society clients. Most of their work is residential, but many decorate commercial interiors also. A group forms the Decorators Club of New York in 1914, and by 1920 the club has about 100 members. The American Institute of Interior Decorators forms in Grand Rapids, Michigan in 1931. As demand for training increases, Frank Alvan Parsons offers decoration courses at the New York School of Fine and Applied Arts in 1904. Most enter the field through apprentice-ships, art study, field study, and/or correspondence courses. Some call for more training and, even, certification of decorators.

- **Elsie de Wolfe** (1865–1950; Fig. 12-2) begins practice in her own home where she lightens colors and sweeps away excess in furniture and accessories in accordance with the principles espoused by Wharton and Codman. Her social contacts and self-promotion of her professionalism, good taste, and talent bring her new clients. One is architect Stanford White, who commissions her to do the interiors of the Colony Club in New York City, the first public rooms by a woman decorator.

- **John La Farge** (1835–1910) is a leading American landscape painter, mural painter, and stained glass artist. He contributes to the development of mural painting and stained glass in the United States though his association with various architects, such as Henry Hobson Richardson and Richard Morris Hunt. His new methods revolutionize stained glass production.

- **McKim, Mead, and White,** the period's leading architectural firm in the United States, is composed of Charles Follen McKim (1847–1900), who studies at L'École des Beaux-Arts, William Rutherford Mead (1846–1928), and Stanford White (1853–1906). The firm designs numerous trend-setting public and private buildings in a variety of classical styles. In New York, their Villard Houses initiate the Neo-Renaissance style, and Pennsylvania Railroad Terminal Station inspires numerous other Beaux-Arts buildings.

- **Richard Morris Hunt** (1827–1925) is a nationally and internationally recognized

architect who creates grand solutions for public buildings and wealthy individuals. Hunt initiates the Stick (see Chapter 10, "Stick Style and Queen Anne") and Châteauesque architectural styles and designs the Tribune Building, which is one of the first tall buildings with elevators, and the entrance to the Metropolitan Museum of Art, both in New York City. Designing several homes for the wealthy Vanderbilts, his best-known house is Biltmore, in Asheville, North Carolina.

- **John Russell Pope** (1874–1937) begins practice in 1903 after studying at L'École des Beaux-Arts and working with McKim, Mead, and White. He designs important national and international buildings primarily in Neoclassical Revival. His best-known American buildings are

the Jefferson Memorial and the National Gallery of Art, both in Washington, D.C. In London, Pope's Duveen Sculpture Gallery in the British Museum houses the Elgin (Parthenon) Marbles.

- **Candace Wheeler** (1827–1923) is a textile designer who helps open the door for women interior decorators. After practicing with Tiffany and Associated Artists, she opens her own firm in 1883. Wheeler works for many major clients and seminal events of the late 19th century. She is the color decorator for the Women's Building at the World's Columbian Exposition in 1893. Wheeler and her daughter, Dora, who follows in her footsteps, show that women can succeed in design and decoration.

arched tops (Fig. 12-27). Some have hood moldings and stained or colored glass.

- *Doors.* All styles have prominent entries usually as the climax of a formal, ceremonial approach. Entries, which may be recessed beneath porticoes or porches, feature pilasters, columns, pediments, or arches (Fig. 12-3, 12-4, 12-11, 12-13, 12-15, 12-22, 12-23, 12-26). Beaux-Arts door surrounds may be composed of engaged columns or pilasters, pediments, or cresting, and entrances have more carved, decorative ornament than the other styles do (Fig. 12-4, 12-15). Neoclassical Revival structures in North America usually have full-height, full- or partial-width porches carried by colossal or two-story columns (Fig. 12-20, 12-21, 12-22, 12-23, 12-28, 12-29). These porches may be rounded or rectangular with pediments. The doorways may have trabeated lights with a balcony above in Greek Revival fashion. For all styles, doors are wooden and may be carved and stained or painted.

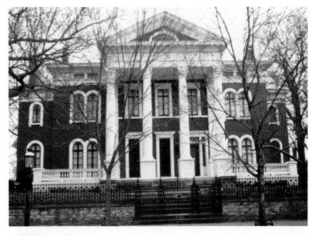

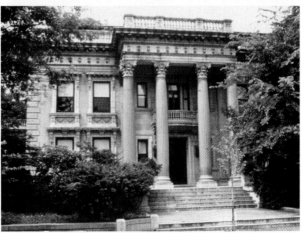

▲ **12-29.** Houses, c. 1910s–1920s; North Carolina, Kentucky, and Virginia. Neoclassical Revival.

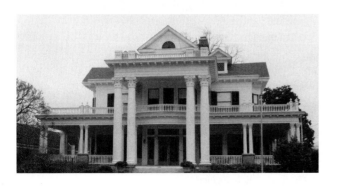

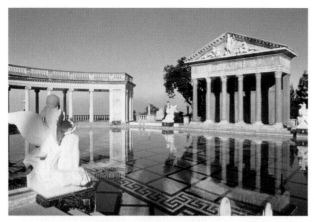

▲ **12-30.** Neptune Pool, Hearst Castle (home of William Randolph Hearst), 1935–1936; San Simeon, California; Julia Morgan. Neoclassical Revival.

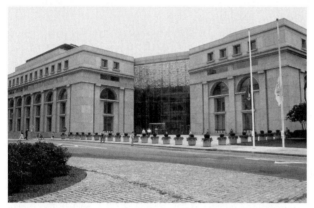

▲ **12-31.** Later Interpretation: Thurgood Marshall Federal Judiciary Building, 1992; Washington, D.C.; Edward Larrabee Barnes. Modern Historicism.

Châteauesque-style buildings have pointed arches and cresting (Fig. 12-27).

■ *Roofs.* Beaux-Arts residences occasionally have a mansard roof, while domes are common on public buildings (Fig. 12-10, 12-13, 12-19). Neo-Renaissance and Neoclassical Revival buildings usually have flat, hipped roofs sometimes hidden by a classical balustrade (Fig. 12-8, 12-26, 12-28). Some Neo-Renaissance examples have tile roofs supported by large brackets. Steeply pitched hipped roofs, parapets, and wall and roof dormers identify Châteauesque (Fig. 12-9, 12-27). Towers have conical roofs. Decorative cresting and pinnacles are typical.

■ *Later Interpretations.* Beaux-Arts-style public buildings, particularly for the federal government in the United States, are occasionally built today but are usually simpler in design (Fig. 12-31). Similarly, later interpretations of Neoclassical Revival buildings are more simplified than the original ones. Houses in later periods interpret or imitate Classical Eclecticism in a smaller-scale

and with much plainer façades than the original versions. Sometimes, residences in suburbs copy classical characteristics but ignore the classical proportions (see Chapter 30, "Modern Historicism").

INTERIORS

Interiors during the period follow two paths: the Aesthetic Movement or Classical Eclecticism. In the 1870s and early 1880s, Aesthetic or Artistic interiors show visual complexity through decoration or pattern on all surfaces and free eclecticism, borrowing from past styles and exotic cultures (see Chapter 16, "Aesthetic Movement"). By the 1880s, Classical Eclecticism initiates a move toward simplification, which eliminates the number of patterns and clutter. At the same time, an emphasis on archaeological correctness supplants the random eclecticism and helps create the period room or period-style decoration. Concern for order, balance, excellent proportions, and discipline

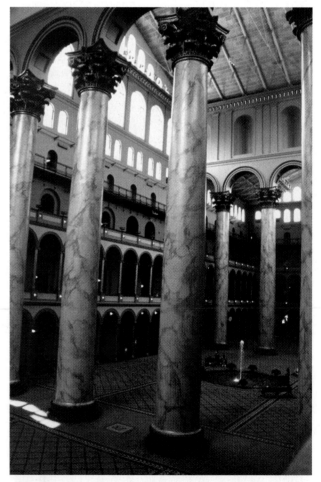

▲ **12-32.** Central Court, Pension Building (National Building Museum), 1882–1887; Washington, D.C.; by General Montgomery C. Meigs. Neo-Renaissance.

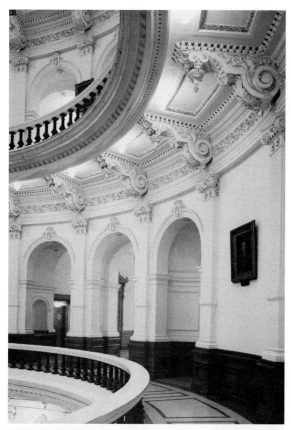

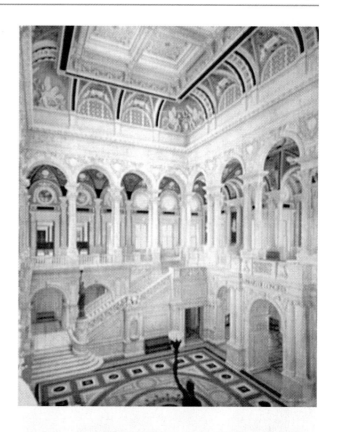

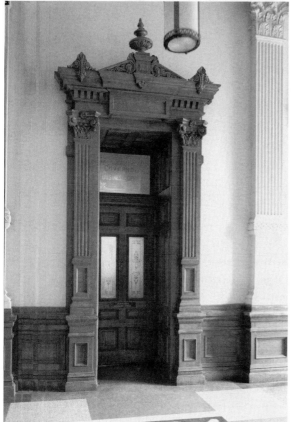

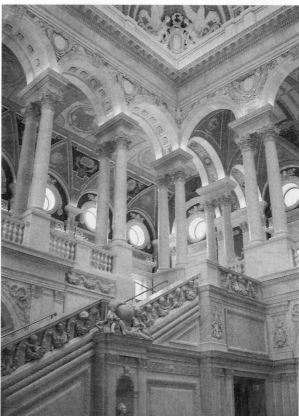

▲ 12-33. Rotunda and door detail, Texas State Capitol, 1882–1888; Austin, Texas; Elijah E. Myers. Neo-Renaissance.

▲ 12-34. Lobby, Main Reading Room, and capital detail, Library of Congress Building (Jefferson Building), 1897; Washington, D.C.; John L. Smithmeyer and Paul J. Pelz. Neo-Renaissance.

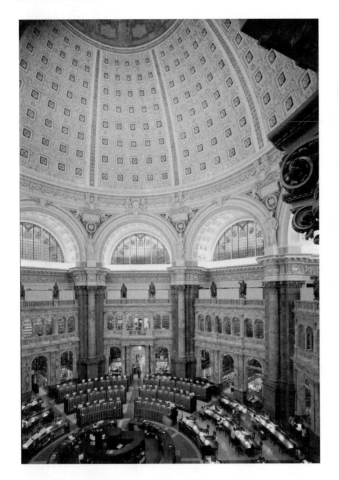

▲ **12-35.** Trellis Room, The Colony Club, 1906; New York City, New York; Elsie de Wolfe.

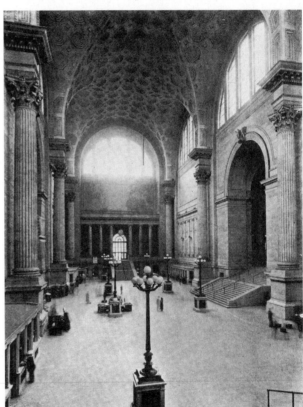

▲ **12-36.** Waiting room and concourse, Pennsylvania Railroad Terminal Station, 1906–1910; New York City, New York; McKim, Mead, and White. Beaux-Arts.

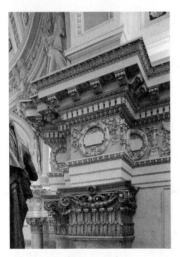

▲ **12-34.** *(continued)*

again becomes important. Architectonic interiors that reappear as surface decoration, complexity, and contrast are rejected. As in architecture, designers and decorators seriously study and hold up as exemplary the best examples of the past. French and Italian Renaissance styles are common choices. The Baroque and Rococo of Versailles and the Neoclassicism of the Petit Trianon are greatly admired as are the palaces and villas of the Italians.

In keeping with their increased professionalism, architects often control the decoration of interiors,

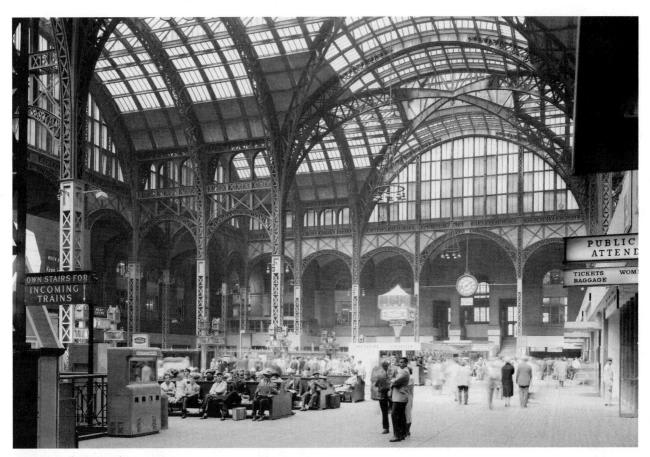

▲ **12–36.** *(continued)*

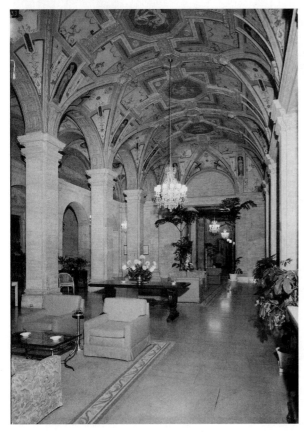

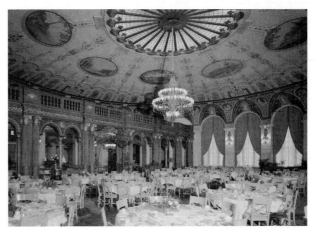

▲ **12–37.** Lobby and Rotunda dining room, The Breakers Hotel, 1925–1928; Palm Beach, Florida; Leonard Schultze of Schultze and Weaver. Neo-Renaissance.

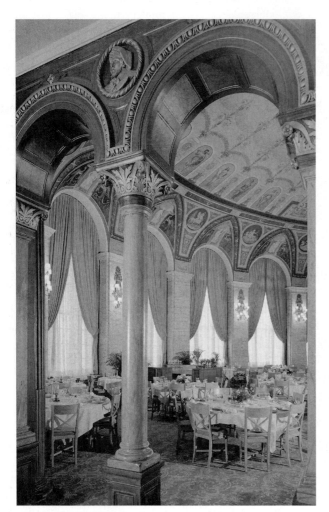

▲ **12-37.** *(continued)*

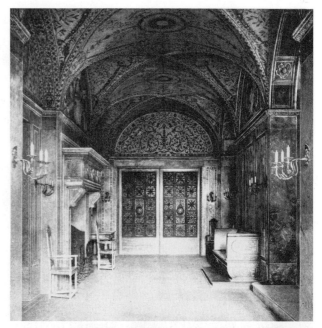

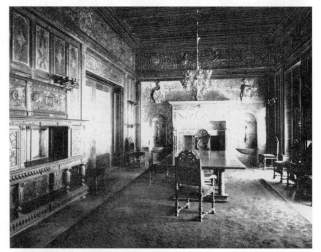

particularly of important buildings or for important people. They may create the designs themselves and supervise designers, artists, sculptors, and others who carry them out, or they may hire firms or individuals for this task. Interiors in pubic and private buildings are often works of art to which many contribute. Lavish materials and decoration are typical. Often displayed are collections of antiques, paintings, sculpture, manuscripts, and other artifacts. To achieve the period look, entire rooms or individual parts, furniture, and textiles may be copied or imported from Europe to North America.

As in architecture, the wealthy are at the forefront as tastemakers. Like princely patrons of the Renaissance, they have fine homes to display their affluence, social standing, and erudition. They favor extravagant and elaborate rooms to exhibit their collections and as settings for lavish gatherings and entertainments, and they have sufficient wealth to use the best Beaux-Arts-trained

▲ **12-38.** Entrance hall, dining room, and floor details, Villard Houses, 1882–1885; New York City, New York; McKim, Mead, and White. Neo-Renaissance.

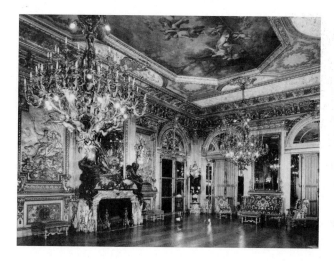

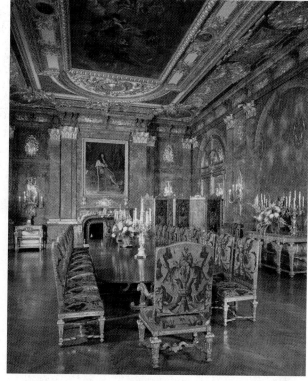

▲ **12-39.** Ballroom and dining room, Marble House, 1892; Newport, Rhode Island; Richard Morris Hunt. Beaux-Arts.

architects and artists and professional decorating firms. Believing that they have a moral obligation to educate the masses in matters of culture and taste, the wealthy may open their homes to the public or publish them in vanity publications or catalogs. In addition, they are the chief providers of funds and/or collections for public museums.

Classical Eclecticism does not become pervasive until the first decades of the 20th century when principles of lavish decoration diminish and less expensive means develop to carry them out. Decorating advice manuals, such as *The Decoration of Houses* (1897) by Edith Wharton and Ogden Codman and *The House in Good Taste* (1913) by Elsie de Wolfe (Fig. 12-2), advance this trend. The authors espouse the importance of careful proportion and simplicity, pale colors, light-scale furniture, and fewer objects (Fig. 12-35, 12-42). They insist that good taste is bound to past styles, particularly those of France and Italy. Many follow their advice, especially interior decorators who create period-style rooms for their affluent clients.

Public and Private Buildings

■ *Types.* Spaces derive from the functions of public buildings. Examples include entrance lobbies (Fig. 12-34), courtrooms, senate chambers, executive offices, art galleries,

library reading rooms, music halls, and restaurants. Public rooms are grand with lavish furnishings (Fig. 12-32, 12-33, 12-34, 12-36) while private rooms may be simpler but richly furnished. Residences of affluent people often have conservatories, galleries to display collections, and recreational spaces. Staircases are focal points (Fig. 12-40). Built-in closets and richly appointed bathrooms are pervasive.

■ *Color.* Colors return to primary hues from the tertiary hues of the 1870s. Colors in French rooms vary from the whites, blues, and greens of Rococo and Neoclassical to the rich tones of Baroque (Fig. 12-39, 12-42). Renaissance colors are deep reds, blues, greens, and golds (Fig. 12-40, 12-41). Gilding covers or highlights many surfaces, including moldings, beams, and door panels.

■ *Lighting.* Gas lighting is common, but newly introduced electricity rapidly increases in use during the period (see Chapter 1, "Industrial Revolution"). Some fixtures combine electricity and gas because of the limitations of both. Types include chandeliers and sconces with cut-glass prisms; and brass and glass ceiling lights, sconces, and lamps (Fig. 12-48). Some fixtures reproduce earlier lighting fixtures or are antique ones that are wired for electricity.

■ *Floors.* Floors in public buildings are usually masonry, with marble or terrazzo most common. Homes have

DESIGN SPOTLIGHT

Interiors: Stair hall and music room, The Breakers (Cornelius Vanderbilt House), 1892–1895; Newport, Rhode Island; Richard Morris Hunt. Neo-Renaissance. The Breakers, a Neo-Renaissance "cottage," centers on this two-story hall with its monumental stairway, lavish finishes, and rich ornamentation. Arched openings separated by colossal Corinthian pilasters on pedestals create a series of vistas. Swags, cartouches, and roundels in various colors of marble embellish them. Smaller marble Corinthian columns highlight the upper walkway leading to private rooms. Above a modillioned cornice, a gilded coffered ceiling finishes the composition and adds to the richness of materials and detailing. The French firm of Allard and Sons selects finishes and fixtures. The private family rooms are decorated by Ogden Codman. The music room repeats a similar character but showcases rich colors and decoration inspired by the Renaissance.

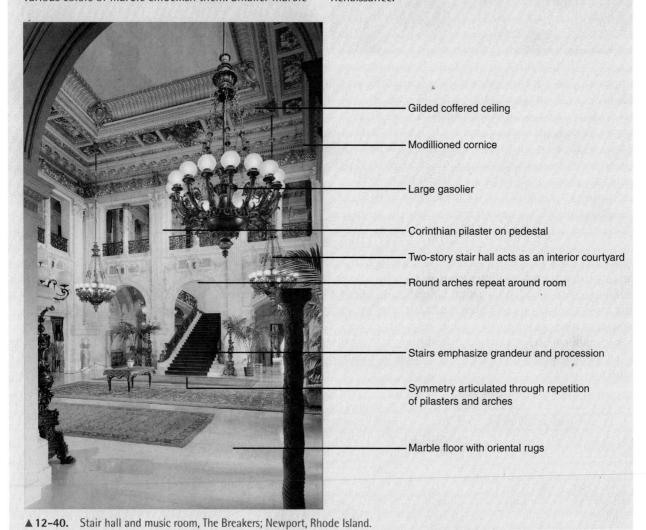

Gilded coffered ceiling

Modillioned cornice

Large gasolier

Corinthian pilaster on pedestal

Two-story stair hall acts as an interior courtyard

Round arches repeat around room

Stairs emphasize grandeur and procession

Symmetry articulated through repetition of pilasters and arches

Marble floor with oriental rugs

▲ **12-40.** Stair hall and music room, The Breakers; Newport, Rhode Island.

marble, mosaic, tile, and parquet wood floors. Area rugs include Orientals, Savonnerie, Aubusson, and other hand-woven or hand-knotted types (Fig. 12-40). Bedrooms and boudoirs often have wall-to-wall carpet in solid colors.

■ *Walls.* Marble or limestone usually covers the walls in important rooms and circulation spaces in public buildings. Alternative treatments include painted murals, wood paneling, or painted plaster (Fig. 12-33, 12-37). In residences, marble walls also are common in entrances, stair halls, and principal public rooms (Fig. 12-39, 12-40). Some replicate the colorful geometric marble designs of the French Baroque at Versailles. Wood paneling is used in drawing rooms, dining rooms, libraries, and some bedrooms (Fig. 12-38, 12-44, 12-45, 12-46, 12-47). For authenticity, antique or new paneling is imported from Europe. Rococo paneling features the curving shapes and foliage of the

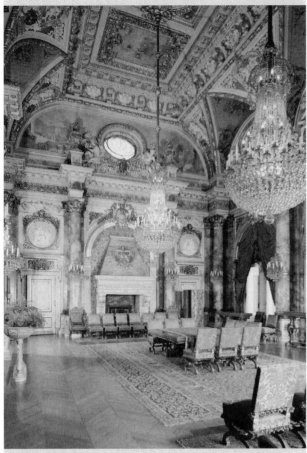

▲ 12-40. *(continued)*

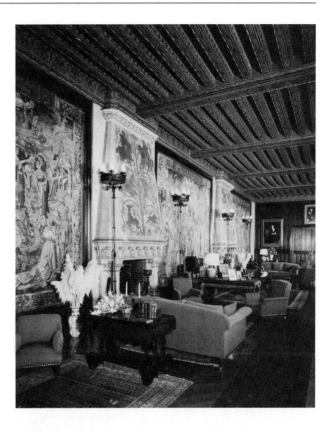

18th century, whereas the Neoclassical style has rectangular panels with delicate repeating moldings and classical motifs. Plaster details, such as acanthus leaves and swags, add richness to paneling and walls. Some rooms, including bathrooms, have painted murals by well-known artists. Antique or new leather or imitations may cover dining room or library walls. Tapestries become a popular wall covering during the period. Imported from Europe, they may be antiques or reproductions of old patterns. Their popularity ensures that cheaper forms will soon be available for the middle classes. Bedrooms and boudoirs may have wallpapers in large formal floral or textile patterns. The middle classes emulate these treatments in a simpler way or with less expensive materials.

Elsie de Wolfe, a champion of good taste, introduces lighter, less cluttered, and more modern interiors for public and private buildings. The Trellis Room and her own dining room at Irving House (Fig. 12-35, 12-42) exemplify these principles.

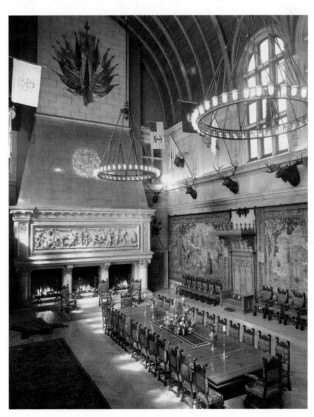

▲ 12-41. Tapestry Gallery and Banqueting Hall, Biltmore Estate, 1890–1895; Asheville, North Carolina; Richard Morris Hunt. Châteauesque.

DESIGN SPOTLIGHT

Interiors: Drawing room and dining room, Irving House, c. 1898–1909; New York City, New York; Elsie de Wolfe; published in *The House in Good Taste*, by Elsie de Wolfe, 1911, 1913. Neoclassical Revival. In the redecoration of these rooms from 1898 to 1909, Elsie de Wolfe transforms them from dark, cluttered Victorian spaces into lighter, less cluttered, and simpler ones. She says in *The House in Good Taste*, that "light, air, and comfort" are the most important elements in a room. In the drawing room, she removes the Turkish corner with its layers of fabrics, pillows, and pictures (see Fig. 9-31). She also eliminates chests, tables, plants, and bric-a-brac. Lighter or jewel tone colors of rose, cream, and dull yellow borrowed from the Persian rug contribute to the new character. Louis XV furniture, which to her conveys sophistication, dignity, and graciousness, replaces the heavy upholstery. The bay window is now filled with palms instead of curtains, allowing light into the room. The dining room color scheme is gray, white, and ivory with white woodwork, and there are very few decorative accessories. Mirrors, which add sparkle to the interior, frame the doors and cupboards and add an unusual and decorative character. Electric wall sconces, which are mounted on mirrors, replace the gasolier over the table. Louis XVI chairs with cane backs and light-weight frames painted ivory replace the dark wood ones. An old Chinese rug in rose with blue and gold medallions and border complements the overall effect.

▲ **12-42.** Drawing room and dining room, Irving House; New York City.

■ *Chimneypieces.* Fireplaces vary in design from the hooded examples of the Renaissance to rectangular mantels with columns or caryatids and carved marble over treatments (Fig. 12-38, 12-39, 12-40, 12-41, 12-42, 12-44).

■ *Windows and Window Treatments.* Window treatments, particularly for public rooms, remain lavish with complicated or swag valances with trims and tassels, under-curtains, and glass curtains (Fig. 12-37, 12-43, 12-44). During the 1870s and 1880s, stained glass is an important decorative treatment in public buildings, wealthy homes, department stores, and, even, Pullman railroad cars.

By the end of the century, stained and colored glass becomes common in all homes. Stained glass compositions substitute for draperies in drawing rooms, provide softly colored light in entrances and stair halls, and, with appropriate iconography, give interest and elegance to dining rooms, libraries, and studies. American designers, such as John La Farge and Louis Comfort Tiffany, experiment with ancient glass techniques, opalescent glass, multiple layers of glass, and adding different materials such as gold. Stained glass soon takes on never-before-imagined depth of shading, variety of textures, and multiplicity of tones, becoming itself a work of art.

■ *Doors.* As important features, single and double doors to principal rooms have elaborate surrounds composed of moldings, engaged columns, pilasters, pediments, entablatures, and fancy over-door compositions of swags, cherubs,

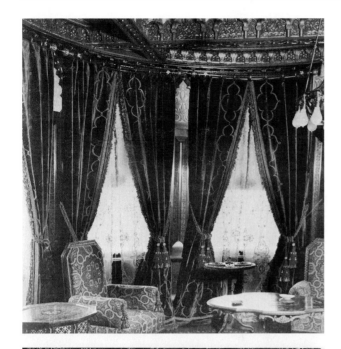

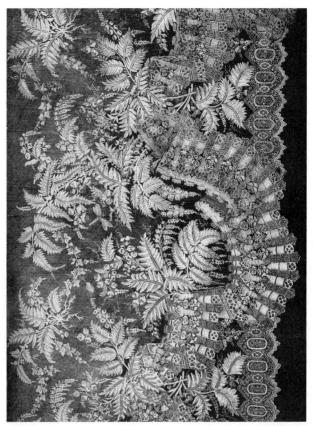

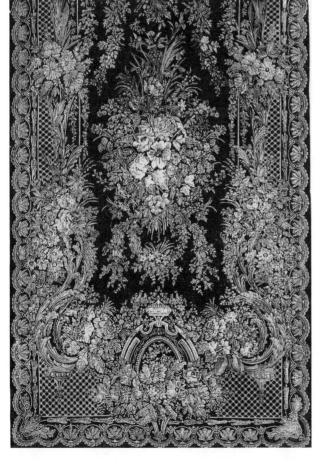

▲ 12-43. Window Treatments: Velvet drapery treatments from the Whittier Mansion in San Francisco and the World's Columbian Exposition, 1893, in Chicago; and lace curtain designs exhibited at the Centennial International Exhibition, 1876, in Philadelphia; manufactured in England, Switzerland, Belgium, and France.

flowers, shells, and the like (Fig. 12-33, 12-36, 12-44). Doors are wood panels that may be stained or painted to match the rooms. *Portières* are universal early in the period but gradually decline in use.

■ *Textiles*. In the 1880s, textiles cover every available surface from mantels to wall shelves. By the turn of the century, this trend diminishes, so rooms display fewer textiles. Used for wall treatments, window treatments

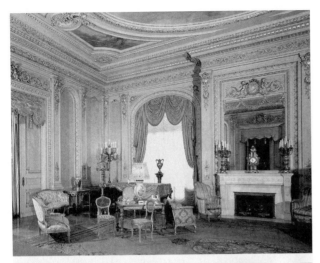

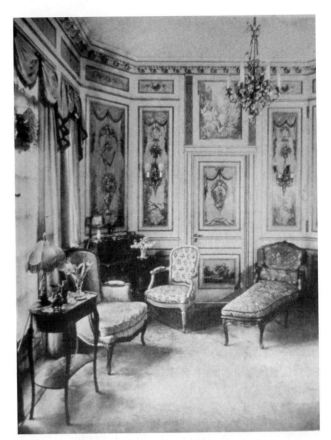

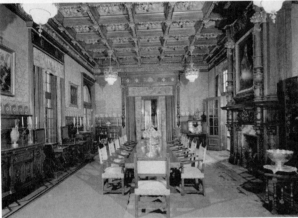

▲ **12-44.** French salon and dining room, Whitehall (Henry Flagler Mansion), 1900–1902; Palm Beach, Florida; John Merven Carrère and Thomas Hastings. Beaux-Arts.

▲ **12-45.** Mrs. Vanderbilt's bedroom, The Breakers, 1910; Newport, Rhode Island; interiors by Ogden Codman. Neo-Rococo.

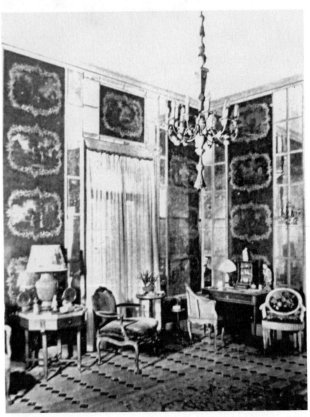

▲ **12-46.** French salons, c. 1920s; New York; Nancy McClelland. Louis XV influence.

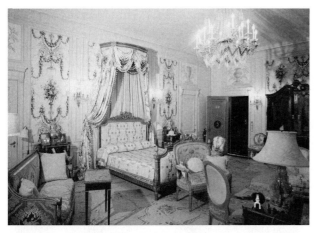

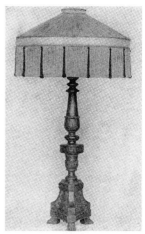

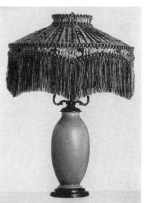

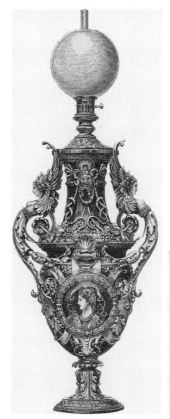

▲ **12-47.** Bedroom, Mar-a-Lago, c. 1920s–1930s; Palm Beach, Florida. Louis XVI influence/Neoclassical Revival.

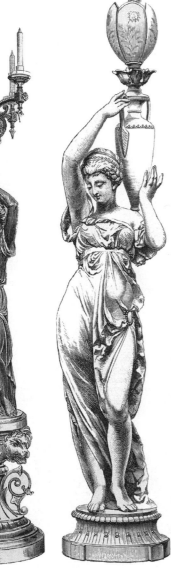

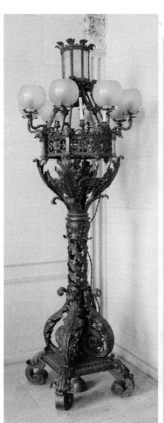

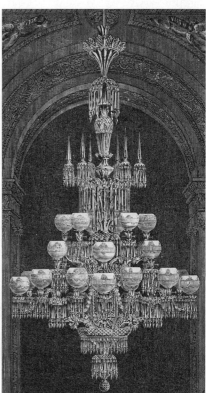

▲ **12-48.** Lighting: Lamps, candelabras, wall sconce, lantern, and crystal chandeliers, c. 1870s–1910s; New York, Rhode Island, and France.

and upholstery are damasks, brocades, velvets, plush, tapestry, lampas, silk, satin, cashmere, and, in lesser rooms, elaborately patterned cretonne or highly polished chintz.

■ *Ceilings*. Ceiling treatments vary and include painted murals, beams, coffers, and plaster designs (Fig. 12-33, 12-34, 12-35, 12-36, 12-37, 12-38, 12-39, 12-40, 12-41, 12-44). All may have carving, painted decoration, and gilding.

■ *Later Interpretations*. During the late 20th century, some Classical Eclecticism interiors change in appearance in response to a new use, such as the original rooms in the Villard Houses converted into Le Cirque bar and restaurant (Fig. 12-49). In other instances, designers borrow from the period influences to create new interpretations for hotels, restaurants, and other hospitality environments (see Chapter 30, "Modern Historicism").

FURNISHINGS AND DECORATIVE ARTS

Furniture is most often large in scale, formal, majestic, and carved or painted to suit a specific room. Many public and private rooms feature antique and reproduction furniture that follows French Renaissance, Baroque,

Rococo, Neoclassical, Italian Renaissance, and Venetian Baroque (Fig. 12-39, 12-40, 12-41, 12-42, 12-44, 12-46, 12-47, 12-50, 12-51). In private rooms, styles in a more human scale (Fig. 12-53), such as Rococo, are fashion-

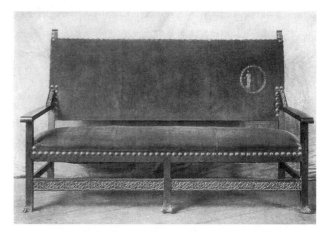

▲ **12-50.** Sofa for Library, Woman's Building, World's Columbian Exposition, 1893; Chicago, Illinois; Candace Wheeler. Neo-Renaissance.

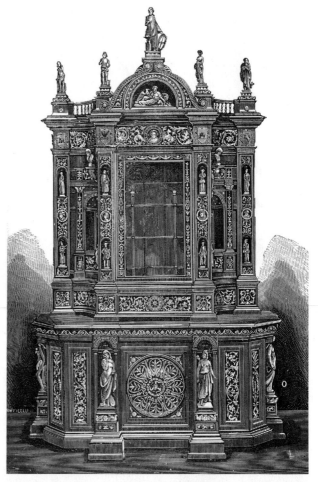

▲ **12-51.** Cabinet with ebony inlay, exhibited at the Centennial International Exhibition, 1876, in Philadelphia; manufactured by S. Coco in Italy. Neo-Renaissance.

▲ **12-49.** Later Interpretation: Bar, Le Cirque restaurant, Helmsley Palace Hotel, c. 2000; New York City, New York; Adam Tihany. Renovation and Redecoration.

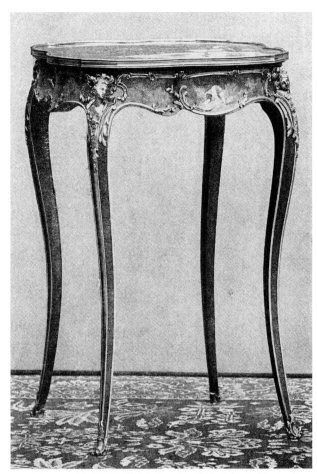

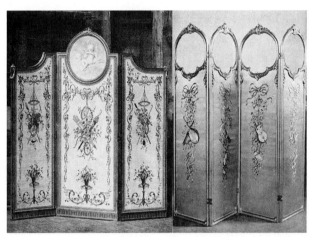

able (Fig. 12-52). Suites of furniture are common, although some rooms may mix a variety of styles for a more individual look. Often supplied by decorating firms, furniture in homes of the affluent may be designed specifically for the room it occupies. Decorative techniques include ebonizing, inlay of many types of materials, carving, gilding, and painting. A variety of upholstery fabrics adds color and pattern. This period witnesses the rise of the antique trade in much of Europe and America. Antique dealers and art gallery owners often offer suggestions for interior decoration.

■ *Decorative Arts.* The wealthy display their collections of art or sculpture in special galleries or in important rooms in residences. Large mirrors with lavishly embel-

▲ **12-52.** Table in Louis XV style; published in *Art and Handicraft in the Women's Building of the World's Columbian Exposition,* 1893; Chicago, Illinois; decoration by Mme. Gabrielle Nieter, France.

▲ **12-54.** Folding screens; published in *Art and Handicraft in the Women's Building of the World's Columbian Exposition,* 1893; Chicago, Illinois; made in France and England.

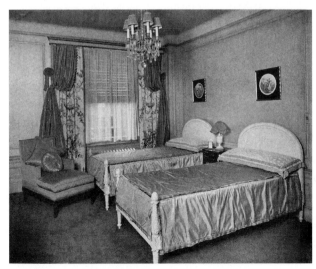

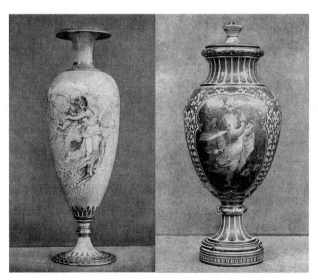

▲ **12-53.** Twin beds; published in *The Practical Book of Furnishing the Small House and Apartment,* 1922.

▲ **12-55.** Polychrome painted vases; published in *Art and Handicraft in the Women's Building of the World's Columbian Exposition,* 1893; Chicago, Illinois; made in France by Mme. E. Apoil.

lished and gilded frames hang over the mantel or on walls between windows. The mantel usually holds a large clock flanked by candelabra or porcelain vases. In 1893, the World's Columbian Exposition in Chicago highlights art and handicraft by women, such as Candace Wheeler, and includes embroidery, decorative screens, vases, and other decorative objects (Fig. 12-54, 12-55). These items are usually prominently displayed in public and private interiors.

Along with these decorative arts, gigantic floral arrangements highlight the entry hall and drawing rooms.

Also on display are porcelains, large silver or brass pieces, and elaborate cut glass. Between 1880 and 1914, America leads the world in cut glass production. Known as Brilliant Cut Glass, glass of the period features deep cuts, curving lines, and elaborate patterns. It is made of lead glass, and the high cost of crafting it makes it a luxury item that only the wealthy can afford. Sets of glassware and tableware are popular items of conspicuous consumption.

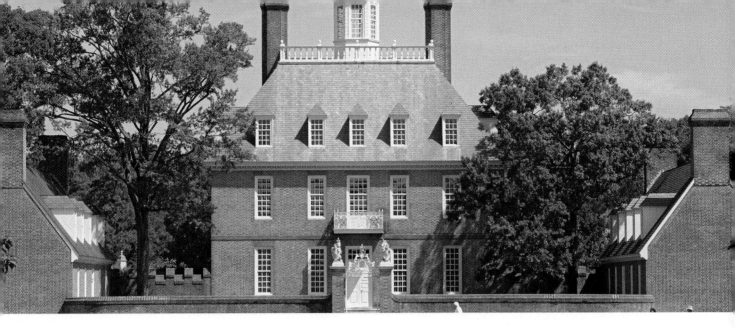

CHAPTER 13

Colonial Revival

1880s–1930s

Colonial is synonymous of the best . . . surely of all types it is the most worthy of emulation.

Mary H. Northend, *Colonial Homes and Their Furnishings*, 1912

With all eccentricity and intricacy shunned, well-proportioned dignity reigned supreme, . . . so admirably created upon sound foundations of good design that countless anomalies of architectural vogue have come and gone, while old Colonial work is increasingly venerated, not by reason of its age alone, but for its intrinsic beauty.

Herbert C. Wise and H. Ferdinand Beidleman, *Colonial Architecture for Those About to Build*, 1913

Within the last decade, however there has been an increasingly noticeable swing back to American furniture and American styles. This is partly due to the revival of nationalism that came after the world war and to a wide-spread desire to build into our surroundings the qualities that we consider purely "American."

Nancy McClelland, *Furnishing the Colonial and Federal House*, 1936

Originating in the second half of the 19th century in the United States, Colonial Revival consciously strives to emulate the architecture, interiors, furniture, and decorative arts of English and Dutch settlements in North America. The style adapts elements from America's colonial past to contemporary lifestyles. Conveying associations of heritage, patriotism, and anti-modernism, the style rapidly becomes fashionable first among the wealthy and then the middle class. Colonial Revival is one of the most enduring of all styles, even maintaining popularity today.

HISTORICAL AND SOCIAL

In some parts of the North America, particularly New England, 17th- and 18th-century styles never really die out. People continue to live in, build, and furnish houses in styles of their ancestors. Colonial Revival has roots in early-19th-century writers, such as Washington Irving, who create images of a mythological past filled with warm and cozy houses and fine people. An antiquing craze in the 1840s leads some to scour the countryside for old furniture and other relics of the past. During the 1860s, attention focuses on colonial towns, such as Newport, Rhode Island, when popular magazines carry stories about them filled with picturesque illustrations. These New England areas soon become fashionable sites for seaside vacations. By the 1870s, following the lead of their

English counterparts in the Queen Anne movement (see Chapter 10, "Stick Style, Queen Anne"), American architects and builders in New England begin exploring their Colonial and/or vernacular heritage. Published examples of 17th- and 18th-century architecture in professional publications, such as the *American Architect and Building News,* inspire other architects. A few, such as Charles Follen McKim of McKim, Mead, and White, remodel true Colonial houses. Colonial Revival in this period is largely architect-designed residences for the wealthy.

Often considered the initial impetus for the Colonial Revival, the 1876 Centennial Exhibition in Philadelphia pays some attention to the past, but its main theme is progress and modern inventions. Nevertheless, some colonial artifacts are exhibited and several exhibition halls, such as the Connecticut Pavilion, are somewhat Colonial in style. A very popular exhibit is the New England kitchen inside a log cabin, which features a real New England dinner served by ladies in colonial costumes. However, much of the importance of the exhibition lies beforehand in the articles and stories about colonial times, the founding fathers, and the Revolution that appear in popular periodicals, the local celebrations and expressions of ancestry, such as Martha Washington teas and colonial balls and plays that take place around the country.

After the Centennial, the collecting of antique furniture and ceramics, especially blue and white china, increases because many are inspired to engage in seeking out and gathering these relics from their seemingly indifferent owners (Fig. 13-1, 13-2). By the first decades of the 20th century, individual collectors, such as Henry Francis DuPont in Delaware and Ima Hogg in Texas, are amassing large collections of American interiors, furniture, and decorative arts. Both will later open their homes, Winterthur and Bayou Bend, respectively, to visitors. Additionally, American museums, such as the Metropolitan Museum of Art in New York City, also begin collecting and exhibiting colonial artifacts, signaling their approval. Also during the period, books about colonial life and art begin flooding the market, and decorating magazines start illustrating "Modern Colonial" houses and interiors and advertising new Colonial-style furniture and reproductions. By 1920, the Colonial Revival has its own aesthetic and becomes increasingly popular with the middle class (Fig. 13-17, 13-33). The style occupies a prominent place in the period house and period decoration trends as practiced by architects, interior decorators, historians, and home owners of the time.

Colonial Revival is revered as an American style, and, as such, maintains prominence throughout the 20th century. It continues in popularity, particularly for suburban housing, because of its traditional appearance and historical and ancestral emphasis.

Colonial Revival derives its character and appearance from the material culture of the English and the Dutch colonists in North America from the first settlements up to about 1840. Each group replicates the buildings, interiors, and furniture its members had known at home. The American Georgian image is the one that is most often repeated in Colonial Revival, although Federal-style architecture, interiors, and furniture also are common. The revival occasionally relies on the 17th century for inspiration.

■ *English Colonial (1608–1720).* Along the eastern seaboard, English settlers, who are largely farmers and laborers, construct small and plain houses that reveal little awareness of the high style Renaissance of Europe. Houses are of unpainted clapboards with small windows placed where needed and a steeply pitched gable roof. Most are one story, but examples from more affluent owners have two stories and may be jettied—the upper story overhangs the lower on the front and back. Chimneys are large and prominent. Plans include one-room, hall and parlor, and lean-to. Interiors are largely Medieval, and oak furniture follows English Elizabethan (1558–1603) or William and Mary (1689–1702) styles.

■ *Dutch Colonial (17th–19th centuries).* Dutch merchants and traders, who settle in present-day New York and New Jersey and along the Hudson River, soon cede their colonies to England, so their influence quickly fades except in small areas. Urban Dutch houses have little influence in America, but the typical gambrel roof, found in rural examples and probably not of Dutch origin, lives on in Dutch Colonial Revival. Interiors and furniture reflect examples in Holland.

■ *American Georgian (1700s–1780s).* Architecture and interiors in this period reveal increasing formality and sophistication and a closer emulation of English Georgian prototypes, especially small manor houses. High-style buildings, inside and out, are symmetrical and ordered with classical and Neo-Palladian proportions, forms, and details. Most are rectangular blocks with or without side additions called wings. A prominent doorway emphasizes the entrance. Sash windows replace casements, and a cornice accentuates the roofline. Inside, walls may be paneled symmetrically with classical details or, occasionally, wallpapered. Floors are wood, sometimes with rugs or wall-to-wall carpet, and ceilings may be plain or have plaster details. As focal points, mantels have classical brackets or columns and pediment above them. Furniture is Queen Anne or Chippendale with curving forms, symmetrical compositions, and harmonious proportions.

■ *Federal (1776–1820).* American Federal emulates the Neoclassical style dominating English and European design. The style maintains the classical forms and details of the Georgian period but with more slender proportions. Buildings

continue the rectangular blocks of Georgian but are three stories. Windows may be rectangular sashes, round, fans, or tripartite Palladians. Doorways have elliptical fanlights and side lights. Circular porches sometimes project. Inside, rooms are refined and elegant with plaster walls and ceilings in strong, clear colors, often with classical details in plaster relief. Furniture follows the Adam, Hepplewhite, and Sheraton styles of England (late 18th to early 19th century) or Louis XVI of France (1774–1789). All are slender with straight lines, geometric curves, and classical details.

■ *Colonial Revival and the Historic Preservation Movement.* Colonial Revival also occupies a prominent place in and contributes to the historic preservation movement (see Chapter 30, "Modern Historicism"). Although some efforts occur earlier, activity increases in the second half of the 19th century when preservation of the past begins to merit serious consideration by individuals and private groups. Women comprise many of the groups, including the Mount Vernon Ladies Association and the Daughters of the American Revolution (DAR). Buildings are preserved and restored primarily because of their associations with founding fathers and mothers, rather than any aesthetic or other considerations.

By the early 20th century, scrutiny of colonial art and times stimulates preservation of the buildings, not only because of association, but because of their artistic value. Groups, like the Society for the Preservation of New England Antiquities (SPNEA) led by William Sumner Appleton, begin developing preservation plans and processes to more accurately protect and restore original historic materials. In the late 1920s, William Archer Rutherford Goodwin and John D. Rockefeller come together to restore Colonial Williamsburg in Virginia. A team of architects, engineers, archaeologists, historians, and furniture experts succeeds in carrying out the first and largest attempt in the United States to preserve and re-create an entire community. Their work affects the preservation movement for decades to come. An unanticipated effect is the huge public interest in the project as a model for home design and furnishing. Following the official opening of Williamsburg in 1934, the reproduction of Colonial-style furniture, historical wallpapers, fabrics, and decorative objects accelerates.

CONCEPTS

Late-19th-century America is particularly receptive to a Colonial Revival because industrialization and urbanization have brought sweeping social and cultural changes. In response, some begin longing for the perceived simpler, more stable Colonial times and lives. A reverence for ancestors, as a reaction to the influx of immigrants and increased nationalism, cause many, particularly in New England, to build and furnish in the Colonial style to tangibly demonstrate their heritage and separate themselves from newcomers. Contemporary architectural and design movements, such as Queen Anne and Arts and Crafts, also provide additional impetus for American designers to examine the English Colonial past, particularly on the East Coast.

To many, Colonial Revival symbolizes America's heritage because it highlights a spirit of nationalism within the context of tradition and middle-class values. Nevertheless, some lingering Victorian notions exert influence, particularly the idea that environments can influence people's characters positively or negatively. Consequently, some promote the style because they believe that the admirable qualities they see in Colonial precursors will engender the same excellence in contemporary people who live in Colonial-style houses with Colonial-style furniture. By the early 20th century, Colonial becomes a tool for simplifying the Victorian house with its multiplicity of styles and bric-a-brac. Decorating magazines of the early 20th century coin the term "Modern Colonial" to describe the overall character. By portraying itself as a Modern style, the Colonial broadens its appeal. Often the descriptions emphasize simplicity, function, and efficiency to reflect health concerns. Examples differ from the earlier precursors in size, proportion, and planning resulting in buildings with open plans, more daylight, and kitchens and bathrooms.

▲ 13-1. "The Cheerful Round of Daily Work"; published in *The House Beautiful*, 1878 by Clarence Cook.

IMPORTANT TREATISES

- *American Furniture*, 1952; Joseph Downs.
- *The Colonial House*, 1913; Joseph Everett Chandler.
- *Colonial Homes and Their Furnishings*, 1912; Mary H. Northend.
- *Domestic Architecture of the American Colonies and of the Early Republic*, 1922; Fiske Kimball.
- *The Dutch Colonial House*, 1919; Aymar Embury II.
- *Early Connecticut Houses: An Historical and Architectural Study*, 1900; Norman M. Isham and Albert F. Brown.
- *Examples of Domestic Colonial Architecture in New England*, 1891; James M. Corner and Eric Ellis Soderholtz.
- *Early New England Interiors*, 1877; Arthur Little.
- *Furnishing the Colonial and Federal House*, 1936; Nancy McClelland.
- *The Furniture of Our Forefathers*, 1924; Esther Singleton.
- *Furniture Treasury*, 1933, 1949; Wallace Nutting.
- *Great Georgian Houses of America*, 1933, 1937; William Lawrence Bottomley, editor.
- *Home Life in Colonial Days*, 1898; Alice Morse Earle.
- *Old Time Wallpapers*, 1905; Kate Sanborn.
- *The Quest of the Colonial*, 1913; Robert and Elizabeth Shackleton.
- *White Pine Series of Architectural Monographs*, 1915–1924; Russell F. Whitehead, editor.

Periodicals and Catalogs: House Beautiful and *House and Garden* magazines; Sears, Roebuck and Company catalogs, c. 1910s–1920s.

Beginning in the final decade of the 19th century, knowledge about the appropriate design language is available from an array of publications, including *Old Colonial Architecture and Furniture* (1887) and *American Architecture, Decoration, and Furniture* (1895) by Frank E. Wallis; *The Georgian Period* (1898) by William Rotch Ware; *Colonial Furniture in America* (1901) by Luke Vincent Lockwood; *Domestic Architecture of the American Colonies and of the Early Republic* (1922) by Fiske Kimball; *Furniture Treasury* (1933, 1949) by Wallace Nutting; *American Furniture* (1952) by Joseph Downs; Sears, Roebuck, and Company catalogs (c. 1910s); and *House Beautiful* and *House and Garden* magazines.

DESIGN CHARACTERISTICS

The Colonial Revival consciously attempts to imitate, but not necessarily copy, the architecture, interiors, and furnishings of the 17th, 18th, and early 19th centuries, except in museums and restorations. Colonial Revival examples often mix attributes from several different periods and differ in design to accommodate modern lifestyles, materials, and technology. True Colonial house types are adapted to contemporary ways of living with picture windows; rooms unknown in the period, such as the living room; kitchens with modern appliances; side or sleeping porches; and attached or unattached garages or carports. Similarly, interiors and furniture usually display characteristics of earlier examples but often with materials, forms, and characteristics that differ or are unknown in the originals. Decoration derives from precedents, but may be simplified, vary in proportion, or combine elements from different periods. Colonial Revival also inspires adaptations and reproductions of period artifacts and finishes. To accommodate contemporary use and conveniences, adaptations may alter scale, proportions, materials, construction techniques, colors, uses, details, and motifs. In contrast, reproductions copy as closely as possible, within the limitations or abilities of modern technology, a historical prototype, which can be a house, interior, piece of furniture, textile, or floor or wall

▲ **13-2.** "Grandmother's Cupboard"; published in *The House Beautiful*, 1878 by Clarence Cook.

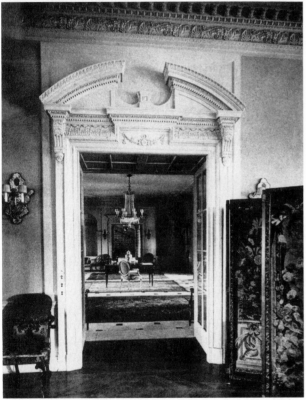

▲ **13-3.** Stair hall; published in *The Room Beautiful*, 1915, and Georgian door; Pennsylvania.

covering. (Note: Some late-19th- and early-20th-century examples called reproductions do not fit this definition; see Chapter 30, "Modern Historicism").

■ *Motifs.* Motifs derive from precedents, but the historical images may be simplified with less detail (Fig. 13-5, 13-11, 13-17, 13-28, 13-32, 13-42, 13-43). Examples include columns, pilasters, pediments, engaged columns, lintels, stringcourses, quoins, urns, acanthus leaves, shells, rosettes, palmettes, and eagles.

ARCHITECTURE

The earliest Colonial Revival examples are an outgrowth of architects' investigations of New England's 17th-century buildings. McKim, Mead, and White undertake a sketching trip through New England in 1877. Soon after, they design broad interpretations of 17th-century houses and work on restorations in Newport, Rhode Island. Other architects, such as Arthur Little and Robert Peabody, follow suit as they explore the vernacular past emulating English architects in the Queen Anne style (1880–1910s) and the regionalism promoted by the Arts and Crafts Movement (1870s–1900). By the 1880s, with the influence of Classical Eclecticism (see Chapter 12, "Classical Eclecticism") and greater knowledge of precedents, high-style houses begin to more closely imitate their Georgian and Federal predecessors, although they are more eclectic and sometimes larger in scale than the originals. As before, these examples are designed by architects, such as the firm of McKim, Mead, and White (Fig. 13-8, 13-9) and

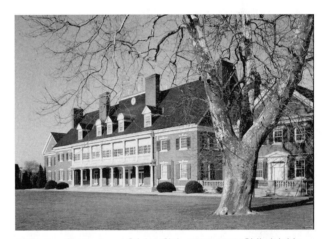

▲ **13-4.** Germantown Cricket Club, 1890–1891; Philadelphia, Pennsylvania; Charles F. McKim of McKim, Mead, and White.

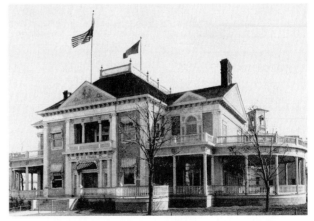

▲ **13-5.** West Virginia State Building, World's Columbian Exposition, 1893; Chicago, Illinois; J. S. Silsbee.

IMPORTANT BUILDINGS AND INTERIORS

- **Amherst, Virginia:**
 - Sweet Briar College, 1901–1902; Cram, Goodhue, and Ferguson.
- **Cambridge, Massachusetts:**
 - Annie Longfellow Thorpe House, 1887; Alexander Wadsworth Longfellow.
- **Chicago, Illinois:**
 - Connecticut State Building, World's Columbian Exposition, 1893; W. Briggs.
 - West Virginia State Building, World's Columbian Exposition, 1893; J. S. Silsbee.
- **Dallas, Texas:**
 - Swiss Avenue neighborhood, c. 1910s–1930s.
- **Fort Worth, Texas:**
 - Wharton-Scott House (Thistlehill), c.1904.
- **Houston, Texas:**
 - Bayou Bend, 1927–1928; John Straub.
- **James City County, Virginia:**
 - Carters Grove, 1751 David Minitree; 1908, W. W. Tyree; 1928–1931, W. Duncan Lee.

- **Newport, Rhode Island:**
 - Commodore William Edgar House, Sunnyside Place, 1884–1885; McKim, Mead, and White.
 - H. A. C. Taylor House, 1886; McKim, Mead, and White. (Destroyed)
 - Hypotenuse (Colonel George Waring House), begun possibly in early 18th century, additions c. 1870–1911; Richard Morris Hunt, and possibly later work by Stanford White of McKim, Mead, and White. Dutch Colonial.
- **Richmond, Virginia:**
 - James W. Allison House (now known as the President's House, Virginia Commonwealth University), 1895–1896; Percy Griffin and Henry Randall.
 - Windsor Farms suburb area, 1910s–1940s.
- **Washington, D.C.:**
 - Kalorama historic area, 1910s–1940s.
 - Woodrow Wilson House, 1915–1916 and 1920s; Waddy S. Wood. Georgian Revival.
- **Williamsburg, Virginia:**
 - Historic Williamsburg restoration, phase 1, 1930s–1940s.

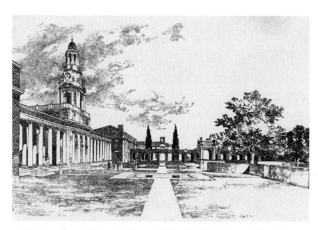

▲ **13-6.** Sweet Briar College, 1901–1902; Amherst, Virginia; Cram, Goodhue, and Ferguson.

architect–designer Ogden Codman, for the affluent in New England and the Midatlantic. Also evident during the period are Queen Anne and Shingle houses with Colonial details in the same areas of the country.

By the beginning of the 20th century, scholarship and new printing methods that permit the wider distribution of photographs foster designs with more correct proportions and details. Frequent publication of plans and designs to professional and popular audiences ensures wide dissemination. Subsequently, anonymous builders begin producing houses for middle-class suburbs, which proliferate throughout North America, especially in the building boom of the 1920s.

Colonial Revival adapts well to a variety of building types and sizes from small houses to large Georgian-style mansions. The most common, but not the only, house type found in Colonial Revival is the double-pile or Georgian rectangular block with center hall floor plan. Particularly suitable for small houses is the adaptation of the 17th-century small, single-story house into the Cape Cod house. Appearing about 1910 is the Dutch Colonial house identified by its gambrel roof (Fig. 13-14, 13-15, 13-16, 13-21). There also are Colonial Revival bungalows and four-squares.

Public and Private Buildings

- *Types.* Houses are the most common expression of Colonial Revival (Fig. 13-8, 13-9, 13-10, 13-11, 13-13, 13-14, 13-15, 13-16, 13-17, 13-18, 13-19, 13-20, 13-21, 13-23). Others include exposition buildings (Fig. 13-5), civic buildings (Fig. 13-7), banks, schools (Fig. 13-6), and even gas stations.

DESIGN PRACTITIONERS AND MANUFACTURERS

Many people capitalize on the Colonial Revival, from architects who design houses and interiors for the affluent and wealthy; to developers, builders, and contractors who supply plans and construct houses for individuals or developments; to early-20th-century interior decorators who specialize in period decoration; to individual homeowners aided by books and decorating magazines.

- **Baker Furniture Inc.** (1890–present), founded by Siebe Baker and Henry Cook, begins producing oak furniture in Allegan, Michigan. The firm expands its lines and productions and moves to Holland, Michigan. In the 1930s, under the direction of Hollis S. Baker, the company begins making reproductions and adaptations of historical furniture. It establishes a reputation for historical integrity and fine craftsmanship that is maintained today. Baker's factories are in North Carolina.

- **Widdicomb Furniture/John Widdicomb Company** (1857–present) opens as a small cabinetmaking shop but soon expands into manufacturing. The company produces Colonial and other revival styles in the early 20th century, adding a line of modern furniture in 1928. With designs by R. H. Robsjohn Gibbings and George Nakashima, it becomes an important producer of 1950s modern furnishings. The firm ceases production in the late 1960s, but in 1970, John Widdicomb Company purchases the name. John Widdicomb is started in 1897 by a brother of the owner of the original firm. Ralph Widdicomb, a nephew and its best-known early designer, introduces French Provincial to America in 1924. The company produces reproductions of English, French, Italian, and Modern furniture. In 2002, John Widdicomb Company begins operating as a division of L. & J. G. Stickley, Inc.

- **Kittinger Company** of Buffalo, New York, which opens in 1866, is one of the oldest companies producing Colonial-style furniture. It is granted a license to reproduce selected pieces from Colonial Williamsburg in 1937 and establishes a quality standard for Colonial Revival reproduction furniture. Kittinger produces custom furniture for home and office.

- **Duncan Lee** (1884–1952) and **William Bottomley** (1883–1951), well-known Richmond, Virginia, architects, draw direct inspiration from neighboring Williamsburg for the creation of significant Colonial Revival houses for the Richmond-area elite.

- **Nancy McClelland** (1876–1959) establishes a decorating department in Wanamaker's department store in New York City in 1913, which specializes in correct period styles. After opening her own firm in 1920, she expands her interest in historic American interiors. She writes several books and works on restorations at museums, such as Colonial Williamsburg, and interiors of houses, such as Blair House in Washington, D.C., Mount Vernon, and the Henry Wadsworth Longfellow House in Portland, Maine. She serves as the first woman president of the American Institute of Interior Decorators from 1941 to 1944.

- **Charles Follen McKim** (1847–1909), **William Rutherford Mead** (1846–1928), and **Stanford White** (1853–1906) form a large and influential New York City architectural firm called McKim, Mead, and White that helps initiate the Colonial Revival in architecture. Following a trip through New England to study the architecture, members of the firm begin to build Colonial-style houses and restore 18th-century houses for clients throughout the New England area but primarily in Newport, Rhode Island. Their interest helps spur the interest of other architects.

- **Wallace Nutting** (1861–1941) tries to record and preserve an American past he believes is rapidly passing away. He begins as a photographer of Colonial scenes, collector of American antiques, and noted author. In 1917, Nutting opens a business to reproduce antiques. Meticulous in his approach, he finds the finest pieces, studies them carefully, and creates detailed drawings, which are then made in his workshops. He does not, however, hesitate to improve an antique. What sets his furniture apart from others is the use of traditional methods of production. His staged photographs of people in colonial dress in colonial rooms are important purveyors of Colonial Revival.

DESIGN SPOTLIGHT

Architecture: Governor's Palace, 1705–1749, reconstruction in 1930s; Williamsburg, Virginia. Located in Colonial Williamsburg, this building illustrates accumulated efforts of scholarship to present an accurate depiction of a historically significant building. Begun in 1706 and finally completed in 1751, the house was intended to be a visual metaphor for the king's immediate representative in the most important capital of England's largest American colony. Two stories with prominent entrance and a tall hipped roof with cupola distinguish the building, which is flanked by smaller dependencies and surrounded at the rear by formal gardens and a naturalistic park to the north. Upon entering the iron gates, visitors follow a carefully planned succession of spaces across the courtyard, into the building, and up the steps to the governor's chamber. Elaborately furnished, the palace is the scene of elegant balls and other festivities until it is destroyed by fire in 1781. After the Civil War, the property passes to the College of William and Mary.

Colonial Williamsburg purchases the property in 1928. The Governor's Palace is reconstructed accurately from a copperplate engraving found in England in 1929, a floor plan drawn by Thomas Jefferson in 1779, Virginia General Assembly records, and foundations of the original building uncovered in archaeological investigations. Some elements, such as the coats of arms, are conjecture. As an important first step, the palace fosters more work in the historic section of the city and leads to broad interests in historic preservation throughout Virginia. These interests support the research and documentation of the architecture, interiors, furnishings, and decorative arts of Colonial Williamsburg.

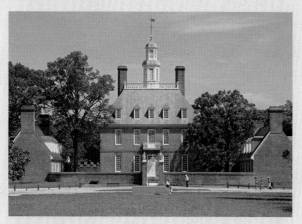

▲ **13-7.** Governor's Palace; Willamsburg, Virginia.

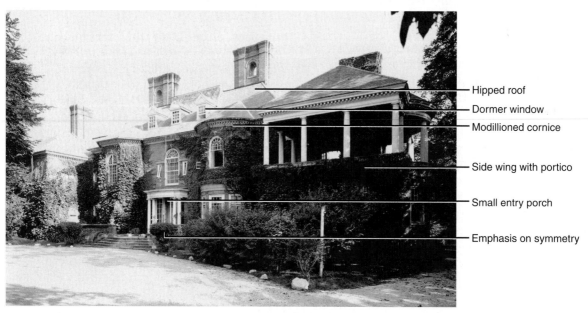

Hipped roof

Dormer window

Modillioned cornice

Side wing with portico

Small entry porch

Emphasis on symmetry

▲ **13-8.** Commodore William Edgar House, 1884–1885; Newport, Rhode Island; by McKim, Mead, and White.

▲ **13-9.** H. A. C. Taylor House, 1886; Newport, Rhode Island; McKim, Mead, and White.

■ *Site Orientation.* Buildings do not replicate the surroundings of the originals. Houses may sit along quiet, tree-lined suburban streets and even form complete subdivisions (Fig. 13-11, 13-17, 13-21, 13-23). Commercial buildings may have large areas of formal green space (Fig. 13-6).

■ *Floor Plans.* Plans for public buildings do not replicate similar originals because the originals are more domestic in scale. Instead, public buildings develop from function and contemporary requirements. Exterior designs usually reflect interior plans. House plans often illustrate openness and asymmetry and do not always support the delineation of the architectural envelope (Fig. 13-12, 13-22). The earliest plans for Colonial-style houses have the living halls and openness

DESIGN SPOTLIGHT

Architecture: Annie Longfellow Thorpe House, 1887; Cambridge, Massachusetts; Alexander Wadsworth Longfellow. One of the earliest Colonial Revival houses in Boston, the house displays typical Colonial-style features. From precursors are symmetry, clapboards, gambrel roof with dormers, prominent entrance, projecting semicircular porch, doorway accented with fanlight and sidelights, and modillioned cornice defining the roofline. The house is larger and differs in proportions, particularly in the entrance porch and other details, from Colonial examples. Signals of Colonial Revival are the side porch (with porte-cochere beyond), picture windows on the first floor, windows on the second story with single-pane lower and multipane upper sashes, prominent recessed picture windows above the front door, and wide

sidelights that flank the door. Designed by Alexander Wadsworth Longfellow, family ties and the nearby Longfellow House (1759) underlie this conscious emulation of earlier architecture.

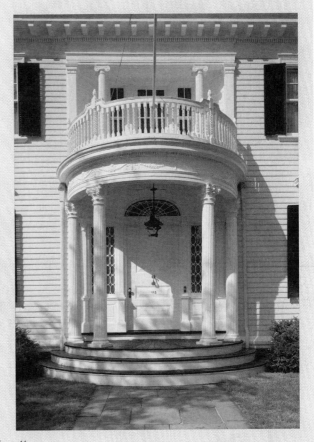

▲**13-10** Annie Longfellow Thorpe House; Cambridge, Massachusetts.

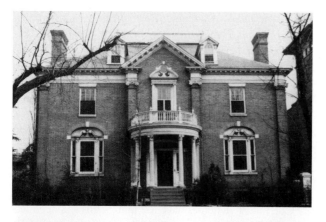

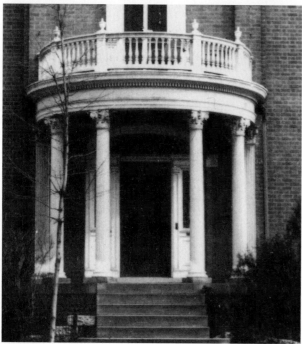

▲ **13-11.** James W. Allison House (now known as the President's House, Virginia Commonwealth University), 1895–1896; Richmond, Virginia; Percy Griffin and Henry Randall.

of Queen Anne and Shingle styles. Later examples are likely to have variations of the Georgian plan with center halls that may be straight or L-shaped with rooms in various sizes and shapes on either side. Prominent stairways are typical but vary in scale and design depending on the house size and importance (Fig. 13-25, 13-27, 13-35). Level changes may also occur on the first floor. Most houses before World War I have one-story loggias or side porches on one or both sides (Fig. 13-15, 13-17), which become outdoor living or sleeping areas to promote health and well-being and assist in the transition of inside to outside space. During this time, a single large living room replaces the front and rear Victorian parlors, reflecting the trend toward fewer rooms and multipurpose spaces. Dining rooms have direct access to serving areas and kitchens. Service areas, such as the kitchen, often are located in an ell on the rear of the house.

■ *Materials.* Brick, stone, and wood are typical, but new materials such as concrete block and stucco may be featured (Fig. 13-7, 13-10, 13-11, 13-14, 13-17, 13-19, 13-23). Wood may be painted white or the traditional colors promoted in Williamsburg or non-Colonial palettes. The most common color scheme is white body with dark green shutters.

■ *Façades.* Buildings reflect symmetry or asymmetry, combine details from several styles, and incorporate one, one and a half, two, or three stories (Fig. 13-4, 13-5, 13-7, 13-8, 13-9, 13-10, 13-13, 13-14, 13-15, 13-16, 13-18, 13-19, 13-20, 13-21, 13-23). Many examples are front gables; smaller houses tend to have side gables (Fig. 13-11, 13-17). Formal facades are symmetrical with projecting centers capped with a pediment or small entry porches. Architectural details include columns, pilasters, pediments, engaged columns, lintels, stringcourses, quoins, modillioned cornices, balustrades, and decorative brickwork. A defining feature for the style is the cornice separating wall and roof with dentils or modillions. The open eaves and exposed rafters on some Colonial Revival buildings are never found on the precursors. Full- and par-

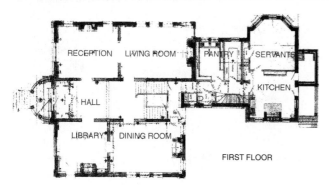

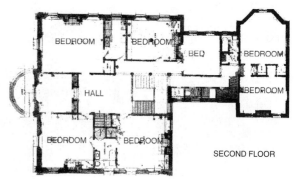

▲ **13-12.** Floor plans, James W. Allison House (now known as the President's House, Virginia Commonwealth University), 1895–1896; Richmond, Virginia; Percy Griffin and Henry Randall.

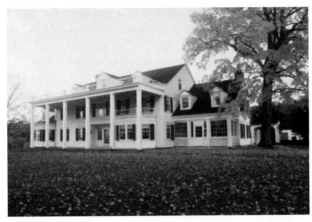

▲ **13-13.** Hill-Stead, c. 1900–1907; Farmington, Connecticut.

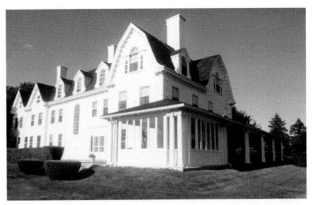

▲ **13-16.** House, early 20th century; Newport, Rhode Island. Dutch Colonial.

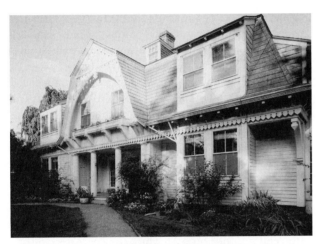

▲ **13-14.** Hypotenuse (Colonel George Waring House), begun possibly in early 18th century, additions c. 1870–1911; Newport, Rhode Island; Richard Morris Hunt, and possibly later work by Stanford White of McKim, Mead, and White. Dutch Colonial.

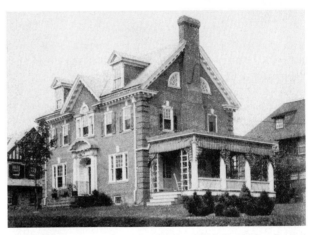

▲ **13-17.** "A Colonial Home at Oaklane, Pa."; Pennsylvania; published in *House Beautiful*, October 1913.

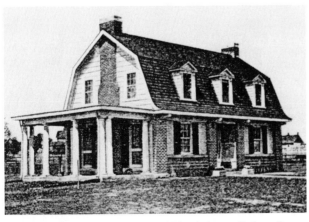

▲ **13-15.** House; Newport, Rhode Island; Aymar Embury II; published in *Inexpensive Homes*, 1912. Dutch Colonial.

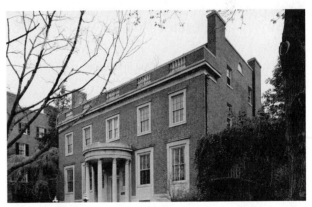

▲ **13-18.** Delano House, 1924; Washington, D.C.; Waddy S. Wood.

tial-width front porches may be on four-squares and Dutch Colonials (Fig. 13-10, 13-11, 13-13, 13-14, 13-18, 13-20, 13-21, 13-23). Some make a distinction between the Colonial Revival and the Georgian Revival. Buildings emulating English Georgian are larger and more formal than Colonial Revivals and may incorporate elements and

details associated with the Italian Renaissance. Most are of brick or stone with a projecting center that may have a pediment and quoins. Stringcourses separate stories, and quoins highlight corners.

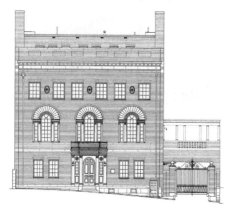

▲ **13-19.** Woodrow Wilson House, 1915–1916 and 1920s; Washington, D.C., Waddy S. Wood. Georgian Revival.

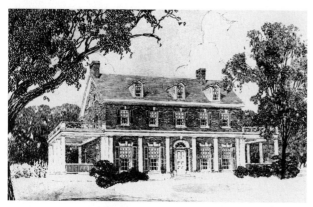

▲ **13-20.** "Preliminary Sketch for a Residence"; published in *Pencil Points*, July 1930.

■ *Windows*. Double-hung windows emulate precursors, except in the variety of pane patterns and sizes (Fig. 13-5, 13-7, 13-10, 13-11, 13-14, 13-17, 13-18, 13-19, 13-20, 13-23). Types never seen on the originals include sashes with multipane uppers and single-pane lowers, double and triple windows, picture windows, bay and bow windows. Larger buildings may have oval, round, fan, or Palladian windows like the originals. Lintels, moldings, or pediments may surmount windows on larger houses. Shutters frame most windows.

■ *Doors*. Doorways are a defining feature of the style and most often resemble Georgian or Federal prototypes. Most common are paneled doors topped by fanlights and flanked by sidelights, sometimes with a projecting rectangular or circular porch with Tuscan, Ionic, or Corinthian columns (Fig. 13-9, 13-10, 13-23, 13-28). Somewhat rare on the originals, full or broken triangular and segmental pediments are common on expensive Colonial-style buildings and may be combined with fanlights. High-style or architect-designed buildings often have formal, ceremonial entrances approached through sweeping exterior staircases. Doorway surrounds are bolder and more elaborate.

■ *Roofs*. Common roofs are gable, hipped, or gambrel, and shingles cover them (Fig. 13-5, 13-7, 13-8, 13-9, 13-10, 13-20, 13-21, 13-23). Gambrel roofs define Dutch Colonials (Fig. 13-14, 13-15, 13-16).

■ *Later Interpretations*. Following World War II, a need for housing and changing fashion dictates a simpler Colonial Revival house with form and details that only suggest its origins. Colonial elements and simple details appear on ranch houses and split-level houses in numerous suburban developments across North America. Also popular is a variation of the 17th-century jettied house in which the upper story, usually in a different material, overhangs the lower. Late-20th-century Colonial houses continue these forms and revive the larger mansions of earlier (Fig. 13-24; see Chapter 30, "Modern Historicism"). Commercial buildings also continue to reflect America's love for Colonial and Georgian design.

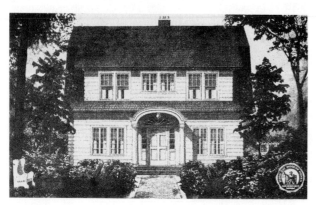

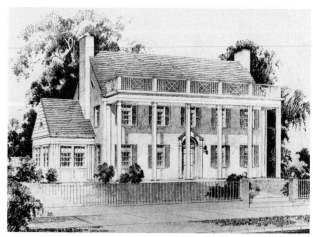

▲ **13-21.** "The Martha Washington" and "The Jefferson," 1921–1937; model homes manufactured by Sears, Roebuck & Company in Chicago, Illinois.

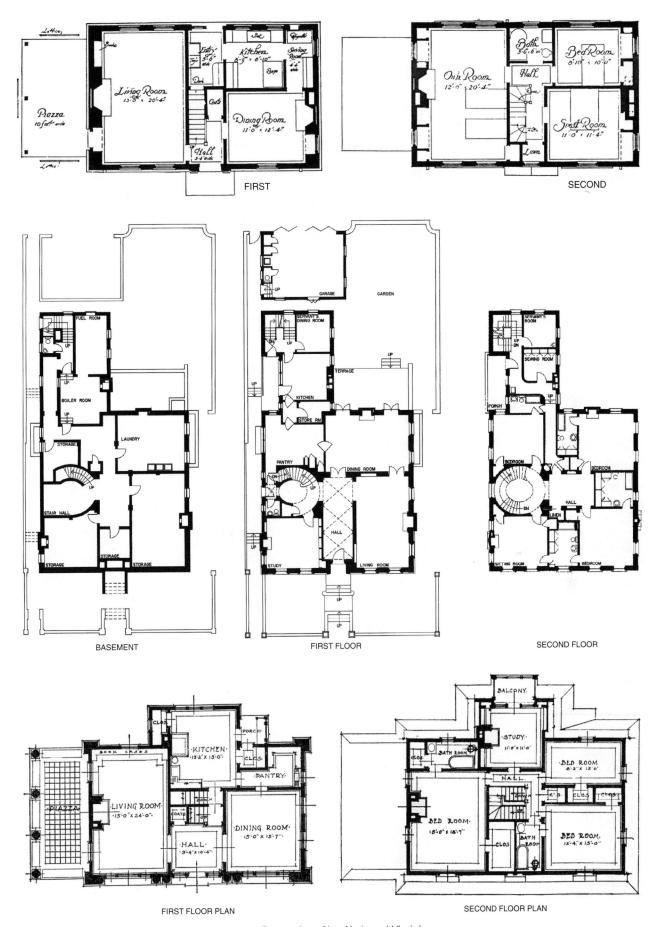

FIRST

SECOND

BASEMENT

FIRST FLOOR

SECOND FLOOR

FIRST FLOOR PLAN

SECOND FLOOR PLAN

▲ 13-22. Floor plans for houses, c. 1920s–1930s; Connecticut, New York, and Virginia.

▲ **13–23.** Houses, c. 1930s; North Carolina, Virginia, and Washington, D.C.

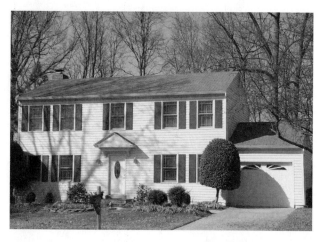

▲ **13–24.** Later Interpretation: Suburban houses, 1990s; Virginia and North Carolina. Modern Historicism/Suburban Modern and Regionalism.

INTERIORS

As with the exteriors, the interiors derive from historical precedents, but do not copy the original models except in museum restorations. Even then, early restorations are more romantic than authentic. Larger and more formal Colonial Revival houses beginning in the early 20th century are influenced by designers and professional decorators who popularize several classically derived ideas,

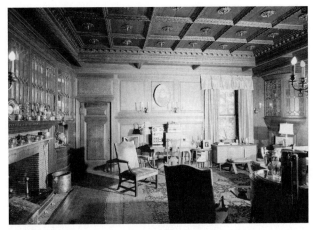

▲ **13-26.** Living room, Commodore William Edgar House, 1884–1885; Newport, Rhode Island; McKim, Mead, and White.

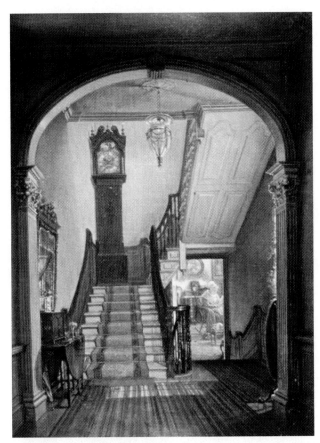

▲ **13-25.** "The Old Clock on the Stairs", 1868; painting by Edward Lamson Henry. Inspired by a Longfellow poem, the painting was exhibited at the 1876 Centennial Exhibition.

including the importance of a processional axis, exterior and interior harmony, symmetrical ordering within a room, and authentic architectural details. Among the middle class, the most favored Colonial interior is one that captures the spirit of the Colonial while retaining contemporary amenities such as asymmetrical furniture groupings, larger-scaled spaces, and higher ceilings. Simplicity offers an antidote to Victorian complexity and clutter resulting in clean lines, flat surfaces, and less ornament.

In the 1930s, Colonial Williamsburg inspires somewhat more authentic 18th-century houses and interior decorations. Manufacturers quickly market house plans, architectural elements, wallpapers, paint, textiles, rugs, furniture, and decorative accessories either copied or adapted from period resources. Also during this time, the Early American room appears. Loosely based upon 17th-century and/or vernacular sources, Early American rooms are casual alternatives to the more formal 18th-century Colonial or Georgian. Colonial Revival does not commonly appear in kitchens or baths until very late in the period. Because of the absence of servants in middle-class houses, kitchens are likely to be simple and efficient, reflect scientific planning, and incorporate progressive technology. Baths, too, follow

this trend, emphasizing the importance of hygiene with easily cleaned fixtures and materials.

Public and Private Buildings

■ *Types.* No room types are particularly associated with Colonial Revival because plans follow contemporary developments, such as the addition of the living room. However, *keeping room* becomes a popular term for an informal room with a large fireplace in the 17th-century manner. Some combine with kitchens.

■ *Relationships.* Interiors maintain a Colonial flavor in keeping with the exterior design. Throughout much of its history, Colonial-style interior decoration and treatments arise from popular notions of Colonial lifestyles rather than any real understanding of them.

■ *Color.* Colors loosely follow precedents or the color trends of their time. Light colors, such as ivory, white, gray, or yellow, dominate in the 1920s. A grayed palette of tans, browns, yellows, blues, greens, and reds copied from existing 18th-century colors in Virginia structures becomes fashionable following the restoration of Williamsburg in the 1930s. White appears extensively during the early 20th-century, reflecting a concern for hygienic interiors.

■ *Lighting.* Lighting comes from contemporary or reproduction fixtures, sconces, or Colonial-style lamps (Fig. 13-29, 13-34). Chandeliers, common in dining rooms, entries, and large spaces in public buildings, often hang from central ceiling medallions. The use of chandeliers in Colonial Revival does not reflect Colonial practice when chandeliers were limited to some public spaces. Additionally, there is more illumination than in the Colonial periods. In the early 20th century, some Colonial Revivalists advocate only candles in Colonial-style rooms, but this quickly changes.

■ *Floors.* Floors, based loosely on earlier treatments, are wood planks usually in a dark stain. Oriental rugs, although rare on floors in Colonial periods, are typical (Fig. 13-26,

DESIGN SPOTLIGHT

Interiors: Stair hall and front parlor, Annie Longfellow Thorpe House, 1887; Cambridge, Massachusetts; Alexander Wadsworth Longfellow. Staircases, such as this one, include elements from the precursors freely interpreted. Although many 18th-century houses had center halls, none is as broad as this one, and none has such wide openings, which reflect a late-19th-century preference for open planning. The staircase is made grander than was usual in the 18th century by centering it at the rear of the hall just beneath an arch, like those that commonly delineated front and back portions of 18th-century halls. The stair rises to a landing and splits with steps to the right and the left in manner that was not usual in the American Georgian house. The elaborate newel post and banisters have 18th-century precedents. Large Oriental rugs on floors were rare in the 18th century.

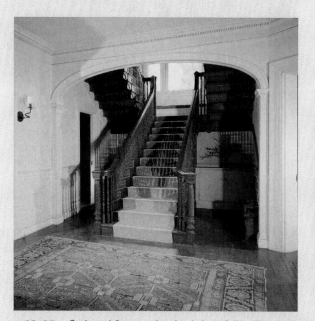

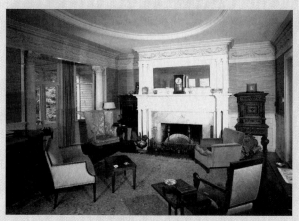

▲ **13-27.** Stair and front parlor, Annie Longfellow Thorpe House; Cambridge, Massachusetts.

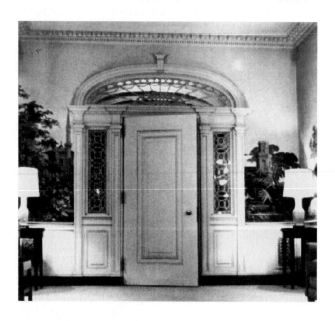

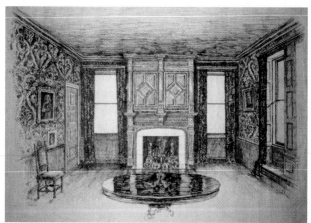

▲ **13-28.** Vestibule and dining room, James W. Allison House (now known as the President's House, Virginia Commonwealth University), 1895–1896; Richmond, Virginia; Percy Griffin and Henry Randall.

13-31, 13-36). Alternatives, some of which are unknown in early times, include braided rugs, rag rugs, rugs with simple floral or geometric patterns, unpatterned rugs, wall-to-wall carpeting, and linoleum.

■ *Walls.* Paneling, wallpaper, and paint are the most common treatments in Colonial-style houses like the precursors (Fig. 13-26, 13-28, 13-34, 13-36). In larger, more expensive Colonial and Georgian houses, interiors follow 18th-century

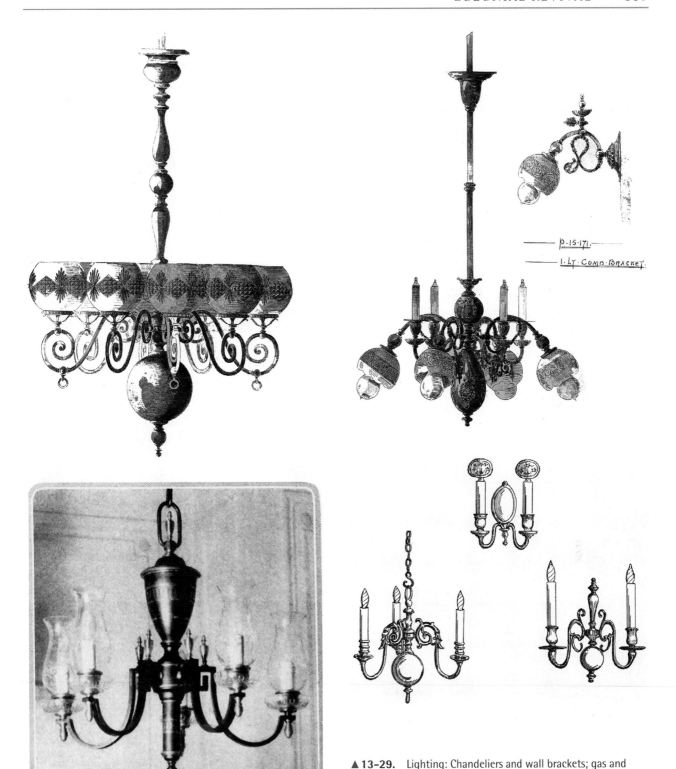

▲ 13-29. Lighting: Chandeliers and wall brackets; gas and electric fixtures manufactured by the Mitchell Vance Company in 1895 and others published in *House and Garden*, 1925.

prototypes more closely with paneling, moldings, baseboards, and cornices deriving from precursors (Fig. 13-27, 13-28, 13-31, 13-33, 13-34). Paneling may be stained or painted. A less expensive alternative to paneling consists of moldings applied to the wall to simulate panels. Architectural details

and moldings often contrast in color to walls. Wallpapers in old-fashioned or Colonial-style patterns also are favored (Fig. 13-30). Reproduction and adaptation Colonial wallpapers in a range of patterns from small geometrics and florals to large florals and stripes appear beginning in the

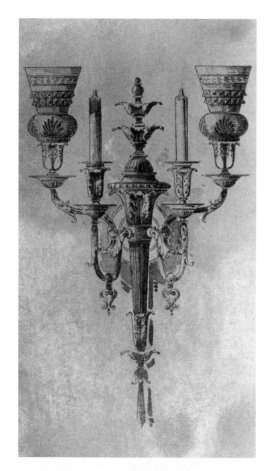

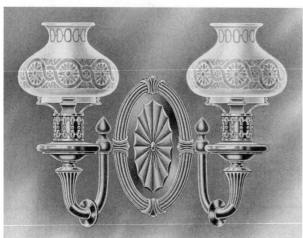

▲ **13-29.** *(continued)*

▲ **13-30.** Wallpaper; published in *Upholstery and Wall Coverings* by A. S. Jennings, 1903.

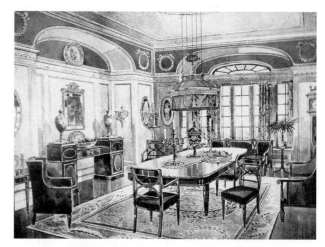

▲ **13-31.** "English dining room in the Adam Revival style"; published in *Style Schemes in Antique Furnishing* by H. P.

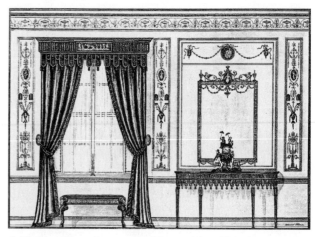

▲ **13-32.** "Reception room in Adam style"; published in *Decorative Draperies and Upholstery*, c. early 1900s; Edward Thorne.

1890s. Scenic papers are more common in Colonial Revival than in the original period because they survived in greater numbers than other papers. Williamsburg inspires numerous reproduction and adaptation wallpapers. Fireplaces, typical in public rooms despite central heating, are usually simpler than the prototypes with plain mantels and no overmantels (Fig. 13-27, 13-34, 13-36). Public rooms in architect-designed houses usually have more elaborate mantels composed of pilasters or engaged columns with pediment overmantels.

■ *Windows.* Interior windows rarely have surrounds or interior shutters derived from historical precedents except

DESIGN SPOTLIGHT

Interiors: Dining room, Little Holme (Harry B. Little Residence), 1916; Concord, Massachusetts; Harry B. Little. Typical features of a Colonial Revival interior of the early 20th century include paneling painted white, an Oriental rug on the floor, and the 18th-century-style furniture. Rooms of the time often mixed several 18th-century-style furnishings with contemporary pieces. The limited number of accessories reflects the Colonial virtue of simplicity.

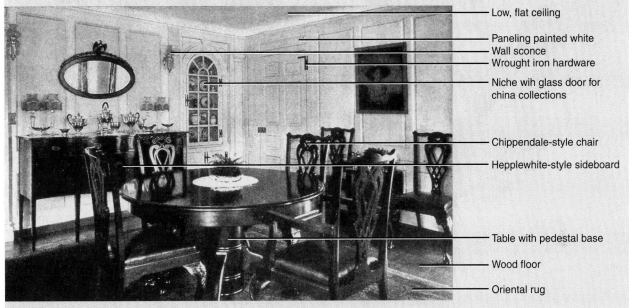

- Low, flat ceiling
- Paneling painted white
- Wall sconce
- Wrought iron hardware
- Niche wih glass door for china collections
- Chippendale-style chair
- Hepplewhite-style sideboard
- Table with pedestal base
- Wood floor
- Oriental rug

▲ **13-33.** Dining room, Little Holme Residence; Concord, Massachusetts.

in high-style examples. Most have simple moldings, if anything. Important rooms in more expensive or architect-designed Colonial-style houses have large cornices of classical moldings and bold surrounds (Fig. 13-31). Window treatments range from simple panels hanging from rings on a decorative rod to elaborate swags, cascades, and/or cornice boards and tied-back draperies (Fig. 13-34, 13-36).

The practice of universal, often elaborate, window treatments is a Colonial Revival characteristic that does not reflect 17th- and 18th-century practices when textile window treatments were rare and only in the most important rooms in homes of the affluent.

■ *Doors.* Like windows, door surrounds may be bold and classical or simple depending upon the importance of the

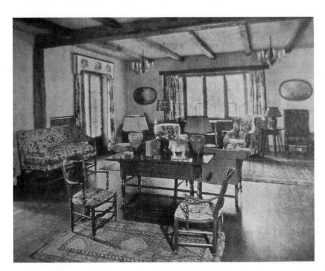
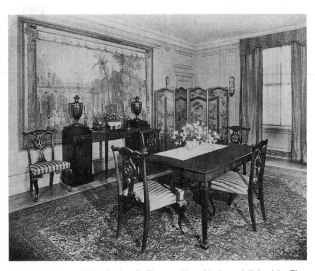

▲ **13-34.** Living room, Mrs. William G. Langley House, Long Island, and dining room, Mrs. E. Van R. Thayer, New York; published in *The Practical Book of Wall Treatments*, 1926, by Nancy McClelland. Colonial Revival.

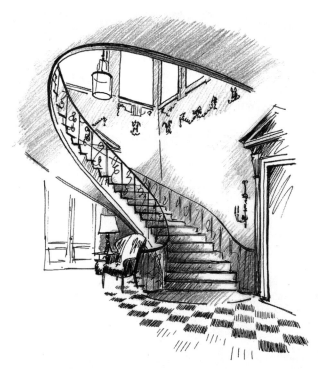

▲ **13-35.** Stair hall, Swan House, 1928; Atlanta, Georgia; Philip Trammell Shutze of Hentz, Reid, and Adler.

room and cost of the house (Fig. 13-28, 13-33, 13-35). Doors may be six or eight panels or plain and painted or stained. Door knobs are brass, white porcelain, or glass. Some early Colonial Revival doorways have *portieres*.

■ *Ceilings.* Most ceilings are plain and painted white or a lighter tint of the wall colors, but ceiling medallions may be used. Some ceilings may have beams and more elaborate designs (Fig. 13-26, 13-34).

■ *Later Interpretations.* Colonial and Early American rooms remain popular in the post–World War II period

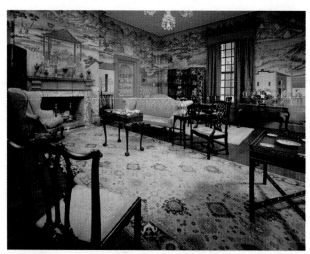

▲ **13-36.** Chinese parlor, Winterthur Museum, c. 1930s; wallpaper c. 1770; Wilmington, Delaware. Historic recreation by Henry Francis DuPont, owner and collector.

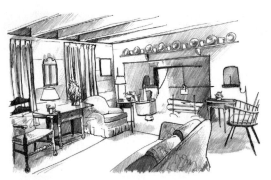

▲ **13-37.** Later Interpretation: Living room; published in *House and Gardens*, 1953.

despite the impetus toward Modernism. They adapt well to decorating trends, colors, and patterns of the times while still retaining an old-fashioned and comfortable appearance (Fig. 13-37). Historical associations of patriotism, family heritage, and old money ensure continuing popularity. Colonial and Georgian are strong stylistic choices into the early 21st century (see Chapter 30, "Modern Historicism"). Manufacturers offer numerous choices, both reproductions and adaptations, in paint, wallpaper, textiles, paneling, moldings, light fixtures, and floor coverings to suit any taste or design intention.

FURNISHINGS AND DECORATIVE ARTS

Colonial Revival furniture varies from reproductions to adaptations to free interpretations of 17th-century, Queen Anne, Chippendale, Federal, and American Empire styles. Copying of historical pieces begins as early as the 1840s but does not constitute a true revival at that time. The revival occurs in earnest in the 1880s when manufacturers begin producing Colonial-style furniture, some of which they call reproductions. Most are not overly concerned with historical accuracy because the intent is to capture the spirit of the precursor image. Some do not hesitate to "improve" extant pieces in proportion or detail. Nevertheless, the best reproductions are made by hand in small cabinetmaking shops. Later reproductions, particularly those licensed by museums such as Winterthur or Williamsburg maintain as complete accuracy to the original models as possible. In its early years, Colonial Revival has certain icons or signals, such as grandfather clocks (a result of Longfellow's poem "The Old Clock on the Stairs"; Fig. 13-25), rifles hanging over fireplaces, and spinning wheels. Their importance fades during the 1920s.

Colonial Revival rooms usually have more furniture in comparison to early spaces and feature more upholstery. Furniture may mix characteristics from several styles or bear little resemblance to the earlier prototypes. Some pieces, such as coffee tables, have no earlier precedents. Colonial-style furniture often has different proportions from the pro-

DESIGN SPOTLIGHT

Furniture: Colonial reproduction chairs and rocker, 1875–1902; New York and Maryland. This late-19th-century adaptation of Chippendale (below) shows that many manufacturers were not overly concerned with historical accuracy. The chair reveals 18th-century character in its overall design, although the proportions are incorrect, particularly in the legs. The splat resembles Philadelphia examples, and the carving on the splat and knees is similar to but coarser than 18th-century prototypes. Although rocking chairs existed in the 18th century (the exact origin is uncertain), rockers would never have been made into a formal parlor chair with ball and claw feet. The rocker, produced by C. F. Meislahn & Company in Baltimore, is a product of an imaginary past.

Furniture of Forefathers.

Colonial Reproductions

CHAIRS

Barnard & Simonds Company
ROCHESTER, N. Y.

Shown also at Square and Yard at GRAND RAPIDS
5th Floor, Furniture Exhibition Bldg.

200 Patterns of Dining Chairs in Oak and Mahogany
150 Pieces for the Parlor, Library and Hall

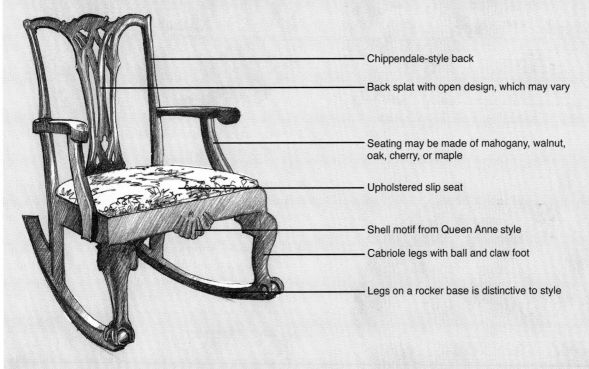

— Chippendale-style back

— Back splat with open design, which may vary

— Seating may be made of mahogany, walnut, oak, cherry, or maple

— Upholstered slip seat

— Shell motif from Queen Anne style

— Cabriole legs with ball and claw foot

— Legs on a rocker base is distinctive to style

▲ **13-38.** Colonial reproduction chairs and rocker; New York and Maryland.

totypes, either because of ignorance of earlier features or because contemporary rooms are different in scale.

Public and Private Buildings

■ *Types.* Typical types of Colonial Revival furniture include chairs, sofas, tables, cabinets, and beds, most of which emulate many of the earlier precursor examples (Fig. 13-26, 13-33, 13-38, 13-39, 13-41, 13-44).

▲ **13-39.** Coffee table and corner chair; published in *The House Beautiful*, 1878 by Clarence Cook.

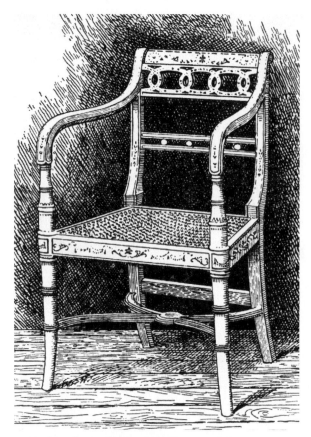

▲ **13-40.** Fancy chair, c. 1922; Sheraton-style.

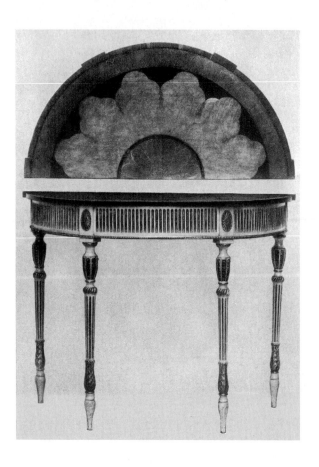

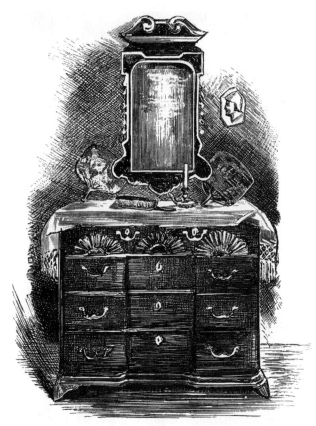

▲ **13-42.** Chest of drawers; published in *The House Beautiful*, 1881 by Clarence Cook.

■ *Distinctive Features.* Colonial Revival furniture is distinguished by its resemblance to earlier styles. However, the woods, decoration, scale, and use vary from the originals.

■ *Relationships.* Antiques are often freely integrated with Colonial Revival and other furniture within room settings. Furniture groupings do not follow earlier examples of

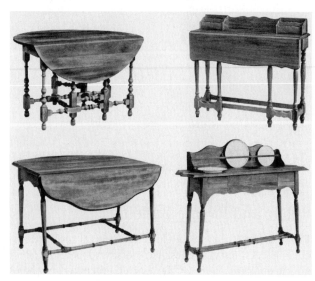

▲ **13-41.** Tables, c. 1910s–1930s.

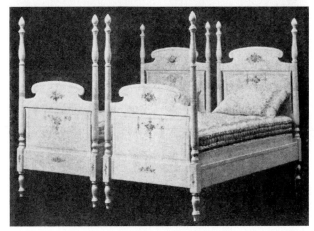

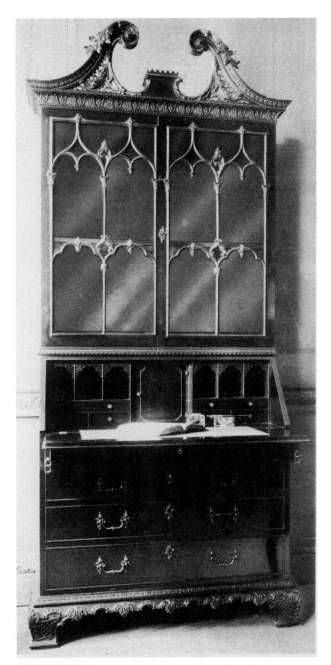

▲ **13-43.** Secretary in mahogany; published in *Art and Industry*, 1929.

lining the walls. Instead, furniture is arranged throughout a space to create comfort and convenience (Fig. 13-27).

■ *Materials*. Colonial Revival furniture is made of mahogany, walnut, oak, cherry, and maple; the latter is characteristic of Early American pieces and may be stained dark to emulate aging. Forms of embellishment include carving, inlay, marquetry, and painted decoration (Fig. 13-43, 13-44).

■ *Seating*. Chairs, settees, and sofas copy, adapt, or freely interpret Queen Anne, Chippendale, Sheraton, Hepplewhite, American Empire, and Regency (Fig. 13-27, 13-31,

▲ **13-44.** Beds, c. 1920s–1930s.

13-33, 13-38, 13-39, 13-40). The latter is most often known as Duncan Phyfe after the popular New York cabinetmaker of the early 19th century. Early American chairs include ladderbacks and Windsors in various forms. Some chairs bear no resemblance to these styles but may

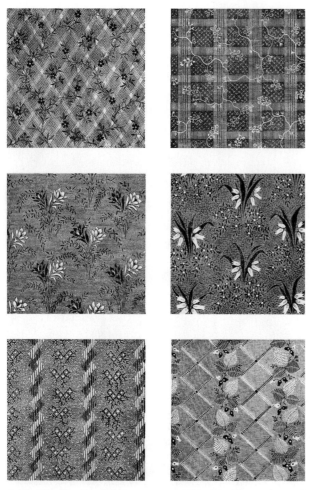

▲ **13-45.** Textiles: Print patterns; published in *Masterpieces of the Centennial Exhibition 1876*; manufactured by American Print Works in Fall River, Massachusetts.

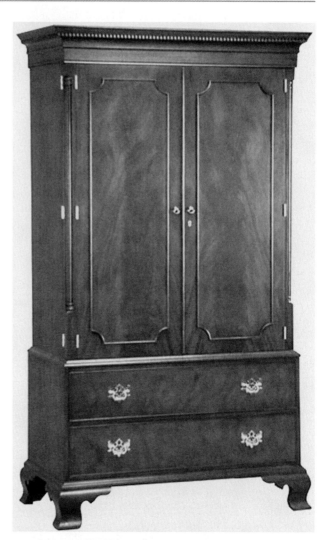

▲ **13-46.** Later Interpretation: Entertainment center or clothes press, 2005; manufacturerd by Kittinger Furniture Company in Buffalo, New York. Modern Historicism.

have elements of Tudor, Elizabethan, or Italian Renaissance. Spinning wheel chairs, popular in the last decades of the 19th century, are constructed of parts of spinning wheels with the wheel itself forming the back. Wing chairs are the most common fully upholstered piece from Colonial times. Unlike their predecessors that were only used in bedrooms or as invalid chairs, wing chairs are often in living rooms, family rooms, and bedrooms (Fig. 13-27, 13-36). Chairs with upholstered seats and backs are revived and given Colonial names. Thus, the 19th-century Lolling chair becomes a Martha Washington chair. Chippendale and Sheraton sofas also are adapted for contemporary tastes and needs in proportions to suit contemporary rooms.

■ *Tables and Storage.* New pieces of furniture include lamp or end tables and coffee tables placed in front of sofas to hold drinks and refreshments (Fig. 13-27, 13-34, 13-39). Some tables common in the 17th and 18th centuries reappear in contemporary rooms, including gateleg tables, nesting tables, and drop-leaf tables (Fig. 13-41).

Blockfront chests, dressing tables or low boys, high chests of drawers or highboys are commonly used in bedrooms or entrance halls (Fig. 13-42). The typical Colonial-style secretary (called a desk and bookcase in the 18th century) has a broken pediment top with glass doors and a drop front with drawers that rest on ogee bracket feet or short cabriole legs (Fig. 13-43). Dining tables most commonly are similar to pedestal extension types that appear in the late 18th and early 19th centuries (Fig. 13-31, 13-33). New in the 1920s are Colonial-style dinettes, small sets of table and chairs for breakfast nooks or kitchens. A popular dining room accessory, unknown in Colonial times, is the tea cart. Other new pieces in Colonial styles include radio cabinets, victrolas, china cabinets, bedside tables, office furniture, bookcases and, in the late 20th century, entertainment and computer units.

■ *Beds.* Most Colonial-style beds have posts and a broken pediment headboard. Posts may be short or tall enough for a tester or canopy (Fig. 13-44). Canopies may be flat or

curved. Although not draped in the 18th-century manner, most canopies have at least a net or cloth valance, if not curtains at the head of the bed. Beds are made in sizes unknown in Colonial times such as twin or king.

■ *Textiles*. Reproduction and adaptation textiles for window treatments, upholstery, and bed hangings include damasks, moirés, toiles, crewels, needlepoint, chintzes, silks, solids, checks, and resists (Fig. 13-45). Reproduction designs are true to original concepts but come in a wider diversity of color palettes. Adaptations, usually inspired by an historic document, vary in scale, proportion, design, and colors. They may be of materials unknown in Colonial times, such as rayon or polyester. Sometimes, apparel fabrics are reinterpreted for furnishing textiles.

■ *Decorative Arts*. There are more decorative accessories in Colonial Revival interiors than was common in earlier periods. Rooms often display new items not previously known such as throw pillows and modern art. Antiques and/or reproductions of Colonial metalwork, ceramics, prints, mirrors, and clocks usually mix with new, contemporary examples. Formerly utilitarian objects, such as bed warmers, become decorative objects and are proudly displayed.

■ *Later Interpretations*. Colonial Revival furniture, although not designated as such, continues to be a popular stylistic choice. The leaders of reproductions include L. & J. G. Stickley (Colonial Williamsburg); Kittinger; Kindel (Winterthur); and Baker (Historic Charleston). A popular new type of furniture piece is the entertainment center, fashioned in the 18th-century character (Fig. 13-46). Wallpapers and textiles are available from firms such as Scalamandré, Brunswig and Fils, Schumacher, and Stark Carpets.

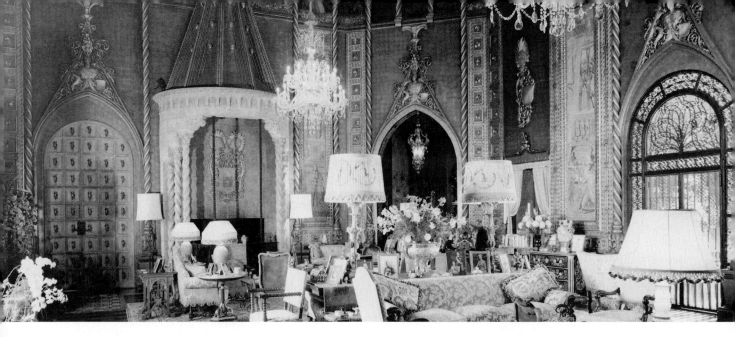

CHAPTER 14

Spanish Colonial Revival

Mission Revival,

Spanish Colonial

Revival, Monterey

Style, Pueblo Revival

1880s–1930s

Los Angeles is the first place in America where I have found original architecture. . . . Many of the houses are in the style of the Spanish Renascence—"Mission style,"—with almost flat roofs of red tiles, little round towers surmounted by Spanish-Moorish domes, and arcaded galleries, like the Franciscan cloisters of the past century. Others mingle the Colonial with the Mexican style, imitating the coarser construction of the adobe. All are very attractive and possessed of individuality.

Jules Huret, "Mission Architecture," published in *The Craftsman 1903–1904*, Vol. 5, Oct. 1903, March 1904

One must remark [on] the extreme simplicity of the Spanish interior. The floors, ceilings, and wainscots, while colourful, are subdued by the large area of simple plastered wall; hangings, while rich, are used with discrimination; and the furniture, often of the richest ornamentation, preserves in its main line a sane architectural mass; nothing is overdone. This is the stumbling block of most Americans; they will get too many things into the room.

Rexford Newcomb, *The Spanish House for America*, 1927

Plymouth Rock was a state of mind. So were the California Missions.

Charles Fletcher Lummis, *The Spanish Pioneers*, 1929

Originating on the west coast of the United States in the late 19th century, Spanish Colonial Revival is a counterpart to the English Colonial Revival in the eastern half of the United States. Encompassing a range of Spanish and Mediterranean styles, forms, and details, the movement responds to renewed interest in the Spanish past in California, the southwestern states, Texas, Florida, Mexico, and the Caribbean. Architecture emulates the Spanish missions in the United States as well as Spanish and other Mediterranean architecture of all

periods, including vernacular. Similarly, interiors and furniture strive to capture a Spanish flavor or repeat aspects of those in Spain, including the use of Spanish imports and antiques.

HISTORICAL AND SOCIAL

Like Colonial Revival, interest in and reverence for Spanish colonial heritage are the impetus for Spanish Colonial Revival. The style originates during the 1880s in the areas of the United States with a Spanish past, such as California, New Mexico, Arizona, Texas, and Florida. Writers, such as Helen Hunt Jackson in *Ramona* (1884) and Charles Fletcher Lummis in *The Spanish Pioneers* (1929), create a vision of an idealized past in which fine people lived simple lives in harmony with nature and free of the daily cares of industrialism. Similarly, dime novels and popular periodicals create images of a mythical Old West filled with cowboys (Fig. 14-1) and brigands and heroes, like Wild Bill Hickock.

Critical to the development of Spanish Colonial Revival are interest in and preservation of Spanish missions in the western United States. Spanish Franciscan and Jesuit missionaries establish these missions in California, New Mexico, Arizona, and Florida in the 17th and 18th centuries to convert natives to the Catholic faith and educate them in Spanish life and culture. Although outposts, the missions often build impressive churches and other buildings in the Late Spanish Renaissance and Baroque styles. Largely abandoned, most begin to fall into ruins during the early 19th century.

Texas makes the first step in the preservation of the missions when it declares the Alamo (built in 1724) an historic site in 1883. In California, Father Angel Casanova begins to restore Mission San Carlos Borromeo del Carmelo (church built in 1793) in 1884. His work inspires others in California, which has more missions than other states do and a larger population to support preservation activities. These early restorations are far more conjectural than accurate, nevertheless they inspire further study of Spain and her colonial buildings. Enthusiasm for restoring the missions soon branches out to include Spanish haciendas and ranchos. As with other styles, publications, museum collections, and newly formed heritage and preservation organizations fuel interest and support stylistic development of Spanish Colonial Revival. The revival style can be subdivided into several phases or styles based upon historical context and characteristics.

The earliest phase of Spanish Colonial Revival, known as Mission or Mission Revival, arises directly from the preservation of the Spanish missions. Originating in California, the style seeks to adapt the character, if not the details, of California missions, which are thought to be indigenous. Mission Revival spreads across the Southwest when it is adopted as the official style for railroad stations and resort hotels. The ensuing tourist boom increases fascination with the missions and early California. However, the limited number of sources, difficulty of adapting missions to contemporary structures, and a new impetus toward more accurate period design contribute to the style's demise. Mission largely dies out by World War I (1914–1918).

The next phase of Spanish Colonial Revival, which borrows and adapts elements from Spain, Italy, and other Mediterranean countries, makes its first important appearance at the Panama-California International Exposition in 1915. Planned to celebrate the completion of the Panama Canal, the exposition also intends to stimulate trade and growth for San Diego, so the city chooses a Spanish theme and commissions Bertram Grosvenor Goodhue to design the buildings. Goodhue attempts to create an ideal Spanish city with impressive buildings. The Indian Arts building is Mission Revival, but the others draw from Spanish, Spanish Colonial, Mexican, and Mediterranean sources. Widely disseminated by fairgoers and through postcards, publications, and even movies, the fair buildings inspire a new, more sophisticated form of Spanish Colonial Revival. Its inception also coincides with a resurgence of historicism and scholarship that gives rise to period styles with a more studied, knowledgeable approach than that taken previously. Books and periodicals with photographs instead of drawings of Spanish buildings and architectural vocabulary aid the stylistic development.

During the 1920s, the style spreads across the United States, although it is more fashionable in states with Spanish heritage than those without it. The spread of the style is aided by movies that glamorize the Spanish and western or cowboy past and the fact that many movie stars live in Spanish Colonial Revival mansions. Developers and architects of the affluent who choose Spanish Colonial Revival for place identity or to suit lavish lifestyles also aid the style's spread. Real estate developers adopt Spanish styles in their promotion of California as a land of sunshine and great living to attract new residents and tourists. Many cities in California, such as Santa Barbara, Pasadena, Palm Springs, and San Diego, reinvent themselves with Spanish-style public and private buildings to create a stronger city identity. Addison Mizner almost single-handedly creates a Spanish Colonial Revival in early-20th-century Florida through his mansions for the wealthy and real estate developments in Boca Raton, Palm Beach, and Coral Gables. In addition, Mizner forms his own companies that produce Spanish-style tiles, architectural details, furniture, and accessories. House plan books and mail-order companies carry a variety of Spanish Colonial Revival houses varying from small cottages to large mansions so that members of many economic classes can choose Spanish-style residences. The advent of modernism slows the

popularity of Spanish styles, although they never completely die out.

Spanish Colonial Revival derives its forms and characteristics from several centuries of architecture, interiors, and furniture of Spain and her colonies in North America. The revival and its subphases borrow selectively from one or more of the Spanish and Mediterranean styles of the past. The intent is to evoke, not copy, the past in most cases.

- *Plateresque (late 15th to mid 16th centuries).* *Plateresque* describes the transition style from Gothic to Renaissance in Spain during the late 15th century and continuing through the middle of the 16th century. Minute, profuse ornament in low relief resembling silverwork is characteristic and gives the style its name. Characteristics and motifs of Gothic and Renaissance intermingle. The abundant ornament that surrounds doors and windows does not relate to the structure and contrasts with the blank walls.
- *Classical, Desornamentado, or Herreran Style (1556–1650).* This style more fully emulates the Italian Renaissance. Symmetry and classical details are features of this plain, relatively unornamented style, which is short-lived in Spain.
- *Churrigueresque (1650–1750).* *Churrigueresque* is the Spanish Baroque style, which is named for the Churriguera family of architects who defined its characteristic ornamentation. In this style, the Spanish love of ornament resurfaces. Decoration again surrounds doors and windows as before, but the vocabulary and motifs are different from the earlier *Plateresque.* More three-dimensional, architectural ornament features stuccowork, twisted columns, and an inverted obelisk.
- *Spanish Colonial (1600–1840s).* Spanish Colonial incorporates local building materials and traditions into Spanish Renaissance and Baroque to create buildings designed to impress. Compositions range from the unornamented geometric adobe of New Mexico to the stone vaulted and domed structures with imposing porticoes in Texas and Arizona. Built of adobe, Spanish Colonial palaces and private dwellings center on courtyards or patios.

CONCEPTS

Spanish Colonial Revival proclaims Hispanic background or place identity, whether of an individual or a local or regional architecture. The architecture, interiors, and furnishings of exotic and romantic Spain appeal to those who possess or wish to possess a Hispanic heritage. The concurrent Arts and Crafts Movement's (see Chapter 18, "Shingle, American Arts and Crafts") emphasis upon local or regional styles, natural materials, and integration of nature and the landscape helps to create a climate

◄ **14-1.** Gaucho (cowboy) at the Panama-California International Exposition, 1915–1916; Balboa Park, San Diego, California.

IMPORTANT TREATISES

- *The Architecture and the Gardens of the San Diego Exposition,* 1916; Bertram Grosvenor Goodhue, Carlton Winslow, Clarence Stein.
- *Florida Architecture of Addison Mizner,* 1928; Ida M. Tarbell.
- *Glimpses of the Missions,* 1883; Helen Hunt Jackson.
- *Majorcan Houses and Gardens,* 1928; Arthur Pyne and Mildred Pyne.
- *Minor Ecclesiastical, Domestic, and Garden Architecture of Southern Spain,* 1917; Austin Whittlesey.
- *Old World Inspiration for American Architecture,* 1929; Richard S. Requa.
- *Provincial Houses in Spain,* 1927; Arthur Pyne and Mildred Pyne.
- *Ramona,* 1884; Helen Hunt Jackson.
- *Spanish Architecture of the 16th Century,* 1917; Arthur Pyne and Mildred Pyne.
- *Spanish Farm Houses and Minor Public Buildings,* 1924; Windsor Soule.
- *Spanish Gardens and Patios,* 1924; Arthur Pyne and Mildred Pyne.
- *The Spanish House for America, Its Design, Furnishing, and Garden,* 1927; Rexford Newcomb.
- *Sunset Western Ranch Houses,* 1946; Cliff May.
- *Western Ranch Houses,* 1958; Cliff May.

conducive to a revival of Spanish architecture in California and other states with Hispanic legacies. Also stemming from the Arts and Crafts Movement is the equation of Spanish Colonial architecture with an idealized, simple, preindustrial lifestyle in which happy people live and work unencumbered in buildings of natural materials that suit the landscape. Thus, at least at its inception, the Spanish Colonial Revival shares the same impetus and motivation as Arts and Crafts and Colonial Revival movements. Additionally, Spanish Colonial Revival carries associations of the exotic culture of Morocco and North Africa, the believed splendor of the Spanish empire in the Americas, and the rustic simplicity of Native American or Mexican design.

DESIGN CHARACTERISTICS

Spanish Colonial Revival and its various architectural styles, interiors, and furniture derive from Spanish and Spanish Colonial architecture, interiors, and furniture of North America. Common exterior characteristics include stucco walls that are usually white or off-white; round arches used in arcades, windows, and doors; and flat or low-pitched roofs covered with red tiles.

■ *Mission Revival (1885–1915).* This style of architecture exhibits elements from the California missions such as arcades, domes, bell towers, or courtyards. Defining characteristics include a curvilinear parapet roof and quatrefoil or foliated windows.

■ *Spanish Colonial Revival (1915–1940s).* Buildings, which derive more directly from Spanish and other Mediterranean sources than from the missions, are usually more ornamented than other styles are, with decoration concentrating at doors and windows. Other defining characteristics include arched doorways and windows, wrought iron or wood grilles, colorful tiles, and round or octagonal towers.

■ *Monterey Style (1925–1955).* This interpretation seeks to replicate the 18th-century Spanish Colonial houses or ones in northern California that incorporate elements of English/Anglo buildings such as porches, balconies, fanlights, transoms, sash windows, New England–style moldings and columns, wooden floors, and picket fences. Examples may mix adobe with clapboard or brick, and each story may be of a different material. Roofs may be wood or tiles.

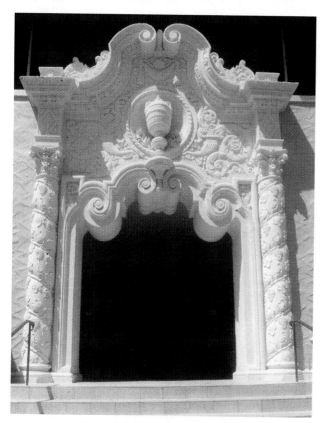
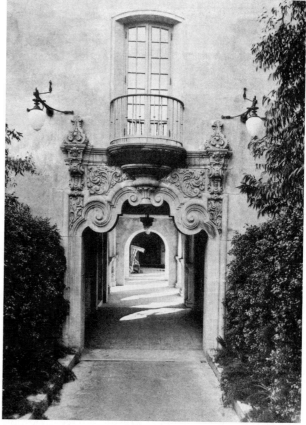

▲ **14-2.** Architectural details, c. 1910s–1930s; Florida and California.

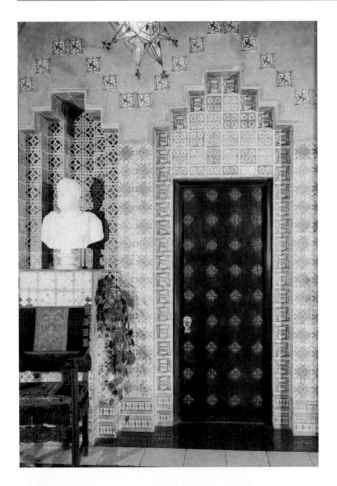

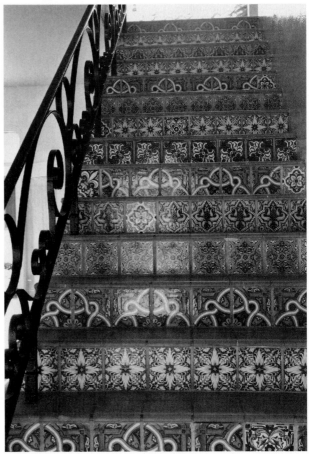

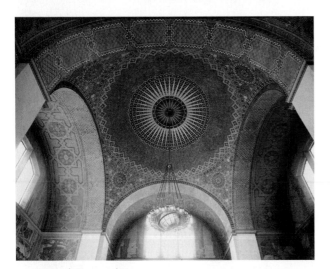

▲ **14-2.** *(continued)*

▲ **14-3.** Stairs and wall with decorative tiles, c. 1920s–1930s; Florida and California.

■ *Pueblo Revival or Santa Fe Style (1912–present).* Architecture uses the blocky, geometric adobe forms of Native American and Spanish Colonial buildings. Plain and usually unornamented, structures have flat roofs with a parapet, vigas, and stucco walls. Corners imitate the softly rounded forms of adobe Spanish Colonial architecture.

Interiors in Spanish Colonial Revival structures may be Arts and Crafts, may replicate the character of

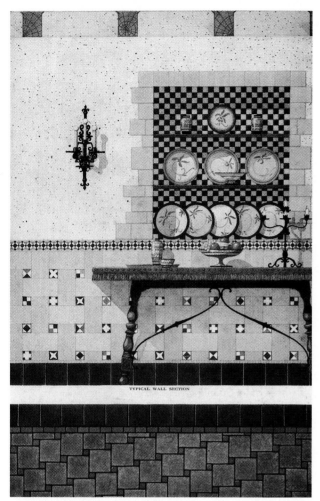

▲ **14-3.** *(continued)*

ARCHITECTURE

The term *Spanish Colonial Revival* covers several architectural styles derived from Spanish sources, including Mission or Mission Revival, Spanish Colonial or Mediterranean Revival, Monterey Style, and Pueblo Revival. Architectural and decorative vocabularies of Spanish Colonial Revival derive from Spanish Renaissance and Baroque styles as well as vernacular examples, particularly those from southern Spain. Revival structures range from relatively plain buildings based upon folk houses to examples with the lavish ornament derived from Spanish, Moorish, and other Mediterranean sources such as churches, public buildings, and mansions of the affluent. Spanish Colonial Revival is especially popular for residences. Architects design grand mansions and manor houses for the affluent in the southwestern United States and Florida. In addition, the Spanish architectural vocabulary readily adapts to bungalows, four-squares, and smaller houses.

■ *Mission Revival (1885–1915).* Mission Revival is the first of the Spanish Colonial Revival styles. Originating in the late 19th century, it adopts elements of the California Spanish missions. Lasting until World War I, the style's downfall is its superficial application of features of the original missions to contemporary buildings and its inability to adapt to residences. Nevertheless, it defines many building types and, even, some cities.

■ *Spanish Colonial Revival (1915–1940s).* This style first appears at the Panama-California Exposition in San Diego, California, in 1915. It reflects a more urbane and sophisticated approach to architecture. World War I (1914–1918) gives additional thrust to the style because it prevents American architects and designers from making the usual Grand Tours to France and Italy. They visit Spain instead, particularly the southern part, where they become acquainted with vernacular structures, thereby adding more models to their repertoire. Accuracy is made easier by the increasing use of photographs, instead of sketches or drawings, in publications. Designers demonstrate their increased understanding of Spanish architecture in compositions that recall a variety of prototypes, a broader range of materials, and a more accurate depiction of Spanish massing and ornament.

■ *Monterey Style.* This style develops during the 1920s in California from the restoration and rehabilitation of Spanish ranch houses and large country estates. Freely deriving and mixing form and details from both Spanish Colonial and English houses, the Monterey style defines many suburban houses in California and the rest of the United States after the second quarter of the 20th century.

■ *Pueblo Revival or Santa Fe Style (1912–present).* Like others, this style is inspired by precedents in Spanish Colonial architecture. But unlike others, it blends precedents with elements of Native American structures. Although

Spanish rooms, or even may contain aspects of Italian or French Renaissance. Common features are tile or wood floors, plaster white or off-white walls, arched openings, and coffered or dark wooden-beamed ceilings. The wealthy import entire rooms or architectural elements from Spain. Colorful ceramic tiles and textiles, contrasting with stark walls, add interest. Similarly, furniture may be Arts and Crafts, Italian or French Renaissance, or Spanish style. Antiques may integrate with contemporary pieces. Most furniture is heavy in scale, rectilinear, and of dark wood. It may be embellished with carving, inlay, or paint.

■ *Motifs.* Motifs include ogee arches, interlaced arabesques, geometric shapes, heraldic symbols, classical architectural details such as pilasters and pediments, twisted columns, *estípite*, niches, niche-pilasters, *zapatas*, foliated or quatrefoil windows, scrolls, garlands, swags, flowers, and foliage (Fig. 14-2, 14-3, 14-5, 14-9, 14-25, 14-32, 14-35, 14-37, 14-41).

IMPORTANT BUILDINGS AND INTERIORS

- **Albuquerque, New Mexico:**
 - Kimo Theater, c. 1920s–1930s. Pueblo Revival.
- **Austin, Texas:**
 - Student Union, Library (now Main Building), and Architecture (now Goldsmith Hall), Home Economics, and Chemistry Buildings, University of Texas at Austin, 1931–1942; Paul P. Cret. Spanish Colonial Revival.
- **Beverly Hills, California:**
 - Beverly Hills City Hall, 1931; William Gage. Spanish Colonial Revival with Spanish Baroque influences.
 - Beverly Hills Hotel, 1911–1912; Elmer Grey. Spanish Colonial Revival.
 - Greenacres (Harold Lloyd House), 1926–1929; Sumner Spaulding. Spanish Colonial Revival.
- **Boca Raton, Florida:**
 - Old City Hall, 1926. William Alsmeyer. Spanish Colonial Revival.
 - Fred C. Aiken House, 1926; Addison Mizner. Spanish Colonial Revival.
- **Coral Gables, Florida:**
 - Coral Gables Gateway and suburb, c. 1920s–1930s. Spanish Colonial Revival.
- **Dallas, Texas:**
 - Highland Park Shopping Village, 1931; Fooshee and Cheek. Spanish Colonial Revival.
 - Highland Park Town Hall, 1924. Spanish Colonial Revival.
- **Hollywood, California:**
 - Andalusia Apartments, 1926; Nina Zwebell and Arthur Zwebell. Spanish Colonial Revival.
- **Indianapolis, Indiana:**
 - Indiana Theatre, 1927; Rubush & Hunter. Spanish Colonial Revival.
- **Los Angeles, California:**
 - Granada Buildings, 1925; Frank Harper. Spanish Colonial Revival.
 - Los Angeles Examiner Building, 1915; Julia Morgan. Mission Revival.
 - S. Vincent de Paul Roman Catholic Church, 1923–1925; Albert C. Martin, Sr. Spanish Colonial Revival.
 - Union Passenger Terminal, 1934–1939; John Parkinson, Donald B. Parkinson, J. H. Christie, H. L. Gilman, and R. J. Wirth. Spanish Colonial Revival and Streamline Moderne.
- **Palm Beach, Florida:**
 - Everglades Club, 1919; Addison Mizner. Spanish Colonial Revival.
 - Mar-a-Lago, c. 1920s–1930s. Marion Syms Wyeth, architect; Joseph Urban, interior decoration. Spanish Colonial Revival.
 - Paramount Theater, 1926; Joseph Maria Urban. Spanish Colonial Revival.
- **Palo Alto, California:**
 - John G. Kennedy House, c. 1920s; Julia Morgan. Spanish Colonial Revival.
- **Pasadena, California:**
 - Pasadena City Hall, 1927; John Bahewell and Arthur Brown. Spanish Colonial Revival.
- **Riverside, California:**
 - Carnegie Library, 1903; Burnham and Bliesner. Mission Revival.
 - Glenwood Hotel (now the Mission Inn), c. 1904; Frank Miller and Arthur B. Benton. Mission Revival.
- **San Diego, California:**
 - California Tower and many other exposition buildings, Panama-California Exposition, 1915–1916; Bertram Goodhue. Spanish Colonial Revival.
 - New Mexico Building, Panama-California Exposition, 1915–1916; Rapp and Rapp Architects. Pueblo Revival.
- **San Simeon, California:**
 - La Casa Grande, Hearst Castle (home of William Randolph Hearst), 1919–1947; Julia Morgan. Spanish Colonial Revival.
- **Santa Barbara, California:**
 - Casa del Herrero, 1922–1925; George Washington Smith. Spanish Colonial Revival.
 - Santa Barbara County Courthouse, 1929; William Mooser and J. William Hersey. Spanish Colonial Revival.
- **Santa Fe, New Mexico:**
 - Cristo Rey Church, 1939–1940; John Gaw Meem. Pueblo Revival.
 - New Mexico Museum of Fine Arts, 1917. Pueblo Revival.
- **St. Augustine, Florida:**
 - Alcazar Hotel (now the Lightner Museum), 1887–1889; Carrere and Hastings. Spanish Colonial Revival.
 - Casa Monica (Cordova Hotel), 1888; Francis W. Smith. Spanish Colonial Revival.
 - Hotel Ponce de Leon (now Flagler College), 1888; Carrere and Hastings. Spanish Colonial Revival.

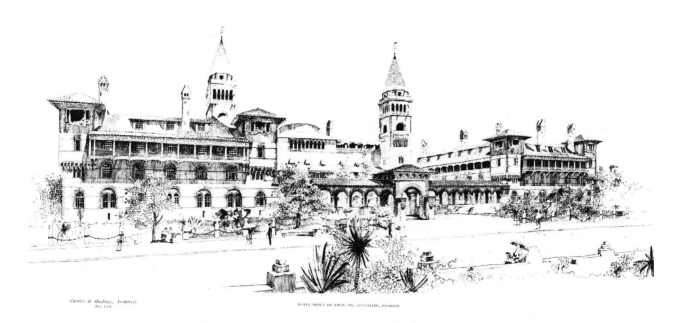

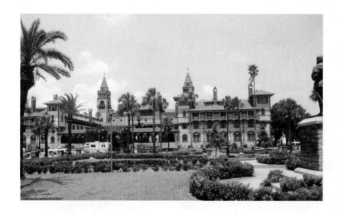

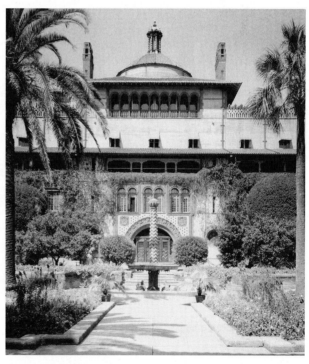

▲ **14-4.** Hotel Ponce de Leon (now Flagler College), 1888; St. Augustine, Florida; by Carrere and Hastings. Spanish Colonial Revival.

the style first appears in California, it becomes extremely popular in Arizona and New Mexico where the Native American precedents are located. Pueblo Revival is a common house style, especially in historic districts, in states throughout the southwestern United States.

Public and Private Buildings

■ *Types.* Spanish Colonial Revival is applied to many building types, including city halls (Fig. 14-12, 14-15), courthouses (Fig. 14-14), hotels (Fig. 14-4, 14-6, 14-7), motels, museums (Fig. 14-10), stores (Fig. 14-11), offices (Fig. 14-8), commercial buildings, school and university buildings (Fig. 14-18), movie theaters (Fig. 14-13), motion picture studios, gas stations, apartments, high-style architect-designed mansions (Fig. 14-22, 14-23, 14-25, 14-26, 14-28), and vernacular builder residences (Fig. 14-27).

■ *Site Orientation.* No particular orientation is associated with Spanish Colonial Revival. Urban public buildings sit

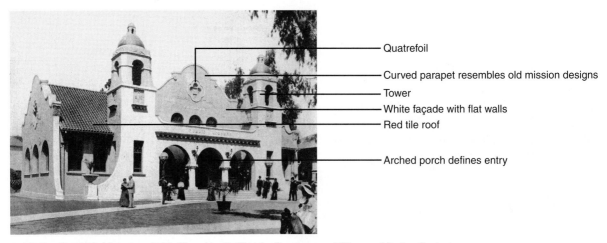

Quatrefoil

Curved parapet resembles old mission designs

Tower

White façade with flat walls

Red tile roof

Arched porch defines entry

▲ **14–5.** Carnegie Library, c. 1903; Riverside, California; Burnham and Bliesner. Mission Revival.

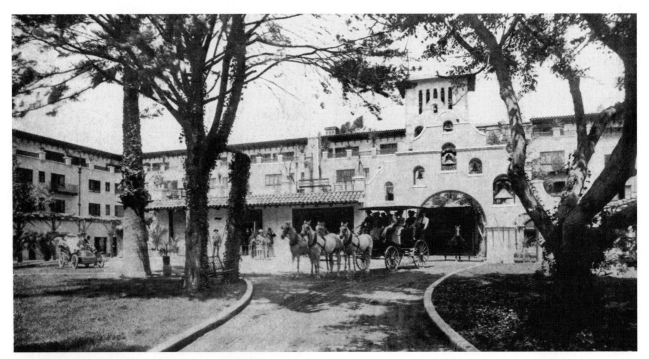

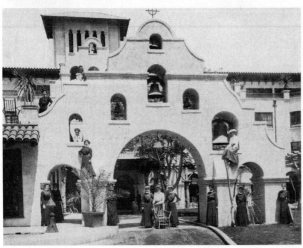

◄**14–6.** Glenwood Hotel (now Mission Inn), c. 1904; Riverside, California; Frank Miller and Arthur B. Benton. Mission Revival.

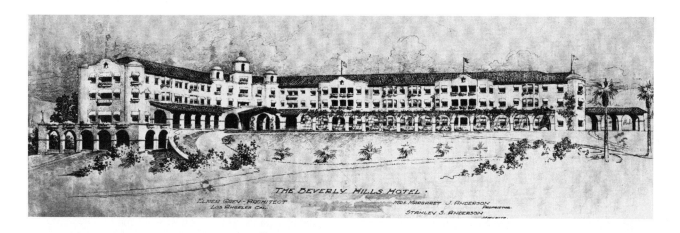

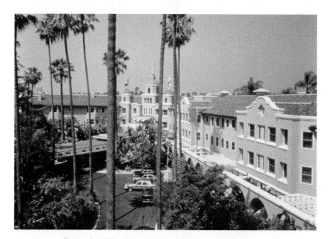

▲ **14-7.** Beverly Hills Hotel, 1911; Beverly Hills, California; Elmer Grey. Spanish Colonial Revival.

buff, gray, ochre, pale yellow, or pink. Details and ornament may be another material, such as stone, and/or it may contrast in color to walls. California architect Irving Gill (see Chapter 22, "Modern Forerunners") pioneers the use of concrete. He finds that it adapts well to his simple geometric style with a Spanish flavor. Grilles at windows and doors are of iron or wood and may be painted bright colors (Fig. 14-25, 14-26). Ceramic tiles display pictorial or Moorish designs in blue, turquoise, red, yellow, orange, green, black, ocher, and buff (Fig. 14-2, 14-3). Roofs are of clay tiles, usually red, in round or half-rounded shapes (Fig. 14-11, 14-20, 14-23, 14-25, 14-26). Some Monterey

upon primary streets or prime locations in cities and towns (Fig. 14-8, 14-11, 14-13, 14-15, 14-16, 14-18). Similarly, Spanish Colonial Revival residences and apartments fill suburbs and line city streets (Fig. 14-20, 14-22, 14-27, 14-28). Adopting the Spanish/Islamic emphasis upon gardens, some public and many private buildings have surrounding lawns, terraces, and gardens with lush plantings and fountains. Spanish-style houses and apartments often are arranged around central courtyards for green space. Most houses, whether small or large, incorporate patios, which are a signature of the style (Fig. 14-20, 14-26). Large-scale mansions and manor houses sometimes are surrounded by Italian-style landscapes incorporating terraces, fountains, pergolas, and patios.

■ *Floor Plans.* Floor plans derive from the building function. However, many structures center on or have courtyards and patios (Fig. 14-20). Small houses and ranch houses have simple rectangular or horizontal floor plans.

■ *Materials.* Walls are of smooth or rough stucco, stone, brick, adobe, or concrete. Colors include white, cream or

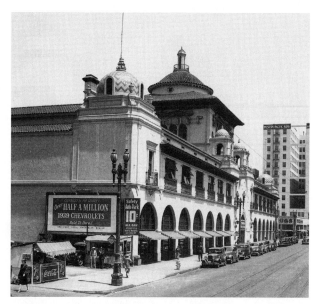

▲ **14-8.** Los Angeles Herald Examiner Building, 1915; Los Angeles, California; Julia Morgan. Mission Revival.

DESIGN SPOTLIGHT

Architecture: California Tower, New Mexico Building, and Foreign and Domestic Building, Panama-California Exposition, 1915–1916; Balboa Park, San Diego, California; Tower, Bertram G. Goodhue; New Mexico Building, Rapp and Rapp Architects; Foreign and Domestic Building, Carlton M. Winslow, Sr.; Spanish Colonial Revival (Tower) and Pueblo Revival (New Mexico Building).

The California Tower, one of four buildings designed to be permanent, is Goodhue's excellent interpretation of Spanish Baroque or Churrigueresque. Of stone and concrete, the domes are covered with colorful ceramic tiles that follow historic precedents. The bold ornament surrounding the doorway and capping the tower consists of scrolls, foliate arches, spiral columns, *estipite*

and figural sculpture that includes Father Junipero Serra, Franciscan priest and founder of the San Diego mission, and King Philip II of Spain under whose rule Spain establishes colonies in the United States. The New Mexico Building, in contrast, recalls Spanish missions of New Mexico, such as San Estevan, Acoma, and churches in Colorado, such as San Buenaventura with its simple outlines and adobe-like forms. Typical mission characteristics include the twin towers and the balcony between them. The architects, while respecting character of the past, better integrated the building parts, and the composition is more balanced than early examples are. The building, much transformed, is now the Balboa Park Club.

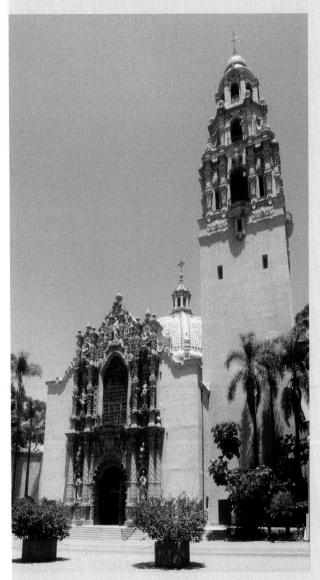

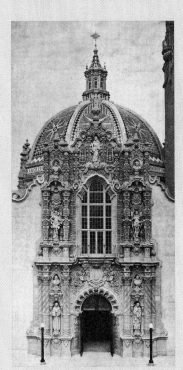

▲ 14–9. California Tower, New Mexico Building, and Foreign and Domestic Building.

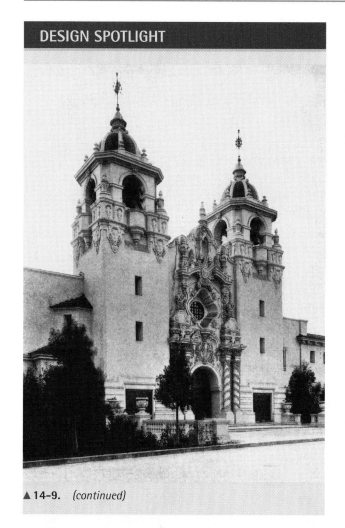

▲ **14-9.** *(continued)*

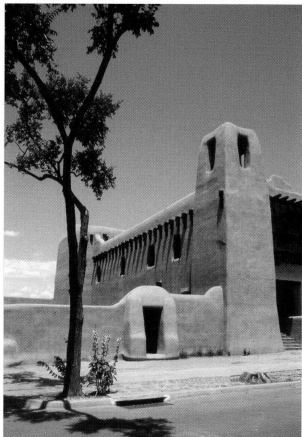

▲ **14-10.** New Mexico Museum of Fine Arts, 1917; Santa Fe, New Mexico; Rapp Brothers and Hendrickson. Pueblo Revival.

examples have wooden shingles and have different materials on each story. Wood clapboards may be combined with stucco or brick. Pueblo examples have stuccoed surfaces to imitate the original adobe (Fig. 14-17, 14-24).

■ *Facades*. Facades may be symmetrical or asymmetrical. Mission-inspired façades feature mission forms and/or details (Fig. 14-6, 14-11, 14-17, 14-19). Although a few high-style architect-designed examples attempt to replicate missions, most compositions bear little resemblance to the originals. Mission favors smooth, flat walls like the original adobe walls (Fig. 14-5, 14-6, 14-11). Facades tend to be unornamented, although arcades, cloisters, and full- and partial-width porches are typical. Important buildings have towers, although most do not have domes as Spanish churches often do. Most examples have a gable or parapet roof, a definitive feature.

Spanish Colonial Revival examples may be larger, more sophisticated, and more ornamented than other styles (Fig. 14-4, 14-9, 14-12, 14-13, 14-14, 14-15, 14-16, 14-23,

14-25, 14-26). Walls may be flat and smooth or covered with rough-faced stucco. Decoration, which usually is derived from Spanish *Plateresque* or *Churrigueresque* sources, concentrates at windows and doorways Some buildings

▲ **14–11.** Joers-Ketchum Store, 1927; Rancho Santa Fe, California; Lillian Rice. Mission Revival.

▲ **14–12.** Pasadena City Hall, 1927; Pasadena, California; John Bahewell and Arthur Brown. Spanish Colonial Revival.

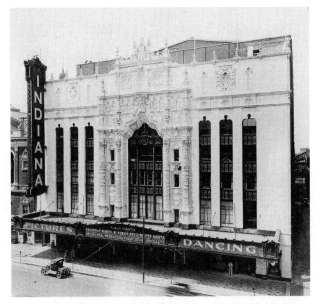

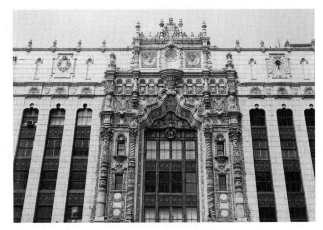

▲ **14–13.** Indiana Theater, 1927; Indianapolis, Indiana; Rubush & Hunter. *Churrigueresque* of Spanish Colonial Revival.

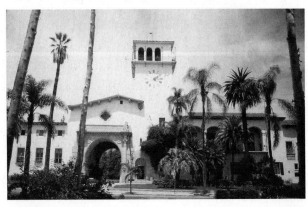

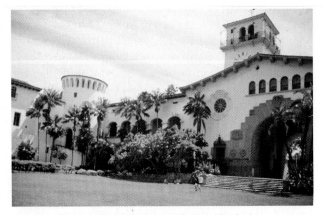

▲ **14–14.** Santa Barbara County Courthouse, 1929; Santa Barbara, California; William Moser III. Spanish Colonial Revival.

DESIGN PRACTITIONERS

■ **Irving John Gill** (1870–1936) designs in many styles including Beaux-Arts, Shingle, and Prairie. Gill trains in the office of Adler and Sullivan in Chicago before moving to San Diego in 1893. In 1906, he begins designing in concrete. This enables him to work in a Mission Revival style that is bold, geometric, largely unornamented, and that captures the essence of the Mission Revival style in a contemporary manner. Gill also designs many small-scale, low-cost housing developments (also see Chapter 22, "Modern Forerunners").

■ **Bertram Grosvenor Goodhue** (1869–1924) introduces Spanish Colonial Revival derived from Spanish Baroque architecture in the planning and exhibition buildings at the San Diego Panama-California Exposition in 1915. Goodhue is also known for his work in Gothic Revival such as the United States Military Academy in West Point, New York. His Nebraska State Capitol, designed in 1932, is Moderne or Art Deco.

■ **Cliff May** (1908–1989) begins his career in San Diego where he builds many Spanish Revival homes. His later work includes the design and marketing of the California Ranch house, which is based on early Spanish Colonial adobe ranch houses. Common characteristics are informality, openness to the outside, large expanses of glass, natural materials, rough wall texturing, uneven clay tile roofs, heavy paneled doorways, and one- and two-story wings surrounding a courtyard. The innovative reinterpretation of the Spanish ranch house still resonates in the California landscape.

■ **Addison Mizner** (1872–1933) is a leading practitioner/developer for Spanish Colonial Revival in Florida. Lacking formal training but well traveled, Mizner settles in Palm Beach, Florida, for his health and begins practicing architecture for wealthy clients. He moves to Boca Raton and transforms it into a resort community with numerous Spanish Colonial Revival structures.

■ **Julia Morgan** (1872–1957) is California's first female architect and the first female accepted at L'École des Beaux-Arts in Paris. Morgan, who designs more than 700 buildings, does not work in a particular style. However, she is known for her client-centered approach to design, use of local materials, and integration of California architectural styles and Beaux-Arts classicism.

■ **Richard S. Requa** (1881–1941) works with Irving Gill, and through his career travels extensively through Spain, southern Europe, and Mexico recording and publishing traditional building details. In 1935, he serves as the supervising architect for the California Pacific International Exposition, where he refurbishes the original 1915 exhibition buildings and adds many more.

■ **George Washington Smith** (1876–1930) is a leading Spanish Colonial Revival architect who works primarily in Santa Barbara. Originally an artist, he begins practicing architecture after his studio, which he designs, brings him clients desiring residences. His houses are derived from Spanish vernacular farmhouses and feature courtyards or patios, garden rooms, terraces, and lavish landscaping.

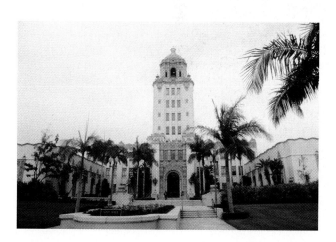

◀14–15. Beverly Hills City Hall, 1931; Beverly Hills, California; William Gage. Spanish Colonial Revival with Spanish Baroque influence.

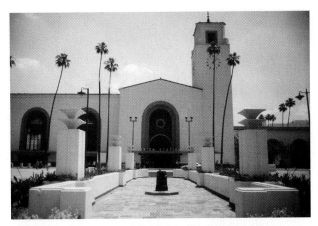

▲ **14-16.** Union Passenger Terminal (Los Angeles Railroad Station), 1934–1939; Los Angeles, California; John and Donald B. Parkinson, J. H. Christie, H. L. Gilman, and R. J. Wirth. Spanish Colonial Revival and Streamline Moderne.

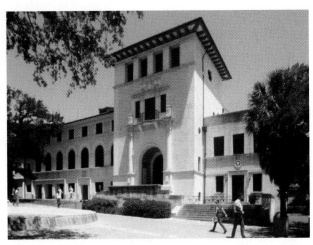

▲ **14-18.** Student Union, University of Texas at Austin, 1931–1942; Austin, Texas; Paul P. Cret. Spanish Colonial Revival.

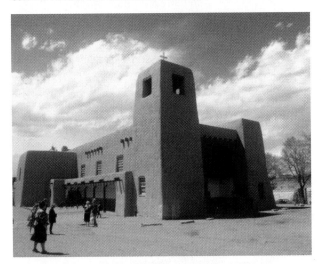

▲ **14-17.** Cristo Rey Church, 1939–1940; Santa Fe, New Mexico; John Gaw Meem. Pueblo Revival.

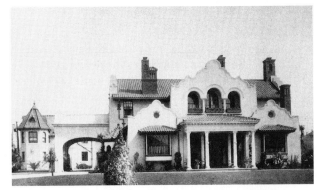

▲ **14-19.** General Harrison Gray Otis House, c. 1904; Los Angeles, California; J. P. Kremple. Mission Revival.

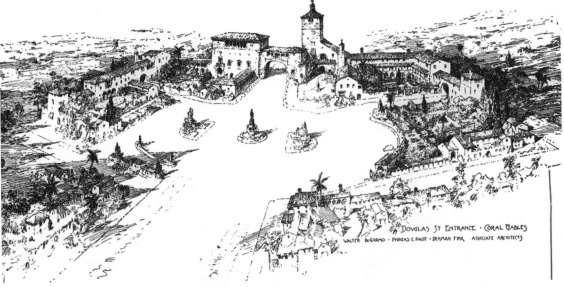

▲ **14-20.** Entry sketch, house and floor plans with Coral Gables Gateway to suburb, c. 1920s; Coral Gables, Florida; Walter C. De Garmo and Robert L. Weed. Spanish Colonial Revival.

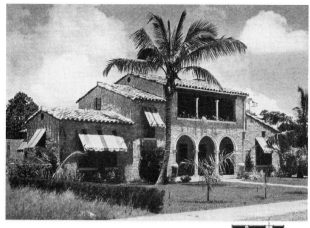

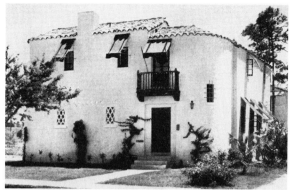

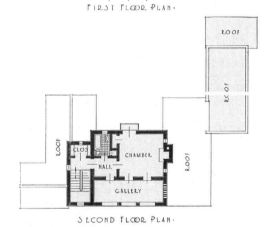

FIRST FLOOR PLAN.

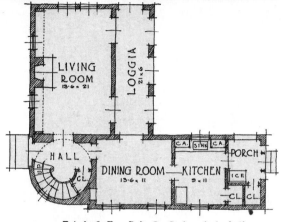

FIRST FLOOR PLAN·

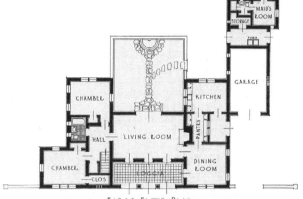

SECOND FLOOR PLAN·

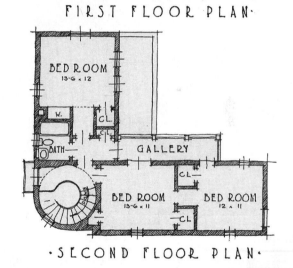

·SECOND FLOOR PLAN·

▲ 14-20. (continued)

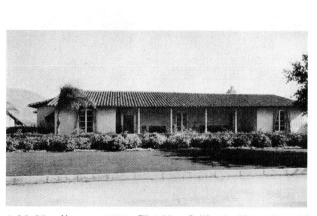

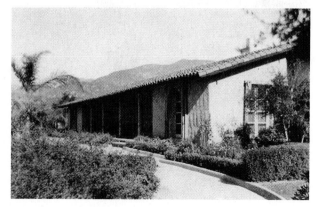

▲ 14-21. House, c. 1920s; Flintridge, California; Myron Hunt. Monterey style.

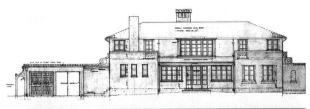

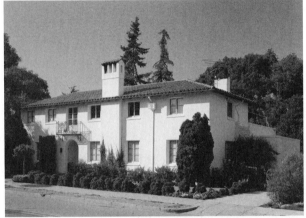

have floral or geometric ornament in terra-cotta panels. As in other styles, arcades, courtyards, and patios are common in Spanish Colonial Revival. Supports may be spiral or twisted columns, classical columns, or wooden posts with bracket capitals. Full- and partial-width balconies with wooden or iron railings in many sizes and shapes also are a characteristic feature, particularly for houses. Important public buildings often have towers, usually rectangular, usually with low-pitched hipped roofs. Houses may have circular towers forming the entrance or defining a corner. Sometimes a side wall extends to create an entrance to the garage or simulate a side entrance. Examples after World War I reveal a more vernacular character in the seemingly random organization and massing that emulates growth over time through additions placed where needed with little regard for symmetry or classical organization.

▲ **14-22.** John G. Kennedy House, c. 1920s; Palo Alto, California; Julia Morgan. Spanish Colonial Revival.

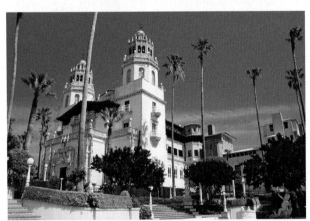

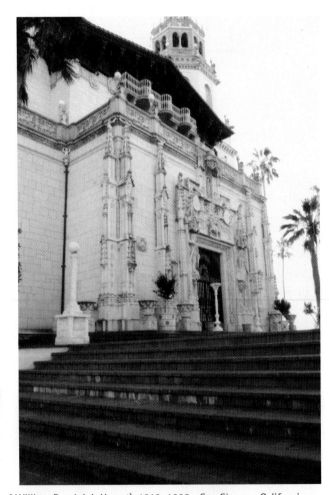

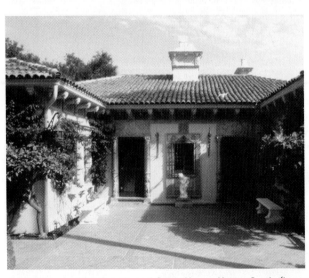

▲ **14-23.** La Casa Grande and Guest House, Hearst Castle (home of William Randolph Hearst), 1919–1920s; San Simeon, California; Julia Morgan. Spanish Colonial Revival.

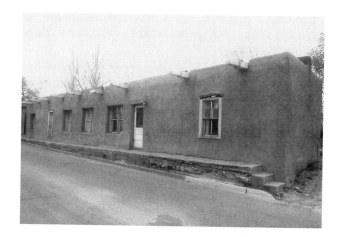

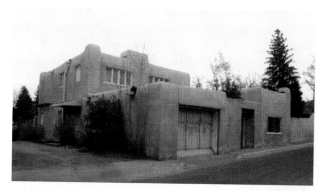

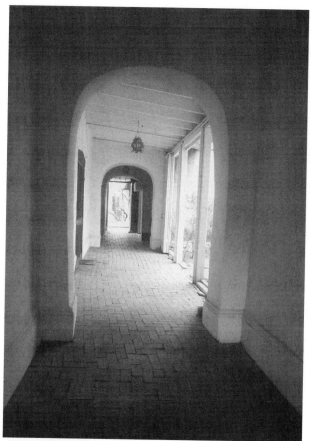

▲ **14-24.** Houses and house arcade c. 1920s–1930s; Santa Fe, New Mexico. Pueblo Revival.

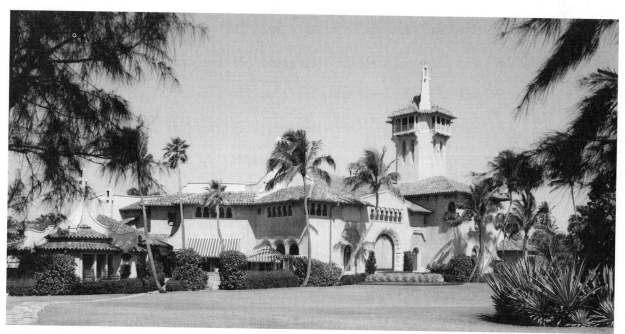

▲ **14-25.** Mar-a-Lago and main entrance door, c. 1920s–1930s; Palm Beach, Florida. Marion Syms Wyeth, architect; Joseph Urban, interior decoration. Spanish Colonial Revival.

▲ **14-25.** *(continued)*

Monterey-style buildings have full- or partial-width porches supported by pillars or columns and a second-story balcony under the main roof (Fig. 14-21).

Pueblo Revival buildings have plain, smooth walls with rounded corners like the adobe prototypes (Fig. 14-9, 14-10, 14-17, 14-24). Rough wooden beams may protrude near the roofline in imitation of the *vigas* of Spanish Colonial buildings.

■ *Windows.* In Mission Revival and Spanish Colonial Revival, at least one, if not all, windows are rounded arches, although they may mix with rectangular sashes or casements (Fig. 14-19, 14-22, 14-25). Foliated or quatrefoil windows in gables or parapets are typical of Mission Revival (Fig. 14-5, 14-19). More elaborate or important structures may have windows set in foliated or horseshoe arches or parabolic windows. Houses often have picture windows or bay windows. Wrought iron or wooden grilles, *Plateresque* or *Churrigueresque* ornament, or colorful ceramic tiles surround or surmount many windows. Some have colored or leaded glass, often designed to look ancient.

Sash windows identify the Monterey style. Also typical are paired windows and shutters.

Windows in the Pueblo style are rectangular, usually deeply recessed, and may have exposed wooden lintels over them.

■ *Doors.* Doors may be recessed or within porches and have red or colorful tiled walkways or steps leading to

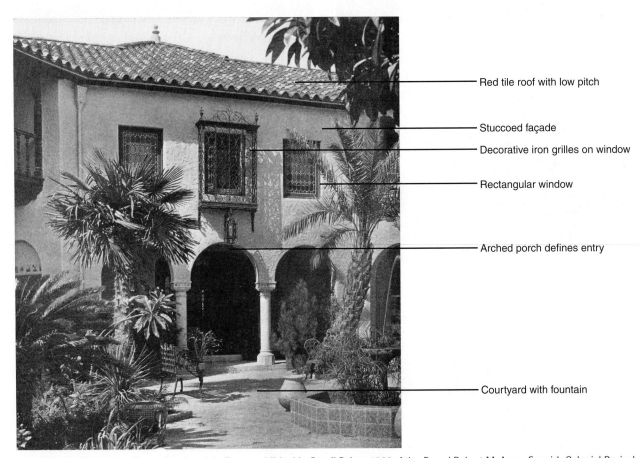

Red tile roof with low pitch

Stuccoed façade

Decorative iron grilles on window

Rectangular window

Arched porch defines entry

Courtyard with fountain

▲ **14-26.** D. T. Atkinson House; San Antoinio, Texas; published in *Pencil Points*, 1930; Atlee B. and Robert M. Ayres. Spanish Colonial Revival.

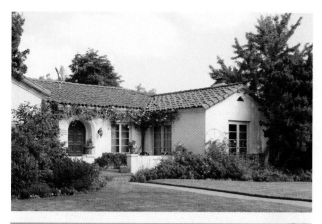

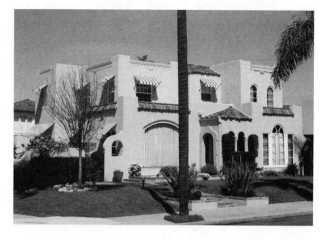

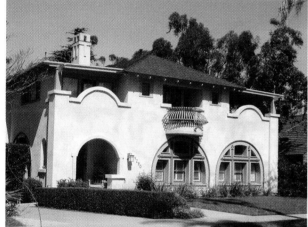

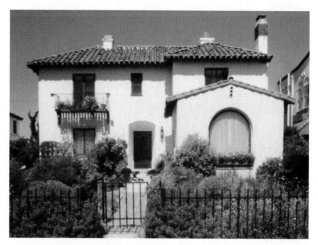

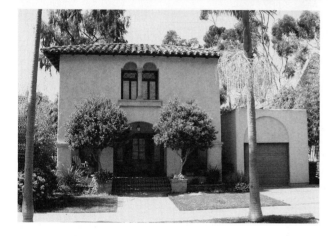

◀ **14-27.** Houses, c. 1920s–1930s; San Diego, California. Spanish Colonial Revival.

them (Fig. 14-2, 14-9, 14-15, 14-17, 14-19, 14-25, 14-27). Most doorways are round arches, but some are within foliated or horseshoe arches. Important Spanish Colonial Revival public and private buildings often have spiral or twisted columns or pilasters and/or *Plateresque-* or *Churrigueresque-*style decoration around them. Doors are dark wood, usually carved. Some have glass in the upper portions. Hinges, strap hinges, door knobs, and knockers are of wrought iron. When garages are shown, their wooden doors are often heavily paneled.

■ *Roofs.* Geometric or curvilinear parapet roofs copied or adapted from mission churches identify Mission Revival (Fig. 14-5, 14-19). Low-pitched gable or hipped roofs are most common in all Spanish Colonial Revival styles (Fig. 14-22, 14-23, 14-25, 14-27) except Pueblo, which always has flat roofs (Fig. 14-10, 14-17, 14-24). Some public buildings, particularly churches, may have domes. Red ceramic tiles in round or half-rounded shapes cover all Spanish Colonial Revival roofs.

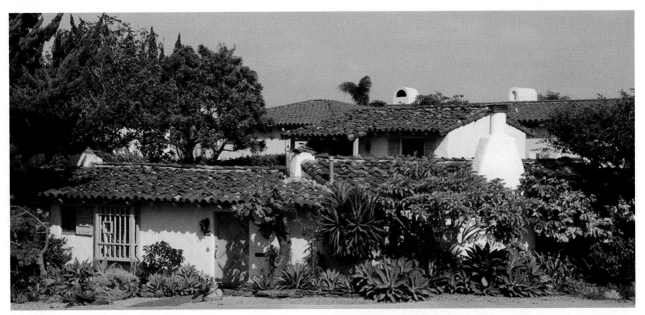

▲ **14-28.** Highland Residence, 1934; San Diego, California; Cliff May; Spanish Colonial Revival.

▲ **14-29.** Later Interpretation: Casino and shopping mall and casino, c. 1990s; San Diego, California. Modern Historicism/Regionalism.

■ *Later Interpretations.* The California Ranch house, developed and promoted by architect Clifford May, becomes extremely popular during the 1940s and is the most common house form after World War II. It gives new life to Spanish Colonial Revival during a time when it is being eclipsed by the Modern movement. Interest in Spanish styles arises again in the late-20th-century revival of historicism and interest in place identification in architecture (Fig. 14-29). Admirers share the similar design interests of simplicity, natural materials and colors, and integration with the landscape with the Arts and Crafts Movement of the 19th century. Spanish

Colonial Revival and more contemporary adaptations continue to define many building types in areas with a Hispanic heritage.

INTERIORS

Interiors in early Mission and Spanish Colonial Revival buildings are more likely to relate to Arts and Crafts than Spanish. Wood planks or paneling, emphasis upon structure, low ceilings, wood floors, and the colors of nature are common. Later interiors have a Spanish,

Italian, French, Mediterranean, or even a rustic character with tile floors, white or light-colored plaster walls, and beamed ceilings. All or parts of rooms may be imported from Spain in significant examples. Antiques and/or imported furniture often mixes with contemporary. Kitchens and bathrooms display a Spanish flavor in colors and materials.

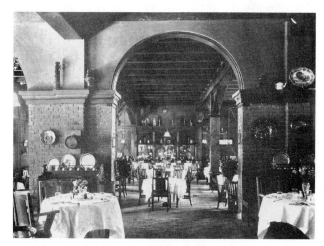

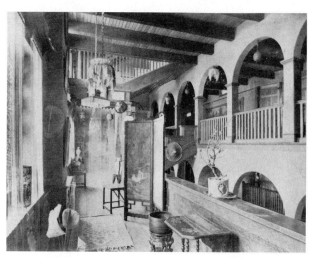

▲ **14-30.** Dining area and mezzanine, Glenwood Hotel (now the Mission Inn), c. 1904; Riverside, California; Frank Miller. Mission Revival.

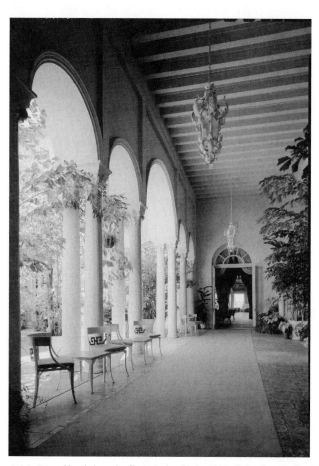

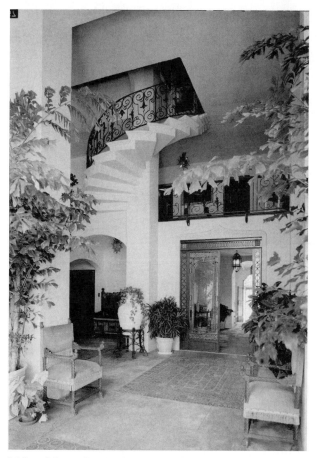

▲ **14-31.** North Loggia, Everglades Club, 1919; Palm Beach, Florida; Addison Mizner. Spanish Colonial Revival.

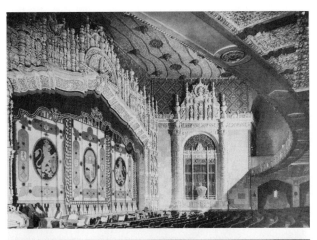

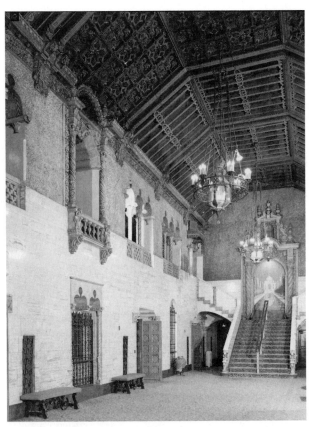

▲ **14-32.** Lobby, auditorium, and women's lounge, Indiana Theater, 1927; Indianapolis, Indiana; Rubush & Hunter. Spanish Colonial Revival.

Public and Private Buildings

■ *Types.* No particular room types are associated with Spanish Colonial Revival. However, front and interior courtyards and patios are characteristic.

■ *Relationships.* Interiors often display an eclectic Spanish or rustic feeling related to the exterior (Fig. 14-30, 14-31, 14-41).

■ *Color.* Walls usually are white, off-white, gray, pale yellow, ocher, or pink. Ceramic tiles, textiles, and decorative ceilings in bright blue, turquoise, yellow, orange, red, and/or green add accents of color (Fig. 14-3, 14-35, 14-37). Woods usually are stained a dark, rich brown.

■ *Lighting.* Electric table and floor lamps, chandeliers, lanterns, and sconces in wrought iron are most typical (Fig. 14-32, 14-33, 14-36, 14-41). Other materials include wood, dull brass, hammered copper or brass, silver, or ceramic. Some fixtures have stained glass shades. Hanging lamps may replicate Spanish or Moorish types, such as mosque lamps. Sconces and lamps sometimes have *Plateresque* or

Churrigueresque ornament. Candlestands in iron or heavy wooden holders add an exotic or romantic touch.

■ *Floors.* Floors are tiles or dark wood planks (Fig. 14-3, 14-34, 14-36, 14-40). Tiles are rectangular, hexagonal, or octagonal in unglazed red or brown clay. Sometimes tiles in other colors or patterns create repeats, borders, or trompe l'oeil area rugs; form baseboards; or cover risers and treads of stairways (Fig. 14-3). Orientals, kelims, dhurries, or Native American rugs may cover floors, but many floors are left bare for an authentic look (Fig. 14-36, 14-37, 14-41). Wall-to-wall carpet is atypical except in bedrooms.

■ *Walls.* Walls usually are smooth or rough plaster with few moldings in both public and private buildings (Fig. 14-31, 14-32, 14-36, 14-37, 14-38, 14-40). Ceramic tiles, Native American rugs, and/or other textile wall hangings supply color and interest. Tiles may be used for dadoes or as surrounds for or insides of niches, fireplaces, doors, and windows (Fig. 14-2, 14-3, 14-37, 14-41). A few rooms,

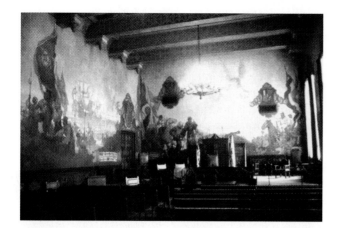

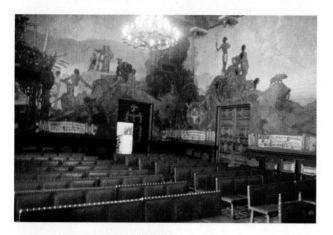

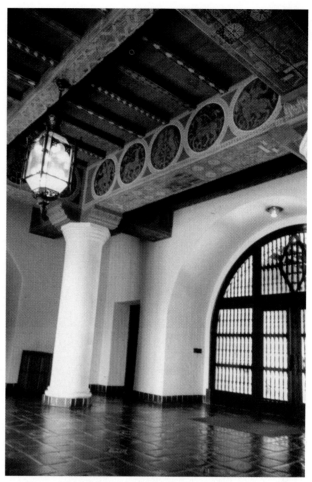

▲ **14-33.** Interiors, Santa Barbara Courthouse, c. 1929; Santa Barbara, California. Spanish Colonial Revival.

mostly in houses in the Arts and Crafts style, have wallpaper or paneling. High-style examples, particularly public buildings such as hotels or theaters, may have elaborate plasterwork decorations like the original Spanish examples or extensive painted decoration such as murals or geometric designs (Fig. 14-33). Fireplaces are rectangular, hooded, corner, or beehive, which is rounded in form with a rounded opening. Mantels range from stone with bold Baroque or Renaissance details to simple rough wood (Fig. 14-38, 14-39, 14-40, 14-41).

Interiors: Ticket room, main waiting room, restaurant, Union Station (Los Angeles Railroad Station), 1939; Los Angeles, California; John Parkinson, Donald Parkinson, J. J. Christie, H. L. Gilman, and R. J. Wirth; restaurant by Mary Colter. Spanish Colonial Revival and Streamline Moderne. Conceived as the gateway to Los Angeles and the last great railroad station in America, this building evokes the Spanish heritage of southern California with its arches, arcades, stucco walls, red tile roof, and beamed ceilings. The interior also reflects the Streamline Moderne style through its light fixtures, decorative details, artwork, and some furnishings. Native American features appear as well, particularly in the decorative floor patterns. Interior colors convey the character of these influences, with a palette primary composed of cream, gold, rust, black, turquoise, and brown.

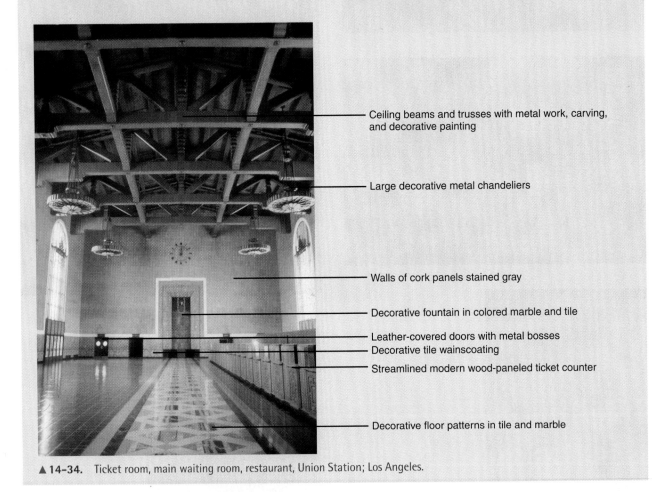

Ceiling beams and trusses with metal work, carving, and decorative painting

Large decorative metal chandeliers

Walls of cork panels stained gray

Decorative fountain in colored marble and tile

Leather-covered doors with metal bosses
Decorative tile wainscoting
Streamlined modern wood-paneled ticket counter

Decorative floor patterns in tile and marble

▲ **14-34.** Ticket room, main waiting room, restaurant, Union Station; Los Angeles.

■ *Windows.* Interior windows are relatively plain with few moldings. Curtains of plain or patterned fabrics hang by rings from iron rods. Elaborate, layered treatments are not typical except in some high-end buildings. Red velvet or damask, often trimmed with fringe and/or braid, are common materials for curtains. Off-white curtains in muslin or linen are also popular.

■ *Doors.* Door surrounds are rectangular, round arches, or foliated arches (Fig. 14-30, 14-36, 14-41). Sometimes ceramic tiles surround them. Doors are of dark paneled or carved wood with wrought iron hinges and knobs (Fig. 14-36, 14-37). Colorful painted decoration and/or gilding may highlight details or panels.

■ *Ceilings.* Ceilings may be plain and flat, or sloped or arched plaster (Fig. 14-37, 14-40, 14-41). Many have wood beams supported by brackets or are compartmentalized with carved and painted decoration (Fig. 14-31, 14-32, 14-34, 14-35, 14-36, 14-37, 14-38, 14-41). Important rooms in public and private buildings often have elaborate ceiling treatments. Some rooms have

DESIGN SPOTLIGHT

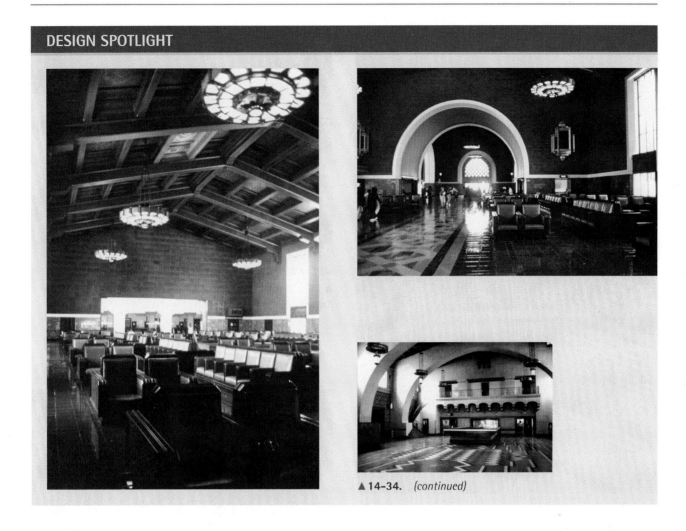

▲ 14-34. *(continued)*

◀ 14-35. Ceilings, Chemistry Building, University of Texas at Austin, 1931–1942; Austin, Texas, and the Biltmore Hotel, 1923; Los Angeles, California, by Schultze and Weaver. Spanish Colonial Revival.

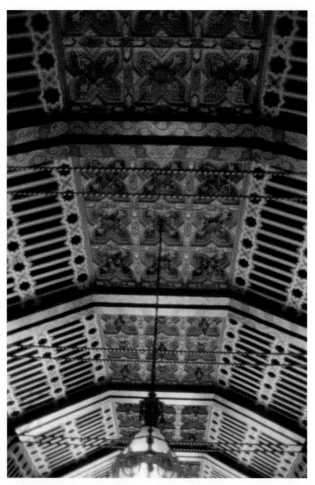

▲ **14–35.** *(continued)*

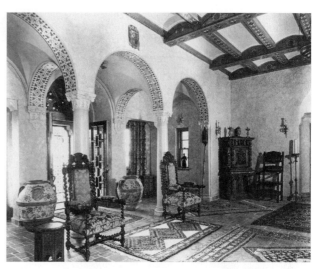

▲ **14–37.** Entry foyer, McNay Residence, c. 1920s–1930s; San Antonio, Texas. Spanish Colonial Revival.

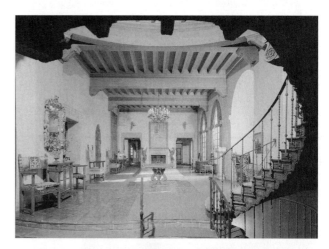

▲ **14–36.** Vestibule, c. 1920s; California; Wallace Neff. Spanish Colonial Revival.

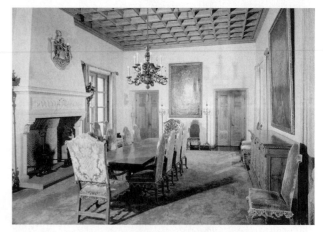

▲ **14–38.** Entrance hall and dining room, Greenacres (Harold Lloyd House), 1926–1929; Beverly Hills, California; Sumner Spaulding. Spanish Colonial Revival.

sloped ceilings with revealed trusses in the medieval manner.

■ *Later Interpretations*. The Mediterranean style of the 1970s uses the white walls, dark floors, and ceiling beams

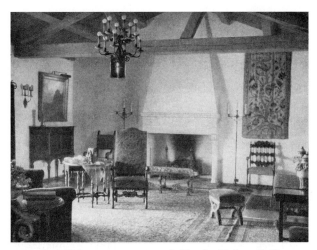

▲ **14-39.** Living room, c. 1920s; California; Wallace Neff. Spanish Colonial Revival.

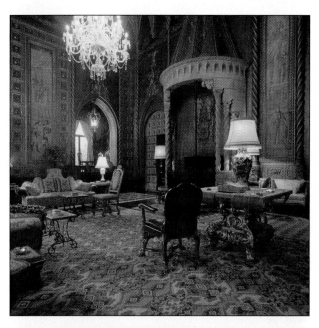

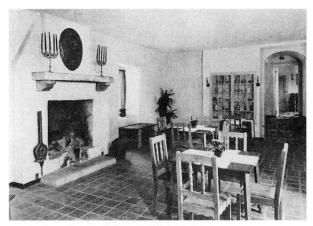

▲ **14-40.** Dining room, Casa Flores, c. 1920s; Pasadena, California; Carleton Winslow. Pueblo Revival.

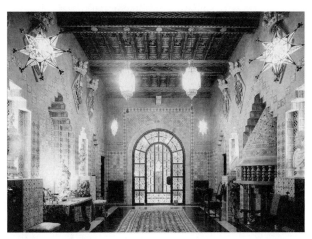

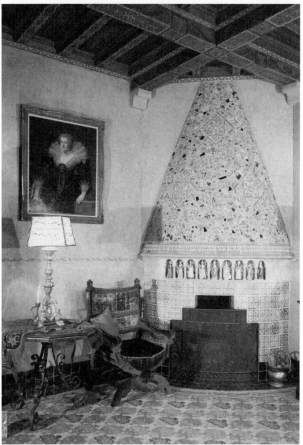

▲ **14-41.** Entrance hall, living room, fireplace, and cloister in Mar-a-Lago, c. 1920s–1930s; Palm Beach, Florida; Marion Syms Wyeth. Spanish Colonial Revival.

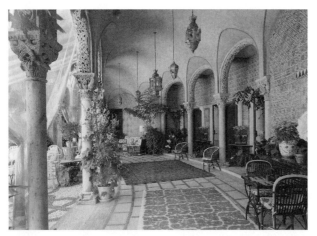

▲ **14-41.** *(continued)*

of Spanish Colonial Revival. Rich colors, such as red, orange, avocado green, brown, and black, crimson-flocked wallpapers, and heavy furniture of dark woods also identify the style. Late-20th-century Spanish Colonial Revival interiors continue the smooth plaster walls, tiled floors, dark woods, and colorful accents of textiles, ceramic tiles, and decorative iron work of earlier (Fig. 14-42).

▲ **14-42.** Later Interpretation: Stair hall, Carol Burnett House, late 1990s; Santa Fe, New Mexico; interiors by Anita Ludovici De Domenico, architecture by Studio Arquitectura. Modern Historicism/Regionalism.

FURNISHINGS AND DECORATIVE ARTS

Mission Revival and early Spanish Colonial Revival interiors, particularly in houses, often have Arts and Crafts or Mission-style furniture. Later furniture replicates or more closely resembles the Spanish originals, at least in wooden or metal pieces. Contemporary upholstery supplies comfort and convenience. Imported Spanish, French, or Italian antiques may join with contemporary furniture, sometimes incongruously. In areas where Spanish Colonial Revival is fashionable, antique collecting, a popular national pastime, begins focusing on Spanish Colonial furniture, and museums begin collecting and displaying prized pieces.

In the 1920s, manufacturers respond to interest in Spanish architecture by producing Spanish Colonial Revival furniture. Most examples are adaptations of Spanish Renaissance or Baroque or Mexican pieces, but some companies reproduce 16th- and 17th-century furniture. Similarly, individual cabinetmakers create reproductions and/or adaptations of Spanish Colonial pieces, usually for wealthy clients. The Arts and Crafts Movement inspires preservation and fostering of local craft traditions, so vernacular examples are copied or adapted. One example is the Monterey Furniture, a fashionable line derived from Mexican folk pieces and produced by Mason Manufacturing in Los Angeles between 1929 and 1943. Some rooms display unusual furniture, such as rustic pieces made of vines and/or tree trunks or limbs, or Cowboy furniture that is made of wagon wheels or barrels.

Public and Private Buildings

■ *Types.* Types associated with Spanish high-style and vernacular furniture of the Renaissance or Baroque are popular for Spanish Colonial Revival. These include the *frailero*, X-form chair and stool, spindle-back chairs, the *amario* or wardrobe, and the *vargueño*.

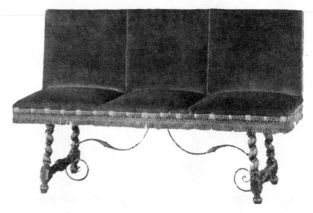

▲ **14-43.** Spanish upholstered bench, c. 1927; manufactured by Kittinger and Hastings. Spanish Colonial Revival.

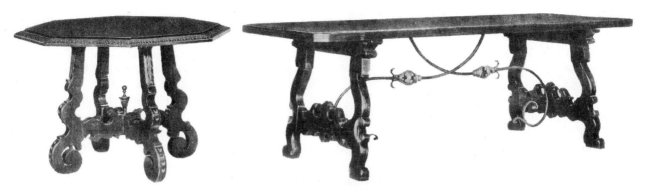

▲ **14-44.** Tables, c. 1927; manufactured by Hastings. Spanish Colonial Revival.

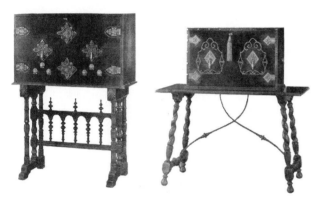

▲ **14-45.** *Varquenos* and *papelerias*, c. 1927; manufactured by Kittinger. Spanish Colonial Revival.

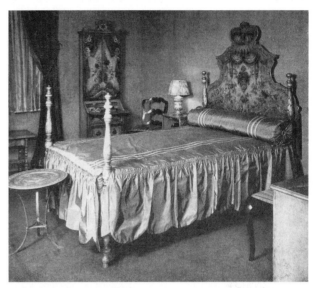

▲ **14-46.** Bed, c. 1920s–1930s; United States. Spanish Colonial Revival.

■ *Distinctive Features*. Dark woods, carving, inlay, wrought iron details, applied ceramic tiles in bright colors, Spanish and Moorish motifs, and a Renaissance or rustic character identify Spanish Colonial Revival furniture.

■ *Materials*. Walnut, yellow pine, oak, and chestnut, usually in a dark stain, are typical woods. Luxury pieces may be of ebony or mahogany. Chairs and tables also may be of wrought iron or bronze. Decoration includes inlay, carving, painting, gilding, ceramic tiles, and leather. Mexican or folk furniture may be decorated with geometric or naturalistic motifs in bright colors such as blue, red, yellow, green, and white. Wooden pieces are also artificially aged by bleaching or sandblasting to look like antiques.

■ *Seating*. Chairs, stools, and benches, instead of upholstery, are the primary examples of Spanish Colonial Revival (Fig. 14-32, 14-33, 14-36, 14-37, 14-38, 14-39, 14-40, 14-41, 14-43). Arm and side chairs may reproduce or adapt Renaissance types such as rectangular or the X form. Occasionally, more ornate and heavier-scaled Baroque-style chairs appear in interiors of the affluent. Also evident are ladder-back and spindle-back chairs, which often reflect a more vernacular character.

They usually have turning, rough carving, and/or painted decoration. Stools usually are X shaped. Window seats and built-in seating appears in living and dining rooms, kitchens, and patios and is often embellished with ceramic tiles.

■ *Tables*. The Spanish table with four scrolled, turned, or columnar splayed or slanted legs and curvilinear wrought iron braces is sometimes copied (Fig. 14-38, 14-41, 14-44). Lamp tables, coffee tables, and extension dining tables, although unknown in the Renaissance or Baroque periods, reflect the form and character of earlier pieces with dark stains, inlay, turning, carving, wrought iron braces, and/or ceramic tile. Tops are round, rectangular, square, hexagonal, or octagonal and have ceramic tiles or leather secured with large brass nail heads.

■ *Storage*. Chests, credenzas, and desks reflect a Spanish spirit in form and design (Fig. 14-45). Proportions are usually heavy and the carving lavish. The *vargueño* or drop-front desk is frequently copied or adapted for contemporary

rooms. Like the originals, the base may have turned or spiral splayed legs with wrought iron supports.

■ *Beds*. Beds vary in design from heavily carved four-posters in dark woods to headboards with ornate shapes composed of C and S scrolls and details highlighted with gilding or paint (Fig. 14-46).

■ *Upholstery*. Common upholstery fabrics include velvets, damasks, leather, corduroy, or canvas. Large nailheads in iron or dull brass secure upholstery to wooden-framed pieces.

■ *Decorative Arts*. Accessories in Spanish Colonial Revival rooms draw from Spanish, Native American, Mexican, and Islamic sources. Pieces include Mexican tinwork, Moorish braziers, Native American pottery, Arts and Crafts pottery, Native American baskets, wrought iron and hammered brass or copper candlesticks, and other decorative objects (Fig. 14-37).

■ *Later Interpretations*. Mediterranean-style furniture of the 1970s adapts elements of Spanish, Islamic, and Jacobean. Characteristics include dark woods, heavy proportions, caned seats and backs, lattice and grille work, arched panels, wrought iron, mosaics, spindles, C and S scrolls, floral patterns, and leather. Several manufacturers, such as L. G. Stickley Company, begin reproducing Mission-style furniture in the late 20th century. Individual craftsmen and small workshops in the southwestern United States create reproductions and modern interpretations of Spanish Colonial Revival furniture.

1775	Shakers establish first colony in Albany, N.Y.
1846	Elias Howe patents the first sewing machine
1849	John Ruskin, *Seven Lamps of Architecture*
	Chinese immigration to United States begins
1850	Harriet Beecher Stowe, *Uncle Tom's Cabin*
1854	Treaty of Peace and Amity opens Japan to international trade
1855	Walt Whitman, *Leaves of Grass*
1856	Owen Jones, *The Grammar of Ornament*
1861	William Morris founds design firm in London
1864	Lincoln sets aside Yosemite from development
1865	Germans use paper for coffee cups
	First socialist party founded in Germany
1867	$300,000 spent in America on fabrics for homemade clothing
1869	First traffic signals installed in London
	Brooklyn Bridge begun
	U.S. transcontinental railway opens
1870	U.S. population stands at 39, 818, 449
1872	Charles Eastlake, *Hints on Household Taste*
1873	Susan B. Anthony arrested for voting in Rochester, N.Y.
1876	Bedford Park, London, is first garden suburb and Aesthetes flock there
1878	Rookwood Pottery established in Cincinnati
	Clarence Cook, *The House Beautiful*
1881	Gilbert and Sullivan's *Patience* brings the Aesthetic Movement forward
	William Morris begins wallpaper and carpet factory
1882	Oscar Wilde tours and lectures in the U.S.
1883	Krakatau blows her top in Indonesia, kills 36,000
	Robert Louis Stevenson, *Treasure Island*
1884	Cocaine used as the first local anesthetic
	Louis Waterman patents the fountain pen
	Art Workers Guild established in London
1885	Art and Crafts Exhibition Society begun with Walter Crane as first president
1889	F. L. Wright House and Studio built in Oak Park, IL.
	Jane Addams founds Hull House in Chicago
	Electric sewing machines start humming
1890	William Morris designs Golden typeface
	Sioux Indians massacred at Wounded Knee, South Dakota
	Forth Bridge near Edinburgh completed
1891	Oscar Wilde's *Picture of Dorian Gray* revealed
1892	Elbert Hubbard visits William Morris and carries the message home
1893	*The Studio* begins publication
1894	France and the world suffer through the Dreyfus Affair
1895	Lumiere brothers show first motion picture
	Grueby Faince Company started in Boston
1896	Puccini's *La Boheme* begins to suffer
1898	Gustav Stickley Company begins in Syracuse, N.Y.
1903	Marconi transmits a radio message from the U.S. to Britain
	Communications cable laid beneath Pacific
1904	First subway in New York
	About 230 murders reported in all of the U.S.
	Average worker in U.S. makes between $200 and $400 per year
1920	Women earn right to vote; U.S. Constitution changed

E. REFORMS

Throughout the 19th century, historicism and revivalism coupled with the Industrial Revolution produce innumerable goods that are often poorly designed and constructed. But a few forward-thinking people begin recognizing these problems and seeking ways to ameliorate them during the second quarter of the 19th century. For many, a strong catalyst for change is London's Great Exhibition of 1851. Dominating the exhibit are overornamented, shoddy, and badly colored items that confirm the design critics' beliefs that design, in the hands of manufacturers and aimed at the minimally educated, has declined to the lowest point imaginable. Further contributing to this disintegration is the lack of a suitable design language for machine-made goods and the emphasis upon fashionable trends, historicism, and sentimentalism. Manufacturers are more concerned about getting goods fabricated and to the consumer. Consumers, largely uneducated in matters of taste, cannot demand better designs, so the reformers decide to do it for them.

Pleas for and attempts to change the quality of design come from many sources, including schools, such as South Kensington Museum's school in England; groups with a common outlook, such as the Aesthetic and Arts and Crafts Movements; and design companies, such as Morris and Company. Particularly significant are the writings of John Ruskin and William Morris who call attention to the deficiencies of design and prescribe remedies. Setting forth theories for design, architecture, and ornament, they advocate that well-designed goods should be available for all levels of society. Echoing A. W. N. Pugin, some strongly equate moralism and design (see Chapter 6, "Gothic Revival"). Always condemned in writings, lectures, and practices are materialism, conspicuous consumption, and what advocates consider bad taste.

At the same time, the Industrial Revolution increasingly affects family life and relationships, so a move to counter its effects through the home arises. Participants regard the family and, by extension, the home as instruments of reform. Critics, architects, and other writers desire to create an ideal dwelling. They believe that the home should be a refuge from the outside world and the place to educate and strengthen the family. Women, they insist, are better suited than men are to create these nurturing environments. By the second half of the 19th century, advice books proliferate, and writers specify rules for decoration that they believe are consistent with the goals of improving family life.

Individuals and groups propose different strategies to bring change depending on their outlook. Although not design reformers, the American Shakers model change through their simple, faith-dominated lifestyles in which they derive joy from labor. They, unlike others of their time, turn away from machine-made goods and reject materialism. Their material culture, made in their communities to support their beliefs,

demonstrates simplicity, functionality, and a respect for materials that is greatly admired by the reformers and others.

The Aesthetic Movement attempts to reform design through education of artistic principles and historic precedents. Not a style but an attitude, its tenets center on beauty and usefulness for all forms of expression, particularly in the home. Followers, who are artists, designers, architects, and dilettantes, establish rules to assess the beauty of an object or artwork and espouse them through their own practices or writings. Like others of their day, they do not separate the fine and decorative arts. In contrast, they absolve the arts of a higher or moralizing purpose, so "Art for Art's Sake" is the movement's motto. In contrast to the Arts and Crafts Movement, the Aesthetic Movement does not reject the machine, advocate the formation of guilds, or emphasize craftsmanship or social reform. It does introduce the idea of art and beauty as important and desirable, elevates furnishing to an art form, and stresses the importance of education. The movement is also important for women as writers and practitioners.

The Arts and Crafts Movement focuses on reform through well-made goods for all and improving the life of the worker. Like the Aesthetic Movement, it does not promote a single style but fosters an attitude toward design embodied in excellent craftsmanship, delight in and honest use of materials, simplicity, functionality, and regionalism or a sense of place. Followers form guilds modeled after medieval ones in which like-minded artists, architects, and designers come together to promote their work and ideas. The guilds give the movement in England cohesion, but there is a strong emphasis upon the creative expression of the individual designer.

The American Arts and Crafts Movement shares similar goals to that of England. However, American expressions are broader, more individualist, and reveal a greater diversity of sources. Americans stress Arts and Crafts ideas as part of a larger reform movement intended to transform life and the family, so there is less emphasis upon the worker. Additionally, Americans use mass production to a greater degree to democratize design.

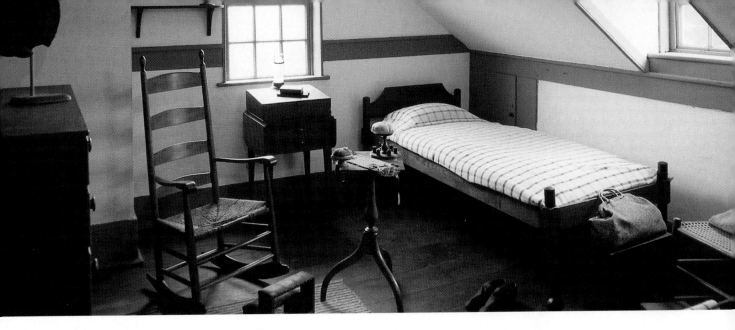

CHAPTER 15

The Shakers

1774–1900

The architecture, interiors, and furniture of the American Shakers, a 19th-century utopian religious group, grow out of their belief system and worldview. Minimal ornament, simple forms deriving from function or utility, perfected proportions, and excellent craftsmanship reflect the communal, celibate, labor-focused lifestyles of the Shakers and anticipate aspects of Modernism of the 20th century.

The streets are quiet; for here you have no grog shop, no beer house, no lock up, no pound; . . . and every building, whatever may be its use, has something of the air of a chapel. The paint is all fresh; the planks are clean and bright; the windows are all clean. A sheen is on everything; a happy quiet reigns.

William Hogarth Dixson, from *All About Old Buildings: The Whole Preservation Catalog*, edited by Diane Maddex, The Preservation Press, c. 1985, p. 158.

Do all your work as though you had a thousand years to live on earth, and as you would if you knew you would die tomorrow.

Mother Ann Lee quoted in Rufus Bishop and Seth Youngs Wells, *Testimonies of the Life, Character, Revelations, and Doctrines of Our Ever Blessed Mother Ann Lee*, 1816

Beauty rests on utility. That which has in itself the highest use possesses the greatest beauty. Any thing may, with strict propriety, be called perfect which perfectly answers the purpose of which it was designed.

Shaker saying

HISTORICAL AND SOCIAL

The Shakers, or the United Society of Believers in the First and Second Appearance of Christ, are the largest and best known of the 19th-century communal utopian societies in the United States. Establishing 19 communities from Maine to Georgia, the Shakers practice celibacy and lead simple lives revolving around worship, community, and work.

The society originates from the French Camisards, a millennium group that immigrates to England in the late 17th century to escape persecution. They unite with a Quaker group and become known as the "Shaking Quakers" because of their vigorous, trembling worship (Fig. 15-1). Eventually, the name shortens to the Shakers. Ann Lee, an illiterate, working-class Englishwoman, becomes the first leader of the American group. Along with seven others, she arrives in America in 1774. The early years are extremely difficult for them as British pacifists during a time of conflict with the Mother country. Life is hard, and converts are few.

In 1775, they purchase land in Albany, New York, and the move to inhabit it yields relative stability and income. Between 1781 and 1783, Mother Ann and others begin to travel and preach. Many people find Shaker beliefs appealing and convert. Of particular importance is new member Joseph Meacham, a former Baptist minister who leads the group following Mother Ann's death in 1783.

Under Meacham's leadership, missionary trips throughout the region expand Shaker influence and set up new villages. Established in 1787, Mount Lebanon in New York becomes the parent community and model for others. By 1805, there are five villages in Ohio (Fig. 15-2), two in Kentucky, one in Indiana, and one in western New York. By the middle of the century, the Shakers reach their peak with about 6,000 members in 19 communities in New England, the Midwest, and the South.

Following the Civil War, membership declines as public fascination with utopian societies and religious fervor wanes. The simple and celibate Shaker way of life no longer has appeal. Economic woes plague some communities, and they begin to disband and sell or abandon their buildings. Membership continues to dwindle through the 19th and 20th centuries. Today, one active community remains, and a few are museums or preservation sites.

CONCEPTS

Shaker doctrines of separation from the world, communal living, lives centered on worship and work, equality between the sexes, and celibacy shape their material culture. Members isolate themselves physically in villages to escape worldly or outside influences. They see the physical environment as a means of creating a heavenly kingdom on earth and believe surroundings can positively affect people who live and work in them. The Shakers' belief in community before individuals, lives that revolve around unity of purpose, and shared experiences of community, life, and work drive the form of their villages, dwellings, workshops, barns, interiors, and furnishings. Their communities become deliberate advertisements of the better world to be had through the Shaker lifestyle.

Shaker communities reflect a similar appearance and organization that is defined by the parent group in Mount Lebanon. All members share equally in the community, so order, uniformity, and consistency are important and dominate daily life, including dress, schedules, tasks, housing, and furnishings. In 1821, the first of the Millennial Laws, rules for life and conduct, are circulated among Shaker communities. Subsequent leaders expand the laws in 1845 and 1860. These later versions specify rules for planning architecture, interiors, and furnishings that are intended to shape Shaker life and labor and to further group identity.

IMPORTANT TREATISES

■ *A Summary View of the Millennial Church, or United Society of Believers,* 1821; revised 1845 and 1860; Calvin Green and Seth Youngs Wells.

Shaker buildings, interiors, and furniture are planned primarily for work, division of labor by task and gender, and celibacy. Mother Ann equates work with worship, so her followers see labor as a positive force in their lives. Consequently, economy, efficiency, and function are important life and design principles that become the guidelines for beauty. Believers are innovators in labor-saving forms and devices, many of which they freely share with the world. Among the labor-saving devices they develop are the flat broom, the circular saw, and the coat hanger. Well ahead of their time, believers regard men and women as equal in power and position; nevertheless the sexes assume different tasks based upon traditional labor divisions. For example, men farm while women weave. Celibacy within the group determines architectural forms and the distribution of rooms to separate men and women. Rules

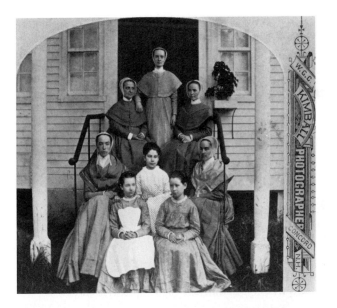

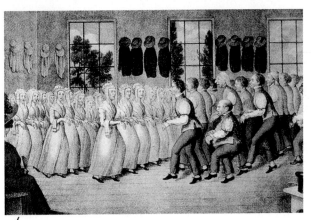

▲ **15-1.** Shaker women; Canterbury, New Hampshire, and "Shakers, a Quaker sect, performing their distinctive, trembling, religious dance"; Currier and Ives.

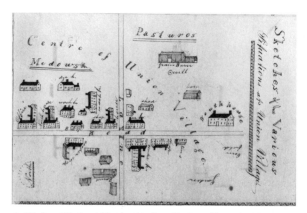

▲ 15-2. "Union Village, the first Shaker village in Ohio."

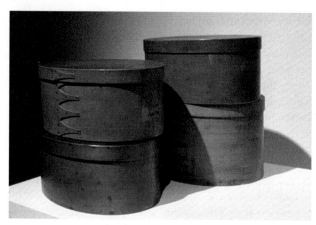

▲ 15-3. Wooden boxes, mid- to late 19th century.

stress order, neatness, and cleanliness, so furnishings are few and designed with ease of maintenance and avoidance of pride in ownership in mind. Other defining principles thoughtfully applied to life and physical surroundings include purity of mind and body, honesty, integrity, prudence, diligence, humanity, and kindness.

Shakers believe that to fulfill a task wholeheartedly is evidence of love for God and the group. It is also a means of asserting individuality in a group that dresses alike; worships alike; and arises, eats, works, and retires at the same time. Shakers value learning new skills and taking on different labors. Versatility is esteemed as evidence of God-given talents.

The uniformity of Shaker architecture, interiors, and furniture, which is striking for so a large group, develops from the shared belief systems as well as the similar backgrounds of members. Other factors include the travel of artisans and craftsmen among communities to teach and assist each other, the sharing of ideas and forms among members, and training through apprenticeships.

DESIGN CHARACTERISTICS

Unembellished forms, refined proportions, and beauty in materials define Shaker architecture, interiors, and furniture. Shakers mainly abstract and adapt the character of 18th-century Georgian and Federal and 19th-century Greek Revival styles to community needs and preferences in buildings and furnishings, with some later influences of Victorian. Public and private buildings feature symmetry, little or no ornament, and efficient planning that supports Shaker work and worship and reinforces expected behaviors. For example, buildings often have separate entrances for male and female believers.

The typical Shaker interior has white plaster walls with brightly painted trim, built-in cupboards and drawers,

a wood strip with pegs for hanging clothing or objects, and a cast-iron stove. Rooms have few furnishings beyond necessities. Shaker built-ins and peg rails are one of their most distinctive characteristics and one of their design legacies.

Lightness, respect for materials, and functionality distinguish Shaker furniture. Craftsmen work in standard furniture types but adapt them to community and individual needs. Furniture relies on materials, form, and function for beauty instead of fashionable types of applied ornament, carving, inlay, marquetry, fluting, and reeding.

■ *Motifs.* Because the Shakers regard decoration as worldly, thus forbidden, no motifs are associated with them other than flowers and hearts that appear in their paintings.

ARCHITECTURE

Shaker architecture, whether domestic or utilitarian, eschews fashion and style in favor of neatness, efficiency, function, and easy maintenance. This contributes to a similar appearance in the communities with some differences arising from the size of the community, its location, the available materials, and members' backgrounds. Converts, most of the working class, bring their previous building and carpentry skills to the community, so they build in the simple forms that they know. Awareness of prevailing high styles sometimes appears in proportions and a few details in the first half of the 19th century. Following the Civil War, Shaker buildings to some extent begin to reflect Stick, Queen Anne, and Shingle styles as the Shakers, always progressive, seek to modernize.

Architectural innovations include dwellings that house large numbers of people and adapting the form and construction of meetinghouses, barns, and utilitarian buildings to the community needs. Always frugal and efficient,

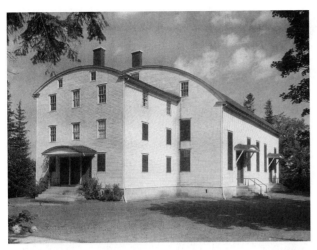

▲ **15-4.** Second Meetinghouse, 1824; New Lebanon, New York; Moses Johnson.

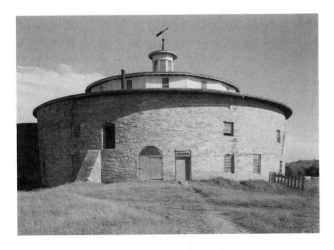

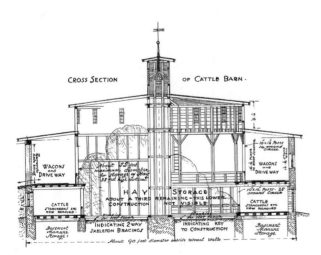

▲ **15-5.** Round Stone Barn, Hancock Shaker Village, 1826; Pittsfield, Massachusetts.

Shakers remodel and renovate buildings to meet the community's changing needs.

Public and Private Buildings

■ *Types.* Communities have a meetinghouse (Fig. 15-4, 15-6), dwelling houses for families (Fig. 15-7, 15-9, 15-10), and a variety of utilitarian support buildings such as barns (Fig. 15-5), stables, sheds, laundries, shops, workshops, privies, and bath houses. Most villages have a trustee office that links them to the outside world through commerce and/or to accommodate visitors and tourists.

■ *Meetinghouses.* Meetinghouses (Fig. 15-4, 15-6) are the physical and spiritual center of Shaker villages because lives and worship centered on God are the foundations on which the group is built. Symmetry, order, and architectural perfection symbolize the hope of salvation and the new kingdom on earth that the Shakers strive to create. Most early meetinghouses follow the original at Mount Lebanon with two or three stories, white painted clapboard, two entrances, and gambrel roof. Later examples reveal more diversity. The first floor of the meetinghouse is a large open

IMPORTANT BUILDINGS AND INTERIORS

■ **Alfred, Maine:**
—Alfred Shaker Historic District, 1793–1930s.

■ **Albany, New York:**
—Watervliet Shaker Historic District, 1776–1890s.

■ **Canterbury, New Hampshire:**
—Canterbury Shaker Village, begun 1792.

■ **Enfield, New Hampshire:**
—Enfield Shaker Historic District, 1793–1923.

■ **Harrodsburg, Kentucky:**
—Shakertown at Pleasant Hill Historic District, 1805–1850s.

■ **Harvard, Massachusetts:**
—Harvard Shaker Village Historic District, 1769–1890s.

■ **New Gloucester, Maine:**
—Sabbathday Lake Shaker Village, begun 1782.

■ **New Lebanon, New York:**
—Mount Lebanon Shaker Society, 1785–1947.

■ **Pittsfield, Massachusetts:**
—Hancock Shaker Village, 1783 to late 19th century.

■ **South Union, Kentucky:**
—South Union Shakertown Historic District, 1807–1922.

Architecture: Village area and Community Meeting-house, Sabbathday Lake Shaker Village, 1884; New Gloucester, Maine; Moses Johnson. Established in 1794, the Sabbathday Lake community includes lands of the first converts. As is common for Shaker villages, the community centers on the meetinghouse with dwelling houses, workshops, and barns arranged nearby. The buildings illustrate common features of plain architecture, neatness, and orderly planning. The meetinghouse, erected by Moses Johnson in 1794, follows the New Lebanon prototype. The rectangular block structure has a gambrel roof with Johnson-style double pitches nearly equal in length and three dormers on each façade. The main façade has the usual double entrances, one for the Brothers and one for the Sisters, with three windows between and one outside each door. Large single shutters block light, and two chimneys extend from

the roof's ridge. Commonly, meetinghouses are painted white to set them off from less important buildings. The meetinghouse continues in use by the surviving Shaker community.

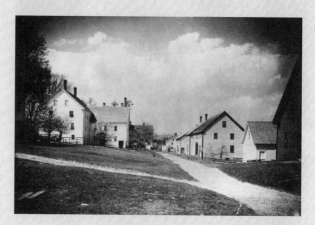

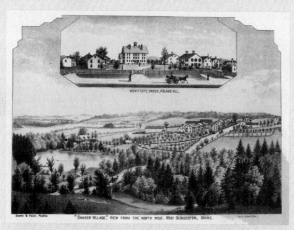

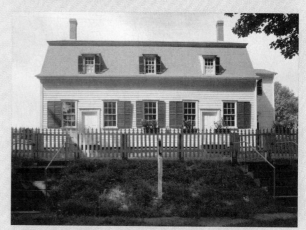

▲ **15-6.** Village area and Community Meetinghouse, Sabbathday Lake Shaker Village.

space with no interior columns so that the Shakers can perform their ritual dances during worship. Upper stories have living quarters for ministry leaders who do not associate with regular believers.

■ *Dwelling Houses.* Dwelling houses (Fig. 15-7, 15-9, 15-10) support the group's organization into families, which disregard blood ties to further group identity. These large communal or family residences are designed to conform individual behavior to Shaker laws. Each family builds its own house, which reflects its character. Children (orphans or brought by converts) and the elderly live separately from others. Larger, wealthier families build stately dwellings of stone or brick with two to six stories and 40 to 50 rooms to house up to 100 members (Fig. 15-18). Southern dwellings have higher ceilings, wider hallways, and larger rooms than those of other

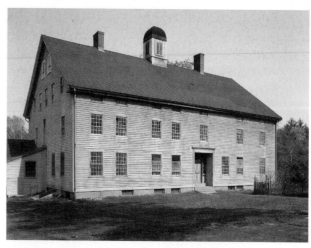

▲ **15-7.** South Family Dwelling House, 1790s–1820s; Harvard, Massachusetts.

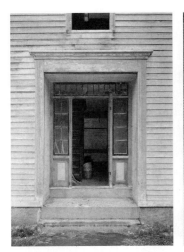

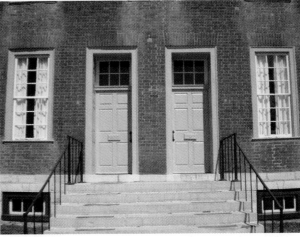

◀15-8. Door and window details; Massachusetts and Kentucky.

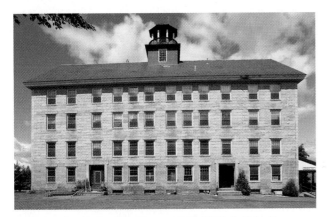

▲ 15-9. Family Dwelling House, 1841–1846; Enfield, New Hampshire; Moses Johnson.

communities. Within dwellings, four to eight members with similar labor roles share rooms. Elders and eldresses live in first-floor quarters near an entrance to permit them to observe behavior (Fig. 15-13). Movement within and between dwelling houses is frequent as members change roles, leave, or grow older.

Despite diversity in appearance, dwellings are similar in plan organization (Fig. 15-11). Usually there are two sets of stairs, one for men and another for women (Fig. 15-17). They may be located near each other or side by side. Basements house kitchens, bakeries, pantries, storage rooms, and communal dining rooms in eastern communities. Those in the west usually place these services in a rear ell

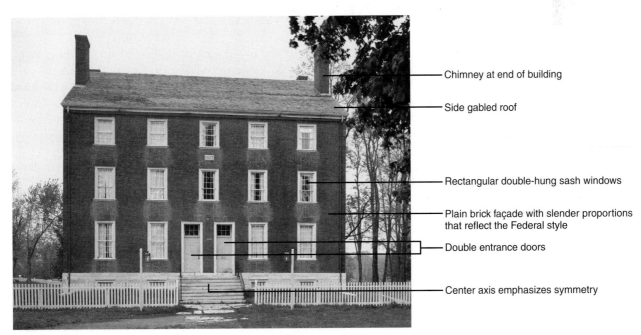

Chimney at end of building

Side gabled roof

Rectangular double-hung sash windows

Plain brick façade with slender proportions that reflect the Federal style

Double entrance doors

Center axis emphasizes symmetry

▲ 15-10. Family Dwelling Houses (now called the Shakertown Inn), Shaker Village of Pleasant Hill, 1820s–1850s; Harrodsburg, Kentucky; Micajah Burnett.

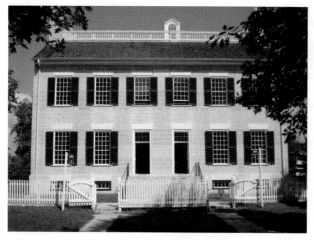

▲ **15-10.** *(continued)*

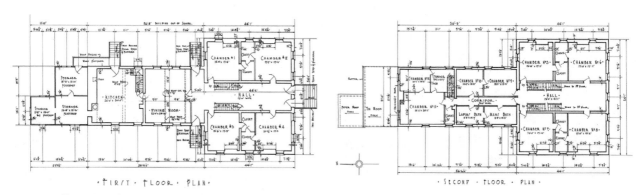

▲**15-11** Floor plans, Shaker Centre Family Dwelling House, Shaker Village of Pleasant Hill, 1820s–1850s; Harrodsburg, Kentucky; Micajah Burnett.

or in a separate building behind the main house. The first floor has a meeting room that is used for family worship, lectures, or socializing (Fig. 15-14, 15-15). The communal dining room and waiting rooms may be on the first floor (Fig. 15-20). Upper floors have symmetrical, separated retiring (sleeping) rooms and sitting rooms for men and women (Fig. 15-20, 15-26). Some dwellings have small weaving or spinning shops on upper levels. Finished attics usually have built-in storage for out-of-season bedding and clothing.

■ *Site Orientation*. Shaker villages often begin on the farm of a new convert. They usually align with or intersect a main road in rural areas to maintain isolation from the world but still have access to a town. Generally, main buildings line the major road with secondary buildings behind them (Fig. 15-2, 15-6). The meetinghouse is centrally placed and the dwelling of the First or Central Family is across from it or nearby. (The Central Family is made up of people most devoted to the faith, hence their location near the house of worship.) Other dwellings, also

named by their locations, scatter throughout the community. Workshops and support buildings surround each dwelling. Diversity in layout as well as the number and types of buildings in Shaker villages reflects the makeup of each group. Shakers vigorously adapt the landscape by clearing trees and brush, building ponds, diverting streams, and planting crops.

■ *Materials*. Building materials vary with regions. Following the example set at Mount Lebanon, meetinghouses are of clapboards, although other materials are occasionally used (Fig. 15-4). Dwellings may be wood, brick, limestone, or granite. Kentucky and New Hampshire Shaker families build in brick and limestone (Fig. 15-9, 15-10). Ammi B. Young, a prominent but non-Shaker architect, designs a granite dwelling house for the Enfield, New Hampshire, group. Meetinghouses are painted white to stand out among the other structures. Dwellings and other structures may be yellow, red, brown, or tan. In the late 19th century, most buildings are painted white despite earlier prohibitions. Wooden barns may be painted black.

■ *Façades*. All façades are plain and unadorned like the Shakers and their lives (Fig. 15-4, 15-7, 15-10). Millennial Laws mandate rectangular forms and straight walls. There are no pilasters, quoins, columns, or fancy moldings. Some buildings in western communities reveal a bit of embellishment such as cove or bead moldings. Façades of meetinghouses and dwellings are symmetrical to reflect order. Workshops and other utilitarian buildings have windows where needed. Most dwelling houses have a cupola or belfry for the bells that announce times for rising, dining, working, meeting, and retiring (Fig. 15-7, 15-9).

■ *Windows*. Large sash windows with shutters are typical (Fig. 15-8, 15-10). Stone lintels surmount windows in brick or stone buildings. A few Palladian or arched windows appear in the 1840s.

■ *Doors*. Most Shaker meetinghouses and dwelling houses have two entrances; the left is for Brothers and right for Sisters (Fig. 15-8, 15-10). The Mount Lebanon meetinghouse has a third door for the ministry leaders. Paneled doors have simple surrounds. A few entrances, such as in Pleasant Hill, Kentucky, have fanlights or side lights. Some may have rectangular transoms above them to let in light. Porches are rare, but eastern buildings have shed roofs over the entrances in the Anglo-Dutch tradition. Unique to Canterbury, New Hampshire, are small gable roofs with supports of curved brackets above doorways.

■ *Roofs*. Early meetinghouses have gambrel roofs with dormers (Fig. 15-6). Some later ones and those in the west have gable roofs (Fig. 15-10). Dwelling houses usually have gable roofs with dormers. The Mount Lebanon meetinghouse has an unusual and innovative curved roof (Fig. 15-4).

■ *Later Interpretations*. Modern houses built in the 1970s and onward display characteristics of Shaker design through their simplicity, orderliness, form, and craftsmanship (Fig. 15-12). Variations may appear in the use of more contemporary materials and forms.

INTERIORS

Shaker interiors exhibit uniformity, simplicity, function, and ease of maintenance through materials and furnishings. Wood and plaster are common materials, and there is little applied decoration and ornament. The characteristic

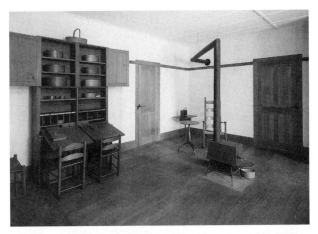

▲ **15-13.** Elder's Room, Main Dwelling House, c. 1820s–1850s; Hancock, Massachusetts.

▲ **15-12.** Later Interpretation: Mayer House, 2004; Anchorage, Alaska; Mayer Suttle-Smith.

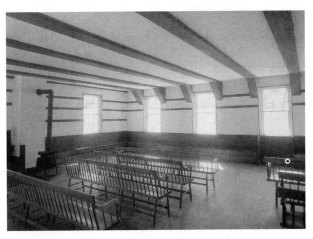

▲ **15-14.** Meeting room, Community Meetinghouse, Sabbathday Lake Shaker Village, 1884; New Gloucester, Maine; Moses Johnson.

DESIGN PRACTITIONERS

In keeping with Shaker beliefs, design practitioners do not exclusively build or make furniture. They serve wherever the society needs them, performing tasks associated with the need. Many are not only cabinetmakers but builders, printers, tailors, engineers, farmers, or elders.

- **Henry Clay Blinn** (1824–1905) joins the Canterbury, New Hampshire, Shakers in 1838. Blinn has many occupations from printer to tailor to stonecutter to cabinetmaker. He is known for his sewing desks, one of which is signed, and cupboards.

- **Micajah Burnett** (1791–1879) is the master planner and builder for the Pleasant Hill, Kentucky, group, which he joins in 1808. Burnett has some training as a carpenter and joiner before joining the Shakers and owns a library of architectural pattern books. Spiral staircases and arched fan windows are details found only in Burnett's work.

- **Henry Green** (1844–1931) works in Alfred, Maine, and is one of the last great Shaker craftsmen. Cabinetmaking is his main occupation between 1870 and 1890. Although some pieces follow earlier, simpler traditions, Green's later pieces are more elaborate, revealing awareness of late-19th-century furniture trends.

- **Moses Johnson** (1752–1842) enters the Canterbury Shaker Village, New Hampshire, community in 1792. Because he previously served an apprenticeship as a carpenter and joiner, he is called to Mount Lebanon, New York, to build the first meetinghouse because it sets the pattern for these important Shaker structures. Johnson subsequently builds 10 more meetinghouses for communities in New York and New England.

- **Amos Stewart** (1802–1884) is a cabinetmaker in New Lebanon, New York, for more than 60 years. Several pieces signed by Stewart survive. Details in his work reveal the skill and care of a master craftsmen.

- **Isaac Newton Youngs** (1793–1865) comes from a family of clockmakers and becomes a well-known clockmaker for the New Lebanon, New York, Shakers. Youngs makes both tall case and wall clocks.

built-in cupboards and drawers provide storage and a way of controlling behavior. The limited storage encourages sharing and discourages accumulating possessions. Most rooms are sparsely furnished with a mixture of Shaker-made and other furniture brought by new converts. The Millennial

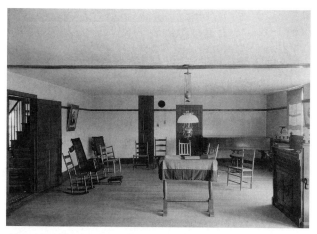

▲15-15 Meeting room, Family Dwelling House, 1824; New Lebanon, New York; Moses Johnson.

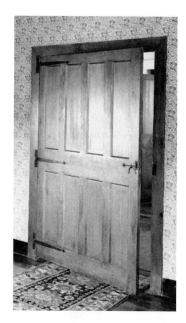

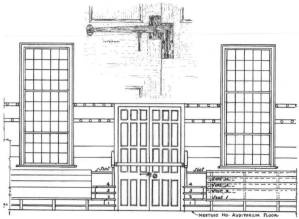

▲15-16. Door, window, and hardware details and storage walls, c. 1830–1850s; New York.

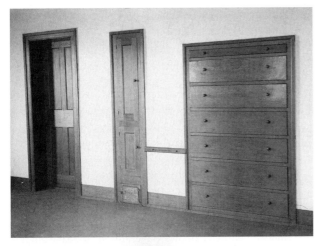

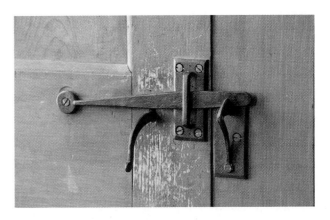

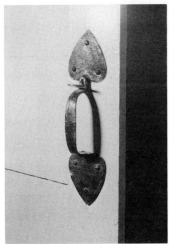

▲ **15-16.** *(continued)*

wallpaper, carpet, and horsehair upholstery as well as walnut or mahogany furniture. By the end of the 19th century, other Shaker interiors also begin to have wallpaper, carpet, and more upholstered and ornamented furniture.

Public and Private Buildings

■ *Types.* The most common types of spaces are worship areas, meeting rooms, and retiring rooms.

■ *Relationships.* Like exteriors, interiors are simply treated and plainly furnished. They are planned to facilitate work and worship and to separate the sexes.

■ *Color.* Common colors for wood trim include Prussian blue in the meetinghouse, blue, brown-red, yellow ocher, green, and black in other spaces. Walls are always pristine white in dwellings and meetinghouses (Fig. 15-20, 15-26).

■ *Lighting.* Light is important to the Shakers, so large windows illuminate spaces during the day (Fig. 15-14). Interior windows in strategic spots bring light into rooms without windows. Like others of their time, Shakers use lamps and candles for artificial lighting. Fixtures and holders are simple in design. Always progressive, Shakers install gas and electricity for lighting when available (Fig. 15-15).

Laws define room furnishings for uniformity and specify rules for their placement to prevent individuals from arranging spaces for themselves. Exceptions are the spaces for visitors located in trustee office buildings, which may have

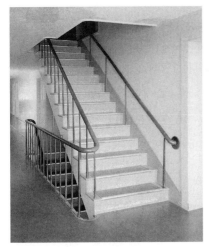

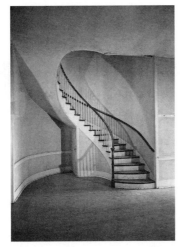

▲ **15-17.** Stair halls, 1830s–1850s; Enfield, New Hampshire, and Pleasant Hill, Kentucky.

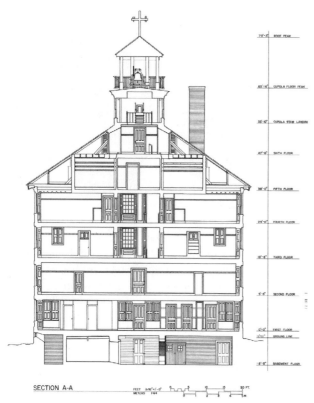

SECTION A-A

▲ 15-18. Section, Family Dwelling House, 1841–1846; Enfield, New Hampshire; Moses Johnson.

■ *Heating.* Most rooms have Shaker-built cast-iron stoves that protrude into the room space instead of fireplaces (Fig. 15-13, 15-14, 15-19, 15-20).

■ *Floors.* Floors are wood planks (Fig. 15-13, 15-19, 15-20). Millennial Laws prescribe that floors, if painted or stained, should be reddish yellow. Only those in the meetinghouse are polished. Kitchens and other utilitarian spaces may have stone floors for easy cleaning. Linoleum becomes typical in the second half of the 19th century. Rag, braided, woven, hooked, knitted, or crocheted rugs may cover floors (15-16, 15-20). Linen, wool, or cotton rugs are colorful combinations of orange, yellow, green, black, brown, rose, and purple. Blue and red are especially favored. Rugs may

be round or rectangular and come in many sizes from long runners to rectangles shaped to fit various spaces. Painted floor cloths sometimes cover floors in the first half of the 19th century, whereas some rooms have ingrain carpets in the late 19th century.

■ *Walls.* Walls are white plaster with painted wooden trim (Fig. 15-13, 15-15, 15-19, 15-20). Some rooms have paneled dadoes (Fig. 15-14). About three-quarters of the way up the wall is a narrow board with pegs for hanging clothing, possessions, lighting, and even chairs (Fig. 15-15, 15-19, 15-20, 15-21). Although function is primary, the peg board adds an architectonic element to interiors. Most spaces, including attics, have built-in storage drawers and cabinets (Fig. 15-16, 15-19).

■ *Windows.* Most windows have simple wood trim surrounding them (Fig. 15-16, 15-19, 15-20). Windows often have simple curtains hanging from rods in the lower half. Curtains usually are plain white linen or cotton, although some are green or blue. The color red, checks, plaids, and stripes are prohibited.

■ *Doors.* Interior doors are usually wood and have simple wood molding surrounds that contrast in color to walls (Fig. 15-15, 15-16). Many have transoms to allow light into interior rooms. The Center Family Dwelling House in Pleasant Hill, Kentucky, has arched doorways (Fig. 15-20).

■ *Textiles.* Household textiles may be homemade or purchased. Those made by the Shakers are well executed and carefully planned with symmetry and nonrepresentational patterns. Colors are bright, not drab, and never flashy. Other textiles include splash cloths behind washstands and wall cloths near beds for warmth.

■ *Ceilings.* Ceilings are plain white (Fig. 15-7, 15-20). Most are flat, although one in Pleasant Hill, Kentucky, is arched. Meetinghouse ceilings are often beamed to support large open spaces.

■ *Later Interpretations.* Functional, sparsely furnished Shaker rooms appeal to modern designers who eschew ornament, pattern, and decoration. They also admire Shaker attention to detail and planning. Rooms throughout the 20th and into the 21st centuries emulate Shaker concepts with wood floors, white walls and ceilings, and colorful trim.

DESIGN SPOTLIGHT

Interiors: Dwelling room with storage wall, Family Dwelling House, 1841–1846; Enfield, New Hampshire. The walls of this room feature typical Shaker treatments of white plaster and painted woodwork. Reflecting Shaker concern for neatness and cleanliness, the peg board or rail holds furniture, clothing, and other items. A small Shaker-designed cast-iron stove supplies heat. The storage wall is a Shaker innovation. These built-in arrangements of drawers and cupboards allow the many believers residing in dwelling houses to store out-of-season clothing, bedding, and other possessions. Larger communities often have entire rooms devoted to storage. As is usual, no patterned fabrics, framed pictures, mirrors, decoration, or excess furniture mar the simplicity or encourage pride or worldliness among the brethren who live here. Other interior spaces copy these design concepts so the building interiors appear as a unified whole.

DESIGN SPOTLIGHT

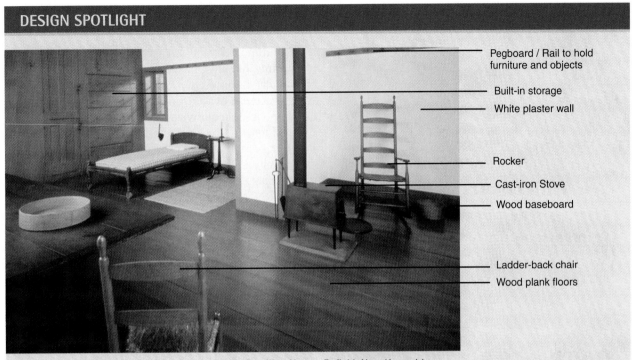

- Pegboard / Rail to hold furniture and objects
- Built-in storage
- White plaster wall
- Rocker
- Cast-iron Stove
- Wood baseboard
- Ladder-back chair
- Wood plank floors

▲**15–19** Dwelling room with storage wall, Family Dwelling House; Enfield, New Hampshire.

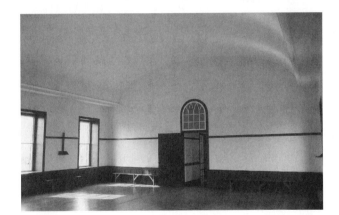

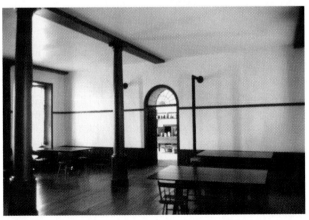

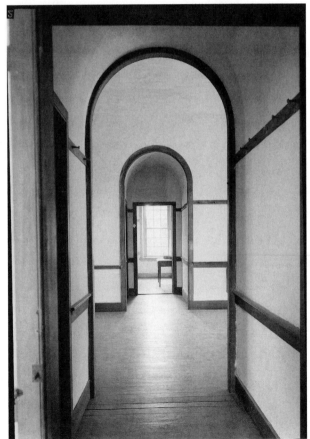

▲**15–20.** Meeting room, hall, dining room, kitchen, and sleeping room, Center Family Dwelling House, Shaker Village of Pleasant Hill, 1820s–1850s; Harrodsburg, Kentucky; Micajah Burnett.

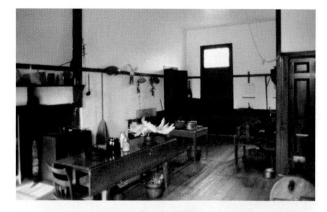

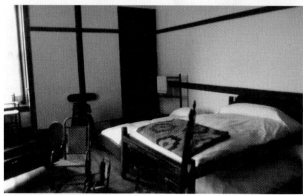

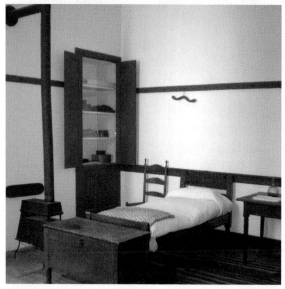

▲ 15-20. *(continued)*

DESIGN SPOTLIGHT

Furniture: Side and dining chairs, early to late 19th century. Although similar to American Colonial or vernacular furniture, simplicity and refined proportions characterize Shaker furniture, reflecting the community's belief in purity and a simple life. No carved embellishment, veneers, or painted decorations obscure form or multiply housekeeping tasks. The plainness of the chairs (and other furniture) encourages unity by discouraging individuality. Following the Civil War, Shakers find a ready market for their chairs in the outside world.

▲ 15-21. Side and dining chairs, early to late 19th century.

the community, although some pieces are made for individuals, such as the aged. Rooms are sparsely furnished because accumulating possessions is believed to engender worldliness and pride. Shaker artisans do not sign their furniture but often apply number and letter codes to indicate in what room a piece belongs and/or for whom it is made.

There is little distinctive Shaker furniture before 1800. After that time, Shaker craftsmen begin to adapt standard types to their lifestyles. After 1860, furniture is no longer made in the western communities, and some is marketed to the world in New England and New York. Following the Centennial International Exhibition in 1876 in Philadelphia, interest in handcrafted furniture sparks great interest in Shaker furniture, the sale of which becomes a major source of income for the group. Market furniture is offered in fewer types. Chairs and rockers are the most common. They come in several standard sizes and different finishes. A distinctive aspect of Shaker furniture is the variety of colored tapes used for seats and cushions.

The simplicity of Shaker furniture reflects the simple lifestyle as well as the humble, working-class backgrounds of

FURNISHINGS AND DECORATIVE ARTS

Shaker furniture, like architecture and interiors, reflects their belief system and supports their lifestyle. Plain and utilitarian, movable and built-in furniture is uniform in appearance and distribution among members. The Millennial Laws prescribe what furnishings each member should have so that no one has more or less than anyone else. All furnishings belong to

most members who are unfamiliar with high-style furnishings. Furniture is practical and easy to clean and maintain. Because Shakers equate beauty with utility, furniture is designed to suit the user or users and the task. Dimensions are adapted to individuals or community requirements. For example, dining tables are made in different sizes, and some can accommodate up to 20 diners. Craftsmen often make multiples of pieces for uniformity and invent new forms to accommodate changes in technology or work requirements. Shaker belief in work as worship yields perfection of proportion and craftsmanship. Materials are used appropriately

and honestly. Because ornament is considered worldly, furniture has little. Nothing superfluous is allowed to disturb the beauty of proportions and craftsmanship.

Public and Private Buildings

■ *Types.* Worship spaces have little furniture except seating located on one end. Meeting rooms may have benches or settees, or believers may bring their own chairs (Fig. 15-14, 15-15, 15-21). Retiring or sleeping rooms have a bed, a chair, and storage for each inhabitant, and a communal washstand and a table or candlestand (Fig. 15-19, 15-20). There is no padded upholstery until the late 19th century.

■ *Distinctive Features.* Shaker furniture is light in scale and distinguished by simplicity, excellent proportions, and no applied ornament. Infinitely practical in design, its form, silhouette, and material provide beauty. Furniture from the eastern groups is lighter and more austere than is western furniture, which is heavier with some embellishment.

■ *Materials.* Eastern furniture is of pine, maple, birch, ash, cherry, hickory, and butternut. That made in western villages is of walnut, cherry, beech, or poplar. Shakers use no veneer, inlay, marquetry, or graining. Sometimes, drawer

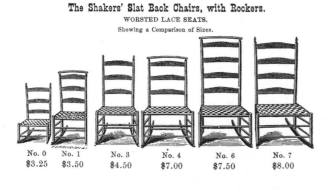

The Shakers' Slat Back Chairs, with Rockers.
WORSTED LACE SEATS.
Showing a Comparison of Sizes.

| No. 0 | No. 1 | No. 3 | No. 4 | No. 6 | No. 7 |
| $3.25 | $3.50 | $4.50 | $7.00 | $7.50 | $8.00 |

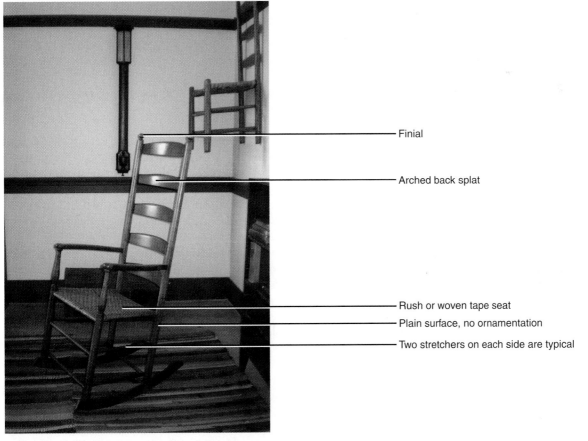

▲ **15-22.** Rocking chairs, early to late 19th century.

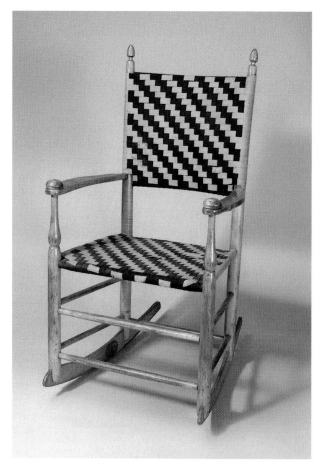

▲ **15-22.** (Continued)

▲ **15-23.** Trestle table, early to late 19th century.

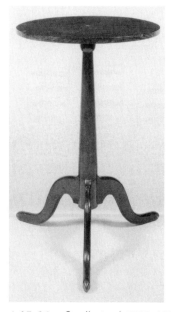

▲ **15-24.** Candlestand, 1790–1830; Connecticut.

fronts, tabletops, or entire pieces are of figured woods, such as curly maple or flame cherry. Early furniture is stained or painted red, blue, or yellow. Later pieces are simply varnished. Mushroom-shaped knobs for cupboards or drawers are of wood because brass is considered worldly.

■ *Seating.* Shaker seating includes chairs, rockers, settees, and benches (Fig. 15-14, 15-15, 15-19, 15-20). Ladder-back chairs and rockers (Fig. 15-21, 15-22), the most common type of seating, display regional differences in materials and appearance. Other types include low-back chairs with one or two slats to enable them to be pushed under dining tables or hung from the peg rails, high-legged chairs used by weavers, and revolvers, which have a rotating seat. Legs usually are cylindrical, one piece of wood, and may taper near the floor. After 1825, back legs often have a tilter, a Shaker innovation of a flat bottom ball that allows the chair to lean backward yet remain stable on the floor. Two stretchers on all four sides is typical. Back slats are usually arched and may graduate in size. A rounded cushion rod may surmount the uppermost slat. Finials, used as hand grips, vary in shape, and their distinctive shape may indicate where the chair is made. Arms may be flat, slightly curved, or rolled with mushroom-shaped or round handholds. Seats are planks, rush, cane, splint, or colored tape. Shakers weave cotton tape for seats until 1850 when they begin to purchase it. Colorful tapes may form patterns such as checkerboards or herringbone (Fig. 15-22). Rockers with and without arms resemble chairs. Benches and settees, used in meetinghouses and rooms, have shaped seats, tapering legs, and spindle backs.

■ *Tables.* Shakers make and use many different types of tables. Trestle tables are used for dining (Fig. 15-20, 15-23). Early trestles are chamfered with flat, tapered feet. Later ones are rounded or quadrangular with arches. Lighter than traditional examples, Shaker trestle tables have a heavy stretcher under the top. Most candlestands have round tops, a baluster support, and spider or arched legs (Fig. 15-24). Drop-leaf, work, and sewing tables usually have four slender, tapered legs and sometimes a drawer in the apron. Some work or sewing tables have a pull-out work surface and two sets of drawers on opposite sides to accommodate two or more users. Sewing desks, unique to the Shakers, rest on short legs and have several drawers with smaller drawers in the top gallery.

■ *Storage.* Shakers use both movable and built-in storage (Fig. 15-16, 15-19, 15-20, 15-25). Large Shaker families

▲ **15–25.** Chest of drawers, early to late 19th century.

▲ **15–26.** Interior with bed, early to late 19th century.

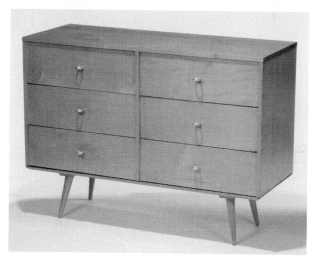

▲ **15–27.** Later Interpretation: Planner Group chest of drawers, 1960s; Massachusetts; Paul McCobb, manufactured by Winchendon Furniture Mfg.

require great amounts of storage, so built-ins may fill attic spaces and be fitted into odd or small spaces such as corners or under stairs or eaves. Built-ins may consist of only drawers or can combine drawers and cupboards. Function determines the arrangement and size of drawers and cupboards. Drawers are plain with no moldings or embellishment and simple wooden knobs. Early cupboard panels are raised, whereas later ones are flat with quarter-round edges

for greater simplicity and ease of cleaning. Chests of drawers have simple silhouettes and no embellishment, including no escutcheon plates around keyholes (Fig. 15-25).

■ *Beds*. Beds parallel developments in Shaker history. Early on, two adult brothers or sisters or several boys or girls sleep in double beds to accommodate as many people possible in little space or to use furniture brought by converts. Trundle beds are common during the height of Shaker membership to conserve space and to help care for the sick. As membership declines, narrow, single beds prevail. Simple in design, beds have cylindrical legs, low headboards, and stretcher footboards (Fig. 15-19, 15-20, 15-26). They are often on wheels to make moving easier. The Millennial Laws prescribe green for bed colors. In the infirmary, adult-sized cradles gently rock the sick and help prevent bed sores.

■ *Decorative Arts*. Accumulating and displaying possessions are incompatible with Shaker beliefs and lives, so rooms typically have no decorative accessories, except possibly a painting or scroll. The Millennial Laws forbid pictures and paintings, although they do permit a single, small mirror in retiring rooms. At first, clocks also are forbidden, but later the elders realize that time pieces help maintain orderly lives. Many communities have a tall case clock in the hall of their dwelling houses and in their shops and barns. Shakers do not make their own tablewares, but purchase plain, white utilitarian ceramics. The Shakers are known for the elegance and beauty of their baskets and oval boxes that they make in various sizes and shapes (Fig. 15-3). Toward the end of the 19th century Shaker dwellings have more accessories, a reflection of the lessening of rigid laws.

■ *Later Interpretations*. During the mid-20th century, designers such as Paul McCobb interpret the concept of Shaker simplicity in their furniture designs (Fig. 15-27). During the early 21st century, Shaker-style furniture is extremely popular, as reproduced or interpreted by various manufacturers. Plain, unadorned, simple Shaker forms are adapted for dining rooms, living rooms, and bedrooms and made in types and materials unknown in their day.

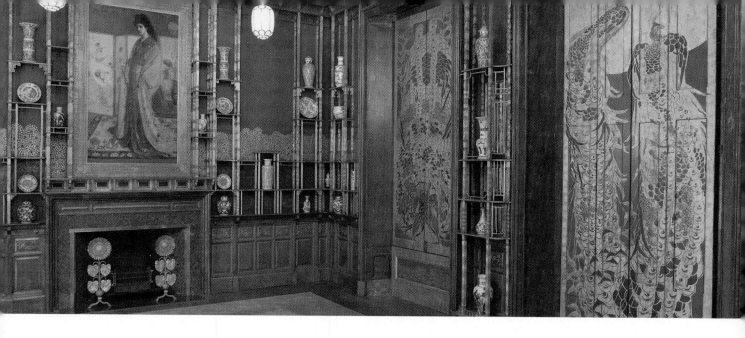

CHAPTER 16

Aesthetic
Movement

1860s–1890s

The Aesthetic Movement attempts to reform design through education of artistic principles. Not a single style but an attitude or philosophy, the movement draws upon many styles and cultures for inspiration and largely rejects the idea that art should serve a higher, moral purpose. Followers see no division between the fine and decorative arts, so they introduce principles of Art into interiors, furniture, textiles, accessories, and other areas. Primarily focused on the ordinary home, the movement inspires artistic interiors and furniture in England and the United States. Lasting only about two decades, the Aesthetic Movement brings changes with immediate and far-reaching influences.

The ceiling is frescoed in bold work of black and gold of unsymmetrical design. The walls are paneled with Japanese painted stuffs framed in gilt bamboo, and the frieze is a continuous band of brilliant figures on paper crêpe. Over the doors, and in the spaces where the tint of wall is flat, fans of brilliant colors have been tastefully displayed. A table in blue and white, and red lacquer saucers inserted in the dull black wood of the furniture, help the effect.

William A. Hammond House, *The Art Amateur*, June 1879 (description of Japanese bedroom)

Whistler's house in Tite Street, Chelsea, built for him by Godwin, had white and rich yellow walls, Japanese matting on the floors, plain curtains in straight folds, some pieces of Chinese porcelain, and a few simply framed pictures and etchings.

Nicholas Pevsner, *Pioneers of Modern Design*, 1974

The reign of Japanese colouring in English art still continues, even where the beneficial influence takes other names. That our recognition of the artistic merits of Japan did not stop short at colour was matter of course; but some of our cynical Goths may perhaps have wondered sometimes why we did not proceed to imitate paper dwellings and "quaint" joss-houses in our fashionable building.

James Ferguson, *History of the Modern Styles of Architecture*, Vol. II, 1899

HISTORICAL AND SOCIAL

The Aesthetic Movement arises from a desire to reform the home and its design following London's Great Exhibition, Crystal Palace, 1851. The movement begins to take form

when poet Charles Algernon Swinburne and writer Walter Pater bring the cult of Aestheticism to England from France in the 1860s. Finding a sympathetic audience in the artists and designers of the Pre-Raphaelite Brotherhood and others, their discussions of aesthetics begin to take a

different, less moralistic direction in contrast to other reform ideas and movements.

Many adherents of the Aesthetic Movement follow Matthew Arnold's *Culture and Anarchy*, which defines two groups according to their taste and ability to appreciate art. The more important group is the Aesthetes, who enjoy "artistic" sensibilities. In contrast stand the Philistines, members of the middle class, who possess little or no appreciation for or capacity to assess beauty. Crass materialists, Philistines lack the high-minded, artistic natures of the Aesthetes. The most aesthetic Aesthetes, such as James A. M. Whistler and Oscar Wilde (Fig. 16-1), reject everything admired by the Philistines. They esteem delicacy, refinement, soft colors, anything old, and the young. Although the more radical group remains small, many others in England during the 1870s are inspired to cultivate their artistic sensibilities to live in beautiful surroundings. In the United States, the Aesthetic Movement is at its height in all levels of society from the mid-1870s to the mid-1880s. The Centennial International Exhibition of 1876, publications, and visits from Aesthetes, such as Wilde, introduce the American public to English artistic precepts.

Aesthetic discussions of what constitutes beauty inspire various artists, designers, and architects to establish principles based on usefulness, color, form, and ornament to assess the beauty of an object or artwork. With missionary passion, followers set out to reform taste through example and publication. Firms, artists, and designers create "Artistic" rooms and design "Artistic" furniture. Others advance the movement through lectures, plays, and novels. The well-known Liberty's Department Store in London as well as other department stores sell "Art Furniture," and local and imported "Artistic" goods reflective of the Aesthetic taste. Numerous books and periodicals serve as guides and educate the public on matters of design and taste. *Hints on Household Taste*, by Charles Locke Eastlake published in 1868 and running to numerous editions, begins a deluge of books by artists, designers, and dilettantes offering advice on decorating and furnishing the home. Artistic journals include *The Decorator and Furnisher*, New York, and *The House, An Artistic Monthly for Those Who Manage and Beautify the Home*, London. The movement also inspires various art societies and groups in England and America who spread its tenets. One outgrowth of the Aesthetic Movement's passion for education comes from the affluent who, believing in noblesse oblige, sometimes open their homes for tours by lesser folk. In addition, it is during this period that the wealthy patrons' collections of art and objects often form the basis for public museums. The Aesthetic Movement also gives rise to the Household Art Movement or Art at Home.

Women are especially important in the Aesthetic Movement as the focus of reform and as transmitters of reform. Critics, many of whom are female, devote their attention to housewives. They now bear the duty of decorating their homes artistically to demonstrate the family's culture and taste and responsibly to create a wholesome environment and refuge to counter the negative effects of contemporary life (Fig. 16-2). This new role, coupled with the emphasis upon education, prompts many women to become artists, designers, decorators, and critics. Not only do they create artistic goods and interiors, but they also write books and articles to assist other women in doing the same. They form and participate in art groups, such as china painters or embroidery societies, as leisure activities or to produce an income. Some of these groups exert important and longlasting effects on art education by establishing art schools or museums.

Regarded by some as an excuse for excess and self-indulgence, Aesthetes and the Aesthetic Movement are ridiculed in the press and become the subject of numerous satirical articles, cartoons, songs, and even an opera, *Patience*, by Gilbert and Sullivan. Nevertheless, the movement has positive effects on design, the home, and, more important, the way people think about them. The deemphasis of styles helps loosen the grip of historicism. Promoting principles of "Art" increases awareness that art is important in all areas of life, which in turn helps to promote the worth of an object as deriving from its intrinsic beauty instead of its associations. By the 1880s, the Aesthetic Movement begins to move in other directions, such as the Arts and Crafts Movement and Art Nouveau. However, discussions about beauty and the pursuit of excellence in design continue long after the Aesthetic Movement ends. Its ideas influence subsequent movements.

CONCEPTS

The Aesthetic Movement advances the idea that good taste is not ostentatious display, but careful planning based on educated knowledge of artistic principles and historic precedents. Consequently, taste can be acquired through learning the principles of art and applying them to everyday life. Developing from various artistic theories, the movement does not distinguish between the fine and decorative arts but emphasizes beauty and usefulness for all forms of expression, particularly the home. Thus, it elevates decoration and furnishing to a high Art, ennobling them with purpose above mere fashion, novelty, or conspicuous consumption. Adherents believe that each surface, object, or pattern provides an encounter with Art and, as such, must be carefully chosen and placed or arranged. Some reject the idea that art should have a moral purpose and avow a credo of "Art for Art's Sake"—the idea that art and beauty, above all, should give pleasure in

◄16-1. Oscar Wilde, c. 1882.

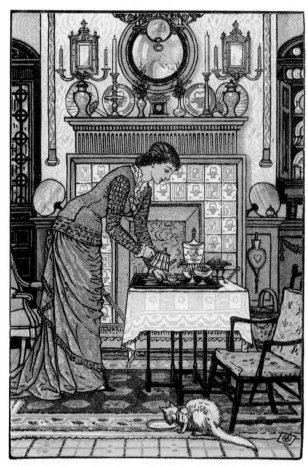

▲16-2. "My Lady's Chamber"; published in *The House Beautiful*: *Essays on Beds and Tables, Stools and Candlesticks*, 1878; Clarence Cook.

IMPORTANT TREATISES

- *The Aesthetic Movement in England,* 1882; Walter Hamilton.

- *Art Decoration Applied to Furniture,* 1878; Harriet Prescott Spofford.

- *Art Furniture with Hints and Suggestions on Domestic Furniture and Decoration,* 1877; Edward W. Godwin.

- *Culture and Anarchy,* 1869; Matthew Arnold.

- *The Gentle Art of Making Enemies,* 1888; James A. M. Whistler.

- *Hints on Household Tastes,* 1878; Charles L. Eastlake.

- *The House Beautiful: Essays on Beds and Tables, Stools and Candlesticks,* 1878; Clarence Cook.

- *Intentions,* 1891; Oscar Wilde.

- *Japan, Its Architecture, Art, and Art-Manufactures,* 1882; Christopher Dresser.

- *Japanese Homes and Their Surroundings,* 1886; Edward S. Morse.

- *Principles of Decorative Design,* 1873; Christopher Dresser.

- *Principles of Home Decoration,* 1903; Candace Wheeler.

- *Suggestions for House Decoration in Painting, Woodwork and Furniture,* 1876; Agnes Garrett and Rhoda Garrett.

- *Studies in the History of the Renaissance,* 1873; Walter Pater.

which one should freely indulge. In contrast to the English, Americans cannot completely reject the moral purpose of art, but they do accept the notion that Art is good for them.

Preferring no style above any other and avoiding historicism, the Aesthetic Movement internationalizes design by drawing upon scores of styles and cultures, most of which are preindustrial, a signal of its rejection of contemporary values. Sources of inspiration include Greece, Rome, the Middle Ages, Italian Renaissance, vernacular traditions, and the arts of Japan, China, India, and the Near East. From nationalistic frevor and to promote its own culture above that of others, the English movement scrupulously avoids anything French as the embodiment of false principles of design in its curvilinear silhouettes and decoration, veneers and graining, naturalistic shading of flowers and plants, and overornamentation.

The movement stimulates artistic activity and opportunities for collaboration among designers in both England and the United States. Designers, artists, and architects come together to create artistic architecture, interiors, furniture, and decorative arts. Their roles change and expand.

Architects not only routinely design the building but also the interiors, furniture, wallpaper, textiles, and accessories. Painters and sculptors also design interiors or furniture. Designers publish books of ornament drawn from every culture.

The terms *Art* and *Artistic* signal aesthetic sensibilities early in the movement's development. By the late 1870s and 1880s, the terms become synonymous with the latest fashion, and anyone and everyone uses them to appeal to consumers. Architecture, interiors, furniture, and accessories are never described as *Aesthetic*, but rather as *Artistic*.

DESIGN CHARACTERISTICS

There is no specific architectural style called the Aesthetic Movement, so most of the design characteristics appear in interiors. Important design principles include asymmetry, unity, harmony, and contrast. Simplicity, as

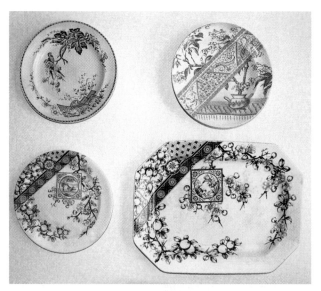

▲ **16-4.** Plates, 1870s–1880s; England.

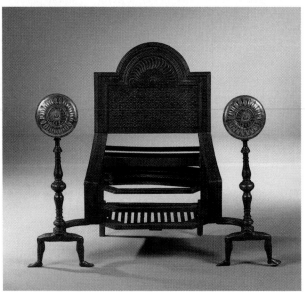

▲ **16-3.** Sunflower decorative screen, 1876, by Barnard, Bishop, and Barnards; andirons c. 1870s, by Thomas Jeckyll; England.

defined by the period, and eclecticism also are typical. Characteristics of Artistic interiors include tertiary colors; a variety of patterns on walls, floors, ceilings, furniture, and accessories; wooden floors with area rugs; portieres and banded curtains hanging from rings on rods; and furniture and accessories from different periods, cultures, and styles. Art Furniture, inspired during this time, reflects Anglo-Japanese (Fig. 16-32, 16-34), Eastlake, and vernacular expressions. Also important and characteristic are needlework and other crafts that show off the talent of the lady of the house (Fig. 16-39, 16-41).

■ *Motifs.* Motifs include sunflowers, peacock feathers, lilies, paisley, flowers, leaves, Japanese forms, insects, butterflies, and birds (Fig. 16-3, 16-4, 16-16, 16-18, 16-19, 16-28, 16-32, 16-38, 16-39).

ARCHITECTURE

Although there is no specific architectural style called Aesthetic Movement, Queen Anne and Old English in England and Queen Anne in North America are associated with it. Architects and designers working in those styles often share Aesthetic concerns, from which their designs arise (Fig. 16-6). The movement inspires far-ranging effects in architecture and subsequent stylistic developments in both England and America. Immediate changes include a new diversity of sources, including Japan and vernacular traditions (Fig. 16-5). New open planning and simplicity in the United States will affect later styles such as Shingle and Arts and Crafts. The emphasis upon vernacular traditions also helps open the door for the

IMPORTANT BUILDINGS AND INTERIORS

- **Chicago, Illinois:**
 - —Japanese Ho-o-den Pavilion, World's Columbian Exposition, 1893.
- **London, England:**
 - —James A. M. Whistler residence, White House, Tite Street, 1877; Edward W. Godwin.
 - —Dining room, Frederick Leyland House (now located in the Freer Gallery, Washington, D.C.), 1876–1877; Thomas Jeckell and James Abbott McNeill Whistler.
- **Newport, Rhode Island:**
 - —Mr. Wetmore's bedroom, Château-Sur-Mer, 1851–1852, enlarged 1872; interiors by Seth Bradford, house enlarged by Richard Morris Hunt.
- **New York City, New York:**
 - —Veteran's Room and Trophy Room, Seventh Regiment Armory, 1879–1880; interiors by Louis Comfort Tiffany and Associated Artists, and the building by Charles V. Clinton.
 - —Japanese Room, W. H. Vanderbilt House, 1879–1882; Charles B. Atwood at Herter Brothers.
- **San Diego, California:**
 - —Entry hall and drawing room, Villa Montezuma, 1887; Comstock and Trotsche.

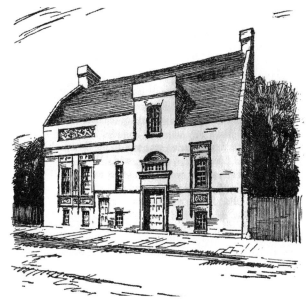

▲ **16–6.** James A. M. Whistler residence, White House, Tite Street, 1877; Chelsea, London, England; Edward W. Godwin.

on the west side of London becomes the first garden suburb and a haven for Aesthetes.

INTERIORS

The natural focus for the Aesthete is the home because it is the repository for the badly designed, poorly made goods that pervade the domestic market. Homeowners purchase them in great numbers. Reformers believe that

Colonial Revival in the United States and the preservation movements in both England and America. Garden suburbs, inspired by the Aesthetic Movement, profoundly affect urban planning and landscape. In 1876, Bedford Park

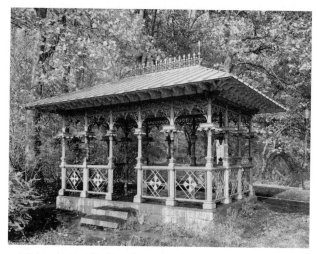

▲ **16–5.** Ladies' Pavilion, Central Park, 1871; New York City, New York; J. Wrey Mould.

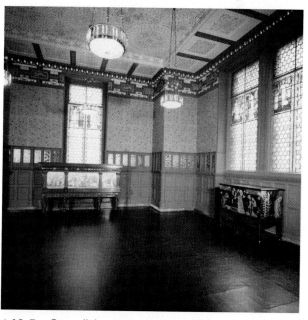

▲ **16–7.** Green dining room, 1867; located in the Victoria and Albert Museum in South Kensington, London, England; Philip Webb.

DESIGN PRACTITIONERS

- **Collinson and Lock** (1870–1897) is formed by Frank G. Collinson and George James Lock to manufacture Art Furniture. The English firm produces Anglo-Japanese furniture and furniture according to Eastlake's precepts and also decorates interiors. E. W. Godwin and William Burges, among others, execute designs for this firm. Important London commissions include the Savoy Theater and mansions for prominent citizens.

- **Walter Crane** (1845–1915) is a versatile English designer who creates artistic stained glass, textiles, wallpaper, tiles, ceramics, and embroidery. His most important contribution is in book design, especially children's books.

- **Christopher Dresser** (1834–1904), a prominent English designer, begins as a botanist but later turns to industrial design. Devoted to the arts of Japan, Egypt, and South America, Dresser designs furniture, pottery, textiles, glass, silver, metalwork, and wallpaper. He believes design should be free of historical associations, stylized, and derived from nature. Dresser's many publications influence designers from this and later movements.

- **Edward W. Godwin** (1833–1886) is an English architect, journalist, theater critic, set and costume designer, and designer of furniture, wallpaper, and textiles. Enamored with Japanese art, he is one of the first to decorate his home in a Japanese style and, along with Whistler, is the first to design Anglo-Japanese furniture. He and others form the Art Furniture Company in 1867. Homes for artists on Tite Street in London are some of his most original architecture.

- **Herter Brothers** (1865–1905) is a prominent furniture and interior decorating firm in New York City founded by Gustave Herter and Christian Herter, immigrants from Germany. The firm, which is known for high-quality craftsmanship and luxury, designs home interiors for the wealthy such as William H. Vanderbilt and Jay Gould. It also decorates banks, offices, and clubs in New York and across the United States.

- **Liberty and Company,** founded by Arthur Lazenby Liberty in 1875, is a London department store that carries fine household goods, textiles, and furniture. It specializes in Islamic and Oriental imports, but also features British manufactured goods. In 1883, Liberty sets up the Furnishings and Decorating studio. The Studio markets work by various artists, architects, and designers, including those in the Aesthetic and Arts and Crafts Movements.

- **Louis Comfort Tiffany and Associated Artists** is an interior decorating firm active between 1879 and 1883. Founded in New York City by Tiffany, members include the painters Samuel Colman and Lockwood de Forest and textile designer Candace Wheeler. The firm uses exotic materials and finishes and designs all parts of the interior. Important commissions include the home of Mark Twain and the White House for President Chester Arthur.

- **James Abbott McNeill Whistler** (1834–1903), an American painter and printmaker who spent his entire creative life in England and Europe, is one of the most controversial artists of the 19th century. As one of the leading theoreticians of the Aesthetic Movement, he promotes its precepts through his painting, prints, and interior decoration. He and Godwin design pieces for the furnishings firm William Watt that they exhibit in the Paris Exposition Universelle of 1878.

homeowners have little, if any, notion of good taste and are more concerned about fashion. Like other reformers, Aesthetic Movement adherents and writers advance the notion that choosing and arranging furnishings and finishes are critical to the comfort and well-being of the family. They insist that the home and its furnishings demonstrate the family's culture and social status, help to educate children, and influence character. For assistance in achieving these significant decorating goals, the wealthy look to architects; decorating firms such as Morris, Marshall, and Faulkner in London and Associated Artists in New York; or cabinetmaking firms such as

Herter Brothers in New York (Fig. 16-9, 16-15, 16-23, 16-25, 16-26). The middle class relies on the numerous decorating books to assist them in correctly decorating their homes and department stores like Liberty's in London that actively advance Aesthetic ideas.

Although designers and writers specify rules for decorating, they encourage personal expression through eclecticism balanced by unity and harmony. Especially important are principles of arrangement and composition, which are carefully studied and planned to give the most artistic result. Juxtapositions and contrasts are common, and simple forms

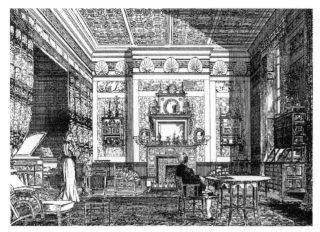

▲ **16-8.** Furniture designs for the Art Furniture Warehouse, 1877; London, England; by Edward W. Godwin.

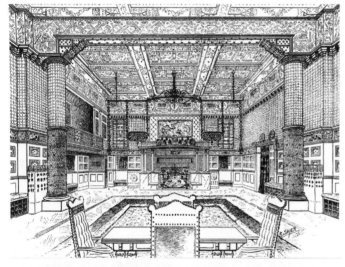

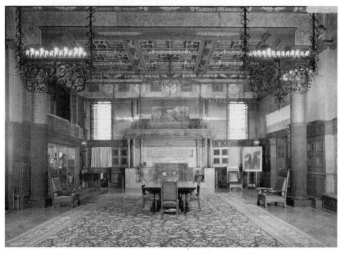

▲ **16-9.** Veteran's Room in the Seventh Regiment Armory, 1879–1880; New York City, New York; published in *Scribner's Monthly*, 1881; interiors by Louis Comfort Tiffany and Associated Artists, and the building by Charles V. Clinton.

▲ **16-10.** Lighting: Wall sconce and chandeliers, Seventh Regiment Armory, 1879–1880; New York City, New York; published in *Scribner's Monthly*, 1881; interiors by Louis Comfort Tiffany and Associated Artists.

▲ **16-11.** Japanese Tea Room, Congress Hotel, 1893; Chicago, Illinois; designed by William Holabird and Martin Roche, and decorated by Edward J. Holslag.

▲ **16-10.** *(continued)*

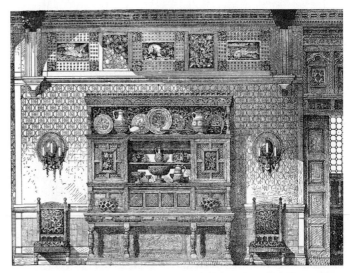

▲ **16-12.** Design for a dining room, 1870; exhibited at the Royal Academy in London, England; Bruce J. Talbert.

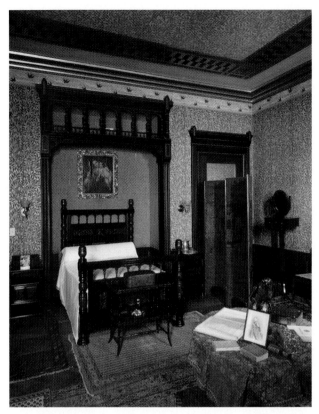

▲ **16-13.** Mr. Wetmore's bedroom, Château-Sur-Mer, 1851–1852, enlarged 1872; Newport, Rhode Island; interiors by Seth Bradford, house enlarged by Richard Morris Hunt.

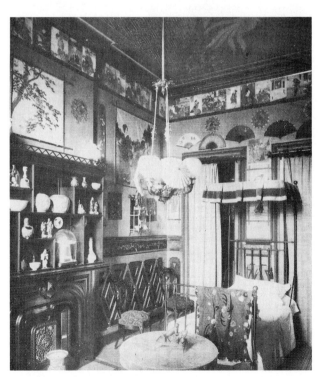

▲ **16-14.** Japanese bedroom, Dr. William A. Hammond House, 1873; New York City, New York; published in *Artistic Houses*, 1883.

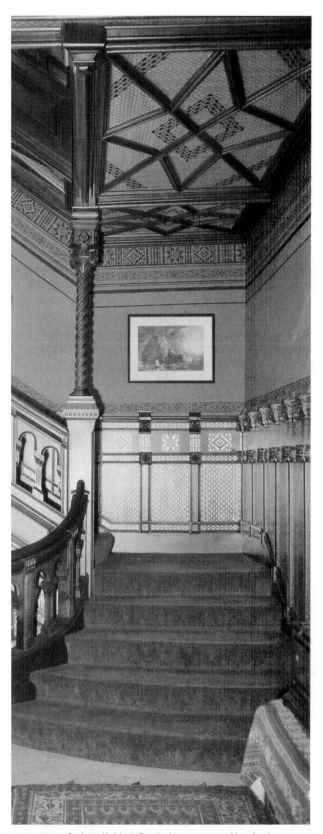

▲ **16-15.** Stair hall, Mark Twain House, 1874; Hartford, Connecticut; Edward Tuckerman Potter and Louis Comfort Tiffany and Associated Artists.

DESIGN SPOTLIGHT

Interiors: Dining room, Frederick Leyland House, 1876–1877; London, England (now located in the Freer Gallery, Washington, D.C.); Thomas Jeckyll and James A. M. Whistler. Thomas Jeckyll originally designs the room as a setting for Whistler's *Princesse de la Pays du Porcelain* and the shelving to accommodate Frederick Leyland's collection of Oriental porcelain. When the room is almost done, Jeckyll consults Whistler about the colors for the shutters and doors. Whistler, believing that the wall

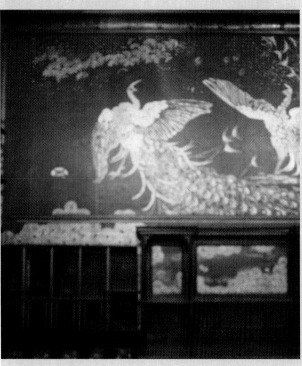

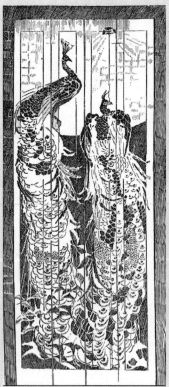

color clashes with the painting, volunteers to overpaint the walls and decorate the cornice. Like a true Aesthete, Whistler spends eight months redecorating the room in the manner he thinks appropriate, largely without Leyland's approval. He paints the antique Spanish leather wall coverings the present blue-green, gilds the shelving, and decorates the ceiling with gilded imitation vaulting, pendant lighting, and a pattern of peacock feathers. On the shutters and doors, he paints gold peacocks with lavish tails. He also invites friends and acquaintances to view his accomplishments while in process, which further antagonizes Leyland. When Leyland refuses to pay him what he asks, Whistler exacts revenge by depicting two fighting peacocks with a sack of gold coins at their feet. The downtrodden bird represents the artist and the angry one Leyland. The blue-green here is first used by Morris and Company in the South Kensington Museum and becomes a signature Aesthetic Movement color. Also characteristic of the Aesthetic Movement are peacocks, lavish patterns, Oriental porcelains, and the sunflower andirons adapted by Jeckyll.

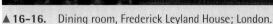
▲ **16-16.** Dining room, Frederick Leyland House; London.

DESIGN SPOTLIGHT

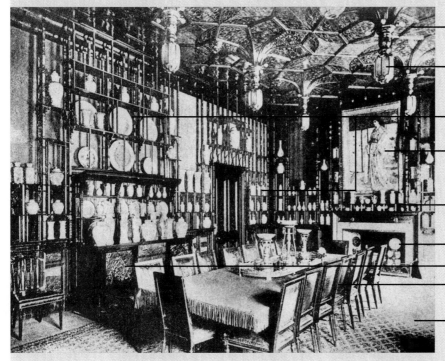

- Gilded imitation vaulting
- Pendant lighting
- Shelving for Oriental procelain
- *Princesse de la Pays du Porcelain,* painting by Whistler
- Shelving for display of Oriental porcelain in mantel area
- Sunflower andirons
- Anglo-Japanese sideboard
- Black and gold framed dining chairs
- Geometric patterned area rug

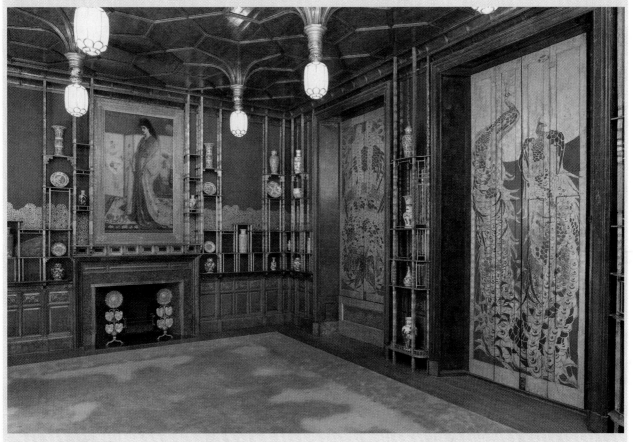

▲ 16–16. *(continued)*

often contrast with complex or multiple patterns. Patterns usually layer upon each other from floor to walls and their components to ceilings as well as to furniture and accessories. The movement advocates simplicity, but its highly patterned rooms seem cluttered and complicated to modern eyes. When compared with revival styles, Artistic rooms are somewhat simpler and may have fewer furnishings, but use a greater variety of patterns throughout.

Arising from the unification of the fine and decorative arts, pattern is regarded as so important that it is the focus of intense discussions to define the best patterns. Prominent artists and architects often create designs for wallpapers, textiles, floor coverings, or embroidery (Fig. 16-19). Naturalistic or geometric artistic patterns usually are flat, two-dimensional, and stylized with a bold outline and no shading following Pugin's earlier admonitions (see Chapter 6, "Gothic Revival"). Some examples may be more realistic, but the subtle shadings typical of French patterns are rigorously avoided. Asymmetrical patterns reflect the interest of designers in things Japanese.

In the 1870s and 1880s, Japan and the Aesthetic Movement are nearly synonymous. English and American designers who avidly collect Japanese prints and ceramics are inspired by their inherent simplicity, asymmetry, and unity. Japanese motifs, details, and decorative arts soon freely mix with other interior details and furnishings. No one considers a room complete without its Japanese pottery or porcelain, parasol, fan, kimono, and/or lantern. Textiles and wallpapers with Japanese motifs and asymmetrical designs add an exotic touch to Western rooms. Designers, such as E. W. Godwin and Charles F. A. Voysey, create Anglo-Japanese furniture inspired by Japanese design principles (Fig. 16-8, 16-32, 16-34, 16-37). Soon, manufacturers produce popular versions that bear little, if any, resemblance to Japanese design. Following or adapting principles of Japanese design is more important than re-creating her material culture.

Public and Private Buildings

■ *Types*. Through the influence of the Aesthetic Movement, the term *living room* gains prominence and begins to replace the term *parlor*, signaling a move to an inclusive and informal lifestyle. Similarly, the entrance hall becomes less formal than before, with open planning and inglenooks, reminiscent of settles, flanking a fireplace. The affluent tastemakers continue to incorporate conservatories and smoking rooms in their homes during the period (Fig. 16-25).

■ *Relationships*. There is little relationship between Artistic interiors and exteriors of buildings except for the Queen Anne style, which closely aligns with Aesthetic concerns mainly in England. The exteriors of a few Queen Anne houses have niches to display blue and white porcelain and are decorated with sunflowers. Artistic interiors appear in all house styles including those of the wealthy. Writers promote asymmetrical furniture arrangements as more useful and convenient and, therefore, beautiful.

■ *Color*. In reaction to the brilliant, almost gaudy, hues obtained from the newly introduced synthetic dyes in the 1840s and 1850s, Artistic colors are muted. Tertiary colors, such as blue-green, old gold, olive, terra-cotta, and drab or khaki, dominate the palette (Fig. 16-16). Some secondary colors are used. Japanese-inspired colors include golds, yellows, and reds.

Writers advance certain colors and color schemes for particular rooms. Because entrance halls have little light, they require lighter colors than other rooms. Appropriate dining room colors are rich and dark, although if used as family rooms, lighter colors are more appropriate. Drawing rooms, parlors, or living rooms should have light colors to create an Artistic atmosphere.

■ *Lighting*. As before, candles, oil lamps, and gas lamps light the home. Although electric lighting becomes available in the 1880s, few homeowners use it because it is notoriously unreliable. Most writers recommend candles over oil or gas lamps because candles produce a softer light and do not smell. Fixtures are made of glass, brass, bronze, wrought iron, or silver (Fig. 16-10, 16-16, 16-25, 16-28). Many have shades in the new Art Glass in unusual shapes, colors, and finishes.

■ *Floors*. Aesthetic writers, beginning with Eastlake, promote wood floors and area rugs despite the fact that manufacturers are producing greater quantities of less-expensive carpet (Fig. 16-16, 16-17, 16-25, 16-27). Reformers insist that wall-to-wall carpet is wasteful and cannot be moved to other rooms. Particularly important, carpet is difficult to clean. During the 1870s, germs are discovered to be the cause of disease, and reformers promote the idea that dirt and dust harbor germs and are a reason for discarding wall-to-wall carpet. If a house's wood floors are unappealing, parquet should replace them. If the homeowner cannot afford parquet, then writers suggest a wood carpet on the existing floor. Wood carpets, new on the market, are inexpensive thin strips of wood glued to muslin backing.

Hand-knotted Oriental rugs are preferred. Geometric Turkish rugs are to be used in the dining room and more curvilinear Persians in the drawing room. They are considered Artistic because of their irregularities and jewel-like colors. In response, manufacturers produce Brussels, Wilton, and ingrain in Oriental designs, which are called Art Squares. If a homeowner prefers wall-to-wall carpet, critics recommend small geometric, stylized patterns in muted colors (Fig. 16-21). The naturalistic and shaded floral floor coverings that Aesthetic and other reformers so despise continue as a popular choice of the middle class. Plain and

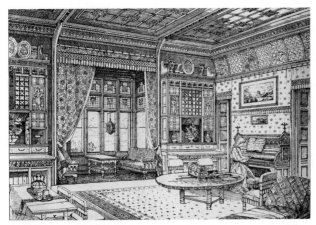

▲ **16-17.** Design for a drawing room, plate no. 35; published in *Examples of Ancient and Modern Furniture, Metalwork, Tapestries, Decoration*, 1876; Bruce J. Talbert.

patterned grass matting remains a summer or year-round floor covering.

Alternative floor coverings include ceramic tiles, linoleum, and kamptulicon. Frederick Walton invents linoleum in 1863 in England. It soon is used in kitchens and stairs in England and North America. Patterns imitate tile, wood, and ingrain carpet. Kamptulicon is the more expensive and less popular version of linoleum.

■ *Walls.* Aesthetic rooms usually have tripartite walls with three horizontal divisions (Fig. 16-7, 16-8, 16-9, 16-12, 16-13, 16-15). The dado or lower portion is 3′ to 4′ high. Darkest in color, the dado provides a background for furniture. Dados can be covered with wood paneling, tiles, matting, or wallpaper. Above the dado in the middle of the wall is the fill, which varies in height. Because pictures hang there, it usually has an unobtrusive pattern. The frieze, lightest in color, is above the fill near the ceiling. Moldings, wallpaper borders, or changes of paint color mark divisions between the dado, fill, and frieze. Sometimes drawing rooms have only a wide frieze and no dado if large furniture sits against the walls. Late in the period, plate rails become fashionable for dining rooms.

Critics promote wood paneling as the preferred wall treatment, especially for halls and dining rooms where furniture would not hide it (Fig. 16-9). Paneling in a dark stain shows Japanese influence. Rails and stiles sometimes are darker than the panels. Painted woodwork is especially recommended for kitchens, bathrooms, and bedrooms because it is easier to clean than stained or natural wood is (Fig. 16-13). In important rooms, wood trim may be painted in two or more coordinating colors that are darker than the walls. Graining, to imitate wood, is less fashionable than before because critics condemn it as dishonest. Not everyone can afford paneling. Alternatives include wallpaper, moldings with different colors of paint on either

▲ **16-18.** Mantel lambrequins and decorative arts, c. 1870s–1890s.

side, or ready-made wainscoting made of wood strips glued to heavy cloth and available in the 1880s.

■ *Wallpaper.* For most people, wallpapers in coordinating patterns for dado, fill, frieze, and borders are a popular choice (Fig. 16-7, 16-13, 16-19). Wallpaper sets even come in angled shapes for stairways. In keeping with most reform precepts, patterns are geometric, stylized, and two-dimensional in secondary or tertiary colors. Papers

▲ **16–19.** Wallpapers, 1876–1880s; England; Bruce J. Talbert, Christopher Dresser, Edward W. Godwin, Jeffery and Company, and Walter Crane.

designed by William Morris and his associates have similar characteristics interpreted in rich, naturalistic patterns. Naturalistic shaded wallpapers still abound in middle-class homes despite reformers' efforts to eliminate them. Some of Godwin's designs, influenced by Japanese art, are asymmetrical.

Wallpapers with raised or embossed patterns also are used in Aesthetic rooms. Japanese leather paper, an inexpensive paper made in Japan, is one of several similar means of imitating the more expensive leather used on the walls in wealthy homes. Made of heavy paper, it can be embossed, painted, and varnished to enhance its leatherlike appearance. Lincrusta Walton is an English product that successfully imitates the appearance of leather, plaster, or even carved architectural details.

Patented by Frederic Walton in 1877, Lincrusta is derived from solidified linseed oil and comes embossed with various designs, including Renaissance, Japanese, Moorish, Byzantine, Greek, Gothic, and Modern. It is painted after hanging. Then the excess paint is wiped away and gold is generously applied. Lincrusta proves to be indestructible. Anaglypta, introduced in 1887 and made of embossed cotton pulp, is a lighter weight and affordable competitor to Lincrusta.

■ *Mantels.* The mantel is a focal point because writers insist that the hearth should be the center of the home. Some rooms have symmetrical corner fireplaces arising from the Japanese influence. The Artistic mantel unites the useful and the beautiful by having cabinets, niches, shelves, and brackets above it to display Oriental ceramics,

▲ **16–19.** *(continued)*

porcelain, glass, and other carefully chosen objects (Fig. 16-14, 16-16, 16-18, 16-23, 16-24, 16-26, 16-36). Art Tiles in plain and embossed designs and subdued colors surround the fireplace opening. Andirons shaped like sunflowers are popular (Fig. 16-3).

■ *Windows.* Usually hanging from rings on plain rods, Aesthetic curtains have horizontal bands of contrasting plain, printed, or embroidered fabric or appliqué that correspond to the wall divisions (Fig. 16-17, 16-20). Unlike before, they are not tied or looped back. Fabrics for curtains include velvet, plush, silk, satin, damask, serge, moreen, cretonne, chintz, and Oriental or other exotic fabrics. Underneath are lace or muslin glass curtains. A few rooms have roller shades or Venetian blinds beneath the curtains. Some people still use layered curtains with complicated valances.

■ *Doors.* Paneled doors may be stained or painted wood to match the rest of the woodwork (Fig. 16-13). Rails and stiles usually are lighter in color than panels are. Some panels have painted decorations, and occasionally the designs continue from panel to panel. Doorways to most public rooms have portieres (Fig. 16-8, 16-20, 16-25, 16-27) to shut out drafts and enhance comfort. Hanging from rings on rods, portieres may be more elaborate than window curtains. They come in different types of fabrics including chenille, Indian dhurrie rugs, or exotic fabrics. Each side may be different to match the room it faces. Reflecting Japanese influence, the space above portieres may be filled with openwork grilles composed of balls and spindles or other carved decoration.

■ *Textiles.* Textiles abound in Artistic interiors to add comfort, interest, and to display the needlework talents of the lady(ies) of the house (Fig. 16-18, 16-20, 16-33, 16-39, 16-41). In addition to the usual rugs, curtains, and upholstery, scarves, fabrics, and shawls may drape seating, tables, pianos, the mantel, shelves, wall cabinets, and pictures. White or colored antimacassars cover backs of chairs and sofas to protect and embellish them. Shelf and mantel lambrequins or table covers, purchased or made at home, are decorated with embroidery, appliqué, fringe, or beading. If

▲ **16-19.** *(continued)*

the back of an upright piano faces into the room, it has its own set of curtains to hide its back. Another set of curtains can hide an ugly fireplace and be opened when a fire is needed.

■ *Ceilings.* Critics condemn white ceilings and insist that they at least should be painted a lighter tint of the wall colors. Consequently, most ceilings are very decorative (Fig. 16-8, 16-9, 16-15, 16-16, 16-17, 16-27, 16-28). Painted decorations include flowers, foliage, clouds, stenciling, and stripes in various colors and widths. Artistic three-dimensional ornament in wood, plaster, or papier-mâché comes in sets with central medallions, cornices, and details for corners. Japanese influence appears in coffered or beaded-board ceilings. Ceiling papers are a common and inexpensive way to decorate ceilings. These specialty papers have patterns that look the same from all over the room. Forming the fourth element in wallpaper sets along with the dado, frieze, and fill,

ceiling papers typically have lighter colors such as cream, light olive, light blue, and light gray. If the ceiling is low, its treatment may continue down the wall. A few homes use tin ceilings, although these ceilings are more common in commercial buildings. Once in place, tin ceilings are painted and otherwise ornamented to suit the taste and style of the room.

■ *Later Interpretations.* Aspects of the Aesthetic Movement influence later interiors. Its emphasis upon unity and good craftsmanship continue in the Arts and Crafts Movement (Fig. 16-29). Appreciation of the asymmetry and fluidity of line in Oriental art, which is also inherent in Aesthetic rooms and patterns, influences Art Nouveau in the 1890s. Artistic interiors with their profuse patterns and cluttered appearance are so savagely criticized by 20th-century modernists that they are rarely reinterpreted or, even, desirable today. However, Aesthetic influence reappears in eclecticism, which characterizes

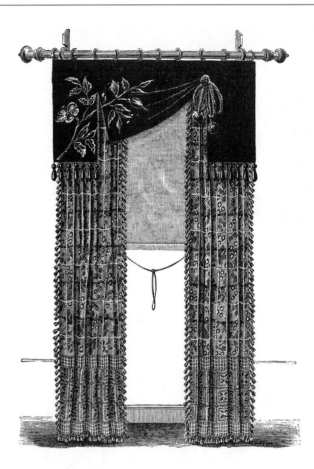

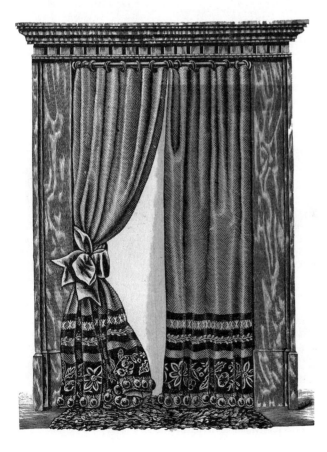

▲ 16–20. Window treatments and portieres; published in *Peterson's Magazine*, May 1877, and *Needlecraft, Artistic and Practical*, 1890.

▲ **16-21.** Carpet patterns; published in *Hints on Household Taste*, 1877; Charles Eastlake.

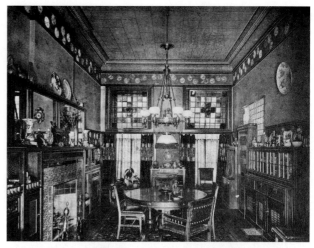

▲ **16-23.** Dining room, Dr. William T. Lusk House, c. 1867–1880; published in *Artistic Houses*, 1883; Louis Comfort Tiffany & Company.

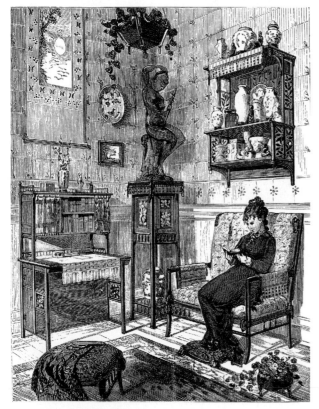

▲ **16-22.** "Much in Little Space"; published in *The House Beautiful*, 1878; by Clarence Cook.

▲ **16-24.** Design for interior decorations in Anglo-Japanese character; published in *The British Architect*, 1881; Edward W. Godwin.

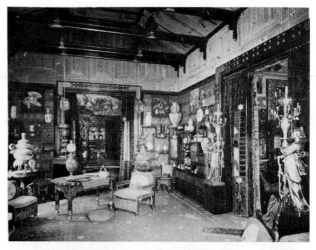

▲ **16-25.** Japanese room, W. H. Vanderbilt House, 1879–1882; New York City, New York; published in *Artistic Houses*, 1883; Charles B. Atwood at Herter Brothers.

interiors of the late 20th century with multipatterned rooms appearing in the 1970s and continuing in use. Contributing to this concept, manufacturers such as J. Burrows and Company reproduce or create artistic wallpapers, fabrics, and rugs. Owners of Victorian and Queen Anne houses, in particular, provide a market for these products.

DESIGN SPOTLIGHT

Interiors: Dining room, Louis Comfort Tiffany apartment; published in *Artistic Houses*, 1883; Louis Comfort Tiffany. This room epitomizes Aesthetic Movement principles as espoused by Tiffany and Associated Artists. Contrast and eclecticism characterize the space, which is of no particular style but brings together numerous styles and cultures. Japanese wallpapers adorn the wall, frieze, and ceiling, with a different flat, stylized pattern on each. In contrast, the large, naturalistic harvest painting over the fireplace is in strong yellows, blues, and reds. The circular shapes of the ceramics differ with the rectangular shapes of the walls and shelves. The plates on the mantel shelf repeat the shapes of the painting above them. A few pieces of simple, vernacular American furniture contrast with the many decorative objects in the space.

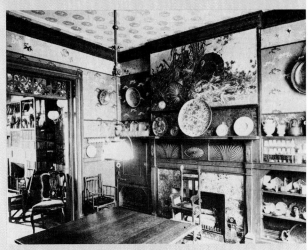

▲ **16-26.** Dining room, Louis Comfort Tiffany apartment.

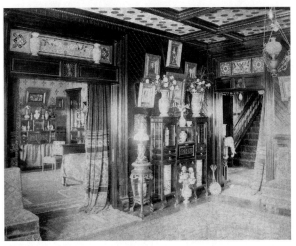

▲ **16-27.** Entry hall, Villa Montezuma, 1887; San Diego, California; Comstock and Trotsche.

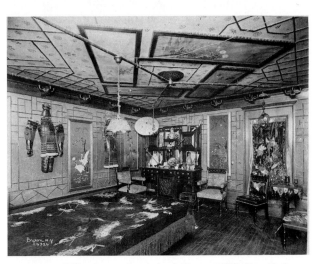

▲ **16-28.** Billiard room, Lauterbach House, 1899; New York.

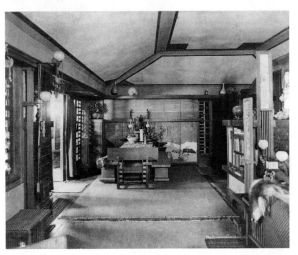

▲ **16-29.** Later Interpretation: Living room, Taliesin, begun 1911, rebuilt 1930s; Spring Green, Wisconsin; Frank Lloyd Wright.

FURNISHINGS AND DECORATIVE ARTS

The Aesthetic Movement shuns historical styles and sets or suites of furniture for a more personal expression and a new informality. Consequently, Artistic rooms display numerous pieces of furniture in a variety styles and from different cultures. Although simplicity is a precept, rooms still may be cluttered with arm chairs, side chairs, footstools, small tables, large tables, plant stands, music stands, shelves, wall cabinets, and folding screens. Bay windows and inglenooks often have built-in furniture. Because of a lack of well-designed furniture on the market, the movement advocates using antique furniture with its honest construction and appropriate ornament that does not obscure its form. Chippendale and Sheraton especially are favored.

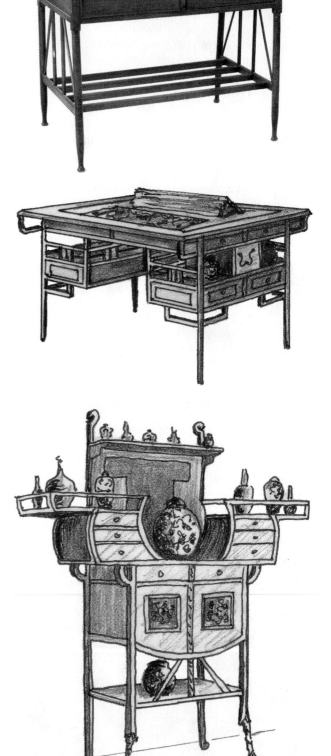

▲ **16–30.** Armchair based on an example from *Hints on Household Taste* by Charles Eastlake, c. 1860–1890s; England.

▲ **16–31.** Armchair; from the *Advertisement of Gardner and Company*, the Asher and Adams Commercial Atlas, New York City, c. 1870. Eastlake style.

▲ **16–32.** Anglo-Japanese drawing room furniture, 1860s–1880s; London, England; Edward W. Godwin.

The Aesthetic Movement inspires Art Furniture, which initially is designed by architects and artists and exhibits elements of honest construction and craftsmanship (Fig. 16-8). Later, manufacturers apply the term to any style and type of furniture they sell. Art Furniture varies in design but has some common characteristics. Anglo-Japanese furniture displays characteristics of Japanese art

(Fig. 16-32, 16-34, 16-37), and Eastlake furniture, enormously popular in America, derives from principles established by Charles Lock Eastlake in his treatise on decoration. However, manufacturers so debase it that Eastlake rejects any association with it.

Public and Private Buildings

■ *Types.* The Aesthetic Movement does not introduce new types of furniture. As adherents redesign existing types, all types of furniture may exhibit Artistic characteristics.

■ *Distinctive Features.* Common characteristics for Art Furniture include slender, usually turned or quadrangular legs often with casters; spindle supports and uprights; numerous brackets and shelves on cabinets and tables; ebonized woods or black or green stains; coved or arched panels; mirrors with beveled edges; and limited decoration such as gilding, incised patterns, and painted figures or foliage in panels. Eastlake furniture emulates Medieval influence in its rectilinear form that expresses honest,

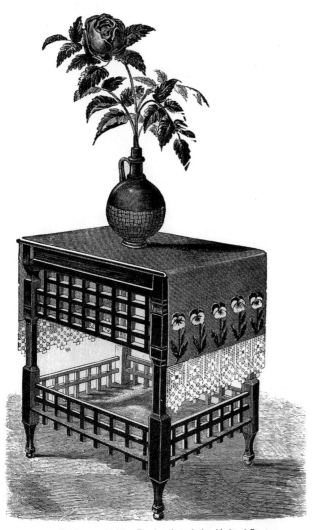

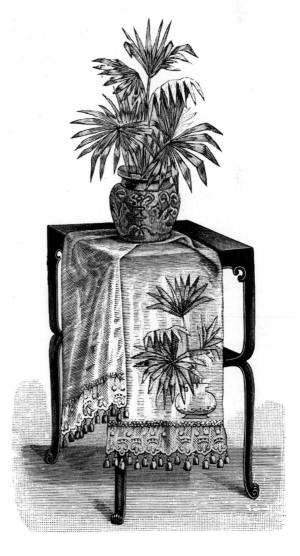

▲ **16-33.** Tables, c. 1890s; England and the United States.

DESIGN SPOTLIGHT

Furniture: Anglo-Japanese sideboard, c. 1867; ebonized wood and embossed panels of Japanese leather paper; Edward W. Godwin. Inspired by Japanese woodcuts, Godwin's composition is a careful balance of horizontals and verticals, solids and voids like Japanese architecture. The simplicity and elegance also reflect the Japanese aesthetic. Japanese leather paper covers the doors, and silvered handles and hinges add a touch of decoration. Like most Japanese-style furniture, the sideboard is ebonized. Godwin succeeds in capturing the essence of Japanese design in this piece, in contrast to many others who simply add Japanese motifs and some forms to Western furniture.

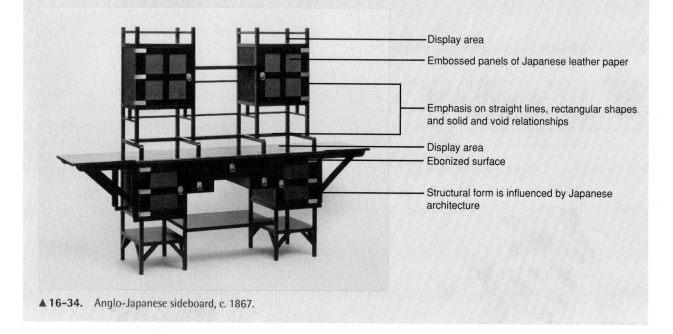

Display area

Embossed panels of Japanese leather paper

Emphasis on straight lines, rectangular shapes and solid and void relationships

Display area
Ebonized surface

Structural form is influenced by Japanese architecture

▲ **16–34.** Anglo-Japanese sideboard, c. 1867.

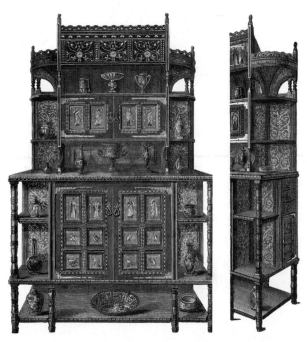

▲ **16–35.** Cabinet; London, England; exhibited at the Centennial International Exhibition 1876; Collinson and Lock.

strong construction, reeding, incising, spindles, balusters, finials, chamfering, and low-relief, carved, geometric, or stylized naturalistic motifs. Anglo-Japanese furniture exhibits Japanese design principles of asymmetry, balance of solid and void, brackets, fretwork, faux bamboo, dark finishes, spindles, and Japanese motifs such as cherry blossoms or chrysanthemums.

■ *Relationships.* Large case pieces and cabinets may line walls, while seating and tables are dispersed throughout the space in informal groupings that are intended to look unplanned. The marble-topped center table of earlier with a suite of furniture surrounding it disappears.

■ *Materials.* Most people favor walnut or mahogany in a dark stain and oak in a light stain. Japanese pieces often are lacquered. Faux bamboo, usually made of maple, may appear on Anglo-Japanese furniture. Blue and blue-green are typical stains for Art Furniture. Ebonizing with gilded incising also is common, but veneers and faux finishes are avoided. Marquetry and inlay of various woods and materials, such as mother-of-pearl, embellish expensive furniture and are imitated in paint on cheaper versions. Carving is generally out of favor but still highlights some

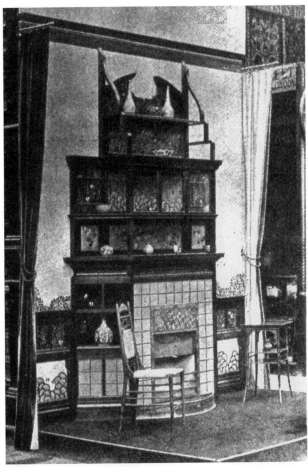

▲ **16-36.** Harmony in Yellow and Gold: The Butterfly Cabinet; London, England; exhibited at the Paris Exposition Universelle, 1878; designed by Edward W. Godwin as a fireplace with shelves and painted by James A. M. Whistler, manufactured by William Watt.

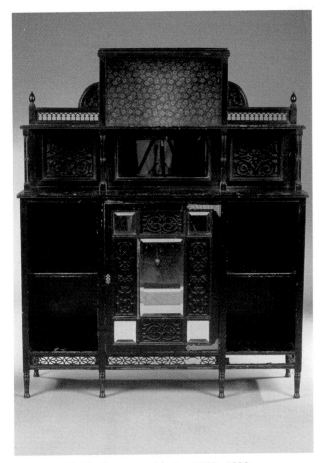

▲ **16-37.** Anglo-Japanese cabinet, c. 1860s-1890s.

pieces. Eastlake advocates low-relief carving and walnut veneers for more expensive furniture. Art Tiles may adorn beds or cabinets.

■ *Seating.* Manufacturers continue to produce seating with stylistic designations and in matching sets even though critics decry them. To reduce costs, the number of pieces in a parlor set decreases. Three or five pieces become the norm instead of six to eight. In the United States, most parlor sets have at least one rocker. Chairs and sofas have simplified, angular silhouettes and turned legs (Fig. 16-22, 16-30, 16-31, 16-32). Backs and seats have wooden frames and tufting. Rows of spindles top backs or appear below arms. Incising and low-relief carving add decoration. Individual chairs are usually slender, somewhat spindly, with ladder- or spindle-backs, and stained green or black. Seats may be upholstered, caned, or rush. Some rooms have overstuffed upholstery although critics condemn it.

■ *Tables.* Most Aesthetic rooms have many small tables for convenience and displaying objects (Fig. 16-24, 16-33).

Tops are wood because marble is considered cold and uninviting. Desks and other tables have numerous shelves and brackets supported by spindles and/or have galleries composed of spindles. Anglo-Japanese tables are characterized by an asymmetrical arrangement of shelves or brackets and legs, aprons, and stretchers with brackets or fretwork.

■ *Storage.* Still an important piece, the drawing room cabinet or étagère displays a carefully chosen collection of vases, plates, tiles, Oriental porcelains, and other objects. Rectangular in form with a façade composed of solids and voids, it is made up of shelves, brackets, spindles, cabinets or arched niches, mirrors with beveled edges, and may be topped with a spindle gallery or a coved panel (Fig. 16-17, 16-24, 16-27, 16-35, 16-36). Decoration may include painted or carved sunflowers, lilies, or foliage. Anglo-Japanese cabinets are rectilinear with a balanced, often asymmetrical, arrangement of vertical and horizontal lines, solids, and voids. Minimal surface decoration and no elaborate carving, ornament, or moldings are characteristic. Eastlake cabinets feature

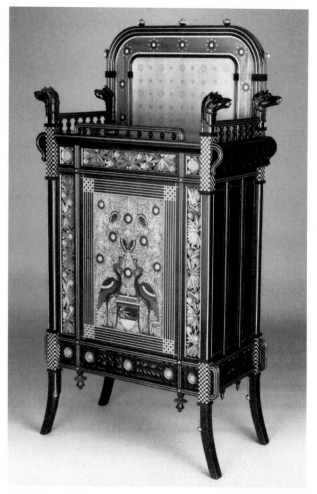

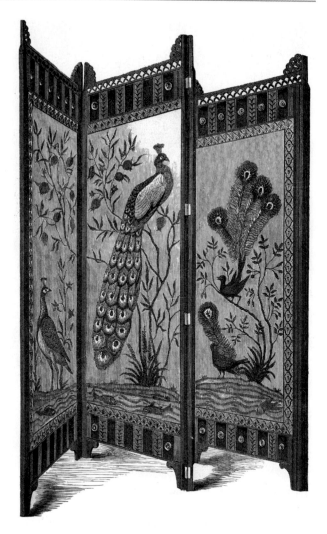

▲ **16-38.** Cabinet and secretary in ebonized cherry inlaid with gilded woods, c. 1880–1882; New York; Herter Brothers.

incising, spindles, and simplified ornament usually derived from Medieval sources. Many Artistic rooms have Eastlake-style or Anglo-Japanese wall cabinets for additional display space (Fig. 16-12, 16-16, 16-22, 16-25, 16-28, 16-38). Like other pieces, sideboards and secretaries reflect Aesthetic design principles (Fig. 16-34, 16-37).

■ *Beds.* Most beds have tall rectangular headboards and lower footboards (Fig. 16-13, 16-40). Paneled head- and footboards may have diagonal boards, plain or printed textiles, Art Tiles, or painted decorations. Cresting is made up of galleries of spindles or roof-like projections. Anglo-Japanese beds have bamboo spindles or moldings. Eastlake beds have incising and diaper or sawtooth edging. Matching the bed are dressers with matching tops, washstands, armoires, night stands, and shaving stands.

■ *Textiles.* Plain and patterned upholstery fills the Artistic interior. Upholstery no longer matches window treatments or wall coverings. Instead, it deliberately contrasts with other textiles. Bands of contrasting fabric or

▲ **16-39.** Screens and commodes; London, England; exhibited at the Centennial International Exhibition 1876; Royal School of Needlework.

needlework may outline backs or seats. Artists, architects, and designers create Artistic patterns for textiles in colors compatible with interiors. Realistic and shaded florals still adorn middle-class furniture but are not favored by reformers. Furniture cases to protect expensive fabrics still

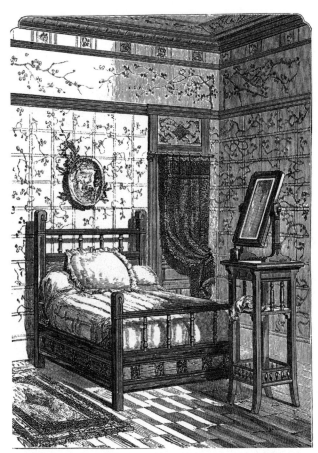

▲ **16-40.** Bed; published in *The House Beautiful*, 1878; by Clarence Cook.

are common in summer or year-round, but bed hangings are no longer fashionable for health reasons. Appearing in the 1870s in America, crazy quilts or Victorian slumber throws (Fig. 16-41) display feminine creativity. They are derived from Japanese *kirihame*, a complex form of patchwork appliqué.

■ *Decorative Arts.* Accessories are extremely important and an integral part of Aesthetic interiors. Collections showcase the artistic sensibility and culture of the family, and each piece is regarded as a lesson in taste for the children. Pictures hang in symmetrical arrangements from picture moldings near the ceiling. The dining room usually displays oil paintings, while in the living room hang prints, photographs, and watercolors of artistic subjects. Tastemakers especially favor Japanese prints and Oriental ceramics (Fig. 16-4, 16-14, 16-16, 16-18, 16-22, 16-25, 16-26, 16-27). Artists and others avidly collect much esteemed blue and white porcelains from China and Japan. Folding screens (Fig. 16-39), filled bookcases, canterburies holding magazines, plants, and flowers enhance the Artistic interior.

■ *Art Pottery.* During the 1870s, a mania for china collecting explodes. In response, manufacturers, such as Royal Doulton and Wedgwood in England, and a number of individual potteries in the United States, such as Rookwood

▲ **16-41.** Textiles: Crazy quilts, c. 1870s–1880s; United States.

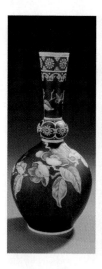
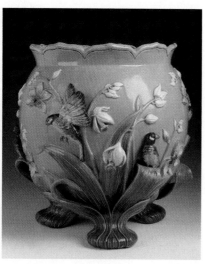

▲ **16-42.** Decorative Arts: Cameo glass vase and majolica jardinière, late 19th century; England.

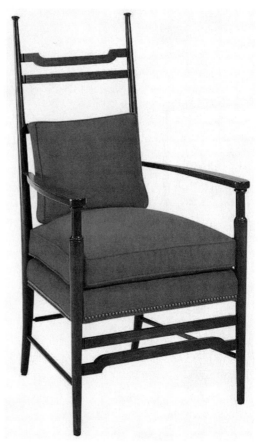

▲ **16-43.** Later Interpretation: Country occasional chair #0337-23; manufactured by Hickory Chair in Hickory, North Carolina.

in Cincinnati, begin producing Art Pottery, which experiments with form, colors, glazes, and surface decoration (see also Chapter 18, "Shingle Style and American Arts and Crafts"). Artistic precepts and creativity are important design principles. Manufacturers often employ art students, artists, or industrial designers to create unique designs derived from ancient Greek vases, Islamic pottery, and Oriental ceramics. Oriental-style ceramics copy or adapt the forms, glazes, and motifs of the originals. Glazes or colors often imitated are celadon (gray-green to blue-green), *sang-de-boeuf* (deep red), deep blue, apple green, mustard yellow, and peach bloom. Motifs include cranes, butterflies, lotus blossoms, and chrysanthemums. Islamic Art Pottery replicates forms, such as mosque lamps; colors like cobalt blue, red, green, or turquoise; and Islamic motifs. Some pottery has applied relief decoration or surface enameling with gold outlines. Minton, Wedgwood, and others revive Renaissance *maiolica*, renaming it majolica (Fig. 16-42). Its figurines and naturalistic forms in shiny colorful blue, yellow, pink, and green glazes have great appeal.

■ *Art Tiles.* Floors, fireplaces, sideboards, cabinets, beds, stoves, and clocks display Art Tiles. Decoration, which follows artistic principles, is in relief, painted, transfer-printed, imprinted, or glazed. Sunflowers, butterflies, latticework, hexagons, fan shapes, and figures in Greek or Japanese dress are typical motifs. Colors, which are compatible with interiors, include brown, gold, yellow, blue, or green.

■ *Art Glass.* In contrast to Art Pottery, which may be made by individuals, Art Glass production is always industrial. Like Art Pottery, Art Glass experiments with form, color, and surface decoration, but it is not as

enthusiastically collected as ceramics are. Like ceramics, models include Roman, Oriental, and Islamic glass. Experiments with color yield shaded wares like Amberina, which changes from amber to deep ruby, and Burmese, blending from yellow to pink with a shiny or matte surface. Makers revive early techniques such as cameo glass, which depicts relief ornament in contrasting colors to the body (Fig. 16-42). Japanese Art Glass often features enameled surface decoration of grass, flowers, or birds, while Islamic Art Glass replicates the form of mosque lamps and arabesques or rosettes in blue, red, or gold. Because much Art Glass is too expensive for the middle class, pressed glass is made in artistic colors and patterns with names like Queen Anne or Lily.

■ *Later Interpretations.* Art Furniture and Eastlake are not revived in later periods, but Japanese influences continue in furniture, varying from close approximations to those including various characteristics (Fig. 16-42). Bamboo furniture remains a popular choice. Art Pottery and Art Glass are avidly collected in the late 20th century. Artists continue to make ceramics and glass following Artistic design principles, most notable in the Studio Glass Movement.

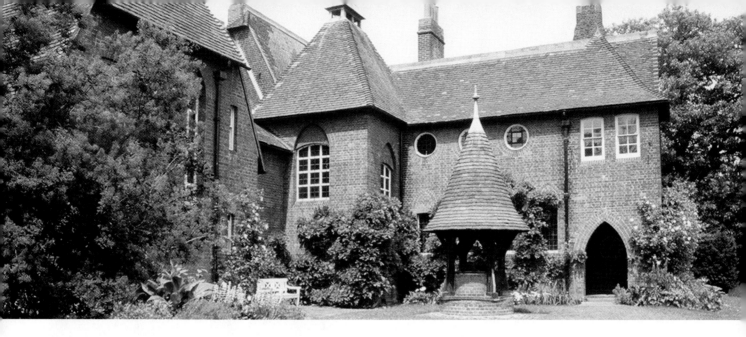

CHAPTER 17

English Arts and Crafts

1860s–1910s

The Arts and Crafts Movement, a reform development in England, strives to change the working conditions of craftsmen while improving the quality of design. It emphasizes preindustrial values and medieval-like craft guilds in the midst of rapid industrial growth centered on machine production. The ideal concept promotes intelligent space planning, allowances for human needs, design unity, harmony with the natural environment, and honesty of materials. Individual designers blend these principles with concepts derived from the vernacular, Japan, and a variety of sources.

HISTORICAL AND SOCIAL

The Arts and Crafts Movement builds on the principles and theories of Augustus Welby Northmore Pugin, a Gothic Revival architect, and John Ruskin, an art historian and critic, and more important, on the theories and practice of William Morris. Pugin is the first to apply a moral dimension to art and calls for designs that develop from function and appropriate context, structural honesty, and an honest use of materials. He also is instrumental in the revival of Gothic craft techniques, such as stained glass (see Chapter 16, "Gothic Revival").

John Ruskin also admires Gothic, functionality, and honesty, but he also reveres the Middle Ages. He equates good design with joy in labor, which lays the foundation for reforming the work process. Ruskin believes that industrialization has dehumanized the laborer, resulting in badly designed and poor quality manufactured goods, and that society itself is debased by purchasing these goods. He therefore advocates a return to hand craftsmanship, guilds patterned after those of the Middle Ages, and the elimination of false and applied ornament. He establishes the Guild of S. George in 1871, the first of the 19th-century guilds modeled after medieval ones. It quickly fails but sets an important precedent. Ruskin's writings, especially *The Stones of Venice* and *The Seven Lamps of Architecture,* are important to the movement.

William Morris (Fig. 17-1) has the greatest influence on the Arts and Crafts Movement through his writing, his lectures, and his work. Influenced by Ruskin, Morris comes to

advocate simplicity in design, structural honesty, medieval-inspired treatments, and handcrafted production. Morris calls for unity between the fine and decorative arts and advances the Ruskinian idea of an individual craftsman conceiving and executing an object. He puts these ideas into practice through his design company, Morris, Marshall, Faulkner and Company, founded in 1861 and later known as Morris and Company. A Socialist, he advocates well-designed goods for everyone but largely rejects the means for achieving this goal, the machine. In a further paradox, the goods produced by him and his firm are only affordable by the affluent. Besides Morris, the firm includes Sir Edward Burne Jones, Ford Maddox Brown, and artist Dante Gabriel Rossetti (Fig. 17-3), all of whom are members of the Pre-Raphaelite Brotherhood.

In the 1870s, Morris's ideas find sympathetic ears in many progressive architects, artists, and designers. Regarding all creative endeavors as equal in value, they strive through a variety of means to restore harmony between designer and maker, art and craft. One method is to form guilds. These organizations of the Middle Ages had promoted a craft or trade. In contrast, Arts and Crafts guilds, beginning with the Century Guild in 1882, are commercial enterprises intended to promote the work and ideas of a group of like-minded architects, artisans, and designers. Few are commercially successful, but they give structure and cohesion to the movement and are able to achieve more as groups than individuals can. Interdisciplinary works, professionalism, and a sense of unity and brotherhood characterize Arts and Crafts guilds. They spread their ideas through meetings and discussions, exhibitions of their work, and publications, such as *The Hobby Horse* put out by the Century Guild. The first exhibit of the Art Workers' Guild in 1888 gives the movement its name.

England's Arts and Crafts Movement is vastly influential, providing models for design reform in the United States, Scandinavia, and Continental Europe. Nevertheless, by the turn of the century, the Arts and Crafts Movement begins to lose momentum. Morris dies in 1896, and the guilds prove to be commercially unsuccessful. As society loses interest in the Arts and Crafts Movement, the marketplace for handcrafts disappears. Great Britain exports fewer goods, and prosperity of the middle and upper classes declines. Ideals begin to change and a return to classicism and formality increasingly replaces medieval informality. The death blow to the movement comes following World War I when Modernism gains favor in Britain.

CONCEPTS

The Arts and Crafts Movement attempts to reform design and society by uniting art and craftsmanship. Not a single style, the movement reflects an attitude that develops in response to the effects of industrialization on mass-produced goods and the quality of life. Not all followers adhere to all precepts, but most believe that well-designed goods should be available to all and that resurrecting craftsmanship is

▲ **17-1.** Portraits of William Morris and Miss L. Alma-Tadema, c. 1870s–1890s; England.

IMPORTANT TREATISES

- *Architecture, Mysticism, and Myth,* 1891; William R. Lethaby.

- *The Art of Building a Home,* 1901; Barry Parker and Raymond Unwin.

- *Arts and Crafts Essays,* 1893; Arts and Crafts Exhibition Society.

- *A Book of Cottages and Little Houses,* 1906; Charles R. Ashbee.

- *Craftsmanship in Competitive Industry,* 1894; Charles R. Ashbee.

- *Garden Cities of Tomorrow,* 2nd ed., 1902; Ebenezer Howard.

- *Garden Suburbs, Town Planning, and Modern Architecture,* 1910; M. H. Baillie Scott.

- *Home and Garden,* 1900; Gertrude Jekyll.

- *News from Nowhere,* 1891; William Morris.

- *The Seven Lamps of Architecture,* 1851; John Ruskin.

- *Small Country Houses of Today,* 1908; Lawrence Weaver.

- *The Stones of Venice,* 1853; John Ruskin.

Periodicals: The Hobby Horse, 1884–1892; The Studio, 1893; and Country Life, 1897.

the means to achieve this goal. Other key concepts stemming from the ideas of Pugin, Ruskin, and Morris include simplicity, elimination of the unnecessary, structural honesty, honest use of materials, functionality, and regionalism or a sense of place. The movement has a variety of expressions that are informed by the past but do not attempt to copy or revive it. Indeed, followers reject the very notion of style in favor of individual freedom in design and concern for and delight in materials, which underlies all creative endeavors from architecture to textile design. Excellent craftsmanship is of utmost importance, so some architects and designers become makers to more fully understand the process of design and creation as well as the qualities of the materials involved. Also underlying the movement is a strong sense of nationalism in its admiration for vernacular traditions and the simple, rural life. Although the vernacular influences design, the result is not a copy but an abstraction of its elements and forms. Despite regarding itself as rural, the movement largely takes place in urban settings.

Many Arts and Crafts adherents are believers in Socialism and strive through example to improve the life of the worker and effect change in working conditions. Although progressive in its concern for the worker, the Arts and Crafts Movement looks back to the preindustrial past.

Instead of reforming the design and manufacturing relationship, adherents largely reject the machine in favor of handmade goods. In reality, the machine produces goods that most can afford, despite the drudgery and repetition in the manufacturing process. The notion of the individual craftsman creating an object reflects an elitist ideal.

DESIGN CHARACTERISTICS

Arts and Crafts architecture, interiors, and furnishings maintain a strong, visible relationship to each other in their reliance upon common precepts. These principles include a relationship to the environment, place, or region, simplicity, suitability to purpose, emphasis on revealed structure, truth of materials, and excellent craftsmanship. Two varieties of expression are most common. One derives from rural vernacular traditions, whereas the other relies more strongly on the medieval or Renaissance past. Some examples are simple and plain with little or no ornament, applied or inherent. Others are visually complex, revealing excellence in execution.

Stylistically, early Arts and Crafts examples of interiors, furniture, textiles (Fig. 17-2), wallpapers, and book art (Fig. 17-4) exhibit the colors, forms, and interest in surface

▲ 17-2. "Flora," 1886; Edward Burne-Jones, executed by Morris and Company, and an image of women published in *The Studio*, March 1901, Vol. 22, No. 96, p. 122; England.

▶ **17-3.** "Joli Coeur," c. 1900; England; Dante Gabriel Rosetti. Pre-Raphaelite school.

Chapter II. Evil tidings come to hand at Cleveland

OT long had he worked ere he heard the sound of horse-hoofs once more, and he looked not up, but said to himself, "It is but the lads bringing back the teams from the acres, and riding fast and driving hard for joy of heart and in wantonness of youth". But the sound grew nearer and he looked up and saw over the turf wall of the garth the

▲ **17-4.** "The Song of Solomon" and "The Glittering Plain," book designs, c. 1890s; England; H. Granville Fell, and William Morris with Walter Crane.

decoration of the Aesthetic Movement (see Chapter 16, "Aesthetic Movement"). Soon, the movement evolves to a more structural, rational approach to design that more closely relates to architecture. England never wholeheartedly adopts the sinuous curvilinear *fin-de-siecle* Art Nouveau style that is briefly fashionable in Europe. (see Chapter 19, "Art Nouveau.")

■ *Motifs.* Typical motifs of the period are sunflowers, lilies, birds, images and letters from medieval manuscripts, Gothic details, and Oriental images (Fig. 17-2, 17-4, 17-14, 17-21, 17-27, 17-28, 17-31, 17-37).

ARCHITECTURE

Arts and Crafts architecture illustrates a variety of expressions produced by individualist architects who believe in freedom of expression and frequently experiment with form and materials. Most examples are country houses for the prosperous, upper middle class. Buildings exhibit no imposed style, but appear to grow out of the surrounding landscape and to have been there for centuries. Architects strive to maintain a sense of place through regional or local forms and materials. The visual language uses individual forms and elements to symbolize home, family, refuge, and

▲ **17-5.** First Church of Christ Scientist, 1903; Manchester, England; Edgar Wood.

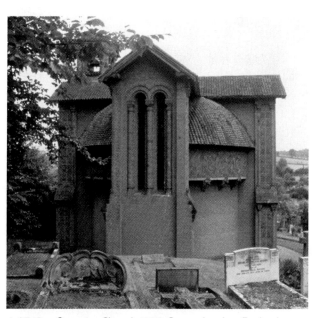

▲ **17-6.** Compton Chapel, 1906; Surrey, London, England; Mrs. G. F. Watts.

IMPORTANT BUILDINGS AND INTERIORS

■ **Chorley Wood, Hertfordshire, England:**
 —The Orchard, 1900; Charles F. A. Voysey.

■ **Devon, England:**
 —The Barn, 1896; Edward Schroder Prior.

■ **Herefordshire, England:**
 —All Saints Church, 1901–1902; W. R. Lethaby.

■ **Hoy, Orkneys, Scotland:**
 —Melsetter House, completed 1900; W. R. Lethaby.

■ **Kent, England:**
 —Red House, Bexleyheath, 1859–1860; Philip Webb.

■ **Lake Windemere, England:**
 —Broadleys, 1898; Charles F. A. Voysey.

■ **Leicester, England:**
 —Stoneywell Cottage, 1898; Ernest Grimson.

■ **London, England:**
 —Houses, begun 1906; Hampstead Garden Suburb; Parker and Unwin.

 —House at Turnham Green, c. 1890s; Charles F. A. Voysey.

 —S. Jude's Catholic Church, c. 1909-1914; Hampstead Garden Suburb; Sir Edwin L. Lutyens.

■ **Manchester, England:**
 —First Church of Christ Scientist, 1903; Edgar Wood.

■ **Oxfordshire, England:**
 —White Lodge, 1898–1899; M. H. Baillie Scott.

■ **Staffordshire, England:**
 —Wightwick Manor, 1887–1888, 1893; architecture by Edward Ould with interiors by Morris and Company.

■ **Surrey, England:**
 —Compton Chapel, 1906; Mrs. G. F. Watts.

 —Littleholme Cottage, c. 1890s; Guilford; Charles F. A. Voysey.

 —Lodge, c. 1897; Shackleford; Charles F. A. Voysey.

 —Merlshanger Lodge, 1897; Guilford; Charles F. A. Voysey.

 —The Hut, Munstead Wood, 1892–1895; Sir Edwin L. Lutyens.

 —The Orchards, 1897–1899; Sir Edwin L. Lutyens.

 —Tigbourne Court, 1899; Sir Edwin L. Lutyens.

■ **Sussex Weald, England:**
 —Standen, 1891–1894; Philip Webb.

shelter. Materials and structure express function of the building and the interiors within. Architects search for the finest materials and use local artisans to ensure that the building expresses timelessness. Emphasis upon texture, color, and pattern, harmony with nature, and catching light and casting shadows reflects the architect's delight in materials and the process of design. Overall, buildings are clean and sparse with little ornament. They generally depict an informal character blended with natural building materials, medieval imagery, and Japanese design.

An important outgrowth of the Arts and Crafts Movement is the founding of the Society for the Protection of Ancient Buildings (SPAB) by William Morris in 1877. Formed in reaction to the damaging restorations of the time, SPAB strives to preserve old buildings, restore old buildings gently, and inspire new construction. As a meeting place for architects and others interested in old buildings, it becomes a vehicle for such ideas as the study

DESIGN SPOTLIGHT

Architecture: Red House, 1859-1860; Bexleyheath, Kent, England; Philip Webb. Following his marriage, William Morris commissions his friend Webb to design a house for him. Webb and Morris collaborate in the design of the first example of Arts and Crafts architecture, which is very influential. The house, conceived from the inside out, has an L-shaped floor plan that gives a feeling of welcome and hospitality. The plan also is practical with its line of rooms and secondary corridor to the rear. Facades reveal the function of rooms within, and windows are placed to give maximum light and air instead of according to the dictates of a style. Although there are a few Gothic details, such as the steeply pitched roof and pointed arches in windows and doors, the house is not Gothic. Rather it has a medieval and centuries-old feeling. The plain red brick is unusual at the time because brickwork was most often covered with stucco. Webb carefully selected the brick for its color variations and to give a handmade appearance. No applied ornament detracts from form. Unable to find suitable furnishings, Morris founds Morris and Company to supply them. On weekends, friends and guests assist the Morrises in decorating the house.

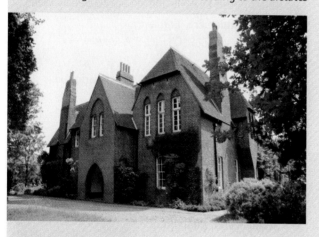

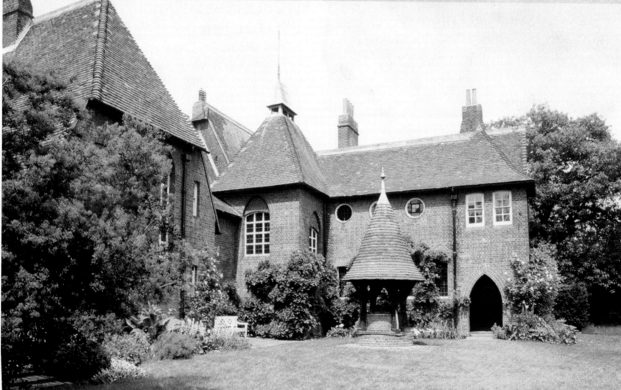

▲ 17–7. Red House; Kent, England.

of past building traditions, contemporary work that looks new but harmonizes with the old, and use of quality materials in restoration.

Urban examples of Arts and Crafts architecture are rare because cities lack the strong sense of place of rural villages. The main manifestations are garden suburbs that use vernacular cottages as models. In London, for example, architects begin designing low-density garden suburbs for the middle and professional classes to counter the city's unplanned approach to urban worker housing. These planned environments, such as Hampstead Garden (Fig. 17-15), are filled with picturesque, sanitary, detached houses set within their own individual gardens.

Public and Private Buildings

■ *Types.* Most Arts and Crafts structures are country houses (Fig. 17-7, 17-9, 17-10, 17-11, 17-13, 17-17), although some churches (Fig. 17-5, 17-6, 17-16), parish houses, terraces or row houses, and single-family houses exist. Freedom of expression is particularly difficult for terraces or row houses because sites and codes prescribe their forms and arrangements. Single-family homes often

are in suburbs (Fig. 17-12, 17-15) and planned urban developments for workers and the middle class.

■ *Site Orientation.* Unity and harmony between building and landscape are important concepts that are expressed through architectural features. Architects strive to give the appearance of a house developing from the land. The surrounding landscape (Fig. 17-9, 17-13, 17-17) becomes almost as important as the design of the structure, thus leading to a revival of garden design. A formal garden is thought to balance the informal planning of the house. Formal and informal plantings, walks, and trees are carefully balanced with an eye toward vistas. Features, such as sundials and fountains, are integrated into the design.

■ *Floor Plans.* Layouts grow from use rather than a prearranged order, resulting in asymmetrical designs and open flowing movement. Courtyards are common. Floor plans composed of an *L, T,* or elongated rectangular shapes

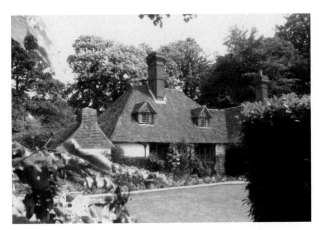

▲ **17-9.** The Hut, Munstead Wood, 1892–1895; Surrey, London, England; Sir Edwin L. Lutyens.

▲ **17-8.** Floor plan, Red House, 1859–1860; Bexleyheath, Kent, England; Philip Webb.

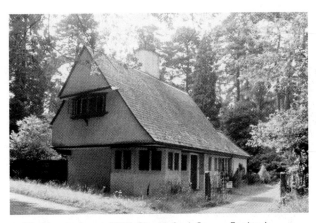

▲ **17-10.** Lodge, c. 1897; Shackleford, Surrey, England; Charles F. A. Voysey.

DESIGN SPOTLIGHT

Architecture: Broadleys, 1898–1899, Lake Windermere; The Orchard, 1899–1900, Chorley Wood, Hertfordshire as published in *Modern British Domestic Architecture and Decoration*, 1901, by Charles Holme; and other country houses; England; Charles F. A. Voysey. Broadleys, which overlooks Lake Windermere, embodies Voysey's distinctive style that simplifies and abstracts elements of traditional buildings. Seeming to grow out of its site, the house is long and low with horizontal emphasis. Typical Voysey details include the battered corner buttresses, deep hipped roof with broad overhangs supported by iron brackets, and bands of tall, narrow windows.

The L-shaped house has an entrance courtyard off of which a long corridor opens and allows access to the line of rooms on the other side of it. On the lake side are three curving bay windows extending through the roofline. Besides anchoring the house to the land like the tapered buttresses, they give vertical accents and light the dining room, two-story hall, and drawing room. At one end, the roof extends over a verandah. The marked horizontality, clean lines, and plain surfaces give an air of repose and domesticity. The Orchard evidences a similar architectural vocabulary with its low, sloping roof, stucco facade, and tall, narrow windows.

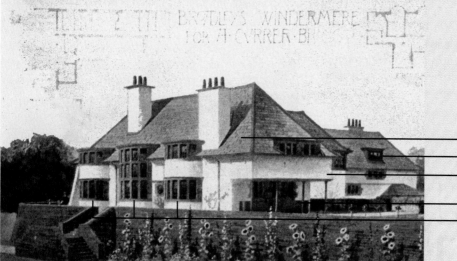

— Deep roof with broad overhang
— Horizontal windows
— White stucco facade with dark trim, and no applied ornament
— Verandah
— Bay windows face lake

Lake view

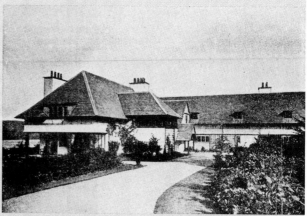

Entrance view

▲ **17-11.** Broadleys, The Orchard, and other country houses; England.

DESIGN SPOTLIGHT

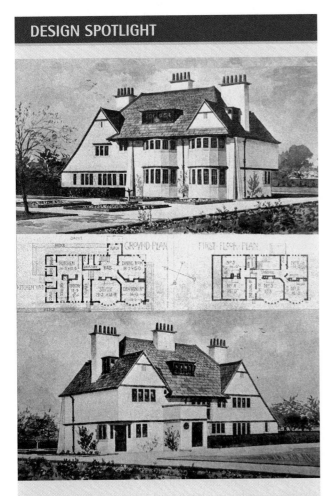

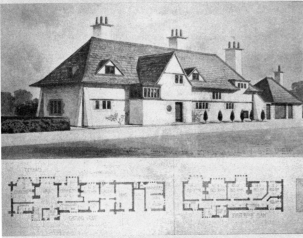

▲ **17-11.** *(continued) Country houses.*

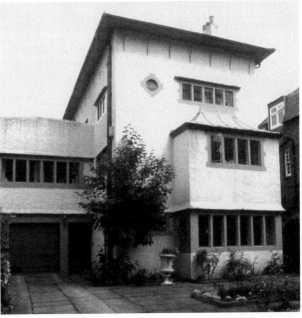

▲ **17-12.** House at Turnham Green, c. 1890s; London, England; Charles F. A. Voysey.

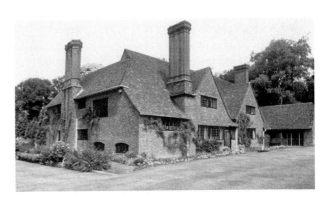

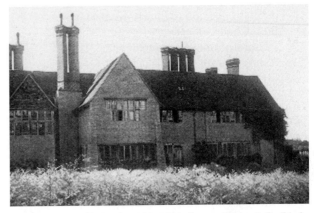

▲ **17-13.** The Orchards, 1897–1899; Surrey, England; Sir Edwin L. Lutyens.

provide clear and direct circulation (Fig. 17-8). A series of rooms directly behind one another with a side corridor is a common plan for country houses. Economical in space, the corridor allows access to individual rooms without passing through one to get to another. A variation is the butterfly plan in which the corridor plan is bent to form a symmetrical V with a central core. It symbolizes arms of welcome or

GUILDS AND DESIGN PRACTITIONERS

■ **Century Guild,** 1882–1888, is founded by Arthur Heygate Mackmurdo, who becomes its leading practitioner. Intent on raising the quality of design, the guild produces some of the finest Arts and Crafts textiles, furniture, and metalwork. Its publication, *The Hobby Horse,* is a forum for its aesthetics.

■ **Art Worker's Guild,** 1884 to present, is a professional group of architects, designers, and artisans. Although exclusive with membership by election, the group becomes the leading guild of the Arts and Crafts Movement.

■ **Arts and Crafts Exhibition Society,** 1886–1916, is the exhibition arm of the Art Worker's Guild. In addition to presenting the works of its members, the group holds lectures and discussions, thus furthering the movement.

■ **Guild of Handicrafts,** 1888–1910, is founded by Charles R. Ashbee. Seeking a more bucolic environment to better integrate design and nature, the guild moves to Cotswold in 1902 where it is commercially successful for several years before its demise. Woodworking and metalwork are its main crafts.

■ **Charles Robert Ashbee** (1863–1942), founder of the Guild of Handicraft workshop in London, is an architect but is better known for his metalwork with its sinuous lines and excellent craftsmanship. He is at the forefront of the preservation of numerous buildings.

■ **Mackay Hugh Baillie Scott** (1865–1895) is an architect who designs houses and their furnishings in the city and country. His interiors feature built-in furniture and colorful applied decorations inspired by folk and vernacular art.

■ **Sir Edward Burne-Jones** (1833–1898), foremost decorative painter of the Pre-Raphaelite Brotherhood, embellishes furniture with designs interpreted from medieval manuscripts and historical allegories. He along with Morris leads the revival of medieval crafts, including stained glass, tapestries, and mosaics.

■ **Sir Edwin Landseer Lutyens** (1869–1944), an admired English architect, advocates a planned, natural environment for wealthy, intellectual, and socially elite clients. Lutyens works in many styles but remains an individualist.

■ **Arthur Heygate Mackmurdo** (1851–1942), founder of the English Century Guild, is an architect concerned with reforming design. Some of his furniture has details that are precursors to Art Nouveau. He produces *The Hobby Horse,* an influential crafts journal.

■ **May Morris** (1862–1938), daughter of William Morris, designs fine embroidery hangings for beds, walls, and doorways. She continues her father's work by publishing his writings and through her own lectures. Because of her father's influence, she is one of the few women permitted to enter the design profession in the 1890s.

■ **William Morris** (1843–1896) is the leading theorist of the Arts and Crafts Movement. He spreads his ideas through his lectures, writings, and practice. Trained as an architect, Morris designs furniture, wallpapers, and fabrics sold through his firm Morris and Company.

■ **Charles Francis Annesley Voysey** (1857–1941), an English architect, designs country houses in which he promotes open, flowing floor plans, integrated design details including furniture, and a vernacular character. He also designs carpets and wallpapers for commercial firms.

■ **Philip Speakman Webb** (1831–1915) lays the architectural foundation for the Arts and Crafts Movement. His urban and rural buildings emphasize medieval traditions, functional plans, and simple environments. As a founding member of Morris and Company, Webb designs furniture and other objects.

hospitality. The formal Victorian drawing room or parlor becomes an informal sitting area or living room. Some plans revive the medieval great hall, a communal living space that forms the hub of the home.

■ *Materials.* Stone, brick, and wood convey textural harmony and simplicity of appearance (Fig. 17-5, 17-6, 17-10, 17-11, 17-13, 17-14, 17-15, 17-16). Architects, favoring local materials over exotic or imported ones, carefully select materials with an eye to the combination of colors, textures, light, and shade. Variations of material on the façade indicate function of rooms within or articulate different parts of the structure. Sometimes more contemporary materials, such as concrete or stucco, are used for structural or functional purposes.

■ *Facades.* Exteriors feature a horizontal emphasis, structural repetition, and an asymmetrical silhouette and fenestration (Fig. 17-6, 17-7, 17-11, 17-12, 17-13, 17-15,

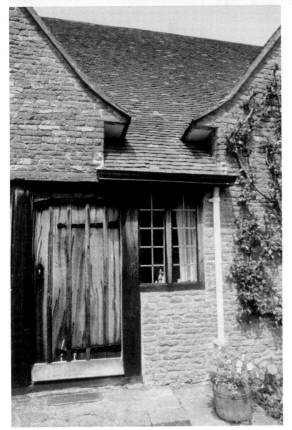

▲ **17-14.** (top) Door and window; published in *The Studio, An Illustrated Magazine of Fine and Applied Art*, April 1895, Vol. 5, No. 25; England; M. H. Baillie Scott and (bottom) entry, The Orchards, 1897–1899; Surrey, England; Sir Edward Lutyens.

▲ **17-15.** Houses, begun 1906; Hampstead Garden Suburb, London, England; Parker and Unwin.

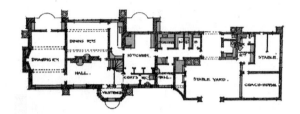

▲ **17-16.** S. Jude's Catholic Church, c. 1909–1914; Hampstead Garden Suburb, London, England; Sir Edwin L. Lutyens.

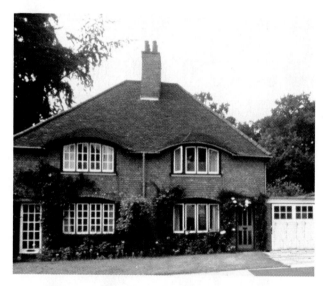

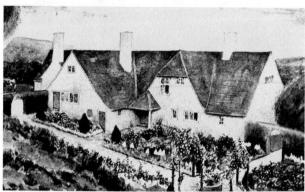

▲ **17-17.** Houses, c. 1900–1910; England.

17-17). Facades are largely unornamented, having few architectural details such as stringcourses, columns, pediments, and the like. Interest and variety come from forms, textures, and materials. Structures may be rambling with multiple gables and roofs or self-contained under a single, deep roof. Designs strive to recall, but not copy, the past, so forms and details often are simplified or abstracted. Walls may be rough or smooth in texture, plain and flat, or have half-timbering, crow-step gables, and/or projections or overhangs. Individual features, such as a corner chimney, buttresses, or stair halls rising from the ground, may be exaggerated to emphasize function, construction, or to integrate with the landscape. Changes of material or color around doors and windows highlight these elements and add interest.

■ *Windows.* A variety of window types alternate in size and placement (Fig. 17-5, 17-7, 17-11, 17-12, 17-14, 17-17). Single, groups, or bands of casements or mullioned windows are placed where needed to provide light or views instead of according to the dictates of style. Also arched, bay, or oriel windows add variety and a sense of place. Windows appear in repetitive horizontal bands directly under long overhanging roofs, reinforcing the union of the building to the land (Fig. 17-11, 17-13, 17-15, 17-17).

■ *Doors.* Entry doors defined by low-hanging projections are usually placed asymmetrically on the facade composition (Fig. 17-7, 17-14, 17-15). Deeply recessed, arched entrances symbolize shelter and refuge.

■ *Roofs.* Roofs frequently alternate in height and have planes at many angles to catch the light (Fig. 17-5, 17-6, 17-7, 17-11, 17-12, 17-15, 17-17). To further symbolize shelter and refuge, architects often use a single, deep roof with deep overhangs. Some revive thatched roofs but combine

them with more practical, weatherproof materials such as concrete.

■ *Later Interpretations.* Beginning in the late 20th century, structures with elements of Arts and Crafts design again

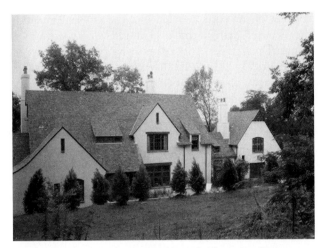

▲ **17-18.** Later Interpretation: House in the style of Lutyens, 2001; Birmingham, Alabama; Henry Sprott Long and Associates. Modern Historicism.

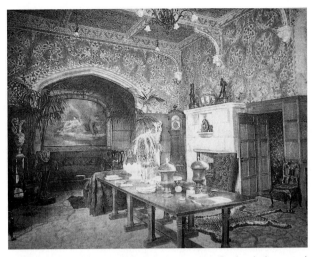

▲ **17-20.** Entrance hall, Stanmore, c. 1893; England; decorated by William Morris and Company.

appear in cities, suburbs, and the country (Fig. 17-18). Renewed interest in crafts, a sense of place, delight in materials, and individualism prompt a revival of the movement's architectural forms and details. Functionality and human scale of Arts and Crafts structures appeal to many people.

INTERIORS

Arts and Crafts architecture, interiors, furnishings, and decorative arts integrate into a unified whole. Meticulous attention to details and handcrafted work complement the

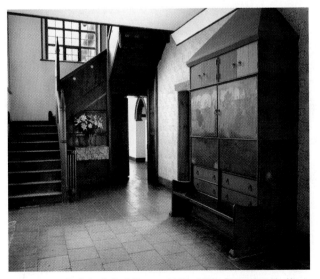

▲ **17-19.** Stair hall, Red House, 1859–1860; Bexleyheath, Kent, England; Philip Webb.

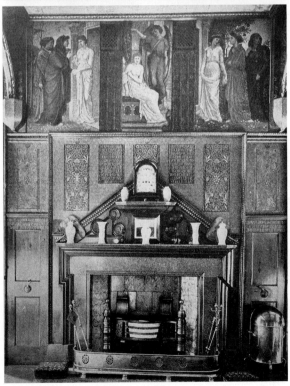

▲ **17-21.** "The Cupid and Psyche" frieze, No. 1 Palace Green, c. 1899; London, England; Sir Edward Burne-Jones.

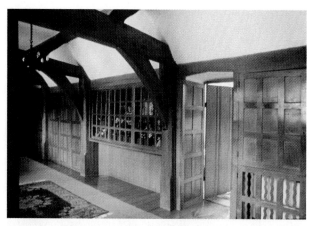

▲ **17-22.** Second floor hall, The Orchards, 1897–1899; Surrey, England; Sir Edwin L. Lutyens.

concept of the parts blended into the whole. Emulating the exterior design, the overall interior appearance is informal portrayed in intimate scale, free-flowing space, asymmetrical organization, horizontal movement, rectangular shapes, and straight lines. Some interiors display a vernacular appearance while others recall medieval or Gothic rooms.

Architects frequently design the interiors and furniture for their buildings and oversee the creation of them by local artisans, the guilds, or commercial firms, such as Morris and Company. However, these services are limited to the wealthy. By the early 20th century, department stores begin offering handcrafted or machine-made goods and decorating services that are affordable for more people.

DESIGN SPOTLIGHT

Interiors: Entrance hall (1901 image and contemporary color interpretation), dining room, and floor plan, The Orchard, 1899-1900; Chorley Wood, Hertfordshire, England, as published in *Modern British Domestic Architecture and Decoration*, 1901, by Charles Holme; Charles F. A. Voysey. Built as a house for himself, this building expresses Voysey's personal concepts of simplicity, honesty, and plainness. The exterior, following other Arts and Crafts models, has long horizontal windows, low deep gables, wide porches for shelter, and an overall vernacular appearance. The entrance hall illustrates his innovative use of purple and white walls, all white woodwork, and white ceiling combined with large expanses of

glass windows to bring in light. Not only is the interior cheerful and bright, but it is also follows Voysey's principles of easy cleaning and inexpensive maintenance. Distinctive features include a large scaled mantel with green fireplace tiles, a vertical slat screen by the stairs, green or patterned carpets, plain wood furniture, and crafts-style metal door hinges. Ornament and decoration consist only of a few decorative accessories. This design statement contrasts with earlier dark and cluttered Victorian interiors and consequently appeals to those seeking a more contemporary home environment. As such, it is widely copied and garners significant recognition for Voysey.

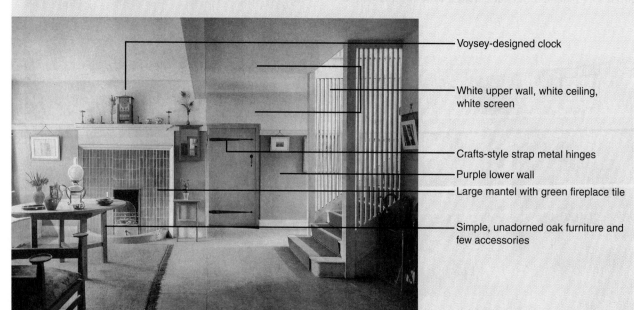

- Voysey-designed clock
- White upper wall, white ceiling, white screen
- Crafts-style strap metal hinges
- Purple lower wall
- Large mantel with green fireplace tile
- Simple, unadorned oak furniture and few accessories

▲ **17-23.** Entrance hall, dining room, and floor plan, The Orchard; Hertfordshire, England.

Dining room (top right, lower left)
(COLOR RENDERING OF THE ENTRANCE HALL BY CHRIS GOOD, 2007.
WATERCOLOR OF THE DINING ROOM BY WILFRID BALL, c. 1901)

GROUND FLOOR

SECOND FLOOR

▲ **17-23.** *(Continued)*

Arts and Crafts principles evolve into the Cottage or Vernacular style for popular consumers.

Public and Private Buildings

■ *Types.* Some architects revive the great hall as a living room (Fig. 17-20). Less-formal living rooms replace formal entertaining spaces. Richard Norman Shaw reintroduces the inglenook in the 1860s, and it becomes a common feature in large stair halls that are used as living rooms in Arts and Crafts houses (Fig. 17-24).

■ *Relationships.* Interiors replicate the feeling, if not the appearance, of exteriors. Similar architectural concepts, such as simplicity, vernacular traditions, expressed

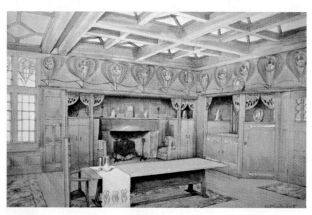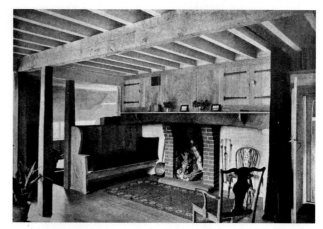

▲ **17–24.** Interiors; England; published in *The International Studio, An Illustrated Magazine of Fine and Applied Art* (left), 1900, and *The Studio Year Book of Decorative Art* (right), 1908; both by M. H. Baillie Scott.

structure, truth of and delight in materials, and minimal ornament, are characteristic. Bands of windows invite the outside in; rough textures and naturalistic color schemes and patterns further integrate interior and exterior. Built-in furniture gives rooms an architectonic appearance and emphasizes structure.

■ *Color.* Designers advocate color schemes derived from nature to further integrate interior with exterior. Brown, ochre, buff, and off-white are typical wall colors (Fig. 17-19, 17-23) with brighter ochres, blue-greens, olive-grays, roses, russets, and black incorporated in wallpapers, textiles, stained glass, and accessories (Fig. 17-27, 17-28, 17-29). Wood often is left unstained or is lightly stained for a natural appearance (Fig. 17-21, 17-22, 17-25). Philip Webb and C. F. A. Voysey stress off-white color palettes in public and private spaces, which is a noticeably different concept from other designers (Fig. 17-23).

■ *Lighting.* Natural light fills the interiors (Fig. 17-23), particularly in social spaces. At night, candlesticks, table lamps, wall brackets, and hanging lamps and fixtures of wood, ceramic, copper, iron, or brass with a rustic appearance illuminate spaces (Fig. 17-26). Fixtures frequently have hand-blown or stained glass shades.

■ *Floors.* Naturally finished wood-planked floors covered with decorative area rugs are common (Fig. 17-22, 17-24), along with tile and painted wood floors. Wall-to-wall carpet is rare. Leading architects and practitioners, such as Morris and Voysey, design carpets commercially or for individual clients. Hand-knotted or machine-made designs feature graceful and flowing lines and stylized plants and flowers in bright colors. Handmade Oriental or scatter rugs may be used.

■ *Walls.* Stucco walls with rough wood posts, half-timbering, or wood paneling with a clear finish are usual treatments. (Fig. 17-19, 17-22). There are few applied architectural details, such as moldings. However, built-in furnishings are common, including benches or settles in inglenooks, bookcases, and window seats (Fig. 17-24, 17-25). Stucco or plaster walls may be white- or color-washed (Fig. 17-23). Leading architects and practitioners, such as Morris, design wallpapers with stylized plants and flowers in bright colors (Fig. 17-20, 17-27). Frieze papers and plate rails divide walls into two parts (Fig. 17-24) instead of the three favored by the Aesthetic Movement. Other less common wall treatments include murals of medieval scenes or landscapes or painted decorations (Fig. 17-21), such as folk designs. Tapestries or embroidered wall hangings may add warmth and color. Public rooms usually center on the fireplace or hearth as a symbol of home and family. Some chimneypieces are large and prominent with deep hoods, while others are smaller and feature handmade tiles, copper or brass detailing, or rustic wooden mantel shelves (Fig. 17-23, 17-24, 17-25). Mottos, sayings, and proverbs may be inscribed or painted beneath the mantel shelf or in the frieze.

■ *Textiles.* Textile design relies upon geometric repeats, natural objects transformed into abstracted shapes, and flat two-dimensional treatments (Fig. 17-27, 17-28). Compositions may be flat with little depth, in the manner advocated by Pugin and Owen Jones, or more naturalistic and complicated as Ruskin recommends. Wallpapers and fabrics created by Morris and Company usually illustrate tightly clustered foliage motifs rendered in natural colors printed on cotton or linen grounds. Textiles include cretonnes, cotton, velvet, plush, linen, wool, and leather with little decoration. Hand-blocked printing replaces mechanized roller techniques for

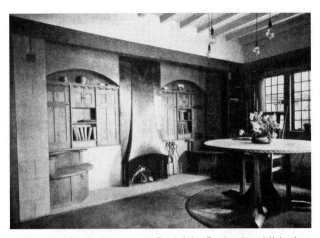

▲ **17-25.** Study, house near Rochdale; England; published in *The Studio Year Book of Decorative Art*, 1911; Parker and Unwin.

printed fabrics and most wallpapers, creating goods available only to the affluent.

■ *Windows*. Surrounding moldings, when present, are simple and either contrast to or blend with the wall color. Stained glass appears frequently as a decorative element (Fig. 17-29). Simple drapery treatments composed of panels hanging from rings complement plain window designs. Fabrics may be plain, patterned, or embroidered.

■ *Doors*. Large, wood-planked doors with iron hardware, representing a medieval image, are common (Fig. 17-22, 17-23). Doors may be left unpainted or be painted with a medieval scene or landscapes.

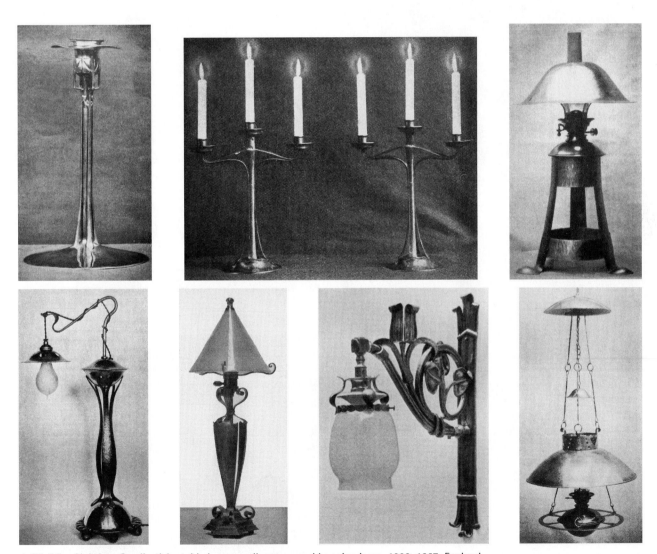

▲ **17-26.** Lighting: Candlesticks, table lamps, wall sconce, and hanging lamp, 1900–1907; England.

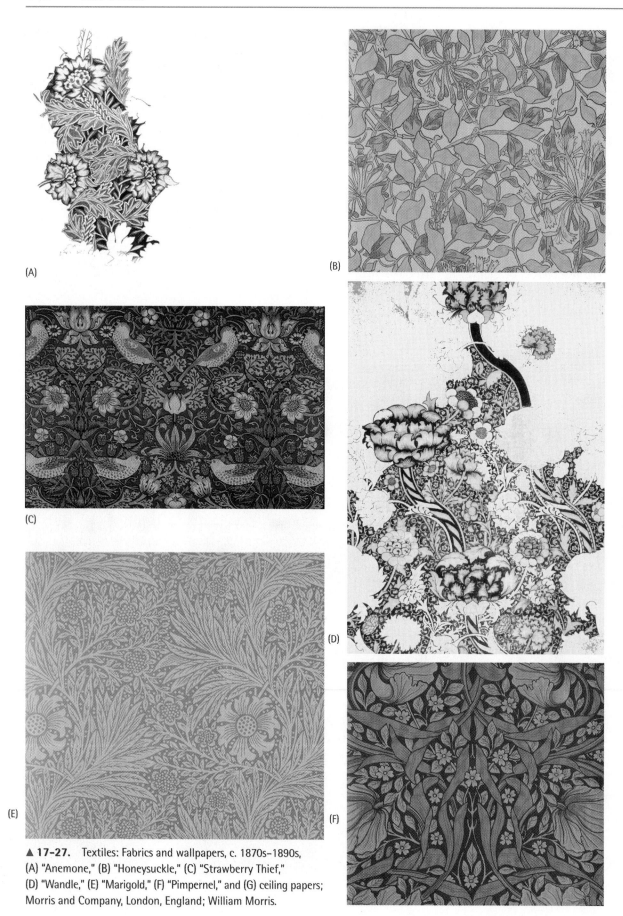

▲ **17-27.** Textiles: Fabrics and wallpapers, c. 1870s–1890s,
(A) "Anemone," (B) "Honeysuckle," (C) "Strawberry Thief,"
(D) "Wandle," (E) "Marigold," (F) "Pimpernel," and (G) ceiling papers;
Morris and Company, London, England; William Morris.

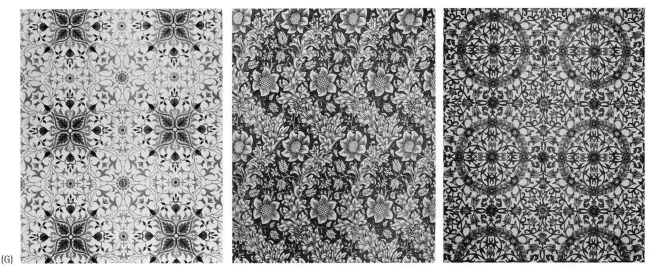

(G)

▲ **17-27.** *(continued)*

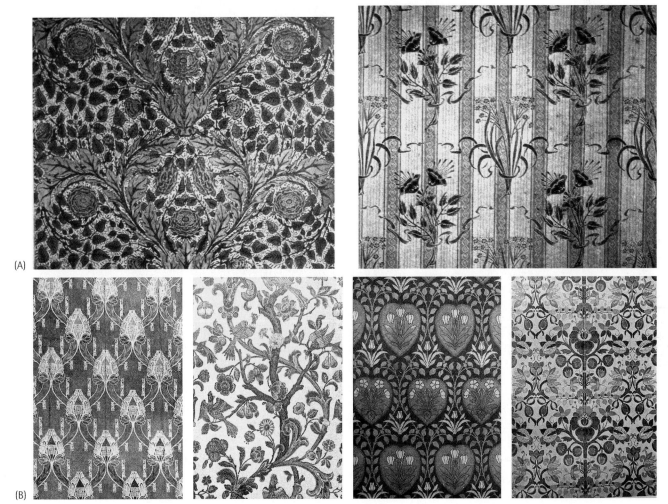

(A)

(B)

▲ **17-28.** Textiles: Fabrics and wallpapers, c. 1890s–1900s; England; designed by A. H. Mackmurdo (A), Liberty & Company (B), C. F. A. Voysey (C), and Jeffrey and Company (D).

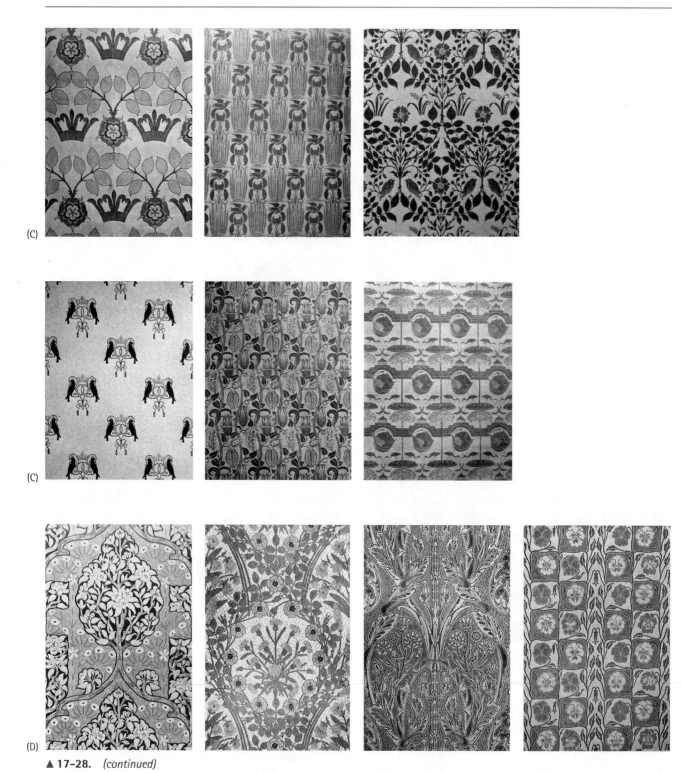

(C)

(C)

(D)

▲ **17-28.** *(continued)*

■ *Ceilings*. Ceilings may be low and beamed or higher with other decorative treatments (Fig. 17-20, 17-22, 17-24). Designs generally enhance the image of the wall composition with wooden beams, coffers, pargework, or plain, painted cream surfaces.

■ *Later Interpretations*. English Arts and Crafts interiors have a significant impact on the design of North American ones during the 1880s through the 1930s (see Chapter 18, "Shingle and American Arts and Crafts"). One of the most noteworthy designers is Gustav Stickley, who promotes

▲ **17-29.** Stained glass window, Castle Howard, c. 1860s; Yorkshire, England; Edward Burne-Jones and William Morris.

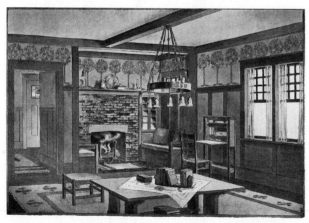

▲ **17-30.** Later Interpretation: Living room, Craftsman house; published in *The Craftsman*, October, September, and November 1905; Gustav Stickley. American Arts and Crafts/Craftsman style.

the Craftsman style as appropriate for middle-class living (Fig. 17-30). In the late 20th century, renewed interest in Arts and Crafts interiors increases the demand for rooms designed according to the movement's principles. Simplicity, rough textures, integration of interiors and exteriors, naturalistic patterns, and handcrafting are again fashionable in affluent and middle-class rooms. Carpets, wallpapers, and textiles by leading designers, such as Voysey and Morris, again become available.

FURNISHINGS AND DECORATIVE ARTS

Arts and Crafts furniture displays similar concepts to architecture and interiors, including revealed structure, truth of and delight in materials, and compositions based upon vernacular or traditional forms. Frequently designed by architects for specific clients or interiors, freedom in expression and marked individuality define compositions. Individual pieces are human scale and often have unique design features. Vernacular or medieval forms inspire designers, but imposed style is rigorously avoided. Consequently, within the body of work for a guild, firm, or individual, there may be few common elements. Designs range from simple, plain, rectangular, and rustic to refined, sinuous in line, and complicated with inlay, carving, or painted decorations. Decorative, painted symbolism, an extension of medieval storytelling, is a common characteristic feature. By the turn of the century, furniture manufacturers hire prominent designers to create furnishings utilizing Arts and Crafts principles, which become known as the Cottage style. Department stores, such as Liberty's, and commercial firms such as Heal and Sons and Wylie and Lockhead offer mass-produced Arts and Crafts furniture.

Designers strive for simplicity with fewer pieces of furniture that blend into the interior so that the room looks and is uncluttered. Functional arrangements emphasize major architectural elements, and easy maintenance is important. To support a vernacular or rustic tradition, some rooms have a decidedly uncomfortable look with little upholstery and few textiles. Antiques are a frequent addition to Arts and Crafts rooms.

Hand construction is favored and revived. Some designers make furniture to better understand designing to suit material and construction. A few designers, such as Ernest Grimson (Fig. 17-32), achieve the ideal of the craftsman conceiving and creating the pieces by setting up furniture-making shops in the countryside. More typically, the designer creates the piece that is then made commercially or in a cabinetmaking shop.

Public and Private Buildings

■ *Types.* Some medieval types, such as settles or dressers, are reintroduced (Fig. 17-33).

■ *Relationships.* Like architecture and interiors, furniture designs emphasize simplicity, revealed construction, suitability to purpose, truth in materials, excellent craftsmanship, and vernacular traditions. Furniture maintains a strong relationship to the interior and exterior.

■ *Distinctive Features.* The work of individual designers is distinctive depending upon use of form and materials, construction methods, application of decorative details, and sources of inspiration.

Furniture: Armchair upholstered in "Bird" woolen tapestry with ebonized wood, c. 1870s; Saville armchair (bottom left) in mahogany, c. 1890s; and the Sussex chair, c. 1864; made by Morris, Marshall, Faulkner and Company, London, England; 1870s by Philip Webb, 1890s by George Jack. The rectangular armchair designed by Philip Webb from a traditional English form, often called the Morris Chair, has spindles, flat arms, and cushioned seat and back. It typifies the suitability of purpose characteristic of Arts and Crafts in its wide arms and adjustable back. The adjustable back is a newly reintroduced concept in design, and one that is much copied in later periods. The Saville armchair by George Jack, who became the company's chief furniture designer after 1890, reflects the same general style as the Webb version, with a variation in the spindles and legs, and no option for reclining. Both chairs are upholstered in the company's textile patterns. The Sussex chair, attributed to Ford Maddox Brown, derived from a country chair supposedly in Sussex. It was produced by the firm from 1864 until 1940 and was very popular.

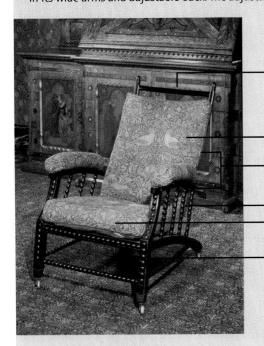

— Emphasis on rectangular form

— Woolen tapestry with bird motif

— Adjustable back

— Spindles
— Loose cushioned seat and back

— Oak frame

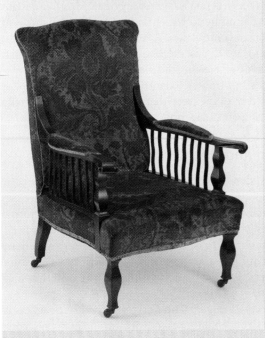

▲ **17-31.** Armchair upholstered in "Bird" woolen tapestry, Saville armchair, and the Sussex chair.

▲ **17-32.** Ladderback chair, c. 1880s; England; Ernest Gimson.

■ *Materials.* Local woods, such as oak or elm, are favored. Some designers use exotic woods for accents, inlay, veneers, and marquetry. Ebonizing and green and brown stains are used earlier. Later pieces have only a shellac finish so as to reveal the inherent beauty of the wood. Tiles and decorative painting may add color to casepieces (Fig. 17-35, 17-36). Joints may be revealed or hidden.

■ *Seating.* Wood chairs (17-31, 17-32) with and without arms are common in all interior spaces. Traditional models, such as ladderbacks, are favored, and individual designers adapt these forms to their own design preferences. For example, Voysey's ladderback chairs are tall and slender, sometimes with a heart motif. The others copy past examples such as the Sussex chair (Fig. 17-31), with spindles and rush seat copied from a country chair. Offered by Morris and Company, it is one of the firm's most commercially successful pieces. One of the most common chairs, offered by nearly every firm, is the Morris chair (see Design Spotlight, 17-31). Settles with tall backs and painted decorations are common, but sofas appear less frequently (Fig. 17-33).

■ *Tables.* Tables are square, rectangular, or round and often have wood plank tops (Fig. 17-20, 17-23, 17-24). Legs may be straight or curved. Trestles are used as dining tables. Legs may have inlaid or painted decoration. Designers also turn their attention to writing desks. (Fig. 17-34).

■ *Storage.* Cabinets (Fig. 17-19, 17-24) are often built into the wall composition for simplicity and an architectonic appearance. Other types, such as wardrobes and secretaries, reveal a variety of designs (Fig. 17-35, 17-36). Some are refined, slender, and tall. They may be raised upon legs to emphasize lightness. Others present a rustic appearance and are composed of heavy planks in the medieval manner.

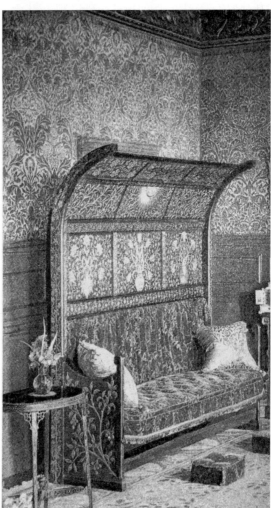

▲ **17-33.** Sofa and settle, c. 1890s; England; A. H. Mackmurdo (sofa) and Philip Webb (settee) for Morris and Company.

▲ **17-34.** Writing desk in oak, c. 1885; made by the Century Guild, London, England; A. H. Mackmurdo.

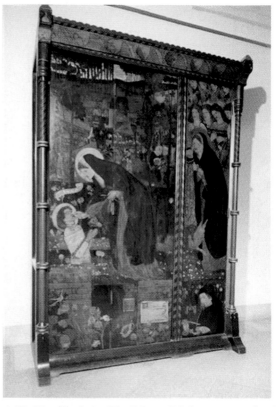

▲ **17-35.** Wardrobe, "The Prioress Tale," 1858–1859; London, England; designed by Philip Webb, painted by Sir Edward Burne-Jones.

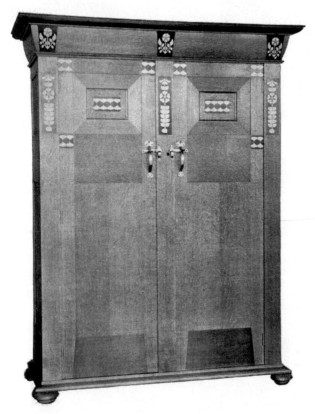

▲ **17-36.** Wardrobe, c. 1900; Ambrose Heal, manufactured by Heal and Son; and Anglo-Japanese secretary in oak, 1896, by Charles F. A. Voysey; England.

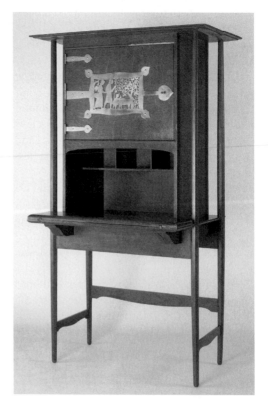

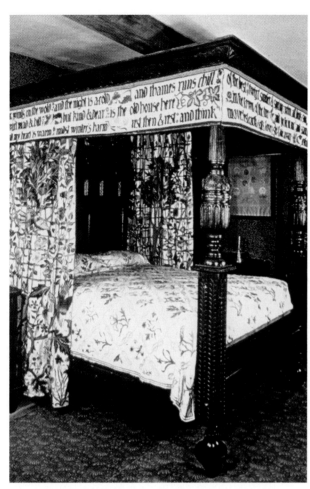

▲ **17-37.** Bed, William Morris's bedroom, Kelmscott Manor; bed c. 17th century, embroidered bed hangings 1891; Hammersmith, England; bed hangings by May Morris.

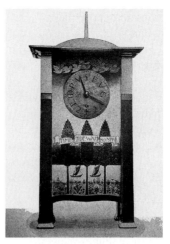

▲ **17-39.** Mantel clock, 1896; England; Charles F. A. Voysey.

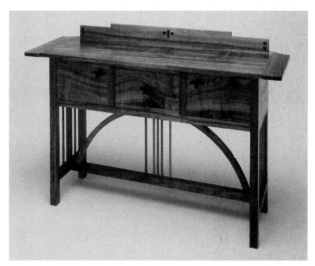

▲ **17-40.** Later Interpretation: Sideboard, 2002; manufactured by Jaeger & Ernst, Inc., in Barboursville, Virginia.

▲ **17-38.** Decanter, 1901; England; made by the Guild of Handicraft; Charles R. Ashbee.

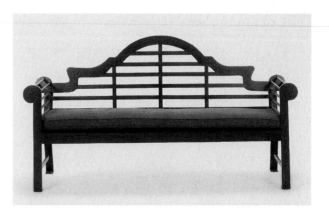

▲ **17-41.** Later Interpretation: Lutyens bench in teak, 2004; Colorado; manufactured by Smith and Hawken. Environmental Modern.

Large dressers with drawer bases and upper shelves often appear in dining rooms or kitchens.

■ *Beds*. Rectangular-shaped beds with plain headboards are common. Morris favors Elizabethan-style four-posters with embroidered hangings (Fig. 17-37).

■ *Decorative Arts*. Designers advocate craft or handmade decorative arts, not only English, but Indian, Japanese, Chinese, Persian, and other cultures. Evident in Arts and Crafts rooms are historic textiles produced with natural dyes, handmade ceramics, metalwork, and wooden objects. The crafts of embroidery and book binding are revived (Fig. 17-4, 17-37).

Artisans, professionals, or hobbyists create handmade products (Fig. 17-38, 17-39). Crafts are used as a tool of moral and social reform. Wealthy and upper-class women and philanthropists promote the idea of crafts made by the working and lower classes for income and to uplift them. Similar groups seek to preserve or revive regional crafts such as lace making, needlework, and knitting.

■ *Later Interpretations*. By the 1920s, Modern-style, machine-made furniture replaces Arts and Crafts. Although traditional handcraftsmanship withers, a few struggle to maintain it, mostly in the Cotswolds where life and craft are closely united. The Arts and Crafts Movement is largely forgotten. However, in the 1970s and 1980s, scholars and collectors discover its furniture, which soon becomes fashionable and collectable. Manufacturers begin to reproduce and adapt original designs to suit contemporary tastes. Individual craftsman begin making furniture according to Arts and Crafts principles. The revival of interest in Arts and Crafts furniture continues in the 1990s and 2000s through works of individuals and various reproductions by furniture companies (Fig. 17-40, 17-41).

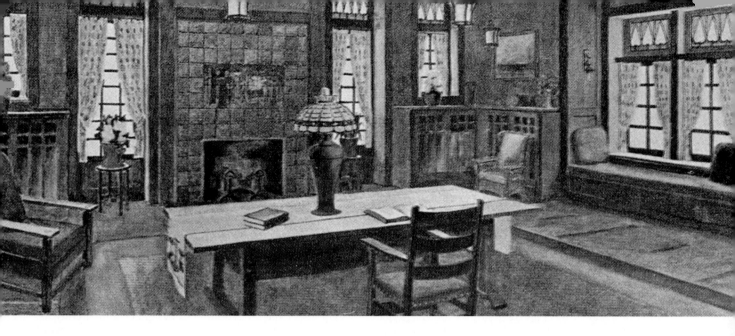

CHAPTER 18

Shingle Style and American Arts and Crafts

1880s–1930s

We have selected for presentation here what we consider the best of the houses designed in The Craftsman Workshops and published in "The Craftsman" during the past five years. Brought together this way in a closely related group, these designs serve to show the development of the Craftsman idea of home building, decoration and furnishing, and to make plain the fundamental principles which underlie the planning of every Craftsman house. These principles are simplicity, durability, fitness for the life that is to be lived in the house and harmony with its natural surroundings. Given these things, the beauty and comfort of the home environment develops as naturally as a flowering plant from the root.

Gustav Stickley, *Craftsman Homes*, 1909

No house should be on any hill or on anything. It should be of the hill, belonging to it, so hill and house could live together each the happier for the other.

Frank Lloyd Wright,
An Autobiography, 1932

The Shingle Style, unique to architecture in the United States, evolves from architects' explorations of New England's Colonial architecture combined with aspects of the English Queen Anne style. Buildings are picturesque, rambling, irregular, and covered with wood shingles. Although most examples are architect-designed and found in coastal or resort areas, builder expressions appear across the country.

The American Arts and Crafts Movement follows the principles and tenets of the English Arts and Crafts Movement, but interprets them in a more individualistic way and integrates more diverse influences. Design advocates promote similar ideals and social transformation to a wealthy elite as well as an expanding middle class. The broad style and character of American Arts and Crafts varies by regions of the country and by individual designers, builders, entrepreneurs, or mail-order catalogs. Examples include Craftsman furniture by Gustav Stickley, Prairie houses in Illinois by Frank Lloyd

Wright, individually designed and crafted bungalows in California by the Greene brothers, and smaller bungalows produced by various builders throughout the United States. The overall visual image is one of simplicity and a handmade character.

HISTORICAL AND SOCIAL

A culture of reform dominates the United States during the last two decades of the 19th century. Economic woes, political failures, industrialization, urbanization, and immigration lead to calls on all sides for social and political transformations. Some see the quality of architecture, interiors, and furnishings as indicative of much that is wrong in the nation. Believing that art reflects the nation that creates it and influences the individual user or inhabitant, the reformers look for ways to bring about change in architecture and decorative arts. This atmosphere of change is particularly receptive to the Arts and Crafts agenda of reforming design through handicraft. Many are familiar with its tenets through reading John Ruskin's books or seeing William Morris's ideas in periodicals. English reformers, such as Walter Crane, Charles R. Ashbee, and May Morris, travel the lecture circuit in the United States. Likewise, architects, designers, and artisans from the United States travel to England where they meet Morris and other leaders of the English Arts and Crafts Movement.

The American movement has a greater moral dimension than the one in England, but it is less concerned with the plight of the individual worker. Some manufacturers, such as Gustav Stickley, do try to provide excellent working conditions. The movement is part of continuing efforts to transform the family and the individual by reforming the home and its interiors. As in England, American tools of social reform include guilds, cooperatives, and utopian communities, such as Elbert Hubbard's Roycroft and Rose Valley.

To a greater degree than in England, Americans use craft as a tool for moral and social reform for groups such as immigrants in settlement houses or Native Americans on Indian reservations. This also extends into a strong hobbyist or do-it-yourself component marketed to individual homeowners through magazines such as *Popular Mechanics* and *The Craftsman* and workshop courses for males at high schools. More people have access to the appropriate information to produce Craftsman-inspired furnishings, thereby transforming their lives. Arts and Crafts writings, like others of the period, are couched in a language of virtue that includes such terms as *contentment, simplicity, honesty, truth, sincerity,* and *comfort.* Writings stress the desirability of the simple life, the necessity of rejecting materialism, and a return to nature.

International expositions also acquaint the public with Arts and Crafts beginning with the Centennial International Exhibition of 1876 in Philadelphia and continuing in the World's Columbian Exposition of 1893 in Chicago, the Pan-American Exposition of 1901 in Buffalo, the Louisiana Purchase Exposition of 1904 in St. Louis, the Panama Pacific Exposition of 1915 in San Francisco, and the Panama California Exposition of 1915 in San Diego. English architecture books, decorating manuals, and magazines such as the *International Studio* spread Arts and Crafts principles. Numerous American shelter magazines and journals, such as *The Craftsman, The Bungalow Magazine, Lady's Home Journal,* and *House Beautiful,* publish articles, plans, and photographs, some by prominent designers and architects. As in England, American Arts and Crafts societies spring up, and some operate like medieval guilds. Unlike in England, these groups are egalitarian and made up of artists, dilettantes, and hobbyists who practice, exhibit, and sell their works; publish journals; listen to lectures; and form discussion groups.

CONCEPTS

■ *Shingle Style.* The roots of Shingle Style are in English Queen Anne architecture and 17th-century buildings of New England. The shingles, additive or rambling quality, and broad roofs characteristic of early houses become defining elements of this Americanized version of Queen Anne. Designers strive to create order and unity within complex architectural form by using shingles to

IMPORTANT TREATISES

- ■ *Arts-Crafts Lamps: How to Make Them,* 1911, John Adams (Popular Mechanics Handbooks).

- ■ *Bungalows: Their Design, Construction and Furnishings, with Suggestions also for Camps, Summer Homes and Cottages of Similar Character,* 1911; Henry H. Saylor.

- ■ *The Bungalow Book,* 1908; Henry L. Wilson.

- ■ *Craftsman Homes,* 1909; Gustav Stickley.

Periodicals and Catalogs: Catalogue of Craftsman Furniture Made by Gustav Stickley at The Craftsman Workshops, 1910; *The Craftsman,* 1901–1916; *The House Beautiful,* 1898–present; *Ladies Home Journal,* 1880–present; *House and Garden,* 1901–2007; *Mission Furniture: How to Make It,* 1910 (Popular Mechanics Handbooks).

▲ **18-1.** Frank Lloyd Wright (left), and Gustav Stickley and friends.

unify irregular shapes and massing. Further unity is achieved through eliminating and reducing individual details. Because early proponents are trained at L'École des Beaux-Arts (see Chapter 12, "Classical Eclecticism"), many examples display a fundamental geometry and careful relationship of parts. A picturesque image is characteristic; thus, builders often refer to the new houses in Newport, Cape Cod, Long Island, and coastal Maine as "cottages with shingles." Noteworthy examples are high-style homes designed by architects. Although frequently published, there are fewer builder examples of the Shingle Style.

■ *American Arts and Crafts.* American Arts and Crafts derives concepts from Pugin, Ruskin, Morris, and other English design leaders, and manifestations reveal shared principles instead of unified style: honesty, simplicity, regionalism, vernacular traditions, and harmony with the landscape. Within these principles, individual designers strive to create their own American expression. Less cohesive than its English counterpart, the American movement reveals greater diversity in appearance. Like the English, Americans look longingly back to an imaginary preindustrial past. However, the medieval and Gothic are one of many pasts, including regional ones, from which Americans can choose. The English movement's emphasis upon individualism is more appealing to the educated men and women who make up the American movement, giving rise to individualist architects, artisans, and entrepreneurs. Furthermore, the size

of the country and its regional differences preclude any real unity.

The American movement also is influenced by other countries such as France, through L'École des Beaux-Arts and the writings of Viollet-le-Duc; Japan; and, to a lesser extent, Art Nouveau and other European movements of the period. Unlike their English counterparts, Americans are far less likely to reject the machine while embracing principles of handcraftsmanship and good design. In fact, mechanization democratizes Arts and Crafts. The movement's principles and products are available to any and all consumers through mass production and mass marketing. Thus, the American Arts and Crafts Movement appears in several venues such as elite, custom-designed total environments created for individual clients by architects and designers as well as in less expensive, machine-made and mass-marketed houses and furnishings created for and by the middle class. The style is also identified as Craftsman, Mission, or Prairie style.

DESIGN CHARACTERISTICS

Both the Shingle Style and the American Arts and Crafts Movement favor the styles, forms, and details of the Middle Ages. Common design principles include asymmetry, irregularity, verticality, and simplicity. However, neither strives for a literal interpretation but seeks

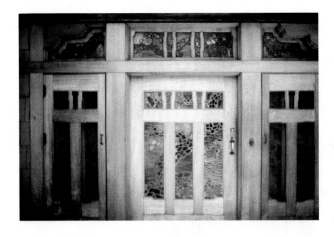

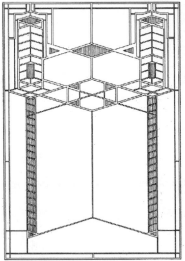

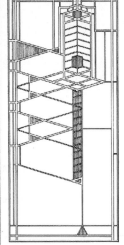

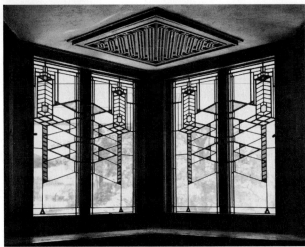

▲ **18-2.** Stained glass doors and windows; 1890s–1910s; Greene and Greene brothers and Frank Lloyd Wright.

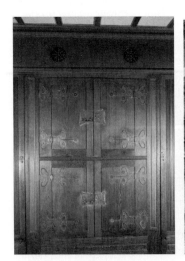

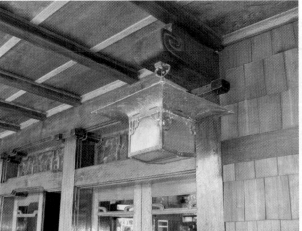

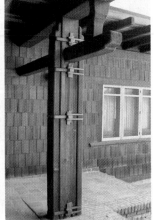

▲ **18-3.** Cabinet door detail, Samuel Tilton House, 1881–1882; Newport, Rhode Island; McKim, Mead, and White, and structural details, Blacker House, 1907; Pasadena, California; Greene and Greene brothers. Shingle, and American Arts and Crafts.

to capture the essence of the past while reforming design of the present.

■ *Shingle Style*. Shingles covering all or nearly all wall surfaces, columns, and details define the Shingle Style. Other characteristics include asymmetry, irregular massing, horizontal emphasis, a broad gable or gables on one or more facades, towers, bay windows, porches, and multiple roofs. Buildings exhibit more continuity in surface material, texture, line, and form than those in the Stick Style or Queen Anne. Although resembling Queen Anne, the effect is calmer and quieter, while maintaining a free-form character. Spatial interplay absorbed from Japanese architecture and achieved through open, flowing space is characteristic.

■ *American Arts and Crafts*. As in England, American Arts and Crafts architecture, interiors, furniture, and decorative arts display simplicity, honesty through revealed structure and suitability to purpose, truth in materials, vernacular traditions, integrated interiors and exteriors, close ties to the landscape and location, and a handcrafted appearance. A strong thread of back-to-nature is evident in the emphasis upon naturalistic colors and motifs. Local regional traditions are especially strong, which give rise to great diversity of expression. Particularly important are unity of interior and exterior and interior to furnishings; economy of space, furniture, and objects; and efficiency and functionality in planning and organization.

■ *Motifs*. Motifs of the period are flowers, trees, foliage, animals, geometric motifs, Gothic details, and Oriental images (Fig. 18-2, 18-3, 18-30, 18-31, 18-36, 18-37, 18-38).

ARCHITECTURE • SHINGLE STYLE

In the late 1870s, the Shingle Style grows out of architects' explorations of Colonial architecture and resort vacations taken by the newly wealthy leisured class. The style appeals because it recalls, but is not shackled by, the past and exhibits freedom of expression, informality, and continuity of texture. The first examples are architect-designed homes in resort areas in New England, but the style spreads quickly across the country through other architects, builders, and publications. Absorbing characteristics from many influences, the uniquely American style incorporates shingles, irregularity, and a picturesque image from Queen Anne; rambling additions, gambrel roofs, and Palladian windows from New England Colonial buildings; Romanesque arches and curved shapes from Romanesque Revival; and free-flowing space and structural emphasis from Japan. Called Queen Anne in its day, art historian Vincent Scully gives it the name Shingle Style in 1955. Shingle Style has no corresponding expression in interiors and furniture.

Public and Private Buildings • Shingle Style

■ *Types*. Although largely residential, Shingle Style often defines hotels and commercial and retail buildings (Fig. 18-4, 18-11, 18-13, 18-14).

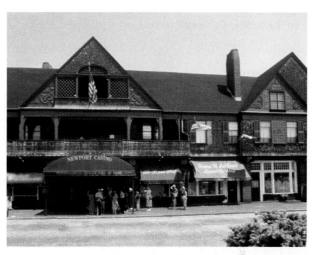

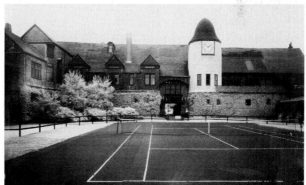

▲ **18-4.** Newport Casino, 1880–1881; Newport, Rhode Island; McKim, Mead, and White. Shingle Style.

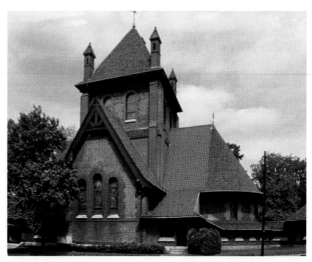

▲ **18-5.** Cathedral of All Souls Episcopal Church, 1896; Asheville, North Carolina; Richard Morris Hunt. Arts and Crafts.

IMPORTANT BUILDINGS AND INTERIORS

- **Asheville, North Carolina:**
 - Cathedral of All Souls Episcopal Church, 1896; Richard Morris Hunt. Arts and Crafts.
 - Grove Park Inn, 1912–1913.

- **Berkeley, California:**
 - First Church of Christ Scientist, 1910–1912; Bernard Maybeck. Arts and Crafts.
 - First Unitarian Church, 1898; A. C. Schweinfurth. Shingle Style.
 - Hearst Hall, 1899; Bernard Maybeck. Arts and Crafts.

- **Bristol, Rhode Island:**
 - William Low House, 1887; McKim, Mead, and White (Destroyed). Shingle Style.

- **Buffalo, New York:**
 - Darwin D. Martin House, 1904; Frank Lloyd Wright. Prairie style.

- **Chicago, Illinois:**
 - Frederick C. Robie House, 1909–1910; Frank Lloyd Wright. Prairie style.
 - Second Presbyterian Church, 1901; Howard Van Doren and muralist Frederick Clay Barlett.

- **Clackamas County, Oregon:**
 - Timberline Lodge, c. 1937; W. I. Turner, Linn Forrest, Howard Gifford, Dean Wright with the United States Forestry Service and Gilbert Stanley Underwood and Company.

- **Detroit, Michigan:**
 - Charles Long Freer House, 1887; Wilson Eyre. Shingle Style.

- **Grand Rapids, Michigan:**
 - Meyer May House, 1905; Frank Lloyd Wright. Prairie style.

- **Highland Park, Illinois:**
 - Ward W. Willits House, 1902; Frank Lloyd Wright. Prairie style.

- **Morris County, New Jersey:**
 - Craftsman suburb, 1900s; Gustav Stickley and Harvey Ellis. Arts and Crafts.

- **Nantucket, Massachusetts:**
 - Sandanwede for the Stifel family, 1881. Shingle Style.

- **Newport, Rhode Island:**
 - Isaac Bell House, 1883; McKim, Mead, and White. Shingle Style.
 - Newport Casino, 1880–1881; McKim, Mead, and White. Shingle Style.
 - Samuel Tilton House, 1881–1882; McKim, Mead, and White. Shingle Style.

- **Oak Park, Illinois:**
 - Edwin H. Cheney House, 1904; Frank Lloyd Wright. Prairie style.
 - Frank Lloyd Wright House and Studio, 1889; Frank Lloyd Wright. House in Shingle Style; Studio in Prairie style.

- **Pasadena, California:**
 - Robert C. Blacker House, 1907; Charles Sumner Greene and Henry Mather Greene. Arts and Crafts.
 - James A. Culbertson House, 1907; Charles Sumner Greene and Henry Mather Greene. Arts and Crafts.
 - David B. Gamble House, 1907–1908; Charles Sumner Greene and Henry Mather Greene. Arts and Crafts.
 - Theodore Irwin House, 1906; Charles Sumner Greene and Henry Mather Greene. Arts and Crafts.

- **Riverside, Illinois:**
 - Avery Coonley House, 1908; Frank Lloyd Wright. Prairie style.

- **San Francisco, California:**
 - Goslinsky House, 1909; Bernard Maybeck. Arts and Crafts.

- **Springfield, Illinois:**
 - Susan Lawrence Dana House, 1903; Frank Lloyd Wright. Prairie style.

- **Spring Green, Wisconsin:**
 - Taliesin, 1911–1950s; Frank Lloyd Wright. Prairie style.

- **Tuxedo Park, New York:**
 - William Kent House, 1885–1886; Bruce Price. Shingle Style.

- **Yellowstone National Park, Wyommg:**
 - Old Faithful Lodge, 1903; Robert Reamer. Arts and Crafts.

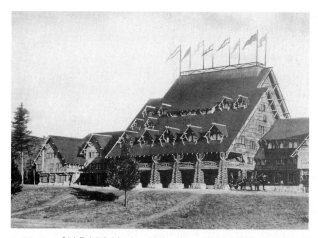

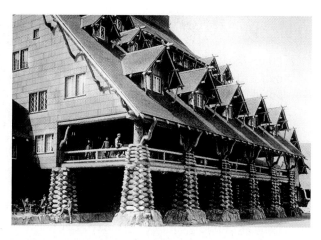

▲ **18-6.** Old Faithful Lodge, Yellowstone National Park, 1903; Wyoming; Robert Reamer. Arts and Crafts.

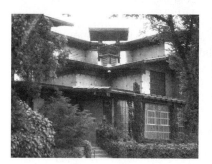

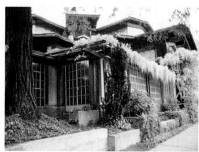

▲ **18-7.** First Church of Christ Scientist, 1910–1912; Berkeley, California; Bernard Maybeck. Arts and Crafts.

■ *Site Orientation*. Most often, designers locate houses and hotels in natural settings with open space and wide expansive views (Fig. 18-11). In resort areas, Shingle Style houses may line streets leading to beaches in New England or group around a lake in the Adirondacks, often with large Shingle-Style hotels nearby. Or houses may be in certain suburbs in the Midwest (Fig. 18-14) and California.

▲ **18-8.** Grove Park Inn, 1912–1913; Asheville, North Carolina. Arts and Crafts.

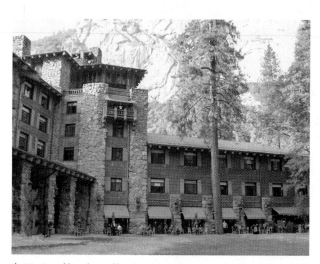

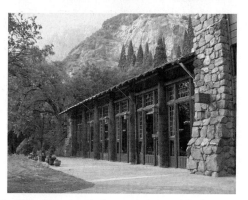

▲ **18-9.** Ahwahnee Hotel, c. 1927; Yosemite National Park, California; Gilbert Stanley Underwood. Arts and Crafts.

DESIGN PRACTITIONERS

- **Charles Sumner Greene** (1868–1957) and brother **Henry Mather Greene** (1870–1954), noted California architects, combine Japanese wood traditions and California regional styles with northern European crafts to create custom bungalows throughout California. For these houses, they also design furniture and decorative accessories to create total environments.

- **Elbert Hubbard** (1873–1915), founder of the Roycroft Shops in New York, promotes a communal living and working environment concerned with quality crafts production. A flamboyant businessman, Hubbard takes advantage of interest in his products by establishing a hotel for visitors in the community and publishing *The Philistine* (1895–1915), a magazine devoted to his philosophy and Roycroft products.

- **Bernard Ralph Maybeck** (1862–1957), a northern California architect, encourages a strong relationship between the artist and the craftsman. His highly individual work reveals a variety of influences such as Japanese, Gothic, and the vernacular.

- **Gustav Stickley** (1857–1942) is the great promoter of Arts and Crafts principles in the United States. Not only does he manufacture furniture, he publishes *The Craftsman*, a magazine in which he advocates comfortable furniture and naturally landscaped suburban houses planned for economy, efficiency, practicality, coziness, spaciousness, healthfulness, and family life. He popularizes the name Mission for plain, rectilinear Arts and Crafts furniture. Stickley's brothers also produce Arts and Crafts furniture, including Stickley Brothers of Grand Rapids (1891–1930s), Stickley and Brandt of New York, and L. & J. G. Stickley (1901 to present).

- **Frank Lloyd Wright** (1860–1959), an innovative American architect, advocates a new Prairie style that emphasizes human proportions, simplicity, interlocking interior space, natural materials, and organic concepts. Derived, in part, from Arts and Crafts precepts, Wright's architecture influences Europe instead of the usual other way around.

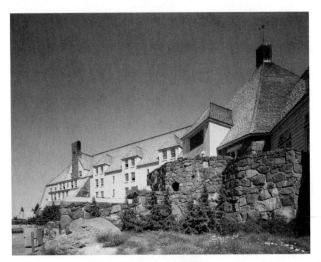
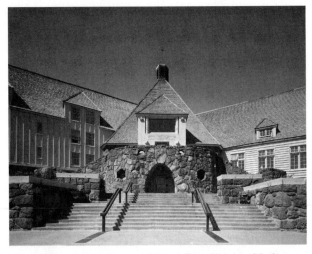

▲ **18-10.** Timberline Lodge, c. 1937; Clackamas County, Oregon; W. I. Turner, Linn Forrest, Howard Gifford, Dean Wright with the United States Forestry Service and Gilbert Stanley Underwood and Company. Arts and Crafts.

- *Floor Plans.* Floor plans are usually large and rambling and center on a stair hall (Fig. 18-12). Continuity with the exterior is maintained in the open space planning. Large openings visually connect spaces. Architects sometimes modify the traditional enfilade by placing offsetting rooms in sequence to create more dynamic diagonal vistas.

- *Materials.* Wood is the building material (Fig. 18-4, 18-11, 18-13). A few examples have stone or rubble ground stories, but their upper stories are shingled. Shingles, although typically square, may be round, hexagonal, or diamond shaped, and most often are left to weather naturally. Roofs are of slate or wooden shingles.

DESIGN SPOTLIGHT

Architecture: Isaac Bell House, 1883; Newport, Rhode Island; McKim, Mead, and White. Shingle Style. The Isaac Bell House by McKim, Mead, and White features complex massing, shingled surfaces, and the elimination of details to create order and unity. The character of composition resembles a New England farmhouse but lacks direct historical references. A large front gable dominates the façade and is balanced by one to the right and smaller ones on the porch. The chimneys, a turret, and two-storied sleeping porch are vertical elements. Rooflines, projections, and the negative space of the porch emphasize horizontality. Bamboo-like porch supports offer an exotic touch. The entire house is covered with shingles in several forms, including curving ones in the apex of the small gable.

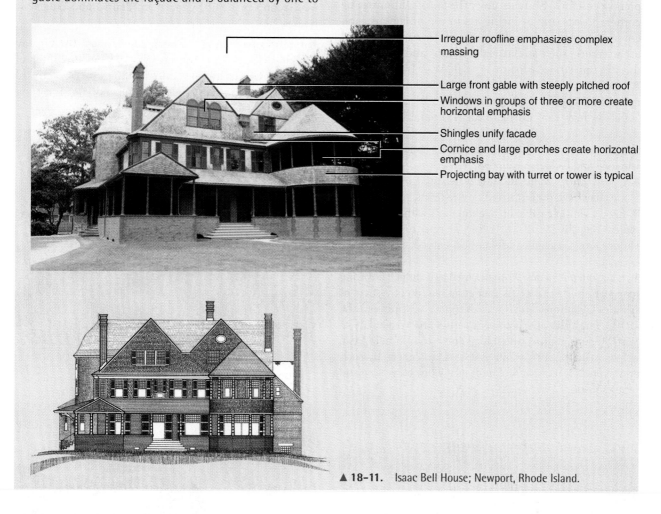

Irregular roofline emphasizes complex massing

Large front gable with steeply pitched roof

Windows in groups of three or more create horizontal emphasis

Shingles unify facade

Cornice and large porches create horizontal emphasis

Projecting bay with turret or tower is typical

▲ **18-11.** Isaac Bell House; Newport, Rhode Island.

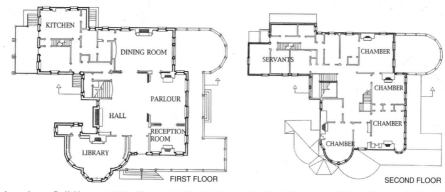

▲ **18-12.** Floor plans, Isaac Bell House, 1883; Newport, Rhode Island; McKim, Mead, and White. Shingle Style.

■ *Facades*. Usually asymmetrical, facades are more horizontal and quieter with fewer textures than in Queen Anne (Fig. 18-4, 18-11, 18-13, 18-14). A broad triangular gable or gables may dominate one or more sides. Additionally, fronts may have towers, turrets, and bay or oriel windows. Towers often blend into the form of the façade and roofline instead of being separated as in Queen Anne. Most structures have porches that may project or be integrated with the body of the building. Porch supports may be stone arches or shingle-covered piers or columns. Shingles unify the façade. Eliminating corner boards and reducing textures, ornament, and color adds further unity. Elements of American colonial architecture, such as classical columns and lean-to additions, appear occasionally.

■ *Windows*. Sash windows (Fig. 18-11) with a multipaned upper sash over a single-pane lower sash are common. Windows may vary in size, form horizontal bands across the façade, or be placed symmetrically or asymmetrically (Fig. 18-11, 18-14). Other window types include casement windows and Palladian windows.

■ *Doors*. Entry doors are usually recessed in the porch. Doors may have transoms and/or side lights.

■ *Roofs*. Multiple gable or gambrel roofs with dormers are typical (Fig. 18-11, 18-13, 18-14). Dormer roofs may take various forms, including gable, shed, curved, eyebrow, and conical.

■ *Later Interpretations*. Shingles used as a surface covering reappear in the work of numerous architects, such as Charles Gwathmey and Robert Venturi, beginning in the 1970s. Thus, shingles become a part of the vocabulary of Post-Modern architecture. Elements of the Shingle Style reappear in the 1980s and 1990s in residences by such architects as Robert A. M. Stern, Jacquelin Robertson, and Jeremy Kotas.

ARCHITECTURE • AMERICAN ARTS AND CRAFTS

Although deriving from English principles, American Arts and Crafts architecture differs greatly in result. Lacking the cohesiveness of England, America produces a wider diversity of expression arising from a strong emphasis upon regionalism and individuality. Each region and individual interprets honesty of structure, harmony with the environment, good craftsmanship, and simplicity in its own fashion. Examples include Craftsman, Prairie, and Bungalow houses.

■ *Craftsman Houses*. Craftsman homes by Gustav Stickley (Fig. 18-1), the great voice and promoter of Arts and Crafts in the United States, vary greatly in type and size. Houses in *The Craftsman* do not illustrate

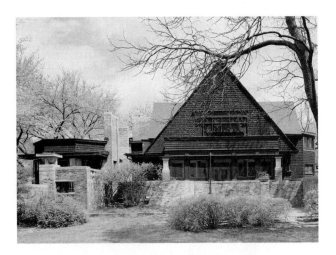

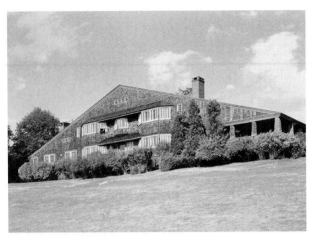

▲ **18-13.** William Low House, 1887; Bristol, Rhode Island; McKim, Mead, and White. Shingle Style.

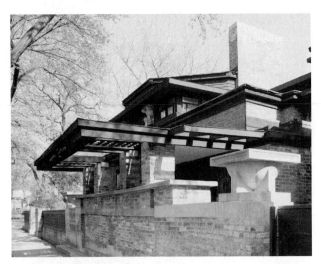

▲ **18-14.** Frank Lloyd Wright House and Studio, 1889; Oak Park, Illinois; Frank Lloyd Wright. House in Shingle Style; Studio in Prairie style.

a particular style but conform to his philosophy, which includes the expression of structure and simple, rustic materials used in a natural state and derived from the site or region.

■ *Prairie Houses*. Prairie houses by Frank Lloyd Wright (Fig. 18-1) in Chicago are fully integrated custom designs. He develops the Prairie style in the early 20th century to reflect his version of Arts and Crafts principles, his admiration of nature, and the art and architecture of Japan. Central to Wright's philosophy is the concept of the house growing from nature, which manifests in harmony of form and material with the environment and the integration of exterior and interior. Plans evolve from the inside out, and horizontality is a primary characteristic. Other architects, both in Wright's office and elsewhere, adopt principles of the style. A popular manifestation appears on the American four-square, a two-story cubical-shaped house type.

■ *Bungalow Houses*. California popularizes the bungalow. High-style examples are large custom-designed bungalows of Henry Mather Greene and Charles Sumner Greene, most of which are in Pasadena. Few in number but important, these homes reveal a carpenter approach to design, exquisite craftsmanship inside and out, and influences from Japan, England, and the Spanish missions. In contrast, the

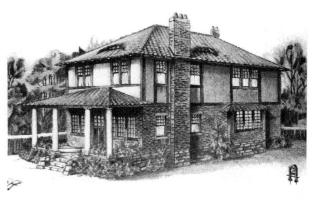

▲ **18-16.** "A Comfortable and Convenient Suburban House"; published in *The Craftsman*, 1907; Gustav Stickley. Craftsman style.

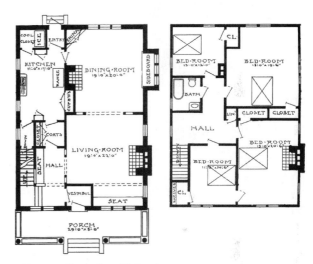

▲ **18-17.** Floor plans, "A Comfortable and Convenient Suburban House"; published in *The Craftsman*, 1907; Gustav Stickley. Craftsman style.

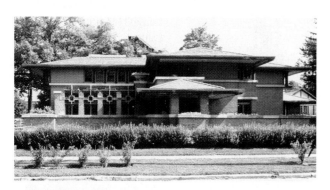

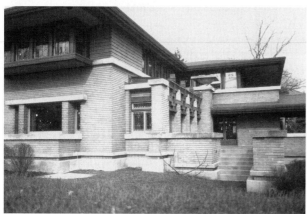

▲ **18-15.** Meyer May House, 1905; Grand Rapids, Michigan; Frank Lloyd Wright. Prairie style.

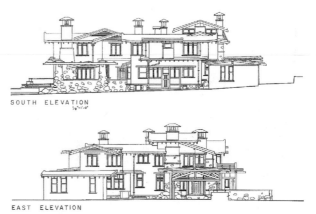

▲ **18-18.** Elevations, Theodore Irwin House, 1906; Charles Sumner Greene and Henry Mather Greene. Arts and Crafts.

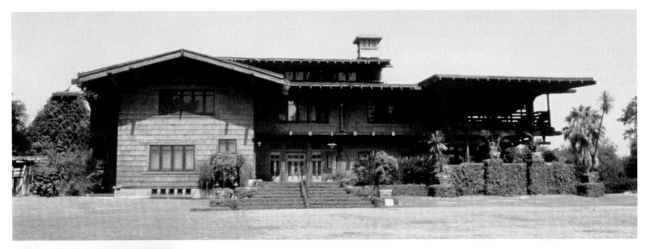

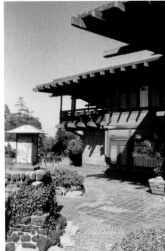

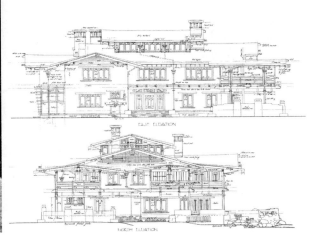

▲ **18-19.** David B. Gamble House, 1907–1908; Pasadena, California; Charles Sumner Greene and Henry Mather Greene. Arts and Crafts.

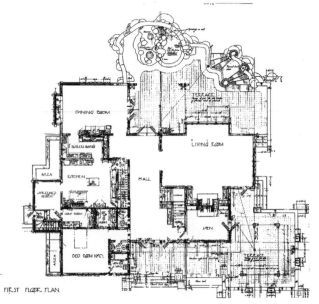

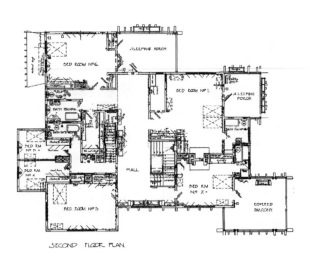

▲ **18-20.** Floor plan, David B. Gamble House, 1907–1908; Pasadena, California; Charles Sumner Greene and Henry Mather Greene. Arts and Crafts.

DESIGN SPOTLIGHT

Architecture: Frederick C. Robie House, 1909–1910; Chicago, Illinois; Frank Lloyd Wright. Prairie style. A masterpiece of the Prairie style, the Robie house has a marked horizontality that integrates the structure with the open midwestern landscape. Low, broad, cantilevered hipped roofs and protected courtyards emphasize the home's sheltering nature. Complementing this idea, the entry is almost hidden on the far side of the house and away from both streets. Bands of windows, narrow Roman brick, and concrete accents emphasize horizontality while contrasting with the verticality of the central core, which houses the hearth or center of the home. Wright's elongated plan takes advantage of the narrow lot with important public spaces located near the front entry. Inhabitants have large window views to the outside with direct access to the terraces, thereby bringing the outside inside.

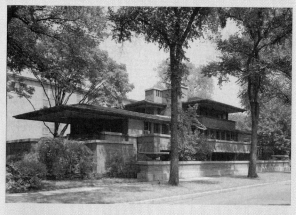

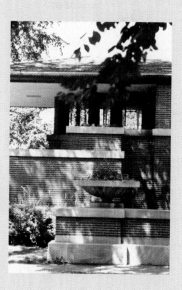

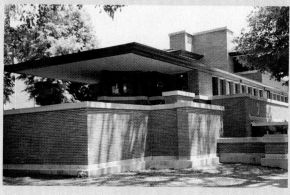

▲ **18-21.** Frederick C. Robie House; Chicago.

middle-class version of the bungalow is a small, single-story house with a broad sheltering roof. A house type rather than a style, the bungalow exhibits Arts and Crafts character in its simplicity, functionality, materials, and adaptability to climate. Bungalows and other similar small homes fulfill the American dream of home ownership for all. Not all Craftsman houses are bungalows, nor are all bungalows Craftsman style despite the popular interchangeable use of the term.

Public and Private Buildings • American Arts and Crafts

■ *Types.* Single-family houses dominate American Arts and Crafts architecture (Fig. 18-15, 18-16, 18-18, 18-19, 18-21, 18-23, 18-24, 18-25, 18-26). There also are Arts and Crafts hotels (Fig. 18-6, 18-8, 18-9, 18-10), vacation houses, churches (Fig. 18-5, 18-7), and clubs.

■ *Site Orientation.* A sense of place and regional character are important, so structures relate to their sites whether through form, as in the horizontality of the Prairie style, materials, or style, such as Craftsman examples. Buildings integrate with the outside using large windows, porches, patios, pergolas, and planters.

■ *Floor Plans.* Plans vary from rectangular to cruciform to T- or L-shaped (Fig. 18-17, 18-20, 18-22). Small square or rectangular plans are the most common with cheaper houses exhibiting the least variety in plan. Designers experiment with open planning for efficiency, freedom, and functionality. Open plans usually center on

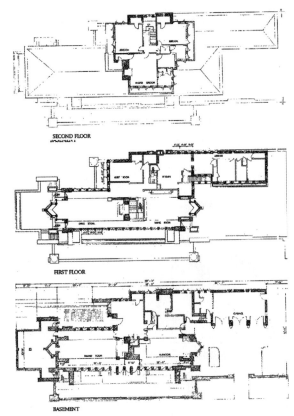

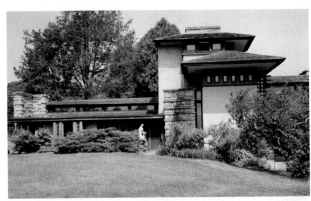

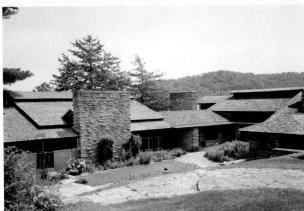

▲ **18-22.** Floor plans, Frederick C. Robie House, 1909–1910; Chicago, Illinois; Frank Lloyd Wright. Prairie style.

▲ **18-23.** Taliesin, 1911–1950s; Spring Green, Wisconsin; Frank Lloyd Wright. Prairie style.

the fireplace as symbolic of home and family. Porches, sleeping porches, and terraces extend living space outdoors.

Arts and Crafts plans, particularly Prairie house examples, develop from the inside out with space flowing around the fireplace, which is usually near the center of the house. The elimination of doors and walls allows spaces to interconnect. Changes in floor level and ceiling heights help differentiate spaces. Only the second-story bedrooms and bathrooms are private. California houses by the Greene brothers incorporate these planning principles in designs for wealthy clients. The overall perception of interior space is enhanced by adding a large entry hall, separating the living and dining rooms, and extending porches or outside living areas.

Bungalow floor plans, most of which are small and rectangular, make the most of limited space by having no separate entry hall and connecting the living and dining rooms with a low or half wall or an arched opening. The kitchen usually is behind the dining room and bathroom, and bedrooms are on the opposite side. Plans for small houses often combine multiple functions and eliminate unnecessary rooms for greater economy.

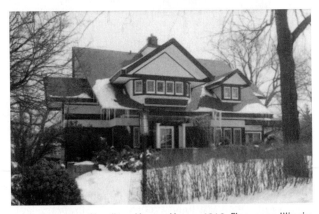

▲ **18-24.** Amy Hamilton Hunter House, 1916; Flossmoor, Illinois; William Gray Purcell and George Grant Elmslie. Prairie style.

■ *Materials.* Materials in natural colors and textures relate buildings to their environments. Building materials include stone, rubble, brick, wood, clapboard or board and batten siding, shingles, stucco, concrete, and concrete blocks. Stucco in a variety of textures may be tinted beige, tan, or gray. Some houses have stained wooden

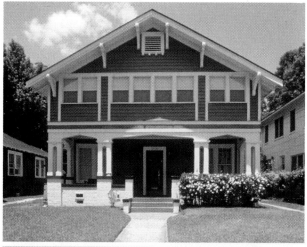

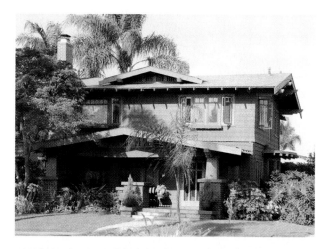

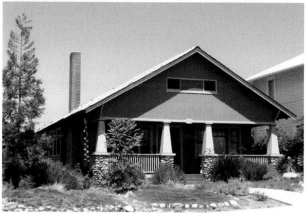

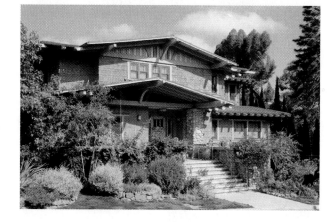

▲ **18-25.** Bungalows, 1900s–1920s; Alabama and California.

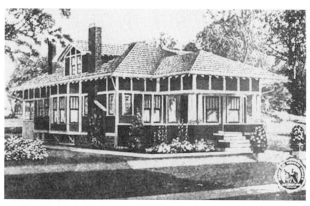

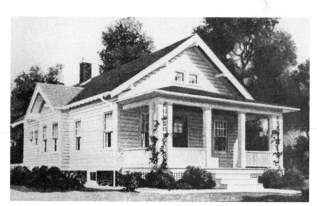

▲ **18-26.** "The Hawthorne" and "The Winona," 1913, 1916; Sears, Roebuck and Company mail-order houses. Bungalows.

slats on exterior walls, which resemble half-timbering. Siding stained green or brown gives an informal, rustic appearance to vacation homes and resorts, but often exterior woods are allowed to weather naturally. To further emphasize their characteristic horizontality, Prairie houses are usually constructed of horizontal wooden siding or narrow Roman brick with wood, stone, or concrete trim. Sometimes the mortar in vertical joints is applied flush

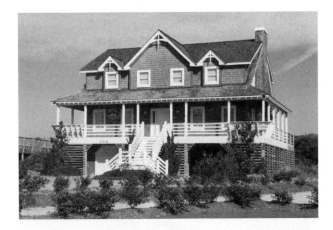

▲ **18-28.** Later Interpretation: The Lodge at Torrey Pines, 2002; La Jolla, California; Wimberly, Allison, Tong & Goo.

▲ **18-27.** Later Interpretation: Beach houses, 1980s; Nags Head, North Carolina, and Seaside, Florida.

and tinted the same color as the brick to further increase horizontality. Greene and Greene houses, bungalows, and others may have stone or rubble foundations and clinker brick.

■ *Facades.* Arts and Crafts façades frequently give an air of vernacular or rustic origins, simplicity, structural honesty, and good craftsmanship (Fig. 18-5, 18-6, 18-8, 18-9, 18-16). Decoration comes from materials, forms, and structure rather than applied ornament. Classical elements are rare. Horizontal emphasis, structural repetition, asymmetrical groupings, and a mix of materials are common characteristics.

The Greene brothers use simple elements to form rambling, complex compositions in houses (Fig. 18-18, 18-19). Asymmetrical façades feature horizontal emphasis created by line and form. Apparent structure is evident, and houses have a carpenter/craftsman appearance

in which each joint is carefully articulated. Balconies and porches project from and penetrate the body of the house.

Prairie houses (Fig. 18-15, 18-21, 18-23, 18-24), in contrast to others, are two or three stories with a pronounced horizontality that is further emphasized by bands of windows and trim and the interpenetration of roofs and terraces into the body of the house. A large and broad chimney, usually in the center, and piers at corners and between windows appear to anchor the house to the landscape while providing vertical elements. Some have wings at right angles to the main house. Often cantilevered, porches with massive square or rectangular supports, decks, terraces, and balconies form transitional spaces to the outdoors, and urns, planters, and window boxes are integrated into walls, porches, and terraces.

Bungalows (Fig. 18-25, 18-26) are one or one and half stories with a front full- or partial-width porch. The two-story variation, which is not considered a true bungalow, may be described as built along bungalow lines or may be called a semi-bungalow or bungaloid. Bungalows have front or side gables with dormers. Organization, symmetry, and decorative elements may relate the house to a particular region, such as Colonial for New England or Prairie for the Midwest. Those on the West Coast often reflect a Japanese sensibility. Porch supports may be tapered square columns; short, square columns with large piers beneath; or solid balustrades. Many columns or supports extend to the ground with no break at the floor of the porch.

■ *Windows.* A variety of window types appear on Arts and Crafts houses and commercial buildings (Fig. 18-6, 18-16, 18-19, 18-21, 18-26). Prairie houses have bands of windows with solid piers between. Windows may turn corners to give the impression of transparency. Stained

glass in geometric patterns depicts local foliage or flowers. Other types of windows include casements with leaded glass or single-pane lower sashes with multipane uppers.

■ *Doors*. Prairie house entrances often are hidden to avoid interrupting the horizontality of the house (Fig. 18-15, 18-23). Generally, entry doors, located symmetrically or asymmetrically under porches, often have a geometric balance of natural wood, usually oak, panels, and small windows (Fig. 18-19). Art glass often fills the windows and side lights, particularly in the work of Wright and the Greene brothers (Fig. 18-38). Bungalows have simple paneled doors, sometimes with glass panes.

■ *Roofs*. Arts and Crafts roofs frequently have varying roof levels, sometimes in different shapes, and wide overhangs with exposed rafters (Fig. 18-5, 18-6, 18-7, 18-18, 18-19). Some have decorative beams or braces under the gable. Low-pitched roofs, usually hipped, emphasize horizontality on Prairie houses (Fig. 18-15, 18-21). A few have gable roofs with a flat or low-pitched roof. Lower stories may have their own roofs parallel to the main roof. Eaves extend far beyond the wall for shelter and protection from sun and rain.

Bungalows have front or side gabled roofs with or without dormers (Fig. 18-25, 18-26). Side gables usually have a wide dormer with ribbon windows. A few have hipped or cross-gabled roofs.

■ *Later Interpretations*. In the 1950s, Frank Lloyd Wright reinvents the Prairie house in smaller low-cost houses, which he calls Usonian houses. They maintain the horizontality, open planning, built-ins, and economy of space of Prairie houses. The ranch house of the 1950s borrows the horizontality, single story, no wings, and open planning of Prairie houses. In the 1950s and 1960s, Joseph Eichler builds tract-homes in California that utilize many of the principles of the Arts and Crafts Movement in a very contemporary manner. Modern forms of the bungalow appear in patio houses of today. In the early 21st century, architects use the Arts and Crafts vocabulary in various buildings, including beach houses and resort hotels (Fig. 18-27, 18-28).

INTERIORS

Whether elite and architect-designed or more middle class, both Shingle Style and Arts and Crafts houses integrate architecture, interiors, furnishings, and decorative arts into a unified whole. Shingle Style house interiors may derive influences from English Queen Anne and Japanese architecture, but most feature characteristics of Arts and Crafts interiors. Meticulous attention to details and handcrafted work complement the harmonious concept of the parts blended into the whole. Like the exterior, interiors have an informal or vernacular feeling arising

from intimate scale, open space, asymmetrical arrangements, horizontality, rectangular shapes, and straight lines. Japanese influences are prevalent. Architects such as McKim, Mead, and White and writers such as Stickley emphasize that

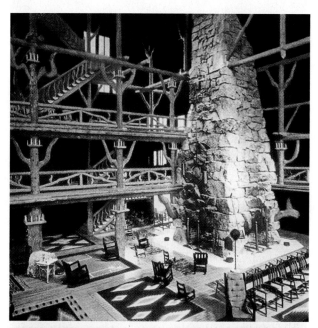

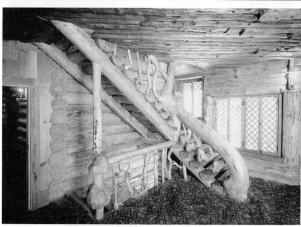

▲ **18-29.** Interiors, Old Faithful Lodge, Yellowstone National Park, 1903; Wyoming; by Robert Reamer. Arts and Crafts.

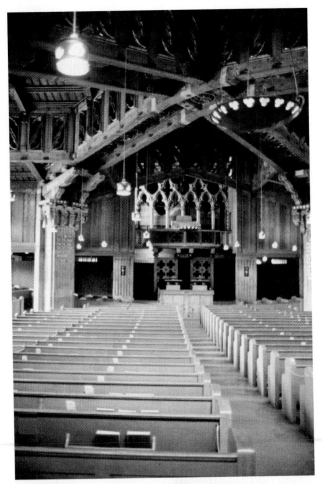

▲ 18-30. Nave, First Church of Christ Scientist, 1910–1912; Berkeley, California; Bernard Maybeck. Arts and Crafts.

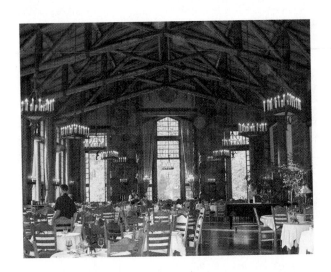

◄ 18-31. Dining room and floor details, Ahwahnee Hotel, c. 1927; Yosemite National Park, California; Gilbert Stanley Underwood. Arts and Crafts.

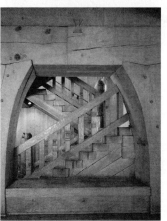

▲ **18-32.** Interiors and architectural details, Timberline Lodge, c. 1937; Clackamas County, Oregon; W. I. Turner, Linn Forrest, Howard Gifford, Dean Wright with the United States Forestry Service and Gilbert Stanley Underwood and Company. Arts and Crafts.

a room's character should reflect its function and the individuals who use it. Equally important design principles are visual continuity among rooms, informal materials and finishes, rough or natural textures, warmth, and light.

Frank Lloyd Wright, the Greene brothers, and other architects create totally designed interior environments for their clients, which may incorporate custom furniture, light fixtures, accessories, and textiles. The middle class seeks assistance from periodicals, such as *The Craftsman* and *House Beautiful*. Prominent architects, such as Wright, occasionally design small houses that are published in these shelter magazines.

Public and Private Buildings

■ *Types*. Houses eliminate superfluous rooms to advance simplicity and efficiency. Although the fireplace is no longer needed for heat, living rooms focus on the hearth as the center of home and family. An inglenook (Fig. 18-33, 18-34, 18-36) often sits adjacent to either side of a fireplace in living rooms or stair halls and supports family

unity. Stickley and other writers emphasize that the dining room is important to family life. They insist that dining rooms (Fig. 18-35, 18-36, 18-37, 18-38, 18-40) express warmth and gracious hospitality to support the important ritual of meals and family bonding.

■ *Relationships*. Interiors maintain a strong and visible relationship to exteriors by repeating exterior characteristics, such as structural details, colors, and materials (Fig. 18-29, 18-31, 18-32, 18-36, 18-37, 18-38). Windows, terraces, and porches bring the outside into the home.

■ *Color*. Colors of nature define the Arts and Crafts interior, and include red, yellow, green, ochre, brown, buff, and tan. Common wall colors are brown, ochre, buff, and off-white. Color selection may be determined by the room's exposure, with warm colors used in northern rooms and cool colors in room's facing south. Wallpapers, textiles, and accessories add accents in brighter colors. Wright is known for his earth-tone color palette.

■ *Lighting*. Numerous, large windows fill the interiors with natural light. Simple, angular light fixtures (Fig. 18-31, 18-37, 18-38, 18-41), such as chandeliers, table and floor lamps, and wall sconces, convey an image of humble

DESIGN SPOTLIGHT

Interiors: Stair hall and living room hall, Samuel Tilton House, 1881–1882; Newport, Rhode Island; McKim, Mead, and White. These spaces display a Medieval spirit that is common in many Shingle, Queen Anne, and Arts and Crafts houses of the late 19th century. The living hall with staircase, inglenook, and built-in seating derives from English Queen Anne houses. Arising from Japanese architecture is the open and interpenetrating space in which vistas change and flow among the hall, living room, and dining room. The fireplace design, niches, paneling, and spindles recall 17th- and early-18th-century buildings with which architects McKim, Mead, and White are especially familiar.

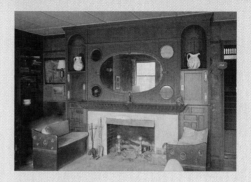

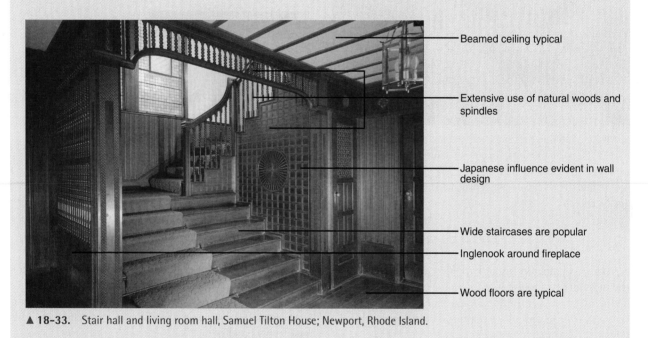

Beamed ceiling typical

Extensive use of natural woods and spindles

Japanese influence evident in wall design

Wide staircases are popular

Inglenook around fireplace

Wood floors are typical

▲ **18-33.** Stair hall and living room hall, Samuel Tilton House; Newport, Rhode Island.

craftsmanship. Iron, copper, brass, and wood combined frequently with opalescent or amber-tinted glass are typical materials.

■ *Floors.* Wood floors covered with decorative area rugs are common, along with painted floors, and tile and linoleum for kitchens and baths (Fig. 18-29, 18-31, 18-33, 18-34, 18-35, 18-36, 18-37). Parquet, with and without borders, is also used. Hand-knotted Oriental rugs, machine-made Orientals, Native American, duggets, or animal skins cover floors. A few rooms use wall-to-wall carpet in simple patterns or the new plain solid-colored carpets. Magnasite, a concrete-like material, may be used for both

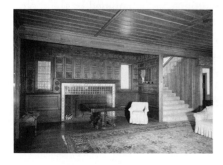

◄ **18-34.** Stair hall and inglenook, Isaac Bell House, 1883; Newport, Rhode Island; McKim, Mead, and White.

flooring and counters in kitchens. Ceramic tile in squares or hexagons and neutral colors covers floors in bathrooms.

■ *Walls.* Stucco walls with wood moldings or slats create a compartmentalized appearance and replicate the structural character of exteriors. Some walls may be of stone or wood to emulate the exterior design (Fig. 18-29, 18-31). In houses

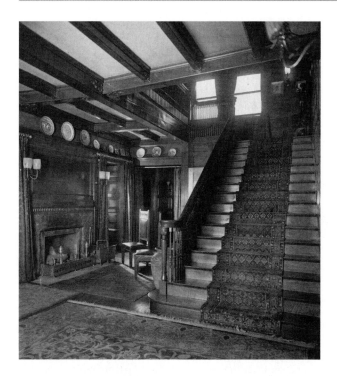

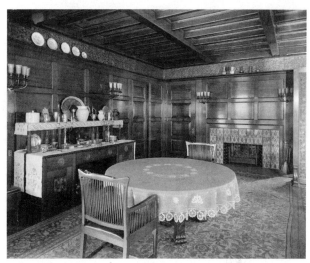

▲ **18-35.** Stair hall and dining room, J. J. Glessner House, 1885–1887; Chicago, Illinois; Henry Hobson Richardson. Arts and Crafts.

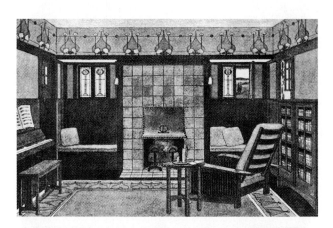

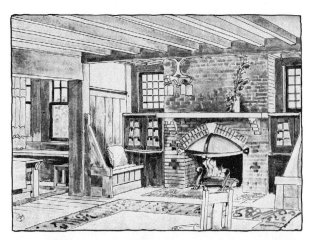

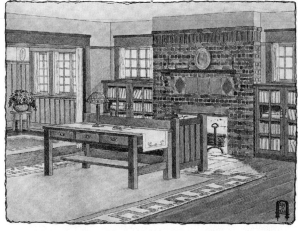

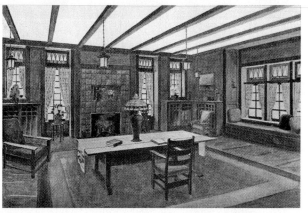

▲ **18-36.** Living rooms and kitchen; published in *The Craftsman*, 1905–1906; Gustav Stickley and Harvey Ellis. Craftsman style.

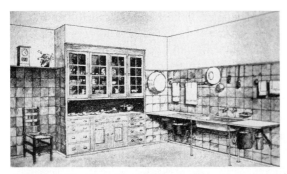

▲ **18-36.** *(continued)*

and commercial buildings, natural wood dados or paneling with detailed joinery embellishes the walls (Fig. 18-33, 18-34, 18-36, 18-38). Wood paneling is an important design element in Greene brothers' work. Rooms occasionally have some built-in seating or storage integrated into the overall interior architectural design. Plain, painted, or wallpaper treatments are common for walls as well. Many rooms have a frieze embellished with wallpaper, painted decoration, fabric, and/or a plate rail to display a limited number of carefully chosen accessories (Fig. 18-35, 18-36, 18-39). Friezes

DESIGN SPOTLIGHT

Interiors: Living room, hall, and dining room, Meyer May House, 1905; Grand Rapids, Michigan; Frank Lloyd Wright. Prairie style. A low ceiling and open, flowing space defines the living and dining rooms, which display Wright's earth-toned palette of soft green, gold, and brown. Large stained glass windows and skylights bring the outside into the space. The fireplace wall is of Roman brick to emphasize horizontality, and glass tiles embedded in the mortar enhance the light in the space. Built-in seats and bookcases flank the hearth opening. The architectonic furniture of oak designed by Wright and interior designer George Niedeken and the area rugs unify the space. The rugs and glass feature stylized plant motifs. Tall-backed chairs and a table with lighted corner posts create the impression of enclosure in the dining room, which also has a built-in sideboard.

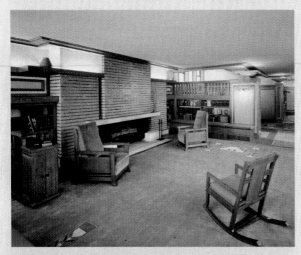

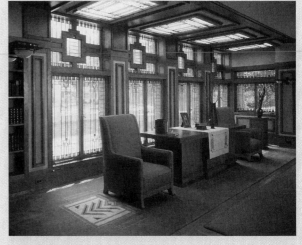

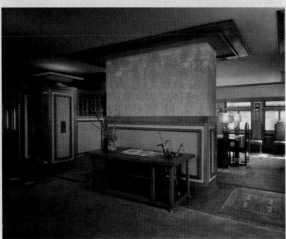

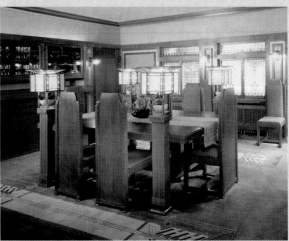

▲ **18-37.** Living room, hall, and dining room, Meyer May House.

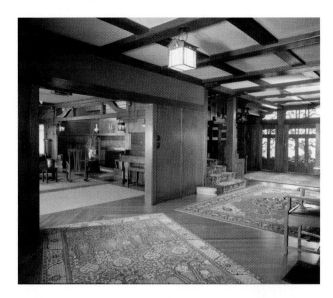
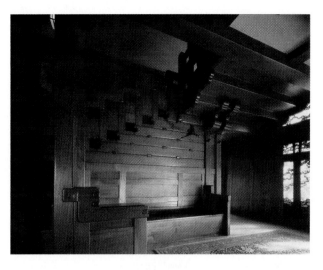

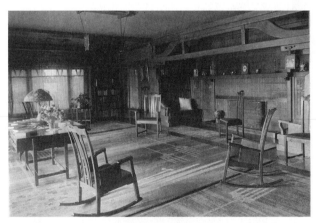
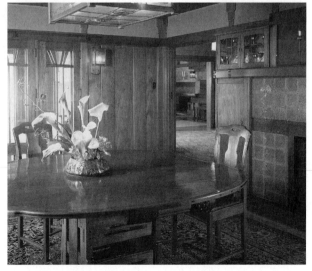

▲ **18-38.** Entry, living room, dining room, and sections, David B. Gamble House, 1907–1908; Pasadena, California; Charles Sumner Greene and Henry Mather Greene. Arts and Crafts.

and wallpapers have stylized naturalistic, geometric, or abstract patterns and natural colors. Wright often uses a frieze to establish visual continuity between rooms. Alternatives to patterned papers include Lincrusta Walton, felt papers, Japanese grass cloth, denim, burlap, and canvas.

■ *Windows.* Simple drapery treatments of panels suspended from rings hang at windows. (Fig. 18-36). Most curtains are sill length and can be tied back to allow in more light. Fabrics are most often plain, natural colored linen or cotton. Naturalistic motifs in brown, gold,

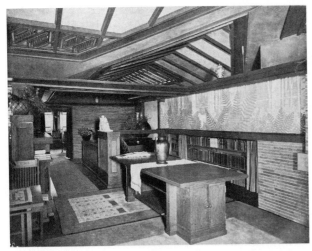

▲ **18-39.** Dining room, Avery Coonley House, 1908; Riverside, Illinois; Frank Lloyd Wright. Prairie style.

green, or coral could be stenciled or embroidered onto plain fabric. Stained glass is a common decorative element (Fig. 18-37), and half or "Morris" curtains cover the lower half of the window when the upper part is stained glass.

■ *Doors.* Large, wood-planked doors with iron hardware are common (Fig. 18-32). Most are paneled and of gum wood with a clear finish. Graining to imitate other woods is condemned as false. Portieres reach their height of popularity in the last decade of the 19th century. They hang at doors to living rooms, dining rooms, and libraries. Each side matches the room it faces.

■ *Ceilings.* Most ceilings are plain and painted white or cream, but some have beams, planks, or compartments to repeat exterior structural character (Fig. 18-30, 18-31, 18-33, 18-35, 18-38, 18-39, 18-40). Ceilings may be

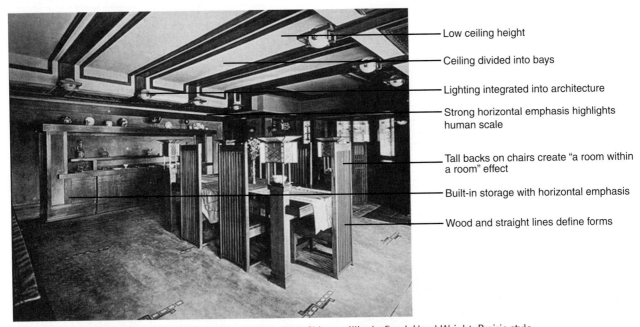

— Low ceiling height

— Ceiling divided into bays

— Lighting integrated into architecture

— Strong horizontal emphasis highlights human scale

— Tall backs on chairs create "a room within a room" effect

— Built-in storage with horizontal emphasis

— Wood and straight lines define forms

▲ **18-40.** Dining room, Frederick C. Robie House, 1909–1910; Chicago, Illinois; Frank Lloyd Wright. Prairie style.

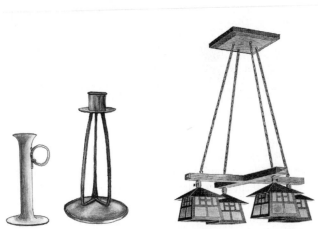
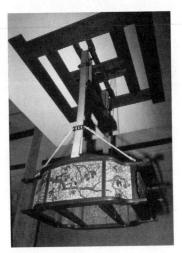

▲ **18-41.** Lighting: Candlesticks, hanging lanterns, and lamps, 1900–1915; United States.

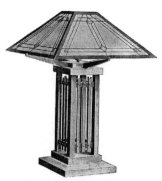

▲ **18-41.** *(continued)*

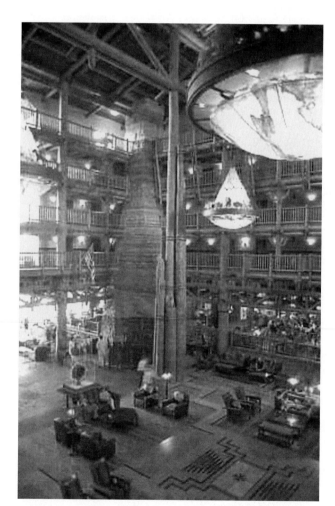

lower in the inglenook or some rooms to create a cozier atmosphere. Wright sometimes incorporates decorative stained glass ceilings in important rooms (Fig. 18-37).

■ *Later Interpretations.* Simplicity, the vernacular, natural colors and textures, and handcraftsmanship of the Arts and Crafts style appeal to late-20th-century and early-21st-century homeowners who desire the appearance of an informal and uncomplicated lifestyle that is not driven by modern technology. Many also enjoy hotels and resorts with this character (Fig. 18-42).

FURNISHINGS AND DECORATIVE ARTS • AMERICAN ARTS AND CRAFTS

Like architecture, Arts and Crafts furniture may be designed by architects, such as Wright or the Greene brothers, for total environments, or mass-produced in factories

▲ **18-42.** Later Interpretation: Interiors, Wilderness Lodge, Disney World, 1994; Lake Buena Vista, Florida; Peter Dominick, Urban Design Group. Modern Historicism/ Regionalism.

◀ **18-43.** Armchair, Darwin R. Martin House, 1904; Buffalo, New York; Frank Lloyd Wright.

DESIGN SPOTLIGHT

Furniture: Craftsman armchair, side chair, rocker, and tables, 1905; manufactured by Craftsman Workshops, New York; Gustav Stickley. Gustav Stickley is the best known and most influential producer of American Arts and Crafts furniture. In 1899, he forms the Gustav Stickley Company in New York, and it produces furniture in many styles. In 1900, Stickley introduces the Craftsman line, consisting of well-designed and well-made furniture in keeping with his Craftsman philosophy, which he absorbs from the English Arts and Crafts Movement. Made of quarter-sawn American white oak, his furniture is simple, rectilinear with mostly straight lines, with revealed construction in pegs and mortise and tenon joints. It is heavy and solid, and the splats give a rhythmic quality. Stickley refuses to use commercial finishes but develops a process he calls fuming to give the wood its characteristic nut-brown color. The company produces quantities of furniture for every room in the house and is widely imitated. The recliner chair, often known as the Morris Chair, is based on the English Arts and Crafts version produced by Willam Morris and his firm.

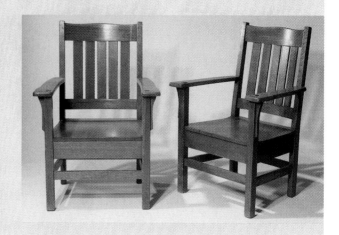

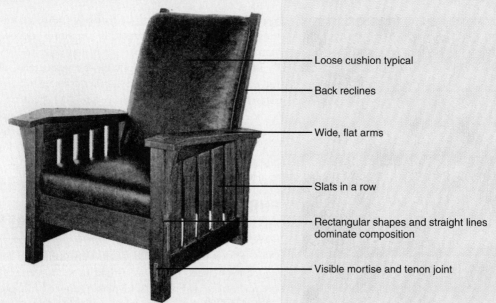

Loose cushion typical

Back reclines

Wide, flat arms

Slats in a row

Rectangular shapes and straight lines dominate composition

Visible mortise and tenon joint

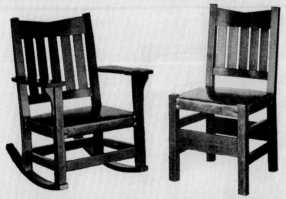

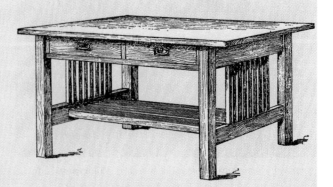

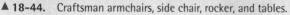

▲ **18-44.** Craftsman armchairs, side chair, rocker, and tables.

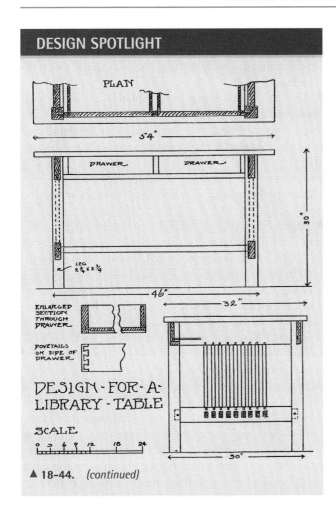

PLAN

54"

DRAWER DRAWER

30"

LEG
2¾ x 2¾

46"

32"

ENLARGED
SECTION
THROUGH
DRAWER

DOVETAILS
ON SIDE OF
DRAWER

DESIGN · FOR · A ·
LIBRARY · TABLE

SCALE

0 3 6 9 12 18 24

30"

▲ 18-44. (continued)

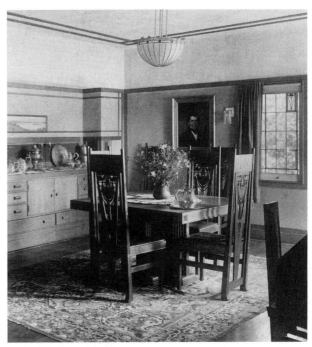

▲ **18-46.** Dining table and chairs, Amy Hamilton Hunter House, 1916; William Gray Purcell and George Grant Elmslie.

like Stickley's, or handcrafted in cooperative or utopian communities, such as Roycroft. Most furniture displays honest use of materials, structural emphasis, and rectangular shapes. Distinctive joinery highlights the work of several designers, such as the beautiful wood dowels visible on

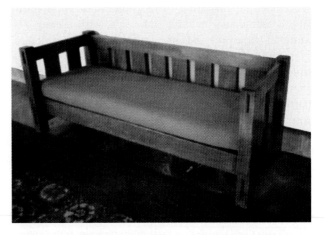

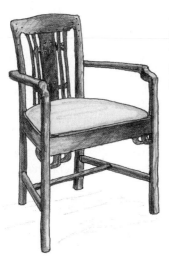

◀ **18-45.** Armchair, Robert C. Blacker House, 1907; Pasadena, California; Charles Sumner Greene and Henry Mather Greene.

▲ **18-47.** Sofas in oak, 1912.

chairs by the Greene brothers. Often limited in quantity, furniture reflects the interior design to reinforce simplicity and openness. Furniture is arranged around major architectural elements.

As with architecture and interiors, much of American Arts and Crafts furniture is machine-made instead of handcrafted, so it reaches a widespread audience. Most examples adhere visibly to Arts and Crafts principles, but lack the philosophical foundation. Some manufacturers create original expressions and devote their entire production to Arts and Crafts–style furniture. Others simply add the style to their existing lines and/or copy examples by Stickley and other prominent manufacturers. A well-known variety of Arts and Crafts is Mission furniture, which seems to arise from California and Spanish mission architecture and furniture. It also is inspired by English Cotswold furniture. Mission may also refer to Gustav Stickley's furniture.

Public and Private Buildings

■ *Types.* All types of furniture appear in interiors. The reclining lounge chair, often known as the Morris chair and based on English Arts and Crafts models, is very common in North America. Stickley produces the best known version of this chair (Fig. 18-44).

■ *Distinctive Features.* Arts and Crafts design principles characterize furniture, whether it is architect-designed, individually handcrafted, or mass-produced. Most furniture is rectangular in form and shape, with no veneers, minimal finishes, and revealed joints and structure. Horizontal in orientation, pieces may illustrate influence from English designers such as Voysey or Mackmurdo. Prairie furniture (Fig. 18-37, 18-40), when designed for a particular space in a particular house, is more architectonic and directly linked to the architecture than other furniture is because it relates more to the house instead of the user. Furniture by the Greene brothers has rounded edges, tapering forms, and subtle curves in backs, stretchers, legs, and arms (Fig. 18-38, 18-45). Brackets and stepped-back forms are borrowed from Japanese furniture. Like Prairie furniture, designs of Greene and Greene relate to the architecture but are more human in scale, reveal more careful detailing, and have softer edges. Craftsman furniture, generally produced by machine, is simple in design with an emphasis on straight lines and wood slats (Fig. 18-36, 18-44).

■ *Materials.* Oak is the common wood, but local woods also are favored. A few examples use mahogany or rosewood. Greene and Greene favor teak and ebony. Decorative inserts are of more valuable woods such as rosewood or ebony. Hinges and pulls may be of brass, copper, or iron, and hammer marks are characteristic. Simple finishes or no stains are preferred over highly finished shiny surfaces. A wax or lightly shellacked finish is the most common, and oak often is fumed with ammonia for an aged look. Veneer, inlay, and marquetry are uncommon except in work by individual craftsmen, such as Harvey Ellis, or communities, such as the Shop of the Crafters in Cincinnati.

■ *Seating.* Most seating is completely of wood with loose cushions instead of attached upholstery. Backs, arms, seats, legs, and stretchers have large, straight components that may be flat planes or quadrangular forms (Fig. 18-36, 18-37, 18-38, 18-40, 18-44, 18-46, 18-47). Backs may have vertical slats, spindles, or pierced splats. Occasionally, curved brackets may support wide, flat arms.

■ *Tables.* Tables are square, rectangular, round, or polygonal and often have wooden plank tops (Fig. 18-36, 18-38, 18-39, 18-44, 18-46, 18-48). Leather, anchored with large nails, or decorative tiles may cover tops. Aprons may be straight or slightly curved. Stretchers may cross and have oversized pegs joining them to legs. Some tables have rectangular spindles between quadrangular legs. Some have planar or flat stretchers, and legs have cutout rectangles or squares. Pegged and mortise and tenon joints are common.

■ *Storage.* Storage is plain, rectangular, and horizontal in orientation (Fig. 18-49, 18-50, 18-51). Planks compose sides and tops. Brackets and overhangs are typical. Hinges and pulls may be overlarge and prominent. Forms emphasize structure with dominant frames composed of rails and stiles. Bookcases have rectangular glazed doors. Many homes have built-in buffets in the dining room and built-in bookcases either separating the living and dining room or flanking the fireplace (Fig. 18-36).

■ *Beds.* Bedroom suites with matching furniture remain fashionable (Fig. 18-51). Beds have simple, plain wood headboards. However simple, painted metal beds or headboards often are used in lesser rooms.

■ *Textiles.* Textile design relies upon geometric patterns stylized natural objects, and flat two-dimensional treatments. Common fabrics include cotton, linen, wool, and leather with little decoration. Textiles may be decorated with embroidery, appliqué, cutwork, or stenciling.

■ *Decorative Arts.* Arts and Crafts rooms usually have fewer decorative accessories than in other styles. Guilds, cooperatives, and manufacturers turn out numerous accessories, including pottery, glass, metal work, baskets, and embroidery. Many objects, however, are handmade by artisans or members of the household. Art education classes, focusing on needlework and pottery, become popular with middle- and working-class women. Many women actively participate in guilds, cooperatives, and societies as designers and makers of ceramics, metal, and needlework. For some, this remains a fashionable hobby, but for others it becomes an important means of supplementing or earning a living. Some, following Candace Wheeler's example, sell their needlework. Art Pottery (see Chapter 16, "Aethetic Movement") remains

▲ **18-48.** Table, 1906; Charles Limbert.

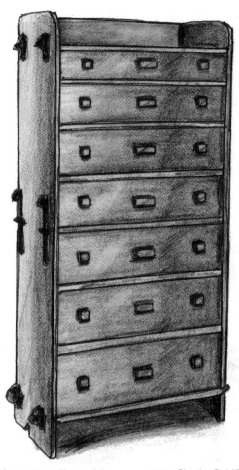

▲ **18-50.** Chest of drawers, c. 1900; Charles Rohlfs.

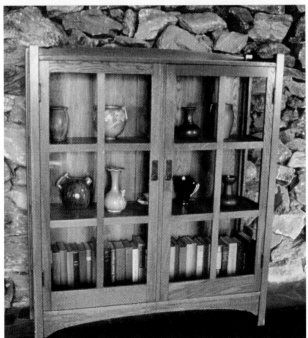

▲ **18-49.** Sideboard and display cabinet in oak with wrought iron pulls and hinges, c. 1904–1905; Stickley workshops. Craftsman style.

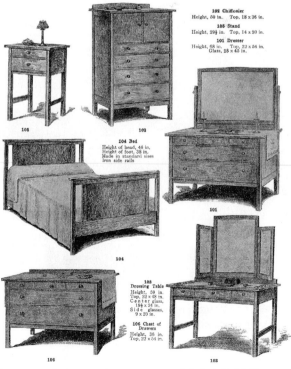

▲ **18-51.** Bedroom suite, c. 1900–1905; L. & J. G. Stickley. Craftsman style.

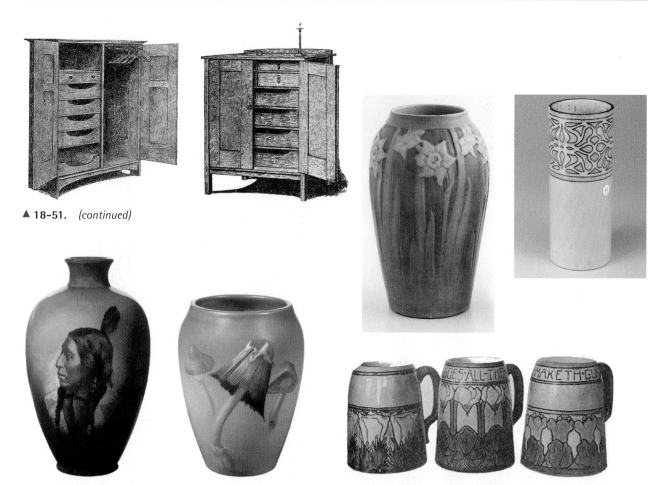

▲ **18-51.** *(continued)*

▲ **18-52.** Art Pottery: Rookwood Pottery and Newcomb College Pottery, c. 1900s–1920s; Ohio and Louisiana.

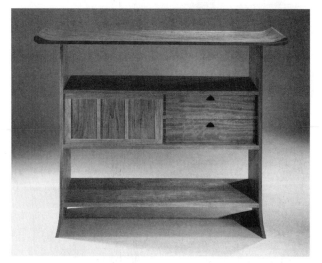

▲ **18-53.** Later Interpretation: Kusaka sideboard in walnut and bubinga, 2002; Massachusetts; John Reed Fox.

a common accessory. Noteworthy examples come from Newcomb College Art School in New Orleans (Fig. 18-52). Pieces feature designs of local flowers, such as magnolias and wisteria. Rookwood Pottery in Cincinnati emphasizes nature, crafts, and an aesthetic image (Fig. 18-52).

■ *Later Interpretations.* In 1989, the L. & J. G. Stickley Company reintroduces Mission furniture that reproduces its earlier pieces. In response to demand, other companies follow suit. Today, individual craftsmen in the United States and England create furniture according to Arts and Crafts design principles (Fig. 18-53).

1883	Anton Gaudi's Church of Sagrada Familia
	John Roebling's Brooklyn Bridge opens
1884	First steel-framed building begun in U.S.
	Seurat paints *Sunday Afternoon on the Island of the Grand Jatte*
1885	Home Insurance in Chicago becomes prototype skyscraper
1888	George Eastman invents the Kodak camera
1889	Vincent Van Gogh paints *Starry Night*
	Paris Exposition gives us the Eiffel Tower
1891	Toulouse-Lautrec's posters become popular
1892	Louis Sullivan, *Ornament in Architecture*
1893	Oscar Wilde's *Salome* causes a scandal
	Edvard Munch presents *The Scream*
1894	Claude Debussy plays *Prelude to the Afternoon of a Faun*
1895	Sullivan completes the Prudential Building, Buffalo
	Siegfried Bing opens *Salon de l'Art Nouveau*
	Oscar Wilde tried and imprisoned
1896	Otto Wagner, *Modern Architecture*
	The Yellow Kid becomes the first comic strip
1897	Vienna Secession founded
	Tiffany begins a foundry manufacturing lamps
	Mackintosh's Glasgow School of Art established
1898	Otto Wagner's Majolica House makes a scene in Vienna
	Victor Horta completes the *Maison du Peuple*
1899	Sullivan showcases the Carson, Pirie and Scott Building
1900	Exposition Universelle opens in Paris
	Hector Guimard wows with the Paris Metro stations
1903	Auguste Perret builds apartment house in Paris
	Wiener Werkstätte founded
1904	Hermann Muthesius explores *Das Englische Haus*
1906	Henry van de Velde founds the Grand Ducal School of Arts and Crafts
1907	H. Muthesius founds *Deutsch Werkbund*
1908	Adolf Loos, *Ornament and Crime*
	F. L. Wright, "In the Cause of Architecture" in *Architectural Record*
1910	Europe sees F. L. Wright's Wasmuth volume
1912	Otto Wegner's Post Office Savings Bank opens in Vienna
1914	World War I begins
1917	*De Stijl* magazine begins publication
1918	Rietveld designs the *Red/Blue chair*
	De Stijl Manifesto published
	World War I ends
1919	Bauhaus founded by Walter Gropius
	The Cabinet of Dr. Caligari creaks open
1921	First group of Constructivists formed, Moscow
1923	F.L. Wright's Imperial Hotel survives earthquake in Japan
1924	Schoenburg produces 12-tone music
	Rietveld's Schröder House completed in Utrecht, Netherlands
1927	Paul Renner designs Futura typeface
	Isadora Duncan dies while out on a ride
	Dupont begins development of nylon
	Metropolis thrills wordwide
1933	*42nd Street* and Busby Berkeley kick up heels
	Adolf Hitler takes power in Germany
	President Roosevelt proposes a New Deal
	Nazis close the Bauhaus

F. INNOVATION

During the 1880s through the 1930s, some architects and designers try to integrate design, mechanization, and the idea of modern. Within various countries, individually or in groups, they create forms or styles that strive to express their time and, thus, advance the concept of modern. Although expressions of each individual or group are quite different in appearance, their ideas arise from some shared concepts. These include the rejection of historicism as no longer valid or appropriate, the integration of the machine and mechanization, and the adoption of new technologies and new materials. Each group strives to develop a new design language to express its world as transformed by industrialization from agrarian to urban, handcrafted to machine-made, and producing to consuming. Additionally they respond to other factors such as the end of the 19th century, World War I, and economic instability.

The resulting new ways of living demand new building, interior, and furniture types, as well as forms and designs that respond to the needs of contemporary consumer societies that are no longer based on aristocracy or class. Many hope to improve life and reform society through their work. Although they share some of the views of the earlier Aesthetic and Arts and Crafts Movements, such as art for art's sake and an emphasis upon craftsmanship, this generation of designers recognizes the failure of the previous one to utilize the machine, the very tool that would enable them to reach the goal of good design that is available for everyone. The concepts and work of these groups set precedents for the development and evolution of other modern styles that follow in the 20th century.

As an international style at the end of the 19th century, Art Nouveau has two major trends, one that is curvilinear and organic, and another that is geometric and abstracted. Designers strive for complete unity and total works of art by designing the building, interiors, furniture, and decorative arts. Art Nouveau absorbs influences from many sources, including non-Western ones such as Japan, and past historical styles such as Baroque, Rococo, and Biedermeier. Individuality and creativity of the designer are critical.

Members of the Vienna Secession want to create a modern, Viennese style outside of academic traditions. This group exhibits its own and others' work and produces architecture, interiors, furniture, and decorative arts in forms, details, and colors generally not popular before. The Vienna Secession advocates simplicity in design, geometric forms, rational construction, and the rejection of ornament, which greatly influences subsequent modern developments, including Art Deco.

A group of progressive architects, known as the Chicago School, introduces the skyscraper in early-20th-century Chicago, Illinois. A new building type, these multistory buildings respond to the spatial needs of modern businesses coupled with the high cost of urban land. Additionally, they take advantage of new and developing technologies such as reinforced concrete, steel frames, and the passenger elevator. Members of the group also grapple with the design and articulation of this new building type for which there is no design precedent.

The Modern Forerunners, a group of individualist architects working in Europe and the United States, strive to develop a functional and economically practical architecture that meets the needs of, or even reforms, contemporary society. Their experiments with form and structure arise from diverse approaches, theories, and aesthetics instead of from a common movement. The works of these innovators provide important theoretical and functional foundations for the further development of modern architecture.

Founded in Holland by painters and architects around 1917, De Stijl or The Style is an art and design movement that expresses universal concepts through abstraction, right angles, straight lines, an asymmetrical balance of rectangles, and the primary colors plus black, white, and gray. Members totally reject subject matter, the imitation of nature, and individuality. Although it produces only a handful of examples of architecture, interiors, and furniture, De Stijl profoundly influences other avant-garde architects and designers, particularly those of the Bauhaus.

The Bauhaus, a German art and design school founded in 1919 by Walter Gropius, exerts a profound influence upon art education, architecture, interior design, textiles, and decorative arts through its theories, practices, and products. The school's program of study trains students in both theory and practice to design for modern machine production as opposed to handcrafting. Although rejecting a common style, Bauhaus works have a similar appearance that results from emphasis upon function, mass production, geometry, absence of any ornament, and the use of new materials. Many of its graduates assume important places in industry or become prominent architects, designers, and educators, particularly during the International Style in the 20th century.

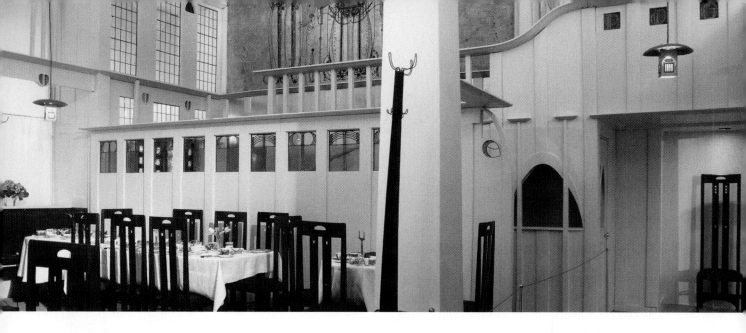

CHAPTER 19

Art Nouveau

1880s–1910s

Art Nouveau is a complex, eclectic international movement that comprises various styles in Europe and North America. It has two general trends, one is a stylized organic, curvilinear form called *Art Nouveau* in France, Belgium, Holland, Czechoslovakia, and the United States; *Stile Liberty* or *Stile Floreale* in Italy; and *Arte Moderno* in Spain. The second, more rectilinear, geometric, and abstract trend, dominates in Glasgow, Scotland; Scandinavia; Germany; and Austria where it is called *Jugenstil*. Although contributing to it, Great Britain, in the midst of the Arts and Crafts Movement, remains largely outside of Art Nouveau developments.

HISTORICAL AND SOCIAL

Art Nouveau is a conscious attempt to create a new style that rejects historicism and adopts a new visual language. Anticipated first among some artists and writers before 1890, by 1895 it has become a major force in architecture, followed later by the decorative arts. Primarily a style of line and ornament, its most typical manifestations are in architecture, interiors, furniture, graphic arts, and the

Nature proceeds by continuity, connecting and linking together the different organs that make up a body or a tree; she draws one out of the other without violence or shock.

Henri van de Velde, *Le Formule de la beauté architectonique moderne*, 1916

The only true modern individual art in proportion, in form and in colour, is produced by an emotion, produced by a frank and intelligent understanding of the absolute and true requirements of a building or object—a scientific knowledge of the possibilities and beauties of material, a fearless application of emotion and knowledge, a cultured intelligence, and a mind artistic yet not too indolent to attempt the task of clothing in grace and beauty the new forms and conditions that modern development of life— social, commercial, and religious—insist upon.

Charles Rennie Mackintosh,
Lectures on "Seemliness," 1902

decorative arts mostly in urban centers. Art Nouveau is dynamic, individualist, but short lived, dominating the arts in Europe and the United States from about 1890 to 1910.

By the end of the 19th century, much of the world has changed dramatically in response to the Industrial Revolution. Population explosions, longer life spans, and scientific and technological progress have transformed lives. Lifestyles are vastly different from even 50 years before, forcing people to look for ways to understand and cope with the changes. Although industrialization has spread to almost all parts of the world, its influence is not equal because it brings greater change in some countries than in others. A common element in all countries, however, is

urbanization in which people give up lives of agricultural subsistence and move to the cities for jobs in industry. Another commonality is the growing power of consumers (Fig. 19-1), with their demands for a greater array of choices in goods. The balance of world power also is changing. Great Britain, the major world power for much of the 18th and 19th centuries, declines, and Germany and the United States become the new industrial and world leaders. Imperialism, in which powerful nations seek to exert control over weaker ones, spurs nations to colonize in Asia, Africa, and the Pacific arenas. Trade and competition become more international.

As the end of the century approaches, some regard it pessimistically, seeing decline and the end of an era. Others who view the change more optimistically see opportunities, particularly to develop a new style, which reflects the changed, new world of the 20th century. Arising from the latter, Art Nouveau represents the first major attempt to portray a visual language as modern, with no allusions to the past.

An exact beginning of the style is difficult to determine because artists, writers, and thinkers anticipate some of Art Nouveau's aspects and character during the 1880s, particularly in England. For example, in 1883, Arthur Heygate Mackmurdo creates an Art Nouveau–like title page for his book on Sir Christopher Wren's churches in London, and curving, organic designs also appear later in a side chair by him (Fig. 19-42). In 1893, the first issue of a new English journal, *The Studio*, features some of the first Art Nouveau images in work by young illustrator Aubrey Beardsley (Fig. 19-2). Europeans eagerly scrutinize the curvilinear, conventionalized illustrations by Beardsley and others in *The Studio* and other English journals. Also influential on the development of Art Noveau are England's Aesthetic Movement, with its focus upon art for its own sake and little or no stress upon morality, and the Arts and Crafts Movement, which advances the individuality of the designer and emphasizes craftsmanship. Images and ideas spread through exhibitions, posters, books, periodicals, trade, and travel.

As a product of various movements, artists, and writers, Art Nouveau emerges full blown in Paris and Brussels in the early 1890s. In 1893 in Brussels, Belgium, Victor Horta designs the Hôtel Tassel (Fig. 19-14), the first major expression of the new style to illustrate the unity of architecture and interior design. The façade integrates the use of stone, iron, and glass in a new design language that influences others. In 1895, Belgian Henry van de Velde publishes the important manifesto *Déblaiement d'art* (A Clean Sweep for Art). Identifying key concepts of the movement, it has a significant impact on many designers. In that same year, Siegfried Bing opens a shop and gallery in Paris named Salon de l' Art Nouveau. In addition to giving the new style its name, the shop, which displays glass, textiles, and furniture, becomes an international center for Art Nouveau in France. The shop inspires an entrepreneurial spirit resulting in new galleries, shops, department stores, and companies. Frequently housed in examples of the style, these retail firms market Art Nouveau ideas, art, and products, including paintings, textiles, furnishings, decorative arts, art glass, ceramics, and jewelry. This helps spread the style and promote individual artists and designers. For a brief period in the early 20th century, Art Nouveau becomes mainstream.

The international expositions are particularly influential in the development and spread of Art Nouveau because they provide visibility for designers and their products all over the world. In 1900, the Exposition Universelle (Fig. 19-6) in Paris prominently displays the versatility and diversity of Art Nouveau. In 1902, the Prima Esposizione d'Arte Decorativa Moderna (referred to as the International Exhibition of Decorative Art; Fig. 19-7) in Turin, Italy, showcases the work of designers from France, Belgium, Scotland, Germany, Austria, and Italy. It displays the most comprehensive scope of Art Nouveau to date. In 1905, the Exposition Universelle in Liege, Belgium, with its strong representations from France and Belgium, reinforces the notion that Art Nouveau is a public style. Finally, in 1908, the Franco-British Exhibition in London displays the largest collection of French Art Nouveau objects ever seen in England. From 1910 on, international exhibitions no longer represent the style. Subsequently, designs become more simplified and move in other directions.

■ *Belgium.* Brussels is the center for Belgian Art Nouveau. The style emerges from urban development sponsored by King Léopold II, who desires to transform the city with monumental boulevards, parks, and streets lined with elegant middle-class houses. Patrons of the style see themselves rejecting tradition and conservatism and adopting the avant garde. Victor Horta, Henry van de Velde, and Gustave Serrurier-Bovy are the leading designers.

■ *France.* Two schools of Art Nouveau develop in France, one in the capital of Paris and the other in Nancy. Seeking to maintain France's dominance in art and culture, the French government provides funding to art schools, for exhibitions, and for the reorganization of museums. It also sponsors numerous initiatives to improve living conditions for the French. In Paris, the principal designer is Hector Guimard, who introduces Art Nouveau in buildings and in the Paris Métro (Fig. 19-11) entrances. Consequently, Art Nouveau is briefly called *le style metro*. The Art Nouveau school in Nancy promotes decorative arts, such as furniture, glass, and ceramics, more than architecture. Leading practitioners include Émile Gallé, Eugène Vallin, and Louis Majorelle.

■ *Germany.* Germany rapidly industrializes during the second half of the 19th century. The affluent country has

a strong urge for national identity. Munich becomes the major art center following the publication in 1896 of the *Jugend*, a journal with the aim of rejecting historicism and developing a new concept of design for the future. Advocates of these ideas interpret a German version of Art Nouveau called *Jugenstil*, meaning "young style." Their emphasis upon cooperation among designer, craftsman, and manufacturer influences the Deutsche Werkbund and the Bauhaus (see Chapter 24, "The Bauhaus"). Leading practitioners include Hermann Obrist, Auguste Endell, Peter Behrens, Bruno Paul, and Richard Riemerschmid (Fig. 19-43).

■ *Spain*. In Spain, Art Nouveau appears primarily in Barcelona, the leading industrial center. The Spanish government pushes a modernization program for the city to promote political, social, and cultural reform. Spanish Art Nouveau reveals two trends. The mainstream Art Nouveau, called *Modernismo* or *Arte Modern*, which follows the artistic lead of Belgium and France. The second trend is inspired by the Catholic Church's view of contemporary life, which seeks to mold society both theologically and aesthetically. The idiosyncratic, highly personal, and sometimes bizarre work of Antoni Gaudí i Cornet (Fig. 19-12, 19-13) dominates this trend.

■ *England and Scotland*. Great Britain largely rejects Art Nouveau with the exception of Glasgow, Scotland. An industrial city, Glasgow has a healthy economy and close ties to the Continent. Highly influenced by machine precision and the Scottish landscape, Art Nouveau in Glasgow develops around a group of practitioners who are neither teachers nor publicizers of their work. Known as "The Four," the group consists of Charles Rennie Mackintosh (Fig. 19-37, 19-38), Herbert McNair, and sisters Margaret and Frances MacDonald. Their work greatly influences Europe, particularly Vienna and Munich.

■ *United States*. As in Britain, the United States does not fully embrace Art Nouveau because Americans are wary of the style's associations with decadence, the erotic, and socialism. The most prominent practitioners are Louis Sullivan (Chapter 21, "Chicago School"), who experiments with architectural ornamentation, and Will Bradley, who develops and publishes interior and graphic designs. The decorative arts represent some of the best expressions of Art Nouveau particularly in art glass, ceramics, and decorative painting. Important designers and firms include Louis Comfort Tiffany and the Tiffany Studios (Fig. 19-40), Frederick Carder and the Steuben Glass Company, and the Durand Art Glass Company.

Art Nouveau succeeds as a creative and imaginative style that creates total works of art. However, many designers are unable to completely divest themselves of the past. Despite an emphasis upon craftsmanship and good design for the masses, many works are not suitable for mass production. Nevertheless, Art Nouveau lays important groundwork for subsequent modern movements in its attempts to throw off the past, its stress on total works of art, and its emphasis upon new technology and contemporary materials.

CONCEPTS

Complex and multifaceted, Art Nouveau has many roots, appearances, and participants. Various artists, architects, and designers create unique individual and innovative expressions that reflect the geography, governments, economies, lifestyles, and patterns of behavior within their respective countries. A key concept shared by all participants is the desire to create a new style, divorced from those of the past, that expresses a modern urbanized, commercial society. Its genesis often coincides

IMPORTANT TREATISES

■ *Art-Studies from Nature as Applied to Design,* 1872; F. E. Hulme.

■ *L'Art dans l'Habitation Moderne*, 1898; Hector Guimard.

■ *L'Art Moderne*, 1881; Octave Maus.

Periodicals and Magazines: Art et Décoration, France, begun 1897; *Die Jugend*, Germany, 1896; *Hobby Horse*, England, 1884; *L'Art Moderne*, Belgium, 1881; *Le Japon artistique*, France, 1888–1891; *Pan*, Germany, begun 1895; *The Studio*, England, begun 1893.

◄**19-1.** "Portrait"; published in *Art et Décoration*, 1902; La Gandara.

▲ **19-2.** "The Peacock Girl" from *Salome*, c. 1894; Aubrey Beardsley, and "Sarah Bernhardt," c.1895; Alphonse Mucha.

with urban renewals and redevelopments that are part of governmental or social reforms. In the spirit of reform, artists and architects search for a new style, one that expresses their world as transformed by the Industrial Revolution. They want to create a new design language and vocabulary in which buildings and objects look contemporary and are not tied to the past.

A highly eclectic style, Art Nouveau, in reality, does not completely break with the past. Absorbing influences from contemporary art and literature (pre-Raphaelites, Symbolism, and the Nabis), non-Western cultures (Japan, Islam, and China), past styles (Celtic Revival, classicism, Baroque, Rococo, Biedermeier, and Gothic Revival), and vernacular traditions and folk art, Art Nouveau adapts and reinvents them in a spirit of transformation for a modern age. At the heart are the imagination and creativity of the artist or designer.

To an even greater degree than others before them, Art Nouveau designers see no separation between the fine arts of painting and sculpture and architecture and the decorative arts, such as glass, ceramics, and furniture. They strive for unity in design to create complete expressions, or what they call total works of art. Thus, the architect or designer is called upon to design the building and all its aspects, including the interiors, furniture, and decorative arts, to achieve a synthesis of design. Other shared concepts include an emphasis upon craftsmanship, a reverence for the individuality of the artist or designer, art for its own sake, and art for the masses not just for the wealthy elite. Rooted in theory, these concepts prove difficult to maintain and contribute to the style's demise.

Individuals see themselves as a vehicle for a transformation of culture. Many designers believe they are developing a completely new art vocabulary and that individuals serve as the vehicles for change. The style sets a precedent for other modern styles that follow in the 20th century.

DESIGN CHARACTERISTICS

Despite its individual manifestations, Art Nouveau design displays some common characteristics. Line, whether curving and sensuous or straight and geometric, is an important principle that designers explore and exploit (Fig. 19-2, 19-3, 19-4, 19-5). Line together with form conveys energy, force, dynamism, and/or organic growth. Designers reduce traditional and naturalistic forms and motifs to their essence, transforming them and ascribing to them their design intentions in appearance and meaning. Expressions strongly emphasize decoration, particularly surface decoration, which may be linear rather than plastic. Consequently, Art Nouveau often is more successful in interiors, furniture, decorative arts, and graphic arts than in architecture. Overall, design is totally integrated so that

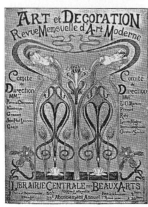

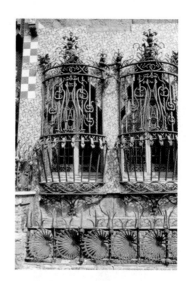

▲ **19-3.** Book covers for *Art et Décoration,* published in 1899.

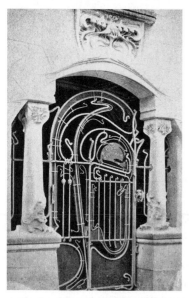

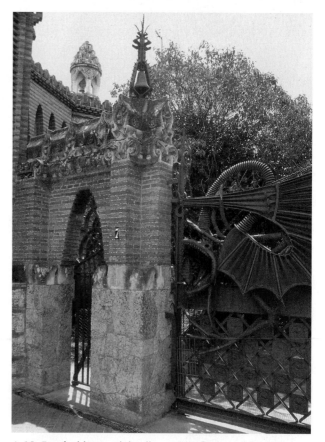

▲ **19-4.** Entrance gate, Le Castel Béranger, 1898; Paris, France; Hector Guimard.

▲ **19-5.** Architectural details, c. 1900; Spain and France.

architecture, interiors, and furnishings convey the same visual language and are in harmony with each other.

Other common characteristics include asymmetry, abstraction of natural forms, free-flowing organic plant forms, whiplash curves, and symmetry with geometric shapes. From Japanese woodblock prints, the Art Nouveau image extracts simplicity, asymmetry, flat pattern, linearity, and color. Also important are the dynamic and

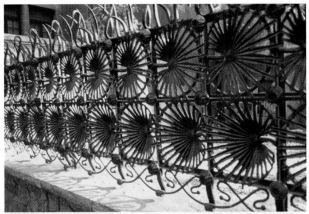

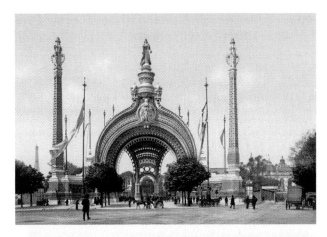

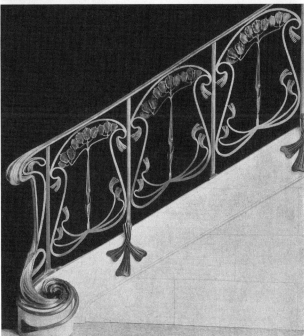

▲ **19-5.** *(continued)*

▲ **19-6.** Porte d'Entrée Principale, Exposition Universelle (Paris Exposition), 1900; Paris, France; M. R. Binet.

exuberant qualities of the Baroque; the asymmetry, naturalism, and cabriole leg of Rococo; the sensuous, curvilinear lines of Islamic art and the Celtic Revival; the restrained classicism of Biedermeier; and Gothic Revival structural theory. New technology and modern materials, such as iron, often are incorporated into designs and frequently drive or inspire design concepts, contrast between function and form, and the dramatic color interpreted by individual designers.

■ *Art Nouveau.* In France, Belgium, and the United States, nature and organic motifs are important. Curvilinear forms, whiplash curves, and stylized plants and flowers are typical. In contrast, in Scotland, designs are more linear, geometric, and symbolic. In Czechoslovakia, buildings are decorative but overall plainer than in France or Belgium.

■ *Jugenstil.* In Germany, the visual language evidences a strong geometry with whiplash curves and an emphasis upon decoration. The style has minimal impact on architecture but greatly affects textiles, jewelry, and furniture.

■ *Stile Liberty or Stile Floreale*. Taking its name from Liberty department stores, Italian design is pluralistic, free of eclecticism, and maintains a strong national character. Most examples are curvilinear with a Neo-Baroque heaviness and are highly decorative.

■ *Arte Moderno*. In Spain, work by Antonio Gaudí has a unique organic character, one that is not copied much by others. Work by other designers follows European curvilinear forms and details.

■ *Motifs*. Popular motifs stylized from nature include flowers such as the rose, violet, iris, and water lily, and animals such as the dragonfly, butterfly, snail, and peacock (Fig. 19-3, 19-31, 19-32, 19-36, 19-39, 19-40, 19-41, 19-49).

ARCHITECTURE

Art Nouveau architecture strives to create a modern style free from historicism and academic traditions. Emphasizing the individuality of the architect, this new architecture incorporates new materials and industrial processes and an emphasis on structure and function. Influences include Viollet-le-Duc, the French architect and restorer, Gustav Eiffel, and Parisian department stores, such as Au Printemps and Bon Marché that have large, open interiors composed of iron and glass. As socialists and political activists, many architects strive to improve the quality of life for individuals and society through their designs. However, their work is largely composed of commissions from individuals and groups with little influence.

Public and Private Buildings

■ *Types*. Commercial buildings include stores (Fig. 19-8), hotels (Fig. 19-9), offices, schools (Fig. 19-10), churches

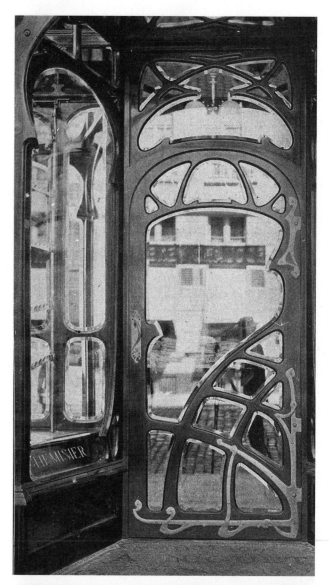

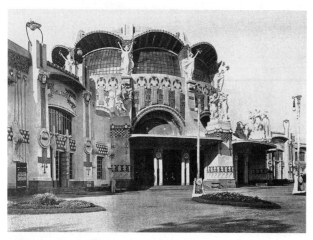

▲ **19-7.** Entrée Principale de l'Exposition, International Exhibition of Decorative Arts, 1902; Turin, Italy; Raimondo d'Aronco.

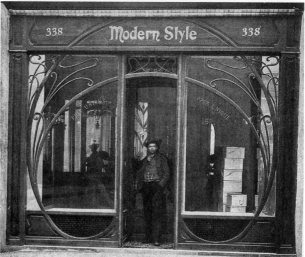

▲ **19-8.** Shop fronts, 1897, 1904; Brussels, Belgium, and Paris, France.

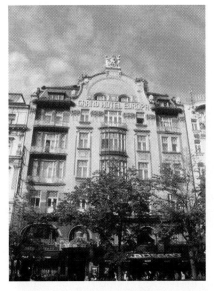

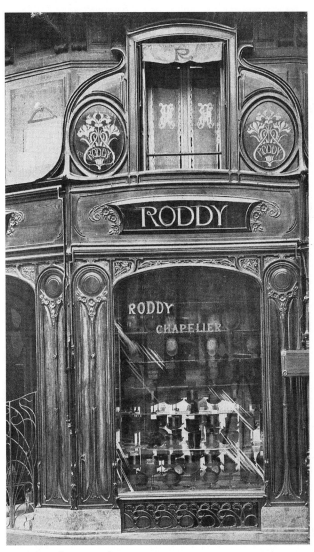

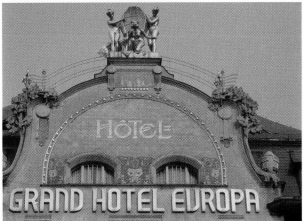

▲ **19-9.** Europa Hotel, c. 1903–1905; Prague, Czechoslovakia; Bedrich Bendelmayer and Alois Dryák.

▲ **19-8.** *(continued)*

(19-13), auditoriums, concert halls, and metro stations (Fig. 19-11). Houses (Fig. 19-14, 19-16, 19-17, 19-18, 19-19, 19-20, 19-22) and stores are a more frequent expression than other buildings.

■ *Site Orientation.* As part of urban renewals, most Art Nouveau buildings are located in city centers, with some appearing in suburbs. Because nature is an integral part of the overall design concept, houses may feature lawns or garden areas that extend the interior space.

■ *Floor Plans.* Many designs incorporate open plans (Fig. 19-15, 19-24) with free-flowing space to minimize visual separateness and to connect interior spaces to the exterior. Level changes may define and link rooms and circulation areas. Floor plans emphasize important public spaces, stairways, center halls, living rooms, and dining rooms. Plans show a logical flow of movement, an axial alignment of windows to help air circulation, defined bays, and rectangular room shapes.

■ *Materials.* Buildings exhibit an extensive use of iron, glass, and stone in combination (Fig. 19-10, 19-11, 19-12, 19-14, 19-16, 19-17, 19-18, 19-19, 19-20), and various parts may be prefabricated. Iron appears structurally as well as decoratively, outside and within. It may twist and turn to achieve a fluid motion of form and shape. Glass may be clear and layered or stained and decoratively detailed. Other materials include brick, tile, and wood. Each designer conveys his or her own individual expression through form and/or decoration to create a unique image.

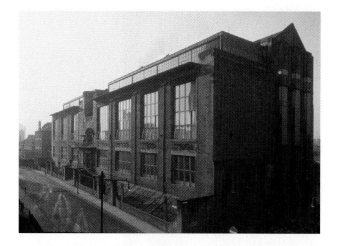

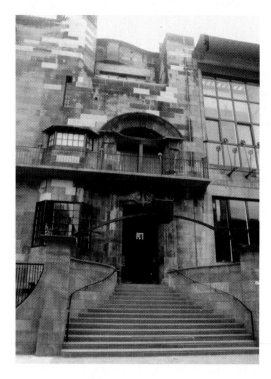

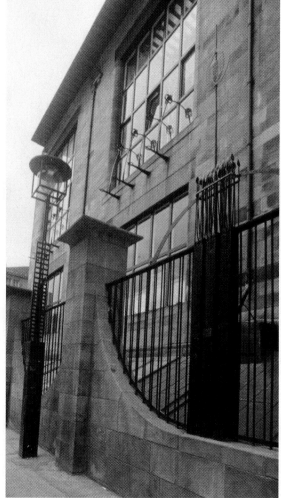

▲ **19-10.** Glasgow School of Art, 1897–1909; Glasgow, Scotland; Charles Rennie Mackintosh.

■ *Facades*. Exterior facades display movement vertically and horizontally to create a sculptural, fluid expression. Some are plain with little ornamentation, while others exhibit decoration as an inherent part of the structure and to emphasize structural elements (Fig. 19-6, 19-7, 19-8, 19-9, 19-14, 19-16, 19-17, 19-18, 19-19, 19-21, 19-22, 19-23). Compositions may be symmetrically or asymmetrically balanced, with variety determined by the individual designer, client, or the site. Interior planning often is clearly articulated in the façade composition. Verticality, symmetrical and asymmetrical rounded arches, and separation of stories also are characteristic.

IMPORTANT BUILDINGS AND INTERIORS

■ **Amsterdam, Netherlands:**
—American Hotel, 1897; W. Kromhout.

■ **Barcelona, Spain:**
—Café-Restaurant, 1888; Luis Domènech i Montaner (now Zoological Museum).
—Casa Batlló, 1904–1906; Antonio Gaudí i Cornet.
—Casa Milá, 1905–1910; Antonio Gaudí i Cornet.
—Palau Güell, 1889; Antonio Gaudí i Cornet.
—Park Güell, 1900–1914; Antonio Gaudí i Cornet.
—Sagrada Familia, begun 1883; Antonio Gaudí i Cornet.

■ **Brussels, Belgium:**
—Hôtel de S.-Cyr, 1903; Gustave Strauven.
—Hôtel Hankar, 1893; Paul Hankar.
—Hôtel Solvay, 1894; Victor Horta.
—Hôtel Tassel, 1893; Victor Horta.
—Hôtel van Eetvelde, 1895; Victor Horta.
—Maison Ciamberlani, 1897; Paul Hankar.
—Maison D'Horta, 1898–1901; Victor Horta.
—Maison du Peuple, 1896–1900 (destroyed 1964); Victor Horta.

■ **Glasgow, Scotland:**
—Glasgow School of Art, 1897–1909; Charles Rennie Mackintosh.
—Queen's Cross Church, 1899; Charles Rennie Mackintosh.
—Willow Tea Room, 1903; Charles Rennie Mackintosh.

■ **Helensburgh, Scotland:**
—Hill House, 1902–1903; Charles Rennie Mackintosh.

■ **Kilmacolm, Scotland:**
—Windyhill, 1899–1901; Charles Rennie Mackintosh.

■ **Milan, Italy:**
—Palazzo Castiglione, 1900–1903; Guiseppe Sommaruga.

■ **Munich, Germany:**
—Elvira Photographic Studio, 1896–1898; August Endell.

■ **Nancy, France:**
—Villa Majorelle, 1898–1900; Frédéric-Henri Sauvage.

■ **Paris, France:**
—Chez Maxim's, c. 1900; Louis Marnez.
—Le Castel Béranger, 1898; Hector Guimard.
—Ecole du Sacré Coeur, 1895; Hector Guimard.
—Entrances, Paris Métro stations, 1900–1910; Hector Guimard.
—Entry building, Paris Exposition, 1900; M. R. Binet.

■ **Prague, Czechoslovakia:**
—Ambasser Hotel, 1912.
—Europa Hotel, c. 1903–1905; Bedrich Bendelmayer and Alois Dryák.
—Municipal House, 1903–1911; Osvald Polívka and Antonín Balsánek.

■ **Turin, Italy:**
—Central Rotunda and Galerie des Beaux Arts, International Exhibition of Decorative Arts, 1902; Raimondo d'Aronco.

■ **Uccle, Belgium:**
—Villa Bloemenwerf, 1895–1896; Peter Anton von Verschaffelt

■ **Vienna, Austria:**
—Majolika Haus, 1898; Otto Wagner.
—No. 38 Linke Wienzelle, 1898; Otto Wagner, with decoration by Koloman Moser.

Elements may appear layered with balconies, grillwork, window forms, applied decoration, and bargeboards or decoration in the apexes of gables and dormers. Art Nouveau details include curving details or plant forms reinterpreted or reshaped in classical capitals, columns, pilasters, or other aspects; rounded fenestration and grillwork; and window mullions with whiplash curves or tendrils.

■ *Windows.* Windows are a distinguishing feature of the style (Fig. 19-8, 19-10, 19-12, 19-14, 19-16, 19-18, 19-19, 19-20, 19-22, 19-23). Generally, they are large and have a vertical emphasis. Some are rectangular, but many are symmetrical or have asymmetrically rounded arches or curves. Arches may be low or tall. A few windows have a second rounded arch or a teardrop-shaped window above them. Prominent moldings and curving, often whiplashed, grilles give a linear and decorative, organic emphasis. Some of Horta's houses have rows of windows in different heights on different levels, with prominent bay windows on the front street side (Fig. 19-14, 19-16, 19-17). Windows in

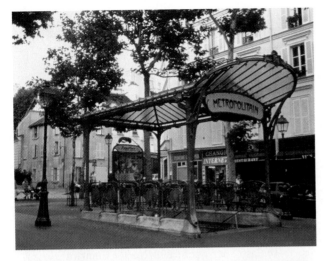

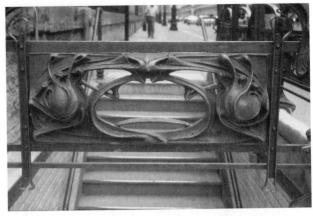

▲ **19-11.** Entrances, Paris Métro stations, 1900–1910; Paris, France; Hector Guimard.

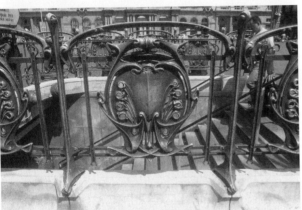

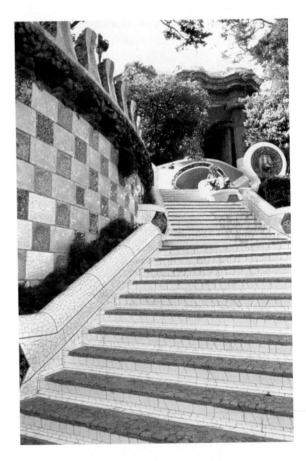

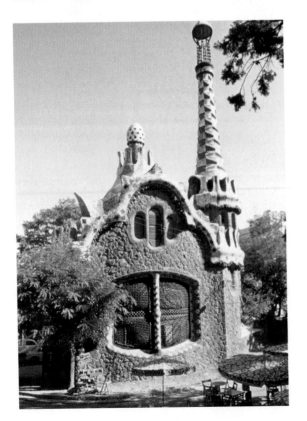

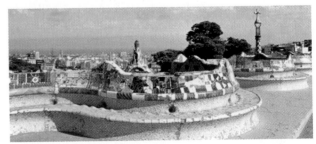

▲ **19-12.** Park Güell, 1900–1914; Barcelona, Spain; Antonio Gaudi i Cornet.

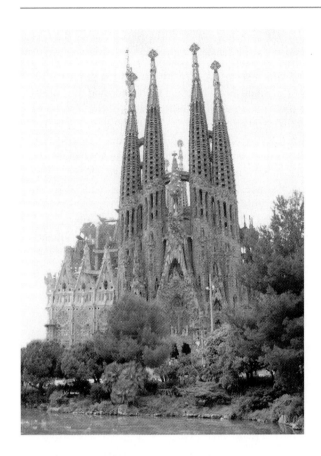

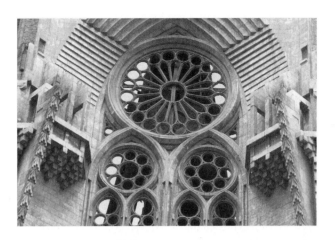

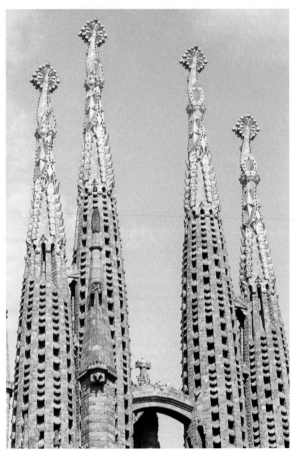

▲ **19-13.** Sagrada Familia, begun 1883; Barcelona, Spain; Antonio Gaudi i Cornet.

DESIGN SPOTLIGHT

Architecture: Hôtel Tassel, 1893; Brussels, Belgium; Victor Horta. This town house is the first example of fully developed Art Nouveau architecture and interior design in Brussels. One of Horta's most important buildings and his first major commission, this "portrait house" represents a sophisticated, simple statement of Art Nouveau and it establishes a new architectural style through its elegant, restrained façade and three-dimensional form. The symmetrical composition with a vertical emphasis resembles other four-story, narrow town houses in the area. At first glance, the composition seems classical in its vocabulary and disposition of elements. However, the individual articulation of parts disappears in the masonry skin of the house, which seems to push forward in the semicircular bow oriel windows centered on the façade and the lintels over the flanking windows. The capitals of the first-floor columns are plant-like and curve over the supports above and below them. The iron grilles on the second- and third-floor windows feature the Art Nouveau whiplash curves. Important design features include iron columns and balustrades, iron and glass windows and skylights that allow light to penetrate within, decorative details accenting architectural elements and arch supports, and a dominant entry door. Horta uses this design language for other clients, and for himself, with some variation in overall character and detail.

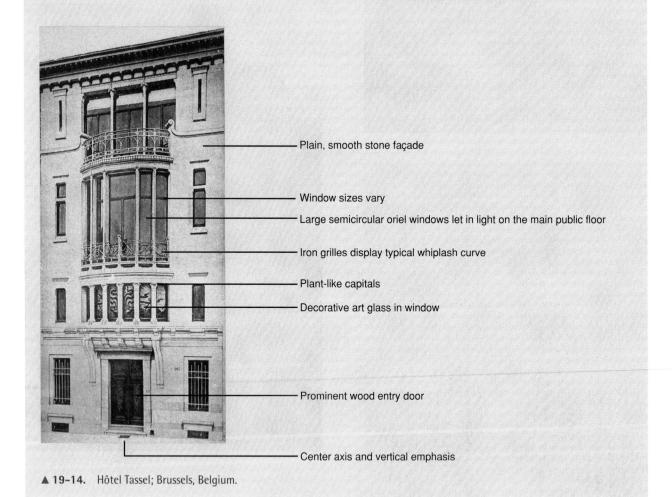

Plain, smooth stone façade

Window sizes vary

Large semicircular oriel windows let in light on the main public floor

Iron grilles display typical whiplash curve

Plant-like capitals

Decorative art glass in window

Prominent wood entry door

Center axis and vertical emphasis

▲ **19-14.** Hôtel Tassel; Brussels, Belgium.

Mackintosh's buildings show greater variety in size, height, and prominence, such as those on the Glasgow School of Art (Fig. 19-10). They also convey more regularity and simplicity. Gaudí's windows have large areas of glass broken into defined sections with curved wood framing. Window shapes and sizes repeat on large apartment houses. Surrounds, such as those at Casa Milá (Fig. 19-23), are sculptural and undulate to create movement.

DESIGN SPOTLIGHT

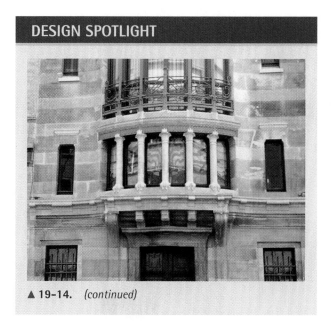

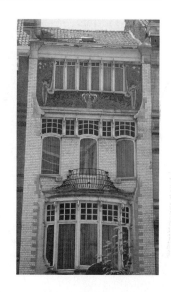

▲ **19-14.** *(continued)*

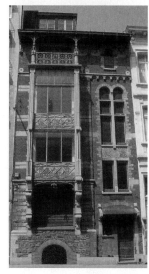

▲ **19-16.** House facades and details, c. 1890s–1900; Brussels, Belgium.

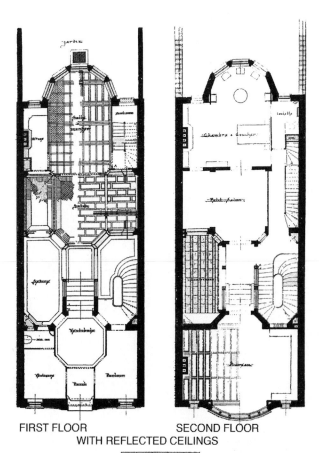

FIRST FLOOR SECOND FLOOR
WITH REFLECTED CEILINGS

▲ **19-15.** Ground- and first-floor plans showing ceiling treatments, Hôtel Tassel, 1893; Brussels, Belgium; Victor Horta.

■ *Doors.* In many countries, entry doors have numerous curves and intricate details, and are often of wood with glass inserts (Fig. 19-8, 19-17). Three-dimensional curved moldings frame the doorway opening. Elaborate, curving, organically inspired iron gates may announce entry into a small vestibule.

■ *Roofs.* Roofs and rooflines may be downplayed or prominent (Fig. 19-6, 19-7, 19-9, 19-12, 19-13, 19-19, 19-21, 19-22, 19-23). Prominent expressions are tall with a marked verticality. Wall and roof dormers with pointed or rounded arches permit light into upper stories and attics. Iron and glass roofs may create light wells over stairways and center halls (Fig. 19-33, 19-35).

■ *Later Interpretations.* Art Nouveau architecture is rarely imitated during the 20th century. Sometimes the general architectural form may borrow from individual designers (Fig. 19-25).

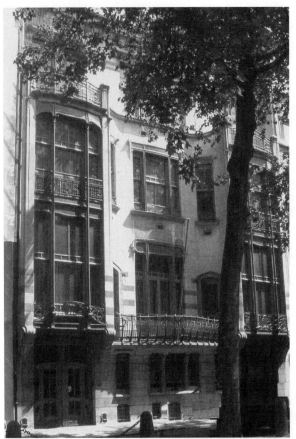

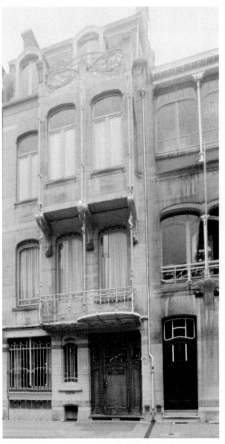

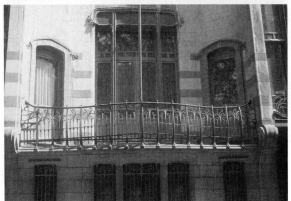

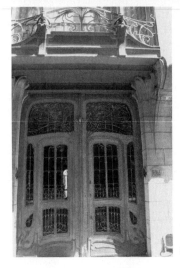

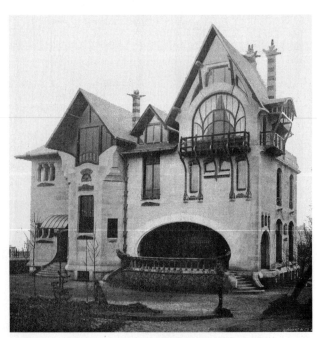

▲ **19-18.** Maison D'Horta, 1898–1901; Brussels, Belgium; Victor Horta.

▲ **19-17.** Hôtel Solvay, 1894; Brussels, Belgium; Victor Horta.

▲ **19-19.** Maison de M. Majorelle; published in *Art et Décoration*, 1902.

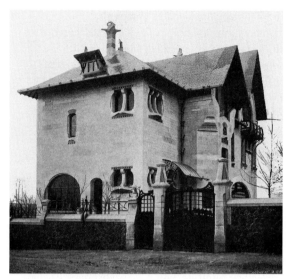

▲ **19-19.** *(continued)*

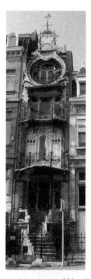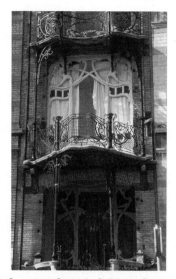

▲ **19-20.** Hôtel de S.-Cyr, 1903; Brussels, Belgium; Gustave Strauven.

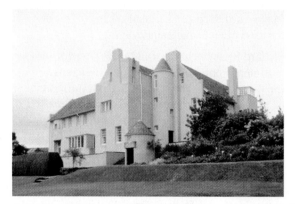

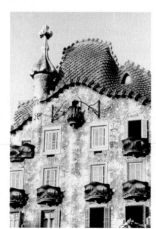

▲ **19-21.** Hill House, 1902–1903; Helensburgh, Scotland; Charles Rennie Mackintosh.

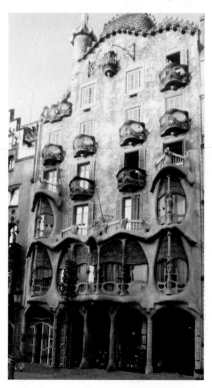

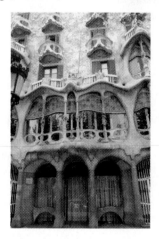

▲ **19-22.** Casa Batlló, 1904–1906; Barcelona, Spain; Antonio Gaudi i Cornet.

- **Émile Gallé** (1846–1904), one of the most important French glassmakers of his day, creates numerous designs using a combination of traditional and new techniques. His atelier uses mass-production methods to create quantities of glass, but Gallé has a hand in each design. Gallé also designs ceramics and furniture in traditional shapes with marquetry of naturalistic motifs. His work is influenced by Japanese prints and his passion for botany.

- **Antonio Gaudí i Cornet** (1852–1926), a Spanish architect with distinctive originality, designs buildings, parks, furniture, ironwork, tiles, light fixtures, and decoration mainly in Barcelona and Catalonia. Sculptural forms display twisted features, decorative details, and attention to ergonomics. Construction materials such as iron, stone, and ceramic tile often transform natural objects into stylized renditions of flowers, trees, vegetables, and waves to create a surreal sense of place. The church of the Sagrada Familia, still under construction, is his most noteworthy project.

- **Hector Guimard** (1867–1942), an innovative French architect, introduces the curvilinear Art Nouveau to France. Well known for his Paris Métro stations, his buildings display a quality of vernacular romanticism with organic, fluid designs incorporating iron and glass in prefabricated parts and handcrafted materials such as tile. Architectural features include numerous curves, large overhanging eaves, and elaborate brackets. Guimard also designs interiors, furniture, and even clothing. His work emphasizes sensuous line and surface ornament over materials, construction, and function.

- **Victor Horta** (1861–1947), the initiator of Art Nouveau in Brussels, creates unique "portrait houses" and commercial buildings for intellectually elite patrons in and around Brussels. He develops new concepts in architectural planning that incorporate open, free-flowing spaces and emphasize three-dimensional volumes. Important design features include twisted iron columns and balustrades, skylights and ceilings of iron and glass, organic motifs for light fixtures and hardware, and customized wood furnishings to coordinate with the interiors. His most famous projects are the Hôtel Tassel, Hôtel Solvay, and his own house.

- **Charles Rennie Mackintosh** (1868–1928) is an internationally acclaimed architect and designer from Glasgow who is an important precursor for the Modern Movement. His buildings convey dramatic simplicity, spatial complexity, functionalism, asymmetry, human scale, linear repetition, and an inventive modernist spirit. The fully integrated interiors often have contrasts of white and black; large expanses of glass; decorative details including floral accents in rose, lilac, and gray; and wood and painted furnishings. His most important projects include the Glasgow School of Art and the Willow Tea Rooms in Glasgow, and Hill House in Helensburgh. He and his co-designers, "The Four," produce decorative designs for posters, glass, and textiles and in 1901 create an influential room at the Secessionist Exhibition in Vienna.

- **Louis Majorelle** (1859–1926), a successful furniture maker from Nancy, France, uses a combination of machine and hand labor to produce well-made furniture with reasonable prices. His furniture, made mostly in suites, is composed of simple, naturalistic shapes that are often derived from French Rococo. Particularly characteristic are the opulent metal pulls and mounts.

- **Richard Riemerschmid** (1868–1957), one of the most important German *Jugendstil* designers, trains as a painter but designs his first furniture in 1895. By 1899, his reputation as a furniture designer is established, and he goes on to design architecture, interiors, ceramics, textiles, wallpaper, cutlery, and other metal products. In 1907, he is one of the founders of the *Deutsche Werkbund*, a design reform group.

- **Louis Comfort Tiffany** (1848–1933) is a well-known American glass designer who experiments with decorative glass influenced by Art Nouveau principles, particularly that of nature. He invents a process for making opalescent glass he calls *favrile*. Tiffany is also known for decorative stained glass lamp shades composed of illustrations of flowers, fruit, and insects.

- **Henry van de Velde** (1863–1957) is not only an important Belgian Art Nouveau architect and interior and furniture designer, but he is also one of the country's leading theorists and teachers. His work is particularly important for eliminating references to past styles and placing emphasis on function and structure. Van de Velde helps bring Art Nouveau to Paris through his association with Siegfried Bing. In addition to bringing Art Nouveau to Germany, his reorganization of the Kunstgewerbeschule (Arts and Crafts School) in Weimar, Germany, lays the foundation for the emergence of the Bauhaus in 1919. Van de Velde's designs include architecture, interiors, furniture, and graphic art.

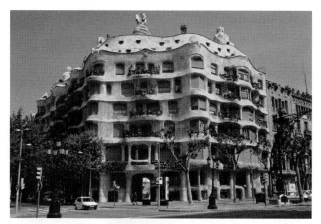

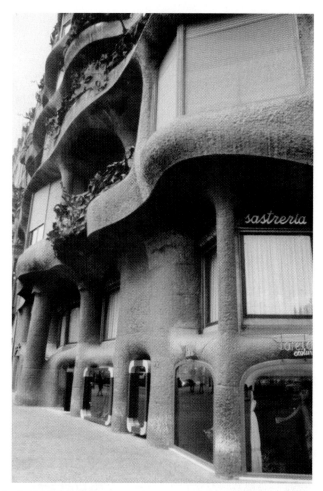

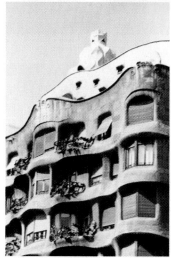

▲ **19-23.** Casa Milá (La Pedrera), 1905–1910; Barcelona, Spain; Antonio Gaudi i Cornet.

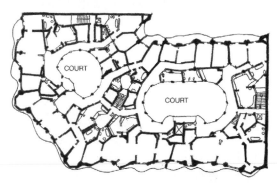

▲ **19-24.** Floor plan, Casa Milá, 1905–1910; Barcelona, Spain; Antonio Gaudi i Cornet.

INTERIORS

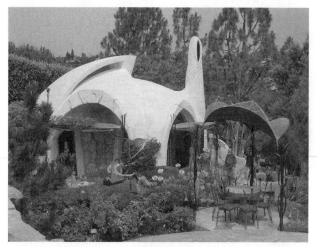

▲ **19-25.** Later Interpretation: House, c. 1980–2000; San Diego, California; James Hubbell. Environmental Modern.

Like architecture, Art Nouveau interiors are primarily curvilinear with abstracted floral or naturalistic motifs in France, Belgium, and Italy and strongly geometric with rectangular or square shapes dominating the compositions in Germany and Scotland. Rooms of both trends are unified and regarded as works of art. The designer, usually the architect, creates the exterior, interiors, furniture, and decorative art with an eye to complete unity in form, color, and decoration. Individually designed, all parts relate to each other and the whole. Designers hope to reform interiors by providing more light and air and through liveliness

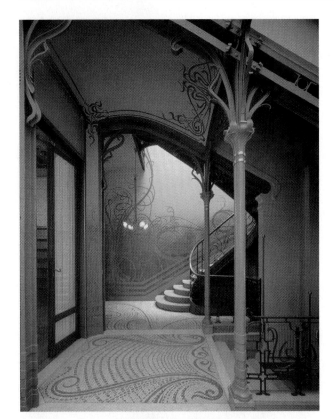

▲ **19-26.** Stair hall, Hôtel Tassel, 1893; Brussels, Belgium; Victor Horta.

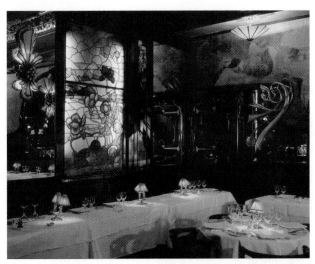

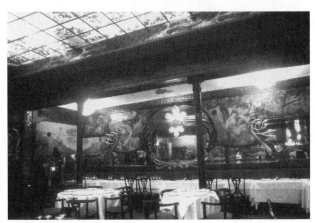

▲ **19-28.** Dining area, Maxims Restaurant, c. 1900; Paris, France.

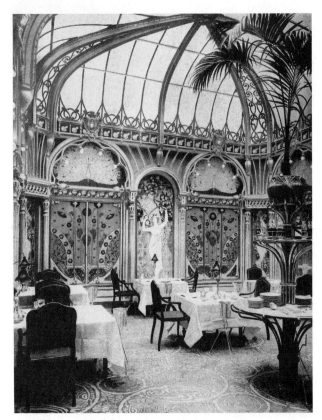

▲ **19-27.** Salle de Restaurant; published in *Art et Décoration*, 1899.

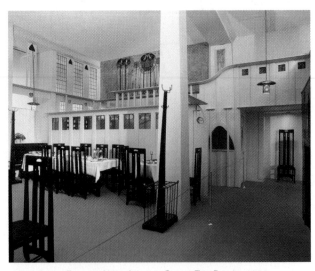

▲ **19-29.** Front saloon, Ingram Street Tea Room, 1900; Glasgow, Scotland; Charles Rennie Mackintosh.

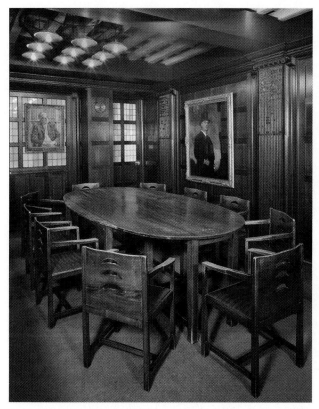 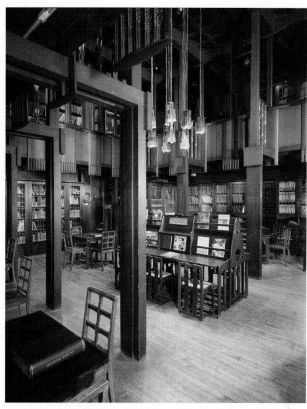

▲ **19-30.** Board room and library, Glasgow School of Art, 1907–1909; Glasgow, Scotland; Charles Rennie Mackintosh.

of form, shape, and color. Complete architect-designed Art Nouveau interiors are uncommon and limited to model rooms at international expositions, commercial interiors, and residences of the affluent (Fig. 19-26, 19-33, 19-35, 19-37, 19-38). Other rooms show the style's influence in one or more of the following: wallpapers, decorative painting, rugs, furniture, and decorative accessories. By the time Art Nouveau becomes mainstream, most of the early practitioners have moved on to other styles or joined other movements.

Public and Private Buildings

■ *Types*. No particular room types are associated with Art Nouveau. Room shapes remain traditional rectangles or squares, but balustrades, windows, doors, ceilings, fireplaces, and other details may be composed of organic curves or arches (Fig. 19-26, 19-27, 19-31, 19-33, 19-35), which gives the impression of movement. Ornament and decoration are concentrated on structural elements. Exceptions are the spaces designed by Gaudí in which walls and ceilings often undulate.

■ *Relationships*. As total works of art, interiors strongly relate to exteriors in form and detail. Developing from the inside out, exteriors articulate the distribution and importance of rooms. Rooms may also display a strong relationship to nature in forms, motifs, and color.

■ *Color*. Nature provides sources for color, including earth tones and pastel shades of blue, green, brown, gold, white, rust, and purple. Warm colors, such as red, rose, yellow, gold, ochre, and orange, dominate in Belgium. Designers frequently use bright colors to enhance their designs or to make a design statement. Mackintosh interiors often illustrate contrasts between white and black with

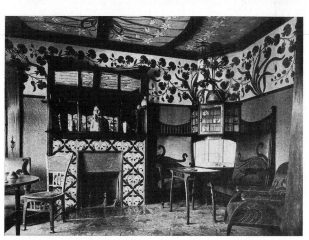

▲ **19-31.** Salons; c. 1898–1900; France and the United States.

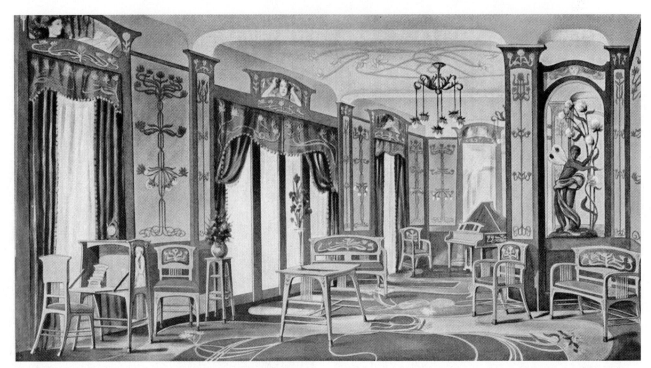

▲ **19-31.** *(continued)*

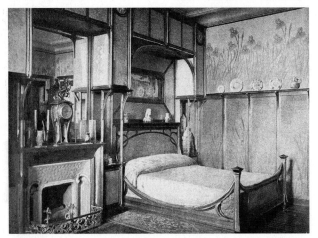

▲ **19-32.** Chambre à coucher; published in *Art et Decoration*, 1898; France; T. Selmersheim.

decorative accents in rose, lilac, and gray, common colors of Scottish landscapes (Fig. 19-29, 19-30, 19-37, 19-38).

■ *Lighting.* Natural light from numerous large windows usually floods Art Nouveau interiors. Light fixtures, candlesticks, and candelabra of wood, iron, copper, brass, silver, and ceramics display curving floral or geometric forms (Fig. 19-33, 19-34, 19-38, 19-39, 19-40). Usually designed by the creator of the building or interior, they relate to the interior design and furniture.

■ *Floors.* Designers use many types of flooring materials to support their design concepts (Fig. 19-26, 19-31, 19-34). Wood, a common material, may feature curvilinear or

geometric designs repeating those of the walls and furniture. Marble, brick, or ceramic tiles are often used in entries and lower stories. Some department stores have floors of glass tiles to permit light to pass between stories. Rugs are designed in unity with the interior.

■ *Walls.* Walls display a variety of treatments (Fig. 19-26, 19-27, 19-28, 19-29, 19-31, 19-32, 19-34, 19-36, 19-38). Most are stenciled or painted with linear or floral motifs and patterns near the ceiling or highlighting architectural features, such as doors or windows. Many walls have picture moldings at varying heights from the ceiling. Wallpapers may have naturalistic patterns, geometric designs, or women in floral bowers. Some designers favor wallpapers designed by William Morris or C. F. A. Voysey (see Chapter 17, "English Arts and Crafts"). Wood paneling declines in use. When adopted, it may have organic shapes and whiplash curves or geometric and rectangular forms. Paneling may be stained, painted, or lacquered. Wall hangings with appliqué or embroidered decorations created by the designer or tapestries also may cover walls. Some designers favor unusual materials, such as ceramic panels or tiles, for wall treatments in important rooms.

■ *Windows and Window Treatments.* Wood moldings frame the upper portion of curved and rectangular windows. Window treatments are usually plain panels hanging from rods by rings. Embroidery, stenciling, or applied decorations of flowers or foliage may embellish the panels (Fig. 19-31) Lace curtains sometimes cover windows (Fig. 19-41).

DESIGN SPOTLIGHT

Interiors: Salon or hall, Hôtel van Eetvelde, 1895; Brussels, Belgium; Victor Horta. Sited in an Art Nouveau neighborhood, this multistory house exhibits a similar character as Horta's Hôtel Tassel. The plain, ordered, symmetrical facade has large windows to let light inside and prominent vertical and horizontal structural moldings defining bays. Horta, like other Art Nouveau architects, strives to design interiors with more light and air. Additionally, he dislikes closed spaces that hinder not only air and light but circulation, so he often places important spaces within an iron framework supporting a glass roof as he has done in this salon. Centrally located,

the octagonal hall incorporates a low-domed stained glass ceiling permitting light to enter. Clustered iron columns, an arched arcade with built-in lighting, and a decorative balustrade frame the seating area and define the circulation path at all levels. Naturalistic curving shapes in the glass are repeated in the iron balustrade and accent the upper walls and floor. The color scheme, which uses brown, gold, and pale green, reflects the organic character and the hues of nature. Horta creates complete unity by designing all elements in a light and airy open space. This is one of his most important interiors.

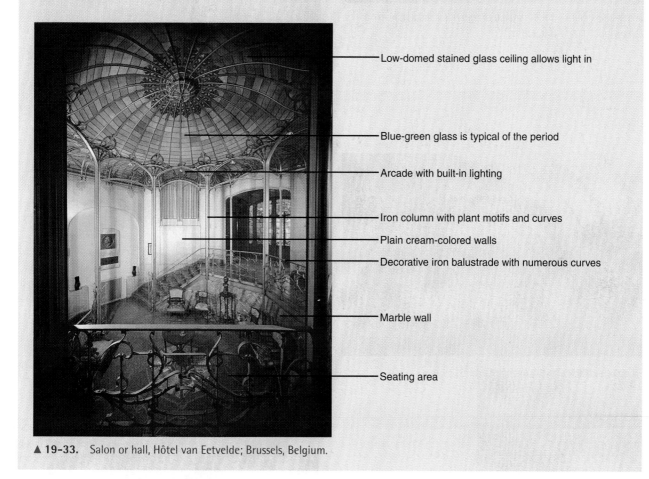

Low-domed stained glass ceiling allows light in

Blue-green glass is typical of the period

Arcade with built-in lighting

Iron column with plant motifs and curves

Plain cream-colored walls

Decorative iron balustrade with numerous curves

Marble wall

Seating area

▲ **19-33.** Salon or hall, Hôtel van Eetvelde; Brussels, Belgium.

■ *Doors.* Doorways are three-dimensional and often curve at the top. Doors are usually of wood. Some have plain or stained glass decoration.

■ *Staircases.* Staircases are important conveyors of Art Nouveau character for most designers (Fig. 19-26, 19-33, 19-35). Horta places stairs centrally inside iron cages

with glass roofs that allow in natural light and offer a decorative medium for his creativity. Columns, supports, rails, banisters, and mullions replicate curving, abstracted naturalistic forms. Some designers, like Majorelle, create very ornate rails and banisters with twisting, curving organic forms.

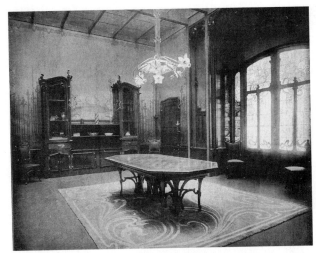

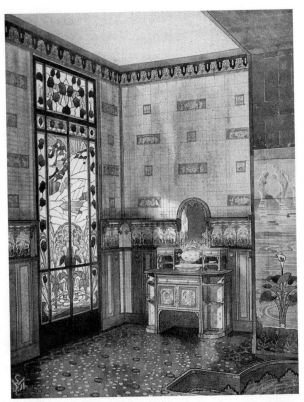

▲ **19-34.** Dining room (*salle à manger*); published in *Art et Décoration*, 1897; Victor Horta.

▲ **19-36.** Bathroom; published in *Art et Décoration*, 1903.

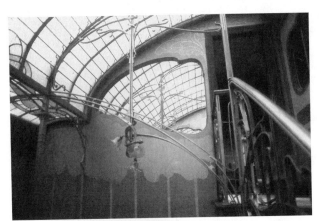

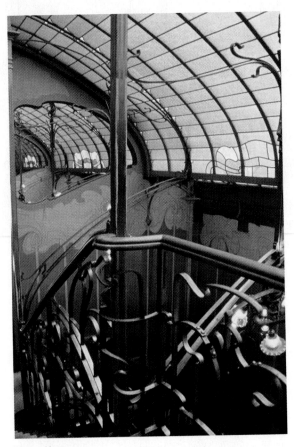

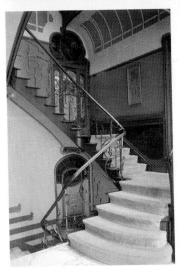

▲ **19-35.** Stair hall, Maison D'Horta, 1898–1901; Brussels, Belgium; Victor Horta.

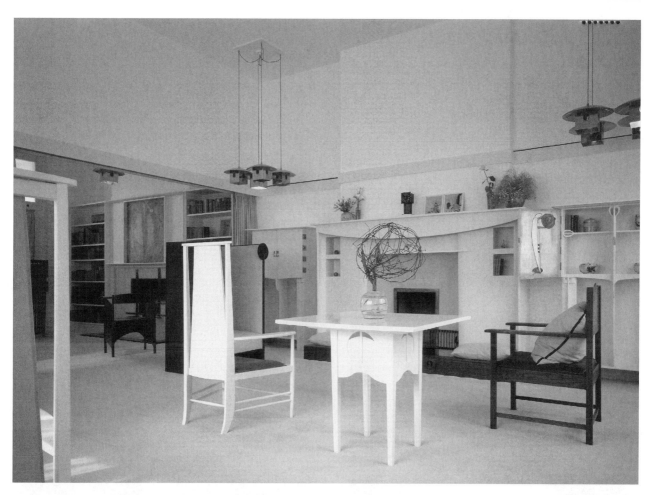

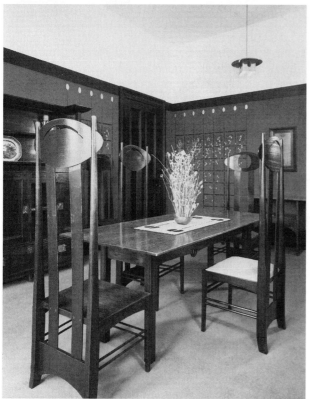

▲ **19-37.** Sitting room and dining room, C. R. Mackintosh House, 1900, 1906; Glasgow, Scotland; Charles Rennie Mackintosh.

Interiors: Entrance hall and bedroom, Hill House, 1902–1903; Helensburgh, Scotland; Charles Rennie Mackintosh. Walter W. Blackie, a prominent businessman and publisher, commissions Hill House. A suburban home for family weekends, Hill House sits on a small hill as its name implies. Mackintosh, like other Art Nouveau designers, creates a total work of art in Hill House. He achieves unity through the repetition of rectangular and square shapes in walls, floors, furnishings, and decorative arts, all of which he designs. To soften and for contrast, he introduces curves and naturalistic forms in details and fabrics. Colors of gray, black, white, purple, and rose also unify the spaces. The entry hall is refined and quiet with its black, gray, and purple color scheme, whereas the bedroom, with its all-white colors, reflects a lighter, more airy aesthetic.

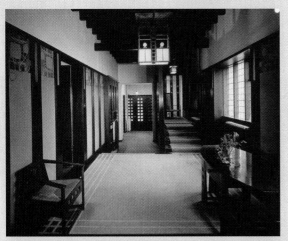

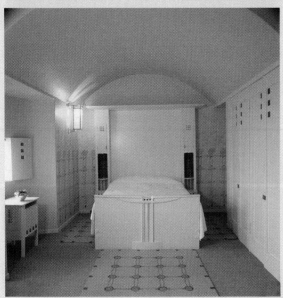

▲ **19-38.** Entrance hall and bedroom, Hill House; Helensburgh, Scotland.

■ *Ceilings*. Ceilings may be flat, curved, coved, or beamed (Fig. 19-27, 19-31, 19-33, 19-35, 19-37, 19-38). Treatments include paint, plasterwork, tiles, papers, and glass.

■ *Later Interpretations*. In the late 20th century, theme parks and some restaurants, bars, and casinos adopt the curving forms, floral ornament, and other aspects of Art Nouveau, often in a highly theatrical manner.

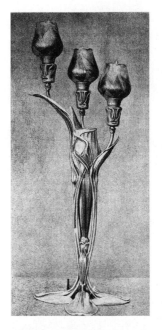
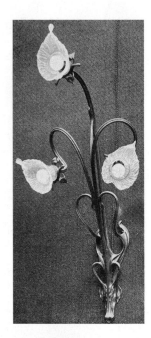

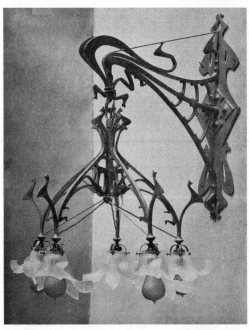

▲ **19-39.** Lighting: *Flambeaus, applique électrique, lampe électrique, table el lampe, and lustre*, 1901–1902; France.

FURNISHINGS AND DECORATIVE ARTS

Art Nouveau furniture, designed for contemporary interiors or model rooms, displays great diversity of form, shape, and concept. Some designers reject traditional forms and methods of construction, while others use them as springboards for their own creations. Some strive for function over decoration, a strong relationship with architecture, and visible structure. Others create sculptural, highly decorative, richly appointed designs. Furnishings vary in form from curvilinear, flowing, and naturalistic to geometric, hard edged and minimal decoration depending upon the geographic location and the intent of the designer. Even within each country there is great diversity of form and design with some revealing strong ties to vernacular or folk traditions. Nevertheless, most furniture is individually designed to suit the space in which it inhabits. Each piece is conceived in relationship to the other furniture as well as the entire composition. Although some designers, such as

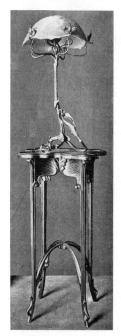

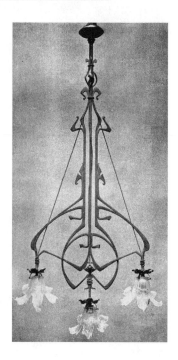

▲ **19-39.** *(continued)*

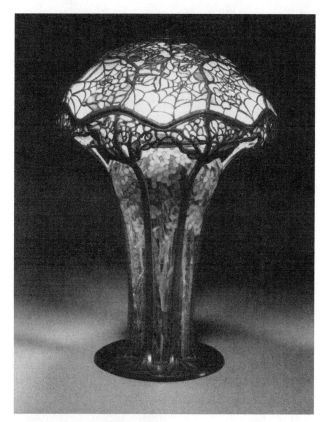

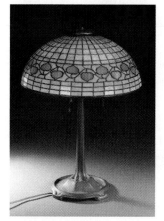

▲ **19-40.** Lighting: Lamps, c. 1906; United States; Louis Comfort Tiffany.

Majorelle, attempt to mass produce their furniture, much Art Nouveau furniture is far too expensive for the general market. An exception is Thonet, whose mass-produced bentwood furniture blends well with Art Nouveau (Fig. 19-48). Thonets' furniture does not, however, arise from Art Nouveau precepts. Rather, its innovations are in its manufacturing processes, which give it simplicity, functionally, and beauty without historic references. Late in the period other manufacturers begin selling furniture with curves and naturalistic ornament.

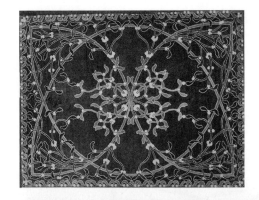

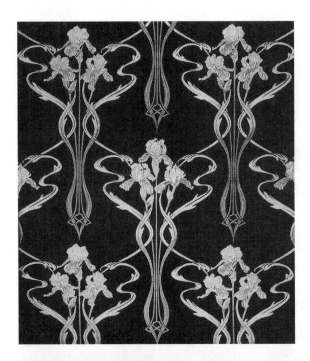

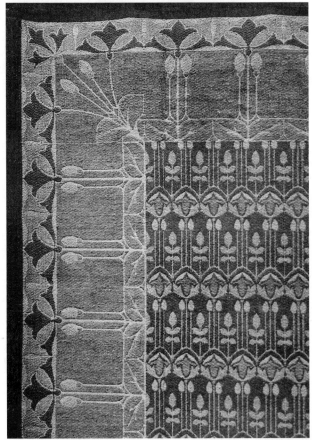

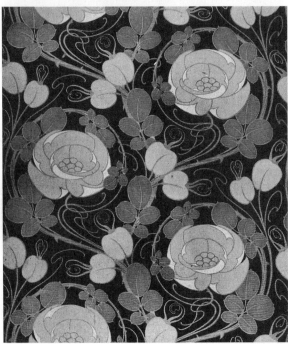

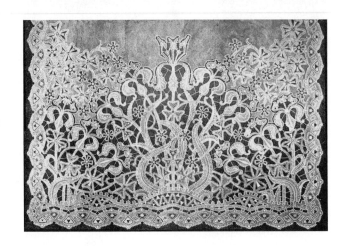

▲ **19-41.** Textiles: Fabrics, rug, and lace curtain, c. 1900.

As a style, Art Nouveau emphasizes the ability of wood to be carved for furniture, even though it may visually represent another material. Designers use imaginative designs and creative and unique construction methods to achieve their aims. Some designs reveal an awareness and understanding of the material, while those with twisted, tortured forms seem to ignore it. Designers often stretch the limitations of the medium and the maker. Subsequent movements will become less dependent upon wood and seek newer materials and technology that can more readily adapt to mass production.

■ *Belgium.* Belgian furniture reveals influences from past styles such as Baroque, Gothic, and Rococo (Fig. 19-45). Heavier than French, it is dynamic and plastic with abstracted ornament.

■ *France.* French furniture reveals Rococo influence (Fig. 19-44, 19-46, 19-49, 19-51, 19-52, 19-53). The Paris School is more individualistic, refined, and restrained. Decoration is stylized and naturalistic. The School of

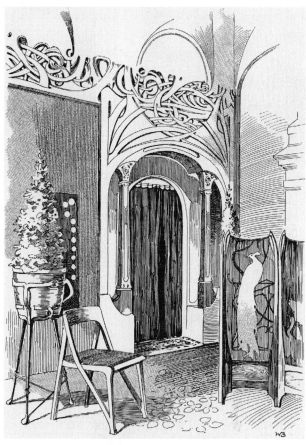

▲ **19-43.** Chair for a music room, 1898–1899; Germany; Richard Riemerschmid.

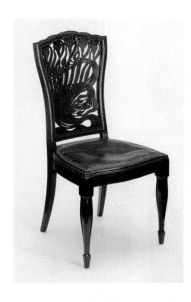

◄ **19-42.** Dining chair, 1882–1883; England; Arthur Heygate Mackmurdo.

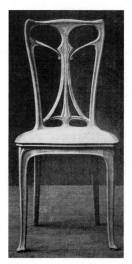
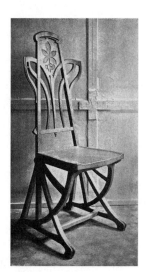
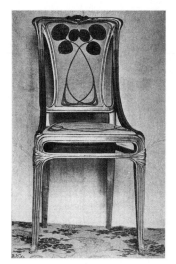
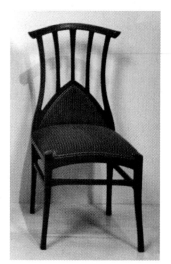

▲ **19-44.** Side chairs, 1899–1901; France; by E. Colonna, Du Buisson, A. Landry, and H. Van de Velde.

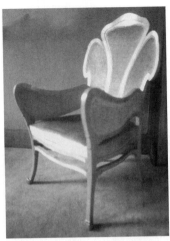

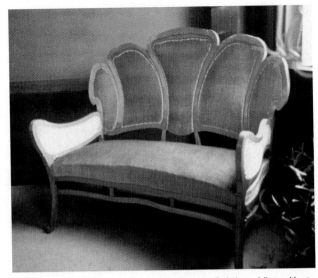

▲ **19-45.** Armchair and settee, Carpentier Villa (now in Maison D'Horta), 1899; Renaix, Belgium; Victor Horta.

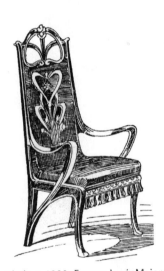

▲ **19-46.** Armchair, c. 1900; France; Louis Majorelle.

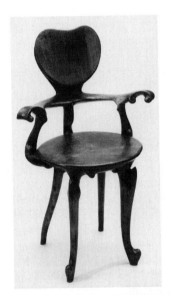

▲ **19-47.** Armchair, Casa Calvet, c. 1900–1910; Spain; Antonio Gaudi i Cornet.

Nancy closely aligns with Rococo. Much of the output is traditional in form with Art Nouveau curvilinear and naturalistic decoration.

■ *Spain.* Spanish furniture usually is sculptural and plastic, eccentric, and idiosyncratic as shown in the work of Gaudí (Fig. 19-47).

■ *Germany.* The Neo-Renaissance and folk art influence German furniture. Nevertheless that which develops in Munich and Dermastadt is remarkably free of historicism. Designers emphasize construction and curving sculptural form (Fig. 19-43).

■ *Scotland.* Mackintosh's work reveals Scottish and Celtic roots. Individually designed pieces are rectilinear

yet softened with gentle curves (Fig. 19-37, 19-38, 19-50). Tall and thin, pieces are works of art but are often poorly constructed and uncomfortable. Some is lacquered white or stained black with jewel-tone decorations.

Public and Private Buildings

■ *Types.* No particular types of furniture are associated with Art Nouveau, but architects individually design much of it, including small accent pieces such as mirrors, shelves, and music stands.

■ *Distinctive Features.* Like interiors, furniture displays two trends in form and decoration. In France, Belgium,

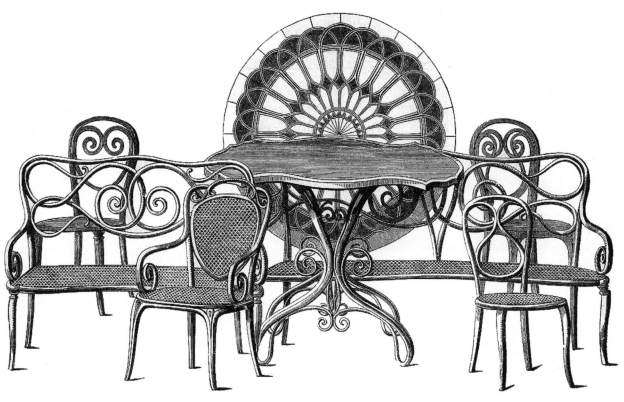

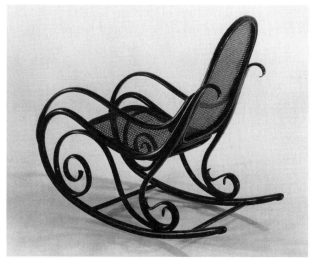

▲ **19-48.** Chairs, settee, table, and rocker, c. 1900; Vienna, Austria; Michael Thonet.

Spain, and Italy, whiplash curves, sculptural form, and elongated shapes with a strong visible relationship to nature dominate. In Scotland and Germany, furniture is rectilinear or geometric, and attenuated with minimal surface decoration.

■ *Relationships.* Individually designed to suit the space, furniture supports the design concept. Because most designers are architects, many conceive of their furniture in an architectural manner. Therefore, it is often a multipurpose product to increase its functionality.

■ *Materials.* Art Nouveau revives such woods as mahogany and pear. Other common woods include walnut and oak. Some pieces are highly polished, heavily stained, or lacquered as in Scotland, while others are unfinished or unpolished to convey a rustic or vernacular appearance. Carving, gilding, marquetry, and inlay of exotic woods, ceramics, glass, or metals are common decorative techniques.

■ *Seating.* Art Nouveau's greatest diversity appears in seating, where the individual imagination of the creator can

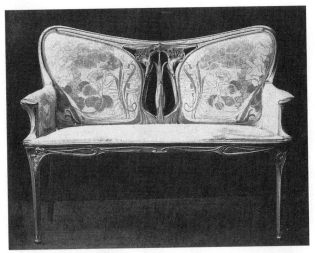

▲ **19-49.** *Canapé* for the Paris Exposition 1900; published in *Art et Décoration*, 1901.

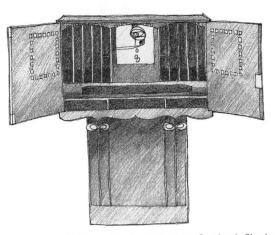

▲ **19-50.** Writing cabinet, 1900–1904; Scotland; Charles Rennie Mackintosh.

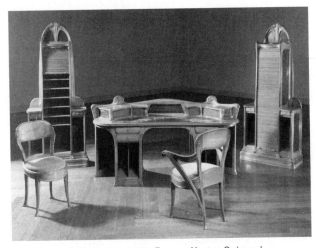

▲ **19-51.** Office suite, 1909; France; Hector Guimard.

find its fullest expression. Some chairs and settees display Rococo roots in the wooden frames around backs and seats, modified cabriole legs ending in plant forms, and continuity of parts (Fig. 19-31, 19-44, 19-45, 19-46, 19-47, 19-49, 19-51). Others reveal a concern for structure and function over historic precedents in their simply curved wooden backs and plain quadrangular legs and arms (Fig. 19-43). Mackintosh designs reveal no evidence of past roots but are rectilinear, often with tall, attenuated backs accented with subtle curves (Fig. 19-29, 19-30, 19-37). Thonet emphasizes curved lines and no decoration in his very plain bentwood furniture (19-48; see Chapter 1, "Industrial Revolution").

■ *Tables.* Tables display a range of forms, designs, and embellishments. (Fig. 19-31, 19-32, 19-34, 19-37). Some follow Gallé's traditional forms with plant, insect, and floral marquetry or Guimard's round tops and legs of stems or curving tendrils. In contrast, those by Mackintosh have oval and rectangular tops, legs of curving flat boards, and may be lacquered white with pink and blue ornament.

■ *Storage.* Storage may have an architectural quality or be sculptural with organic forms and motifs (Fig. 19-34, 19-50, 19-51, 19-52). Desks often have whiplash curving tops, sides, and drawers (Fig. 19-51). Sides may be divided into asymmetrical curving panels. Doors and drawers of buffets or china cabinets feature curving corners, tops, glazing, handles, and pulls composed of whiplash tendrils and stems (Fig. 19-52). Some combine open shelves, cabinets, and drawers. Designers may choose woods with strong grains to emphasize the curving organic nature of their design or use marquetry for ornamentation.

■ *Beds.* Beds have curvilinear headboards and footboards but no posts. Like storage pieces, their outlines, composed of flowing moldings, may undulate or curve (Fig. 19-32, 19-53). Their broad surfaces often are a particular focus for decoration. Head and footboards may be divided into asymmetrically shaped panels with floral marquetry or contrasting colors of wood and applied ornament.

■ *Upholstery.* Many architects, designers, and graphic artists create textiles and upholstery to suit the concepts of their interiors, so there is a broad range of patterns, weaves, and colors (Fig. 19-41). Expressions vary with geography and ethnicity. Some reveal vernacular or folk roots while others show little influence from the designer's heritage or the past in general. Some revive hand techniques such as batik, embroidery, or lace. Others use sophisticated machine or professional embroiders.

Fabrics include printed cottons and velvets, silk, and stenciled linens. Designs may be naturalistic and curvilinear or geometric. Colors are strong and contrasting, although some geometric designs are monochromatic.

DESIGN SPOTLIGHT

Furniture: Cabinet, c. 1899; France; Hector Guimard. Guimard challenges traditional notions of design for cabinets in this undulating cabinet with whiplash curves and plant-like movements. The composition conveys the energy and vitality characteristic of Art Nouveau in France. The asymmetrical form, derived from nature, has two parts blended together, a tall and slender unit on the left and a wider and shorter unit with drawers on the right. Although rectangular in its overall shape, organic curves define and soften the tops, sides, and corners of doors and panels. A vine-like element rises from the side and sweeps across the front, adding dynamism while supporting the upper cabinet. Its curving shape is repeated in the panels and drawers, some of which terminate in stylized floral forms. Door and drawer pulls become a part of the overall integrated composition. The various surfaces have numerous intricate, twisted curving lines and details that convey an organic, fluid design.

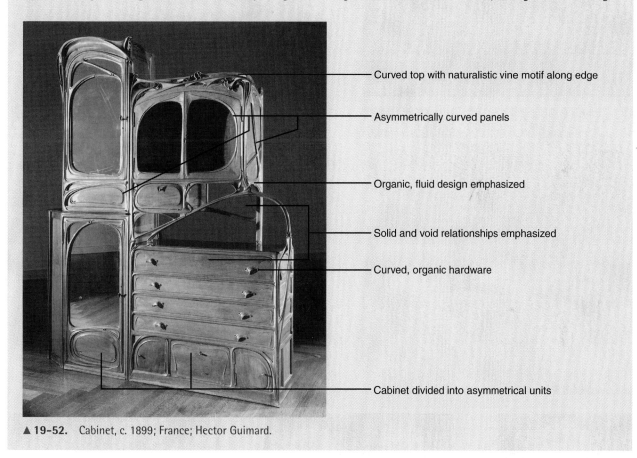

— Curved top with naturalistic vine motif along edge

— Asymmetrically curved panels

— Organic, fluid design emphasized

— Solid and void relationships emphasized

— Curved, organic hardware

— Cabinet divided into asymmetrical units

▲ **19-52.** Cabinet, c. 1899; France; Hector Guimard.

Some interiors use Arts and Crafts textiles by Morris and others.

■ *Decorative Arts.* Art Nouveau greatly influences the decorative arts. Many architects and artists, like Riemerschmid, design metalwork in forms, shapes, and motifs that complement their interiors. Similarly, artists and ceramists create ceramics that reflect Art Nouveau design principles, whether curving forms and naturalistic details or geometric with minimal surface decoration (Fig. 19-54). Also evident in ceramics is a shift in hierarchy of importance from porcelain to stoneware or earthenware. Glassmakers revive and exploit traditional techniques such as enameling, cased glass, and iridescence. They also adopt new technologies in color and heating methods and use new materials such as metal foils. Gallé in France, one of the most prolific and innovative of the Art Nouveau glassmakers, uses numerous decorative techniques. He is particularly known for cased glass compositions of leaves, plants, flowers, and insects. Louis Comfort Tiffany in the United States also

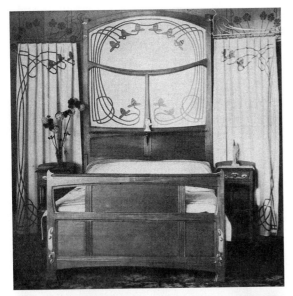

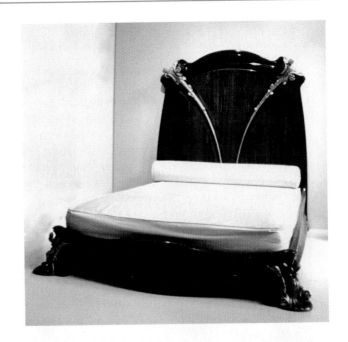

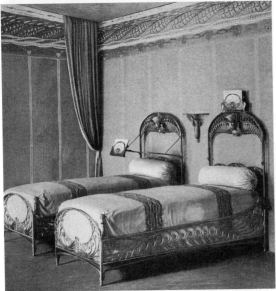

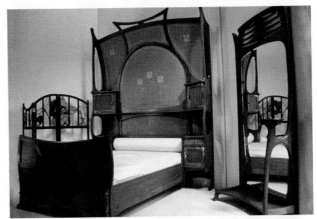

▲ **19–53.** Beds, c. 1900–1910; France; G. Serrurier, Lambert, L. Marjorelle, G. Serrurier-Bovy.

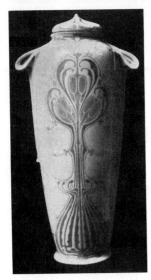

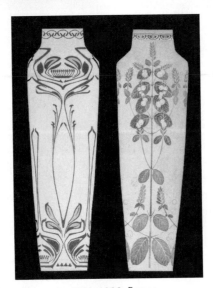

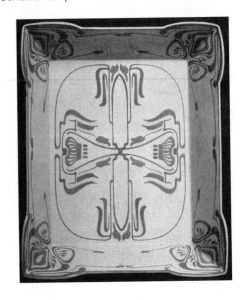

▲ **19-54.** Decorative Arts: Ceramic containers, c. 1902–1906; France.

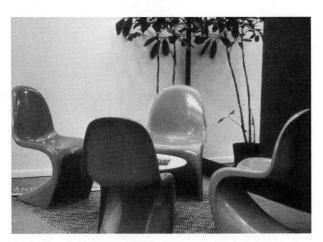

▲ **19-55.** Later Interpretation: Panton stacking chair, 1960–1967; Switzerland and the United States; Verner Panton, manufactured by Vitra and Herman Miller.

experiments with glass and creates naturalistic Art Nouveau designs in colored and stained glass.

■ *Later Interpretations.* In the last half of the 20th century, new materials and techniques not previously available allow designers to create works that reflect the whiplash curves of Art Nouveau. Individual craftsmen adopt particular elements, such as its curvilinear or geometric forms and floral ornament. Verner Panton's work (Fig. 19-55) in plastics and Frank Gehry's in bent wood, while not obviously influenced by Art Nouveau, do echo the creations of Art Nouveau designers.

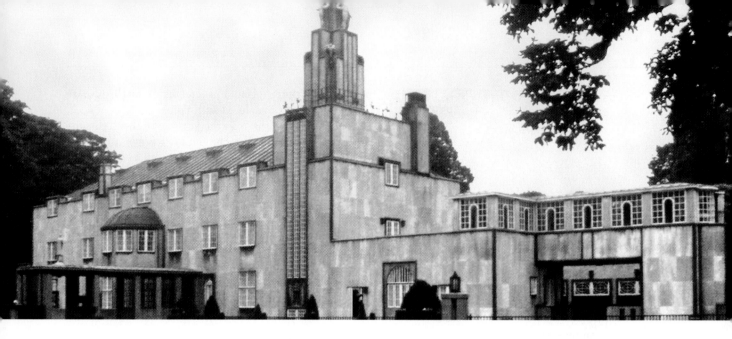

CHAPTER 20

Vienna Secession

1897–1920s

Vienna Secession strives to create a modern style devoid of historicism and free of academic stagnation. Founded in 1897, in Vienna, Austria, by a group of artists, sculptors, architects, and designers, it is more influenced by Britain, Scotland, and Germany than by France or Belgium. Rejecting the more flamboyant Art Nouveau expressions, the Secession advocates simplicity, rational construction, and honest use of materials, which will, in turn, influence subsequent modern developments. The Wiener Werkstätte, a crafts organization similar to a guild, is formed by members of the Secession. It shares similar beliefs, but puts more emphasis on unity and excellent craftsmanship.

HISTORICAL AND SOCIAL

During the late 19th century, rapid industrialization and a significant increase in population provide the framework for urban growth in Vienna. A bustling, multicultural city, it becomes a center for artistic creativity with far-reaching influences on later design. Architecture in the city favors a strong academic tradition, a hierarchy of importance among buildings, historicism, and expressions of imperial grandeur. The Künstlerhaus (Academy of Arts) controls art in Vienna, both who creates it and what it looks like. Otto Wagner, Hans Olbrich, and Josef Hoffman are members, but they break away from it to show their rejection of its academic position and reliance on traditional theories of art. They, along with Josef Maria Olbrich, Koloman Moser, painter Gustav Klimt, and others, found the Vienna Secession (Wiener Sezession) in 1897. This society of avant-garde architects, designers, sculptors, and painters

strives to unite art and design, mainly by showcasing their work and that of others in prominent exhibitions. Affected by the concurrent rational construction of architecture and furniture in Munich, Germany, the group also follows, to some degree, the principles of craftsmanship and production promoted by the English Arts and Crafts Movement. Work by Charles Rennie Mackintosh in Scotland provides a major source of design inspiration. The society publishes its own journal, *Ver Sacrum (Sacred Spring)*, during 1897 to 1903. Members also spread their ideas through professorships in various art schools.

The first Secessionist exhibition held in 1898 displays paintings, wallpaper, stained glass designs, and book illustrations. Some of the noteworthy participants include James McNeil Whistler, Walter Crane, and Gustav Klimt, all of whom receive wide acclaim. The exhibition is such a success that later in the year the group builds an exhibition hall (Fig. 20-3), the design of which declares its rejection of academic traditions and illustrates a new architectural language in overall form and design. Later exhibitions take the form of complete room settings to showcase the talents of the group's members. The eighth exhibition in 1900 is particularly significant because it includes work by C. R. Ashbee's Guild of Handicraft from England and a room by the Glasgow Four (Charles Rennie Mackintosh, Herbert McNair, and the MacDonald sisters, Margaret and Frances) from Scotland. Although the new Viennese style receives positive critical acclaim, the Secession group begins to lose cohesion as an art movement in 1905 when members move in new directions. It evolves into an artists' union and continues exhibitions into the late 20th century.

In 1903, inspired by the success of the Secession group, Josef Hoffman and Koloman Moser form the Wiener Werkstätte (Vienna Workshops), a craft studio inspired by Ashbee's Guild of Handicraft and opposed to methods of mass production. Many members of this group are females.

Projects, mostly for wealthy patrons, include the decoration of individual rooms, entire houses, or small apartments. Products range from furniture and textile designs, cabinetwork, and lighting to ceramics and silver objects, all bearing a similar unified appearance. The group's passion for unifying all arts extends even to the clothing (Fig. 20-1) worn by the lady of the Wiener Werkstätte house. The studio initiates artist workshops to promote artistic experimentation in ceramics, woodcarving, enameling, wallpapers, and fashion design. Commercially successful largely because of wealthy patrons and good advertising, the Werkstätte continues operations until 1932. Viennese architect Josef Urban opens a New York branch in 1922.

Both the Vienna Secession and Wiener Werkstätte make significant contributions to subsequent modern developments. In their quest for a new design language, they explore forms, details, and colors generally not popular before. Additionally, they favor simplicity, rational construction, honest use of materials, and, ultimately, a rejection of ornament.

CONCEPTS

Secession members call for architecture, interiors, and furnishings that develop from contemporay life. Additionally, they strive to dissolve divisions between the fine and decorative arts and design through their exhibitions. Following Otto Wagner in *Moderne Architektur* (1895), the group believes in the expressive power of construction and materials instead of historicism, form over ornament, rationalism, and stylistic simplicity. Like Art Nouveau artists and designers, the Secessionists believe in the power of architecture not only to reform taste, but the very lives of their clients. The Wiener Werkstätte

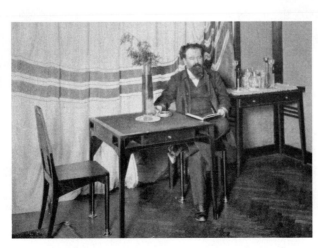

◀ **20-1.** Summer dress, 1911; published in *Mode* from Wiener Werkstätte; by Josef Hoffman; and Josef M. Olbrich at Villa Bahr, c. 1901.

shares similar ideals but adds an emphasis on honest use of materials and excellent craftsmanship. They realize that their products are too expensive for most consumers, but they insist that the very exclusivity is evidence of their appeal to the highest tastes and their socially reforming role.

DESIGN CHARACTERISTICS

Designs in architecture, interiors, furniture, textiles, and decorative arts exhibit minimalism, geometric silhouettes, and strong contrasts. All emphasize geometric forms, shapes, repetition, defined outlines, vertical movement,

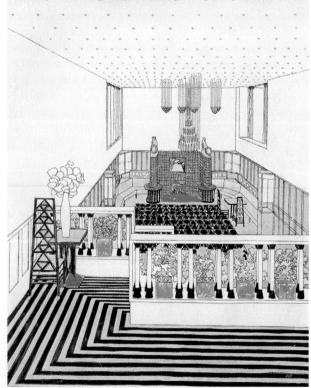

▲ **20-2.** Posters and decorative designs, 1898–1903; Austria; Koloman Moser, Josef Hoffman, Josef Olbrich, and others.

volumes as planes, functionalism, simplicity, and an honest use of materials. Interiors and furniture are plain, stark with little or no ornament although often made in rich materials. Quality, details, and human scale also are important. Rectangles or squares and a limited palette of black, white, and gray with occasional accents of brighter colors often characterize designs.

■ *Motifs*. Motifs are squares and checker patterns in black and white or in solid and void renditions like dots, repetitive geometric designs, medallions, circles, carved floral ornament, sunflowers, philodendrons, roses, and laurel trees or leaves (Fig. 20-2, 20-5, 20-6, 20-10, 20-11, 20-17, 20-18, 20-24, 20-26, 20-28, 20-29, 20-30).

ARCHITECTURE

Secessionist architecture strives to evolve from and, at the same time, reform modern life. Design goals include rectangular and cubic forms that dominate the composition, monumental mass, sparing use of ornament, and an emphasis on function, light, and air. In designing new buildings, architects often strive to transform Vienna's existing classical architecture with simplicity, functionality, and modern materials. These creations are highly individual and, often, innovative. Two of the Secessionist's most famous projects are its own exhibition space, the Secessionist Building (Fig. 20-3) and the Palais Stoclet (Fig. 20-11, 20-12, 20-21), a sophisticated private house for millionaire banker and art collector Adolphe Stoclet in Brussels, Belgium.

Public and Private Buildings

■ *Types*. Projects include offices (Fig. 20-9), railway stations (Fig. 20-5), museums, shops, galleries (Fig. 20-3), churches (Fig. 20-8), large apartment complexes (Fig. 20-10), and tenement houses. Private houses for affluent patrons are important examples of the style (Fig. 20-11).

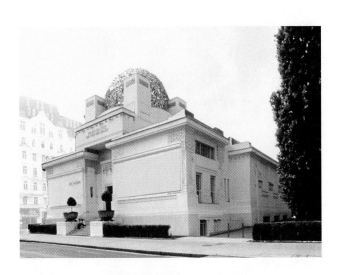

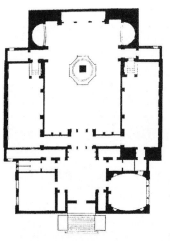

◀ **20-4.** Floor plan, Vienna Secession Building, 1897–1898; Vienna, Austria; Josef Maria Olbrich.

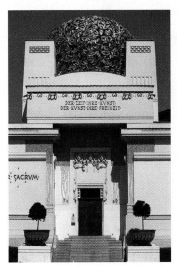

▲ **20-3.** Vienna Secession Building, 1897–1898; Vienna, Austria; Josef Maria Olbrich.

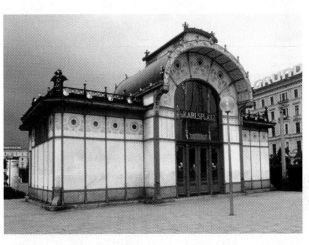

▲ **20-5.** Karlsplatz Stadtbahn (railway) Station, 1898; Vienna, Austria; Otto Wagner.

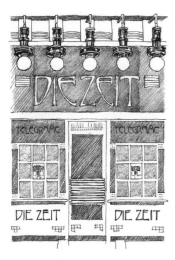

▲ **20-7.** Purkersdorf Sanatorium, c. 1904; Vienna, Austria; Josef Hoffman.

◀ **20-6.** Die Zeit Dispatch Bureau, 1902; Vienna, Austria; Otto Wagner.

■ *Site Orientation*. Important buildings, such as banks and churches, site on prominent streets to provide focal points (Fig. 20-8, 20-9). Tenement houses and apartment complexes are arranged in grid patterns and grouped in neighborhoods that are joined by major streets. Private houses are on residential city blocks or in suburbs (Fig. 20-11).

■ *Floor Plans*. Nonresidential plans develop from the function of the building. Rectangular spaces are arranged to provide maximum light and air and to enhance function and practicality, which are key design principles (Fig. 20-4). To signal their importance, circulation spaces are centrally located in both public and private buildings. Tall apartment complexes feature prominent

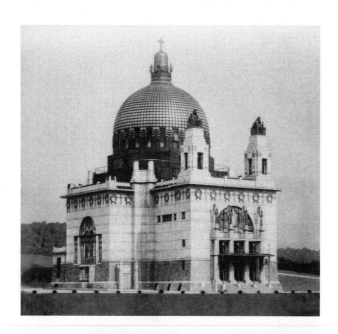

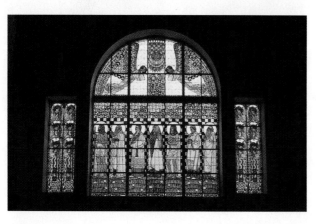

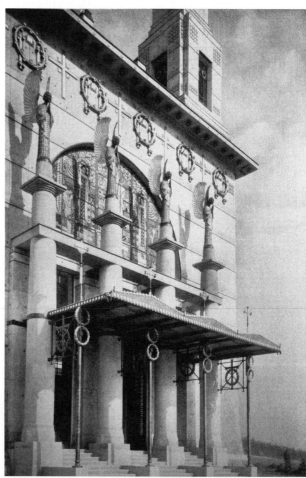

▲ **20-8.** Steinhof Church (Church of S. Leopold), 1904–1906; Vienna, Austria; Otto Wagner, with glass windows by Koloman Moser.

DESIGN SPOTLIGHT

Architecture: Post Office Savings Bank, 1904–1912; Vienna, Austria; Otto Wagner. Wagner's design wins the competition for this building in 1903, and construction occurs in two phases, in 1904–1906 and again in 1910–1912. The façade is his idea of simplified classicism using new modern materials. Symmetrical rows of slender tall windows and marble tiles held in place with aluminum bolts cover the façade and create a decorative checkered pattern. The bolts are functional as well as decorative. Bold iron columns supporting a glass canopy define the entrance. The roof has picturesque details of figures and carving. The building has a glass vaulted roof over the main banking hall. Innovatively suspended from cables with a second roof above, the glazing allows light into the hall and atrium. Glass block floors permit light to penetrate to the floor below.

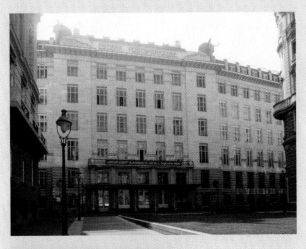

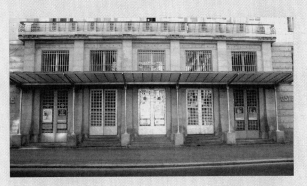

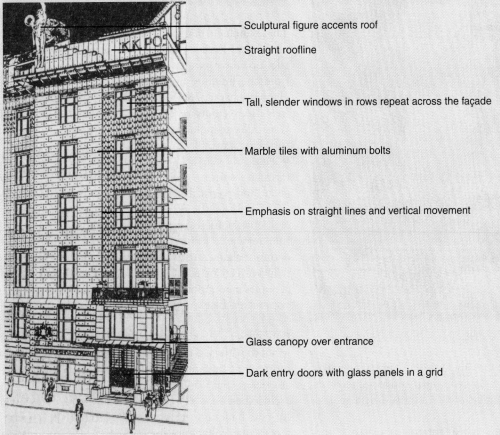

- Sculptural figure accents roof
- Straight roofline

- Tall, slender windows in rows repeat across the façade

- Marble tiles with aluminum bolts

- Emphasis on straight lines and vertical movement

- Glass canopy over entrance

- Dark entry doors with glass panels in a grid

▲ 20-9. Post Office Savings Bank; Vienna, Austria.

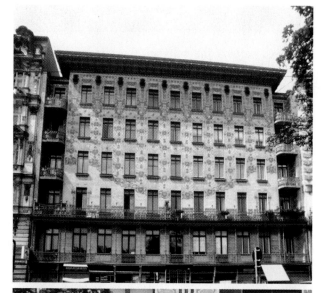

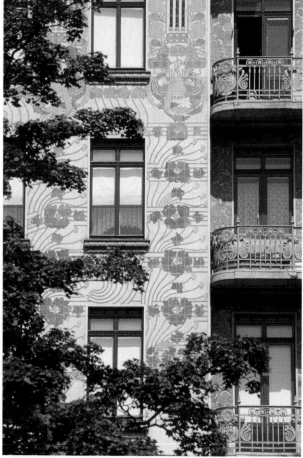

▲ **20-10.** Majolika Haus, 1898; Vienna, Austria; Otto Wagner.

These include marble, granite, brick, glass, steel, and aluminum. Some structures have white plaster, colored tile, or brown granite façades. Generally, color evolves from the building materials, but a few structures have elaborate carved, painted, or tile decoration that may be in various colors or have gilded accents (Fig. 20-10). Usual colors include dull shades of green, brown, gold, rust, blue, gray, black, and white.

■ *Façades.* Plain, generally flat façades display smooth surfaces and a strong geometry with an emphasis on rectangular and vertical movement (Fig. 20-3, 20-7, 20-9, 20-11). Geometric or organic decorative designs may accent entries, friezes, façades, edges, or important architectural features. Horizontal bands of color in the frieze are a defining characteristic. Patterns of metal bolts or inlays help enliven or accent façades. Iron and glass walls or canopies may announce the entry and establish the design vocabulary. Black or gilded iron balconies are a frequent detail.

■ *Windows.* Most structures have unadorned casement windows with glass panes in grids of different sizes. Windows in the same or various heights repeat across the façade or at corners (Fig. 20-7, 20-9, 20-10, 20-11). Surrounds may include narrow moldings or a prominent lintel and/or sill. In some buildings the window panes repeat the square or rectangular volumes of the building itself. An example is the Purkersdorf Sanatorium by Hoffman and Moser, in

elevator lobbies, a prestigious addition to enhance vertical circulation. House plans are linear and asymmetrical, with primarily rectangular rooms arranged in a logical sequence (Fig. 20-12).

■ *Materials.* Designers use a variety of existing and newly developed materials to achieve their concepts.

DESIGN SPOTLIGHT

Architecture: Palais Stoclet, 1905–1911; Brussels, Belgium; Josef Hoffman, with murals by Gustav Klimt and decorative work by Wiener Werkstätte (Vienna Workshops). Begun in 1905 from designs by Hoffman, it establishes the visual language of the Werkstätte and subsequently becomes an innovative masterpiece of the Modern Movement. The Palais Stoclet, a collaboration between Hoffman, Moser, and artist Klimt, exhibits the concept of a total work of art through the integration of architecture and interior design, an idea shared by Art Nouveau. Marble tiles held in place by gilded metal define the asymmetrical geometry of the façade. Rectangles dominate the composition from the marble slabs to the pattern of the windows. Circular forms of the entry serve as balance to the severity of the rectangles. A geometric grid leads the eye to culmination of the composition, the stair tower roof composed of figures supporting a foliage dome that is reminiscent of the Secessionist building.

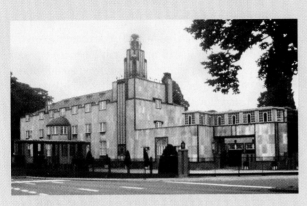
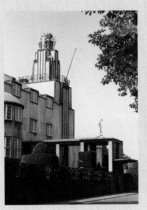

▲ **20-11.** Palais Stoclet; Brussels, Belgium.

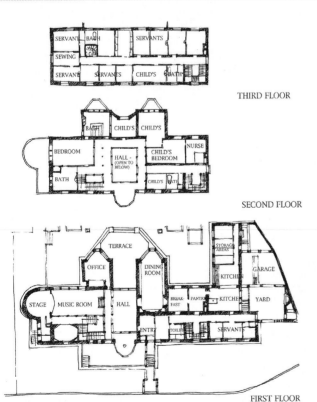

▲ **20-12.** Floor plans, Palais Stoclet, 1905–1911; Brussels, Belgium; Josef Hoffman, with murals by Gustav Klimt and decorative work by Wiener Werkstätte (Vienna Workshops).

which the upper parts of the windows have small, square panes that not only repeat on the exterior but also in the interior design and furniture.

■ *Doors.* Entry doors are generally plain and austere, in natural or painted wood. Some have inserts of plain glass arranged in grids or with stained glass panels. Glass awnings and/or other details may set off entries for public buildings (Fig. 20-3, 20-5, 20-9).

■ *Roofs.* Prominent projecting cornices accent roofs and separate them from the façade, as a terminus. Rooflines may be straight or curved, or a combination of the two. Roofs are usually hipped or gabled. Often the roof is not visible from the street level because of the height of the building. In a few examples, the roof displays unique design features such as an orb composed of metal vines (as in the Secessionist building), human figures, or triple arches.

■ *Later Interpretations.* In its quest for a modern style, Art Deco architecture adopts the rationality and geometry of the Vienna Secession, but with more and varied ornament. Some designers of the 20th century emulate the work of Hoffman, Wagner, and Loos. The legacy of the Vienna Secession group is evident in projects by Walter Gropius, Richard Neutra, Rudolph Schindler, Philip Johnson, and Richard Meier through their careful attention to geometric massing, plain façades, and structural detail (Fig. 20-13).

DESIGN PRACTITIONERS

■ **Josef Hoffman** (1870–1945), a pupil and protégé of Otto Wagner and a professor at the Vienna Academy of Fine Art, is one of the foremost promoters of the Vienna Secession movement. He establishes the Wiener Werkstätte with Koloman Moser. His design inspiration stems from English vernacular architecture, the Arts and Crafts Movement, and the work of Charles Rennie Mackintosh. Projects reflect the total design integration of architecture, interiors, and furnishings and display richness in decoration and detail. Two of his most well known projects are the Palais Stoclet and the Purkersdorf Sanatorium. Hoffman also produces important furniture designs and decorative objects for these projects as well as others.

■ **Gustav Klimt** (1862–1918), artist and one of the founders and first president of the Vienna Secession, paints in a lyrical style that contrasts hard, flat surfaces with a richly decorated stylization of natural forms. His work draws from a range of sources such as those of ancient Greece and Byzantium, as well as Symbolist painting. The mosaic and painted murals created for the Palais Stoclet are one of his most celebrated works.

■ **Koloman Moser** (1868–1918), cofounder of the Wiener Werkstätte and collaborator with Hoffman, conveys some of his most interesting design concepts through his furniture, textiles, and posters. As a unit, they illustrate the Secessionist ideas through cube forms, geometric repetition, luxurious materials, and rectilinear order.

■ **Josef Maria Olbrich** (1867–1908), a pupil of Wagner, has a brief but significant career as an architect and designer. One of the founders of the Vienna Secession, he designs its exhibition building, a testament to the group's anti-historicist, rational mind-set. He also designs interiors and arts and crafts.

■ **Dagobert Peche** (1887–1923), considered second to Hoffman, is one of the most influential figures of the Wiener Werkstätte. After studying architecture, he works for the Wiener Werkstätte from 1915 and is the director of the Zurich branch. He is a master of ornament and works in most materials.

■ **Otto Wagner** (1841–1918), a leading architect and professor at the Vienna Academy of Fine Art, promotes a new modern style with no historical references and totally integrated in design. He advocates a modern architecture that responds to the needs of modern life and simple ornament derived from structure. His buildings emphasize structural honesty, function, practicality, simplicity, easy maintenance, economical costs, and decorative symbolism. Wagner's most famous building, the Post Office Savings Bank in Vienna, evidences the richness and elegance of his design vocabulary.

◄ **20-13.** Later Interpretation: Neiman Marcus Store, 1970s; San Francisco, California; Philip Johnson and John Burgee. Late Modern.

INTERIORS

Secessionist and Werkstätte members consider interiors as equal in importance to architecture. Designers strive to create total works of art (*Gesamtkunstwerk*) deriving

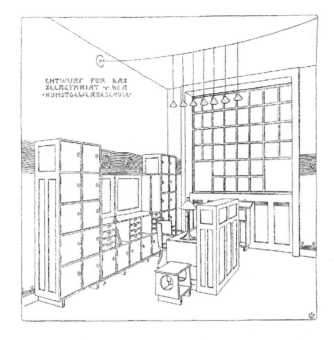

▲ **20-15.** Dining room, Purkersdorf Sanatorium, c. 1904; Vienna, Austria; Josef Hoffman.

from function, simplicity, geometric forms, defined outlines, and smooth surfaces. Rooms are uncluttered and reveal a preference for geometric patterns and details. Designers portray simplicity and richness through painted surfaces, colored tile, marble, wood, metal, mirrors, and plain and stained glass. They frequently design the furniture, textiles, and decorative accessories, often of costly materials, for their interiors. Sometimes they use mass-produced furniture. Wagner, for example, uses Thonet furniture in some rooms of the Post Office Savings Bank in Vienna.

Public and Private Buildings

■ *Types.* No particular spaces are associated with Secessionist public buildings, although designers focus upon circulation and important spaces. Rooms in houses of the wealthy may emphasize social activities with a prominent entry hall, living room, dining room (Fig. 20-21), and possibly a music room. Elaborately detailed bathrooms also are more common.

■ *Relationships.* Interiors in public buildings often reveal similar geometry and linear details to exteriors. Generally, the overall simplicity is enriched with selected, geometric design details. In private houses, there is a strong connection between interiors and exterior often achieved through the use of transitional terraces connected on axes to main rooms.

■ *Color.* White walls are standard for all interiors, often with doors, trim, and storage areas rendered in black, showing the influence of Mackintosh (Fig. 20-14, 20-15, 20-16, 20-17). Bright red, green, yellow, rose, or blue textiles, floor coverings, artwork, and decorative arts may enliven

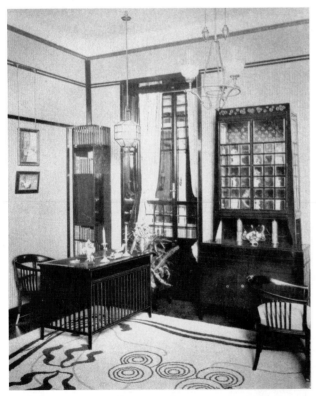

▲ **20-14.** Offices; Austria; published in *Das Interieur II*, 1901.

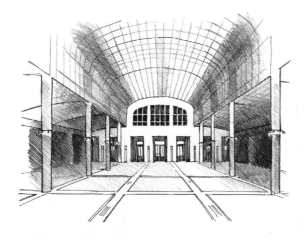

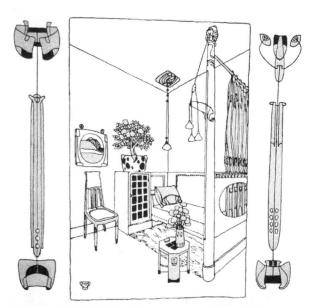

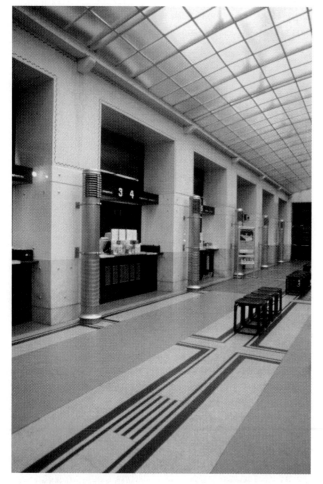

▲ **20-16.** Main hall, Post Office Savings Bank, 1904–1912; Vienna, Austria; Otto Wagner.

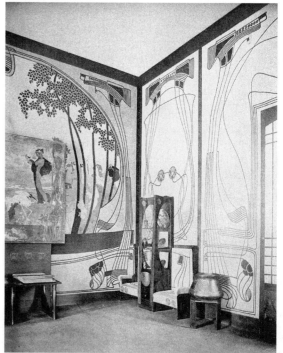

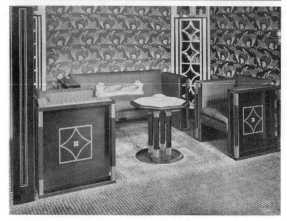

rooms by punctuating important details (Fig. 20-21). Materials or decoration also may repeat the colors of the exterior. Hoffman interiors often use white, black, and gray. Gustav Klimt's designs provide ornamental richness with decorative patterning in spirals, rectangles, lozenges,

▲ **20-17.** Interiors, 1898–1904; Austria; Josef Hoffman.

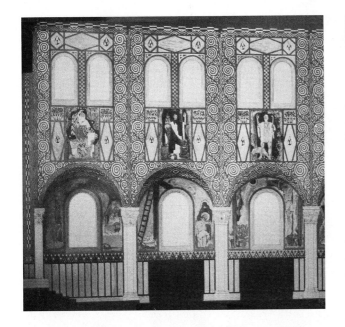

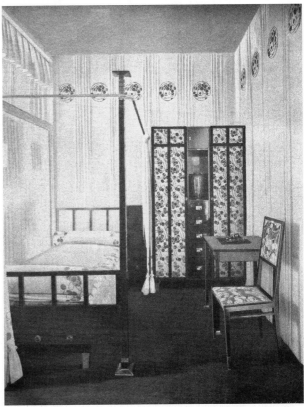

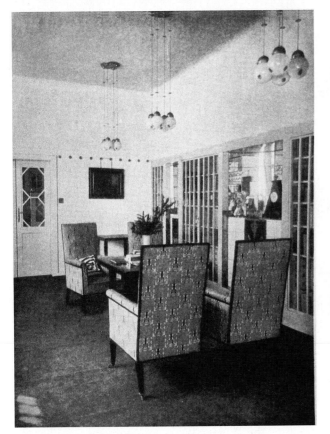

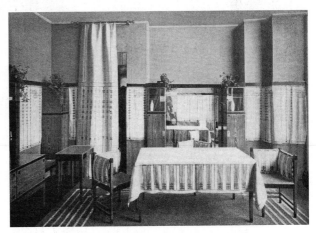

▲ **20-19.** Bedroom, 1901; Austria; Wilhelm Schmidt.

▲ **20-18.** Interiors, 1911; Austria; Koloman Moser.

▲ **20-20.** Dining area, 1922; Austria.

and triangles enhanced with a Byzantine palette of color such as rich red and blue.

■ *Lighting.* The simplicity in form and design of lamps, wall sconces, pendant lights, surface-mounted fixtures, and chandeliers integrate with the interior and support concepts of total unity (Fig. 20-14, 20-16, 20-18, 20-22). Most fixtures are electric.

■ *Floors.* Floor materials include marble, tile, and wood usually in geometric patterns such as rectangles or squares that carry over from the exterior (Fig. 20-16).

DESIGN SPOTLIGHT

Interiors: Living room and dining room with frieze detail, Palais Stoclet, 1905–1911; Brussels, Belgium; Josef Hoffman, with murals by Gustav Klimt and decorative work by Wiener Werkstätte. Palais Stoclet is designed as a total work of art for wealthy Belgian banker and art collector Adolphe Stoclet. The unlimited budget is reflected in the luxurious materials used throughout the house. Its dramatic and sophisticated interiors glitter with marble, onyx, mosaic, gold, glass, teak, and leather. The long, narrow dining room walls are white marble. Black lacquered sideboards run the length of the room and over them are frieze panels by Gustav Klimt. The bold mosaics depict stylized figures and scrolling trees of life in copper, tin, coral, semiprecious stones, and gold. Black and white marble tiles cover the floor. Hoffman designs the furniture, which is composed of large rectangles.

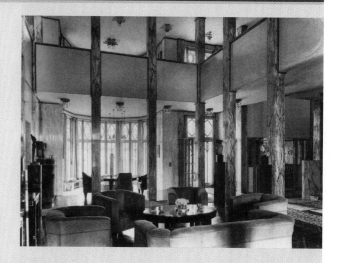

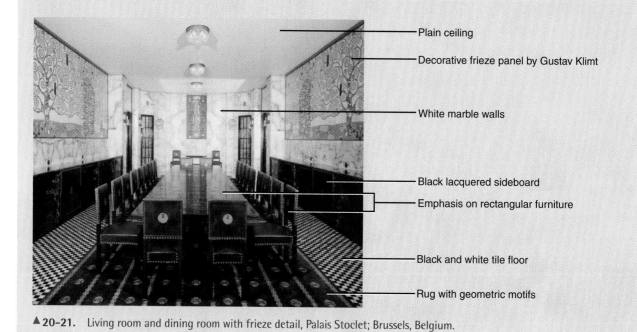

- Plain ceiling
- Decorative frieze panel by Gustav Klimt
- White marble walls
- Black lacquered sideboard
- Emphasis on rectangular furniture
- Black and white tile floor
- Rug with geometric motifs

▲ **20-21.** Living room and dining room with frieze detail, Palais Stoclet; Brussels, Belgium.

Black and white patterned floors of marble are especially popular. Similarly, rugs designed by members of the Wiener Werkstätte have geometric designs and linear patterns to unify with interiors (Fig. 20-14).

■ *Walls.* Plain, unadorned walls are most common (Fig. 20-14, 20-15, 20-16, 20-17, 20-18). Tiled dadoes appear in vestibules and stair halls and contrast with white walls. Some interiors have decorative frieze bands composed of repeating black squares on a white background. Sometimes wallpaper or fabric in geometric or linear patterns designed by members of the Secessionist group or the Wiener Werkstätte enlivens a wall treatment (Fig. 20-17, 20-19). Built-in storage, when present, integrates into the wall composition and is arranged in geometric compositions emphasizing rectangles and squares.

■ *Windows.* Windows are plain, simple, rectangular, often unadorned, and blend in with the interior architectural composition. Drapery, if used, usually has simple panels and a valance, sometimes with a sheer curtain

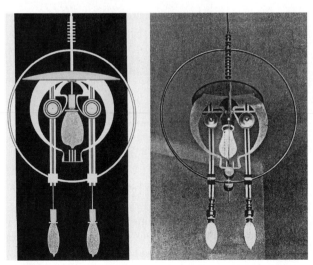

▲ **20–22.** Lighting: Lamp and chandeliers, c. 1900; Austria.

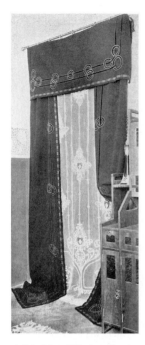
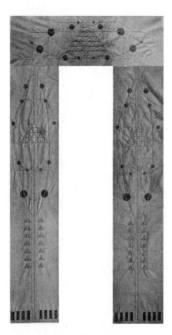
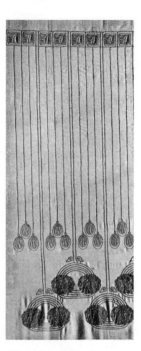

▲ **20-23.** Window Treatments: Over-draperies and window curtains, c. 1900–1904; Otto Prutscher.

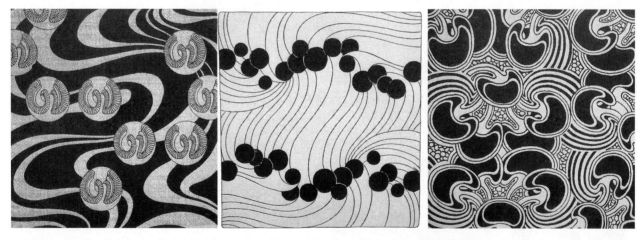

▲ **20-24.** Textiles: Fabrics, wallpapers, table covers, and carpet; Austria; J. M. Auchentaller, O. Prutscher, J. Hoffman, and G. Kleinhempel.

against the glass (Fig. 20-23). The fabric usually is custom designed to match the interior architecture and décor.

■ *Doors.* Interior doors are of wood, either solid with some geometric details or with glass inserts in a grid pattern. They may be painted black or white or stained a very dark mahogany color.

■ *Ceilings.* Ceilings generally are plain, although those in public buildings or important rooms in residences may be coffered or compartmentalized. Architects sometimes use

glass ceilings in public buildings to enhance the quality of light (Fig. 20-16).

■ *Later Interpretations.* Later interiors are influenced by the Secession in their plainness and/or reliance upon simplicity and geometry instead of historic decorations, particularly Art Deco movie sets. During the Late Modern period, simplicity and strong grids may define interior surfaces, as in the work of Andrée Putman and Vignelli Associates. Sometimes, hospitality spaces, such as restaurants, also may exhibit Secessionist influences (Fig. 20-25).

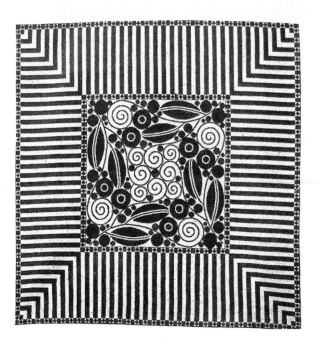

▲ 20–24. *(continued)*

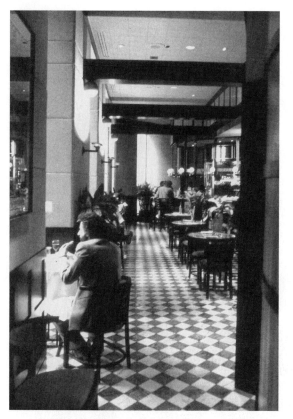

▲ **20-25.** Later Interpretation: Café Spiaggia, 1983; Chicago, Illinois. Modern Historicism.

FURNISHINGS AND DECORATIVE ARTS

The Wiener Werkstätte, which designs most of the furniture and decorative arts, is strongly influenced by the craftsmanship focus of the English Arts and Crafts Movement as well as Charles Rennie Mackintosh's innovative furniture that is individually designed for each space. Equally important is the principle of harmony between the exterior and interiors. Consequently, the furniture reflects an architectonic quality, strong geometry, and rectilinear emphasis like the exterior as well as excellent craftsmanship. Truth to materials in design, construction, and use is also a guiding design principle. Designs reveal simplicity, modesty, and classic proportions derived from the earlier Biedermeier style, an unpretentious version of French Empire for the middle class (see Chapter 3, "German Greek Revival, Biedermeier"). Although furniture's simplicity looks easily adapted to mass production, Werkstätte designers' emphasis on craftsmanship and individuality prevents this. They are not concerned with the relationship of mass production and design, although in several cases their designs are produced in large numbers.

DESIGN SPOTLIGHT

Furniture: Chairs, rocker, settee, and table, 1900–1909; Austria; Josef Hoffman, with much of the furniture manufactured by Thonet Brothers. Noteworthy for its three-dimensional character, Hoffman's furniture illustrates his fascination with basic geometric shapes (circles, squares, and rectangles), flat plane surfaces, solid and void patterns, and artistic details. Sometimes large wooden balls or spheres act to reinforce the joints of horizontal and vertical members or to add decoration. Linear elements interact with three-dimensional ones. He considers his furniture as an art object first, and then addresses the functional purpose, a concept common to architects during this period. Much of his furniture draws inspiration from the Biedermeier tradition in Vienna, particularly the work of Michael Thonet and his use of bentwood. Hoffman mixes the elegance of bentwood with the more traditional English Arts and Crafts character to design furniture that is more avant-garde, refined, unique, and luxurious.

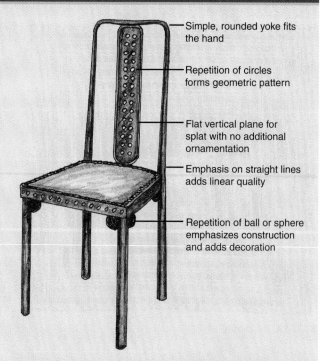

Simple, rounded yoke fits the hand

Repetition of circles forms geometric pattern

Flat vertical plane for splat with no additional ornamentation

Emphasis on straight lines adds linear quality

Repetition of ball or sphere emphasizes construction and adds decoration

▲ **20-26.** Chairs, rocker, settee, and table, 1900–1909; Austria.

DESIGN SPOTLIGHT

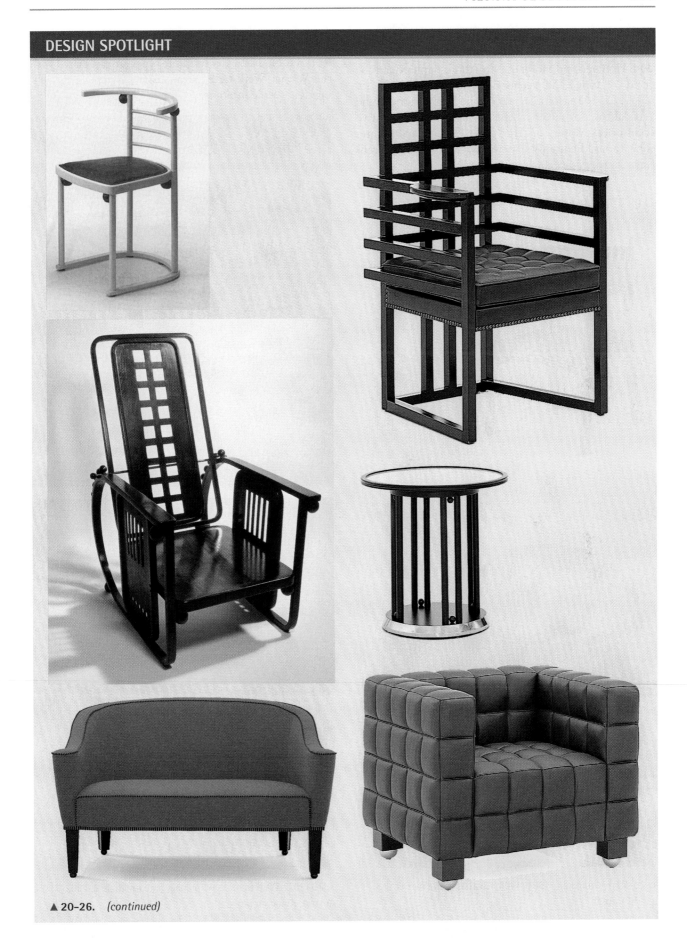

▲ **20–26.** *(continued)*

Although usually created for specific spaces, the furniture of individual designers reveals similar characteristics. Both Hoffman and Moser use structural simplicity, strong purity of form, and geometric repetition (Fig. 20-15, 20-17, 20-26). Hoffman also includes horizontal and vertical rows of squares in his furniture and decorative accessories. Moser, on the other hand, incorporates cube forms, luxurious materials, and intricate details (Fig. 20-18, 20-28).

Public and Private Buildings

■ *Types.* No particular furniture types are associated with the Wiener Werkstätte. Members usually create furnishings for specific interiors.

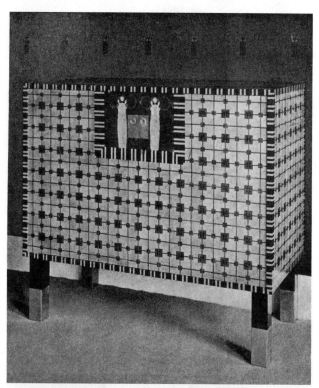

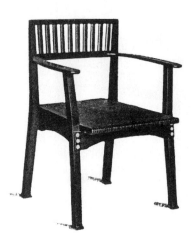

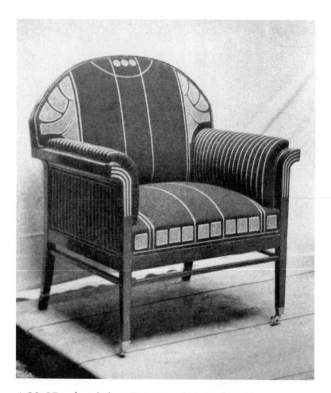

▲ **20–27.** Armchairs, 1901–1904; Austria; Otto Wagner and R. Tropsch.

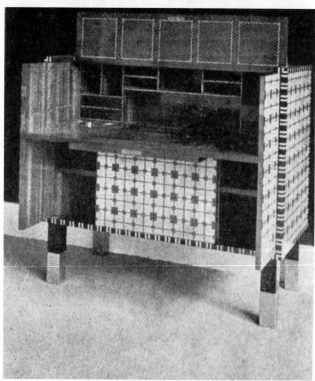

▲ **20–28.** Writing desks with chair, and armchair, c. 1902–1903; Austria; Koloman Moser.

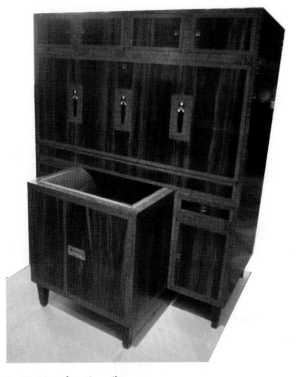

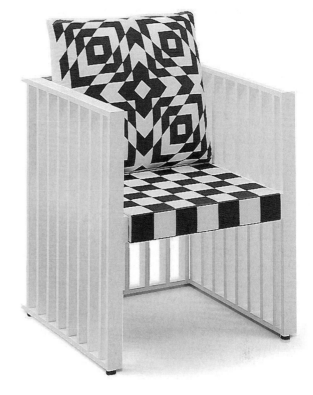

▲ **20-28.** *(continued)*

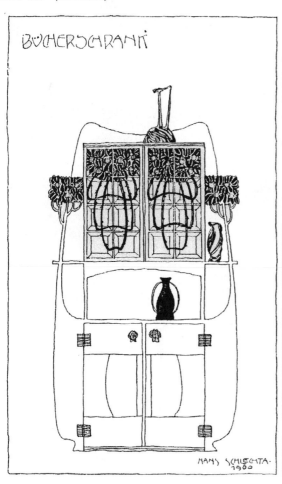

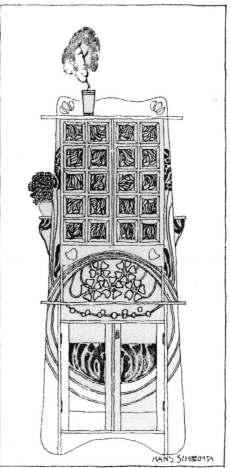

▲ **20-29.** Storage cabinets, c. 1900; Austria.

■ *Distinctive Features*. Forms are practical and usually severely plain. Surfaces and shapes are unadorned, smooth, and geometric. Checker patterns in black and white or solid and void are common features and may serve as decorative accents (Fig. 20-14, 20-26, 20-30). Hoffman's furniture features squares as voids and small spheres accenting joinery.

■ *Relationships*. Members design furniture to integrate with their interiors to create total works of art, like Art Nouveau designers do.

■ *Materials*. Common woods include beech, spruce, and oak. Rich veneers and mother-of-pearl inlays are typical of furniture designed by Hoffman and Moser, although some pieces have plywood parts. Wood may be left natural, stained, lacquered, or painted white or black.

■ *Seating*. Seating, particularly chairs, typify the design vocabulary. Wooden examples are usually tall and slender with smooth surfaces. They are generally rectilinear with an emphasis upon line, like architecture (Fig. 20-14, 20-26, 20-27, 20-28). Curves may appear in backs or seat corners. The straight legs are often quadrangular. A few examples have metal feet. Designs may recall traditional types, such as ladder-backs or rectangular arm chairs, in a simplified vocabulary with a greater emphasis upon outlines and shape. Squares, rectangles, or circles are the only ornament. Upholsterered pieces may be boxy or have simple curves but no carving, inlay, or other ornament (Fig. 20-18, 20-21, 20-27). Nails secure fabric to the frame.

■ *Tables*. Tables usually are slender and rectilinear with some curves. Tops may be round or square, and legs are usually straight and quadrangular in form. The Wiener Werkstätte vocabulary often redefines traditional types that support interior design concepts.

■ *Storage*. Storage pieces, such as cabinets, have a rectangular outline (Fig. 20-14, 20-17, 20-19, 20-28, 20-29, 20-30). Inlay or marquetry in repeating patterns of squares, rectangles, ovals, and/or circles may cover fronts. Door and drawer handles are simple, rectangular, and flat so as not to disrupt the composition.

■ *Beds*. Like other furniture, beds have simple rectilinear headboards and footboards (Fig. 20-19, 20-30).

■ *Upholstery*. Cotton and wool in plain weaves and velvets are the most common materials (Fig. 20-24). Geometric and curved flat, stylized patterns recall architectural forms and nature. Colors, which may repeat those of the architecture, are in dull shades of green, brown, gold, rust, blue, gray, black, and white or bright reds, greens, or yellows.

■ *Decorative Arts*. Like furniture, decorative arts reflect the Wiener Werkstätte design vocabulary. Conceived as part of total works of art, the glass, metalwork, tablewares, and even cutlery feature geometric forms, shapes, and details.

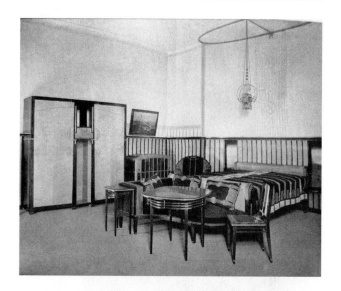

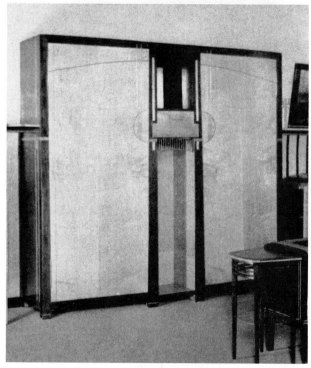

▲ **20-30.** Bedroom furnishings; 1901–1904; Austria.

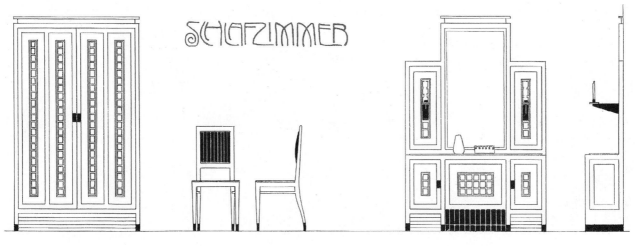

SCHLAFZIMMER

▲ **20–30.** *(continued)*

◄ **20-31.** Later Interpretation: Armchair model 810, 1982; United States; Richard Meier, manufactured by Knoll International. Modern Historicism.

■ *Later Interpretations*. During the 1920s, Art Deco designer Robert Mallet-Stevens, among others, designs furnishings and interiors in character and form that reflect the influence of the Vienna Secessionists. Few interpretations occur after this time until the late 20th century when various manufacturers produce variations of Hoffman's furniture (Fig. 20-31). Jack Lenor Larson and his designers reinvent the textiles of the period with great success.

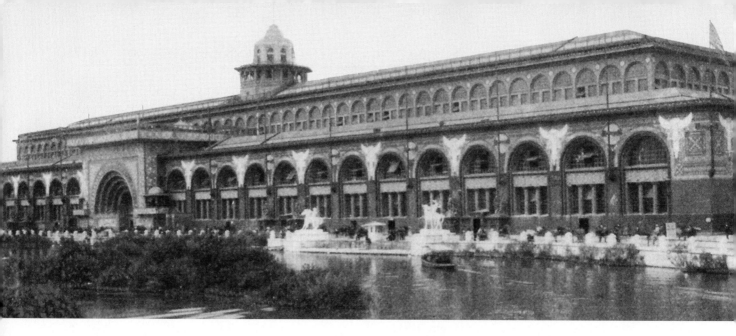

Chicago School

1880s–1910s

All life is organic. It manifests itself through organs, through structures, through functions. That which is alive acts, organizes, grows, develops, unfolds, expands, differentiates, organ after organ, structure after structure.

Louis H. Sullivan, *Kindergarten Chats*, 1901–1902

Louis Sullivan gave America the skyscraper as an organic modern work of art. While America's architects were stumbling at its height, piling one thing on top of another, foolishly denying it, Louis Sullivan seized its height as its characteristic feature, and made it sing; a new thing under the sun! One of the worlds greatest architects, he gave us again the ideal of a great architecture that informed all the great architecture of the worlds.

Frank Lloyd Wright, *Frank Lloyd Wright on Architecture*, 1941

In the First Leiter building, the Manhattan, Marquette and Reliance buildings, and the Carson Pierre Scott department store, for the first time in the world, engineer and architect collaborated and produced new forms in which construction and architecture became indissoluble. These Chicago buildings were the beginning of the modern business buildings of the world; with their creation, architecture took on a new and splendid lease for its future life.

T. H. Robsjohn-Gibbings, *Good-bye, Mr. Chippendale*, 1944

The Chicago School comprises an intellectually elite group of progressive architects in late-19th-century Chicago, Illinois. They introduce the skyscraper, a new building type for the new 20th century. This multistory structure establishes a new design language for commercial buildings and comes to dominate the urban landscape. Various factors in the Untied States facilitate the expansion of skyscraper construction. These include phenomenal commercial and business growth; the development of huge, national corporations; new technology such as the elevator and the typewriter; an inexpensive process for making steel; and an emerging American architectural theory. Influences of the group's work filter to other cities.

HISTORICAL AND SOCIAL

Following the Civil War, a second wave of the Industrial Revolution arises with America at its forefront. New technology, improvements in communication and transportation, and new or improved manufacturing processes usher in a period of extraordinary growth in industry and commerce. In response, American businesses reorganize and

revolutionize how they work. They also recognize that a different structure is needed to conduct business effectively nationally and internationally, so the modern corporation is born. As corporations expand, they increase the number of employees and require more space. Desiring prime locations, they relocate within or move to city centers, creating land shortages and soaring prices for real estate. Consequently, office buildings must grow taller instead of broader. Progress of a new architectural type is not impeded in the United States because it does not share with Europe centuries-old cultural traditions and considerations for the common good. An atmosphere of innovation and the demand for quick profits foster the growth of commercial architecture and offices.

New technologies, many from before the Civil War, also contribute to this development. Until the invention of the passenger elevator in 1857 by Elisha Graves Otis, buildings are seldom more than four or five stories high. The elevator's appearance and popularity in the Eiffel Tower sets the stage for its use in skyscrapers. Tall office buildings or skyscrapers reaching to at least 10 stories begin to dominate the urban skyline. In the 1840s and 1850s, cast and wrought iron are used for façades and some structural elements. In the late 1850s England, Sir Henry Bessemer develops an inexpensive process for making steel, which is more fireproof than cast iron is. Other new inventions, such as the typewriter (1868), the telephone (1876), incandescent light (1879), and the dictaphone or gramophone (1888), transform office planning, types of workers, and their methods of working.

Chicago experiences phenomenal growth beginning in the late 1830s. Already known for its stockyards, the city becomes an important railroad hub and manufacturing center in the 1850s. Immigrants flock there for jobs. Many new buildings are constructed with wood frames and cast-iron columns and façades. However, these materials are not fireproof, as proved by the disastrous fire in Chicago in 1871 in which wood buildings are consumed and iron structures collapse. In addition to the economic and commercial growth that creates a demand for more space, Chicago has few established traditions in architecture in the late 19th century, so architects are free to experiment and, thus, to produce the skyscraper. William Le Baron Jenney, architect and engineer, creates the prototype (Fig. 21-5). Four architects who work in his office, Daniel Burnham, William Holabird, Martin Roche, and Louis Sullivan, further develop his work. They or their firms become the leaders of the Chicago School, known for its development of the tall commercial buildings.

Changes in how businesses do business also affect the development of the skyscraper and its interior planning and furnishing. Before the Civil War, most businesses are small with only a few male employees. Relatively simple office tasks are easily handled individually by hand.

Following the Civil War, tasks and paperwork multiply as businesses grow in size and scope. Productivity and profitability begin to drive office work and planning. Companies now require managers (Fig. 21-1) to develop and oversee a greater variety of jobs, from marketing strategies to transportation arrangements to tracking sales. At the same time, more clerks, typists, and secretaries are needed to process orders and handle correspondence. Managers (Fig. 21-1) find that women are well suited for these tasks, so women enter the office workforce in greater numbers. Besides being more socially acceptable than previously, office pay is better than that of factory or domestic work. However, women still are paid considerably less than men are.

CONCEPTS

Need drives the development of the tall commercial structure, which has no precedent in architecture. Once the technology and construction methods are in place and prototypes appear, the architect's dilemma becomes how to articulate a multistory building to reflect a human scale. These first manifestations of modern architecture often express the structure on the exterior. Additionally, architects and engineers, such as Dankmar Adler and Louis Sullivan, work together to solve structural and architectural problems. These partnerships are less bound by the European Beaux-Arts tradition. Consequently, their ideas and Chicago School traditions of minimal ornament with little historical precedent run counter to the concepts of design promoted in the 1893 World's Columbian Exposition by McKim, Mead, and White and others (see Chapter 12, "Classical Eclecticism").

American architects have increased training at home and abroad in architectural theory. They are more keenly aware of a need for design theory based on function, construction, and scale and are better able to develop their own ideas. At the forefront in Chicago, architect Louis

▲ 21-1. Lady's dress; published in *The Delineator*, July 1901; by the Butterick Publishing Company; and a man at his desk.

IMPORTANT TREATISES

- **The Autobiography of an Idea,** 1924; Louis Sullivan.

- **Kindergarten Chats and Other Writings,** 1901; Louis Sullivan.

- **The Modern Office Building,** 1896; Barr Ferree.

- **A System of Architectural Ornament According to a Philosophy of Man's Powers,** 1924; Louis Sullivan.

- **The Tall Office Building Artistically Considered,** 1896; Louis Sullivan.

Periodicals: *Architectural Record, Engineering Magazine, Engineering Record,* and the *Journal of the Franklin Institute.*

Sullivan believes that the building's form should express the interior function. "Form follows function" becomes his dictum. Sullivan develops the expressive qualities of the skyscraper using classical precedent and his own unique style of ornament. He creates an architectural language for tall buildings.

DESIGN CHARACTERISTICS

Early skyscrapers have grid-patterned façades, large windows for light, and little ornament. Verticality is emphasized as façades rise relatively unhindered by horizontals. Land size and the need for light in interior spaces drive overall shape and configuration. Façades, covered with terra-cotta or masonry, may have bay or oriel windows or, more often, rectangular ones between vertical piers (Fig. 21-2). Lower stories, which house shops, have large plate glass windows to make merchandise visible. At the

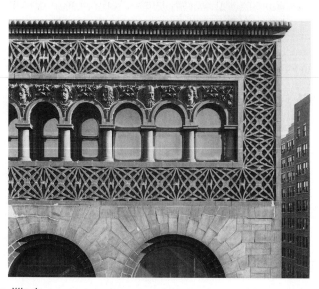

▲ **21–2.** Chicago style window and other windows, c. 1900; Chicago, Illinois.

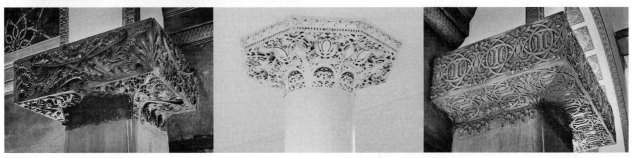

▲ **21–3.** Architectural details and capitals, c. 1880s–1890s; Illinois, Iowa, and Minnesota.

▲ **21–4.** Floors c. 1890s; Illinois and New York; Dankmar Adler and Louis H. Sullivan, and Daniel H. Burnham and John W. Root.

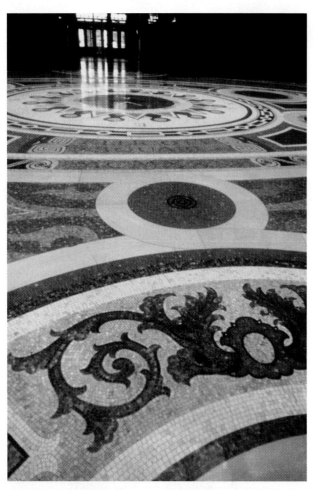

▲ **21-4.** *(continued)*

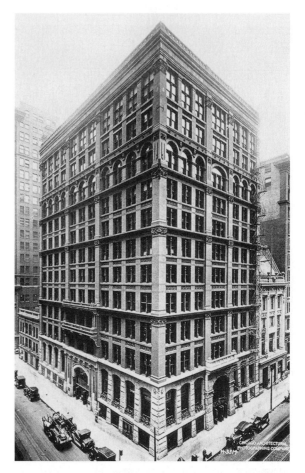

▲ **21-5.** Home Insurance Company Building, 1883–1885; Chicago, Illinois; William Le Baron Jenney.

street level, shops, architectural features, and details provide a human scale. Louis Sullivan uses stringcourses, projecting cornices, richness of detail and decoration as a part of the structure (Fig. 21-8, 21-14).

Entries, lobbies, and atriums are large impressive spaces with expensive treatments and materials. Offices, in contrast, may seem more residential or are strictly utilitarian in appearance. The office hierarchy drives planning, finishes, and furniture with executives having the most space, best treatments, and nicest furniture (Fig. 21-26).

■ *Motifs.* Some buildings have classical details, such as pilasters or stringcourses (Fig. 21-5, 21-17). Sullivan incorporates plant forms and geometric designs, such as the square, oval, and rectangle (Fig. 21-3, 21-8, 21-11, 21-18, 21-19).

ARCHITECTURE

Significant advances in construction technology affect the structure, form, and composition of buildings in Chicago, New York City, and other metropolitan areas during the

second half of the 19th century. Steel skeletons to replace masonry bearing walls or piers, foundations that can support tall buildings, and elevators to access upper floors come together to create the first skyscrapers, or buildings 16 to 20 stories high. Jenney's Home Insurance Building (Fig. 21-5) of 1885 in Chicago is the prototype. It uses a metal skeleton composed of cast-iron columns and steel beams that support the masonry walls and floors. To fireproof them, iron beams are usually clad with terracotta. Steel frame construction leads to the introduction of curtain or non-load-bearing exterior walls that hang from the metal frame. Curtain walls permit large windows for more light, a design characteristic exploited by members of the Chicago School. It ultimately leads to the glass exterior walls that characterize the work of early modern designers and the International Style (see Chapters 22, "Modern Forerunners"; 24, "The Bauhaus"; and 26, "International Style"). Holabird and Roche introduce a reinforced concrete foundation to support a building structure in sandy or muddy soil like that of Chicago.

Construction improvements occur incrementally, so some early skyscrapers retain load-bearing masonry walls

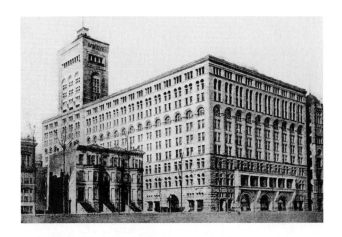

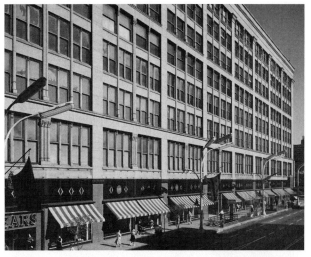

▲ **21-7.** Second Leiter Building (later Sears, Roebuck and Company Building), 1889–1891; Chicago, Illinois; William Le Baron Jenney.

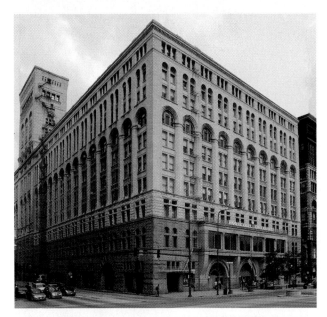

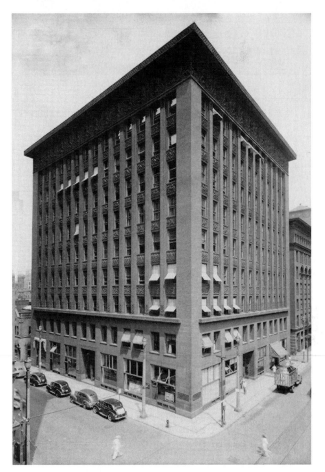

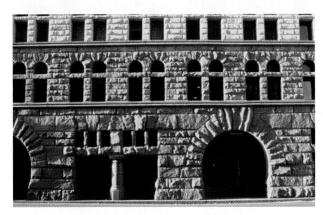

▲ **21-6.** Auditorium Building (Roosevelt University), 1887–1889; Chicago, Illinois; Dankmar Adler and Louis H. Sullivan.

▲ **21-8.** Wainwright Building, 1890–1891; St. Louis, Missouri; Dankmar Adler and Louis H. Sullivan.

combined with wooden or metal beams. However, the thick load-bearing walls take up valuable interior space. The need for more space and profits will soon eliminate masonry walls except as a cladding. In the late 1880s and early 1890s, architects and engineers in other cities begin to employ steel frames extensively, and the modern sky-scraper is born. Building lots created by a grid pattern of streets determine the sizes of skyscrapers. Wider lots

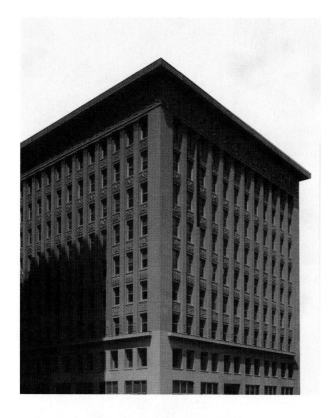

▲ 21-8. *(continued)*

permit buildings to assume hollow square shapes, whereas narrow ones are rectangular boxes or U-shaped to permit as much light as possible to enter the interiors. Incandescent light, although readily available, is inefficient and unreliable.

Because these unusually tall buildings prevent light from getting to the narrow streets below, New York City and Chicago pass laws requiring upper stories to have a series of setbacks to alleviate the problem. In 1916, New York City passes a setback ordinance mandating that new buildings in selected zoned districts can rise upward two and a half times the street width and then must have a setback. In 1918, a Chicago architectural committee proposes that building heights be limited to 260 feet above grade and that architectural standards be introduced. Consequently, architects design buildings with tall, slender towers for space and height while permitting light and air to filter to the streets below.

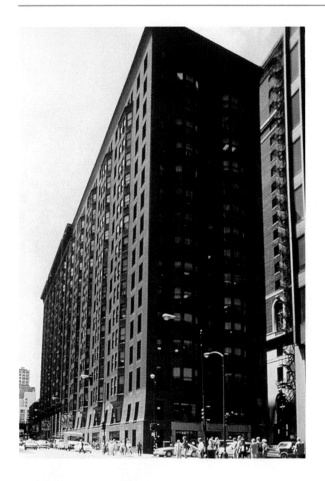

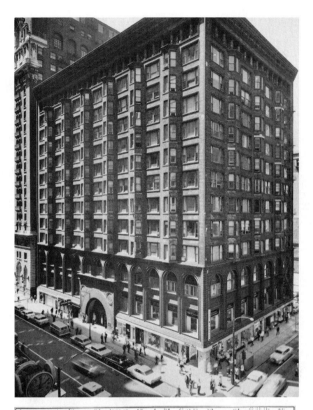

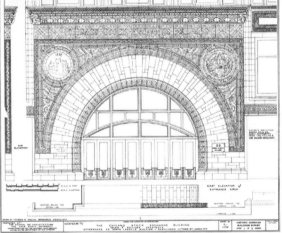

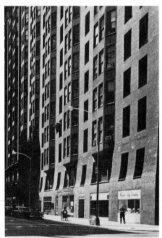

▲ **21-9.** Monadnock Building, 1889–1891, 1893; Chicago, Illinois; Daniel H. Burnham of Burnham & Root (north half), and William Holabird and Martin Roche (south half).

Public Buildings

■ *Types*. Commercial office buildings dominate steel frame construction throughout Chicago and New York City during the late 19th century (Fig. 21-5, 21-7, 21-9, 21-10, 21-12, 21-15, 21-16, 21-17, 21-20). Other types of

▲ **21-10.** Stock Exchange Building, 1893; Chicago, Illinois; Louis H. Sullivan.

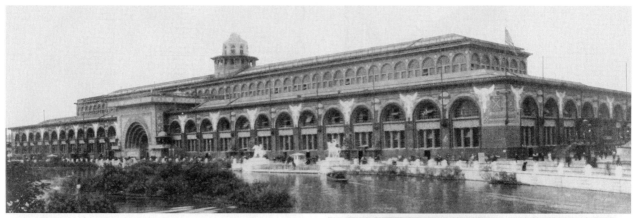

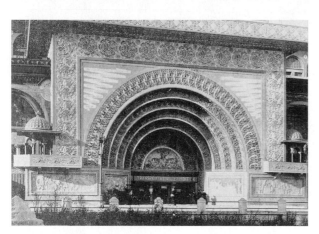

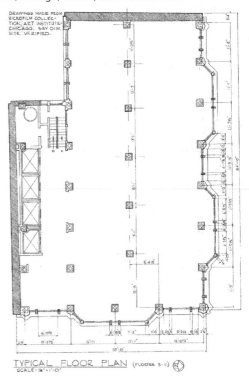

▲ 21-11. Transportation Building, World's Columbian Exposition, 1893; Chicago, Illinois; Louis H. Sullivan.

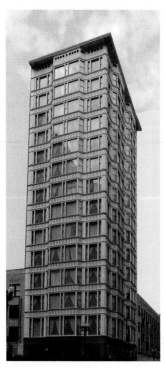

◄ 21-12. Reliance Building, 1890–1891, 1894–1895; Chicago, Illinois; Daniel H. Burnham and John W. Root.

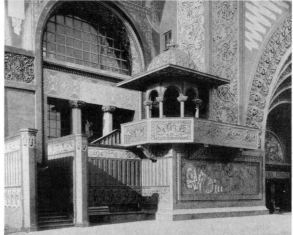

TYPICAL FLOOR PLAN (FLOORS 3-1)
SCALE 1/16" = 1'-0"

▲ 21-13. Floor plan, Reliance Building, 1890–1891, 1894–1895; Chicago, Illinois; by Daniel H. Burnham and John W. Root.

IMPORTANT BUILDINGS AND INTERIORS

- **Baltimore, Maryland:**
 - One South Calvert Building, 1901; Daniel H. Burham and Company.

- **Buffalo, New York:**
 - Ellicott Square, 1892–1896; Daniel H. Burnham and Company.
 - Guaranty Trust Building (later Prudential Building), 1895–1896; Dankmar Adler and Louis Sullivan, with ornamentation designed by Sullivan and George Elmslie.

- **Chicago, Illinois:**
 - Auditorium Building (Roosevelt University), 1887–1889; Dankmar Adler and Louis H. Sullivan.
 - Carson, Pirie, Scott, and Company Department Store (formerly Schlesinger-Mayer Store), 1899–1904, with additions in 1906; Louis H. Sullivan, and additions by Daniel H. Burnham.
 - Fisher Building, 1897; Daniel H. Burnham and John W. Root.
 - Gage, Keith, and Archer Buildings, 1898–1900; Louis H. Sullivan (façade of Gage Building), with William Holabird, and Martin Roche.
 - Home Insurance Company Building, 1883–1885; William Le Baron Jenney.
 - Manhattan Building, 1889–1890; William Le Baron Jenney and Louis E. Ritter.
 - Monadnock Building, 1889–1891, 1893; Daniel H. Burnham of Burnham & Root (north half), and William Holabird and Martin Roche (south half).
 - Montauk Building, 1881–1882; Daniel H. Burnham and John W. Root.
 - Reliance Building, 1890–1891, 1894–1895; Daniel H. Burnham and John W. Root.
 - Rookery Building, 1885–1888, 1905; Daniel H. Burnham and John W. Root, with Frank Lloyd Wright who was responsible for later changes to the lobby.
 - Schiller Building, 1891–1892; Dankmar Adler and Louis H. Sullivan.
 - Second Leiter Building (later Sears, Roebuck & Company Building), 1889–1891; William Le Baron Jenney.
 - Stock Exchange Building, 1893; Louis H. Sullivan.
 - Tacoma Building, 1887–1889; William Holabird and Martin Roche.
 - Transportation Building, 1893; Louis H. Sullivan.

- **New York City, New York:**
 - Bayard-Condict Building, 1897–1899; Louis H. Sullivan.
 - Equitable Building, 1912–1915; Ernest Graham of Graham, Anderson, Probst, and White Architects.
 - Flatiron Building (Fuller Building), 1901–1903; Daniel H. Burnham.
 - Produce Exchange, 1881–1885; George B. Post.
 - Singer Building, 1907; Ernest Flagg.
 - Woolworth Building, 1911–1913; Cass Gilbert.

- **Owatonna, Minnesota:**
 - National Farmers Bank, 1907–1908; Louis H. Sullivan and George Elmslie.

- **San Francisco, California:**
 - Hallidie Building, 1917–1918; Willis Polk.

- **Sidney, Ohio:**
 - Peoples Federal Savings & Loan Association, 1917–1918; Louis H. Sullivan.

- **St. Louis, Missouri:**
 - Wainwright Building, 1890–1891; Dankmar Adler and Louis H. Sullivan.

- **Winona, Minnesota:**
 - Merchants National Bank, 1911–1912; Purcell, Feick, and Elmslie.

structures include auditoriums (Fig. 21-6), department stores (Fig. 21-18), hotels, banks (Fig. 21-19), and libraries.

- *Site Orientation.* Office buildings and large complexes sit on prominent city streets, often on corner lots.

- *Floor Plans.* Floor plans are generally rectangular or square, so the building forms a rectangular box or sometimes a U shape (Fig. 21-13). Plans often have a central corridor with shallow rectangular rooms on both sides. A typical layout, which usually repeats on every floor, is multiple modules composed of a large office with two smaller ones behind it. Some floors have large open spaces for many workers. Heavy metal or steel piers punctuate the plan in a grid system at all levels to support the concentrated weight load. Piers permit more open and spacious interiors with fewer load-bearing walls, an early prototype for later 20th-century high-rise office buildings. Prominent entries lead to vestibules and major public circulation areas, such as hallways, corridors, stairways, and

DESIGN SPOTLIGHT

Architecture: Guaranty Trust Building (later Prudential Building), 1895–1896; Buffalo, New York; Dankmar Adler and Louis Sullivan, with ornamentation designed by Sullivan and George Elmslie. In the design of the Guaranty Trust Building, Sullivan captures the expressive power of the skyscraper and exhibits his own theory of skyscraper design in which "form follows function." Like classical architecture, the building has a beginning, middle, and end. Each is treated differently, reflecting its function within the building. A two-story base houses shops that have large plate glass windows for display. Terra-cotta

ornament of triangles, circles, and foliage covers the entrance portals and window surrounds. In the middle section, corner pilasters and piers with reddish terra-cotta geometric and floral ornament rise unimpeded from the base to the top story to emphasize verticality. The ornament in panels between the windows adds interest but does not compete with that of the vertical piers. Identical exterior treatments of this section accentuate the identical floors of offices within. The top story, a service floor, has round windows with low-relief terra-cotta floral ornament. A bold cornice caps the entire composition.

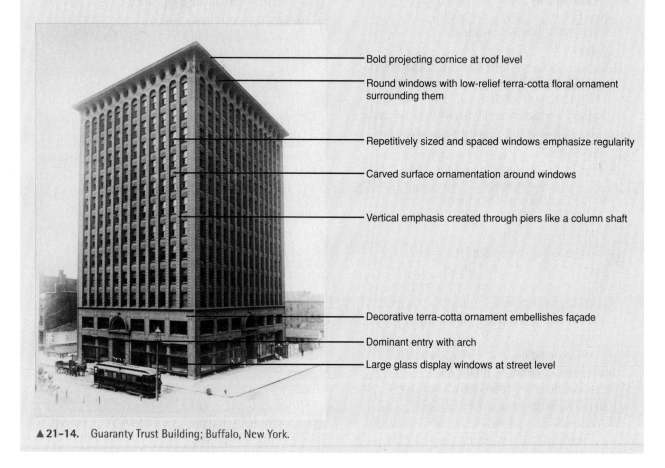

Bold projecting cornice at roof level

Round windows with low-relief terra-cotta floral ornament surrounding them

Repetitively sized and spaced windows emphasize regularity

Carved surface ornamentation around windows

Vertical emphasis created through piers like a column shaft

Decorative terra-cotta ornament embellishes façade

Dominant entry with arch

Large glass display windows at street level

▲ **21-14.** Guaranty Trust Building; Buffalo, New York.

elevators. Architects put vertical circulation on axis with entries and exits, recognizing the importance of fire safety and egress. Elevators, stairways, and bathrooms are centralized.

■ *Materials*. Exterior walls may be of brick, terra-cotta, granite, or other types of stone, giving no hint of the interior metal skeleton (Fig. 21-6, 21-7, 21-14). At first, Adler and Sullivan use granite and limestone to cover load-bearing brickwork. They subsequently adopt steel-skeletal construction covered with brick, terra-cotta, or sandstone, thereby using an outer masonry envelope to cover the

skeletal structure. Color comes from the variety and naturalness of building materials. Sullivan incorporates colored tile to highlight important architectural features such as entryways (Fig. 21-10, 21-11). Some decorative details are of cast iron (Fig. 21-19). After 1893, skyscrapers often have white terra-cotta or limestone cladding to replicate the image of the White City of the World's Columbian Exposition.

■ *Facades*. Building façades exhibit large scale, verticality, repetition, order, and simplicity (Fig. 21-5, 21-6, 21-7, 21-8, 21-9, 21-10, 21-12, 21-14, 21-15, 21-16, 21-17,

DESIGN SPOTLIGHT

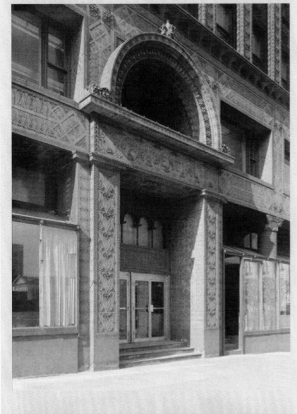

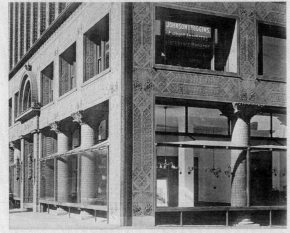

▲ **21-14.** *(continued)*

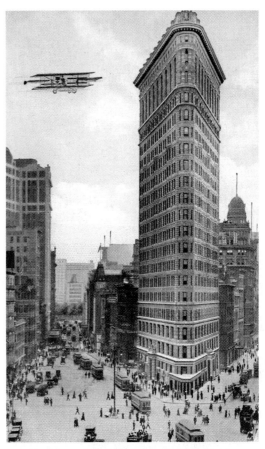

▲ **21-15.** Flatiron Building (Fuller Building), 1901–1903; New York City, New York; by Daniel H. Burnham.

structure and give the impression of support. Large, wide display windows at this level showcase the merchandise in shops. Entries are large and prominently placed. Upper floors have many windows arranged in grid patterns around the entire exterior. Rooflines have heavy cornices that are generally either a plain, flat slab or a projecting form that is more decorated.

Sullivan, who is widely copied, incorporates an aesthetically pleasing façade composition in his office buildings that represents the base, shaft, and capital of a classical column and distinguishes the various functions within the building (Fig. 21-8, 21-10, 21-14). These structures soar vertically upward from the heavy base through prominent piers rising 12 or more stories to the decorated frieze and projecting cornice emphasizing the roofline. Between the piers are large windows. Elaborate carved surface decoration accents entries, piers, bays, spandrels, and the frieze and may accentuate the edges of the building. The profuse decoration, a trademark of Sullivan's work, features richly carved geometric and organic motifs (Fig. 21-3, 21-8, 21-11, 21-18). Flower and plant forms are particularly important. Some of his buildings have large, stepped, arched entries framed with a U-shaped surround, all of which are highly ornamented.

21-18, 21-20). Speculative buildings, built by developers for rentals, have plain, unadorned exteriors. Corporate headquarters, in contrast, are more lavishly embellished. Piers rising from ground to roof level separate façades into bays and organize the exterior composition. Street-level and second floors, which are tall, provide a heavy base with structural supports acknowledged in the design. Piers are wide and heavy at these levels to support the

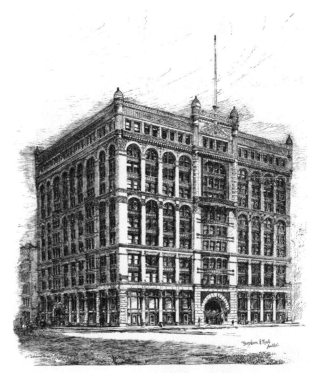

▲ **21-16.** Gage, Keith, and Archer Buildings with lintel detail of Gage Building, 1898–1900; Chicago, Illinois; Louis H. Sullivan (façade of Gage Building on far right), with William Holabird and Martin Roche.

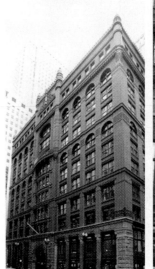

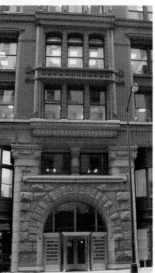

▲ **21-17.** Rookery Building, 1885–1888, 1905; Chicago, Illinois; Daniel H. Burnham and John W. Root, with Frank Lloyd Wright as architect of the lobby renovation in 1905.

■ *Windows*. Buildings show wide expanses of glass windows arranged in rectangular grids that cover most of the façade (Fig. 21-2, 21-7, 21-10, 21-12, 21-15, 21-16, 21-18). The windows form walls, often referred to as curtain walls, a term reflecting a steel and glass construction system. A few examples have bay or oriel windows that rise from the third or fourth floors to the roofline. A new introduction is the Chicago window, a tripartite composition with a fixed wide center window flanked on one or both sides by double-hung sash windows for light and ventilation, as shown on the Carson, Pirie, Scott Department Store (Fig. 21-2, 21-18). Windows come in prefabricated, standard sizes to take advantage of the new technology. The increasing

ability to manufacture larger pieces of plate glass benefits the architectural developments of the time. The glass itself is most often plain. Sullivan uses opalescent leaded glass in some of his buildings to accentuate major architectural features such as entryways. The windows of many buildings have adjustable exterior shades.

■ *Doors*. Monumental entries, often with large arches surrounded by heavy architectural features or stonework, lead

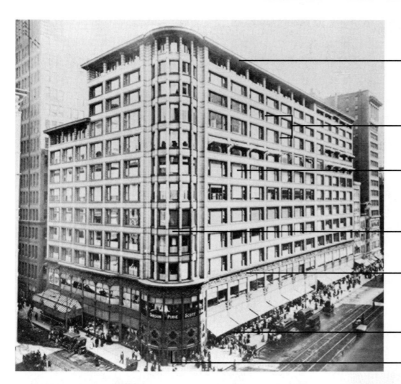

Projecting cornice at roof level

Emphasis on straight lines

Repetitively sized and spaced Chicago-style windows form a grid across façade

Rounded corner addresses street and entry below

Stringcourse separates base from middle section

Large display windows at street level

Art Nouveau-like decoration announces main entry

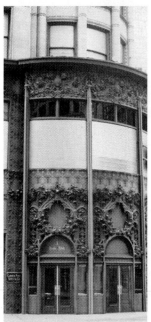

▲ **21-18.** Carson, Pirie, Scott, and Company Department Store (formerly Schlesinger-Mayer Store), 1899–1904, with additions in 1906; Chicago, Illinois; Louis H. Sullivan, and additions by Daniel H. Burnham.

to major circulation areas (Fig. 21-6, 21-10, 21-11). There may be more than one major entry.

■ *Roofs*. Roofs are not visually apparent because heavy or projecting cornices often hide them.

■ *Later Interpretations.* Throughout the 20th and 21st centuries, variations of the high-rise commercial office building proliferate in large urban cities across North America and in other parts of the world. Initially, buildings

DESIGN PRACTITIONERS

- **Daniel Hudson Burnham** (1846–1912) and **John Wellborn Root** (1850–1891) form an architectural firm in 1873 with Root as designer and Burnham as administrator. The firm's mansions for Chicago magnates lead to commissions for office buildings. Two of their most influential buildings in Chicago are the Rookery Building and Monadnock Building. After Root's death, the firm becomes D. H. Burnham and Company and continues to design buildings that influence Chicago's cityscape. Burnham also is chief of construction for the World's Columbian Exposition of 1893 and creates a plan for the city of Chicago in 1909. The firm continues as Graham, Anderson, Probst, and White.

- **William Holabird** (1854–1923) and **Martin Roche** (1853–1927) meet in Jenney's office and found their firm in 1883. They design numerous skyscrapers in Chicago beginning with the Tacoma Building in 1887, now destroyed. Subsequent commissions range from hotels to department stores. Following Roche's death in 1927, the firm becomes Holabird and Root.

- **William Le Baron Jenney** (1832–1907), a prominent architect and engineer, is primarily responsible for developing skyscraper construction in Chicago. He collaborates with local engineer Louis E. Ritter to design the Manhattan Building in Chicago in 1889–1890. It is the first picturesque skyscraper to incorporate a metal skeleton devoid of masonry support.

- **Louis Henri Sullivan** (1856–1924), a student at the Massachusetts Institute of Technology and the L'École des Beaux-Arts, is the creative genius of the Chicago School and the first modern architect of the 20th century. Working together, partner and engineer Dankmar Adler (1844–1900) and Sullivan achieve prominence for numerous skyscraper office buildings incorporating steel-skeletal construction typically covered with brick, terra-cotta, or sandstone. The Wainwright Building and the Guaranty Building are two noteworthy examples. His protégé is Frank Lloyd Wright, another genius of the 20th century.

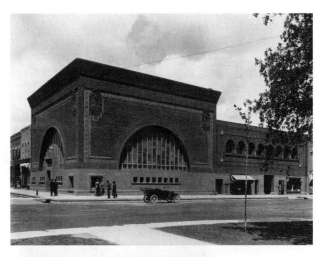

▲ **21-19.** National Farmers Bank, 1907–1908; Owatonna, Minnesota; Louis H. Sullivan and George Elmslie.

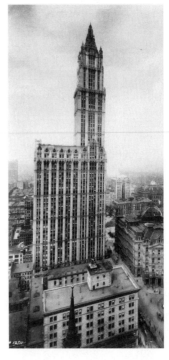

◀ **21-20.** Woolworth Building, 1911–1913; New York City, New York; Cass Gilbert.

are often a box shape, which becomes extremely common in the mid-20th century through the influence of Bauhaus designers, such as Walter Gropius and Mies van der Rohe, and later their protégés (Fig. 21-21). But in the 1970s, the

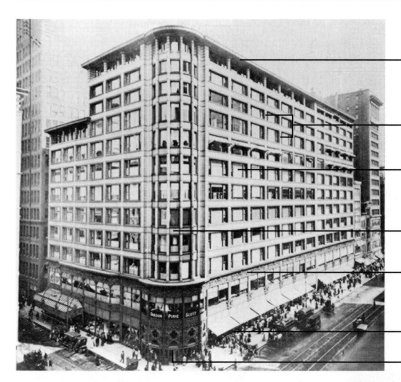

— Projecting cornice at roof level

— Emphasis on straight lines

— Repetitively sized and spaced Chicago-style windows form a grid across façade

— Rounded corner addresses street and entry below

— Stringcourse separates base from middle section

— Large display windows at street level

— Art Nouveau-like decoration announces main entry

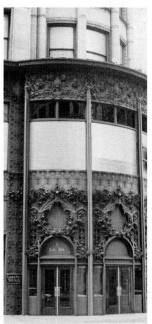

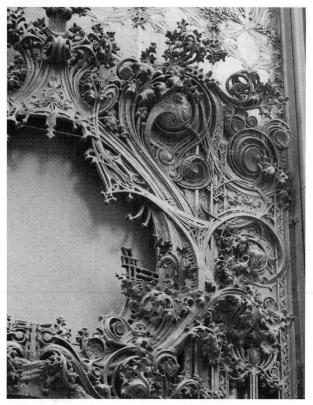

▲ **21-18.** Carson, Pirie, Scott, and Company Department Store (formerly Schlesinger-Mayer Store), 1899–1904, with additions in 1906; Chicago, Illinois; Louis H. Sullivan, and additions by Daniel H. Burnham.

to major circulation areas (Fig. 21-6, 21-10, 21-11). There may be more than one major entry.

■ *Roofs.* Roofs are not visually apparent because heavy or projecting cornices often hide them.

■ *Later Interpretations.* Throughout the 20th and 21st centuries, variations of the high-rise commercial office building proliferate in large urban cities across North America and in other parts of the world. Initially, buildings

DESIGN PRACTITIONERS

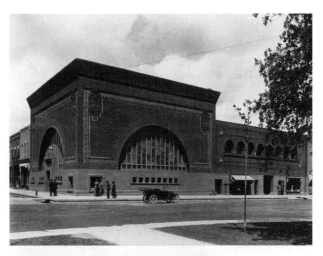

■ **Daniel Hudson Burnham** (1846–1912) and **John Wellborn Root** (1850–1891) form an architectural firm in 1873 with Root as designer and Burnham as administrator. The firm's mansions for Chicago magnates lead to commissions for office buildings. Two of their most influential buildings in Chicago are the Rookery Building and Monadnock Building. After Root's death, the firm becomes D. H. Burnham and Company and continues to design buildings that influence Chicago's cityscape. Burnham also is chief of construction for the World's Columbian Exposition of 1893 and creates a plan for the city of Chicago in 1909. The firm continues as Graham, Anderson, Probst, and White.

■ **William Holabird** (1854–1923) and **Martin Roche** (1853–1927) meet in Jenney's office and found their firm in 1883. They design numerous skyscrapers in Chicago beginning with the Tacoma Building in 1887, now destroyed. Subsequent commissions range from hotels to department stores. Following Roche's death in 1927, the firm becomes Holabird and Root.

■ **William Le Baron Jenney** (1832–1907), a prominent architect and engineer, is primarily responsible for developing skyscraper construction in Chicago. He collaborates with local engineer Louis E. Ritter to design the Manhattan Building in Chicago in 1889–1890. It is the first picturesque skyscraper to incorporate a metal skeleton devoid of masonry support.

▲ **21-19.** National Farmers Bank, 1907–1908; Owatonna, Minnesota; Louis H. Sullivan and George Elmslie.

■ **Louis Henri Sullivan** (1856–1924), a student at the Massachusetts Institute of Technology and the L'École des Beaux-Arts, is the creative genius of the Chicago School and the first modern architect of the 20th century. Working together, partner and engineer Dankmar Adler (1844–1900) and Sullivan achieve prominence for numerous skyscraper office buildings incorporating steel-skeletal construction typically covered with brick, terra-cotta, or sandstone. The Wainwright Building and the Guaranty Building are two noteworthy examples. His protégé is Frank Lloyd Wright, another genius of the 20th century.

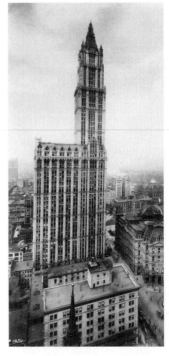

◄ **21-20.** Woolworth Building, 1911–1913; New York City, New York; Cass Gilbert.

are often a box shape, which becomes extremely common in the mid-20th century through the influence of Bauhaus designers, such as Walter Gropius and Mies van der Rohe, and later their protégés (Fig. 21-21). But in the 1970s, the

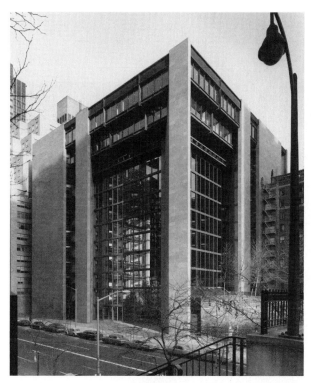

▲ **21-21.** Later Interpretation: Ford Foundation Headquarters, 1967; New York City, New York; Kevin Roche, John Dinkeloo and Associates.

building form changes to express design innovations, functional issues, urban context, and/or environmental concerns. By the late 20th century high-rise commercial buildings become innovative and signature design statements of corporations, countries, and well-known or celebrity architects.

INTERIORS

Entries and lobbies, which are usually two stories and atrium-like, are lavishly decorated with rich materials. Impressive iron or marble staircases lead to upper floors.

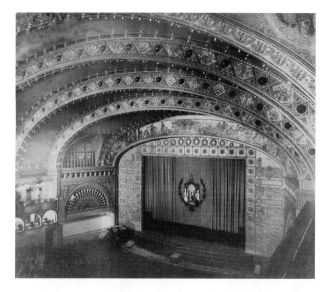

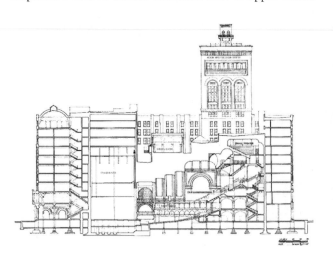

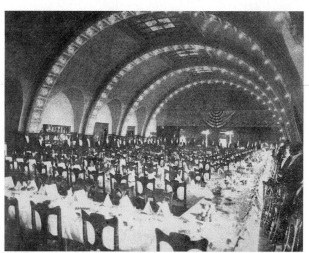

▲ **21-22.** Section, theater, details, and dining room, Auditorium Building (Roosevelt University), 1887–1889; Chicago, Illinois; Dankmar Adler and Louis H. Sullivan.

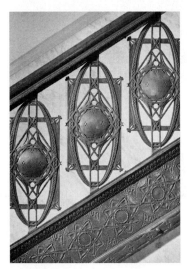

◀**21-23.** Trading room, Stock Exchange Building, 1893; Chicago, Illinois; Louis H. Sullivan.

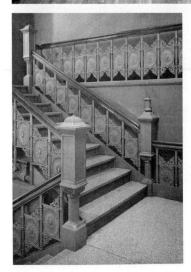

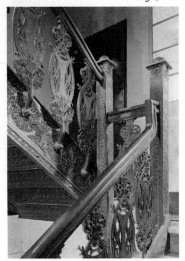

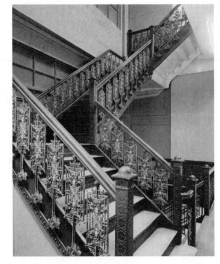

▲**21-24.** Staircases, Second Leiter Building, Guaranty Building, and the Carson, Pirie, Scott and Company Department Store, 1889–1906.

DESIGN SPOTLIGHT

Interiors: Main lobby, Rookery Building, 1885–1888, 1905; Chicago, Illinois; Daniel H. Burnham and John W. Root, with Frank Lloyd Wright as architect of the lobby renovation (bottom left and right) in 1905. Root, likely inspired by French department store design, creates this two-story interior court, which was hailed at the time as bold, original, and inspiring. Flooded with light from a glass roof, retail stores surround the court. Glazed white brick maximizes the light that enters the shops and offices on the first floor and mezzanine. A prominent staircase with cast-iron railing and newel post cantilevers into the space. In 1905, Frank Lloyd Wright gives the space a more modern appearance without altering its essence by replacing the cast iron with white and gold geometric details.

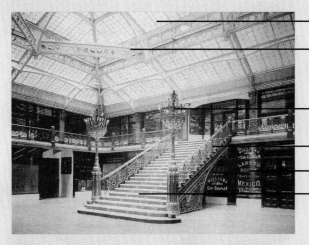

Windows at upper level allow natural light to filter inside

Exposed iron ceiling construction with no columns in interior court

Some lighting is built in

Iron stairway with decorative balustrade

Retail shops surround interior court

Large stairway creates procession into interior court

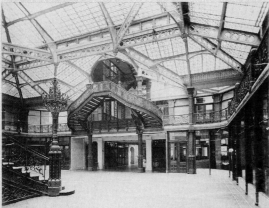

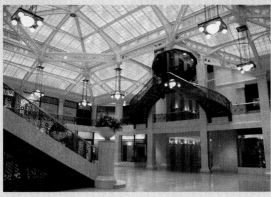

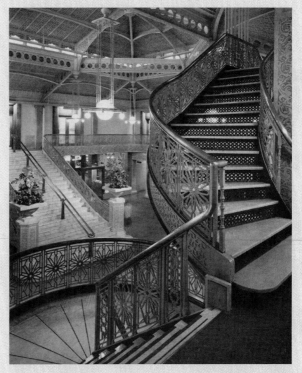

▲ **21-25.** Main lobby, Rookery Building; Chicago.

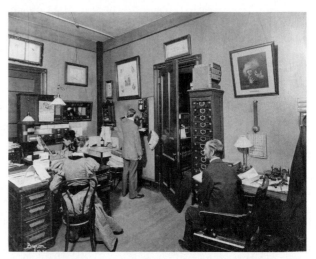

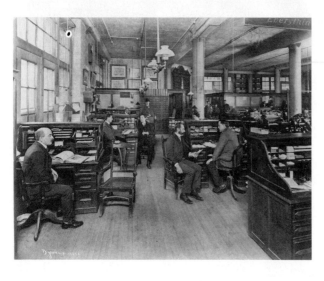

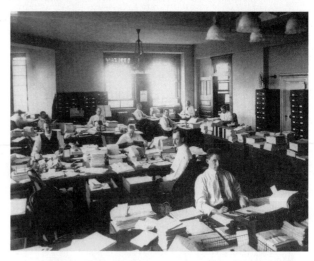

▲ 21-26. Offices, c. 1900; Chicago and New York.

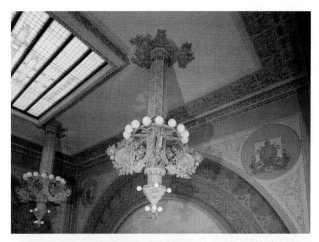

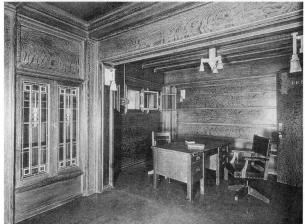

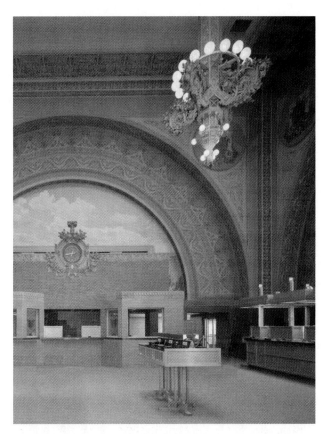

▲ **21-27.** Banking hall, lighting fixture, and office, National Farmers Bank, 1907–1908; Owatonna, Minnesota; Louis H. Sullivan and George Elmslie.

Elevators often appear in open cages, at least on the ground floors, with elaborate cast metal doors. Similarly, restaurants, department stores, and shops have open, light-filled spaces and rich finishes to attract customers.

Small, private offices maintain a domestic appearance with area rugs, wallpaper, or paneling. In contrast, larger offices, which are planned by managers, are plain and utilitarian with little color and decoration. Furniture defines the spaces. By the turn of the century, the office hierarchy becomes more evident. Sizes and locations of offices identify executives, managers, and workers, with executives and managers in corner offices or offices with windows. Most workers have small, windowless offices or sit in rows of desks in large open spaces, which become known as bull pens (Fig. 21-26).

Public Buildings

■ *Types.* Significant spaces in public buildings include vestibules, elevator lobbies, stair halls (Fig. 21-24, 21-25), offices (Fig. 21-26), and retail sales areas. Other spaces vary with the type of building, such as banking halls (Fig. 21-27) in banks or lobbies in theaters and auditoriums.

■ *Relationships.* Major circulation paths from exterior to interior connect important spaces. There is often little design relationship between interior and exterior although entries and some spaces may adopt exterior materials.

■ *Color.* As with the exterior, the primary color palette derives from the architectural materials, including various shades of wood, brick, marble, granite, metal, and stained glass. Staircases and elevator doors display various metals. Walls are often smooth plaster and may be partially painted in an off-white, cream, or light gold. Other colors include earth-tone shades of green, rust, orange, gold, brown, cream, and deep gray. In Sullivan's work, decorative painting may accent friezes, ceilings, and/or a prominent architectural feature such as an arch.

■ *Lighting.* Architects design interior plans to take advantage of natural light. Often they integrate the artificial lighting design into the total interior composition, so it becomes architectonic (Fig. 21-22, 21-27). The lighting fixture materials usually repeat the interior materials. Gas or electric chandeliers, wall sconces, and lamps are common fixtures in all types of spaces (Fig. 21-26).

Fixtures often are no more than a glass shade with a dropped cord, or a socket with a bare bulb. Portable lamps providing direct task illumination are a critical necessity in offices. In some of Sullivan's major projects, decorative glass panels, often covering a skylight, may be built into an architectural framework in a ceiling of an important space (Fig. 21-23).

■ *Floors*. Common flooring materials include marble, granite, limestone, ceramic tiles, terrazzo, linoleum, and wood (Fig. 21-4, 21-26). Carpets, such as ingrains or Brussels, cover floors in smaller offices. Individual offices may have Oriental rugs.

■ *Walls*. Walls are generally plain, but those in important spaces such as lobbies, stair halls, or executive offices, may have a marble dado or wainscoting. Some are paneled, and individual offices may have wallpaper. Sullivan decorates some friezes and arches with large-scale carved decoration, infill painting, or stenciling (Fig. 21-22, 21-23, 21-27). Interior partitions in offices may have glass panels near the ceiling to allow light to penetrate within.

■ *Windows and Doors*. Windows and doors in important offices may have moldings around them (Fig. 21-26). Others are more likely to be plain. Doors to offices often have glass panels or transoms above them for light and air. A few doorways have portieres. Most spaces do not have textile window treatments, although some have roller blinds or shades.

■ *Ceilings*. Ceilings are high and plainly treated. Many have ceiling-mounted gas or electric light fixtures.

■ *Later Interpretations*. As the 20th century progresses, interior architectural features of large commercial buildings repeat the exterior design with numerous variations in simplicity and character. Standardization defines office interiors and furnishings for most workers. Bauhaus architects, their midcentury protégés, and later modernists strive to unify the outside and inside as one total composition. As a result, buildings designed by architects look architectonic with a heavy emphasis on structure, form, scale, and materials (Fig. 21-28).

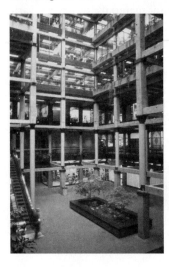

◄ **21-28.** Later Interpretation: Atrium, Butler Square Building, 1906-1908; Minneapolis, Minnesota; Harry Wilde Jones; renovated in 1972 by Miller Hanson Westerbeck Bell Architects.

FURNISHINGS AND DECORATIVE ARTS

During the last half of the 19th century and into the early 20th century, office furniture (Fig. 21-29) differs little in form and appearance from residential furniture. The simple boxlike furniture of the American Arts and Crafts period (see Chapter 18, "Shingle Style, American

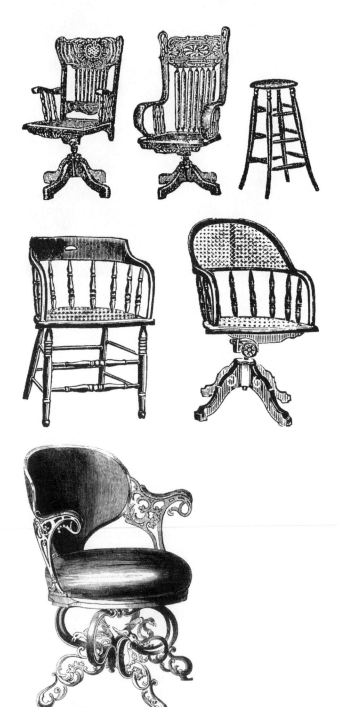

▲ **21-29.** Office chairs and desk, c. 1900.

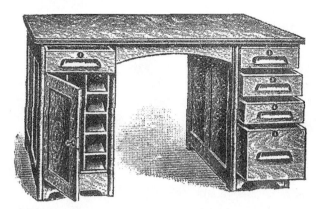

▲ **21-29.** *(continued)*

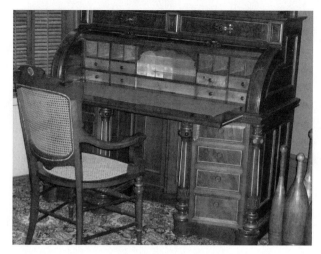

▲ **21-30.** Desk, c. 1900–1910; United States.

Arts and Crafts") is very popular in many offices. Furniture in other more public places reflects the character, scale, and importance of the particular space. Desks are of wood and of three types: rolltops, slant tops, and flat tops with drawers on one or both sides (Fig. 21-26, 21-29, 21-30). Most are plain, but some used by executives are Renaissance Revival or Eastlake in style. Metal office furniture is introduced in the early 20th century. Desk chairs range from simple turned or bentwood chairs to Windsor types (Fig. 21-29). Although swivel chairs are available, many still use straight chairs. Paper, which comprises the majority of office work, is bound in books or stored in pigeonholes either inside roll-top desks, on open shelves, or in cabinets with doors. Filing cabinets are shown in the 1876 Centennial Exposition but do not become common until the turn of the century. Other office furnishings include tables, safes, bookcases often with glass doors, and built-in counters.

In the early 1900s, standardization becomes the norm for paper, filing systems, furniture (Fig. 21-30), and people. Motion and efficiency studies scrutinize office tasks and procedures to increase productivity and profits. Rows of workers seated at flat-top desks replace the individual seated at a rolltop or Wooten desk (see Chapter 1, "Industrial Revolution") so that managers can more easily monitor work flow, behavior, and productivity, Additionally, office machines, such as typewriters and adding machines, become increasingly common. The typewriter standardizes the paper sheet to 8 1/2 × 11 inches, leading to standard size manila folders and file cabinets.

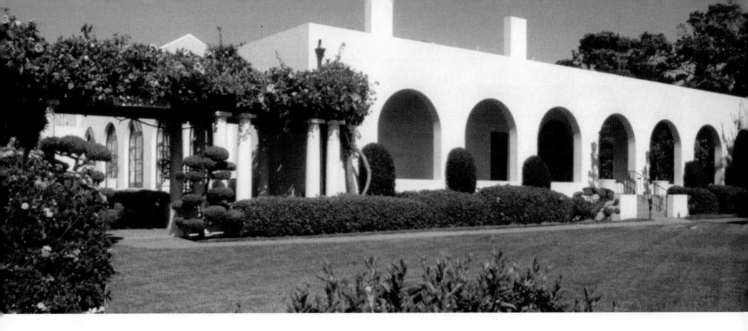

CHAPTER 22

Modern Forerunners

1900–1920s

At the beginning of the 20th century, certain architects advance the search for a modern architecture to express the spirit of a new age. Although unified in purpose, their approaches and aesthetics are diverse, arising from individual experimentation, theory, and personal expression rather than from a common, unified style or movement. Collectively, they share an emphasis upon function, structure, construction, new materials, and urban planning to create new design images. These innovators include August Perret of France, Peter Behrens of Germany, Adolf Loos of Austria, Henrik Petrus Berlage of Holland, Hans Poelzig of Poland, and Frank Lloyd Wright and Irving Gill of the United States. Although they are not the only important designers active during this period, because of their work and influence, architecture becomes simpler, less ornamented, and adopts newer materials and construction methods. This sets the stage for future developments.

The house has to please everyone, contrary to the work of art which does not. The work is a private matter for the artist. The house is not. The work of art is brought into the world without there being a need for it. The house satisfies a requirement. The work of art is responsible to none; the house is responsible to everyone. The work of art wants to draw people out of their state of comfort. The house has to serve comfort. The work of art is revolutionary; the house is conservative. The work of art shows people new directions and thinks of the future. The house thinks of the present.

Adolf Loos, *Architecture*, 1910

Any deviation from simplicity results in a loss of dignity. Ornaments tend to cheapen rather than enrich; they acknowledge inefficiency and weakness. A house cluttered up by complex ornament means that the designer was aware that his work lacked purity of line and perfection of proportion, so he endeavored to cover its imperfection by adding on detail.

Irving Gill, "The New Architecture of the West," *The Craftsman*, 1916, p. 147

HISTORICAL AND SOCIAL

Industrialization continues unabated in Europe during the early 20th century. This is particularly evident in expanded businesses, more factories, mass transportation, and the growth of cities. Additionally, the period marks the widespread adoption of electricity as well as an increase in the number of automobiles, telephones, and cinemas. Despite an increase in wealth and jobs, the social problems

of industrialization and urbanization continue to plague cities and nations. Low pay, long hours, and poor working conditions persist, but now workers are more apt to form labor unions and strike for better wages and work environments. Political and social reforms intensify in various European countries as well as in North America. Important thinkers and theorists, such as Sigmund Freud, Karl Marx, and Friedrich Nietzsche, identify the causes of and propose solutions for the problems inherent in modern industrial life.

The chief catalyst of transformation, however, is World War I (the Great War), which breaks out in August 1914. Involved are the Allied Powers of the United Kingdom, France, Belgium, Serbia, and Russia and the Central Powers including Germany, Austria, Hungary, Bulgaria, and Japan. The United States enters the war as an Ally in 1917 after attempting to remain neutral. Economic and political policies of Europe in the late 19th century are the basic causes of the war, which mobilizes millions of men as well as the entire populations and economic resources of the countries involved. When the war ends in November 1918, Europe is forever changed politically, socially, and geographically. New nations arise as the boundaries of older ones are changed. The German and Austrian empires collapse, and the war helps bring on the Bolshevik Revolution in Russia. The war's cost in money, people, and physical destruction affects the stability of Europe for many years to come.

Like others before them, the forerunner architects, designers, and theorists continue to search for an architecture that reflects the times in which they live. Unlike many of their predecessors, they do not start movements or schools to achieve their aims. Recognizing the failure of Art Nouveau and previous art movements to come to grips with mechanization, they increasingly embrace or celebrate the machine as the means to express modern life and democratize art and architecture. They maintain the belief in the power of buildings to transform what they see as failing societies and are especially concerned with architecturally solving problems of industrialization, most important, the demand for housing. Additionally, they begin to challenge the traditional boundaries of architecture and engineering, arguing that the architect could and should design all buildings for a modern society. Because each architect or designer approaches these problems differently, solutions are varied instead of unified. Their opinions and debates center on form versus function, use of new materials and construction methods, innovative planning, and the application of ornament. These forerunners are relatively few in number, and their work has little immediate impact on the public. However, their architecture and ideas give rise to nearly all subsequent modern developments.

As before, books, schools, and organizations play an important role in the dissemination of ideas. Individuals and groups describe their beliefs and theories in treatises and manifestos such as Loos's *Ornament and Crime* and Antonio Sant'Elia's *Messagio*, which are widely read. Design schools refocus their teaching in line with the ideas of progressive directors and professors. For example, in 1903 Peter Behrens becomes the director at the Arts and Crafts School in Dusseldorf and Hans Poelzig assumes the directorship of the Royal Arts and Crafts Academy in Breslau (now Wroclaw, Poland), both in Germany.

CONCEPTS

Individualists working in Europe and North America experiment with form and structure and develop new and diverse ideas in architecture and design. These individuals strive to create an architecture that is economically practical and functional, expresses the modern experience, and meets the needs of and, even, attempts to reform the society of their time. While grappling with how to express new materials and construction methods through structure, volume, and geometry instead of historicism and applied ornament, they draw from many sources and work out solutions that lay important foundations for the further development of modern architecture both theoretically and functionally.

Influences upon these forerunners are many, including classicism, Gothic churches, Karl Friedrich Schinkel, Eugène Emmanuel Viollet-le-Duc, C. F. A. Voysey, L'École des Beaux-Arts, the Chicago School, Henri van de Velde, the Vienna Secessionists, European vernacular and traditional architecture, factories, and warehouses. Architects sometimes align with or are influenced by early-20th-century avant-garde art movements that reject traditional depictions of visual reality in favor of abstraction. These include Expressionism in Germany, which seeks to demonstrate inner thoughts and subjective feelings through painting; Cubism in France, which depicts time and space through multiple images and fractured planes; and Futurism in Italy, a movement that celebrates the machine and motion.

◄**22-1.** Frank Lloyd Wright, c. 1926; United States.

IMPORTANT TREATISES

- *Abstraktion und Einfühlung (Abstraction and Empathy),* 1907; Wilhelm Worringer.
- *Alpine Architecture,* 1919; Bruno Taut.
- *Ausgefuhrte Bauten und Entwurfe von Frank Lloyd Wright,* 1910; E. Wasmuth.
- *Le béton armé et ses applications (Reinforced Concrete and Its Use),* 1902; Paul Christophe.
- *The City Crown,* 1919; Bruno Taut.
- *Das Englische Haus,* 1905; Hermann Muthesius.
- *"The Home of the Future: The New Architecture of the West," The Craftsman* magazine, 1916; Irving Gill.
- *The House Beautiful,* 1897, William C. Gannet.
- *Ornament und Verbrechen (Ornament and Crime),* 1908; Adolph Loos.
- *Spoken into the Void,* 1932; Adolph Loos.
- *Une Cité Industrielle (An Industrial City),* 1917; Tony Garnier.

Another source of ideas is urban planning. In 1904, Tony Garnier develops Cité Industrielle, a hypothetical industrial city in Lyons, France. This socialist-influenced complex includes housing, government buildings, and industrial structures set along a river valley. Representing a blend of architecture and engineering methods, the buildings are simple, unadorned, and of reinforced concrete. Structures are unified, but there are distinct differences in home and work place, city center and suburbs. Garnier's concepts have a significant impact on those who seek solutions to unmanaged urban growth and the need for decent housing for workers.

DESIGN CHARACTERISTICS

There is no specific design expression because architects create individual interpretations based on a new language for design. Buildings are unadorned, utilitarian, industrial looking, and monumental. Some have industrial features as designers experiment with reinforced concrete construction, metals for structure and surfaces, and larger areas of glass in different sizes. Many solutions emphasize solid and void relationships. Mass, form, hard edges,

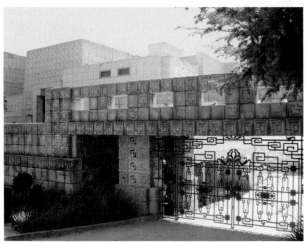

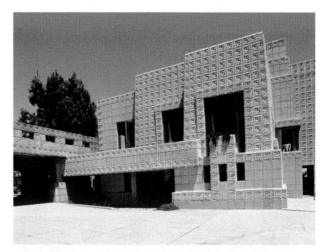

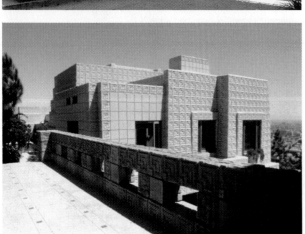

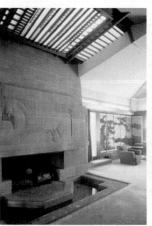

▲ **22-2.** Architectural details, c. 1910–1920s; California; Frank Lloyd Wright and Irving Gill.

interpenetration of spaces, and minimalism are characteristic. Compositions develop as volumes with an emphasis on geometry and axial relationships giving a distinctive architectonic quality. Some buildings are more expressive, organic, or sculptural in character or may have parts that curve or move in and out. Common to all is the importance of spatial organization, which is often volumetric. Architecture is reduced to basics with an emphasis on structure and planning. Some produce buildings with a pure, precise, machine-like appearance, while others reveal a stripped-down classicism, are more expressionist, or evoke traditional, vernacular forms.

Similarly, interiors repeat the exterior character in spaces that are functional, simple, and unornamented. Most of these architects do not design furniture, and those who do adopt principles of the Arts and Crafts Movement, such as honest construction and minimal applied decoration (see Chapters 17 and 18, "English Arts and Crafts" and "Shingle Style, American Arts and Crafts").

■ *Motifs*. There is no vocabulary for motifs because buildings are generally unadorned. Some architects include unique architectural details that are a part of the building structure (Fig. 22-2).

ARCHITECTURE

Architects and engineers, sometimes working together, develop a new visual language, without reference to previous historical styles, except perhaps through classical ordering or attributes such as symmetry. Form and its manipulation is all important to communicate construction demands, function, new relationships, and a machine aesthetic. Ornament, particularly if derived from the past, is rejected. As a result, buildings are plain and functional. Industrial structures provide an opportunity for more experimentation and the use of industrial technology in design.

■ *Form Innovators*. Peter Behrens's design for Germany's A. E. G. Turbine Factory (Fig. 22-7) sets the standard of form for many subsequent buildings. In the first appearance of corporate identity, he also designs the offices, worker housing, logos, advertising, and some products, such as electric fans and light fixtures, for the company. Adolph Loos in Vienna vehemently rejects ornament and designs residences with plain, concrete or stucco exteriors and volumetric interiors, such as evident in his Steiner House (Fig. 22-13). Because of him, subsequent modern architecture eschews ornament in any form for a long time.

■ *Construction Innovators*. August Perret of France is one of the first architects to exploit the potential of reinforced concrete and to use it in an aesthetically pleasing manner. Through his influence, concrete becomes a viable building material. One of his landmark projects is Notre Dame du Raincy (Fig. 22-25), a church near Paris that has a precast, pierced concrete façade with a large, open interior space

shaped by a concrete vaulted ceiling and supported by a minimal number of free-standing solid columns, all of which are unadorned. Henri Sauvage, another French innovator, gains recognition nationally through his low-cost apartment complexes built with reinforced concrete frames and often faced with white and sometimes blue faience tiles. His apartment block on Rue Vavin (Fig. 22-14) in Paris is noteworthy for

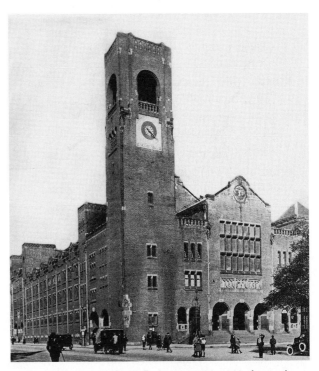

▲ **22-3.** Amsterdam Stock Exchange, 1898–1903; Amsterdam, Holland; Hendrik Petrus Berlage.

▲ **22-4.** Garage Ponthieu, 1905–1906; Paris, France; August Perret.

IMPORTANT BUILDINGS AND INTERIORS

- **Alfeld-an-der-Leine, Germany:**
 - —Fagus Shoe Factory, 1911–1913; Walter Gropius and Adolph Meyer.
- **Amsterdam, Holland:**
 - —Eigen Haard Housing, 1913–1919; Michel de Klerk.
 - —Amsterdam Stock Exchange, 1898–1903; Hendrik Petrus Berlage.
 - —Diamond Workers Union, 1898–1900; Henrik Petrus Berlage.
- **Basel, Switzerland:**
 - —Goetheanum, 1913; Rudolf Steiner.
- **Berlin, Germany:**
 - —A. E. G. Turbine Factory, 1908–1910; Peter Behrens.
 - —Grosses Schauspielhaus, 1919; Hans Poelzig.
- **Buffalo, New York:**
 - —Larkin Administration Building (demolished), 1903–1906; Frank Lloyd Wright.
- **Chicago, Illinois:**
 - —Unity Temple, 1906; Oak Park; Frank Lloyd Wright.
- **Cologne, Germany:**
 - —Glass Pavilion, Werkbund Exhibition, 1914; Bruno Taut.
 - —Model Factory, Werkbund Exhibition, 1914; Walter Gropius and Adolf Meyer.
 - —Model Theater, Werkbund Exhibition, 1914; Henri van de Velde.
- **Los Angeles, California:**
 - —Charles Enis House, 1923; Frank Lloyd Wright.
 - —Hollyhock (Barnsdall) House, 1919–1921; Frank Lloyd Wright.
 - —Walter L. Dodge House (demolished), 1914–1916; Irving Gill.
- **Luban, Poland:**
 - —Chemical Factory, 1911–1912; Hans Poelzig.

- **Paris, France:**
 - —Airship hangars, 1916–1924; near Orly; Eugène Freyssinet.
 - —Apartments at 25 bis Rue Franklin, 1903–1904; August Perret.
 - —Flats at 26 Rue Vavin, 1912; Henri Sauvage and Charles Sarazin.
 - —Flats on Rue des Amiraux, 1925; Henri Sauvage.
 - —Garage Ponthieu, 1905–1906; August Perret.
 - —Le Parisien Offices, 1903–1905; Georges Chedanne.
 - —Notre-Dame du Raincy, 1923–1924; Le Raincy near Paris; August Perret.
 - —S. Jean-de-Montmarte, 1897–1904; Anatole de Baudot and Paul Cattacin.
- **Pasadena, California:**
 - —Millard House (La Miniatura), 1923; Frank Lloyd Wright.
- **Potsdam, Germany:**
 - —Einstein Tower, 1919–1924; Eric Mendelsohn.
- **San Diego, California:**
 - —La Jolla Woman's Club, 1912; Irving Gill.
 - —La Jolla Community Center, 1914; Irving Gill.
- **Tokyo, Japan:**
 - —Imperial Hotel, 1916–1922 (demolished 1968); Frank Lloyd Wright.
- **Vienna, Austria:**
 - —American Kärntner Bar, 1907; Adolf Loos.
 - —Café Museum, 1899; Adolf Loos.
 - —Haus am Michaelerplatz (Goldman and Salatsch Building), 1910; Adolf Loos.
 - —Scheu House, 1912; Adolf Loos.
 - —Steiner House, 1910; Adolf Loos.

its stepped-back form that addresses height requirements while providing interesting sun exposure and balconies on the front façade.

■ *Expressionist Innovators.* Hans Poelzig is the most important German expressionist in architecture. Characteristics of his work include angular or organic forms and monumental interior volumes. His compositions are highly individual and, occasionally, bizarre. One of his important projects is the Centennial Hall in Breslau. Bruno Taut, another German visionary, experiments with novel uses of glass through domes and colored prisms. His creative Glass Pavilion (Fig. 22-11) at the Werkbund Exhibition of 1914 showcases his unique ideas and helps promote the German glass industries.

■ *Nationalist and Regionalist Innovator.* Henrik Petrus Berlage from Holland develops a new architectural language that borrows from the vernacular of the country and conveys a simple, unadorned character. One of his most important and influential projects is the Amsterdam Stock Exchange (Fig. 22-3), which is built of brick, glass, and iron and evidences strong spatial organization with attention to details. His emphasis upon exposed construction influences De Stijl (see Chapter 23, "De Stijl") and other modernist groups.

■ *American Innovators.* The most influential American architect of the period in Europe is Frank Lloyd Wright (Fig. 22-1). His work is admired for its organic concepts,

DESIGN SPOTLIGHT

Architecture: Unity Temple, 1906; Oak Park, Chicago, Illinois; Frank Lloyd Wright. One of the first buildings of poured concrete, Unity Temple makes a bold and sculptural statement of modern design. The building is composed of cubic volumes capped with heavy, flat, interpenetrating roofs. The four corner blocks contain the stairs, and the taller volumes comprise the sanctuary. Wright deliberately inserts no windows in the lower walls for privacy and to muffle noise. The clerestory windows, which illuminate the sanctuary, are separated by bold piers with geometric ornament, the only decoration on the plain façade. Green, yellow, brown, and white stained glass provide a soft,

mystical light. The form and composition are suitable to the material and construction method, the congregation's limited budget, and Wright's design concept intended to convey the simplicity and power of an ancient temple.

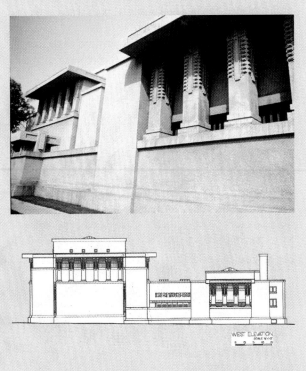

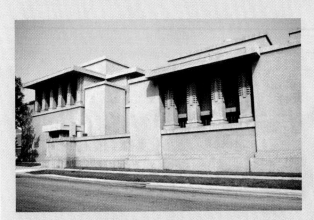

▲ **22-5.** Unity Temple; Oak Park, Chicago.

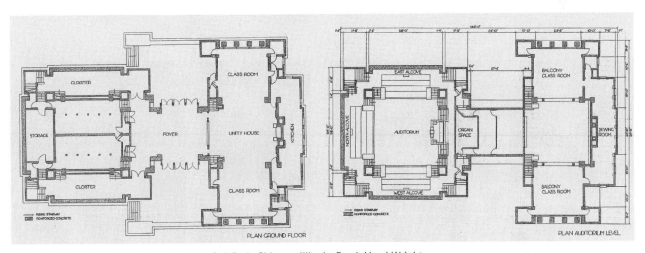

▲ **22-6.** Floor plans, Unity Temple, 1906; Oak Park, Chicago, Illinois; Frank Lloyd Wright.

open planning, integration of structure, geometric forms, horizontality, and natural use of materials. Wright's abstraction of natural forms as ornament is unparalleled in Europe, as are his structural and mechanical innovations, such as textile-block construction (Fig. 22-2) in concrete

and air conditioning. Unlike most others, Wright designs the building and its furnishings to create a unified and total work of art. Of his many influential projects of the time are Unity Temple (Fig. 22-5) in the Chicago area, one of the first buildings in poured concrete, and the Larkin Building

DESIGN SPOTLIGHT

Architecture: A. E. G. Turbine Factory, 1908–1910; Berlin, Germany; Peter Behrens. The best-known and most influential of the buildings Behrens designs for the A. E. G. Turbine Factory reveals his concern for imbuing technology with a noble spirit by using art. Although not obvious at first glance, the building recalls a spare classical temple that is transformed with modern materials and construction methods into a modern factory. Instead of the orders, tapered steel beams resting on bases composed of rocker hinges form the colonnade of the long side. The spaces between are glazed to permit as much light as possible to enter the work space. The main façade has battered concrete corner piers and a rounded gable roof or pediment. In an unclassical move, the bold central window instead of the piers seems to support the pediment. Additionally, the heavy piers are an illusion because they are not necessary for support. Behrens creates a sense of the modern and the eternal for this expression of industry.

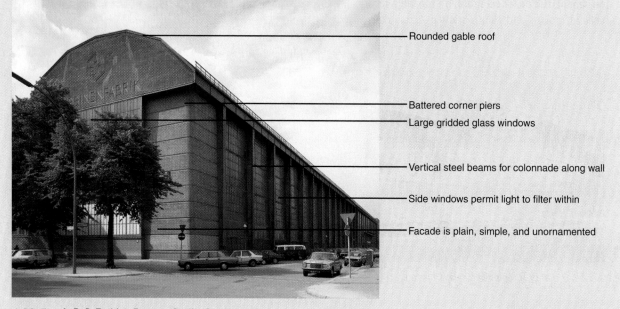

Rounded gable roof

Battered corner piers
Large gridded glass windows

Vertical steel beams for colonnade along wall

Side windows permit light to filter within

Facade is plain, simple, and unornamented

▲ **22-7.** A. E. G. Turbine Factory; Berlin, Germany.

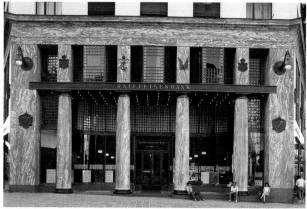

◀ **22-8.** Haus am Michaelerplatz (Goldman and Salatsch Building), 1910; Vienna, Austria; Adolf Loos.

(Fig. 22-21) in Buffalo, which was seen by H. P. Berlage as a great modern work unequaled in Europe. Irving Gill, a former Wright colleague in the office of Louis Sullivan, experiments with reinforced concrete in California. Because of his concern with economy, efficiency, and function, his designs are stark, geometric, and filled with labor-saving devices. Similar to the work of Loos in Vienna, his buildings are unadorned, rectilinear, and white with smooth walls, large glass windows, and flat roofs. Gill's work is comparable to, if not ahead of, other forerunners in Europe, but World War I limits his influence. One of his most important projects is the Walter L. Dodge House (Fig. 22-15) in Los Angeles, a structure whose design simplicity prefigures the later work of Le Corbusier.

Public and Private Buildings

■ *Types.* Commercial buildings are the most important structures. Examples include office buildings (Fig. 22-3, 22-8), city/town halls, railway stations, factories (Fig. 22-7, 22-10), churches (Fig. 22-5), auditoriums, theaters, libraries, department stores, and garages (Fig. 22-4). Residential buildings include apartment (Fig. 22-14) and low-cost housing complexes as well as individual houses (Fig. 22-13, 22-15, 22-17).

■ *Site Orientation.* Architects most often situate commercial buildings on prominent city streets, in parks, and in commercial zones where they will be accessible to large numbers of people (Fig. 22-3, 22-5, 22-8, 22-9). They frequently place apartment and mass housing complexes on

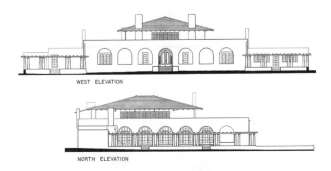

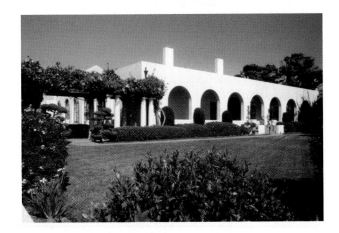

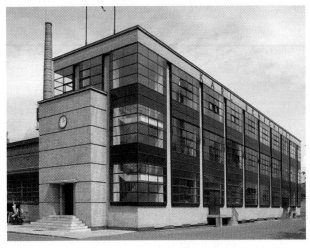

▲ **22-10.** Fagus Shoe Factory, 1911–1913; Alfeld-an-der-Leine, Germany; Walter Gropius and Adolph Meyer.

▲ **22-9.** La Jolla Woman's Club, 1912; La Jolla, California; Irving Gill.

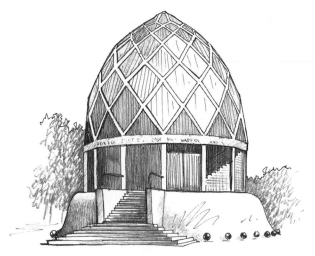

▲ **22-11.** Glass Pavilion, Werkbund Exhibition, 1914; Cologne, Germany; Bruno Taut.

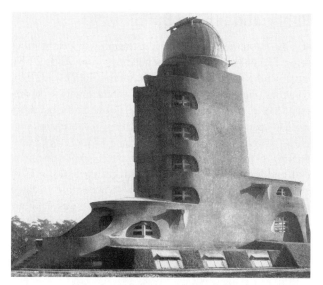

▲ **22-12.** Einstein Tower, 1919–1924; Potsdam, Germany; Eric Mendelsohn.

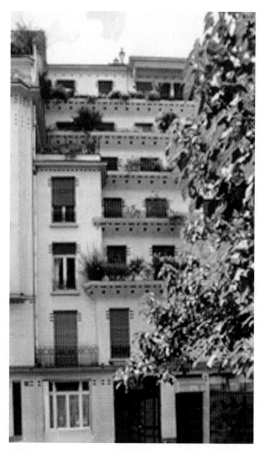

▲ **22-14.** Flats at 26 Rue Vavin, 1912; Paris, France; Henri Sauvage and Charles Sarazin.

▲ **22-13.** Steiner House, 1910; Vienna, Austria; Adolf Loos.

more private streets where there is less traffic. As a result of Garnier's and other's ideas, some large cities in Europe begin to group buildings by function into separate zones marked for culture, government, industry, and residences. There is a strong push to decentralize city centers by creating garden suburbs. Because these new city zones do not emulate the old European city squares, there is little sense of community or intermingling between public and private activities to keep downtowns active and alive. Consequently, these areas often do not thrive.

■ *Floor Plans.* Designers pay much attention to building function in shaping forms and volumes of space to develop plans. The compositions may be asymmetrical, which is more common, or symmetrical. Plan layouts emphasize geometry (rectangles, squares, circles, half-circles) and axial relationships. Beaux-Arts concepts of ordering based on hierarchy influence some plans. Commercial plans usually display open free space, interpenetrating spaces, nonstructural interior walls, and vertical circulation grouped in one or two locations. Typical areas include open atriums or halls, reception spaces, and service areas in the rear of a building. A central court or hall often opens to skylights above. Tiered, open galleries may surround the hall. Open and structurally exposed stairways, many located in the corners of buildings, are more common. In factories, while the process of manufacturing determines most plans, there is often a traditional organization with an emphasis on a main building for the headquarters and side pavilions or blocks for the factory operations.

In contrast, Wright develops plans from the inside out. His public buildings of the time tend to have symmetrical plans with a large, central, inward-looking interior space, such as the sanctuary at Unity Temple (Fig. 22-5, 22-22) in Chicago, or the main work space in the Larkin Building (Fig. 22-21) in Buffalo, which intends to foster community among the worshippers and workers. Houses center on the fireplace or hearth and often emerge in a cruciform shape. Exterior compositions express internal organization and function.

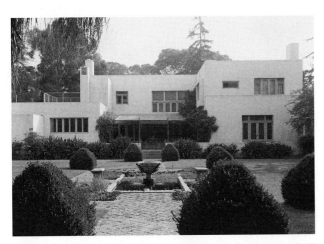

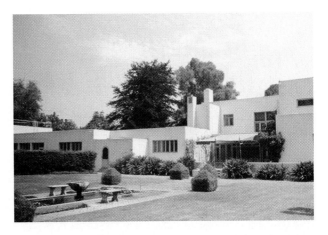

▲ **22-15.** Walter L. Dodge House, 1914–1916; Los Angeles, California; Irving Gill.

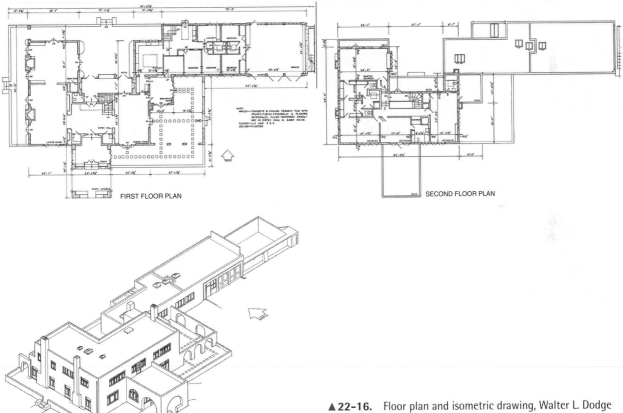

FIRST FLOOR PLAN

SECOND FLOOR PLAN

▲ **22-16.** Floor plan and isometric drawing, Walter L. Dodge House, 1914–1916; Los Angeles, California; Irving Gill.

In general, houses and apartments display a similar plan concept with open space between rooms or areas with vistas between them from large openings (Fig. 22-16). In individual houses, some adopt Loos's emphasis upon volume with changing levels and ceiling heights, and broad openings between and among spaces.

■ *Materials.* New materials for walls are reinforced concrete or brick covering a steel frame and glass walls. Some concrete walls may be precast, stuccoed, or covered with tile (Fig. 22-14, 22-15). Glazed or polished tiles in blue or green or other colors may accent the façade. Bricks vary in color, depending on architect and

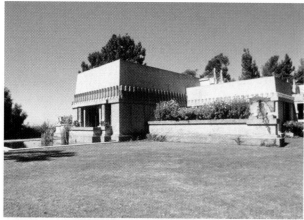

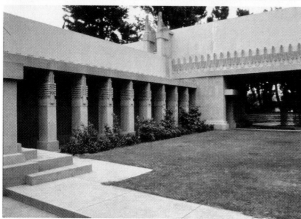

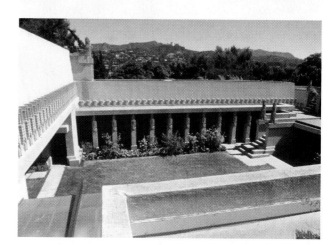

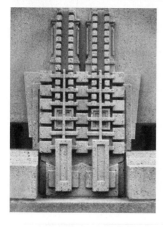

▲ **22-17.** Hollyhock (Barnsdall) House, 1919–1921; Los Angeles, California; Frank Lloyd Wright.

country, with usual selections being red and brown (Fig. 22-3, 22-5). In commercial structures, large areas of glass or glass blocks often highlight façades and stair towers (Fig. 22-4, 22-7, 22-10, 22-11). Columns or piers may be reinforced concrete or stone, and some are brick, wood, or metal. Exposed structural iron and steel trusses may span an open ceiling. Fireproof terra-cotta, another recently developed material, may appear on those commercial structures with a more traditional look.

Wright's work also increasingly incorporates mechanical systems such as the pioneering air quality control with a built-in duct system that cleans and heats the air in the Larkin Building. This is particularly important because his design seals the building against the heavy air pollution of its industrial location.

■ *Reinforced Concrete.* Perhaps the single most important building material in the early 20th century is reinforced concrete, a concrete that has internal metal rods to strengthen it. Although its exact origin is uncertain, it emerges in 1850s France in houses by François Coignet. However, it is not until the 1890s that François Hennebique, also from France, uses the reinforced concrete construction technique in industrial buildings. In 1897, Anatole de Baudot and Paul Cattacin perfect its

DESIGN PRACTITIONERS

- **Peter Behrens** (1868–1940) begins his career as an architect at Darmstadt, and he quickly becomes the foremost German designer of the period. Behrens strives to unite art with technology, and his buildings emphasize simplicity, flatness, careful ordering, and structural delineation. Projects include houses, low-cost housing complexes, factories, concert halls, exhibition spaces, shops, embassies, and office buildings. The A. E. G. Turbine Factory in Berlin is his most important project. Behrens's theories and designs influence later architects associated with the Bauhaus, including Walter Gropius, Mies van der Rohe, as well as Le Corbusier, who all work in his office.

- **Henrik Petrus Berlage** (1856–1934), the leading Dutch architect, conveys a conservative, vernacular image with plain, unadorned façades. His projects include office buildings, low-cost housing complexes, hotels, and city plans. An intermediary between traditional designers and modernists, Berlage is considered the father of Modern architecture in the Netherlands. His work influences the Amsterdam School and De Stijl. The Amsterdam Stock Exchange is one of his most important buildings.

- **Irving Gill** (1870–1936), an important California architect and an early advocate of Modernism and reinforced concrete, creates many impressive houses and a few commercial buildings inspired by California missions and haciendas. Appearing almost as abstract compositions, his buildings are unadorned, cubic, and white with smooth walls, large windows, and flat roofs. His most noteworthy project is the Walter L. Dodge House in Los Angeles.

- **Adolf Loos** (1870–1933) becomes the leading advocate to rid architecture of any type of ornament. His theories, articulated in many essays and books, provide a catalyst for simplicity and austerity in buildings and interiors with an emphasis on construction and materials. Loos is vehemently critical of the Secession and Art Nouveau and disassociates himself from them. One of his most important concepts is planning room layouts based on volumes of space. His most famous project is the Steiner House in Vienna.

- **August Perret** (1874–1954), the leading French architect of the time, is one of the first designers of his generation to work with reinforced concrete. He adopts a French classical rationalist approach to design that emphasizes revealed structure and functional planning. Perret experiments with concrete in houses, apartment complexes, office buildings, garages, theaters, churches, banks, and government buildings. One of his most noteworthy projects is Notre-Dame du Raincy, a church near Paris. His early work gains more recognition than do buildings produced later in his career.

- **Hans Poelzig** (1869–1936), one of the earliest and most distinctive of the Expressionists in architecture, develops unique solutions for residences and commercial buildings in Poland and Germany. After studying in Germany, Poelzig becomes an influential member of the Deutsche Werkbund. Noteworthy projects include the Luban Chemical Factory in Luban, Poland, and the Grosses Schauspielhaus in Berlin.

- **Frank Lloyd Wright** (1860–1959) influences the Modern Movement in Europe through unity and integration of exterior, plan, interiors, and furnishings. Particularly influential are Unity Temple and the Larkin Building. Like his Prairie houses, these buildings are geometric, human in scale, unadorned, and innovative. Wright, unlike some others, designs the furnishings for his buildings for complete unity. These and other buildings, which are published in Europe in 1910, establish Wright as a modernist pioneer and one that influences European designers (see Chapter 18, "Shingle Style, American Arts and Crafts").

application in S. Jean-de-Montmarte, a novel new church in Paris (Fig. 22-20). Perret, Loos, Gill, and Wright use it, and soon others follow suit. Perret pioneers the use of exposed concrete, a concrete used without the application of tiles or other veneers (Fig. 22-25). Gill in 1912 develops an insulating core for concrete panels that eliminates condensation and loss of heat (Fig. 22-9, 22-15). He is also one of the first to use a lift-slab method of construction.

During the 1920s, Wright explores new construction methods using standardized concrete blocks, made and patterned at the site. Called textile-block construction, the blocks are tied together with horizontal and vertical steel rods and reinforced with mortar (Fig. 22-2). Because

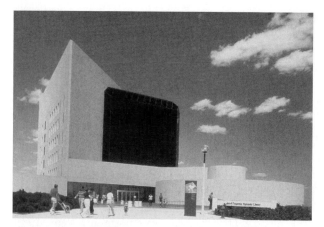

▲ 22-18. Later Interpretation: John F. Kennedy Library, 1964–1979; Boston, Massachusetts; I. M. Pei. Late Modern.

constructing the blocks is a new process, they are made on site instead of industrially and are, therefore, fragile and porous. They soon need replacement. Nevertheless, textile-block construction gives a structural unity not evident in wood or steel frames.

■ *Facades*. Exteriors display the uniqueness and individualism of architects as they work with new materials in a new way. Often unadorned, plain façades evidence a formal grid or repetitive structural pattern highlighted with focal points created through arches, towers, entryways, balconies, windows, and roofs (Fig. 22-4, 22-7, 22-9, 22-10, 22-11, 22-12). This application creates three-dimensionality through a change of depth and makes the building seem more active. In commercial structures, towers that announce and identify the building often have symbolic meaning and may have clocks on their fronts (Fig. 22-3). Tall apartment complexes may have stepped façades with balconies that project out to punctuate the façade (Fig. 22-14). Windows in groups may project or recede at one or various levels to create movement. Roofs may be flat and disappear or create a more defined focal point. Any detailing usually is a part of the structure, whether it is in concrete, brick, or metal.

Commercial structures display a substantial increase in the use of glass set within a metal grid (Fig. 22-4, 22-7, 22-10). The glass, which comes in standard sizes, is most often within a steel framework so that there is a repetition of shape and materials on the exterior. The surrounding area is reinforced concrete or brick, or sometimes metal cladding. Frequently, these glass walls define the overall building character. In houses, large glass windows may punctuate the entire building perimeter. Loos experiments with extremely plain façades and volumetric planning (Fig. 22-13). Wright's façades are profoundly geometric with interpenetrating volumes. Unlike others, he uses stylized ornament to accentuate important architectural features and maintain a sense of

place (Fig. 22-5, 22-17). Gill's façades frequently display a series of arches, reflecting the early Spanish influence of southern California (Fig. 22-9).

■ *Windows*. Size and placement of windows vary according to building use and functions. Designers primarily use double-hung, fixed, and casement windows (Fig. 22-4, 22-7, 22-10, 22-15). In expressionist compositions, windows may be round, oval, or curvilinear. Sometimes the windows are flat against the façade, and sometimes they project to enhance the composition. Large windows over entryways are particularly noticeable in churches, railway stations, and city halls. Clerestory windows may appear near a roofline. Flat moldings in wood, metal, brick, or glazed tile may frame the opening.

■ *Doors*. Architects integrate the entry doors into the overall building composition. In contrast, Wright often hides the entrance but creates a processional path to it. Usually unadorned and plain, the doors are large, but do not overly dominate the façade. Some are solid and others have glass panels in the center.

■ *Roofs*. Roofs, which display much variety through experimentation by different architects, may be flat, geometrical, or sculptural (Fig. 22-5, 22-7, 22-11, 22-12, 22-13, 22-15). Sometimes the roof is a visual icon or symbol for the building and very expressive in form, such as the Glass Pavilion by Bruno Taut (Fig. 22-11) or the Einstein Tower (Fig. 22-12) by Eric Mendelsohn. Roofs may be reinforced concrete, sculptural concrete, built-up wood and rolled asphalt, metal with steel supports, glass supported by steel and/or wrought iron trusses, and gables in various materials. A flat band or projecting cornice often separates the roof from the building façade. During this period, Frank Lloyd Wright develops a new internal roof drainage system that he repeats in his later buildings.

■ *Later Interpretations*. Designers in later periods explore and interpret ideas from these precursors as they expand on the unity of architecture and engineering. Like their predecessors, each expression is a unique statement of the individual designer. Some experiment more with concrete or glass, while others emphasize the simplicity, regularity, and plainness of the façade. Noteworthy descendents, such as Mies van der Rohe, Le Corbusier, Pier Luigi Nervi, Alvar Aalto, Louis Kahn, I. M. Pei (Fig. 22-18), and others, help establish an international vocabulary and shape the Modern Movement.

INTERIORS

Many leading architects design interiors for their buildings or contribute to the interiors and furnishings of buildings with which they are not involved. They strive for a utilitarian, functional appearance with little ornament and plain furniture. Building interiors generally

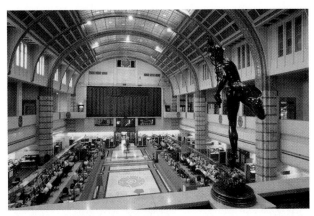

▲ **22-19.** Main hall, Amsterdam Stock Exchange, 1898–1903; Amsterdam, Holland; Hendrik Petrus Berlage.

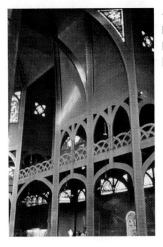

◀ **22-20.** Nave, S. Jean-de-Montmarte, 1897–1904; Paris, France; Anatole de Baudot and Paul Cattacin.

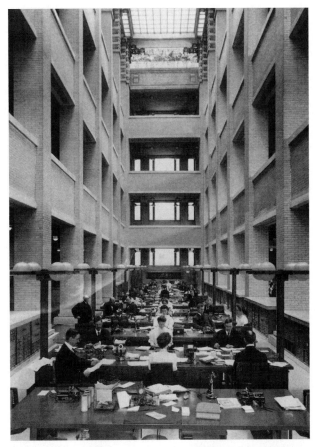

▲ **22-21.** Central atrium, Larkin Building, 1903–1906; Buffalo, New York; Frank Lloyd Wright.

repeat the architectural vocabulary of the exterior. New construction methods and materials transfer from the exterior to the interior to reinforce a more modern appearance. But the interiors may exhibit formal ordering and some reference to historical forms, such as temples and vaults, because architects are familiar with these construction features. Many architects include built-ins as an expression of their own vocabulary. Wright designs the interior as an extension of the exterior and to create unity.

Public and Private Buildings

■ *Types*. Public spaces in commercial structures are defined by the function of the building. Some include large vestibules, formal reception rooms, banquet spaces, auditoriums, and business or factory work areas (Fig. 22-19, 22-21).

■ *Color*. Most of the colors derive from the building materials or textiles. Consequently, the palette includes shades of brown, gold, rust, cream, white, gray, and black. Tiles in these colors and in white with blue and green may enliven the interior.

■ *Lighting*. Natural light enters spaces through large windows, light wells, or skylights. Artificial lighting primarily includes wall sconces and chandeliers that are architecturally designed to integrate into the interior composition.

■ *Floors*. Commonly employed flooring materials include stone, marble, terrazzo, or wood. Gill often uses tan or ocher concrete composition floors in residences.

■ *Walls*. Interior walls and treatments generally repeat the exterior, so the structure often is exposed or repeated inside (Fig. 22-24). Walls in some churches and other public buildings are reinforced concrete slabs or poured concrete (Fig. 22-20, 22-22, 22-25). Wright frequently articulates walls and other architectural features, such as piers or columns, with simple bands of contrasting materials such as stone or wood (Fig. 22-22). Sometimes materials are left natural or may be covered by stucco. Rarely are wallpaper or other decorative materials applied.

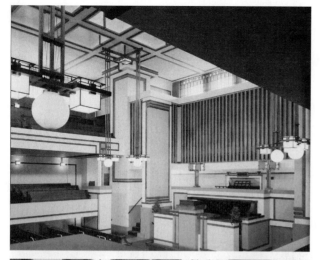

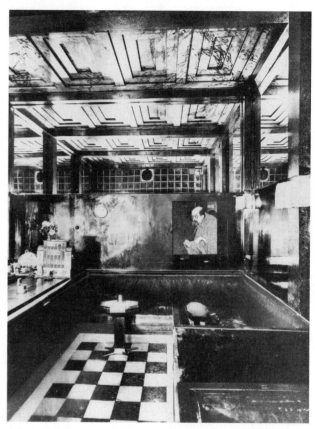

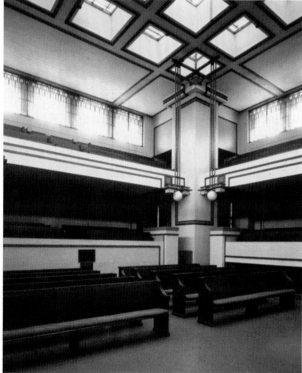

▲ **22-23.** American Bar, 1907; Vienna, Austria; Adolph Loos.

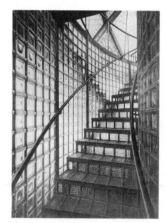

◄ **22-24.** Staircase, Glass Pavilion, Werkbund Exhibition, 1914; Cologne, Germany; Bruno Taut.

▲ **22-22.** Nave, Unity Temple, 1906; Oak Park, Chicago, Illinois; Frank Lloyd Wright.

■ *Windows*. Most often, windows are left plain and unadorned to reflect the overall design character. If window treatments are used, they are simple curtains or flat shades.

■ *Doors*. Doors, like windows, are plainly treated. Gill adopts frameless doors in 1902.

■ *Ceilings*. The exterior roof structure repeats inside to form the dominant ceiling design, particularly in the most important spaces. Some ceilings are reinforced concrete with curves and vaults (Fig. 22-20, 22-25). Others may be flat or three-dimensional in the same material, plastered, or a combination of plaster and wood (Fig. 22-22, 22-23).

DESIGN SPOTLIGHT

Interiors: Nave, Notre-Dame du Raincy, 1923-1924; Le Raincy near Paris, France; August Perret. Perret reinvents the traditional cathedral using exposed reinforced concrete and glass. A large concrete vault covers the nave while smaller transverse vaults identify the side aisles. Thirty-five columns in four rows support the roof. The 37'-0" tall columns taper from 17" at the base to 14" inches at the ceiling and are reminiscent of Gothic cluster columns. Non-load-bearing exterior walls are composed of precast concrete panels and stained glass. Color is arranged according to the spectrum, changing from yellow at the entrance to purple at the altar. A rational and pleasing aesthetic solution for a modern church, the materials do not live up to their expectations. The exposed concrete begins to crumble and metal reinforcements rust within a few years after construction.

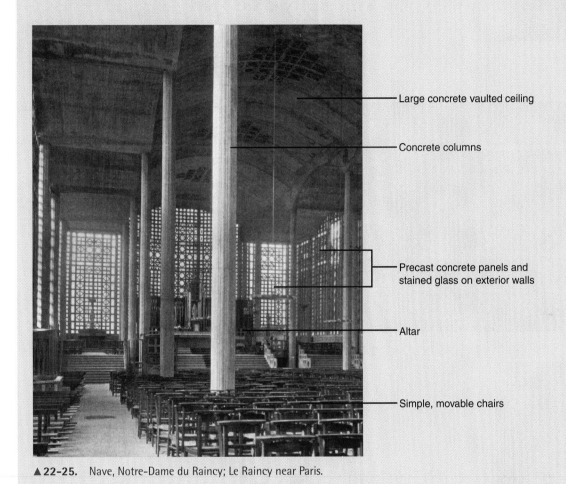

Large concrete vaulted ceiling

Concrete columns

Precast concrete panels and stained glass on exterior walls

Altar

Simple, movable chairs

▲ **22-25.** Nave, Notre-Dame du Raincy; Le Raincy near Paris.

Still others incorporate central glass skylights with exposed metal trusses over central courts or halls to create light wells above several floors (Fig. 22-19, 22-21). The skylights may be pitched or curved and/or mounted above glass screens with geometric patterning.

■ *Textiles.* Linens, cottons, and wools are the most common fabrics during the early 20th century. Designs are generally simple, plain, and geometric, with an emphasis on regularity, lines, and shapes. Behrens experiments with tapestry patterns, while Frank Lloyd Wright provides custom fabric designs for individual clients (Fig. 22-26, 22-27). His textiles often display the earthy colors associated with his nature-based concepts or derive from ideas related to the building design.

■ *Later Interpretations.* Building upon the work of their predecessors, architects and designers in subsequent periods experiment with form, function, and volume, while maintaining the unity of exterior and interior. Attention to simplicity and plainness continues to be important as structure and scale change. Innovation continues to

◄**22-26.** Textiles: Tapestry, 1909; Germany; Peter Behrens.

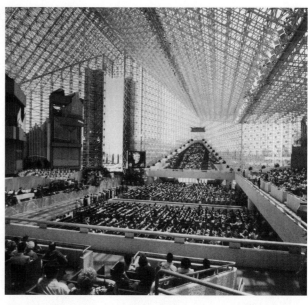

▲**22-28.** Later Interpretation: Interior, Garden Grove Community Church (Crystal Cathedral), 1977–1980; Garden Grove, California; Philip Johnson and John Burgee. Late Modern.

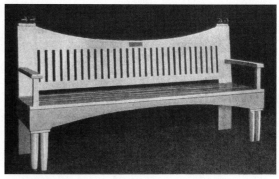

▲**22-27.** Textiles: Fabrics, 1910s–1920s; United States; Frank Lloyd Wright.

▲**22-29.** Garden seat and chair, 1909; Germany; Peter Behrens.

FURNISHINGS AND DECORATIVE ARTS

expand as new materials and technologies develop. A unique interpretation of some of these concepts is evident in Philip Johnson's Crystal Cathedral (Fig. 22-28) in California.

During this period, these innovative architects and designers often pay little attention to furniture and decorative arts. When they do, however, furniture reflective of the Arts and

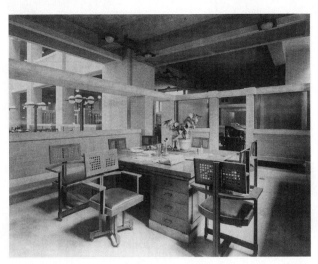

▲ **22-30.** Desk and office chairs, Larkin Building, 1903–1906; Buffalo, New York; Frank Lloyd Wright.

Crafts Movement is often the choice, with designs that are simple, plain, and unadorned. Peter Behrens, an architect from Germany, provides furniture for particular projects with selected examples published internationally in *The Studio Yearbook of Decorative Art* (Fig. 22-29). In North America, Frank Lloyd Wright is another exception because he creates furnishings and decorative arts for his buildings as a part of the whole concept. For example, the backs of the office chairs in his Larkin Building repeat the grid pattern of the interior and the bases repeat the linearity of the overall design (Fig. 22-30). These chairs and the desks are among the earliest mass-produced metal furniture, so are therefore influential. Wright's office chairs, desks, and tables often convey an architectonic quality, simplicity, concern for human scale, and inventiveness. Compositions are severe, angular, and often uncomfortable. Furniture designs usually appear as parts of a whole integrated unit like his interiors.

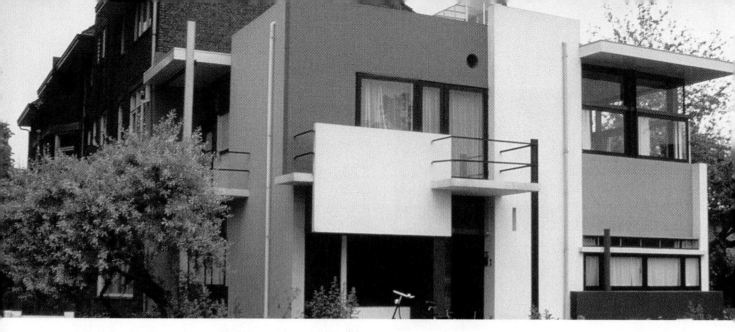

De Stijl

1917–1931

De Stijl, or The Style, is an art and design movement founded in Holland by painters and architects around 1917. The movement strives to express universal concepts through elimination, reduction, abstraction, simplification, and a dynamic asymmetrical balance of rectangles, planes, verticals, horizontals, the primary colors, and black, white, and gray. Termed neoplasticism, these principles characterize an art and architecture of spiritual order and harmony, which the followers hope will transform society. The group spreads its philosophies through *De Stijl*, its journal. Although producing few actual works of architecture, interiors, and furniture, De Stijl strongly influences the Modern Movement in art and design by articulating and exploring foundational design principles.

The visual artist orders, multiplies, measures, and determines congruences and proportions of forms and colors and their relation to space. For the artist, every object has a particular relationship to space; it is an image of space. The artist derives his repertoire of color and form from a certain number of objects. With a constantly changing spatial scheme, with a moving object, a space–time framework is generated. It is the artist's function to amalgamate these into a harmonious, melodious unity. I believe the same holds for architecture and that the modern painter, sculptor and architect find each other in this visual consciousness, with only this difference: architecture has to cater not only to spiritual, but also to material needs.

Theo van Doesburg, "Het Aestetisch Beginsel der Modern Beeldende Kunst" (lecture delivered in Haarlem), in *Drie Voordrachten over de Nieuwe Beeldende Kunst*, 1916

The new architecture has broken through the wall and in so doing has completely eliminated the divorce of inside and out. The walls are non-load bearing; they are reduced to points of support. And as a result there is generated a new open plan, totally different from the classic because inside and outside space interpenetrate.

Theo van Doesburg, *De Stijl*, 1924

HISTORICAL AND SOCIAL

Until the formation of De Stijl, Holland (today known as the Netherlands) contributes little to the modern movement, being less affected by Art Nouveau than other European nations are and producing only one or two innovative architects or designers in the early years of the 20th century. Like other European countries, she enjoys economic expansion resulting from industrialization, trade, and commerce from the end of the 19th century until World War I. During the war, she remains neutral, and this isolation permits building and artistic explorations to continue. After the war, Dutch artists and architects, like others in Europe, react to the upheaval and devastation by seeking means to stimulate universal peace and harmony.

Individually exploring principles of abstraction as expressions of universality before the war are painters Piet Mondrian (Fig. 23-2) and Theo van Doesburg (Fig. 23-2, 23-4). They, and other like-minded artists, come together when Mondrian must remain in Holland during the war. Mondrian and van Doesburg work together closely from 1917 to 1919, advancing their own work and formulating the group's philosophy and the tenets of what they call neoplasticism. They issue the group's first manifesto in 1918.

Composed of individualists rather than a unified group, the movement's basic goal is to free art from various nonessentials such as subject matter, illusion, ambiguity, and subjectivity. Followers renounce what they consider to be the overdecorated and decadent art of the late 19th and early 20th centuries. Looking toward the future, they want to clear the way for a radical new art form for a modern, industrial society. They believe in a social and artistic revolution where art and daily life would be inseparable.

Mondrian and van Doesburg are the main theorists of the movement, but van Doesburg is its leading spirit. In 1917, he instigates the monthly avant-garde magazine *De Stijl* from which the movement derives its name. *De Stijl* magazine spreads the movement's theory and philosophy to a larger audience and becomes a natural vehicle for expressing the movement's principles in graphic design. As the unifying force for the movement, the magazine highlights the activities and ideas of the artists, architects, designers, and writers who form the De Stijl group. Members include Dutch artists van Doesburg, Mondrian, and Bart van der Leck; architects Gerrit Rietveld (Fig. 23-1), Jacobus Johannes Pieter Oud (Fig. 23-5), Robert van't Hoff (Fig. 23-6), and Jan Wils; Belgian sculptor Georges Vantongerloo (Fig. 23-2); and Hungarian painter Vilmos Huszar (Fig. 23-3). Their emphasis is on group interaction through *De Stijl* and shared ideas rather than on individual recognition, group exhibits, or meetings. Membership changes often as members disagree, move in other directions, or simply abandon the principles.

Van Doesburg is the most vocal of the movement's proponents. His writing, travels, and lectures spread De Stijl principles and practices. In 1921, he visits the Bauhaus at Weimar, an event that significantly affects the students and faculty alike. Additionally, several exhibitions spread the De Stijl aesthetic, one in Berlin in 1920 and another at the Galerie L'Effort Moderne in Paris in 1923. Van Doesburg dies in 1931 and with him the cohesion and force of De Stijl. A few members, such as Mondrian and Rietveld, maintain some of the group's design principles until their deaths.

The movement's total rejection of subject matter, reliance on geometry and color, and deemphasis of individualism is too radical for any real public acceptance during this period. The total artistic output of the movement is small, but it has far-reaching influence upon other avant-garde artists, architects, and designers. De Stijl makes a profound impact upon the development of the International Style.

CONCEPTS

De Stijl seeks to reduce, simplify, and abstract to express concepts of beauty and produce universal, rather than individual, responses. Because they are tied to the past and inappropriate for modern times, visual reality, ornament, and style are rigorously rejected in favor of neo-plasticism, harmony, and unity. The individual is subservient to the universal in thought and design. De Stijl compositions seek a dynamic organization through the balance of unequal opposites of the right angle and primary colors (Fig. 23-2). Movement or the plastic is achieved through the actions and interactions of form and color instead of the usual means such as linear perspective. Purity of form means the expression of reality without the imitation of nature, references to the past, or decoration. Straight lines and right angles are considered the purist of forms, so pure, in fact, that some of the most vehement arguments among members center on the use of diagonal lines. Rebelling against previous developments focusing on individualism, the proponents emphasize harmony and universal values. Stressing the connections between art and life, they also advocate a clean, pure, and simple design language and lifestyle envisioned through architecture, furniture, painting, and typography. This, they believe, will bring forth order out of the social chaos of the war and universal harmony.

IMPORTANT TREATISES

- **De Stijl manifestos,** published in *De Stijl* magazine, 1918–1921; Theo van Doesburg.

- **"Neoplasticism in Painting,"** published in *De Stijl* magazine, 1915–1916; Theo van Doesburg.

- **Principles of Plastic Mathematics,** 1916; M. H. J. Schoenmaekers.

- **"Reflections I and II,"** published in *De Stijl* magazine, 1918–1919; Georges Vantongerloo.

- **The New Image of the World,** 1915; M. H. J. Schoenmaekers.

- **Three Lectures About the New Art,** 1919; Theo van Doesburg.

- **Towards Plastic Architecture,** published with the second De Stijl architecture exhibition in Paris, 1924; Theo van Doesburg.

▲ **23-1.** Gerrit Thomas Rietveld and staff, c. 1919.

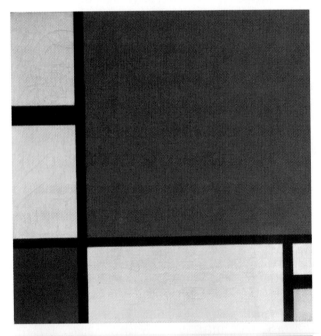

▲ **23-2.** "Composition with Red, Blue, and Yellow," 1930, Piet Mondrian; "Composition IX," 1916–1917, Theo van Doesburg; and sculpture, c. 1917, Georges Vantongerloo.

One of the most influential theorists on the movement is mathematician and philosopher M. H. J. Schoenmaekers who articulates his views in *The New Image of the World* and *Principles of Plastic Mathematics*, published in 1915 and 1916, respectively. In these books, he states the need for regularity and the harmonious balance between the vertical (male) and the horizontal (female), a relationship that forms a right angle. His ideas, which strongly influence painter Piet Mondrian, also focus on reality as a series of opposing forces and the importance of primary colors, two other concepts readily explored and expanded by Mondrian in painting and van Doesburg in architecture. Mondrian articulates his ideas in *Neo-Plasticisme*, 1920; van Doesburg in the journal, *De Stijl*.

De Stijl followers are well acquainted with avant-garde or modern art and architecture in Europe and America. Concepts derive from as well as influence art movements and the work of architects Henrik Petrus Berlage and Frank Lloyd Wright (see Chapter 22, "Modern Forerunners"). From the Cubists, such as Picasso, De Stijl followers learn to break form into planes that interpenetrate and to show multiple views of an object. Russian movements of Constructivism (sculpture and industrial design) and Suprematism (painting), which arrive at abstraction around 1913, push reduction, geometry, and deconstruction of form. The work of fellow Dutch architect Berlage stresses the importance of interior space, systematic proportions, and walls that create and articulate space. From Wright, De Stijl followers absorb ways to break up the architectural envelope by the interpenetration of wall and roof planes, balconies, and terraces. They admire Wright's rationalism, embrace of the machine, and use of new materials and construction methods. Like Wright and others, they design the building and its contents for total unity and strive for the open, spatial relationships and continuity evident in Wright's Prairie houses.

DESIGN CHARACTERISTICS

The new style has no reference to past history and no connection to visual reality. Abstract, man-made, and calm, it

▲ **23-3.** Cover designs for *De Stijl* magazine, 1917; Vilmos Huszar.

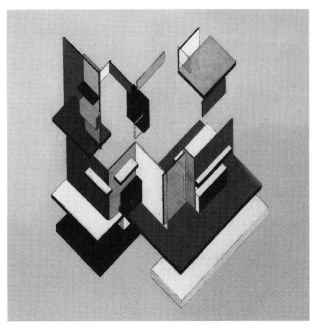

▲ **23-4.** Color construction, private house, 1922; Theo van Doesburg and Cornelis van Eesteren.

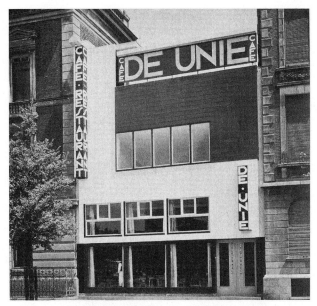

▲ **23-5.** Cafe De Unie, 1924–1925; Rotterdam, Netherlands; J. J. P. Oud.

▲ **23-6.** Henny House, 1916; Huis-ter-Heide, Netherlands; Robert van't Hoff.

reveals no emotion, but instead embraces simplicity and regularity. Geometry with no parts dominant or subordinate to the whole is important. De Stijl designers discover beauty in art through the straight line arranged as a horizontal, vertical, or right angle and through the primary colors of red, blue, and yellow often placed in concert with black, white, and gray. References to nature are eliminated, an idea in opposition to the traditional and individual Dutch landscape expression. Instead, the movement favors a machine vocabulary, one stressing flat shapes, unadorned surfaces, asymmetry, and the purity of the graphic language. The emphasis on two-dimensional flatness delineates the need to understand space to achieve pure spatial relationships. Designers transport this idea into three-dimensional, volumetric spaces and furnishings with a focus on solid and void interaction. In buildings, spatial harmony develops through an interpenetration of exterior and interior space so that the proportional relationship of solid and void is emphasized (Fig. 23-7). This same effect, on a smaller scale, is also true in furniture design (Fig. 23-18).

■ *Motifs*. There are no decorative motifs in De Stijl design. Instead, beauty evolves from simple, unadorned surfaces arranged in geometric relationships and from construction detailing.

ARCHITECTURE

Designers formulate a new language and vocabulary for architecture. To do this, they take the traditional house apart, analyze it like an object, abstract it to eliminate traditional references, and then reassemble it in a new way. The new form emphasizes the cube. However, it is not a solid box, but instead opens up from outside to inside with solid and void relationships established through flat planes. Color is important because it articulates the solid planes in opposition to the voids or empty space. Much of pure De Stijl architecture is conceptual because designers find it difficult to persuade their clients to accept it.

Typical characteristics are a flat roof, asymmetry, geometric forms, white or gray walls with details highlighted by primary colors. However, only Rietveld's Schröder House reveals all of them. Other buildings may be symmetrical or have pitched roofs. All share the elimination of ornament. The Prairie houses by Frank Lloyd Wright serve as important models for some De Stijl architects such as Robert van't Hoff (Fig. 23-6) and Jan Wils. Compositions incorporate spatial interplay, solid and void relationships, horizontal movements, flat façades, repetitive bands of windows, and overhanging roofs.

DESIGN SPOTLIGHT

Architecture: Schröder House, 1924; Utrecht, Netherlands; Gerrit Thomas Rietveld in association with owner Truus Schröder-Schräder. Gerrit Rietveld, architect and furniture designer, epitomizes the language of abstraction in one of his most famous projects, the Schröder House in Utrecht. The house illustrates De Stijl design principles of asymmetry, geometry, flat roof, white or gray walls, and primary colors that highlight details. Originally intended to be constructed of concrete slabs, it is built of brick covered with stucco. Envisioned through models and with the assistance of its owner, Truus Schröder, the house highlights changeable space, interdependent parts, and spatial continuity. It fulfills the concepts of neoplastic architecture by being unmonumental, elementary, functional, formless, and universal not individual. Color is not decorative but an organic means of expression. The house is a model for future middle-class houses, but many of its design elements, such as the open plan and changeable spaces, are adopted later in a variety of planning considerations.

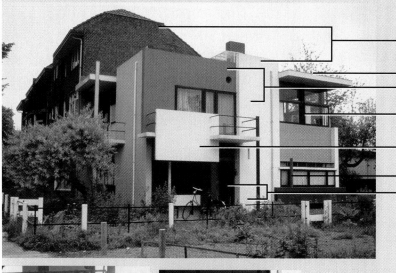

House stands out in neighborhood

Flat roof projects asymmetrically
Asymmetrical arrangement of building form

Black window trim separates solid and void areas

White rectangular plane contrasts with flat gray wall
Primary colors used as architectural accents
Solid and void relationships appear throughout building design

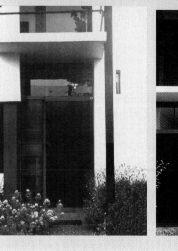
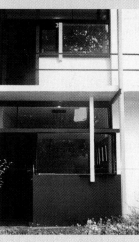

▲ 23-7. Schröder House; Utrecht, Netherlands.

Public and Private Buildings

■ *Types*. Houses for individuals are the most important buildings (Fig. 23-6, 23-7). Other types include restaurants (Fig. 23-5), exhibition spaces, mass housing complexes, apartments, and shopping areas. Some examples are conceptual and not built.

■ *Site Orientation*. Houses usually sit on private streets, with or without large yards surrounding them.
■ *Floor Plans*. Plans have an asymmetrical and functional organization of rooms and areas with multifunction spaces common. Rooms are square or rectangular, often with broad openings between them. With the elimination of

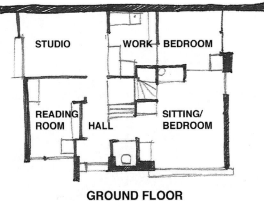

GROUND FLOOR

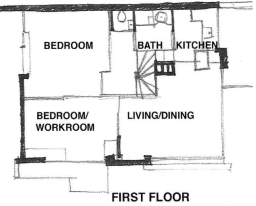

FIRST FLOOR

▲ **23-8.** Floor plans, Schröder House, 1924; Utrecht, Netherlands; Gerrit Thomas Rietveld.

IMPORTANT BUILDINGS AND INTERIORS

- **Huis-ter-Heide, Netherlands:**
 —Henny House, 1916; Robert van't Hoff.
- **Meudon, France:**
 —Van Doesburg House, 1929; Theo van Doesburg.
- **Noordwijkerhout, Netherlands:**
 —De Vonk Residence, 1917; J. J. P. Oud and Theo van Doesburg.
- **Rotterdam, Netherlands:**
 —Cafe De Unie, 1924–1925; J. J. P. Oud.
 —Manager's House, Oud-Mathenesse estate, 1923; J. J. P. Oud.
- **Strasbourg, France:**
 —Cafe Aubette, 1928–1929; Theo van Doesburg, Jean Arp, and Sophie Taeuber-Arp.
- **Utrecht, Netherlands:**
 —Schröder House, 1924; Gerrit Thomas Rietveld in association with owner Truus Schröder-Schräder.

load-bearing walls, interior space at the Schröder House can be divided into smaller volumes through sliding panels, allowing the space to change with the function (Fig. 23-8, 23-14). Vertical circulation is usually in the center of the house.

- *Materials.* Houses are often brick with stucco cladding to make them smooth. Some are of concrete.

DESIGN PRACTITIONERS

- **Jacobus Johannes Pieter Oud** (1890–1963) adapts neoplastic principles primarily in his architecture, which is mostly mass housing in reinforced concrete. As chief architect of Rotterdam from 1918 to 1927, he has numerous opportunities for creating low-cost, well-designed worker housing. A founding member of DeStijl, he withdraws from it in 1921. In the 1932 exhibit called "International Style" at the Modern Museum of Art in New York, Henry Russell Hitchcock and Philip Johnson name Oud as one of the leaders of modern architecture.

- **Gerrit Thomas Rietveld** (1888–1964), an innovative architect and furniture designer, is a leading advocate of De Stijl concepts. He works primarily with three-dimensional form expressed in architecture and furniture. His work has no reference to past designs (see Design Spotlights).

- **Theo van Doesburg** (1883–1931), architect, artist, and theoretician, is a multifaceted practitioner of pure abstraction. A leader of De Stijl, he expounds and spreads its principles through his painting, architecture, interiors, lectures, and writings. He experiments with its principles in axonometric drawings and later in his own house. He is particularly instrumental in spreading these concepts during his short tenure at the Bauhaus in Weimar. His advocacy of neoplasticism has an immediate effect on the students' work, resulting in new spatial principles for interiors and furniture.

- **Robert van't Hoff** (1887–1979), architect, studies in England but is strongly influenced by Frank Lloyd Wright, whom he meets in 1914 on a trip to the United States. Upon his return to Holland, van't Hoff designs several houses that reveal strong ties to Prairie houses. However, these examples are of concrete and stand out from their surroundings like a piece of sculpture. Van't Hoff contributes articles to *De Stijl* but abandons the movement in 1919.

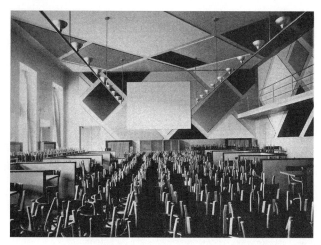

▲ **23-9.** Later Interpretation: DuPage Children's Museum, 2001; Naperville, Illinois; architectureisfun, Inc.

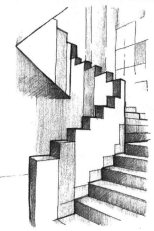

▲ **23-10.** Cinema Dance Hall and stairs, Cafe Aubette, 1928–1929; Strasbourg, France; Theo van Doesburg, Jean Arp, and Sophie Taeuber-Arp.

■ *Facades.* Compositions generally emphasize the separation of planes, the application of primary colors, and the spatial relationship of solids to voids. Rectangular shapes define the geometric repetition of windows, doors, and blocks of color. Interlocking planes and stepped-back façades identify individual units and provide privacy within mass housing complexes. Individual house façades are not flat; the vertical and horizontal planes composing them advance and recede or interpenetrate. Proportional relationships and asymmetrical arrangements are important. Right angles delineate changes in vertical and horizontal surface movement. Surfaces themselves are flat, painted, and unadorned except to emphasize architectural construction or linear elements. Some buildings have white façades with no primary colors but with a dark gray or black band to define edges (Fig. 23-6). Others boast walls resembling Mondrian paintings (Fig. 23-5). The Schröder House, located within a neighborhood of traditional styles, stands out as a distinctively different three-dimensional visual statement (Fig. 23-7). It totally separates from its surroundings like a piece of sculpture.

■ *Windows.* Window sizes vary on an individual building from large to small (Fig. 23-5, 23-7). They may be arranged in patterns or be one unit on a large wall. Casement windows in mass-produced, standard sizes are typical. Architectural moldings are down played. In some examples, the De Stijl emphasis upon right angles continues in windows that open only to 90 degrees. The window frames on some brick buildings may be painted primary colors. Some windows have stained glass in geometric, abstract compositions.

■ *Doors.* Entry doors may be solid or incorporate panes of glass. They may be painted black or rendered in a primary color such as red.

■ *Roofs.* Flat roofs are typical, and distinctly different from other structures (Fig. 23-6, 23-7). Some architects use overhanging roofs, copying the work of Wright.

■ *Later Interpretations.* Some designers inspired by De Stijl include Mies van der Rohe, Rudolf Schindler, Andrée Putman, Richard Meier, and Peter Eisenman. Other designers also interpret the concepts of De Stijl, as seen in an example of a children's museum (Fig. 23-9).

INTERIORS

Interiors are important exponents of De Stijl design principles and often are a collaboration between painters and architects. Interior design emulates the exterior design, so there is a complete interpenetration and repetition of design elements. Houses are generally compact and evolve from a cube form. Volumes of space are interlocked and merged into a complex organization. Architectural surfaces such as floors, walls, and ceilings serve as artistic canvases for De Stijl design principles. Repeating linear or rectangular forms unify structural elements. Rectangular patches of color on walls, floors, and ceilings serve to highlight them and, at the same time, merge structure, ornament, and furnishings. The form and color of structural elements and furnishings are carefully considered in relation to each

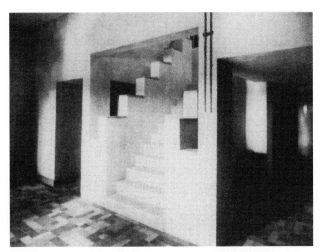

▲ **23-11.** Central stairway, De Vonk Residence, 1917; Noordwijkerhout, Netherlands; J. J. P. Oud and Theo van Doesburg.

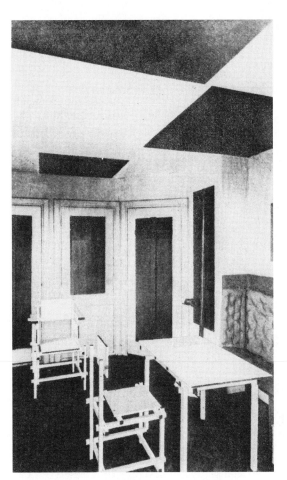

▲ **23-12.** "Example of Coloristic Composition in an Interior," 1919; published in *De Stijl* magazine, 1920; Theo van Doesburg.

▲ **23-13.** Study for Dr. A. M. Hartog, 1922; Maarsen, Netherlands; Gerrit Thomas Rietveld.

architectural composition. Furnishings often align against walls so that they become an extension of the architecture.

As shown in the Café Aubette (Fig. 23-10), the intent is to place a person inside a painting so that he or she may become one with it. Consequently, all aspects of the interior merge as a total unit. Each component of interior structure serves to emphasize or delineate important features in the painting, but no one item stands out more than another. Instead, unity results from the repetition and integration of like components. Furnishings are architectonic to create a seamless blend between fixed structure and mobile objects (Fig. 23-13, 23-14).

Public and Private Buildings

■ *Types.* There are no new types of rooms in houses, but there is more emphasis on multifunctional spaces than there was earlier.

■ *Relationships.* Interiors share the same design goals as exteriors: interconnecting planes, geometry, straight lines and primary colors plus black, white, and gray.

■ *Color.* The palette features the primary colors of red, blue, and yellow arranged within compositions of white, black, and gray (Fig. 23-7, 23-11, 23-12, 23-14). Occasionally, some designers use the secondary colors of orange, green, and purple.

other horizontally, vertically, and across and between spaces. Architects and painters often collaborate on colors for interiors. This becomes a source of conflict when colors overlap each other or the walls and deconstructs the

DESIGN SPOTLIGHT

Interiors: Interior, Schröder House, 1924; Utrecht, Netherlands; Gerrit Thomas Rietveld in association with owner Truus Schröder-Schräder. Transformable space characterizes the upper floor of the Schröder House. Originally conceived by Rietveld as a large open space with no interior partitions, Mrs. Schröder wanted the ability to open or close spaces for herself and her children as they desired or as their needs changed. So, Rietveld designs the space with sliding or folding partitions similar to those in Japanese houses. The space can take on seven different forms.

Rooms are organized into areas by color. The lower floor, by contrast, is conventionally divided into individual rooms. Walls are gray or off-white. Exceptions are the blue chimney and a yellow wall in Mrs. Schröder's bedroom. The partitions, painted gray, white, or black, slide on tracks painted the primary colors. Interlocking rectangles of gray, black, white, and red compose the floor. The shapes and forms of panels and furniture merge within walls, ceiling, and floor planes. Much furniture is built in and/or multipurpose. The design utilizes every inch of the limited space.

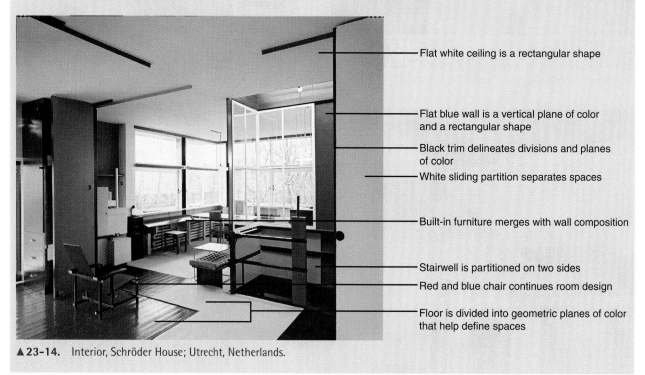

Flat white ceiling is a rectangular shape

Flat blue wall is a vertical plane of color and a rectangular shape

Black trim delineates divisions and planes of color

White sliding partition separates spaces

Built-in furniture merges with wall composition

Stairwell is partitioned on two sides

Red and blue chair continues room design

Floor is divided into geometric planes of color that help define spaces

▲ **23-14.** Interior, Schröder House; Utrecht, Netherlands.

■ *Lighting.* Natural light penetrates the interiors through large windows and sometimes skylights. Light fixtures are architecturally designed and integrated into the walls and ceilings. Typical examples include chandeliers, surface-mounted globes, and movable floor and table lamps (Fig. 23-15).

■ *Floors.* Tile floors in black and white asymmetrical compositions are common (Fig. 23-11, 23-14). Sometimes other colors are added. Wood floors are less common. Occasionlly, colored rectangles or squares compose floors like walls or ceilings.

■ *Walls.* Walls articulate space, rather than confine or separate it. They are plain, flat, smooth, and sometimes movable. Usually designers emphasize geometric patches of color, treat walls as separate compositions, align colored planes, and highlight vertical and horizontal elements (Fig. 23-10, 23-12, 23-14, 23-16).

■ *Windows.* Windows are plain and simple (Fig. 23-14). Most are left bare of coverings. Some have sliding screens

▲ **23-15.** Lighting: Lamps, 1920s; Gerrit Thomas Rietveld.

▲ **23-16.** Interior after Classic Drawing #5 by Piet Mondrian, 1970; New York City, New York; executed by the Pace Gallery.

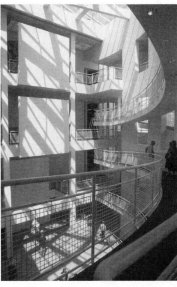

▲ **23-17.** Later Interpretation: Atrium, High Museum of Art, 1980–1983; Atlanta, Georgia; Richard Meier. Late Modern.

to hide the sun or flat treatments, such as roller blinds, that blend in with the wall composition.

■ *Ceilings.* Some ceilings are plain and flat, and painted white or a light gray. Others become artistic canvases with bold geometric designs related to the wall treatments (Fig. 23-10, 23-12, 23-16). Variations in ceiling heights within an individual interior are rare.

■ *Later Interpretations.* Bauhaus designers borrow many ideas from the De Stijl group, particularly their concepts for simplicity, geometry, and color. Later the Art Deco period, International Style, and Late Modern developments may use one or more of these ideas to define interior space (Fig. 23-17).

FURNISHINGS AND DECORATIVE ARTS

Furniture and decorative arts are conceived as one with the architecture and interior design. Designers similarly emphasize structure, construction, proportion, and the balance between solid and void relationships. They carefully place individual parts to develop visual balance and harmony so that all parts are appreciated alone as well as in

DESIGN SPOTLIGHT

Furniture: Red and Blue chair, 1918; Gerrit Thomas Rietveld. Rietveld's furniture provides the best illustration of De Stijl concepts. His Red and Blue chair of 1918, the first chair recognized as totally abstract, is a neoplastic icon of order, harmony, and minimalism. Its simple form, flat planes, and primary colors establish Rietveld's design language. The chair is made up of many small-sectioned pieces at right angles to one another that do not join. Painted black with yellow ends, they emphasize their supporting function and become the strong horizontals and verticals in a Mondrian painting. The diagonal seat and back are red and blue. Like his other furniture, the chair can also be easily produced by machine. As a craftsman, Rietveld builds much of his own furniture, which permits him to experiment with form and color. The Red and Blue chair originally is stained wood but after connecting with De Stijl, Rietveld creates its well-known color combination. He also crafts other variations of its form and colors, and later repeats these ideas in custom chairs, tables, and built-in furniture developed for the Schröder House.

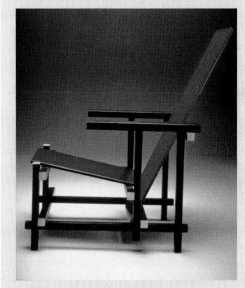

▲ **23-18.** Red and Blue chair.

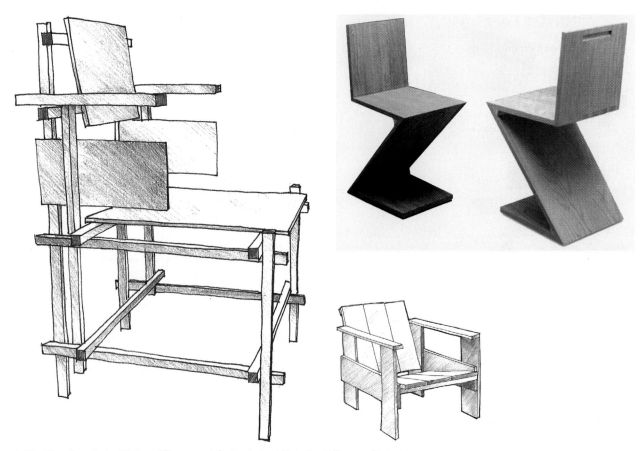

▲ **23-19.** Armchair, 1919, and Zigzag and Crate chairs, 1934; Gerrit Thomas Rietveld.

context with the whole furniture piece. Great attention is given to the size of the part and its construction. Primary colors accent some components. Function is less important than conveying De Stijl concepts of design. Although the furniture and decorative arts look machine-made and some do incorporate machine production, very little is actually mass-produced. Gerrit Rietveld's furniture is the best known, but others such as Wils and Oud, also design furniture for their projects.

Public and Private Buildings

■ *Types.* Chairs and tables are the most important conveyors of concepts.
■ *Relationships.* Furniture complements the architectonic character of an interior through its emphasis on straight lines, rectangular planes, and geometric forms (Fig. 23-13, 23-14, 23-18, 23-19).
■ *Materials.* Most furniture is made of wood. It may be stained a dark color or painted in the De Stijl palette of red, blue, yellow, gray, white, and/or black (Fig. 23-18).
■ *Seating.* Chairs emphasize geometric components with variations in rectangular shapes and spatial composition (Fig. 23-13, 23-18, 23-19). Most are composed of quadrangular stretchers, legs, and arms that do not intersect but

remain separate, especially at the joints. Seats and backs are solid rectangular planes. Color highlights individual parts and unifies with the surroundings for which the piece is intended. Just four planes compose Rietveld's Zig Zag

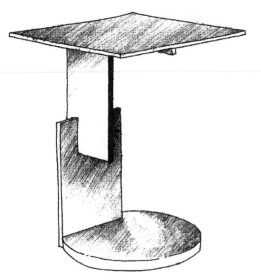

▲ **23-20.** Berlin end table, 1923; Gerrit Thomas Rietveld.

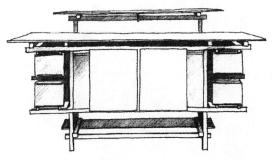

▲ **23-21.** Sideboard, in beechwood painted with white aniline, 1919; Gerrit Thomas Rietveld.

chair (Fig. 23-19). Two are horizontal and two are diagonal. The chair is produced by hand and machine. Rietveld's most commercially successful design is for Crate Furniture, a group composed of flat boards of red spruce. Pieces are bolted together by the purchaser.

■ *Tables and Storage.* Few tables or storage pieces are created. Rietveld designs a sideboard (Fig. 23-21) that is similar in appearance to E. W. Godwin's 1869 sideboard (see Chapter 17, "English Arts and Crafts Movement"). It emulates the interpenetrating horizontals and verticals in Godwin's design, but with greater emphasis upon them and the rectangular planes that make up the piece. Rietveld's work has a greater sense of lightness. The design reduces a traditional form to essential elements of structure. The Berlin end table by Rietveld, an experimental piece, is composed of 4 planes: a circular base, two interpenetrating rectangles for support, and a rectangular top (Fig. 23-20). It is painted black, white, and red. The Crate Furniture group includes two occasional tables, a bookcase, and desk.

■ *Decorative Arts.* Decorative arts are limited in De Stijl houses. Artwork is prohibited because the house itself is a piece of art. Few designers create decorative arts.

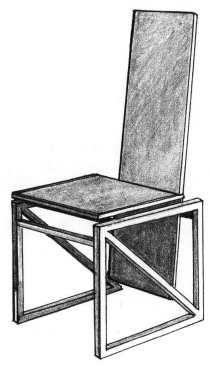

▲ **23-22.** Later Interpretation: Dining room chair, c. early 2000s; manufactured by Kasuga & Company, Japan; Kisho Kurokawa. Late Modern.

■ *Later Interpretations.* During the 1920s and 1930s, the two most imitative designers of De Stijl are Marcel Breuer and Eileen Gray. In the 1980s Italians Stefano Casciani and Mario Botta are influenced by De Stijl. Continuing from the 1990s, minimalism and geometric forms characterize the work of German Rolf Sachs and Japanese designer Kisho Kurokawa (Fig. 23-22).

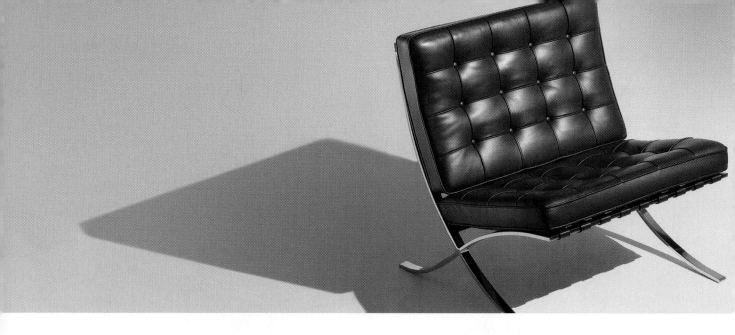

The Bauhaus

1919–1933

The Bauhaus, an innovative German school of art and design, strives to unite art, craftsmanship, and technology in an aesthetic expression that reflects modern industrial life. Founded in 1919 by Walter Gropius, the school uses a foundations course and workshop experiences to train students in theory and form, materials, and methods of fabrication. This enables them to design for and assume roles in modern industry. Although eschewing historicism and style, Bauhaus works reveal a similar character through emphasis upon function, mass production, geometric form, an absence of applied ornament, and the use of new materials and methods of construction. The Bauhaus exerts a significant impact on art education, architecture, interior design, textiles, and furniture through its ideas, attitudes, principles, and products.

HISTORICAL AND SOCIAL

In 1919, the armistice of World War I, formalized in the Treaty of Versailles, dissolves the German Empire with its kingdoms and duchies and creates a new government, the Weimar Republic. The treaty also ascribes sole responsibility for the war to Germany, so she is required to make

Let us create a new guild of craftsmen without the class distinctions that raise an arrogant barrier between craftsman and artist! Together let us desire, conceive, and create the new structure of the future, which will embrace architecture and sculpture and painting in one unity and which will one day rise toward heaven from the hands of a million workers like the crystal symbol of a new faith.

Walter Gropius, "Program of the Staatliche Bauhaus in Weimar," 1919

The Bauhaus in Dessau, Institute of Design, has developed more and more into a center for the gathering of all ideas concerning the contemporary intellectual and theoretical foundations of building. . . . The integration of the practical work and instruction at the Institute conveys to the coming architectural generation exactly that which has been missing up to now: an accurate knowledge of new technological inventions, constructions, and materials.

Walter Gropius, "Request for Contributions to the Bauhaus," 1927

restitutions. The resulting inflation, unemployment, food shortages, widespread destruction of industry, and housing set the stage for the growth and acceptance of radical political groups. Although some stability is achieved in the late 1920s, the economic depression of 1929 destroys it. The Weimar Republic is defeated in the 1933 election by the Communist and National Socialist Parties, or Nazis. The Nazis soon gain control and set up a totalitarian state lead by dictator Adolf Hitler.

It is into this culture of disarray, difficulty, and despair that the Bauhaus (literally, "house of building") comes into being. In Weimar, German architect Walter Gropius

establishes a new school that merges the Grand Ducal School of Arts and Crafts (originally headed by Henry van de Velde) and the Academy of Fine Arts. The school strives to unite all the arts with craft and technology, to elevate crafts disciplines to the level of the fine arts, and to establish connections with industry. Gropius further envisions a unity of art and technology, an end to historic style imitation, and an establishment of new cultural values.

The Bauhaus program of study uniquely combines academic and craft training. Upon entering the school, students complete a preliminary course (*Vorkurs*) lead by a Master of Form who is an artist. Coursework strives to develop the student's creativity and imagination through theory and experimentation in form and color. The remainder of the course of study consists of workshops in which students become acquainted with materials and techniques of construction by designing and making products. Reminiscent of a medieval guild, a Workshop Master leads the class. Students (called apprentices or journeymen depending upon their skill levels) collaboratively learn by doing. Craft workshops include furniture, weaving, metalwork, ceramics, mural painting, photography, print and advertising, and theater.

Gropius also strives to establish connections between the school and industry. Links between schools or art associations and industry are stronger in Germany than in other countries. This is a result, in part, of government-sponsored organizations, such as the Deutscher Werkbund, founded in Munich in 1907 by Hermann Muthesius. An association of architects, designers, craftsmen, manufacturers, and writers, the group emphasizes crafts education, tries to unify art and industry, and promotes simplified German machine-made products internationally. Some architects and designers associated with the Modern Movement are members, including Peter Behrens (see Chapter 22, "Modern Forerunners"). Others, such as Le Corbusier (see Chapter 25, "International Style"), participate in Werkbund conferences or exhibitions. In 1914, the Werkbund has a major exhibition in Cologne, Germany, that showcases the work of numerous designers, including Gropius. Mies van der Rohe heads the 1927 *Wiessenhofsiedlung* exhibit on mass housing. The association continues until 1933, but its influence lasts to the early 1940s, just before the start of World War II.

Although the Bauhaus receives funds from the state, these are never enough for complete autonomy. Workshops create prototypes for industry, which help to provide additional monies through patents, marketing, and sales. Besides providing practical experience, this furthers the goal of creating a new type of designer, one who can work with industry to provide inexpensive well-designed and well-made goods for the middle and working classes.

During the Weimar years, a lack of materials, funds, and facilities hampers the achievement of the school's goals. Nevertheless, it begins to develop a reputation for its work.

In 1923, the Bauhaus holds its first formal and public exhibition, which is a huge success. In 1924, the political climate in Weimar changes, resulting in far less support monetarily and socially. Additionally, the state's contract with the Bauhaus ends, so Gropius is forced to move the school.

In 1925, the Bauhaus reopens in Dessau, a larger, more industrial city than Weimar. The program is reorganized. Workshop Masters and Masters of Form become professors (Fig. 24-1), who include Josef Albers (stained glass, color; Fig. 24-2), Marcel Breuer (furniture, cabinetmaking), Wassily Kandinsky (basic instruction), Paul Klee (stained glass and basic instruction), Laszlo Moholy-Nagy (metal, lighting), George Muche (weaving), and Gunta Stölz (weaving). Function, geometry, and a design vocabulary that emphasizes mechanization and mass production become the focus of study and production. Some workshops, such as stained glass, are closed because of budget issues, whereas others, such as cabinetmaking and metalwork, are combined. Ties with industry increase, bringing greater opportunities and more money, although the school is never quite self-supporting. A Bauhaus company to market designs opens, and a school journal and Bauhaus books are published (Fig. 24-3). Most important, the department of architecture opens. Gropius designs new facilities for the school (Fig. 24-4) that announce to the world its modern machine aesthetic and design principles. The Bauhaus begins to achieve an international reputation.

Relations with the city and state remain tenuous at best, so in 1928, Gropius resigns as director of the school, hoping a new leader will improve the relationship. New director Hermann Meyer is an architect who strengthens the architecture department so that other workshops become subordinate to it. He also broadens course content to include anatomy, psychology, and economics. Meyer encourages students to become politically active, which increases tensions with the city. These tensions lead to his forced resignation in 1930.

Architect Ludwig Mies van der Rohe succeeds Meyer. Mies strives to regain a positive reputation by ending political activism. He emphasizes architecture more than Meyer did; consequently the school has two main emphasis areas: architecture, which focuses mainly on theory; and interior design, composed of the furniture, metalwork, and mural painting workshops. But all is not well.

In 1931, the Nazis take over Dessau. They regard the anonymous, modern style produced by the Bauhaus as anti-German. Equally suspect are the Jewish teachers and students, so the school is closed in September 1932. After moving to an unused telephone factory in Berlin, it barely survives on student tuition, receiving no state funds. When the National Socialist party takes over the country, the Bauhaus closes in April 1933. However, its pedagogy, design methods and principles, aesthetics, and products live on in its teachers and students who emigrate to other

European nations and the United States. Many of its graduates find positions in education and industry. Bauhaus architecture and furniture become and remain statements of the Modern Movement, influencing countless designers and students of design. Projects by leading architects at the school convey a new, original language for architecture that has a significant impact on 20th-century design.

CONCEPTS

Bauhaus design concepts include an emphasis on the functional aspects of the object, an honest statement of form and truth of materials, good design for mass production, use of the machine by the artist, integration of fine art and applied art, and the production of a new kind of beauty based on these factors. A rhetoric of truth, purity, and honesty reveals a moral dimension. Theory develops from practice. Designs grow out of the vocabulary of construction, economy, and practicality. Style, historicism, and applied ornament are rejected in favor of use, purpose, and the visual language of the machine. Designs strive to meet peoples' needs, and designers assume all have the same needs. A belief that democratizing design will, in turn, reform society reveals a utopian outlook. The overarching vision is one of artists and craftsmen collaborating on building projects, because this, according to Gropius, is the ultimate goal of all creative activity.

Influences derive from other painting and crafts approaches articulated by the Expressionists (demonstration of feelings), the Fauves (expressive color use), the Futurists (action sequences), the Blue Reiter Group (emotion and abstract symbols), the Cubists (deconstruction of three-dimensional compositions), the Dadaists (denying the importance of art), De Stijl (flat plane constructionist compositions; see Chapter 23, "De Stijl"), and the Arts and Crafts Movement (handcraft production; see Chapter 17, "English Arts and Crafts Movement"). Other early influences include Frank Lloyd Wright (see Chapter 22, "Modern Forerunners"), the Chicago School (see Chapter 21, "Chicago School"), and Far Eastern philosophies. The work of Adolf Loos (see Chapter 22, "Modern Forerunners") also serves as a primary influence, particularly his

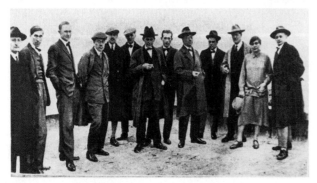

▲ **24-1.** The Bauhaus Masters, 1926; Germany.

IMPORTANT TREATISES

- ■ *Anni Albers: On Designing,* 1959; Anni Albers.
- ■ *Anni Albers: On Weaving,* 1965; Anni Albers.
- ■ *The Art of Color,* 1961; Johannes Itten.
- ■ *Interaction of Color,* 1963; Josef Albers.
- ■ *The New World,* 1926; Hannes Meyer.
- ■ *Vision in Motion,* 1947; László Moholy-Nagy.

overall simplicity of design achieved in white, box-shaped buildings.

DESIGN CHARACTERISTICS

Striving to avoid a style, designers emphasize asymmetry, straight lines, rectangles, and flat planes. Parts are arranged in a series of geometric shapes and forms usually with linear elements. Light and dark relationships are important. A machine aesthetic that includes functionality, simplicity, purity, anonymity, standardization, and flexibility or adjustability is a defining precept. Designers emphasize geometry to unify the whole of a building, interior, or piece of furniture. Other key characteristics are modern industrial materials, such as tubular steel, primary colors, and no applied ornament.

Bauhaus-designed buildings become modern industrial products with an emphasis on purpose and form. They are

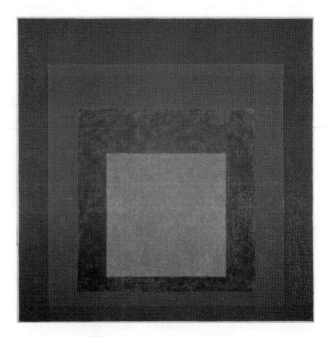

▲ **24-2.** Artwork, 1920s; Germany; Josef Albers.

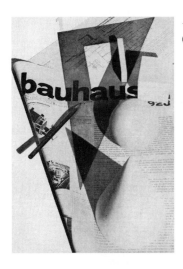

◀**24-3.** Artwork, 1920s; Germany; Herbert Bayer.

plain, unornamented, asymmetrical, geometric, and functional like factories. Structural ordering, large windows, and flat roofs are definitive. Interiors repeat the exterior vocabulary and materials with an emphasis upon function, practicality, and efficiency in the manner of factories. The light-filled spaces have minimal furnishings, patterns, and colors. Furniture also is functional, space saving, and made of industrial materials. That which is not built-in is lightweight and easy to move to support the space's activities. Designed to be machine made, important design considerations are standardization of form and interchangeable parts.

■ *Motifs.* There is no vocabulary for motifs because buildings are generally unadorned. Some architects include unique architectural details that are a part of the building structure.

ARCHITECTURE

Although the school has no architecture department until it moves to Dessau in 1925, commissions by Gropius afford opportunities for collaboration in keeping with the goals of the school. One of the earliest is Sommerfeld House in Berlin, designed by Gropius and Meyer with decoration and furnishings by the Bauhaus workshops. More important is the Experimental House (Haus um Horn) designed by painter Georg Muche and furnished by Bauhaus workshops for the exhibit of 1923. Intended as a prototype for inexpensive mass-produced housing, it features innovative planning and furnishings of the latest materials.

Buildings are simple, functional, and industrial. Devoid of any applied decoration, they often appear asymmetrical and three-dimensional, such that one must experience the building from all sides. This fairly new concept in design borrows from some De Stijl influences. Designers frequently experiment with mass and rectangular form. Equally important is the structural ordering of a building to

achieve regularity, often evident in the placement of interior columns and the use of standardized parts for construction. Most have flat roofs. Because they do not originate in Germany nor do they possess a history of use there, flat roofs are controversial. They are seen as anti-German. Walter Gropius and Ludwig Mies van der Rohe create the most important projects.

Public and Private Buildings

■ *Types.* Important commercial buildings include schools (Fig. 24-4), offices (Fig. 24-6), and government buildings. Apartment projects, low-cost housing complexes, and individual houses are equally as significant (Fig. 24-10, 24-11, 24-12).

IMPORTANT BUILDINGS AND INTERIORS

■ **Barcelona, Spain:**
 —German Pavilion, International Exposition, 1929; Ludwig Mies van der Rohe.

■ **Berlin, Germany:**
 —Siemensstadt Housing Estate, 1930; Walter Gropius.

■ **Bernau, Germany:**
 —Union School of the General Federation of German Trade Unions, 1928; Hannes Meyer.

■ **Brno, Czechoslovakia:**
 —Tugendhat House, 1930; Ludwig Mies van der Rohe.

■ **Dessau, Germany:**
 —Bauhaus buildings (studio, workshop, technical), 1925; Walter Gropius.
 —City Employment Office, 1927–1928; Walter Gropius.
 —Masters' Houses, Bauhaus, 1925–1926; Walter Gropius.

■ **Paris, France:**
 —Werkbund Exhibition, 1930; Walter Gropius and Marcel Breuer.

■ **Probstzella, Germany:**
 —Bauer House, 1927–1928; Alfred Arndt.

■ **Stuttgart, Germany:**
 —Weissenhof Housing Development, Werkbund Exhibition, 1927; Ludwig Mies van der Rohe (planning director) with others.
 —Prefabricated houses, Weissenhof Housing Development, Werkbund Exhibition, 1927; J. J. P. Oud.
 —Prefabricated House, Weissenhof Housing Development, Werkbund Exhibition, 1927; Walter Gropius.

Architecture: Bauhaus buildings (studio, administration, classroom, and workshop), 1925; Dessau, Germany; Walter Gropius. Rational planning and the primacy of function dictate the organization and appearance of the new school designed by Gropius. The various buildings, which are separated by function but unified in appearance, form a sort of swastika, an unusual design in a time when courtyards predominate. Administrative offices join the workshops, auditorium, cafeteria, theater, and studios via a bridge across a road, which was never built. Façades exemplify Bauhaus design principles in the geometric forms punctuated with linear elements, broad windows, and flat roofs. The workshops have glass curtain walls to admit as much light as possible, and balconies identify dormitories. Constructed of reinforced concrete, the buildings are plain, geometric, and industrial. Inside, subdued colors distinguish different areas as a means of wayfinding. Contrasting textures identify load- and non-load-bearing walls. Walls have little articulation, relying on texture or color for interest. Students design and craft much of the furniture and lighting, a great deal of which is multifunctional and of tubular steel.

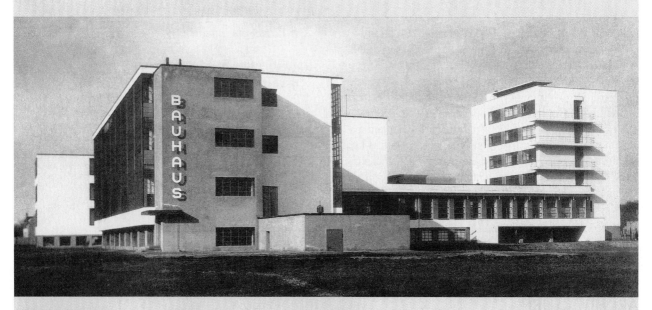

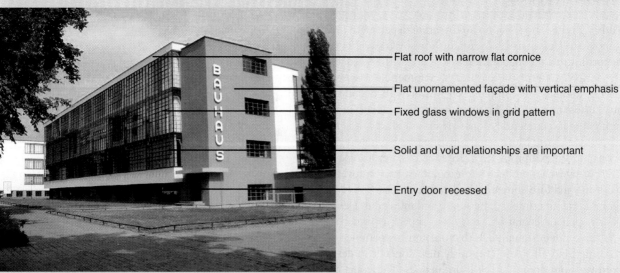

Flat roof with narrow flat cornice

Flat unornamented façade with vertical emphasis

Fixed glass windows in grid pattern

Solid and void relationships are important

Entry door recessed

▲ 24-4. Bauhaus buildings, 1925; Dessau, Germany.

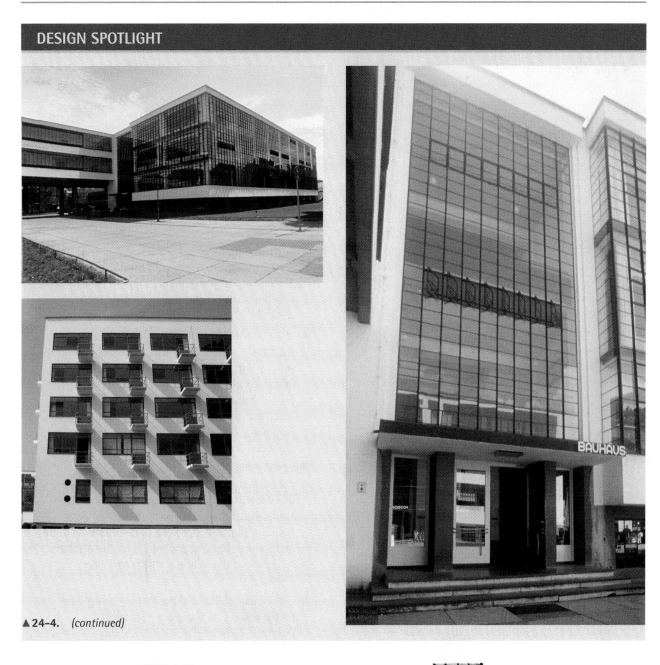

▲ 24-4. (continued)

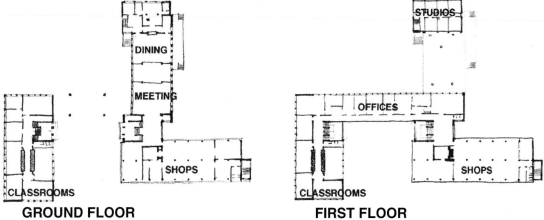

GROUND FLOOR

FIRST FLOOR

▲ 24-5. Floor plans, Bauhaus buildings (studio, administration, classroom, and workshop), 1925; Dessau, Germany; Walter Gropius.

DESIGN PRACTITIONERS

- **Anni Albers** (1899–1994; neé Anneliese Fleischmann) enters the Bauhaus as a student weaver in 1922. She designs fabrics and wall hangings for the Dessau Bauhaus and becomes the foremost textile designer of the school and assistant director of the weaving workshop. Albers experiments with weave structure, color, and texture. Her work significantly influences textile design.

- **Josef Albers** (1888–1976) is a painter, designer, and graphic artist. After studying at the Bauhaus (1920–1923), he teaches there until 1933. Albers is most influential in developing the foundations course. He emphasizes suitability, function, and rectilinear shapes of strong, flat color and garners recognition for his series of paintings examining the relationship of colors through placement, shape, and light. After the school closes, he moves to the United States and teaches Bauhaus principles at Black Mountain College in North Carolina and Yale University from 1950 to 1958. Albers's work influences op art and minimal art in the 1960s.

- **Alfred Arndt** (1896–1976), student and later instructor, is in charge of the department of interior design and the furniture workshop under Meyer's directorship. His students design inexpensive, adaptable furniture for workers' housing. Much is in wood and the result of extensive study of the storage needs of the worker.

- **Marcel Breuer** (1902–1981) enrolls at the Bauhaus in 1920 and becomes an outstanding carpentry student. After briefly practicing architecture, Breuer returns to the Bauhaus Dessau in 1925 as head of the cabinetmaking workshop. His experiments with tubular steel and the cantilevered concept begin with the Wassily chair and culminate in the Cesca chair. Breuer also develops a line of modular furniture and designs significant interiors. In 1937, he joins Walter Gropius at Harvard University, where he continues to teach and practice architecture and interior design.

- **Walter Gropius** (1883–1969), founder and director of the Bauhaus from 1919 to 1928, emphasizes function, efficiency, and technology in his architecture. His Fagus Factory, which he designs with his partner Adolf Meyer, introduces what will become the character and visual elements of the International Style. In this project, he uses the glass curtain wall with steel and glass, later seen in his design of the Bauhaus buildings. In the late 1930s, he emigrates to the United States and becomes a strong advocate of the International Style.

- **Johannes Itten** (1888–1967), the most colorful of the Bauhaus instructors, controls the carpentry, metal, stained glass and wallpainting, and carving workshops. More important, he devises the foundations course, which through various exercises, develops student awareness of the qualities of materials and underlying structure of art and design. A follower of Mazdaznan, a cult, Itten incorporates elements of its strange lifestyle into his teaching, which divides the school. He leaves in 1922.

- **Hannes Meyer** (1899–1954), director of the Bauhaus from 1928 to 1930, earns a reputation as a strong modernist in architecture. His uncompromising belief in standardization and functionalism alienates many of the Bauhaus teachers. Following his resignation, he moves to Russia and becomes a professor of architecture and designer of buildings and urban plans.

- **László Moholy-Nagy** (1895–1946) is a painter, sculptor, and designer. Strongly influenced by Constructivism, he teaches and heads the metal workshop at the Bauhaus from 1923 to 1928. Moholy-Nagy moves to the United States in 1937 and founds the New Bauhaus, later the Institute of Design at the Illinois Institute of Technology in Chicago.

- **Lilly Reich** (1885–1947) begins her career as a textile and clothing designer. She joins the Deutsche Werkbund in 1912, becoming its first woman director in 1920. Through the Werkbund, she meets Mies van der Rohe, and they collaborate on Werkbund exhibits and other projects. When he becomes director of the Bauhaus in 1930, Reich joins him as a teacher and the director of the interior design workshop. Reich and Mies continue to work together, most notably on furniture for his architectural projects.

- **Gunta Stölzl** (1897–1983) leads the weaving workshop at Dessau, guiding students in hand-loom and industrial weaving production. Under her directorship, the weaving workshop becomes very successful. As one of the leading Bauhaus textile designers, Stölzl designs hand- and machine-woven wall hangings, rugs, and curtains.

DESIGN PRACTITIONERS

- **Ludwig Mies van der Rohe** (1886–1969) is director of the Bauhaus from 1930 to 1932 and also heads the architecture department. Mies advocates "less is more" and advances theories of spatial composition. Two early masterpieces, the German Pavilion for the Barcelona International Exhibition (1929) in Spain and the Tugendhat House (1930) in Czechoslovakia, illustrate his experimentation with steel frames and glass walls and open interior spaces with few walls and lavish materials. His furniture designs, such as the Barcelona chair, earn significant acclaim for their unity of art and technology. In the late 1930s, he immigrates to Chicago, where he designs many buildings and becomes an architectural icon of the International Style.

▲ **24-6.** Municipal Employment Office, 1927–1928; Dessau, Germany; Walter Gropius.

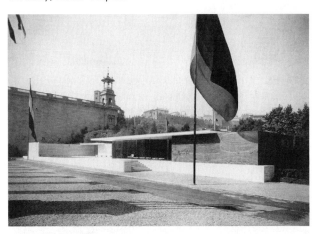

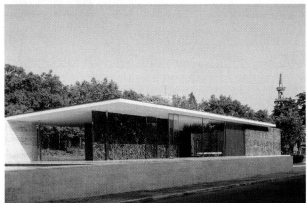

▲ **24-7.** German Pavilion (rebuilt), International Exposition, 1929; Barcelona, Spain; Ludwig Mies van der Rohe.

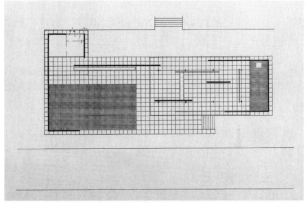

▲ **24-8.** Floor plan, German Pavilion, International Exposition, 1929; Barcelona, Spain; Ludwig Mies van der Rohe.

- *Site Orientation.* Architects orient buildings so that offices, living and dining areas, bedrooms, and roof gardens have the most sun exposure to take advantage of natural light. Stairways, studios, kitchens, and bathrooms locate toward the north for softer light.
- Structures sit on flat plains of grass with limited plantings surrounding them and with only a few trees (Fig. 24-4, 24-6, 24-9, 24-10, 24-11, 24-12). Because of this siting, the buildings stand out from their surroundings like pieces of geometric sculpture. Fronts of buildings most often are parallel to the street. Some large housing complexes may have individual apartment fronts repetitively staggered or at an angle to take advantage of the sun and to increase privacy (Fig. 24-11).
- *Floor Plans.* Floor plans develop primarily from function, which may divide areas into units (Fig. 24-5). Spatial organization, flexibility, practicality, ventilation, and privacy are very important. Some plans spread out to form open, geometric arrangements, while others are confined to a box shape. Rooms are most often rectangular, vary in size, and align along exterior walls that have large areas of glass. They may connect to interior halls or to each other. Sometimes instead of defined rooms, open spaces penetrate from one to another with only a few carefully positioned walls or vertical planes, as in the Barcelona Pavilion (Fig. 24-8, 24-17). Major circulation paths such as halls and stairs are

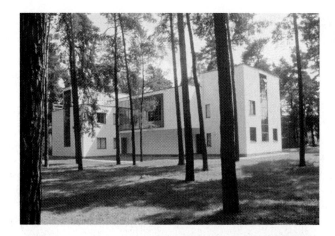

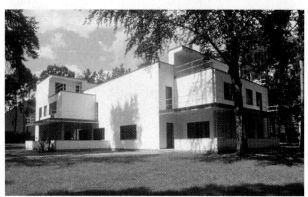

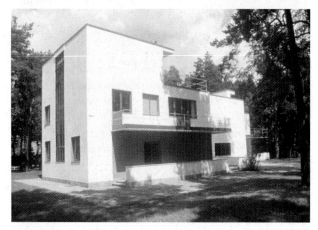

▲ **24-9.** Masters' Houses, Bauhaus, 1925–1926; Dessau, Germany; Walter Gropius.

▲ **24-10.** Apartment complex, Weissenhof Housing Development, 1926–1927; Dessau, Germany; Ludwig Mies van der Rohe (planning director) with others.

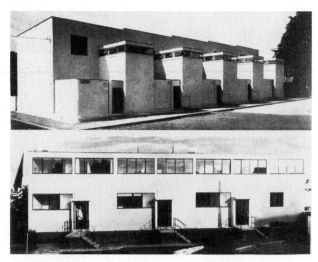

▲ **24-11.** Houses, Weissenhof Housing Development, Werkbund Exhibition, 1927; Stuggart, Germany; J. J. P. Oud.

located centrally to support a direct, straight access. In houses, living, dining, and kitchen areas are on the ground floor, while bedrooms and studios occupy upper floors. Terraces and roof gardens extend the interior space.

■ *Materials.* The most important construction materials include steel, glass, and reinforced concrete, sometimes with a brick masonry applied on the face of the concrete. Industrial materials are also popular.

■ *Façades.* Exteriors are plain, simple, and unornamented (Fig. 24-4, 24-6, 24-7, 24-9, 24-10, 24-11, 24-12,

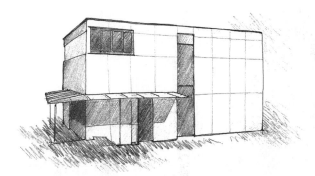

▲ **24-12.** Prefabricated House, Weissenhof Housing Development, Werkbund Exhibition, 1927; Stuggart, Germany; Walter Gropius.

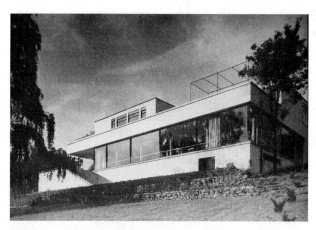

▲ **24-13.** Tugendhat House, 1930; Brno, Czechoslovakia; Ludwig Mies van der Rohe.

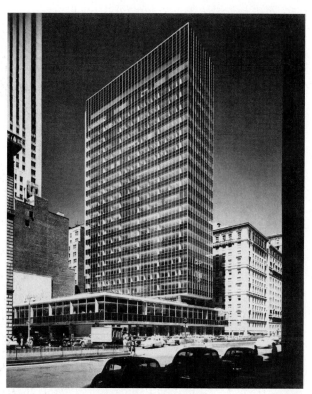

▲ **24-14.** Later Interpretation: Lever House, 1951–1952; New York City, New York; by Gordon Bunshaft at Skidmore, Owings, and Merrill. Geometric Modern.

24-13). Compositions emphasize asymmetry and repetition through solid and void proportional relationships. Solid, flat concrete surfaces, rendered most often in white, define and support the structure. On commercial buildings, large areas of repetitive windows and glass curtain walls over steel grids cover façades. On houses, windows often vary in size and placement to create interesting asymmetrical arrangements. Some may also have glass curtain walls. Cantilevered balconies or projecting roof terraces may punctuate the façade and add three-dimensional movement.

■ *Windows.* Windows may be fixed in grid patterns or different types such as casement, awning, and sliding glass (Fig. 24-4, 24-6, 24-10, 24-11, 24-13). Repetition in type is a key characteristic. Groupings of fixed glass windows and sliding glass windows are common. Windows do not interrupt the overall smoothness of the façade, so black or white narrow moldings frame the openings and divide glass areas.

■ *Doors.* Entry doors, which are often recessed, integrate into the overall building composition so that they appear

unobtrusive (Fig. 24-4, 24-7, 24-10, 24-12). They are plain, flat, and often wider than an interior door. Most are wood painted either black or white.

■ *Roofs.* Roofs are mainly flat (Fig. 24-4, 24-6, 24-9, 24-11, 24-12, 24-13). A narrow, flat cornice trim surrounds, projects slightly, and defines the perimeter edge. It is usually black against the white façade.

■ *Later Interpretations.* Bauhaus influences and characteristics appear repeatedly in later periods and shape the overall design of architecture throughout the 20th century. Noteworthy designers whose work illustrates these influences include Le Corbusier; Philip Johnson, a protégé of van der Rohe; Skidmore, Ownings, and Merrill (Fig. 24-14); Richard Meier; and Peter Eisenman. Because many of the Bauhaus design theories and principles still inform education today, there are many practitioners who continue to articulate the language of industrialization and simplicity (see Chapter 31, "Late Modern·1" and Chapter 33, "Late Modern·2").

INTERIORS

Primarily the work of architects, interiors emphasize function, flexibility, efficiency, and practicality. Efficiency, hygiene, economy of space and time underscore planning and furnishings in much the same manner as factories. Because most households no longer have servants, Bauhaus interior planning strives to simplify housekeeping

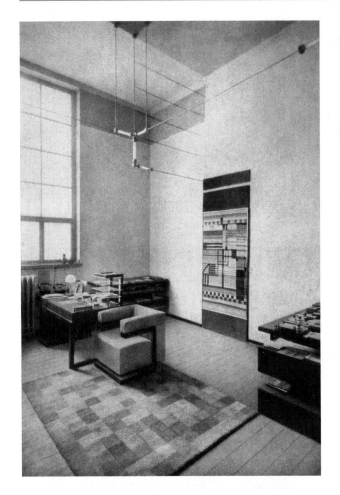

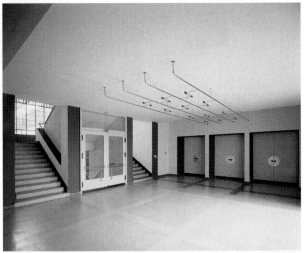

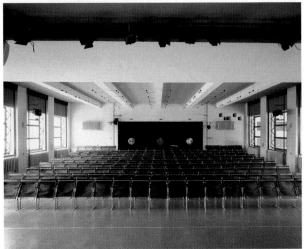

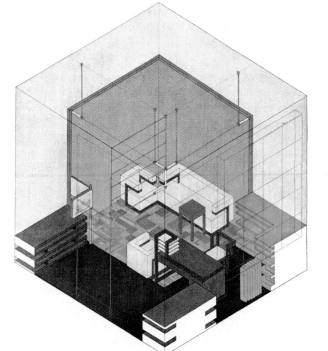

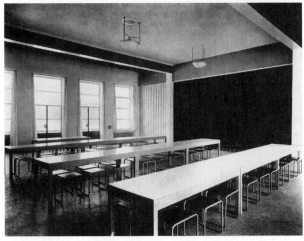

▲ 24–16. Vestibule, auditorium, dining room, and dormitory room, Bauhaus buildings, 1925; Dessau, Germany; Walter Gropius.

▲ 24–15. Office of the Director, Weimar Bauhaus, 1923; Weimar, Germany; Walter Gropius.

and incorporate principles of household management. Breuer's kitchen in the Experimental House of 1923 is one of the first kitchens in Germany with built-in wall and base cabinets. Strictly functional, the design features a continuous

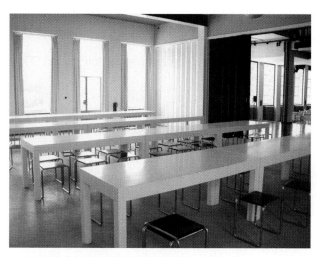

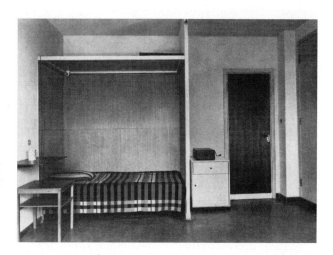

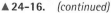
▲ **24-16.** *(continued)*

work surface that eliminates the need for a table in the middle of the room.

Standardization of parts is characteristic. Often, as in the Masters' Houses (Fig. 24-21) at the Bauhaus, room designs repeat from one building to another, but with variations in placement and height. Details may also repeat, but are always simple and industrial looking. Built-in cabinets and storage areas, which are common, order the rooms so that they appear uncluttered and almost empty. Items, such as office supplies, books, glassware, and clothes, are hidden in specially designed compartments (Fig. 24-19). All rooms are sparsely furnished, another factor that adds to the overall empty appearance. Most furniture is placed in open space, rather than against walls, in some harmonious relationship to the vertical planes (Fig. 24-18, 24-19, 24-20).

Until 1928, the mural painting department usually designs Bauhaus interiors, while the cabinetmaking workshop supplies furniture. In 1928, Meyer combines mural painting with the metal and furniture workshops to create an interior design department. In addition to furniture, the department creates wallpaper that is sold to the public.

Public and Private Buildings

■ *Types.* New types of rooms derive from new functions or building types, such as cafeterias and workshops in schools and design studios in houses. Some rooms are multipurpose.

■ *Relationships.* Interiors repeat many of the exterior characteristics. Because they are designed with the same goals as exteriors, interiors stress simplicity, functionality, standardization, anonymity, and flexibility. They exhibit a similar importance of geometric forms, industrial materials, and no applied decoration.

■ *Color.* Interiors are usually painted white and black, and sometimes gray (Fig. 24-19, 24-21). Some walls may be accented with a warm or cool hue or feature a large multicolored wall mural or textile hanging. Large areas of flat color highlight architectural features, such as walls or ceilings. Within the Bauhaus buildings in Dessau, color differentiates areas and provides a means of wayfinding.

■ *Lighting.* Glass and metal table lamps, task lights, hanging lamps, and ceiling fixtures emphasize form and function (Fig. 24-15, 24-23). Designs, a pleasing combination of curves and straight lines, adopt a machine vocabulary. Most are made of plain, brushed, or lacquered steel, aluminum, or glass with opalescent and frosted glass globes or shades. Lamps and hanging fixtures often have movable arms and shades that offer adjustability. Flexibility for the user is a key consideration.

The lighting workshop, particularly after moving to Dessau, creates many successful and innovative fixtures and lamps that are mass-produced and marketed by various firms. One is the 1927 *Wandarm* (wall arm) wall lamp with its adjustable reading light and push button switch that is designed for hospital rooms.

■ *Floors.* The most common flooring materials are tile and linoleum. Mies van der Rohe uses richer materials, such as travertine, marble, and onyx, than other Bauhaus designers do (Fig. 24-17). Wall-to-wall carpet is rare, but area rugs in brightly colored geometric designs created by the weaving workshop are more common (Fig. 24-15).

■ *Walls.* Most often, solid walls are flat and white with no ornamentation (Fig. 24-15, 24-16, 24-21). They may be broken up into rectangular units or standardized parts for ease of construction. The intent is to achieve an industrial, slick appearance. Some walls are accented in a bright color, while others may feature a mural with geometric designs that becomes an architectural component

DESIGN SPOTLIGHT

Interiors: Interiors, German Pavilion, International Exposition, 1929; Barcelona, Spain; Ludwig Mies van der Rohe. The pavilion, built of glass, different kinds of marble, and travertine, illustrates Mies's severely plain, geometric style that relies on careful proportions, precise details, and opulent materials rather than applied ornament for beauty. Clearly this is an architecture of volume, not mass. In the manner of a classical temple, the building rests on a travertine base, which it shares with a reflecting pool. The flat roof extends beyond the walls and is carried by interior columns whose slenderness is accentuated by their sheaths of reflective chrome. The space inside is asymmetrical and fluid. Mies places the walls of glass and marble at right angles to the flow of movement to help move visitors through the space to other parts of the exposition. Richness, strong contrasts of light and dark, and a variety of surfaces and textures, such as marble, glass, chrome, and rugs, characterize the interiors.

Mies designs chairs and other furnishings for the pavilion to accommodate the King and Queen of Spain when they officially open the exposition. Designed for royalty to sit in while signing their names into a guest book, the ample proportions of the famous Barcelona chair lend dignity and importance. The X-shape of shining chrome and warm tufted leather are plain, modern, elegant, and aesthetically pleasing. Despite its machine-made appearance, the chair requires much handcraftsmanship. The frame is almost completely handmade, and the upholstery is composed of 40 individual pieces of leather sewn together. Mies designs the ottomans, which line one wall, in a similar shape and later adapts them to a bench and table. The pavilion is dismantled at the exposition's closing in 1930.

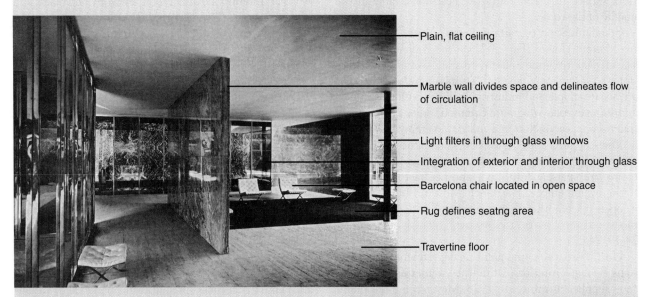

Plain, flat ceiling

Marble wall divides space and delineates flow of circulation

Light filters in through glass windows

Integration of exterior and interior through glass

Barcelona chair located in open space

Rug defines seatng area

Travertine floor

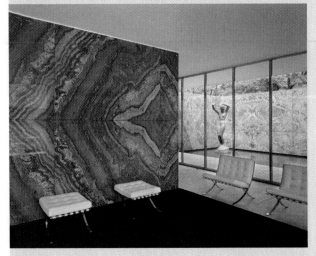
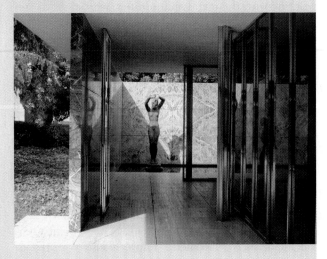

▲24-17. Interiors, German Pavilion (rebuilt), International Exposition, 1929.

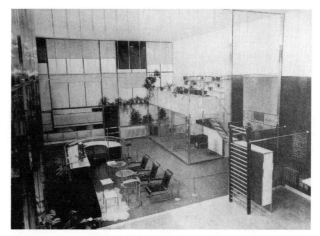

▲ **24-18.** Lounge and coffee shop, German Pavilion, International Exhibition, 1930; Paris, France; Walter Gropius.

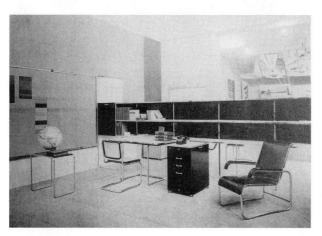

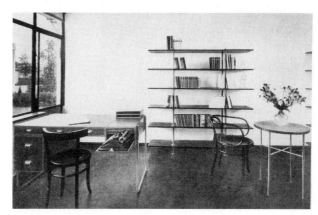

▲ **24-19.** Offices; published in *Le Salon des Artistes Décorateurs*, 1930; Marcel Breuer and Mart Stam.

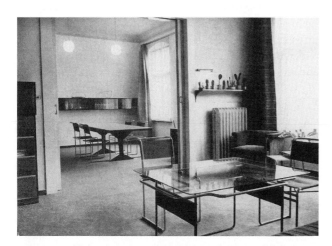

▲ **24-20.** Dining room, c. 1920s; Dessau, Germany; Marcel Breuer.

of the interior. Wallpaper and wall hangings created by the textile workshop appear less commonly in interiors. The mural painting department designs wallpapers with

subtle, textural designs that are marketed by several firms and produce considerable income for the school. Large wood, marble, onyx, or travertine walls may serve as focus points to shape and define spaces (Fig. 24-17, 24-22). Mirrors sometimes cover large wall areas to extend a space. Occasionally walls may be totally of glass so that there is an endless integration of space from outside to inside, thereby allowing a person to participate with nature. Baseboards and architectural trim are usually painted black. Chrome columns are seen in some structures, such as the Tugendhat House (Fig. 24-22) by Mies van der Rohe.

■ *Textiles*. Weavers Gunta Stölzl, Lilly Reich, and Anni Albers produce numerous unique and creative pieces. Factory production techniques and processes influence the end products, which include wall hangings, tablecloths, rugs, and upholstery in bright colors and geometric and abstract designs (Fig. 24-15, 24-36). Because of a lack of materials, early examples display a creative use of nontextile materials such as fur, wire, or beads. These early creations are individually designed and produced;

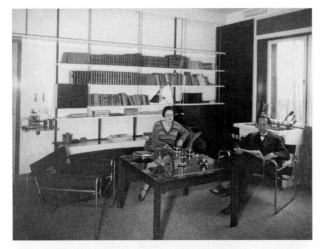

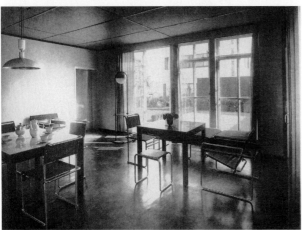

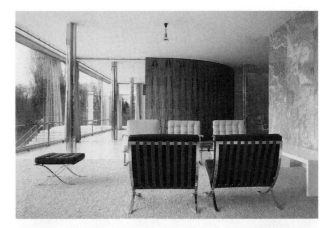

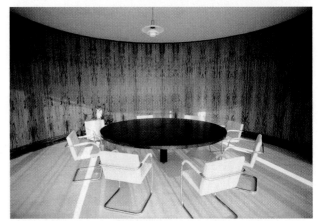

▲ **24-22.** Living room and dining room, Tugendhat House, 1930; Brno, Czechoslovakia; Ludwig Mies van der Rohe.

▲ **24-21.** Interiors, Masters' Houses, Bauhaus, 1925–1926; Dessau, Germany; Walter Gropius.

later emphasis switches to designs for mass production. Under the directorship of Meyer, the Bauhaus introduces new concepts for interior textiles by creating fabrics with specific characteristics or to meet functional requirements, an outgrowth of investigations into strength, colorfastness, and other physical qualities. Designers also experiment with fabrics made of aluminum, glass, or cellophane. Structure and texture instead of pattern create interest. Draperies and upholstery fabrics are simply constructed with either a few small pattern repeats or none, and in only one or two colors. In the 1930s, coordinating wallpapers and textiles are designed.

■ *Windows*. Interior window trims repeat the simplicity of the exterior with narrow moldings used to articulate and frame the opening (Fig. 24-15, 24-21). Some windows are intentionally left bare to enhance the architectural character, while others may have very plain floor-to-ceiling paneled curtains or shades in neutral colors (Fig. 24-17, 24-20).

■ *Doors*. Interior doors are plain, unpaneled, and usually of wood or metal. They may be stained or painted black or white. Surrounding trim is plain and narrow.

■ *Ceilings*. Ceilings are most often flat, plain, and painted either white or black.

■ *Later Interpretations*. Architectural disciples of the Bauhaus design concepts proliferate throughout the 20th century. Some are direct protégés, such as Philip Johnson (Fig. 24-24), while others are second- or third-generation

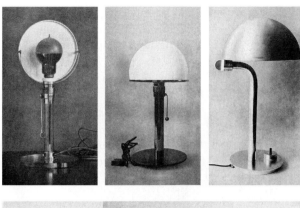

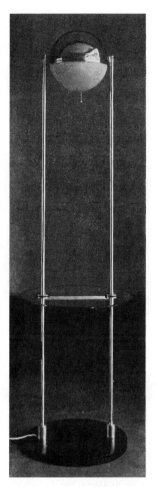

▲ **24–23.** Lighting: Lamps, wall sconce, and hanging lights, c. 1920s; Germany.

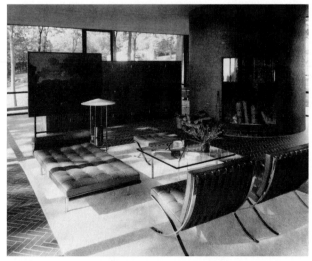

▲ **24–24.** Later Interpretation: Interior, Glass House, 1949; New Canaan, Connecticut; Philip Johnson. Geometric Modern.

advocates of modernism. Influences gradually begin to affect interior designers' work beginning in the 1950s. Interiors designed by Florence Knoll and the Knoll Planning Unit are examples (see Chapter 28, "Geometric Modern").

FURNISHINGS AND DECORATIVE ARTS

Unornamented and radically different from other examples, Bauhaus furnishings suit Bauhaus concepts of the modern home. Designs stress simplicity, functionality, excellent construction, and hygienic industrial materials. Furniture is lightweight and space saving. Standardization of form and interchangeable parts are key design considerations. Furnishings are movable to support flexible arrangements. Students investigate user needs as part of the design process so that resulting pieces support diverse user functions. Leading designers Marcel Breuer, Ludwig

Mies van der Rohe, and others (Fig. 24-26, 24-27, 24-28, 24-29, 24-30) experiment with tubular steel for construction, cantilevered principles, spatial composition, solid and void relationships, and factory production techniques.

This gives rise to a new vocabulary that emulates the machine aesthetic of architecture. Much furniture is designed for Bauhaus buildings, and manufacturers purchase prototypes for mass production.

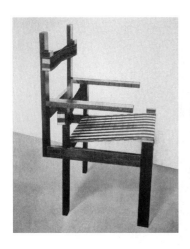

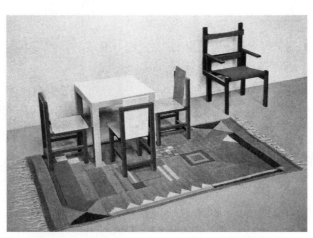

◀**24-25.** Armchair and children's furniture, c. 1923–1925; Germany; Marcel Breuer.

DESIGN SPOTLIGHT

Furniture: Wassily chair, 1925; Germany; Marcel Breuer. This chair is the first one made of tubular steel that Breuer designs. Named for his friend Wassily Kandinsky, it was created for Kandinsky's home at the Dessau Bauhaus. Seeking a form and material that would be light yet sturdy and adaptable to standardization and mass production, Breuer, like others, explores the possibilities of tubular steel in this chair. For him, the material represents modern technology. The design is intricate as steel tubes intersect with and pass one another. The seat and back originally are of fabric and later of canvas or leather. Breuer chooses a warmer, softer textile to contrast with the cold steel. The chair is one of the most copied of Breuer's designs.

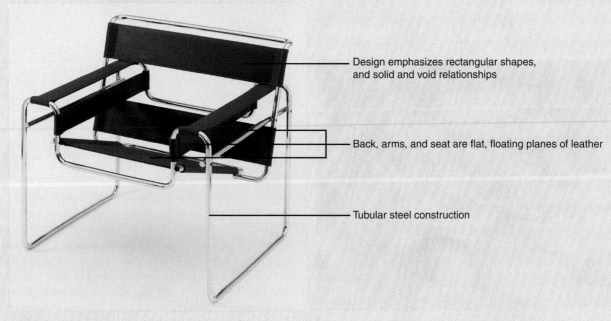

Design emphasizes rectangular shapes, and solid and void relationships

Back, arms, and seat are flat, floating planes of leather

Tubular steel construction

▲**24-26.** Wassily chair, 1925; Germany; Marcel Breuer.

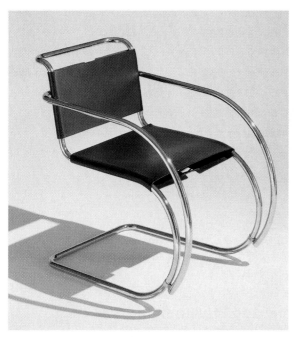

▲ **24–27.** MR chair, 1926; Germany; Ludwig Mies van der Rohe.

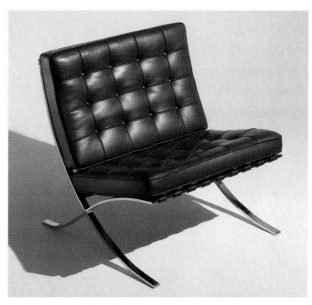

▲ **24–29.** Barcelona chair, for the German Pavilion, 1929; Barcelona, Spain; Ludwig Mies van der Rohe.

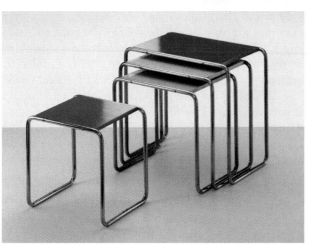

▲ **24–28.** Cesca chair and nesting tables, 1925–1929; Germany; Marcel Breuer.

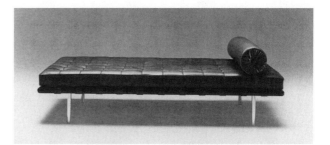

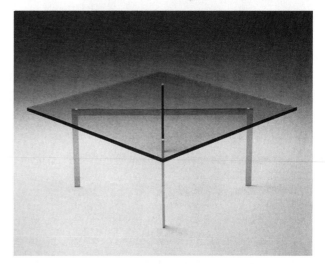

▲ **24–30.** Platform couch and table with glass top and steel base, 1929–1930; Germany; Ludwig Mies van der Rohe.

The furniture workshop opens in 1921 but is hampered by a lack of materials. Early furniture is inspired by De Stijl's Gerrit Rietveld (see Chapter 23, "De Stijl") or primitive or exotic sources. Design takes a radical turn

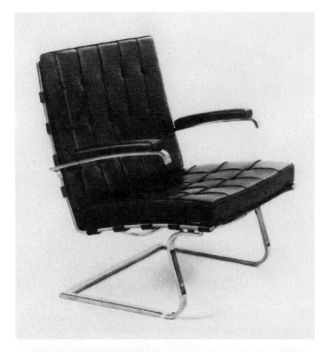

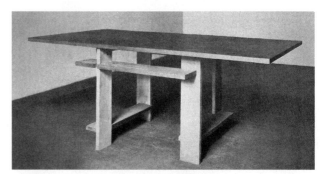

▲ **24-32.** Table, 1923; Germany; Josef Albers.

creating low-cost furniture for limited spaces, students study workers' possessions so as to develop appropriate storage furniture.

Public and Private Buildings

■ *Types.* Seating, tables, and storage units are the most important pieces of furniture (Fig. 24-17, 24-18, 24-19, 24-20, 24-26, 24-27, 24-28, 24-29, 24-30, 24-31). Although less well known, some designers, including Breuer, create children's furniture (Fig. 24-25) such as cribs, chairs, and storage pieces that incorporate the newest ideas of child development.

■ *Distinctive Features.* Designs, often of metal, are simple and functional with no applied ornament or historical style. Anonymity, standardization, geometry, and flexibility are key features.

■ *Relationships.* Furniture designs come from the same design goals as architecture and interior design, so they share the same aesthetic and appearance. Furnishings arrangements are ordered, geometric compositions that integrate as a design component with the interior architecture. Sofas and chairs may be placed perpendicular to a wall to achieve a harmonious balance of form and shape.

■ *Materials.* Early prototype furniture and some later examples are of stained, lacquered, or painted wood (Fig. 24-25, 24-32). Later, steel in tubular components or thin strips or sheets takes precedent. Besides its hygienic qualities, metal furniture looks machine-made (Fig. 24-28), an important consideration to Bauhaus designers. Glass for tabletops is a new innovation.

■ *Seating.* Side and armchairs, sofas, and some stools are the most common types of seating (Fig. 24-26, 24-27, 24-28, 24-29, 24-30, 24-31). Breuer's fascination with tubular steel, reportedly arising from his bicycle's handlebars, inspires numerous forms of cantilevered chairs (Fig. 24-27, 24-28), which have no back legs but instead are supported by a continuous metal loop, an extremely novel idea at the time. Although Breuer promotes the industrial potential of cantilevered metal chairs, Dutch designer Mart Stam is credited with the design of the first one. Breuer's tubular

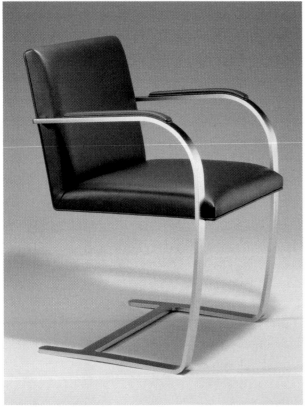

▲ **24-31.** Tugendhat chair and Brno chair, Tugendhat House, 1929–1930; Germany; Ludwig Mies van der Rohe.

from wood to tubular steel under the leadership of Marcel Breuer at Dessau. Later, under the direction of Meyer, the target market for furniture changes from the middle class to the worker. As part of the process of

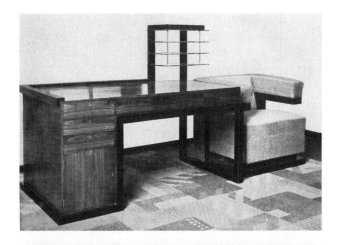

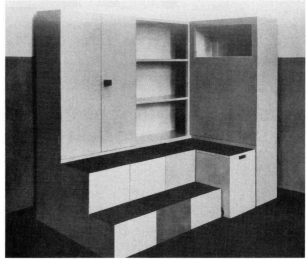

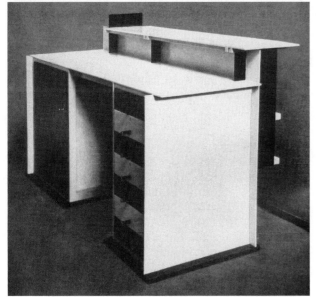

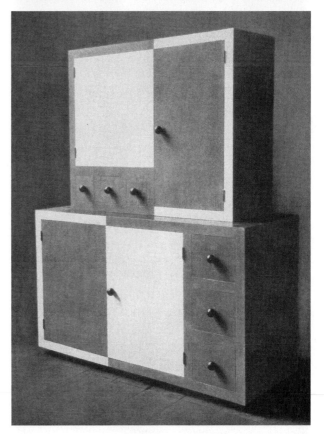

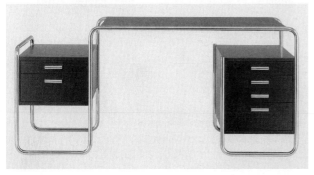

▲ **24-33.** Desks, 1923–1931; Germany; W. Gropius and M. Breuer.

▲ **24-34.** Storage units, 1923; Germany; A. Buscher and M. Breuer.

steel chairs are rectangular with rounded corners and have backs and seats of leather or a durable textile developed in the Bauhaus textile workshop. In contrast, Mies van der Rohe's chairs often have broad, sweeping curves. The Bauhaus patents a cantilevered tubular steel work chair

with an adjustable wooden seat. The workshop makes some wooden chairs with quadrangular legs and molded plywood seats and backs for adults and children. Fully up-holstered chairs, which are less common, are composed of rectangular blocks of upholstery.

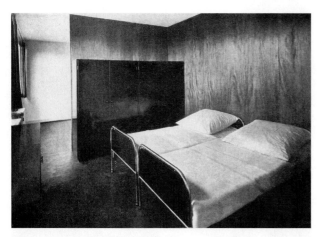

▲ **24-35.** Bedroom, 1929; Germany; Ludwig Mies van der Rohe.

Icons of Bauhaus seating design include the Breuer's Wassily chair (named after painter Wassily Kandinsky; Fig. 24-26) and Cesca chair (another use of the cantilever principle; Fig. 24-28), and Mies's MR chair (an early use of the cantilever principle; Fig. 24-27), Barcelona chair (produced for the Barcelona Pavilion; Fig. 24-29), and a platform sofa upholstered in leather, which is often grouped with Barcelona chairs (Fig. 24-30).

■ *Tables.* Some tables are of wood with a constructionist appearance (Fig. 24-32). Designs feature interconnecting planes of wood. In the 1920s under Breuer's leadership, the furniture workshop designs round and rectangular cantilevered tubular steel occasional tables with glass tops (Fig. 24-19, 24-30). Dining tables are simple and functional wood or metal (Fig. 24-20).

■ *Storage.* At the Bauhaus, much attention is given to storage furniture for both adults and children. The workshop develops unit furniture, storage pieces of glass and metal or wood composed of individual modules with doors or drawers (Fig. 24-19, 24-33, 24-34). Modules can be combined to suit the spatial and storage needs of the user. Like all other Bauhaus furniture, storage is plain and geometric with no ornament.

■ *Beds.* Simplicity is a key factor in the design of beds. They are plain, low to the ground, and have tubular steel

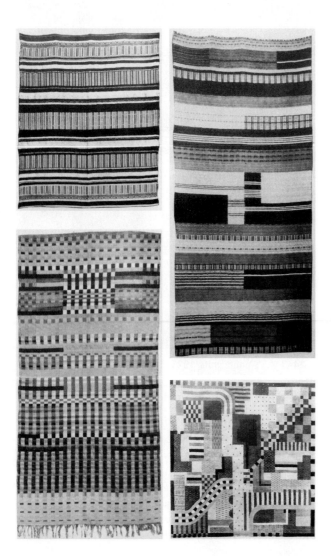

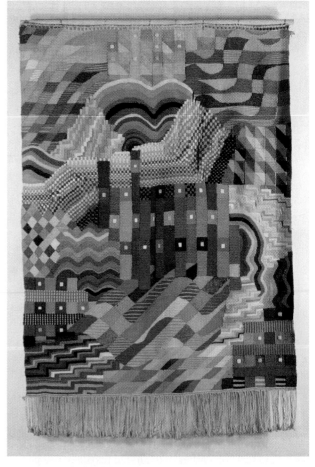

▲ **24-36.** Textiles: Wall hangings from the weaving workshop at the Bauhaus, c. 1920s; Germany; R. Hollós, M. Erps, and B. Otte.

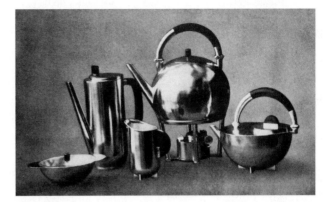

▲ **24-37.** Decorative Arts: Metalwork, 1924–1925; Germany; M. Brandt.

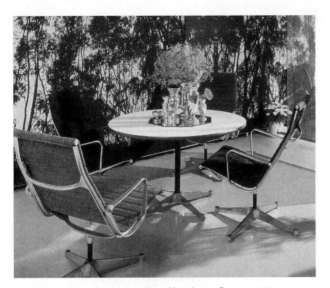

▲ **24-38.** Later Interpretation: Aluminum Group, 1958; Zeeland, Michigan; by Charles Eames and Ray Eames, manufactured by Herman Miller. Geometric Modern.

head- and footboards (Fig. 24-35). As with the other Bauhaus furniture, they are machine produced in standardized units.

■ *Upholstery.* The most popular upholstery materials are canvas, leather, pigskin, sheepskin, and cowhide, in natural colors.

■ *Decorative Arts.* After 1923, the metals workshop produces many ash trays, tea and coffee services, kettles, dresser sets, and pitchers in brass, bronze, and silver (Fig. 24-37). Forms are simple and geometric with no applied ornament. Most are machine made. The ceramics workshop is highly successful in designing industrial prototypes and handmade wares. Early pieces reflect a vernacular tradition in earthenware. Later designs in stoneware are modular, geometric, and plain, often with decorative glazes and work together without applied decoration. Individual parts could be made in the same molds, a process that approaches mass production.

■ *Later Interpretations.* Furniture of the 1950s by Charles Eames (Fig. 24-38), Harry Bertoia, George Nelson, and Florence Knoll expresses Bauhaus design ideas in new ways. In the late 20th century, designers such as David Rowland, Till Behrens, Mario Botta, Charles Pollock, Donald Chadwick, and William Stumpf create furniture that emphasizes a machine aesthetic, function, and construction concepts derived from Bauhaus principles.

1913	First performance of Igor Stravinsky's *The Rite of Spring*
	The Armory Show held in New York
1917	Thanks to Otto Messmer, *Felix The Cat* shows up
1919	Robert Wiene, *Cabinet of Dr. Caligari*
1920	Le Corbusier and Ozenfant found the review *L'Esprit Nouveau*
1921	Karel Capek coins term *robot* in play *R.U.R.*
1922	Chicago Tribune Tower competition
	Syrie Maugham opens shop in London
1923	Neon advertising signs introduced
	Plate glass manufactured in continuous sheets
1924	Rayon manufactured in United States
	George Gershwin, *Rhapsody in Blue*
	George Birdseye has frozen peas
1925	Coco Chanel introduces *No. 5*
	Adolf Hitler, *Mein Kampf*
1926	B. F. Goodrich markets vinyl
1927	The Academy Awards get their start
	Norman Bel Geddes is first to call himself an Industrial Designer
1928	Stock market crash heard around world
1929	Mies van der Rohe opens the Barcelona Pavilion
	Popeye: "I am what I am."
1930	Henry Dreyfuss designs classic table telephone
	Louis Bunuel seeks *L'Age d'Or*
1931	Empire State Building begins to dominate
1932	First drive-in theater opens in Camden, New Jersey
1933	A Century of Progress exhibition, Chicago
1935	Charlie Chaplin hopes for *Modern Times*
	Frank Lloyd Wright, Fallingwater
1936	Development of lucite announced
1937	Fred Astaire asks, *Shall We Dance?*
	Picasso stuns with *Guernica*
1939	Television debuts at the New York World's Fair
1940	First Social Security check sent: $22.54
	Eames and Saarinen win the MOMA Organic Design Competition
1941	Sigfried Giedion's seminal *Space, Time and Architecture*
	World War II begins
1942	Bogart and Bergman in *Casablanca*
1943	Penicillin is mass produced
	IKEA starts putting it together in Sweden
1945	Bruno Taut leans *Towards an Organic Architecture*
	United States drops atomic bombs on Japan
1946	Paul Rand, *Thoughts on Design*
	ENIAC, vacuum tube computer, developed
1948	Velcro starts closing and opening
	Scientists at Bell Labs invent the transistor
1949	Levittown opens with whites-only restrictive covenants
1951	*An American in Paris* dances up a storm
1952	John Diebold, *Automation*
1953	Spray-can paints become available
1954	Buckminster Fuller's first geodesic dome
	U.S. Supreme Court bans segregation
1955	Henry Dreyfuss, *Designing for People*
	Jonas Salk develops polio vaccine
	Saul Bass is *The Man with the Golden Arm*
	Disneyland in California opens, $1.00 for adults, 50 cents for kids
1956	Britain enacts a Clean Air Act
1957	Jorn Utzon wins for the Sydney Opera House
1958	Max Miedinger designs Helvetica typeface
	United States launches Explorer I satellite

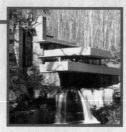

G. MODERNISM

For the most part, Modernism strives to design for the present and eliminate most traditions, forms, and elements of the past, rejecting historicism, the academic tradition, and the idea of style. Many consider the past obsolete, offering no solutions to modern problems. To seek solutions from the past is to regress, and to look toward modern science and technology is to progress and to be modern. Modernists believe that a new architecture, interiors, and furniture are needed for modern lifestyles, which are hurried, tense, and shaped by the machine. Although Modernism sees itself as separate from what had gone before, in reality it builds upon ideas from 19th-century design reform movements, such as Arts and Crafts; Art Nouveau; De Stijl; the Bauhaus; and innovative designers, such as Frank Lloyd Wright and Peter Behrens. These ideas include honesty of materials, revealed structure, and the use of modern materials and techniques. Much of Modernism rejects ornament or applied decoration and prefers abstraction over objective design, rationality, and geometric forms. Additionally, Modernist designers emphasize functionalism for use and as a design concept, seek universal solutions over individual ones, and embrace a machine aesthetic.

Several movements, each with different ideas or theories of what it means to be modern, occur during the first half of the 20th century. The International Style arises in Europe in the 1920s and gets its name from a 1932 exhibit at the Museum of Modern Art in New York. Evolving from Bauhaus design language, characteristics include regularity, volume over mass, geometry, steel framework and glass curtain walls, smooth white walls, minimal color, and no applied ornament. Although it is most common in architecture, interiors and furniture follow its principles.

Art Deco develops in Paris about 1910. After making a strong impact at the Exposition Internationale des Arts Decoratifs et Industriels Modernes held in Paris in 1925, Art Deco quickly becomes a worldwide style in all arts, including architecture, interiors, and furniture. Its manifestations range from highly decorative and lavish to geometric and simple. Unlike other Modern styles, Art Deco retains a respect for the past and relies on capitalism and consumerism to spread its aesthetics. Closely aligned with Art Deco is Art Moderne, a simplified geometric style with more curvilinear forms.

The Scandinavian countries, Denmark, Sweden, Finland, and Norway, create their own version of Modernism, called Scandinavian Modern. The style unites elements of the Bauhaus or International Style with Scandinavian traditions. Expressions in architecture, interiors, furniture, and the decorative arts are simple, functional, and often minimal. They feature natural materials, such as wood, and reveal a concern for the individual over the universal. Scandinavian design retains a strong sense of pride in the traditions and collective design identity of Scandinavian countries.

Beginning in the 1930s, Geometric Modern continues the design language and many of the important ideas of Bauhaus and International Style in architecture, interior design, and furniture. Definitive characteristics include regularity, rectilinear grids, geometric form, no applied decoration, and functionalism. New materials, technologies, standardization, and prefabrication drive goals and concepts. Modernism aligns with capitalism during this period and becomes the style for office buildings and commercial structures as well as commercial interiors and furnishings.

Paralleling the development of Geometric Modern, Organic and Sculptural Modern rejects the geometry and hard edges of the International Style and instead looks to sculpture or living organisms for inspiration. It shares simplicity, little applied ornament, and mass production with other modern designs, but expresses a unified symbolic design language. Designs may be curvilinear, spherical, or parabolic in form. Elongation, abstraction, and asymmetry also are common. Organic and Sculptural Modern becomes very popular in furniture and the decorative arts following World War II.

Although Modernism is mainstream, Historicism and period styles continue to appeal to many people throughout the 20th century and into the 21st. Modern Historicism uses past styles to represent family heritage, express context, or to signal a function, a theme, or a brand. Designers adopt a variety of methods as they make period styles relevant to modern lifestyles and needs. These may include reproducing or replicating the past, suggesting or alluding to the past, or creatively adapting vernacular, historical, or classical principles, elements, and/or attributes. The result often is intrinsically modern, and it usually is evident that this is a building or interior of its time. Common styles, themes, or movements include Historic Preservation, Suburban Modern, Period Interior Decoration, and a new Classical Revival in the late 20th century.

TWELVE PRECEPTS OF MODERN DESIGN

Out of a hundred years of development certain precepts have emerged and endured. They are generally conceded to be:

1. Modern design should fulfill the practical needs of modern life.

2. Modern design should express the spirit of our times.

3. Modern design should benefit by contemporary advances in the fine arts and pure sciences.

4. Modern design should take advantage of new materials and techniques and develop familiar ones.

5. Modern design should develop the forms, textures and colors that spring from the direct fulfillment of requirements in appropriate materials and techniques.

6. Modern design should express the purpose of an object, never making it seem to be what it is not.

7. Modern design should express the qualities and beauties of the materials used, never making the materials seem to be what they are not.

8. Modern design should express the methods used to make an object, not disguising mass production as handicraft or simulating a technique not used.

9. Modern design should blend the expression of utility, materials and process into a visually satisfactory whole.

10. Modern design should be simple, its structure evident in its appearance, avoiding extraneous enrichment.

11. Modern design should master the machine for the service of man.

12. Modern design should serve as wide a public as possible, considering modest needs and limited costs no less challenging than the requirements of pomp and luxury.

Edgar Kaufman, Jr. Reprinted by permission from *What Is Modern Design?* © 1950 The Museum of Modern Art.

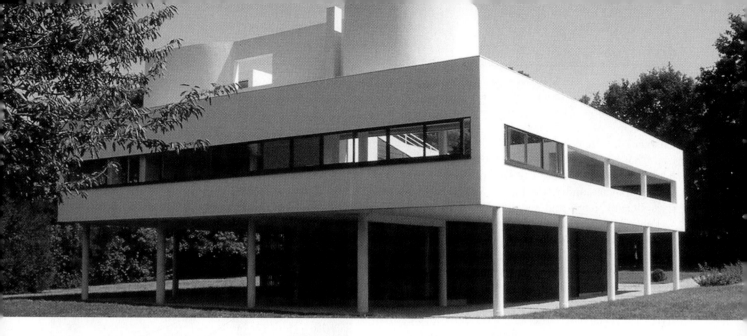

International Style

1920s–1930s

The International Style broadly refers to a modern architectural style arising in Europe in the 1920s, and in the United States and rest of the world from the1930s onward. More narrowly, the term refers to a 1932 exhibit at the Museum of Modern Art in New York City. Synonymous with modernism and evolving from the work of a small group of architects, characteristics of the International Style in architecture include geometric forms, regularity, volume instead of mass, smooth white or glass walls, minimal color, and no applied ornament. The style comes to dominate commercial architecture, factories, and public housing in the United States and Europe. Interiors and furniture exhibit a similar aesthetic.

HISTORICAL AND SOCIAL

The International Style gets its name and identity from "Modern Architecture: An International Exhibition," a 1932 show at the Museum of Modern Art in New York

*The actual needs of the dwelling can be formulated and demand their solution. We must fight against the old-world house, which made a bad use of space. We must look upon the house as a machine for living in or as a tool. . . . Till now a house has consisted as an incoherent grouping of a number of large rooms; in these rooms the space has been both cramped and wasted. Today, happily, we are not rich enough to carry on these customs, and as it is difficult to get people to look at their problem under its true aspect (machines for living in), it is nearly impossible to build in our towns, with disastrous results. . . . Henceforth the problem is in the hands of the technical expert: we must enlist the discoveries made in industry and change our attitude altogether. As to beauty, this is always present when you have proportion; and proportion costs the landlord nothing, it is in the charge of the architect! . . . And one **can** be proud of having a house as serviceable as a typewriter.*

Le Corbusier, *Mass-Production House*, 1921

The distinguishing aesthetic principles of the International Style as laid down by the authors [Hitchcock and Johnson] are three: emphasis upon volume—space enclosed by thin planes or surfaces as opposed to the suggestion of mass and solidity; regularity as opposed to symmetry or other kinds of obvious balance; and, lastly, dependence upon the intrinsic elegance of materials, technical perfection, and fine proportions, as opposed to applied ornament.

Alfred H. Barr, Jr., preface of *The International Style*, 1932

City organized by Alfred Barr, Henry Russell Hitchcock, and Philip Johnson. The exhibit features projects from the late 1920s and 1930s by architects in Germany, France,

Czechoslovakia, Switzerland, Holland, Scandinavia, and the United States. The group includes Bauhaus designers Walter Gropius and Ludwig Mies van der Rohe (see Chapter 24, "The Bauhaus"); De Stijl advocate J. J. P. Oud (see Chapter 23, "De Stijl"); French architects Charles-Edouard Jeanneret known as Le Corbusier (Fig. 25-1), Pierre Jeanneret, and Andre Lurcat; and American architects Richard Neutra and Rudolph Schindler.

Published in conjunction with the exhibit is *The International Style Since 1922*, which becomes the definitive treatise on the new architecture. In it, Henry Russell Hitchcock and Philip Johnson give a brief history of style in general and the Modern movement in architecture, and articulate the language and vocabulary that defines the style. They emphasize the architect and the industrial designer over the artist and craftsman. Discussions of planning, structure, materials, and color ensure that the publication becomes a handbook for the International Style. Hitchcock and Johnson identify four leaders of modernism, all Europeans: Walter Gropius, Mies van der Rohe, J. J. P. Oud, and Le Corbusier. Although they acknowledge the pioneer work of Frank Lloyd Wright, they dismiss it as romantic and individualist. The authors include some American work, such as skyscrapers, and that of Europeans who work in the United States—Rudolph Schindler, William Lescaze, and Richard Neutra. By identifying visual characteristics of modern European architecture, Johnson and Hitchcock characterize it as a style instead of a movement. They largely ignore the social and political reforms attached to modernism as well as the idealism and theories of designers such as Le Corbusier. While not well received by the European designers, this omission makes International Style architecture more acceptable in the United States, a country that does not have the social and political upheavals from which modern European architecture arises.

The exhibit is a seminal event for modern architecture in the United States. It makes modern architecture more acceptable to designers and the public, thereby setting the stage for the United States to become the leading world power and main promoter of modernism in architecture and design following World War II. Although social and economic climates aid this development, the presence of European artists, architects, and designers furthers it as well as validates it. Prior to and during the war, many designers, including some from the Bauhaus, migrate to England and the United States, which become safe havens for the nourishment and growth of new ideas.

▲ **25-1.** Le Corbusier, c. 1930s.

IMPORTANT TREATISES

- *L'Art Décoratif d'aujourd'hui,* 1925; Le Corbusier.

- *The International Style Since 1922,* 1932; Henry Russell Hitchcock and Philip Johnson.

- *La Ville Radieuse,* 1933; Le Corbusier.

- *Les 5 Points d' une architecture nouvelle,* 1926; Le Corbusier.

- *Modern Architects,* 1932; Alfred Barr, Henry Russell Hitchcock, Philip Johnson, Lewis Mumford.

- *Pioneers of Modern Design from William Morris to Walter Gropius,* 1936; Nikolaus Pevsner.

- *Urbanisme,* 1925; Le Corbusier.

- *Vers une architecture,* 1923; Le Corbusier.

Periodicals: *L'Espirit Nouveau,* 1920 (founded by Le Corbusier and painter Amedée Ozenfant).

CONCEPTS

The International Style arises from converging ideas of early-20th-century architects in Germany, France, and Holland. This group believes that the development and implementation of modern materials and construction methods, including reinforced concrete and steel, demands a new architectural interpretation both for new building types, such as public housing, and existing ones, like private dwellings. Instead of reinventing the past or maintaining the status quo, modernist architects challenge traditional ways of designing and construction methods

and look for ways to improve life through modern architecture. Additionally, the enormous upheavals and devastation of World War I engender widespread disillusion with European politics and culture, including the Beaux-Arts tradition in architecture. This, in turn, reinforces the earlier idea of an architectural style that expresses modern life and makes good design available to everyone. Many designers see an architecture that is functional, rational, and efficient, like the machine, as a key means of transforming European culture by democratizing design and creating new ways of living and working for a modern industrial society. These ideas also extend into interior planning and furniture.

Although there are no direct references to the past developments in the International Style, expressions build upon the ideas and works of such designers and theorists as Adolf Loos, Peter Behrens, and Auguste Perret (see Chapter 22, "Modern Forerunners"), Hitchcock and Johnson specifically cite as important contributors to the style the factory

buildings and Bauhaus ideas of Walter Gropius, the clarity and simplicity of Mies van der Rohe, the housing projects of J. J. P. Oud, and the work and writings of Le Corbusier.

DESIGN CHARACTERISTICS

Johnson and Hitchcock classify architecture as International Style by three broad principles: emphasis upon volume rather than mass; regularity arising from standardized elements rather than axial symmetry; and emphasis on proportions and materials rather than arbitrarily applied decoration. Their choice of buildings for the exhibition based upon these principles promotes a strong homogeneity, yet some individualism is also apparent.

International Style buildings display simplicity, clean lines not obscured by ornament, and purity of forms, which are often cubes, cylinders, or rectangles. Some reveal floating planes. A skeleton, often of steel and reinforced

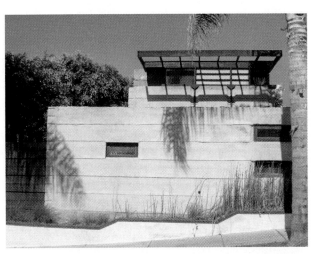

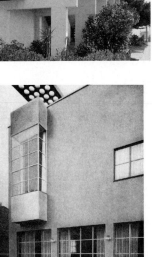

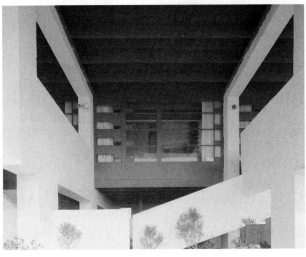

▲ **25-2.** Architectural details.

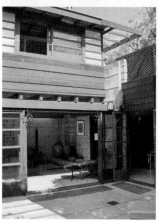

▲ **25-2.** *(continued)*

buildings, particularly residences, are raised above the ground on thin columns to take advantage of ground space. Roofs are often flat, sometimes with usable terraces or gardens. Some architects create individual compositions for the client or programmatic requirements, while others advocate one solution for many situations.

Interior spaces are often open, simply treated, and sparsely furnished. Partitions may be fixed or movable. Glass walls invite the outside into the interior space and expand it visually. Walls are usually plain with no applied decoration, although occasionally rich materials are used for wall surfacing. Furniture may be movable or built-in and of wood or metal with no applied ornament.

■ *Motifs*. There is no vocabulary for motifs because buildings are generally unadorned. Some architects include unique architectural details (Fig. 25-2) that are a part of the building structure, such as those on the Villa Savoye (Fig. 25-17).

ARCHITECTURE

The International Style arises from theories, forms, technology, and construction methods developed during the late 19th and early 20th centuries by individuals, movements, and design schools. Of particular importance is the German school, the Bauhaus, where these ideas and methods come together under the direction of Walter Gropius and others. Bauhaus architecture, interiors, furniture, and other objects have a similar appearance deriving from a focus on geometry, economy, practicality, function, mass production, new materials and construction methods, and no or minimal applied ornament. Bauhaus designers and students strive to create works that can easily be mass-produced and meet the needs of users, who are assumed to

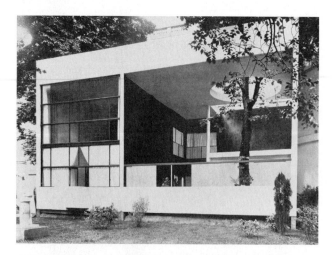

▲ **25-3.** Pavillon de l'Esprit Nouveau, Exposition des Arts Décoratifs et Industriels, 1925; Paris, France; Le Corbusier and Pierre Jeanneret.

concrete, carries the structure's load. This permits free and open floor plans that can adapt to any functional requirements and a thin exterior covering with no need to express structure. Thus, the exterior covering can be any material, even glass, and usually has a smooth surface. Because the design of the façade is independent of the structure, fenestration becomes an important design element. Doors and windows are no longer recessed to emphasize mass, and their frames are integrated into the structure. Bands of windows, including corner windows, are common. Some

be all the same. Designs spread through regional and international exhibits and the work of students and masters.

Another significant contributor to the International Style is Le Corbusier, who believes in a radical architecture as a

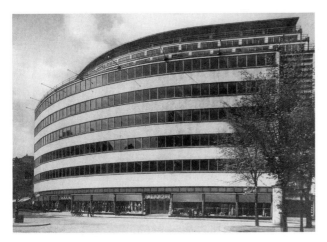

▲ **25-4.** Schocken Department Store, 1928–1930; Chemnitz, Germany; Eric Mendelsohn.

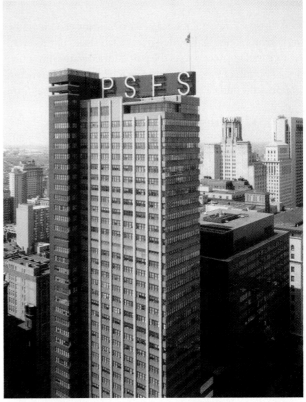

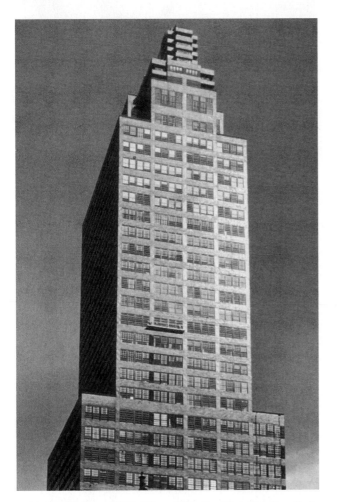

▲ **25-5.** McGraw-Hill Building, 1931; New York City, New York; Hood and Fouilhoux.

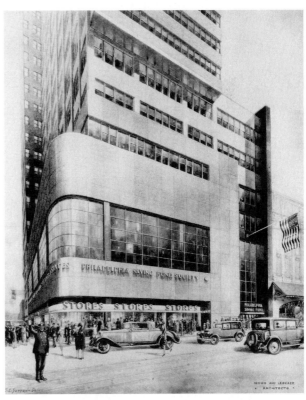

▲ **25-6.** Philadelphia Savings Fund Society (PSFS; now Lowes Philadelphia Hotel), 1929–1932; Philadelphia, Pennsylvania; William Lescaze.

tool for social reform and suggests new solutions for houses and urban planning. Key design characteristics of this architecture include rejection of the past and decorative ornament and adoption of functionalism, machine precision, standardization, and purism, a theory that promotes universal forms and anonymity over individualism. Le Corbusier advocates a stronger machine aesthetic in architecture, identifies five important principles for modern buildings, and creates a modular system based upon human scale. He strives to create *objet-types*—universal solutions to problems in design—and

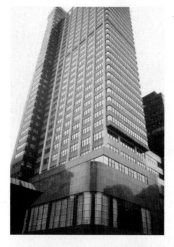

◀ **25-6.** *(continued)*

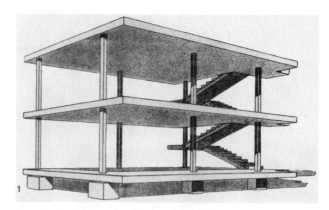

▲ **25-7.** Dom-ino Housing Project, 1914; Le Corbusier.

IMPORTANT BUILDINGS AND INTERIORS

- **Beeston, England:**
 - Boots Factory, 1930–1932; Evan Owen Williams.
- **Bexhill-on-Sea, England:**
 - De La Warr Pavilion, 1933–1935; Erich Mendelsohn and Serge Chermayeff.
- **Bordeaux, France:**
 - Pessac Housing Estate; 1926, Le Corbusier.
- **Chemnitz, Germany:**
 - Schocken Department Store, 1928–1930; Eric Mendelsohn.
- **Como, Italy:**
 - Casa del Fascia, 1932–1936; Giuseppe Terragni.
- **Hampstead, London, England:**
 - Lawn Road Flats, 1932–1934; Wells Coates Isokon.
- **Highgate, London, England:**
 - Highpoint Flats, 1935; Tecton and Lubetkin.
- **Hook of Holland, Netherlands:**
 - Workers' Houses, 1924–1927; J. J. P. Oud.
- **La Jolla, California:**
 - Pueblo Ribera, 1923; Rudolph Schindler.
- **London, England:**
 - Penguin Pool, Zoological Gardens, Regents Park, 1934; Lubetkin and Tecton.
- **Los Angeles, California:**
 - Garden Apartments, 1927; Richard Neutra.

- Philip Lovell (Health) House, 1928–1929; Richard Neutra.
 - Schindler-Chase House, 1921–1922; West Hollywood; Rudolph Schindler.
- **Newport Beach, California:**
 - Lovell Beach House, 1925–1926; Rudolph Schindler.
- **Paris, France:**
 - Cite de Refuge, 1929–1933; Le Corbusier and Pierre Jeanneret.
 - L'Esprit Nouveau Pavilion, Exposition des Arts Décoratifs et Industriels, 1925; Le Corbusier.
 - Le Roche-Jeannert Houses, 1923; Le Corbusier.
 - Maison de Verre, 1928–1932; Pierre Chareau and Bernard Bijvoet.
 - Pavilion Suisse (Swiss Hotel), Cité Universitaire, 1931–1932; Le Corbusier.
 - Villa Savoye, 1928–1931; Poissy; Le Corbusier.
- **Philadelphia, Pennsylvania:**
 - Philadelphia Savings Fund Society (PSFS; now the Lowes Philadelphia Hotel), 1929–1932; William Lescaze.
- **Stuttgart, Germany:**
 - Schocken Department Store, 1926–1930; Eric Mendelsohn.
 - Weissenhof Housing Project, 1927; Le Corbusier and Pierre Jeanneret.

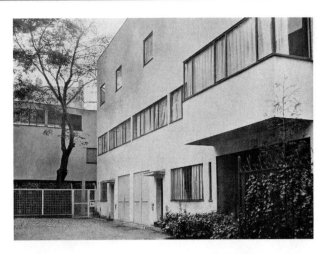

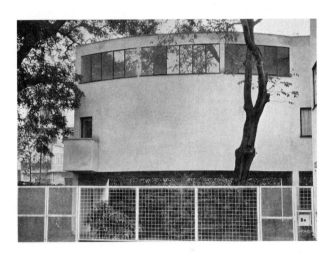

▲ **25-8.** Freehold Maisonettes; published in *Vers une architecture* (Towards a New Architecture), 1923; Le Corbusier.

looks to industry for models. His dictum that "a house is a machine for living in" summarizes his ideas that the precision, efficiency, and sleekness of the machine should be the example for all architecture, especially residences. His Dom-ino project (Fig. 25-7) of 1914 proposes a faster standardized construction method based upon prefabricated elements of reinforced concrete roof, ceilings, and walls defined and supported by slender columns.

Le Corbusier's "Five Points of New Architecture" include pilotis; free plans because the structural frame is independent of the non-load-bearing walls; a freely designed façade that is independent of structure; strip or band windows; and flat roofs for living space and gardens. The free floor plan permits its organization to be adapted to individual clients. Le Corbusier also develops *Modular*, a modular system in the tradition of the Greeks, which grows out of the Golden Section and measurements of the human body. His ideas for urban planning are very different from the garden cities proposed by the Arts and Crafts Movement or even the solutions of other modernist architects. Le Corbusier designs multistory towers within green space and working and shopping areas connected by roadways. His 1930 concept called *Ville Radieuse* (Radiant City) illustrates apartment complexes where elite and working

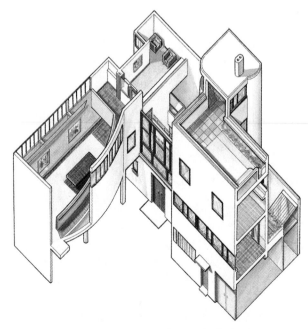

▲ **25-9.** Villa La Roche, c. 1924; France; Le Corbusier.

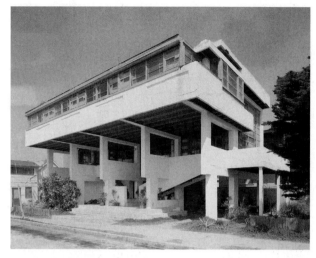

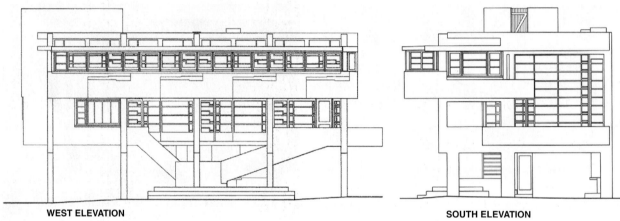

WEST ELEVATION

SOUTH ELEVATION

▲ **25-10.** Lovell Beach House, 1925–1926; Newport Beach, California; Rudolph Schindler.

classes live in units with an ordered division of functions by zones.

Residences are a particular focus of the International Style because it is through them that many architects make their ideas concrete. Both Neutra and Schindler follow the design character of Le Corbusier. Most noteworthy are their houses, which are a series of white box shapes that emphasize minimalism, exhibit beautiful proportions, show a relationship of outside to inside, and stand out as pieces of sculpture on the landscape (Fig. 25-10, 25-14).

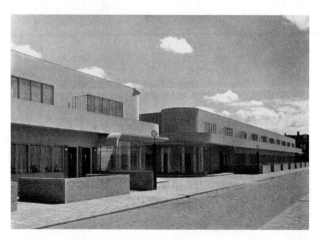

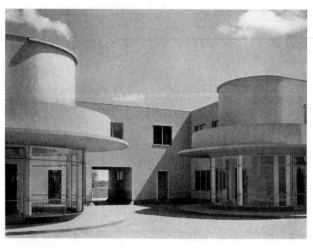

▲ **25-11.** Workers' Houses, 1924–1927; Hook of Holland, Netherlands; J. J. P. Oud.

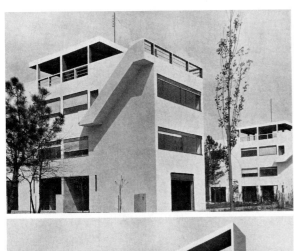

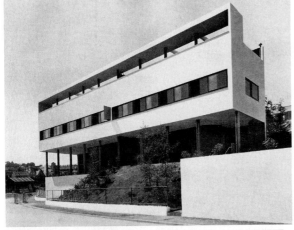

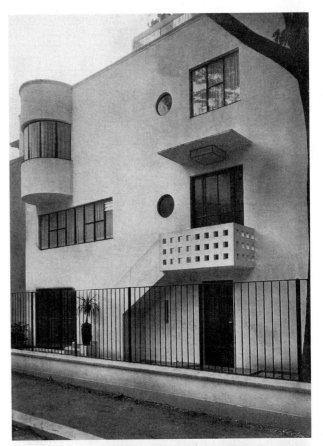

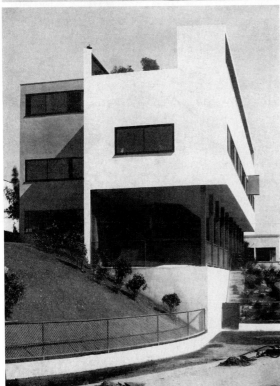

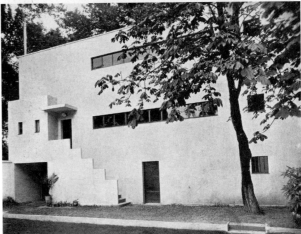

▲ **25-12.** Houses; Bordeaux, France, and Stuttgart, Germany; published in *Examples of Modern French Architecture*, 1928; Le Corbusier and Pierre Jeanneret.

▲ **25-13.** Houses; Paris and Versailles, France; published in *Examples of Modern French Architecture* and *The New Interior Decoration*, 1928, 1929; Andre Lurcat.

Public and Private Buildings

■ *Types*. Commercial building types include exposition pavilions (Fig. 25-3), stores (Fig. 25-4), office complexes (Fig. 25-5), banks (Fig. 25-6), and factories. Some of the best expressions of the style, however, are apartment houses (Fig. 25-8, 25-11, 25-16) and private houses (Fig. 25-9, 25-10, 25-12, 25-13, 25-14, 25-17, 25-19, 25-21).

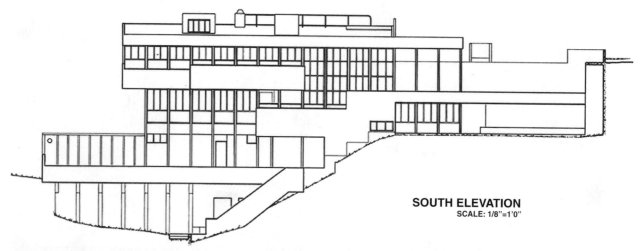

SOUTH ELEVATION
SCALE: 1/8"=1'0"

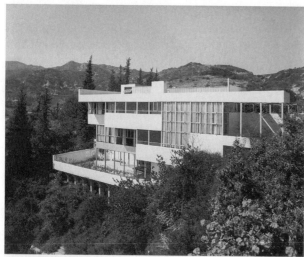

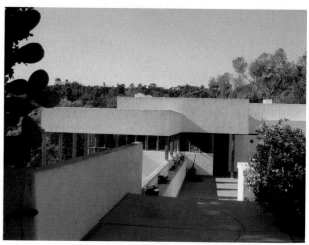

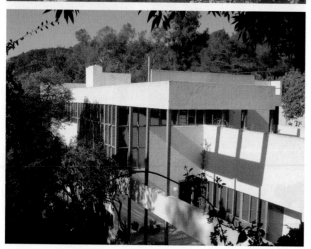

▲ **25-14.** Philip Lovell (Health) House, 1928–1929; Los Angeles, California; Richard Neutra.

■ *Site Orientation.* Architects place buildings to take advantage of the sun, such as locating terraces with southern exposure. Some structures sit on flat plains of grass with only a few plantings around them (Fig. 25-17, 25-19,

25-20). The intent is to contrast the artificial building with the natural environment. Those in cities align with streets and usually have little green space (Fig. 25-11, 25-12, 25-13, 25-16). Urban housing structures are at right angles to access streets and are sited to provide the most light and air for each apartment.

■ *Floor Plans.* The structural skeleton permits free and individually determined floor plans. They are usually asymmetrical arrangements with program requirements and room function determining placement. Major circulation paths such as halls and stairs are located centrally for direct access to entries, while private areas maintain spatial separation. Structural supports within interiors exhibit regularity.

Plans emphasize three concepts identified by Hitchcock and Johnson: interior volume, open space, and enclosed rooms. Thin vertical planes define large, three-dimensional, volumetric areas in nonresidential structures, such as exhibition spaces, auditoriums, and stores. Some residences have a mix of one- and two-story open spaces. Open, free-flowing interior space incorporates dividing screens to partition areas but at the same

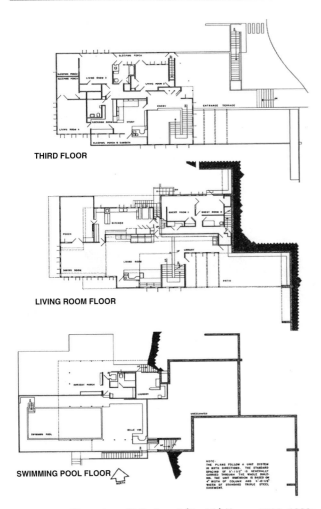

THIRD FLOOR

LIVING ROOM FLOOR

SWIMMING POOL FLOOR

NOTE:
THE PLANS FOLLOW A UNIT SYSTEM
IN BOTH DIRECTIONS. THE STANDARD
SPACING OF 3'-1 1/2" IS GENERALLY
CARRIED THROUGH THE WHOLE BUILD-
ING. THE UNIT DIMENSION IS BASED ON
4" WIDTH OF COLUMN AND 4'-0 1/8"
WIDTH OF STANDARD TRIPLE STEEL
CASEMENT.

▲ **25-15.** Floor plans, Philip Lovell (Health) House, 1928–1929; Los Angeles, California; Richard Neutra.

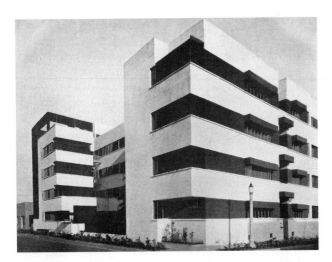

▲ **25-16.** Apartment house; Los Angeles, California; published in *The New Interior Decoration*, 1929; Richard Neutra.

DESIGN PRACTITIONERS

- **Charles-Édouard Jeanneret** (1887–1965), known as Le Corbusier, is one of the most influential architects and designers of the 20th century. He greatly affects the direction of the Modern Movement and International Style, and he inspires many architects through his work, theories, exhibits, and publications. Le Corbusier works with Auguste Perret in Paris and Peter Behrens in Germany. His most famous project during this period is the Villa Savoye. His furniture designs are also influential.

- **Richard J. Neutra** (1892–1970) introduces Modernism to California with his design for the Lovell (Health) House. Born in Vienna, Neutra comes to the United States to meet Frank Lloyd Wright. In 1927, Neutra and his family settle in California, where he opens an office. Much of his work is in the International Style, but, like Wright, Neutra believes that buildings must integrate with their sites. He is best known for his residences.

- **Charlotte Perriand** (1903–1999), furniture and interior designer, works in the atelier of Le Corbusier creating furnishings for his projects. Perriand's room and furniture in the 1929 Salon D'Automne bring her to Le Corbusier's attention. Her best-known designs created in collaboration with Le Corbusier and his cousin Pierre Jeanneret are the *Chaise Longue*, *Grand Confort*, and *Basculant* chair. She leaves Le Corbusier's studio in 1937 but continues to design furniture and interiors.

- **Rudolph Schindler** (1877–1953) moves from Vienna to the United States in 1913. After working for Frank Lloyd Wright, he opens a practice in California in 1922. Schindler believes that space is architecture, composed of interpenetrating volumes using simple materials, such as reinforced concrete. Spaces are visibly organized by solids (structural components) and voids (interpenetrating open spaces, both inside and outside). In the traditions of Vienna, Schindler also believes in a totally designed environment, so he designs furniture in simple geometric forms, like his architecture. Among his best-known works is the beach house for Philip Lovell.

Architecture: Exterior, details, and roof decks, Villa Savoye, 1928–1931; Poissy, Paris, France; Le Corbusier. The Villa Savoye is a weekend house for wealthy owner Pierre Savoye and his wife, who use it frequently until 1938. Considered to be one of the finest examples of 20th-century Modern architecture, it is the culmination of Le Corbusier's experimentation and investigations of purist form. In it, he employs his famous Five Principles of the New Architecture. Raised on slender pilotis (Principle 1), the house seems weightless and hovers above the ground. Each of the three floors has a different, free, and open plan, permitted by the independent structural frame (Principle 2). Le Corbusier arranges the interior spaces in a carefully planned progression. The ground floor area beneath the raised portion houses a three-car garage, servants' quarters, and entry. A ramp, which is considered one of several architectural promenades, and circular stairs provide vertical circulation. On the first floor is a living space that opens by sliding glass partitions to a terrace.

All four elevations are the same: a freely designed rectangular façade (Principle 3) with full-width strip windows (Principle 4) and curved screen walls on the roof. The stark white cubic form has classical proportions and contrasts with the surrounding landscape. The façade's strip windows frame views to the landscape beyond, permitting an interpenetration of outdoors with indoors. Pastel duck-egg blue and soft coral on living room walls recall the sky and atmosphere outside. The flat roof (Principle 5) provides additional living space, the integration of nature, light, and air, all of which are considered important in early 20th-century Modern residences. Le Corbusier chooses industrial interior finishes, such as ceramic tiles and smooth plaster surfaces, and sleek, industrial-style light fixtures. Similarly, the few pieces of furniture are mostly of modern materials such as tubular steel. Among the furniture is the *Chaise Longue* (1928), designed with Charlotte Perriand.

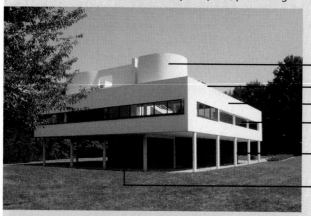

— Curved wall shields solarium

— Flat roof

— Stark white rectangular facade with no ornamentation

— Horizontal strip windows

— Building raised on pilotis

— Entry door

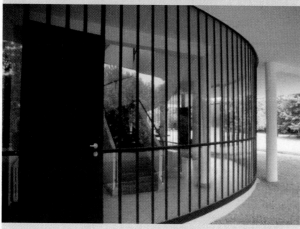

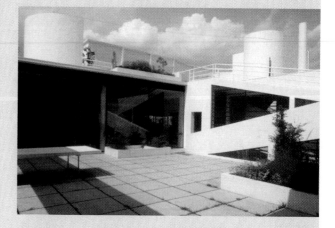

▲ **25–17.** Exterior, details, and roof decks, Villa Savoye; Paris.

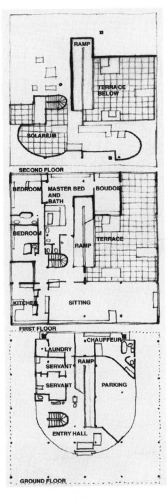

◀ **25-18.** Floor plans, Villa Savoye, 1928–1931; Poissy, Paris, France; Le Corbusier.

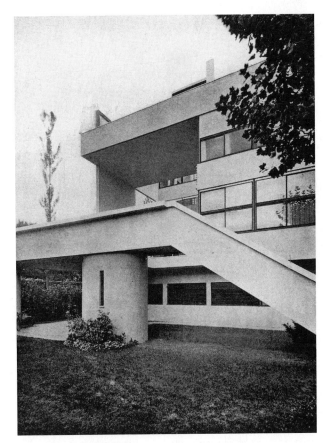

▲ **25-19.** Villa Les Terrasses, c. 1930; Garches, France; Le Corbusier.

time support unity, interdependence, and continuity between spaces, such as between living and dining areas (Fig. 25-15). Enclosed rooms with rectangular and square shapes vary in size, align along exterior walls with large areas of glass, and may connect to interior halls or to each other. In houses, such as the Le Corbusier's Villa Savoye (Fig. 25-17; see Design Spotlight), exterior and interior spaces flow together through glass windows, ramps, and connected roof terraces. This interconnectivity of space is an important principle of International Style design.

■ *Materials.* Smooth white stucco with large expanses of windows or glass curtain walls predominates. Construction materials include steel, glass, reinforced concrete, marble, granite, brick, glazed tile, concrete blocks, terra-cotta blocks, and aluminum.

■ *Façades.* Exteriors of public and private buildings are simple and unornamented, and compositions are independent of and de-emphasize structure (Fig. 25-3, 25-9, 25-10, 25-11, 25-12, 25-13, 25-14, 25-16, 25-17, 25-19, 25-20, 25-21). Walls serve primarily as screens, with an emphasis on transparency or thinness. The organization of elements usually stresses asymmetry and repetition through solid and void proportional relationships. Regularity in window

placement helps to reinforce the solid-to-void conections. Large areas of rectangular windows and glass curtain walls with steel grids cover façades on commercial buildings (Fig. 25-4, 25-6), and some houses also have glass curtain walls. To create symmetrical compositions on houses, designers employ windows varying in shape, size, and placement (Fig. 25-9, 25-13). Cantilevered balconies or projecting roof terraces accent the façade and create three-dimensionality (Fig. 25-14).

■ *Windows.* Many types of windows highlight façades. They may be fixed or types that open, such as casement, awning, or sliding glass (Fig. 25-4, 25-9, 25-12, 25-13, 25-14, 25-17). All are large and horizontal, and their rectangular shapes repeat across the façade but do not interrupt its smoothness. In houses, large windows may afford panoramic views to the outside, while smaller windows may focus to a private space. Corner windows and bands of windows de-emphasize structure and emphasize the thinness of the façade. Black or white narrow metal moldings frame window openings and divide glass areas.

■ *Doors.* Doorways integrate with the rhythm and regularity of the exterior so that they often become an extension of glass walls or solid surfaces (Fig. 25-13, 25-17,

▲ **25-20.** "Design for an Eight Room House, the Pencil Points' Competition"; published in *Pencil Points*, September 1930; Marion Spelman Walker.

▲ **25-21.** Maison de Verre, 1928–1932; Paris, France; Pierre Chareau and Bernard Bijvoet.

▲ **25-22.** Later Interpretation: Neurosciences Institute, 1995; La Jolla, California; by Tod Williams and Billie Tsien. Late Modern.

25-20). Plain, flat entry doors may be glass or wood, or a combination of both. Projecting canopies may shield the entry area, or the entry may be recessed to provide protection.

■ *Roofs.* Flat roofs are common (Fig. 25-6, 25-9, 25-11, 25-12, 25-13, 25-14, 25-17, 25-20). Sometimes a narrow, flat cornice trim surrounds and defines the perimeter edge. In houses, terraced roofs increase in use following the influence of Le Corbusier. Occasionally, a roof with a single slant is used.

■ *Later Interpretations.* The International Style influences continue throughout the 20th century through the work of the original advocates, such as Gropius, Mies van der Rohe, Breuer, Le Corbusier, and Neutra. And it continues through their protégés or disciples, such as Philip Johnson, Louis Kahn, Paul Rudolph, Charles Eames, Eero Saarinen, Kevin Roche, John Dinkeloo, Luis Barragán, I. M. Pei, Richard Meier, and Gordon Bunshaft and others at Skidmore, Owings, and Merrill. Subsequent architects reinvent this language during Late Modern, including Tadao Ando, and Tod Williams and Billie Tsien (Fig. 25-22).

INTERIORS

Interiors are created primarily by architects who emphasize function, flexibility, efficiency, and practicality. Form and proportion are more important than ornament and decoration are. Character comes from geometric forms, asymmetry, free-flowing and open spaces, and no applied ornament. In some environments, exotic woods and stones are used as wall treatments. Volume is important, so rooms often have high ceilings, and adjoining spaces may have different ceiling heights. Rooms are light and airy from large windows or glass walls. Spaciousness is important, so furnishings are minimal. There is little texture, pattern, color, and few decorative objects, which contributes to the overall anonymity.

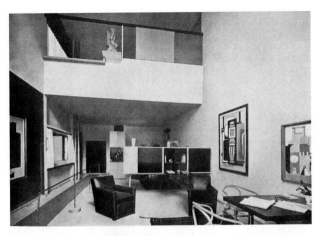

▲ **25-23.** Hall, Pavillon de l'Esprit Nouveau, Exposition des Arts Décoratifs et Industriels, 1925; Paris, France; Le Corbusier and Pierre Jeanneret.

Particularly important to the development of modernism and the International Style in housing and residences is the 1927 model housing exhibit *Weissenhofsiedlung*, held in Stuttgart, Germany, and sponsored by the Deutsche Werkbund. The exhibit opens the door wider for the acceptance of modernism and brings its principles into the home. The 21 model dwellings by Gropius, Le Corbusier, J. J. P. Oud, and others have open, fluid spaces instead of rooms to be decorated or filled with furnishings; double-height living spaces; and plain, simple furniture and accessories. Kitchens and baths are models of machine-like efficiency because designers plan them according to principles developed by the new discipline of domestic science or home economics. Many of these ideas are worked out in public housing where space is extremely limited.

Public and Private Buildings

■ *Types*. Interior spaces derive from the building function and follow principles set by the Bauhaus designers and Le Corbusier. In commercial structures, offices become more common, reflecting the growth of businesses.
■ *Relationships*. As in other modern examples, similarity in design principles, organization, and materials create relationships between exteriors and interiors. Important public and private spaces utilize the sun's exposure to take advantage of natural light and to emphasize the interconnectivity of exterior and interior space (Fig. 25-25, 25-26, 25-27, 25-28, 25-30). A harmonious relationship and interplay of forms and shapes between and within exterior and interior are crucial.
■ *Color*. The color palette is simple, usually white and black, and sometimes gray. Accents of a single warm or cool hue may be used. In the Villa Savoye, Le Corbusier showcases a range of accent colors, including blue, ochre, and coral.

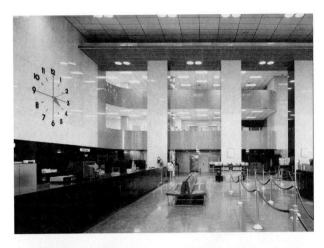

▲ **25-24.** Banking Room, Philadelphia Savings Fund Society (PSFS; now Lowes Philadelphia Hotel), 1929–1932; Philadelphia, Pennsylvania; William Lescaze.

■ *Lighting*. Glass and metal table lamps, task lights, wall sconces, hanging lamps, and ceiling fixtures express a machine vocabulary to stress function over ornament (Fig. 25-24). Light fixtures are often unobtrusive and blend in with the overall interior. Lamps and fixtures are made of plain, brushed, or lacquered steel; aluminum; or

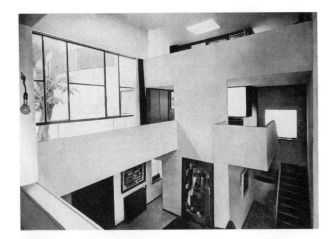

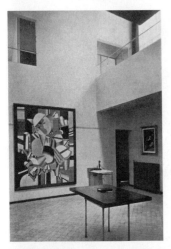

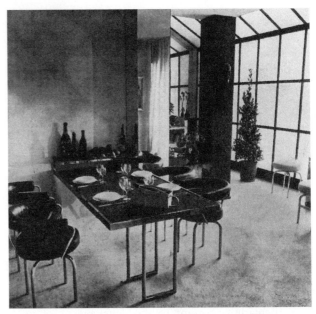

▲ **25-26.** Salle á Manger, 1928; France; Charlotte Perriand.

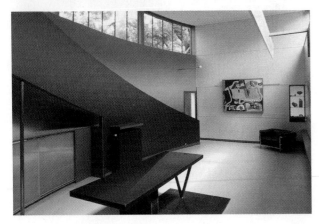

▲ **25-25.** Interiors, Laroche House, c. 1928; Paris, France; Le Corbusier and Pierre Jeanneret.

glass with opalescent and frosted glass globes or shades following Bauhaus design principles.

■ *Floors*. Wood, tile, travertine, marble, and linoleum are the most common materials for floors (Fig. 25-24). Wall-to-wall carpet is rare, but area rugs, either plain or in geometric designs, may cover certain sections of the floors (Fig. 25-29). For example, designers position rugs

under seating groupings to add visual weight and tie the furnishings together.

■ *Walls*. Most walls are plain, unornamented, and painted white (Fig. 25-23, 25-25, 25-28). Some walls are painted a bright color, while others may feature a colorful poster or painting with geometric designs. In more formal or expensive environments, exotic woods or patterned stones may be chosen. Some walls are of glass blocks to allow natural light into a space, while others may have three-dimensional openings to shape and frame space. The interplay of solid and void space is very important, so architects experiment more than earlier with the articulation of interior structure. Walls that are completely glass give a total integration of space from outside to inside (Fig. 25-26). Architectural trim is usually black or white to de-emphasize its importance.

■ *Windows*. Interior window trims are narrow moldings that articulate and frame the opening (Fig. 25-25, 25-26, 25-28, 25-29). Many windows are bare, but others have plain curtains, blinds, or shades in neutral colors and plain or textured weaves.

■ *Doors*. Doors are plain and usually in wood or sometimes metal. They may be painted black, white, or stained. Flat, narrow door trims repeating the character of window moldings articulate and frame the opening.

■ *Ceilings*. Ceilings are most often flat, plain, and painted white or sometimes black. Designers lower ceiling heights to create intimacy and use higher ones to emphasize scale.

■ *Later Interpretations*. International Style architects and their protégés and disciples continue their design legacy in Europe and North America throughout the middle of the

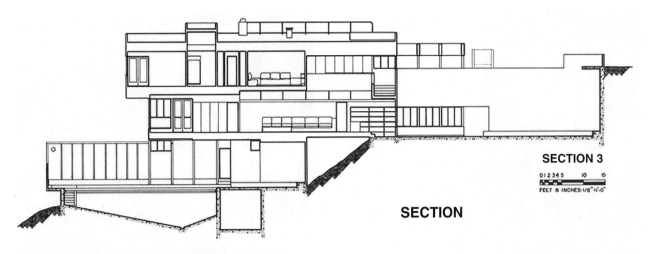

SECTION 3

012345 10 15
FEET & INCHES: 1/8"=1'-0"

SECTION

◄ **25-27.** Interiors and section, Philip Lovell (Health) House, 1927–1929; Los Angeles, California; by Richard Neutra.

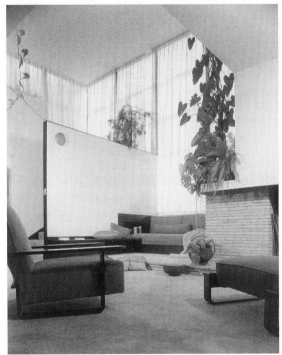

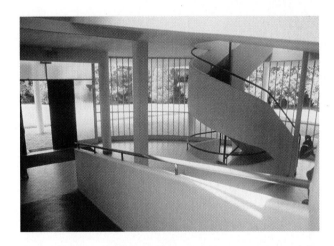

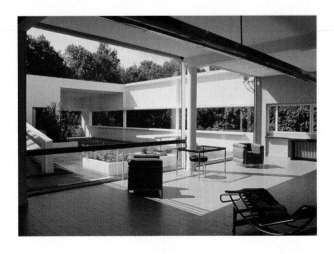

► **25-28.** Entry, stairs, and rooms, Villa Savoye, 1928–1931; Poissy, Paris, France; Le Corbusier.

◀ **25-28.** (continued)

▲ **25-31.** Later Interpretation: Interior, J. Paul Getty Museum, 1997; Los Angeles, California; Richard Meier. Late Modern.

▲ **25-29.** *Le Bureau d'un Artiste Décorateur*, c. 1930; France; P. E. Brandt.

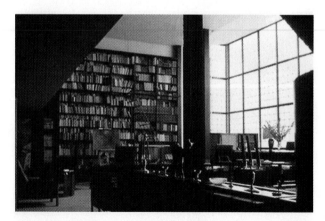

▲ **25-30.** Interior, Maison de Verre, 1928–1932; Paris, France; Pierre Chareau and Bernard Bijvoet.

20th century. Examples include later work by Mies van der Rohe as well as work by Eero Saarinen, I. M. Pei, Richard Meier (Fig. 25-31), Tadao Ando, and Tod Williams and Billie Tsien (see Chapter 31, "Late Modern · 1" and Chapter 33, "Late Modern · 2").

FURNISHINGS AND DECORATIVE ARTS

Furniture and decorative arts follow the concepts and language of design established earlier by the Bauhaus designers and others. Many pieces are by architects. Designs are simple and functional with no applied ornament or references to historical styles. Anonymity, geometry, and hygienic industrial materials are key features. Many pieces incorporate tubular or flat steel for structural support. Although designers want to make well-designed furniture available to everyone, mass production of some of their designs is difficult and/or expensive because of technical innovations in construction that sometimes require hand labor. Furnishings may be built-in or movable to support flexibility in arrangements and different user functions. Modular units and stacking chairs offer additional flexibility. Designers, such as Le Corbusier, sometimes choose bentwood furniture or other simple pieces readily available on the market. Upholstered pieces exhibit an extensive use of black, brown, or natural leather to coordinate with the stark interiors.

Public and Private Buildings

■ *Types.* Seating, tables, and storage units are the most important pieces of furniture (Fig. 25-23, 25-26, 25-29, 25-32, 25-33, 25-34, 25-36).
■ *Relationships.* Furniture arrangements are grouped in relationship to the interior architecture. As a consequence, sofas and chairs may focus on a fireplace, dining tables may align

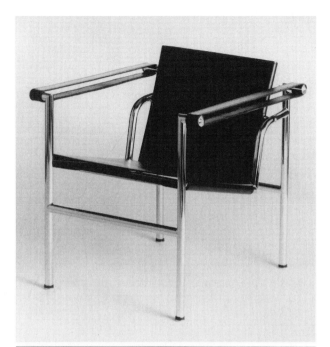

◀ **25-32.** Sandows chair, 1928–1929; France; René Herbst.

on axis with a window or wall openings (Fig. 25-26), and beds may line up parallel to built-in storage units (Fig. 25-37).

■ *Materials*. Steel, aluminum, nickel, and wood are typical furniture materials.

■ *Seating*. Seating consists of side and armchairs, lounge chairs, and sofas (Fig. 25-23, 25-26, 25-29). Le Corbusier, Pierre Jeanneret, and Charlotte Perriand create room ensembles with an array of tubular and flat steel pieces (Fig. 25-33, 25-34, 25-35). Their designs, which emphasize the contours of the human body, are geometric with soft curves. The structural framework is exposed even on fully upholstered chairs and sofas, which is a radical idea at the time. Newly developed flat springs contribute to the development of the simple, uncluttered appearance desired. Some designs are adjustable (Fig. 25-35; see Design Spotlight). Similarly, other designers use tubular steel or metal frames and experiment with different materials for seats. Rene Herbst, for example, uses elastic cords for seats and backs (Fig. 25-32).

■ *Tables*. Square, rectangular, and round tables (Fig. 25-26, 25-36) vary in size and scale based on use. Tops are most often glass because the transparency of the glass does not interrupt the free flow of space. Alternative materials include wood and marble. Both tops and edges are smooth and plain without moldings.

■ *Storage*. Movable and built-in storage units help articulate the division of space within interiors. Most units are integrated with the interior architecture and made in modular sections (Fig. 25-23). They are plain, simple, and unadorned except for simple frames and hardware.

■ *Beds*. Beds are of wood or tubular steel with flat, rubber-coated springs (Fig. 25-37). Most often headboards are low and unobtrusive, so the bed looks mainly like a flat horizontal plane and/or a geometric shape in a room. Twin beds may be grouped together to create a larger sleeping surface.

■ *Upholstery*. Black or natural leather is the most common upholstery material. Other materials include canvas or plain woven cottons or linens and animal skins.

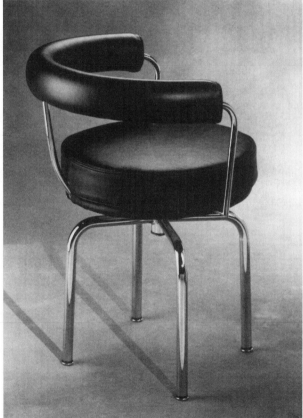

▲ **25-33.** Basculant and model B302 armchairs, and room ensemble, 1928–1929; France; Le Corbusier, Pierre Jeanneret, and Charlotte Perriand.

■ *Decorative Arts*. Decorative accessories are limited to a few, usually functional, pieces, such as bowls or ash trays. Designs, which reveal a machine aesthetic, are simple, geometric, and unornamented.

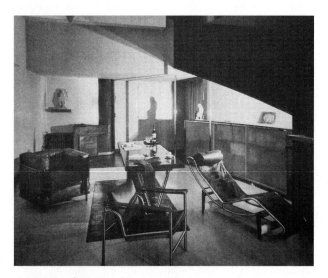

▲ **25-33.** *(continued)*

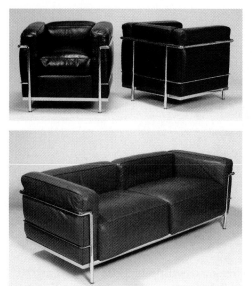

▲ **25-34.** *Grand Confort* armchair and sofa in tubular steel, 1928; France; Le Corbusier, Pierre Jeanneret, and Charlottte Perriand.

DESIGN SPOTLIGHT

Furniture: Chaise Longue, 1928; France; Le Corbusier, Pierre Jeanneret, and Charlotte Perriand. Designed initially for the Villa d'Avray, the Chaise Longue boasts a complicated construction consisting of a separate supporting frame and seat to create a fully adjustable lounge chair. The rectangular supporting frame is of flat steel painted with a matte texture. The seat, composed of three planes that contour to the body, provides maximum comfort. It is covered with a light padding and canvas, leather, or pony hide and connected by steel tension springs to a curving tubular steel frame. A rubber covering on the cross members of the support frame permits the seat to be set at any angle chosen by the user, but one must get up to do so. The idea of adjusting the seat in this manner was new and innovative at the time. Le Corbusier noted that the chair's concept is derived from his idea of a cowboy lounging with his feet raised.

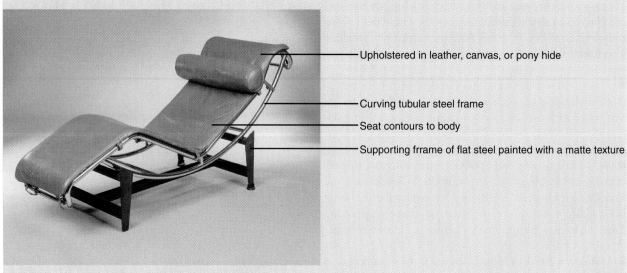

Upholstered in leather, canvas, or pony hide

Curving tubular steel frame

Seat contours to body

Supporting frrame of flat steel painted with a matte texture

▲ **25-35.** Chaise Longue; Le Corbusier, Pierre Jeanneret, and Charlotte Perriand.

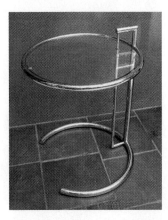

◄ **25-36.** E. 1027 Occasional table, c. 1927–1928; France; Eileen Gray.

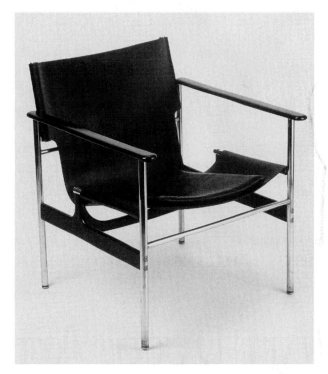

▲ **25-38.** Later Interpretation: Sling Lounge Chair 657, 1960; United States; Charles Pollock, manufactured by Knoll International. Late Modern.

■ *Later Interpretations.* Numerous designers in the 20th century draw inspiration from work by Le Corbusier and his contemporaries. Some include Donald Deskey, Charles Eames and Ray Eames, George Nelson, Gae Aulenti, Warren Platner, and Charles Pollock (Fig. 25-38). While varying in form and style, pieces capture the essence of minimalism, flexibility, modular components, and human scale.

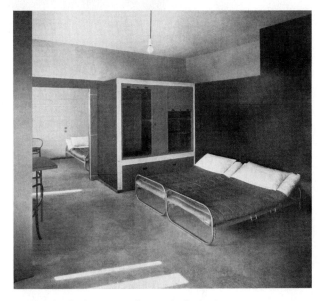

▲ **25-37.** Beds, c. 1928; France; Le Corbusier.

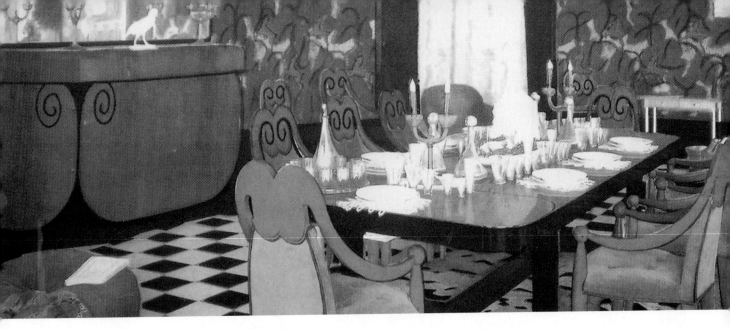

Art Deco, Art Moderne

1920s–Early 1940s

Art Deco is a worldwide style with a diversity of expressions in all the design arts, including architecture, interior design, furniture, decorative arts, graphic design, book arts, fashion, and film. Originating in Paris in the 1910s, this decorative, modern style makes a strong design statement at the Exposition Internationale des Arts Décoratifs et Industriels Modernes held in Paris in 1925. Art Deco expressions range from highly decorative and lavish to geometric and simple. In the 1930s, American designers promote the related Art Moderne or Streamlined Modern, a simplified geometric style with curvilinear forms and modern materials.

HISTORICAL AND SOCIAL

Contrast and change, initiated by the social, political, and economic effects of World War I and continued industrialization, define the years between the two world wars. On one side, there is great growth and prosperity in many

Ours is the era of the Machine. Machinery is creating our style. It is imposing a new tempo and a new mode of life. With shameful sentimentality we still cling to the outgrown "styles" of the past—to houses designed in period styles ridiculously alien to their settings; to gilded gewgaws and polished marbles, to pseudo-period furniture.

Paul Frankl, *Form and Re-Form: A Practical Handbook of Modern Interiors*, 1930

When, in 1925, Paris presented its great Exposition of Modern Decorative and Industrial Arts, the American decorative scene was pretty much becalmed. President Hoover declared in that year that America would not participate in the Paris Fair because we had no modern art. We were still riding high on the building boom that followed the war. And the new houses were being rapidly filled with the same taupe-mohair, three-piece, overstuffed suites which had pocked the face of America for more than a decade. Grand Rapids manufacturers found they could not turn out enough of that cheap, over-elaborate, poorly-constructed and even more poorly-designed stuff known to the trade as "borax", or Bronx Renaissance, to meet the demand for it. There were many persons not yet aspiring even to this mire of mohair. These were still in the golden-oak era.

Emily Genauer, *Interiors Today and Tomorrow*, 1939

countries. Businesses are larger and more complex than ever; factories are producing more new goods; communication is faster and easier; and building booms in many countries provide employment. Additionally, World War I brings a break with the past, so the world becomes

enamored with the idea of Modern. To many people, Modern means the machine, science, business, youth, new roles for women, cityscapes dominated by skyscrapers, speed of the automobile and airplane, and social, economic, and industrial progress. Most people optimistically desire to change the world so that nothing like the Great War can happen again. On the other hand, there is massive devastation, debts, and reparations caused by the war, especially in Germany and among her allies. This, along with a consumer culture that encourages people to live beyond their means, and the increasing income separation between the wealthy and the middle class soon create economic depression and unemployment worldwide.

The widespread adoption of electricity accelerates industrialization and enhances people's lives. The marketplace showcases new materials, such as Vitrolite or Bakelite and man-made fibers (rayon, nylon); new technologies (electric washing machine and vacuum cleaner); and improved products (radio, phonograph). To market these products, manufacturers increasingly focus their promotions and advertising on the opinions and desires of the middle class, which creates mass consumerism. Installment buying becomes the norm for many. A media culture emerges from improvements and leads to further developments in means of communication. After the war, the daily newspaper remains important for news, fashion, and entertainment. More people own radios and read magazines, so are better informed than ever before. Mass entertainment—movies, dance halls, clubs, speakeasies, spectator sports—increases in popularity. Hollywood extends American ideas and culture across the world, first in silent films, and then in "talkies" after 1928. Travel is increasingly easy. More highways, automobiles, buses, trains, and airplanes make the world seem smaller. With an increase in transatlantic travel, luxury cruise ships become important venues for illustrating new ideas. Art Deco develops within and from this cultural landscape.

In 1901, a group of artist–designers, including Art Nouveau designer Hector Guimard (see Chapter 19, "Art Nouveau"), organizes the Société des Artistes Décorateurs (SAD; Society of Decorative Artists). Wanting to promote its work as well as to distinguish it from that of artisans and craftsmen, the group holds exhibitions, which become showcases for new designers, model rooms, and the new, modern style that will be called Art Deco. In 1903, the Salon d'Automne is established to spotlight and endorse independent artists whose work is not supported by official salons. Exhibitors include Emile-Jacques Ruhlmann, Le Corbusier (see Chapter 25, "International Style"), and the Deutscher Werkbund (see Chapter 24, "The Bauhaus"). Elements of Art Deco appear in exhibitions by both of these groups as well as in the furniture and interiors created by individuals, firms, and department stores in early-20th-century Paris. In these early years, examples of Art Deco are largely limited to Paris and focus on the elite. Expressions follow two forms. One is very decorative and more traditional in form and materials, while the other is more modernist and influenced by the Vienna Secession, the Bauhaus, and Le Corbusier.

Early on, members of the Société des Artistes Décorateurs want an international exhibition to highlight French modern decorative arts, but their idea does not come to fruition until after World War I. In 1925, Paris hosts the Exposition Internationale des Arts Decoratifs et Industriels Modernes, which is organized by the French government, not the members of the Société des Artistes Décorateurs, to promote luxury French products to the world and to reestablish France's supremacy in art and decoration. The exhibition ushers in the Art Deco style by promoting a forward-looking approach to design, one that fully unites art and industry. It exhibits Parisian Art Deco or *moderne* and French interior decorators and artists, such as Emile Jacques Ruhlman, Maurice Dufrêne, Robert Mallet-Stevens, and René Lalique, who have developed their styles over the previous decade. Various countries send delegations, but the new movement is essentially activated and supported by French artists and patrons. There is great interest in the exhibition worldwide because no previous exhibition has had as much publicity in newspapers, journal articles, photographs, and prints. Practitioners of the period denote their work as Modern or *Moderne;* the actual term *Art Deco* does not come into general use until the late 1960s after the publication of *Art Déco* by Bevis Hiller.

Following the exhibition, progressive museums, galleries, and department stores in several countries, including Great Britain and the United States, promote Art Deco by displaying objects from the Paris exhibition. Some displays travel, thereby showcasing the work of Art Deco designers to more people. As its reputation as a Modern style catches on, Art Deco spreads and begins to assume a variety of expressions as designers in Australia, eastern Europe, South America, India, and Japan adapt it to their homelands.

Believing it lacks a modern style, the United States does not participate in the Exposition Internationale des Arts Decoratifs et Industriels Modernes. Publicity about the Paris exposition and traveling exhibits of objects from it, imported French furnishings, immigrant French designers, and museum and department store exhibits acquaint American architects, designers, and the public with Art Deco. During the late 1920s and 1930s, the American Art Deco skyscraper becomes a symbol of modernity throughout the world. American designers also democratize the style through interpretations and adaptations of elite examples in affordable materials for the middle class. In the 1930s, the United States replaces France as the most important purveyor of the Art Deco and the later Art Moderne styles. After World War II, she will become the main promoter for modernism, unseating France and Germany.

The American stock market crash in 1929 and subsequent Depression end the country's prosperity and building boom and affect the rest of the world. Widespread unemployment slows consumerism. In response, a plainer, more simplified variation of Art Deco arises. Deriving its imagery from speed and transportation, industrial designs with their stronger machine aesthetic, and the emerging International Style, this variation becomes known as Art Moderne or Streamlined Modern. Stylistic concepts of streamlining come from experiments in aerodynamics and their application to modern means of transportation, such as locomotives and airplanes. Art Moderne is especially important in the United States. Its popularity signals a renewed attempt to lessen her aesthetic dependence upon Europe as designers search for an American style. Throughout the 1920s and 1930s, Hollywood and the movies are an important source of information for the public about Art Deco and Art Moderne (Fig. 26-28). Many films feature elaborate sets using the precepts of both movements. Art Moderne also becomes aligned with consumerism. With profits dwindling, manufacturers and advertisers look for new ways to increase sales. One method is to deliberately and quickly outdate a style, which leads to stylistic obsolescence and ushers in yearly introductions of new models, which usually have only minor and/or decorative changes.

After a period of popularity, Art Moderne and Art Deco gradually decline and disappear with the increasing dominance of the Modern aesthetic, the onset of World War II, and subsequent austerity following the war. During the war, architectural and other commissions are few, so many European designers immigrate to the United States. As a result, American designs evidence a fusion of Art Deco and the new emerging International Style, which will dominate the 1939 World's Fair in New York.

The 30-year popularity of Art Deco and Art Moderne attests to their adaptability and flexibility. Both define a surprising variety of building types, interiors, and furniture for the wealthy and the middle class (Fig. 26-1). They become associated with travel, leisure, entertainment, romance, youth, civic pride, and, in the United States, free trade, and commerce. They can define a corporation; convey a chic image for a restaurant, a ship, or a boutique; create a tropical setting for a hotel; form a social backdrop for the wealthy; become a practical, functional living room for a working woman or modern family; or provide a glamorous set for an equally glamorous movie. Most important, they convey an image of modernity, progress, and the future while retaining a respect for that which has gone before.

CONCEPTS

During the first decade of the 20th century, elements of Art Deco arise in France in the work of a group of progressive

◀ **26-1.** Women's and men's costumes, c. 1920s; France and the United States.

IMPORTANT TREATISES

- *Ensembles Mobiliers à L'Exposition Internationale de 1925,* 1928; Maurice Dufrene.
- *Examples of Modern French Architecture,* 1928; Paul Patout.
- *Exposition Internationale des Arts Décoratifs et Industriels Modernes,* 1925.
- *Form and Re-form: A Practical Handbook of Modern Interiors,* 1928; Paul Frankl.
- *Horizons,* 1932; Norman Bel Geddes.
- *Le Décor Moderne au Cinema,* 1928; Robert Mallet-Stevens.
- *New Dimensions,* 1928; Paul Frankl.
- *The New Interior Decoration: An Introduction to Its Principles and International Survey of Its Methods,* 1929; Dorothy Todd and Raymond Mortimer.

Periodicals: Art et Décoration (1897–1930s), *Art et Industrie* (1922–1935), *Intérieurs Français au Salon des Artistes Décorateurs* (1920s–1930s), *L'Art Vivant* (1925–1938), *Les Arts de la Maison* (1920s), *Mobilier et Décoration* (1930s), *The Studio Yearbook of Decorative Art* (1906–1932).

designers. Their work continues some elements of Art Nouveau, such as the minimalism and geometry of the Vienna Secession (see Chapter 20, "Vienna Secession") and Charles Rennie Mackintosh in Glasgow, Scotland (see Chapter 19, "Art Nouveau") as well as the more stylized, naturalistic expressions in Paris. Whereas Art Deco absorbs some ideas of the Bauhaus, Le Corbusier, and the International Style (hereafter referred to as Modernism), such as function and new materials, it rejects others, such as the

unornamented aesthetic. Art Deco, like other modern developments, embraces the machine and seeks a machine design vocabulary while maintaining good craftsmanship (Fig. 26-2, 26-3), like Art Nouveau. Art Deco respects the past in form and ornament and draws from national or regional traditions.

Like Art Nouveau and Modernism, Art Deco strives to create a style suitable for the modern age. All three movements acknowledge the importance of unity among the arts and the totality of design. But Art Deco does not put modernist faith in the redeeming value of art and neither has it a crusading sprit to improve people's lives. Like Art Nouveau, Art Deco presents a variety of expressions arising from a diversity of influences. It relies far more, than either Art Nouveau or Modernism, upon capitalism and consumerism for dissemination. It pervades all arts, high-style first and then popular, in many countries.

Art Deco draws inspiration from many Western and non-Western sources, including avant-garde art, design, and architecture. An important one comes from the 1909 work for the Ballet Russes in Paris by costume designer Erté who adapts elements from Russian folk art and the brilliant colors of Symbolist painting to the theater. Costumes and sets show design coordination and reflect naiveté, vivid colors, abstract designs, and Persian and Oriental influences. Many Art Deco designs reflect the influence of avant-garde art movements, such as Cubism, Futurism, Expressionism, and Fauvism, in forms, colors, and use of non-Western elements. The style also adopts exotic influences, particularly those of Africa, Egypt, and Latin America. African designs, colors, and concepts materialize because of various exhibitions of African art in Paris, the popularity of jazz music, and the influence of Cubism. In 1923, the opening of King Tutankhamen's tomb in Egypt renews interest in Egyptian designs and motifs. During the 1920s and 1930s, exhibitions, publications, and collections promote the Indian cultures of North and South America. As a result, Native American, Mexican, and Peruvian designs grow increasingly popular, particularly in textiles and pottery.

Art Moderne, which has less ornament than Art Deco, retains influences from avant-garde art movements, particularly abstraction, and some exotic elements. Among its main influences are the idea of speed, as derived from trains and automobiles, and sleek aerodynamic forms of industrial design.

DESIGN CHARACTERISTICS

Art Deco modernizes forms and ornament of the past through stylization and contemporary colors and materials. Art Moderne, in contrast, looks to the future and adopts principles of simplification and abstraction based on speed and motion.

■ *Art Deco*. Designs reflect a coordinated and integrated approach for total unity. Early examples are primarily the artists' creations intended for the elite and emphasize aesthetics over function, extravagant materials, and custom designs. Forms often reflect a traditional influence, such as Rococo or Neoclassicism. Solid and void as well as light and dark relationships are important. Rich decoration in the form of two-dimensional or shallow bas-relief ornament drawn from many sources is a definitive characteristic.

Building forms and ordering take either of two approaches. Some have classical elements, such as columns, and attributes, such as symmetry. Others reflect a more Modernist approach with simple geometric compositions. No matter what the overall form, color and stylized and abstracted geometric, floral, and figural decoration are key characteristics of Art Deco architecture. Skyscrapers are slender volumes with setbacks and ornament at important points.

Interiors reflect a variety of design approaches, which may be singular or mixed. Early examples are classically inspired with lavish ornament and materials. Some, especially later, are closer to architecture with verticality, stepped lines, and profuse stylized ornament. Some are architectural, while others are decorative. Art Deco designers who are influenced by the precepts of the Bauhaus and Le Corbusier adopt a more functional and practical approach, sometimes with an eye toward mass production. In their work, forms become geometric or biomorphic and machine-inspired. Ornament is less profuse and concentrates at important points. Hard edges often softened by curves, sleekness, and new or industrial materials, such as tubular metal, are characteristic.

The underlying forms of much Art Deco furniture is derived from past styles, particularly those of the 18th century, but its stylized and lavish ornament identifies it as Art Deco. Outlines may be curvilinear, stepped, or layered. Another variation has simple forms and minimal ornament and is made of modern and/or industrial materials.

■ *Art Moderne*. During the 1920s with the advent of Art Moderne, buildings, interiors, and objects show influences from trains, automobiles, and airplanes. Forms become simplified, sleek, and efficient. Surfaces are smooth and corners rounded. Horizontality is emphasized through shape and with contour lines. Ornament is kept to a minimum so as to not disturb an aerodynamic appearance. New materials, such as Vitrolite and tubular steel, are characteristic.

■ *Motifs*. Natural motifs (Fig. 26-7, 26-10, 26-23, 26-31, 26-32, 26-38, 26-41) include stylized flowers and garlands, banana leaves, stylized water fountains, feathers, doves, deer or antelopes, elephants, greyhounds, exotic

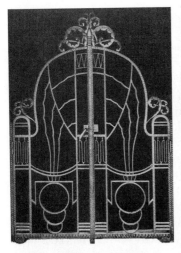
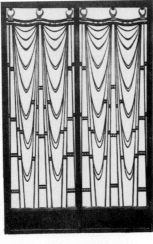
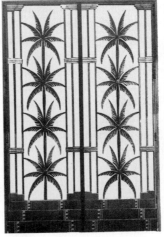
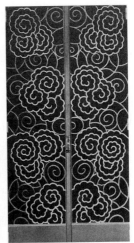

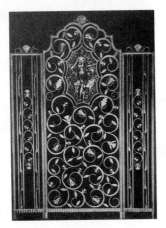
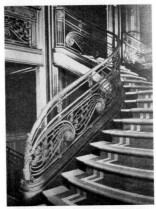

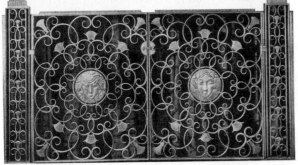
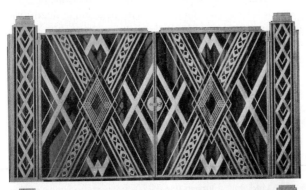

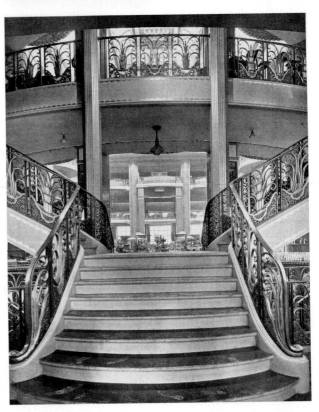

▲ 26-2. Iron entry gate portals, stairs, and balustrades,
c. 1920s–1930s; France.

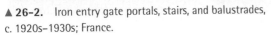

animals, human figures, sun rays and sunbursts. Geometric motifs (Fig. 26-2, 26-3, 26-9, 26-15, 26-16, 26-17, 26-24, 26-26, 26-28, 26-33, 26-35, 26-38, 26-48) that are machine-inspired include circles, spirals, squares, rectangles, diamond shapes, chevrons, lightning bolts, parallel lines, and striped bands. Female figures appear as spotlights in wall murals and decorative arts objects. Other exotic motifs derive from the Ballet Russes, Egypt, African art, and Oriental influences.

ARCHITECTURE

Art Deco architecture develops from the application of stylized and abstracted geometric, floral, and figural decoration to classical and modernistic forms. Many Art

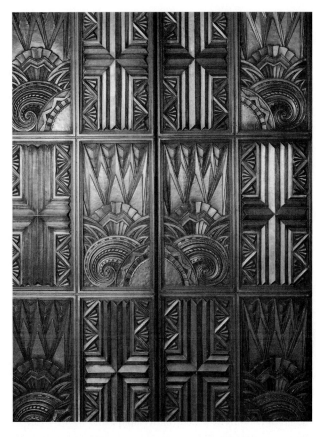

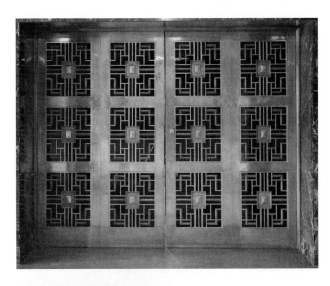

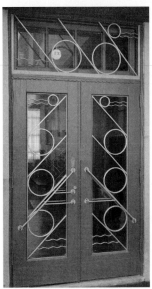

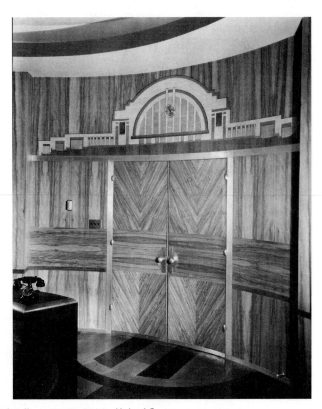

▲ **26-3.** Doors and architectural details, c. 1920s–1930s; United States.

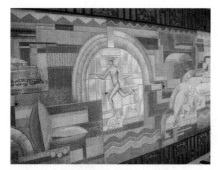

▲ **26-3.** *(continued)*

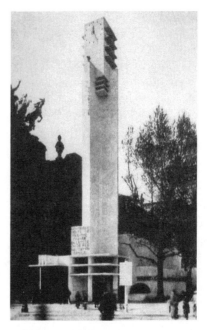

▲ **26-4.** Tourism Pavilion, published in *Exposition Internationale des Arts Décoratifs et Industriels Modernes*, 1925; Paris, France; Robert Mallet-Stevens.

Deco architects are classically trained, but they also are influenced by modern movements, such as Expressionism or De Stijl, and design trends and experiments of the period including those of the Bauhaus or theories of Le Corbusier. Consequently, some buildings display classical attributes, such as symmetry, mathematical proportions, and classical elements and motifs such as columns or pilasters. Others display the symmetrical or asymmetrical geometric, simplified compositions of Modernism. Unlike Modernism, which eschews ornament of any kind, these expressions use brilliant colors and some applied ornament. The Art Deco architectural vocabulary and its language of ornament prove highly adaptable to any theme, image, or message that a designer anywhere wants to convey in the building image.

Art Deco style architecture is rare before the Exposition Internationale des Arts Décoratifs et Industriels Modernes in 1925. At the exposition, the straight lines, cubic and curving forms, layered façades, projecting horizontal planes, prominent entryways, stepped rooflines, and lavish ornament of the French pavilions confront visitors and make a strong design statement (Fig. 26-4, 26-5, 26-6).

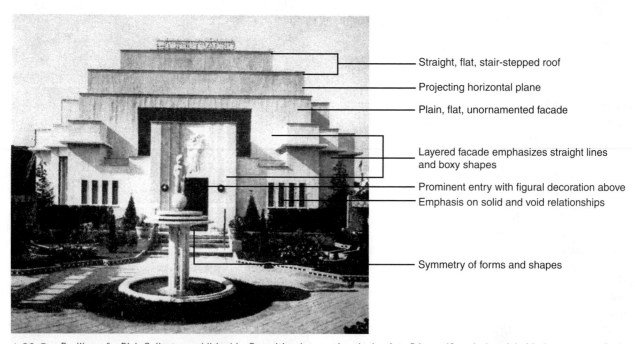

Straight, flat, stair-stepped roof

Projecting horizontal plane

Plain, flat, unornamented facade

Layered facade emphasizes straight lines and boxy shapes

Prominent entry with figural decoration above
Emphasis on solid and void relationships

Symmetry of forms and shapes

▲ **26-5.** Pavilion of a Rich Collector, published in *Exposition Internationale des Arts Décoratifs et Industriels Modernes*, 1925; Paris, France; Emile-Jacques Ruhlmann and Pierre Patout (Ruhlmann Group).

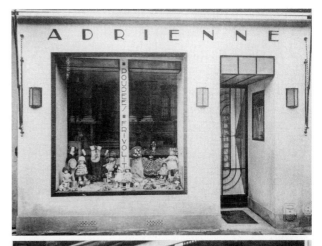

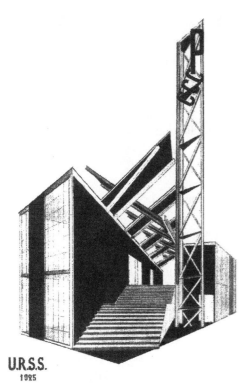

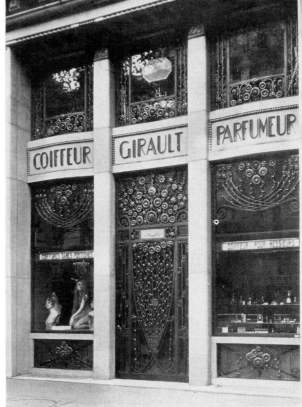

U.R.S.S.
1925

▲ **26-6.** USSR Pavilion, published in *Exposition Internationale des Arts Décoratifs et Industriels Modernes*, 1925; Paris, France; Konstantin Melnikov.

Because the pavilions are temporary, designers freely experiment with form, color, and unusual materials, such as laminates. These characteristics become common in architecture in the late 1920s through the early 1930s, primarily in skyscrapers and buildings associated with modern life, such as power stations, movie theaters, and airports.

The plainer, more volumetric Art Moderne or Streamlined Modern appears in the late 1920s. Like Art Deco, Art Moderne defines numerous building types and other structures such as dams and bridge supports. Characteristics are rounded corners, cantilevered eyebrows or projections over doors and windows, glass block or porthole windows, bands of windows, projecting and open linear balustrades, and minimal ornament, most often with an asymmetrical arrangement. Later, Art Moderne residential structures attempt to displace the popularity of the period house in the United States.

An important legacy of Art Deco is the use of new and creative lighting designs made possible by the widespread adoption of electricity. Inspired by the spectacular lighting of the Eiffel Tower at the Exposition Internationale des Arts Decoratifs et Industriels Modernes in 1925, architects develop night architecture in which lighted buildings make strong design statements after dark.

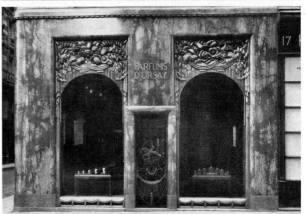

▲ **26-7.** Shop fronts, 1926–1928; Paris, France.

IMPORTANT BUILDINGS AND INTERIORS

- **Albuquerque, New Mexico:**
 - KiMo Theater, 1925; Carl Boller. Pueblo Deco.

- **Baton Rouge, Louisiana:**
 - New State Capitol, 1932; Weiss, Dreyfous, and Seiferth.

- **Berlin, Germany:**
 - Universum Cinema, 1926–1928; Eric Mendolsohn.

- **Cincinnati, Ohio:**
 - Cincinnati Union Terminal, 1929–1933; Fellheimer and Wagner.
 - Carew Tower-Netherland Plaza Hotel, 1930; Walter Ahlschlager with Delano and Aldrich.

- **Honolulu, Hawaii:**
 - Honolulu Academy of Fine Arts, 1926–1927; Bertram G. Goodhue.

- **Kansas City, Missouri:**
 - Municipal Auditorium, 1934–1936; Alonzo H. Gentry Voskamp and Neville Hoit, Price and Barnes.

- **Lincoln, Nebraska:**
 - Nebraska State Capitol, 1922–1932; Bertram G. Goodhue.

- **London, England:**
 - Daily Express Building, Fleet Street, 1930–1932; Herbert Ellis, and W. L. Clarke, with Owen Williams.
 - Gillette Factory, 1936; Sir Bannister Fletcher.
 - Hoover Factory, 1932; Wallis, Gilbert, and Partners.
 - Hornsey Town Hall, 1935–1937; R. M. Uren, Slate and Moberly.
 - Lounge, Claridges Hotel, 1930; redecorated by Oswald P. Milne.
 - National Radiator Company Building, 1928; Raymond M. Hood and Gordon Jeeves.
 - New Victoria Cinema, 1930; Trent and Lewis.
 - Odeon Theater, Leicester Square, 1937; Harry W. Weedon and Andrew Mather.
 - Strand Palace Hotel, foyer, 1929; Oliver P. Bernard.

- **Los Angeles, California:**
 - Academy Theater, 1939; S. Charles Lee.
 - Bullocks Wilshire Department Store (now Southwestern Law School), 1928; John Parkinson and Donald Parkinson.
 - Coca-Cola Bottling Company, 1936–1937; Robert V. Derrah.
 - Grauman's Chinese Theater, 1927; Meyer and Holler.
 - Los Angeles Public Library, 1925–1926; Bertram G. Goodhue.
 - Pan Pacific Auditorium, 1935; William Wurdeman and Welton Becket.
 - Richfield Building, 1928–1930; Morgan, Walls, and Clements.

- **Miami Beach, Florida:**
 - Century Hotel, 1939; Henry Hohauser.
 - Cardoza Hotel, 1939; Henry Hohauser.
 - Hotel Taft, 1936; Henry Hohauser.
 - Main Post Office, 1937–1939; Howard L. Chesney.
 - The Carlyle Hotel, 1941; Kichnell and Elliott.

- **Montreal, Canada:**
 - Alfred Building, 1928.

- **New York City, New York:**
 - Chrysler Building, 1928–1930; William Van Alen.
 - Empire State Building, 1930–1931; Shreve, Lamb, and Harmon.
 - Rockefeller Center and Radio City Music Hall, 1931–1940; Reinhard and Hofmeister, Harvey W. Corbett, Raymond Hood, and Edward Durell Stone, with Donald Deskey on interior decoration.

- **Oakland, California:**
 - Paramount Theater, 1931; Miller and Pflueger.

- **Paris, France:**
 - Houses on rue Mallet-Stevens, 1927; Passy area; Robert Mallet-Stevens.
 - Musée d'Art Moderne, 1937; J. C. Dondel.
 - Pavilion for Baccarat Glass, Exposition des Arts Décoratifs et Industriels, 1925; Georges Chevalier.
 - Pavilion of a Rich Collector, Exposition des Arts Décoratifs et Industriels, 1925; Emile-Jacques Ruhlmann and Pierre Patout.
 - Porte de la Concorde, Exposition des Arts Décoratifs et Industriels, 1925; Pierre Patout (Ruhlmann Group).
 - Tourism Pavilion, Exposition des Arts Décoratifs et Industriels, 1925; Robert Mallet-Stevens.
 - USSR Pavilion, Exposition des Arts Décoratifs et Industriels, 1925; Konstantin Melnikov.

- **Phoenix, Arizona:**
 - Arizona Biltmore, 1929; Albert Chase MacArthur.

IMPORTANT BUILDINGS AND INTERIORS

- **Roquebrune-Cap-Martin, France:**
 - Seaside house, 1929; Eileen Gray and Jean Badovici.
- **Sidney, Australia:**
 - Maritime Services Board (Museum of Contemporary Art), designed 1930s and built 1952; William Henry Withers.
- **Tokyo, Japan:**
 - Prince Asaka Residence (Tokoyo Metropolitan Teien Art Museum), 1933; Imperial Household Department.
- **Tulsa, Oklahoma:**
 - Theodore N. Law House, 1935; William H. Wolaver.
 - Riverside Studio, 1929; Bruce Goff.

- John L. Shakely House, 1937.
- Tulsa Air Terminal Administration Building, 1928; Jesse L. Bowling and Isadore Shank.
- Tulsa State Fairground Pavilion, 1932; Leland I. Shumway.
- **Washington, D.C.:**
 - Folger Shakespeare Library, 1932; Paul Philippe Cret with Alexander B. Trowbridge.
 - Greyhound Bus Terminal, 1938; W. S. Arrasmith.

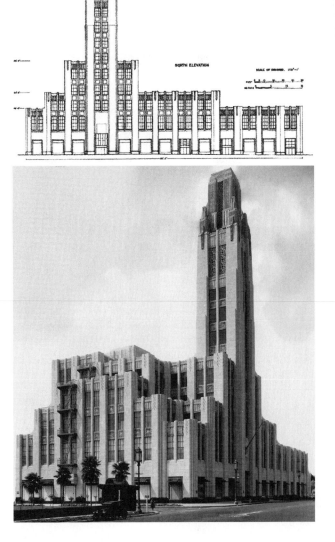

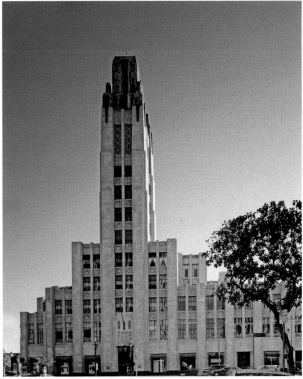

▲ **26-8.** Bullocks Wilshire Department Store, now Southwestern Law School, 1928; Los Angeles, California; John Parkinson and Donald Parkinson.

DESIGN SPOTLIGHT

Architecture: Chrysler Building, 1928-1930; New York City, New York; William Van Alen. Designed for the Chrysler Corporation, this building is an Art Deco architectural icon. The stainless steel pointed tower and spire are among the most recognizable architectural details in New York City. Designed by William Van Alen, the 77-story skyscraper was briefly the world's tallest building. It is of white brick trimmed with gray brick. Entrances are triangular shaped and trimmed with gray. The ornament, most of which is almost too small to be seen from the street, is inspired by automobiles. At the setback on the 31st story are winged radiator caps and a frieze of stylized hub caps. Stainless steel gargoyles highlight the setback and beginning of the tower at the 59th story. The tower, which rises seven stories, is composed of rounded sunbursts with triangular windows and culminates in a spire. The triangular lobby is an Art Deco masterpiece. The floor is red marble, and the walls are yellow-ochre trimmed with amber and blue. On the ceiling is a fresco by Edward Turnbull titled "Energy, Result, Workmanship, and Transportation." It shows airplanes, buildings, and the Chrysler assembly line. The inlaid wood and metal on the elevator doors repeat elements of the tower with details forming arcs and foliage.

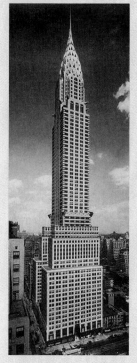
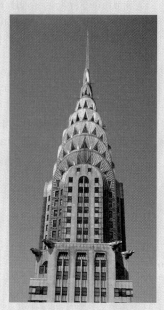

▲ **26-9.** Chrysler Building, New York City.

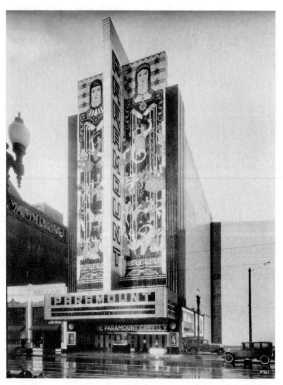
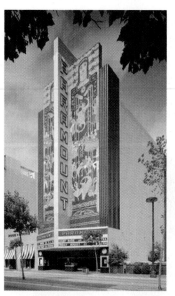
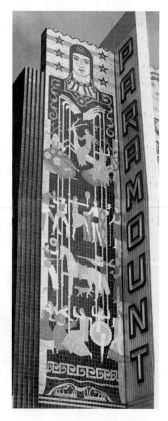

▲ **26-10.** Paramount Theater, 1931; Oakland, California; Miller and Pflueger.

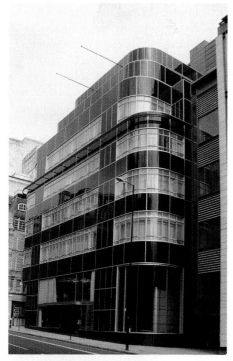

Characteristics include internal illumination made visible through transparent walls and dramatic exterior lighting in which the newly popular neon plays a major role. Architects use colorful neon lighting to generate excitement and create rhythms and focal points. Additionally, uplights, downlights, and concealed lighting emphasize important forms, volumes, and/or ornament.

Public and Private Buildings

■ *Types*. New commercial structures include theaters (Fig. 26-10, 26-18), skyscrapers (Fig. 26-9, 26-18), office buildings (Fig. 26-11), diners (Fig. 26-15), bus stations (Fig. 26-14), airports, gas stations, and power stations. Other structures revealing the Art Deco character include factory buildings (Fig. 26-12, 26-16), train and subway stations (Fig. 26-13), luxury cruise ships, hotels (Fig. 26-17), restaurants, boutiques (Fig. 26-7), beauty shops, barbershops, department stores (Fig. 26-8), exhibition buildings (Fig. 26-4, 26-5, 26-6), churches, schools, civic structures, apartment complexes, and houses (Fig. 26-19, 26-20).

▲ **26-11.** Daily Express Building, Fleet Street, 1930–1932; Herbert Ellis, and W. L. Clarke, with Owen Williams.

▲ **26-12.** Hoover Factory, 1932; London, England; Wallis Gilbert and Partners.

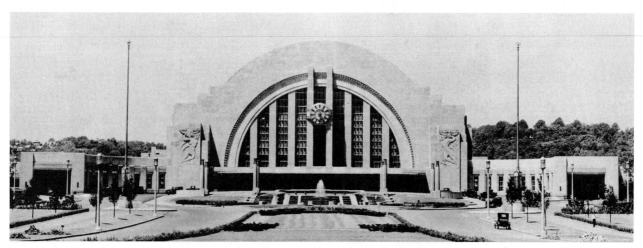

▲ **26-13.** Cincinnati Union Terminal, 1929–1933; Cincinnati, Ohio; Fellheimer and Wagner.

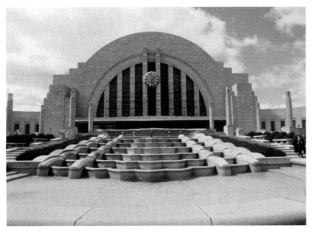

▲ **26-13.** *(continued)*

■ *American Skyscrapers.* America's significant contribution to architecture during the period is the Art Deco skyscraper (Fig. 26-9, 26-18). Architects build upon earlier precedents, such as the Woolworth Building (1911–1913), in which ornament at strategic points emphasizes the building's verticality and a richly decorated lobby makes a design statement. A second precedent is the design competition for the Chicago Tribune Tower held in 1921. Although the winning entry is Gothic Revival, submissions show the limitations of historical styles to define modern buildings. A third, more important influence is the 1916 New York zoning law, which requires setbacks on tall buildings to permit light and air to penetrate to the streets below. The number and size of setbacks are dependent upon the height of the building and width of the street. The law challenges architects to come up with solutions that meet both their clients' needs for space and the code requirements. Ultimately, they create skyscrapers with sculptural, complicated forms and a variety of volumes. Most typical is the tall, slender, usually pointed, central tower surrounded by wider geometric forms at the base. These forms influence skyscrapers in the rest of the country.

■ *Theaters, Cinemas, Movie Palaces.* The film industry is an important and influential purveyor of design, in both movies and movie houses. Consequently, cinemas or movie palaces, sometimes dubbed "atmospheric theaters," proliferate as fantasy escape environments across Europe and America (Fig. 26-10, 26-18). The buildings and interiors often are collaborations of architects, artists, and designers. Some convey a modernist image, while others illustrate exotic cultural influences from countries such as China, Egypt, Africa, and Spain. Still others depict historical periods, nautical environments,

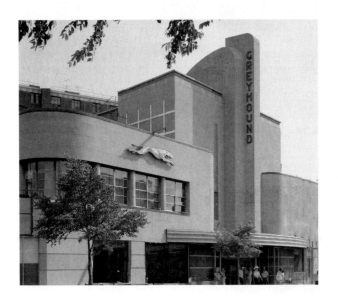

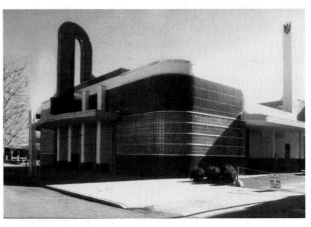

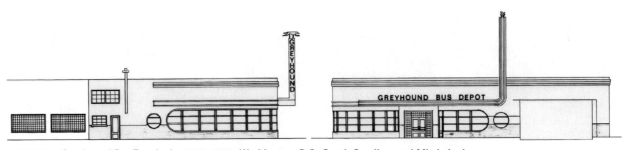

▲ **26-14.** Greyhound Bus Terminals, 1938–1939; Washington, D.C., South Carolina, and Mississippi.

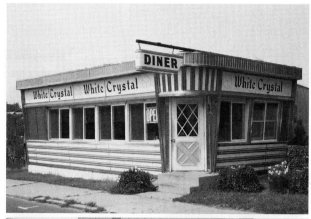

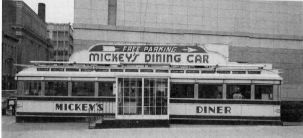

▲ **26-15.** Diners, c. 1930s; New Jersey and Minnesota.

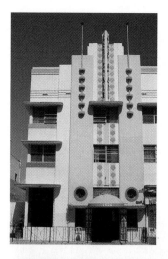

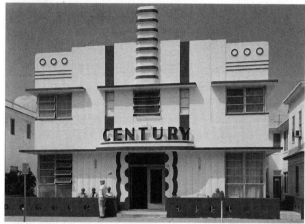

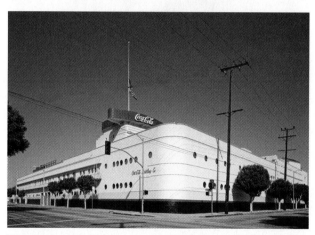

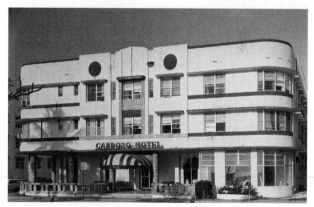

▲ **26-17.** Greystone Hotel, Century Hotel, and Cardoza Hotel, 1935–1939; Miami Beach, Florida; Henry Hohauser (Century and Cardoza).

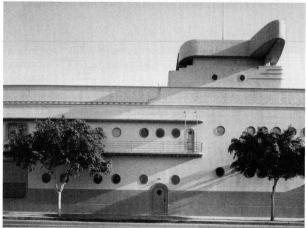

▲ **26-16.** Coca-Cola Bottling Company, 1936; Los Angeles, California; Robert V. Derrah.

fairy tales, and the Wild West in the United States. The overall intent is to create a theatrical experience that makes a lasting impression.

■ *America's Miami Beach Art Deco.* Mainly dating to the 1930s when the area was a haven for resort vacationers, Miami Beach boasts more than 400 hotels (Fig. 26-17), theaters, apartment buildings, houses, and other types of

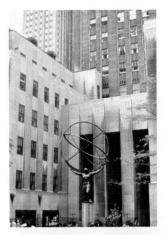

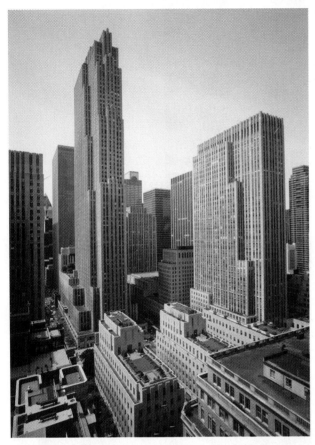

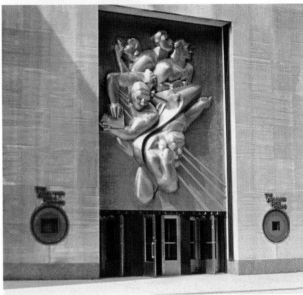

▲ **26-18.** Rockefeller Center 1931–1940; New York City, New York; Reinhard and Hofmeister, Harvey W. Corbett, Raymond Hood, and Edward Durell Stone, with Donald Deskey on interior decoration.

structures in the Art Deco and Art Moderne styles. It possesses the world's largest collection of buildings in these styles. Designs have various combinations of flat and curved walls, circular windows, rows of vertical or horizontal lines, plain walls, surface ornamentation, metal railings, and the use of glass blocks. Compositions are strongly geometric, streamlined, and theatrical with pastel or clear colors, so the architecture is often referred to as Tropical Deco.

■ *Site Orientation.* Large and important buildings in urban areas are sited on major city streets to ensure easy access (Fig. 26-9, 26-11, 26-16, 26-18). Fronts of buildings most often are parallel to the street. Architects usually place exhibition buildings within parklike settings near or in city centers along a well-defined circulation axis (Fig. 26-4, 26-5, 26-6). Because of the popularity of automobile travel, diners, whose forms are derived from railroad dining cars, sit along roadsides or find havens in city neighborhoods near transportation hubs (Fig. 26-15). In Europe and North

America, architects group similarly designed houses together in preplanned neighborhoods in cities or suburbs (Fig. 26-19, 26-20).

■ *Floor Plans.* Plans vary in size and configuration based on building use and spatial requirements. They may be symmetrical or asymmetrical, but usually emphasize regularity developed through a preponderance of square and rectangular spaces. Horizontal and vertical circulation patterns are direct, controlled, and centralized. Commercial structures often have a prominent, large entry and lobby to indicate welcome and to support the movement of people. In the 1930s, middle-class houses and apartments have multipurpose spaces reflecting the continued trend toward smaller residences (Fig. 26-34).

■ *Materials.* Building materials include traditional ones, such as white or colored bricks and stone, and newer materials, such as reinforced concrete and steel, which are mixed with more traditional ones such as plaster cladding and glass. Some traditional materials assume more innovative

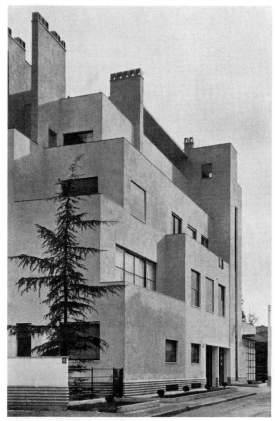

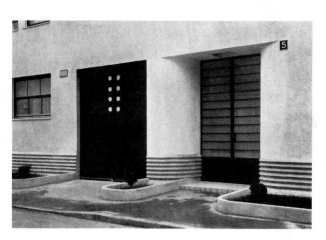

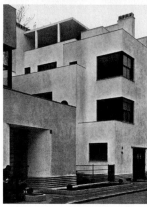

▲ **26-19.** Houses on rue Mallet-Stevens, 1927; published in *Examples of Modern French Architecture*, 1928; Passy area, Paris, France; Robert Mallet-Stevens.

forms. An example is glass, which can be used as a building covering or for walls as glass blocks. Sold as Carrara glass or Vitrolite, glass panels may be colored, cut, sculpted, or curved. Glass, which gives a new or an older building a sleek and shiny modern look outside and inside, appears on and in many Art Moderne structures in the 1930s. Frequently, buildings display accents of stainless steel, aluminum, or other metals, colorful terra-cotta tile cladding and/or decoration, gilding, and decorative iron grilles or gates (Fig. 26-2, 26-9, 26-11, 26-17). Designers of thematic theaters sometimes incorporate a wide diversity of materials to create a distinctive and unusual appearance (Fig. 26-10).

■ *Façades*. Building façades vary in design based on the individual architectural need or patron's desire, but they commonly appear as sleek, elegant, and monumental design compositions. Forms can take a variety of design interpretations within an overall, unified character. Some buildings are blocky and boxlike, while others are tall and slim. Most convey simplicity, regularity, and austerity. Generally, Art Deco buildings show three-dimensionality composed of layered flat surfaces and projecting vertical or horizontal planes (Fig. 26-4, 26-5, 26-6, 26-10, 26-11, 26-14, 26-17, 26-18, 26-19). Solid and void and light and dark relationships are carefully planned and delineated. Straight lines dominate compositions. Ornament, which is a defining element, is usually low relief, and highlights important parts. Although many buildings have architect-designed concepts with iconographies suited to the client,

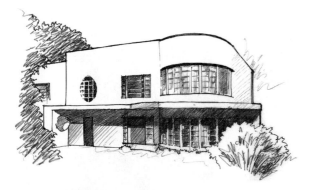

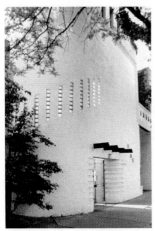

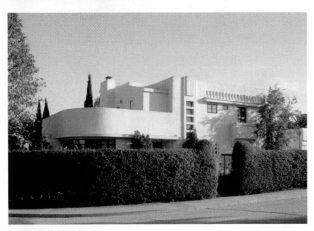

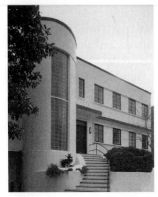

▲ 26-20. Houses, c. 1920s–1930s; Oklahoma, Illinois, California, and Washington, D.C.

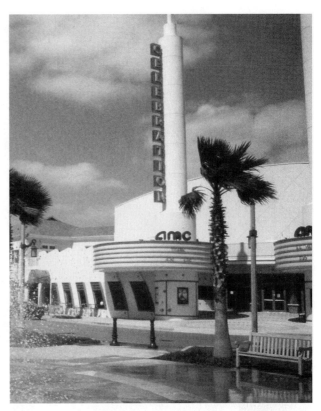

▲ 26-21. Later Interpretation: Cinema, 1996; Celebration, Florida; Cesar Pelli and Associates.

others have characteristic Art Deco ornament acquired from stock items sold by manufacturers. Some Art Deco buildings are cubic or geometric in form with straight lines, horizontal emphasis, and minimal ornament, like Modernist ones. More extensive use of color, materials, or lighting usually identifies them as Art Deco.

Art Deco skyscrapers and some office buildings have a strong vertical emphasis, surface enrichment, and stepped rooflines, frequently with symmetrical ordering (Fig. 26-9, 26-18). Decoration in horizontal bands or panels beneath windows establishes a counter rhythm. Color may delineate the entire building through materials or accentuate important parts, such as corners or entrances, and applied decoration. Ornament consists of sunbursts, stylized fountains, chevrons, zigzags, lightning bolts, overlapping squares or arcs, stylized flowers or foliage, and people. The decoration may be vertical to emphasize height, and it frequently signals setback portions or changes in height. Other Art Deco buildings, particularly movie theaters (Fig. 26-10), have towers and vertical projections, patterns of vertical ribs organizing the façade, and decorative elements to accent prominent architectural features, such as entries.

Art Moderne buildings illustrate a more horizontal emphasis with repeating striped bands that may be horizontal and/or vertical; projecting and open linear balustrades on porches, balconies, or parapets; smooth walls; rounded

DESIGN PRACTITIONERS

- **La Compagnie des Arts Français** (Süe et Mare) is a group of artists, designers, and craftsmen, headed by Louis Süe and André Mare, that works together to create Art Deco interiors in Paris. Designs, which are often theatrical, reveal Louis XV and Louis XVI antecedents with the addition of modern, stylized details and motifs. The firm's best-known works are the Musée d'Art Contemporain at the 1925 Paris exhibit and the grand salon of the S. S. *Ile-de-France*.

- **Donald Deskey** (1894–1989), inspired by the Paris exhibit of 1925, returns to New York and opens a design firm with Phillip Vollmer. The firm designs furniture, model rooms, window displays for department stores, and interiors for a host of clients, including Helena Rubinstein and John D. Rockefeller. Deskey's furniture, usually of aluminum, chrome, and Bakelite, varies from geometric to biomorphic.

- **Jean Dunand** (1877–1942) is a preeminent designer of metalwork and sculpture but is primarily known for his lacquerwork, which he uses to decorate vases, panels, and furniture. He uses numerous decorative effects in his work, including the application of crushed eggshells for texture. He contributes lacquered furniture and panels for luxury oceanliners such as the S. S. *Ile-de-France* and the S. S. *Normandie*.

- **Raymond Hood** (1881–1934) becomes well known after winning the design competition for the Chicago Tribune building with John Mead Howells in 1922. Over the next 12 years, Hood designs several of the most important Art Deco buildings in New York City, including the American Radiator Building (1924) and the McGraw-Hill Building (1929–1930), and he collaborates on Rockefeller Center (1932).

- **Eileen Gray** (1878–1976) is one of the most important female designers of her day. She becomes interested in lacquerwork and apprentices with Japanese master Seizo Sugawara. Her red lacquer screen in the 1913 Société des Artistes Décorateurs (SAD) exhibit brings her further commissions, so she begins designing furniture and interiors and opens her own shop in 1922. Gray also designs houses in the Modern or International Style although she has little training. One of her best-known furniture pieces is the Pirogue daybed, c. 1919–1920.

- **Betty Joel** (1894–1985) is an interior and furniture designer in London. She has her own furniture manufacturing plant. Although she works for well-known, wealthy clients such as Winston Churchill, her work is functional and practical. She designs a line of furniture for working women that has curving corners and no carving or ornament so that it is easy to clean and maintain.

- **Rene Lalique** (1860–1945) is the best-known Art Deco glassmaker, producing vases, tableware, lamps, mirrors, chandeliers, and hood ornaments for automobiles. Originally a noted Art Nouveau jewelry maker, Lalique turns to glass in the early 20th century. He produces perfume bottles for Coty and other perfumers. His pavilion at the 1925 Paris exhibit wins international acclaim, particularly for its 45'-0" tall fountain. Other noteworthy projects include interior decorations and tableware for the S. S. *Normandie* in 1935.

- **Robert Mallet-Stevens** (1896–1945) is a modernist architect who also designs interiors and furniture. Color, geometry, modern materials, and open spaces characterize his work. His Pavillion du Tourism at the 1925 Paris exhibit becomes a model for Art Deco. His most noteworthy projects include homes on rue Mallet-Stevens, Paris. He is one of the founders of the Union des Artistes Modernes (UAM).

- **Emile-Jacques Ruhlmann** (1878–1973) is the premier French interior decorator and furniture designer in the early 20th century. After making his debut in the 1913 Salon d'Automne, Ruhlmann opens his own firm, Rulhman et Laurent, in 1919. His 1925 Paris exhibit pavilion, Pavilion of a Rich Collector, brings him international recognition. His work, which is usually for wealthy, sophisticated clients, shows inspiration from traditional French 18th- and early-19th-century forms. Ruhlmann uses only the finest of materials in his rooms and furniture and is noted for his attention to detail.

- **Josef Urban** (1872–1933), trained in Vienna, moves to America in 1911 where he becomes the principal set designer for the Boston Metropolitan Opera. After moving to New York about 1914, Urban begins designing sets for the famous Ziegfeld Follies. Urban also creates sets for other theater productions and in the 1920s begins designing Art Deco style movie sets.

corners; and bands of windows. Compositions may be rectangular blocks or geometric and/or rounded in form. Ornament and color are usually kept to a minimum except when colorful structural glass is used. Houses may emulate commercial structures in overall form and design, but in a smaller scale.

■ *Windows.* Mass production influences all window designs. Sizes vary, but are standardized for efficiency, ordering, and use. Most windows are framed in flat metal bands set flush with the walls. Common examples include rectangular windows that may be fixed, sliding, casement, or double hung; rows of glass blocks in large wall sections; and porthole windows like those on ships (Fig. 26-7, 26-11, 26-16, 26-17, 26-19, 26-20). Corner windows are frequent. Vitrolite panels may frame and/or accentuate windows. Some Art Moderne examples have eyebrows or cantilevered projections over windows.

■ *Doors.* Entry doors are usually simple and blend in with the overall building design (Fig. 26-3, 26-7, 26-19). But some feature decorative metal or ironwork in distinctive compositions. Placement, light and dark contrast, and/or a horizontal canopy may spotlight them on the facade. On some commercial buildings, the area above the entry doors exhibits structural decoration (Fig. 26-10, 26-18), color change, large signage, and/or interesting lighting as a way to mark the primary entrance, as shown in Miami Beach hotels (Fig. 26-17). Colorful Vitrolite panels and details and eyebrows or cantilevered projects often accent entrances of Art Moderne buildings.

■ *Roofs.* Prominent towers and other vertical projections often highlight Art Deco structures (Fig. 26-4, 26-6, 26-8). Sometimes unique shapes and distinctive materials define the roof's architectural appearance, as in the Chrysler Building (Fig. 26-9). Movie theaters with cultural or historical influences may have unusual roof shapes that relate specifically to a country or period. Roofs on Art Moderne residences and commercial buildings are often flat and/or stepped to create a layered look. Rather than using large moldings, designers trim the edges with narrow bands or a small projecting ledge that may contrast in color to the main body of the structure.

■ *Later Interpretations.* After World War II, particular components of Art Deco and Art Moderne, such as flat roofs and/or plain facades, consistently reappear in International-Style architecture. In the late 1960s, Art Deco is rediscovered and becomes an important part of preservation movements in many countries. Buildings are preserved, rehabilitated, and adaptively used. Numerous books and articles describe and promote the style. Art Deco societies hold exhibitions and sponsor lectures and tours. During the late 1980s through the early 21st century, these influences resurface in hospitality environments such as movie theaters, hotels, and theme parks (Fig. 26-21). In the late 20th century, Art Deco and Art Moderne buildings inspire Post-Modern architects, such as Michael Graves, Robert Venturi, and Ettore Sottsass.

INTERIORS

Interior design, designers, and decorators become more important in the Art Deco period. Working individually, in partnerships, in design firms, or department stores, progressive French artistic designers, not architects, develop the style during the 1910s. Appearing first in individually designed interiors for well-to-do clients, the style arises from a renewed importance of and emphasis upon decoration and the supremacy of the designer's creativity. The individuality of the client surpasses Modernist universal concepts of interior design. Inspired by French 18th- and 19th-century styles, early Parisian Art Deco interiors have an underlying classical simplicity and organization of forms. Classical motifs may be evident in moldings or ornament. Superb craftsmanship, expensive materials, and lavish decoration that derives from many sources are definitive characteristics.

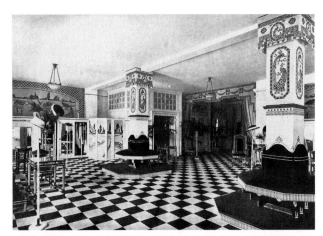

▲ **26-22.** Shop interior; published in *The Room Beautiful*, 1915.

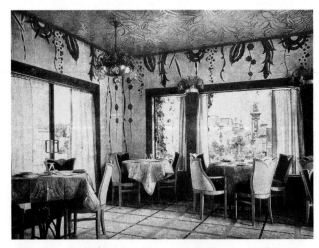

▲ **26-23.** "La Maitrise" restaurant; Paris, France; published in the *Exposition Internationale des Arts Décoratifs et Industriels Modernes*, 1925; Maurice Dufréne.

Art Deco interiors exhibit great variety in stylistic interpretation. When the architect is responsible for both the exterior and the interior design, Art Deco and Art Moderne architectural design characteristics repeat in the interiors because the intent is to achieve a totally integrated concept. These Art Deco interiors often have a vertical emphasis, lavish surface enrichment, and stepped lines or forms. Other rooms with a modernist approach show simplicity along with a greater emphasis on architectural structure and asymmetry. Art Moderne interiors display rounded corners, glass block walls or windows, and projecting horizontal planes. Some interiors, however, may blend aspects of these design approaches.

Interiors completed by those with a more architectural emphasis often present more simplicity, starkness, and rectilinear features, while those completed by artistic designers or decorators incorporate more decoration, patterns, textiles, and stronger colors. Additionally, the latter tend to display more individuality and diversity in character in their work. All of these design approaches coexist during the period, thereby producing a wide diversity of creative expressions.

Because numerous commissions come from the design of custom interiors and furnishings, interior design work may be the responsibility of an architect, interior decorator, artist, furniture designer, theater designer, and/or fashion designer. Sometimes teams of designers collaborate on projects. Designers produce furniture, fabrics, rugs, draperies, wallpapers, lighting fixtures, metalwork, glass, ceramics, and numerous decorative arts to support the customized interior designs.

The Modern Movement inspires a variation of French Art Deco in which the designers reject excessive ornament

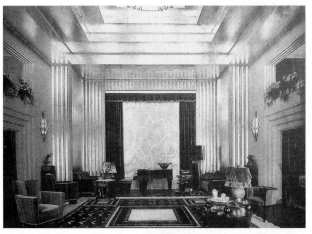

▲ **26-24.** Hall, hotel lobby, 1927; Paris, France; Paul Follot.

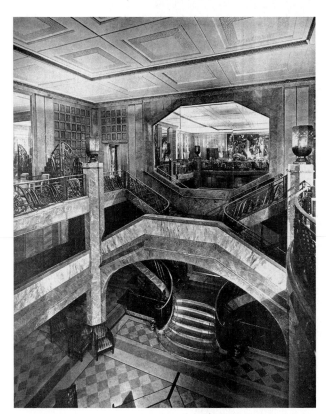

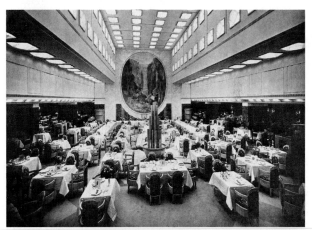

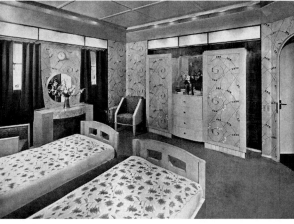

▲ **26-25.** Main staircase, dining salon, and guest cabin, S. S. *Ile-de-France* oceanliner, c. 1928; France; Pierre Patout and R. Bouwens van de Boijen.

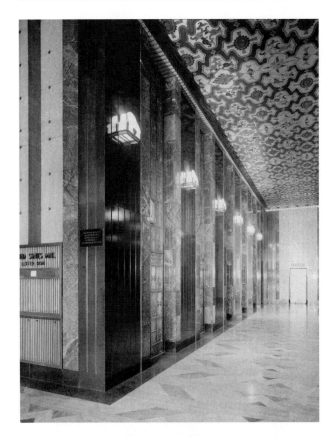

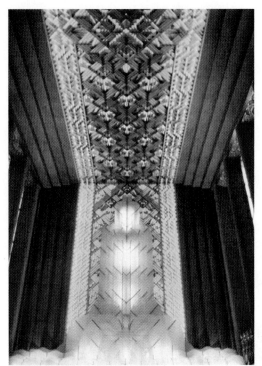

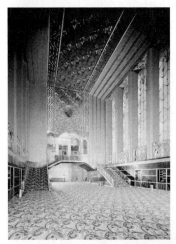

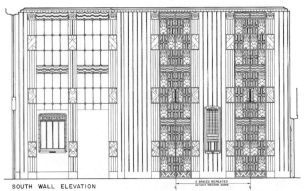

SOUTH WALL ELEVATION

▲ **26-26.** Lobby and wall elevation, Richfield Building, 1928–1930; Los Angeles, California; Morgan, Walls, and Clements.

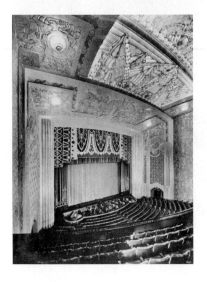

▲ **26-27.** Grand lobby, auditorium, and women's smoking room, Paramount Theater, 1931; Oakland, California; Miller and Pflueger.

and adopt new or industrial materials but retain the creativity of the designer and the importance of individuality. In 1930, French designers who support this view and promote mass production form the Union des Artistes Modernes (UAM). Members of the organization include Robert Mallet-Stevens, Pierre Chareau, François Jourdain, Eileen Gray, and Le Corbusier. Their designs reflect a strong geometry, bold forms, and often the use of chrome and steel.

Following the 1925 exhibition, rooms around the world begin to display Art Deco characteristics. In France, Art Deco is more common than Art Moderne, and there is less variety in types of rooms; most are residential. Because of a strong emphasis upon period decoration, Art Deco does

not have much impact in Great Britain until the late 1920s. During the 1930s, popularity increases when the Ideal Home exhibits, held in London, begin featuring modern spaces and prominent decorators, such as Betty Joel. The Ideal Home Shows, which continue today, are sponsored by the *Daily Mail* newspaper beginning in 1908. They bring together new technology, furnishings, and planning for the modern home. The United States has the greatest diversity of Art Deco interiors with influence arising from the glamour of Hollywood shown in the movies, the cosmopolitan sophistication of the Manhattan skyscraper, and the mass-produced inexpensive middle-class living rooms. By the 1930s, Art Moderne or Streamlined Modern begins to surpass high-style Art Deco in many interiors in the United States and Great Britain. Its simplicity and modernness appeal to many, and it more easily adapts to less expensive products for middle-class interiors.

Public and Private Buildings

■ *Types.* Large commercial circulation, waiting, congregation, dining, and retail spaces become more important during this period. Art Deco affects many interiors, including lobbies and entrance halls (Fig. 26-24, 26-26, 26-27, 26-28, 26-30, 26-33, 26-35), lounges, dining areas (Fig. 26-23, 26-25, 26-31, 26-32, 26-33), and guest suites for luxury cruise ships (Fig. 26-25); ticket, waiting, dining, and service areas in bus stations and airport terminals; passenger and dining cars in trains; beauty and barbershops; dry cleaners; auditoriums in movie houses and theaters (Fig. 26-27, 26-30); particular kinds of retail display spaces (Fig. 26-22); and dining and service areas in diners.

■ *Kitchens.* Planning concepts born in the Industrial Revolution are more fully realized in kitchen design during this period. The new discipline of domestic science, or home

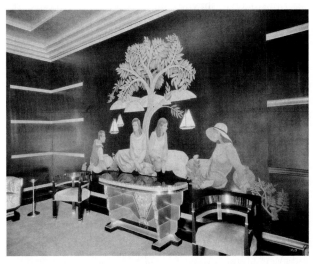

▲ **26-27.** *(continued)*

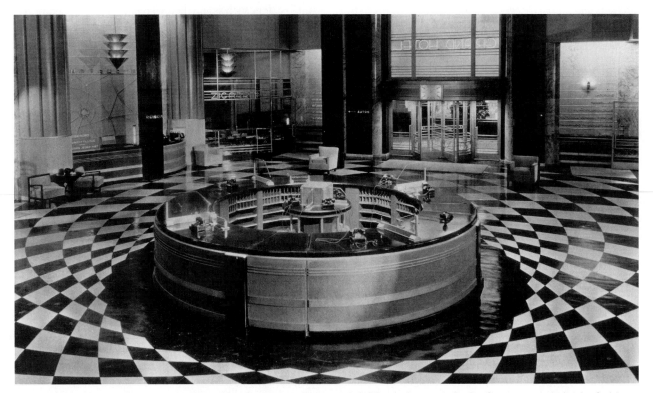

▲ **26-28.** Lobby, movie set of "Grand Hotel," 1932; made in Hollywood, California, but set in Berlin, Germany; set design by Cedric Gibbons.

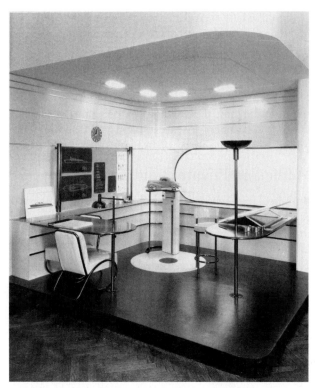

▲ **26-29.** Office, exhibited at the Contemporary American Industrial Art Show at the Metropolitan Museum, 1934; New York City, New York; Raymond Loewy and Donald Deskey.

economics, formulates functional planning concepts for kitchens and baths. Designers give greater attention to the aesthetic, functional, storage, and maintenance concerns in kitchens. Layouts are organized to enhance function and aesthetic appeal and more integrated into the overall interior environment. Work areas are zoned within a triangle

for greater efficiency. Built-in cabinets increase, and provide more storage and reduce clutter. Fixtures, appliances, floors, and countertops have tile and steel surfaces that are more sanitary and easily maintained. And, newly available appliances and fixtures support and improve kitchen activities. Many reflect the Art Moderne character of simplicity and streamlined forms.

■ *Bathrooms.* It is not until the 1920s that most bathrooms incorporate toilets, tubs, and sinks and support multiple functions, such as shaving, applying makeup, and brushing teeth. As a consequence, designers pay particular attention to transforming bathrooms for the well-to-do into aesthetic palaces with lavish materials and decoration (Fig. 26-36). Even baths in middle-class houses reflect new planning concepts as well as new materials and fixtures. Stepped forms, simplicity, and streamlining proclaim Art Deco or Art Moderne influences. Because bathrooms and kitchens are a focus for interior schemes, those created by designers appear in shelter magazines, displays at international expositions, and exhibits in department stores.

■ *Relationships.* Interiors maintain a strong relationship to exteriors by continuing Art Deco or Art Moderne influences. Some show a more architectural character, while others are more decorative.

■ *Color.* Generally, during the early 1920s colors are brighter and more saturated (Fig. 26-30, 26-31). Colors include royal blue, rose, pearl white, gray, purple or lavender, lemon yellow, fern green, and Chinese red with accents of black. The economic depression in the late 1920s brings a palette of more muted colors, such as gray, bottle green, and brown. Throughout the period in more decorated spaces, colors are often richer and reflect influences from the Ballet Russes, avantgarde art, and Persia, the Orient, Egypt, Africa, and Latin America. Pastel hues also are popular in decorative spaces

DESIGN SPOTLIGHT

Interiors: Grand Foyer and Music Hall, Radio City Music Hall, 1931–1940; New York City, New York; Raymond Hood and Edward Durell Stone, with Donald Deskey on interior decoration. Radio City Music Hall, an important example of Art Deco, sits within the Rockefeller Center complex of buildings, plazas, and gardens. The center is a significant early-20th-century solution to the integration of structures into and within an urban context. Donald Deskey wins the competition to design the interiors. While designing many interiors, textiles, carpets, wall coverings, and furnishings himself, Deskey also collaborates with artists, painters, sculptors, and craftsmen to complete the more than 30 spaces. Designs incorporate new materials, such as aluminum and Bakelite, and traditional ones, such as copper and cork, often in innovative ways. Deskey calls the style Modern Rococo.

In the impressive Grand Foyer, golden draperies, red walls with gold-backed mirrors and sconces, monumental chandeliers, and gold leaf ceiling and walls create a dramatic entry to the Music Hall beyond. A mural by Ezra Winter depicts the Fountain of Youth. The proscenium arch and stage with its golden silk curtains dominate the vast Music Hall (auditorium). Cove lighting produces dramatic effects on the gilded ceiling. Panels depicting Dance, Drama, and Song by Ruth Reeves cover the walls, and on the floors is a carpet designed by Deskey. In the Ladies Lounge on the second Mezzanine, a mural with huge flowers by Japanese artist Yasuo Kuniyoshi covers the walls. Deskey designs the round mirrors and chairs, which are inspired by Emile-Jacques Ruhlmann's furnishings.

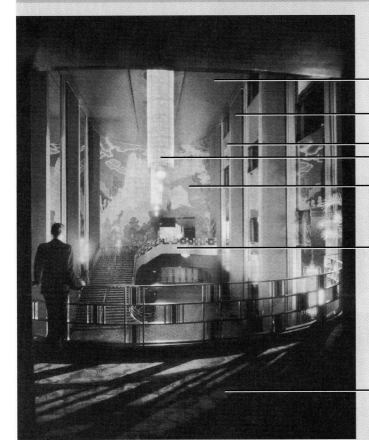

Gold leaf ceiling

Red wall

Mirrors inset into wall
Decorative chandelier

Decorative mural depicts the fountain of youth

Grand staircase with metal balustrade

Patterned carpet

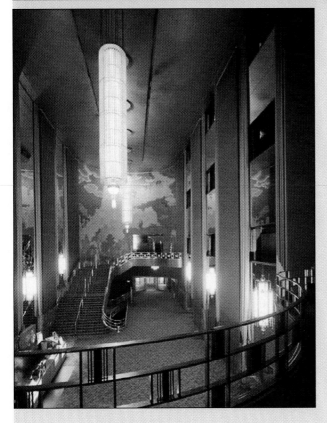

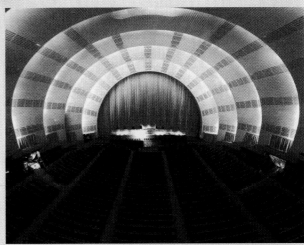

▲ **26-30.** Grand Foyer and Music Hall, Radio City Music Hall, New York City.

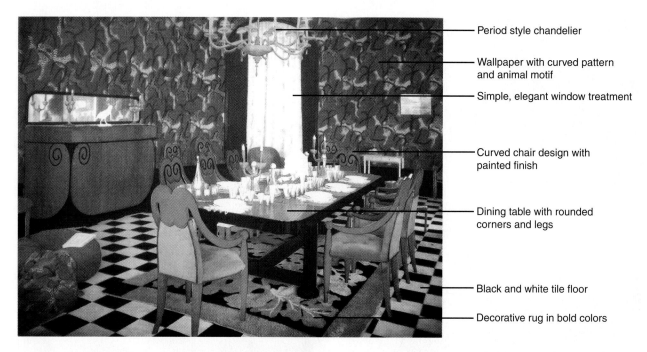

Period style chandelier

Wallpaper with curved pattern and animal motif

Simple, elegant window treatment

Curved chair design with painted finish

Dining table with rounded corners and legs

Black and white tile floor

Decorative rug in bold colors

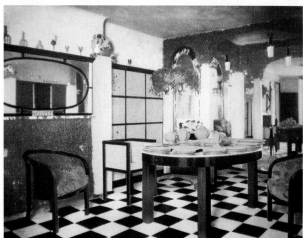

▲ **26–31.** Dining rooms; published in *Les Arts de la Maison*, 1926, and *Intérieurs Français*, 1925; France; Martine.

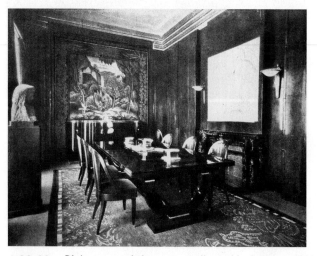

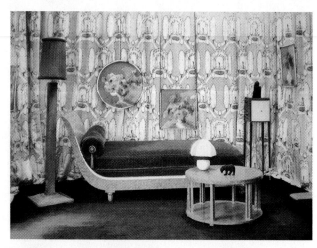

▲ **26–32.** Dining room, sitting area, studio, and bedroom, c. 1923–1925; France; Emile-Jacques Ruhlmann.

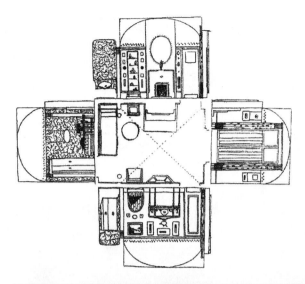

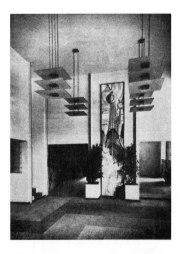

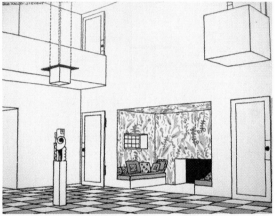

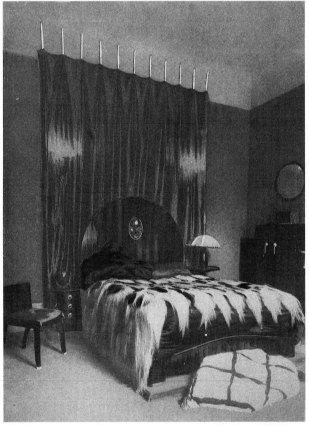

▲ **26-32.** *(continued)*

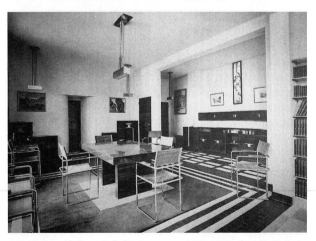

▲ **26-33.** Halls and dining room, c. 1925–1926; France; Robert Mallet-Stevens.

and in Art Moderne interiors. Sometimes brilliant colors are juxtaposed for heightened contrasts. Gold and sliver leaf are common in high-style interiors. In more modernist interpretations of Art Deco, the dominant color is white. The palette in more architectural spaces may be more monochromatic with textiles providing color enrichment.

■ *Lighting.* With the influence of Modernism and new technology after World War I, lighting design changes

from a decorative approach to one that is more architectural, integrating harmoniously with the building structure (Fig. 26-24, 26-26, 26-27, 26-30, 26-33, 26-35, 26-37). Designers use fixtures and concealed direct and indirect lighting to accent architectural details or create drama and excitement. Incandescent lighting is most common, but neon lighting emerges as a new application in interiors like it does on exteriors. Tall panels or grids of lighting often

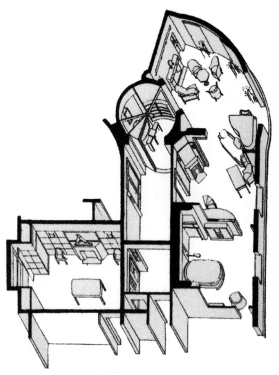

▲ **26-34.** Furnishings arrangement and interior, residence, c. 1926; France; Pierre Chareau.

accentuate walls or staircases in important public spaces, such as movie theaters or dining rooms in cruise ships. Light panels may form supports or newel posts at stairs and may alternate with wood panels or other wall treatments in other spaces.

Individual lighting fixtures and lamps are simple, streamlined, and geometric, showcasing circles, squares, rectangles, and triangles (Fig. 26-29, 26-37). Metal, such as wrought iron, aluminum, and steel, is the most common material for fixtures. Glass shades usually have no applied color but may be etched or sand blasted for decoration. Art Moderne fixtures sometimes have accents of rubber, plastic laminate, or Bakelite. Decorative table and floor lamps have stylized naturalistic or geometric ornamentation, including female figures. In high-style rooms, monumental crystal chandeliers and sconces may dominate the space.

■ *Floors.* Floor surfaces are usually wood, ceramic tile, linoleum, or wall-to-wall carpeting (Fig. 26-22, 26-27, 26-28, 26-31, 26-33). Considering them essential to the space, designers, such as Eileen Gray, create rugs and carpets in designs that support the room's concept (Fig. 26-45). Carpet and rug manufacturers sometimes commission designers and artists to create Art Deco designs for their product lines. In Art Deco and Art Moderne rooms, rugs in simple geometric patterns may provide some warmth and color. Some spaces have glass tile or glass block floors.

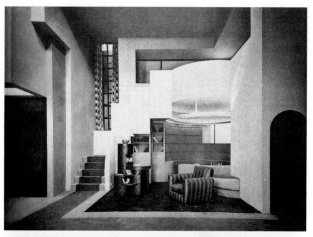

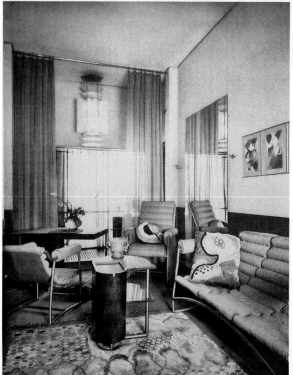

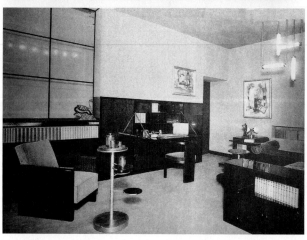

▲ **26-35.** Interiors, published in *Intérieurs au Salon des Artistes Decorateurs*, late 1920s; France.

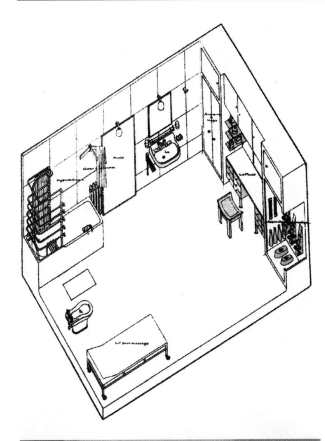

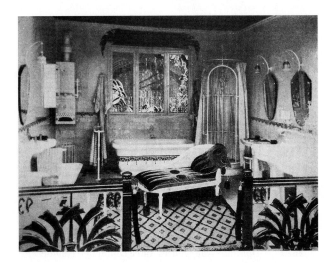

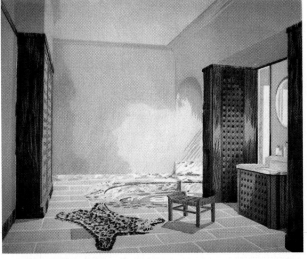

▲ **26-36.** Bathrooms, c. 1915–1926; France.

■ *Walls.* Walls may be painted or lacquered a single color or richly decorated with custom and individual geometric, abstract, or stylized naturalistic designs (Fig. 26-23, 26-25, 26-26, 26-27, 26-30). Treatments are the most lavish in high-style Art Deco interiors in residences; public spaces in ships, hotels, and commercial buildings; and movie theaters. Most walls usually display a strong architectural emphasis with three-dimensional variation in all types of interiors. Designers construct wall compositions with rectangular columns or pilasters, layered planes, panels, and/or alcoves and niches (Fig. 26-24, 26-27, 26-35). Surfaces may have large areas of

solid colors or decorative treatments, as conveyed in textiles, wallpaper, mosaics, murals, or gold or silver leaf, or a combination of both (Fig. 26-30, 26-31, 26-32, 26-36). Finishes are smooth, sleek, and shiny. Dark and light contrasts are common, particularly when all of the walls are plain.

Mirrored and glass panels also may appear in Art Deco or Art Moderne rooms. The latter often has glass block interior partitions. Decorative ironwork may embellish walls and is used for elevator cages and stair balustrades. Built-in storage that blends in with the overall wall design appears frequently in both commercial and residential

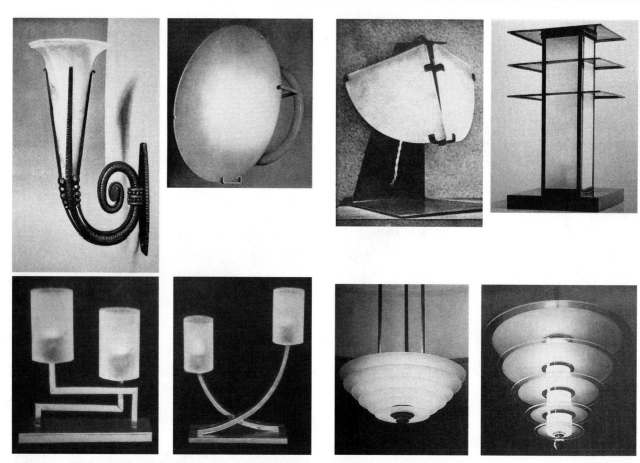

▲ **26-37.** Lighting: Wall sconces, table lamps, and chandeliers, c. 1920s–1930s.

spaces. Moderne wall treatments often include industrial materials such as plastic laminate or Vitrolite; other common treatments include cork and metallic finishes. Parallel contour lines, of which three is the most common number, frequently define Art Moderne spaces (Fig. 26-29).

■ *Windows and Window Treatments*. Windows repeat the exterior design and convey an architectural simplicity (Fig. 26-23, 26-29). Glass may be clear, frosted, or etched. Most window treatments are plain or pleated fabric panels hanging from rods, cornices, or padded cornice boards (Fig. 26-23, 26-25, 26-35). They may be sill- or floor-length and tied back or hang straight. Most are of plain fabrics, such as velvet or silk, although some are patterned. Because of the cost, fabric window treatments become very simple so as to use less fabric during and after the Depression. Some Moderne rooms have no curtains, substituting shades or blinds or leaving the windows bare.

■ *Doors*. Simple, plain, rectangular doors are common. Most are glass, wood, or metal or a combination of two materials (Fig. 26-33). They often blend in to the wall composition to emphasize an architectonic composition. Some doors have applied moldings in a geometric pattern similar to the wall composition. Surrounds are simple, flat, and narrow.

■ *Textiles*. Designers use a variety of textiles for wall coverings and drapery during the period (Fig. 26-38). Synthetic fibers, such as rayon and acetate, join the natural fibers of linen, silk, cotton, and wool. Damask, brocade, brocatelle, lampas, velvet, satin, and plush enhance high-style spaces, whereas plain, often heavily textured, weaves dominate in more modernist interpretations. Colors follow period trends with textures becoming more important as colors become more muted in the 1930s. Patterns, which are usually flat instead of three-dimensional, include geometrics, such as squares and triangles; abstracts, such as lightning bolts; and stylized naturalistic forms, including the human figure. Some designs reflect avant-garde art, such as Cubism, or exotic or nonindustrial cultures such as Egypt or Africa. Designers frequently custom design textiles in colors and patterns for clients or manufacturers. Art Moderne rooms have fewer patterns than Art Deco ones do. Usually, the only pattern is in an area rug or window treatments.

■ *Ceilings*. Ceilings may be plainly treated, or decorated with paintings, paper, or fabrics, coffers, compartments, layers, or coves (Fig. 26-23, 26-24, 26-25, 26-26, 26-27, 26-30, 26-32, 26-33, 26-35). A few are glass. Murals and other decoration usually support the room's design concept or iconography. The ceilings in high-style spaces, such as skyscraper lobbies, movie theaters, and bus terminals, often have the most dramatic treatments of prominent recessed, projecting, or concealed lighting; stepped or layered elements; murals; and bold motifs.

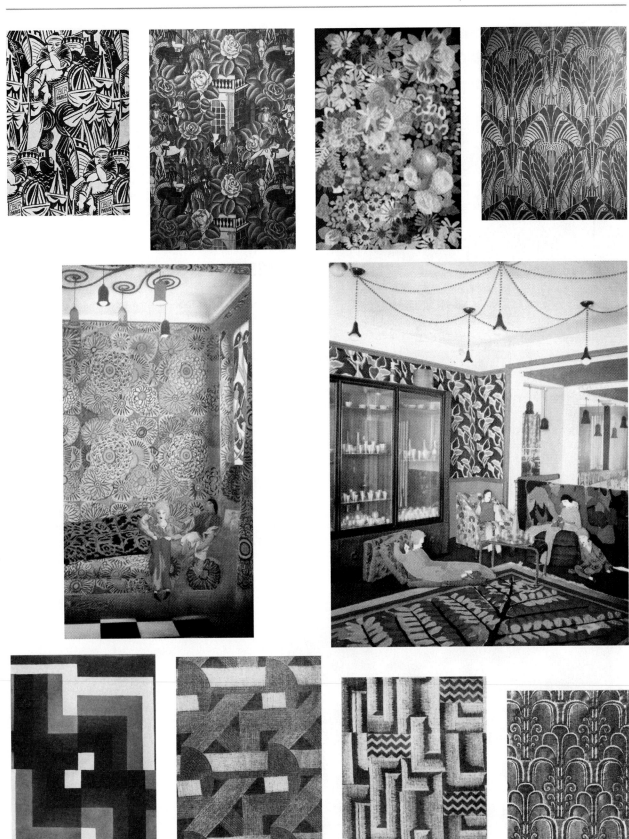

▲ **26-38.** Textiles: Woven and printed fabrics in various designs, c. 1920s, France and the United States; including work by R. Dufy, M. Dufréne, Martine, J. Coudyser, E. Brandt, and S. Delaunay.

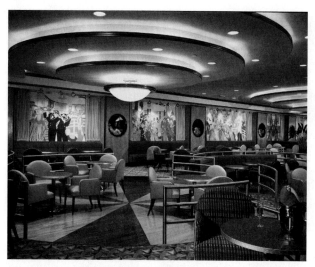

▲ **26-39.** Later Interpretation: Lounge, Sugar Bay Plantation Resort, c. 2002; St. Thomas, Virgin Islands; architecture by Archeon, with interior design by Interior Design Force, Inc.

■ *Later Interpretations.* As in architecture, interest in Art Deco interiors revives during the 1960s with the preservation of interiors. The work of prominent designers, such as Ruhlmann, is documented and reappraised in books and museum exhibits. Period rooms are re-created, restored, and rehabilitated. Examples include the installation of rooms by Armand-Albert Rateau of fashion designer Jeanne Lavin in the Museé des Arts Décoratifs in Paris and the rehabilitation of the Hilton Cincinnati Netherland Plaza Hotel in Cincinnati, Ohio, by Rita St. Clair. Art Deco rooms inspire late-20th-century designers, such as Charles Jencks, Andrée Putnam, and others (Fig. 26-39), as well as individual homeowners, who create rooms with Art Deco concepts.

FURNISHINGS AND DECORATIVE ARTS

Art Deco and Art Moderne manifest in several types of furniture. High-style French furniture is usually custom

DESIGN SPOTLIGHT

Furniture: Chair, dressing table, desk, armoire, cabinet, 1915–1925; France; Emile–Jacques Ruhlmann. Rococo, Neoclassical, Directoire, and Empire styles of the 18th- and early-19th-century furniture inspire Ruhlmann's furniture. However, his work does not copy the past, so it is clearly modern. Generally, the forms are simple and reveal a preference for soft curves, which are much harder and more expensive to fabricate. Legs are often straight and tapered or curved. Fronts vary from rectangular to modified serpentine, bow, or kidney-shaped. What sets Ruhlmann's work apart are the richness of materials, such as the ebony, amboyna, and

ivory in these pieces; ornament, which may be floral or linear as in the ivory inlay on the desk and armoire; and the attention to detail, such as the tassels on the door pulls of the armoire. Ruhlmann works in the tradition of the French *ébéniste* of the past, overseeing every step in the design and fabricating process and exerting complete aesthetic control. His furniture is best appreciated in the interior for which it is designed along with his custom textiles, carpet, and decorative arts. The premier French Art Deco designer, he modernizes past traditions for a wealthy, sophisticated 20th-century clientele.

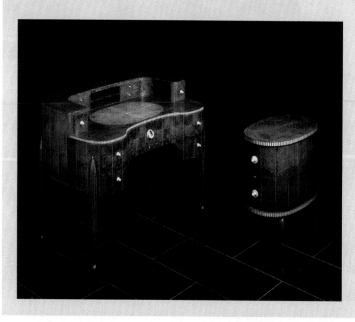

◀ **26-40.** Desk, cabinets, dressing table, armoire, 1915-1925; France; Emile–Jacques Ruhlmann.

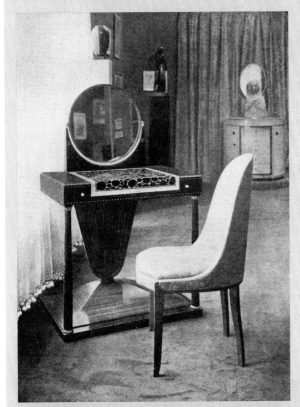

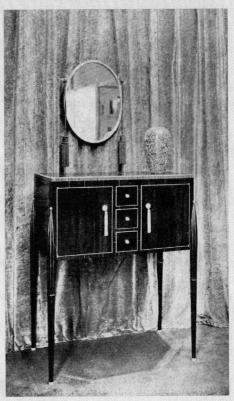

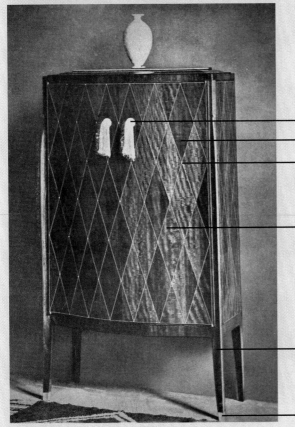

Decorative tassel door pulls

Wood veneer in geometric pattern with exotic woods

Ivory inlay

18th Century Neoclassical form and proportions

Straight tapered legs

Metal toe caps

▲ 26–40. *(continued)*

designed to suit a particular space for a wealthy and sophisticated clientele who see interiors as settings for social rituals. Elegance, individuality, excellent craftsmanship, and expensive materials define these furnishings. Forms and ornament often are inspired by 18th- and early-19th-century French traditions, particularly Neoclassical. Important traditionalists include Emile-Jacques Ruhlmann and the Süe et Mare design firm in France.

A variation influenced by the Bauhaus and Le Corbusier is more modernist in appearance. This furniture may be custom designed for individual spaces and rely more on the individuality and creativity of the designer. Typical furnishings of this variation have geometric forms and volumes, less ornament, and modern materials, such as tubular steel. Some may be mass produced. Designers include Eileen Gray (Fig. 26-45) and members of the Union des Artists Modernes (UAM) in France.

Art Moderne furniture, usually mass-produced and sometimes created by a designer, has streamlined, geometric or biomorphic forms, simple contours, and no ornament. Standardization, materials, and functionality give furniture a similar appearance. Furniture in this group responds to consumers and the depressed economic conditions of the late 1920s. Usually inexpensive, it is small-scale and multipurpose to suit modern apartments and houses. Function and practicality are important considerations because households generally have no servants. Additionally, people spend less time at home because they go out to work, travel more, or seek entertainment outside the home. Designers in this group include Donald Deskey and Walter Dorwin Teague in the United States.

Public and Private Buildings

■ *Types.* Art Deco and Art Moderne characteristics appear on all types of furniture. New to the period is the cocktail cabinet to hold liquors, barware, and glasses, and the cocktail or coffee table.

■ *Distinctive Features.* Designers fully integrate furnishings and decorative arts in interior environments, both commercial and residential, high style and middle class

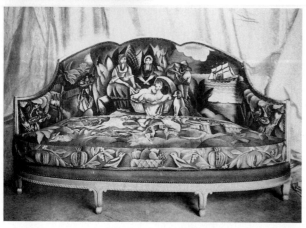

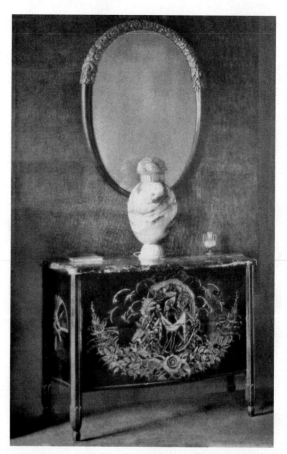

▲ **26-41.** Armchair, canapé, and commode, c. 1910s–1920s; France; La Compagnie des Arts Français (Süe et Mare).

(Fig. 26-32, 26-33, 26-45). Like architecture, furniture forms, motifs, and colors reflect a wide variety of influences. Matching pieces of furniture are common in all types of spaces.

■ *Relationships*. Furniture often repeats the architectural and interior character in form and motif. Art Deco furniture and architecture may have similar decoration derived from the same sources. Art Moderne furniture reflects the geometric volumes, standardized forms, and modern or industrial materials of architecture. For example, Paul Frankl creates skyscraper furniture composed of seating and storage pieces with stepped forms reflecting the setbacks of skyscrapers (Fig. 26-42). He proposes that as the skyscraper solved the urban space problem, so skyscraper furniture will solve space problems in the urban home.

■ *Materials*. Art Deco designers employ a great variety of materials including wood, lacquer, ivory, leather, other animal skins, mother-of-pearl, semiprecious stones, marble, glass, and metal. More modernist Art Deco and Art Moderne furniture uses newer materials such as plastic laminates, Bakelite, Vitrolite, and plywood. Ebony is often the featured wood in Art Deco, but rosewood, mahogany, amboyna, walnut, zebrawood, satinwood, sycamore, beech, and palmwood also are used as solids or veneers. Matched patterned burls are common in panels. Materials for inlays

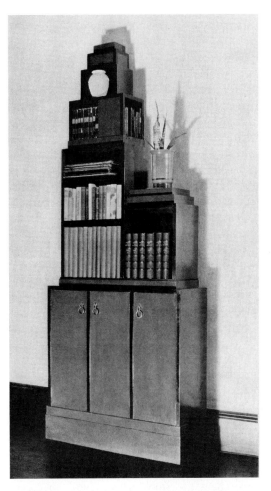

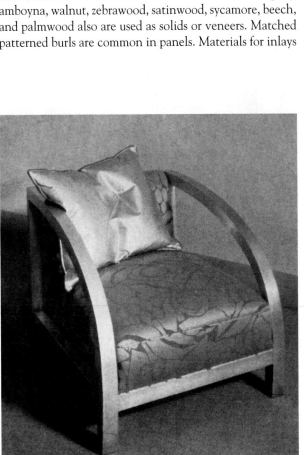

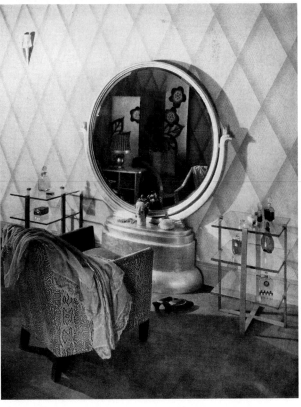

▲ **26-42.** Armchair in silver leaf finish, skyscraper bookcase, and dressing table in glass and silver, c. 1926–1927; United States; Paul Theodore Frankl.

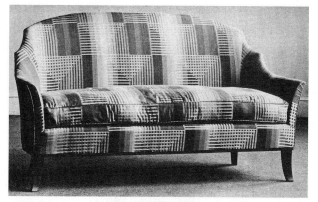

▲ **26-43.** Sofa, c. 1930s; United States.

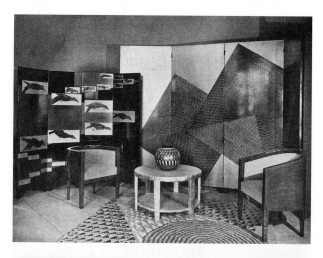

▲ **26-44.** Ensemble and tables, c. 1920s–1930s; France; Jean Dunand.

include ivory, mother-of-pearl, various woods, tortoise-shell, or metals. Exotic animal skins, such as shagreen, snakeskin, pony hide, and leather cover entire pieces or sides and/or tops. Lacquer treatments, in various colors, cover or accent many different types of furniture. Because lacquer is expensive, furniture manufacturers develop alternative finishes that resemble it. Mirrors or glass panels cover the entire surfaces of some pieces of furniture.

■ *Seating.* Seating has many types and variations, with Art Deco examples showing the greatest variations. Art Deco side and armchairs generally have an underlying traditional form, usually Neoclassical (Fig. 26-23, 26-31, 26-32, 26-40, 26-41). Some chairs and stools have a curule or curved X shape. Legs may be slender and tapered, modified cabrioles, or sabers; backs are square, round, or gondola forms; seats are often upholstered trapezoids. Frames may be stained, painted, or gilded with fretwork, inlay, or marquetry ornament. Upholstered chairs often have wood or metal trim and legs. Seating influenced by the Modern Movement has wooden or metal arms and legs or cantilevers (Fig. 26-29, 26-33, 26-35). It may be rectangular and blocky in form or have curves to soften corners. Large, comfortable lounge chairs become very popular during the period (Fig. 26-24, 26-35). Sofas may have curving or stepped ends and/or backs (Fig. 26-41, 26-43). They may be tufted or plain and have wood or metal trim and/or legs. Sofas, daybeds, and chaise lounges often have a variety of throw pillows in contrasting fabrics and colors.

■ *Tables.* Tables come in a wide variety of forms (Fig. 26-27, 26-45, 26-46). The most decorative are those in Art Deco spaces. These tables usually have underlying Neoclassical, Directoire, or Empire forms with ornament derived from numerous sources (Fig. 26-32, 26-44). Simple outlines may be obscured by exuberant decoration. Tops, plain or patterned, may be square, rectangular, round, oval, or kidney-shaped. Legs are straight or modified cabrioles. Consoles and tables have scrolled supports of decorative wrought iron and marble or wooden tops. Some tables,

consoles, or desks may be mirrored or have applied or structural glass panels. Dining tables have rectangular wooden or tubular metal legs, or U-shaped trestles of wood and/or metal (Fig. 26-32, 26-33). The rectangular or oval tops are of wood and/or glass. A few examples have lighting built into the tops for drama. Art Moderne tables in wood and metal usually are round or rectangular with plain legs or solid supports and little or no ornament. Usually lamp tables and coffee tables within a room match each other. Desks illustrate diversity is design, with some soft and feminine looking, while others may follow the aesthetic language of buildings with stepped planes and hard edges (Fig. 26-29, 26-40, 26-47). Vanities or dressing tables (Fig. 26-40, 26-42) become fashionable because they are seen in movies. These low tables with mirrors are made to match many bedroom suites. Like other bedroom pieces, night stands and vanities are sometimes made of tubular metal with a metal or glass top.

■ *Storage.* Art Deco commodes and other storage pieces may adopt the *bombé* or serpentine shapes of 18th-century

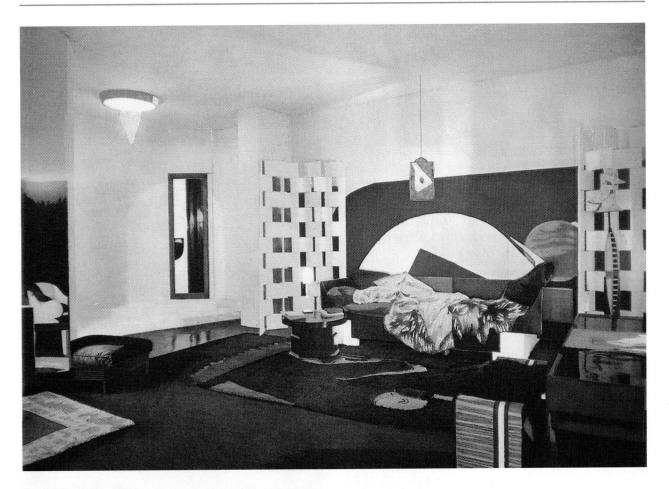

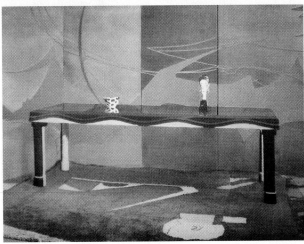

▲ **26-45.** Interior and furnishings, c. 1922; France; Eileen Gray.

Rococo. Unlike their elaborate predecessors, decoration sometimes comes from the grain of the wood instead of applied bronze mounts and marquetry or veneer patterns. Alternatively, storage pieces are rectangular and usually have marquetry, inlaid, painted, or lacquered ornament (Fig. 26-40, 26-41). Art Moderne storage, in contrast, has no ornament, sometimes relying on the pattern of the wood for decoration. In geometric shapes sometimes with curving corners or ends, most have no moldings or applied decoration (Fig. 26-33, 26-42, 26-47, 26-48). These pieces rely on form and wood grain for interest. Some dressers, chests, and night stands have metal trim to match head- and footboards on beds. Dressers often have circular mirrors. Bedroom suites consisting of bed, dresser, chests, vanities, and night stands in coordinating designs are common in the period.

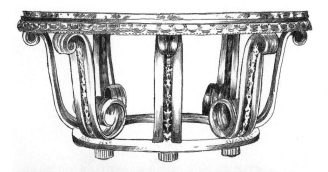

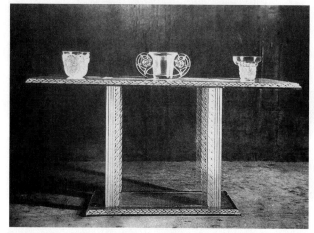

▲ **26-46.** Console tables, c. 1920s; France; Edgar Brandt and Rene Lalique.

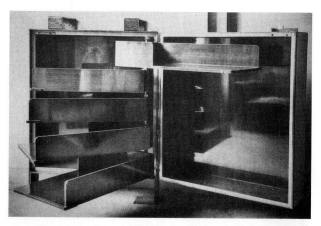

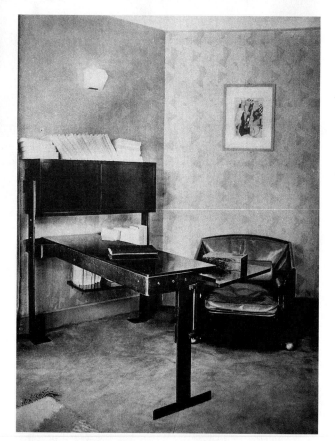

▲ **26-47.** Storage cabinet and desk, c. 1920s; France; Pierre Chareau.

■ *Beds.* Art Deco beds may be in traditional shapes such as the boat beds of Empire or have one curving end (Fig. 26-25, 26-32). They are usually of expensive wood veneer or lacquered and can have drapery that falls from a canopy attached to the wall above them or simple curtains hanging at the head of the bed. Eileen Gray designs a bed shaped like a canoe, called Pirogue. Wooden Art Moderne beds may have semicircular headboards and no footboards. Also common are semicircular or rectangular headboards and footboards of tubular metal or solid metal.

■ *Upholstery.* Designers use a variety of plain woven and printed textiles for upholstery such as leather, animal skins, linen, cotton, silk, velvet, rayon, and acetate. Tapestry weave is revived and frequently used on Art Deco furniture. Upholstery patterns are geometric, abstract, and stylized naturalistic, and colors follow period trends (Fig. 26-41, 26-43). Some Art Deco and Art Moderne designers use plain, unpatterned upholstery.

■ *Decorative Arts.* Designers and consumers choose from a variety of decorative accessories for both Art Deco and Art Moderne rooms. Common accessories include fabric-covered, painted, or lacquered screens (Fig. 26-44, 26-45); wood, metal, or Bakelite clocks; ceramic, glass, or metal tea, coffee, and cocktail services; candelabra; ceramic or glass vases and bowls (Fig. 26-49); mirrors in wooden or metal frames; wooden and metal sculptures; African masks; Native American baskets and pottery; and posters, prints, and paintings.

Artists, designers, and traditional manufacturers produce ceramics, glass, and metalwork. Unless intended for mass production, the work of artists consists of individual, high-style examples of Art Deco or Moderne. Manufacturers adapt high-style designs for mass production to appeal to consumers. Recognizing the importance of design to sell products, manufacturers sometimes commission artists, designers, and architects to create designs for modern

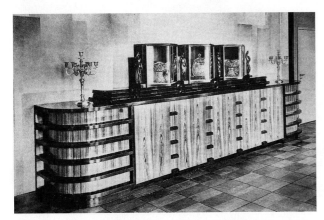

▲ **26-48.** Dining room cabinet, c. 1920s; France; Harvey Rosenthal.

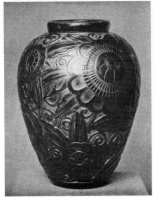 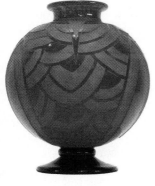

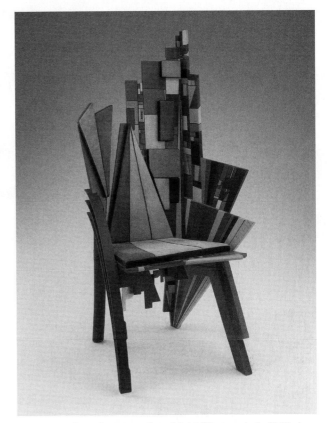

▲ **26-50.** Later Interpretation: Bright City armchair, 1987; Jay Stanger.

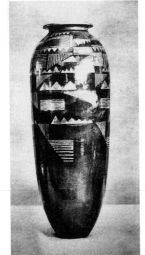

▲ **26-49.** Decorative Arts: Vases in glass and ceramic, c. 1920s; Daum Frères (top left), Charles Schneider (top right), Rene Lalique (bottom left), and Jean Dunand (bottom right).

products. However, industrial designers become increasingly important during the period because they create many different types of products for the home that are economical and functional. While influencing the Art Moderne style, they also help democratize Modernism. One of the most successful dinner services is Fiesta, introduced by the Homer Laughlin Company in 1927 and created by industrial designer Frederick H. Rhead. Heavy and colorful, Fiesta is still produced.

■ *Later Interpretations*. In the 1970s, many begin collecting Art Deco and Art Moderne furniture and decorative arts. Soon, reproductions, adaptations, and interpretations by designers and manufacturers appear, and the concept remains today (Fig. 26-50).

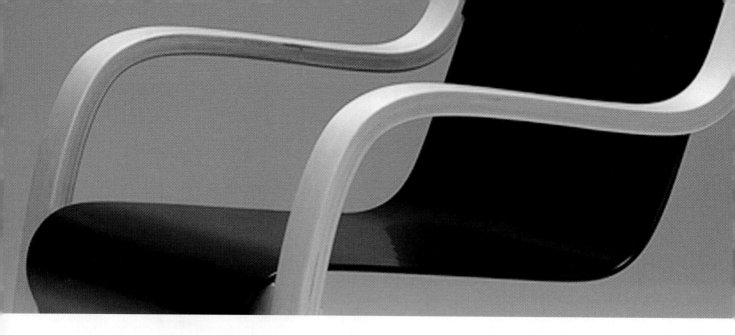

CHAPTER 27

Scandinavian Modern

1900s–1960s

*There is an ulterior motive, too, in architecture, which is always peeping out from around the corner, the idea of creating paradise. It is **the** only purpose of our buildings. If we do not carry this idea with us the whole time all our buildings would be simpler, more trivial and life would become—well, would life amount to anything at all? Every building, every work of architecture, is a symbol which has the aspiration to show that we want to build a paradise on earth for ordinary mortals.*

Alvar Aalto, 1958

Wherever one goes in Scandinavia one will find a relaxed pleasure in architecture, a delightfully human scale—not bombastic, not self-important—and a very deep respect for nature and architecture together—not in competition, not via a triumphant bulldozer. This bespeaks an educated, mature approach to life and the shelter.

G. E. Kidder Smith,
The New Architecture of Europe, 1961

Scandinavian Modern refers to a specific architecture and design from Denmark, Sweden, Finland, and Norway in the early 20th century. Although adopting elements of Bauhaus and International Style modernism, expressions are simple, functional, often minimal, yet incorporate a concern for the individual and an emphasis upon natural materials. Works share a similar aesthetic that arises from nationalism, folk or vernacular and craft traditions, nature, excellence in craftsmanship, and a desire to provide well-designed buildings and objects are for all members of Scandinavian society.

HISTORICAL AND SOCIAL

The term *Scandinavian* generally refers to four northwestern European countries that share strong historical, cultural, and linguistic ties. This includes the Scandinavian peninsula countries of Sweden and Norway, plus Denmark and Finland. Although historically Iceland is sometimes included, it has fewer ties to the others. An alternative term referring to these countries is *Nordic*. Because of these ties, Scandinavian architects and designers have similar aesthetic concerns, which embraces a modern appearance strongly grounded in naturalism and vernacular and/or craft traditions.

Scandinavian languages have a common heritage in the Germanic tongues, Western Germanic and Dutch for Finland, and Eastern Germanic for the other countries. Additionally, the histories of Scandinavian countries intertwine with each other, and each is a possession of one or more of the others at some point during their individual pasts. Norway, Denmark, and Sweden share a Viking

heritage, so Norse mythology is important in those countries. Southernmost of the Scandinavian countries, Denmark unites with Norway in 1380 and acquires Sweden, on the eastern portion of the Scandinavian peninsula, a few years later. The three countries are united until Sweden gains independence in the early 1500s. In the early 19th century, Denmark's reluctant alliance with Napoleon ultimately forces her to cede Norway to Sweden. Norway, occupying the western part of the Scandinavian peninsula, gains her independence in 1905. Finland, easternmost of the Scandinavian countries, is a province of Sweden from the 1100s until she is given to Russia as reparations in 1809. She gains her independence during the Russian Revolution and World War I in 1918.

The four countries also share similar climates, which vary from moderate in Denmark to harsher ones in Sweden and Norway where winters are very snowy and windy with periods of little or no sun. Scandinavian landscapes are composed of timber, fjords, lakes, streams, mountains, and farmlands. Consequently, adaptations to climate and the importance of the natural environment are important characteristics in Scandinavian design. Scandinavian vernacular forms and craft traditions in building, furniture, textiles, and decorative arts are strong. Remaining so from their inception to industrialization and into the 21st century, they inform architectural and design concepts, creating a common visual and aesthetic heritage. Collaborative efforts between artisans, designers, and manufacturers are an important feature of architecture, interiors, and decorative arts.

The Scandinavian countries, less densely populated than the rest of Europe, retain an agrarian economy until the end of the 19th century when industrialism begins to take hold. Industrialization is gradual and does not create the monumental upheavals as in Europe or England. Therefore, the Scandinavian countries are able to maintain their rich folk cultures and craft traditions while mechanizing. In the first decades of the 20th century, industrialization ushers in a general move to the cities. Although there are few slums, more housing for workers and the general population becomes a governmental concern in all of the Scandinavian countries. In public housing, for example, Sweden leads the way in the 1910s with improved housing standards, planning guidelines, and government subsidies. By 1945, Sweden, as a social welfare state, provides housing, health care, education, and pensions for its citizens. The government also uses principles of modern design as propaganda tools to inform and improve Swedish public taste. *Möbelråd* (Furnishing Suggestions), a government-sponsored design handbook, establishes room sizes, kitchen layouts, materials, and finishes and gives recommendations for well-designed low-cost furniture. The other Scandinavian countries also have government-sponsored housing programs and endorse good design.

The Scandinavian countries spread their design aesthetics in displays and exhibitions at the various World's Fairs in the early 20th century, including the 1925 Exposition Internationale des Arts Decoratifs et Industriels Modernes in Paris. The most significant exposition for Scandinavian design, however, is the 1939 New York World's Fair, which is promoted as modern, progressive, and leading to the future. All the Scandinavian countries have pavilions, but the Swedish and Finnish ones have the most impact, winning international acclaim and generating great interest in Scandinavian furniture and design. Unfortunately, World War II intervenes, delaying further growth and expansion.

Following the war, Scandinavia recovers quickly and strives to make Scandinavian design important both at home and abroad. Working for mostly middle-class societies with few rich or poor, designers (Fig. 27-1) concentrate on modest and practical forms, not luxurious ones. Sweden, Finland, and Denmark, more than Norway and Iceland, market themselves and their designs as forward thinking and progressive. To emphasize good design and increase connections between art and industry, Scandinavian design and craft organizations hold exhibitions and competitions at home and display their works at various international design fairs, such as the Milan Triennales. During the 1950s and 1960s, North America embraces architectural principles, furniture, and decorative objects from Scandinavia. Danish and Swedish Modern became indicative of a whole way of designing buildings, interiors, and furniture, which preserves the look of handicrafts while adopting modern manufacturing methods. Designers and manufacturers in North America began to emulate the look, if not the concepts, of works from Scandinavia.

CONCEPTS

Scandinavian designers and architects are less concerned with design theory than practical and social humanitarian matters. This approach centers on creating designs that are functional yet reflect humanity in planning, scale, and materials. Designers believe that architecture and design are not just about aesthetics, but also must address economical housing and functional living quarters for all citizens and make good design available for the worker as well as the well-to-do. Accordingly, designs are often modest, adaptable, and utilize natural materials and simple construction methods. Scandinavians promote good design through education and collaboration among designers, architects, manufacturers, and, sometimes, the state. Equally important is Nordic or Scandinavian identity, so the vocabulary of design frequently derives from folk or vernacular forms, the natural environment or landscape, native materials, as well as individual elements

▲ **27-1.** Arne Jacobsen, and Hans Wegner.

IMPORTANT TREATISES

- *Aalto: Architecture and Furniture,* 1938; The Museum of Modern Art.

- *Architecture: Nineteenth and Twentieth Centuries,* 1958; Henry-Russell Hitchcock.

- *Gunnar Asplund, Arkitekt,* 1943; Hakon Ahilberg.

- *Modern Houses of the World,* 1964; Sherban Cantcuzino.

- *The New Architecture of Europe,* 1961; G. E. Kidder Smith.

- *Space, Time and Architecture,* 1959; Sigfried Giedion.

Periodicals and Magazines: *Domus* (1930).

from each country or their collective heritage. Designers maintain a sense of nationalism, while accepting ideas of modernism.

DESIGN CHARACTERISTICS

Common to Scandinavian design are simplicity, human scale, modesty, practicality, elegance, and excellent craftsmanship. Also evident are such shared Scandinavian traditions as the environment or landscape, respect for materials,

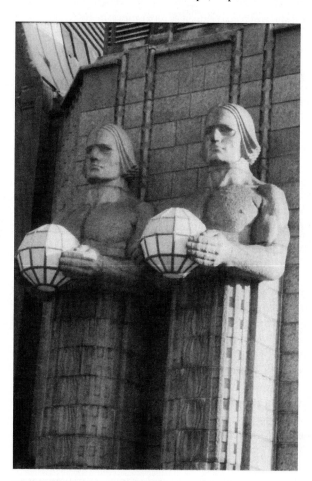

▲ **27-2.** Architectural and furniture details; Eliel Saarinen, Alvar Aalto, Hans Wegner, and Bjorn Winblad.

and natural materials. Characteristics deriving from the landscape include movement, textures, complex compositions, and/or curvilinear forms. Expressions in architecture, interiors, and furniture are often a reworking of traditional forms in a simplified or refined manner. Whether purely functional, modernist, or organic, important design characteristics are unity, texture, and light. Designs may be eclectic, adapting elements from other architects, styles, and cultures.

Scandinavian architectural expressions range from rugged stone compositions with steeply pitched roofs and bay windows to plain brick façades composed of geometric forms and rectangular windows to purely International Style buildings with flat roofs, glass curtain walls or large windows, pilotis, and white concrete walls. Interiors and furniture are plain and simple with elegant lines and display a high regard for materials and textures. Wood is an important element whether through its direct application as a major building component, an interior finish, or in furniture or accessories. Texture and natural materials are emphasized over applied ornament and industrial materials such as tubular steel. Design is made available to all through mass production, yet handcrafting techniques remain until well after World War II.

■ *Motifs*. Purely modern expressions often have no or minimal applied ornament or decoration, so there are few motifs, except stylized foliage and plants, associated with them. National Romanticism adapts and stylizes Scandinavian plants and foliage for decoration.

ARCHITECTURE

National Romanticism and Neoclassicism dominate architecture during the first decades of the 20th century in Scandinavia. Dating from the late 19th century, National

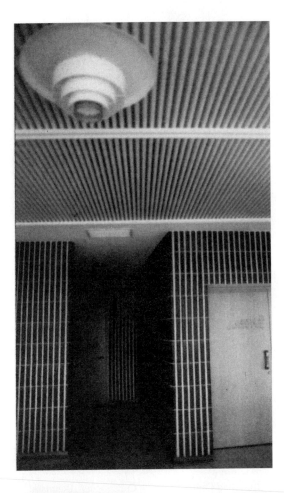

▲ **27-2.** *(continued)*

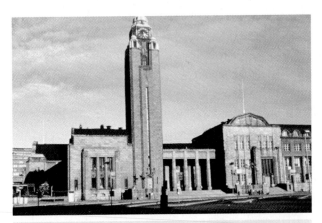

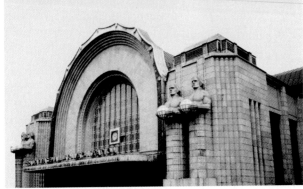

▲ **27-3.** Main Railway Terminus, 1904–1914; Helsinki, Finland; Eliel Saarinen, Herman Gesellius, and Armas Lindgren.

IMPORTANT BUILDINGS AND INTERIORS

- **Boston, Massachusetts:**
 - —Baker House (student dormitory), Massachusetts Institute of Technology, 1946–1949; Alvar Aalto.
- **Copenhagen, Denmark:**
 - —Grundtvig Church, 1913, 1921–1926; Peter Jensen-Klint.
 - —Police Headquarters, 1919–1924; Hack Kampmann.
 - —S.A.S. Royal Hotel, 1959; Arne Jacobsen.
- **Helsinki, Finland:**
 - —Alvar Aalto House in Munkkiniemi, 1936; Alvar Aalto.
 - —Cultural Center, 1955–1958; Alvar Aalto
 - —Main Railway Terminus, 1904–1914; Eliel Saarinen, Herman Gesellius, and Armas Lindgren.
 - —Villa Hvittrask, 1902; Eliel Saarinen, Herman Gesellius, and Armas Lindgren.
- **Jyväskylä, Finland:**
 - —Säynätsalo Town Hall, 1949–1952; Alvar Aalto.
- **Oslo, Norway:**
 - —Town Hall, 1918–1947; Arnstein Arneberg and Magnus Poulsson.
- **Noormarkku, Finland:**
 - —Villa Mairea, 1937–1938; Alvar Aalto.
- **Paimio, Finland:**
 - —Tuberculosis Sanatorium, 1929–1933; Alvar Aalto.
- **Stockholm, Sweden:**
 - —Stockholm City Library, 1920–1928; Gunnar Asplund.
 - —Town Hall, 1923; Ragnar Ostberg.
 - —Werkbund Exhibition, 1930; Erik Gunnar Asplund.
 - —Woodland Crematorium (Chapel of the Holy Cross), 1935–1940; Gunnar Asplund.
- **Viipuri, Finland:**
 - —Municipal Library, 1927–1935; Alvar Aalto.

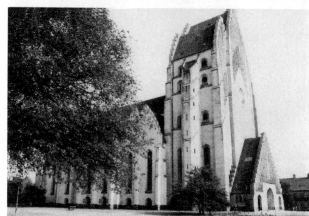

▲ **27-4.** Grundtvig Church, c. 1920; Copenhagen, Denmark; Peter Jensen-Klint.

Romanticism draws on folk or vernacular traditions to establish a national identity. Believing that folk traditions are unspoiled by modern life and industry, architects incorporate wood for material and construction methods, handicrafts, and local traditions into building types and forms to devise what they hope is an indigenous design language.

Important precursors to National Romanticism include Scandinavian log cabins and other wooden architecture, the Arts and Crafts Movement in England, the architecture of H. H. Richardson in the United States, and Art Nouveau. In Finland, Eliel Saarinen's work in particular is influenced by medieval architecture, Art Nouveau, and Richardsonian Romanesque.

Dominating architecture through the 1920s, Scandinavian Neoclassicism, like that in the rest of Europe, is made more relevant for the 20th century by simplification and

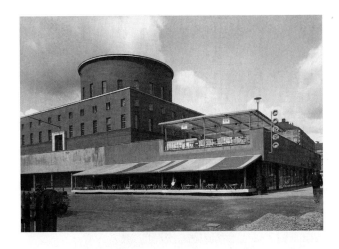

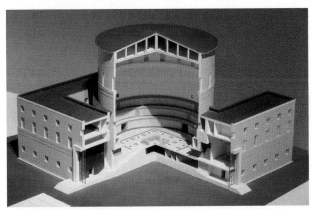

▲ **27-5.** Stockholm City Library, 1920–1928; Stockholm, Sweden; Gunnar Asplund.

▲ **27-7.** Tuberculosis Sanatorium, 1929–1933; Paimio, Finland; Alvar Aalto.

▲ **27-6.** Werkbund Exhibition, Paradise Restaurant, 1930; Stockholm, Sweden; by Gunnar Asplund.

elimination. A spare and stripped-down appearance defines the style, although classical ordering and some classical elements, such as columns, may appear. Geometric forms create the composition, and rules and order are balanced

▲ **27-8.** Town Hall, 1918–1947; Oslo, Norway; Arnstein Arneberg and Magnus Poulsson.

▲ **27-9.** Baker House, Massachusetts Institute of Technology, 1946–1949; Boston, Massachusetts; Alvar Aalto.

or enhanced by individual creativity. Often eclectic, Scandinavian Neoclassicism borrows from the Renaissance, Baroque, early-19th-century Neoclassicism, and vernacular traditions.

Modernism, or Functionalism as it is called there, makes its appearance in Scandinavia about 1930. There is some awareness of Modernism in the late 1920s evident in Scandinavian publications, especially after the 1927

DESIGN SPOTLIGHT

Architecture: Säynätsalo Town Hall, 1949–1952; Jyväskylä, Finland; Alvar Aalto. Small in scale and defined by a central courtyard, this town hall has four wings that contain offices, shops, the Council Chamber, and a library. Administration offices are placed around the courtyard to take advantage of the views. Located close to the central marketplace, the structure uses traditional building materials, including uneven red brick for the facade, wood for trim and ceilings, and copper for the roof. Groups of tall windows covered with vertical slats to filter the light repeat along the walls. Custom details in materials, joinery, and hardware add to the overall effect of a building integrating with its surroundings.

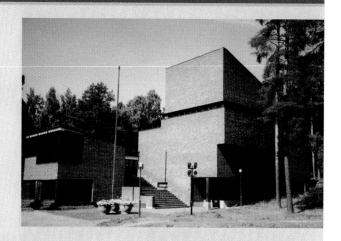

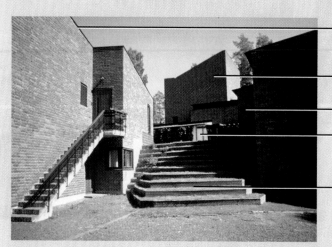

Copper roof

Uneven brick façade

Irregular grouping of buildings

Administration offices around courtyard

Stairs to courtyard

▲ **27-10.** Säynätsalo Town Hall; Jyväskylä, Finland.

DESIGN SPOTLIGHT

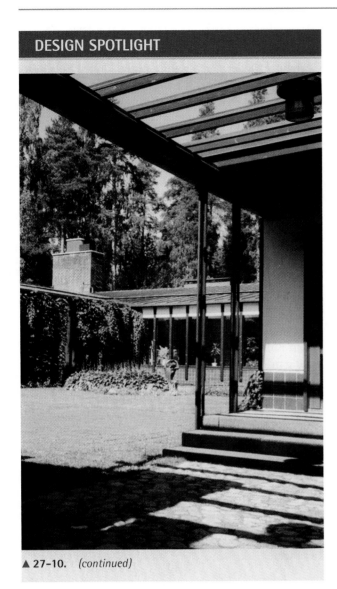

▲ **27-10.** *(continued)*

Weissenhofsiedlung housing exhibit in Stuttgart, Germany (see Chapter 25, "International Style"). Public housing during this period, especially in Sweden and Denmark, begins to follow modernist principles for site and layout. Exterior design may still incorporate traditional forms and materials. Finland leads the way toward Modernism in the work of a group of progressive young architects, including Alvar Aalto and Erik Bryggman. Aalto's Turku Sonomat Building (1927–1929) is considered the first Modern or International Style building in Finland.

The 1930 Stockholm Exhibition is the seminal event in the adoption of Modernism in architecture and interiors, less so in decorative arts and furniture, in Sweden, Denmark, and Norway. Designed by Erik Gunnar Asplund, the buildings exemplify German and French principles of modern architecture and bring together many examples of the International Style in one location. Leaders of Modernism in Scandinavia include Asplund of Sweden, Eliel Saarinen and Aalto of Finland, and Arne Jacobsen (Fig. 27-1) of

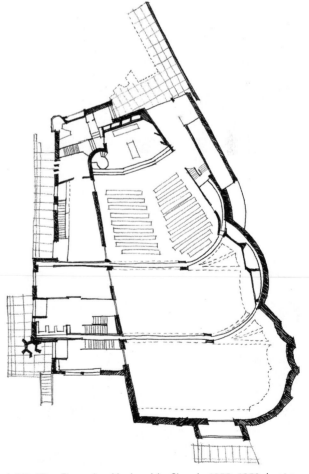

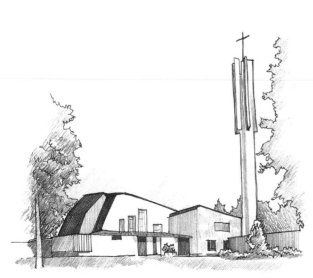

▲ **27-11.** Vuokseniska Church, 1955–1958; Imatra, Finland; Alvar Aalto.

▲ **27-12.** Floor plan, Vuokseniska Church, 1955–1958; Imatra, Finland; Alvar Aalto.

Denmark. Although some buildings are purely International Style, some architects, like Aalto, soon move beyond the cubic flat-roofed forms of the Bauhaus and Le Corbusier to incorporate Scandinavian forms and materials, thereby creating individuality and uniqueness of expression. Aalto's work lays important foundations for postwar Organic and Sculptural Modern architecture in the United States (see Chapter 29, "Organic and Sculptural Modern").

Through the middle of the 20th century, Scandinavian architects continue to refine their understanding of the Modern or International Style, adapting concepts, techniques, and material usage from both inside and outside the region. Some, such as Aalto and Jacobsen, who are recognized for their creative solutions to design projects in other parts of the world, including North America.

Public and Private Buildings

■ *Types.* Common building types include railway terminals (Fig. 27-3), churches (Fig. 27-4, 27-11), libraries (Fig. 27-5), town halls (Fig. 27-8, 27-10), houses (Fig. 27-14, 27-16, 27-18), and public housing developments in which standardization, prefabrication, and mass production enable numerous dwellings to be built quickly.

■ *Site Orientation.* Harmony with the landscape is a governing principle of design. Architects pay particular attention to positioning buildings within the site to take advantage of views and sunlight and to create wind breaks where needed (Fig. 27-6, 27-7, 27-10, 27-11, 27-16, 27-18). Buildings in cities usually relate to public transportation routes or dominate city centers (Fig. 27-3, 27-4, 27-8, 27-13). Public housing blocks generally are arranged in parallel rows perpendicular to streets and to permit the maximum light and air for each unit. Some developments contain schools, day care centers, community centers, and green spaces. A few are picturesque groups of individual buildings, reflecting a vernacular heritage.

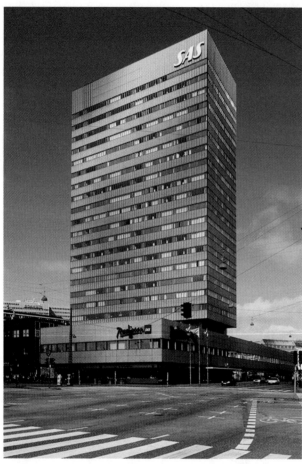

▲ **27-13.** S.A.S. Royal Hotel, 1959; Copenhagen, Denmark; Arne Jacobsen.

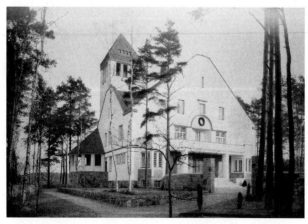

▲ **27-14.** Molchow House; Finland; published in *Die Kunst*, 1908; Eliel Saarinen, Herman Gesellius, and Armas Lindgren.

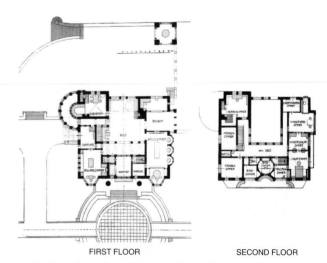

FIRST FLOOR SECOND FLOOR

▲ **27-15.** Floor plans, Molchow House; Finland; published in *Die Kunst*, 1908; Eliel Saarinen, Herman Gesellius, and Armas Lindgren.

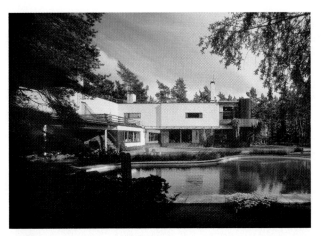

▲ **27-16.** Villa Mairea, 1937–1938; Noormarkku, Finland; Alvar Aalto.

■ *Floor Plans.* Plans may be simple or interlocking rectangles (Fig. 27-15, 27-17). Some have circular or curvilinear spaces or walls (Fig. 27-12). Open planning permits flexibility in arrangements in both pubic and private buildings. In public buildings, important entries and circulation spaces are carefully situated to permit access to other spaces. Some public buildings and large residences center on semienclosed courtyards (Fig. 27-10). Function and practicality are important planning concepts, so multifunctional rooms with activity zones characterize residences, which are usually small.

■ *Materials.* Materials include stone, brick, wood, reinforced concrete, steel, and glass (Fig. 27-3, 27-6, 27-9, 27-10, 27-13, 27-18). Buildings are often white stucco, concrete,

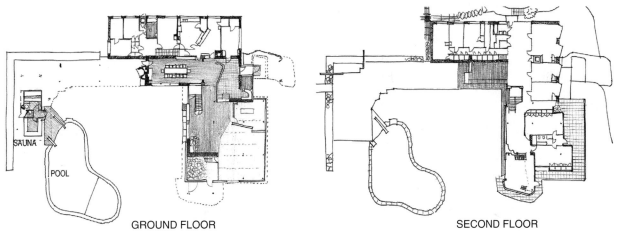

GROUND FLOOR SECOND FLOOR

▲ **27-17.** Floor plans, Villa Mairea, 1937–1938; Noormarkku, Finland; Alvar Aalto.

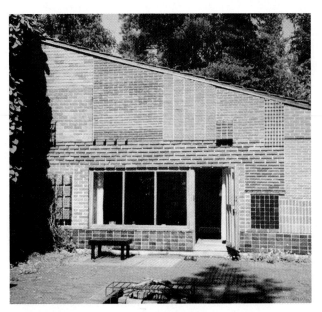

▲ **27-18.** Experimental Summer House, 1952–1954; Muuratsalo, Finland; Alvar Aalto.

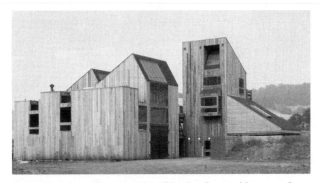

▲ **27-19.** Later Interpretation: Douglas County Museum of History, 1969; Douglas County, Oregon; designed by Bakken, Arrigoni and Ross.

DESIGN PRACTITIONERS

■ **Alvar Aalto** (1898–1976), from Finland, is an innovator in architecture, interior design, furniture, and the decorative arts, especially glass and lighting. His work is internationally acclaimed for its functionalism, warmth, and humanness. His early work is classical, but he turns to the International Style in the late 1920s. By the early 1930s, his work becomes inspired by traditional Scandinavian elements and integrates the landscape, organic qualities, and natural materials. His early furniture is of tubular metal, which he soon discards for laminated wood and plywood. He is an innovator in the use of bent laminated wood. Aalto strives for total unity in his projects, so he designs the architecture, interiors, and furnishings. He and his first wife, Aino Marsion, found Artek, a firm to market his furniture.

■ **Arne Jacobsen** (1902–1971) is one of the most influential 20th-century Danish designers. His work encompasses architecture, interior design, furniture design, and industrial design. Like others, he interprets modern within Scandinavian traditions. Although not as innovative as some in architecture, his furniture designs are often cutting edge, particularly those in plywood and plastic. Work ranges from hard-edged geometrics to soft, sculptural forms. He designs a wide variety of objects including lighting and cutlery.

■ **Grete Jalk** (1920–2005), from Denmark, gains a reputation for her innovative furniture and interior design, which meet the needs of the user. She achieves international acclaim in the 1950s, becoming the leading Danish female furniture designer. Throughout her career, she experiments with new materials and production methods.

■ **Finn Juhl** (1912–1987), from Denmark, trains as an architect and also designs interiors, furniture, and decorative arts. He is best known for his sculptural furniture that reveals influences from primitive art, the Shakers, and Le Corbusier. Adopting complex forms, Juhl often uses diagonal bracing and floats the seat and back instead of connecting them to the frame.

■ **Kaare Klint** (1888–1954), architect and furniture designer, is recognized as the father of Danish Modern furniture. Klint establishes the very influential Furniture Department of the Royal Academy of Art in Copenhagen. There he teaches many of the later designers of Danish Modern furniture. Klint makes extensive studies of human proportions. He continually refines his chair designs, which are often inspired by the past, striving to improve their form and comfort.

■ **Bruno Mathsson** (1907–1988), from Sweden, comes from a family of cabinetmakers, although he also designs buildings and interiors. He makes detailed anatomical studies from which he develops his very comfortable furniture. He is best known for his series of chairs, loungers, and sofas with bent laminated wooden frames. During the 1930s, Mathsson designs several houses with glass walls and newly developed heated floors.

■ **Armi Ratia** (1912–1979), from Finland, is a textile designer who along with her husband, Viljo, founds the innovative textiles company Marimekko in 1951. The company becomes known for its nontraditional, contemporary, stylized, and colorful designs. Creating fabrics first for fashion and then interior design, the firm introduces a lifestyle branding concept. It also hires young designers to continually supply novel and modern ideas.

■ **Eliel Saarinen** (1873–1950), from Finland, adapts Finnish traditions to architecture, particularly farmhouses, developing a design language of cultural symbolism evident in form and material. His best-known works in Scandinavia are the Train Station in Helsinki and Hvitträsj studios and living quarters, which he designs with partners Herman Gersllius and Amas Eliel Lindgren. Saarinen emigrates to the United States in 1923 where he heads the Cranbrook Academy of Art.

■ **Timo Sarpaneva** (1926–2006), from Finland, is a painter, graphic designer, and industrial designer. He works in ceramics, metal, textiles, and glass, creating products for numerous companies, such as Venini Glass and Rosenthal Porcelain. Sarpeneva takes a comprehensive approach to design, so he studies the material and the manufacturing process. He is best known for his glass in which he strives to capture light as reflected in the sea or forest.

■ **Hans Wegner** (1914–2007), from Denmark, is a designer and cabinetmaker. After working with Arne Jacobsen, Wegner opens his own studio in 1943. Inspired by Chinese, Shaker, and Windsor chairs, many of his designs are reworkings of traditional forms in a modern, simplified expression that may include mass production. Although he is best known for his wooden chairs, he experiments with molded plywood and metal.

or marble that may be mixed with wood planks or logs. Houses in brick and wood are common.

■ *Façades.* With the exception of National Romantic examples, façades are plain and clean lined with few applied moldings or stringcourses (Fig. 27-6, 27-7, 27-9, 27-10, 27-18). Horizontality is emphasized especially through bands of windows. Façades with environmental or traditional elements mix concrete or stucco with brick, stone, or wood, but still have few moldings or other articulation. The harsh Scandinavian climate limits expressions of structure typical of Modernist architecture, and naturalism appears in complex forms that suggest growth and movement. Balconies, stairs, entire or parts of floors, and other elements may project in rectangular or curvilinear forms (Fig. 27-2). Some structures or parts of them are raised on piers, and balconies or porches may have plain metal or wooden railings. Pergolas, found on large residences, act as transition spaces to the exterior. Geometric forms, symmetry, and simplified details define Neoclassical façades. National Romantic façades may be asymmetrical with rough stone bases and upper stories of stone or brick. Contrasting colors of stone may define fenestration. Wooden details, such as roof rafters or logs, are important.

■ *Windows.* Window walls or horizontal bands of windows define modern buildings (Fig. 27-6, 27-7, 27-10, 27-13). Neoclassical buildings often have rectangular windows with no moldings surrounding them, whereas National Romantic ones have a variety of windows from bays to arched to rectangular with various surrounds (Fig. 27-3, 27-14).

■ *Doors.* Entrances, often covered to protect from the weather, may be either prominent or somewhat hidden. Doors are usually wood with glazing.

■ *Roofs.* Flat roofs are typical of modernist or Bauhaus-influenced buildings, although some question their suitability to the Scandinavian climate. Architects adopt single- and double-pitched gables and, later, curved or free-form roofs.

■ *Later Interpretations.* Following World War II, architects in North America incorporate aspects of Scandinavian architecture, especially its regard for nature, the use of natural materials, fitting a building into a natural setting, and a respect for fine craftsmanship (Fig. 27-19).

INTERIORS

Most interiors are simple and modest with minimal furnishings. Function, lightness, natural light, and an appreciation for natural materials and textures are more important than applied decoration and/or just filling a space. Interiors designed by architects exhibit the most variety and a greater concern for pleasant sensory experiences through spatial changes, color, light, and texture.

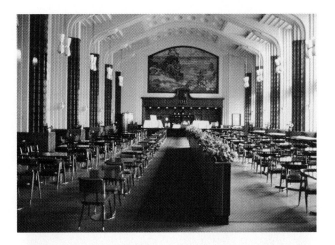

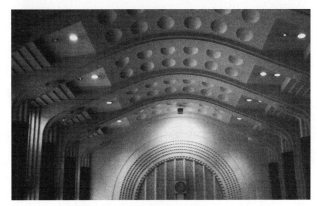

▲ **27-20.** Interior, Main Railway Terminus, 1904–1914; Helsinki, Finland; Eliel Saarinen, Herman Gesellius, and Armas Lindgren.

Where possible, architects use large windows for light and air and to unite the interior with the landscape. This, together with the long winters, results in interior environments that contrast large glazed openings with more intimate, often fireplace- and hearth-centered alcoves.

For total unity, architects often design both the interiors and furnishings. Interiors, like architecture, reveal a strong sense of nationalism in traditional materials and forms, wood construction, and craftsmanship. To make small spaces seem larger, windows borrow space from outside, colors are light, and high ceilings add volumetric space. Because of the climate, many living areas have fireplaces, and designers, such as Aalto, frequently envision the Scandinavian hearth with modern, sculptural elements. Furniture arrangements are planned to give the greatest freedom of activity within the usually limited amounts of space. Storage or seating may be built in.

Public and Private Buildings

■ *Types.* No particular interior types, other than saunas, are associated with Scandinavia. Designers pay attention

Interiors: Discussion and lecture hall, Municipal Library, 1927–1935; Viipuri, Finland; Alvar Aalto. Surrounded by grass and tall trees, this building shows inspiration from the International Style with its stark, smooth white plastered exterior walls and rectangular grid windows. The interiors, however, project a more natural, earthy character because of the extensive use of wood, which is introduced by Aalto with this project. Six different types of wood cover ceilings, walls, floors, and furnishings. The building, composed of two main volumes, develops in plan view from two overlapping blocks, one for the library space and the other for the lecture hall. Unique in concept, the lecture hall features plain wall treatments that emphasize materials, a long row of windows to emit light, and an undulating, wood paneled ceiling that enhances the acoustics of the space. To complete the effect, Aalto designs custom furnishings that include stools, bookcases, wall panels, and light-diffusing lamps. Specialized construction details are apparent throughout the building.

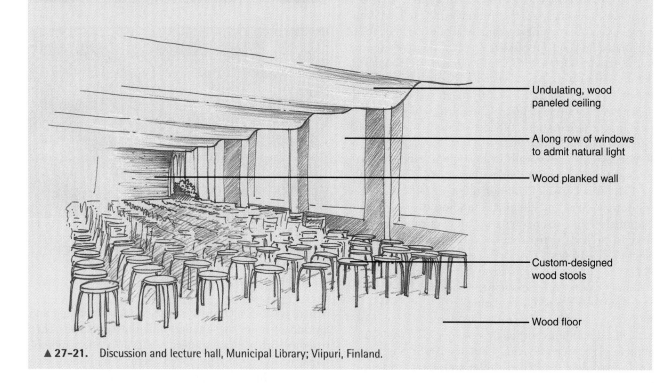

Undulating, wood paneled ceiling

A long row of windows to admit natural light

Wood planked wall

Custom-designed wood stools

Wood floor

▲ **27-21.** Discussion and lecture hall, Municipal Library; Viipuri, Finland.

to all types of public and private interiors, especially those of public housing.

■ *Relationships.* Unity is important, so interiors repeat characteristics of exteriors in materials and forms.

■ *Color.* Most often colors are muted. Reflecting nature and the landscape, hues include shades of brown, green, blue, and yellow, accented with white and black. Occasional spots of bright colors, such as orange or red, add dynamism, variety, and interest.

■ *Lighting.* Natural lighting pervades all types of interiors. There usually is a variety of artificial lighting sources, most of which are incandescent. Fixtures, which may be designed by the architect, can be a combination of recessed, surface-mounted, hanging pendants, floor lamps, and table lamps (Fig. 27-20, 27-25, 27-27, 27-29). Made of metal, wood, and ceramic, forms harmonize with the rest of the interior.

■ *Floors.* Floors are of wood, tile, marble, stone, and concrete (Fig. 27-21, 27-28). For color and warmth, designers incorporate white rugs with deep piles and soft patterns, sisal matting, or flat woven or piled rugs with geometric designs in strong colors similar to other modern rooms in other countries (Fig. 27-25, 27-28). Used extensively, rya rugs originate in Sweden, Norway, and Finland. These hand-knotted rugs with a long pile have colorful geometric or floral patterns.

■ *Walls.* Walls are plainly treated often with plaster and paint of a single hue or with wood planks or large panels (Fig. 27-20, 27-22, 27-23, 27-24, 27-27). Rooms often combine several wall treatments, most commonly wood or

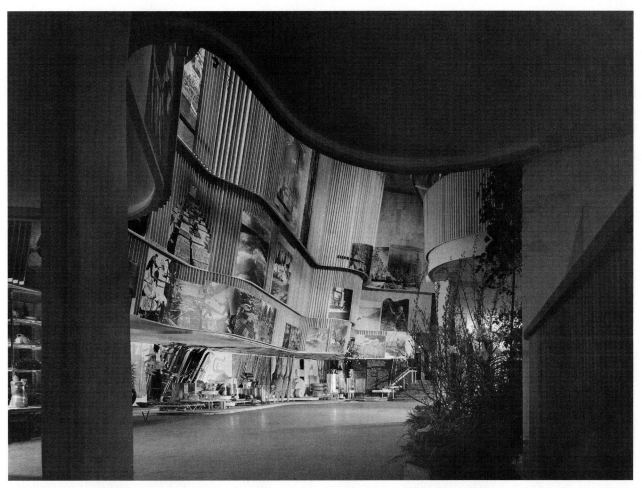

▲ **27-22.** Interior, Finnish Pavilion, World's Fair Exhibition, 1939; New York City, New York; Alvar Aalto.

▲ **27-23.** Interior, Vuokseniska Church, 1955–1958; Imatra, Finland; Alvar Aalto.

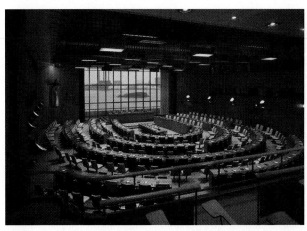

▲ **27-24.** Trustees Council Chamber, United Nations, 1952; New York City, New York; Finn Juhl.

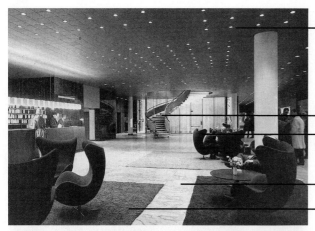

— Flat ceiling with recessed down lights

— Curving stair continues the sculptural character of the furniture
— Lounge chairs that contour to fit the human body

— Stone floors

— Plain area rugs define seating grouping

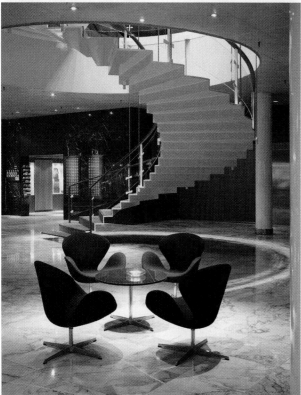

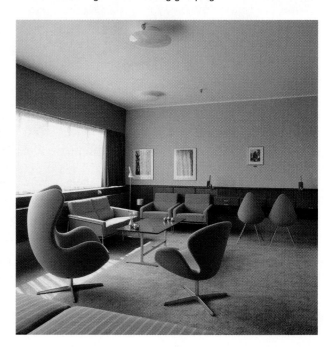

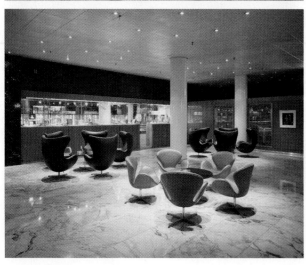

▲ **27-25.** Lobby, bar, and guest room, S.A.S. Royal Hotel, 1959; Copenhagen, Denmark; Arne Jacobsen.

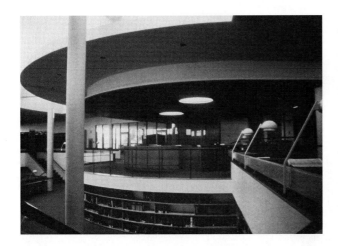

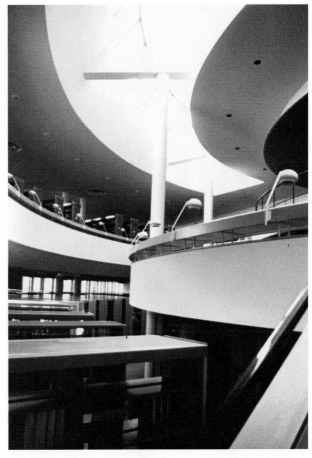

▲ **27-26.** Interiors, Mt. Angel Library, 1964–1970; St. Benedict, Oregon; Alvar Aalto.

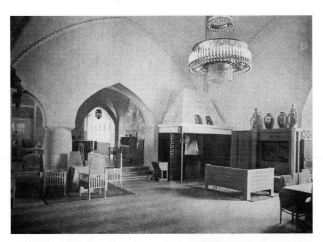

▲ **27-27.** Music hall, Château de Suur-Mérojoki; Finland; published in *Art et Decoration*, 1908; Eliel Saarinen, Herman Gesellius, and Armas Lindgren.

brick and plaster. Brick walls may be whitewashed. Wallpapers are not common, but fabrics sometimes cover walls. Shelves or other storage may be attached to walls to free the floor space below. Structural supports or pillars of metal or concrete may be covered in wood, rattan, or leather.

■ *Windows*. Simple metal or wood moldings frame windows. Curtain panels hang straight so that they can open or close easily. Fabrics may be plain, woven solids, open weaves, or heavily textured solids, and usually are in light colors. Alternative treatments include blinds and shades. Where possible, windows are left bare to enhance the view or allow in the most natural light.

■ *Doors*. Interior doors are plain or have panels and are surrounded by simple wooden moldings. Some have glazing or transoms.

■ *Textiles*. Natural fibers, such as wool or linen, and handwoven textiles are common. Fabrics may be plain or feature Scandinavian patterns and bright colors (Fig. 27-30). Patterns include naturalistic or stylized natural designs, stripes, or geometric shapes. Texture is important in plain fabrics.

■ *Ceilings*. Ceilings may be flat, curved, or sloped with a variety of treatments (Fig. 27-20, 27-23, 27-25, 27-26, 27-28). Wood and plaster are most typical. Some have unique architectural light wells that flood the interiors with natural lighting.

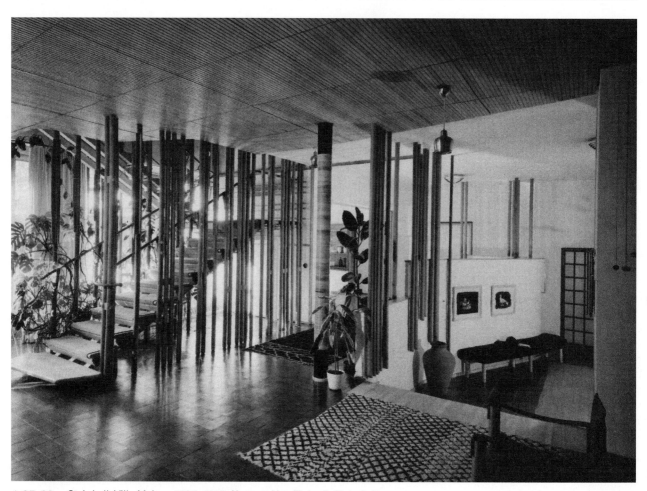

▲ **27–28.** Stair hall, Villa Mairea, 1937–1938; Noormarkku, Finland; Alvar Aalto.

▲ **27–29.** Lighting: Candleholder, floor lamp, chandeliers, and wall sconce, c. 1950s; Finland and Denmark.

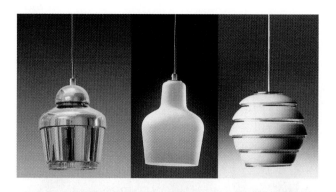

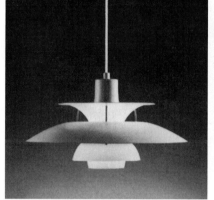

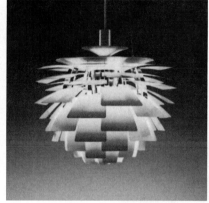

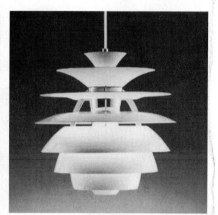

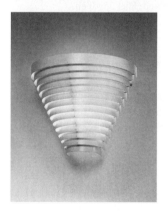

▲ **27-29.** *(continued)*

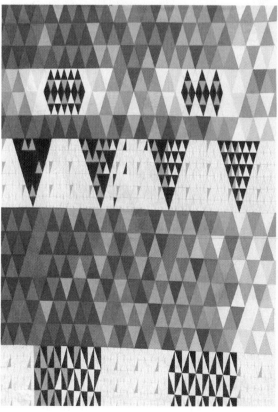

▲ **27-30.** Textiles: Cottons and linens, c. 1950s–1960s; Sweden and Finland; Sven Marklius, Maija Isola, and others, manufactured by Nordika, Unikko, and Marimekko.

■ *Later Interpretations.* The simplicity of Scandinavian interiors is adopted during the post–World War II period. Clarity in interior planning, respect for natural materials and fibers, simply finished woods, and plain walls are key elements in a contemporary style called Danish or Swedish Modern in North America. In the early 21st century, many designers continue to model interiors on major components of Scandinavian design, including functionality and the use of natural textures and materials (Fig. 27-31).

▲ **27–30.** *(continued)*

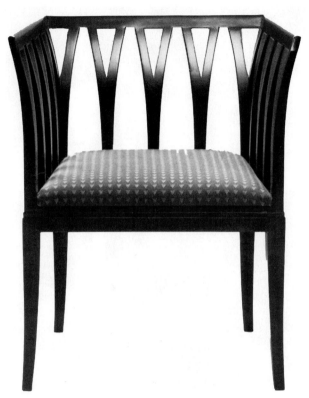

▲ **27–32.** Blue chair, 1929; Finland; Eliel Saarinen.

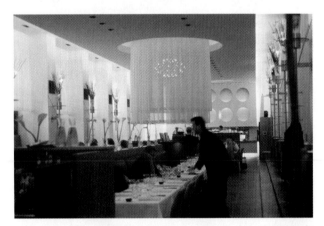

▲ **27–31.** Later Interpretation: Restaurant, c. 1990s; Helsinki, Finland.

FURNISHINGS AND DECORATIVE ARTS

Scandinavian furniture ranges from totally handmade to completely mass-produced, with varying increments between the two. As the countries industrialize, especially after World War II, furniture design evolves as a collaborative effort between designers, artisans, and manufacturers, a concept that arises from strong craft and cabinetmaker organizations. Furniture designers view themselves as artists to industry, similar to the Deustche Werkbund, the Bauhaus, and Le Corbusier. But they do not feel compelled to incorporate machine or industrial imagery into their work. Instead, the Vienna Secession model of craftsmanship and individuality more strongly influences them. As a result, their furniture reflects their crafts heritage in wood, illustrates simple but often beautifully detailed forms, has contours that fit the human body, and possesses a warm, timeless quality. Often designed for small spaces, furnishings are also economical and practical.

Scandinavian furniture can be categorized into three types: designs inspired by or based upon traditional forms that are simplified for the 20th century and adapted to mass production; furniture designed by architects for their projects to achieve total unity; and experiments with new materials and techniques of construction. Preferring the warmth and humanness of wood to steel, designers use such modern techniques as prefabrication, laminated wood, and new materials such as plywood. They also consider the needs of the user, particularly in areas where space is limited and functional requirements are important. Like other modernists, they usually believe that all people have the same basic needs. After World War II, Scandinavian

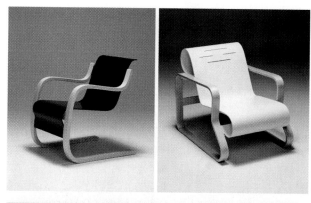

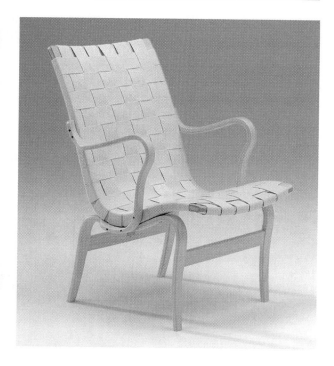

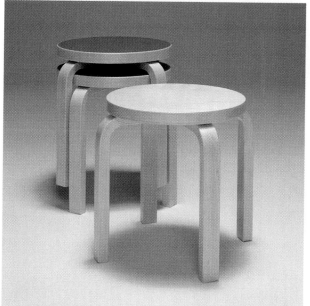

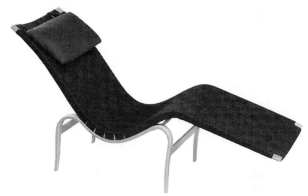

▲ **27-34.** Eva armchair and Model 36 lounge chair in laminated beech, 1934, 1935; Sweden; Bruno Mathsson.

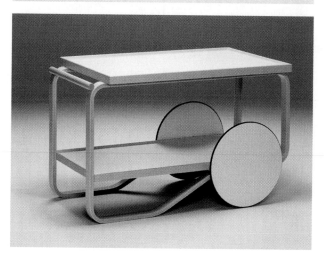

▲ **27-33.** Paimio armchair, stool, and teacart, 1932–1933; Finland; Alvar Aalto.

governments, many designers, and architects see furniture as a tool to improve the lives and tastes of the public. They promote simplicity and excellence in design through publications and exhibits.

In the postwar period, Scandinavian furniture becomes extremely popular in modern or contemporary houses, particularly in the United States, and one of several alternatives for furnishings. Sleek and unadorned, the furniture appears up-to-date, and its form looks good from any angle. The lightness, warmth, and handcrafted appearance appeal to consumers, and it mixes well with traditional furnishings to easily achieve a more contemporary look. Scandinavian furniture is marketed as Danish or Swedish Modern and the Teak Style.

Public and Private Buildings

■ *Types.* Scandinavian designers create all types of furniture but become particularly well known for their lounge and dining chairs and storage units (Fig. 27-32, 27-33,

DESIGN SPOTLIGHT

Furniture: Peacock chair, armchairs, and storage cabinet in teak, 1944–1949; Denmark; Hans Wegner. These examples reflect the simplicity, sophistication, and depth of Wegner's furnishings. Working primarily in wood, he consistently emphasizes naturally finished materials, handcrafted processes, and ergonomically contoured seating. Chairs are noteworthy for their smooth curved surfaces, rounded legs, cane or wood seats, and beautiful proportions. Joints are elegant and well detailed. Based on the traditional 18th-century Windsor chair, the Peacock chair has an ash frame, bentwood hoop back, teak armrests, and wenge dowel splines. Storage units are typically plain, rectangular, and unadorned. Some have open compartments covered by sliding doors. Emphasis is on the beauty of the wood.

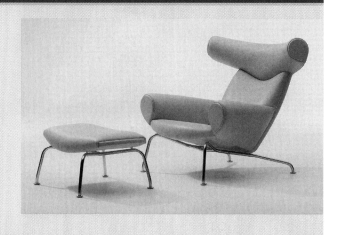

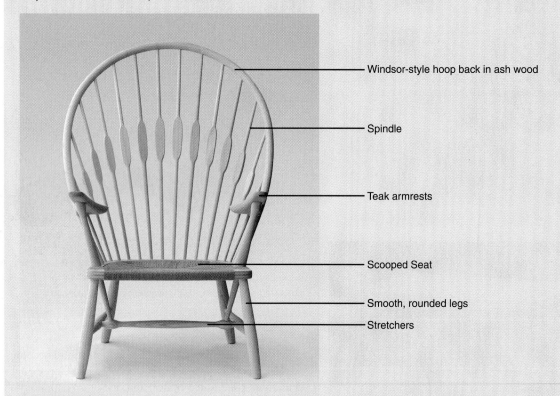

Windsor-style hoop back in ash wood

Spindle

Teak armrests

Scooped Seat

Smooth, rounded legs

Stretchers

▲ **27-35.** Peacock chair, armchairs, and storage cabinet in teak.

27-34, 27-35, 27-36, 27-37, 27-40). Designers around the world adapt Scandinavian ideas for commercial and residential applications.

■ *Distinctive Features.* Furniture, which translates modern design concepts into wood, is clean lined, practical, and modest. Sometimes, designers, such as Hans Wegner (Fig. 27-35) and Finn Juhl (Fig. 27-36), incorporate

references to past examples or other cultures different from Scandinavia in their work. One feature contributing to the worldwide popularity of Scandinavian furniture is flat packaging or knock-down (KD) fittings used by many manufacturers. Both practical and economical, KD allows individual pieces, large or complex storage systems, or entire room furnishings such as a kitchen to be

DESIGN SPOTLIGHT

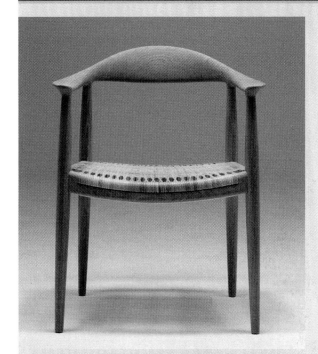

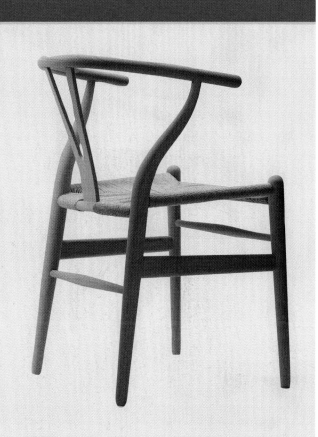

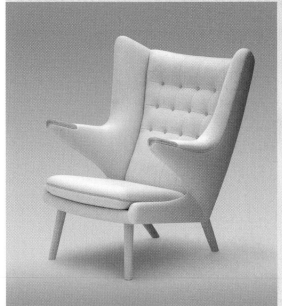

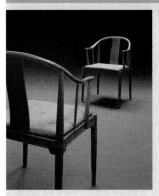

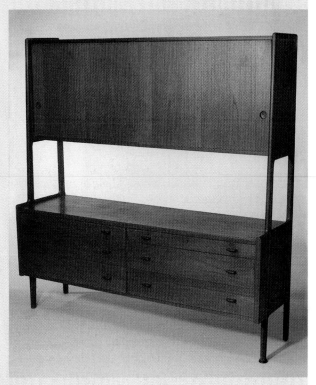

▲ **27-35.** *(continued)*

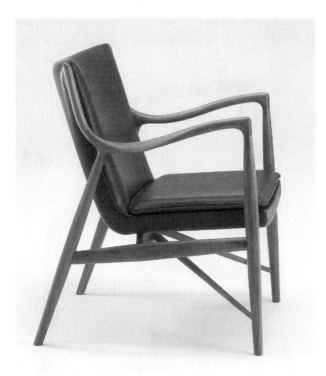

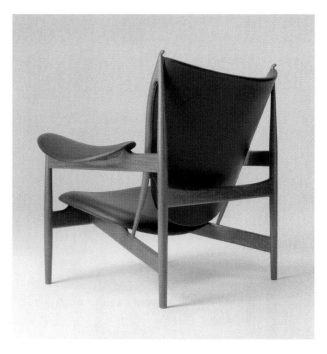

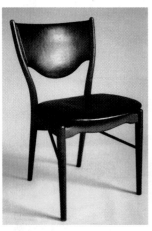

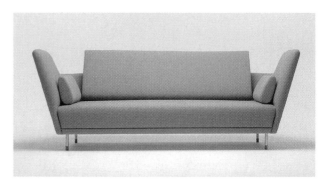

▲ **27-36.** Armchairs, side chair, and sofa, 1945–1949; Denmark; Finn Juhl.

shipped in flat cartons and assembled on site with simple tools. The joinings are so uncomplicated that they have become almost universal in the manufacturing and shipping of furniture from one part of the world to another. A pioneer in marketing KD furniture is Sweden's IKEA, whose first store opens in 1953. In 1965, the firm opens its first outlet where customers choose furnishings from displays and take the cartons of unassembled furniture with them.

■ *Relationships*. Furniture relates to interiors in form, material, and concept. Some architects design furniture to ensure total unity in their projects.

■ *Materials*. Early on, a few designers use tubular metal for furniture, but most use common woods native to their individual countries, including oak, fir, birch, beech, and ash. For more expensive pieces, designers choose teak, rosewood, mahogany, or wenge, a black wood from Africa. Pieces are lightly stained or left unfinished and simply waxed or polished. A linseed oil finish is the most popular on open-grained woods. Designers sometimes choose light-colored stains in reaction to public tastes for dark, imitation mahogany ones.

Plywood becomes a more common furniture material in Scandinavia after World War I, partly because it can be easily bent and shaped. Previously considered a cheap substitute for wood, its use in the construction of airplanes and boats substantially improves the overall quality. And newly invented glues make it even stronger than before. Designers, such as Aalto (Fig. 27-33) and Bruno Mathsson

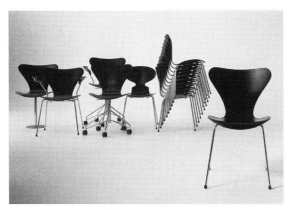

▲ **27-37.** Ant chair/Model 3107–Series 7 chair (top), 1955; Egg chair (right), 1956–1957; and Swan Chair (far right) 1956–1957; Denmark; Arne Jacobsen.

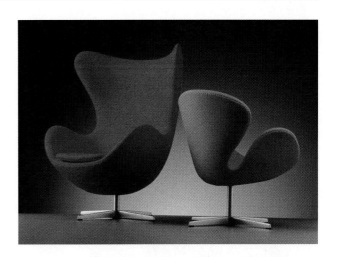

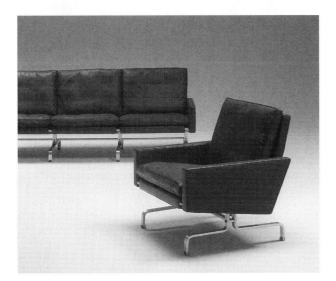

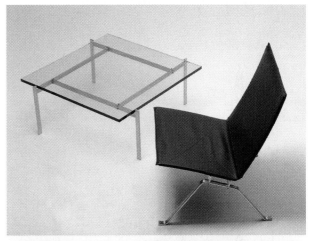

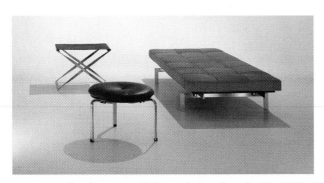

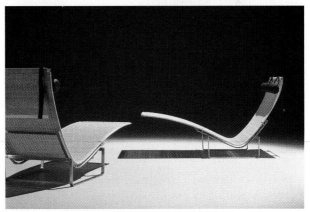

▲ **27-38.** Seating group, chair, stools, bench, and table, 1955–1965; Denmark; Poul Kjaerholm.

(Fig. 27-34), experiment with laminated wood for furniture frames. Laminated wood is stronger than solid wood, may be easily shaped, and is flexible.

After World War II, Scandinavian designers turn to new or industrial materials. Some, such as Poul Kjaerholm (Fig. 27-38), use metal either entirely or for important elements in their pieces. Beginning in the 1960s, Arne Jacobsen and Eero Aarnio create seating from molded, continuous plastic forms, sometimes covered with padding and upholstery (see Chapter 29, "Organic and Sculptural Modern").

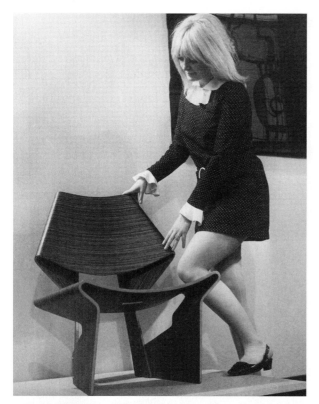

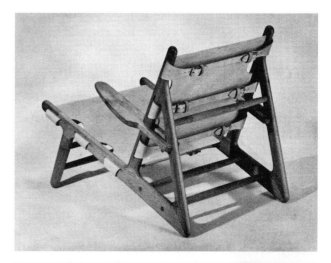

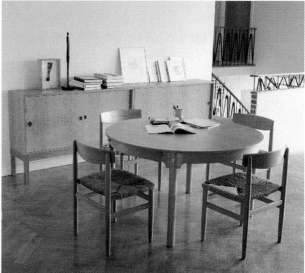

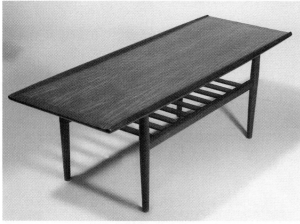

▲ **27-39.** Chair, 1963, and coffee table in laminated teak, 1960s; Denmark; Grete Jalk.

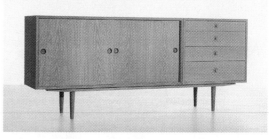

▲ **27-40.** Lounge and dining chairs, table, and storage cabinets, Ørensend Series, 1955; Denmark; Børge Mogensen.

■ *Seating*. Seating includes chairs, lounges, stools, and sofas (Fig. 27-2, 27-25, 27-32, 27-33, 27-34, 27-35, 27-36, 27-37, 27-38, 27-39, 27-40). In search of forms that fit the human body, many designs grow out of the study of anthropometics and ergonomics. Thus, seating often has a sculptural appearance and is very comfortable. Much seating is of wood with simplified traditional forms or adaptations from other cultures. Legs, arms, and supports may be solid or laminated wood. Solid wood legs are usually straight, rounded, and tapered, while laminated ones are curved for flexibility. Some seating is cantilevered or has

continuous, closed curvilinear frames instead of legs. Backs and seats may be lightly upholstered, have fabric webbing, or be of shaped plywood. Seats may be solid wood, cane, rush, rattan, or upholstered. Designs may be distinctive as in Finn Juhl's chairs and settees in which the back and seat appear to float above the frame instead of being attached to it (Fig. 27-36). Lounge chairs and sofas may have

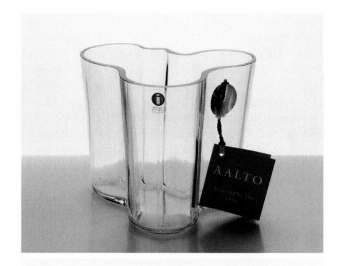

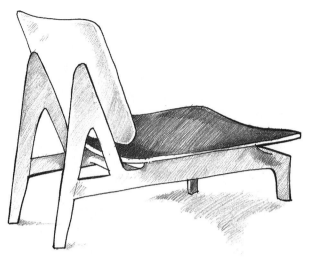

▲ **27–42.** Later Interpretation: Lounge chair, 2002; Japan; Sunao Jindo, manufactured by Goby Works.

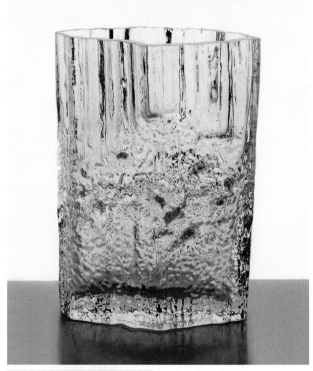

▲ **27–41.** Decorative Arts: Glassware, c. 1930s–1950s; Finland and Sweden; Alvar Aalto, Tapio Wirkkala, and Nils Landberg.

exposed wooden frames that match chairs or may be fully upholstered with or without arms. Sometimes seating consists of a low, built-in platform with a cushion and backrest separated or attached to the wall. Wegner designs a sofa that can easily become a sleep unit, and therefore offers great flexibility.

■ *Tables*. Tables, which vary in size and shape, are usually of wood, wood with glass tops, or marble (Fig. 27-39, 27-40). Aalto's tables have curving laminated wooden legs and wooden or glass tops. Dining tables usually extend for greater flexibility, such as one by Bruno Mathsson that extends from only a few inches wide to over 100" wide.

■ *Storage*. Storage may be free-standing, built-in, or hang on the wall to save floor space (Fig. 27-35, 27-40). Most storage pieces are rectangular in form with no applied decoration or moldings. Beauty lies in the combination of shapes and the grain of the wood. Pulls may be wood or metal, but are always simple in design. An innovation is unit furniture in which the user chooses individual modules or units to meet particular storage needs. Unit furniture adapts to any room through a combination of shelves and cabinets with doors and drawers. Designers develop sizes and shapes of individual modules by studying the requirements of the users and the dimensions of the objects to be stored.

■ *Beds*. Beds are low with simple headboards and, sometimes, footboards, relying on proportions and the wood itself for beauty. Headboards are usually rectangular panels or are composed of vertical uprights within a frame. Some unit furniture includes a pullout bed. Aalto designs a bed resembling a greatly simplified Empire boat bed.

■ *Upholstery*. Upholstery consists of plain woven fabrics, often of wool or linen, in muted colors, white, or black, and vinyl, leather, or animal skin. Designers prefer woven textiles over printed. Although this in part derives from their

hand weaving tradition and is similar to the Bauhaus aesthetic, Scandinavian designers admire the simple honesty of woven textiles. Some designers use webbing of jute or hemp in place of upholstery.

■ *Decorative Arts*. Designers create beauty in everyday objects in ceramics, glass (Fig. 27-41), metal, and wood. Architects, such as Aalto and Jacobsen, design lighting, glass, and other decorative objects either for specific interiors or for mass production.

■ *Later Interpretations*. Many postwar furniture designers, including Charles and Ray Eames, are inspired by Scandinavian design concepts of lightness, flexibility, good craftsmanship, and use of laminated woods. They develop these ideas further (see Chapters 28, "Geometric Modern," and 29, "Organic and Sculptural Modern"). The Scandinavian craft traditions find many adherents in North America, England, and Japan (Fig. 27-42), including Wharton Eshrick, George Nakashima, and Sam Maloof (see Chapter 34, "Environmental Modern"). Many pieces of furniture by prominent Scandinavian designers are still in production in the early 21st century, a testament to their originality, functionality, and adaptability. Scandinavian furniture designers continue adapting earlier forms and elements and develop new ones to meet contemporary needs and requirements. IKEA stores continue to sell Scandinavian furniture and accessories throughout the world.

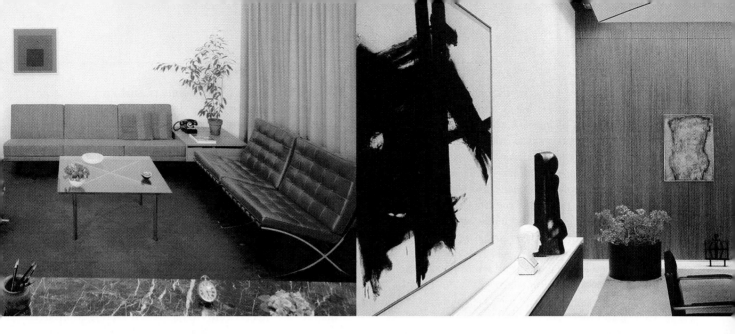

CHAPTER 28

Geometric Modern

1930s–1960s

The word modern means up to date; and to use the modern style means to take advantage of the technical achievements of the age. It means using the new materials and the new ways of construction that have been developed in recent years. It also means to study changes in our way of living and in our taste.

Philip Johnson, ideas derived from "Drama of Decoration," *Arts and Decoration*, February 1935

With increasing facilities for travel, communication, and the exchange of goods and ideas, art in a sense has become international in scope and has had a more universal appeal. The world is perhaps on the threshold of an artistic awakening that should be a logical sequel to the material advantages gained by an industrial age. A study of the arts must be on a firm foundation to meet the broader understanding that the future will require.

Sherrill Whiton, *Elements of Interior Design and Decoration*, 1951

Geometric Modern continues the design language and many of the ideas of the Bauhaus and International Style through work of the originators and their followers. Key characteristics include functionalism, geometric forms, little applied decoration, and new materials and technologies. During the period, Geometric Modern architecture and design enter the mainstream, particularly in the United States, which becomes the world leader of Modernism. Also important are the development of modern commercial interiors and furnishings and the expansion of the interior design profession.

HISTORICAL AND SOCIAL

During the 1930s through the mid-1940s, the world of design is in turmoil. The rise of Fascism in Germany and Italy and the militaristic expansion of Japan through much of East Asia stifle growth. World War II brings more world involvement and greater destruction across the globe than

World War I had. World's Fairs or exhibitions are held in many parts of the United States despite the tragedy unfolding overseas. These exhibitions, all of which feature a streamlined look into the future, are the major outlets for creative expression prior to World War II. Following the war, there is a period of optimism and enthusiasm for the future in the United States, which receives no physical damage from the war. Europe must recover and rebuild following the devastation and destruction.

In the postwar period, United States industries are able to convert quickly from war to civilian production and build upon wartime developments in technology, speed of production, and new materials. Because of this, the United States becomes the leading industrial power, producing half of the world's goods, particularly automobiles, chemicals,

and electronics. Americans ship their products and, by extension, their culture, design, and construction expertise all over the world. Spending by the U.S. federal government for veterans' support and education, loans, social programs, and the European Economic Recovery, or Marshall Plan, to help rebuild Europe contribute to the nation's prosperity. The booming economy creates new jobs, so standards of living rise, social mobility is higher, and more people own homes than ever before. The middle class grows larger, and the number of white-collar workers expands. More people go to college as educational opportunities increase. Although many women leave factories and return home, others enter the workforce in greater numbers.

Although one of the victors, France does not recover quickly, and this causes her to lose artistic supremacy, except in couture fashion. Neither does Modernism become mainstream there, Before the war, the International Style and Bauhaus principles had only minimal acceptance, and following the war, most French designers turn their attention to luxury goods as in the heyday of Art Deco. A few attempt to revive the notion of the *artiste-décorateur*.

Germany recovers quickly despite her defeat, but takes little artistic leadership in modern design. Many of the early Modernist leaders who could have assumed a leading role were forced to immigrate to other countries during the war.

Italy recovers from the war quickly also. Freed from the repression of prewar Fascism, creative energy and innovation burst forth in many areas, and Italy begins to assert supremacy in design and the decorative arts. In 1947, the Milan Triennale resumes, soon becoming the world's leading design show and a platform for Italian designs as well as new and progressive ideas from other countries.

England continues to suffer from shortages in materials. The Utility Scheme, which restricts materials and governs design as it had during the war, encourages practicality and simplicity but little innovation in design. The 1951 Festival of Britain attempts to overcome this problem by promoting excellence in British art, architecture, design, and decorative arts. Not until the 1960s does Britain exert leadership in art, design, and popular culture.

Japan, recovering from its defeat under the guidance of the United States, quickly becomes an industrial power and a major design force. It welcomes a number of European designers in the 1930s and embraces modern.

All is not well, however. The Cold War threatens to destroy the hard-won peace. This hostility between the United States and its allies and the Union of Soviet Socialist Republics (USSR) and her allies from the 1940s through the 1980s stops just short of an all-out war and includes the nuclear arms race. Fears of nuclear war and the spread of Communism prompt Americans to build home bomb shelters. Anti-Communist concerns arise, and perceived un-American ideas and practices are questioned. In further attempts to stop the spread of Communism, the United States engages in conflicts, such as the Korean War, fought from 1950 to 1953. Consumer debt from mortgages and the new credit cards increases. Minorities, although employed in greater numbers in industry, do not experience the widespread prosperity.

During the postwar period, the United States also becomes the world leader in Modernism. Widespread prosperity and optimism establish a favorable climate for and public acceptance of the Modern image. Also contributing is the significant and lasting impact on the language of the new architecture and architectural education made by prominent Bauhaus practitioners. Beginning in the middle of the 1930s, influential members of the Bauhaus immigrate to the United States to escape the war. Among the first are architects Walter Gropius and Ludwig Mies van der Rohe, who bring Bauhaus ideas and principles to England, and then to the United States. Gropius teaches in, and later chairs, the architecture department at Harvard University in Boston. In 1937, he hires Marcel Breuer, also from the Bauhaus, as a professor, and the two become partners in architectural practice. After his arrival in 1937, Mies van der Rohe becomes director of architecture at the Armour Institute, later the Illinois Institute of Technology (IIT) in Chicago. Through the efforts of Gropius, Breuer, and Mies, the Bauhaus methods of teaching architecture replace the European Beaux-Arts model of studying exemplary buildings of the past. Although Le Corbusier does not come to the United States and designs only one building there, he influences architecture through his work in which he explores new directions for functionalism, his Five Points of New Architecture, and his modular systems. He collaborates with architects in the United States and Brazil.

In the early 1950s, critiques of Modernism begin. Some originate in appraisals of modern life and society, particularly the role of consumerism and corporate influences. Others arise from individuals and groups, such as Congres Internationaux d'Architecture Moderne (CIAM), which challenge the anonymity of Modernism, charging it with lacking community identity and, more importantly, not providing appropriate monuments or symbols of a particular group or society. Universal solutions and standards for good design and taste are questioned, especially in light of the needs of minorities, the individuality of consumer markets, and planned obsolescence of yearly models. Designers begin exploring different means to address these issues.

By the end of the 1950s, high-style Modern architecture and design begin to move in different directions as important postwar architects and designers establish their own identities and/or explore new theories and design vocabularies. In the 1960s, a more youth-oriented culture arises, which craves excitement, novelty, and a faster pace of living supported by inexpensive, disposable items of material culture. The dominance of Geometric Modernism begins to fade but does not completely disappear.

CONCEPTS

Geometric Modernism continues the design vocabulary of the Bauhaus and International Style but not necessarily their political overtones or desire to reform society and

IMPORTANT TREATISES

- **Introduction to Modern Architecture**, 1940; James Maude Richards.

- **Elements of Interior Decoration**, 1937; Sherrill Whiton.

- **Elements of Interior Design and Decoration**, 1951; Sherrill Whiton.

- **The Modern House in America**, 1940; James Ford and Katherine Morrow Ford.

- **Problems of Design**, 1957; George Nelson.

- **Space, Time and Architecture**, 1941; Sigfried Giedion.

- **What Is Modern Design?** 1950; Edgar Kaufman, Jr.

- **Who Designs America?** 1966; Laurence B. Holland, editor.

Periodicals and Magazines: *The Architectural Forum, Architectural Record, Arts & Architecture* (1938–1962), Domus (Italy, after 1945), *House and Home, Home Furnishings Daily, Interior Design and Decoration* (later *Interior Design), Interiors,* and *Stile Industria* (Italy).

▲ **28-1.** Florence Knoll Bassett and members of the Knoll Planning Unit, c. 1960s.

culture through architecture and design. In the United States, for example, Geometric Modernism becomes aligned with faith and hope in democracy, egalitarianism, dynamism, and new technologies. The United States design agenda of creating images for herself as a new world power and leader of industry is different from that of Europe where the priority is rebuilding damaged cities and supplying housing for displaced citizens. The thrust for new and modern construction in the United States comes from the private sector to which style and image are more important than ideas and theories. Geometric Modernism downplays the originators' ideas of social reform in deference to the ideals of capitalism in the public arena and the image of the good life in private, reflecting a strong confidence in free enterprise.

In the postwar era, designers and architects embrace standardization, prefabrication, mass production, and new materials and technologies, particularly those developed during the war. The debate is no longer whether these techniques should be used, but how to use them quickly and effectively to produce well-designed goods and architecture for modern society. The inherent character of Geometric Modern offers additional attractive ideas and associations. Some believe that functionalism, efficiency, simplicity, and new materials and techniques point toward a new world where progress and growth fulfill the promises of a better tomorrow today. Elements of modern readily adapt to various needs and functions. Furthermore, the efficiency, practicality, and economy of modern architecture, interiors, and furniture appeal to those who revel in a no-nonsense or modest approach to life and design.

The spread of Modern ideas and design is aided by museums, periodicals, and department stores. They sponsor contests, competitions, and exhibitions that promote the principles of Modern design as excellent and demonstrating good taste. For example, beginning in 1951 Good Design competitions and exhibits of winning products are held by the Museum of Modern Art (MOMA) and the Chicago Merchandise Mart. Winners, whose work exemplifies modern design, technical innovation, and unity, include Frank Lloyd Wright and George Nelson. Books and periodicals in the United States and abroad champion modernism, including *Architectural Forum, Domus* in Italy, *Form* in Sweden, and *Architectural Review* and *Design* in Britain. Additionally, architectural handbooks, manuals, and graphic standards focused on modern design replace the theories and manifestos of earlier. Through these means, principles of Modernism become institutionalized in the United States, and the term *Modern* comes to mean up-to-date, in step with technical advancements of the time, new materials, and new construction methods, new ways of living, and most importantly, good design. Sometimes designs of modernist character are called Contemporary to further divorce Modernism from its previous political and social reform ideology. Contemporary, like Modern, implies designs that are for today.

DESIGN CHARACTERISTICS

Geometric Modernism incorporates such characteristics of the Bauhaus and International Style as simplicity, geometry, rectilinear grids, regularity but not necessarily symmetry, and minimal applied decoration. New materials, such as aluminum and plastics; standardization; and prefabrication are considered essential elements in achieving design goals.

Architects emphasize newness and modernity in design and purity in form. Most buildings are simple and rectilinear in silhouette. Even those that are more complex are still rectilinear. Also important are simplicity, sleekness, and compatibility between style and materials. Architects often experiment with orientation, form, construction techniques, or materials to suit clients or to move design in different directions. Those buildings that closely follow the International Style display flat, transparent façades, glass curtain walls, and volume as opposed to mass. Other structures maintain the regularity of the grid but use concrete or other materials to express heaviness and monumentality in the manner of Le Corbusier. Their façades may be flat or have projections and recesses, and windows vary between small slits and entire façades.

Similarly, interiors and furniture are mostly rectangular or geometric in form with new materials and technologies highlighted. Large windows or glass curtain walls bring in natural light and help integrate the indoors with the outdoors. Open, uncluttered spaces may repeat the grid concept of the exterior. In corporate interiors, pattern and color are usually minimized to help create an architectonic look. Furniture is lighter in size and weight than before. It is often low and horizontal with hard edges and geometric forms. There is usually a visual and material separation between functional parts, such as legs and seats.

■ *Motifs.* Modern buildings have no motifs or references to the past. Geometric shapes are the dominant motif, with architectural details spotlighted (Fig. 28-2).

ARCHITECTURE

Geometric Modernism defines both public and private architecture because it is economical, easy to construct, and adaptable to a variety of building types and user/client needs. Work by International-Style pioneers Walter Gropius, Marcel Breuer, Ludwig Mies van der Rohe, and Le Corbusier both defines and dominates the style. New design leaders arise, such as Philip Johnson, Louis Kahn, Paul Rudolph, Buckminster Fuller, Oscar Niemeyer, Luis Barragán, and architectural firms such as Skidmore, Owings, and Merrill (SOM).

Most architects emulate purity of form and the "less is more" concepts of Mies van der Rohe, so numerous rectangular buildings with glass curtain walls that become known as "glass boxes" spring up across North America. During the 1960s, prosperity stimulates a desire for more luxurious materials and signature buildings to define a corporate image or express symbolism or monumentality. To achieve these goals, some architects follow the postwar concepts of Le Corbusier while others adopt a more sculptural, expressionist, and personal approach (see Chapter 29, "Organic

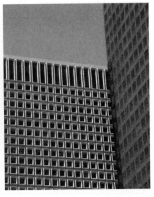
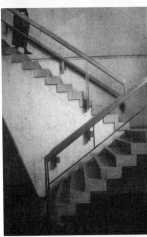
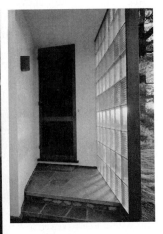
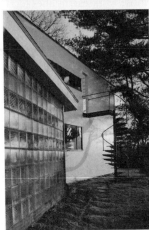

▲ **28-2.** Architectural details, 1950s–1960s; New York and Massachusetts.

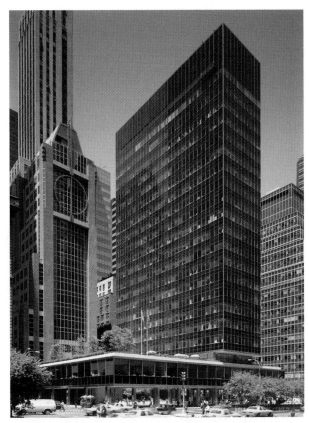

▲ **28-3.** Lever House, 1951–1952; New York City, New York; Gordon Bunshaft at Skidmore, Owings, and Merrill.

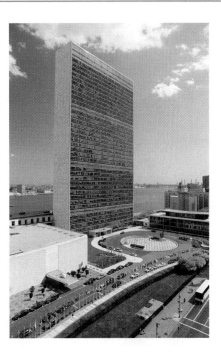

▲ **28-4.** United Nations Secretariat Building, 1947–1952; New York City, New York; Wallace K. Harrison and Max Abramovitz in association with Le Corbusier, Sven Markelius, Oscar Niemeyer, N. D. Bassov, and other members of the advisory committee.

and Sculptural Modern"). As always, the work of some individualist architects and designers does not fit into any particular mode.

Geometric Modernism is not widely accepted, especially in some parts of the United States, where attention to site, climate, and materials are important design goals. Neither is it much in evidence in the numerous suburban developments across the United States, where traditional Cape Cods or Ranch houses predominate.

■ *New Brutalism.* During the 1950s, New Brutalism, a modern architecture composed of bold concrete in geometric forms, develops. Combining the logical structure of Mies van der Rohe with Le Corbusier's robust forms, buildings project massiveness and a sense of tension thought to mirror the pressures of modern life. The overtly abstract nature of the style does not tie buildings to their locations, so New Brutalist buildings lack a sense of place, for which they are greatly criticized. The style appears to derive its name from *béton brut*, or raw concrete, a term Le Corbusier uses to describe his work constructed in rough-faced concrete. Most examples are in Great Britain, where the style is primarily adopted as a means of swift, inexpensive construction particularly for public housing. Americans Louis Kahn and Paul Rudolph work in the style. An example in the United States is the Boston City Hall, the result of a controversial competition (Fig. 28-14).

Public and Private Buildings

■ *Types.* Building types include offices, corporate headquarters (Fig. 28-3, 28-4, 28-6, 28-10, 28-12), banks,

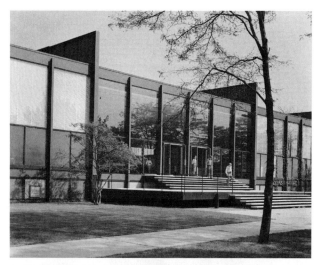

▲ **28-5.** Illinois Institute of Technology, Crown Hall, 1950–1956; Chicago, Illinois; Ludwig Mies van der Rohe.

stores, schools (Fig. 28-5, 28-11), art galleries, museums, exhibition buildings (Fig. 28-13, 28-15, 28-16), churches (Fig. 28-8), apartment buildings (Fig. 28-23), transportation terminals, and private dwellings (Fig. 28-17, 28-18, 28-19, 28-20, 28-22, 28-24, 28-25). Geometric Modern also defines public housing projects arising from the federally sponsored urban renewal efforts during the 1950s.

■ *Corporate Office Buildings.* The corporate office building, a new building type as defined by Geometric Modernism, is formulated in the United States and spreads to the rest of the world. These buildings take two forms: a high-rise or glass box in an urban context, or an expansive single or group of buildings set within a campus-like landscape. Structures contributing to the development of this type after World War II appear in various locations. The Equitable Building in Portland, Oregon, is one of the first

DESIGN SPOTLIGHT

Architecture: Seagram Building, 1954–1958; New York City, New York; Ludwig Mies van der Rohe and Philip Johnson. This first commercial building by Mies displays elegant simplicity in its pure geometric form and richness of material. Raised on columns, the structure is sheathed in amber-tinted glass with bronze I-beams and panels. American fire codes require that steel be covered with fireproof materials, which Mies would not do. So, the bronze grid is not the actual structure of the building but covers the steel structure beneath. During the day, the building is warm and dense, but becomes transparent golden brown at night when lit internally. Placement at the rear of the site focuses greater attention on the building. Spreading before it is a granite plaza with two symmetrical reflecting pools with fountains. The Seagram Building, along with the earlier nearby Lever Building by SOM, establishes the precedent and sets the design standards for corporate headquarters in the 1950s and 1960s.

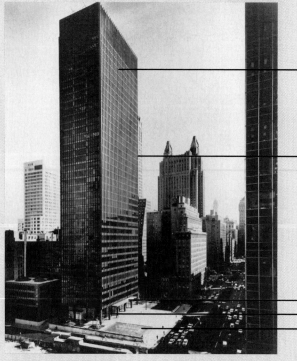

Glass curtain wall facade with bronze grid and no ornamentation

Staight edges define tbe corporate glass box

Main entry at plaza/street level
Base raised on columns
Granite plaza in front

▲ **28-6.** Seagram Building, New York City.

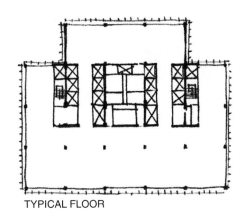

TYPICAL FLOOR

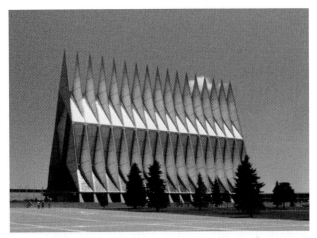

▲ **28-8.** Chapel, United States Air Force Academy, 1956–1962; Colorado Springs, Colorado; Skidmore, Owings, and Merrill.

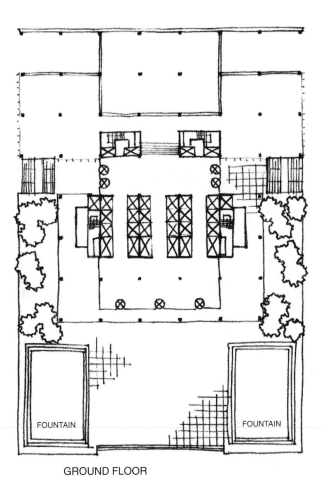

FOUNTAIN FOUNTAIN

GROUND FLOOR

▲ **28-7.** Floor plans, Seagram Building, 1954–1958; New York City, New York; Ludwig Mies van der Rohe and Philip Johnson.

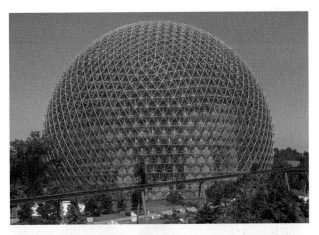

▲ **28-9.** Geodesic domes, mid-1950s to early 1960s; developed by Buckminster Fuller.

tall glass boxes to use aluminum on the exterior and to be fully air conditioned. The United Nations Secretariat Building (Fig. 28-4) in New York City pioneers the use of glass curtain walls for high-rise buildings. Equally important are the Lake Shore Drive apartments and the Illinois Institute of Technology (IIT; Fig. 28-5) campus plan and buildings in Chicago by Mies van der Rohe. The Lake Shore Drive apartments look no different from an office building of the period. The IIT buildings rely on modules and grids for placement within the site and façade design.

▲ **28-10.** Pan Am Building (now Met Life), 1963; New York City, New York; Walter Gropius (The Architects' Collaborative) and Pietro Belluschi.

▲ **28-11.** Art and Architecture Building, Yale University, 1961–1963; New Haven, Connecticut; Paul Rudolph. New Brutalism.

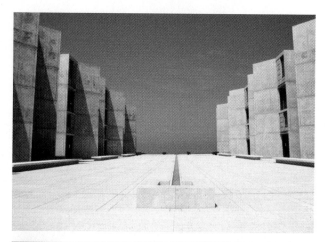

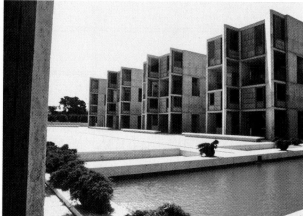

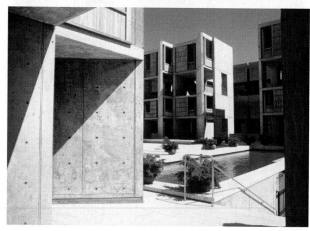

▲ **28-12.** Salk Institute of Biological Studies, 1959–1966; La Jolla, California; Louis Kahn.

In these buildings, Mies's use of structural elements, particularly exposed I-beams to add interest, is widely imitated. Throughout the period, high-rises become taller and taller as land-use taxes and clients' need for space increase. Structures compete to be called the world's tallest building.

■ *Geodesic Dome.* An innovative development during this period is the geodesic dome, designed by Buckminster Fuller (Fig. 28-9). The round shape is composed of prefabricated modular parts that easily interlock together. Construction is fairly simple, inexpensive, and fast. Its unique structure offers open interior space, which is large and unhindered by columns. Because of this, the geodesic dome is a popular architectural form for exhibit spaces, theaters, and greenhouses.

■ *Case Study Houses.* To promote Modernism, John Entenza, editor of *Arts and Architecture* magazine, establishes a program to create residential prototypes that can be built quickly and economically for any client anywhere in the United States. Called Case Study Houses, 36 are designed and built largely in California from 1945 to 1966. They are marketed as having superior environments that promote

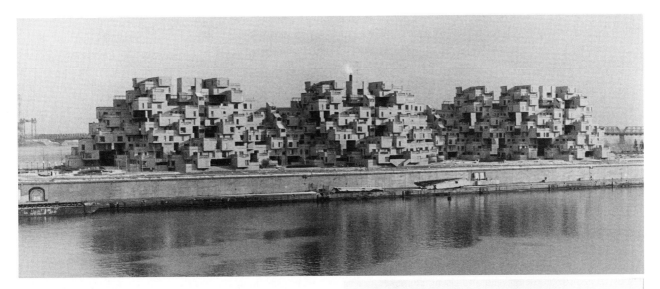

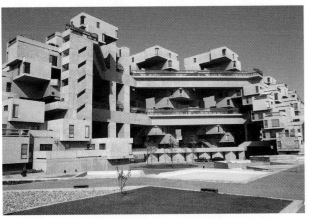

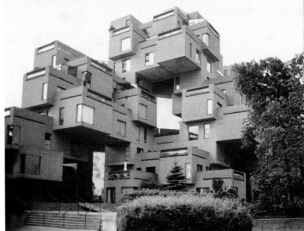

▲ **28-13.** Habitat, EXPO 67, 1967; Montreal, Canada; Moshe Safdie.

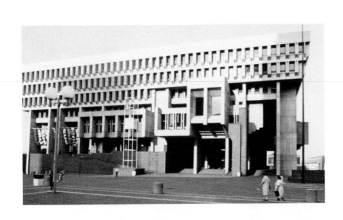

◄ **28-14.** Boston City Hall, 1969; Boston, Massachusetts; Kallmann, McKinnell & Knowles; master plan by I. M. Pei. New Brutalism.

practicality and functionality. Most are created for imaginary families of different sizes, budgets, and requirements. Well-known architects and designers such as Richard Neutra, Charles and Ray Eames (Fig. 28-22), and Eero Saarinen, and less well-known ones, such as Pierre Koenig (Fig. 28-25), produce designs. Although varying in design, commonalities normally include a single story, flat roofs, simplicity, open planning, and integration of interior and exterior.

IMPORTANT BUILDINGS AND INTERIORS

■ **Baton Rouge, Louisiana:**

—Dome, Union Tank Car Company, 1958; Buckminster Fuller.

■ **Bloomfield, Connecticut:**

—Connecticut General Life Insurance Company, 1957; Skidmore, Owings, and Merrill and Knoll Planning Unit.

■ **Boston, Massachusetts:**

—Boston City Hall, 1969; Kallmann, McKinnell & Knowles; master plan by I. M. Pei. New Brutalism.

■ **Brasilia, Brazil:**

—Congress complex, Plaza of the Three Powers, 1956–1960; Lucio Costa and Oscar Niemeyer.

■ **Cambridge, Massachusetts:**

—Harvard University Graduate Center, 1949–1950; Walter Gropius (The Architects' Collaborative).

■ **Chandigarh, India:**

—Capitol of Chandigarh, including the Secretariat and Assembly Building, 1950–1964; Le Corbusier, and Pierre Jeanneret, with Michael Fry and Jane Drew.

■ **Chicago, Illinois:**

—Crystal House, Century of Progress, 1934; George Keck and William Keck

—House of Tomorrow, Century of Progress, 1933; George Keck and William Keck.

—Illinois Institute of Technology, 1939–1940; Chemistry Building, 1946; Alumni Memorial Hall, 1946; and Crown Hall, 1950–1956; Ludwig Mies van der Rohe.

—Inland Steel, 1957–1958; Skidmore, Owings, and Merrill.

—Lake Shore Drive Apartments, 1950–1952; Ludwig Mies van der Rohe.

■ **Colorado Springs, Colorado:**

—Chapel and buildings, United States Air Force Academy, 1956–1962; Skidmore, Owings, and Merrill.

■ **Hunstanton, Norfolk, England:**

—Secondary Modern School, 1950–1954; Alison Smithson and Peter Smithson. New Brutalism.

■ **La Jolla, California:**

—Salk Institute of Biological Studies, 1959–1966; Louis Kahn.

■ **Lincoln, Massachusetts:**

—Gropius House, 1937–1938; Walter Gropius and Marcel Breuer.

■ **London, England:**

—Dome of Discovery, Festival of Britain, 1949–1951; Ralph Tubbs.

—Economist Building, 1959–1965; Peter Smithson and Alison Smithson. New Brutalism.

—National Theater, 1951; Denys Lasdun.

—Royal Festival Hall, 1951; Robert Matthew, J. L. Martin, Edwin Williams, and Peter Moro.

■ **Marseilles, France:**

—Unité d'Habitation, 1946–1951; Le Corbusier.

■ **Mexico City, Mexico:**

—Cuadra San Cristobál, 1966–1968; Luis Barragán.

—Luis Barragán House, 1947; Luis Barragán.

■ **Montreal, Canada:**

—Habitat, EXPO 67, 1967; Moshe Safdie.

—United States Pavilion, EXPO 67, 1967; Fuller and Sadao, Inc.

■ **Milan, Italy:**

—Pirelli Building, 1956; Gio Ponti.

■ **New Canaan, Connecticut:**

—Breuer House, 1947; Marcel Breuer.

—Glass House (Residence of Philip Johnson), 1949; Philip Johnson.

■ **New Haven, Connecticut:**

—Art and Architecture Building, Yale University, 1961–1963; Paul Rudolph. New Brutalism.

—Beinecke Rare Book Library, Yale University, 1961–1963; Skidmore, Owings, and Merrill.

■ **New York City, New York:**

—CBS Building, 1960–1965; Eero Saarinen and Associates, with interiors by Florence Knoll.

—Chase Manhattan Bank, 1957–1960; Skidmore, Owings, and Merrill.

—Chemical Bank, 1953–1954; Gordon Bunshaft, Charles E. Hughes, with interior design by Eleanor Le Maire at Skidmore, Owings, and Merrill.

—Ford Foundation Headquarters, 1966–1967; Kevin Roche, John Dinkeloo and Associates.

—Knoll Showroom, 1951; Florence Knoll.

—Lever House, 1951–1952; Gordon Bunshaft at Skidmore, Owings, and Merrill.

—Museum of Modern Art, 1938–1939, with additions in 1950–1953, 1964, and 1979–1984; Philip L. Goodwin and Edward Durell Stone, 1939; Philip Johnson, 1953, 1964.

IMPORTANT BUILDINGS AND INTERIORS

- —Pan Am Building (now MetLife), 1963; Walter Gropius (The Architects' Collaborative) and Pietro Belluschi.
- —Seagram Building, 1954–1958; Ludwig Mies van der Rohe and Philip Johnson, with interiors by Florence Knoll.
- —United Nations Secretariat Building, 1947–1952; Wallace K. Harrison and Max Abramovitz in association with Le Corbusier, Sven Markelius, Oscar Niemeyer, N. D. Bassov, and members of the advisory committee.
- —Whitney Museum of Art, 1963–1966; Marcel Breuer.

■ **Pacific Palisades, California:**

- —Eames House, 1945–1950; Kenneth Acker and Charles Eames.

■ **Palm Springs, California:**

- —Kaufmann Desert House, 1945–1947; Richard Neutra.

■ **Paris, France:**

- —UNESCO Headquarters, 1958; Marcel Breuer, Pier Luigi Nervi, and Bernard Zehrfuss.

■ **Plano, Illinois:**

- —Farnsworth House, 1950–1952; Ludwig Mies van der Rohe.

■ **Rio de Janiero, Brazil:**

- —Ministry of Education and Health, 1936–1943; Oscar Niemeyer (with others), and consultant Le Corbusier.

■ **Warren, Michigan:**

- —General Motors Technical Center, 1951–1956; Eero Saarinen and Associates.

Wood construction dominates the first examples, but during the 1950s steel framing and industrial materials become more common. Thousands of people visit the Case Study Houses, which are instrumental in promoting Modernism.

■ *Site Orientation.* Buildings in urban settings are oriented toward the street, sometimes covering an entire block. They often stand in self-contained isolation with no attempt to relate to surrounding structures. Zoning laws in New York no longer require setbacks as long as a percentage of the site is left open or is lower than the tower. Therefore, following Lever House (Fig. 28-3) by Skidmore, Ownings, and Merrill (SOM), most high-rises become rectangular boxes with open piazzas, courtyards, or terraces

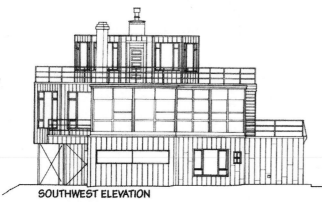

SOUTHWEST ELEVATION

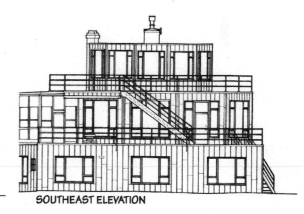

SOUTHEAST ELEVATION

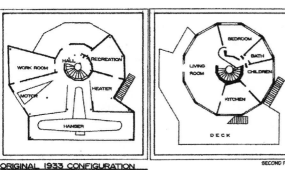

ORIGINAL 1933 CONFIGURATION
NOT TO SCALE

▲ **28-15.** House of Tomorrow, Century of Progress International Exhibition, 1933; Chicago, Illinois; George Fred Keck.

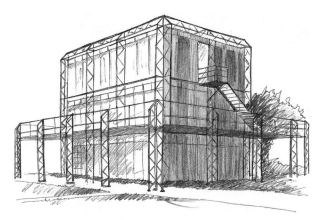

▲ **28-16.** Crystal House, Century of Progress Exhibition, 1934; Chicago, Illinois; George Fred Keck.

▲ **28-18.** Kaufmann Desert House, 1945–1947; Palm Springs, California; Richard Neutra.

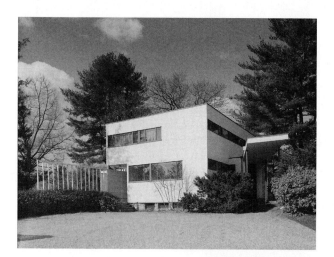

▲ **28-19.** House, Mexico City, Mexico; Luis Barragán.

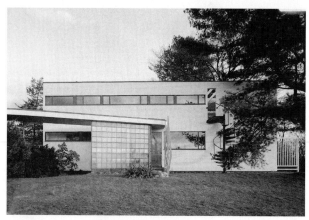

▲ **28-17.** Gropius House, 1937–1938; Lincoln, Massachusetts; Walter Gropius and Marcel Breuer.

on one or more sides. Some, like Lever House, have broad horizontal lower portions with the tower rising above. Depending upon the site, the long or short side of a rectangular building may face the street.

Architect-planned residences orient toward sun, landscape, and views. Most compositions adapt to the climate and landscape of the region and requirements of the homeowners. Some are designed around natural features, such as trees or hillsides. Others integrate with the landscape. Those in suburbs sit in rows along grids of streets with surrounding lawns. In contrast to earlier, most postwar houses are built on concrete slabs instead of over basements.

■ *Heating and Cooling Systems.* With the increased usage of heating and cooling systems (like air-conditioning) during the 1950s, architects can create glass box buildings that are healthier and more comfortable, without the need for the traditional elements of wide roof overhangs, high ceilings, thick walls, and building footprints that create cross-ventilation.

DESIGN SPOTLIGHT

Architecture: Glass House (Residence of Philip Johnson), 1949; New Canaan, Connecticut; Philip Johnson. Establishing a dialogue between site and natural environment, this steel and glass house integrates the outdoors with the indoors. Placed on a flat manicured lawn, it is a monument to the minimalist machine aesthetic. Translucent window walls frame the open living area and the contrasting brick cylinder bathroom/chimney core. Furnishings designed by Mies van der Rohe continue the character with steel frames and leather upholstery. In 1957, the architect stated: "I consider my own house not so much as a home (though it is that to me) as a clearinghouse of ideas which can filter down later, through my work or that of others."

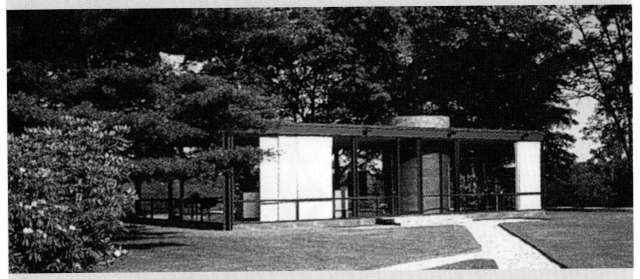

▲ **28-20.** Glass House (Residence of Philip Johnson); New Canaan, Connecticut.

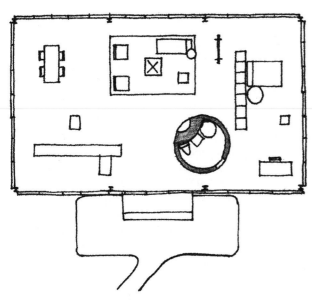

▲ **28-21.** Floor plan, Glass House (Residence of Philip Johnson), 1949; New Canaan, Connecticut; Philip Johnson.

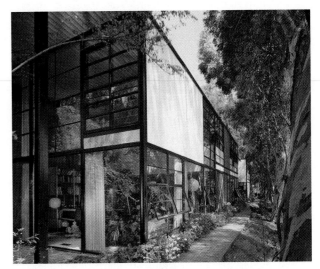

▲ **28-22.** Eames House, 1945–1950; Pacific Palisades, California; Kenneth Acker and Charles Eames.

DESIGN PRACTITIONERS

- **Luis Barragán** (1902–1988), who practices mainly in Mexico, learns architecture on his own. Influenced by Le Corbusier and Spanish architecture, his early works are International Style, but later Barragán formulates a more regional style derived from native Mexican and vernacular art and architecture. Characteristics are natural materials, thick walls, small openings, minimal applied decoration, harmony and integration with nature and the landscape, and bright wall colors. In 1980, Barragán receives the prestigious Pritzker Prize in Architecture, in recognition of the overall quality of his work.

- **Charles Eames** (1907–1978) and **Ray Kaiser Eames** (1912–1988) are a husband and wife design team who create architecture, interiors, furniture, toys, film, and exhibitions. Charles trains as an architect and Ray as a textile designer and painter. They meet at the Cranbrook Academy of Art, marry, and go on to collaboratively create some of the best-known and innovative furniture of the 20th century. Recognized for their creative problem solving, they experiment with new materials and develop new construction techniques always with mass production in mind.

- **Philip Johnson** (1906–2005), one of the stars of Modern architecture, has a profound impact through his theories, writings, and work on two of the most important architectural movements of the 20th century: the International Style and Post-Modernism. Johnson has a long and distinguished architectural career and works on or designs some of the most important modern buildings in the United States: Seagram's Building with Mies van der Rohe; his own home, the Glass House; and the A. T. & T. (Sony) Building. In 1979, Johnson is the first to receive the prestigious Pritzker Prize in Architecture, recognizing his impressive body of work.

- **Louis Kahn** (1901–1974) begins work in a predominately International Style, but moves toward a more individualist expression. Buildings convey monumentality and massiveness while maintaining a strong relationship with the site. He creates units of spaces in a variety of forms, such as strings and clusters, and he then develops the form and structure from the space. Although Kahn designs few buildings, his influence is extended through teaching architecture at Yale University and the University of Pennsylvania. His most renowned works are the Yale University Art Gallery and the Salk Institute of Biological Studies.

- **Florence Knoll Bassett** (b. 1917; née Florence Schust) studies design and architecture. After working for various architectural firms, she joins Hans Knoll's furniture business as a designer and space planner. They marry in 1946 and form Knoll Associates. Through her work as director of the Knoll Planning Unit and president of the company, Knoll transforms the decorator into the interior designer and profoundly affects the direction of modern interiors, particularly commercial ones. She introduces the idea that the interior designer should put together the space planning and mechanical equipment in addition to choosing the color scheme, textiles, finishes, furniture, and accessories. In 1955, after Hans's death, she becomes president of Knoll International, and through her extensive contacts with modern designers, the Knoll company takes the lead in producing modern furniture. Her best-known interiors are those in the Seagram and CBS Buildings.

- **George Nelson** (1907–1986) works in interior design, furniture design, industrial design, and exhibition design. In 1945, he joins Herman Miller as head designer, a position he maintains until 1972. At Herman Miller, Nelson shapes the corporate philosophy and marketing strategies of the company. He also produces groundbreaking designs himself and brings to the firm such well-known and innovative designers as Charles Eames, Ray Eames, and Isamu Noguchi.

- **Skidmore, Owings, and Merrill** (1936–present) is founded by Louis Skidmore (1897–1962) and Nathaniel Owings (1903–1984) in Chicago in 1936. The firm opens a New York branch in 1937, and in 1939 John Merrill (1896–1975) becomes a partner, creating SOM. The firm emphasizes teamwork and collaboration among the design disciplines. In 1952, SOM principal Gordon Bunshaft's Lever House propels the firm to national recognition. Known for its tall buildings, SOM introduces structural innovations and works in a range of modern architectural styles. It remains a leading firm in architecture, engineering, interior design, graphic design, and project management. In 1988, Bunshaft receives the prestigious Pritzker Prize in Architecture.

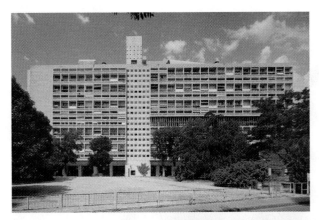

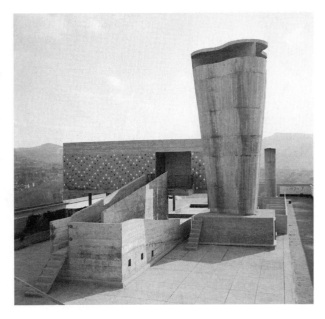

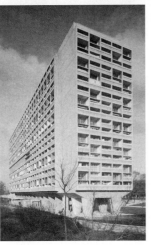

▲ **28-23.** Unité d'Habitation, 1946–1951; Marseilles, France; Le Corbusier.

■ *Floor Plans*. There is no typical floor plan because they develop from function. Most commercial buildings are modular with structural columns forming a geometric grid and organizing the building form, establishing window openings, and defining placement of interior partitions (Fig. 28-7). This permits large open spaces that can be subdivided as necessary, so in many buildings form no longer follows function. In fact, form develops first and functions fit into it. Commercial buildings have centralized service cores and stairwells that may be in the center of the building or on one end.

Residential floor plans exhibit considerable variety and flexibility, particularly in architect-designed examples (Fig. 28-21). Key considerations are the site and zoning. Plans may incorporate features of the site and/or be oriented toward views. Zoning, which places like activities near each other, arises from increased emphasis upon balancing and separating social activities with and from privacy. Because most houses are a single story, plans may be U or L shaped or have interior courtyards or swimming or reflecting pools to more easily place living or public areas away from bedrooms and private

areas. Open plans with few fixed interior partitions characterize activity and living areas. This suits informal modern lifestyles and makes the most of limited space. Hallways and other circulation spaces are minimized to conserve space.

■ *Materials*. The most common materials, especially in nonresidential buildings, are steel, reinforced and exposed concrete, aluminum, and tinted and plain glass (Fig. 28-3, 28-5, 28-6, 28-8, 28-10). Skyscrapers have structural skeletons and mainly glass walls. Many are prefabricated with modular components and have exposed or covered steel or aluminum frames. Apartment complexes and some houses imitate this concept with steel framing (Fig. 28-20, 28-22, 28-24). Like public structures, houses have large expanses of glass, but often use other materials such as wood, brick, stone, concrete blocks, ribbed steel decking, and wood. This use of various materials is different from earlier International-Style or Bauhaus concepts.

■ *Façades*. Most façades on Geometric Modern commercial buildings are modular and exhibit large areas of glass in a rectangular grid to provide a feeling of aloofness or anonymity. An overall rectangular box form is common for

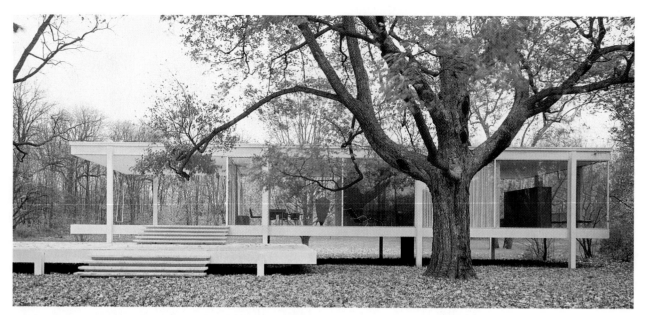

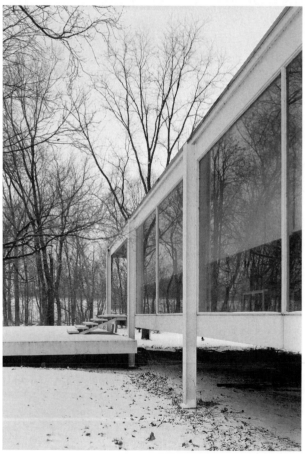

▲ **28-24.** Farnsworth House, 1950–1952; Plano, Illinois; Ludwig Mies van der Rohe.

all types of buildings, especially skyscrapers (Fig. 28-3, 28-4, 28-6, 28-10). Some are raised on pilotis in the manner of Le Corbusier. Others have low horizontal portions to balance verticality and provide open space required by zoning. Architects may use angles to shape and

add variety to a building (Fig. 28-10). Mies van der Rohe's use of construction elements to organize the façade and add a decorative element influences many others. Commercial buildings may have green, gray, or amber tinted glass accentuated with black, gray, or amber steel frames or

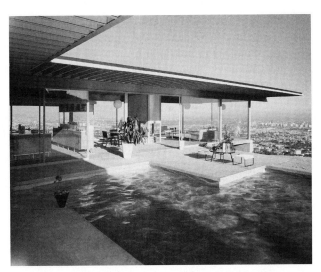

▲ **28-25.** Case Study House 22, 1959–1960; Los Angeles, California; Pierre Koenig.

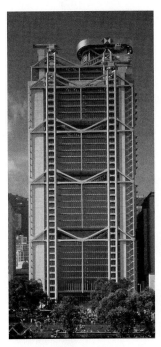

◄**28-26.** Later Interpretation: Hong Kong and Shanghai Bank Headquarters, 1979–1986; Hong Kong, China; Norman Foster. Late Modern.

aluminum panels. Some incorporate panels of primary colors. New Brutalist buildings feature contrasts of solid and void relationships but retain a strong grid concept (Fig. 28-11, 28-14). Most façades have projections, so are not flat. Although there is considerable variety in residential façades, most are rectangular and horizontal with large areas of transparent or translucent glass, which contributes to the feeling of light and openness (Fig. 28-17, 28-18, 28-20, 28-22, 28-24). Façades are rarely plain white as earlier but usually combine several materials and may incorporate primary colors.

■ *Windows.* Window walls or large areas of glass dominate, aided by the universal incorporation of air-conditioning in commercial buildings. New Brutalist buildings have small, slit-like windows or rectangular windows with deep insets. Windows on commercial buildings, including New Brutalist, are usually fixed and in grid patterns, while those on houses may include fixed plate glass, sliding glass, casement, and/or awning (Fig. 28-17, 28-18, 28-20, 28-22, 28-24, 28-25, 28-38, 28-40). On residences, picture windows afford panoramic views to the outside, while smaller ones may focus on a private garden space. Some houses have frameless corner windows with miter joints, which allow in lots of light and provide uninterrupted views. Windows usually have narrow metal moldings and mullions that frame the openings and divide glass areas. Sometimes they are black or bronze to accent the grid effect. Some large plate glass windows have no mullions.

■ *Doors.* Doorways integrate with the rhythm and regularity of the exterior so that they often become an extension of glass walls or solid surfaces (Fig. 28-5, 28-20, 28-24). Entrances on New Brutalist structures often are obscured and difficult to find, which adds to their formidable appearance. Entry doors may be glass or wood, or a combination of both. They are plain, flat, and often wider than an interior door. Projecting canopies or an upper floor may shield the entry area, or it may be recessed to provide protection.

■ *Roofs.* Most roofs are flat with no spires or setbacks, but they may have a slight pitch to allow water to run off. Others are single or double pitched, or asymmetrical.

■ *Later Variations.* In the 1970s and 1980s, the vocabulary of the skyscraper box grid continues in the Late Modern expression (see Chapters 31, "Late Modern · 1," and 33, "Late Modern · 2"), but with changes in form accentuated by improved technology. Breaking the box with an inward angle, a more exposed structure, or an angled roofline becomes common. Noteworthy examples include the Sears Tower in Chicago and Pennzoil Place in Houston. The vocabulary expands further through the work of the next generation of innovators, with more changes in building form and with continued advances in technology. Exposed structural elements become common, unusual shapes develop, and buildings reach new heights to garner attention. Two of the most prominent examples of these concepts are Hong Kong and Shanghai Bank Headquarters (Fig. 28-26) in Hong Kong and the Lloyd's Building in London. New Brutalism experiences a reinterpretation at the end of the 20th century in which the roughness of the concrete is covered with stucco or softened with sandblasting or pattern molding.

INTERIORS

Geometric Modern commercial interiors follow Bauhaus and International-Style principles that focus on function and reject decoration. Designers emphasize simple forms, clean lines, architectural structure, open space, and a harmonious integration of parts. Interiors are airy and light.

In public structures and houses with steel frames, the geometric, usually rectangular, grid of the exterior is often a design feature in the interiors. In commercial buildings, suspended ceilings, which integrate mechanical systems, lighting, and air-conditioning, permit greater freedom in space planning. Many spaces have open plans and are sparsely furnished with modern furniture. Walls are often plain and unadorned. Fabric covered partitions may subdivide areas.

During the 1950s, commercial interior design becomes important as interior planning grows more complex and specialized. Creating or enhancing image, increasing productivity, and creating pleasant work environments are important design goals, especially to corporations. Architectural firms, such as SOM, establish interiors units, usually headed by men, to design commercial spaces. The Knoll Planning Unit, directed by Florence Knoll (Fig. 28-1), becomes a leader in the design and furnishing of modern commercial interiors, particularly offices for corporate America (Fig. 28-31). Interiors by Knoll and the Planning Unit blend modern furnishings, textiles, and lighting together as an integrated whole and are models of simplicity and order. Called the Knoll look, other features include open space and furniture lining or at right angles

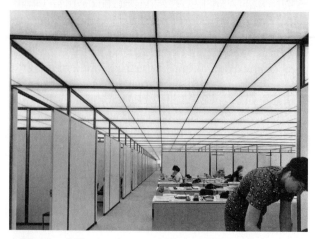

▲ 28-27. Office interiors, c. 1930s to mid-1960s.

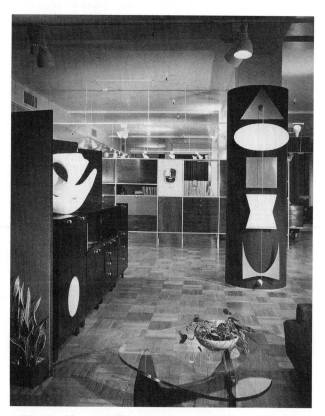

▲ 28-28. Herman Miller showroom, 1954; Chicago, Illinois; George Nelson.

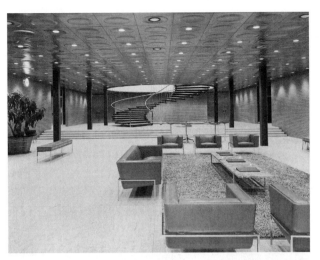

▲ **28-29.** Lobby, General Motors Technical Center, 1951–1956; Warren, Michigan; Eero Saarinen and Associates.

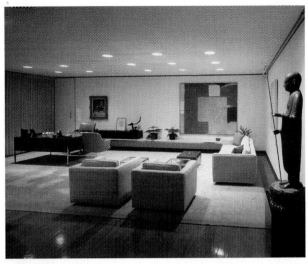

▲ **28-30.** Office of David Rockefeller, Chase Manhattan Bank, 1961; New York City, New York; Skidmore, Owings, and Merrill and Ward Bennett.

to walls for an architectonic appearance. Florence Knoll also revolutionizes executive office planning when she replaces the customary cluttered and messy table behind the desk with a storage piece or credenza. Following her examples, executive offices and lounge areas often resemble living rooms with modern sofas and chairs and a variety of textiles, finishes, and accessories. Furnishings are grouped for informal conversation, but align in relationship to walls and windows. Those who work in nonresidential design often describe themselves as space planners or interior designers to separate themselves from decorators who mainly work in residences. To most people, all are decorators.

In houses and apartments, exteriors integrate with interiors through the use of large areas of glass, similar materials and textures, and careful orientation, which also make spaces light and airy. The living room, dining room, and kitchen are frequently one large space subdivided by furniture and/or changes in floor level. Besides providing social interaction for the homemaker, this highlights her prominent role in the home. Open planning also makes meal serving and cleanup easier and increases apparent room size. New or experimental materials, such as fiberglass textiles and plastic laminates, vinyl wall coverings, and aluminum furniture, enhance the Modern look.

The world strives to emulate modern American kitchens and bathrooms. Efficiently planned around work centers, kitchens are filled with labor-saving appliances. Ranges, ovens, refrigerators, dishwashers, dryers, and washing machines reflect the modern idiom and come in a variety of colors and sizes. Kitchen cabinets in standard sizes have no applied moldings. Less expensive than before, they come in wood or plastic laminate in colors such as the primaries. Countertops are of easy-to-clean materials such as plastic laminate, ceramic tiles, or stainless steel. Similarly, bathrooms

are more colorful than before. Fixtures are smaller and more sculptural.

Public and Private Buildings

■ *Types*. Offices dominate commercial interiors (Fig. 28-27, 28-30, 28-31). But, with changes in interior design, furniture showrooms (Fig. 28-28, 28-33) emerge as retail venues to market new ideas. They soon multiply because of increased demand for innovative furnishings. Most residences have open, free-flowing public spaces with less restriction on room designation. Family rooms, spaces adjacent to the kitchen where family members and guests gather for informal activities such as watching television, become a mainstay of modern houses during the period.

■ *Offices*. Office hierarchy is still evident in the size, location, number of windows, and type of furniture, which convey status (Fig. 28-27, 28-30, 28-31). Bull pens remain the norm for workers, while management and executives have enclosed offices. Many offices have functional open planning with rows of desks between the service core and windows.

During the period, the Knoll Planning Unit introduces the study of user needs and work procedures as part of the design process, a concept that eventually is integrated into programming practice. Florence Knoll and her team collect and analyze information from user interviews to develop office layouts so that their designs relate the interior to the building and the furniture to the interior and human needs. Knoll also pioneers the use of floor plans, elevations, and/or perspectives with textiles and finishes as a means to fully illustrate concepts to the client.

■ *Relationships*. Modules from the exterior define the floors, ceilings, and location of furnishings. Rectangular spaces and

DESIGN SPOTLIGHT

Interiors: Executive offices, CBS Building, c. mid-1960s; New York City, New York; Florence Knoll. With their uncluttered appearance, these executive offices emphasize simple forms, clean lines, architectural structure, open space, and a harmonious integration of parts. Ceilings are painted white or a neutral color or have suspended grids with acoustical or textured panel inserts, air diffusers, and lighting. Walls are plain, simple, in a neutral color, and have large windows. Plain, straight casement draperies shield window openings. As was typical of Knoll's work, the spaces resemble living rooms with modern sofas and chairs that are grouped for informal conversation or conferences, but align in relationship to walls and windows. Most furniture designs are by her or her contemporaries. Fabric upholstery or leather covers most seating, with a few pieces accented in bright colors such as red. As usual, there are few accessories.

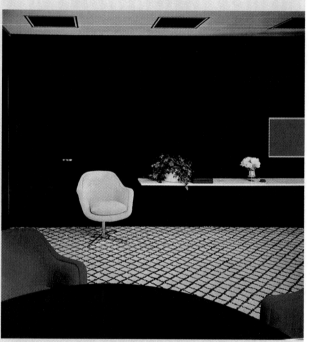

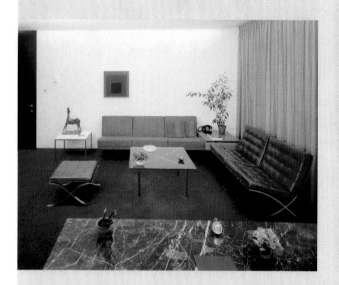

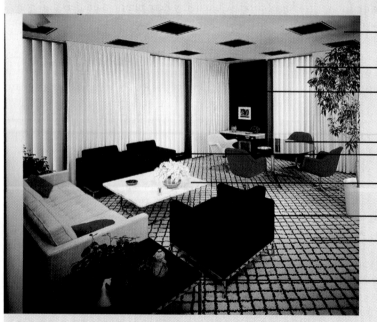

Suspended grid ceiling in a neutral color

Plain, straight casement draperies

Dark accent wall

Conference table with chrome pedestal base
Boxy chairs align with walls

Marble top coffee table with chrome legs

Boxy chair in woven fabric

Wall-to-wall carpeting with simple geometric pattern

Wood side table with chrome legs

▲ 28–31. Executive offices, CBS Building; New York City.

DESIGN SPOTLIGHT

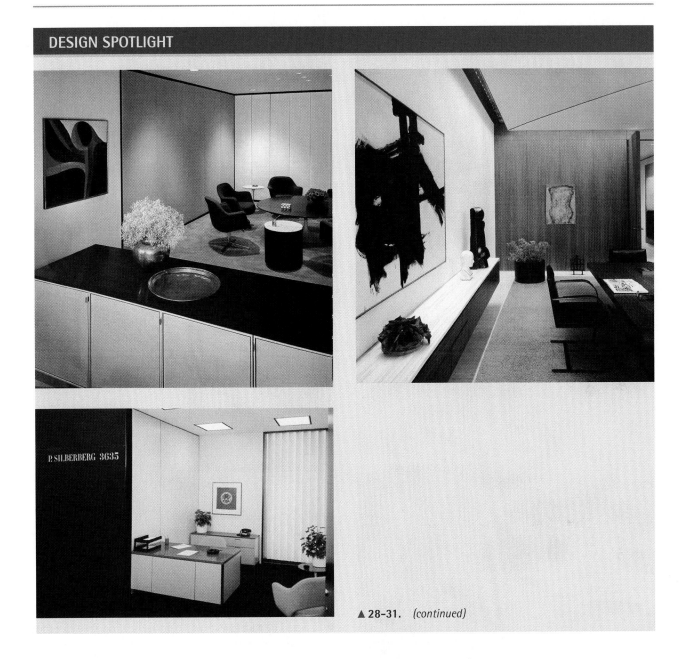

▲ **28–31.** *(continued)*

furniture reflect rectilinear exteriors, making a connection between façade and interior. Natural light from glass curtain walls, lighting in suspended ceilings, and air-conditioning enhance the office environment year-round (Fig. 28-27, 28-31, 28-35). For continuity, residential interiors often repeat the textures and materials of the exterior. Furniture groups may be arranged to take advantage of views, landscape, and reflecting pool features. Large windows and plants also bring in the outside.

■ *Color.* A variety of color schemes define Geometric Modern interiors. Open offices are often neutral with spots of dark or bright colors for contrast. Florence Knoll often uses a rich or bright color on the wall behind the executive's desk. Additionally, she works out new or innovative color schemes in Knoll's showrooms where there are fewer

limitations. Both public and private interiors use natural colors and materials (Fig. 28-30, 28-39). Color psychology notes that neutrals and grays provide a feeling of rest and quiet.

Bold, highly saturated or primary colors appear in all types of interiors in part as a reaction to the dull and dark colors used during the Depression and war years and to signal optimism. Bright turquoise, orange, pink, and lime green, and red, blue, and yellow with white and black enhance interiors, textiles, tableware, and light fixtures. The so-called harlequin color schemes combine a range of bright tones. Most woods are stained rich warm colors to emulate more expensive woods.

■ *Lighting.* Large windows flood rooms with natural light. Suspended ceiling grids with integrated lighting are common

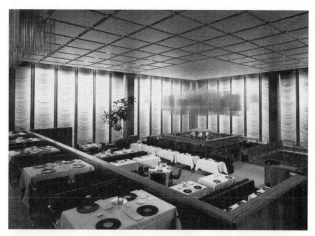

▲ **28-32.** Four Seasons Restaurant, Seagram Building, 1954–1958; New York City, New York; Philip Johnson.

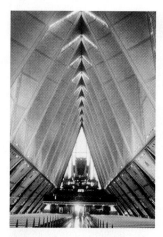

◀ **28-34.** Nave, Chapel, United States Air Force Academy, 1956–1962; Colorado Springs, Colorado; Skidmore, Owings, and Merrill.

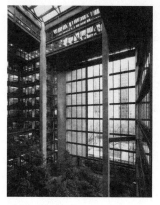

◀ **28-35.** Atrium lobby, Ford Foundation Headquarters, 1967; New York City, New York; Kevin Roche, John Dinkeloo and Associates.

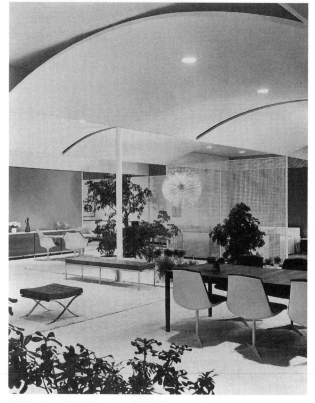

▲ **28-33.** Knoll showroom, 1961; Miami, Florida; Florence Knoll.

in offices and other commercial spaces (Fig. 28-27, 28-29, 28-31), and the illuminated ceiling is introduced. Specialists in lighting design emerge during the period, including Richard Kelley whose luminous ceilings make important design statements in modern corporate buildings. Recessed lighting replaces or supplements surface-mounted ceiling fixtures (Fig. 28-30). Pendant lights, usually in sets of three, are common in houses. Floor and table lamps provide

light where needed (Fig. 28-41). The Arco floor lamp designed in 1962 is a favored fixture for high-style, modern interiors. Most light fixtures are simple, unadorned, geometric, and flexible with metal stems. Many of the lamp shades are metal, either in silver, white, black, or red. George Nelson designs a line of lightweight metal and sprayed plastic lanterns that become very popular.

■ *Floors.* The widespread use of central heating allows for the use of materials earlier considered cold, including concrete, marble, terrazzo, ceramic tile, stone, brick, and glass. Various rooms, particularly executive offices and living rooms, may feature the warmer patterns of wood blocks, strips, or parquet. Natural and synthetic materials, such as cork, vinyl, rubber, and linoleum, increase in use because they are hygienic and easy to maintain. SOM introduces wall-to-wall carpet for noise suppression in offices in 1959, and it becomes common in important commercial areas (Fig. 28-31). Carpet is popular for bedrooms, whereas in living areas most floors are uncarpeted. Different flooring materials may visually separate space in open rooms in houses. Area rugs in contemporary patterns, asymmetrical designs, curving or rectangular shapes, and plain also subdivide open conversation areas and anchor furniture groupings (Fig. 28-29, 28-30, 28-40). Rugs are simpler than other textile or wallpaper patterns and often limited to one or two colors.

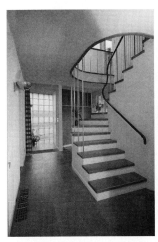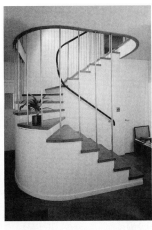

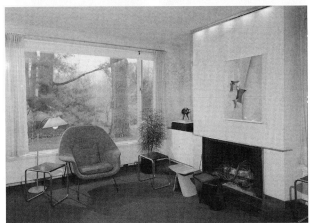

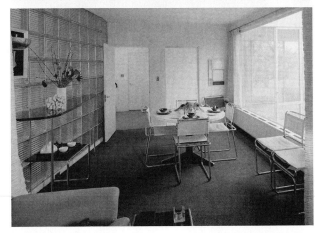

▲ **28-36.** Stair halls, living room, and dining room, Gropius House, 1937–1938; Lincoln, Massachusetts; Walter Gropius and Marcel Breuer.

▲ **28-37.** Stair and living area, Luis Barragan House, 1947–1948; Mexico City, Mexico; Luis Barragan.

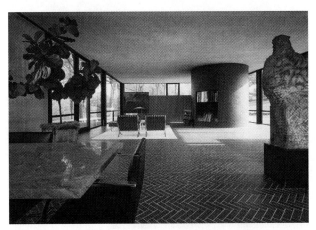

▲ **28-38.** Living area, Glass House (Residence of Philip Johnson), 1949; New Canaan, Connecticut; Philip Johnson.

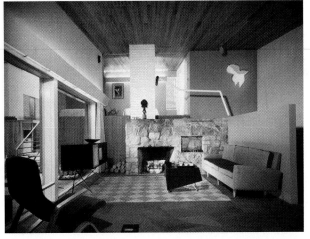

▲ **28-39.** Living area, house built in the garden of the Museum of Modern Art, 1949; New York City, New York; Marcel Breuer.

■ *Walls*. Drywall (often referred to as gypsum or sheetrock) begins to replace plaster for interior partitions during the period, especially in commercial spaces. Walls are plain and flat with no moldings, except maybe a baseboard (Fig. 28-30, 28-31, 28-37, 29-39). White or neutral painted walls continue, particularly in large office areas.

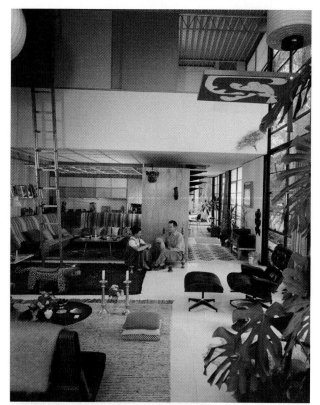

▲ **28-40.** Interiors, Eames House, 1945–1950; Pacific Palisades, California; Kenneth Acker and Charles Eames.

Sometimes designers incorporate accent walls in rich or primary colors. Fabric-covered partitions may subdivide open office spaces. Natural materials, such as painted or plain brick, stone, wood panels, and plywood veneer, are favored for the home, but synthetics, such as plastic laminate or vinyl wallpapers, are also acceptable. Wallpapers, common in houses, have abstract, linear, or stylized patterns in varying scales. Borders are out of fashion. Because textures are important, rooms often have different textures on walls, floors, and/or ceilings. Patterns are also important, so two papers with contrasting patterns may cover a single wall or different walls in the same room or in an open space. Patterns relate to the room. For example, kitchen papers have patterns of fruit, vegetables, bottles, and other objects associated with the space.

Built-in storage units integrated with the architecture provide storage and/or subdivide offices and other commercial spaces (Fig. 28-28). In houses, they are often a feature

▲ **28-41.** Lighting: Table and floor lamps, c. 1950s–1960s; manufactured by Knoll, Nessen, and Laurel.

in and/or between living and dining rooms (Fig. 28-38). Staircases, often in conversation areas, are a distinctive feature and often have open risers to visually open space (Fig. 28-29, 28-36, 28-37).

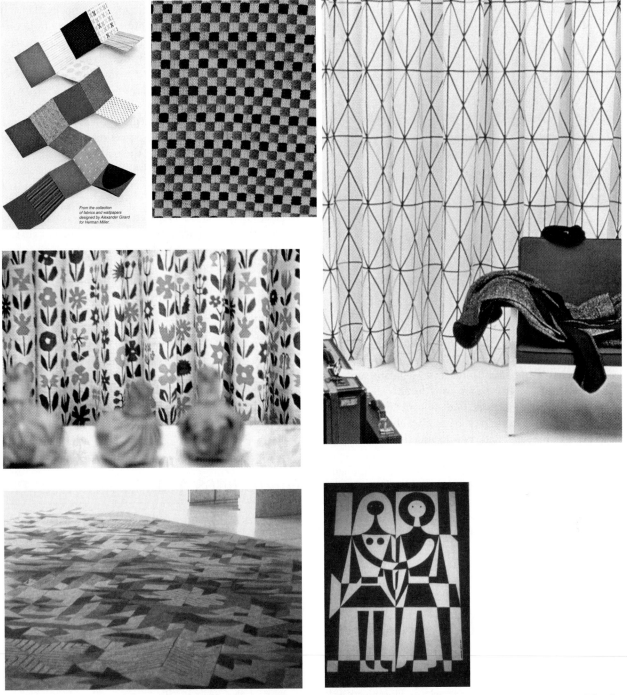

From the collection of fabrics and wallpapers designed by Alexander Girard for Herman Miller.

▲ **28-42.** Textiles: Fabrics, carpet, and wall hangings, c. 1950s–1960s; United States; Alexander Girard, and Erwin Laverne and Estelle Laverne.

■ *Fireplaces.* Central heating is now almost universal, but many houses still have fireplaces (Fig. 28-36, 28-38, 28-39). No longer centered on a main wall, asymmetry or central placement is the rule. The design usually follows the house style, with a heavy emphasis on straight lines and geometry. The chimney face may be brick or concrete blocks.

■ *Window Treatments.* Simple, pleated window treatments hung straight from ceiling to floor are typical (Fig. 28-31, 28-42). Most are of unpatterned, woven fabrics or sheers in white or natural colors that blend in with the architecture, walls, and surrounding area. Designers strive to keep them unobtrusive and architectural looking. New to the period are casements, which are introduced

▲ **28-43.** Later Interpretation: Herman Miller office, c. 2000s; United States; furniture manufactured by Herman Miller. Late Modern.

commercially at Lever House. Some offices and houses have the new vertical blinds inside or large adjustable, angled panels (*brise soleil*) outside to regulate sunlight. Venetian blinds or the newly introduced café curtains cover windows in residences. Wall-to-wall curtains sometimes are used to emulate picture or full-wall windows.

■ *Doors.* Doors are flat, plain, usually in wood or sometimes metal, and may be painted black, white, a primary color, room color, or stained. Door trims, like window moldings, are flat, narrow, and used to frame the opening.

■ *Textiles.* Textiles in natural and man-made fibers are used less than previously and primarily for window treatments. Some are simple monochromatic woven designs, while others may be linear, geometric, or stylized patterns in bright colors. Newly developed protective finishes, such as Scotchgard, are introduced during the period. In 1947, the newly formed Knoll Textiles division opens a showroom exclusively for fabrics in New York, expanding the company's product line and design services. Knoll Textiles strives to create fabrics in appropriate patterns and colors that will withstand the wear of commercial applications. The line includes men's suiting, which Florence Knoll frequently uses in offices, innovative fabrics, such as Nylon Homespun, and more traditional designs such as Knoll Stripe. Marketing innovations in the showroom include the fabric wall and small samples attached to cardboard with descriptive information about the fabric. In 1952, Herman Miller opens a textiles division with designer Alexander Girard in charge (Fig. 28-42). He introduces bright colors and simple stylized or abstract designs inspired by folk and contemporary art. Girard designs more than 300 fabrics, wall hangings, and wallpapers for Herman Miller.

■ *Ceilings.* Ceilings in all buildings are usually flat and plain (Fig. 28-30, 28-36). Treatments may vary from one space to another, based on function and aesthetic choices, but overall there is much more variety than earlier. Ceilings in public buildings are painted white or a neutral color; have suspended grids (Fig. 28-27, 28-29, 28-31, 28-32) with acoustical or textured panel inserts, air diffusers, and lighting; or are covered with wood strips or a material used in the building design, such as metal. Sometimes architects create unusual ceilings that interpret the building character (Fig. 28-34, 28-35, 28-37, 28-39, 28-40). Some living spaces are double height for more openess and may have rooms at half levels like mezzanines.

■ *Later Interpretations.* Geometric Modern, as typified by the Knoll look, characterizes corporate and high-style residential interiors for many decades with variations or further developments in design concepts or through new furniture designs (Fig. 28-43). Later designers place more emphasis on specific designs to meet client needs, functional requirements, and aesthetic considerations of character, branding, or corporate image. Interiors created by architects often follow the language of the building exterior. Those by interior designers may imitate that language or exhibit new design concepts. For instance, they may incorporate the grid forms of systems furniture but layer the design with elements that humanize and warm the space. Or a restaurant or retail store may display a concept centered on an image specifically designed for the space.

FURNISHINGS AND DECORATIVE ARTS

The lighter scale, airiness, and visual weight of Geometric Modern furniture eminently suit modern rooms, whether residential or commercial. Furniture often has a machine aesthetic, blending with the hard-edged geometry of the architecture and interiors. Many pieces are multipurpose and/or modular for flexibility. Architects and the new profession of furniture designers create furnishings in new materials using new construction techniques, most of which emerge during the war. In addition, rooms, especially in houses, also have Scandinavian or Italian Modern furniture (Fig. 28-39).

During the period, offices, especially when planned by office managers, retain a traditional appearance because little moderately priced, well-designed modern furniture is available. Exceptions are custom-designed offices, such as those by the Knoll Planning Unit or SOM (Fig. 28-30, 28-31). Knoll, Inc., and Herman Miller introduce lines of modern office furniture in the 1940s and 1950s. Although not inexpensive, they are functional, aesthetically pleasing, and suit modern interiors. Both companies offer pieces with sleek, simple designs in different materials, finishes, and colors. Knoll, Inc., and Herman Miller begin aggressively marketing good design during this

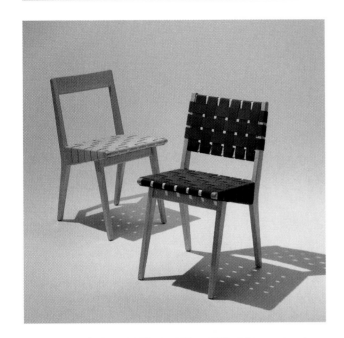

▲ **28-45.** T chair, 1950–1952; United States; William Katavolos, Ross Littell, and Douglas Keley, manufactured by Laverne International.

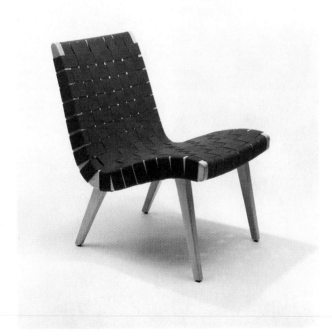

▲ **28-44.** Side and lounge chairs, c. 1940s; United States; Jens Risom, manufactured by Knoll International.

period. Florence Knoll and George Nelson, director of design at Herman Miller, believe that good design is good business and make it a strength of their companies. They hire prominent and relatively unknown designers to create pieces and/or lines for them and give the designers royalties or other creative means of compensation. In this way, both companies become leaders in a reassessment of the relationship of art to industry. Herman Miller Company and

Knoll International are the most influential modern furnishing manufacturers of the period.

Public and Private Buildings

■ *Types.* Manufacturers and designers, like the Herman Miller Company and Florence Knoll, increasingly strive to create or produce office furniture that suits modern offices and aids the process of work. Suites of office furniture, room dividers, and storage systems are important (Fig. 28-28, 28-33, 28-48). New to the period is mass seating such as in airports. Designers modernize traditional furniture types with new forms, materials, and construction for the residential market. Some pieces suit both commerical and residential applications.

■ *Modular Furniture.* Producing furniture in modular geometric units becomes an important focus for furniture and industrial designers in the mid-1940s. The idea is not a new one. Marcel Breuer designs a component system in 1924 and Le Corbusier's Casiers Standard Units group is shown in the Pavillion Espirit Nouveau in 1925. During the postwar period, modular furniture appeals because it relates to exterior and interior modules while giving flexibility and customization to individual needs. Additionally, standardized parts are easily and inexpensively manufactured and quickly

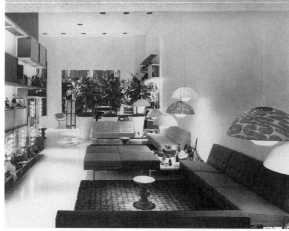

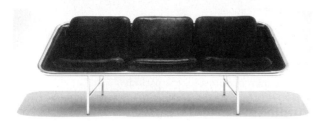

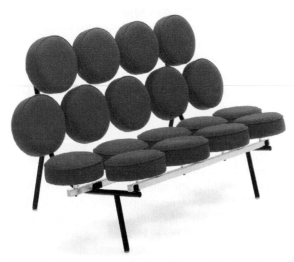

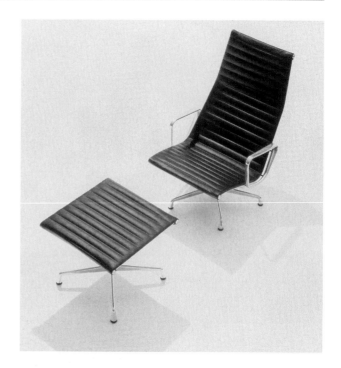

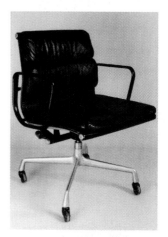

▲ 28-46. Chair, modular seating, Sling and Marshmallow sofas, 1954–1955, 1964; United States; George Nelson Associates, manufactured by Herman Miller.

▲ 28-47. Armchairs, Aluminum Group, 1958, 1969; table, 1964; and Tandem sling seating for O'Hare Airport, 1960; United States; Charles and Ray Eames, manufactured by Herman Miller.

▲ **28-47.** *(continued)*

shipped. While working at Herman Miller, top designers Charles and Ray Eames and George Nelson explore sectional seating and ways to store numerous modern possessions of various sizes and shapes efficiently. For storage, they create stackable units with exposed construction and interchangeable parts. Sizes are standardized but allow flexibility in height, width, depth, materials, and overall arrangement. Materials include various woods, plastic laminate in several colors, and metal grilles. Systems can grow horizontally or vertically. Modular furniture suits both home and office.

■ *Herman Miller Furniture.* In 1942, Herman Miller enters the commercial furniture market with Gilbert Rohde's Executive Office Group (EOG), a suite of interchangeable parts and pieces. The line includes executive and secretarial

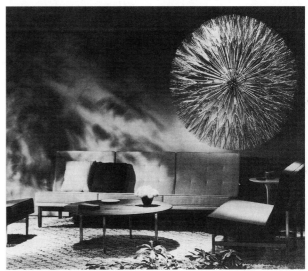

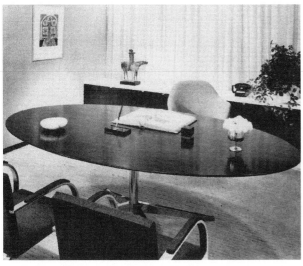

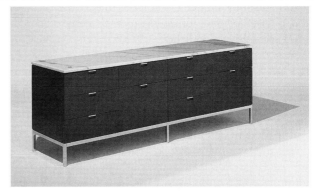

▲ **28-48.** Sofa, lounge chair, table/desk, and credenza, 1950s–1960s; United States; Florence Knoll, manufactured by Knoll International.

◀ **28-49.** Parsons table, 1956; United States; Edward Wormley, manufactured by Dunbar.

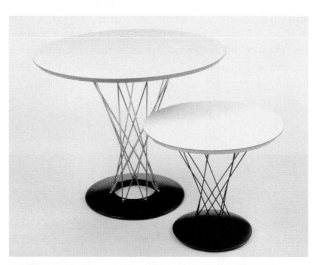

▲ **28-50.** Cyclone tables, c. 1953–1957; United States; Isamu Noguchi, manufactured by Knoll International.

desks with many choices for finishes, pulls, tops, drawer combinations, and configurations of pedestals. Also offered are matching tables, file cabinets, credenzas, storage units, and conference tables. Although L-shaped desks are known, the EOG's L-shaped executive desk functions more like a workstation and foreshadows later systems furniture. Beginning in the mid-1940s, Herman Miller expands its modern offerings by introducing the work of George Nelson and Charles and Ray Eames for seating, tables, storage units, textiles, decorative arts, and graphics. With examples in geometric, organic, and sculptural forms, their work becomes the standard for office furnishings through the next decades (also see Design Spotlight, Fig. 28-52, and Chapter 29, "Organic and Sculptural Modern").

■ *Knoll Furniture.* Knoll aligns closely with the International Style and the Bauhaus. Hans Knoll, founder of the company, is German, and Florence Knoll believes that the International Style expression is most suitable for Geometric Modern buildings. In 1948, for example, Knoll becomes the exclusive maker of the Barcelona chair by Mies van der Rohe. Although Florence Knoll claims she isn't a furniture designer, out of necessity she creates what she calls fill-in furniture—sofas, chairs, tables, desks, storage units, and conference tables (Fig. 28-31, 28-48).

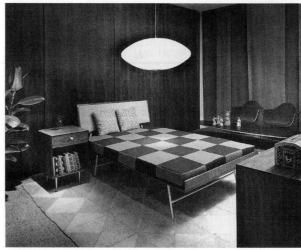

▲ **28-51.** Storage units, desk, and bed, c. 1950s; United States; George Nelson, manufactured by Herman Miller.

DESIGN SPOTLIGHT

Furniture: Storage units, 1949–1950; United States; Charles and Ray Eames, manufactured by Herman Miller. The Eames husband and wife team designs the Eames Storage Units (ESU). Inspired by Bauhaus aesthetics and Japanese influences, the units have standardized parts made of exposed steel frames with storage units of perforated, plastic-coated plywood. Completely interchangeable, the system includes open shelves, cabinets, drawer units, and desks. The units, which come in eight colors and black, white, or birch plywood, have an industrial appearance. Originally shipped KD (unassembled), Herman Miller adds cross-wire supports to the frame to begin shipping them assembled in 1952. Conceptually, the units reflect a practical approach to furniture design because they adapt well to a variety of uses.

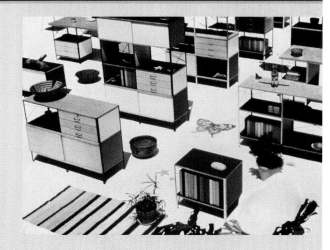

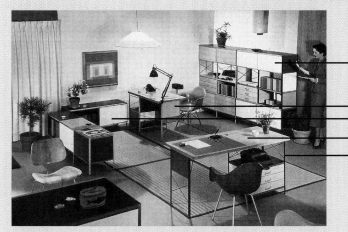

Storage unit with steel frame and plywood

Desk with shelves
Storage cabinet

Desk with drawers

Steel frame

▲ 28-52. Storage units by Charles and Ray Eames.

■ *Distinctive Features*. Characteristic features include slender metal or wooden legs, lightness, man-made materials, and a machine aesthetic. Furniture is low and horizontal with hard edges, so it may not look comfortable. Different materials create a visual separation of parts.

■ *Relationships*. Furniture continues the machine aesthetic of the Bauhaus and International Style. Its rectilinear shape or cubic form reflects interiors, and it is durable and often made of new materials. Because it is light weight, it is easy to move and arrange for use and convenience.

■ *Materials*. Designers use materials previously found only in the manufacturing or aircraft industries, such as rubber, plywood, foam rubber, aluminum, and plastic laminates. Tubular metal, usually in thinner gauges than before, remains a core furniture material as does wood. Foam rubber, readily available after 1940, radically changes the over-stuffed look of upholstery into one that is sleek, trim, and boxy.

■ *Seating*. With less need for storage and other pieces, chairs become a special concern for furniture designers (Fig. 28-44, 28-45, 28-46, 28-47, 28-48). User comfort is an important design goal. To address this goal, designers begin to pay more attention to human proportions, relying on the new disciplines of anthropometrics and ergonomics to guide them. Charles Eames and Ray Eames, for example, study how people actually sit and design accordingly. This concept is new in design.

Chairs and sofas are usually long, low, and rectangular with thin wood or metal legs (Fig. 28-29, 28-30, 28-31). Florence Knoll designs boxy chairs and sofas that work well in commercial interiors (Fig. 28-48). Most have flat or rectangular metal bases and legs. Loose and attached foam rubber cushions with and without some slight button tufting give a light, refined appearance. Nelson designs (Fig. 28-46) modular seating in rectangular forms with numerous options for office or home, building upon industrial

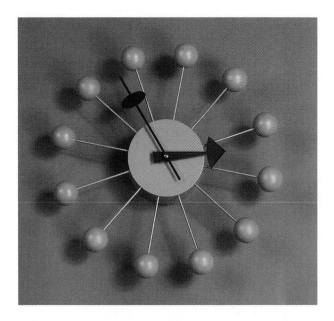

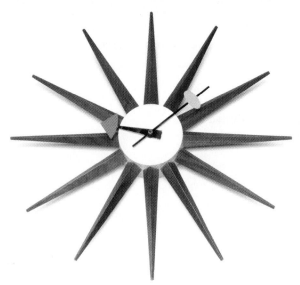

▲ **28-53.** Decorative Arts: Clocks, c. 1947; United States; George Nelson, manufactured by Howard Miller.

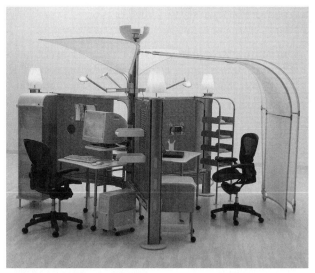

▲ **28-54.** Later Interpretation: Resolve systems furniture, c. 1999, and Aeron chairs, 1994; United States; Ayse Birsel (Resolve unit), Don Chadwick and Bill Stumf (Aeron chair), manufactured by Herman Miller. Late Modern.

designer Gilbert Rohde's original concepts of sectional sofas for the home. Nelson's whimsical Marshmallow sofa (Fig. 28-46), consisting of round cushions on a metal frame, looks machine made, but in reality requires a lot of hand labor.

In 1958, Charles and Ray Eames design the Aluminum group for Herman Miller (Fig. 28-47). Originally intended for outdoor furniture, the group, consisting of chairs and tables, has aluminum frames and a four-legged pedestal base. Distinctive is the thin Naugahyde (vinyl) upholstery with horizontal grooves that is one continuous piece. The 1969 Soft Pad Group uses the same frame as the Aluminum Group but has thicker individual cushions on back and seat. In 1962, Herman Miller introduces Eames

Tandem Sling Seating (Fig. 28-47), a multiple or mass seating system that was first designed for use in airport waiting areas.

■ *Tables*. Tables are often anonymous in design to permit diverse uses and applications. Size and height distinguish conference tables from lamp tables. Most are of wood and/or metal in geometric shapes emphasizing straight lines (Fig. 28-29, 28-31, 28-32, 28-47, 28-48, 28-50). Supports may be straight legs, metal wire in a variety of arrangements, or pedestals. Round, oval, square, or rectangular tops are of wood, glass, or plastic laminate. Laminates may be solid colors or resemble various woods or marbles. As with other furniture, simplicity and flexibility govern table designs. One of the best examples of these concepts is the Parson's table (Fig. 28-49). It is square and boxy with straight legs and is available in natural wood, plastic laminate, and painted finishes.

■ *Storage*. Room dividers, prominent features in many open interiors, include a variety of storage elements such as desks. Rectilinear in form with few applied moldings, they have open shelves or cabinets, some of which open on both sides of the unit. They may have glass doors or solid ones in wood grain or colors to contrast or complement each room's color scheme. Built-ins and room dividers replace the typical china cabinet and sideboard in the dining room.

Between 1949 and 1950, Charles and Ray Eames design the Eames Storage Units (ESU) with exposed steel frames and storage units of perforated, plastic-coated plywood (Fig. 28-52; see Design Spotlight). Also in 1949, Nelson adapts his earlier storage wall ideas (1945) to mass production and more economical prices in the Basic Storage Components (BSC) made by Herman Miller (Fig. 28-51). One of the first modular storage systems in the United

States, the system has a variety of components, including ones for a hi-fi group and television, as well as choices for hardware and lighting. Units attach to a Herman Miller frame or can be custom configured by a carpenter. In 1959, Nelson brings out the Comprehensive Storage System (CSS) for office or home in which components attach to adjustable metal poles stretching from floor to ceiling. Storage units, such as shelves, desks, music center, and file cabinet, could be attached at any height or configuration.

■ *Beds.* Modern beds are low and simple in design, resembling Japanese futons (Fig. 28-51). They may be of metal or wood with or without headboards and footboards. Mattresses are often thin slabs of foam rubber in keeping with the spare, light, modern aesthetic. Nelson designs a bed with an adjustable headboard to accommodate reading in bed. Bookcase headboards and corner beds are introduced during the period.

■ *Upholstery.* Numerous types of fabrics cover furniture, including vinyl (or Naugahyde) and leather. Upholstery fabrics are usually plain, nubby weaves in contrast to other fabrics. Deep tufting and applied trims other than cording are rare. Occasionally, sofas have throw pillows in bright colors for variety and interest.

■ *Decorative Arts.* The Modern style, sleek and simple with no ornament, extends to the decorative arts, including clocks (Fig. 28-53), glassware, dishes, cutlery, vases, and other accessories. Most commercial spaces have few decorative accessories, while houses have more that are usually in bright colors to coordinate with color schemes. Plants are a common feature in homes.

■ *Later Interpretations.* Geometric Modern furniture continues to be designed and made into the 21st century. Some pieces from the postwar period remain in production. Knoll and Herman Miller (Fig. 28-54) continue to dominate commercial and contract furnishings. Their innovative furniture may be by prominent designers or architects or may result from experiments or research and data collection.

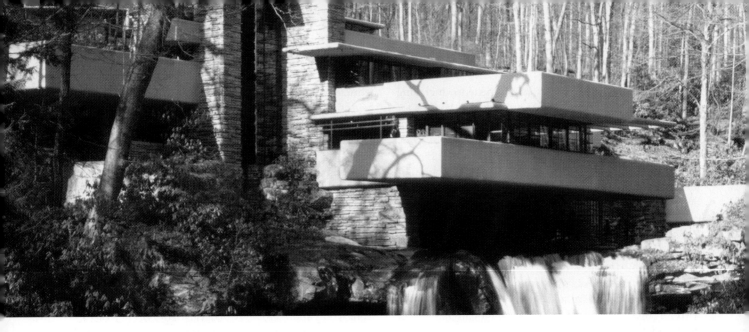

CHAPTER 29

Organic and Sculptural Modern

1930s–Early 1970s

> *By organic architecture I mean an architecture that* **develops** *from within outward in harmony with the conditions of its being as distinguished from one that is* **applied** *from without.*
>
> Frank Lloyd Wright,
> *What Is Architecture*, 1937

> *A design may be called organic when there is an harmonious organization of the parts within the whole, according to the structure, material, and purpose. Within this definition there can be no vain ornamentation or superfluity, but the part of beauty is none the less great—in ideal choice of material, in visual refinement, and in the rational elegance of things intended for use.*
>
> Eliot F. Noyes, *Organic Design*
> *in Home Furnishings*, 1941

> *The details are not the details, they make the product. The connections, the connections, the connections.*
>
> Charles Eames, 1978

Organic and Sculptural Modern, inspired by sculptural forms or abstracted living organisms, rejects the hard edges and geometry of the International Style. It seeks total unity within the design or scheme through harmony with nature and a human touch. Following World War II, the style becomes extremely popular in furniture and the decorative arts, whereas the few examples in architecture and interiors are limited to individualistic examples. Although it is a worldwide phenomenon, the design leaders are Scandinavia, the United States, and Italy.

HISTORICAL AND SOCIAL

For much of the industrialized world, the 1950s and 1960s are a time of prosperity, optimism, idealism, and great confidence in the future during World War II and the Cold War. The world that had been on the brink of annihilation strives to prevent this from happening again through conservatism, calmness, and conformity. Radicalism, liberalism, women's rights, and civil rights are suppressed or ignored during the 1950s but return with great force during the 1960s.

Thriving economies demand more buildings and a corresponding need for furnishings, both residential and nonresidential. Consumerism increases, and fashion begins to drive design more than ever before as manufacturers create new products in the latest designs to satisfy the buying public. Television replaces radio as the medium of information and programs center on idealized middle-class families who live in perfect houses, raise model children,

734

and own all the latest appliances. A youth culture develops as teenagers embrace the new music of rock and roll. Beatniks and rebels introduce a deliberate counterculture, which will flourish during the 1960s. Most of the world looks to the United States as design innovator and lifestyle model. The notion of the American dream influences other countries through American movies, television, and exported goods.

Within this cultural landscape, Organic Modernism, an international movement, arises, deriving its characteristic abstracted curvilinear shapes, undulating lines, and bright colors from avant-garde painters and sculptors of the early 20th century. Amoeboid and asymmetrical curving shapes translate easily into interiors and decorative arts, including furniture and textiles. Although examples appear during the 1930s and are seen at World's Fairs, popularity is limited before World War II.

With few exceptions, most early designers in the organic mode are sculptors or associated with painters, so the early decorative arts examples are most often conceived of as pieces of sculpture. Frank Lloyd Wright is an early and important advocate of organic concepts and forms in architecture, interiors, and furniture. Architect Alvar Aalto of Finland helps popularize organic form (see Chapter 28, "Scandinavian Modern"). Before the war, Aalto rejects the linear or boxlike International Style for softer, more curvilinear forms and naturalistic materials in architecture, furniture, and glass. His furniture is exported to North America in the early 1930s, but the 1939 Finnish Pavilion at the New York World's Fair brings Aalto's work to a much broader audience. Also influential in 1939 is Oscar Niermeyer's Brazilian Pavilion with its parabolic curves. In 1942, Frederick Kiesler creates a biomorphic interior and furniture for The Art of This Century Gallery owned by Peggy Guggenheim. Open until 1947, the space, which is one of the few completely organic interiors, displays Surrealist and Abstract Expressionist art. A few furniture designers create some organic designs for manufacturers, including Gilbert Rohde at Herman Miller.

Additionally, art schools experiment with organic and biomorphic forms before the war. Notably, in the United States, this occurs during the late 1930s at the Cranbrook Academy of Art in Michigan. Founded in 1923 by George G. Booth and Eliel Saarinen, Cranbrook is one of the first American schools to adopt the European/Bauhaus model for art and design education. Influential artists, designers, and artisans collaborate with the students and each other. Participating in a working environment for artists and designers, students learn by observation, conversation, and doing. Every student has a studio and a master under whom he or she works. Like the Bauhaus, designers consider the total environment and relate form and function to mass production. Many of the most influential designers of this period study at Cranbrook, including Charles and Ray Eames, Florence (Schust) Knoll, and Eero Saarinen (Fig. 29-1).

Following the war, aided by the renewed creative energy of designers and the availability of new materials and techniques, organic forms explode in popularity, first among the elite, and then the public. Organic and sculptural forms become, for a brief period, synonymous with modern, especially in furniture, textiles, and decorative arts. The style and its forms also express concepts of the future as an important illustration of optimism and progress during the period. Kidney-shaped swimming pools, boomerang tables and desks, and textiles with amoeboid shapes in bright colors characterize homes and some offices. Buildings most often are architect designed and not builder interpretations. Similarly, organic interiors are primarily the work of architects, as few interior designers follow the design trend. Furniture designers and architects produce organic furnishings for public and private buildings that are marketed by such manufacturers as Knoll International and Herman Miller in the United States. By the mid-1950s, simpler, less radical forms appear, and the popularity of organic and sculptural design begins to fade. In furniture, there is a brief resurgence of organic forms during the 1960s with the development of plastics.

CONCEPTS

Organic and Sculptural Modern represents a deliberate move away from geometry and hard edges toward asymmetrical, expressionistic designs that are still dependent upon functionalism and mass production. This functionalism, however, emphasizes humans and the human body, expressionism, and symbolism, qualities the designers see lacking in the International Style. However, like International and Geometric Modern designers, Organic Modern designers believe that technology, not craft, should drive design concepts and appearances. Accordingly, innovations often come about from designers' experiments with

IMPORTANT TREATISES

- *The Future of Architecture*, 1953; Frank Lloyd Wright.

- *Horizons*, 1932; Norman Bel Geddes.

- *Living Spaces*, 1952; George Nelson.

- *The Natural House*, 1954; Frank Lloyd Wright.

- *Problems of Design*, 1957; George Nelson.

- *Streamlining*, 1934; Norman Bel Geddes.

- *A Testament*, 1957; Frank Lloyd Wright.

- *Tomorrow's House*, 1945; George Nelson and Henry Wright.

- *Towards an Organic Architecture*, 1950; Bruno Zevi.

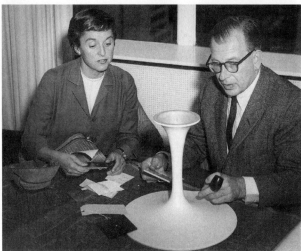

▲ **29-1.** Charles and Ray Eames, and Florence Knoll and Eero Saarinen, c. 1950s.

new construction techniques derived from other industries or new materials, which they believe demand new forms. Some concepts are in advance of technology, such as Eero Saarinen's desire for a single molded chair and base, which he had in mind for the Pedestal Chair (Fig. 29-37). The result is a softer, curvilinear modern that relates to nature or is derived from sculpture. Despite its organic nature, much that is produced is of inorganic materials such as reinforced concrete in architecture or plastic in furniture.

The movement, particularly in the decorative arts, absorbs influences from European and American painters and sculptors, including Jean Arp, Salvador Dali, René Magritte, Joan Miró, Ferdinand Leger, Alexander Calder, and Henry Moore, and Abstract Expressionists such as Jackson Pollock, Willem de Kooning, and Franz Kline. From them come organic or biomorphic forms, abstraction, simplification, energy, and randomness. In architecture, important theorists and precursors include Frank Lloyd Wright and Alvar Aalto.

DESIGN CHARACTERISTICS

Organic and Sculptural Modern exhibits smooth, curving forms and shapes that are often pierced, abstracted, elongated, attenuated, and asymmetrical like in nature. Also characteristic are exaggerated and abstracted naturalistic

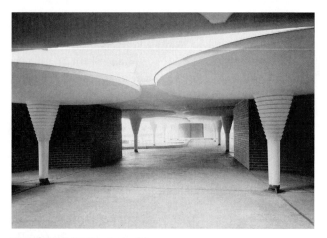

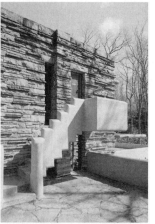

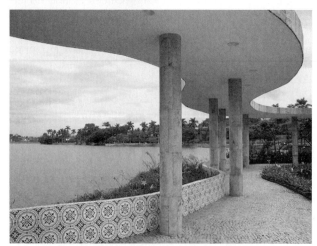

▲ **29-2.** Design details, 1930s–1960s; Frank Lloyd Wright, Oscar Niemeyer, Isamu Noguchi, and Charles and Ray Eames.

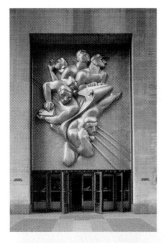

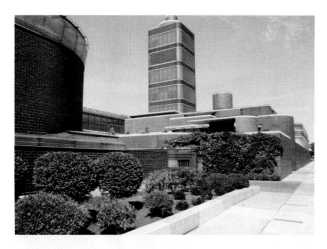

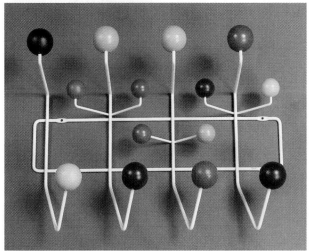

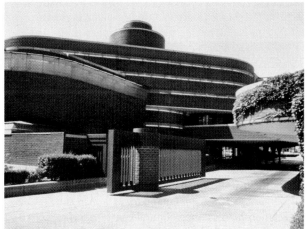

▲ **29-2.** *(continued)*

forms, such as the tulip, hourglass, amoeba, or kidney. Curves may be long and flowing, asymmetrical, or undulating. Unity is an important design goal. With other modernist expressions, Organic shares simplicity, no applied ornament, and a focus upon designing for mass production. The style creates a new, more expressive or symbolic design language arising from experimentation and energy, one that evinces irregular surfaces, boldness, rhythm, continuous surface, parabolic arches, spherical forms, and oblique angles (Fig. 29-2). Colors come from nature or modern art, including Pop Art of the 1960s.

■ *Motifs.* Common motifs include amoeboid and kidney shapes (Fig. 29-27, 29-28, 29-29, 29-33), spheres, parabolas, atoms, molecules, rockets, satellites, flying saucers, abstracted and stylized fruit, flowers, plants (Fig. 29-27, 29-29), and objects of daily life.

ARCHITECTURE

Organic architecture has roots in primitive vernacular forms and a specific architectural language, which can also

▲ **29-3.** Administration Building, S. C. Johnson and Son Factory, offices 1936–1939, tower 1947–1950; Racine, Wisconsin; Frank Lloyd Wright.

be seen in Art Nouveau (see Chapter 19, "Art Nouveau"). The meaning of organic architecture tends to evolve over time and within the work of individual architects. Common elements include a focus on humans and humanness in the design, materials and forms derived from nature, and form growing out of the building's site or project

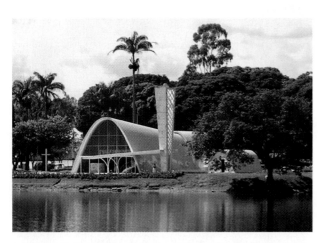

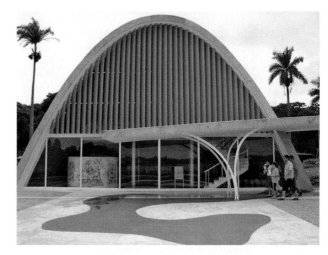

▲ **29-4.** S. Francis Church, c. 1943; Pampulha, Brazil; Oscar Niemeyer.

DESIGN SPOTLIGHT

Architecture: Nôtre-Dame-du-Haut (Pilgrimage Chapel), 1950–1955; Ronchamp, France; Le Corbusier. Sited on a high plateau near Besançon, this expressionist church is a statement to Le Corbusier's goal of "a place of silence, of prayer, of peace, of spiritual joy." Defined by its organic form and monumental scale, the building is a symbol of spirituality. Its design exhibits an asymmetrical composition emphasizing light and dark as well as solid and void relationships. White sculptural concrete surfaces contrast sharply with the dark, curved, overhanging roof. Various sizes and shapes of windows with colored glass and deep reveals cover two walls, filtering dramatic qualities of light within. Theatrical and inspirational at the same time, the building is unique among churches, as well as a major departure from the architect's other work.

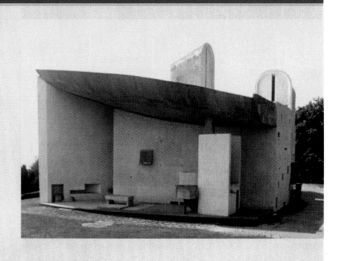

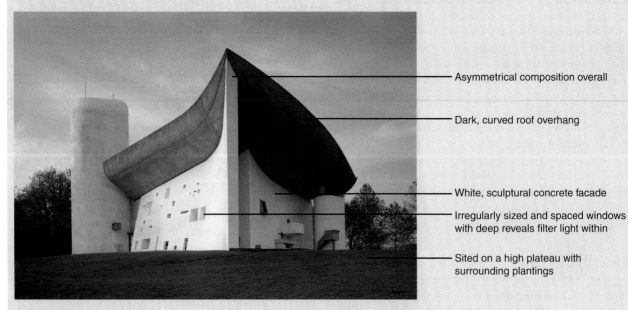

Asymmetrical composition overall

Dark, curved roof overhang

White, sculptural concrete facade

Irregularly sized and spaced windows with deep reveals filter light within

Sited on a high plateau with surrounding plantings

▲ **29-5.** Nôtre-Dame-du-Haut (Pilgrimage Chapel), 1950–1955; Ronchamp, France; Le Corbusier.

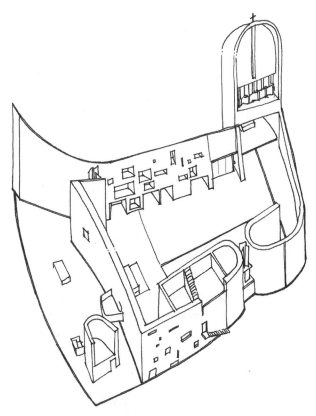

▲ **29-6.** Axonometric view, Nôtre-Dame-du-Haut (Pilgrimage Chapel), 1950–1955; Ronchamp, France; Le Corbusier.

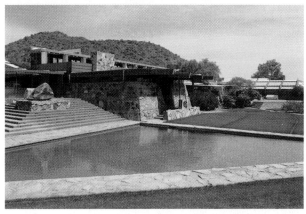

▲ **29-8.** Taliesin West, 1938–1959; Scottsdale, Arizona; Frank Lloyd Wright.

▲ **29-7.** David S. Ingalls Skating Rink, Yale University, 1958; New Haven, Connecticut; Eero Saarinen and Associates.

constraints. The relationship of a building to its site may create a sense of place.

In the postwar period, Organic and Sculptural Modern broadens the notion of modern architecture from an assertion of pure form expressed in a straightforward, geometric, hard-edged character to forms that are softer, rounded, and expressive, often monumental and yet totally

unified. Elements of streamlining evident in the late 1930s continue, most notably smooth curves and a sleek outer skin (see Chapter 26, "Art Deco"). Organic and Sculptural Modern shares with Geometric Modern an emphasis on function and rejection of applied ornament. Unique in Organic and Sculptural Modern are buildings with fluid, curving forms that grow from a specific purpose, a desire for a personal architectural statement, or programmatic goals such as symbolism, dynamism, or motion. Consequently, these buildings make bolder, more powerful design statements than Geometric Modern examples do. For example, the TWA Terminal Building (now called Terminal 5; Fig. 29-11) at Kennedy Airport in New York by Eero Saarinen conveys motion, flight, and a sense of the future.

Frank Lloyd Wright begins to espouse organic concepts during the early 1910s. To Wright, organic means an architecture that evolves from the principles of nature. These principles include unity of site and structure, unity of form and function, and natural materials and colors. Accordingly, Wright's forms frequently develop from the inside out, usually along an axis that may be compared to a tree trunk or plant stem, and the decorative elements

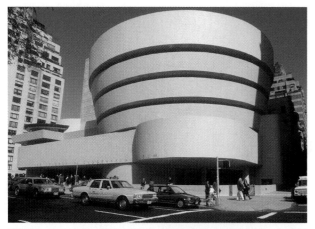

▲ **29-9.** Solomon R. Guggenheim Museum, 1957–1959; New York City, New York; Frank Lloyd Wright.

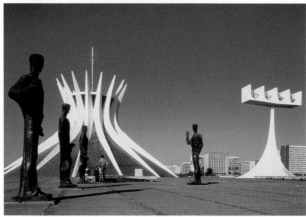

▲ **29-10.** Office building, Senate, and Cathedral, 1956–1960; Brasilia, Brazil; Lucio Costa (planner) and Oscar Niemeyer (architect).

arise from the flora and fauna of the building's location. His Prairie Houses exemplify these principles through geometric forms (see Chapter 18, "Shingle Style and American Arts and Crafts"). Although at that time he rarely designs buildings in the curving naturalistic form of nature, these principles underlie his own architectural philosophy and influence subsequent organic architectural theory. His most famous work of the 1930s expressing this concept is Fallingwater (Fig. 29-16), a building that embodies a strong sense of place primarily because of its harmonious relationship to nature.

During the 1920s, in Germany, a few architects break with the dominant Bauhaus geometric interpretation of form follows function. The main advocate is Hugo Häring, who believes that structures should develop from explorations of function and place and they should depict this process instead of the designer's personal tastes. He rejects geometry in favor of forms from nature, the site, and/or the individual program. His ideas influence Hans Scharoun, Alvar Aalto, and Louis Kahn. However, there are only a few, isolated examples of curvilinear organic forms until after World War II.

As architects move away from geometric purity to expand the meaning of Modernism, two particular buildings

influence them. Frank Lloyd Wright's Guggenheim Museum (Fig. 29-9), conceived in 1947, unites space, function, and sweeping movement in an expanding spiral form. Here, Wright integrates his organic theories with organic form. The second is Nôtre-Dame-du-Haut (Fig. 29-5), a modern church with no references to the past, in which Le Corbusier expresses symbolism through a wave-like roof and curving walls.

Although these works inspire others in a similar mode, Organic examples remain few and specific to some individuals or selected applications. Eero Saarinen strives to create personal, expressionist structures whose forms arise from function, unity, and symbolism. Not many architects work exclusively in the style. Organic and Sculptural Modern demands extraordinary creativity, technical genius, and innovative construction techniques made possible by reinforced concrete.

IMPORTANT BUILDINGS AND INTERIORS

- **Bear Run, Pennsylvania:**
 - —Fallingwater, 1935–1937; Frank Lloyd Wright.
- **Brasilia, Brazil:**
 - —Office and Senate buildings and Roman Catholic Cathedral, 1956–1960, 1966; Oscar Niemeyer.
- **Cambridge, Massachusetts:**
 - —Kresge Auditorium, Massachusetts Institute of Technology, 1955; Eero Saarinen and Associates.
 - —Chapel, Massachusetts Institute of Technology, 1953–1955; Eero Saarinen and Associates.
- **Caracas, Venezuela:**
 - —Great Auditorium, City University of Caracas, 1952–1953; Carlos Raúl Villanueva.
- **Chandigarh, India:**
 - —Capitol of Chandigarh, including the Secretariat and Assembly Building, 1950–1964; Le Corbusier, Pierre Jeanneret, with Michael Fry and Jane Drew.
- **Chantilly, Virginia:**
 - —Terminal Building, Dulles International Airport, 1958–1962; Eero Saarinen and Associates.
- **Dhahran, Saudi Arabia:**
 - —Dhahran Air Terminal, 1959–1961; Minoru Yamasaki.
- **Glencoe, Illinois:**
 - —North Shore Congregation Israel, 1964; Minoru Yamasaki.
- **Mexico City, Mexico:**
 - —Restaurant Floating Gardens, 1958; Felix Candela and Joaquín Alvarez Ordóñez.
- **New Harmony, Indiana:**
 - —Roofless Church, 1958–1960; Philip Johnson.
- **New Haven, Connecticut:**
 - —David S. Ingalls Skating Rink, Yale University, 1956–1958; Eero Saarinen and Associates.
- **New York City, New York:**
 - —Solomon R. Guggenheim Museum, 1957–1959; Frank Lloyd Wright.
 - —Trans World Airlines Terminal (TWA; Kennedy International Airport), 1956–1962; Eero Saarinen and Associates.
- **Norman, Oklahoma:**
 - —Bavinger House, 1950–1955; Bruce Goff.
- **Pampulha, Brazil:**
 - —S. Francis Church, 1943; Oscar Niemeyer.
- **Racine, Wisconsin:**
 - —Administration Building, S. C. Johnson and Son Factory, 1936–1939, with tower added in 1947–1950; Frank Lloyd Wright.
- **Rio de Janeiro, Brazil:**
 - —Ministry of Education and Health, 1937–1942; Lucio Costa, Oscar Niemeyer, Le Corbusier, Jorge Machado Moreira, and Alfonso Eduardo Reidy.
- **Rome, Italy:**
 - —Palazzetto dello Sport, 1958–1960; Annibali Vitellozzi and Pier Luigi Nervi.
- **Ronchamp, France:**
 - —Nôtre-Dame-du-Haut (Pilgrimage Chapel), 1950–1955; Le Corbusier.
- **Scottsdale, Arizona:**
 - —Taliesin West, 1938–1959; Frank Lloyd Wright.
- **Seattle, Washington:**
 - —Science Center, World's Fair Exposition, 1967; Minoru Yamasaki.
- **St. Louis, Missouri:**
 - —Gateway Arch, 1962–1968; Eero Saarinen and Associates.
- **Tokyo, Japan:**
 - —Olympic Sports Hall, 1961–1964; Kenzo Tange.
 - —S. Mary's Cathedral, 1961–1964; Kenzo Tange with Wilhelm Schlombs.
- **Turin, Italy:**
 - —Exhibition Halls, 1947–1949; Pier Luigi Nervi.

Public and Private Buildings

- *Types.* The limited examples of Organic and Sculptural Modern define a surprising variety of public buildings, including large corporate headquarters (Fig. 29-3), government complexes (Fig. 29-10), churches (Fig. 29-4, 29-5, 29-10), museums (Fig. 29-9), sports facilities (Fig. 29-7, 29-13), airport terminals (Fig. 29-11, 29-12), train stations, and concert halls (Fig. 29-15). Innovative and unusual houses are the most expressive form of residential construction (Fig. 29-16, 29-18). Organic forms often define concept houses of the future (Fig. 29-19).

- *Site Orientation.* Large corporate, government, transportation, and sports complexes are often sited in expansive planned areas with park-like settings in or just outside of major cities (Fig. 29-10, 29-11, 29-12, 29-13). There

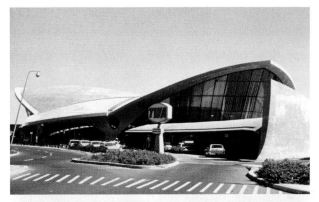

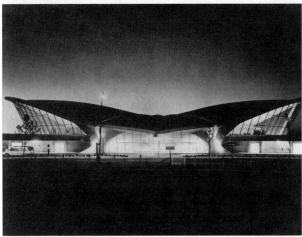

▲ **29-11.** Trans World Airlines Terminal (TWA; Kennedy International Airport), 1956–1962; New York City, New York; Eero Saarinen and Associates.

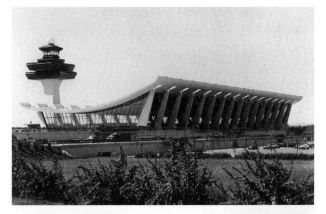

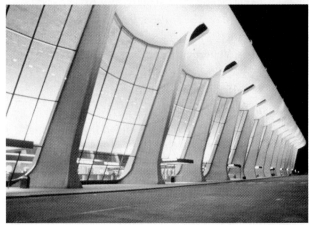

▲ **29-12.** Terminal Building, Dulles International Airport, 1958–1962; Chantilly, Virginia; by Eero Saarinen and Associates.

may be one or more structures in the complex, with placement based on functional relationships. Architects frequently position churches on large green areas with commanding vistas, sometimes within a large building complex, or near water, or on high plateaus (Fig. 29-4, 29-10). Notre-Dame-du-Haut (Fig. 29-5) by Le Corbusier becomes a sculptural monument on its high, flat plateau in France. Sun orientation is important because the design often emphasizes the penetration of light into the interior spaces. Museums, usually in large cities, appear on major streets for easy access (Fig. 29-9). The location and orientation of houses vary depending on the designer, owner, and geography of the area.

■ *Floor Plans.* Floor plans evolve primarily based on relationships between particular functional areas. Each building is different and individual, and therefore, its planning reflects diversity in approach and design. Some plans display modernist formality in arrangements. More than ever, architects experiment with the interrelationship and transformation of curving two-dimensional shapes into volumetric three-dimensional forms arising from the biomorphic, sculptural, and abstract character of the overall building design and programmatic needs (Fig. 29-6).

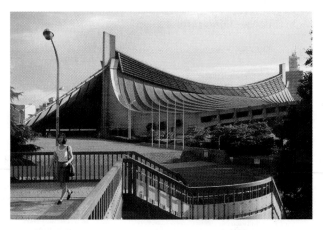

▲ **29-13.** Olympic Sports Hall, 1961–1964; Tokyo, Japan; Kenzo Tange.

Forms are translated into a plan concept that addresses the needs of the users and the artistic expression and creativity of the designer (Fig. 29-17). Sometimes the plans derive from organic shapes, such as the chambered nautilus concept of the Guggenheim Museum by Wright

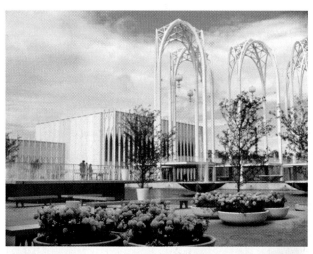

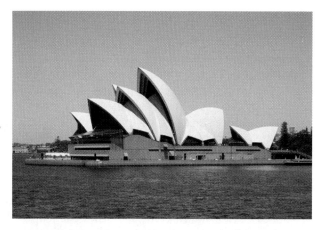

▲ **29-15.** Sydney Opera House, 1956–1973; Sydney, Australia; Jorn Utzon, and Peter Hall.

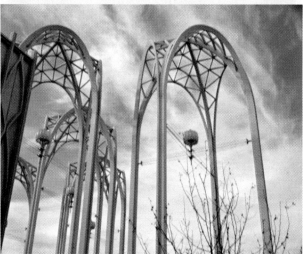

▲ **29-14.** Science Center, World's Fair Exposition, 1967; Seattle, Washington; Minoru Yamasaki.

(Fig. 29-9). Or they may evolve from natural forms, such as the bird's wings concept of the TWA Terminal by Saarinen (Fig. 29-11).

■ *Materials*. Architects exploit reinforced concrete in a variety of curvilinear or parabolic shapes that move and undulate in biomorphic and sculptural forms (Fig. 29-5, 29-7, 29-9, 29-10, 29-11, 29-12, 29-15). Some buildings, however, are of traditional masonry construction. Organic ones incorporate a variety of materials, such as wood, stone, concrete, and steel. Large areas of fixed glass are typical, as in other modern residences.

■ *Façades*. The most important characteristic of all building façades is their sculptural monumentality shown by their imposing presence on the landscape. Forms curve, undulate, move, and develop in a unified harmony that balances a rhythm of shapes, heights, and contours (Fig. 29-3, 29-5, 29-10, 29-14, 29-15). Surfaces are often smooth and uninterrupted. Architects' attention to light and dark is expressed in solid and void relationships. Symmetry or asymmetry may characterize individual parts as well as the façade itself. Massing and volume define the effect. A lightweight structure produces a characteristic simplicity of volume and line. Sometimes large- or small-scale vertical or linear movements repeat in a rhythmic sequence to create architectural texture and/or the interplay of light and dark (Fig. 29-8, 29-12, 29-13, 29-14).

■ *Windows*. Some buildings feature repeating window styles and shapes, evidence of modernist principles of regularity (Fig. 29-3, 29-12, 29-16). These structures have large areas of fixed glass panes inserted in vertical or horizontal metal grids. Others may illustrate randomness or unusual repetitions in window sizes and shapes but an overall unified visual appearance (Fig. 29-5, 29-6). Variety in design and character is common.

■ *Doors*. Commercial buildings, irrespective of type, have large, prominent entryways that are easily recognizable and contribute to user wayfinding (Fig. 29-9). The scale and design may vary based on function and designer, but the entryway always blends in well with the structure. Doors are often of clear glass with metal frames.

■ *Roofs*. Many roofs have curving shapes made possible by reinforced concrete or the use of a cable-hung system. They may blend in or be separate from the overall building design. On commercial buildings, they are often the most distinctive feature of the design. Shapes vary: some illustrate soft geometric curves, while others convey more abstract, undulating, and rounded curves (Fig. 29-4, 29-5, 29-7, 29-8, 29-10, 29-11, 29-12, 29-13, 29-15). And still others may have flatter, slightly pitched roofs hidden behind a sculptural façade. Sometimes skylights pierce the roof surface, allowing natural light to punctuate the interior space (Fig. 29-9, 29-24).

DESIGN SPOTLIGHT

Architecture: Fallingwater, 1935–1937; Bear Run, Pennsylvania; Frank Lloyd Wright. One of the landmarks of 20th-century architecture, this country house for Edgar Kaufman is a testament to Wright's vision of organic architecture. Nestled into a hillside covered with trees, it literally becomes one with nature through site, materials, and structure. Positioned over a rocky waterfall, the house's cantilevered terraces overhang it in horizontal layers. From the living room, there is access to a natural swimming pool below. Materials of natural stone, ochre concrete, and russet-painted steel window frames contribute to the building's earthy character. The terraces and large glass windows and doors support Wright's organic concept of "space flowing outward, space flowing inward." The interiors continue this idea with open spaces, built-in walnut furniture, flagstone floors, large skylights, and earth-toned colors. Natural light penetrates from all sides. Low ceiling heights and horizontal lines contribute to a sense of human scale. Meandering circulation paths add a sense of informality. These attributes convey Wright's principal themes and help to create a harmonious fusion of parts.

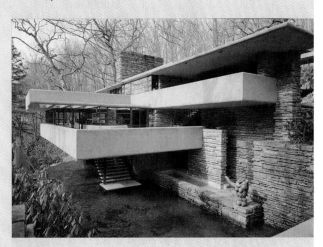

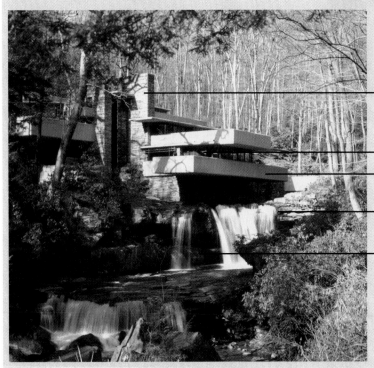

— Natural stone building material, along with ochre concrete, and russet-painted steel

— Natural light penetrates from all sides

— Cantilevered terraces project in horizontal layers over a waterfall

— Building integrates with the site to become one with nature

— Organic architecture emphasizes asymmetry

▲ **29-16.** Fallingwater; Bear Run, Pennsylvania.

■ *Later Interpretations*. During the 1990s, architects continue some of the organic and sculptural concepts but experiment with Neo-Modernist principles defined by an extreme abstraction of form. Examples of this approach include the City Hall in London by Norman Foster and the Museum of Glass in Tacoma, Washington, by Arthur Erickson (Fig. 29-20). Late-20th- and early-21st-century Organic architectural interpretations, often idiosyncratic and individualistic, are made easier by computer-aided design software.

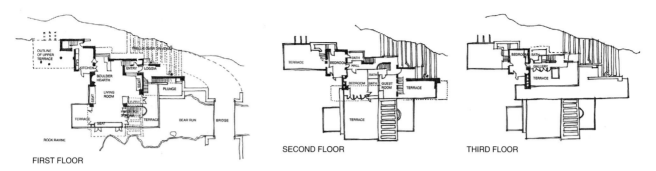

▲ **29-17.** Floor plans, Fallingwater, 1935–1937; Bear Run, Pennsylvania; Frank Lloyd Wright.

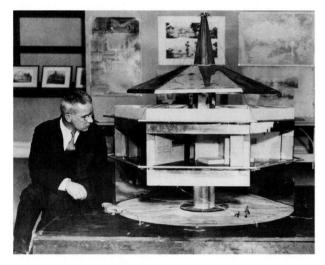

▲ **29-18.** Dymaxion House, 1947; United States; Buckminster Fuller.

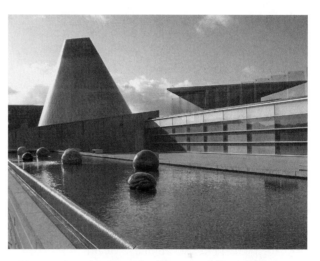

▲ **29-20.** Later Interpretation: Museum of Glass, 1996; Tacoma, Washington; Arthur Erickson with Nick Milkovich Architects and Thomas Cook Reed Reinvald. Neo-Modern.

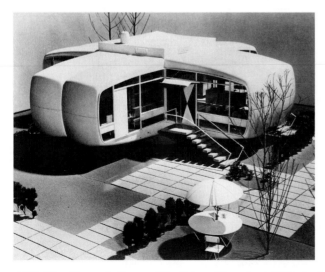

▲ **29-19.** Monsanto House of the Future, Disneyland, 1959; Anaheim, California.

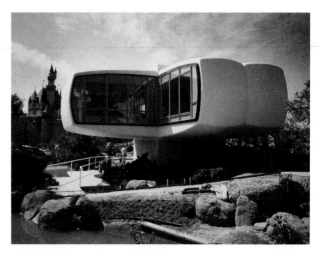

DESIGN PRACTITIONERS

- **Harry Bertoia** (1915–1978) is a printmaker, jewelry maker, and furniture designer, but he is best known for his sculpture. In 1950, Florence Knoll brings him to Knoll International and gives him free reign to design furniture and/or sculpture. After creating the Diamond Group and Bird Chair of metal wire, Bertoia goes on to create architectural and floating sculpture for well-known architects such as Eero Saarinen and Edward Durell Stone.

- **Jack Lenor Larsen** (b. 1927) is an inventive textile designer. His firm, Jack Lenor Larsen, produces textiles beginning in the 1950s. Innovations include casements, batik designs, printed velvets, and extra-wide fabrics. Textiles may be woven by hand or machine in natural and synthetic fibers. His work has been exhibited throughout the world, and he has been recognized with numerous awards in the United States and abroad.

- **Oscar Niemeyer** (b. 1907), a Brazilian architect, explores the construction possibilities of reinforced concrete in a dynamic, curvilinear, sculptural style. Parabolas often characterize his work. Influences include Baroque and the architecture of his native Brazil. In 1936, he and others collaborate with Le Corbusier on the Ministry of Education and Health in Rio de Janeiro, one of the first modernist government buildings in the Americas. Niemeyer's best-known work is the new capital of Brasilia where he explores new ideas in city planning and symbolism in building.

- **Isamu Noguchi** (1904–1988) is a Japanese American sculptor and furniture and lighting designer. Born of an American mother and Japanese father, Noguchi tries throughout his life to meld the two cultures. His furniture and lighting designs arise from his biomorphic sculpture and exploration of various materials and techniques. In additional to sculpture and furniture, Noguchi designs theater sets, gardens, and industrial products.

- **Eero Saarinen** (1910–1961), architect and furniture designer and son of Eliel Saarinen, emigrates from Finland with his family in 1923. After studying sculpture in Paris, he receives a master's degree in architecture from Yale. He strives to create a truly organic chair, one unified in form, material, and technology, and nearly succeeds with the Pedestal Group. The last 10 years of his life are his most productive in architecture, especially in the diverse expressions of spiritual and practical functionality. His best-known organic buildings are the TWA Terminal in New York and Dulles International Airport in Virginia.

- **Kenzo Tange** (1913–2005), a Japanese architect, engineer, urban planner, and architectural educator, seeks to unite Modernism with Japanese design principles. His work on five continents ranges from buildings with a human, organic quality to those that are more starkly modern with a technological feeling. In 1987, Tange receives the prestigious Pritzker Prize in Architecture.

- **Frank Lloyd Wright** (1860–1959), an innovative modern architect, evolves these principles of organic design during this period. Based on his intense study of nature, his principles include unity of site and structure; unity of form and function; and use of natural materials. Accordingly, Wright's forms frequently develop from the inside out, usually along an axis that may be compared to a tree trunk or plant stem, and the decorative elements arise from the flora and fauna of the building's location. These buildings show a strong sense of place, natural colors, and the unity of the architecture, interiors, and furnishings. His most famous projects expressing organic concepts are Fallingwater and the Guggenheim Museum in New York City.

INTERIORS

Most Organic and Sculptural interior design work, particularly nonresidential, is done by architects who continue the exterior design, shapes, and materials into the interior.

Otherwise, most interiors convey a very simple, box-like appearance with plain walls, minimal trim, and no ornamentation. These minimalist interiors reflect a modernist aesthetic, while their furnishings convey an artistic and innovative character, much as paintings or pieces of

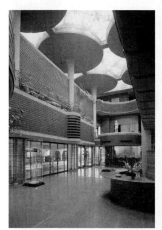
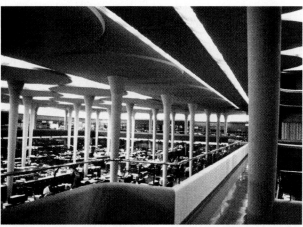
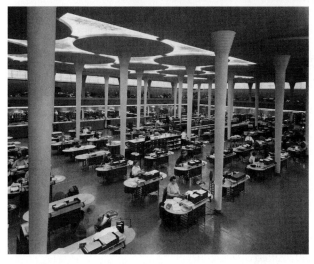
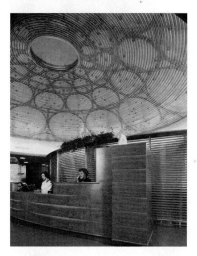

▲ **29-21.** Great Workroom, Administration Building, S. C. Johnson and Son Factory, offices 1936–1939; Racine, Wisconsin; Frank Lloyd Wright.

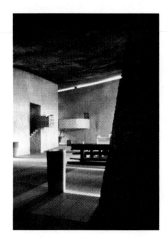
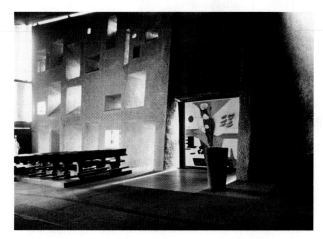

▲ **29-22.** Interior, Nôtre-Dame-du-Haut (Pilgrimage Chapel), 1950–1955; Ronchamp, France; Le Corbusier.

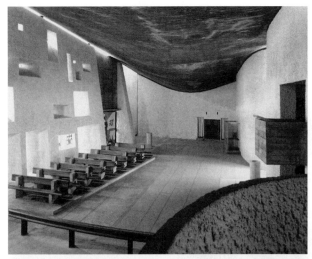

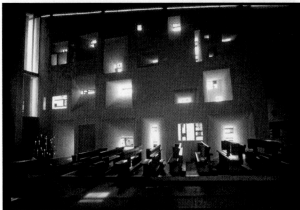

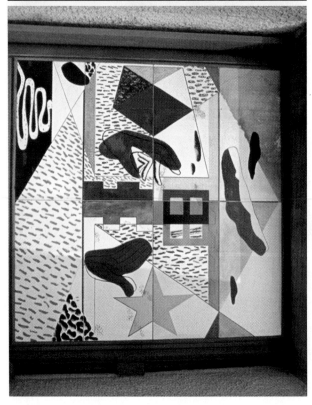

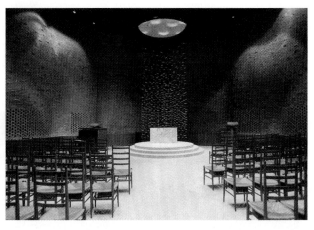

▲ **29-23.** Interior, Chapel, Massachusetts Institute of Technology; 1953–1955; Cambridge, Massachusetts; Eero Saarinen.

sculpture do in a very plain environment. Most commonly, biomorphic, sculptural, or abstract concepts come through the furniture, textiles, lighting, decorative arts, and artwork in many midcentury interiors no matter what the exterior style (see also Chapter 28, "Geometric Modern"). Plants, especially rubber plants and others with bold leaf patterns, are important accessories.

Public and Private Buildings

■ *Types.* Interiors for airport terminals (Fig. 29-24) and sports complexes are some of the newest types of spaces.
■ *Relationships.* In Organic and Sculptural buildings, there is a close interrelationship between the exterior design and the interior space because one forms the other. Often exterior materials repeat on the interior either from the inherent, visible construction or by deliberate choice. Interior spaces illustrate movement, openness, organic, and/or sculptural qualities like the exterior as part of a total unified design concept.
■ *Color.* Most interior walls in commercial buildings are white or off-white following the modernist approach or display the color of the exterior building material, usually a neutral tone. In contrast, many residential rooms are ablaze with brilliant colors in furniture, finishes, and accessories. Primary and strong secondary colors, often contrasting and mixed with black or white, characterize textiles, wallpapers, area rugs, and decorative arts. By the second half of the 1950s, shocking pink, orange, magenta, brilliant green, dark blue, purple, lemon yellow, mustard, and red appear in all manner of decorative arts and furniture. Designers sometimes derive colors and color schemes from modern art and artists such as Mondrian, Paul Klee, Alexander Calder, or Joan Miró.
■ *Lighting.* Architects place greater emphasis on built-in architectural lighting, following Modernism and to accent the architectural form. Large, volumetric spaces have a combination of indirect lighting, recessed downlights, and

▲ **29-22.** (continued)

DESIGN SPOTLIGHT

Interiors: Interior, Trans World Airlines Terminal (TWA; Kennedy International Airport), 1956–1962; New York City, New York; Eero Saarinen and Associates. Saarinen's poetic, expressionist building appears to be a piece of sculpture on an airport runway—symbolizing a bird in flight. Its reinforced concrete structure undulates and moves so that there is complete fusion between roof, walls, and floor—outside and inside. Four roof vaults with Y-shaped columns blend together to form the overall composition. Natural light entering from ceiling crevices accents important spaces. Contoured surfaces shape and define circulation paths, terminal desks, and waiting areas. Numerous level changes, bridges, and stairs lead to departure areas, conversation pits, and restaurants. This exciting three-dimensional quality creates an important and memorable structure for TWA. The interior, restricted in color and ornament, appears lively as people congregate within. A circular ceramic tile from Japan covers most interior surfaces.

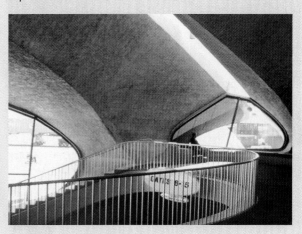

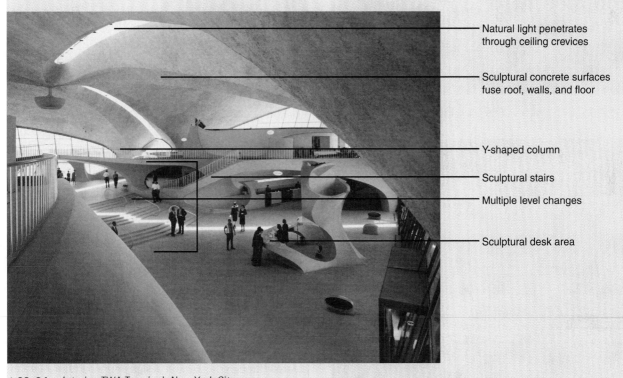

Natural light penetrates through ceiling crevices

Sculptural concrete surfaces fuse roof, walls, and floor

Y-shaped column

Sculptural stairs

Multiple level changes

Sculptural desk area

▲ **29-24.** Interior, TWA Terminal; New York City.

surface-mounted fixtures (Fig. 29-21, 29-24). Supplementing this in residences or individual offices is an assortment of table lamps, floor lamps, chandeliers, and/or wall sconces (Fig. 29-28) that offers flexibility. Sometimes designers create unique and individual fixtures or lighting treatments for a particular project that showcase innovation and creativity as well as add to the personality of the space (Fig. 29-23). Natural lighting is also important, so frequently there are large areas of glass on walls and ceilings (Fig. 29-22, 29-25).

Lighting specialists, architects, and designers, such as George Nelson, and sculptors, such as Isamu Noguchi design functional and aesthetically pleasing light fixtures in organic shapes (Fig. 29-28). Nelson's Bubble Pendant and wall lamps,

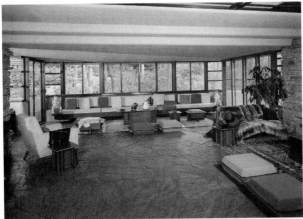

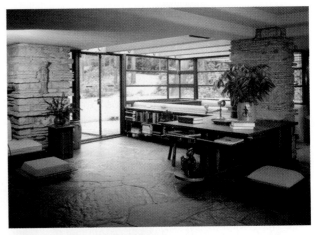

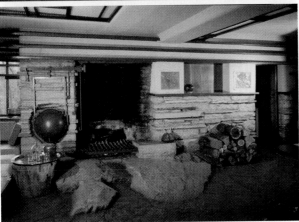

▲ **29-25.** Living room and fireplace, Fallingwater, 1935–1937; Bear Run, Pennsylvania; Frank Lloyd Wright.

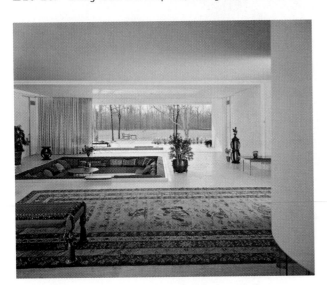

▲ **29-26.** Living area, J. Irwin Miller House, 1952; Columbus, Indiana; by architect Eero Saarinen and interior and fabric designer Alexander Girard.

originally for Howard Miller, have sprayed fiberglass shades in various rounded shapes. Akari Light Sculptures by Noguchi are a bamboo frame with a handmade paper covering. They come as floor and table lamps and hanging fixtures.

■ *Floors.* Wood, concrete, ceramic tile, and composition tile floors are common. Different flooring materials may define areas within open spaces. Some floors are covered with area rugs or wall-to-wall carpeting, which again becomes popular during the 1950s. Area rugs may feature abstract or organic patterns in brilliant or subdued colors.

■ *Walls.* Walls are most often plain, bare, and unornamented with no moldings and only a baseboard (Fig. 29-26). Shapes and forms define their character and enrich the surface appearance. Architectural features, such as curved walls, windows, and interior columns, add interest and variety (Fig. 29-21, 29-22, 29-24). Some, however, may display a textural focal point or a surface enrichment created through the use and design of the building material (Fig. 29-23). In many modern rooms, particularly in residences, wallpapers with amorphous shapes and patterns give an organic quality (Fig. 29-27) or display futurist motifs such as rockets. Wallpapers and textiles are rarely in the same pattern because contrast is preferred. Because they cover large areas, wallpaper patterns generally are less demanding and brilliant in color than those of textiles. As in other Modern-Style houses, two contrasting wallpapers or paint colors may define some walls, particularly to define and separate individual areas in open plans.

▲ **29-27.** Interiors, c. 1950s; United States.

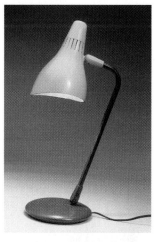
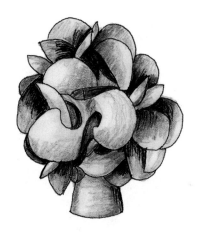

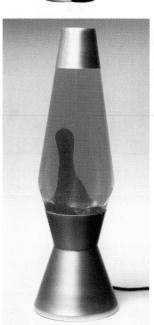
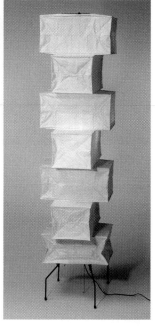
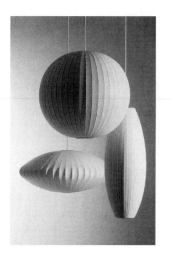

▲ **29-28.** Lighting: Table lamps, lava lamp (lower left), floor and hanging lamps, 1940s–1960s; Raoul Raba (sculptural table lamp), Isamu Noguchi (floor lamp) George Nelson (hanging bubble lamps) for Howard Miller and Lightolier.

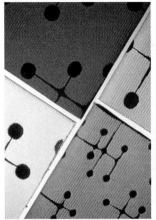
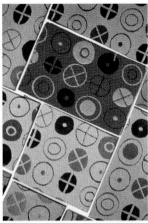

◄**29-29.** Textiles: Fabrics, c. 1950s–1960s; United States; Ray Eames (top and middle/geometric patterns) and Alexander Girard (bottom left/flower pattern), manufactured by Herman Miller; and Jack Lenor Larson, manufactured by his firm.

■ *Stoves.* Stoves are an alternative to built-in fireplaces. Usually freestanding, stoves have sculptural or organic shapes and come in white, black, and a range of colors. They may be in the center or at the perimeter of the room. Because of a concern for safety, the walls near stoves are often of a flame-proof material such as brick or stone.

■ *Window Treatments.* Most windows in large public spaces are left bare but often shielded by an architectural feature. Window treatments, when present, are plain and simple, hanging in straight panels from ceiling to floor. Made of loosely woven casements or thin sheers in white or natural colors, curtains inconspicuously blend with the space. In houses, printed curtains add interest to spaces with little architectural articulation. Patterns on curtains often have large repeats.

■ *Doors.* Doors are plain, usually in wood, glass, or sometimes metal. Often they are designed to be inconspicuous. Flat, narrow door trims frame the opening.

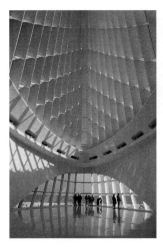

◀29-30. Later Interpretation: Interior, Milwaukee Art Museum, 2002; Milwaukee, Wisconsin; Santiago Calatrava. Neo-Modern.

illustrate the application of advanced technology and creative ingenuity. In the early 21st century, organic patterns and bright colors in textiles and wallpapers experience a resurgence in popularity. As in architecture, organic interiors often incorporate natural materials and principles of sustainable or green design.

FURNISHINGS AND DECORATIVE ARTS

Furnishings and decorative arts convey some of the best representations of the abstract, biomorphic, and sculptural character. Organic furniture is often of new materials in

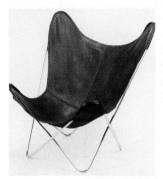

◀29-31. Butterfly or sling chair, 1938; Brazil; Jorge Ferrari-Hardoy, Juan Kurchan, and Antonio Bonet, manufactured by Knoll International.

■ *Textiles*. Fabrics display abstract, biomorphic, and sculptural designs with figures, symbols, floral motifs, geometric shapes, animals, masks, calligraphy, earth forms, rockets, atoms, and numerous lines and shapes against large areas of background (Fig. 29-29). Sometimes fantasy or humor may dominate the overall character. Some designs relate to modern art or are designed by modern artists such as Pablo Picasso, Raoul Duffy, or Joan Miró. Many fabrics (and wallpapers) are screen printed, which allows large repeats of up to 60", because the process permits pattern and color individuality while keeping costs down. Textile firms market fabrics by collections and/or by individual designers, capitalizing on the period's promotion of good design.

Fibers include cotton, linen, rayon, wool, nylon, polyester, and fiberglass. Colors vary by designer with a range of bright or subdued colors in shades of orange, green, pink, cream, brown, gold, black, yellow, red, and blue. Color is brighter than before because of improvements in dyes and printing processes. In the United States, Knoll and Herman Miller are innovators in the creation and use of brilliant colors in textiles. For example, Knoll introduces the orange and pink color combination, and Herman Miller showcases Alexander Girard's textile and wallpaper designs that combine brilliant colors not seen before. Texture is important, so designers experiment with new textural effects, often aided by new synthetic fibers.

■ *Ceilings*. Ceilings in Organic and Sculptural buildings emulate the character of the architecture and create interest through sculptural form and design (Fig. 29-21, 29-24). Some may be pierced with skylights in a rhythmic manner. But many ceilings in corporate and residential environments are plain, white or off-white, and unadorned so that they blend in with the wall treatment. This is particularly true if the interior showcases unique furnishings and decorative arts.

■ *Later Interpretations*. Later sculptural interpretations appear in the Neo-Modern work of architects Santiago Calatrava (Fig. 29-30) and Frank Gehry. They play with form, light, and curves in dramatic and dynamic ways that

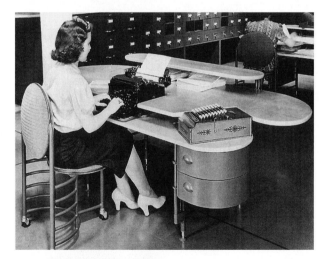

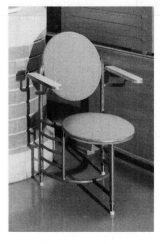

▲29-32. Desk and armchair, Administration Building, S. C. Johnson and Son Factory, 1936–1939; Racine, Wisconsin; Frank Lloyd Wright, manufactured by Steelcase.

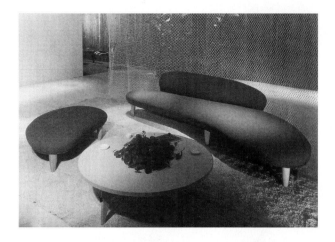

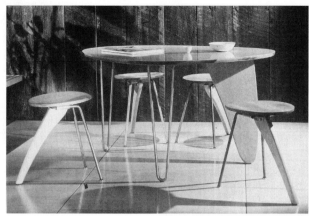

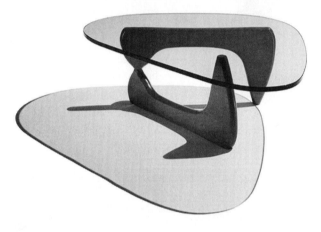

▲ 29-33. Lounge seating, dining and coffee tables, c. 1940s; Isamu Noguchi, manufactured by Herman Miller.

fluid or free-form shapes that suit the human frame. Unlike Geometric Modern furniture, Organic and Sculptural furniture is rarely modular. Although mass produced, examples often offer a variety of choices for chair or table legs and bases, colors, and finishes for individuality or total unity within an interior. Most furniture designers are architects or sculptors. They often develop construction techniques to suit their design concepts and pay close attention to comfort.

The United States leads the way in Organic and Sculptural Modern furniture, followed by Italy and Scandinavia. Furniture ranges from creations of avant-garde designers to mass-produced pieces by anonymous creators. Along with Herman Miller and Knoll, other furniture manufacturers, such as Baker, Dunbar, and John Widdicomb, commission furniture from less well-known designers. Generally, modern design is accepted by the furniture-buying public, so manufacturers produce modern furniture in large quantities. Designers have difficulty obtaining patents for their designs, so good and bad copies increase. Knockoffs of popular pieces resemble the originals but sell for far less because of minimal development and production costs. A common occurence is kitsch, originally German for "knockoff" or "trash," that refers to cheap, poorly designed objects made for the mass market.

In 1940, the Museum of Modern Art and Bloomingdale's department store sponsor a competition called "Organic Design in Home Furnishings." Charles Eames and Eero Saarinen enter the competition. Their chairs of plywood bent in two directions win first place. The structurally innovative design consists of compound curves that have to be seen in the round. By using very thin veneers to achieve the curves, Eames and Saarinen give great strength to the design. The resulting exhibit of the same name introduces organic design, total unity, and new advances in furniture design to the public. Following the exhibit, some work in the exhibit is sold at Bloomingdales, but with limited public success. However, the experimentation and innovation of this early work influence Eames's and Saarinen's later designs. Eames continues to experiment and explore new materials and constructions throughout his long career. Saarinen searches for his ideal of one-piece construction.

Public and Private Buildings

■ *Types*. There are no new types of furniture, but designers do focus more on furnishings for particular types of spaces, such as airport terminals, school classrooms, executive offices, living and dining rooms, and outdoor areas.

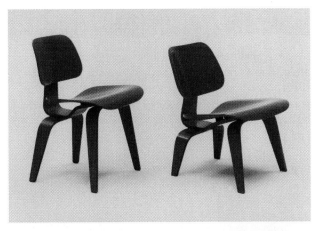

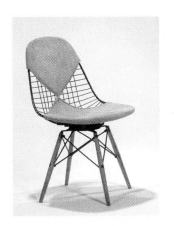

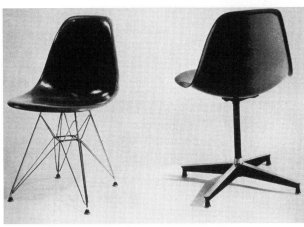

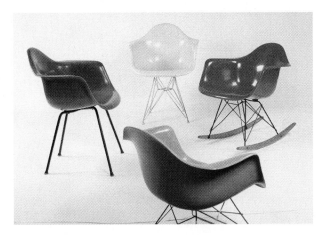

▲ 29-34. Side chairs and armchairs in molded plywood, wire, and molded plastic, 1946–1951; United States; Charles and Ray Eames, manufactured by Herman Miller.

Many pieces designed for nonresidential spaces appear in residences because of their excellence in design and reasonable costs. Sometimes designers retrofit existing or new designs to make them adaptable to a different kind of space. Designers often focus upon the design of chairs and give their designs colorful names inspired by nature, such as the Coconut chair (Fig. 29-39).

■ *Distinctive Features*. Characteristic fluidity of line, rounded forms, free-form, biomorphic shapes, and lightness are made possible by new materials, such as fiberglass, and new construction techniques, such as molding and laminating.

■ *Relationships*. Long, low proportions of furniture relate well to interiors, and rounded furniture forms contrast with more angular interior spaces. Many pieces, especially seating examples, are meant to be seen from any angle, so their sculptural qualities are suitable in rooms with broad expanses of glass or when placed away from walls or in the center of a space (Fig. 29-27).

■ *Materials*. Biomorphic shapes and forms in furniture are made possible by inorganic materials such as fiberglass, plastics, aluminum, polyester resins, and plastic foams. Traditional furniture materials include solid or veneered

woods such as ash, walnut, and birch, which may be left natural or stained. Rosewood is also used, but it is expensive. Designers, such as Charles and Ray Eames (Fig. 29-34) and Saarinen, experiment with bending laminated plywood into curvilinear shapes.

■ *Seating*. Seating choices expand substantially during the period, with more variety and experimentation. Seats and bases often are separated visually as well as by the choice of material. Designers test materials not only for variety in design but also to create more comfortable seating. Some early examples experiment with steel frames and construction methods (Fig. 29-31, 29-32), such as the innovative office furniture by Frank Lloyd Wright. Later ones exploit laminated plywood, metal wire, and plastic (Fig. 29-34, 29-37, 29-38, 29-40). Although lightweight, these chairs are comfortable with well-conceived profiles that appeal from any angle of view. Improvements in wood lamination, molding processes, and welding assist or even drive design concepts.

From earlier experiments with Saarinen, Charles and Ray Eames design side and armchairs with separate seats and backs of plywood bent in two directions to suit the

DESIGN SPOTLIGHT

Furniture: Lounge Chair and ottoman, 1956; United States; Charles and Ray Eames, manufactured by Herman Miller. Charles Eames formulates this lounge chair and ottoman from concepts first presented in 1940 in the Organic Designs in Home Furnishings exhibition at the Museum of Modern Art. His design emphasis is on comfort and luxury, achieved through a flexible swivel and tilt-mounted base, contoured and separate seat, back and headrest, and soft padded leather upholstery. Cushions are of down and foam. Constructed in molded plywood shells with a rosewood veneer, most of the chair is machine produced, except for a few parts that are made by hand. The overall design resembles a piece of sculpture and presents a quality of elegance in a room, something that is important to Eames. The design also becomes very popular, and eventually an icon of the period.

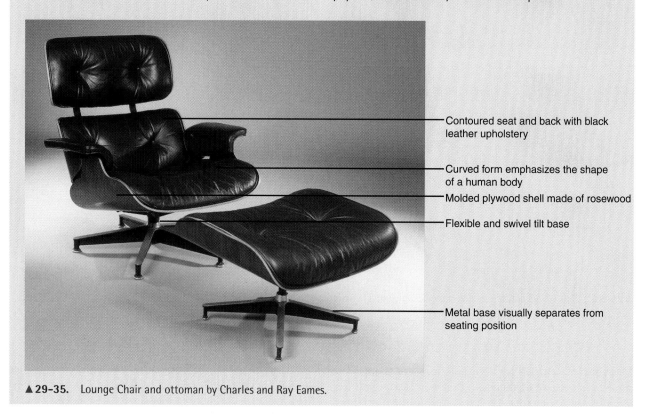

Contoured seat and back with black leather upholstery

Curved form emphasizes the shape of a human body

Molded plywood shell made of rosewood

Flexible and swivel tilt base

Metal base visually separates from seating position

▲ **29-35.** Lounge Chair and ottoman by Charles and Ray Eames.

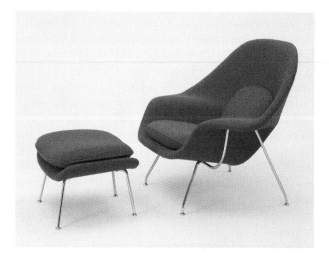

▲ **29-36.** Womb chair and ottoman, 1948; United States; Eero Saarinen, manufactured by Knoll International.

human shape (Fig. 29-34). Rubber shock mounts developed in the automobile industry add flexibility and unite the same or two entirely different materials in seat, back, and supports. Extremely popular in a variety of interiors, the chairs come in several versions with choices of materials for legs, seats, and backs, as well as upholstery. Their well-known Lounge Chair (Fig. 29-35), although expensive, is one of Herman Miller's most successful pieces. The Eameses also design a group of chairs with fiberglass-reinforced shells or welded metal wire molded into various shapes that may be upholstered (Fig. 29-34). The chairs come in more than 15 variations, including choices of shell color, upholstery, and various legs or bases, including a rocker.

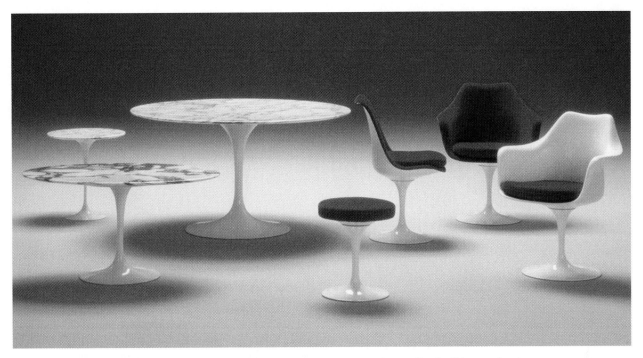

▲ 29-37. Pedestal chairs and tables, 1956; United States; Eero Saarinen, manufactured by Knoll International.

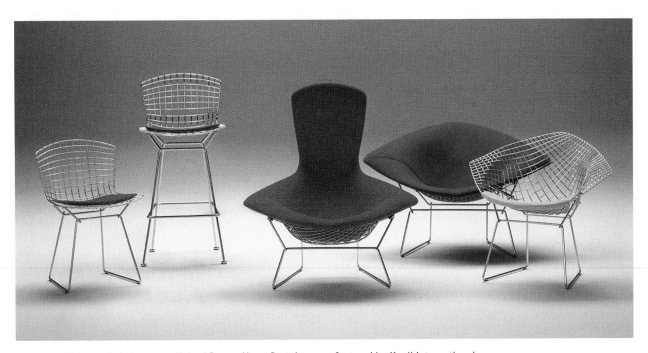

▲ 29-38. Diamond chairs, 1952; United States; Harry Bertoia, manufactured by Knoll International.

Similarly, Eero Saarinen designs chairs and sofas of molded fiberglass. His Womb chair (Fig. 29-36) is a fiberglass sculptural shell resting on slender metal legs. The shell is upholstered and has a separate seat and back cushion as well as an ottoman. In contrast, the Pedestal group (Fig. 29-37), which includes arm and side chairs, stools,

and tables, is composed of a single plastic-coated aluminum stem or pedestal arising from a round base and supporting a fiberglass-reinforced plastic-molded shell seat and back. Similar in shape, but of transparent plexiglass, is the series of chairs by Erwin and Estelle Laverne (Fig. 29-40). Names, such as Lily, reflect the abstracted naturalistic

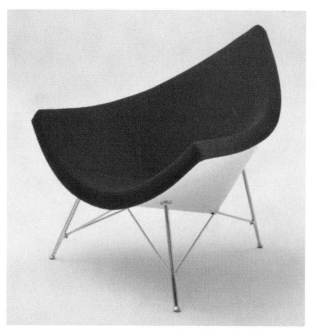

▲ **29-39.** Coconut chair, 1956–1957; United States; George Nelson Associates, manufactured by Herman Miller.

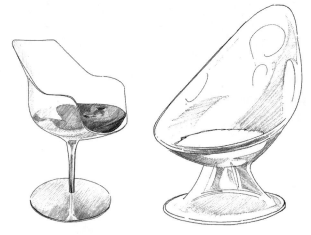

▲ **29-40.** Champagne chair and Lily chair, 1952–1957; United States; Erwin Laverne and Estelle Laverne, manufactured by Laverne International.

shapes. Interested in wire construction, Eames and sculptor Harry Bertoia create chairs constructed of welded steel rods. Bertoia also uses welded lattice forms to create seating with more sculptural forms, such as the Diamond chair (Fig. 29-38).

Asymmetry, an organic design goal, appears in a variety of examples, including those with molded steel upholstered shells (Fig. 29-39). Sofas sometimes are expanded chair forms. Others have biomorphic, kidney, or boomerang shapes and resemble a piece of sculpture.

■ *Tables.* Tables come in a wide diversity of types, including dining, conference, end or lamp, and coffee. Tops are round, oval, free-form, amoeboid, boomerang, and kidney shapes. Many have glass tops and bases of wood, plastic, or metal. Heights of tables vary depending on function. Eames designs dining and coffee tables to match his plywood chair. Saarinen's Pedestal group has matching dining or conference, coffee, and side tables with round or oval tops. Noguchi designs a table with parabolic legs and a round asymmetrical top (Fig. 29-33).

■ *Upholstery.* There is an ever increasing range of upholstery materials including wool, nylon, polyester, and vinyl produced in an assortment of textures and colors for various applications. Vinyl often is embossed to simulate leather or other materials, but it begins to lose popularity in the late 1950s because it is not comfortable for the sitter. To enhance organic or sculptural forms, solids with textural weaves are used. Prints appear mostly in houses. Other materials include leather as well as jersey, introduced in the late 1950s, and both remain popular until the 1970s. Jersey knits suit new furniture designs that demand stretchable

fabrics. Some have upholstery covers that may be removed for cleaning or replacement.

■ *Decorative Arts.* Architects and furniture designers produce decorative art objects with organic forms and patterns in glass, ceramics, wood, and metal. For example, Charles and Ray Eames create an undulating wooden folding screen based on early plywood experiments with Saarinen. Decorative objects often have rich textures emulating the textural contrasts of interiors. Many glass manufacturers worldwide produce glassware and art glass in biomorphic, undulating, and/or rounded shapes (Fig. 29-41). Forms include bubbles, abstracted flowers, and stems in transparent or translucent clear and/or colored glass. Particularly successful and much copied are the undulating, free-form, handkerchief glass vases by Venini, no two of which have the same shape or decoration. In 1962, Studio Glass emerges as a venue for individual artists to create work in studios instead of factories. This is made possible by the development of small inexpensive furnaces that can achieve the high temperatures required to make glass. The leaders, Amercians Harvey Littleton (Fig. 29-41) and Dominic Labino, inspire others, achieve worldwide recognition in their work, and foster the studio glass movement.

Like glass, ceramics display organic shapes influenced by sculpture, abstract patterns, and bright colors. Designers use a wide range of decorative techniques to give more and varied patterns to pieces. Some patterns come from modern art. Plain dinnerware with fluid organic shapes is preferred over richly decorated and gilded floral porcelains. Industrial designer Russel Wright's American Modern dinnerware (Fig. 29-42) of the 1930s for Steubenville is an early example of mix-and-match dinnerware. Combining organic and streamlined shapes, the dishes come in seven different but coordinating colors. Similarly, Eva Zeisel's Town and Country dinner service also mixes colors, even among individual pieces. The mix-and-match concept

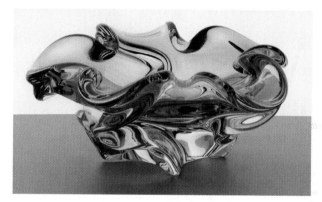

▲ **29-41.** Decorative Arts: Vases, mid-1950s–1960s; Italy and the United States; Harvey Littleton (top right) and others.

extends to glass as well. Timo Sarpaneva's I-glass series for Iittala includes bottles, drinking glasses, and plates in soft tones of lilac, green, blue, and gray.

■ *Later Interpretations.* During the early 1960s, plastic, solid foam, or foam-covered tubular steel seating sometimes has neo-organic or undulating shapes inspired by Pop Art (see Chapter 31, "Late Modern · 1"). Neo-organic shapes

frequently repeat in furniture design into the early 21st century as designers continue to experiment with form, materials, and construction techniques (Fig. 29-43). They are, however, not as dominant and pervasive as during the 1950s.

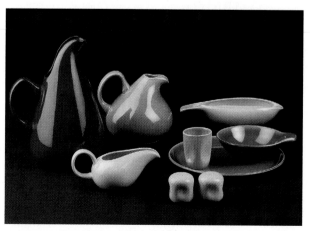

▲ **29-42.** "American Modern" dinnerware, 1939; Steubenville, Ohio; Russel Wright.

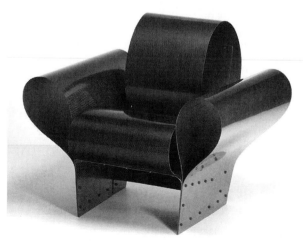

▲ **29-43.** Later Interpretation: Bad Tempered Chair, 2002; Germany; Ron Arad Associates, manufactured by Vitra. Neo-Modern.

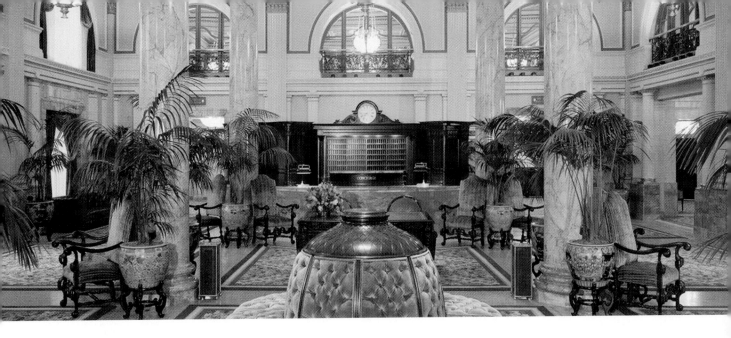

CHAPTER 30

Modern Historicism

1930s–2000s

Developing in the first decades of the 20th century and continuing into the 21st century, Modern Historicism emphasizes the importance of history by using attributes and/or elements from past styles or periods within a modern framework. Recognizing the associative or representative potential of past styles, architects, interior designers, interior decorators, and others look to historical structures, artifacts, and design principles as valid models for and solutions to modern design problems. Modern Historicism includes several styles, themes, and movements, including Suburban Modern, New Urbanism, New Formalism, Regionalism, a new Classical Revival in the late 20th century, and Period Interior Decoration.

HISTORICAL AND SOCIAL

Modern Historicism looks to and uses the past in a variety of ways to express a diversity of themes in the context of contemporary life and requirements. Growing out of the 19th-century Victorian Revivals and Academic Tradition,

it both responds to and assimilates influences from design movements and trends of the 20th century including the Bauhaus, Art Deco, and the International Style, and the Historic Preservation Movement.

With the exception of Modernism, nearly all previous styles and periods look to the past, especially antiquity, for

inspiration. Most often designers attempt to create works that expand, build upon, or further previous theories, ideas, and examples, as in the Renaissance, Baroque, or Neoclassical periods. Although more imaginative and evocative than accurate, revivals of past styles during the Victorian period (1830s–1910s) lay the foundation for using the past in a contemporary context. Victorians associate past styles with wealth, culture, and status. During the last decades of the 19th century, greater historical accuracy in expressions of Classical Eclecticism (see Chapter 12, "Classical Eclecticism") arises from the new discipline of art history and the study of historical structures and artifacts. Inspired by the academic tradition, architects, artists, furniture makers, and designers look to the best examples of the past to learn principles of design that they can apply to their own situations. As a result, architecture, interiors, and furnishings take on a more accurate historical appearance than in the earlier Victorian revivals. Culture and status remain important associations. Writers of the period, architects, and interior decorators tie good taste to period styles, particularly styles of France and Italy. Although Classical Eclecticism is a grand and expensive style, it lays foundations for Modern Historicism in its emphasis upon period rooms and styles. Unlike Modern Historicism, it generally does not regard itself as modern because associations of culture and status as linked to the classical past are more important.

During the first half of the 20th century, Modern Historicism dominates public and institutional architecture and residences, and it conveys associations of culture, status, and family heritage. Exteriors of both public and private buildings usually maintain at least a period flavor in form and details, but floor plans, interior treatments, and furnishings suit modern functions, building code requirements, and lifestyles. Period styles still are considered expressions of good taste. Interior decorators are the primary purveyors of period-style interiors in the homes of the affluent and some hotels and clubs. With increasing prosperity and greater demand for their services, decorators begin to turn their attention to the rooms of the middle class. At the same time, builders and architects create numerous Modern Historical houses, cottages, and town houses that fill newly created subdivisions in and around cities.

As the 20th century progresses and architects and designers (Fig. 30-1) respond to Modern design movements and concepts, so simplification, sleekness, and stylization unite with period influences and styles. The emphasis on historical accuracy diminishes, and eclecticism, combining different styles or mixing period styles with contemporary, becomes the norm. By the late 20th century and into the 21st century, public architecture, particularly corporate, is dominated by Modernism, rather than period styles. However, period architectural styles, including Georgian, and Colonial Revival (see Chapter 13, "Colonial Revival"), Queen Anne (see Chapter 10, "Stick Style, Queen Anne"), and Arts and Crafts (see Chapter 17, "English Arts and Crafts" and Chapter 18, "Shingle Style and American Arts and Crafts"), maintain their importance in residences, hotels, and other public buildings. Modern Historicism and period styles are a favored choice for interiors and furnishings, especially in residences, so choices of past styles expand to include Victorian styles, the Aesthetic Movement, Arts and Crafts, Art Deco, and Art Moderne. Eclecticism and simplification continue to characterize the majority of expressions, although some strive for greater historical accuracy. By the end of the 20th century, period styles are less often tied to good taste and more commonly tied to individuality, personal choice, and even antiquarianism. Modern Historicism is usually more prominent in areas that have a strong sense of place or history.

Throughout its history, Modern Historicism is affected by events and trends that focus on the past. For example, during the 1930s and 1940s the reconstruction and restoration of Colonial Williamsburg in Virginia (Fig. 30-3), beginning in 1927, inspires 18th-century Colonial-style and reproduction houses, interiors, furniture, wallpapers, textiles, and decorative arts in the United States. Historic Preservation also influences Modern Historicism during the 1970s and 1980s in the United States when federal tax credits and an economic downturn make it far more cost effective to reuse old buildings than to tear down and build new (Fig. 30-8). Many older structures, including factories and warehouses, experience new life as shops, restaurants, offices, and hotels. Additionally, when people purchase older homes, they often seek ways to decorate them in a period manner. Developers and manufacturers respond to this trend with more products, books, and magazines. History becomes a big business. Toward the end of the 20th century, the environmental movement helps foster preservation because, when compared to new construction, preserving is more cost effective, saves energy, and produces less waste (Fig. 30-9).

The media also influence Modern Historicism. For example, in the 1930s, many movies depict Art Deco and Art Moderne interiors, but period movies, such as *Gone with the Wind* in 1939, also shape design sensibilities for many. The notions of home, family, and tradition are especially important during the 1950s. Television programs and movies show typical American families in period houses with a mixture of period and modern furnishings. In the late 20th and early 21st centuries, period movies and television programs, home decoration and remodeling programs, and important museum exhibitions continue to advance and influence Modern Historicism.

■ *Historic Preservation Movement.* The Historic Preservation Movement (or Heritage Conservation in Canada) recognizes the importance of the past and seeks to save it by protecting and maintaining historic structures and sites. Originating largely as a grassroots movement in the second half of the 19th century in Europe and North America, most early preservation efforts are sporadic. They come

from individuals and volunteer groups who identify structures that they consider important and seek to save them from destruction, usually through purchase and management. Buildings or structures associated with historic events or people are the most common choices. There is minimal local or national government involvement.

Preservation broadens its scope throughout the 20th century to include all types of significant historic structures and sites. And local and national governments become increasingly involved. They work toward creating comprehensive preservation policies that protect important places from inappropriate alterations, destruction, or demolition. They seek to guard significant historic resources by developing comprehensive laws and policies. Among the means they adopt are legal recognition for significant sites, neighborhoods, and individual structures. This includes inventories or lists such as the National Register of Historic Places in the United States. National and local governments pass laws such as the 1966 Historic Preservation Act in the United States, that identify and protect historic resources. They also create organizations (National Trust, United Kingdom, and National Trust for Historic Preservation, United States) and departments (Department of the Interior and National Park Service, United States) to oversee these resources and provide means to maintain historic resources, such as loans or tax credits.

Even with more government involvement, volunteer organizations continue to play an important role in historic preservation throughout the 20th century and into the 21st century. They advise individuals, groups, and the government on preservation and restoration and provide educational tools and publications. Some own and maintain historic properties or collections of artifacts. Most important, they create awareness and recognition of the value of history and a sense of place.

Preservation becomes global in 1972 when the United Nations Educational, Scientific, and Cultural Organization (UNESCO) sponsors an international treaty to protect natural and cultural sites and objects around the world. The treaty creates a listing of significant places, the World Heritage List, and requires the home nations to develop policies to protect and manage them with UNESCO's assistance. Sites include the Pyramids of Egypt; Brasilia, Brazil; the Great Wall of China; the Palace and Park of Versailles, France; and the Great Barrier Reef in Australia.

CONCEPTS

Modern Historicism: Reinterpreting the Past

Modern Historicism in architecture, interiors, and furniture uses the past in a variety of ways to express a theme, symbolism, or monumentality, while adapting it to modern tastes and needs in architecture, interiors, and furnishings.

IMPORTANT TREATISES

- *Architecture through the Ages,* 1940; T. F. Hamlin.
- *Billy Baldwin Remembers,* 1974; Billy Baldwin.
- *The Complete Guide to Furniture Styles,* 1959, 1969, 1997; Louise Ade Boger.
- *David Hicks on Decoration,* 1966; David Hicks.
- *David Hicks on Home Decoration,* 1972; David Hicks.
- *Decorating Is Fun!,* 1939; Dorothy Draper.
- *The Encyclopedia of Furniture,* 1938; Joseph Aronson.
- *A Field Guide to American Houses,* 1984; Virginia McAlester and Lee McAlester.
- *History of Architecture on the Comparative Method,* 1897; Sir Banister Fletcher.
- *Inside Design,* 1962; Michael Greer.
- *Modern Classicism,* 1988; Robert A. M. Stern.
- *Old and New Architecture, Design Relationship,* 1980; National Trust for Historic Preservation (U.S.).
- *Pahlmann Book of Interior Decoration,* 1960; William Pahlmann.
- *Period Furnishings,* 1922; C. R. Clifford.
- *Presence of the Past: A History of the Preservation Movement in the United States Before Williamsburg,* 1965; Charles B. Hosmer.
- *Recreating the Historic House Interior,* 1979; William Seale.
- *The Restoration Manual,* 1966, 1978; Orin M. Bullock.
- *The Secretary of the Interior's Standards for Rehabilitation and Guidelines for Rehabilitating Historic Buildings,* 1979.
- *With Heritage So Rich: Special Committee on Historic Preservation, United States Conference of Mayors,* 1966.

Journals and Magazines: *Colonial Homes, Historic Preservation, Journal of the Society of Architectural Historians, Old House Journal,* and *Old House Interiors.*

Past styles appeal to a broad array of people, not just the design elite, so Modern Historicism can represent an expression of self, old money, culture, taste, wealth, and family heritage. It may offer context or a sense of place or signal function and/or monumentality (Fig. 30-11). The past also can be thematic, as at the Disney theme parks (Fig. 30-6),

or a branding or marketing tool, as in a Las Vegas hotel (Fig. 30-13, 30-29). Sometimes period architecture or interiors may indicate a rejection or reaction to modern or they may simply be anti-modern. Past styles have an inherent complexity and richness because of their adaptability, which is derived from a multiplicity of elements, details, patterns, colors, and objects (Fig. 30-2).

Architects, decorators, and designers adopt a variety of approaches to Modern Historical design in architecture and interiors. They may focus on a particular style or aspect of the past, especially as individual styles come in or out of favor. Other approaches, which are selective and fluid, may include replicating the past accurately or loosely (Fig. 30-19); using the past as inspiration (Fig. 30-28, 30-34); suggesting or alluding to the past (Fig. 30-4, 30-14); reinventing the past; or creatively adapting vernacular, historical, or classical principles, elements, and/or attributes. Some designers take a more academic approach to the past. They study its principles and character so as to design in the manner of the past but not necessarily to revive or re-create it. No matter which approach is taken, the result grows out of the designer's creativity, the knowledge and attitudes of the designer and/or client toward the past, and the needs of the project. The result often is intrinsically modern, and it usually is evident that this is a building or interior of its time.

▲ **30-1.** John Fowler, 1945; Edward Wormley, c. 1956; William Pahlmann, 1959; and Nancy McClelland, c. 1950s.

Historic Preservation: Saving the Past

Historic Preservation strives to conserve or retain historic sites, structures, and objects. It takes one of several overall approaches, including preservation, rehabilitation, restoration, reconstruction, and adaptive use, as defined in 1976 and later by the Secretary of the Interior and the National Park Service in the United States. The choice for an approach depends upon many factors, including the historical significance of the structure, its physical condition, budget, available documentation, proposed use, and code requirements.

■ *Preservation.* Preservation, which is the least invasive or destructive approach, maintains and sustains the form, details, and materials of a site, building, interior, or object (Fig. 30-36). The process requires repairs instead of rebuilding or replacing, and tries to retain the building or interior as it has evolved. Some changes are permitted to update systems and bring structures up to current building codes when required. Adding or rebuilding details can be appropriate to preservation.

■ *Rehabilitation.* Rehabilitation makes a building and/or its interiors usable (Fig. 30-8, 30-18, 30-22, 30-23). To this end, the process repairs and replaces with greater latitude than preservation, but tries to retain as many of the significant or defining historic features as possible, such as the façade, the floor plan, a staircase, finishes, or decorative details. More repairs and alterations are permitted to help make the structure meet building codes, update systems, or become more energy efficient or accessible, but the essential character of the building and its interiors is maintained. Details may be added where there is evidence of their original appearance.

■ *Restoration.* Restoration takes a building, interior, site, or object to a significant time in its history by relying on physical and documentary evidence (Fig. 30-9, 30-20, 30-21, 30-24). The result presents a truer period character than the previous approaches do. Accomplishing this may mean removing all parts that do not belong to the chosen time, so restoration can be the most destructive of these approaches. The term *restoration* is the one that is most often used when referring to work on an historic building or interiors, but only parts of most buildings or interiors usually are restored, while other parts are rehabilitated. True restorations generally take place only in house museums, which are taken back, more or less entirely, to particular and significant time periods. Abundant physical and archival documentation is critical to this process. Details may be rebuilt or added where there is evidence.

■ *Reconstruction.* This approach accurately re-creates a lost building, interior, or site based upon physical and archival evidence (Fig. 30-7), as in the Capitol Building and Governor's Mansion (Fig. 30-3) at Colonial Williamsburg in Virginia. Missing parts may be reconstructed if there is evidence. This approach is rare and applies specifically to structures and buildings instead of details.

■ *Adaptive Use*. Adaptive use, which the Secretary of the Interior's standards do not specifically address, is the reuse of a building or site in a different way from how it was originally intended, giving the building a new function. Historic forms, details, and materials should be retained when possible. Facadism is a particularly destructive variation in which only the façade is retained while the rest of the building is substantially altered or destroyed. Although most architects and designers try to preserve or rehabilitate façades, they frequently alter the interiors, often radically, to suit the building's function.

These approaches are most easily applied to buildings, although appropriate and used for interiors (Fig. 30-22, 30-23). In all types of projects, whether exterior or interior or both, the approaches are sometimes mixed because different parts may be preserved, rehabilitated, or restored. For example, a building may be approached as a rehabilitation, but some parts, such as architectural details of the façade, may be preserved or restored. Adaptive use may restore the exterior to a particular period but completely reshape the interiors of a building. Restoration, rehabilitation, and reconstruction demand meticulous research and analysis of the architecture, its interiors,

people who lived or worked there, and the surroundings. Physical and documentary evidence is needed for all-important historical accuracy. Where historical accuracy is not a goal, other approaches, like adaptive use, are more appropriate.

DESIGN CHARACTERISTICS

Modern Historicism adapts the elements and attributes of many past styles to contemporary buildings, interiors, and/or furniture. They usually reflect attributes, forms, elements, and/or motifs of the particular style or styles so that their specific characteristics vary. However, some general characteristics may be discerned. Expressions change or exploit one or more aspects, such as scale or color, of the original; use them in a new or different way; or combine details from other styles or periods. Simplification and abstraction are the most common changes. The end product may closely approximate the original or bear a range of resemblances to the historic original. For example, buildings and interiors may maintain the overall form and proportions of a past example, but reduce or eliminate the

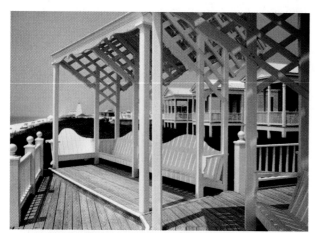

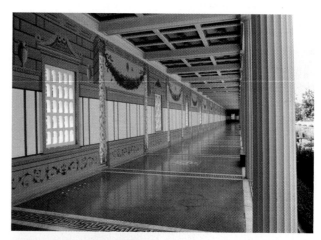

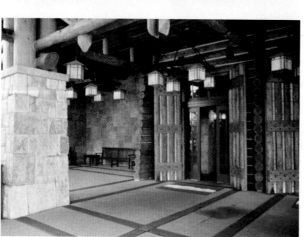

▲ **30-2.** Design details; Florida, California, and New Mexico.

ornament. A Louis XV chair may be wider or taller than the original, or a floral motif on a piece of 18th-century porcelain may be used as a textile pattern. Past styles sometimes define previously unknown types of buildings, rooms, and furniture, such as skyscrapers, bathrooms, or television cabinets (Fig. 30-52). They also may reflect previous associations and uses, such as Gothic Revival for ecclesiastical buildings or ancient temple forms for government buildings or banks. Some forms, configurations, and treatments become conventions and are widely accepted as historical whether accurate or not.

Modern Historical interiors usually are eclectic, often combining antique and contemporary architectural details, paneling, wallpapers, tapestries, furniture, and artwork (Fig. 30-17, 30-29, 30-35). Designers, decorators, and homeowners may mix styles and/or use unexpected elements, patterns, colors, and finishes to create a distinctive and personal look. They most often strive to create a period look or ambiance instead of replicating the original spaces. Modern Historical furniture may be an adaptation, an exact copy or reproduction, or a new creation usually unknown in the past but inspired by it nevertheless (Fig. 30-42, 30-44, 30-45, 30-48, 30-53).

Historic Preservation design characteristics are a product of the time and style of the structure or building and the approach chosen. Preservation and restorations will reflect as accurately as possible the original style of the building and its interiors, whereas rehabilitation and adaptive use may not.

■ *Motifs.* Modern Historicism features period elements, details, and motifs derived from past styles, such as pediments, columns, pointed arches, flowers, ogee arches, pagodas, birds, leaves, medallions, arabesques, and shells (Fig. 30-2).

ARCHITECTURE

Throughout the 20th century and, to a lesser extent, into the 21st, many public and private buildings still follow past types or styles. Architects often work in historic styles because of

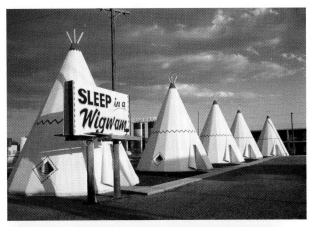

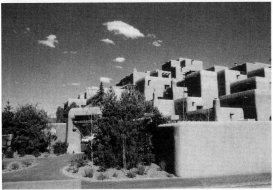

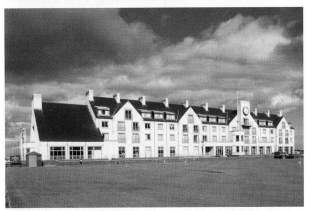

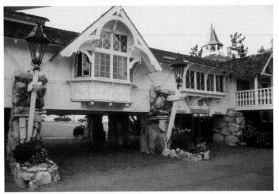

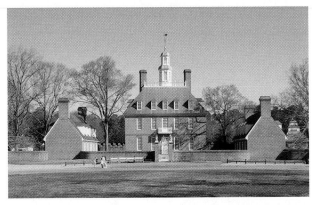

▲ **30-3.** Governor's Palace, 1705–1749, reconstruction in the 1930s; Williamsburg, Virginia. Reconstruction.

▲ **30-4.** Wigwam Motel, Holbrook, Arizona; Inn of Loretto, Santa Fe, New Mexico; Carnoustie Golf Course Hotel, Scotland; and Madonna Inn, Paso Robles, California; c. 1950s–1990s; United States. Modern Historicism and Regionalism.

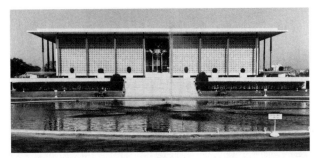

▲ **30-5.** United States Embassy, 1957–1959; New Delhi, India; Edward Durrell Stone. New Formalism.

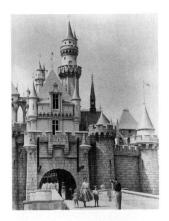

client preference and/or symbolic or associative reasons, such as Gothic for churches or Classical Revival for government buildings. Additionally, many early-20th-century architects are Beaux-Arts trained, so have a thorough grounding in the theories and design language of styles of the past. Several developments or styles centering on the past arise beginning in the 1950s. Most are inspired by or derived from past forms or styles and do not attempt to replicate the past. These movements or stylistic variations include Historic Preservation, Suburban Modern, New Urbanism, New Formalism, Regionalism, and New Classicism.

■ *Historic Preservation Approach.* Preservation planning identifies significant structures or areas to be preserved, rehabilitated, or restored usually by individuals, developers, or the government. Areas with many significant structures may be designated historic districts to protect their character. Within historic districts, only certain changes are permitted. Rehabilitations and adaptive-use projects convert residential, commercial, religious, and institutional structures to the same or new uses for individuals, retail stores, or commercial firms. Schools may become low-income apartments or prestigious condominiums. Churches sometimes are turned into residences, or factories into apartments or artists' studios, and urban town houses are transformed into restaurants or day spas.

■ *Suburban Modern* (late 1940s–1960s). Following World War II, many countries in Europe and North America experience a housing shortage. Most European countries respond by building government-sponsored public housing. In the United States and Canada (elsewhere later), available land in city centers is limited and expensive, so developers respond by creating large suburbs outside many cities. During the 1950s and early 1960s, developers, builders, and some architects construct millions of homes using modern materials and mass-production techniques, such as prefabrication. Tracts, whether small or large, go up quickly and economically. They are filled with houses that are modern and/or derived from period styles or earlier house types. Suburban Modern unites designs that suit popular tastes (often traditional or period style) with rapid construction methods to accomplish the modernist's dream of mass-produced housing for many people. Although not the first such development, Levittown, New York, built by

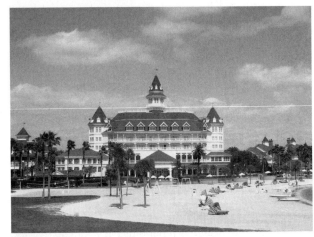

▲ **30-6.** Sleeping Beauty Castle (top), 1955, Disneyland Anaheim, California, by Walt Disney Imagineering Division; and the Grand Floridian Hotel (center), 1988, by Wimberly Allison, Tong, & Goo; and Wilderness Lodge (bottom), 1994, by Peter Dominick of the Urban Design Group; both at Walt Disney World, Lake Buena Vista, Florida. Modern Historicism.

Levitt and Sons in 1949 is, one of the best-known suburbs. Later developments become more extensive with shopping centers, parks, and community centers, and many have curving streets and cul-de-sacs for variety.

Modern suburban houses usually evolve from past house types but incorporate modern construction techniques, new

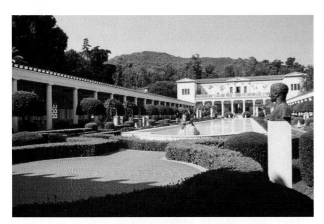

▲ **30-7.** J. Paul Getty Museum at the Getty Villa, 1973–1974; Malibu, California; Langdon and Wilson, Stephan Garrett, and Norman Neuerberg, consultant; 2006, Rodolfo Machado and Jorge Silvetti. Reconstruction and Restoration.

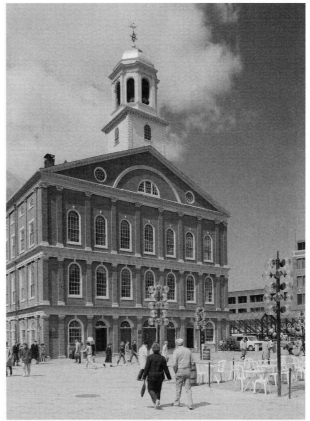

▲ **30-8.** Faneuil Hall Marketplace, 1740–1742; Quincy Market, 1824–1826, by Alexander Parris; 1976, F. A. Stahl & Associates with Benjamin Thompson and Associates. Restoration and Rehabilitation.

▲ **30-9.** Willard Intercontinental Washington Hotel, 1904; Washington, D.C.; by Henry Janway Hardenbergh, 1986 restoration and addition by Hardy Holzman Pfeiffer. Restoration and new construction.

and modern materials, and contemporary floor plans, kitchens, and baths. American postwar suburban house types include the Ranch, Cape Cod, and split-level (Fig. 30-14). The Ranch house is the most common suburban house after 1945. Assumed to be archetypal of the ranch house of the Old West, these house types first appear in the early 20th century as custom, architect-designed houses (see Chapter 14, "Spanish Colonial Revival") sometimes in large subdivisions. The postwar Ranch, also called a rambler, is more compact than its predecessor, with one story in an L- or U-shaped configuration with a garage or carport. The Cape Cod, especially popular on the Eastern seaboard, is a rectangular story-and-a-half house type with a gable roof derived from the hall or half house of the 17th century (see Chapter 13, "Colonial Revival"). Developing somewhat later, the split-level house has a two-story section inserted about midway in a single-story section to make three living levels.

As the 20th century progresses, more styles and regional expressions begin to dominate suburbs, and their character changes in response to the market and other external factors. New styles include English Georgian, French, Tudor, Victorian, and Arts and Crafts. Some subdivisions have small houses occupying less land to cope with rising costs in land, materials, and construction. These include garden homes, zero lot-line dwellings in which the house sits on or very close to one property line, developments for older adults and retirees, condominiums, and townhouses. In contrast, many suburbanites in the late 20th and early 21st centuries want houses larger than ever. They demand additional rooms, such as home offices, exercise or media rooms, gourmet kitchens, and master suites with sitting areas and luxurious baths or spas. In the early 21st century, the popular term for these large homes is *McMansion* (Fig. 30-14), which is adapted from the fast-food giant McDonald's.

DESIGN SPOTLIGHT

Architecture: Richmond Riverside, 1984–1989; London, England; Quinlan Terry. New Classicism. Sited on a wide grassy area facing the Thames River, the Richmond Riverside complex houses shops, offices, restaurants, apartments, and gardens. The sloping site and scale of the surroundings dictate several buildings instead of one large structure. Designed by New Classical architect Quinlan Terry, the complex retains two earlier buildings with new facades and includes others that are new. Terry uses forms and details from 18th-century English architecture such as red and yellow brick, slate roofs, and sash and casement windows. He derives various details from past architects such as Andrea Palladio, Nicholas Hawksmoor, and William Chambers. The complex fits well into its surroundings, appearing as if it has been there for centuries. Proving popular and commercially viable, Richmond Riverside has become an icon of traditional urban design.

Architectural features derive from Palladio, Hawksmoor, Chambers, and 18th-century English architecture

Façade imitates the work of 18th century architects through classical ordering, architectural features, and the use of red brick

Buildings appear in context to the site and surrounding area, adding a sense of place

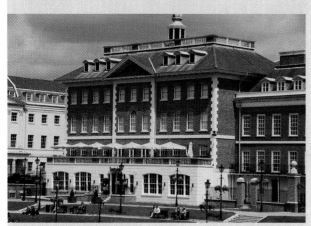

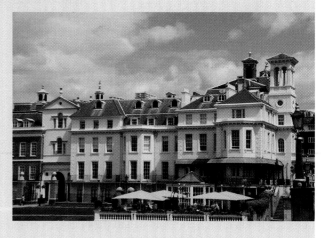

▲ **30-10.** Richmond Riverside; London, England.

■ *New Urbanism.* In the 1970s, new types of suburbs and towns arise in response to the critiques of existing ones by sociologists, ecologists, and designers. Their criticisms include monotony in design, a lack of community spirit, isolation especially for those who cannot or do not drive, high energy and water consumption, and damage to the environment from land use and the chemicals used to maintain lawns. In the 1980s, designers begin to create small towns with place identity, greater density, and an emphasis upon pedestrians instead of automobiles. Town centers are a key element in this development, which is called New Urbanism. It is the brainchild of architects Andres

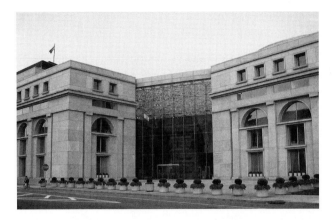

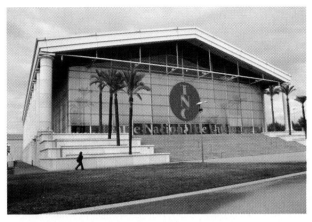

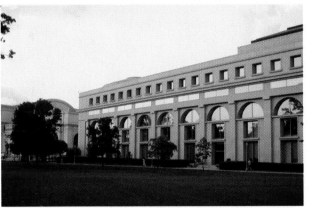

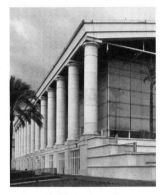

▲ **30-12.** Teatro Nacionale de Cataluña, 1997; Barcelona, Spain; Ricardo Bofill. New Classicism.

▲ **30-11.** Thurgood Marshall Federal Judiciary Building, 1992; Washington, D.C.; Edward Larrabee Barnes. Modern Historicism.

Duany and Elizabeth Plater-Zyberk (DPZ). One of the first examples is Seaside, Florida (Fig. 30-15), where DPZ creates both urban codes for planning and building codes derived from traditional and vernacular styles of the Gulf Coast region. The goal was to create a pedestrian town with a sense of place by using small lots surrounding a town center that has shops and stores. The designers formulate the town's building codes by studying vernacular architecture of the area and small southern towns. Seaside becomes an important model of New Urbanism.

■ *New Formalism.* In the late 1950s, some architects decide to take the International Style in another direction by turning to the past for inspiration. The group includes Edward Durrell Stone, Minoru Yamasaki, and, briefly, Philip Johnson. In a style called New Formalism, the group uses past elements and attributes as springboards for its own creativity. The work is eclectic and characterized by forms and details inspired by the past, particularly classicism but occasionally Gothic or Victorian. The formal style only slightly recalls the past and is expressed in luxurious materials and increased ornament and applied decoration (Fig. 30-5). Grilles or screens are a common feature.

■ *Regionalism.* Inspired by the Historic Preservation Movement and criticisms that the International Style lacks context, connection, and a sense of place, architects and

designers begin to consider the surroundings or locales of their work. The resulting Regionalism is defined by buildings and interiors that link to place and the character of a region (Fig. 30-4, 30-14, 30-31). Designs address local traditions, vernacular forms, and cultural norms related to the form, elements, ornament, and materials. Expressions of past or vernacular character, such as adobe residences in the Southwest, are common. Some closely copy the existing fabric, while other solutions adopt or adapt elements and attributes of nearby historic structures or the site itself. A few are modernist interpretations with key elements or symbols derived from the site or older buildings.

New construction or additions acknowledge surroundings, regional context, and existing structure in a variety of ways, including scale, orientation, articulation, individual elements of the existing building, and materials. Architects use many design devices to achieve the effect including horizontal or vertical orientation, form, shape, height, scale, proportion, roofline, distribution of openings, materials, and/or colors. Consequently, compositions vary from close approximations to reinterpretations with subtle hints of the surroundings or region (see Chapter 34, "Environmental Modern").

■ *New Classicism.* In the late 1970s in reaction to Modernism, some architects deliberately return to classicism. Adherents support their cause by citing the importance of

DESIGN SPOTLIGHT

Architecture: Caesar's Palace Hotel, Venetian Hotel, and Paris Las Vegas Hotel, c. 1990s; Las Vegas, Nevada; Veldon Simpson and Marnell Corrao Associates. Modern Historicism. These Las Vegas hotels represent modern, theatrical interpretations of older, well-known buildings in Rome, Venice, and Paris through the perspective of contemporary popular culture in the United States. Envisioned as destination playgrounds within a sprawling desert landscape, they offer a fantasy or theme-park-like character, charm, and extreme comfort to pleasure-seeking travelers. Caesar's Palace Hotel is a vast sprawling Greco-Roman-styled environment. The language of Classicism establishes the theme as well as formality, balance, and order. Temple fronts at the roofline and entry, Corinthian columns, and pilasters define the 13-story guest towers. Pediments and other classical details punctuate structures throughout the complex. The shopping mall features sound and light shows centered on live classical statues to enhance the overall, classical ambiance. The Venetian Hotel's façade re-creates some of Venice, Italy's, most famous buildings, including the Ducal Palace with its Gothic arches and motifs. The Palace and the Bridge of Sighs surround a Venetian-style canal, complete with

gondoliers and other well-known symbols and emblems of the city. Both the elegantly designed exterior and interiors (Fig. 30-29) feature marble and painted decoration commonly seen in Venetian buildings. The Paris Las Vegas Hotel features a smaller-scaled Eiffel Tower, with a restaurant and observation deck, along with a re-created Paris Opera House that functions as a casino and entry to the rest of the hotel. A grand Second Empire–style multistoried guest tower with a Mansard roof completes the architectural composition.

▲ **30–13.** Caesar's Palace Hotel (top right), Venetian Hotel (bottom left), and Paris Las Vegas Hotel (bottom right).

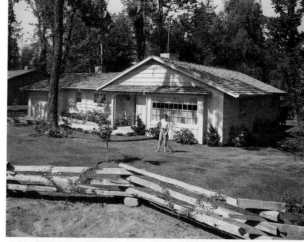

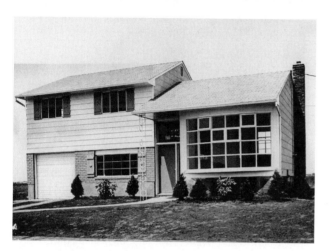

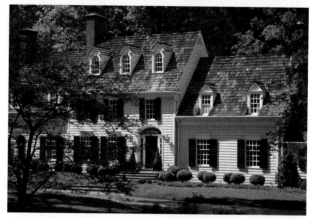

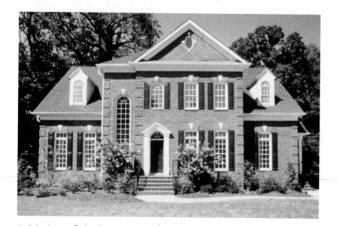

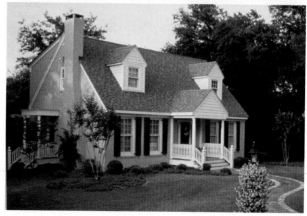

▲ **30-14.** Suburban houses; (left column) Regionalism, split-level, McMansion; (right column) ranch, Williamsburg-style, CapeCod; c. 1950s–2000s; United States. Suburban Modern and Regionalism.

maintaining a connection with the past. The order and monumentality of classicism are associated with dignity. Classicism is familiar and appealing to many people, not just the design elite. Although a minority, the group studies design principles and significant examples from ancient Greece, ancient Rome, the Renaissance, Neo-Palladian, English Georgian, and English Regency. Generally, compositions, which may sometimes reveal an element of nationalism, closely follow the precursors or have some direct quotes from historic monuments. Work is often inserted

into similarly styled historical sites and areas (Fig. 30-10, 30-12, 30-27). Important theorists and practitioners include Demetri Porphyrios, Quinlan Terry, Allan Greenburg, Robert A. M. Stern, and Ricardo Bofill.

Public and Private Buildings

■ *Types.* Modern Historicism defines numerous building types including multistory buildings (Fig. 30-4, 30-11), banks, hotels (Fig. 30-4, 30-6, 30-13), restaurants,

IMPORTANT BUILDINGS AND INTERIORS

- **Alexandria, Virginia:**
 —Torpedo Munitions Plant, c. 1919; late 1970s to early 1980s; converted into the Torpedo Factory Arts Center, by Keyes, Condon, and Florance. Adaptive Use.

- **Athens, Georgia:**
 —The News Building, 1992; Allan Greenberg. New Classicism.

- **Barcelona, Spain:**
 —Teatro Nacionale de Cataluña, 1997; Ricardo Bofill. New Classicism.

- **Boston, Massachusetts:**
 —Faneuil Hall Marketplace, 1740–1742; Quincy Market, 1824–1826, by Josiah Quinn; 1976, F. A. Stahl & Associates with Benjamin Thompson & Associates. Restoration and Rehabilitation.

- **Cambridge, England:**
 —Maitland Robinson Library, Downing College, 1982; Quinlan Terry. New Classicism.

- **Charleston, South Carolina:**
 —Interiors, Drayton Hall, 1738–1742; 1974 preservation work begun by the National Trust for Historic Preservation. Preservation.

- **Charlottesville, Virginia:**
 —Observatory Hill Dining Hall, University of Virginia, 1984; Robert A. M. Stern. New Classicism.

- **Cincinnati, Ohio:**
 —Starrett-Netherland Plaza Hotel (later a Hilton hotel), 1930, Walter Ahlschlager with Delano and Aldrich; 1982–1992 by Richard Rach and Associates with interiors by Rita St. Clair. Restoration and Rehabilitation.

- **Chicago, Illinois:**
 —Harold Washington Library Center, 1990–1992; Thomas Beeby. Modern Historicism.

- **Dubai, United Arab Emirates:**
 —Interiors, Park Hyatt Hotel, 2004–2005; Wilson Associates Singapore. Regionalism.

- **Las Vegas, Nevada:**
 —Luxor Hotel, 1993; Veldon Simpson and Marnell Corrao Associates. Modern Historicism.
 —Venetian Hotel, 1998; Wimberly, Allison, Tong & Goo; interiors by Wilson Associates. Modern Historicism.

- **London, England:**
 —Docklands, Canary Wharf, 1988–2006, original dock area (c. 1500s) and wharf (1802) converted into business district with condominiums, shops, and restaurants. Rehabilitation, Adaptive Use, and new construction.
 —John Fowler's House, Kings Road, 1934; interiors by John Fowler. Modern Historicism.
 —Richmond Riverside, 1984–1989; Quinlan Terry. New Classicism.

- **Malibu, California:**
 —J. Paul Getty Museum at the Getty Villa, 1973–1974 by Langdon and Wilson, Stephan Garrett, and Norman Neuerberg, consultant; 2006, Rodolfo Machado and Jorge Silvetti. Reconstruction and Restoration.

- **Miami, Florida:**
 —Fontainebleau Hotel, 1954; Morris Lapidus. Modern Historicism.

- **New York City, New York:**
 —Fulton Market area, 1822–1830s; 1980s, converted to South Street Seaport; Rouse Company. Rehabilitation and Adaptive Use.
 —Levittown (residential community), Long Island, 1949; developed by William Jaird Levitt. Suburban Modern.
 —Lincoln Center of the Performing Arts, 1957–1966; Wallace K. Harrison, Philip Johnson, and Eero Saarinen. New Formalism.
 —Interiors, renovation and redecoration of old Music Room, c. 1882, into Lounge, Palace Hotel (formerly the Villard Houses designed by McKim, Mead, and White), c. 1981 by Sarah Tomerlin Lee; redecoration into Le Cirque bar and restaurant, c. 1997 by Adam Tihany. Renovation and Redecoration.

- **Orlando area, Florida:**
 —Grand Floridian Hotel, 1988; Walt Disney World, Lake Buena Vista; by Wimberly, Allison Tong & Goo. Modern Historicism.
 —Wilderness Lodge, 1994; Walt Disney World, Lake Buena Vista; by Peter Dominick of the Urban Design Group. Modern Historicism.

- **Ottawa, Canada:**
 —U.S. Chancery, 1931–1932; Cass Gilbert; 2001, converted into the Portrait Gallery of Canada, Dixon Jones Architects. Adaptive Use.

- **Paris, France:**
 —Gare d'Orsay (train station), 1897–1900; 1980–1987, converted to Musée d'Orsay, interiors by Gae Aulenti. Rehabilitation and Adaptive Use.

IMPORTANT BUILDINGS AND INTERIORS

- **Santa Fe, New Mexico:**
 - —Interiors, Inn of the Anasazi, c. 1996; Trisha Wilson Associates. Regionalism.

- **Seaside, Florida:**
 - —New town and residential buildings; 1981–1987; Andres Duany and Elizabeth Plater-Zyberk. New Urbanism.

- **St. Louis, Missouri:**
 - —Union Station Railway Depot, 1891–1894; 1980s, converted into the Hyatt Regency St. Louis Hotel, by Oppenheimer Properties, Rouse Company, and Omni International Hotels. Rehabilitation and Adaptive Use.

- **San Diego, California:**
 - —Gaslamp Quarter, 19th Century; mid-1970s. Preservation, Restoration, Rehabilitation, Adaptive Use in the area; c. 1980, designated a Historic District.

- **Surrey, England:**
 - —Clandon Park, 1720s, by Giacomo Leoni; 1968–1970, interiors restored by John Fowler. Restoration.

- **Washington, D.C.:**
 - —Diplomatic Reception Rooms, State Department, c. 1980s; Edward Vason Jones and others. Modern Historicism.
 - —Pension Building, 1887; mid-1980s, converted to the National Building Museum; Keyes, Condon, and Florance. Restoration and Rehabilitation.
 - —Union Station, 1907, by Daniel Burnham; 1981–1988, continued use as a train station with some areas converted into shops and restaurants, by Jones Lang, LaSalle. Restoration and Rehabilitation.
 - —Willard Intercontinental Washington Hotel, 1904; Henry Janway Hardenbergh; 1986 restoration by Hardy Holzman Pfeiffer, with interiors by Sarah Tomerlin Lee; 2000, redecoration of guest rooms by Forrest Perkins. Restoration and Redecoration.

- **Williamsburg, Virginia:**
 - —Governor's Palace, 1705–1749; reconstruction in the 1930s. Reconstruction.

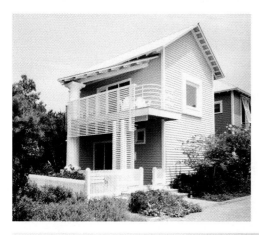

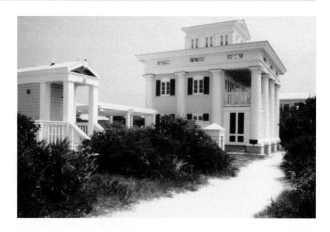

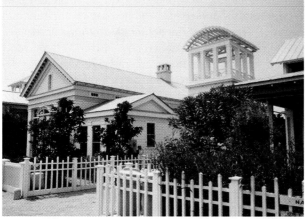

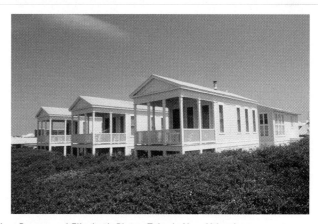

▲ **30-15.** New town and houses; 1981–1987; Seaside, Florida; Andres Duany and Elizabeth Plater-Zyberk. New Urbanism.

commercial buildings, retail establishments, government buildings, university buildings, and residences (Fig. 30-14, 30-15). Some architects apply classical styles to buildings not usually associated with those styles, such as supermarkets, as a direct juxtaposition of style with function.

■ *Site Orientation.* No particular orientation is associated with Modern Historicism. Classically styled public buildings usually have prominent entries on axis with the building to create a processional path. Suburban houses usually have expansive lawns. The broad side of the house usually faces the street for convenient access to the garage or carport. To the rear is a patio or courtyard for casual outdoor living. Houses and townhouses line streets in New Urban developments, with wide sidewalks and garages as part of the structure or at the rear, sometimes in the alleys. Preservation practice usually seeks to maintain the integrity of the site and location.

■ *Floor Plans.* Plans develop from building function, client preference, and modern needs and requirements. Some plans are based on earlier building types, including vernacular. Urban structures often blend older floor plan features, such as symmetry, with modern planning concepts to address codes, circulation, identity, character, and context. Often, areas such as entries, halls, and public spaces are larger than in the prototype historical building. Preservation practice retains defining features of floor plans.

Suburban house plans support informal lifestyles. They are rectangular, L, or U shaped with separate public and private areas. Regarded as quiet living areas, the formal living and dining rooms usually are at the front of the house and the kitchen is next to the dining room. Kitchens usually open to a family room, considered a noisy living area, that has access to the outside patio or courtyard.

■ *Materials.* Modern Historical buildings often use luxurious and traditional or typical materials of the past, such as marble or stone. Alternatives include wood, brick, and concrete blocks that may be covered with stucco and scored to resemble stone. Suburban houses display a variety of materials, which are often mixed and may reflect a regional character. Materials include brick; wooden, vinyl or aluminum horizontal or vertical siding; stone; stucco; and shingles. In the second half of the 20th century, paint companies offer collections of historic colors for exteriors, such as Williamsburg by Martin Senour and the Preservation Palette by Sherwin Williams.

■ *Façades.* Classical elements, such as rustication, columns, and pediments, identify many public and affluent private examples of Modern Historicism, but these details may be greatly simplified, abstracted, or merely suggested through form (Fig. 30-11, 30-12). Designs may follow classical proportions or have classical attributes such as symmetry. Those following other styles, such as medieval, may feature many of their stylistic forms, attributes, and details. For example, Tudor-style houses are often asymmetrical with an emphasis upon height. A tall gable or gables often dominate the façade.

Façades of Suburban Modern houses are usually long, low, and horizontal (Fig. 30-14). They may be symmetrical or asymmetrical with a covered porch centered or on one side. Elements and decoration identify individual styles, when present, and provide variety, but simplicity defines the overall appearance. Garages or carports sometimes dominate façades.

■ *Windows.* Windows usually are large and rectangular (Fig. 30-10, 30-11, 30-13, 30-14). Most are double hung and subdivided by panes as in their prototypes. Surrounds are in the building's style. Sizes of windows may become smaller as they ascend the building. Picture windows are a defining feature of most postwar houses, although some have few windows or doors on the front. Also evident are awning, jalousie, horizontal sliding or ribbon windows, and bow and bay windows, often with shutters.

■ *Doors.* On all styles or modes, main entries may be centered or to one side, and are often recessed or under an entry colonnade or porch. Prominent entries, often under a portico, define most public buildings. Entry doors, in both public and private buildings, are usually wood panels, sometimes with rectangular or oval glass that may be beveled or stained. Sliding glass or French doors access outdoor living areas.

■ *Roofs.* Roofs include flat (usually with a balustrade), hipped, or gabled. Significant buildings may have domes or towers (Fig. 30-10, 30-13). For houses, low-pitched hipped, gabled, side gabled, and cross gabled are common roof types. Some homes have shed or flat roofs.

INTERIORS

Many public and private interiors display Modern Historicism in various ways throughout the 20th century. They may closely resemble the past, as in buildings by New Classical architects; be composed of antiques and historic elements, as in period decoration; or have a period/traditional appearance or transitional look. Most exhibit great variety in treatments and furnishings depending upon the intention, client preference, budget, and/or the designer's creativity or understanding of the past. And they reflect a myriad of choices available for furniture and treatments. Modern Historical interiors are found in residences, government buildings, offices, hotels, clubs, banks, restaurants, and institutional buildings such as universities.

■ *Period-Style Decoration.* Period decoration—decorating a room or rooms in a particular historical period—includes numerous past styles within a modern context of smaller

DESIGN PRACTITIONERS

Numerous architects throughout the United States, Canada, England, and Europe work on old buildings, both residential and commercial, and some specialize totally in this direction. This practice becomes more common during the 1970s because of various changes in attitudes toward older buildings and their use as well as an increase in scholarship. The design approach varies with the type of project and client. Through education and practice, architects become more knowledgeable of historic construction, materials, technology, maintenance, regional interpretations, and other building characteristics that are important to the design process. As a result, they have enhanced the quality of many structures and given them new life. In doing so, they, along with home builders, have contributed to the development of and interest in period-style suburbs and urban centers.

Decorators of the early 20th century continue working and are joined by a new generation. Prominent American decorators and designers of the postwar period include Mrs. Henry Parish II, Dorothy Draper, Eleanor McMillen Brown, T. H. Robsjohn-Gibbings, Billy Baldwin, and William Pahlmann. Many give decorating advice in books, columns in newspapers, or periodicals and/or become members of professional associations. During the 1950s, the last of the first generation of female decorators dies including Elsie de Wolfe, Syrie Maugham, and Nancy McClelland (see Chapter 12, "Classical Eclecticism," and Chapter 14, "Colonial Revival").

Although organizations for decorators exist during the first decades of the 20th century, in 1931 the American Institute of Interior Decorators (AIID) forms in Grand Rapids, Michigan. One of its goals is to separate interior decorators from the many people who decorate interiors and call themselves decorators, including painters and wallpaper hangers. AIID, like others, begins to call for education and training for decorators and look at standards for practice. In 1936, AIID changes its name to the American Institute of Decorators (AID) and moves its headquarters to New York City (see Interior Design Professional Timeline). Many well-known decorators are members.

Following World War II, more practitioners have architecture and/or design schooling, unlike their predecessors, and more universities and schools offer courses and degree programs in interior decorating and design. Much of the teaching and writings of the postwar period are heavily based on the history of architecture, interiors, furniture, and the decorative arts, a reflection of the Beaux-Arts methods of education. During this period, women decorators and designers enter commercial design in greater numbers. Nevertheless, most women are residential designers, whereas interior design departments in large architectural firms are headed by males.

- **Billy Baldwin** (1903–1983) begins his career as assistant to Ruby Ross Wood, and then opens his own firm in 1952. His trademarks include rich colors, lavish use of chintz, mixed patterns, eclecticism, contrasts of texture and scale, and carefully considered decorative accessories. Baldwin Americanizes the English Country House look.

- **Barbara Barry** is a California interior designer who creates refined, sophisticated, and tranquil residential and commercial interiors. She also designs furniture and other products with a simple classical flair. Seeing rooms and furniture as paintings, she often works out concepts with watercolors. Barry opens her firm, Barbara Barry, Inc., in 1985. She has received numerous design awards, including her induction into the Interior Design Hall of Fame in 2000.

- **John Blatteau** practices architecture in Philadelphia and specializes in classical architecture, restorations, and renovations. His work and that of his firm, John Blatteau Associates, established in 1983, is published and wins numerous awards for design excellence. Important work includes the Benjamin Franklin State Dining Room at the Department of State in Washington, D.C., the Forbes Galleries in the Forbes Magazine Building in New York City, and several projects for the Riggs National Bank of Washington, D.C.

- **Dorothy Draper** (1889–1969; Fig. 30-1) begins her New York design firm in 1923, decorating her own home and those of her friends. In 1930, the firm's name changes to Dorothy Draper & Company. Although she designs interiors in stores and residences, she specializes in hotels, creating lobbies and other spaces with vivid colors, bold patterns, and large-scale details in a neo-Baroque style. As a columnist for *Good Housekeeping*, she dispenses decorating advice. Brilliant colors, black and white checkered floors, and large plaster architectural details are her trademarks.

- **John Fowler** (1906–1977; Fig. 30-1) is known for his elegant, refined period-style interiors, which become known as the English Country House look. Inspired by the past, he is known for his richly detailed window treatments and adaptations of designs from 18th- and 19th-century wallpapers and textiles. In 1938, he joins Lady Sibyl Colefax, and their firm, Colefax and Fowler, decorates many important residences in England. Fowler is best remembered for his restoration work for England's National Trust.

DESIGN PRACTITIONERS

- **David Hicks** (1929–1998) studies design in London, and soon after his interiors are published, he becomes well known nationally and internationally. A master in the use of color for strong visual impact, his eclectic rooms center on one main color with accents that often clash. Other signature characteristics include geometric patterned carpet, juxtapositions of scale, especially large furnishings in a small room, and symmetry. Hicks designs houses, hotels, restaurants, carpet, fabrics, and furniture.

- **Sarah Tomerlin Lee** (1911–2001) makes important contributions in both fashion and interior design. She is an editor for *Vogue* and *Harper's Bazaar* before becoming editor-in-chief at *House Beautiful* from 1965 to 1979. She enters interior design, intending only to complete projects for her husband after his death in 1971. However, she expands the firm and becomes known for restorations and renovations of hotels, including the Helmsley Palace in New York and the Willard Hotel in Washington, D.C. In 1986, Lee is received into the Interior Design Hall of Fame.

- **Syrie Maugham** (1879–1955) begins decorating after opening a shop in London in the early 1920s. She quickly makes a name for herself with her modernistic all-white rooms. Most of her interiors are characterized by few, if any, architectural details, pale colors, and an eclectic mix of furnishings.

- **Nancy McClelland** (1877–1959) earns a BA in English and Latin from Vassar in 1897 and begins decorating at AU Quatrieme, a specialty shop in the New York Wanamaker's Store in 1913. After opening her own firm in 1922, she works in period styles and becomes known for her expertise in historic wallpapers and antiques. She writes a correspondence course on decorating, four books, numerous articles, and is a strong advocate for professional standards and licensing in interior design. A founding member of AID, she is the fifth national and first woman president of the association in 1941.

- **William Pahlmann** (1900–1987; Fig. 30-1) strives to blend traditional with modern in his work, and his use of eclecticism greatly influences interior design and decoration. He begins his career at Lord and Taylor, where he creates model rooms that are often thematic and show a bold use of color. He opens his own firm in 1946 and designs hotels, restaurants, shops, stores, offices, lobbies, and residences.

- **Mrs. Henry Parish** (1901–1994; Sister Parish) begins decorating her own home and those of her society friends. In 1933, she opens her own firm, and over the next decades perfects her version of the English Country House look. This is characterized by English and French furniture, floral chintzes, pastel walls, comfortable upholstery, pillows, soft rugs, and traditional decorative accessories. Albert Hadley joins the firm in 1962 and the firm becomes Parish-Hadley, Inc.

- **T. H. Robsjohn-Gibbings** (1907–1973) studies architecture and works as a designer in England before coming to the United States to work with antique dealer Charles Duveen. Although not strictly a traditionalist, his work transforms classicism with elegant simplicity, natural materials, and by using squares and rectangles. Robsjohn-Gibbings also designs furniture in a simple minimalist style for Widdicomb Company.

- **Rita St. Clair** works in both residential and nonresidential design, with an emphasis on hospitality design. In 1964, she opens her own firm in Baltimore, Maryland. She is national president of the American Society of Interior Designers (ASID) in 1980–1981. In 1986, she is recognized by ASID with a Designer of Distinction award. Inducted into the Interior Design Hall of Fame in 1989, her renovation of the City Hall in Baltimore and the Starrett-Netherland Plaza Hotel (later a Hilton hotel) in Cincinnati win her national acclaim.

- **John Saladino** (b. 1939) designs interiors and furniture using classical principles combined with a mixture of old and new implicit historical references. Trained as an artist, Saladino opens his firm, the Saladino Group, in 1972 in New York City. The firm designs and restores interiors, completes landscapes, and designs furniture. Saladino is published widely and inducted into the Interior Design Hall of Fame in 1985.

- **Edward Durrell Stone** (1902–1978) studies architecture at Harvard and MIT. Through traveling in Europe he becomes familiar with the Bauhaus and other modernist buildings. Upon his return to the United States, he is one of the earliest practitioners of the International Style. In the postwar period, in a search for greater richness, he transforms his modernist style by using formalism, luxurious materials, and decorative details. A common element in many of his buildings is an exterior grille.

- **Quinlan Terry** (b. 1937) does much to promote classicism in England through his work and

DESIGN PRACTITIONERS

writings. Terry adopts the language of Andrea Palladio, Inigo Jones, Sir Christopher Wren, and other great English classicists for much of his work, which is often criticized. He incorporates luxurious materials and details in an effort to bring richness and context to his work.

- **Carleton Varney** (b. 1937) joins Dorothy Draper and Company in 1959 and now is its president. In addition to numerous interiors, he designs furniture, fabrics, carpets, china, and other decorative accessories. Author of numerous books on decorators and decorating, he founds the Carlton Varney School of Design at the University of Charleston, West Virginia, and is inducted into the Interior Design Hall of Fame in 1990.

- **Trisha Wilson** (b. 1947) studies interior design in Texas, and later opens her own firm in Dallas

specializing in hospitality design. Her firm, Wilson Associates, creates hotels, restaurants, casinos, and retirement communities worldwide. The work is imbued with a cultural spirit that focuses on the region as well as the client and user. She is inducted into the Interior Design Hall of Fame in 1993, and she wins numerous awards for design excellence.

- **Edward Wormley** (1907–1995; Fig. 30-1) is the director of design for Dunbar Furniture Company from 1931 to 1970. There, he strives for well-designed and well-made pieces and creates new lines with many pieces each year. He sets up his own firm in 1945 and designs residences and showrooms. Wormley is best known for his transitional furniture, as he calls it. Influenced by many cultures and periods, his furniture is timelessly elegant and simple and appeals to many people.

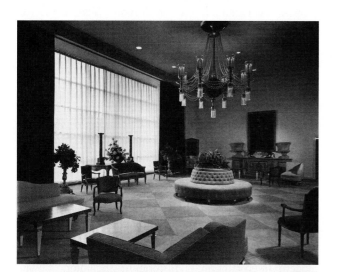

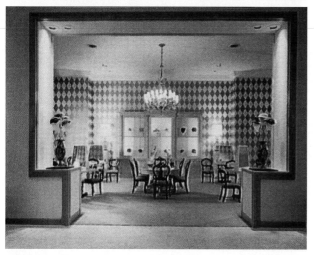

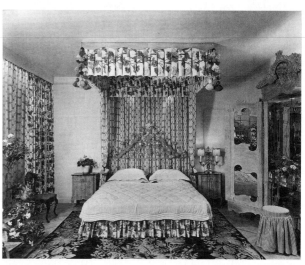

▲ **30-16.** Sales areas, Bonwit Teller Department Stores, 1949–1951; Chicago, Illinois, and Cleveland, Ohio; and bedroom, Peruvian Show, Lord and Taylor, 1941; New York City, New York. William Pahlmann. Modern Historicism.

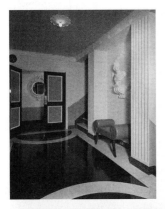

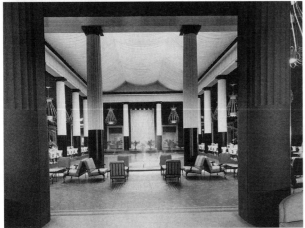

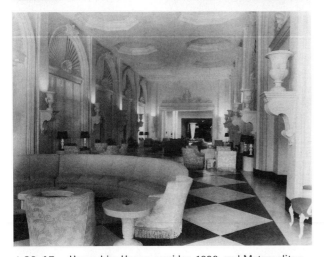

▲ **30-17.** Hampshire House, corridor, 1936, and Metropolitan Museum of Art Restaurant (dubbed The Dorotheum), 1954; New York City, New York; and Quitandinha Hotel and Resort, Lobby, 1944; Petropolis, Brazil; Dorothy Draper. Modern Historicism.

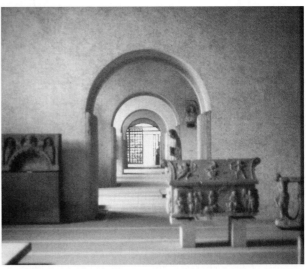

▲ **30-18.** Interior, Castel Vecchio Museum, 1956–1967; Verona, Italy; Carlo Scarpa. Rehabilitation and Adaptive Use.

rooms, antique and/or contemporary furnishings, and modern preferences and manners of living (Fig. 30-32, 30-33, 30-34). Thus, diversity of expressions results. Favored high styles include French Provincial, French Rococo, French and English Neoclassical, English Georgian, English Regency, French Empire, and Baroque. These styles come

in and out of fashion throughout the 20th and 21st centuries. For example, Rococo is highly esteemed in the early 20th century but less so in the early 21st. Interest in the Victorian styles and Chinoiserie arises about midcentury. Also fashionable are the English country house look and theatrical, romantic, or fantasy rooms.

Period-style decoration in the first decades of the 20th century has a somewhat truer period character resulting from greater attention to details, particularly of walls, floors, and ceilings. The French styles dominate. During the 1930s, Art Deco and Art Moderne help foster a trend toward modernization within period decorating, such as the all-white rooms of Syrie Maugham. Spaces become even more eclectic, frequently mixing antiques with contemporary pieces and adopting colors atypical of the past. The French styles remain popular along with English 18th-century styles. Some decorators and designers actively seek an even more modern interpretation of historicism, including William Pahlmann (Fig. 30-1, 30-16), T. H. Robsjohn-Gibbings (Fig. 30-42), and Edward Wormley (Fig. 30-1, 30-43). They create so-called transitional rooms that have a refined, simplicity in keeping with Modernism and a mixture of modern and past or traditional treatments and furniture. Transitional rooms and furniture are neither completely modern nor exact representations of a particular period.

Even greater simplification occurs beginning with the World War II era and continuing through the rest of the 20th century (Fig. 30-29, 30-35, 30-37). Interiors have fewer architectural details and less ornament. Individualism, accomplished with even more eclecticism, and informality dominate, especially in suburban houses. English and American 18th-century, English Country, Arts and Crafts, and Victorian styles surpass French in popularity. Some homeowners and others strive to create

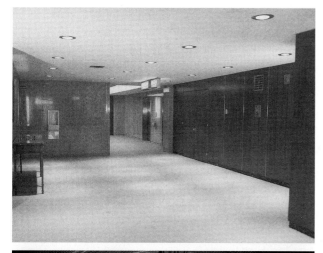

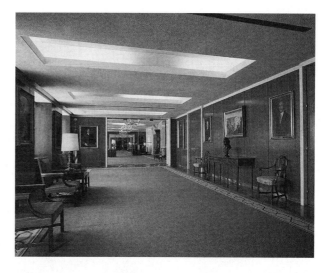

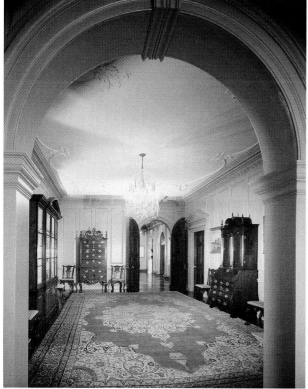

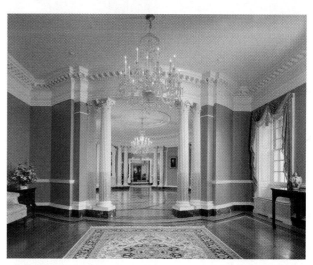

▲ **30-19.** Entrance Hall, Edward Vason Jones Memorial Hall, and ladies lounge in the Diplomatic Reception Rooms (before/above and after images), State Department, 1979–1986; Washington, D.C.; entry and lounge by Edward Vason Jones, and Memorial Hall by Allan Greenberg. Modern Historicism.

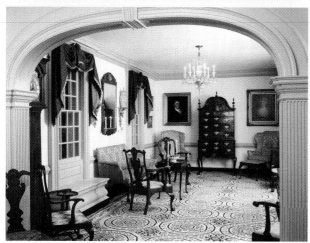

period-appropriate settings for their collections of antique furniture or decorative arts. Magazines with glossy and colorful photos, such as *House Beautiful* and *Architectural Digest,* popularize many of the middle-class looks.

Decorating in styles of the past remains popular throughout the late 20th and into the 21st century as architects, interior designers, decorators, and homeowners create modern expressions of period rooms (Fig. 30-28), based on budget, preferences or personalities, and the needs of modern lifestyles (Fig. 30-31, 30-37). They are aided by manufacturers who produce reproductions, adaptations, and modern interpretations of period paints,

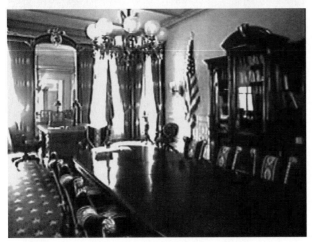

▲ 30-20. Andrew Johnson Suite, Treasury Building, 1836–1869; Washington, D.C.; 1985 restoration begun Office of the Curator. Restoration.

Period-style decoration characterizes the work of the early interior decorators whose backgrounds or preparation focuses on historic architecture, antiques, and period styles, mostly European. They often import entire rooms or paneling and details for their wealthy clients and/or make buying trips to Europe. Some strive for innovation and unusual color schemes to distinguish their work while retaining or reflecting a period character. Others, such as Dorothy Draper (Fig. 30-17) and Billy Baldwin, develop a trademark style characterized by signature details. During the post–World War II period, as decorators transform into interior designers, many leave behind their emphasis upon period styles especially when they focus on nonresidential spaces. But some interior designers do not abandon Modern Historical design altogether because they continue to create period-style rooms in a variety of public and private buildings for a diversity of clients.

■ *Historic Preservation Approach.* Within the Historic Preservation Movement, interiors, entirely or in part, are preserved, restored, or rehabilitated, the latter being the most common treatment (Fig. 30-20, 30-22, 30-23, 30-24, 30-36). In the United States, interiors are less often preserved or restored than are exteriors. This is often because they have fewer protections against demolition or alteration than in other countries, such as the United Kingdom. Additionally, rooms are more likely to be redecorated, refurbished, or renovated in response to events or as fashions, styles, budgets, and modern requirements change. Often, there is far less documentation of interiors, whether physical, archival, or visual. Usually only parts of interiors, such as architectural features and details, are restored. Historically accurate finishes may be applied to them to maintain defining historic features and support the ambiance of the period. Restorations, in contrast, attempt to create a moment in the past as well as the expression of the tastes and preferences of the previous, usually significant, inhabitants. While developing from evidence, documentation is often lacking for some parts or details. For example, there may be physical evidence that a space once had wall-to-wall carpet, but no documentation of the carpet itself. In this case, the curator or designer relies on reproductions appropriate to the period and makes an educated choice of style, pattern, and color (Fig. 30-20, 30-21).

■ *Suburban Modern.* Especially when the exterior is traditional or a period style, interiors in Suburban Modern houses may display a period flavor in finishes and furniture, such as Mediterranean or Early American. Open planning typifies most living areas, and rooms are furnished for a casual lifestyle. Furniture increasingly is arranged around the television instead of the fireplace or the view. No matter what the exterior design, kitchens and baths usually are contemporary in design

wallpapers (Fig. 30-39), textiles (Fig. 30-40), area rugs (Fig. 30-41), furniture, lighting (Fig. 30-38), and decorative arts. Sometimes designers also create contemporary interpretations within older interiors by renovating the interiors and redecorating the spaces to contrast with the past by using very contemporary floor plans, furnishings, color, and lighting, as Adam Tihany did in Le Cirque restaurant (Fig. 30-25, 30-26).

DESIGN SPOTLIGHT

Interiors: 1915 lobby, 1981 lobby under construction, 1986 building opening and restoration, Willard Hotel, 1904; Washington, D.C.; 1986 restoration by Henry Janway Hardenbergh, with interiors by Sarah Tomerlin Lee; 2000 restoration and redecoration of interiors by Forest Perkins. Restoration and Redecoration. The original Willard Hotel, built in 1850, was demolished to make way for a new, larger Beaux-Arts structure in 1904. The 1915 lobby is of this early period. After losing business for several years, the hotel closed in 1968. It reopened in 1986 after an extensive restoration and rehabilitation under the direction of the National Park Service. Original blueprints,

1901 photographs by Francis Benjamin Johnston, and paint analysis guided the architects and designer Sarah Tomerlin Lee in accurately re-creating the appearance of original interior spaces. Fragments of damaged moldings were used to replicate the originals, and the chandeliers were recast in Brussels, Belgium. The designers made a few changes, such as using the original yellow marble front desk as the concierge's desk. The old storage cabinet behind it was restored. A large Turkish circular sofa and potted palms dominate the space with its period colors and classical details. The redesign by Lee was recognized by ASID with an honor award.

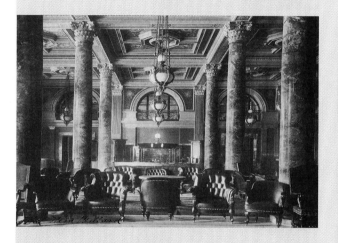

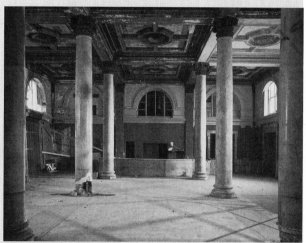

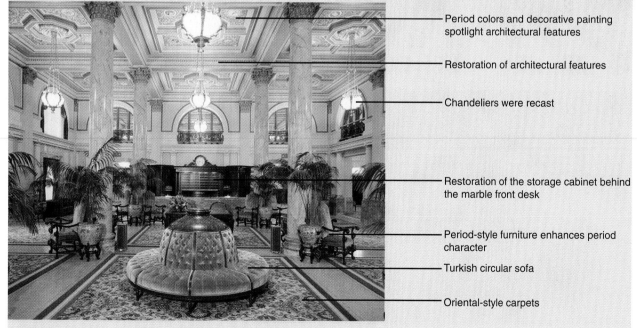

Period colors and decorative painting spotlight architectural features

Restoration of architectural features

Chandeliers were recast

Restoration of the storage cabinet behind the marble front desk

Period-style furniture enhances period character

Turkish circular sofa

Oriental-style carpets

▲ **30-21.** 1915 lobby, 1981 lobby under construction, 1986 building opening and restoration, Willard Hotel; Washington, D.C.

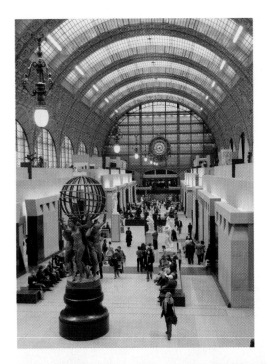

▲ **30–22.** Interiors, Musée d'Orsay, 1980–1987; Paris, France; interiors by Gae Aulenti. Rehabilitation and Adaptive Use.

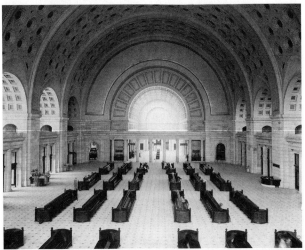

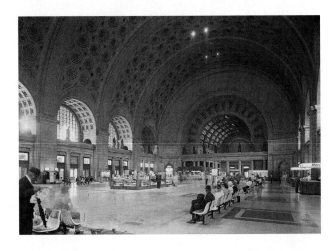

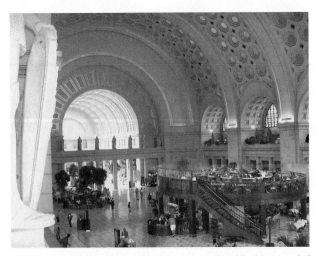

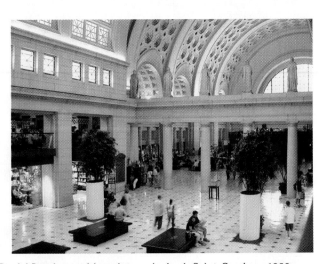

▲ **30–23.** Interiors, Union Station, 1903–1908; Washington, D.C.; Daniel Burnham, with sculptures by Louis Saint-Gaudens; 1988 restoration by Benjamin Thompson and Associates. Rehabilitation, Restoration, and Adaptive Use.

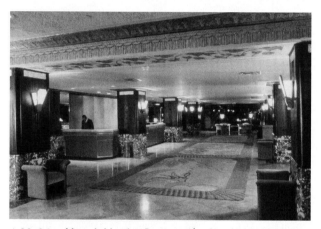
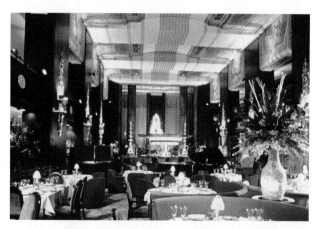

▲ **30-24.** Mayor's Meeting Room and/or City Council Chamber, Baltimore City Hall, 1974–1977; Baltimore, Maryland, with interiors by Rita St. Clair; and lobby and dining room, Starrett-Netherland Plaza Hotel, 1930, Walter Ahlschlager with Delano and Aldrich; 1982–1992 restoration by Richard Rach and Associates, with interiors by Rita St. Clair. Restoration and Rehabilitation.

and treatment. By the end of the 20th century, however, traditional or period-style cabinets, fixtures, and appliances are available so that even kitchens and baths can have a period look.

■ *Regionalism.* Like architecture, Regional-style interiors reflect the locale in treatments, finishes, and furnishings to highlight a sense of place or heritage. Expressions may be literally or loosely interpreted. Some interior designers become known for Regionalist designs in residential, commercial, and hospitality interiors, such as Trisha Wilson (Fig. 30-31) of Texas.

■ *New Classicism.* Modern Historical interiors, often seen in New Classical buildings, reflect the monumentality and formality of the exteriors (Fig. 30-27, 30-30). Classical proportions, architectural details, motifs, and treatments characterize these spaces.

Public and Private Buildings

■ *Types.* Period-style decoration may define all room types, most often in a residential context. New rooms that emerge in late-20th-century residences include the media room, exercise room, hobby room, and master suite. Nonresidential interiors in historic or even modern buildings may be Modern Historical depending upon what the client wishes to communicate about the firm or its employees. Banks, clubs, government reception rooms, attorneys' offices, and assisted living facilities, for example, are frequently designed in a period style to convey prestige, status, longevity, or continuity or to appeal to a particular market segment (Fig. 30-19, 30-28, 30-30).

■ *Relationships.* Modern Historical interiors are most likely to occur in period-style public buildings, urban apartments

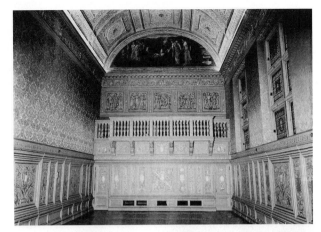

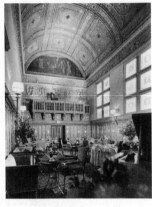

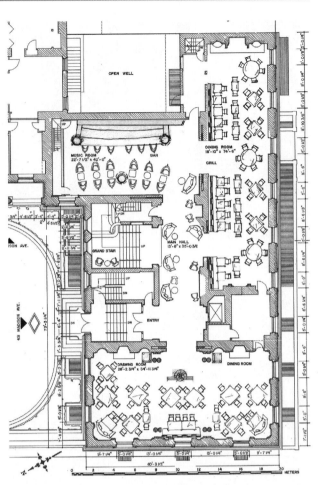

▲ **30-26.** Floor plans of entry, bar, dining room, and grill, Villard Houses, c. 1997; New York City, New York; Adam Tihany. Redecoration.

▲ **30-25.** Music Room (Neo-Renaissance), 1882, Villard Houses; New York City, New York, by McKim, Mead, and White; renovation and redecoration into a lounge, Palace Hotel, c. 1981 by Sarah Tomerlin Lee; redecoration into Le Cirque bar and restaurant, c. 1997 by Adam Tihany. Renovation and Redecoration.

and townhouses, country houses and retreats of the wealthy, and suburban houses. Occasionally, period-style or traditional interiors are in strictly modern buildings.

■ *Color.* Modern Historical rooms display a variety of colors ranging from those that are bright and highly saturated, such as lemon yellow or Chinese red, to rich or dark blues, greens, or browns, to soft pastels thought typical of the Georgian periods. Colors are more often suggestive of period styles than the actual colors of the period, which may be imperfectly understood and identified particularly during the first half of the 20th century. Woods are painted, usually white or a light color or stained in rich warm tones. Suburban interiors frequently display a variety of color schemes dominated by bright and contrasting hues. In the late 20th century, some paint companies begin to offer interior paints in historic color collections from museums, restorations, and historic sites, such as the Colors of Historical Charleston and Mount Vernon Estate of Colours by Duron.

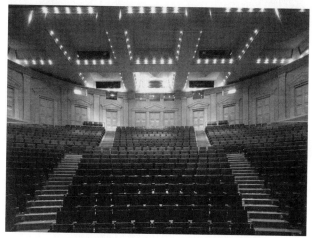

▲ **30-27.** Entry lobby and auditorium, Teatro Nacional de Cataluña, 1997; Barcelona, Spain; Ricardo Bofill. New Classicism.

■ *Lighting.* Light fixtures in Modern Historical rooms include chandeliers, wall sconces, and table lamps, which may be copied or adapted from antiques; antiques that are wired for electricity; or modern designs of period styles (Fig. 30-38). Because modern lighting requirements are very different from those of the past, new types of lighting, controls, and fixtures, such as fluorescent, dimmers, and recessed or hidden light sources, are integrated into Modern Historical rooms. Table and floor lamps come in many different materials, colors, shapes, and sizes to suit any interior, whether closely or loosely based on the past. Historic buildings, such as house museums, and some owners of historic houses strive to maintain a period look in lighting while preserving antiques and textiles and facilitating activities. In the late 20th century, historic sites begin using lower levels of artificial lighting to more closely simulate original conditions.

■ *Floors.* Floors in homes of the affluent and commercial buildings may be wood parquet, stone, terrazzo, ceramic tiles, brick, marble, or carpet. Suburban homes incorporate a variety of flooring materials, including wood, terrazzo, ceramic tile, linoleum, vinyl, and carpet. Different materials visually separate different areas in open plans. Area rugs, which define furniture groupings, include Orientals, needlepoint, Aubussons, Savonneries, and contemporary machine-made rugs in traditional or past patterns (Fig. 30-19, 30-28, 30-32, 30-35). Bedrooms are usually carpeted.

Manufacturers offer reproductions of 19th-century wall-to-wall carpets and area rugs for restorations and period-style rooms. Like the originals, some are woven in the narrower widths of earlier carpets. Reproductions of

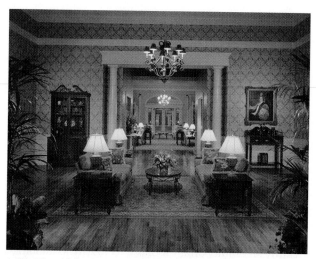

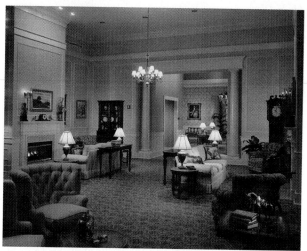

▲ **30-28.** Main entrance and Great Room, Bishop Gadsden Episcopal Community (Assisted Living Facility), 1999; Columbia area, South Carolina; GMK Associates, with interiors by Barbara Summerford and Katharine Kaylor Slayden. Modern Historicism.

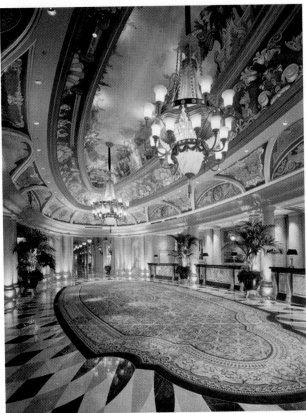

▲ **30-29.** Great Hall and Venezia Lounges, Venetian Hotel, c. 1999–2000s; Las Vegas, Nevada; Venetian by Wimberly, Allison, Tong & Goo, with interiors by Trisha Wilson, Wilson Associates Texas. Modern Historicism.

area rugs are sometimes machine-made instead of hand-knotted.

■ *Walls.* Wall treatments may closely copy period treatments, reflect a period flavor, or become backgrounds that support the furniture and accessories of the space. A diversity of wall treatments characterizes Modern Historical rooms in commercial buildings and homes of the wealthy. Public and important rooms often have architectural

details such as columns or moldings (Fig. 30-17, Fig. 30-19, 30-29, 30-30, 30-37). When present, cornices, chair rails, and baseboards may be stained or painted to match or contrast with wall colors. Paneling is common in houses of the wealthy and in important rooms in commercial buildings, such as executive offices. Rooms in homes of the affluent sometimes have antique paneling imported from Europe. When paneling is not an antique, its design often is simpler

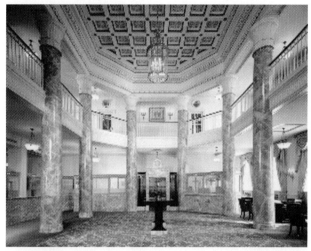

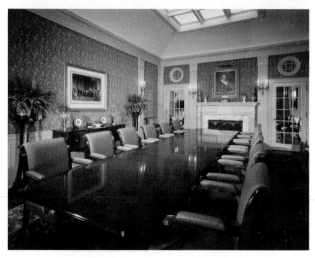

▲ **30-30.** Hall, architectural details, and conference room, Riggs Bank–F & M Office, c. 2000s; Washington, D.C.; JBA Interiors. New Classicism.

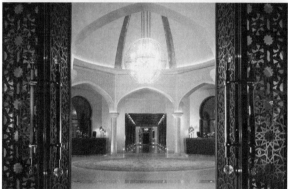

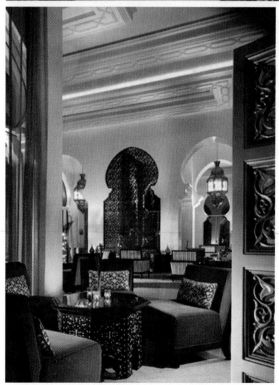

than the prototypes were. Paneling may be painted, pickled, or stained. Sometimes moldings are used to simulate paneling. Built-in bookcases and cabinets with a period look are likely in such spaces as private executive offices and libraries or media rooms in residences.

▲ **30-31.** Terrace, lobby, and lobby lounge, Park Hyatt Hotel, 2004–2005; Dubai, United Arab Emirates; and lobby, Inn of the Anasazi, c. 1996; Santa Fe, New Mexico; by Wilson Associates Singapore and Texas. Regionalism.

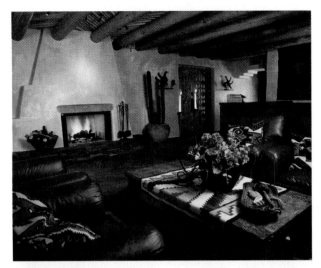

▲ 30-31. (continued)

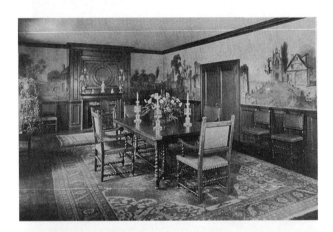

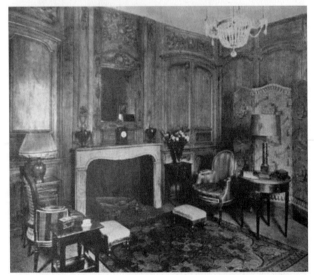

▲ 30-32. Dining Room, Mrs. George B. Hedges, Westbury, Connecticut, from *The Practical Book of Wall Treatments,* 1926, and "Room from a French Manor House in America" from *The Decorator and Furnisher,* 1929; Nancy McClelland. Modern Historicism.

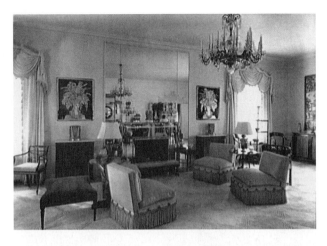

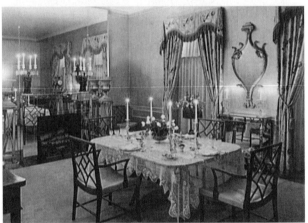

▲ 30-33. Living room and dining room, Mrs. Hugh Mercer Walker residence, 1930s; New York City, New York; Ruby Ross Wood. Modern Historicism.

Most walls are painted, often with shiny finishes, especially when forming a background for artwork. Alternatives are painted decorations, murals, or *faux* finishes such as marbling. Reproductions or adaptations of traditional patterns of wallpaper (Fig. 30-39) frequently cover walls, especially in dining rooms and bedrooms. Reproduction wallpapers are usually machine printed, but some are hand block printed as in the early 19th century. Reproductions also may come in colorways other than those of the original paper. Less common treatments include ceramic tiles, especially in Renaissance or Spanish rooms, tapestries, and stuccowork based upon traditional forms and designs.

In suburban houses, walls may be painted or natural brick, stone, wood panels or planks, plywood veneer, or covered with paint or plastic laminate. Wallpapers with abstract, linear, stylized, and naturalistic patterns also are common. Sometimes contrasting wallpapers are combined within or among rooms to vary the amount and sizes of patterns.

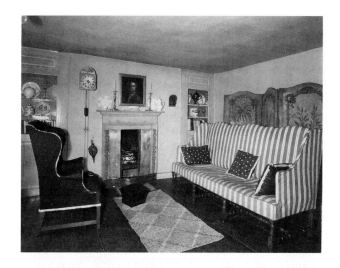

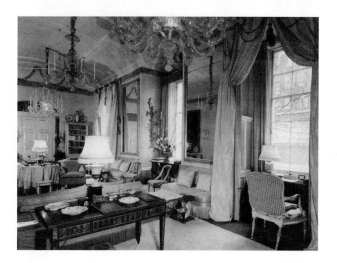

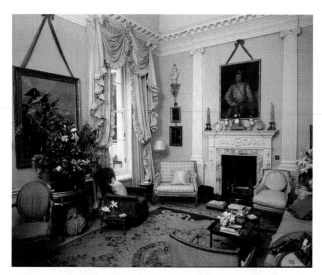

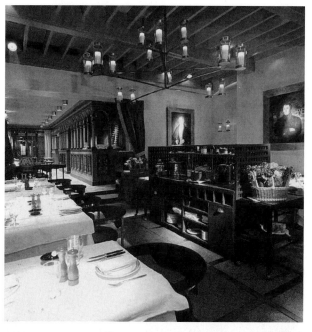

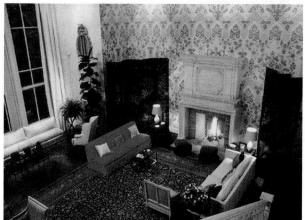

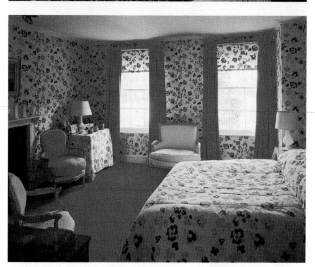

▲ **30-34.** John Fowler's House, Kings Road, 1934; A London Drawing Room, 1960s; and Nancy Lancaster's Yellow Room, Avery Row, 1960; London, England; John Fowler. Modern Historicism.

▲ **30-35.** Bar in The Grange restaurant, *salon* (living area) in Paris, and bedrooms (most interiors showing Hicks textiles and wallcoverings), c. 1960s–1970s; England; David Hicks. Modern Historicism.

▲ **30-35.** *(continued)*

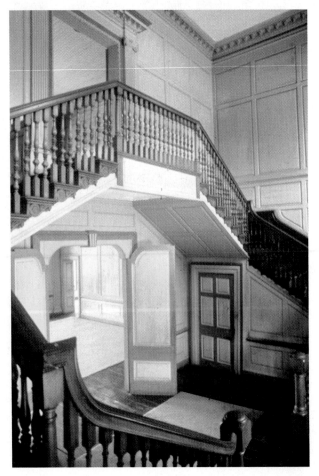

Kitchen wallpapers usually feature designs of fruit, vegetables, dishes, and other objects associated with food or cooking. By the late 20th century, suburbanites more often use reproductions and adaptations of wallpapers and other wall treatments because they are more readily available and affordable.

■ *Windows.* In Modern Historical high-style rooms in public and private buildings, windows often have elaborate moldings surrounding them, whereas other windows have

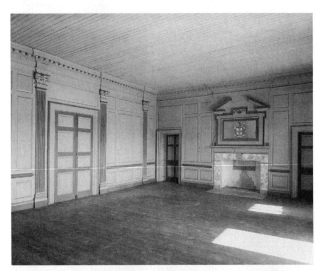

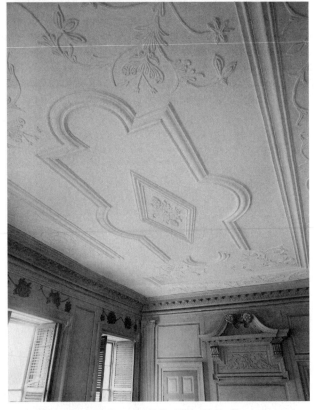

▲ **30-36.** Interiors, Drayton Hall, 1738–1742; Charleston, South Carolina; 1974 preservation work begun by the National Trust for Historic Preservation.

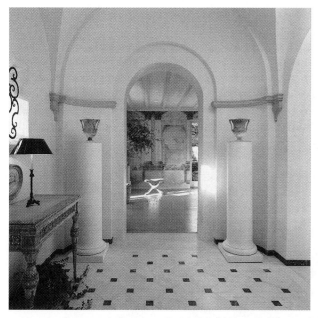
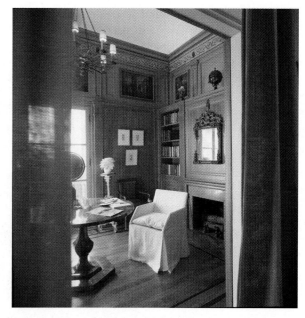

▲ **30–37.** Entrance hall and reading room, residence, c. 1990s; Santa Barbara, California; John Saladino. Modern Historicism.

▲ **30–38.** Lighting: Table lamps, wall brackets, and chandeliers, c. 1940s–2000; United States.

simple surrounds, if any. Window treatments in these rooms sometimes are opulent with a cornice or valance in complicated patterns, under-curtains, and glass curtains with rich trims. However, the most common treatments are floor- and sill-length plain panels that are either pleated or hung from rings (Fig. 30-16). Sill-length pleated curtains or café curtains cover kitchen and bedroom windows in many suburban homes. Traditional houses often have Priscilla curtains. Curtains may be of plain woven fabrics or sheers in white or natural colors, damasks, brocades, silks, or patterned fabrics. Fabrics are reproductions, adaptations, or Modernist designs. Other window treatments include Venetian blinds, shades, interior shutters, and vertical blinds, which are new in the mid-20th century. Windows in restorations may have no window treatments to replicate earlier periods or have curtains copied from

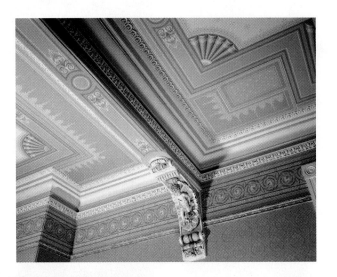

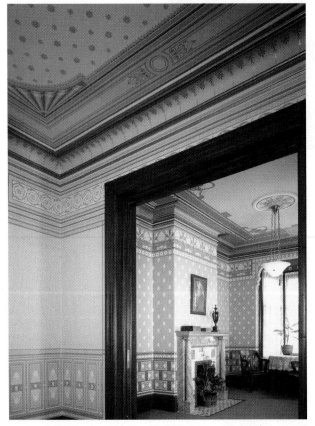

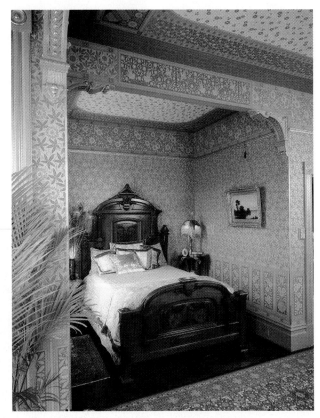

▲ **30-39.** Wallpapers: Various designs with Neoclassical and Victorian influences, c. 1990s–2000s; manufactured Bradbury and Bradbury. Modern Historicism and Reproductions.

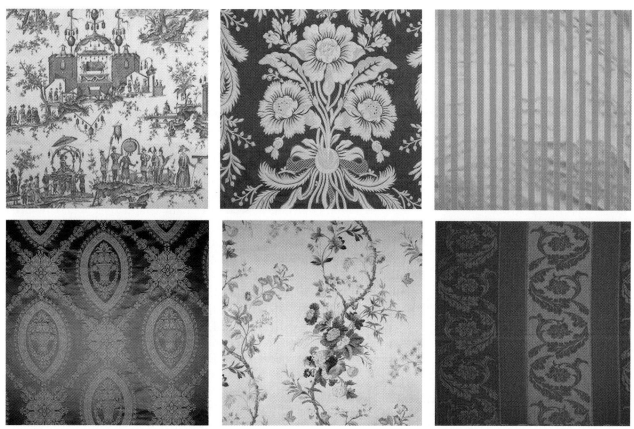

▲ **30-40.** Textiles: Toile de Jouy–Panurge Dan L'Ile Des Lanternes; floral–Readbourne Bouquet; stripe; oval repeat–Rust House; floral–Meissen; and stripe–Isabella Stripe, c. 1970s–2000s; manufactured by Scalamandré. Modern Historicism and Reproductions.

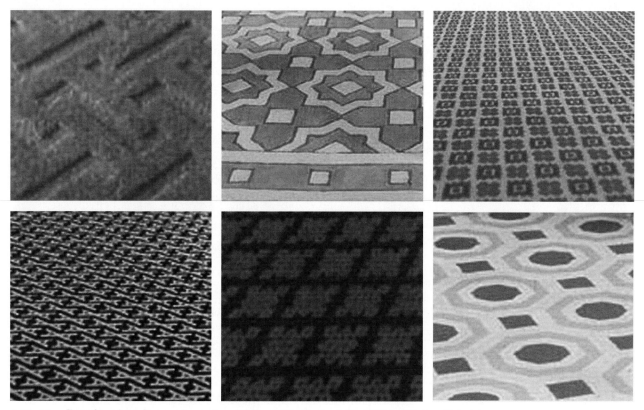

▲ **30-41.** Floor Coverings: Rugs and carpets, c. 1960s–1970s; England; David Hicks. Modern Historicism.

period sources. Occasionally, owners of historic houses re-create period window treatments.

■ *Doors.* Doorways in high-style rooms may have elaborate moldings around the opening, but most are flat, narrow, and simple. Doors are plain or paneled and may be painted or stained. A few high-style rooms have portieres at their doorways.

■ *Textiles.* Textiles may be plain weaves, traditional weaves, such as damasks or brocades, or have traditional patterns such as stripes and florals. Common fibers include silk, cotton, and synthetics. Patterns, usually in fashionable colors, may be abstract, organic, or naturalistic designs of geometric shapes, figures, animals, foliage, and flowers. Throughout the 20th and 21st centuries, textile companies, such as Scalamandré and Schumacher, offer reproductions and adaptations of fabrics from many periods (Fig. 30-40).

■ *Ceilings.* Most ceilings in public and private buildings are plain, flat, and painted white or a light neutral color. Ceilings in important spaces in wealthy homes and public buildings may have coffers, compartments, beams, or painted or stucco decorations (Fig. 30-19, 30-21, 30-22, 30-27, 30-29, 30-30, 30-31). Some living areas or family rooms in suburban homes have ceilings that are painted, stained wood planks, or flat or sloped with or without wooden beams that are left natural wood or painted. A few have skylights.

FURNISHINGS AND DECORATIVE ARTS

Furniture in Modern Historical rooms in public and private buildings may be antiques or period styles of modern manufacture arranged for modern use. In contrast are period rooms in museums, which strive to replicate historic furnishings and arrangements. A piece of furniture may be a loose interpretation, adaptation, reproduction, or new invention of a new period style, such as Italian Provincial. Transitional and eclectic spaces may have only contemporary-style furniture or mix contemporary with antiques or period-style furniture. Some designers, decorators, and architects, such as Dorothy Draper (Fig. 30-53), William Pahlmann, Trisha Wilson, and Barbara Barry (Fig. 30-45), design custom furniture for their projects or individual pieces and/or complete lines, sometimes in a period flavor, for manufacturers.

■ *Period Styles.* Common period furniture styles include the French styles such as Rococo, Neoclassical, Empire, and French Provincial; English Georgian styles such as Chippendale, Sheraton, and English Regency; American Colonial, Federal, and Empire; and Victorian Rococo Revival, as well as interpretative expressions such as Mediterranean and Early American. Period styles may define pieces unknown in the precursor period, such as computer desks, file cabinets, television cabinets (Fig. 30-52), coffee tables, and tea carts.

▲ **30-42.** Dining room and bedroom furniture, c. 1930s–1940s; United States; T. Robsjohn-Gibbings, manufactured by Widdicomb. Modern Historicism.

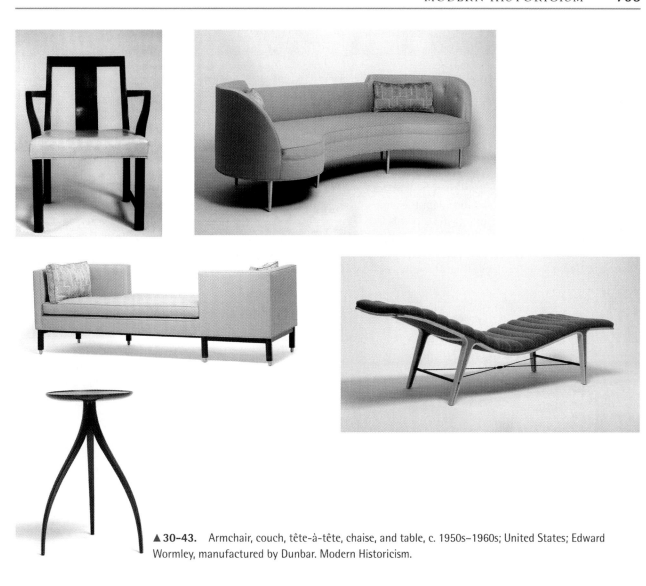

▲ **30–43.** Armchair, couch, tête-à-tête, chaise, and table, c. 1950s–1960s; United States; Edward Wormley, manufactured by Dunbar. Modern Historicism.

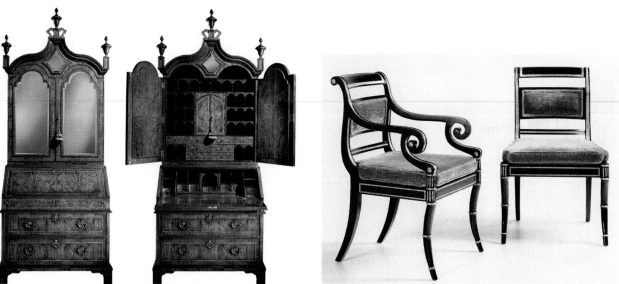

▲ **30–44.** Queen Anne bureau cabinet, 1705, England; and Regency chairs, c. 1810, England; The Stately Homes Collection, c. 1981; United States; Baker Furniture. Reproductions.

DESIGN SPOTLIGHT

Furniture: Oval X-back Chair, The Barbara Barry Collection; Brighton Arm Chair, The Milling Road Collection; and Victorian loveseat, c. 1980s, The Stately Home Collection; United States; Baker Furniture. Modern Historicism. These pieces show a range of Modern Historical furniture expressions from the fairly close adaptation of the Brighton chair to the very contemporary version of an 18th-century chair by Barbara Barry. All simplify and refine details and adapt the scale of the originals to better suit modern tastes and interiors. The Oval X-Back chair by Barbara Barry is based on an 18th-century chair type of the Neoclassical period in France or Late Georgian in England. The silhouette, oval back, legs, and arms follow the lines of the original but are greatly simplified to enhance the contemporary look. The designer's signature X shape inside the oval wooden back frame adds an interesting detail. The Brighton chair closely adapts elements of Chinese bamboo and rattan furniture introduced by George, Prince of Wales, at the Royal Pavilion in Brighton, England, in the early 19th century. Made in rattan like the originals, the chair features the oval horseshoe back common in Chinese furniture. The Victorian sofa, designed after an 1845 English loveseat, retains the Victorian details of deep tufting, curving back, and scrolled arms within a contemporary context.

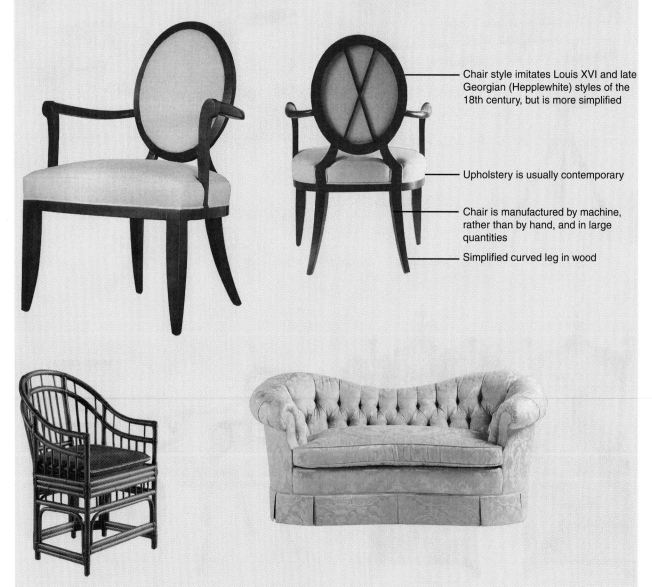

Chair style imitates Louis XVI and late Georgian (Hepplewhite) styles of the 18th century, but is more simplified

Upholstery is usually contemporary

Chair is manufactured by machine, rather than by hand, and in large quantities

Simplified curved leg in wood

▲ **30-45.** Oval X-back Chair, Brighton Arm Chair, and Victorian loveseat.

■ *Reproductions. Reproductions*, a term that was imprecisely defined in the first half of the 20th century, now are considered furniture, textiles, finishes, and decorative arts that copy an historical object or document as exactly as possible in scale, form, and details using modern production methods (Fig. 30-44, 30-50). For example, a chair may accurately copy a handmade antique, but be, at least partially, machine-made. And original hand-blocked textiles and wallpapers usually are screen printed today.

■ *Furniture Manufacturers*. During the mid-20th century, American museums, such as Winterthur in Delaware and Colonial Williamsburg in Virginia, and preservation organizations, such as the Historic Charleston Foundation, license manufacturers such as Kindel (Fig. 30-53), Stickley (Fig. 30-50), and Baker (Fig. 30-44, 30–45), to produce adaptations and reproductions of furniture, textiles, wallpapers, and paint from their collections. Numerous companies produce adaptations, and some take great liberties with period designs or invent new period styles such as Mediterranean, which is vaguely Spanish in dark wood with carving and/or wrought iron.

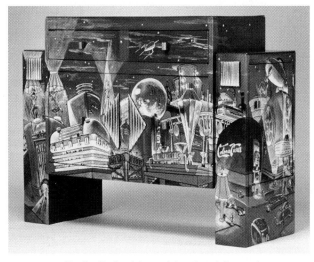

▲ **30-46.** "Radio City" cabinet with painted decoration, 1994; Virginia; Rob Womack. Modern Historicism.

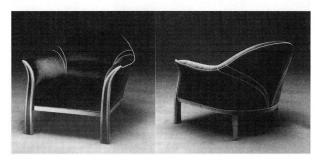

▲ **30-47.** Armchair, c. 1990s; New York; Adam Tihany. Modern Historicism.

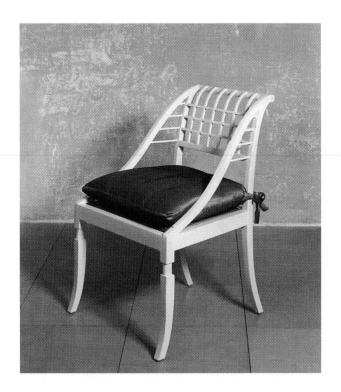

▲ **30-48.** Sleigh chair and Balustrade table, c. 2000; New York; John Saladino. Modern Historicism.

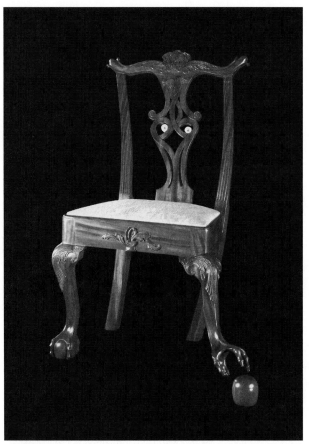

▲ **30-49.** "Oops" (Chippendale-style chair), 2001; United States; Jacob Cress. Modern Historicism.

■ *Contemporary Period Interpretations.* Beginning in the late 20th century, various artists and designers mix contemporary and period influences in furnishings to create new interpretations of Modern Historical concepts, which are distinctly different from the norm and reflect new design ideas. For example, artists and furniture designers create "furniture as art," which often includes unusual pieces made for personal expression, exhibition, sale, or display design. These pieces, which may deemphasize functional requirements, show numerous artistic variations such as furniture accented with elaborate painted decoration (Fig. 30-46) or period furniture forms developed in unique, creative ways (Fig. 30-49, 30-54). Sometimes the examples are nonsensical and primarily created for artistic enjoyment. In contrast, architects and interior designers often follow a more practical approach because they are designing for manufacturers or specific interiors with specific purposes or to create a specific character. As a result, their creations frequently illustrate abstracted period shapes and forms mixed with contemporary color and/or materials defined by specific functional requirements. Often these furnishings are for use in commercial spaces such as hotels (Fig. 30-47, 30-51), offices, and shops. Designers follow this approach, particularly when they are working in a regional or ethnic character or are presenting a themed environment.

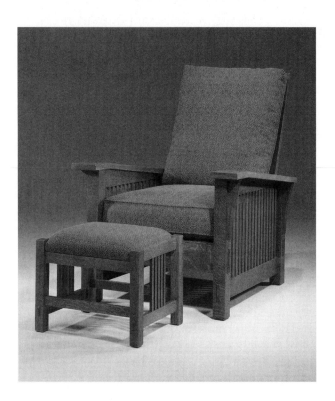

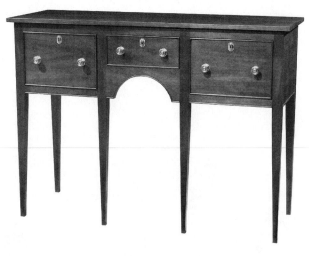

▲ **30-50.** Spindle Morris Chair, early 20th century, The Mission Collection; and Piedmont sideboard, late 18th century, The Williamsburg Reserve Collection; c. 2000s; United States; by L. & J. G. Stickley Furniture. Reproductions.

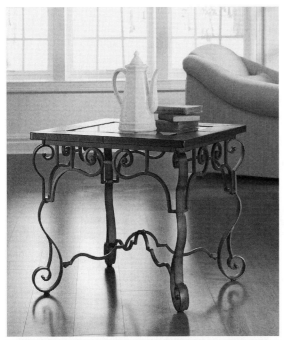

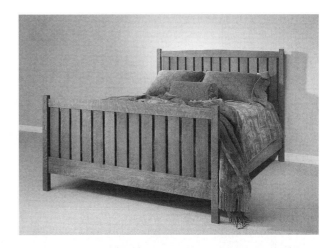

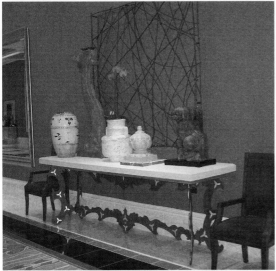

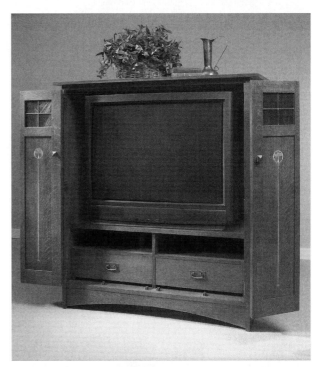

▲ **30-52.** Slat queen bed and entertainment unit, late 20th century; The Mission Collection; c. 2000s; L. & J. G. Stickley Furniture. Modern Historicism.

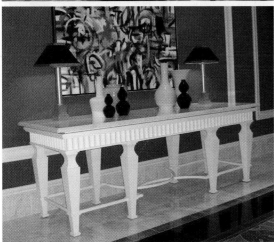

▲ **30-51.** Tables, Thomasville Furniture and Wynn Hotel, Las Vegas, c. 2000s; United States. Modern Historicism.

■ *Materials.* Modern Historical furniture usually is of wood, such as cherry, walnut, maple, or pine, that may be stained, painted, or lacquered. High-style furniture may have veneer patterns, inlay, or marquetry decoration. In less expensive pieces, details and parts may be of plastic finished to resemble wood. A few entire pieces, such as beds, or parts of pieces, such as table bases or legs, are of metal. Decorators and homeowners sometimes strip the finishes of antique furniture to pickle or repaint it, remove, add, or combine portions, or otherwise change the appearance to suit interior concepts.

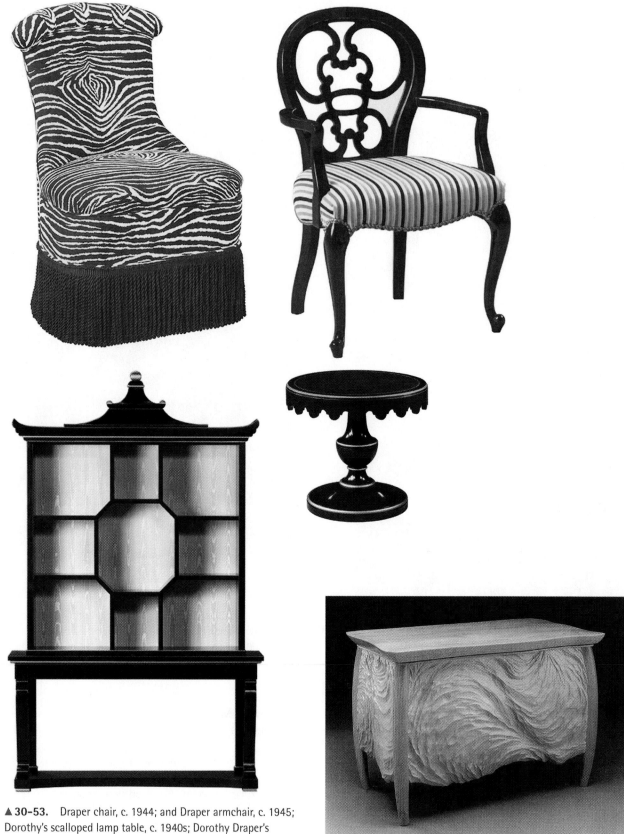

▲ **30–53.** Draper chair, c. 1944; and Draper armchair, c. 1945; Dorothy's scalloped lamp table, c. 1940s; Dorothy Draper's console and curio, c. 1945; The Dorothy Draper Collection for Varney and Sons, c. 2004; Kindel Furniture. Reproductions and Adaptations.

▲ **30–54.** Bombe cabinet, c. 2004; Maine; SB Studios, by J. M. Syron and Bonnie Bishoff. Modern Historicism.

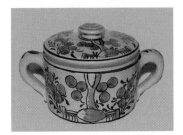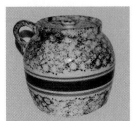

▲ **30-55.** Decorative Arts: "Colonial Times" salad plates, c. 1930s, Crown Ducal, Great Britain; and adaptations of tin-glazed earthenware and spatterware, c. 1980s; American.

■ *Decorative Arts.* Modern Historical interiors display numerous decorative period accessories including paintings and prints, clocks, screens, mirrors (Fig. 30-55), wall shelves and brackets, ceramics, glass, and metalware. Accessories may be antiques, reproductions, or modern pieces in traditional or modern styles. Plants and flowers are an integral part of many rooms. Decorators, designers, and homeowners use accessories to support the room's concept; make a statement about the clients, owners, or themselves; or personalize a space.

1959	Xerox makes its first copier
1960	Aircraft builder Boeing coins term "computer graphics"
	Frederico Fellini lives *La Dolce Vita*
	National Historic Landmarks sponsored
	by the National Parks Service
	Lasers begin to focus
1961	Barbie dates Ken, dumps him in 2004, reunites in 2006
1962	Aldo Novarese designs *Microgramma* typeface
	Peter O'Toole in *Lawrence of Arabia*
	First Wal-Mart opens in Arkansas
	The Beatles first single, "Love Me Do"
	Seattle World's Fair raises the Space Needle
	Telstar, the first communication satellite
	Andy Warhol brings Campbell Soup to the galleries
1963	President John F. Kennedy assassinated
1964	The Vietnam War begins
	Computers and the fax machine introduced at the New York World's Fair
1965	IBM develops word processing
	Saarinen's St. Louis Gateway Arch opens
	Television is broadcast by U.S. satellite
1966	National Historic Preservation Act enacted
	Plastic bags on a roll for grocery shopping
1967	Victor Papanek, *Design for the Real World*
	The Graduate is told to get into plastics
	The Big Mac debuts
1968	U.S. Fair Housing Act enacted
	Martin Luther King assassinated
1969	Neil Armstrong lands on the moon
	Woodstock is the first major counter-culture festival
	Sesame Street starts to have fun
	Aluminum foil and Teflon head for the kitchen
1970	EXPO 70 in Osaka, Japan, wows
	U.S. begins Environmental Protection Agency
1971	First micro (PC) computers available
1972	Robert Venturi, and friends, *Learning from Las Vegas*
1973	Endangered Species Act enacted in the U.S.
	Cell phones start to call
	The U.S. loses the Vietnam War
1974	World population estimated at 4 billion
1976	U.S. Bicentennial promotes preservation
1979	Philip Johnson awarded Pritzker Prize in Architecture
	Sony introduces the first Walkman
	William Pahlman becomes the first ASID
	Designer of Distinction
	This Old House starts to build PBS
1981	First Memphis exhibition in Milan a hit
	Maya Lin designs the Vietnam Veterans Memorial
1982	*Blade Runner* gives a view into a future
1983	I. M. Pei awarded Pritzker Prize in Architecture
1984	Apple Computer introduces the Macintosh
1986	Lloyd's Building by Richard Rogers a hit
	Interior Design Hall of Fame begins
	Chernobyl nuclear power plant melts down
1989	Frank Gehry awarded Pritzker Prize in Architecture
	Tim Berner-Lee creates the World Wide Web
1990	First Earth Day celebrated around the world
1993	U.S. Green Building Council established
1997	Dolly the sheep is cloned in Scotland
	The Pathfinder robot broadcasts from Mars
2000	LEED Green Buildings number grows
2002	HGTV reaches 86 million homes

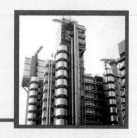

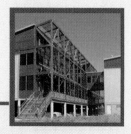

H. EXPERIMENTATION

Soon after the mid-20th century, architects and designers begin to question and critique the Modern Movement as defined by the International Style. The masters of Modern, such as Mies van der Rohe and Charles Eames, are gone, and this new generation of designers does not see itself as inheriting Modernism. Maintaining the Modern Movement's design goals and language as defined and practiced by the masters is no longer as important as it once was. Additionally, new technologies, consumerism, and a global community demand new and different approaches to design and even a new design language to express changing contemporary times.

One result of this critique is the plurality of design approaches that arises. No longer is there a single design vision, although the notion of modern as forward thinking and promising a new and bright future remains. How to achieve a modern design language and form that expresses its time is open to question, experimentation, and debate. Architects and designers have a greater freedom of choice in how to express their times. No longer is one form of modern preeminent. Some even work outside of modern.

Within the context of a global community united and driven by new technology, architecture, interior design, and furniture designs become even more market driven. Niche markets, image, and branding are important concepts that designers cannot ignore. Previously, the Modern Movement had not addressed consumerism, but in the 1980s, many designers turn their attention to creating a variety of mass-produced objects. The notion of the designer as celebrity arises. Architects, interior designers, and others create products such as furniture, decorative arts, sheets, towels, carpets, and rugs. Their names, ideas, and concepts become marketable and recognizable. Previously, architects' and designers' ideas were often ahead of technology, but with new materials, structural techniques, environmental controls, and design tools, they now create what their imaginations can identify. Also driving design are important issues, such as increased regulation, building codes, research and development, and environmental concerns that give impetus to and provide new ways of doing things.

Late Modern, from the mid-1960s to the 2000s, maintains many of the design goals and language of the International Style but expands and/or exaggerates them to express the complexity and rapidly changing nature of the times. Several different approaches within the Late Modern development arise. Beginning in the 1970s, High Tech buildings, interiors, and furniture embrace and celebrate technology with complexity and industrial materials and finishes. Pop Modern of the 1960s pursues consumerism and the youth market, especially in interiors and furniture, often in brightly colored plastic. In contrast is Minimalism, which rejects the acquisitive side of consumerism. Architecture, interiors, and furniture are plain and simple with pure forms, few details, and little color but often with rich textural contrasts.

Beginning in the late 1970s, Post-Modern architects and designers address the lack of context and communication of the International Style through plurality of approach, which may include historicism, complexity, wit, whimsy, and classicism. Designs attempt to communicate to the common person as well as the design elite. Many Post-Modern designers create mass-produced objects as part of that effort. Contemporary with Post-Modern is Memphis, an Italian avant-garde style in interiors and furniture. Memphis confronts traditional notions of design with odd shapes and forms, high-style and common materials, and strong colors and patterns.

Environmental Modern develops from the larger movement that strives to maintain the earth and its resources. Beginning in the late 1970s, architecture, interiors, and furniture respond to the environment with an evolving design process that includes energy conservation, waste management and recycling, land use, climate, and wise stewardship of resources. Also called green design or sustainable design, expressions may show little evidence of these concepts or may show a strong contextual relationship to site and location.

In the 1980s, Neo-Modern architects and designers create innovative, unique, and individual buildings, interiors, and furniture that would not be possible without the new technology. Designs, which greatly challenge previous ideas of Modernism, are complex with expressive form, curves and oblique angles, and unusual juxtapositions. This group of designers often disregards context and communication except within their own circle.

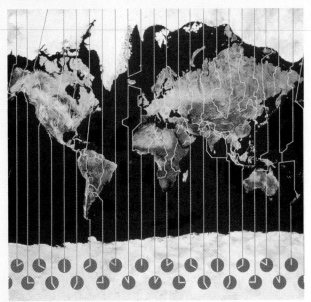

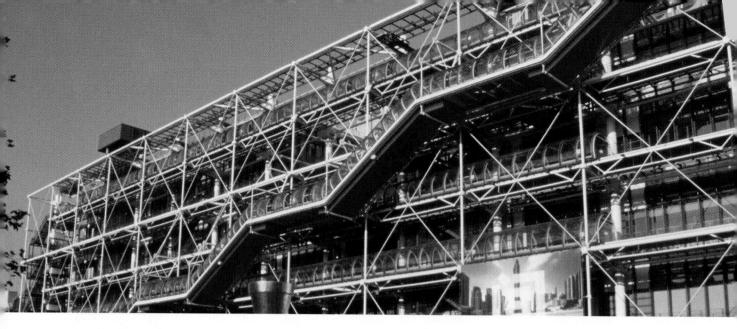

Late Modern • 1

Mid-1960s–Mid-1980s

Late-Modern architecture, "singly coded," takes the ideas and forms of the Modern Movement to an extreme, exaggerating the structure and technological image of the building in its attempt to provide amusement, or aesthetic pleasure.

Charles Jencks,
Late-Modern Architecture, 1980

When a society needs buildings that are capable of responding to changing requirements, then, I believe, we must seek to provide flexibility and search for new forms that express the power of change. . . . Inflexible buildings hinder the evolution of society by inhibiting new ideas.

Richard Rogers,
Cities for a Small Planet, 1995

It's truly amazing the number of decisive events and critical dialogues that occur when people are out of their seated, stuffy contexts, and moving around chatting with one another.—The Action Office was supposed to be invisible and embellished with identity and communication artifacts and whatever you needed to create individuation. . . . We wanted this to be a vehicle to carry other expressions of identity.

Robert Probst, "The Man Behind the
Cubicle," *Metropolis*, November 1998

During the 1960s, a new generation of architects and designers reevaluates the value of Modernism and the International Style. Finding them lacking applicability to their times, the designers adopt new approaches that address the complexity, revolutionary changes, plurality, and rampant consumerism of their time. Some expand or exaggerate the language of the International Style. Others turn to Minimalism, a pared-down purist application, while others embrace and celebrate technology. Still others embrace consumerism and the youth or popular culture in Pop Modern.

HISTORICAL AND SOCIAL

Revolution defines the 1960s and 1970s. Immense social and political transformations in North America and Europe, to which design responds, occur as an outgrowth of the overall questioning and challenging of tradition during the period. Various social and political movements arise or resurface. Particularly significant is the youth movement in which young people strive to change the world. Questioning nearly everything, they reject the traditional values and culture of their parents, what they call the Establishment, in favor of their own ideas. Rejecting the existing political processes to effect change, they demonstrate, protest, and picket. They, along with the Civil Rights, Feminist, and the Environmental Movements,

bring significant and long-lasting social and political changes.

By the mid-1960s, increased industrial production, new technologies, and booming economies are creating a more complex and pluralistic world. Consumerism and the emerging global economy become more important. The media, particularly television, rapidly disseminates new ideas, products, trends, and fashions. In doing so, it plays a significant role in defining consumer choices in working, living, dressing, leisure, and entertainment. The huge youth market of the postwar baby boom generation starts to drive production and consumerism. Growing up with plenty, this new generation is unacquainted with the austerity and hardship of the Great Depression and the shortages and sacrifices of World War II. Consummate consumers, they favor contemporary fashions, nontraditional manners of living, the inexpensive and the disposable, television, and rock-and-roll music. London, with its hip and trendy boutiques and restaurants, especially on Carnaby Street, becomes the center for the youth culture and the marketing of design. Design leadership passes to Britain and Italy, especially for furniture.

During the 1970s, as numerous factors erode American confidence, significant change becomes evident in American culture. The Vietnam War conflict divides the nation more than ever as protests and demonstrations against American involvement mount. Intensification of the conflict and more social programs raise inflation and interest rates, which signal a weakening of the earlier widespread prosperity. Wage and price controls do not stem the economic decline. For the first time since the 19th century, a trade deficit indicates declining industry. In the early 1970s, the Arab oil embargo sharply increases oil prices, creating a gasoline shortage and energy crisis. At the same time, more immigration creates greater diversity, which tends to undermine national unity. With the breakdown of the traditional social system, increased drug use, swelling welfare rolls, and rising crime rates plague the country.

Within the atmosphere of activism and revolution, a new generation of designers begins to question the effectiveness of the International Style. Although being modern and up-to-date is important throughout the period, their definition and appearance changes as questions about what it now means to be modern arise. Designers reassess and challenge previous design movements while embracing, rejecting, or reinterpreting their own world. They move away from strict adherence to the vocabulary of the International Style toward a multiplicity of design methods, approaches, and languages.

During the late 1950s and early 1960s, critiques of the International Style and Modernism arise from inside and outside the design community as designers and others begin to recognize their limitations and question their principles and practices. They see that although the International Style claims to offer universal solutions to architectural problems, in reality it gives similar design solutions to a variety of functions and needs often at the expense of users. Particularly criticized is the style's anonymity, which results from a limited architectural vocabulary that adopts few, if any, ties with location, the past, or culture. Additionally, creative designers handle a limited vocabulary well, but less inventive ones simply repeat the elements with little originality, and these dominate the expression. Thus, large, modern, standardized buildings, produced in assembly-line fashion, repeat the International-Style language of buildings such as the Seagram Building in an effort to maintain a purist vocabulary without fully expressing their intended function. Housing units look like office buildings, art galleries appear to be warehouses or hospitals, and collegiate structures resemble factories. Furthermore, they are in direct contrast to what the public wants, leading to a conflict between designers and users.

Designers also recognize that modern buildings are plagued with numerous design and construction problems arising from the modernist emphasis upon anonymity and the assumption that all users have the same needs. They also question innovations that do not develop from programmatic or user needs. Although technically workable, large expanses of unprotected glass, leaks, air-conditioning difficulties, and a lack of integration of the exterior and interior characterize many buildings. As a response, designers begin to look for new methods that strive to meet human needs and develop from diversity, complexity, and context rather than universal concepts, solutions, and sameness.

All of the International Style's faults seem to come together in 1972 in the failures of two buildings. A technological failure is the John Hancock Center in Boston by the office of I. M. Pei. Intended as a tall glass tower, the windows begin to fail and fall out even before construction is completed. The building stands empty for several years until a solution is found. The second and even more significant design failure is the Pruitt-Igoe Housing complex in St. Louis by George Hellmuth and Minoru Yamasaki completed in 1956. Composed of a series of plain modern 14-story boxes, they are devoid of any architectural personality or sense of place, creating a hostile, sterile environment. Hellmuth and Yamasaki make few efforts to address the needs of the inhabitants through the building character, planning, scale, safety, sunlight, or green space. As a result, the residents rebel by constantly vandalizing and mutilating the structure. Ultimately, the city demolishes the complex in 1972, a signal of the end of Modernism's dominance and the beginning of new design directions and movements that celebrate diversity, communication, and complexity.

CONCEPTS

Shattering the unity of Modernism, as evident in the International Style, is the multiplicity of approaches that surface as architects (Fig. 31-1) and designers challenge, reassess, and reinvent its principles and practices. They seek a contemporary expression that addresses the complexity, diversity, and plurality of their time. Underlying this development are the importance of individuality and rejection of static, uptight formalism. Equally important are customization, identity, and design for the individual. Choices expand, so the design revolution is not a single movement, and neither do architects and designers share a unified viewpoint.

■ *High Tech.* Some designers celebrate technology and early Modern's notion of a building as a machine. The resulting High Tech mode, which combines high style and technology, explores and articulates the relationship of industry, technology, and art. Buildings, interiors, and

◀ **31-1.** Richard Meier.

furniture are creations and expressions of industrial concepts and products. During the 1970s, High Tech is especially fashionable for the home and office.

■ *Minimalism.* Other designers reject rampant consumerism in favor of Minimalism following in the tradition of William Morris's reductivism, Adolf Loos's elimination of ornament, and Mies's idiom of less is more. The term *Minimalism,* first applied to visual art and music, refers to work stripped to its fundamentals. Using the newest technologies, Minimalist designers simplify and eliminate everything they consider nonessential. Closely tied to Minimalism is a resurgence of rationalism. Especially important in Europe, adherents advocate typologies and explore pure form as an expression of beauty.

■ *Pop Modern.* During the late 1950s, Pop Art arises in England and North America as a reaction to the solemnity and intellectualism of avant-garde art movements, such as abstract expressionism. Pop artists transform low art into high art and unite elitist and mass culture. Accordingly, offerings are characterized by images of everyday or popular culture, such as comic books, advertisements, and soup cans; modern materials such as plastic and acrylic paint; and mass-production techniques, such as Andy Warhol's multiple silkscreen images. Pop art affects fashion, graphic design, furniture, and interiors. Also developing in the 1960s is Op Art (Optical Art), a painting movement exploiting optical illusions. Through geometric patterns in black, white, and bright colors, artists create visual effects such as movement, vibrations, confusion of foreground and background, and manipulate the viewer's perceptions. Op Art affects furniture and interiors, but its greatest influence occurs in fashion, graphic design, wallpapers, and textiles.

IMPORTANT TREATISES

■ *The Death and Life of Great American Cities,* 1961; Jane Jacobs.

■ *The Failure of Modern Architecture,* 1970; Brent Brolin.

■ *From Bauhaus to Our House,* 1981; Tom Wolfe.

■ *Form Follows Fiasco: Why Modern Architecture Hasn't Worked,* 1977; Peter Blake.

■ *A Guide to Business Principles and Practices for Interior Design,* 1968; Harry Siegel.

■ *High Tech: The Industrial Style and Sourcebook for the Home,* 1978; Suzanne Slesin and Joan Kron.

■ *Late-Modern Architecture,* 1980; Charles Jencks.

■ *The Office: A Facility Based on Change,* 1968; Robert Probst.

■ *Twentieth Century Architecture: A Visual History,* 1990; Dennis Sharp.

Other Works: Monographs and books on individual architects and designers.

Periodicals and Journals: *Architectural Record, Progressive Architecture, Interior Design, Journal of Interior Design Education and Research, Journal of the Society of Architectural Historians.*

DESIGN CHARACTERISTICS

Architecture, interiors, and furniture reveal a variety of expressions with an expanded vocabulary. Function, efficiency, and practicality no longer solely define concepts, so designs are often innovative, individualistic,

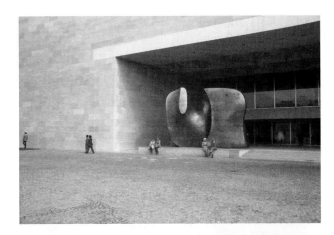

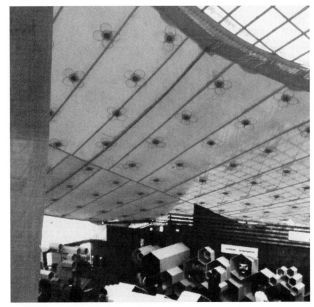

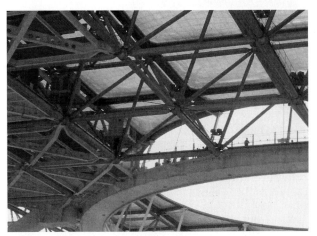

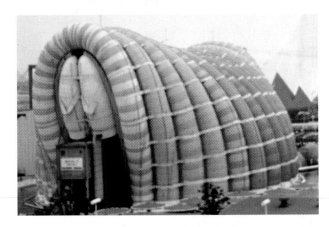

▲ **31-2.** Architectural details, 1970s–1980s; United States, Canada, and Japan.

monumental, and stand out within their environments. As before, designers continue to use new materials and techniques, prefabrication, and mass production. Characteristics are exaggerated and defined by exposed structure, radical articulation of form, and an impression of stretched skin (Fig. 31-2). Compositions may display extreme and complex technology and a high-tech image. The expression of joints and construction dominates other features, and function and service areas become important design elements. Designs are often anti-historical,

with no displays of a base in architecture, and no moldings or transitions of structure in architecture, interiors, and furniture.

■ *High Tech.* The facades display the building components and elements of systems, which articulate and ornament the structure. These details may be on corners, but can be distributed across the surface. Large open interiors also display building components and systems, often brightly colored to highlight them. Industrial and/or prefabricated

materials and furnishings, color coding, and the bright colors of industrial machinery are typical.

■ *Minimalism*. In a purist approach, structure and construction become ornament characterized by clean form, extreme simplicity, repetition, and articulation. Colors, textures, materials, and details are reduced to essentials in architecture, interiors, and furniture.

■ *Pop Modern*. While reflecting many of these characteristics, Pop Modern interiors and furniture are youthful and hip, exciting, novel, colorful, and nontraditional with an emphasis on appealing to the masses. New materials such as plastics, shiny finishes, and bold patterns create dramatic effects. Colors may be bright or subdued, and patterns range from hard-edged and geometric to the visual effects of Op Art.

■ *Motifs*. There are no specific motifs common to the period. Individual designers use details from projects to emphasize innovative structure, construction, and materials (Fig. 31-2). Pop Modern motifs include elements of popular culture, words or letter forms, human anatomy, rockets, pods, and geometric forms.

ARCHITECTURE

A new generation of architects forges diverse approaches that create compositions with unique and individual expressions. Architects, developers, and clients alike recognize the importance of identity for corporate headquarters, office buildings, and retail stores. Experimentation with the overall visual form is common and important because the building often sits as a monument (to consumerism or capitalism) within its environment.

In the most common new approach, the overall box form of early Modernist buildings disappears through the use of curves, angles, indentations, stepped forms, pitched

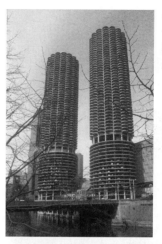

◀ **31-4.** Marina City, 1964–1965; Chicago, Illinois; Bertrand Goldberg and Associates.

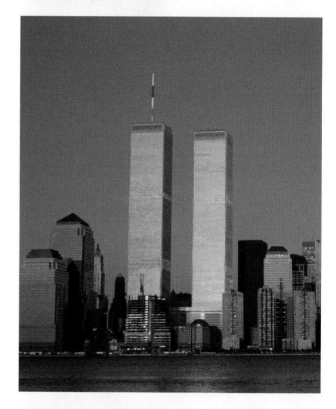

▲ **31-3.** Retti Candle Shop and Schulin Jewelry Shop, 1965, 1972–1974; Vienna, Austria; Hans Hollein.

▲ **31-5.** World Trade Center, 1962–1967; New York City, New York; Minoru Yamasaki.

◀**31-6.** Shizuoka Press Office, 1967; Tokyo, Japan; Kenzo Tange.

▲**31-7.** John Hancock Center, 1967–1970; Chicago, Illinois; Bruce Graham and Skidmore, Owings, and Merrill.

▲**31-8.** Hyatt Regency Hotel, 1967–1972, and Bonaventure Hotel, 1974–1976; Atlanta, Georgia, and Los Angeles, California; John Portman and Associates.

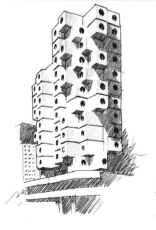

◀**31-9.** Nakagin Capsule Tower, 1971–1972; Tokyo, Japan; Kisho Kurokawa.

roofs, and exposed structure, although the elements and design language remain largely the same (Fig. 31-4, 31-12, 31-13, 31-14). Cutouts in the building become common, and designers continue to place a strong emphasis upon solid and void relationships to highlight the building form (Fig. 31-3, 31-16, 31-17). Although many façades follow a grid concept, the grid may be logical or irrational or both within a packaged expression of harmony. Buildings have

IMPORTANT BUILDINGS AND INTERIORS

- **Atlanta, Georgia:**
 - High Museum of Art, 1980–1983; Richard Meier.
 - Hyatt Regency Hotel, 1967–1968; John Portman.
- **Boston, Massachusetts:**
 - John F. Kennedy Library, 1964–1979; I. M. Pei.
- **Cancun, Mexico:**
 - Hotel Camino Real, 1973–1975; Ricardo Legorreta.
- **Chicago, Illinois:**
 - John Hancock Center, 1967–1970; Bruce Graham and Skidmore, Owings, and Merrill.
 - Hyatt Regency Hotel, Airport, 1971; John Portman and Associates.
 - Marina City, 1964–1965; Bertrand Goldberg and Associates.
 - Sears Tower, 1974; Skidmore, Owings, and Merrill.
 - Xerox Center, 1977–1980; Helmut Jahn.
- **Dallas, Texas:**
 - Dallas City Hall, 1966–1978; I. M. Pei.
 - Hyatt Regency Hotel, 1976–1979; Welton Beckett Associates.
- **Darien, Connecticut:**
 - Smith House, 1965–1967; Richard Meier.
- **Des Moines, Iowa:**
 - Des Moines Art Center Addition, 1982–1985; Richard Meier.
- **Fort Worth, Texas:**
 - Hotel Americana, 1979; interiors by Benjamin Baldwin.
- **Garden Grove, California:**
 - Garden Grove Community Church (Crystal Cathedral), 1977–1980; Philip Johnson and John Burgee.
- **Harbor Springs, Michigan:**
 - Douglas House, 1971–1973; Richard Meier.
- **Haslemere, England:**
 - Olivetti Training Centre, 1969–1972; James Stirling.
- **Houston, Texas:**
 - Pennzoil Place, 1974–1976; Philip Johnson and John Burgee.
- **Jeddah, Saudi Arabia:**
 - National Commercial Bank Headquarters, 1981–1983; Gordon Bunshaft at Skidmore, Owings, and Merrill.
- **Leicester, England:**
 - Leicester University Engineering Building, 1964; James Stirling with James Gowan.
- **Littleton area, Colorado:**
 - Johns-Manville Headquarters, 1973–1976, The Architects Collaborative.
- **London, Hampstead, England:**
 - Michael Hopkins House, 1975; Michael Hopkins.
- **Los Angeles, California:**
 - Bonaventure Hotel, 1974–1976; John Portman and Associates.
 - Pacific Design Center, Blue building, 1975–1976, by Victor Gruen Associates; and Green building, 1988, by Cesar Pelli & Associates.
- **Miami, Florida:**
 - The Atlantis Condominum, 1980–1982; Arquitectónica.
- **Minneapolis, Minnesota:**
 - Federal Reserve Bank of Minneapolis, 1973; Gunnar Birkerts and Associates.
 - IDS Center, 1972–1975; Philip Johnson and John Burgee.
- **New Harmony, Indiana:**
 - The Atheneum, 1975–1979; Richard Meier.
- **New Haven, Connecticut:**
 - Laboratory Tower, Yale University, 1964–1966; Philip Johnson and Richard Foster.
 - Headquarters of the Knights of Columbus, 1965–1969; Kevin Roche & John Dinkleloo and Associates.
- **New York City, New York:**
 - Citicorp Office Building, 1976–1978; Hugh Stubbins and Associates.
 - Jacob K. Javits Convention Center, 1979–1986; I. M. Pei.
 - L. J. Glickman Offices, 1961; Ward Bennett.
 - Morgan's Hotel interiors, 1985; Andrée Putman.
 - World Trade Center, 1962–1967; Minoru Yamasaki.
 - Windows on the World Restaurant, World Trade Center, 1976; Warren Platner.
- **Norwich, England:**
 - Sainsbury Centre for the Visual Arts, University of East Anglia, 1974–1978; Norman Foster.
- **Osaka, Japan:**
 - Sony Tower, 1976; Kisho Kurokawa.
 - EXPO 70, 1970; many designers.

IMPORTANT BUILDINGS AND INTERIORS

- **Paris, France:**
 - Pompidou Centre, 1971–1977; Richard Rogers and Renzo Piano.
- **San Francisco, California:**
 - Hyatt Regency Hotel, 1970–1972; John Portman and Associates.
 - Trans-America Headquarters, 1968–1972; William Pereira.
- **Tasaki, Japan:**
 - The Gumma Prefectural Museum of Fine Arts, 1972–1974; Arata Isozaki.
- **Ticino, Switzerland:**
 - House, Massagno, 1979–1981; Mario Botta.
 - House, Pregassona, 1979–1980; Mario Botta.
 - House, Riva San Vitale, 1971–1973; Mario Botta.
 - House, Stabio (Casa Rotunda), 1980–1982; Mario Botta.
- **Tokyo, Japan:**
 - Hillside Terrace Apartment, 1969–1974; Fumihiko Maki.
 - Kaijima House, 1974–1976; Arata Isozaki.
 - Nakagin Capsule Tower, 1971–1972; Kisho Kurokawa.
 - Shizuoka Press Office, 1967; Kenzo Tange.

- **Toronto, Canada:**
 - Canadian National (CN) Tower, 1977; John Andrews.
 - Eaton Center, 1974–1977; Zeidler Roberts Partnership.
 - Roy Thompson Hall, 1982; Arthur Erickson Architects.
- **Vancouver, Canada:**
 - MacMillan Blodel Building, 1970; Erickson Massey Architects.
 - Robson Square, 1979; Arthur Erickson Architects.
 - Simon Fraser University, 1965; Erickson Massey Architects.
 - Museum of Anthropology, University of British Columbia, 1976; Arthur Erickson Architects.
- **Vienna, Austria:**
 - Retti Candle Shop, 1965; Hans Hollein.
 - Schulin Jewelry Shop, 1972–1974; Hans Hollein.
- **Washington, D.C.:**
 - National Gallery of Art, East Building, 1968–1978; I. M. Pei.
 - Hirschorn Museum, 1973; Gordon Bunshaft and Skidmore, Owings, and Merrill.

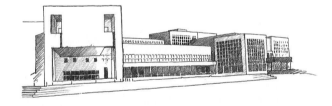

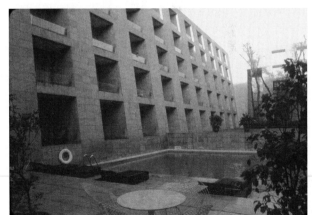

▲ **31-10.** The Gumma Prefectural Museum of Fine Arts, 1972–1974; Tasaki, Japan; Arata Isozaki.

▲ **31-11.** Hotel Camino Real, 1973–1975; Mexico City, Mexico; Ricardo Legorreta.

a slick skin with flat surfaces that may be solid, glass, or a combination of both. Some buildings have a plan axis on an oblique angle rather than on a 90-degree angle. Less overall unity in design is replaced by more experimentation with form and individual expression. As a result, the building structure may be exposed (Fig. 31-7,

▲ 31-11. *(continued)*

31-14), curved (Fig. 31-8), angled (Fig. 31-11, 31-15), or punctuated (Fig. 31-17) to define a new aesthetic language.

■ *High Tech*. High Tech architecture articulates the building components and systems on the exterior as a celebration or exploration of technology. As if turned inside out, structural parts may sweep across and envelop the façade or only cluster in certain areas. Interior space now is freed from the whims of climate and orientation and can be totally flexible. One of the best examples is the Pompidou Centre (Fig. 31-14) in Paris.

■ *Minimalism*. In reaction to consumerism and Pop Modern, some architects adopt a minimalist approach to building in a search for pure form. They explore space

▲ 31-12. Pennzoil Place, 1974–1976; Houston, Texas; Philip Johnson and John Burgee.

▲ 31-13. Pacific Design Center, Blue building, 1975–1976, by Victor Gruen Associates, Los Angeles, California; and Green building, 1988, by Cesar Pelli Associates.

DESIGN SPOTLIGHT

Architecture: Pompidou Centre, 1971–1977; Paris, France; Richard Rogers and Renzo Piano. In 1970, French authorities hold an international design competition for a new cultural center and a multiuse facility housing a museum of modern art, a library and research centers, a movie theater, and restaurants. The industrial or high-tech design by Rogers and Piano wins the competition. The Pompidou Centre is one of the best examples of extreme machine articulation with exposed circulation systems, mechanical ducts, and skin and bones structure composed of prefabricated steel supports and trusses. It also features diversity in materials and an exaggerated use of color. Starkly contrasting with buildings around it, a large escalator on the west façade provides movement and carries visitors to the observation deck on the roof. The steel skeleton permits open interiors, and movable partitions allow configurations to meet any requirements. The large open space with little fixed wall space presents a challenge for interior exhibitions. Although a popular attraction, the building is less representational of French culture than it is a monument to industrial technology.

Exaggerated use of color conveyed on structural and mechanical systems

Exposed prefabricated steel supports and trusses

Asymmetry on facade with strong grid frame

Emphasis on solid and void, straight and curved lines, and celebration of technology

Exposed mechanical systems

Building stands out from its environment

▲ **31-14.** Pompidou Centre; Paris.

through planar geometry and reduce form to its essence. Examples are the Douglas House (Fig. 31-18) in Michigan by Richard Meier and Riva San Vitale (Fig. 31-19) in Switzerland by Mario Botta.

Public and Private Buildings

■ *Types.* The most important public facilities include office buildings (Fig. 31-5, 31-6, 31-7, 31-9, 31-12), museums (Fig. 31-10, 31-14, 31-15, 31-17), hotels (Fig. 31-8, 31-11), shops (Fig. 31-3), and libraries. Custom-designed houses (Fig. 31-18, 31-19, 31-20) offer the best representation of Late Modern principles.

■ *Site Orientation.* Plazas and mixed use facilities surrounding buildings become more common as concepts of urban planning evolve in response to consumerism and the desire to make structures recognizable. Most urban buildings sit on prominent city streets, waterways, public squares, or malls with green space nearby. Hotels may locate in these areas or near beaches and lakes. Buildings often contrast with their surroundings and thereby, it is assumed, acquire greater importance. For example, the John Hancock Center (Fig. 31-7) in Chicago and the Pompidou Centre (Fig. 31-14) in Paris are surrounded by older, historical buildings. Houses, usually situated away from urban centers, are often surrounded by green space with only a few plants near the main structure.

DESIGN PRACTITIONERS

Throughout this Late-Modern period, the increasing complexity of the built environment calls for specialization in design projects based on the major categories of offices, hospitality, retail, health care, and institutional. This complexity also leads to a greater separation between architecture and interior design based on specific and specialized knowledge. (See the Introduction, Architecture and Interior Design Professional Timelines.) Architects address the site and design the building envelope and interior architectural components, whereas interior designers concentrate on the human dimensions of interior space associated with behavior, function, color, light, furnishings, and materials. Sometimes they work in teams, and sometimes they work independently. Research and programming are more important and begin to inform the development of projects.

Reflecting ongoing changes in practice, the architectural profession in the United States and Canada evaluates the standards, criteria, and direction for education, experience, and examination standards to meet professional competency. As a result, professional organizations advance accreditation processes and practices for university architectural programs, develop a monitored work experience program for beginning architects, update and administer a comprehensive professional examination, and expand legal recognition requirements. One of the most critical considerations is the expansion and enhancement of the architect's knowledge of health, safety, and welfare codes and regulations to meet the growing demands of practice and professional responsibility.

As with architecture, interior design education and practice standards also continue to expand and evolve. New professional organizations form in North America that focus on different aspects of practice and education. The first interior design programs at the university level are accredited and an examination for competency for practitioners is established. The first title and practice acts in the United States are passed, marking the beginning of legal recognition of the profession.

- **Mario Botta** (b. 1943), architect, emphasizes geometric form, texture, solidity, and permanence in his work. Known for his respect for context and environment, he strives to bring together traditional architectural symbols and a modernist design vocabulary. His work has been called Neo-Rationalist and Minimalist. Early in his career he works with Le Corbusier, Louis Kahn, and Carlo Scarpa, who influence his development. Botta has had his own firm in Lugano, Switzerland, since 1970.

- **Cesare (Joe) Columbo** (1930–1970) designs many innovative pieces of furniture, lighting, and other products in his short career. Experimenting with new materials and construction methods, Columbo creates designs that serve people's current and future needs. He envisions interiors and furniture forming total multifunctional environments. His work is often light and sculptural, reflecting his earlier training as a painter and sculptor.

- **Joe (Joseph Paul) D'Urso** (b. 1943) uses minimalist principles with a focus upon function and an innovative use of materials in his interior and furniture designs. Influential features include white walls, dark industrial carpet, industrial furniture, track lighting, and vertical blinds. Nevertheless, interiors reveal a strong sense of scale and a sculptural arrangement with emphasis on the furniture. A designer, educator, and preservationist, D'Urso is inducted into the Interior Design Hall of Fame in 1986.

- **Arthur Erickson** (b. 1924), who first came to prominence in 1965, is one of Canada's best-known Modernist architects. Important design characteristics of his work include buildings that are constructed in concrete, related to the site, responsive to natural environments, developed from cultural awareness, distinguished by a dramatic interplay of space and light, and marked by an inventive use of form. He is known for his ability to create large-scale architecture. Major projects include Simon Fraser University and the Museum of Anthropology at the University of British Columbia.

- **Richard Meier** (b. 1934) is an architect and educator. His work, which is remarkably consistent yet varied, builds on the work of Le Corbusier in its use of white, geometry, and purist forms. Meier relies on simple rectangular and curvilinear forms intersected or pierced by openings and planes. Ramps and railings emphasize line and form. His best-known works are the High Museum of Art in Atlanta and the Getty Center in Los Angeles. In 1984, Meier receives the prestigious Pritzker Prize in Architecture.

DESIGN PRACTITIONERS

- **Ieoh Ming Pei** (b. 1917) is born in China but comes to the United States to study architecture at MIT and Harvard. He opens his own firm, I. M. Pei and Associates, in 1955. Pei's work relates to the Bauhaus and the International Style in its geometry and minimalism. But he expresses original design concepts in steel, glass, stone, and concrete. He is best known for his museum designs, such as the addition to the National Gallery of Art in Washington, D.C., and the redesign and additions to the Louvre in Paris. In 1983, Pei receives the prestigious Pritzker Prize in Architecture. He retires from practice in the late 1990s.

- **John Portman** (b. 1924), American architect, developer, painter, and sculptor, is best known for his atrium hotels, a new inventive concept in design. His firm, Portman and Associates, also designs trade marts, mixed-use facilities, and offices. Portman expands his design services as developer and part owner of the Hyatt Regency Hotel in Atlanta.

- **Andrée Putman** (b. 1925; née Andrée Christine Aynard) has careers in music and journalism before turning to interior design. She opens her first firm, Ecart International, in Paris in 1978, and in 1997 opens a new company in her name. Her work is minimalist, avant garde, elegant, and luxurious. One of the world's best-known interior designers, her most recognized works are interiors for Yves S. Laurent, the Morgans Hotel, and the Concorde Airplane. Putman is inducted into the Interior Design Hall of Fame in 1987.

- **Richard Rogers** (b. 1933) studies architecture in London and at Yale. His first partnership is with Norman Foster at Team 4. In the early 1970s, he forms Richard Rogers Partnership. His designs embrace and celebrate technology with an emphasis on open spaces, which relates him to other early Modernists. Unlike them, he strives for total flexibility, adopts the imagery of technology, and stresses the social potential of architecture. Rogers, a recognized award winner, is one of Britain's most influential architects. Two of his most famous landmarks are the Pompidou Centre in Paris and Lloyd's Building in London.

- **Minoru Yamasaki** (1912–1986) is a second-generation Japanese American. A prolific designer, he is best known for the infamous Pruitt Igoe Complex and the twin towers of the World Trade Center in New York City. He works in a refined and modified International Style that sometimes reinterprets traditional or Japanese elements in refined materials such as wood and steel instead of rough concrete.

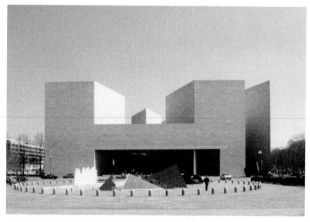

▲ **31–15.** National Gallery of Art, East Building, 1968–1978; Washington, D.C.; I. M. Pei.

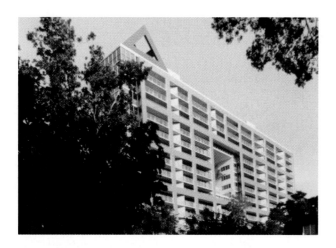

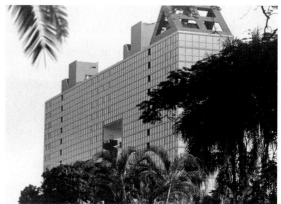

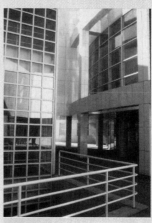

▲ **31–16.** The Atlantis Condominium, 1980–1982; Miami, Florida; Arquitectónica.

DESIGN SPOTLIGHT

Architecture: High Museum of Art, 1980–1983; Atlanta, Georgia; Richard Meier. One of the members of the so-called New York Five, Meier reinterprets Le Corbusier's Five Points of New Architecture in the High Museum of Art. He manipulates the structural grid and free plan into complex quadrants that provide the variety of spaces inside required for display and the myriad of functions needed by a museum. The stark, white, layered façade, mainly of tiles, features curves and bold geometric interpenetrating forms highlighted by grid-patterned ribbon windows. The soaring atrium interior space celebrates the ramp as viewing space like the Guggenheim Museum, permitting the visitor to glimpse exhibits as he or she ascends.

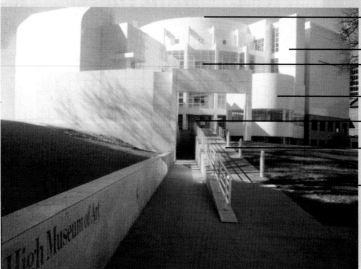

Flat roof

Façade made of stark white tiles

Repetition of square grids on windows

Bold geometric forms used extensively

Interplay of solid and void relationships, curves and angles

Processional path to entrance

Building looks like white sculpture on a green lawn

▲ **31–17.** High Museum of Art; Atlanta, Georgia.

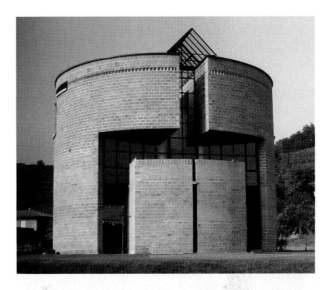

▲ **31-18.** Douglas House, 1971–1973; Harbor Springs, Michigan; Richard Meier.

Richard Meier's buildings look like pieces of white sculpture on a green landscape (Fig. 31-17, 31-18), and many other architects follow this concept.

■ *Floor Plans.* Buildings with a high-tech look have plans that reject the rectangular shapes of earlier periods, and this is a significant change. Architects move from conceiving a plan as a two-dimensional feature based on a grid to one that is more aesthetically diverse and innovative. They play more with interpenetrating geometries, complexity in scale and space, and solid and void relationships. Rather than one dominant building axis, there may be one important axis along with other subdominant ones that define structure, entry, circulation, and function. Although some of these changes begin before the 1960s, they are more fully realized during this period as a result of technological advancements.

Overall, plan shapes often have straight edges, but the sides may be angled, curved, or indented with either solid or glass walls (Fig. 31-4, 31-8, 31-10, 31-11, 31-13, 31-15, 31-17). Or the building may express a variety of these features in the overall plan, have a circular plan, or have a portion of the building with a circular plan. The connection between the shapes and the solid and void relationships is important. Plan development and interior circulation may be formally or informally organized, two-dimensionally by the placement of spaces and three-dimensionally by the volumetric relationship of spaces, based on aesthetics and function. Centrally located circulation cores continue, but there is more variety and innovation in their design, particularly in the shape and placement of stairways. Often interior stairways

▲ **31-19.** Houses, Riva San Vitale, 1971–1973, and Stabio (Casa Rotunda), 1980–1982; Ticino, Switzerland; Mario Botta.

become major architectural features that continue the building's exterior design language (Fig. 31-25).

The three-dimensional character of spaces changes, too. Rectangular room shapes continue but may be grouped in different ways to create interest and add variety (Fig. 31-9, 31-10). New shapes of spaces that follow the building language are introduced, so there are more

▲ **31-20.** Kaijima House, 1974–1976; Tokyo (in Musashino City), Japan; Arata Isozaki.

▲ **31-21.** Later Interpretation: Seattle Public Library, 1999–2004; Seattle, Washington; Rem Koolhaas. Neo-Modern.

angles, curves, and indentations throughout the plan. Spaces may also show spatial layering and level changes to delineate and zone public areas by function, as shown in hotel lobbies, offices, or living areas (Fig. 31-22, 31-23, 31-30). Or they may contain more multifunctional areas, a concept that becomes more important as the cost of interior square footage escalates. Plans accommodate new interior configurations that allow in more natural light, so there are atriums in hotels (Fig. 31-22), offices, museums, and houses. Additionally, exterior views become more important, so key spaces orient to them.

■ *Materials.* The most common materials are steel, reinforced and precast concrete, aluminum, and mirrored, tinted, and plain glass (Fig. 31-7, 31-13, 31-14). Most construction materials are prefabricated with modular components. Other materials used by various architects during this period include stone (Fig. 31-3), brick (Fig. 31-19), and tile. These materials may cover the main building surface or accent particular features. Sometimes architects become well known for their repetitive use of certain materials, such as Richard Meier, who uses white tile extensively (Fig. 31-17). The relationship between materials and the exposed building structure is important.

■ *Facades.* Facades exaggerate elements of the International Style, especially the simple, purist, rectangular form or silhouette. Most façades are complex in form and details (Fig. 31-3, 31-6, 31-8, 31-9, 31-10, 31-12, 31-13, 31-14, 31-15, 31-17, 31-18), especially when compared to earlier Modernist buildings. Sometimes, everything is taken equally to an extreme, but most often one or two attributes, such as shape, are emphasized more than the others. Some office buildings and hotels have glass exterior elevators creating vertical movement and interesting views for passengers. And there is much variety expressed among individual buildings. For example, Penzoil Place (Fig. 31-12) in Houston, which appears to continue the Modernist form, has twin trapezoidal towers with bronze-tinted glass façades that convey tension and complexity between multiple repetitions, grid exaggerations, and angled rooflines.

■ *Windows.* Windows on commercial buildings are usually fixed in grid patterns to control air-conditioning and heating systems, whereas those on houses may vary to include fixed plate glass, sliding glass, casement, and/or awning with no molding divisions (Fig. 31-5, 31-7, 31-10, 31-12, 31-16, 31-17, 31-18, 31-20). Also following the earlier Modernist language, windows have narrow metal moldings and mullions that frame the openings and divide glass areas. Sometimes they are black or bronze to accent the grid effect.

■ *Doors.* Some entryways feature unique designs that spotlight the entry, the door, and the front façade, as illustrated in the Schulin Jewelry Shop (Fig. 31-3) in Vienna. On others, the entryway is accented, but it blends into the overall design of the building (Fig. 31-10, 31-12, 31-17), which is generally a more characteristic expression.

■ *Roofs.* Like the facades, roofs may be flat, curved, angled, or punctuated (Fig. 31-5, 31-10, 31-12, 31-13, 31-19, 31-20) to convey individuality. Experimentation in design is common because there is no accepted standard. Some designs are symmetrical, whereas others are asymmetrical. Designers pay more attention than earlier to climate conditions and mechanical issues.

■ *Later Interpretations.* During the 1980s through the 2000s, architects continue to experiment with the building envelope to achieve even greater complexity through the exposed structure, spatial layering, multiple repetitions, grid exaggerations, and unique solid and void relationships. Forms move, unfold, soar, rotate, curve, undulate, open, and close. Many innovative buildings challenge preconceived notions of architecture, particularly during the Neo-Modern style (Fig. 31-21).

INTERIORS

Late Modern interiors often reflect architectural concepts. Designers emphasize function, industrial technology, repetition of modular elements, solid and void relationships, spatial layering, and the use of construction, structure, and materials as ornament. Interiors continue to be light and airy but are more complex than earlier. A geometric grid continues to define and shape interior space and primary circulation areas, but it may be regular and symmetrical, irrational and asymmetrical, or both within the same project. Experimentation with space planning leads to new ways to address functional requirements, public and private zoning, and furnishing arrangements. Furniture arrangements reflect this diversity in experimentation, so some arrangements are tightly structured while others illustrate more variety and uniqueness through placement within spaces. Multifunctional spaces are common. Like the exteriors, the structure of walls and partitions may be exposed, and walls may be curved, angled, punctured, or a combination of these concepts.

■ *Minimalism.* Designers experiment with shapes, forms, scale, light, color, and some materials, but a common design language is minimalism, which simplifies, reduces, and/or eliminates all extraneous visual elements (Fig. 31-26, 31-28, 31-29, 31-30). Rooms become simple boxes with plain walls, floors, and ceilings and little furniture. With almost no color except black and white, or judiciously placed art, these spaces depend upon rich textures and textural contrasts for interest.

■ *High Tech.* Other designers take Minimalism in a High Tech direction by incorporating prefabricated building components, industrial equipment, and utilitarian materials, such as corrugated aluminum siding, loading dock doors, steel decking, metal shelving, office furniture, rolling metal tables, and industrial carpet in both commercial and residential spaces (Fig. 31-24, 31-31, 31-35, 31-48). Residential spaces become more commercial and industrial looking than ever before. Furnishings and materials emphasize flexibility, maintenance, and convenience. Dubbed High-Tech in the 1978 book describing its character, this high-style look becomes extremely popular. Various components of it continue to the present, but are packaged in a different, more updated way.

■ *Pop Modern.* Pop Modern interiors, especially when marketed to the young, emphasize excitement, novelty, fun, and disposability. Interiors, particularly retail spaces and restaurants, reflect the new leisure and social activities associated with shopping and eating out. Image and branding are important, and interiors change quickly, especially those, such as boutiques, that are free to explore and experiment. Bold and bright colors, shiny finishes, dramatic lighting, and modular plastic or foam furniture are key characteristics.

Public and Private Buildings

■ *Types.* There are no new room types, but spaces dedicated to specific uses and multifunctional purposes become more common than earlier. Greater attention is given to offices, showrooms (Fig. 31-28), hotels (Fig. 31-22, 31-27), museums (Fig. 31-23), kitchens, and bathrooms (Fig. 31-27). Rooms in houses open to each other more than previously (Fig. 31-30, 31-31). Spaces emphasizing natural light become more common as people seek greater bonds with nature. Pop Modern defines trendy interiors in boutiques, shops, discotheques, and restaurants, especially those that appeal to young people and residences of the hip and fashionable. The style rarely influences corporate or other similar interiors, such as banks or governmental buildings.

■ *The Open Plan Office.* One of the most profound changes in office design during this period is the development of the open plan office (Fig. 31-46, 31-47). It reflects a shift from an enclosed office with fixed walls, common up to the mid-20th century, to an open plan with flexible wall partitions and modular furniture. The concept stems from a study of the organization and communication patterns of office workers conducted by the Quickborner Team in Germany during the late 1950s. It found that the placement of workers based on communications and paper flow is easier when workers are grouped together in a free, open space. Additional considerations giving rise to open offices are the increasing costs of wall construction, a greater need for flexibility, and a desire to improve interoffice communications and work. Open office or landscape planning inspires a broader definition of physical space and how people function in an office environment. This, in turn, initiates a revolution in office furniture design as offices are redefined as workstations. These smaller spaces, delineated by low partitions from which hang work surfaces and storage, can be easily expanded, changed, and moved as the needs of the individual or company evolve.

■ *Atrium Hotels.* In the late 1960s, John Portman experiments with the first atrium-style hotel, the Hyatt Regency Hotel in Atlanta (Fig. 31-8, 31-22). This innovative idea, which comes from his desire to create interesting spaces for people, results in a hotel with guest rooms and vertical circulation focused around a central atrium, like the Roman atrium or the late-19th-century department store, with a skylight above. Portman's atriums, which extend the full or almost full height of the building, are examples of spatial layering. The spaces strive to be people-friendly through the addition of architectural elements, water features, plants, seating, and moving elevators. The project is so successful that he uses atriums in a series of Hyatt hotels designed in various locations. Other hotel chains emulate this idea, and atriums become common features not only in hotels, but also in other commercial facilities including office buildings in North America and elsewhere.

DESIGN SPOTLIGHT

Interiors: Lobbies, Hyatt Regency Hotels, 1967–1972; Atlanta, Georgia (below), and San Francisco, California (right); John Portman and Associates. John Portman revives the atrium in his quest to modernize the city hotel with its typical dark, confined lobby. He does so, despite objections from many hoteliers, at the Hyatt Regency in Atlanta. It immediately becomes well known and very successful. Providing both drama and congregating space, the hotel design centers on a large, multistory, open atrium with expansive skylights and illuminated glass elevators. Natural light filters downward from the glass roof to enhance the lobby seating, a bar, a restaurant, hotel corridors, and a large contemporary sculpture. Human scale and soft surroundings are important to the total design concept, so there are various changes in scale, texture, and color within the harmonious environment. Lighting, which is integrated into the architectural design, may accent, brightly illuminate, or soften conversation and circulation areas. Adding to the overall sensory quality and enhancing the spatial ambiance, numerous plants are interspersed throughout, and long wind chimes (removed later) tinkle with a soft magical ring. Portman's atrium concept is so unusual that it inspires numerous other projects by Portman as well as other architects.

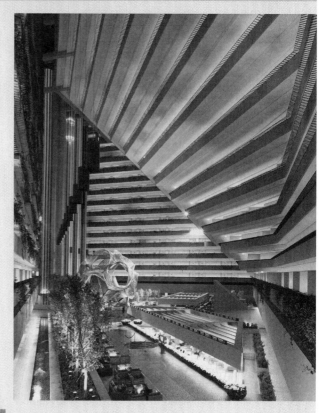

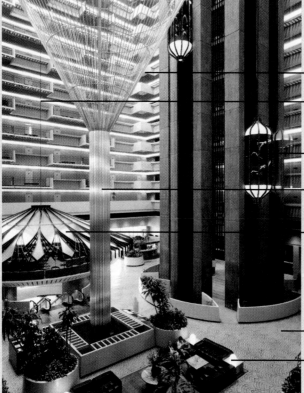

Wind chimes hang in the corners of the balconies

Hotel corridors overlook the atrium

Glass elevators are located near the center of the atrium

Large sculpture serves as an accent

Restaurant housed under umbrella-type canopy located in the atrium

Terrazzo-like flooring helps convey a garden character

Conversation groupings, located throughout atrium, are defined by large plants

▲ **31-22.** Lobbies, Hyatt Regency Hotels; Atlanta, Georgia, and San Francisco, California.

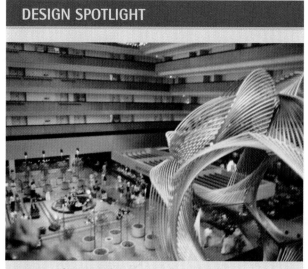

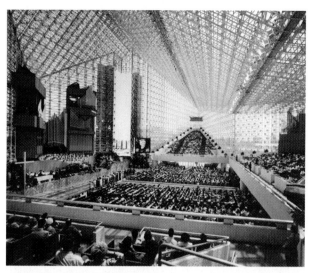

▲ **31-24.** Interiors, Garden Grove Community Church (Crystal Cathedral), 1977–1980; Garden Grove, California; Philip Johnson and John Burgee.

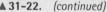

▲ **31-22.** *(continued)*

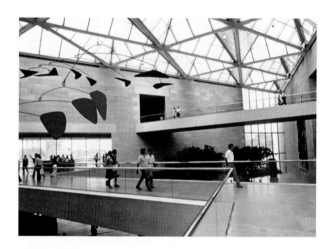

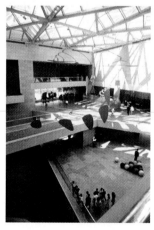

▲ **31-23.** Interiors, National Gallery of Art, East Building, 1968–1978; Washington, D.C.; I. M. Pei.

■ *Furnishings, Textile, and Lighting Showrooms.* During the 1960s, furnishings, textile, and lighting showrooms expand tremendously in major metropolitan cities across North America and elsewhere to meet the demands of architects and designers (Fig. 31-28). Building on the earlier work of Florence Knoll and others (see Chapter 28,

"Geometric Modern"), these showrooms display products available only to the design trade in spaces specifically oriented to attract and support the design community. Some showrooms focus on furnishings, textiles, and lighting by only one manufacturer, while others display products from many of them. This expansion also creates more exposure for the products on display, leading to more concern for the design of the showroom and product presentation. In fact, some designers concentrate their practices in this direction. In metropolitan areas, manufacturers also enhance their headquarters and manufacturing facilities with showrooms or display spaces. Additionally, major cities in many parts of the world begin to host markets specifically oriented toward the design trade, such as NEOCON in Chicago.

■ *Relationships.* Designers strive for a strong aesthetic relationship between the exterior and interior of a building so that the design language is complementary. Architects generally design the interiors of their major buildings to achieve an integrated whole (Fig. 31-23, 31-24, 31-25, 31-30). Interior designers primarily address the renovation of existing interiors and the development of new spaces (Fig. 31-27, 31-28, 31-29).

■ *Color.* Minimalism dictates white interior walls with black, white, or gray trim (Fig. 31-26, 31-27, 31-29). Sometimes primary or earth-tone colors appear as accents in carpet and rugs, artwork, and decorative arts. Eye-catching color is a defining feature of Pop Modern. Bright red, blue, yellow, green, orange, and pink are typical. Boutiques sometimes use dark colors and dramatic lighting to highlight merchandise.

■ *Lighting.* One of the most important aspects of lighting is that designers give more attention to it and its effects on users. Research on fixture choices and types expands significantly so that designers are better able to select and specify

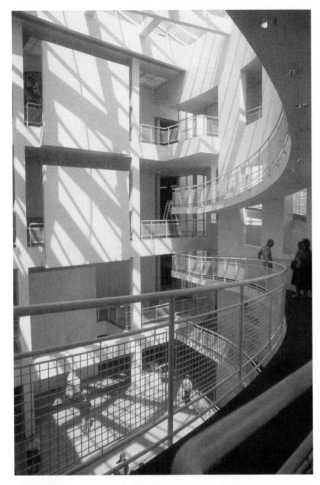

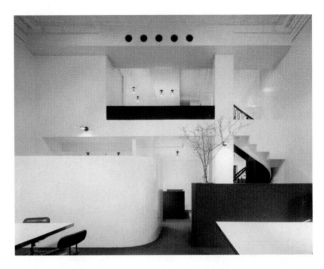

▲ **31-25.** Interior, High Museum of Art, 1980–1983; Atlanta, Georgia; Richard Meier.

lighting that more fully addresses the needs of the users and the type of space. They also incorporate different types of lighting including ambient, task, accent, and mood, as well as specialized lighting for specific projects. Because of the increased complexity in technology, design applications, and client requirements, architects and designers often consult with lighting engineers or lighting designers. Numerous advances are made in the design of architectural lighting, suspended ceiling systems, track lighting, indirect

▲ **31-26.** D'Urso office, and a living area, bedroom, and entry in the minimalist character, 1970s–1980s; New York; office of Joe D'Urso Design.

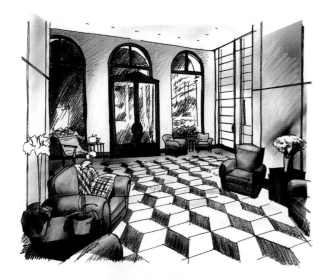

▲ **31-27.** Lobby, guest room, bathroom, Morgan's Hotel, c. 1985; New York City, New York; Andrée Putman.

lighting, and individual fixtures (Fig. 31-22, 31-28, 31-32). With greater demand for natural light, large windows, interior light-filled atriums, and skylights become more common in office buildings, hotels, museums, and houses. Examples include the Hyatt Regency Hotel in San Francisco (Fig. 31-22) and the National Gallery of Art, East Building (Fig. 31-23), in Washington, D.C.

Suspended ceiling grids with integrated lighting and mechanical systems continue, particularly in offices. Individual task lighting addresses individual user needs. Track lighting and light fixtures intended for factories with porcelain-on-steel incandescent light reflectors or fixtures with heavy steel wire cages also become extremely popular for commercial and residential use because of their flexibility, style, and inexpensive costs. Created in the 1920s and 1930s, they are initially used in factories, museums, and retail spaces. Generally throughout this period, there is an overall increase in the use of architectural lighting, with much variety in design and installation.

There are many innovations in the design of lamps, wall sconces, and floor lamps (Fig. 31-32). One of the most important new designs is the Tizio desk lamp, a sleek, black linear fixture that offers flexibility to the user. Another is the Luxo drafting lamp, which offers great flexibility because of its adjustable arm, and often it incorporates both a fluorescent and an incandescent bulb. Most light fixtures are simple, unadorned, geometric, and flexible with metal stems. Lamp shades are metal or glass to follow the architecturally based aesthetic. In contrast, fixtures for Pop Modern spaces may be of glass, ceramics, paper, metal, or plastic in simple shapes in shiny metallic finishes, bright colors, and/or robust patterns.

■ *Floors.* A wider selection of floor materials inspires more inventiveness in their design application. Concrete, marble, terrazzo, ceramic tile, stone, and brick floors are used along with wood in blocks, strips, and parquet. Resilient flooring—rubber, linoleum, and synthetics such as vinyl—also increases in use. Many floors in Pop Modern spaces have shiny finishes to reflect light and heighten the sensory experience. Developed in Italy, embossed rubber floors with circles, squares, and ribs appear in both commercial and residential spaces for floors as well as walls and desk surfaces. Colors of rubber

▲ **31-28.** E. F. Hauserman Company Walls Showroom (light installation by Don Flavin), 1982, and Vignelli Associates Office, 1986; Los Angeles, California, and New York City, New York; Vignelli Associates.

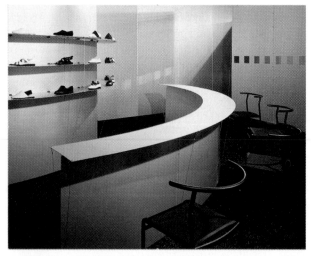

▲ **31-29.** Shoe salesroom, Esprit Clothing Company Shoe Showroom, 1988; New York; Michael Vanderbyl, Vanderbyl Design.

flooring are black, gray, and red. Embossed metal flooring is new for stairways and other high-traffic areas. Wall-to-wall carpeting is common in commercial areas and spaces, such as discotheques, where users sit or lie. Carpet again becomes common in residential spaces as the concept of minimalism enters home environments (Fig. 31-31). To enhance the industrial look, commercial carpets—tightly woven level loops—are used in homes as well as

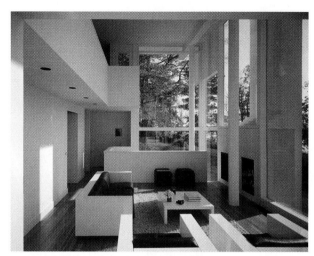

▲ **31-30.** Living area, Smith House, 1967; Rowayton, Connecticut; Richard Meier.

▲ **31-31.** Interiors, Michael Hopkins House, 1975; London, Hampstead, England; Michael Hopkins.

offices. Designers also begin to incorporate custom-designed carpets and rugs into projects to create a more individual look (Fig. 31-27). Sisal and cocoa matting become popular as area rugs or in wall-to-wall applications in residences. Oriental rugs and factory-produced area rugs with simple designs also cover uncarpeted floors.

■ *Walls.* Walls may be of plaster, drywall, glass, marble, stone, or exposed concrete (Fig. 31-23, 31-24, 31-26). They are plain and flat with no moldings except baseboards which, when present, are downplayed as much as possible. White or neutral painted walls are most

common, particularly in large office areas, museums, and residences (Fig. 31-23, 31-25, 31-26, 31-27, 31-29, 31-30). Other types of wall coverings include embossed metal or rubber, glass blocks, corrugated steel, and perforated metal. Wall-to-wall carpeting in gray or black may be applied to walls to define a particular area, such as over a bed. Cyclone fencing sometimes divides or partitions spaces. Some wall treatments develop from a modular system of prefabricated parts and materials to reflect an industrial look. Occasionally, designers deliberately call attention to structural components and/or interior systems by painting them different colors or using a variety of shiny finishes.

Pop Modern wall treatments may be subdued or dramatic, depending upon the use of the space. Subdued treatments, common in spaces that focus on merchandise, include plain dark painted or fabric-covered walls, often with shiny finishes. Dramatic treatments include shiny metals, mirrors, brightly colored and boldly patterned or psychedelic wallpapers, and audacious graphics, murals, and other decorations. Op Art wallpapers in geometric patterns in black and white or the primary colors play havoc with the viewer's senses.

■ *Window Treatments.* Simple, plain window treatments hung straight from ceiling to floor are typical. Most are thin sheers in white that blend in with the architecture. Mini blinds and sun-screen shades are new during the period and are used extensively (Fig. 31-27). Vertical blinds continue to be popular.

■ *Doors.* Doors are flat, plain, usually wood or metal and may be stained or painted black, white, or gray. Borrowing from the Bauhaus aesthetic, door trims, when present, repeat the character of window moldings.

■ *Textiles.* Designers often select commercial-grade fabrics made of cotton, linen, wool, and synthetic fibers for both commercial and residential interiors because of their low maintenance and durability. Most are simple woven, geometric designs in solid colors. New companies, such as Maharam Fabrics and Design-Tex, support the growing commercial design market. And furniture manufacturers significantly increase their inventories of commercial textiles samples.

Pop Modern textiles of the early 1960s have controlled and hard-edged geometric and abstract patterns in bold colors. During the middle 1960s, they are replaced by Op Art patterns with static geometric forms such as squares, circles, and lines creating optical illusions. These patterns signal a move away from strictly controlled patterns into the free psychedelic swirling, curving, and moving patterns of the late 1960s.

■ *Ceilings.* Ceilings are often flat, plain, and painted white, black, or a neutral color (Fig. 31-25, 31-26, 31-27, 31-30). Some Pop Modern spaces feature dramatic treatments, such as dark or bright colors, mirrors, silvering, graphics, or murals. In offices and other commercial spaces, suspended ceiling grids with textured panel inserts

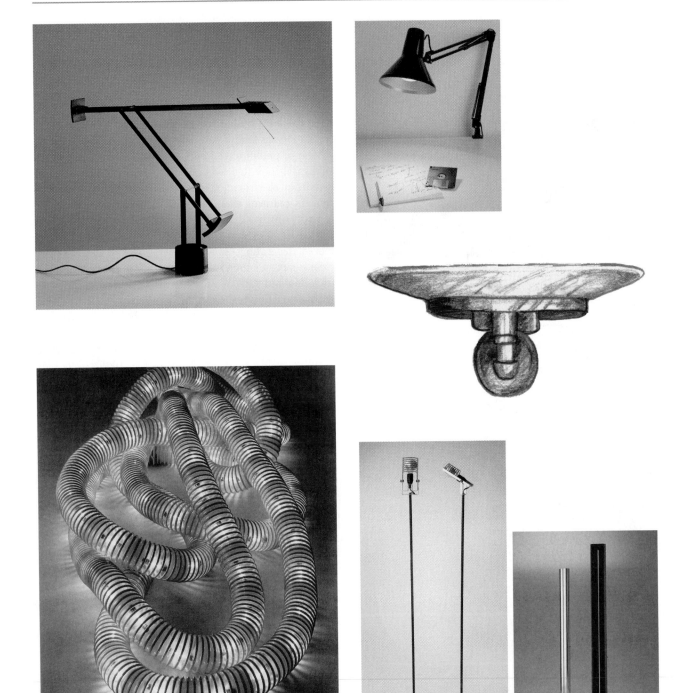

▲ 31–32. Lighting: Tizio desk lamp, 1972, Richard Sapper; adjustable desk lamp, c. 1960s; Boalum, c. 1970s, L. Castiglioni and Gianfranco Frattini; wall lamp, 1979, P. King, S. Miranda, and G. L. Arnaldi; metal floor lamp, 1979, E. G. Sintesi; and Megaron Floor lamp, 1979, Gianfranco Frattini; manufactured by Artemide, Flos, and others.

or metal slats are typical. Sometimes in High Tech spaces, different colors or finishes emphasize interior systems, such as ductwork or sprinklers. Architects often incorporate materials used in the building design for ceiling treat- ments, such as metal, wood, or glass (Fig. 31-23, 31-24, 31-31). Other types of ceilings include corrugated steel and wood. Treatments may vary from one space to an- other, based on function and aesthetic choices. Overall,

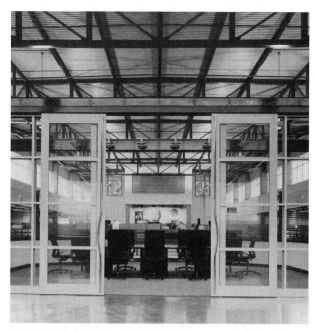

▲ 31–33. Later Interpretation: Conference room, Temerlin McClain offices, 2002; Irving, Texas; Staffelbach Design Associates. Late Modern.

there is much more variety in ceiling treatments than earlier.

■ *Later Interpretations.* Interiors in the rest of the 20th century reflect aspects of Late-Modern design, but forms change and become even more complex. Unusual shapes are common, and the grid is less apparent. Interior designers pay more attention to the complexity and diversity of projects, resulting in more specialization to meet the demands of better educated clients (Fig. 31-33). Technology, its use and products, affects all designers even more as the 20th century progresses. Improved manufacturing processes provide greater goods to more people, not unlike a second Industrial Revolution. As the 21st century begins, these trends continue, but with more experimentation in all facets of design.

FURNISHINGS AND DECORATIVE ARTS

Most furnishings follow two general paths beginning in the 1960s—one focusing on contract furniture, mainly for the office, and the other addressing popular culture. Adopted by major manufacturers, the expanding and changing contract and office furnishings market concentrates primarily on office systems furniture and important office developments, such as changes in the way people work, technology, and the computer. These are regarded as having little applicability to the home. Rationalism, functionalism, flexibility, and durability are important design considera-

tions. Furniture has a refined form and machine-made appearance with no applied ornament, continuing in the traditions of the Bauhaus and International Style. Much of it relates well to the interior environment because of similar materials, form, and/or design.

The other path responds to the domestic, youth, and consumer markets, embracing popular culture, novelty, disposability, and low cost. This Pop Modern furniture encompasses many forms, shapes, and materials. Adopting traditional, nontraditional, and neo-organic forms, it conveys newness, fun, and surprise. It may be imaginative, ingenious, flexible, modular, and/or multipurpose. Despite its spontaneous look, Pop Modern furniture fits the human body and may result from experiments with materials and construction methods.

During the 1950s and early 1960s, functionalism is the main consideration in the design of furniture. But as ideas change during this period, some furniture designers choose a different approach because of the demand for high sales volumes. As a result, they consider ease of manufacture, large production runs, short sales periods, and lower prices for the consumer. Additionally, the period's open-minded and less class-conscious consumers want furnishings that convey an image or make a fashion statement instead of communicating permanence and/or status. Lifestyle becomes an important sales concept as designers and marketers strive to fit consumers with products. Retailers, such as Terence Conran's Habitat stores in London and New York, begin to market to customers who plan their own interiors, select furniture from displays, buy it in flat cartons, and assemble it themselves at home.

Designers also experiment with new ways to organize furnishings based on design trends, evolving functional requirements, and user needs. One result is portable, flexible, and adaptable furniture that can be moved around and positioned or adjusted to fit users. Pieces intended for one

◄ 31–34. 40/4 Stacking chair, 1964; United States; David Rowland, manufactured by General Fireproofing, Inc.

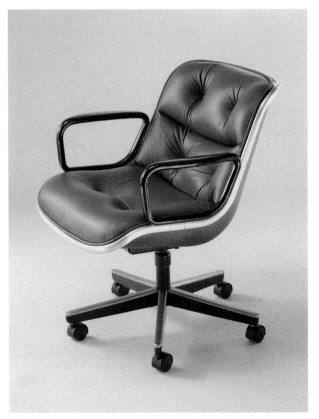

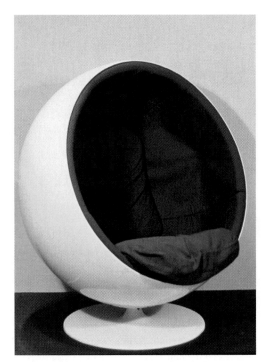

▲ **31-36.** Ball or Globe chair, 1963–1965; Finland; Eero Aarnio.

▲ **31-35.** Office swivel chair 12E1, 1965; United States; Charles Pollock, manufactured by Knoll International.

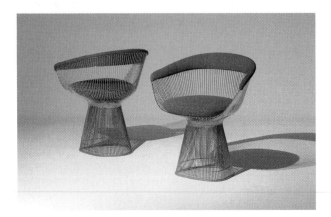

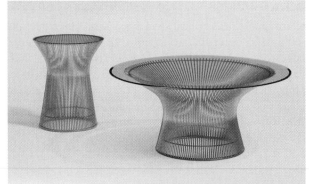

▲ **31-37.** Chairs and table, 1966; United States; Warren Platner, manufactured by Knoll International.

purpose may be used in a different way. As industrial products pervade both office and home spaces, factory-styled furniture also becomes significantly more important.

Public and Private Buildings

■ *Types.* Important introductions to contract furniture are office systems furniture that supports open plan offices (Fig. 31-46, 31-47), office swivel chairs that are more ergonomic (Fig. 31-35, 31-44), and stackable seating used in auditoriums, schools, and offices (Fig. 31-34). Restaurants, discotheques, and trendy homes sometimes have elevated or sunken seating. Also new in the period is furniture made of solid foam (Fig. 31-42), cardboard or paper, and inflatable plastic (Fig. 31-41), as well as individual seating and storage units that combine several functions.

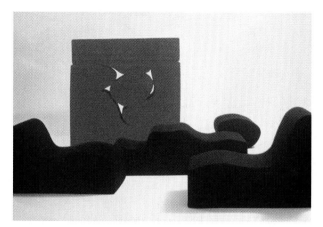

▲ **31-38.** Malitte, 1966; Italy and the United States; Roberto Sebastian Matta, manufactured by Knoll International.

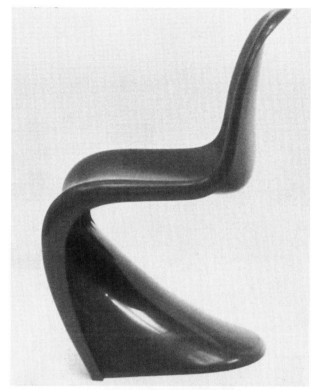

■ *Distinctive Features*. Furniture is sleek, simple, and clean looking to support a design statement based on minimalism. Factory products with chrome and glass appear frequently in commercial interiors. The relationship of art and technology continues to guide designs and details. New materials, human elements, bold forms, large scale, and bright colors distinguish Pop Modern from other furniture. Scale often is larger than the previous decade, but furniture retains lightness and flexibility.

■ *Relationships*. Furniture integrates well with the high-tech or minimalist look of the interiors. Sometimes it makes an architectural statement, while at other times it may stand out as a unique feature of a space (Fig. 31-45, 31-50). Office systems furniture presents regularity in overall design but offers diversity and flexibility in arrangement. Pop Modern furniture shares interior concepts of novelty, optimism, and youthfulness. Mobility becomes such an important quality that designers create a variety of furniture that is intentionally mobile (Fig. 31-34. 31-35, 31-48).

■ *Materials*. The dominant furniture materials are chrome (Fig. 31-37, 31-48), glass, wood, a variety of plastics (Fig. 31-39), and plastic laminate. Many Pop designers abandon traditional furniture materials, such as wood, in favor of plastics, metals, and cardboard. During the 1960s, furniture designers and manufacturers embrace plastics, which are inexpensive, light in weight, strong, and adaptable to many applications. Designers use several types of plastic: acrylics, polyvinyl chloride (PVC), urethane, and ABS (composed of acrylonitrile, butadiene, and styrene). Acrylic is made in sheets that can be bent, cut, folded, and otherwise shaped. PVC is a clear or opaque flexible film used for inflatable furniture. Urethane can be either rigid or flexible, and ABS is moldable, strong, and rigid. It can take any shape and requires no reinforcement.

■ *Seating*. Chairs are the most important pieces of furniture in all environments. Attention is given to their shape,

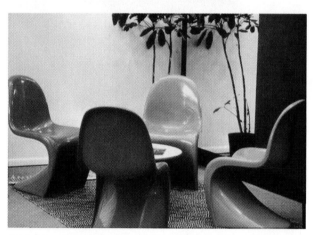

▲ **31-39.** Panton Stacking chair, 1960–1967; Switzerland and the United States; Verner Panton, manufactured by Vitra GmbH and Herman Miller.

◄ **31-40.** Sacco, 1968; Italy; Piero Gatti, Cesare Paolini, and Fraco Teodoro; manufactured by Zanotta.

▲ 31–43. Dijnn sofa, 1970; France; Oliver Mourgue, manufactured by Airborne.

◀ 31–44. Ergon chair, 1976; United States; Bill Stumpf, manufactured by Herman Miller.

▲ 31–41. Blow (top) and Joe chairs, 1967, 1970; Italy; De Pas, D'Urbino, and Lomazzi, manufactured by Zanotta and Poltronova.

▲ 31–42. UP Series chairs, 1969; Gaetano Pesce, manufactured by B & B Italia.

comfort, character, diversity, and mobility (Fig. 31-35, 31-38, 31-39, 31-44, 31-45). Side, arm, and lounge chairs are joined by new examples of lightweight folding and stackable chairs, such as the 4/40 chair (Fig. 31-34) designed by David Rowland. Designers and others sometimes use industrial or commercial furniture in atypical applications (Fig. 31-35). Executive chairs or drafting stools may surround a dining table, for example. Previous Modernist and premodernist furniture such as the Barcelona chair or bentwood chairs continue in use.

Plastic chairs reflect the influences of pop culture. One example is Verner Panton's Stacking chair (Fig. 31-39), the first chair to be molded in thermoplastic in a single continuous piece. Achieving total unity in form and material, the chair adapts the cantilever principle to plastic. A common form for seating is the sphere made in plastic or foam, which is reminiscent of the space age. Resting on a pedestal, Eero Aarnio's Ball or Globe chair (Fig. 31-36) has a spherical exterior and upholstered interior that creates an enclosed, cave-like environment for the sitter.

Some designers sometimes adapt elements of nature or the human body to chair designs resulting in a neo-organic

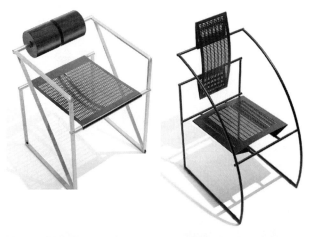

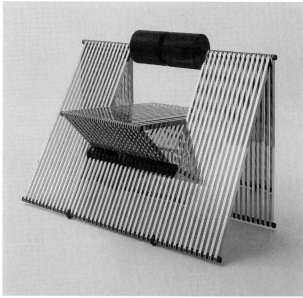

▲ **31–45.** Seconda armchair (top left), 1982, Quinta (top right) and Quarta chairs, 1984–1985; Italy; Mario Botta, manufactured by Alias in Italy.

character. Examples include those with solid foam or tubular steel frames covered with foam and stretch fabric. Roberto Sebastian Matta designs the Malitte Seating System (Fig. 31-38) composed of solid blocks of urethane foam forming a jigsaw puzzle that when taken apart become four lounge chairs and an ottoman. One of the best known of tubular steel and foam seating is Oliver Mourgue's Dijnn group (Fig. 31-43). Its futurist look prompts use by Stanley Kubrick in his 1968 film *2001: A Space Odyssey*. Another version is the Sacco chair (Fig. 31-40), a leather or vinyl sack filled with bits of foam or plastic. Becoming the Pop Modern icon beanbag chair, its shape, which adapts to any sitter, supports casual living.

Designers also create sectional and modular seating using nontraditional materials and construction techniques, such as solid foam in rectangular or undulating shapes and plastic frames with foam upholstery (Fig. 31-42). Also

evident in fashionable living rooms and trendy restaurants or discotheques are platform seating in multiple heights and the conversation pit, sunken or self-contained seating areas. Numerous inflatable chairs appear in the 1960s. The first one to be mass-produced for the home is the Blow chair (Fig. 31-41) by De Pas, D'Urbino, and Lomazzi. Low, bulgy, and transparent, the chair is easily inflated and deflated for the ultimate in transportability. The ultimate in inexpensive and disposable seating is made of cardboard or paper.

■ *Ergonomic Office Chairs.* Contract manufacturers, such as Knoll and Herman Miller, engage in extensive studies of ergonomics for the workplace. Consequently, designers pay more attention to clients' needs, creating seating that better suits the comfort and safety requirements of the users in office environments. An important early example of this idea is the executive swivel chair, most notably the Pollock chair (Fig. 31-35), designed in 1965 by Charles Pollock for Knoll International. It features a swivel-tilt option, a fully upholstered and contoured leather seat, and an adjustable-height pedestal base with branching leg supports and casters. It is immediately accepted as a standard for corporate offices. Almost a decade later a new type of office chair appears, the Ergon chair (Fig. 31-44). Designed by Bill Stumpf and introduced in 1976 by Herman Miller, it is one of the most important chairs designed to meet ergonomic needs. Based on 10 years of research and development on how people sit, it provides better body support, comfort, and flexibility than earlier designs do. Because of its popularity, it soon becomes standard seating in offices, and many manufacturers replicate its concepts.

■ *Office Systems Furniture.* The new open office concept requires flexible furniture that can be rearranged to support change. Storage units designed earlier by Charles Eames and George Nelson had addressed the modular concept but not the diversity and scope of modular parts needed in the new office environment. In the 1960s, Herman Miller introduces the Action Office system (Fig. 31-46) designed by Robert Probst. As the first of its kind, the modular component system reflects the diversity, complexity, and changing of functional requirements in the new office environment, particularly the beginning impact of technology. This type of furniture flexibility leads to a continuing revolution in office furniture design and the advent of more office systems furniture. Primary manufacturers of systems furniture include Herman Miller, Steelcase (Fig. 31-47), Haworth, and Knoll International. They compete with each other in variations in design features, character, materials, and costs to satisfy an ever expanding demand.

■ *Tables.* Dining, coffee, and occasional tables with tubular or square metal legs and glass, wood, or laminate tops advance the Bauhaus and International Style aesthetic (Fig. 31-37). New are rolling tables, used in hospitals, factories, restaurants, and institutions. They convey the high-tech, industrial look. Most have metal supports and come

Furniture: Action Office systems furniture in polished cast aluminum, 1964–1968; United States; Robert Probst with details by George Nelson, manufactured by Herman Miller. After several years of research and development, Herman Miller introduces Action Office, the first modular office furniture system, in 1964. With the concept design by Robert Probst and design details by George Nelson, the group consists of interchangeable components including work surfaces, desks, and storage. Because the system proves unwieldy and difficult to move, in 1968 Herman Miller introduces Action Office 2, the first flexible wall panel office system. It can more easily be reconfigured as the office grows and changes. The group features modular components of writing surfaces, storage units, seating, and support materials that can be adjusted by size and height to fit individual users. Writing surfaces and storage units come in a variety of finishes and can be customized as desired. Like previous Herman Miller designs, the Action Office concept derives from a focus on knowledge-based work, the individual user, and concern for materials, function, and flexibility. The system is so successful that Herman Miller still produces it under other names, evolving the form, components, and design as needs of the modern office change.

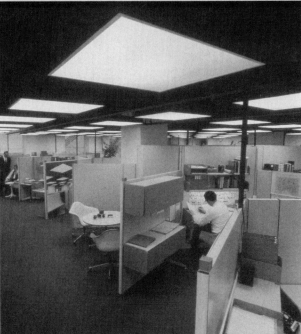

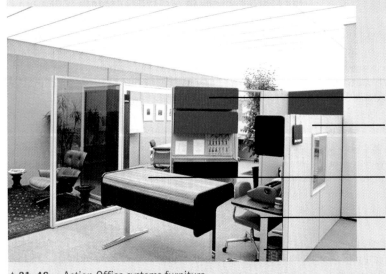

Storage has bumper doors and varies in size and finish

Wall panels come in various sizes, colors, heights, and feature cable management

Movable desk comes in different finishes

Secretarial chair swivels and adjusts to fit user

Individual parts can be customized to address function, flexibility, and aesthetics

▲ **31-46.** Action Office systems furniture.

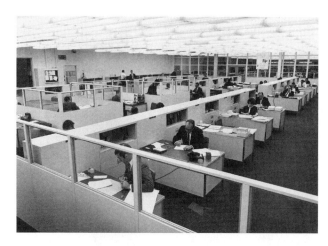

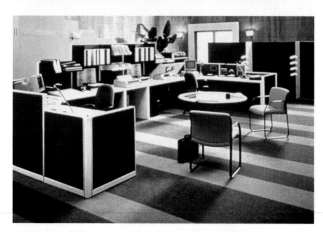

▲ **31-48.** Chrome shelving, rolling cart with detail, c. 1980s; manufactured by Metro.

▲ **31-47.** Office systems furniture, c. 1970s–1980s; manufactured by Steelcase.

with or without adjustable shelves. Tables with pedestal bases in different materials and finishes and top selections appear in homes and commercial spaces. Pop designers create dining, lamp, and coffee tables from ABS plastic and acrylic. Lightweight and easily moved, some retain the traditional legs and tops but are distinguished by their bright colors. Others have nontraditional shapes such as the clear or colored acrylic cubes.

■ *Storage.* The most important changes in nonresidential storage include office systems storage (Fig. 31-46, 31-47),

custom-designed storage, and specialty storage for particular types of interiors (Fig. 31-48, 31-49, 31-50), such as retail, hospitality, health care, institutional, and office. New, diverse, and flexible concepts for storage design flourish for all interiors. A major advantage of systems furniture is that most of the materials and supplies needed by an office worker can be stored within arm's reach. Therefore, most groups include numerous compartments and divisions to help organization. Companies such as Metro Systems create metal component shelving and storage systems including

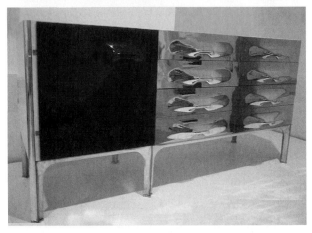

▲ **31-49.** Dresser, DF 2000, c. 1970; France; Raymond Lowey.

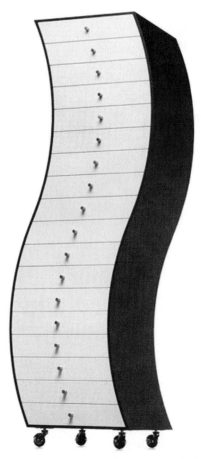

▲ **31-50.** Side 1, Side 2 chest of drawers, 1970; Italy; Shiro Kuramata, manufactured by Cappellini.

bookshelves, wall shelves, and rolling carts (Fig. 31-48). Plastic modular storage units also become very popular, especially in apartments and dormitories, because they are inexpensive, disposable, and very adaptable. White, black, and brightly colored individual units may be open cubes or have shelves or drawers. Designers, such as Joe Columbo, create mobile units that combine several functions such as storage, serving, and working. Metal lockers in a variety of configurations, file cabinets, open shelves, and wire storage bins and closet systems are also used for storage in homes, retail shops, offices, and other nonresidential applications. The Elfa system from Sweden has plastic-coated bins and baskets that can be inserted into freestanding racks or under counters or other similar locations.

■ *Beds.* Designers create beds out of industrial materials such as Metro Systems shelving components, scaffolding, and pipes. New to the period is the platform bed in which a rectangular box or platform, painted or carpeted, supports the mattress. Water beds also become popular but require a more substantial frame.

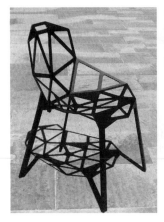

◄ **31-51.** Later Interpretation: Chair One, 2003; Konstantin Grcic, manufactured by Magis in Italy. Neo-Modern.

■ *Upholstery.* Plain fabrics, such as canvas, and leather are common for upholstery. Pop Modern examples are bold with brightly colored geometric and curvilinear patterns that reflect Pop or Op Art. Vinyl remains popular. New to the period are stretch fabrics, used on foam upholstery, and

made of wool, linen or cotton (Fig. 31-42, 31-43). Carpet or matting covers platform seating.

■ *Decorative Arts*. Accessories in Late Modern spaces are kept to a minimum and include metal, glass, ceramic, and plastic objects and plants. Metal accessories, common in High Tech or Industrial rooms, include baskets, ashtrays, clocks, and vases. Plastic accessories, usually brightly colored, are also common and include plant and umbrella stands, ashtrays, vases, and dishes. Russel Wright designs a line of melamine dishes that prove extremely popular.

■ *Later Interpretations*. The Late Modern character continues in furniture through the early 21st century. There are many more varied designs with an industrial look, as well as new concepts that illustrate the use of materials in different ways. One of the most important trends is the geometric grid approach taken by Neo-Modern designer Konstantin Grcic (Fig. 31-51).

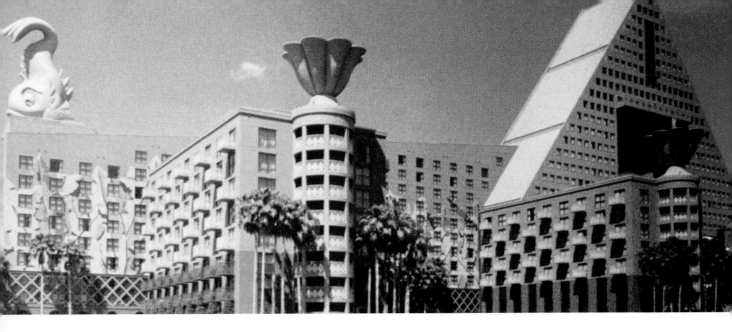

CHAPTER 32

Post Modern

1960s–1990s

Coalescing in the late 1970s and early 1980s, Post Modern embraces a pluralistic and inclusive approach to design that reflects the modern world. Rejecting principles of the International Style, designers celebrate complexity, diversity, and historicism and strive to create expressions that communicate with the design elite as well as the common person. Architecture, interiors, furniture, and decorative arts display a variety of forms, materials, and colors that are often imbued with wit, whimsy, or classicism. Memphis is an avant-garde style based in Italy with an outgrowth of individualism and similar principles to Post Modern. It challenges traditional notions of good design using anti design—quirky forms and shapes, strong colors and patterns rendered in both luxurious and common materials.

HISTORICAL AND SOCIAL

Post Modernism attempts to overcome the stylistic void, universality, and loss of context associated with the International Style, as well as respond to the pluralism created by new technologies and the emerging global economy. Concurrent with Late Modern developments, it reacts to

Architects can no longer afford to be intimidated by the puritanically moral language of orthodox Modern architecture. I like elements which are hybrid rather than "pure," compromising rather than "clean," distorted rather than "straightforward," ambiguous rather than "designed," accommodating rather than excluding, redundant rather than simple, vestigial as well as innovating, inconsistent and equivocal rather than direct and clear. I am for messy vitality over obvious unity. I include the non sequitur and proclaim the duality.

Robert Venturi,
Complexity and Contradiction in Architecture, 1966

A Post-Modern building is . . . one which speaks on at least two levels at once: to other architects and a concerned minority who care about specifically architectural meanings, and to the public at large, or the local inhabitants, who care about other issues concerned with comfort, traditional building and a way of life. Thus Post-Modern architecture looks hybrid. . . . The architects can read the implicit metaphors and subtle meanings . . . whereas the public can respond to explicit metaphors and messages. . . . Of course everyone responds somewhat to both codes of meaning, as they do in a Post-Modern building, but certainly with different intensity and understanding, and it is this discontinuity in taste cultures which creates both the theoretical base and "dual coding" of Post-Modernism.

Charles Jencks,
The Language of Post-Modern Architecture, 1977

them by challenging notions of Modernism, particularly those of the International Style and Geometric Modernism. Instead, it presents a different and more encompassing approach to design, one that stresses period influences, local

836

context, symbolism, and decoration over sleek skin, glass box, and high-tech solutions.

The term *Post Modern* is used in literature, philosophy, sociology, and other disciplines to describe unique features of the late 20th century such as consumerism and globalization. By 1976, *Post Modern* describes a worldwide architecture that is an avant-garde cultural interpretation reflecting modern influences, but illustrating a symbolic design language of traditional or popular double coding recognizable by the design elite as well as the public. Designs reflect the postindustrial age in which the media, knowledge, and consumerism define modern life. More emphasis upon newness, novelty, and quick change encourage aesthetic experimentation and innovation.

Post-Modern architecture in the United States has its foundations in the theories and work of Robert Venturi and his wife, Denise Scott Brown, during the 1960s. During the late 1970s and early 1980s, the style emerges in their work and that of others. The 1980 international exhibition of the Venice Biennale, organized by architect Paolo Portoghesi and called La Strada Novissima, displays street façades designed by Americans and Europeans demonstrating that Post Modernism has spread worldwide (Fig. 32-5). Prominent designers include Michael Graves (Fig. 32-1), Robert Venturi and Denise Scott Brown, Charles Moore, Stanley Tigerman, Robert A.M. Stern, and Philip Johnson of the United States; James Stirling, Thomas Gordon Smith, and Terry Farrell of Great Britain; Hans Hollein of Austria; Ricardo Bofill of Spain; and Paolo Portoghesi and Aldo Rossi of Italy. They establish their own personal vocabularies that are widely imitated. Many revive the architectural tradition of designing the building, interiors, and furnishings, in part responding to consumerism. In the United States, Orlando, Las Vegas, New York City, Houston, and Los Angeles become some of the showplaces for their new ideas and work. By the late 1980s, the style is readily copied and popularized by builders and developers so that it becomes one of a variety of available styles, particularly for houses.

Nevertheless, Post Modern is not a universal style. The architectural community debates its appropriateness and applicability. Many individuals reject its historical allusions and eclecticism. Others embrace and promote its various stylistic or theoretical aspects.

IMPORTANT TREATISES

- ■ *Body, Memory and Architecture,* 1977; Charles Moore and Kent Bloomer.

- ■ *Complexity and Contradiction in Architecture,* 1966; Robert Venturi.

- ■ *The Language of Post-Modern Architecture,* 1977; Charles Jencks.

- ■ *L'Architectura della Citta,* 1966; Aldo Rossi.

- ■ *Learning from Las Vegas,* 1972; Robert Venturi, Denise Scott Brown, Steven Izenour.

- ■ *On the Rise: Architecture and Design in a Postmodern Age,* 1983; Paul Goldberger.

- ■ *Post Modernism: The New Classicism in Art and Architecture,* 1987; Charles Jencks.

- ■ *The Presence of the Past: Venice Biennale,* 1980; Paolo Portoghesi.

- ■ *Versus: An American Architect's Alternatives,* 1982; Stanley Tigerman.

- ■ *What Is Post-Modernism?* 1986; Charles Jencks.

▲ **32-1.** Michael Graves, c. 1980s.

CONCEPTS

Post Modernism directly opposes the International Style and Geometric Modernism. Consequently, Post Modernism adopts a pluralistic, inclusive approach that acknowledges the importance of communication, complexity, and diversity of aesthetics, form, space, and color. Theories and physical elements arise during the late 1960s in response to the perceived failures of Modernism. An early proponent is Robert Venturi who, in *Complexity and Contradiction in Architecture* (1966), describes an architecture that emphasizes intricacy, inconsistency, ambiguity, tension, hybrid elements, and popular culture. All of these aspects are directly opposed to the International Style. Additionally, he borrows features and ideas from Antonio Gaudi, Sir

Edwin Lutyens, Pop Art, Main Street, and Las Vegas—blending aspects from both the past and the present. Venturi's ideas shake up the architectural world because he challenges the established modernist and International Style traditions. His new architectural principles confront the anonymity, purity, clarity, and simplicity in form and function of Modernism seen in the work of Mies van der Rohe and others. Venturi advocates the reintroduction of individuality, wit, and whimsy. He declares that "less is a bore," opposite to Mies's dictum that "less is more." Venturi, Denise Scott Brown, and Steven Izenour write *Learning from Las Vegas* (1972), which further challenges designers, this time to learn from and, even, emulate the glitzy architecture of Las Vegas with its meaningful symbolism and ability to communicate to people.

In Europe, Aldo Rossi's *L'Architectura della Citta* (1966) helps lay the theoretical foundations for Post Modernism. Stressing the importance of restoring monumentality to architecture, Rossi advocates the study and analysis of the development of cities to uncover urban typologies and longstanding social, cultural, and architectural traditions, which can be creatively interpreted in new architecture. Rossi's ideas establish a more political and social foundation along with a greater emphasis upon language. Consequently, Post Modernism in Europe contrasts with that in the United States where the expression aligns with consumerism and capitalism.

Post Modernism's principal theorist, architectural historian, and critic is Charles Jencks, who identifies its character in *The Language of Post-Modern Architecture* (1977). Jencks adopts concepts of literary criticism, most notably semiotics and multiple meanings, in his emphasis on visual communication of signs, symbols, and values. According to Jencks, buildings exhibit double coding. He means that a building speaks on two levels at once, both to the elite modern architects and to the more traditional-leaning public. Accordingly, a modern high-rise office box by Mies van der Rohe may appear intellectually pure and harmonious to the architect, but it represents a symbolic bland, factory-like shoebox to the private citizen. Post-Modern architects adopt a variety of means and meanings to achieve this communication goal, including historicism, revivalism, neo-vernacular, urban context, classical populism, metaphor, symbolism, and new extended space.

Jencks advocates eclecticism and stylistic pluralism to counter the abstractness of modernism. He suggests that, through careful selection and rational choice, the designer can use style to visually articulate a particular meaning or meanings unique to the building, location, or client. In this way, the design can produce the desired visual or communicative effects and convey purpose, symbolism, or monumentality. Public and private buildings may illustrate metaphors through a mixture of iconic symbols, traditional features, and cultural accents that speak in a language of popular American life. Jencks and others advocate ornament,

especially historic, in defiance of Modernism's belief in Loos's equation of ornament and crime. Layering of decoration that is filled with meaning is important.

Architects and designers respond to consumerism in two ways. First they create designs that become fine art and appeal to the consumer elite. Second, they design everyday objects, such as cutlery and door handles, giving them a distinct image and raising their aesthetic status. This deliberate attempt to create an image is substantially different from the goals of postwar designers. It also creates design celebrities and stars with recognizable design expressions to which the public enthusiastically responds. The media—television, magazines, books, and the Internet contribute to this new star quality.

DESIGN CHARACTERISTICS

In contrast to International Style and Geometric Modern, Post Modernism embraces individuality, social diversity, and a traditional or period character. Historicism, classicism, and eclecticism are key concepts, and designers creatively manipulate and reinterpret elements from the past to create new, modern, complex compositions. Reflecting the designers' pluralist approach, compositions may be eclectic, whimsical, bizarre, and/or exaggerated (Fig. 32-13, 32-14, 32-22, 32-28). They also may feature creative inventions, fragments, applied ornament, or ironic juxtapositions (Fig. 32-3, 32-5, 32-6, 32-16, 32-35, 32-39). Variety in size, shape, color, character, and architectural detail expresses diversity and individuality. Designers stress, abstract, imply, or differentiate key compositional features through difference in material and color variation, which sets up a scale of dominance and subordination. Layering of elements, juxtaposition of form, and projecting and receding elements create complexity that is supported or enhanced by contrasts and variations of color and materials. Works reflect an additive design method instead of the integrated one of the International Style. Interior space also is layered, although architects do not necessarily believe that exterior and interior should be connected as earlier modernists did. Sequencing and layering of spaces sometimes creates a sense of procession or infinite extension of space (Fig. 32-26). Designs, even in furniture, look somewhat like stage sets with allusions to the past.

Many Post-Modern designers creatively use or manipulate classical attributes such as scale or elements such as columns. Buildings, interiors, and furniture may display classical details and proportioning of base/bottom, column/midsection, and cornice/top (Fig. 32-6, 32-7, 32-10, 32-17, 32-25, 32-45). Designers ascribe symbolic meaning to architectural features, even in interiors and furniture. For example a fireplace or hearth can equate with the heart; walls may mean territoriality; a roof can symbolize shelter and crown; a column represents a man; and

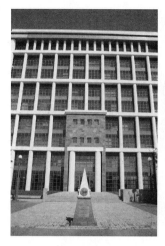
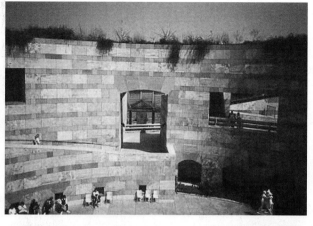

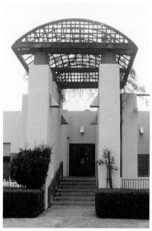
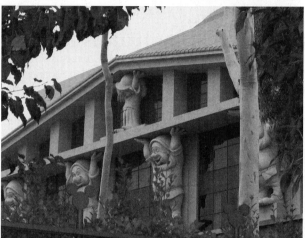

▲ **32-2.** Architectural and interior details; Aldo Rossi, James Stirling, Philip Johnson, Michael Graves, and Robert Stern.

chairs and tables may be symbolic of social interactions. Elements from local, regional, and national architectural history may be expressed in a more modern, symbolic, and distorted way within a small-scale space or a piece of furniture. Buildings, interiors, and furniture may be playful or present fanciful, cartoon-like, or entertainment-like designs and themes (Fig. 32-14, 32-29).

■ *Motifs*. Historically inspired motifs create a multilayered richness. Although many motifs from the past are revived, most come from classicism, including Greece, Rome, Egypt, and the Renaissance. They include columns, pediments, arches, stringcourses, and classical moldings (Fig. 32-2, 32-5, 32-6, 32-8, 32-10, 32-12, 32-25, 32-30). Designers also create motifs from client logos, letters or signs, and abstracted designs.

ARCHITECTURE

Post-Modern architecture displays a broad range of interpretations of the design principles identified by Jencks.

These principles include ornamentalism or more applied decoration; more and brighter color; contextualism through an identifiable relationship with and reinvention of past historical architecture; and allusionism in which the design relationship of the building relates to its intended purpose. Designs are unique with no rigid guidelines for expression. Designers emphasize figurative, poetic, and symbolic architectural language as opposed to the technical and utilitarian approach of the International Style. Often, the building silhouette, roofline, façade, and main entry convey the historical sources and decoration. Architects make items such as doors and windows human in scale unlike earlier large-scale Bauhaus or International Modern buildings with continuous window walls having no relation to people. They also distinguish parts of the building, such as walls and doors, through color, material, texture, and design to make them stand out individually and relate to known compositional parts in historic buildings. Wit and whimsy are important as seen in themed hotels and places such as Walt Disney World (Fig. 32-14, 32-29).

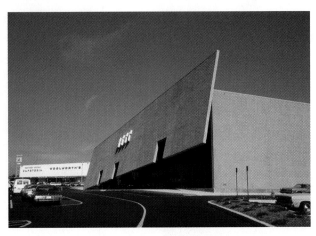

▲ **32-3.** Best Products Showrooms, 1976–1978; Sacramento, California, and Towson, Maryland; SITE Architects.

Public and Private Buildings

■ *Types.* Important public buildings include civic centers, corporate offices (Fig. 32-3, 32-7, 32-10, 32-11, 32-15), art museums, libraries (Fig. 32-17), hotels (Fig. 32-14), shopping centers (Fig. 32-12), exhibition displays (Fig. 32-5), expositions, garages, and medical facilities. The most stylistically expressive residential structures are custom-designed houses and public housing units (Fig. 32-18, 32-19, 32-20, 32-22).

■ *Site Orientation.* Commercial buildings often site in downtown urban areas and make a visible, distinct statement in

IMPORTANT BUILDINGS AND INTERIORS

■ **Burbank, California:**
- Feature Animation Building, 1995; Robert A. M. Stern.
- Team Disney Building, 1990; Michael Graves.

■ **Celebration Place, Florida:**
- Office complex, 1995; Aldo Rossi.

■ **Denver, Colorado:**
- Denver Public Library, 1991–1996; Michael Graves.

■ **Houston, Texas:**
- Best Products Showroom, Alameda Genoa Shopping Center, 1975; SITE Architects.
- Sunar Showroom, 1980; Michael Graves.

■ **Lake Buena Vista, Florida:**
- Casting Center, 1989; Robert A. M. Stern.
- The Dolphin Hotel and the Swan Hotel, Walt Disney World, 1989–1990; Michael Graves.

■ **Louisville, Kentucky:**
- Humana Building, 1982–1985; Michael Graves.

■ **Marne-La-Vallée, France:**
- The Palace of the Abraxas (apartment complex), 1978–1983; Ricardo Bofill.

■ **New Orleans, Louisiana:**
- Piazza d'Italia, 1975–1980; Charles Moore and William Hersey.

■ **New York City, New York:**
- AT&T (now Sony) Building, 1978–1984; Philip Johnson and John Burgee.
- Sunar Showroom, 1979; Michael Graves.

■ **Oakland, California:**
- Paulownia House, 1977; Thomas Gordon Smith.

■ **Philadelphia, Pennsylvania:**
- Franklin Court, 1972–1976; Venturi and Rauch.
- Guild House, 1961–1964; Robert Venturi.
- Vanna Venturi House, 1964; Chestnut Hill; Robert Venturi.

■ **Porter, Indiana:**
- Daisy House, 1976–1977; Stanley Tigerman.

■ **Portland, Oregon:**
- Portland Public Services Building, 1979–1980; Michael Graves.

■ **San Juan Capistrano, California:**
- Public Library, 1980; Michael Graves.

■ **Seattle, Washington:**
- Seattle Art Museum, 1991; Venturi Scott Brown and Associates.

■ **Stuttgart, Germany:**
- New Building and Chamber Theater, 1980–1983; James Stirling.

■ **Warren, New Jersey:**
- Plocek House, 1977; Michael Graves.

DESIGN PRACTITIONERS

- **Michael Graves** (b. 1934) designs buildings, interiors, furniture, rugs, decorative arts, and household items. His work is eclectic, often referencing the past. Also characteristic are elegant colors, rich textures, and aesthetically pleasing materials. Trained at the University of Cincinnati and Harvard, his study at the American Academy of Rome lends his work a classical inspiration. His best-known buildings are the Portland Building and the Dolphin and Swan Hotels in Florida.

- **Charles Moore** (1925–1993) is an architect, author of numerous books and essays, and teacher of architecture. When designing, he focuses upon client preference, sensory experiences, nature, and function. His work has a broad range of expressions but always maintains a strong relationship to the site and the historical context of location. Some of his best-known work is Sea Ranch in California and Piazza d'Italia in New Orleans.

- **Ettore Sottsass** (1917–2007), an architect, industrial designer, glassmaker, ceramicist, and theoretician, is best known as the founder of the Memphis Movement in 1981. Trained as an architect, Sottsass turns to industrial design after working with George Nelson in 1956. He becomes the leader of the Italian avant-garde design movement in the 1960s. In the 1980s, he returns to architecture and opens his own firm, Sottsass and Associates.

- **Robert A. M. Stern** (b. 1939) is a theorist and architect whose work shows a playful reinterpretation of historical influences and a strong relationship between building, site, and region. Stern often uses multiple materials to emphasize texture and contrast. Stern teaches at Columbia and becomes the dean of the School of Architecture at Yale.

- **Stanley Tigerman** (b. 1939), architect, strives to create a unique design solution for each client but one that reflects its time and place. His work is eclectic but reveals a classical vocabulary wittily reinvented. Somewhat theatrical, buildings and interiors reveal organic shapes and bright colors. One of his best known projects is the Daisy House in Indiana.

- **Robert Venturi** (b. 1925) is an architect whose work and writings inspire the critique of Modern architecture during the 1960s and ultimately shape aspects of Post Modernism. His work shows strong senses of context and history that are often ironically or whimsically reinterpreted. In 1960, he begins collaborating in teaching, practice, and research with urban planner Denise Scott Brown (b. 1931). They marry in 1967 and subsequently form the firm Venturi Scott Brown and Associates.

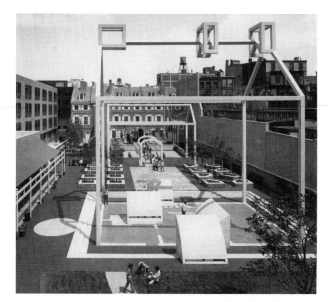

▲ **32-4.** Franklin Court, 1972–1976; Philadelphia, Pennsylvania; Venturi and Rauch.

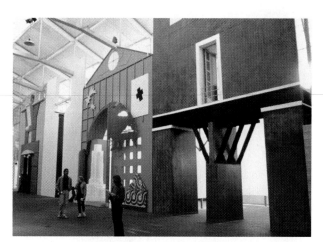

▲ **32-5.** La Strada Novissima—Presence of the Past (street facades), Venice Biennale, 1980; Venice, Italy (as reconstructed in 1982 in San Francisco, California); by Joseph-Paul Kleihaus, Stanley Tigerman, Hans Hollein, Thomas Gordon Smith, Fernando Montes, and Alan Greenburg.

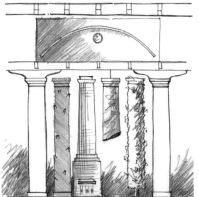

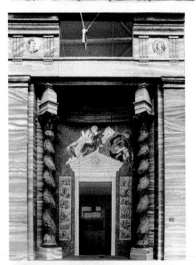

▲ **32-5.** *(continued)*

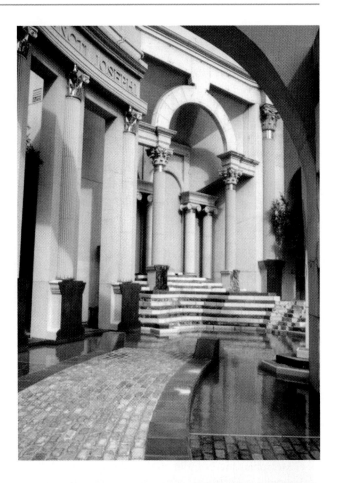

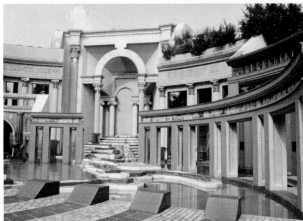

▲ **32-6.** Piazza d'Italia, 1975–1980; New Orleans, Louisiana; Charles Moore and William Hersey.

their environment. Examples include the Portland Public Services Building (Fig. 32-7) in Portland, Oregon, by Michael Graves and the AT&T (now Sony) Building (Fig. 32-10) in New York City by Johnson and Burgee. Some may appear in a park-like setting, which creates a sort of sanctuary around them. Examples include art museums, libraries, and social buildings such as Piazza d'Italia (Fig. 32-6)

DESIGN SPOTLIGHT

Architecture: Portland Public Services Building, 1979–1980; Portland, Oregon; Michael Graves. This first major public building of Post Modernism (and by Graves) helps establish Post Modern as a mainstream architectural style. Featuring classical formality, ornament, and implied details, the building is a bold off-white rectangular block resting on a dark green base. Seven-story barred windows with heavy keystones or stylized swags embellish the facades. A change of color suggests the shaft of a column with triangular capital above on the other facades. A grid of small, square windows repeats around the perimeter. The small square windows do not permit much needed light into the interiors. Much criticized for the ornament, color, and cramped interiors, nevertheless Graves's composition strives to capture the progressive spirit of the city.

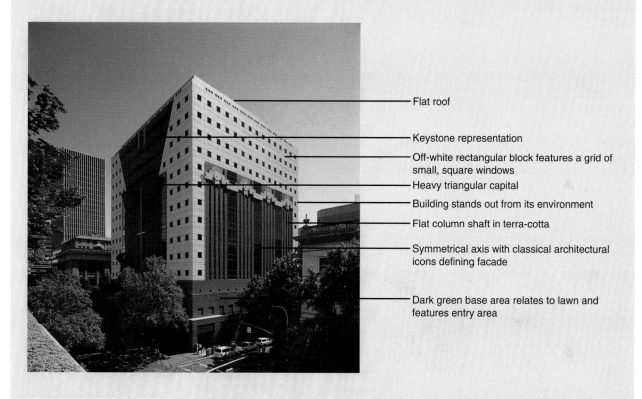

Flat roof

Keystone representation

Off-white rectangular block features a grid of small, square windows

Heavy triangular capital

Building stands out from its environment

Flat column shaft in terra-cotta

Symmetrical axis with classical architectural icons defining facade

Dark green base area relates to lawn and features entry area

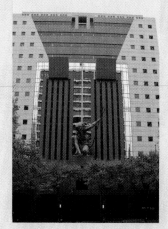

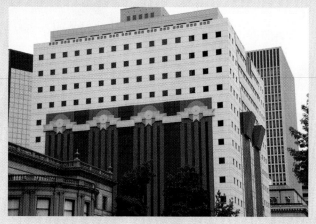

▲ **32–7.** Portland Public Services Building; Portland, Oregon.

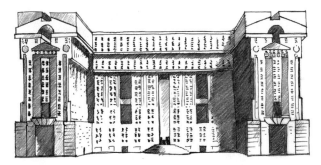

▲ **32-8.** The Palace of the Abraxas, 1978–1983; Marne-La-Vallée, France; Ricardo Bofill.

in New Orleans, Louisiana, by Charles Moore and William Hersey. Architect-designed houses and housing units may also appear in park-like settings with green and/or water space around them or nearby, as in the Daisy House (Fig. 32-20) in Indiana by Stanley Tigerman and the Palace of the Abraxas (Fig. 32-8) in France by Ricardo Bofill.

■ *Floor Plans.* Floor plans for both public and private buildings vary considerably based on facility type, user needs, and architectural expression. But several key characteristics shape and define the Post-Modern planning.

Because of the frequent use of historical allusions, buildings often follow a structured processional development of space (Fig. 32-21, 32-22, 32-26) with changes in the scale of rooms (small to large), definition of classical features (columns and niches), and articulation of ceiling designs (layered, rounded, and pitched). Mixed with the blended period features are juxtapositions and fragments of new elements, such as the layering of planes, angling of an important axis, distortion of circulation flow, and an extension of abstract space. Because these new components are usually unexpected, they give contrast, ambiguity, and tension—distinctive features of Post-Modern plans.

■ *Materials.* Brick, polished marble, and rusticated stone are common building materials, along with wood, concrete, plastic, aluminum, and glass. Painted finishes are prevalent (Fig. 32-7, 32-14). Post Modernism exhibits a wider range and more decorative use of materials per building than the International Style does.

■ *Color.* Colors inspired by designers, such as Michael Graves (Fig. 32-7, 32-14, 32-17, 32-25, 32-29), include dusty pink, mauve, terra-cotta, pale yellow, blue, aqua, and celadon. Materials are often selected because of their color impact.

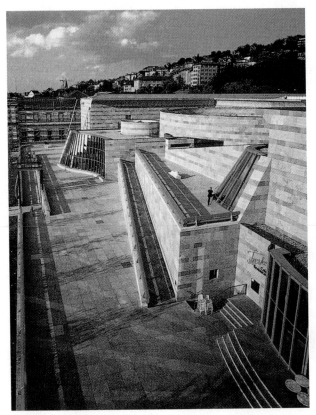

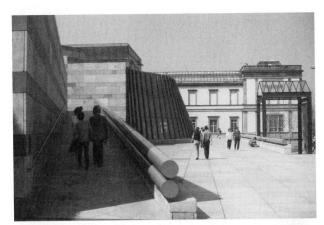

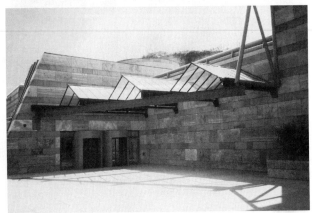

▲ **32-9.** Neue Staatsgalerie and Chamber Theater, 1980–1984; Stuttgart, Germany; by James Stirling, and Michael Wilford and Associates.

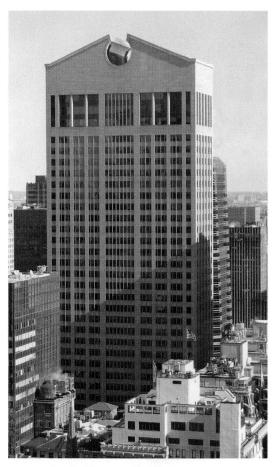

▲ **32-10.** AT&T (now Sony) Building, 1978–1984; New York City, New York; Philip Johnson and John Burgee.

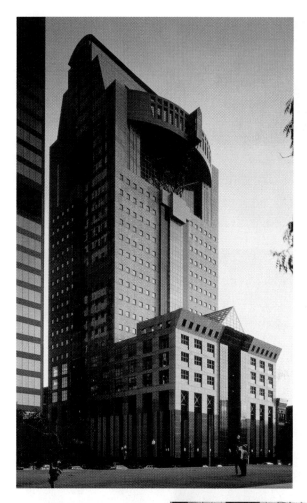

▲ **32-11.** Humana Building, 1982–1985; Louisville, Kentucky; Michael Graves.

■ *Façades.* As the most important and distinguishing feature of a building, the façade establishes the juxtaposition of complexity and contradiction between space and plane, historical allusion and contemporary statement, traditional materials and new ones, formal movement and distorted fragments, and the language of double coding to achieve intellectual as well as popular meaning (Fig. 32-3, 32-4, 32-6, 32-7, 32-9, 32-10, 32-12, 32-13, 32-14, 32-15, 32-16, 32-17, 32-18). Complexities of color and material are important. Façades may be flat with materials or color defining features or decoration. Others are layered with projecting and receding rectangular and rounded elements. Often the exterior shows influences of the International Style (rectangular fixed glass windows bound in thin metal) mixed with witty, sometimes humorous symbols (a Chippendale-style roof with a Palladian arch composition at the base, as on the AT&T Building, Fig. 32-10). Sometimes grand classical influences mix with local vernacular ones, creating an interplay of, as well as opposition to, formal and informal organization, architectural features, and construction details. An entryway composed of a standardized

arch and columns of rusticated wood, on the Paulownia House in Oakland, California, by Thomas Gordon Smith is an example (Fig. 32-22). Pseudohistorical design interpretations are common. Historical influences derive from many facets of design history, including classical, regional, and local forms and details. Some architects incorporate

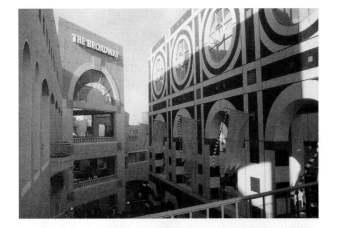

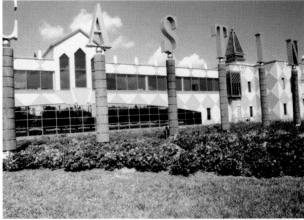

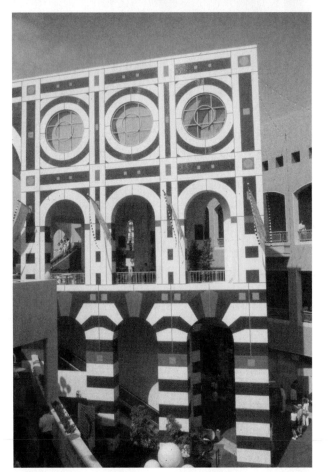

▲ **32-12.** Horton Plaza Shopping Center, 1985; San Diego, California; Jerde Partnership.

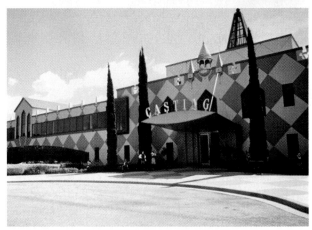

▲ **32-13.** Casting Center, 1989; Lake Buena Vista, Florida; Robert Stern.

surface pattern, letters, signs, and figures into the façade design.

■ *Windows.* Most windows are of fixed glass or double hung and often appear in a modern-style grid (Fig. 32-7, 32-10, 32-11, 32-14, 32-15, 32-17, 32-18). But sizes and shapes vary significantly based on the individual design, designer, and building type (Fig. 32-20). Compositions are symmetrical or asymmetrical, or there may be a combination of both in one building. Frames are of metal or wood. Moldings may enhance the sill line or the surrounding window area. Some window designs are very plain and nondescript following the International Style influence, while others have more historical characteristics related to the particular building.

■ *Entry.* One of the most expressive components of a Post-Modern building is the prominent entry because it conveys the overall character and sets the stage for what is to come (Fig. 32-13, 32-14, 32-16, 32-18, 32-19, 32-22). Sometimes it appears as an integrated unit within the façade design, and at other times it is separated to make a dominant, distinct statement. Designs vary widely by building type as well as designer. There is no common expression. Graves, Smith, and others often incorporate columns and a classical vocabulary at the entry.

■ *Roofs.* Roofs may be angled, flat (Fig. 32-7, 32-15), curved, follow an historical source (Fig. 32-4, 32-10), or have a variety of irregular shapes (Fig. 32-9, 32-11, 32-13, 32-14, 32-16, 32-17, 32-19). As an important component of the building character, they help to convey unique architectural design

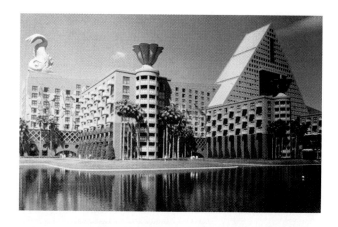

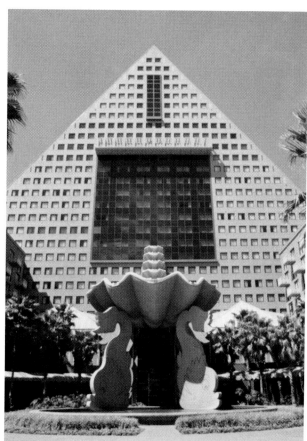

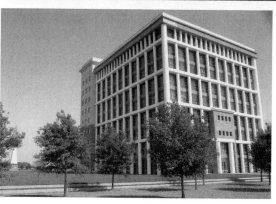

▲ **32-14.** The Dolphin and Swan Hotels, Walt Disney World, 1989–1990; Lake Buena Vista, Florida; Michael Graves.

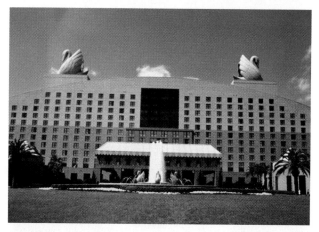

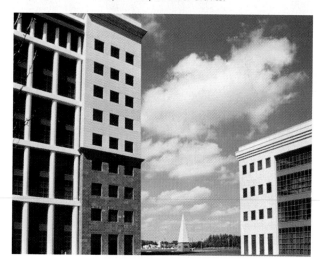

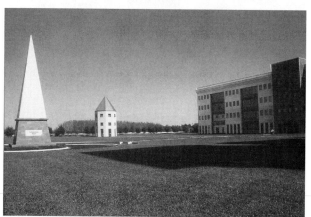

▲ **32-15.** Office complex, 1995; Celebration Place, Florida; Aldo Rossi.

▲ **32-16.** Feature Animation Building, 1995; Burbank, California; Robert Stern.

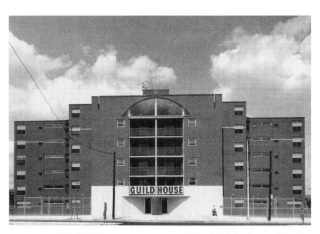

▲ **32-18.** Guild House, 1961–1964; Philadelphia, Pennsylvania; Robert Venturi.

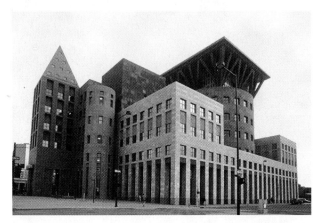

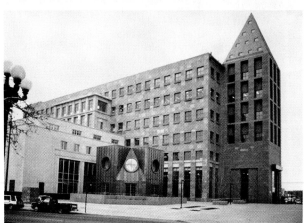

▲ **32-17.** Denver Public Library, 1991–1996; Denver, Colorado; Michael Graves.

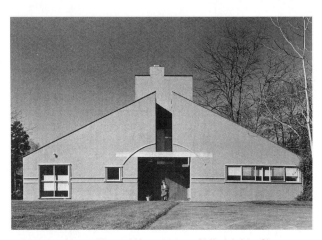

▲ **32-19.** Vanna Venturi House, 1964; Philadelphia, Chestnut Hill, Pennsylvania; Robert Venturi.

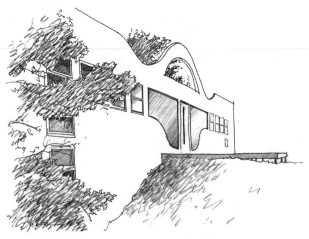

▲ **32-20.** Daisy House, 1976–1977; Porter, Indiana; Stanley Tigerman.

features, establish the identity, provide wayfinding attributes in a busy skyline, and/or provide a crowning detail at the top of a building. Variety in design distinguishes one building from another and from other modernist influences. Post-Modern architects, in reaction to the ubiquitous Modernist flat roof, revive the gabled and shed roof. Roofs were rarely highlighted in the International Style.

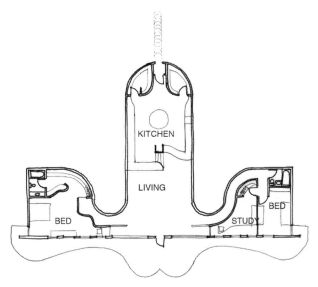

▲ **32-21.** Floor plan, Daisy House, 1976–1977; Porter, Indiana; Stanley Tigerman.

▲ **32-22.** Paulownia House, 1977; Oakland, California, and Matthews Street House, 1978; San Francisco area, California; Thomas Gordon Smith.

■ *Later Interpretations.* Examples of Post-Modern architecture continue in later commercial, retail, and hospitality environments, such as in Las Vegas (Fig. 32-23), in their emphasis on period revival styles, more color, human-scaled spaces, user needs, and theatrical compositions. Post-Modern-style apartments and houses, both builder and architect designed, appear in urban and suburban contexts.

▲ **32-23.** Paris Las Vegas Hotel, c. 1990; Las Vegas, Nevada. Modern Historicism.

INTERIORS

Architects and interior designers create interiors with attention to interior structure, decoration, and color. They use layered, angled, and/or sloped walls and details, color, pattern, and ornament to eliminate the simple, spare rectangular box of the International Style. Historical allusions and details, especially classical ones, are

▲ **32-24.** Interior, travel agency, 1976–1978; Opernring, Vienna, Austria; Hans Hollein.

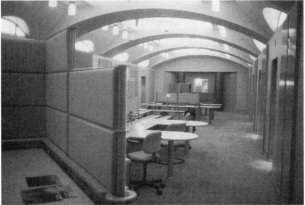

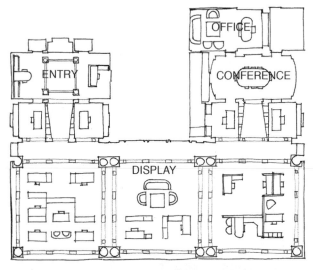

▲ **32-25.** Sunar Furniture Showrooms, 1979–1981; Los Angeles, California, Houston and Dallas, Texas, and London, England; Michael Graves.

▲ **32-26.** Floor plan, Sunar Furniture Showroom, 1979; Houston, Texas; Michael Graves.

common, which gives rise to a revival of traditional style and/or revivalist interiors. Some interiors are highly sophisticated while others are kitsch, bizarre, or ironic. Designers mix high-quality materials such as marble (symbolic of wealth) with less sophisticated materials such as plastic laminate (symbolic of the masses) to achieve contradiction and complexity. Some spaces incorporate dramatic elements such as staircases and water features. Architects' own houses often showcase their ideas or are experiments. Jencks explores themes and symbolism in his Thematic House in London, where each room is inspired by a different historical style or particular season.

■ *Memphis Design.* The avant-garde Italian group Memphis is launched in Italy in 1981 by Ettore Sottsass (Fig. 32-27, 32-44) during the Milan Furniture Fair. Its roots are in the 1970s in the work of Sottsass and others, along with Studio Alchymia in Milan. Memphis takes its name from the Bob Dylan song "Stuck Outside of Mobile with the Memphis Blues." It also alludes to the capital of ancient Egypt and the home of Elvis Presley in a contrast of high and low, elite and popular culture design. Other important Memphis designers include Michele de Lucchi (Fig. 32-37), Nathalie du Pasquier, Marco Zanini, Peter Shire (Fig. 32-38), Javier Mariscal, Matteo Thun, and Andrea Branzi. Their work collectively incorporates fanciful, playful, unexpected designs for interiors and furniture inspired by suburban pop, Asian and Middle Eastern

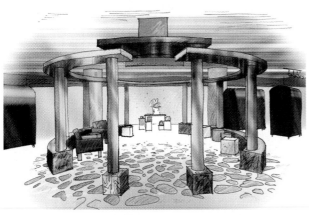

▲ **32-27.** Reception, Esprit showroom, and residential interior, c. 1970s–1980s; Europe; Ettore Sottsass, Memphis.

traditions, and the Arts and Crafts Movement. It is highly individualistic and quirky, but generally unified. Designs favor discontinuity among parts, a new creative expression, use of decoration and color, and the relationship between people and things.

Public and Private Buildings

■ *Types*. Some of the most important Post-Modern designs appear in offices (Fig. 32-24), showrooms (Fig. 32-25, 32-26, 32-27), lobbies (Fig. 32-28, 32-29, 32-30), restaurants, casi-

nos and nightclubs, and exhibition areas as well as all types of residential interior spaces.

■ *Relationships*. Interiors may maintain a strong relationship to exteriors by using Post-Modern influences such as complexity. Some illustrate a more architectural character, while others are more decorative.

■ *Color*. Following exterior colors by Graves and others, interiors repeat the palette of dusty pink, mauve, terra-cotta, pale yellow, blue, aqua, celadon, and white (Fig. 32-25, 32-29, 32-31). Individual colors are usually light and include a combination of earthy tones mixed with pastel ones.

Sometimes bold colors, including the primaries, are used. Memphis uses pastels and various shades of brighter colors that include yellow-gold, red-orange, blue, and green

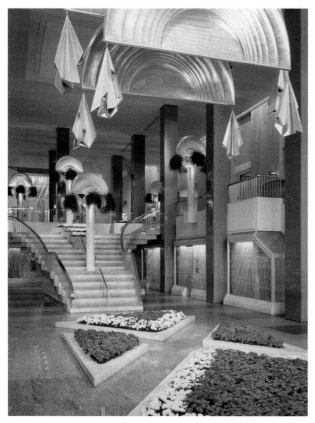

▲ **32-28.** Lobby area, Pan Am Building (later known as Met Life), 1987; New York City, New York; Warren Platner.

(Fig. 32-27, 32-33). Gray, black, and white often become accents to enhance the character of a space.

■ *Lighting.* Interior lighting plans incorporate direct and indirect incandescent, fluorescent, neon, and/or halogen lamps for illumination. Lighting is often dramatic and highlights architectural elements and interior forms. Graves, for example, likes to use indirect lighting hidden in coves, cornices, and brackets (Fig. 32-25). Architects often design custom lighting fixtures and applications for their interiors. Table and floor lamps, sconces, chandeliers, pendant lights, and surface-mounted ceiling fixtures are in forms, materials, and design that complement the interior (Fig. 32-32). They may be in wood, ceramic, or metal with large, simple round globes. Many resemble miniature buildings and feature classical motifs. Memphis designers specialize in table and floor lamps in unique designs that convey whimsy and humor (Fig. 32-32). Usually represented in bright, bold colors mixed with black and white, they stand out as art objects in an interior.

■ *Floors.* Both commercial and residential interiors reveal substantial changes in the design of floors and in the variety of materials used. Common flooring materials include ceramic tile, marble, stone, brick, wood, vinyl, and carpet (Fig. 32-27, 32-34). Architects sometimes design custom wall-to-wall carpets or rugs for their interiors. Designs may be stylized flowers, architectural elements such as columns and capitals, asymmetrical designs, geometric shapes, blocks of color, or interior elements such as pediments. Memphis carpets display bold colors and patterns that are geometric or abstract and often directional.

■ *Walls.* Walls, especially on Memphis-designed interiors, are plain and white, off-white, or pastels when they serve as backdrops for furnishings and decorative arts objects. Blocks of color define or separate walls, architectural

DESIGN SPOTLIGHT

Interiors: Lobbies, the Dolphin and Swan Hotels, 1990; Disney World at Epcot Center, Lake Buena Vista, Florida; Michael Graves. Graves's designs reflect Walt Disney's emphasis upon architecture as a visual metaphor for American themes, dreams, and myths as well as imagination and entertainment. Using Florida colors of turquoise and coral, with repetition, stylization, and whimsy, Graves creates a themed architecture, inside and out, that communicates Disney's ideals to visitors and supports the theme park experience. His sophisticated, unliteral concept combines Florida beaches and resorts with Disney fun and delight. Looking back to the Baroque, Graves chooses Dolphins and Swans as the main characters instead of Disney cartoon figures or

movie motifs. The architecture merges painted stylized triangles and rectangles embellished with square windows on a grid with theatrical and three-dimensional, overscaled cabanas, fish, swans, banana leaves, and fountains. There is constant contrast between sophistication and whimsy, symmetry and asymmetry, and line and form. The escalator lobby of the Dolphin repeats the tent or cabana theme of the main lobby but in bold, flat, stylized, painted drapery instead of fabric. The Swan lobby is a play on a Victorian conservatory but with giant, stylized banana leaves and a striped ceiling that repeats the cabana theme. Graves also designs carpets, furniture, light fixtures, and tableware to complete the concept for both hotels.

DESIGN SPOTLIGHT *(continued)*

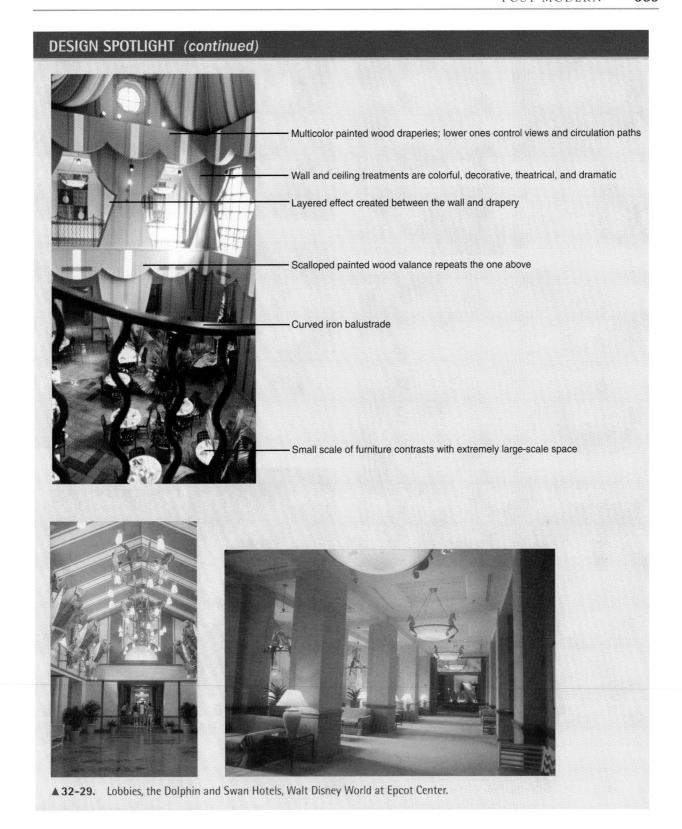

Multicolor painted wood draperies; lower ones control views and circulation paths

Wall and ceiling treatments are colorful, decorative, theatrical, and dramatic

Layered effect created between the wall and drapery

Scalloped painted wood valance repeats the one above

Curved iron balustrade

Small scale of furniture contrasts with extremely large-scale space

▲ **32-29.** Lobbies, the Dolphin and Swan Hotels, Walt Disney World at Epcot Center.

features, projections, niches, layering, or progression (Fig. 32-25, 32-27, 32-29, 32-31). Alternative treatments include wood paneling; sometimes rustic, textural contrasts; or decorative murals. Venetian plaster with its multilayered effect also becomes popular. Some designers use more architectural delineation in their compositions that reflect the classical character and tripartite system of base, shaft, and cornice. Colorful columns, cornice, and

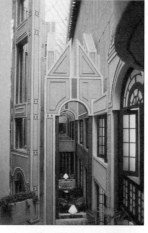
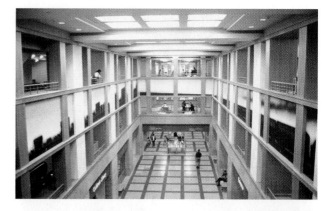

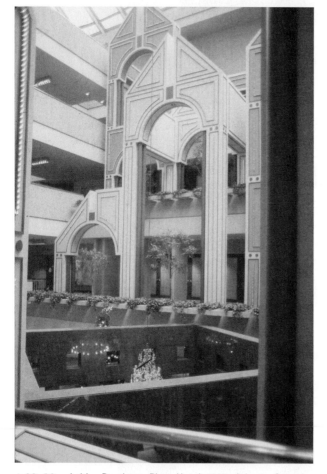
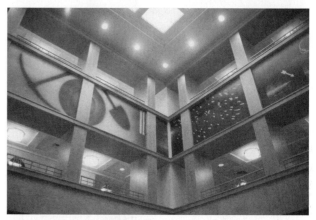

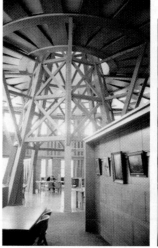
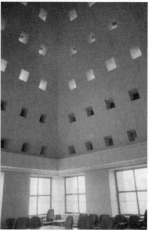

▲ 32–30. Lobby, Peachtree Plaza Hotel, 1990; Atlanta, Georgia.

▲ 32–31. Interiors, Denver Public Library, 1991–1996; Denver, Colorado; Michael Graves.

trim complement walls that are either plain, have a solid–void square design, or display a decorative mural. Some designers, such as Moore and Graves, like to emphasize vistas, so unique focal points (architectural or painted) often appear on walls at the end of passage ways (Fig. 32-25).

■ *Windows.* Arched or rectangular windows support the Post-Modern emphasis upon complexity and whimsy.

Occasionally, they are surrounded by architectural details (Fig. 32-29), but most have moldings. Window treatments, which are less important than architectural details, especially in commercial interiors, are simple panels either plain or in colors that support or complement the space.

■ *Textiles and Plastic Laminates.* Memphis textiles (also used for upholstery) and plastic laminates exhibit a funky

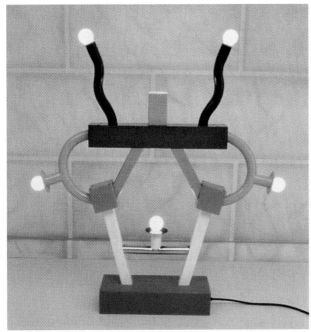

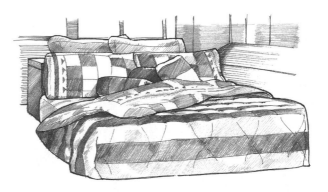

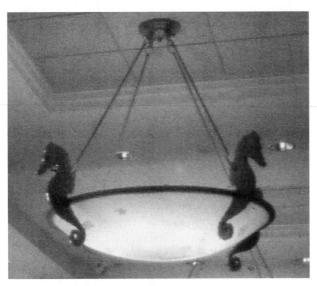

▲ **32-32.** Lighting: Ashoka lamp, 1981, Ettore Sottsass; and chandeliers, c. 1980s, Michael Graves.

▲ **32-33.** Textiles: Studio Alchimia/Memphis; c. 1980s; Milan; Italy.

▲ **32-34.** Carpets: wall-to-wall carpets, Denver Public Library, 1996; Denver, Colorado; Michael Graves.

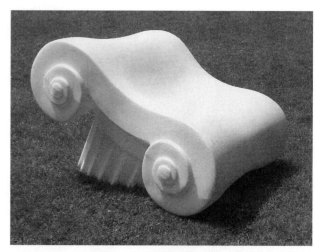

▲ **32-35.** Capitello (foam capital chair), 1971; Studio 65, manufactured in Italy.

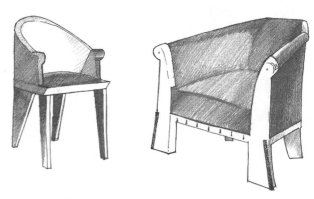

▲ **32-36.** Side chair and armchair, 1977–1981; Michael Graves.

character, dense patterns, and vibrant colors (Fig. 32-33, 32-40, 32-43). The palettes and patterns come from video games, television, ethnic textiles, new-wave graphics, and pop culture, and create a lot of energy and tension in the compositions. Patterns are often abstract shapes that look like microbes, zigzags, dots, inkspots, or electronic wavelengths. Each pattern is unique and distinctive. Fabrics include cotton, wool, polyester, and canvas. They become immensely popular.

■ *Ceilings.* Ceilings may be plainly treated, decorated with paintings, or coffers, compartments, layers, or coves (Fig. 32-24, 32-25, 32-27, 32-29, 32-31). High-style spaces, such as office lobbies, showrooms, hotels, and houses, often have the most dramatic treatments with prominent recessed or concealed lighting, stepped or layered elements, or bold angles.

■ *Later Interpretations.* Post-Modern characteristics in interiors continue through the end of the 20th century, but fade quickly with the emergence of new design directions. But ideas about the treatment of color, pattern, and historical features continue to be sources of inspiration for some designers.

FURNISHINGS AND DECORATIVE ARTS

Post-Modern architecture inspires Post-Modern furniture as designers reject the spare International Style in favor of historicism, color, pattern, and ornament. Like their predecessors, many Post-Modern architects design furniture and decorative objects. In opposition to postwar and International Style furniture design philosophies,

Post-Modern furniture designers want to create fine art instead of designing for mass production. They intend their works to last instead of succumbing to the notion of planned obsolescence like in Pop furniture. Post Modernists believe that style is paramount to function, so they select and adapt elements from all past styles but favor classicism, Neoclassicism, Biedermeier, and Art Deco. Other influences include Pop Art, surrealism, and kitsch. Post-Modern furniture often playfully reinterprets the forms and motifs of the past using unusual or unexpected materials, exuberant color, and abundant ornament (Fig. 32-35, 32-36, 32-39, 32-41, 32-45). Traditionalism is especially strong among American and British designers, whereas Europeans and the Japanese favor a more futurist approach. Reacting to the anonymous machine aesthetic of the Bauhaus and International Style and responding to late-19th-century ideas, designers create furniture as art, which appears as unique objects placed or scattered about an interior.

■ *Memphis.* Memphis furniture intentionally mocks Modernism and challenges ideals of traditional decorating,

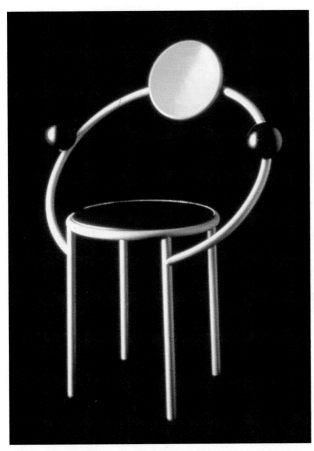

▲ **32-37.** First chair, 1983; Michele De Lucchi, manufactured by Memphis Milano.

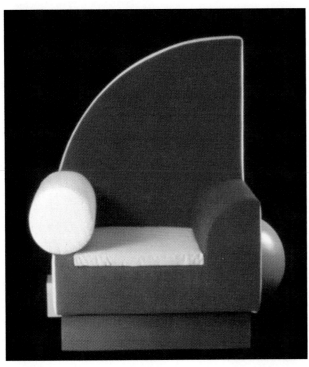

▲ **32-38.** Bel Air armchair, 1982; Peter Shire, manufactured by Memphis Milano.

▲ **32-39.** Queen Anne, Sheraton, Art Deco and other side chairs, 1984; Robert Venturi, manufactured by Knoll International.

such as a Memphis living room filled with furniture that opposes the notion of status, wealth, and formality. Although often made of inexpensive materials, Memphis furniture is not inexpensive. Furniture has defined planes with large blocks of color or pattern, straight and curved lines, and an asymmetrical emphasis (Fig. 32-37, 32-38, 32-40, 32-43, 32-44). Pieces combine broad areas of color and decoration in geometric shapes, cubes, cones, pyramids, and/or spheres. Contrasts of materials are a key feature and evident in combinations of luxurious materials with inexpensive ones, such as costly wood used with

DESIGN SPOTLIGHT

Furniture: Kandissi sofa, 1978; Alessandro Mendini, from Studio Alchimia/Memphis Milano. Memphis designers challenge the intellectual content they see lacking in modern mass-produced objects. Striving to create a new symbolic design language, Mendini redesigns classic pieces such as Breuer's Wassily chair. Here, he attempts to overcome the banality of the traditional sofa by reforming it with innovative colors, patterns, and forms. The Kandissi sofa has lacquered wood in angular forms and a boldly patterned upholstered seat and back.

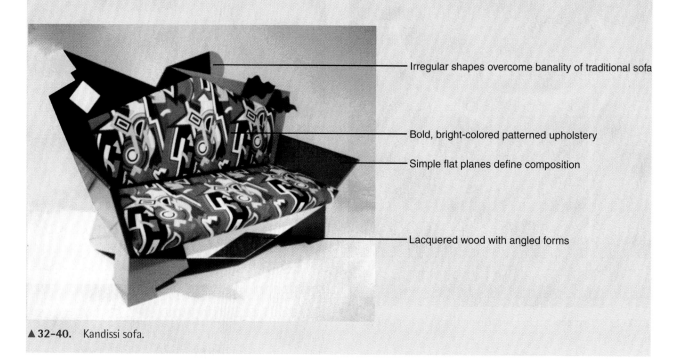

— Irregular shapes overcome banality of traditional sofa

— Bold, bright-colored patterned upholstery

— Simple flat planes define composition

— Lacquered wood with angled forms

▲ **32-40.** Kandissi sofa.

▲ **32-41.** Marilyn and Mitzi sofas, 1981; Hans Hollein, manufactured by Poltronova in Italy.

plastic laminate. Structure integrates with decoration and/or color and defines and identifies volume. Memphis designers create patterns that are abstract, repeating, and nondirectional, and they are often presented as plastic laminates. Color and pattern are defining elements. Bright primaries, pastels, neutrals, black, and white may be combined in a single piece. And each part of a piece may be a different color and/or pattern. Examples may look odd because they challenge common or traditional notions of comfort and function. They require people to question how they interact with furniture in an interior and, in essence, question their living patterns.

Public and Private Buildings

■ *Types.* No new types of furniture are introduced, but existing ones are redesigned in unusual or odd ways or with traditional forms and motifs. Sometimes individual pieces are blended hybrids serving double functions.

■ *Distinctive Features.* Individual furniture pieces are unique and unusual, with no common characteristics other than exhibiting the creativity of the designer. Common to most furniture are ornament, pattern, and color.

▲ **32-43.** Kyoto end table, c. 1980s; Shiro Kuramata, manufactured by Memphis Milano.

▲ **32-42.** Bench, table, and storage, Denver Public Library, 1996; Denver, Colorado; Michael Graves.

■ *Relationships*. Furniture maintains a relationship to architecture through materials, forms, and motifs, which may be derived from styles of the past.

■ *Materials*. Materials include wood (plain, painted, and lacquered), aluminum, steel, plastic laminate, marble, glass, and mirrors. The important innovations of Post Modern and Memphis are the widespread use of plain and decorated plastic laminate and industrial materials, such as sheet metals, industrial paint, neon, colored lights, and decorated glass. Designers especially like materials that imitate other materials. In its use of common materials in high-style designer furniture, Memphis challenges the notion that a particular material conveys a symbolic meaning about living in the world.

■ *Seating*. Seating pieces illustrate wide diversity and uniqueness in design. There is much experimentation with form and shape, solid and void relationships, color, character, decoration, and materials. A pseudoperiod vocabulary defines work by Graves, Venturi, and others. Graves often uses expensive veneers and painted finishes (Fig. 32-36, 32-45). Venturi experiments with historical symbolism in his series of chairs for Knoll International produced in molded plywood covered in laminate or painted, and lacquered (Fig. 32-39). Memphis designers incorporate simpler lines and forms with bright color. Sofas and many chairs are composed of broad planes or geometric volumes of different colors or patterns (Fig. 32-37, 32-38, 32-40). Some have wood or laminate trim.

■ *Tables*. Tables evidence a wide variety of forms. Some have period features, and others are decidedly simple. Tops, plain or patterned, may be square, rectangular, round, oval,

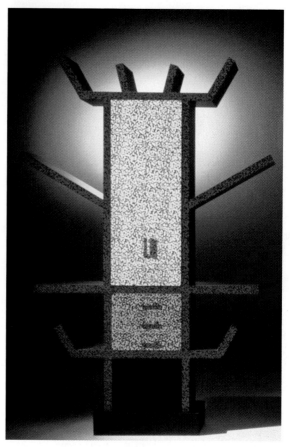

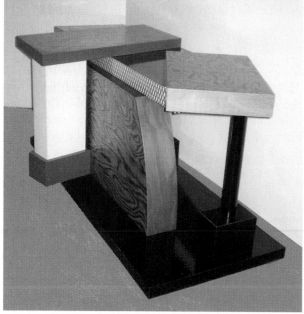

▲ **32-44.** Carlton and Casablanca shelving units, 1981; and Tatar Console, 1985; Ettore Sottsass, manufactured by Memphis Milano.

or a fragmented shape with edges that are straight, curved, angled, or broken. Legs are straight, curved, tubular, round and tapered, boxy, and angled. The Plaza dressing table (Fig. 32-45) designed by Graves reflects an architectonic quality with period influences. Some Memphis tables seem to be heavy and monumental, while others are light and playful (Fig. 32-43). There are few smaller lamp tables.

■ *Storage.* Memphis storage displays a mixture of bright colors, unusual patterns, and funky materials. The overall form may follow a conventional model or it may be

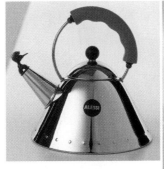
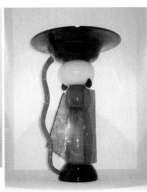

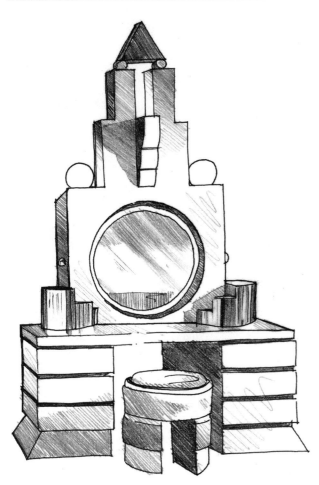

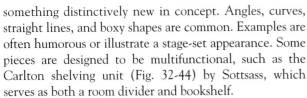

▲ **32-45.** Plaza dressing table and stool, 1981; Michael Graves, manufactured by Memphis Milano.

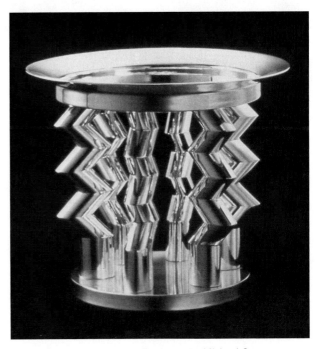

▲ **32-46.** Decorative Arts: Tea kettle by Michael Graves, manufactured by Alessi; glass vase and Murmansk compote by Ettore Sottsass, c. 1970s–1990s; Italy.

something distinctively new in concept. Angles, curves, straight lines, and boxy shapes are common. Examples are often humorous or illustrate a stage-set appearance. Some pieces are designed to be multifunctional, such as the Carlton shelving unit (Fig. 32-44) by Sottsass, which serves as both a room divider and bookshelf.

■ *Beds.* There are only a few new bed designs. The most well known one is the Stanhope by Graves. Because it is expensive, with few in production, it is considered a collector's item. A few Memphis designers create beds composed of geometric planes and solids in contrasting colors.

■ *Decorative Arts.* Post-Modern architects including Venturi, Moore, Tigerman, Graves, and Jencks design decorative accessories such as clocks and tea services (Fig. 32-46). Some also design flatware, china, and even jewelry. These objects in wood, metal, ceramic, and plastic often have a

distinct and recognizable image created by the individual designer. Similar in concept to architecture and featuring an additive approach, forms sometimes resemble small buildings or building types. Classical details are common. In the 1990s, Graves markets designs through Target, a discount department store with a progressive design outlook. Memphis designers produce highly unusual clocks, vases, glassware, and accessory items in bright colors and/or shiny metals. They are designed to fit in a Post-Modern interior furnished in Memphis and other furniture.

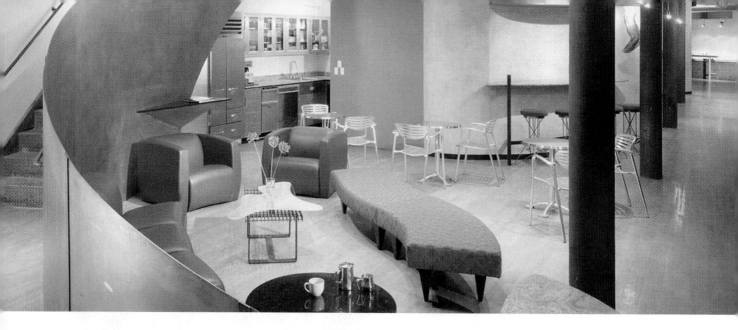

CHAPTER 33

Late
Modern • 2
Mid-1980s–2000s

I think we should actually ignore the historical details and just make very contemporary installations, additions, spaces and objects that are touching this milieu. The past is the past. There is absolutely no reason to imitate or simulate it—or try to marry it. It is our history to respect, and admire, but to let it go—almost as the historic stage sets our props of life—and allow it to exist as monuments of our past, and only that. We must evolve the world and everyday life.

Karim Rashid,
interview in Richmond, Virginia's, *Home Style*, May 2005

Foster + Partners' architecture is driven by the pursuit of quality—a belief that our surroundings directly influence the quality of our lives, whether in the work place, at home or the public spaces in between. It is not just buildings but urban design that affects our well-being. We are concerned with the physical context of a project, sensitive to the culture and climate of their place. . . . The quest for quality embraces the physical performance of buildings.

Norman Foster and Partners,
firm Web site, 2007

No single look dominates Late Modern · 2, a period that continues the language of Geometric Modern and Late Modern · 1. During this time, design plurality is more common than ever. Designers experiment with form, shape, construction methods, and new materials to express the information age, consumerism, and global economy of their time. Architectural, interior, and furniture forms become even more complex as designers now have the technology and other means to create what they can imagine.

HISTORICAL AND SOCIAL

The 1980s are marked by conservatism and economic prosperity as inflation and unemployment of the 1970s decrease. The Cold War ends as Communism weakens, and the Soviet Union dissolves. In 1989, the Berlin Wall tumbles, uniting East and West Germany, once more. However, wars in Latin America and the Middle East and increasing terrorism by radical groups threaten peace across much of the world. During the 1990s, prosperity continues as the global economy expands. Some businesses are forced to make major changes in number of employees, locations, and product lines to compete in world markets. Blue-collar jobs decline as those in the service sector increase. People become more and more dependent upon technology in daily life. A new youth culture develops that is greatly influenced by the media and new technologies, such as cell phones, music videos, and computer games. Increasing violence and vulgarization define popular culture.

The 1980s begin a worldwide shift from an industrial to a postindustrial or information age. This means that technology and information expand and economies rely more on the service sectors, including managers and technicians, instead of manufacturing. As a result, knowledge, ideas, imagination, and creativity become the raw materials of production instead of steel and iron. This trend also is tied to the development of the personal computer and an increasingly global economy. There is also a greater disparity between the have and have-not nations. For instance, subsistence countries, primarily in Africa and East Asia, are often in conflict with the developed countries of North America and Europe.

With the miniaturization of room-size computers to desk size and laptops and the introduction of the Internet and cell phones in the 1990s, business is more easily conducted and worldwide connections and communications are nearly instantaneous. Businesses link or partner with each other, or they expand or move their operations overseas to reduce labor costs. Foreigners invest more heavily in the economy of the United States and vice versa. Countries across the globe enter into trade agreements, such as the Asia Pacific Economic Cooperation Agreement, to ensure the best trade policies are created. As the end of the 20th century approaches, fear of the end and the negative influences and failures of technology plague humankind. As the 21st century begins, the world is made up of highly industrial and technological societies with high rates of literacy and standards of living. In contrast, there are many underdeveloped nations with low literacy rates and standards of living and high rates of disease.

CONCEPTS

During the period, architects and designers continue to explore what it means to be modern in the context of the postindustrial age. As in the 1960s, they experiment with various approaches, methods, and means to achieve their individual or collective visions of the information age, new technologies, and the global economy. As before, no single country, movement, style, or look dominates. Alternative expressions are more acceptable than ever before in the history of design. Previously designers' ideas were often ahead of technology, but now new materials, construction techniques, and design tools enable them to construct whatever they imagine. During the 1980s and 1990s, digital technology for design and manufacturing become significant supporting tools that allow imaginations to soar beyond efficiency and standardization.

Typologies, monumentality, and image are important topics for discussion and debate as designers explore how to express power, authority, respectability, and responsibility in an international context. Nevertheless, the individuality of designer and/or client continues to drive concepts,

▲ **33-1.** Sir Norman Foster, c. 1990s, and Arthur Gensler, c. 2000s.

and image and branding are even more important to distinguish one community, corporation, retail outlet, or person from another. Architects and designers (Fig. 33-1) find that their work must respond to increased limits in the form of building codes, concepts of universal design, and environmental considerations. Additionally, research and development provide rules or guidelines for designs for various populations, individuals with special needs, or simply the so-called average human being. More than ever before,

IMPORTANT TREATISES

- ***America by Design,*** 1987; Spiro Kostof.
- ***The ASID Professional Practice Manual,*** 1992; American Society of Interior Designers.
- ***The Colours of Light,*** 2000; Tadao Ando.
- ***I Want to Change the World,*** 2001; Karim Rashid.
- ***Late-Modern Architecture,*** 1980; Charles Jencks.
- ***Light and Water,*** 2003; Tadao Ando.
- ***Reflections,*** 2006; Sir Norman Foster.
- ***The Singular Objects of Architecture,*** 2002; Jean Baudrillard and Jean Nouvel.
- ***Staircases,*** 2001; Eva Jiricna.
- ***Tihany Design,*** 1999; Adam Tihany.
- ***Work Life,*** 2000; Tod Williams and Billie Tsien.

Other Works: Monographs and books on individual architects and designers.

Periodicals and Journals: *Architecture, Architectural Record, Facilities Design and Management* (1982), *Interior Design, Interiors and Sources* (1990), *Journal of the American Planning Association, Journal of Architectural and Planning Research, Journal of the Society of Architectural Historians, Journal of Interior Design, Progressive Architecture* (1919–1995), *RIBA Journal,* and *Urbanism.*

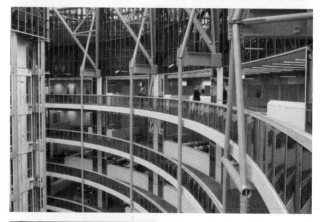

architects and designers create and/or lend their names to recognizable buildings and products for consumers. As a result, architecture, interior design, and furnishings become important aspects of cultural consciousness and global markets.

As during the 1960s (see Chapter 31, "Late Modern · 1"), some designers continue to explore, expand, or reinvent principles of the International Style, particularly the grid system. Others strive for minimalism but with even more extreme simplicity. The High Tech Movement continues to experiment with new materials and technology and the concept of building as a machine. Still others look to the expressionism of the early 20th century in an attempt to depict the spiritual instead of functional or programmatic aspects of design.

DESIGN CHARACTERISTICS

As in the 1960s through the 1980s, architecture, interiors, and furniture have varied appearances as designers continue exploring earlier developments and adopt an even

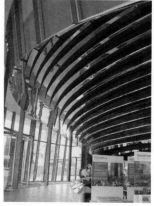

▲ **33–2.** Architectural and interior details, c. 1990s–2000s; United States and England.

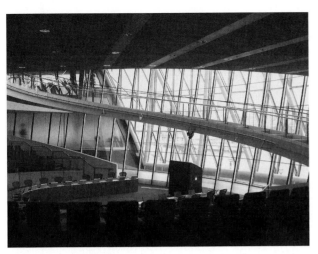

▲ **33-2.** *(continued)*

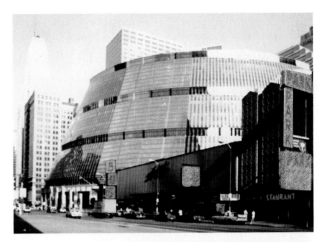

▲ **33-3.** State of Illinois Center (now James R. Thompson Center), 1980–1985; Chicago, Illinois; Helmut Jahn.

more expanded design language. New materials, techniques, and technologies (especially the computer) combine with existing ones, such as prefabrication, to fuel innovation and individualism. As before, expressions may exaggerate characteristics of Modernism such as illustration of joints or structure, geometry, grids or modules, or building as machine (Fig. 33-2). Because of new technologies, form and shape are even more important than they were previously. Form may curve, ripple, layer, or retain the grid, sometimes even in a single composition. Thus, breaking the box is even more common than it was before. Designs are often anti-historical with no visible ties to the past, particularly in reinventions or varied expressions of typologies.

■ *High Tech.* As before, High Tech compositions display extreme and complex technology and a machine image, and they highlight function and service areas. Lightness and transparency are more important than before. Designers push the limits of forms and materials. Interiors become larger and more open.

■ *Minimalism.* Minimalism continues its clean forms, extreme simplicity, repetition, and articulation but with greater flexibility and emphasis upon form and shape.

■ *Expressionism.* Expressionism adopts a variety of forms, and most designs are conceived of as sculpture so they are individual and customized.

■ *Motifs.* There are no specific motifs common to the period. Individual designers use details from projects to emphasize innovative structure, construction, and materials (Fig. 33-2).

ARCHITECTURE

Late Modern · 2 architecture continues the geometry and modularity established in Geometric Modern and Late Modern · 1 (see Chapters 28, "Geometric Modern," and 31,

"Late Modern · 1"). This concept ties them together as a sequential development. In this period, however, the modularity is pushed to an extreme through experimentation with form and structure. Buildings undulate, move, and soar beyond earlier boundaries. This experimentation is possible because of enhancements in technology and improvements in engineering and materials that allow architects to achieve new construction innovations. As a result, exposed structure becomes even more common.

Overall, designs are more complicated, more unusual, and more individualistic as a group than earlier. Buildings continue to exhibit a high-tech image, slick skin, extreme repetition, visual layering, and dynamic abstraction (Fig. 33-3, 33-4, 33-12, 33-13, 33-14, 33-15, 33-16, 33-18). But new features emerge that alter the overall character and imagery. Most notably, architects play with complexity through the separation of unusual contiguous parts and through large spaces that demand attention. For example, the building surface and exposed structure may play against one another to create interest and tension (Fig. 33-4, 33-5, 33-8). Alternatively, mass may be hollowed out to create transitional or negative space within

DESIGN SPOTLIGHT

Architecture: Lloyd's building, 1984–1986; London, England; Richard Rogers and Partners. Designed by Richard Rogers and Partners in a High Tech image similar to the Pompidou Centre in Paris, the Lloyd's building is unusual in that insurance companies favor more conservative designs. Rogers places service areas in six towers on the perimeter of the building, which allows the building to fit into the area's medieval streets and gives it a more expressive form. Often concealed, the clearly delineated service areas become part of the design vocabulary and building's image. Covered in stainless steel and glass, the structure rises 14 stories on the north and 7 stories on the south side. The windows refract artificial light, reducing lighting requirements at night. A large glass-covered barrel vault in the center is reminiscent of the Crystal Palace of 1851. The vault covers the full-height atrium on which the building's interiors center. With service areas on the exterior, the interior space is completely open for maximum flexibility (see Fig. 33–23).

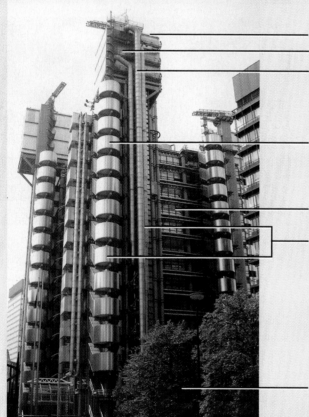

Flat roofs add diversity

Towers help express form

Exposed mechanical systems

Stairs placed on building perimeter form pierced cylinders clad in stainless steel

Repetitive grid on facade

Building expresses extreme articulation and exaggerated structure, along with asymmetrical balance

Building is surrounded by medieval streets, traditional-style buildings, and many low structures, so it stands out on its site

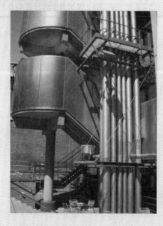

▲ 33-4. Lloyd's building; London.

▲ **33-5.** Hong Kong and Shanghai Bank Headquarters, 1979–1986; Hong Kong, China; Sir Norman Foster.

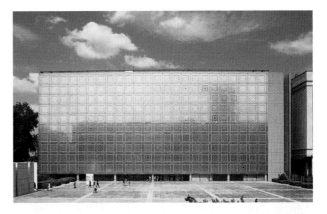

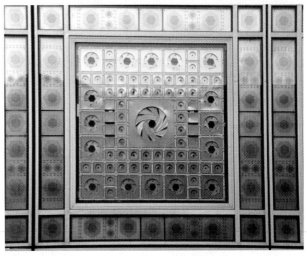

▲ **33-6.** Institut du Monde Arab, 1984–1987; Paris, France; Jean Nouvel.

the building form to establish a unique relationship between solid façade and recessed glass openings (Fig. 33-7, 33-10, 33-11, 33-20). Or two towers may play against each other with negative space between, or the entry area may be unique compared to other parts of the building (Fig. 33-12, 33-14, 33-16).

On some buildings, modules, grids, and skeletons define the building structure and overall design, but the introduction of digital design and computer manufacturing tools allow architects more freedom of expression. Standardization is no longer necessary to maintain efficiency, function, and costs. Computerization within the construction industry allows more complex parts to be fabricated more easily. Architects also take advantage of new materials, methods of structural analysis, and environmental control systems to advance new concepts and forms. Freed from these restrictions and aided by technology, they can experiment with design language in a show of creativity that is a precursor to Neo-Modern.

Architects explore new ways to express older themes or associations such as monumentality, civic pride, corporate image, authority, and responsibility. High Tech civic buildings stress lightness and openness, qualities regarded as important in democracies and liberal societies. More prominent is the mega structure, a new version of the skyscraper, arising in expanding markets in the Near East, Asia, and the Pacific. Representing a new form for commercial buildings, these extremely tall buildings with multiple angles, forms, and towers

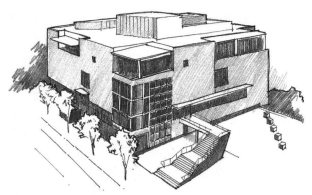

▲ **33-7.** Tepia Building, Science Pavilion, 1989; Tokyo, Japan; Fumihiko Maki.

▲ **33-8.** Glass Pyramid, Louvre Museum, 1984–1989; Paris, France; I. M. Pei.

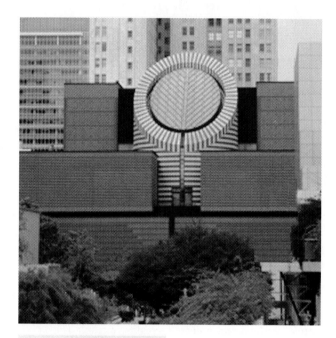

become symbols of the global economy, power, and authority (Fig. 33-5, 33-12).

Recognition of mega structures and other buildings is based on the creation of unusual forms and designs, often as defined by façades and roofs. This gives rise to buildings as sculptural entities with little separation between façade and roof (Fig. 33-3, 33-8, 33-13, 33-14, 33-18), a trend which will become more pronounced in Neo-Modern. In the new global community with instantaneous communications, design teams of architects, contractors, interior designers, engineers, and project managers from different countries work together on architectural projects. Many firms have multiple offices around the globe.

Public and Private Buildings

■ *Types.* The most common building types are office buildings (Fig. 33-3, 33-4, 33-5, 33-10, 33-12, 33-13, 33-14, 33-16), museums (Fig. 33-7, 33-8, 33-9, 33-11, 33-15, 33-19), airport and train terminals (Fig. 33-24), and churches. These types are interpreted within a global context and explore new means of expressing image and monumentality. A few larger residential buildings gain recognition, mainly those that explore theories and themes of form, technology, materials, and color. Residences often are personal expressions of the architect or client (Fig. 33-20, 33-21).

■ *Site Orientation.* Image and recognition drive site orientation, and commercial structures often seek to dominate a skyline or busy highway. Most commercial office buildings and banks site on or very near the heart of a city. Many stand out because of their height, design, and lack of relationship to surrounding structures (Fig. 33-3, 33-4, 33-5, 33-12, 33-13, 33-14, 33-16). Museums frequently appear in landscaped park-like settings in urban areas and are often spotlighted in their environments (Fig. 33-8, 33-11, 33-15, 33-19). Airport terminals are

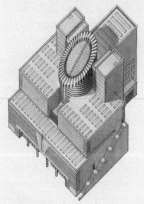

▲ **33-9.** San Francisco Museum of Modern Art, 1989–1995; San Francisco, California; Mario Botta.

located on the outskirts of a city center on major thoroughfares in the hub of transportation areas.

■ *Floor Plans.* Building plans follow earlier Late Modern examples. Designs are aesthetically diverse and innovative with no set pattern for development or layout. Asymmetry

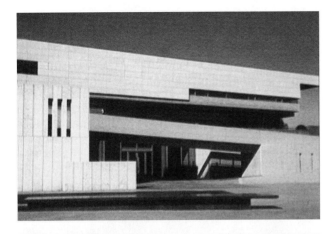

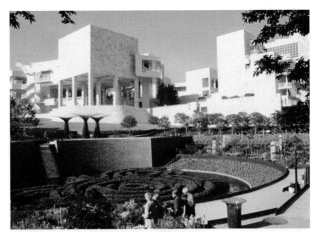

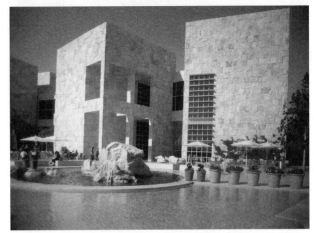

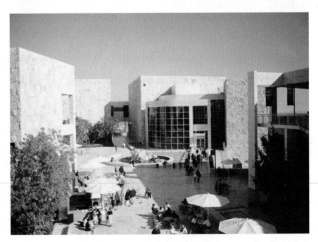

▲ **33-10.** Neurosciences Institute, 1995; La Jolla, California; Tod Williams and Billie Tsien.

▲ **33-11.** Getty Museum, 1985–1997; Los Angeles, California; Richard Meier.

in plan arrangement, variety in shape, and a three-dimensional experimentation with form is characteristic and important. Architects continue to play with interpenetrating geometries, complexity in scale and space, and solid and void relationships, but carry the concepts to an extreme to reflect a three-dimensional relationship to the

building envelope. Unusual contiguous parts or areas often are separated to create complexity, which is a dominant design feature.

As before, plans exhibit variety with straight edges and sides that may be angled, curved, or indented. The plan and interior circulation may be formally or informally

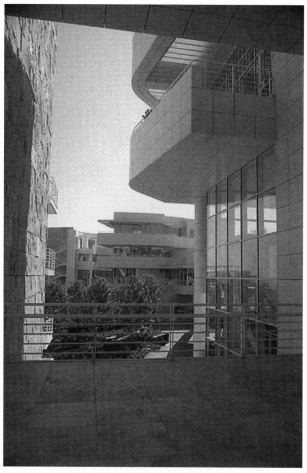

▲ **33-11.** *(continued)*

▲ **33-12.** Petronas Twin Towers, 1997; Kuala Lumpur, Malaysia; Cesar Pelli.

IMPORTANT BUILDINGS AND INTERIORS

- **Barcelona, Spain:**
 - Agbar Tower, 1999–2005; Jean Nouvel.
- **Bilbao, Spain:**
 - Sheraton Bilbao Hotel, 2005–2006; Ricardo Legorreta.
- **Cambridge (near Madingly), England:**
 - Research Center for Schlumberger, 1985–1986; Michael Hopkins.
- **Chicago, Illinois:**
 - DuPont Resource Center, Chicago Merchandise Mart, 1991; Eva Maddox.
 - Klein Tools offices, 1992; Gensler.
 - O'Hare Airport, United Airlines Terminal Building, 1984–1988; Helmut Jahn.
 - State of Illinois Center (now James R. Thompson Center), 1980–1985; Helmut Jahn.

- **Cleveland, Ohio:**
 - Rock and Roll Museum and Hall of Fame, 1995; Pei Cobb Freed and Partners.
- **Dallas, Texas:**
 - Nasher Museum, 2003; Renzo Piano.
- **Ft. Worth, Texas:**
 - Museum of Modern Art, 2004; Tadao Ando.
- **Irving, Texas:**
 - Temerlin McClain offices, 2002; Staffelbach Design Associates.
- **Himijei, Hyogo Prefecture, Japan:**
 - Children's Museum, 1990; Tadao Ando.
- **Hong Kong, China:**
 - Bank of China, 1990; I. M. Pei.
 - Hong Kong and Shanghai Bank Headquarters, 1979–1986; Sir Norman Foster.

IMPORTANT BUILDINGS AND INTERIORS

- **Jerusalem, Israel:**
 - King David Hotel, 1998; Adam Tihany.
- **Kuala Lumpur, Malaysia:**
 - Petronas Twin Towers, 1997; Cesar Pelli.
- **La Jolla, California:**
 - Neurosciences Institute, 1995; Tod Williams and Billie Tsien.
- **Liverpool, England:**
 - Boodle and Dunthorne, 2004; Eva Jiricna.
- **London, England:**
 - Corinthian Television, 2001–2002; Chiswick; Gensler.
 - Daiwa Headquarters, 1991–1992; Richard Rogers and Partners.
 - Great Court at the British Museum, 1994–2000; Sir Norman Foster.
 - Jardine Insurance offices, 1989; Eva Jiricna and Michael Hopkins.
 - Joseph, Fulham Road; 1988; Eva Jiricna.
 - Lloyd's building, 1984–1986; Richard Rogers and Partners.
 - London City Hall, 1998–2002; Sir Norman Foster.
 - Stansted Airport, 1991; Sir Norman Foster.
 - Swiss Re Tower (30 St. Mary Axe) 1997–2004; Sir Norman Foster.
- **Los Angeles, California:**
 - Bastide Restaurant, 2002; Andrée Putman.
 - Getty Museum, 1985–1997; Richard Meier.
 - Los Angeles Museum of Contemporary Art, 1981–1986; Arata Isozaki.
- **McLean, Virginia:**
 - Gannett Co./USA Today Corporate Headquarters, 2001; KPF Architects, Lehman Smith McLeish, interior design.
- **Minneapolis, Minnesota:**
 - Key Investments, 1996; interiors by Gary Wheeler.
- **New York City, New York:**
 - Apple Store, 2006; Bohlin, Cywinski, Jackson.
 - HBF Furniture Showroom, 2000; Vanderbyl Design.
 - Perry Street Loft, 2000–2002; Hariri and Hariri Architecture.
- **Paris, France:**
 - Glass Pyramid, Louvre Museum, 1984–1989; I. M. Pei.
 - Institut du Monde Arab, 1984–1987; Jean Nouvel.
 - Sheraton Hotel, 1994; Andrée Putman.
- **Rome, Italy:**
 - Aleph Hotel, 2003; Adam Tihany.
- **San Francisco, California:**
 - San Francisco Museum of Modern Art, 1989–1995; Mario Botta.
- **Shanghai, China:**
 - Shanghai World Financial Center, 2002; Kohn Pedersen Fox.
- **Tel Aviv, Israel:**
 - Foyer, Tel Aviv Opera House, 1988–1994; Ron Arad and Allison Brooks.
- **Tokyo, Japan:**
 - Spiral Building, Wacoal Arts Center, 1984–1985; Fumihiko Maki.
 - Tepia Building, Science Pavilion, 1989; Fumihiko Maki.
 - Tokyo City Hall, 1994; Kenzo Tange.
 - Tokyo International Forum, 1989–1996; Rafael Viñoly.
 - Watari-um Art Gallery, 1985–1990; Mario Botta.
- **Vancouver, British Columbia, Canada:**
 - Koerner Library, University of British Columbia, 1992; Arthur Erickson with Aiken Wreggleworth Associates.
 - Waterfall Apartment Building, 1996; Arthur Erickson, with Nick Milkovich Architects.
- **Washington, D.C.:**
 - Washington, D.C., Convention Center, 2002; Thompson Ventulett Stainback and Associates.

organized horizontally and vertically to establish spatial zones, functional areas, visual layering, and unique design features (Fig. 33-26, 33-30). New construction methods and environmental systems liberate architects from previous practices. For example, service cores no longer need to be in the center of a building. They can now be on the exterior, the perimeter, corners, or any other location appropriate to the concept. Centrally located circulation cores continue, but with even more variety and innovation in their designs than earlier. Additionally, interior

DESIGN SPOTLIGHT

Architecture: London City Hall, 1998–2002; London, England; Sir Norman Foster. Norman Foster gives the building an asymmetrical shape to reduce the surface for energy conservation. Curved on one side and layered on the other, the building's glass skin gives maximum transparency and openness suitable for a city's governing body. In the center of the spherical façade, the rectangular grid breaks into diagonals, enhancing the graduated and stepped form. Each glass pane has a unique shape, which was cut by lasers. Inside, a spiral ramp rises the full height of the building to a viewing gallery on the top floor.

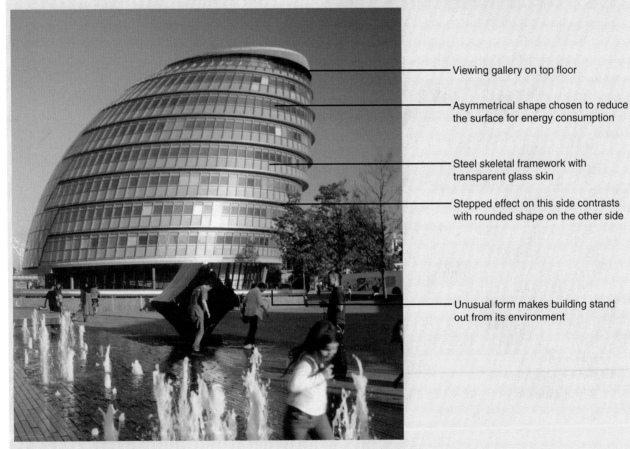

Viewing gallery on top floor

Asymmetrical shape chosen to reduce the surface for energy consumption

Steel skeletal framework with transparent glass skin

Stepped effect on this side contrasts with rounded shape on the other side

Unusual form makes building stand out from its environment

▲ **33-13.** London City Hall; London.

spaces no longer require structural supports at regular intervals. As a result, interior planning is freed from grids and modules, thus permitting new and innovative interior configurations. A common theme is arrangements of atriums and large window walls that allow natural light to penetrate within.

■ *Materials.* Steel, reinforced and precast concrete, aluminum, and tinted and plain clear glass continue to be

▲ **33-14.** Swiss Re Tower (30 St. Mary Axe), 1997–2004; London, England; Sir Norman Foster.

the most common construction materials (Fig. 33-3, 33-4, 33-6, 33-8, 33-10, 33-11, 33-12, 33-13, 33-14, 33-15, 33-16, 33-17, 33-18, 33-21). Most are prefabricated with modular components. Reinforced concrete begins to replace steel for structures. Other surfacing materials include stone, brick, and tile (Fig. 33-9). Stainless steel becomes the new marble or stone. New to the period is the use of fabric for walls and/or roofs. Pioneered in the late 1950s, fabrics coated with Teflon or PVC for weatherproofing are lightweight, low-cost alternative materials for roofs and walls. Sometimes architects become well known for their repetitive use of certain materials, such as Tadao Ando who commonly uses gray concrete and glass (Fig. 33-15). The relationship between materials and exposed building structure continues to be important.

▲ **33-15.** Museum of Modern Art, 2004; Ft. Worth, Texas; Tadao Ando.

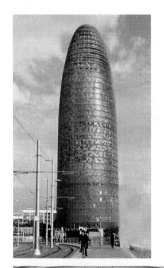

▲ **33-16.** Agbar Tower, 1999–2005; Barcelona, Spain; Jean Nouvel.

▲ **33-17.** Sheraton Bilbao Hotel, 2005–2006; Bilbao, Spain; Ricardo Legorreta.

▲ **33-18.** Apple Store, 2006; New York City, New York; Bohlin, Cywinski, Jackson.

■ *Façades.* Individuality, experimentation, extreme articulation, and exaggerated structure characterize building façades. Because of their shapes and unusual design features, they are even more distinctive than earlier Late Modern examples. Sides may be angled, curved, or indented with either solid or glass walls. Some buildings exhibit an element of lightness through a stretched outer skin of flat, curved, and/or angled glass or sometimes an asymmetrical building shape (Fig. 33-3, 33-6, 33-8, 33-13, 33-18), while others emphasize more modularity through the interplay of concrete and glass walls (Fig. 33-11, 33-17). In some buildings, the grid is apparent, but it is handled in new, unusual ways. Exposed building structure with an expression of joints and construction (Fig. 33-4, 33-12, 33-15, 33-21) is common in all examples and more pronounced than earlier.

Architects continue to emphasize solid and void relationships on the surface of the façade as well as on the attached layered structural parts. The parts undulate and move in either a vertical or horizontal rhythm, which

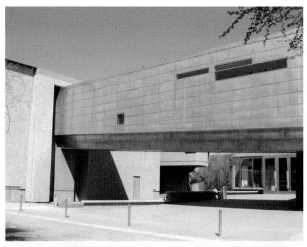

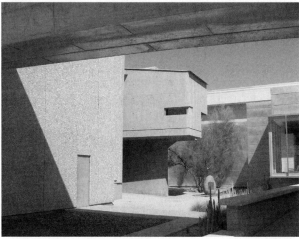

▲ **33-19.** Phoenix Art Museum, 2005–2006; Phoenix, Arizona; Tod Williams and Billie Tsien.

▲ **33-21.** AK Steel Concept Home, 2004.

often announces or defines the building's visual image (Fig. 33-5, 33-21). On other examples, a shape or some repetition of shapes may dominate and define the entire façade or an entry area (Fig. 33-11, 33-17, 33-20). And some examples exhibit the integration of façade with roof so that the building becomes more of an overall sculptural object with less separation between façade and roofline or front and back (Fig. 33-8, 33-13, 33-14, 33-16).

■ *Windows.* Following the earlier modernist language, windows on commercial buildings are usually fixed in grid patterns to control air-conditioning and heating systems. However, new methods of environmental controls allow windows to be opened instead of being hermetically sealed as before (Fig. 33-14, 33-16). Many are tinted to reduce sun exposure. As before, windows usually have narrow metal moldings and mullions that frame the openings and divide glass areas (Fig. 33-11, 33-13, 33-20). Sometimes they are black or bronze to accent the grid effect. Flat glass is common, but there is more use of curved glass to relate to the building form.

■ *Doors.* Most entries blend into the overall design of the building, but some may be accented through a unique architectural feature, unusual scale, or distinctive placement (Fig. 33-7, 33-9, 33-14, 33-16). One well-recognized entry is the glass pyramid at the Louvre (Fig. 33-8) in Paris. Sometimes, important entries also appear on multiple sides of the building.

■ *Roofs.* One of the most distinctive characteristics of these Late Modern buildings is the attention paid to roof areas, with much experimentation and individuality in design. Some are symmetrical, while others are asymmetrical. They may be curved, angled, flat, or pointed, or a combination of several shapes to achieve design variety (Fig. 33-6, 33-9, 33-12, 33-13, 33-15, 33-16, 33-17, 33-18). They may also have cutouts to emphasize solid and void relationships and to make them more unusual (Fig. 33-5). Some roofs also exhibit exposed construction features derived from the façade design (Fig. 33-4), which provide additional accents. Often roofs serve as visual emblems that announce and personify the building's character and importance, similar to the effect created by the roof of the Chrysler Building in New York (see Chapter 26, "Art Deco").

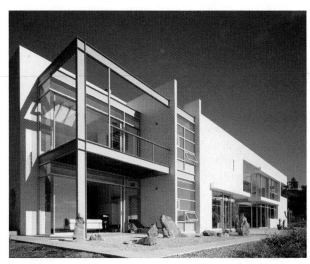

▲ **33-20.** Feinstein House, 2003; Malibu, California; Stephen Kanner of Kanner Architects.

DESIGN PRACTITIONERS

The design professions continue to respond to the increased complexity of the built environment. Overall, specializations continue to include offices, hospitality, retail, institutional, health care, and residential, but there is even more specializing within these areas. Some architects and architectural firms focus on specific types of projects, such as medical centers, shopping malls, colleges, hotels, health spas, and houses. Likewise, some interior designers also begin to specialize in a particular type or types of interiors, such as design showrooms, legal offices, health care facilities, retail boutiques, restaurants, and entertainment centers. Both disciplines cater to the rapidly expanding need for specialized knowledge and expertise required to design these types of spaces. They must address not only aesthetic issues, but also functional requirements necessary to meet building codes, regulations, and universal design requirements. By the turn of the 20th century, both architects and interior designers are involved with strategic planning, branding, and facilities management as they strive to further assist their clients.

Research in design areas expands significantly. Data from research conducted by educators, manufacturers, industry, psychologists, and many others are disseminated in books, journals, and on Web sites. In 2005, major interior design associations and organizations in North America jointly publish *The Interior Design Profession's Body of Knowledge,* the first comprehensive documentation of the profession's evolving knowledge base, compiled by Denise Guerin and Caren Martin.

During the 1990s and 2000s, significant changes occur in the professions of architecture and interior design as each concentrates on expanding and enhancing legal registration (licensing) activity throughout North America to address health, safety, and welfare codes and mutual recognition of qualifications for professional standards. Title and practice laws require precise definitions of what constitutes practice and a delineation of professional requirements to practice, so definitions are updated and requirements are expanded. As a result, the generally recognized professional career paths for both architecture and interior design become more descriptive and specific to include education, experience, examination, legal registration, and the attainment of a specific number of continuing education units (CEUs). Various organizations develop or expand operations to meet these needs as well as to address professional ethics and a greater sense of social responsibility (see the Introduction, Timelines for the Architecture Profession and the Interior Design Profession).

- **Tadao Ando** (b. 1941), unlike most architects, teaches himself architecture by visiting important buildings in Europe, Africa, and the United States.

Ando adopts a minimalist style using mainly cast-in-place concrete and glass. His work achieves richness through simplicity, geometric shapes, excellent craftsmanship, enclosed instead of open spaces, and rich spatial articulation. Complex circulation paths between and among units are a signature feature. Ando opens his firm, Tadao Ando Architect and Associates, in Osaka, Japan, in 1970. Among his many awards is the significant Pritzker Prize in 1995.

- **Sir Norman Foster** (b. 1935) is known worldwide for architecture that unites context, technology, craftsmanship, and modern materials with concern for the environment. His work is often called High Tech because of its celebration of technology and advanced approaches to structure with an emphasis on the repetition of modular structural units. It is a product of Foster's design philosophy, which seeks to unite elements of architecture, such as structure, systems, and context. The recipient of numerous prestigious architecture and design awards for his unique work, Foster also receives the Pritzker Prize in 1999, the year he is also honored with a life peerage in Great Britain's House of Lords.

- **Gensler Architecture, Design and Planning** is founded in 1965 in San Francisco by Arthur Gensler and Drue Gensler. The firm quickly gains a reputation for excellence in its cutting-edge modern urban planning, architecture, and interior design, so it expands its services to include graphic design, strategic planning, product design, and branding. It now has multiple regional and international offices and is a leader in design and planning. Major projects include the redesign of the Sony, Paramount, and Warner Brothers film studios near Los Angeles and the spectacular Sony Theaters in New York City, as well as the restoration and renovation of the Beverly Hills Hotel in Los Angeles.

- **Helmut Jahn** (b. 1940), architect, comes to the United States from Germany in 1961 and he studies with Mies van der Rohe at the Illinois Institute of Technology. Although greatly influenced by Mies, especially Mies's early work, Jahn eventually embraces greater transparency and lightness. He strives to achieve these goals through advanced structural and building systems, new developments in glass, and what he calls archineering, a unification of architecture and engineering. His work reveals minimalism in form and materials, and it often pushes the limits

of structure and materials in a quest to achieve maximum light and transparency.

- **Eva Jiricna** (b. 1939) is a Czechoslovakian architect working in Britain. Blending form and technology, she strives for lightness and transparency in her work, which has a high-tech look. Designs reveal skillful space planning, innovation, and attention to detail, especially joinery. Jiricna is especially known for open structured stainless steel and glass staircases and her innovative, highly influential retail shops. She and her firm, Eva Jiricna Associates, design hotels, restaurants, retail shops, residences as well as interiors, furniture, and other products.

- **Eva Maddox** founds her firm Eva Maddox Associates in 1975. The firm specializes in health care, office, and retail spaces as well as textiles and branding, and it develops a design process and method that focuses upon corporate identity. Maddox, along with Stanley Tigerman, founds Archeworks, an alternative design school that focuses upon meeting social needs through design using a multidisciplinary teaming approach. The firm later merges with Perkins and Will.

- **Jean Nouvel** (b. 1945) endeavors to achieve an architectural language that is neither Modern nor Post Modern and that acknowledges and transcends tradition. He designs for unity of building, site, and surroundings, but most important, the dematerialization of form through great emphasis on transparency, light, and lightness. Both his buildings and his furniture reveal extreme minimalism. Nouvel receives the Pritzger Prize in 2008.

- **Karim Rashid** (b. 1960) is an industrial, furniture, and interior designer. He studies industrial design in Egypt and afterward works with Ettore Sottsass in Italy. In 1993, he opens his own firm in New York City and designs numerous products, including furniture and lighting. Believing that design should be contemporary, beautiful, and inspiring, he creates both one-of-a-kind and mass-produced furnishings.

- **Andre Staffelbach,** a modernist interior designer, founds his own firm in Dallas in 1966. In 1986, he goes into partnership with Jo Heinz, later his wife, as Staffelbach Design Associates. The firm focuses on the design of offices, banks, health care facilities, and technology centers, with an emphasis on form, space, materials, and resources. In 1985, he is inducted into the Interior Design Hall of Fame.

- **Tod Williams** (b. 1943) and **Billie Tsien** (b. 1949), architects and professors, have worked together since 1977 and been in partnership since 1986. They are known for their wide range of projects and high standards for design and craftsmanship. Their work, which is contemporary and minimalist, maintains a sense of place and truth to materials. Many of their projects have won national and international awards.

INTERIORS

Interiors by architects continue the overall design language of the exterior and are often limited to the more public spaces, while those by interior designers usually relate to the whole entity but do not interpret it exactly. Important circulation spaces, reception areas, and special rooms showcase distinctive design ideas, unusual architectural features, ceiling height variations, new furniture arrangements, and experimentation with lighting designs (Fig. 33-25, 33-26, 33-28, 33-29, 33-33, 33-35, 33-37). Office, retail, and health care environments frequently exhibit a wide range of space sizes and types to meet functional and technical requirements. Designers emphasize function, industrial technology, repetition of modular elements, solid and void relationships, spatial layering, and the use of construction and structure as ornament. Minimalism and High Tech (see Chapter 31, "Late Modern · 1") remain as common interior aesthetic languages, but exhibit more individuality and experimentation. The selection and application of materials becomes more important and shows greater variety. A grid continues to define and shape many commercial and some residential interior spaces and primary circulation areas, but there may be more than one axis defining grid directions. Large, open spaces with no structural columns provide opportunities for variety in traditional arrangements and exploration of new ones, but at the same time present design challenges.

Experimentation with space planning continues with more overlap of functional areas and more multifunctional spaces. Interior architectural forms frequently define and divide space to create unique environments. For example, some commercial spaces have large, multileveled, open atriums or light-filled corridors defined by exposed structural features that repeat from outside to inside (Fig. 33-22, 33-23, 33-24, 33-27). Often open stairways, elevators, walkways, and balconies are inserted in these spaces at various levels and angles, reinforcing their importance as major circulation paths.

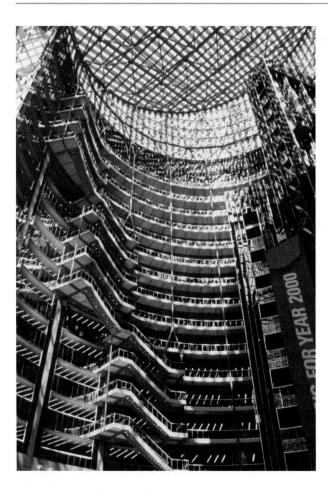

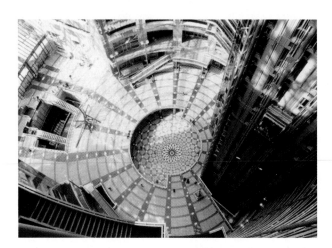

▲ 33-22. Interiors, State of Illinois Center (now James R. Thompson Center), 1980–1985; Chicago, Illinois; Helmut Jahn.

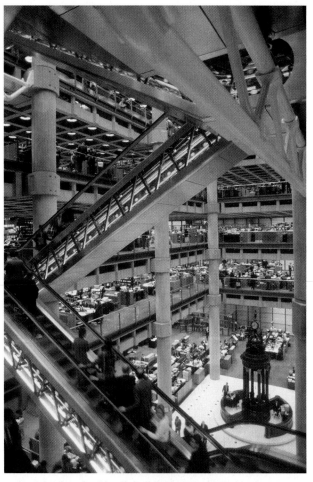

Less important areas are usually restricted to one floor level, but may exhibit variety in solid and void wall partition systems.

Within the international framework and because of information available through various media, regional

▲ 33-23. Interior, Lloyd's building, 1984–1986; London, England; Richard Rogers and Partners.

▲ 33-24. Interiors, O'Hare Airport, United Airlines Terminal Building, 1984–1988; Chicago, Illinois; Helmut Jahn.

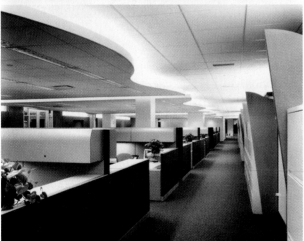

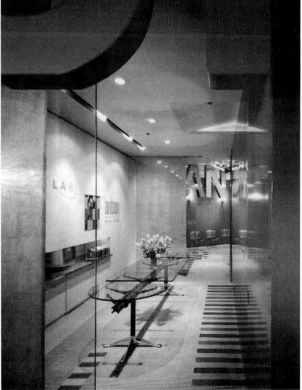

▲ 33-26. Interiors, Dupont Antron Showroom and floor plan—Los Angeles, 1991; AGI Industries, 1991; Rehabilitation Institute of Chicago, 1994; Los Angeles, California, and Chicago, Illinois; Eva Maddox at Perkins and Will.

▲ 33-25. Interiors, Franchising and Licensing World Center, Ernst and Young LLP, and Standard Parking, c. 1990s; Illinois and Ohio; Mekus Johnson.

differences disappear. Designers still address cultural differences in interior space planning, furniture arrangements, and finish selections. Additionally, regulations, such as the Americans with Disabilities Act (ADA) adopted in the United States in 1992, and health, safety, and welfare codes affect interior planning, furniture, and finishes.

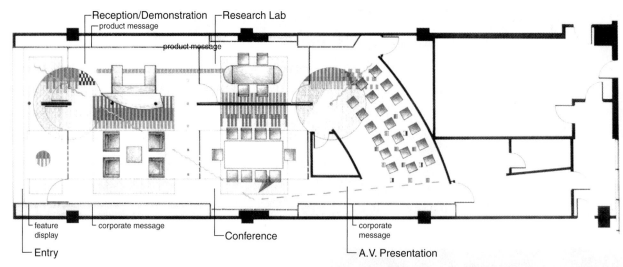

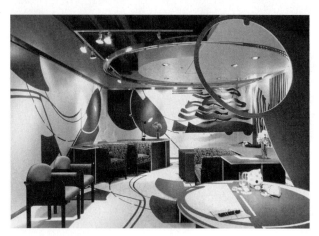

▲ **33-26.** *(continued)*

Public and Private Buildings

■ *Types.* Important public spaces are large circulation areas (Fig. 33-22, 33-23, 33-24, 33-27), reception/lobbies (Fig. 33-25, 33-26, 33-28, 33-29, 33-33, 33-34, 33-36, 33-37), offices/work (Fig. 33-25, 33-29, 33-33), conference rooms (Fig. 33-29, 33-33), food services (Fig. 33-29, 33-32, 33-35), shops (Fig. 33-34), design showrooms (Fig. 33-26, 33-36), museum spaces (Fig. 33-31), classrooms/training (Fig. 33-28), and diagnostic/health/fitness (Fig. 33-37). Important residential spaces now include media rooms and home offices. More attention is given to kitchens and bathrooms (Fig. 33-34, 33-35). Overall, designers focus on spaces that require technical innovation, specialized knowledge, and custom components, a reflection of the increasing complexity and diversity of society as a whole.

■ *The Electronic Office and Alternative Offices.* New technologies radically change the office and the ways people work beginning in the early 1980s. Knowledge and ideas become the office's raw material with an emphasis upon interaction, collaboration, teaming, and individual autonomy. Commercially available desktop computers are introduced in the late 1970s and soon become widely used and placed at almost all workstations. They forever change the work environment. The new technology makes the individual office worker, not the secretary, responsible for typing and primary communication, and redefines the traditional office hierarchy. With the introduction and expansive use of laptop computers in the late 1980s, work portability and movable work spaces become increasingly important and critical to office functions (Fig. 33-25, 33-29, 33-33, 33-49, 33-50). Fax machines, cell phones, voice mail, and e-mail greatly accelerate communication and the speed of work, and profoundly change productivity. Many workers no longer have to come into the office because they can work almost anywhere. Technology changes create a far-reaching revolution, one equal to or greater than the Industrial Revolution. But unlike its predecessor, this technology revolution takes place within a short span of 10 to 15 years.

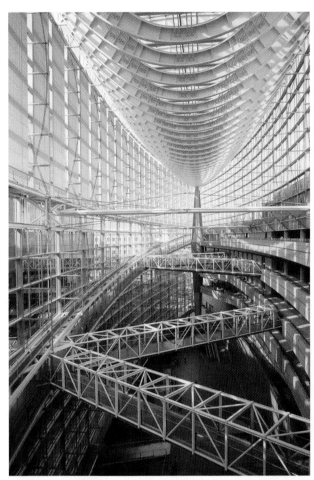

▲ **33-27.** Interiors, Tokyo International Forum, 1989–1996; Tokyo, Japan; Rafael Viñoly.

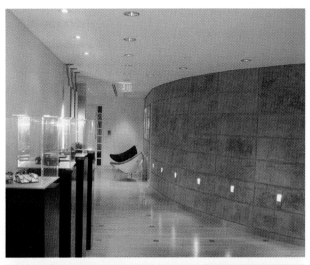

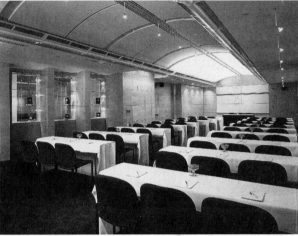

▲ **33-28.** Reception area, Volkswagen of America Legislative Office, 1999, and lecture room, Oceanic Conference Suite, 1998, Ronald Reagan Building and International Trade Center; Washington, D.C.; W. Kevin Wylie at Greenwell Goetz Architects.

Designers explore new ways to design offices that respond to these changing needs. They focus on how the company and its employees do work, the different activities involved, and the ways and means of communicating to develop and enhance appropriate design solutions. A variety of individuals from many disciplines, such as social scientists, behavioral psychologists, ergonomic specialists, facility managers, and designers work together to formulate new design methods and strategies to better address the physical, technological, and behavioral needs of the users within a corporation or company. They come up with a variety of alternative office strategies for effectively using space to increase productivity, decrease costs, and attract and retain workers. Among the alternative officing methods are means for sharing space, facilities, and technology, such as hoteling (a reservation system) nonassigned spaces that are open for anyone and everyone; and hot desks, which are used for hours or days. To save time and space

and better accommodate workers, companies create satellite offices or centers varying distances away from the main branch. Many allow or encourage workers to telework, or work from home, and/or use a virtual office in which work is conducted in one's car or other convenient, available places.

The open plan of earlier continues, but with greater attention to technology, integrated wiring, and lighting. New design strategies and furnishings produce greater individuality in configuration instead of relying only on grid patterns (Fig. 33-49, 33-50). During the 1990s, as the pace of change within offices accelerates, concepts of office landscaping of the late 1950s reappear (see Chapter 31, "Late Modern · 1"). Collaborative spaces, conferencing areas, and neighborhood centers respond to changing work methods. Workstations become smaller and more compact. Individual workspaces, copy centers, and conference areas support numerous technologies, such as

DESIGN SPOTLIGHT

Interiors: Stairs, ING Direct, 2000; reception area and conference room, Swiss Re Financial Services, 1996–1997; office area, Baron Capital, 1997–1998; New York City, New York; and café lounge, Corinthian Television, 2001–2002; Chiswick, London, England; Gensler. With offices in the United States and numerous countries worldwide, Gensler is recognized nationally and internationally for its high-quality design, attention to detail, wide diversity of projects, and top-notch clients. Founded in 1965 by Arthur Gensler, the firm demonstrates design teamwork and synergy on projects. As stated in its marketing material, the firm's mission is to create "design that empowers people and transforms organizations." Often, the firm's projects anticipate as well as reflect changes affecting the future.

Some of the firm's most important work includes office design, as these examples show. The offices illustrate the use of interpenetrating space, collaborative and zoned work and social areas, well-defined circulation paths, a mix of wall partition systems, innovative lighting solutions, and architecturally inspired ceiling treatments. Comfort, function, technical, and code requirements are fully integrated in design solutions. Organized plan layouts developed through extensive programming techniques are common. Often, standard features include custom furnishings, cabinetry, fixtures, and materials. Articulating a strong brand image and corporate identity are often important design responsibilities, particularly in corporate work. Because so many different designers work on projects, there is no specific character or look to the firm's designs other than an overall consistent sophistication and quality developed through harmonious design solutions.

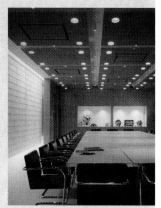
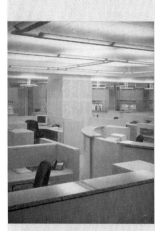
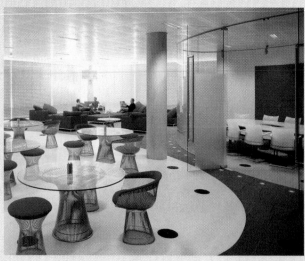

▲ **33-29.** Interiors by Gensler.

▲ 33-30. Floor plans, Baron Capital, 1997–1998, New York City; and Viant, 2000; Culver City, California; Gensler.

▲ 33-32. Café Metropol, Gran Hotel Domine, c. 2000s; Bilbao, Spain.

▲ 33-31. Great Court at the British Museum, 1994–2000; London, England; Sir Norman Foster.

multimedia and distance collaboration. With the advent of electronic files and archival methods, storage requirements diminish.

■ *Relationships*. As with earlier Late Modern developments, designers strive for a strong aesthetic relationship between the exterior and interior of a building so that the design language is complementary. Some architects custom design the interiors of their buildings to achieve an

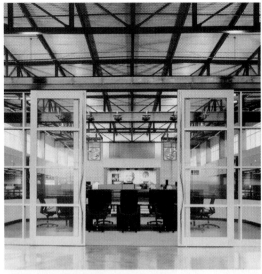

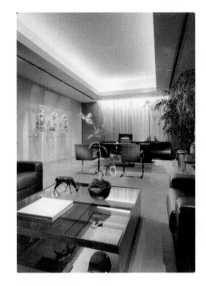

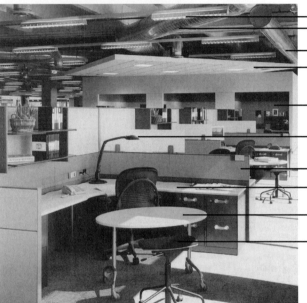

Repeating fluorescent lights on metal bars

HVAC system in metal tubes suspended from the ceiling

Floating rectangular acoustic ceiling enhances spatial layering and the effect of intimacy

Rectangular openings connect spaces

Task light on work surfaces

Low partition enhances communication

L-shaped work surface is typical

Portable round table supports flexibility and communication

Low stool provides seating option and can be hidden easily

▲ 33-33. Conference room, work area, and executive office, Temerlin McClain offices, 2002; Irving, Texas; and Reception area, Boston Consulting Group, 2001; Dallas, Texas; Staffelbach Design Associates.

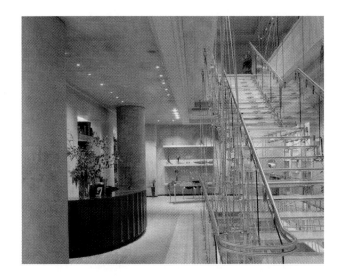

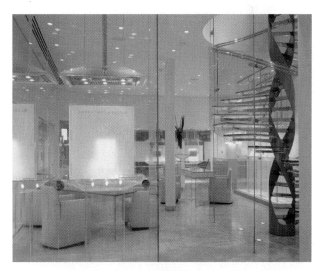

▲ **33–34.** Entry area, Joseph (retail store), 1988 in London, England; kitchen and bedroom, Penthouse Flat in Berkeley Tower, Canary Wharf, 2002 in London, England; and interior, Boodle and Dunthorne Jewellers Shop, 2004 in Liverpool, England; Eva Jiricna Architects.

integrated whole. Others use space planners, interior designers, and other professionals for interiors planning. Some interior designers work on the renovation of existing interiors and the development of new spaces within new or existing buildings, such as large, open office areas, department stores and boutiques, hotel lobbies, and health care facilities.

■ *Color.* The color palette during this time varies significantly by individual designer and type of space, so there is no set preference. But more attention is given to research on color psychology, behavioral aspects, user needs, and cultural contexts in color selections so that the color reflects the intended character and function of the spaces. White walls remain common, but designers experiment with combinations of color palettes more than ever before. Often they select livelier colors for spaces such as hotels, theaters, and boutiques; calmer colors for health care and institutional facilities; and more neutral colors with accents for offices (Fig. 33-25, 33-28, 33-29, 33-33). Office color schemes include the combinations of gray, white, and black with accents of red; and cream, rust, gold, and brown. Jewel colors, such as tan, mauve, navy, and burgundy are common in the 1980s. As earlier, carpet and rugs, artwork, and decorative arts contribute to the overall color schemes.

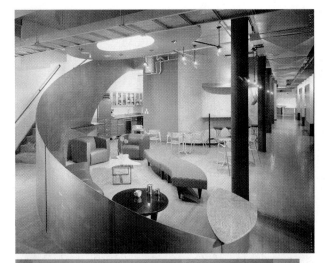

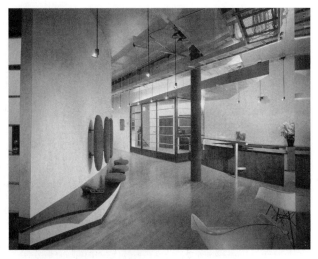

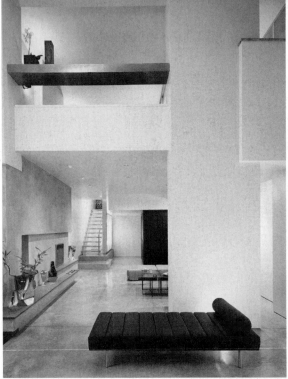

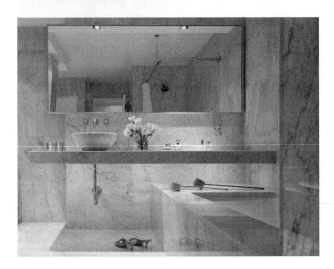

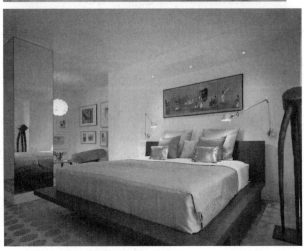

▲ **33–35.** Interior, JSM Music Studios, 1991 (top views); living and dining areas, Perry Street Loft, 2000–2002; and master bedroom and bath, 2003–2004; New York City, New York; Hariri and Hariri Architecture.

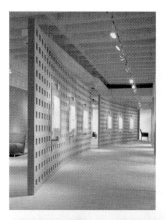

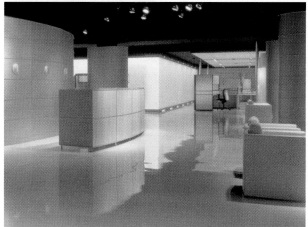

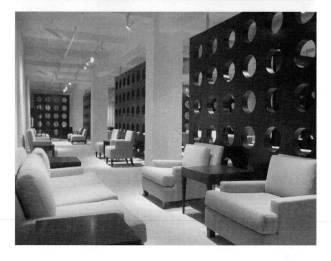

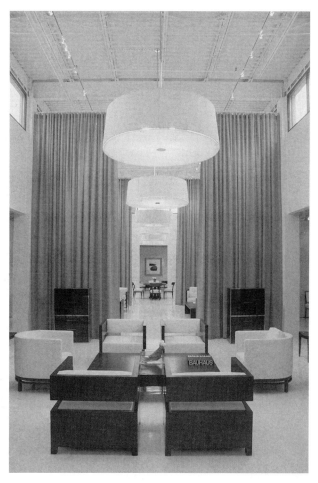

▲ **33–36.** Keilhauer Furniture Showroom (top left), 1998, and Teknion Furniture Systems Showroom (center left), 1999, Chicago, Illinois; HBF Furniture Showroom (bottom left), 2000, New York; and Bolier & Company Furniture Showroom, 2006, High Point, North Carolina; Vanderbyl Design.

■ *Lighting.* Energy conservation and behavioral studies give rise to increasing amounts of natural light in interiors, as earlier (Fig. 33-22, 33-24, 33--34). And lighting installations spotlight diverse fixture or system selections, multi-functional uses, enhanced individual controls, and placement variety. As before, research on lighting and advances in lighting methods and applications continue, and designers take advantage of them to plan and specify lighting that more fully meets the needs of users,

economics, energy conservation, and the type of space. Because of greater complexity and specificity in applications, more choices, life safety codes, and user needs, designers frequently consult or team with lighting engineers and lighting designers. To create ambient, task, accent, and mood lighting as well as specialized lighting for specific projects, designers incorporate architectual lighting, suspended ceiling systems, track lighting, indirect lighting applications, and individual fixtures into

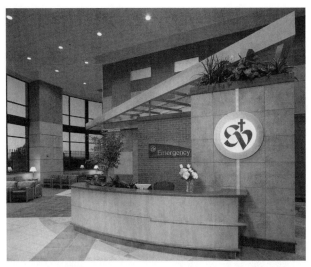

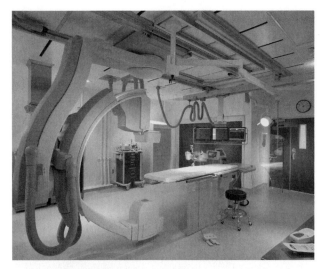

▲ **33-37.** Lobby-wait area, South Tower of S. Vincent's (hospital), 2006; Birmingham, Alabama; and the coronary care diagnostic cardiac catheterization suite, Piedmont Fayette Hospital, 2006; near Atlanta, Georgia; Earl Swensson Associates.

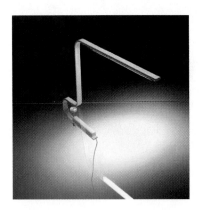

▲ **33-38.** Lighting: One Line Clamp (top left), 2005, by Ora Ito; E Light (bottom left), 2001, by Ernesto Gismondi; Icaro (metal wall sconce; top right), 1985, by Carlo Forcolini; Zefiro (hanging light; top left, next page), 1989, by Mario Botta; and Mikado Track System, 1991, by F. Porsche; manufactured by Artemide; cable-hung systems lighting at Cox Business Solutions, Ronald Reagan Building and International Trade Center, 2001, by W. Kevin Wylie; and Luminous architectural ceiling system and downlights, Dallas-Fort Worth Airport, 2006.

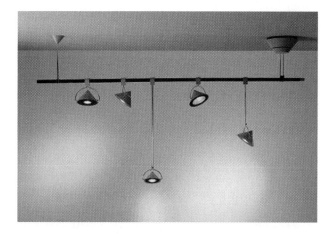

▲ **33-38.** *(continued)*

spaces (Fig. 33-25, 33-26, 33-33, 33-34, 33-36, 33-37, 33-38.).

Architecturally integrated lighting and custom-designed lighting become more important as interior architectural surfaces break the box shape (Fig. 33-24, 33-25, 33-28, 33-29, 33-33, 33-35). For large design projects and small custom ones, architects design the majority of wall sconces, pendants, chandeliers, and dropped lighting units. Manufacturers also expand their lighting choices and allow designers to customize existing items to fit a particular project.

Track systems and task lighting for work surfaces evolve with enhanced features and more flexibility in designs, sizes, and materials (Fig. 33-26, 33-28, 33-33, 33-36, 33-37, 33-38). Attention also focuses on indirect lighting such as up-lighting (typical in offices or where drama is required), cornice lighting, and architecturally hidden ceiling lighting.

As earlier, there are new innovations in the design of lamps, wall sconces, and floor lamps (Fig. 33-38). The most notable changes are the diversity of shapes, options for flexibility, and new use of materials. There are also more

lamp types beyond incandescent and fluorescent, such as halogen and high-intensity discharge. Designs are simple, unadorned, geometric, and flexible, but some may include interesting materials singly or in combination, such as glass, metal, plastic, ceramic, and wood.

■ *Floors.* The selection of floor materials expands considerably, primarily as a result of advances in technology. New materials are combined with older ones for better durability and maintenance, and manufacturers offer more choices in design and installation. Concrete, marble, terrazzo, ceramic tile, stone, brick, wood, bamboo, vinyl, laminate, rubber, and linoleum floors in different designs continue as flooring choices (Fig. 33-24, 33-28, 33-29, 33-32, 33-35, 33-37). Rugs and wall-to-wall carpeting are common in both commercial and residential spaces (Fig. 33-25, 33-26, 33-33). Custom-designed carpets and rugs are typical in high-end projects.

■ *Walls.* Diversity in wall design and the more extensive use of interior architectural features to delineate and articulate interior space (Fig. 33-24, 33-25, 33-26, 33-28, 33-29, 33-31, 33-33, 33-35, 33-36, 33-37) are

more common than any set stylistic features are. Walls may be flat, angled, curved, punctuated, perforated, layered, or transparent. Wall materials include gypsum board (often called sheet rock), glass, and concrete. Common finishes include paint, metal, ceramic or mirror tiles, fabric, and wall coverings. Some wall treatments continue the earlier modular system of prefabricated parts and materials to reflect an industrial look. Others may be smooth or textured, with or without openings. Wall heights vary, with some to the ceiling, while others may be only partial height. Baseboards are plain or may be nonexistent when wall-to-wall carpeting is used. In Minimalist designs, baseboards, when present, are often the same color as the wall to deemphasize them.

■ *Window Treatments*. Simple window treatments are typical. Unpatterned drapery or curtains, miniblinds, vertical blinds, shutters, and sunscreen shades continue in use. Custom-designed sliding screens are alternative choices. Because of tinted glass or an architectural overhang, some windows have no treatments.

■ *Doors*. Doors are often flat and plain, but may vary in design as a result of a wider selection of choices available (Fig. 33-25, 33-33, 33-37). Custom-designed doors that fit particular projects become more common. Door trims continue to repeat the character of window moldings. Often the doors and trim are totally integrated as a prefabricated design unit.

■ *Ceilings*. As with wall design, ceilings offer even more variety than earlier (Fig. 33-24, 33-25, 33-26, 33-27, 33-28, 33-31, 33-32, 33-33, 33-34, 33-35). They may be sloped, curved, or stepped and/or have skylights or translucent panels. Sometimes designers may emphasize pipes and other mechanical items by using contrasting colors. As earlier many continue to be flat, plain, and painted white, black, or a neutral color. Suspended ceiling grids with integrated lighting and mechanical systems are used extensively in a variety of design installations. To meet growing consumer demands for more variety, manufacturers expand options for ceiling surfaces and materials. These include prefabricated metal and translucent glass. Frequently, designers experiment with custom-designed ceilings that integrate lighting, have visual layering, and create interesting focal points (Fig. 33-24, 33-25, 33-26, 33-28, 33-33, 33-35). Treatments may vary from one space or project to another, based on function and aesthetic choices. Experimentation is common during this period.

FURNISHINGS AND DECORATIVE ARTS

Much commercial and residential furniture continues aspects of the Bauhaus and International Style in a machine-made appearance with no applied ornament.

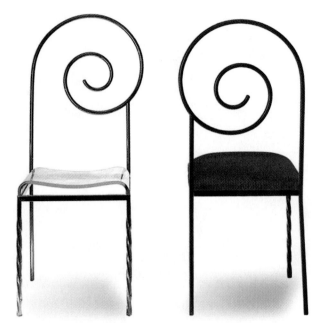

▲ **33-39.** Suspiral chair, 1986; Italy; Luigi Serafini, manufactured by Sawaya & Moroni.

▲ **33-40.** How High the Moon armchair, 1986; Germany; Shiro Kuramata, for Kurosaki in Japan; later reissued by Vitra.

High Tech or industrial factory–style furniture remains a choice, but there are many more design options. There is a market for individual, avant-garde, and one-of-a-kind furnishings among the affluent. Depending upon upholstery color, materials, and/or design, furnishings may blend into the interior environment, emphasize function, appear as art objects or sculpture, or be a combination of all of these. Designs often are more complex because of advancements in technology and materials, and, like architecture, the interplay of solid form versus negative space is important. With High Tech or International Style–influenced furniture, rationalism, functionalism, durability, and craftsmanship remain important design considerations.

DESIGN SPOTLIGHT

Furniture: Aeron chair, 1992; United States; Don Chadwick and Bill Stumpf, manufactured by Herman Miller. Designers Chadwick and Stumpf set out to design a completely new chair that is ergonomically sound and fits people of many sizes and postures. With strong ideas of what a chair should be and none about how it should look, they conduct field studies, anthropometric studies, mapping, and thermal tests. The result is the Aeron chair exhibiting a completely new look for office chairs. Un-

like others, it is not upholstered and reveals no office hierarchy in size. With a curvilinear shape, the chair is adjustable in seat height and tilt as well as arm height and angle, and is available in three sizes. Its transparent Pellicle covering supports the sitter and is form fitting and comfortable because it allows air to penetrate. The covering also is practical and long-wearing. The Aeron chair, which has won numerous design awards, looks and is comfortable for all types of users.

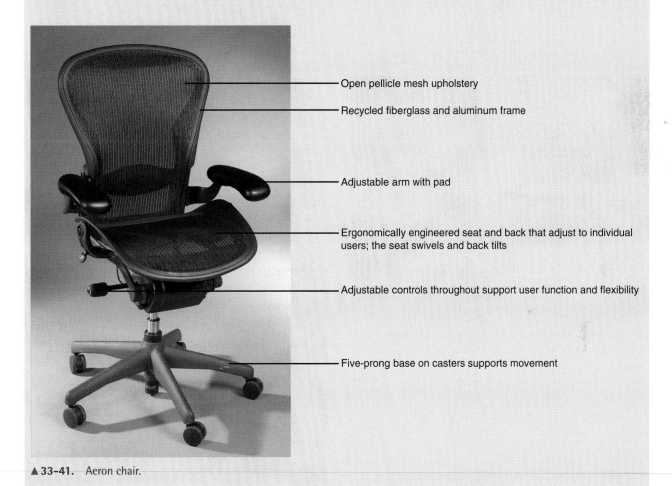

Open pellicle mesh upholstery

Recycled fiberglass and aluminum frame

Adjustable arm with pad

Ergonomically engineered seat and back that adjust to individual users; the seat swivels and back tilts

Adjustable controls throughout support user function and flexibility

Five-prong base on casters supports movement

▲ **33–41.** Aeron chair.

The economic boom of the 1980s increases demand and competition for commercially designed furniture even more than for residential. Corporations and other businesses realize that interior design and furniture choice can create a corporate identity while increasing employee productivity and satisfaction. As a result, contract furniture makers, such as Herman Miller, Knoll, Steelcase, and Vitra, begin focusing on research and development for new furnishings that are ergonomically sound, cost effective, and aesthetically pleasing. Smaller manufacturers with shorter production runs concentrate

on the market for avant-garde and custom furniture. They attract designers who want more freedom to express themselves and employ a greater variety of forms, techniques, and materials. In the 1990s, independent furniture designers promote their work through special galleries. Their furniture usually is one of a kind, made of unusual materials, and highly expressive of their individual aesthetic sensibilities.

As earlier, designers continue to experiment with multifunctional furniture to address specific functional requirements and with new ways to use furniture. Portability,

▲ **33-44.** Alo chair, 2005; Italy; Karim Rashid, from Magis.

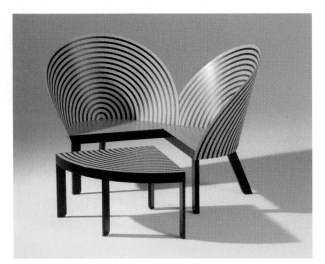

▲ **33-42.** Trinidad chair and Bench for Two, 1993–2000; from Frederica Furniture in Denmark and Hightower Group in the United States; Nanna Ditzel.

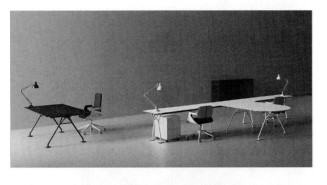

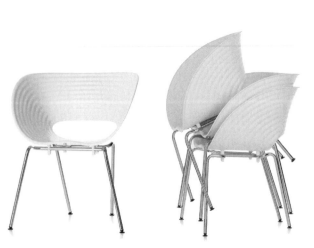

▲ **33-43.** Tom Vac chair, 1997; Germany; Ron Arad, for Vitra.

▲ **33-45.** Nomos table, 1989; Italy; Sir Norman Foster, for Tecno.

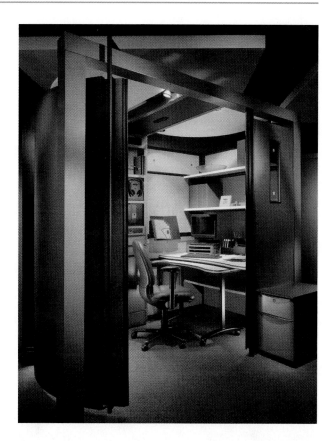

▲ **33-46.** Battista folding extension table 4460 and Mobil storage system, 1991, 1993; Italy; Antonio Citterio and Glen Oliver Löw, for Kartell.

▲ **33-47.** Aspire folding table, 2002; United States; Simon Desanta with König + Neurath, manufactured by Kimball International.

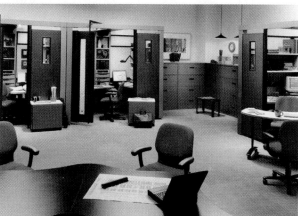

▲ **33-49.** Personal Harbor office furniture, c. 1992; United States; Paul Siebert, Mark Baloga, and Steve Eriksson; manufactured by Steelcase.

▲ **33-48.** Peristyle table, 2005; United States; Stan Carroll.

flexibility, and comfort are important so that furniture can be moved around for greater efficiency, can support change, be positioned to fit users, and address ergonomic considerations. There is greater concern for users than there was earlier, so research findings in ergonomics and anthropometrics and principles of universal design drive concepts more than ever before. Many designers attempt to unite the human body and furniture.

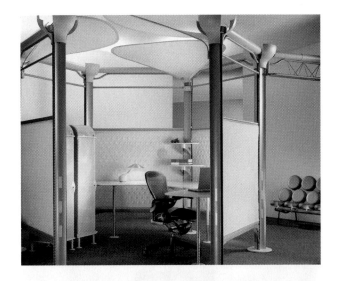

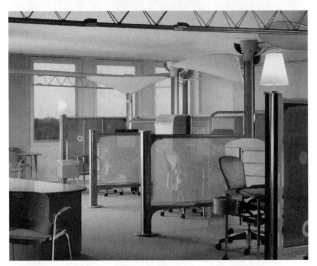

▲ **33-50.** Resolve office system, c. 2006; United States; Douglas Ball, manufactured by Herman Miller.

Public and Private Buildings

■ *Types*. Office furniture continues to expand in design choices based on advances in research and technology, both for the work environment and home (Fig. 33-25, 33-28, 33-29, 33-33, 33-41, 33-45, 33-46, 33-49, 33-50). Office desk chairs become more ergonomic. Furniture designed for a specific purpose is more common in all types of spaces.

■ *Distinctive Features*. Furniture is sleek and simple as earlier, but there is greater unity of art and design. Many strive to create furniture with similar visual and aesthetic characteristics as the fine arts, such as painting or sculpture. Because of this, some examples seem like pieces of sculpture in interior environments (Fig. 33-40, 33-48). These unique and creative expressions, unlike any earlier examples, show greater experimentation by their designers.

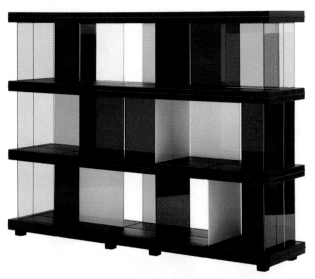

▲ **33-51.** Self (storage system), 2000; Italy; by Ronan Bouroullec and Erwin Bouroullec, manufactured by Vitra.

■ *Relationships*. Furniture may merge with or be conspicuous in an interior, depending on the project, designer, and users. Office systems furniture continues its earlier regularity in overall design but offers greater diversity and flexibility in arrangement. To meet increasing demands from consumers, furniture becomes more mobile and flexible (Fig. 33-41, 33-43, 33-44, 33-46, 33-47, 33-49, 33-50, 33-51).

■ *Materials*. Unlike before, designers experiment with metal above all else. It appears in various forms that may be tubular, thin sheets, perforated, or solid contours. Aluminum and steel are popular materials. Metal in various finishes is often mixed with glass, rubber, laminates, and fabric. Plastic, fiberglass, and other similar materials sometimes are used for furniture. Independent designers employ a variety of materials, many of which are atypical alone or when mixed together, such as glass, concrete, or found objects.

■ *Seating*. Chairs continue to be the most important pieces of furniture in all environments, except retail spaces. Designers continue to explore forms, contours, flexibility, modularity, and ergonomics. The most important new development in ergonomic seating is the Aeron chair (Fig. 33-41), designed by Bill Stumpf and Don Chadwick for Herman Miller and introduced in 1992 after many years of research and development. The designers give it a unique, biomorphic shape. It represents a more advanced level of ergonomic seating as a result of data about size selection, body contour, and material use than was previously available. Because it is extremely adjustable and comfortable, the chair becomes an instant best-seller with many imitators. New designs emerge in side and stacking chairs for use in schools, institutions, health care facilities, and auditoriums (Fig. 33-42, 33-43, 33-44). Some mix metal

▲ **33-52.** Upholstery: Woven fabrics Cipher (left), Gradual (center), Ply Mesh Black (top right), and Tweed Stripe (right); c. 2000s; United States; manufactured by Maharam.

parts with plastic surfaces or fabric upholstery, while others are entirely of metal or plastic. Carts to store and move them on become very important.

Other new developments in chairs focus on furniture with an artistic look. Examples include the Suspiral chair (Fig. 33-39) by Luigi Serafini and the How High the Moon chair (Fig. 33-40) by Shiro Kuramata. These types of chairs address the basic function of sitting, but stress the overall look and aesthetics of the composition above all else. Sometimes they are comfortable, and sometimes they are not.

■ *Tables*. Most tables are sleek and unornamented, with interesting details conveyed in structural components. Designs emphasize flexibility, mobility, and simplicity. Office systems tables support multifunctional uses, with a diverse selection of top sizes, shapes, materials, and colors (Fig. 33-29, 33-33, 33-49, 33-50). Most have casters and wire management features, and some have folding components or elements that can be combined. Some designers explore unusual designs for conference, dining, occasional, and coffee tables using glass, wood, metal, granite, or marble tops, and metal legs or bases in various forms and designs (Fig. 33-33, 33-46, 33-47, 33-48).

■ *Systems Furniture*. As the technology revolution evolves and increasingly affects work, changes in office systems furniture are needed to respond to function, flexibility, and lower costs. Choices increase significantly as more research data and advanced designs address ergonomics, proxemics, communication, and behavioral design (Fig. 33-33, 33-49, 33-50). The greatest need is for flexibility. Systems furniture also must respond to alternative officing concepts and create work areas that can be reconfigured easily to meet changing business requirements and the needs of those who work on site, in groups, or off site. Although office systems furniture is intended to be mobile, most firms do not take advantage of this, and configurations are largely static grids instead of ones customized to the firm as intended. Manufacturers respond with systems that are even easier to reshape and strive to educate designers, clients, office managers, and facility managers.

Systems furniture supports custom designed offices for each company or user. Units can be arranged at different angles to eliminate the grid and create more landscaped patterns that relate to functional needs. Other options include wall panels of different materials and heights; sound-masking systems for more privacy; portable units; more modular components; better storage capabilities; more integrated voice, data, and lighting selections; more seating options; and more aesthetic choices in colors and materials. With these enhancements, individual work areas can be easily tailored to meet individual needs and personal requirements for existing and new employees. One example is Herman Miller's Resolve system (Fig. 33-50), which is pole-based. Resolve has straight and curving components for more openness and greater flexibility. As designs evolve to support functions and the office worker, manufacturers develop small, portable enclosed office units specifically tailored to the worker who is primarily off site, such as Steelcase's Personal Harbor system (Fig. 33-49).

These changes and concepts affect home environments as well. During the 1990s, the number of home offices multiplies to support a more mobile workforce and those who work from home. Teleworkers and others demand the same advantages in their workspaces that are available in commercial office environments. As a result, the design industry begins to offer similar furnishings that are smaller scaled, slightly less expensive, and readily available in stores.

■ *Upholstery*. Designers continue to select commercial-grade fabrics made of cotton, linen, wool, and synthetic fibers for commercial and residential use (Fig. 33-52). There is greater variety in designs, textures, and colors because of advancements in technology and manufacturing. Computer-designed and -manufactured textiles offer even more options for design and customization.

Manufacturers and suppliers offer more textiles that meet building and finish codes and regulations and that have improved specifications to help designers address code and wear requirements for interiors. Textile showrooms continue to expand in size with more diverse examples.

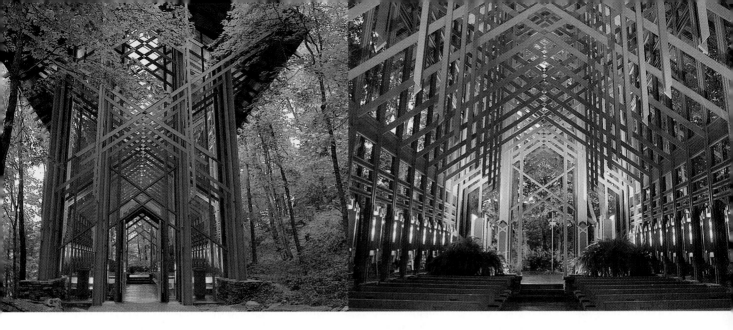

Environmental Modern

1960s–2000s

Environmental Modern architecture, interiors, and furnishings respond to the environment, whether macro (building and site) or micro (interiors and furniture), as part of the larger movement that addresses human needs while safeguarding the earth, its climate, and ecological resources. The movement within design is known by various names such as Green Design, Sustainable Design, or Eco Design. Throughout the 20th century, the movement's concepts in the design community evolve, becoming comprehensive design schemes for protection, conservation, and renewal of resources that include energy conservation, waste management, material conservation, land use and reuse, and climate control. In adopting these concepts, buildings, interiors, and furnishings may show little or no evidence of these ideas or they may reflect a strong contextual relationship to nature, site, and place.

HISTORICAL AND SOCIAL

During the late 19th century, a few people, including William Morris, recognize that the Industrial Revolution is

Fix the position of individual buildings on the site, within the complex, one by one, according to the nature of the site, the trees, the sun: this is one of the most important moments in the language.

Christopher Alexander,
A Pattern Language, 1977

In each project, we seek new ways to integrate an organizing idea with the programmatic and functional essence of a building. Rather than a "style" carried to different sites and climates, or pursued regardless of different programs, we seek the unique character of a program and site, local and global, as the starting point for an architectural idea.

Steven Holl, c. 2000

Our goal is a delightfully diverse, safe, healthy, just world with clean water, clean air, clean soil, clean power—economically, equitably, ecologically, elegantly enjoyed.

William McDonough, Interior Design
Educators Council, Annual Conference, 2005

creating air and water pollution as well as social evils. However, reforms focus on social problems instead of the environment, in part, because there is little understanding of the effects of bad air and water. Early ideas of the Environmental Movement, which influence Environmental Modern, spring from the 19th-century American transcendentalists, such as Henry David Thoreau and his book *Walden*. These writers highlight the significance of nature and link it with spirituality and humanity. They also introduce the notion of nature as teacher, which becomes important for late-20th-century theorists in sustainability.

In the late 19th and early 20th centuries, environmental concerns center on conservation of natural resources.

Canada, for example, establishes her first national park, Banff National Park, in 1885. In the United States, John Muir advances the importance of protecting of natural resources and the wilderness in his writings. Muir and others found the Sierra Club in 1892, one of the first grassroots environmental organizations. Following Canada's example and influenced by Muir, U.S. President Theodore Roosevelt moves to preserve wilderness lands in national parks, including Yosemite and the Grand Canyon. He also establishes the National Forest Service to safeguard natural resources.

Most environmental efforts are individual, sporadic, and focused on conservation during the first half of the 20th century. Scientists begin investigating the effects of pollution, pesticides, and chemicals on humans and the earth. They and a few individuals who recognize the damaging, long-term effects of air and water pollution, as well as some farming practices and insecticides, begin to call for change. During the period, national governments pass a few laws designed to curb pollution and unsafe practices. Some forward thinkers identify a growing need for energy conservation.

During the early 1960s, spurred by greater industrialization, increased production of chemicals, and nuclear testing of the postwar period, there is a growing awareness of numerous environmental problems. Environmentalism begins to take shape as a distinct movement with cultural and political impact in many countries. An important catalyst is the publication of *Silent Spring* (1962) by Rachel Carson, a book that calls attention to the destructive effects of pesticides on people, organisms, and the environment. It inspires a move toward saving the planet, which is mostly a counter-culture trend among young people. Saving the earth suits those who question authority and seek to change the status quo. Although their radicalism helps awareness, it keeps environmentalism from entering the mainstream. In the late 1960s, illnesses and deaths from air pollution and chemicals in the United States and other countries heighten concerns about the increasing environmental problems. At the time, few American designers and architects respond.

These concerns continue during the next decade as the acute effects of pollution become more apparent in many parts of the world, reflected in famines, droughts, and floods. Scientists, researchers, and thinkers increase their study of the consequences of the unchecked use of chemicals and nuclear testing as well as pollution and other environmental concerns. Some small steps toward curbing the destruction of the environment are made as nations across the world initiate discussions on solving environmental problems. Most important, countries begin to realize that environmental problems require holistic solutions that encompass urban planning and growth, transportation alternatives, and controlled development. More nongovernmental groups focused upon the environment

form during the period. For example, in 1971, citizens from Vancouver, British Columbia, protest nuclear testing by the United States. Calling themselves Greenpeace, they form an organization that becomes an effective worldwide force for the environment.

In the early 1970s, concerns about energy conservation arise from the shortage of gasoline, which raises prices and limits supply, especially in the United States. The loss of inexpensive petroleum forces a search for ways to lessen dependence on it and to find materials that are not derived from petroleum. Furthermore, some people begin to question unlimited consumption and the throw-away mentality of most citizens of industrialized nations. These practices further deplete energy sources and generate mountains of waste as well as air and water pollution. During this period, architecture and design responses center on energy conservation through passive and active solar design and a search for alternatives to petroleum-based materials.

In 1970, the first Earth Day is held in the United States. Intended to educate people about the disastrous effects of industrialization on the earth, one important result is the beginning of a national policy for the environment in the United States, seen in the creation of the Environmental Protection Agency and the National Environmental Protection Act of 1970. Earth Day becomes international within a year, and other nations create governmental departments and ministries focused on the environment. In 1972, the first world conference on the environment is held in Stockholm, Sweden. Sponsored by the United Nations (UN), the event is a global forum for concerns about the environment across the world, especially in Europe. The conference links environmental concerns with economic issues, such as growth and development. Nations begin to work individually and collectively to solve problems of air and water pollution, loss of natural resources, disposal of toxic wastes, and the effects of industrialization and nuclear weapons on the environment. From 1972 onward, numerous international treaties are established in which nations agree to adhere to particular standards for protecting the environment.

By the 1980s, there is greater public, scientific, and governmental awareness around the globe of long-term environmental problems such as acid rain, loss of the rain forests, excess garbage, and toxic waste. Throughout the decade, environmental concerns gain more international attention, aided by several actions of the UN. In 1987, the concept of sustainability comes to the forefront with the publication of the Brundtland report entitled *Our Common Future*. It spreads the concept of sustainable development, which it defines as meeting the "needs of the present without compromising the ability of future generations to meet their own needs." The report also links ecology and the environment with development, economy, and equality. This gives impetus to sustainability as a social and economic

movement that centers on the protection and care of the environment in perpetuity. During the 1980s, architects and designers in Europe and North America begin to acknowledge the destructive effects of unchecked development and the negative impact of building upon the environment in terms of loss of green space, destruction of natural resources, pollution, energy consumption, and creation of waste. The first efforts at change are individual and isolated, but increase as the decade progresses.

During the 1990s, environmental emphasis maintains its comprehensive attitude of economic, political, and social responsibility. Concern for the earth and sustainability enters the mainstream as people around the globe experience the effects of a damaged environment in the form of heat waves, droughts, and more diseases. Global, governmental, and organizational groups continue their efforts to develop effective, long-term solutions. However, an economic recession in the early 1990s halts progress, especially when governments curtail spending. As a result, the marketplace begins to have a greater impact by offering more earth-friendly products. By the end of the decade, the recession ends, and governments renew their spending on environmental efforts. In 1992, people from around the world gather in Rio de Janerio for the first Earth Summit. Participants focus on ecoefficiency, a concept that strives to change attitudes of "take, make, waste" into ones that preserve and protect the environment by doing less with more. They agree on principles of environmentalism and set up Agenda 21, a global program for sustainability.

Also during the 1990s, individuals, corporations, and businesses adopt comprehensive environmental policies and sustainable practices, and the terms *green architecture* and *green design* become more prominent. In 1992, the sustainability movement reveals its effects on design at the World's Exposition in Seville, Spain. The exposition is a showcase for sustainable design, as well as for design solutions that respond to climate and conservation technology used to help, not hurt, the environment. In 1993, the U.S. Green Building Council (USGBC) is founded. Made up of architects, builders, and developers, it strives to promote environmental responsibility, profitability, and healthy living and working spaces.

In 1984, the World Health Organization identifies a cluster of symptoms in humans that will become known as Sick Building Syndrome (SBS), which is linked to spending time in certain buildings, either individual rooms or zones. By the 1990s, designers and clients realize that SBS affects the health and productivity of users. Caused by inadequate ventilation, interior and exterior pollutants, allergens, bacteria, and molds, designers begin to look for ways to eliminate these hazards. Indoor air quality (IAQ) becomes critically important, legally and in design. This complex issue arises from a host of factors from the building envelope, mechanical systems, finishes, and furnishings, and solutions must involve a variety of design professionals including interior designers.

Sustainable efforts within individual nations continue into the 21st century. Most countries have departments or ministries that focus on the environment. Many, including Canada, the United Kingdom, and Australia, adopt sustainable policies and programs and include stringent sustainable requirements in their national building codes. Canada's Department of Commerce pursues energy conservation. Great Britain moves to clean up the Thames River and reduce air pollution. Japan passes some of the world's strictest laws to control air and water pollution. Green Parties, political groups devoted to environmental concerns, arise in nearly all countries with free elections. Global involvement also continues with the aid of the UN.

The design and educational communities broaden and increase their environmental efforts and stewardship. In 2000, the USGBC introduces the Leadership in Energy and Environmental Design (LEED) rating system for high-performance, sustainable buildings. In 2004, LEED standards for commercial interiors are established; they are joined by a residential rating system in 2005. By 2007, the USGBC has instituted LEED rating systems for new and existing buildings and is developing ratings for schools, retail, healthcare, and neighborhoods. Canada has a similar program.

Information about sustainability and environmental design and products are readily available through books, journals, and especially the Internet, which is a major resource not only for education but for communication. Museums in many countries mount exhibits, and universities offer coursework and degrees in environmentalism and environmental or green design. Architectural and interior design firms, such as HOK in the United States and Penner and Associates in Canada, specialize in green design and planning for all types of buildings and interiors. Professional and shelter magazines highlight environmentally conscious projects and practices. Professional design organizations move to have sustainable concepts become a part of education, standard practice, professional ethics, and social responsibility. NEOCON, the Environmental Design Research Association (EDRA), and other organizations host conferences, workshops, and trade markets that highlight the newest sustainable products, technologies, and techniques. These efforts create environmental awareness and promote healthy living and socially responsible consumerism.

CONCEPTS

During the late 20th century, a variety of concepts and theories related to environmental and sustainable architecture and design exist internationally. Deriving concepts from science, ecology, philosophy, psychology, and other disciplines, they reflect a comprehensive attitude that strives to limit and/or reverse environmental damage through development and change in thoughts and actions

▲ **34-1.** William McDonough and Clodagh, c. 2000s; United States.

Definitions

- *Sustainability*. Often used to describe the entire environmental movement, sustainability strives to shape societies, economies, and human activities so that all needs are met to the greatest potential but resources for the future are maintained. Sustainable design creates products that comply with principles of economic (production, distribution, and consumption of goods and services), societal, and ecological (living organisms and the natural environment) sustainability. These products do not deplete resources or harm the environment or users.

- *Green Design, Green Architecture*. Green design refers to trends in architecture, interior design, and related design disciplines that adopt sustainable design principles. Practical in concept, green design focuses on energy efficiency, use of renewable resources, and practices and materials that do not harm either the micro environment (building and interiors) or the macro environment (earth). Life cycle costs and durable, local materials with low embodied energy also are important.

- *Environmental Design*. Closely aligned to sustainability and green design is environmental design, which embraces a design process that produces buildings, interiors, and objects that are aesthetically pleasing and functional with a sense of humanity. It encompasses many concepts such as behavior, universal design, energy efficiency, and sustainability.

Theories and Theorists

By the late 20th century, theories centering on environmental concepts influence leaders of thought and forward-thinking design firms. Using these theories, they develop ideas and processes that address new and smarter ways of planning and designing. Beginning in the late 20th century, designers use comprehensive design methods to achieve sustainability, beginning with problem identification and programming. They often incorporate sophisticated and scientific techniques for data collection and analysis, such as

by individuals, designers, businesses, manufacturers, governments, and nations. Most center on conservation, good stewardship, social responsibility, and regeneration of resources. This includes, but is not limited to, eliminating waste, reusing or recycling, minimizing energy consumption, improving indoor air quality, and using only renewable and durable resources. Care and concern for the environment affect economic development, urban planning and land use, architecture, construction techniques, building materials, interior design, interior finishes, textiles, furniture, and decorative arts around the globe. A variety of terms describe environmental concepts.

energy and water analyses, and incorporate the latest re-search findings into their projects and presentations. Some regard the sustainable and green movements as having an equal, if not greater, impact on design than did the Modern Movement of the mid-20th century.

■ *William McDonough*. McDonough (Fig. 34-1) is one of the best-known architectural theorists and practitioners of sustainability (Fig. 34-12, 34-29). He believes that design can solve earth's problems and stop the destructive process of the traditional Industrial Revolution by adopting principles found in nature. McDonough advocates what he and Michael Braungart call a "cradle to cradle" approach in which products are created using sound economic and sustainable principles. Once they have reached the end of their life cycle, they are broken down to be reused, recycled, or replenished, thereby eliminating waste. Products that do not fit into this category are stored until ways to reuse them are discovered.

■ *Paolo Soleri*. Soleri is an architect who formulates Arcology, a theory of urban planning that limits waste of land, energy, and resources. Using new technologies, past practices, and ecological concepts, Arcology encourages a rethinking of the city into a living and working environment (Fig. 34-7).

■ *Christopher Alexander*. Theorist and architectural educator, Alexander stresses design methods that give context,

meet users' needs, and save materials, energy, and labor. He identifies numerous patterns and ideas that people have used to successfully solve problems in design. These patterns can be combined in different ways to create effective, green solutions for cities, neighborhoods, and public and private living and working environments.

■ *Sim Van der Ryn*. Van der Ryn is an architect who believes in the importance of local setting and creating a sense of place. He brings ecology into the design process by stressing that structures should complement climate, nature, and natural processes, such as recycling and reusing. Structures should evolve from the landscape and be responsive to human needs by including the user in the design process.

■ *Other concepts*. Other concepts and principles not directly related to design but informing it include Deep Ecology, which stresses the value of all life, not just human, and Biomimicry, which embraces nature as the model and source of inspiration for business, industry, and design solutions.

DESIGN CHARACTERISTICS

Buildings, interiors, and furnishings can appear in a variety of ways depending upon the view of the designer and client

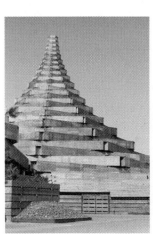
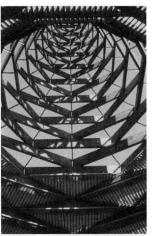

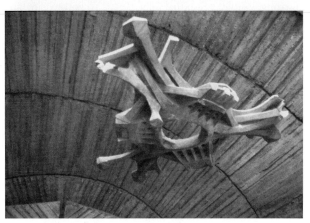

▲ **34-2.** Architectural and interior details, c. 1990s–2000s; Canada, Texas, California, Washington, and Arizona.

regarding context of site and location, sustainable concepts, and new technologies. Some commonalities include natural materials, earth colors, plants, water features, and an abundance of natural light and air. Usually, sustainable materials, construction techniques, and planning concepts are not visually apparent. Nevertheless, they positively affect the health and productivity of users while keeping energy and maintenance costs down.

Whereas most buildings, interiors, and furniture have a strong modernistic or High Tech appearance, others embrace vernacular types or organic and sculptural forms. Most High Tech, Minimalist, or Late Modern (see Chapters 31, "Late Modern · 1" and 33, "Late Modern · 2") examples result from designers who see technology as a means to solve both design and environmental problems. They embody new technologies and materials in their work.

Designers who regard technology as the cause of environmental problems use it minimally or reject it altogether. Consequently, they usually seek a cultural or contextual fit for their work by adopting or interpreting local or regional, traditional, or vernacular building and interior types and forms and by using local materials and construction methods (Fig. 34-2). Ancient planning methods and philosophies, such as Feng Shui, may be adopted. Compositions may have a simple and natural or vernacular appearance or reflect nature-based images or local environmental relationships.

■ *Motifs*. No particular motifs are associated with Environmental Modern because expressions are varied, but designers may use motifs inspired by the site, the locale, the region, or nature itself (Fig. 34-2).

ARCHITECTURE

Beginning in the late 1960s, some architects try to relate new designs to their surroundings by visible and symbolic links. Influenced by concepts from Frank Lloyd Wright, Louis Kahn, and Paolo Soleri, they design buildings with a strong, visible contextual relationship to nature, site, and place. As a result, buildings integrate harmoniously with their natural surroundings (Fig. 34-4, 34-7, 34-8, 34-14, 34-19, 34-22); sit on or near waterways, woods, or large green spaces (Fig. 34-8, 34-13, 34-14, 34-19, 34-23, 34-25); are oriented to take advantage of the sun and breezes (Fig. 34-3, 34-6, 34-7, 34-13, 34-15, 34-24); and create a strong sense of place within their environment (Fig. 34-5, 34-6, 34-8, 34-11, 34-16, 34-23). Often they appear to be calm, contemplative refuges from the complexity of everyday life. A crafts approach may define, frame, and/or articulate the overall design aesthetic. Frequently, forms, shapes, scale, and color come from or reflect the surroundings or the locale. Materials and designs tend to blend in

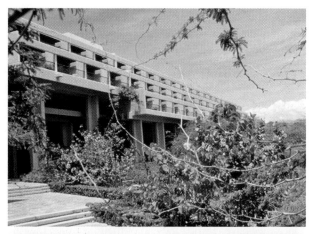

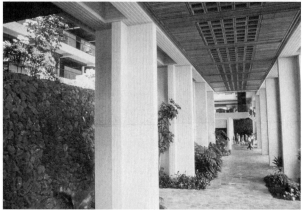

▲ **34-3.** Mauna Kea Beach Hotel, 1967; Kohala Coast, Hawaii; Charles Bassett, at Skidmore, Owings, and Merrill.

rather than stand out from the site to convey the harmonious relationship.

In the second half of the 20th century, architects increasingly consider energy conservation and efficiency in their designs. Comprehensive planning and design schemes have not developed. So, they mainly incorporate active and

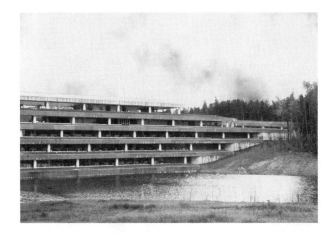

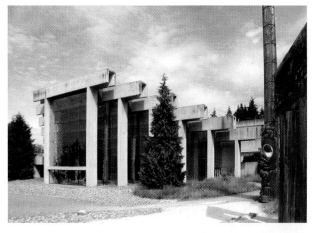

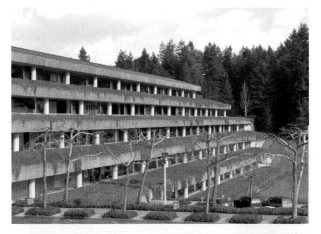

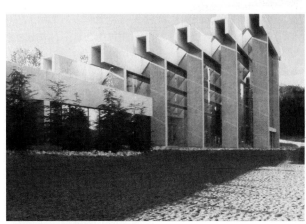

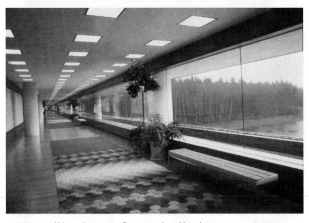

▲ **34-5.** Museum of Anthropology, 1976; Vancouver, British Columbia, Canada; Arthur Erickson.

▲ **34-4.** Weyerhaeuser Corporation Headquarters, c. 1971; Federal Way, Washington; Skidmore, Owings, and Merrill.

passive solar elements that use climate, orientation, and landscape features to make buildings comfortable, but less dependent upon energy sources and more cost efficient (Fig. 34-4, 34-20, 34-27). These features may dominate the design or be concealed. A few architects experiment with solar design and explore new ways for greater energy efficiency and a more effective use and preservation of natural resources. States, such as California, mandate prescriptive

standards that include insulation, glazing, space conditions, and lighting, among other concerns.

As environmental concerns intensify and theories of how to solve them increase in the 1980s, architects turn more to the ideas of green design, sustainable materials, and socially responsible use of natural resources. This is aided by the mid-20th-century critiques of Modernism's lack of context and perpetuation and glorification of industrialization

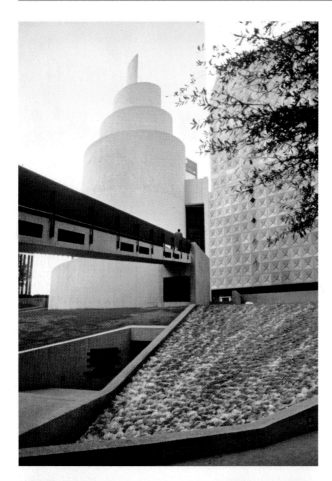

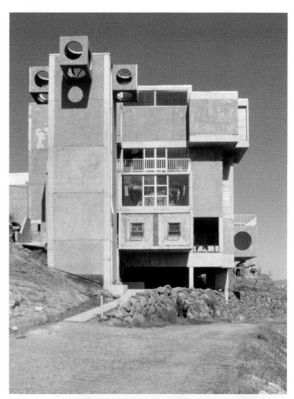

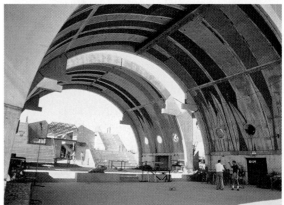

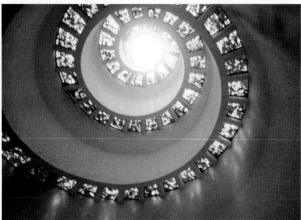

▲ **34-6.** Thanksgiving Square Chapel and ceiling detail, 1977; Dallas, Texas; Philip Johnson.

and technology, which are largely responsible for damaging the environment. Some of the first examples sacrifice aesthetic innovation in the interest of environmental concerns. Later, these two goals unite, producing a variety of aesthetically pleasing and individual works.

In contrast to some other planning methods, green building considers the site and tries to destroy as little of surrounding vegetation as possible while orienting the

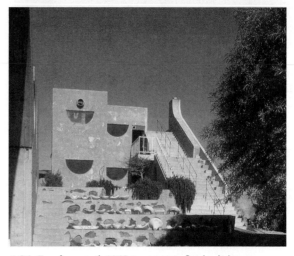

▲ **34-7.** Arcosanti, 1969 to present; Cordes Lakes area, Arizona; Paolo Soleri.

DESIGN SPOTLIGHT

Architecture: Thorncrown Chapel, 1978–1980, and Mildred B. Cooper Chapel, 1986–1987; Eureka Springs and Bella Vista, Arkansas; Fay Jones and Maurice Jennings. Thorncrown Chapel, the architect's masterpiece, is a small, elegant chapel nestled in a quiet forested area. The contemporary, Gothic-inspired structure boasts a cross-lattice system of wooden support members that pitch to center and hold the structure together. Reminiscent of construction techniques seen in rural covered bridges, the wooden supports also create a rhythmical quality and emphasize the use of natural materials. Large glass panels inserted between the supports filter ever-changing natural light to reinforce the relationship of solid to void, chapel to nature, and sacred space to setting. The building is at once complex, intimate, and memorable. It exhibits a strong sense of

place and spirituality through its form, construction, materials, and details, as it responds to its environmental setting. Voted by the American Institute of Architects as the best building of the 1980s, it is recognized in 2006 with the AIA "Twenty-Five Year Award" for its significant influence on the profession.

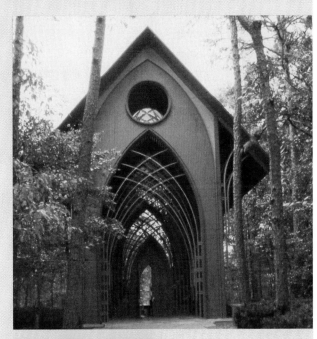

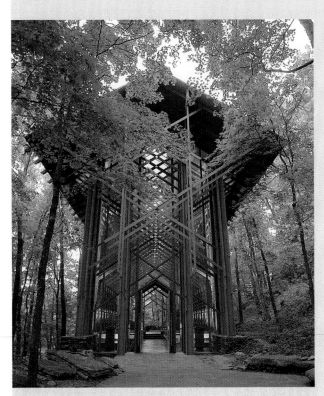

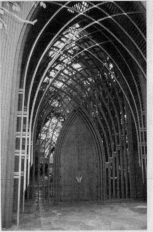

▲ **34-8.** Thorncrown Chapel and Mildred B. Cooper Chapel; Arkansas.

structure toward views, sun, and/or breezes (Fig. 34-13). Some buildings are totally or partially underground to enhance energy efficiency, such as the Bill and Melinda Gates House (Fig. 34-23) in Medina, Washington. Exterior designs may model local or vernacular building types, materials, and construction methods. Green building features

often include structurally insulated panels, photovoltaic panels, and solar heat collectors to increase energy efficiency; geothermal heat pumps to help with heating and cooling; rainwater collectors for cleaning and fire suppression; means of reusing gray water; operable energy-efficient windows for natural ventilation; sun louvers or screens to

IMPORTANT BUILDINGS AND INTERIORS

- **Annapolis, Maryland:**
 - Chesapeake Bay Foundation Building (Philip Merrill Environmental Center; the first building to receive a LEED Platinum rating), 2000; Smith Group, interiors by Cheryl Brown.
- **Austin, Texas:**
 - Austin City Hall (LEED Gold rating), 2004; Antoine Predock.
- **Bella Vista, Arkansas:**
 - Mildred B. Cooper Chapel, 1986–1987; Fay Jones.
- **Cambridge, Massachusetts:**
 - Simmons Hall, Massachusetts Institute of Technology, 1998–2002; Steven Holl.
- **Clermont, Kentucky:**
 - Bernheim Arboretum Visitors Center, 2005; William McDonough + Partners.
- **Dallas, Texas:**
 - Thanksgiving Square Chapel, 1977; Philip Johnson.
- **Eureka Springs, Arkansas:**
 - Thorncrown Chapel, 1978–1980; Fay Jones.
- **Fukuoka, Japan:**
 - ACROS Building, 1989–1995; Emilio Ambasz.
- **Greensboro, Alabama:**
 - Yancey Chapel, 1995; Auburn University's Rural Studio with Samuel Mockbee.
- **Helsinki, Finland:**
 - Kiasma Museum of Contemporary Art, 1998; Steven Holl.
- **Hilversum, The Netherlands:**
 - Nike Regional Headquarters, 1999; William McDonough + Partners.
- **London, England:**
 - Greenwich Millennium Village, 2000–2005; Ralph Erskine.
- **Long Island, New York:**
 - Writing with Light House, 2004; Steven Holl.
- **Martha's Vineyard Island, Massachusetts:**
 - Berkowitz-Odgis House, 1988; Steven Holl.
- **Medina, Washington:**
 - Bill and Melinda Gates House, 1990–1997; James Cutler of Anderson Cutler Architects and Bohlin Cywinski Jackson architectural firm.
- **New York City, New York:**
 - Elizabeth Arden Spa, 1998; Clodagh.
 - Kohler Design Center, 2001; Clodagh.
 - The Solaire/20 River Terrace (the world's first green residential high-rise and LEED Gold building), 2003; Richard De Marco of Schuman, Lichtenstein, Claman, Efron Architects with Cesar Pelli of Pelli Clarke Pelli Architects, Inc.
- **Oakland, California:**
 - Oakland Museum, 1961–1968; Kevin Roche and John Dinkleloo.
- **Omaha, Nebraska:**
 - Carl T. Curtis Midwest Regional Headquarters of the National Park Service, 2004; Patrick Morgan and Edward Vidlak at Leo A. Daly Architects.
- **Oracle (north of Tucson), Arizona:**
 - Biosphere 2 Center, late 1980s; John Polk Allen.
- **Ottawa, Ontario, Canada:**
 - Canadian Museum of Civilization, 1989; Douglas Cardinal and Associates.
- **Phoenix and Scottsdale, Arizona:**
 - Arizona Science Center, 1990–1996; Antoine Predock.
 - Cosanti, begun in mid-1950s; Paolo Soleri.
 - Optima Camel View Village, 2006–2007; David Hovey.
 - Phoenix Art Museum, 1996; addition, 2006; Tod Williams and Billie Tsien.
- **Prescott area, Arizona:**
 - Arcosanti, 1969–1977; Paolo Soleri.
- **San Bruno, California:**
 - GAP Offices, 1994–1997; William McDonough + Partners.
- **Santa Fe, New Mexico:**
 - Inn at Loretto, 1975; Harold Stewart.
 - Shadow House, 2003; Antoine Predock.
- **Santa Monica, California:**
 - Colorado Court Apartments, 2002; Pugh + Scarpa Architecture.
- **Seattle, Washington:**
 - Chapel of S. Ignatius, Seattle University, 1997; Steven Holl.
- **Sonoma County, California:**
 - Sea Ranch Condominiums, 1964–1966; Charles Moore, Donlyn Lyndon, William Turnbull, and Richard Whitaker.

IMPORTANT BUILDINGS AND INTERIORS

■ **Sydney, Australia:**
—Ball-Eastaway House, Artists' House, 1982–1983; Glenn Murcutt.

■ **Taos, New Mexico:**
—Interiors, El Monte Sagrada Resort (one of the world's first eco-hotels), 2005; David Sargert, Sargert Design Associates.

■ **Tempe, Arizona:**
—Nelson Fine Arts Center, Arizona State University, 1985–1990; Antoine Predock.

■ **Tokyo, Japan:**
—Dentsu Ad Agency, 1991; Clodagh.

■ **Vancouver, British Columbia, Canada:**
—Museum of Anthropology, University of British Columbia, 1976; Arthur Erickson.

■ **Washington, D.C.:**
—National Museum of the American Indian, 2004; Douglas Cardinal and Associates, GBQC Architects, Jones and Jones, SmithGroup, Polshek Partnership, and the Native American Design Collaborative.

■ **Zeeland, Michigan:**
—Herman Miller Marketplace, 2002; Integrated Architecture and Tom Powers, Interior Architects—Chicago.

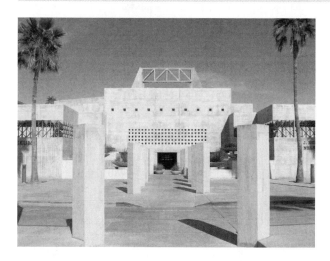

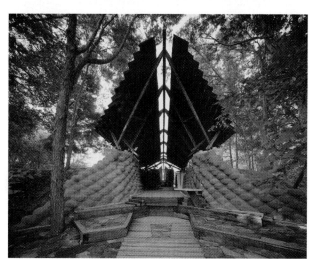

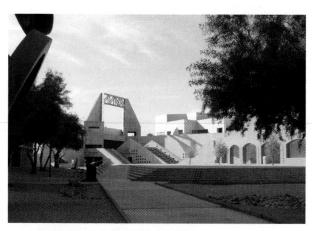

▲ **34-9.** Nelson Fine Arts Center, Arizona State University, 1985–1990; Tempe, Arizona; Antoine Predock.

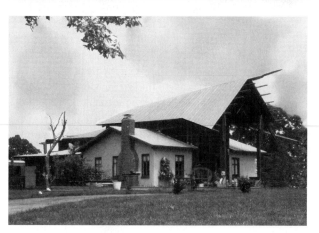

▲ **34-10.** Yancey Chapel and rural house, c. 1990s; Greensboro, Hale County, Alabama; Auburn University's Rural Studio with Samuel Mockbee.

control natural light; low-flow or waterless composting toilets to reduce water consumption; and natural materials that embody low energy and can be locally obtained, easily replenished, and/or reused or recycled. Designers often find that compromises are necessary because of client preference, cost, and tradeoffs in choices.

Some leading design practitioners include Fay Jones (Fig. 34-8), Steven Holl (Fig. 34-11), Antoine Predock

DESIGN PRACTITIONERS

During this period, the number of architects and interior designers who address social responsibility, practice green design, and design using sustainable resources increases significantly. Numerous environmental acts and regulations in the United States, Canada, England, and Europe require design practitioners to address various codes and/or building standards, such as indoor air quality and off-gassing, energy consumption, and the use of lead-based paint and synthetic materials that create toxic pollution. Professional design organizations move to have sustainable concepts become a part of both education and practice. Following the introduction of LEED ratings by the USGBC, numerous design practitioners become LEED-certified to gain the specific knowledge deemed necessary to practice high-quality green design.

- **Clodagh** begins her design career in fashion in Ireland, but comes to the United States in 1983. In commercial and residential spaces, she creates total environments that engage all of the senses. One of the first to adopt principles of Feng Shui in her work, she is known for her sensitive use of materials and textures, the interplay of light, artistic compositions, and sensual spaces that celebrate the "experience of living." Her goals are to create total, timeless designs for interiors, furniture, fabrics, and accessories. She is inducted into the Interior Design Hall of Fame in 1997.

- **Steven Holl** (b. 1947), principal of Steven Holl Architects (SHA), is an internationally recognized architect and Columbia University educator. He is known for his adept handling of space and light and relating his work to its environment. Buildings reflect his influential theoretical concepts, such as anchoring to the site, mixing of functions, hybrid buildings, intertwining, and adapting traditional typologies. Holl is best known for the Kiasma Contemporary Art Museum in Helsinki, Simmons Hall at the Massachusetts Institute of Technology, and the Chapel of S. Ignatius in Seattle. In 2002, Holl receives the Cooper Hewitt National Design Award in Architecture from the Smithsonian Institution.

- **(Euine) Fay Jones** (1921–2004) is Arkansas's best-known regionalist architect. His work shuns architectural trends in favor of simplicity, traditional forms, and craftsman-like conceptions of Arkansas vernacular architecture. He often designs in wood. Many of his buildings emphasize context, natural setting, structure, and

transparency, and they touch people in special ways. Light, shadows, and reflections are important components that play against each other to create interest. In 1990, he receives a Gold Medal from the American Institute of Architects. His most well known project is the Thorncrown Chapel in Eureka Springs, Arkansas.

- **Sam Maloof** (b. 1916) is a furniture designer and woodworker who produces beautifully crafted designs. Maloof's furniture, the forms of which have evolved over his career, has a sculptural quality. Characteristic are slender tapered or swelling lines, no applied ornament, and enhanced wood grain. His work is in museum collections such as the Metropolitan Museum of Art, Smithsonian Institution, and the White House.

- **William McDonough** (b. 1951) is one of the world's leading and best-known architects and theorists on sustainability. Since the late 1970s, McDonough has focused his design, writing, and speaking on ways and means to create earth-friendly structures, buildings, cities, and manufacturing processes. He and his firm McDonough + Partners design worldwide. Another firm, McDonough Braungart Design Chemistry, strives to advance the cradle to cradle protocol to businesses worldwide. His most famous projects are the Gap offices in California and Nike Regional Headquarters in The Netherlands.

- **Samuel Mockbee** (1944–2001) is a prominent architect known as a regionalist. His work reflects southern vernacular architecture. After becoming convinced that architecture had lost its focus of social responsibility and that impoverished people should have well-designed living and working spaces, Mockbee leaves full-time practice to establish in 1992 the Rural Studio at Auburn University along with D. K. Ruth. Under his direction, students participating in studios live and work in some of Alabama's poorest communities. They design and build homes and community facilities using sustainable construction methods and materials. Mockbee is awarded posthumously the AIA Gold Medal in 2003 and the ASID Educator of Distinction in 2006 for his work with Rural Studio.

- **Glenn Murcutt** (b. 1936) is an Australian architect known for his interpretations, often in galvanized iron, of aboriginal buildings. Murcutt practices

alone so that he can concentrate on small, private houses that are environmentally sensitive and energy efficient. Taking cues from the surroundings, his buildings are simple, honest, and touch the earth lightly, a phrase he borrows from the Aborigines. Murcutt is credited with developing an Australian idiom in building. He is awarded the Pritzker Architecture Prize in 2002.

- **George Nakashima** (1905–1990) is a Japanese-American architect, furniture designer, and furniture craftsman. Japanese design and construction methods, the International Style, the Shakers, and American midcentury modern design influence his work. Pieces are simple, sculptural, and rely on the wood grain instead of applied ornament for interest and beauty. Some pieces

have tops and seats of slabs of walnut or other woods.

- **Antoine Predock** (b. 1936) is known for his work in the southwestern United States that exhibits a strong sense of place and context through materials, forms, scale, and orientation. His projects grow from the landscape to express complexity, spirituality, environmental sensitivity, and cultural relationships. Plain surfaces, often earth-colored stucco or limestone, accented with light and shadows characterize many of his buildings. In 2006, Predock receives the Gold Medal from the American Institute of Architects. Two of his well-known projects are the Shadow House in New Mexico and the Nelson Fine Arts Center at Arizona State University in Arizona.

▲ **34-11.** Chapel of S. Ignatius, Seattle University, 1997; Seattle, Washington; Steven Holl.

(Fig. 34-9), William McDonough (Fig. 34-12), and Sim Van der Ryn, of the United States; Glenn Murcutt (Fig. 34-20) of Australia; and Detrich Schwarz of Switzerland. Each interpretation has individual design expression that may emphasize one or more attributes of the environment. Some, such as Murcutt and Jones, work regionally, while others, such as McDonough create projects in national and international locations.

- *Contextualism.* Contextualism, also known as Regionalism, which may be closely related to green design, relates to the macro environment. Designs strive for harmony of setting or sense of place and may adopt or adapt elements and attributes of nearby structures, the site, local materials, local traditions, vernacular forms, and cultural norms (Fig. 34-8,

34-13, 34-16, 34-23). Links are not always obvious or direct quotations, and they may be eclectic. Some closely copy the existing fabric, while other solutions are modernist interpretations with a few key elements or symbols derived from the context. To achieve their goals, designers use a variety of means, including scale, orientation, articulation, individual elements, colors, and materials. Green design and sustainable materials are usually incorporated.

Public and Private Buildings

- *Types.* The most common public buildings include museums (Fig. 34-5, 34-9, 34-16), chapels (Fig. 34-6, 34-8, 34-10, 34-11), corporate offices (Fig. 34-4, 34-12,

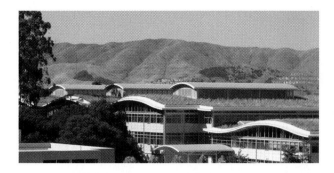

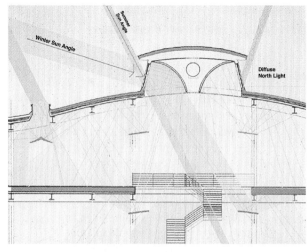

▲ **34-12.** GAP offices, 1994–1997; San Bruno, California; William McDonough + Partners.

34-13, 34-18), hotels (Fig. 34-3), and nature centers, but green concepts appear in all types of buildings. Residences are especially important because architects can experiment with and test concepts and new technologies in sustainable practice (Fig. 34-19, 34-20, 34-22, 34-23, 34-25, 34-26, 34-27). Not all dwellings

are or need to be architect-designed. In 2004, Michelle Kaufmann creates the Glidehouse, a prefabricated, sustainable house that can be configured to meet individual site and user needs. Low-income or public housing and apartment complexes with environmental considerations are built in some locations.

DESIGN SPOTLIGHT

Architecture: Chesapeake Bay Foundation Building (Philip Merrill Environmental Center; the first building in the United States to receive a LEED Platinum rating), 2000; Annapolis, Maryland; SmithGroup, interiors by Cheryl Brown. One of the first buildings in the United States to receive a LEED Platinum rating, this innovative office complex sits on 32 acres of shoreline fronting the Chesapeake Bay and is surrounded by native landscaping and vegetation. Conceived with a strong emphasis on environmental conservation and protection, the building incorporates many important features common to green design, including a shed roof, operable windows, a rainwater catchment system, natural renewable materials, recycled materials, structurally insulated panels, solar water heating, and composting toilets. The south side has a glazed wall of windows to increase daylight and enhance passive solar heating. Sun louvers and architectural overhangs provide protection as needed. Building materials are mainly wood, galvanized recycled steel (roof and siding), and glass. The spacious, open interiors continue the use of earth-friendly materials with cork and bamboo flooring, linoleum, parallel strand lumber (made from scrap wood), medium density fiberboard, and eco-friendly paint.

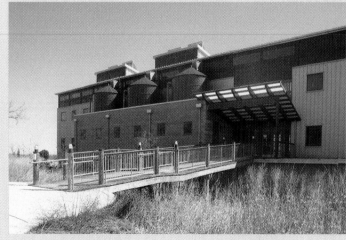

▲ **34-13.** Chesapeake Bay Foundation Building; Annapolis, Maryland.

■ *Site Orientation*. Orientation is critical for energy efficiency and planning. Architects strive to site urban examples as efficiently as possible with the limitations of city lots and zoning requirements. Space may allow green areas and water features. Rural or suburban buildings are often surrounded by landscapes with native vegetation and oriented to best utilize nature and local resources, including waterways, woods, and sunlight (Fig. 34-4, 34-5, 34-7, 34-8, 34-13, 34-14, 34-15, 34-19, 34-23, 34-25). The landscape usually has indigenous grasses, wildflowers, rocks or boulders, and native bushes, and buildings are placed near water (Fig. 34-13, 34-14). Most of the plants require little watering, so there is no need for an irrigation system. Rain gardens or water collectors provide additional resources. If buildings are sited in urban areas, local

vegetation may surround and frame the building to enhance the man-made setting (Fig. 34-16). Some buildings, such as earth-sheltered ones, emerge directly from or within the landscape.

■ *Floor Plans*. Floor plans vary based on the building function. They are usually simple in organization and design and may be symmetrical or asymmetrical based on location, geography, or major circulation paths (Fig. 34-21, 34-27). Some architects regard plan designs as a journey that supports exploration through an open-ended sequence of spatial experiences. Others create direct routes that end in important spaces or focal points or lead to specific activities. Still others use metaphors from nature, such as shells, plants, and water, to guide the arrangement. Processional or transitional spaces that connect the outside to the inside appear often, sometimes as roofed passages (Fig. 34-3, 34-13), which may be open or closed. Usually, they have large walls of glass to let in sunlight and exterior building materials to visually aid the outside-to-inside transition. Water areas may be incorporated to soften the effect.

Plan shapes may be rectangular, curved, or angled, or a combination of different shapes. Some are differentiated by their irregularity. Large spaces or rooms, such as conference rooms or naves, may define the overall shape or project from it to emphasize or increase natural views, focal areas, and/or sun exposure. Open floor plans with minimal wall divisions are common, especially in museums and chapels. Houses feature numerous open areas, sunlit passages, exploratory circulation paths, and contemplative spaces. Public and private areas are defined, but the divisions may be less recognizable.

■ *Materials*. Most buildings incorporate natural materials, some new and some recycled (Fig. 34-10, 34-27), that can be

▲ **34-14.** The Eden Project, 2001; Bodelva, St. Austell, England; Nicholas Grimshaw.

DESIGN SPOTLIGHT

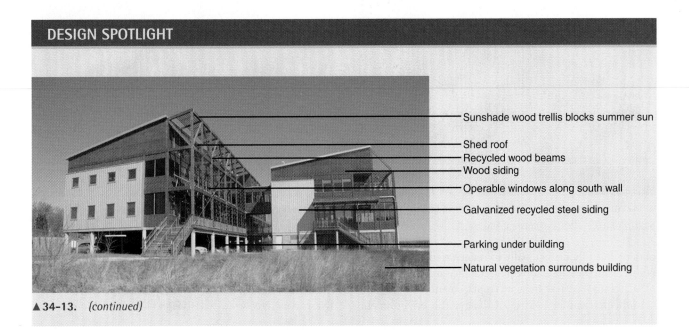

Sunshade wood trellis blocks summer sun

Shed roof
Recycled wood beams
Wood siding
Operable windows along south wall

Galvanized recycled steel siding

Parking under building

Natural vegetation surrounds building

▲ **34-13.** *(continued)*

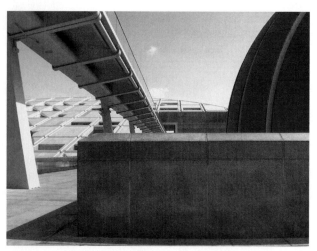

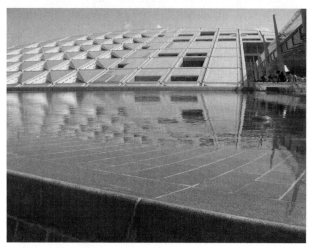

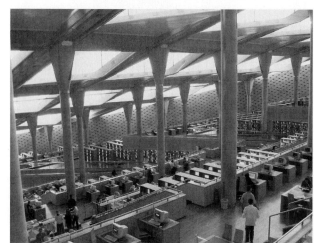

▲ **34–15.** Alexandria Library, 2002; Alexandria, Egypt; Snøhetta.

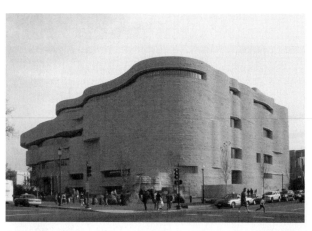

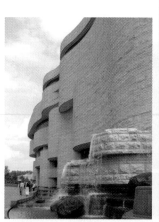

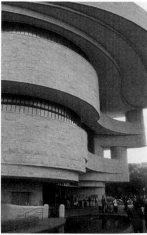

▲ **34–16.** National Museum of the American Indian, 2004; Washington, D.C.; Douglas Cardinal, GBQC Architects, Jones & Jones, SmithGroup, Polshek Partnership, and the Native American Design Collaborative.

obtained locally or regionally to reduce transportation expenses. Designers also consider durability and maintenance of materials because frequent replacement and frequent or difficult cleaning and repairs harm the environment.

Examples include local stone (Fig. 34-7, 34-16), recycled wood, galvanized steel siding (Fig. 34-13), medium density fiberboard, parallel strand lumber, insulated precast concrete, flyash concrete, straw bales (Fig. 34-2, 34-25), aluminum,

▲ 34–18. Hearst Building (the first commercial LEED Gold building in the city), 2006; New York City, New York; Foster and Partners with Adamson Associates. The original, old, lower façade of the building was designed by Joseph Urban in the 1920s.

▲ 34–17. Austin City Hall (LEED Gold rating), 2004; Austin, Texas; Antoine Predock.

▲ 34–19. Sea Ranch Condominiums, 1964–1966; Sonoma County, California; Charles Moore, Donlyn Lyndon, William Turnbull, and Richard Whitaker.

▲ **34–21.** Floor plan, Ball-Eastaway House, Artists' House, 1982–1983; Sydney, Australia; Glenn Murcutt.

▲ **34–20.** Ball-Eastaway House, Artists' House, 1982–1983; Sydney (North), Australia; Glenn Murcutt.

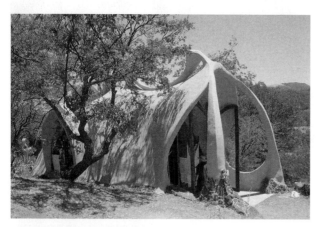

▲ **34–22.** House, James Hubbell Compound, c. 1990s; Santa Ysabel, California; James Hubbell designer.

▲ **34–23.** Bill and Melinda Gates House, 1990–1997; Medina (on Lake Washington), Washington; James Cutler of Anderson Cutler Architects and Bohlin Cywinski Jackson architectural firm.

limestone, granite, brick, and insulated tinted or patterned glass (Fig. 34-14, 34-15). The use of wood is debated as forests begin to disappear. Alternatives include engineered woods and certified sustainably harvested wood, which is responsibly forested. Many material choices are available, but only a few may be selected for a particular building. Color, which is considered carefully, comes from the building materials. Sometimes, architects use stains and paints made from natural materials, or ones that are

biodegradable or emit low amounts of volatile organic compounds (VOCs).

■ *Façades.* Some buildings, particularly those in an urban context, have a contemporary or, even, an avant-garde appearance. Green and sustainable features may or may not define their design concepts but are incorporated nevertheless because of designer or client preference or requirements of building codes (Fig. 34-18, 34-24). Some have an overtly High Tech appearance with glass walls and a

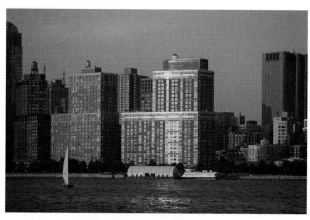

▲ **34-24.** The Solaire/20 River Terrace (the world's first green residential high-rise and LEED Gold building), 2003; New York City, New York; Richard De Marco of Schuman, Lichtenstein, Claman, Efron Architects with Cesar Pelli of Pelli Clarke Pelli Architects, Inc.

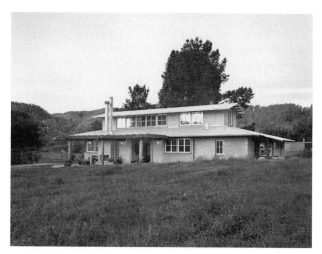

▲ **34-25.** Breeze House (illustrating straw bale construction), 2003; Mill Valley, California; Arkin-Tilt Architects.

▲ **34-26.** McKinley House, 2004; Venice, California; David Hertz and Stacy Fong of Syndesis.

dynamic expression of structure. Others are Late Modern and maintain the grid within varied shapes and with minimal ornament (see Chapters 31, "Late Modern · 1", and 33, "Late Modern · 2").

Architects often adopt Wright's organic design concepts and consider the building's natural surroundings as they develop the individualized façade design. Because of this, buildings commonly blend into their environment with materials that usually come from surrounding areas or nearby towns. Façades are simple and often modernistic in appearance, even if complex in organization. Distinctive volumes and shapes define and personalize their overall character. Some have exposed structural systems that articulate the building form and become its ornament (Fig. 34-8, 34-13, 34-18, 34-23). Some integrate the regularity of glass curtain walls with the random placement of wood,

concrete, or stone (Fig. 34-17). Several exhibit sculptural forms that move and undulate in an organic rhythm (Fig. 34-6, 34-22). And still others develop from the horizontal layering of rectangular concrete planes with vegetated roofs and open terraces (Fig. 34-4, 34-12).

Whatever the design, many façades, especially those of Contextualism, present a wholeness that is interwoven with the landscape. To achieve this concept, buildings are one to three stories high, or they appear as such. Solid walls, which may hide level changes, play against glass windows or glass walls. Sometimes the glass walls have structural features that shield, project, or protrude over or in front of them. The interplay of light against dark is an important and distinguishing feature because it emphasizes the contextual relationship of the building to the environment (Fig. 34-4, 34-5, 34-8, 34-9, 34-13, 34-15, 34-17).

■ *Windows.* Sizes, shapes, and placement of windows vary based on building function, client needs, and green design requirements. Glass walls and windows facing south and east are typical because they increase energy efficiency and provide natural daylight (Fig. 34-4, 34-5, 34-12, 34-13, 34-26). Many buildings incorporate cross-ventilation techniques and operable windows to provide natural ventilation and reduce energy costs (Fig. 34-13, 34-24, 34-25). Clerestory windows are also common, particularly in warm climates, because they filter indirect light throughout the interior. Windows become increasingly energy efficient with double and triple glazing and low-emittance (low-E) coatings. New techniques for coating and applying patterns to glass also aid in energy conservation.

■ *Doors.* Overhanging or projecting roofs that blend into the building design spotlight entryways on commercial buildings. Doors vary in design and materials, but most blend in with the overall building composition (Fig. 34-6, 34-8, 34-23, 34-27). Important doors often have some details that distinguish them from others. Wood or metal frame doors with glass inserts and sliding glass doors are common.

■ *Roofs.* Roofs may be pitched, curved, or somewhat flat (Fig. 34-6, 34-7, 34-8, 34-9, 34-10, 34-11, 34-12, 34-13,

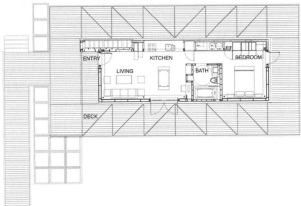

▲ **34-27.** Sustainable House Design Competition, 2005; Blacksburg, Virginia; Virginia Tech University Design Team and Faculty.

34-15, 34-17, 34-19, 34-20, 34-22, 34-25, 34-27). Shed, gabled, and rounded roofs are common. They may personalize a building and set it apart from others. Wide overhangs shade windows and protect from rain. Some architects, such as Predock and Holl, incorporate multiple roofs with different shapes and varying heights (Fig. 34-9, 34-11). Some buildings have roofs insulated with grass, gardens, or other plantings on top (Fig. 34-4, 34-12). Others may have a heat-welded thermoplastic olefin roofing system, photovoltaic panels, and/or roofing materials that save or create energy.

INTERIORS

Like exteriors, interiors illustrate variations in design in response to environmental concerns. Most important, especially in nonresidential spaces, are health, safety, and welfare concerns that inform and define design decisions. Like architecture, interiors incorporating sustainable planning and green materials and finishes often look no different from other interiors unless that is the designer's intention.

Some designers directly follow McDonough's "cradle to cradle" paradigm and apply, in varying levels, sustainable materials, products, and furnishings that are certified or help earn LEED credits (Fig. 34-29, 34-36). Others consider the contextual relationship of nature, site, and place by using Feng Shui concepts, earth colors, natural materials, spatial simplicity, and minimalism. Still others borrow from both expressions to create environmentally interpreted spaces. The infusion of natural lighting, water, plants, and handcrafted decorative arts enhance the overall character. Additionally, designers often try to convey a sense of place. In all interiors, they pay attention to creating environments that have an appealing aesthetic character, as well as respond to and support human needs and functions. To support these concepts, they choose second-hand, refurbished, or recycled furniture and antiques instead of new furnishings.

Many interiors have decidedly High Tech or Late Modern (see Chapters 31, "Late Modern · 1", and 33, "Late Modern · 2") concepts with sleek, simple, industrial-looking forms and little or no applied ornament. They exhibit informal sophistication, rich textural contrast, unique focal points, interesting architectural features, and environmentally friendly finishes and textiles (Fig. 34-35, 34-37). Some, mainly architect-designed, have built-in furniture that integrates with and emphasizes the architectural expression. Others display much diversity in furnishings arrangements and selections, but adhere to a Zen-based, minimalist environment enlivened with a few decorative objects. Many are intended as refuges or antidotes to the stresses of contemporary life. One of the most recognized designers of this concept is Clodagh (Fig. 34-1, 34-31). In offices and houses, furnishing arrangements often reflect attention to personal communication and individual work habits, a sort of "people touch" approach.

By the early 21st century, numerous products that address sustainable concerns are available, and manufacturers regularly add to their offerings. Various organizations certify products as green, earth-friendly, or eco-friendly. However, most are limited in focus, and there are inconsistencies. Sustainable products often are more costly than others are, but life cycle costs are generally less when health and well-being of users are considered. Many earn LEED credits.

Public and Private Buildings

■ *Types.* There are no new types of spaces, but there is much individuality in the organization and placement of spaces. Open, free-flowing spaces are important because they respond to the environmental considerations.

■ *Relationships.* The integration of nature-based exteriors and interiors is extremely important and an overriding design principle. Room layouts are frequently determined by sun orientation, so important spaces and circulation areas are often positioned based on the direct or indirect filtration of sunlight.

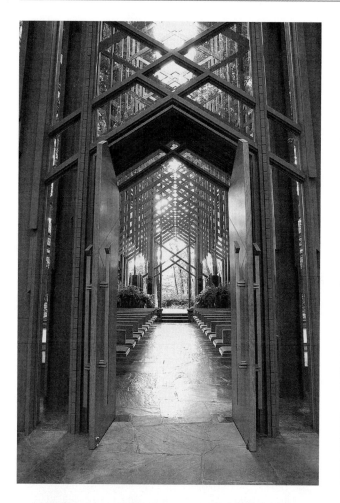

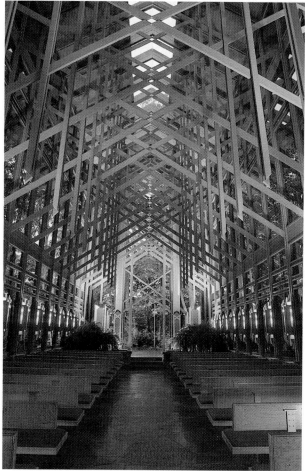

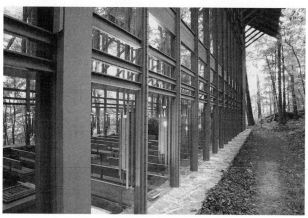

▲ **34-28.** Naves, Thorncrown Chapel, 1978–1980, and Mildred B. Cooper Chapel, 1986–1987; Eureka Springs and Bella Vista, Arkansas; Fay Jones and Maurice Jennings.

■ *Color.* Color palettes develop from the hues of nature and from the building materials so that the interiors present a wholeness of expression (Fig. 34-28, 34-29, 34-30, 34-31, 34-32, 34-34, 34-36, 34-38, 34-40). Designers often want soothing, calming, or quiet atmospheres, so they adopt neutral and monochromatic color schemes. They also choose soft, subdued shades of green, brown, sand, gray, blue, rust, and gold, along with cream. Color accents appear through textural contrast, textiles, and accessories.

Black, rich brown, or a rich wood may accent certain features or furnishings.

■ *Lighting.* The incorporation and manipulation of natural lighting articulates and defines the character of all interiors, both commercial and residential. It is often more important than any type of artificial lighting because it costs nothing and addresses energy concerns. Designers strive for interiors that use only natural light during the day by adopting various means, such as leaving windows bare or

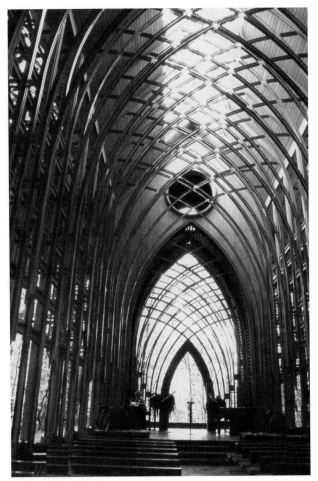

▲ **34-28.** *(continued)*

minimally curtained, and using light-colored and reflective surfaces. For aesthetic appeal, architects and designers may use natural light to create light wells, frame and accent walls, define ceiling compositions, and enhance spaces as artistic compositions (Fig. 34-28, 34-29, 34-32, 34-37, 34-39). Artificial lighting comes from built-in fixtures that may hang, project, or be surface mounted (Fig. 34-30, 34-31, 34-36). Floor and table lamps in interesting designs complement the interior space. There are many choices for fixtures. To minimize energy consumption, designers use new lighting technologies such as fiber optics, compact fluorescent lights (CFLs), and lighting control systems that may include, but are not limited to, dimmers, timers, and/or occupancy sensors.

■ *Floors.* The most appropriate floor materials are of natural materials and include linoleum, recycled rubber, bamboo, cork, wood, limestone, ceramic tile, and concrete (Fig. 34-29, 34-31, 34-33, 34-34, 34-36, 34-37, 34-41). Tiles of recycled materials and glass are less common alternatives. Reclaimed, salvaged, and engineered woods are preferred for wood floors.

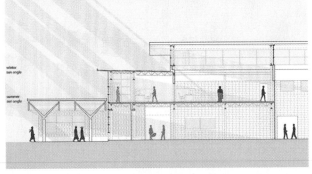

▲ **34-29.** "The Street," Herman Miller "Greenhouse" Factory and Offices, 1995; Holland, Michigan; William McDonough + Partners with VerBurg & Associates.

Carpet is a less desirable green floor covering because it can be a source of off-gassing, or VOCs. Additionally, its short life cycle requires frequent replacement, which creates waste. Carpet also can harbor allergens, molds, and bacteria. Commonly recommended green solutions are carpets of natural fibers (wool, sisal) and carpet tiles. However, rug and carpet manufacturers are among the first to adopt sustainability principles. In the late 20th century, they begin making carpet that can be recycled into new carpet or

▲ **34-30.** Entry and reception, Farralon Restaurant, 1997; San Francisco, California; Pat Kuleto.

other products. They also produce carpet with recycled content and backings that do not off-gas, such as those from recycled automobile tires. Carpet also can be installed with recycled padding and adhesives that do not off-gas.

Designs of environmentally friendly floor coverings vary widely, but smooth, simple ones with few patterns and colors are the most common. Many buildings display only one or two floor materials and colors throughout the entire space to create oneness and emphasize simplicity.

■ *Walls*. Most walls are plain, simple, and unadorned. Some slide, pivot, or hinge to open or close spaces. Designers often emphasize architectural features that come from the building, develop from environmental considerations, or highlight Zen-based compositions (Fig. 34-28, 34-31, 34-32, 34-34, 34-38). Custom-designed wood surfaces, such as paneling, cabinets, and moldings, frequently define and

accent important details and wall compositions. Built-in storage may dominate an entire wall and repeat throughout the interiors. Stone walls are also common (Fig. 34-33, 34-36).

Some walls are made of recycled gypsum board with a variety of coverings including glass, tiles, or concrete. Recycled, reclaimed, or sustainably harvested wood paneling is less common than other wall coverings. Veneers may be used to save materials, particularly endangered or exotic woods. Textiles, especially of natural fibers, and wall coverings are common in homes and some commercial spaces. Wallpapers of natural fibers, like grass, are preferred over vinyl. They and textiles are installed using environmentally friendly adhesives. Paint may be a source of VOCs for years after application, but by the end of the 20th century, more manufacturers offer paint of natural materials, low or zero VOC (emits less than 5 percent). These paints come in a range of colors and finishes so that designers can still create dramatic or subdued effects.

■ *Window Treatments*. Some windows are tinted and often have no or minimal window treatments to take advantage of the natural light (Fig. 34-29, 34-35, 34-36, 34-41). Others may have sun louvers or exterior shades to control sunlight, along with various types of blinds and shutters. Architectural-style treatments are preferred. However, layered window treatments that cover the entire window save energy and are used in some applications.

■ *Textiles*. By the end of the 20th century, textile manufacturers around the world are producing environmentally friendly fabrics using sustainable manufacturing processes for dyeing, weaving, finishing, water and energy conservation, and the production and disposal of waste (Fig. 34-42). Some adopt the cradle to cradle protocol. Environmentally friendly textiles are often of natural fibers, but synthetics are used when they can be manufactured in a less harmful way. For example, synthetics can be solution dyed to save waste. Green textiles use natural or nontoxic synthetic dyes and fabric finishes that do not off-gas. Many textile manufacturers market their products with eco-friendly labels. Some sell only green textiles, while others maintain green textiles as part of their regular lines.

Sustainable textiles usually look no different from others, which is important. Designs emphasize textures, weaves, and organic patterns from nature. Colors derive primarily from the natural environment but may be other hues.

■ *Ceilings*. Architect-designed buildings have ceilings that may be pitched, angled, curved, or flat (Fig. 34-28, 34-29, 34-31, 34-32, 34-34, 34-36, 34-37, 34-39). Architectural features may include indentations, protrusions, beams, and skylights. Exposed structural characteristics from the exterior often reappear in the interior. And, each ceiling becomes an individual area for design expression. Interior designers also play with three-dimensional ceiling compositions to repeat architectural features, create movement, and enhance lighting. Designs overall vary widely by designer, concept, and project. Acoustical ceiling tiles are also made of recycled, environmentally friendly materials.

DESIGN SPOTLIGHT

Interiors: Entry corridor, Noelle Day Spa, 1996; Stamford, Connecticut; Dining room, Downtown Duplex, 2002, New York City, New York; Reception, Dentsu Ad Agency, 1991; Tokyo, Japan; and bedroom, Hampton Designers Showhouse, 2002, Bridgehampton, Long Island, New York; Clodagh. Often relying upon the Chinese principles of Feng Shui, Clodagh creates total living environments with a unique sense of place for both commercial and residential spaces. She is known for her sensitive use of materials and textures, the interplay of light, imaginative compositions, and sensual spaces that celebrate the experience of living. Natural woods, metal, stone, and brick, often with unique patterns, frequently define spaces. Subdued colors borrowed from nature display subtle variations of cream, brown, gold, and stone gray, sometimes with an accent of Chinese red. Important interior design characteristics include the use of custom details, integrated contemporary lighting, and distinctive visual accents, both architectural and decorative. Oriental furniture, ceramics, and flowers sometimes appear as artistic embellishments. Overall, her interiors radiate an elegant simplicity achieved through a sophisticated use of space, form, color, light, and materials.

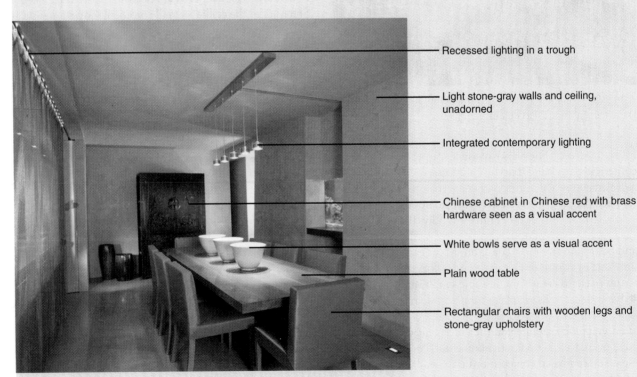

Recessed lighting in a trough

Light stone-gray walls and ceiling, unadorned

Integrated contemporary lighting

Chinese cabinet in Chinese red with brass hardware seen as a visual accent

White bowls serve as a visual accent

Plain wood table

Rectangular chairs with wooden legs and stone-gray upholstery

▲ **34–31.** Interiors by Clodagh.

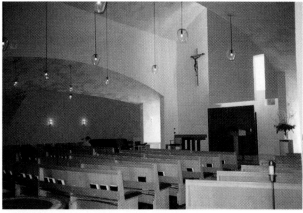

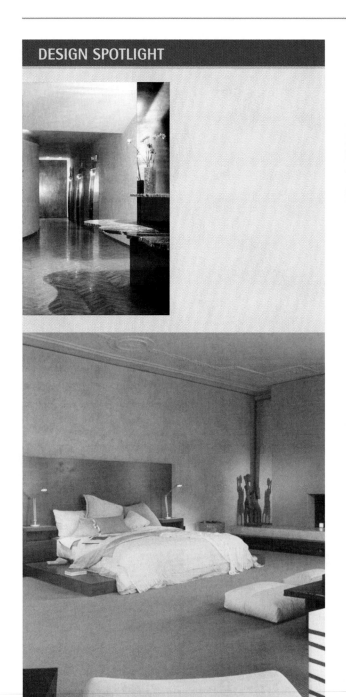

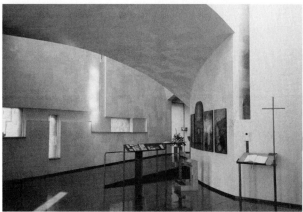

▲ **34-31.** *(continued)*

▲ **34-32.** Nave and entry, Chapel of S. Ignatius, Seattle University, 1997; Seattle, Washington; Steven Holl.

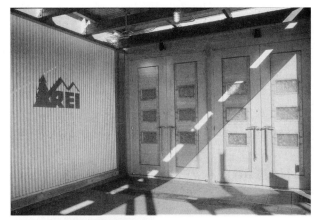

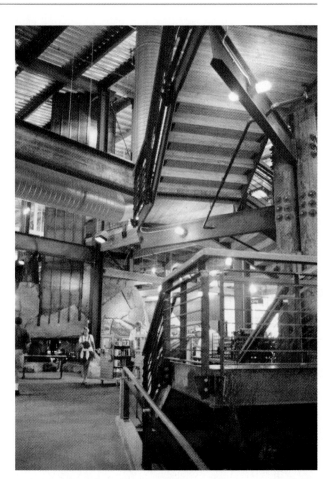

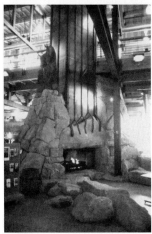

▲ **34–33.** Interiors, REI Flagship Store, 1997; Seattle, Washington.

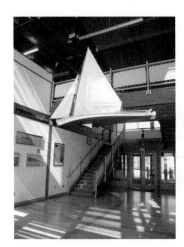

▲ **34–34.** Interiors, Chesapeake Bay Foundation Building, 2000; Annapolis, Maryland; SmithGroup, interiors by Cheryl Brown.

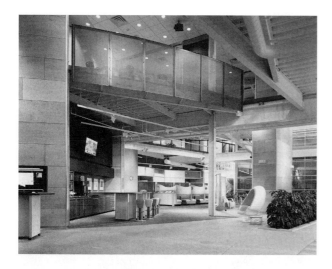

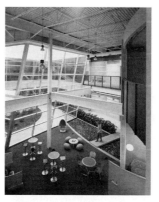

◀ **34-35.** Connection Zone, Herman Miller Marketplace, 2002; Zeeland, Michigan; Integrated Architecture and Tom Powers, Interior Architects—Chicago.

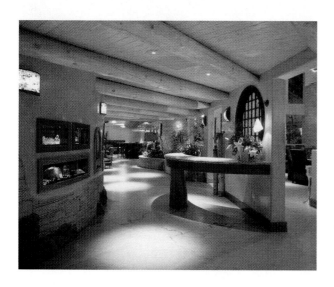

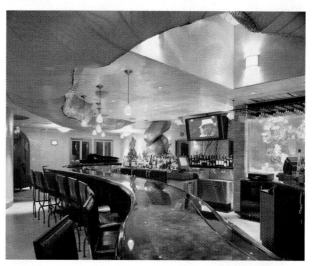

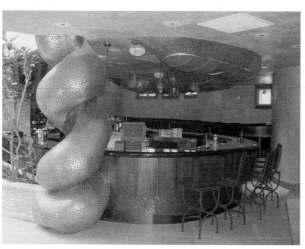

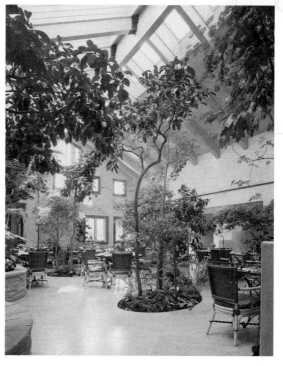

▲ **34-36.** Hostess area, Anaconda Bar, and Garden Dining Room, El Monte Sagrada Resort (one of the world's first eco-hotels), 2005; Taos, New Mexico; David Sargert, Sargert Design Associates.

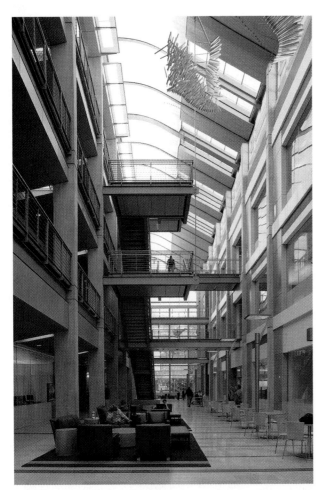

▲ **34–37.** Atrium, stairs, and details, Kelley Engineering Center, Oregon State University, 2006; Corvallis, Oregon; architecture by Nels Hall with interiors by Bethan Clouse of Yost Grube Hall Architecture.

▲ **34–38.** Living room and teahouse, Great (Bamboo) Wall House, 2002; Shuiguan-Badaling, China; Kengo Kuma.

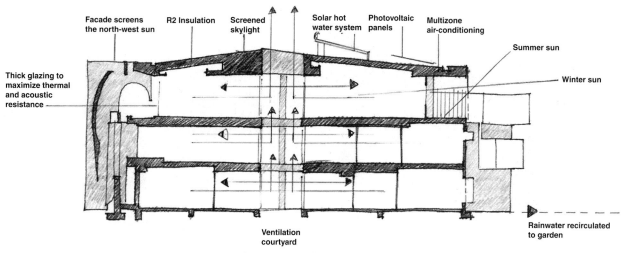

Facade screens the north-west sun

R2 Insulation

Screened skylight

Solar hot water system

Photovoltaic panels

Multizone air-conditioning

Summer sun

Winter sun

Thick glazing to maximize thermal and acoustic resistance

Ventilation courtyard

Rainwater recirculated to garden

▲ 34–39. Section, Swart Residence, 2004; Melbourne, Australia; Peter Carmichael.

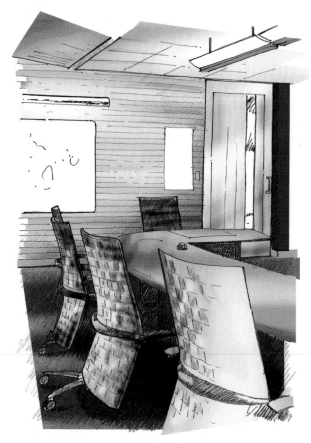

▲ 34–40. Library and meeting room, Leadership Floor, Monsanto Corporation, c. 2000s; St. Louis, Missouri; HOK Architects, with interiors by Holey Associates.

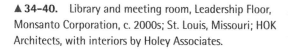

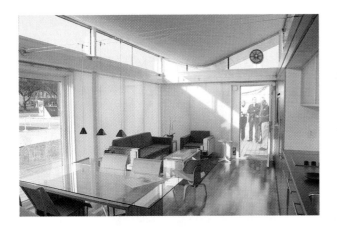

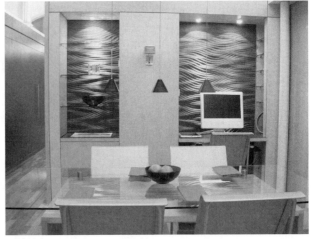

▲ 34-41. Interior, Sustainable House Design Competition, 2005; Blacksburg, Virginia; Virginia Tech University Design Team and Faculty.

▲ 34-42. Textiles: Bamboo Mate, Banyon, Casco, Finn, Mona, and Tibet fabrics, 2007; manufactured by Architex.

FURNISHINGS AND DECORATIVE ARTS

Environmentally friendly furnishings reflect and embrace concepts that include simplicity, vernacular or Late Modern stylistic traditions, minimal use of materials, and eco-friendly production methods. Many are built from natural or nontoxic materials or recycled parts. Some illustrate a handmade, crafts approach, such as the work of furniture designers George Nakshima (Fig. 34-43) and Sam Maloof (Fig. 34-45). Others are machine-made but incorporate the same ideas and may even be inspired by nature. Commercial furniture companies quickly embrace sustainability in making and marketing, whereas residential manufacturers are slower to adopt green principles.

During the late 20th century, small and large furniture manufacturers around the world begin to address sustainability issues in the entire manufacturing process, the use, and end of life cycle. Throughout the manufacturing process, they look for ways to reduce, reclaim, reuse, and recycle, and strive for greater energy efficiency, management of air and water quality, and elimination of waste.

They also move toward natural, biodegradable, and nontoxic durable materials and finishes, including upholstery fillings such as foam; structural materials such as wood or metals; glues and adhesives; and stains, paints, and other finishes. As harmful materials and finishes, such as formaldehyde, are identified, many manufacturers move to eliminate them whether or not required by law.

Furniture manufacturers and suppliers, like IKEA, commit themselves to providing environmentally friendly furniture. In the United States and Canada, manufacturers, such Herman Miller and Knoll, produce more furniture that meets LEED ratings. They and others begin to market their products using a green emphasis and noting certifications. Marketing documents and websites often describe their efforts to eliminate harmful materials and adopt sustainable practices. Nonresidential companies, such as Herman Miller and Steelcase, initiate programs to recycle their used products, especially systems furniture. Nevertheless, sustainable furniture remains a small portion of the market, although the number of manufacturers and products increases yearly.

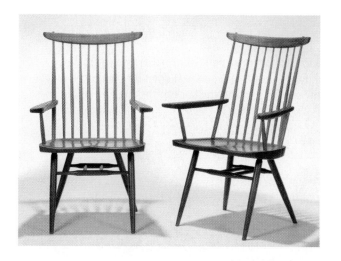

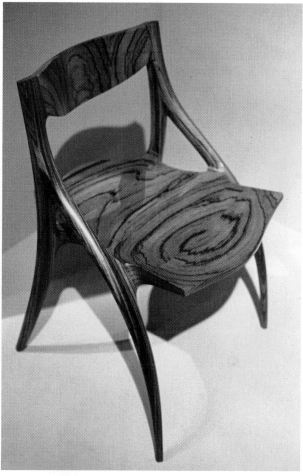

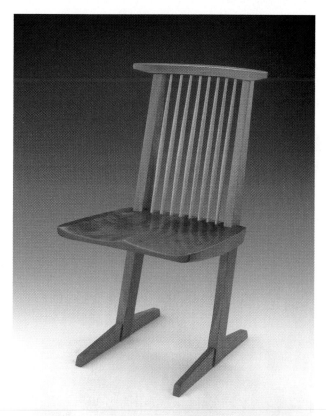

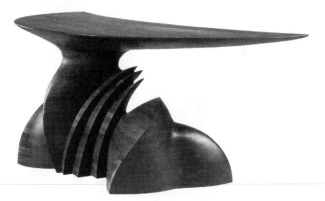

▲ **34–43.** Chairs and Conoid chair, c. 1970s; New Hope, Pennsylvania; George Nakashima.

▲ **34–44.** Chair and table, c. 1970s–1990s; New York; Wendell Castle.

Public and Private Buildings

■ *Types.* All types of furniture may be completely or partially sustainable. The most common furniture pieces are chairs and tables, particularly those designed and constructed in eco-friendly materials. Commercial manufacturers make chairs, tables, desks, storage, and systems furniture that

meet LEED ratings and that can be recycled (Fig. 34-47, 34-49, 34-54).

■ *Distinctive Features.* Most furniture is simple and may exhibit an arts and crafts approach. Manufactured furniture is often sleek with a modernistic, High Tech appearance (see Chapters 31, "Late Modern · 1", and 33, "Late Modern · 2").

DESIGN SPOTLIGHT

Furniture: Armchairs, rocking chair, and pedestal tables, c. 1990s; California; Sam Maloof. Borrowing from Scandinavian traditions, Maloof's chairs softly contour to fit the human body, showing ergonomic considerations. Surfaces are smooth and rounded hardwood, frequently a natural oiled walnut. Saddle seats carved from several joined pieces are common. Hidden dowel joints connect the seat to legs and the back to the leg, and visible ones connect front legs to the seat. The overall image conveys expert craftsmanship.

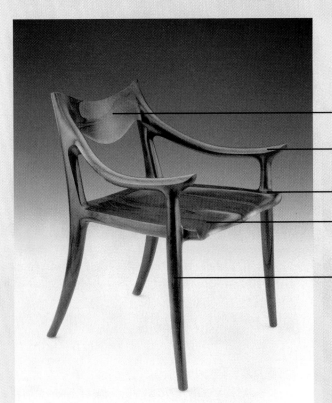

Careful concern for ergonomic features such as the contour of the back

Constructed in walnut with natural oiled finish

Hidden and visible dowel joints connect the seat to the leg and the back to the leg

Saddle seat carved from several joined pieces

Overall form borrows from Scandinavian traditions

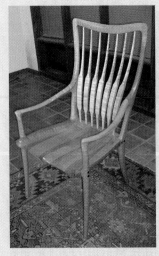
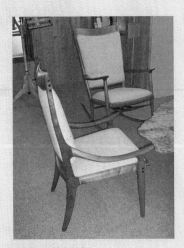
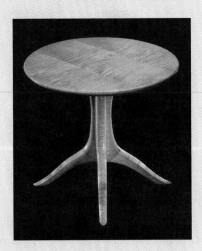

▲ **34–45.** Armchairs and pedestal tables by Sam Maloof.

DESIGN SPOTLIGHT

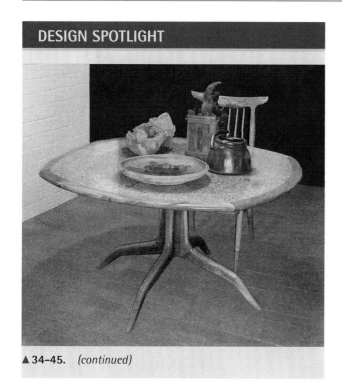

▲ 34–45. *(continued)*

▲ 34–46. Armchair, sofa, and table, 2005; Philippines; Kenneth Cobonpue.

■ *Materials*. Wood is the primary material for construction of handmade items, particularly oak, walnut, and teak (Fig. 34-43, 34-44, 34-45, 34-48, 34-51). Local woods available to the furniture designer, reclaimed, and salvaged woods are used more frequently and may be applied as veneers. Individuals and firms concerned about the environment use sustainably harvested wood that is certified or veneers of endangered or exotic woods. Easily replenished materials such as bamboo are often used too. Mass-produced examples, especially commercial ones, are of steel, glass, engineered wood, laminates, plastics (sometimes recycled), and recycled rubber. Stains, paints,

adhesives, and applied finishes are biodegradable or non-toxic. Individual parts can be reused or recycled. Some designers avoid glues by using intricate joints. Manufacturers develop upholstery fillings, such as foam, that do not off-gas.

■ *Seating*. Seating pieces have soft ergonomic contours (Fig. 34-31, 34-38, 34-40, 34-46, 34-50). Nakashima designs chairs with vertical spindles and contoured wooden seats. They resemble Windsor chairs of the earlier centuries but with an Asian influence (Fig. 34-43). Maloof borrows from Scandinavian traditions in chairs with smooth, rounded wooden frames that contour to fit the human body (Fig. 34-45). Cushions are sometimes used to add comfort. Garden seating, such as examples from Smith &

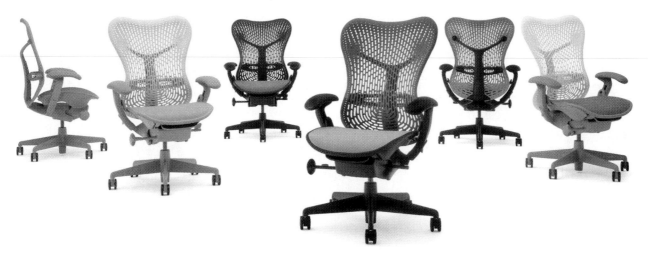

▲ 34–47. Mirra chair (the first chair in the United States to be certified Cradle to Cradle by MBDC), 2003; Michigan; Studio 7.5, manufactured by Herman Miller.

▲ **34-48.** Lutyens bench in teak with painted finish, 2004; Colorado; manufactured by Smith & Hawken.

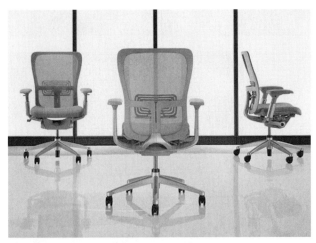

▲ **34-49.** Zody chair (the first task chair to be certified Cradle to Cradle Gold Product by MBDC), 2005; Michigan; manufactured by Haworth.

▲ **34-50.** Bel Air Slipper Chair and Havanawood Coffee Table, 2006; Philippines and Indonesia; from Palecek.

▲ **34-51.** Douglas chair and ottoman, and Japanese bench, 2006; San Francisco, California; Michael Taylor.

▲ **34-52.** Twig table, 2006; Michigan; manufactured by Baker Furniture Company, from the Bill Sofield Collection.

▢ **34-53.** Moiré square side table with rattan poles, c. 2000s; California; Orlando Diaz-Azcuy, manufactured by McGuire.

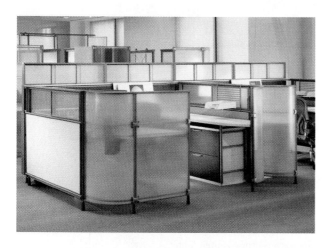

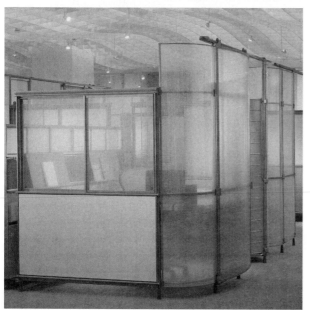

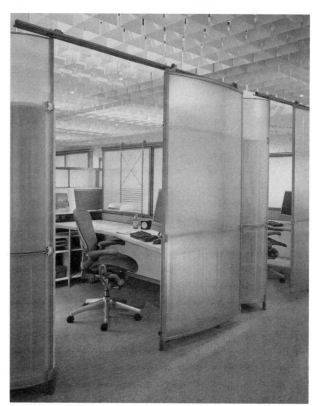

▲ **34-54.** My Studio Environment (sustainable systems furniture), 2006; United States, manufactured by Herman Miller.

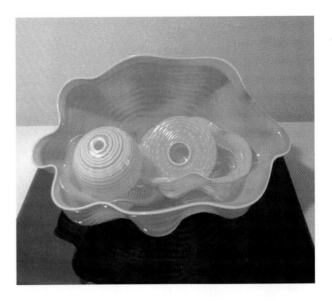

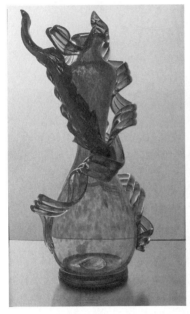

▲ **34-55.** Decorative Arts: Woven basket, earth-strata glass bowls (top center), and glass bowls and vases by Dale Chihuly, c. late 20th century; United States.

Hawken (Fig. 34-48), reflect vernacular traditions, strong design concepts, and use environmentally friendly materials.

Manufacturers produce office seating that is sustainable, ergonomic, and recyclable. For example, Herman Miller's Aeron chair uses pellicle instead of upholstery and parts are recycled aluminum (see Chapter 33, "Late Modern · 2"). In 2003, Herman Miller introduces the Mirra chair, the first chair in the United States to be certified Cradle to Cradle by McDonough Braungart Design Chemistry (MBDC; Fig. 34-47). In 2005, Haworth introduces the Zody chair (Fig. 34-49), which is the first task chair to earn the MBDC Gold, Cradle to Cradle (C2C) Product Certification, meaning that it is made with sustainable components and systems. Some earlier seating is already environmentally sound, such as Aalto's Paimio chair distributed by Herman Miller (see Chapter 27, "Scandinavian Modern"). Manufacturers may change materials of pieces within their lines to make them sustainable. For example, Herman Miller begins making the Eames Lounge Chair in santos palisander, walnut, and cherry instead of endangered rosewood (see Chapter 29, "Organic and Sculptural Modern").

■ *Tables*. Tables are simple, unadorned, and distinctive in design. Some are made from large slabs of natural wood, while others use nature as a source of inspiration (Fig. 34-45, 34-46, 34-50, 34-52, 34-53). Still others may be completely made of recycled or salvaged materials. Examples vary widely and interpret individual concepts from the designer or manufacturer.

■ *Storage and Systems Furniture*. Manufacturers make storage cabinets, shelving, and systems furniture that use minimal materials and nontoxic finishes. Many office systems—desks, workstations, storage—do not harm the environment either during production or use; some can be returned to the manufacturer to be recycled. Examples include Action Office, My Studio Environment (Fig. 34-54), and Ethospace by Herman Miller.

■ *Decorative Arts*. Plants and water features are common in public and private interiors. Decorative objects made of natural materials, such as baskets, glass, ceramics, and some metals, highlight design concepts without harming the micro or macro environments (Fig. 34-31, 34-55). A few manufacturers create sustainable decorative objects of stone, cane, or wicker.

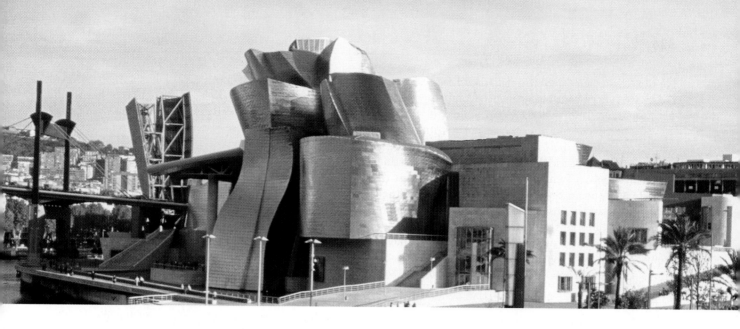

CHAPTER 35

Neo-Modern

1980s–2000s

Now the New Moderns no longer believe in this humanism; rather they present their work as a self-justifying play with metaphysical ideas. The key architects who follow this agenda are Eisenman, Tschumi, Libeskind, Fujii, Gehry, Koolhas, Hadid, Morphosis, and Hejduk, but not Foster, Rogers, Hopkins, Maki, and Pei.

Charles Jencks,
The New Moderns, from Late to Neo-Modernism, 1990

The form is distorting itself. Yet this internal distortion does not destroy the form. In a strange way, the form remains intact. This is an architecture of disruption, dislocation, deflection, deviation and distortion, rather than one of demolition, dismantling, decay, decomposition and disintegration. It displaces structure instead of destroying it.

Mark Wigley,
Deconstructivist Architecture, 1988

Neo-Modern architects and designers seek a new design language for the 21st century by challenging the concepts and principles of the International Style, Late Modern, and Post Modern. They create innovations in buildings and forms that are experimental and creative. Expressive form, curves, oblique angles, a sense of motion, and unusual juxtapositions are characteristic of designs. Complexity becomes the new ornament, and designs often disregard context and historical precedent. New technology is important to the designing and producing of buildings and objects that become art and individual expressions of the designer.

HISTORICAL AND SOCIAL

At the turn of the 21st century, the worldwide shift to the information age accelerates, and economic, social, and political trends of the 1980s and 1990s continue. Many highly developed countries, such as the United States, the United Kingdom, Japan, and South Korea, experience overall prosperity, but the gap between the poor and wealthy and developed nations and underdeveloped ones widens. Globalization continues on an unprecedented scale as capitalism spreads. Trade agreements, growth, and consumerism increase substantially, assisted by new technologies and developments in communication. At the end of the 20th century, China and India become important players on the world stage because of their large populations, economic booms, and growth in the middle classes. More and more firms, companies, and businesses operate internationally. The use of technology, computers, and the Internet dominates business, government, and people's time more than ever. Communication, aided by the Internet and mobile telephones, becomes instantaneous and ubiquitous. People next door or around the globe are readily available to each other.

Many new scientific and medical advances have the potential to make people's lives easier and more healthful,

933

but they create moral and ethical debates. Diseases, such as AIDS and cancer, continue unabated. Conflicts, wars, and terrorism intensify all over the world. Following bombings and acts of violence in numerous countries, the War on Terror begins in the early 21st century.

The number of goods and products are at an all-time high, and access to them in many parts of the world is immediate. Consumers expect instant gratification of their needs and desires. Consumption is regarded as important because it creates jobs and stimulates economies as well as the development of new products that can be marketed around the globe. The media spread an international popular culture characterized by materialism, comfort, and self-interest.

During the late 20th century, design is important, and design expressions, styles, and movements are more diverse than ever. Consumers have abundant choices for products as a result of niche marketing that focuses on a particular population segment and planned obsolescence or the throw-away mentality. More people are more aware of design than ever as a result of museum exhibitions, magazines, books, Internet sites, and television programs in the United Kingdom and the United States. The Home and Garden television (HGTV) channel in the United States is one of the most popular. Contemporary and cutting-edge design is more mainstream than before, and museums for contemporary design and crafts arise, such as the Design Museum in London, 1989, and the Museum of Arts and Design in New York City, 2002.

The birth date of Neo-Modern ideas is generally acknowledged as 1977 when Peter Eisenman publishes "Post-Functionalism," an editorial in his magazine *Oppositions.* Eisenman's critique of two exhibitions introduces the idea of a new modern that is anti-human and unlike, even antithetical to, the International Style, Late Modern, and Post Modern. Another seminal event takes place in 1982 when Eisenman collaborates with philosopher Jacques Derrida. They submit a design for an architectural competition for the Parc de la Villette, a new park on the site of a 19th-century meat market and slaughterhouse in Paris. However, Bernard Tschumi, who also consults Derrida, wins the competition. His design includes a series of Follies (Fig. 35-5), buildings intended to house park activities. The bright red structures grow out of Tschumi's idea that architectural form should be independent of the activities that take place within it, an idea that is counter to much of design history. They also show a relationship to Russia's Constructivist Movement.

In 1988, Philip Johnson and Mark Wigley organize an exhibit entitled Deconstructivist Architecture at the Modern Museum of Art in New York City. The show includes the work of six individuals and one firm: Coop Himmelblau, Peter Eisenman (Fig. 35-3, 35-4, 35-11, 35-30), Frank Gehry (Fig. 35-7, 35-8, 35-13, 35-21, 35-24, 35-26, 35-34, 35-39), Zaha Hadid (Fig. 35-18, 35-35, 35-48), Rem Koolhaas

(Fig. 35-19, 35-25, 35-33), Daniel Libeskind (35-14), and Bernard Tschumi (Fig. 35-5). The architects have built little, so the exhibit centers on conceptual designs. Much of the theoretical language reveals a concern for images and

IMPORTANT TREATISES

- ■ *Architecture and Disjunction,* 1994; Bernard Tschumi.

- ■ *At the End of the Century, One Hundred Years of Architecture,* 1998; Russell Ferguson, editor.

- ■ **"Chaos and Machine,"** *The Japan Architect,* May 1988; Kazuo Shinohara.

- ■ *Deconstructivist Architecture,* 1988; Philip Johnson and Mark Wigley.

- ■ *Of Grammatology,* 1967; Jacques Derrida.

- ■ *The New Moderns,* from Late to Neo-Modernism, 1990; Charles Jencks.

- ■ **"Post-Functionalism,"** *Oppositions 6,* Spring 1977; Peter Eisenman.

Other Publications: Individual books, monographs, and articles on architects, interior designers, and furniture designers.

◀ **35-1.** Frank Gehry and Daniel Libeskind.

language derived from Derrida. More important, the show publicizes these new ideas and names and gives form to the new movement in architecture in much the same way as did the 1932 MOMA exhibition on the International Style (see Chapter 25, "International Style"). Eisenman's (1989) Wexner Center for the Arts (Fig. 35-4), Columbus, Ohio, is considered the first deconstructivist building. It gives visual form to theories and concepts of the exhibit. By the early 21st century, many of the architects in the show are internationally known with projects around the world. Gradually other architects join the recognized group, and all further the notion of the celebrity architect.

Deconstructivist architecture brings a change through ideology, style, and type, but *Neo-Modern* is the term given to the larger movement centering on a new design language. During the 1980s, the term *New* or *Neo-Modern* is often used in the press to refer to an aggressive attack on and counterpoint to Post Modern evident in the work of Deconstructivist architects. A 1988 article, "Chaos and Machine," by Kazuo Shinohara, uses the term *Modern-Next*. It reaffirms the notion of a new version of modern that is different from, if not antithetical to, the International Style, Late Modern, and Post Modern.

CONCEPTS

Neo-Modern, or New Modern, reacts to, rebels against, or rejects International Style, Late Modern, and Post-Modern ideas and imagery. A world movement, Neo-Modern seeks greater diversity of expression and a new design vocabulary for the 21st century. The movement, especially architecture, is influenced by French philosopher Jacques Derrida, especially his writings of the late 1960s and early 1970s. Derrida develops a method of literary criticism he calls deconstruction, which analyzes text using a process of juxtapositions that value absence over presence. Calling this principle "metaphysics of presence," he sees it as opposing traditional Western philosophy that values written word over speech and seeks an immediate understanding or presence of meaning through the written language. Derrida argues that meanings are absent, not present, because they are ambiguous and changeable. So, deconstruction looks for and reinvents hidden or alternative meanings as well as the margins or superficial limits of the text. Deconstruction requires something to play against—a construction to deconstruct.

Other influences include two early-20th-century architectural movements. One is German Expressionism (1910–1925) in which entire buildings are often composed of free-form curved geometries. The other is Russian Constructivism (1913–1921) that contributes the idea of unbalanced geometries. Some modern art movements also influence Neo-Modern, particularly Synthetic Cubism (1913–1920s) with its fragmented images showing multiple views and perspectives. The idea of eliminating context or any references to cultural norms in art and architecture comes from De Stijl and Minimalism (post–World War II; see Chapter 23, "De Stijl", and Chapter 31 "Late Modern · 1"). The notion of designs existing only in drawings and models comes from Conceptual Art (1960s–1970s).

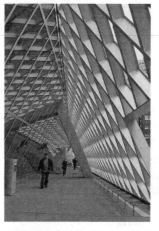

▲ 35-2. Architectural and interior details, 1990s–2000s; Spain, California, Washington, and Germany.

▲ **35-2.** *(continued)*

Neo-Modern architects (Fig. 35-1) and designers actively confront accepted norms and precedents by turning them upside down and developing new approaches to design. They challenge existing and preconceived notions of all aspects of design and conventional images of what everything should be. Architects and designers dispute or deconstruct the basic concepts of modern such as typology, function, and context as well as its formal design language. Seeing these concepts as changeable, indistinct, and subject to contradiction, they feel free to ridicule or exaggerate them or push them to extremes. In Neo-Modern, the earlier modern adage of form follows function becomes "new and diverse forms express diverse functions" in whatever changing manner the designer chooses. Design is autonomous, whereas function is dependent upon change.

In contrast to earlier Modernist designers, Neo-Modernists do not wish to reform society through design or create a style. They often decenter humanity, making human concerns less important than personal statements are. Neo-Modern does not attempt to communicate or connect with the viewer or user like Post Modern. Symbols, precedents, and meanings are not obvious and usually known only to the designer and his or her select group of peers.

DESIGN CHARACTERISTICS

Neo-Modern architecture and, to some extent, interiors and furniture emphasize distortion, disruption, and deviation.

They do not reflect or relate to that which went before them, but strive for a totally new look for the 21st century. Designs disassociate with location and history, especially the classical or modern traditions with their emphasis upon perfection, order, and rationality. Complicated geometry becomes the ornament of Neo-Modern, and it devalues what masters of the International Style deemed important—revealed structure, grids, and forms developing from function. Designs stress complexity and contradictions, but with no set requirements and more improvising than planning. The apparent chaos, variety, and disorder reflect the chaotic character of the modern urban environment. Humanity is less important, so designs do not seem to reflect humans.

Façades, forms, and space often are disconnected and discontinuous. Forms move, unfold, soar, rotate, curve, undulate, interpenetrate, open, and close as designers seek to exaggerate elements of earlier modern styles (Fig. 35-3, 35-4, 35-7, 35-13, 35-17, 35-20, 35-29). Grids disappear, replaced by extreme emphasis on the form of the building or object. Form does not relate to or obviously derive from function, context, or human concerns. Space and mass interpenetrate, and solid and void juxtapose. Also characteristic are fragmentation, extreme abstraction, explosive space, and the separation of unusual contiguous parts to create complexity. Materials vary within a project and by architect and designer.

■ *Motifs.* There are no specific motifs common to Neo-Modern. Individual designers use details (Fig. 35-2) from projects to emphasize innovative structure, construction, and materials as substitutes for ornament.

ARCHITECTURE

Through the end of the 20th century and into the 21st, Neo-Modern architects, including those in the 1988 exhibition as well as new design advocates, continue to experiment with their own individual language to express creativity.

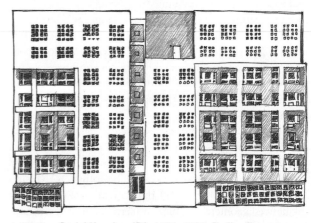

▲ **35-3.** Social Housing, IBA, 1981–1985; Berlin, Germany; Peter Eisenman.

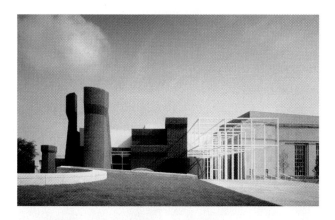

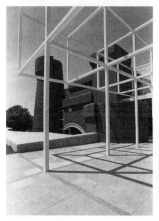

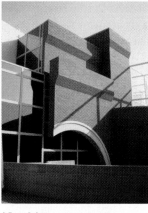

▲ **35–4.** Wexner Center for the Visual Arts, 1983–1989;
Columbus, Ohio; Peter Eisenman.

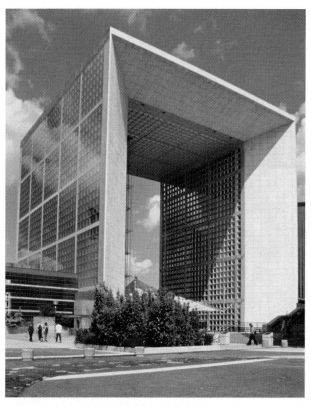

▲ **35–6.** La Grande Arche, Place de la Defense, 1982–1990;
Paris, France; Johann Otto van Spreckelsen.

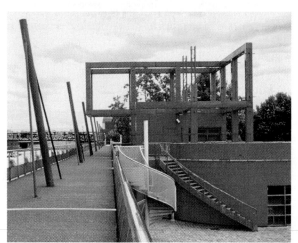

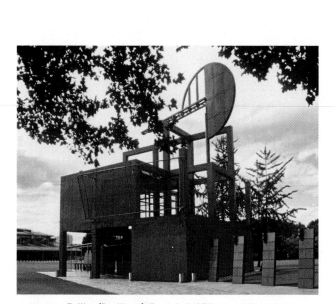

▲ **35–5.** Follies (Pavilions), Parc de la Villette, 1986–1989;
Paris, France; Bernard Tschumi.

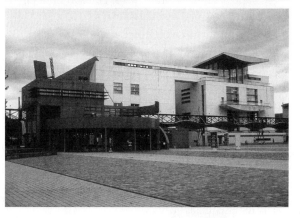

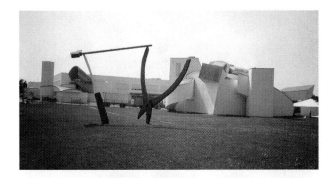

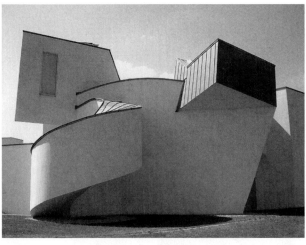

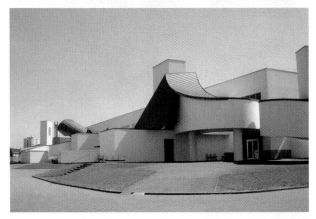

▲ 35-7. Vitra Furniture Design Museum, 1987–1990; Weil-am-Rhein (near Basel, Switzerland), Germany; Frank Gehry.

IMPORTANT BUILDINGS AND INTERIORS

- **Almadén, Spain:**
 —Private chapel, 2000; Sancho-Madridejos Architecture Office.

- **Bangkok, Thailand:**
 —Bangkok Airport, 2006; Murphy/Jahn Architects.

- **Berlin, Germany:**
 —Jewish Museum, 1989–1999; Daniel Libeskind.
 —Social Housing, IBA, 1981–1985; Peter Eisenman.

- **Bilbao, Spain:**
 —Bilbao Airport, 1990–2000; Santiago Calatrava.
 —Campo Volantin Footbridge (or Zubizuri Bridge), 1994–1997; Santiago Calatrava.
 —Guggenheim Museum, 1997; Frank Gehry.
 —Splash and Crash Bar, Gran Hotel Domine, c. late 1990s–2000s; Javier Mariscal and Fernando Salas.

- **Cincinnati, Ohio:**
 —Aronoff Center for Design and Art, University of Cincinnati, 1996; Peter Eisenman.
 —Rosenthal Center for Contemporary Art, 2003; Zaha Hadid.

- **Columbus, Ohio:**
 —Wexner Center for the Visual Arts, 1983–1989; Peter Eisenman.

- **Culver City, California:**
 —Samitaur Building, 1990–1996; Eric Owen Moss.

- **Dubai, United Arab Emirates:**
 —Burj Al Arab Hotel, 1994–1999; Thomas Wright.

- **Hamburg, Germany:**
 —East Hotel interiors, 2005; Jordan Mozer & Associates.

- **Lille, France:**
 —Lille Grand Palais, 2000; Rem Koolhaas.
 —Gare Lille (train station), c. 2000; Rem Koolhaas/OMA.

- **Little Rock, Arkansas:**
 —William J. Clinton Museum, 2004; James S. Polshek Partnership.

- **Lisbon, Portugal:**
 —Orient Railway Station, 1993–1998; Santiago Calatrava.

- **London, England:**
 —Belgo Centraal, 1998; interiors by Ron Arad.
 —Food Theater Café at the Serpentine Gallery, 2001; Daniel Libeskind.

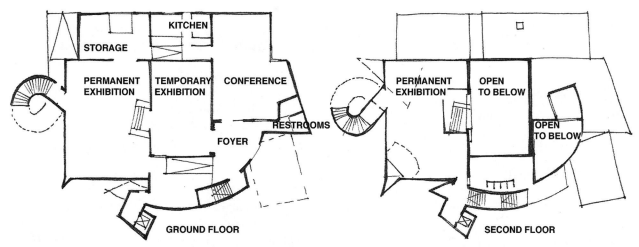

▲ **35-8.** Floor plans, Vitra Furniture Design Museum, 1987–1990; Weil-am-Rhein (near Basel, Switzerland), Germany; Frank Gehry.

IMPORTANT BUILDINGS AND INTERIORS

—London Metropolitan University, 2004; Daniel Libeskind.

■ **Los Angeles, California:**
—Carlson-Reges Residence, 1992–1995; Ro To Architects.
—Lawson-Westen House, 1993–1994; Eric Owen Moss.
—Loyola Law School, 1981–1984; Frank Gehry.
—Schnabel House, 1986–1989; Frank Gehry.
—Walt Disney Concert Hall, 2004; Frank Gehry.

■ **Lyons-Satolas, France:**
—TGV Railway Station, 1990–1994; Santiago Calatrava.

■ **Madrid, Spain:**
—Barajas Airport, 1998–2006; Richard Rogers Partnership.
—Hotel de Puerta America, 2006; design by 12 international designers.

■ **Milwaukee, Wisconsin:**
—Milwaukee Art Museum, 1994; Santiago Calatrava.

■ **Nagoya, Japan:**
—City Art Museum. 1987; Kisho Kurokawa.

■ **New York City, New York:**
—Paramount Hotel, 1990; Philippe Starck.
—Royalton Hotel, 1990–1992; Philippe Starck.
—Technology Culture Museum, 1999–2005; Asymptote.

■ **North Scottsdale, Arizona:**
—Byrne Residence, 1994–1998; Will Bruder.

■ **Orlando area, Florida:**
—Team Disney Building (in Lake Buena Vista), 1989–1991; Arata Isozaki.

■ **Paris, France:**
—Follies (Pavilions), Parc de la Villette, 1986–1989; Bernard Tschumi.
—La Grande Arche, Place de la Defense, 1982–1990; Johann Otto van Spreckelsen.
—New Opera House, 1982–1990; Carlos Ott.

■ **Pomona, California:**
—Diamond Ranch High School, 1993–2000; Morphosis Architects.

■ **Rouen, France:**
—Rouen Concert Hall, 2004–2005; Bernard Tschumi.

■ **Saint-Cloud, France:**
—Villa d'All Ava, 1984–1991; Rem Koolhaas/OMA.

■ **San Francisco, California:**
—Fine Arts Museums of San Francisco-De Young, 2005; Herzog and de Meuron.

■ **Santa Barbara, California:**
—Blades House, 1996; Morphosis Architects.

■ **Santa Monica, California:**
—Edgemar Farms Conversion, 1987–1989; Frank Gehry.
—Gehry House, 1978; Frank Gehry.

■ **Seattle, Washington:**
—Experience Music Project, 1995–2000; Frank Gehry.
—Seattle Public Library, 1999–2004; Rem Koolhaas.

IMPORTANT BUILDINGS AND INTERIORS *(continued)*

- **Strasbourg, France:**
 —Terminus and Car Park, 2002; Zaha Hadid.

- **The Hague, Netherlands:**
 —National Dance Theatre, 1984–1987; Rem Koolhaas.

- **Tacoma, Washington:**
 —Museum of Glass, 1996; Arthur Erickson with Nick Milkovich Architects and Thomas Cook Reed Reinvald.

- **Tenerife, Canary Islands, Spain:**
 —Tenerife Opera House, 1991–2003; Santiago Calatrava.

- **Tokyo, Japan:**
 —Tokyo Institute of Technology, Centennial Hall, 1987–1988; Kazuo Shinohara.

- **Valencia, Spain:**
 —The City of Arts and Sciences, 1991–2004; Santiago Calatrava.

- **Venice, California:**
 —Chiat/Day Building, 1991; Frank Gehry and Associates.

- **Vienna, Austria:**
 —Rooftop remodeling for law firm, 1983–1988; Coop Himmelblau.

- **Weil-am-Rhein (near Basel, Switzerland), Germany:**
 —Vitra Fire Station, 1994; Zaha Hadid.
 —Vitra Furniture Design Museum, 1987–1990; Frank Gehry.

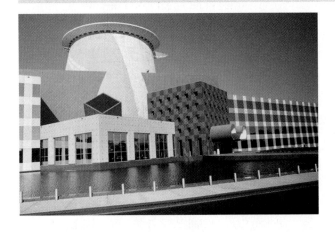

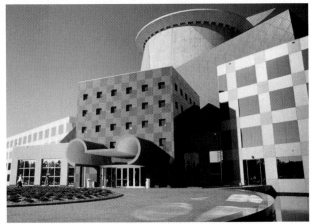

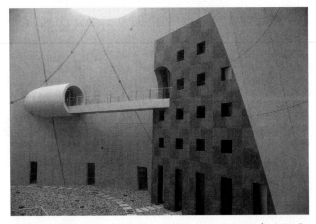

▲ **35-9.** Team Disney Building, 1989–1991; Orlando (in Lake Buena Vista), Florida; Arata Isozaki.

DESIGN PRACTITIONERS

■ **Ron Arad** (b. 1951) is best known for his unique, sculptural furniture, although he and his design team also produce sculpture, interiors, and architecture. Trained in art in Israel and architecture in London where he is now based, Arad creates one-of-a-kind furniture in which he exploits materials and advanced technologies. He forms his own firm, One Off, with Caroline Thorman in 1981, and subsequently in 1989 they form Ron Arad Associates. He also designs for manufacturers such as Cassina, Kartell, Vitra, and Alessi.

■ **Santiago Calatrava** (b. 1951) is a Spanish artist, architect, and engineer known for his innovative structures that push the boundaries among art, architecture, and engineering. His innovative style is organic and sculptural. Complex form and movement are especially characteristic of his work. One of his most noteworthy buildings is Tenerife Opera House in the Canary Islands, Spain. In 2005, he was awarded a Gold Medal by the American Institute of Architects, adding to his numerous other national and international awards.

■ **Peter Eisenman** (b. 1932) is the foremost Deconstructivist theorist and architect. At first, his ideas are more important than his buildings are. After the Wexner Center of Art in Columbus, Ohio, he gains an international reputation for buildings with controversial designs that disconnect with their context and may seem hostile to the user.

■ **Frank Gehry** (b. 1929), a world-reknowned architect, is known for his curvaceous buildings covered with reflecting metal, such as the internationally recognized Guggenheim Museum in Bilbao, Spain. Gehry's work challenges the Modernist traditions of purity of form, expression of structure, and form follows function through sculptural, often disconnected, forms and twisted, tortured shapes. He also designs sculptural furniture, some in unusual materials such as cardboard. In 1989, he receives the Pritzker Architecture Prize, and in 1999 he is awarded a Gold Medal from the American Institute of Architects.

■ **Zaha Hadid** (b. 1950) is one of the world's leading avant-garde female architects. In 2004, she is the first woman architect to receive the Pritzker Architecture Prize. Hadid works out her design ideas in design competitions and through her drawings and paintings. Sometimes Deconstructivist, her work ranges from sculptural to fragmented interpretations of form. She has her own firm in London.

■ **Rem Koolhaas** (b. 1944), principal of the Office of Metropolitan Architecture (OMA), is known for his writings and architectural theories. When he received the 2000 Pritzker Architecture Prize, jurors noted that his work is as much about ideas as buildings.

■ **Daniel Libeskind** (b. 1946) is known for his museums and galleries in which concept is often more important than function is. Using oblique angles, skewed geometric forms, juxtapositions or interpenetrations of solid and void, Libeskind creates architecture that engenders feelings of loss or memory. His work stands out from its environment.

■ **Jordan Mozer** (b. 1958) is a well-recognized interior and product designer based in Chicago who works primarily on hospitality, retail, and entertainment projects. His firm's design work features innovative sculptural forms, dramatic scale, playful design elements, and unusual furnishings that reflect a theatrical character. Building on three-dimensional storytelling, narrative ideas are used to help generate form, materials, and images. Close attention to the architectural composition, details, color, and lighting is characteristic.

■ **Philippe Starck** (b. 1949) is an internationally known and prolific designer of architecture, interiors, furniture, decorative arts, and mass-produced objects. Starck's work is inventive, sensual, stylized, and appealing. He frequently juxtaposes materials, such as wood and glass, and objects, such as an antique chair in a starkly modern interior. He sometimes redesigns traditional forms in new materials and gives his work poetic or whimsical names.

■ **Bernard Tschumi** (b. 1944) is an architect, theorist, and educator. He is first known as a theorist and refines his ideas through teaching in London and the United States. His work explores the relationship of 21st-century life and architecture in a variety of expressions. Characteristics are lightness, oblique angles, intricate structure, and large areas of glass.

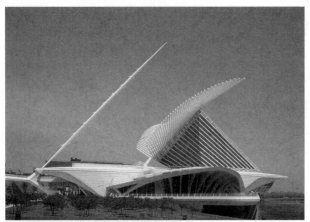

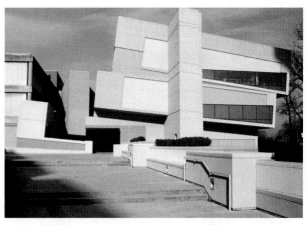

▲ **35-11.** Aronoff Center for Design and Art, University of Cincinnati, 1996; Cincinnati, Ohio; Peter Eisenman.

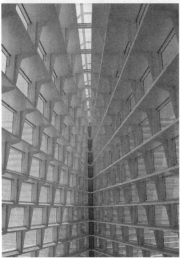

▲ **35-10.** Milwaukee Art Museum, 1994; Milwaukee, Wisconsin; Santiago Calatrava.

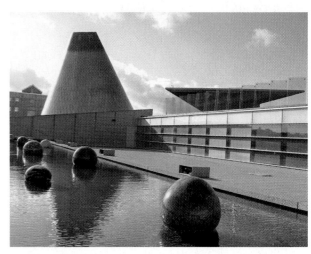

▲ **35-12.** Museum of Glass, 1996; Tacoma, Washington; Arthur Erickson with Nick Milkovich Architects and Thomas Cook Reed Reinvald.

Buildings are complex, expressionistic, dynamic, ambiguous, distorted, disordered, disjointed, chaotic, inventive, anti-human, and in contrast to the International Style, Late Modern, and Post-Modern examples. Forms are fragmented and often appear disconnected. Some buildings are large, while others are small, in contrast to the mega-structures that dominate Late Modern. Architects reject or deconstruct the principles of the International Style and Late Modern, such as expression of structure, pure form, truth to materials, and form follows function. They also discard historic precedent and the importance of context and communication shown in Post Modern. Often, architects incorporate symbolic imagery or codes into their designs, but the vocabulary and meanings are difficult to read unless one understands the particular design principles and ideas. Designs often seem deliberately hostile to the public.

Neo-Modern expressions are especially dependent upon computers and software, which speed up the design process and often reduce development costs. No longer limited by process or methods, architects and designers can explore multiple ideas, often in three dimensions, and rely less on hand drawings and handcrafted models. Communication

between designer and designer as well as between designer and client is faster and easier. Computers make experimentation with form, proportion, color, and materials far easier; changes can be made with a click of a mouse or stroke of a key. Appearance and performance are readily tested using computer models, so problems and mistakes can be corrected before construction or production. Additionally, new computer software permits precise laser cutting of material for construction of these design concepts. However, the ability to actually build some structures is questioned and criticized.

Public and Private Buildings

■ *Types.* Particular types of public buildings are common, specifically structures without a lot of explicit functional requirements. Some of these are buildings where the need for notoriety or public awareness is considered significant. Museums (Fig. 35-7, 35-10, 35-12, 35-13, 35-14, 35-18, 35-22), theaters (Fig. 35-25), and concert halls

DESIGN SPOTLIGHT

Architecture: Guggenheim Museum, 1997; Bilbao, Spain; Frank Gehry and Partners. Internationally recognized as the most important building of the late 20th century, the monolithic Guggenheim Museum is downtown along the main river. The thin, silver titanium surfaces curve and undulate in rhythmical, irregular sequences, creating a dynamic spatial energy. Walls and roof merge as needed. Exterior rectangular elements are covered in limestone. The visual image is at once complex, expressionistic, distorted, disordered, disjointed, chaotic, and inventive. Developed from models and computer drawings, the building illustrates Gehry's design approach in creating spaces, forms, and shapes free of grids. Applying deconstructive theories, he organizes the building through large to small scale, based on the concept of the 19th-century city. To do this, various areas, such as stairs and ramps, are broken down into units of volumetric space that become a metaphor for the Bilbao metropolis. An expansive walkway leads to the museum's main entry, which is glass and partially hidden. The interiors are defined by large areas of curved, open space with few columns because of the underlying steel framework. The central atrium is an open, uncluttered area that rises 164 feet in height; it appears even larger because of the white walls and ceiling, where sculptural skylights filter light from top to bottom. Windows that vary in shape, size, and configuration wash the interior walls with light and highlight the overall sculptural quality of the building.

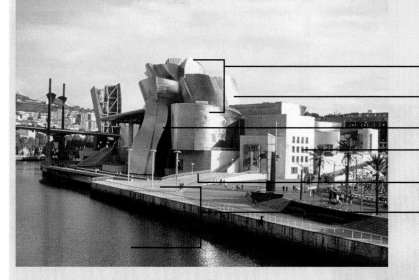

Facade and roof forms move, project, and contour upward

Silver titanium surfaces curve and undulate in rythmical, irregular sequences

Twisted and distorted forms throughout

Geometric forms offer contrast and disorder to curved elements

Asymmetrical emphasis

Building stands out from its site along the river and from other buildings nearby, becoming a visual icon

▲ 35-13. Guggenheim Museum; Bilbao, Spain.

▲ **35-14.** Jewish Museum, 1989–1999; Berlin, Germany; Daniel Libeskind.

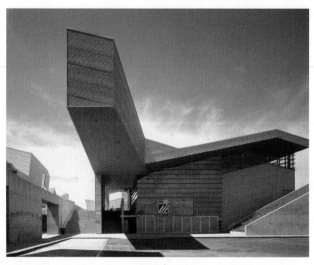

▲ **35-15.** Burj Al Arab Hotel, 1994–1999; Dubai, United Arab Emirates; Thomas Wright.

▲ **35-16.** Diamond Ranch High School, 1993–2000; near Pomona, California; Morphosis Architects.

DESIGN SPOTLIGHT

Architecture: Tenerife Opera House, 1991–2003; Tenerife, Canary Islands, Spain; Santiago Calatrava. Expressionism. Calatrava is a creator of architectural icons, such as the Tenerife Opera House. One of his most famous projects, the building is a bold landmark in an urban area, intended to connect the city to the ocean and transcend its surroundings. Somewhat reminiscent of work by Eero Saarinen and Jørn Utzon, the building boasts sculptural white forms, emphasizing lightness, that move and dance around the exterior like a bird in flight. It is unusual, eye-catching, and conceptually organic, a creation that is at once powerful, lyrical, and moving. Constructed of concrete, steel, and glass, the form and structure blend together as one. Light enters through narrow slits in the roof curves and glass walls at the ground level. Large areas of open space flow throughout the interior. The auditorium best illustrates his concept of interior space with white walls and a dramatic ceiling defined by architectural curves that shape the space and emit light.

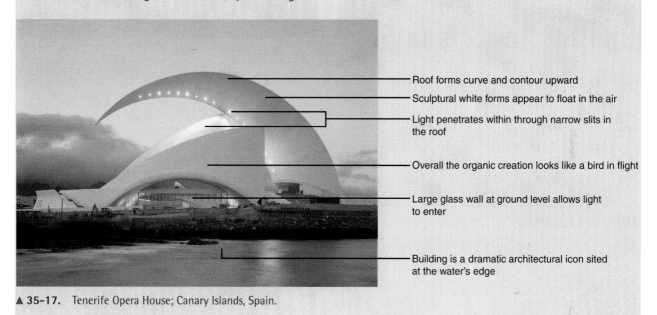

Roof forms curve and contour upward

Sculptural white forms appear to float in the air

Light penetrates within through narrow slits in the roof

Overall the organic creation looks like a bird in flight

Large glass wall at ground level allows light to enter

Building is a dramatic architectural icon sited at the water's edge

▲ **35-17.** Tenerife Opera House; Canary Islands, Spain.

(Fig. 35-17, 35-20, 35-21) represent the most important examples. Other types of structures include rail stations, libraries (Fig. 35-19), offices (Fig. 35-6, 35-9), airports (Fig. 35-36, 35-37), hotels (Fig. 35-15, 35-23), and houses (Fig. 35-24).

■ *Site Orientation.* Most buildings are conspicous because architects often show little respect for location or context. Some dominate through form and scale (Fig. 35-6, 35-13, 35-15, 35-20), and therefore become the site focus. Others dominate simply by their unusual design (Fig. 35-7, 35-12, 35-17, 35-21). The surrounding area may offer a transition through a park, water, or grass area to provide a setting and reinforce vistas. A few may seem to integrate with an urban site and the buildings nearby, but project and protrude to achieve recognition (Fig. 35-18, 35-19).

■ *Floor Plans.* The autonomous forms of the façade are usually juxtaposed to create tension, disorder, and complexity, so the floor plans reflect this same concept. Formal ordering disappears in favor of chaos and disorder. Plans are complex with many layers of interrelationships (Fig. 35-8, 35-29). They develop from a three-dimensional composition rather than from a two-dimensional drawing, an evolution that springs from architectural experimentation during the late 20th century. Designers play with multiple volumes of interrelated and disconnected scales of space with dominant and subdominant forms. Dominant forms usually have a primary axis along with secondary axes that evidence slight deviations, angled tilts, or disconnections from the main composition. Subdominant forms seem randomly placed as related to the whole plan.

Designations of functional space on the plans develop from a random system of importance, but in a pleasing, poetic, and abstract manner complementary to the overall aesthetic composition. Large, important spaces, such as auditoriums or exhibit areas, often define the plan and major axis. Curves, half circles, and linear movements are characteristic. Interior circulation is informally organized horizontally and vertically, with a pattern of disorganization. As a result, wayfinding is often difficult.

■ *Materials.* Common materials are steel (galvanized, corrugated, quilted, stainless, smooth sheets; Fig. 35-14), stone

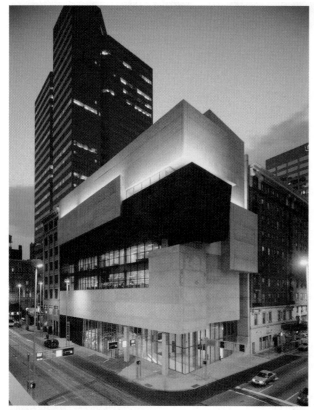

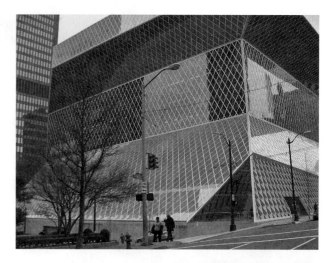

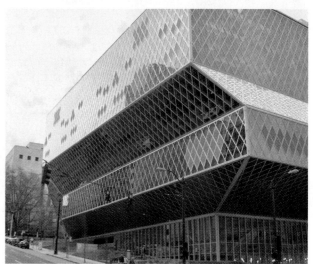

▲ 35-19. Seattle Public Library, 1999–2004; Seattle, Washington; Rem Koolhaas.

▲ 35-18. Rosenthal Center for Contemporary Art, 2003; Cincinnati, Ohio; Zaha Hadid.

(Fig. 35-6), stucco (Fig. 35-7), concrete (Fig. 35-17, 35-20), aluminum (perforated panels are prevalent), titanium (Fig. 35-13, 35-21), copper, glass (Fig. 35-12, 35-15, 35-19), plastics, tile, wood, and brick (Fig. 35-4). Architects challenge previous conventional uses of materials and search for new ways to apply them. Sometimes the applications are totally unexpected, incongruous, and contradictory. Color, often intense, may be used to highlight disorder or create order within disorder. It often functions as communication codes or identifiers, which usually are not evident to others. For example, on the Social Housing building (Fig. 35-3),

Berlin, Peter Eisenman uses green to represent the surrounding 19th-century buildings and a white, red, and gray grid as the Mercator grid of the world (a universal grid location method).

■ *Façades*. Façades evidence individuality, complexity, explosive space, chaos, and fragmentation with no expected stylistic imagery as was common in earlier or parallel developments. Forms may be sculptural (Fig. 35-7, 35-10, 35-13, 35-17, 35-20, 35-21) and filled with motion and/or somewhat lyrical or fragmented and jagged with protrusions and projections (Fig. 35-4, 35-9, 35-11, 35-14, 35-16, 35-24). Façades exhibit a three-dimensional experimentation with forms, materials, and color (Fig. 35-5, 35-9, 35-13, 35-23), which are often used to abstractly define particular layers, zones, or functions. Sometimes this contributes to a separation of parts. Façades also emphasize construction to create order, with engineering innovations that support distinctive new forms, unusual heights, and

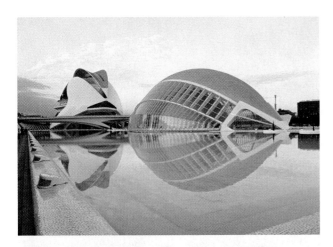

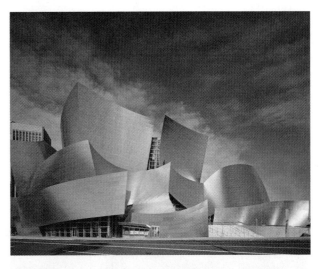

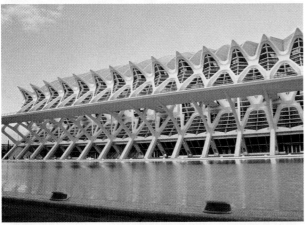

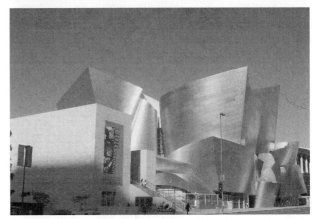

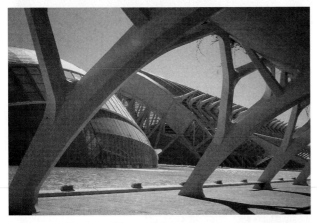

▲ **35-20.** The City of Arts and Sciences, 1991–2004; Valencia, Spain; Santiago Calatrava.

▲ **35-21.** Walt Disney Concert Hall, 2004; Los Angeles, California; Frank Gehry.

extremely wide spaces. Mass and space as solid and void play against each other to create tension. A juxtaposition of geometries creates disorder, distortion, irregularity, and spatial energy. Curved, straight, and angled lines and forms appear in opposition to each other to create contrast. Most façades are asymmetrical, but some have a central entry with symmetrical ordering.

■ *Windows*. There is no standard shape, size, or configuration for windows. Variety within buildings is typical, and diversity within individual forms is expected. Flat, curved, and angled glass shapes are common, as well as glass curtain walls in unusual shapes and windows housed within a grid structure (Fig. 35-3, 35-6, 35-9, 35-14, 35-15, 35-16, 35-17, 35-18, 35-19, 35-20, 35-23, 35-24). Most windows

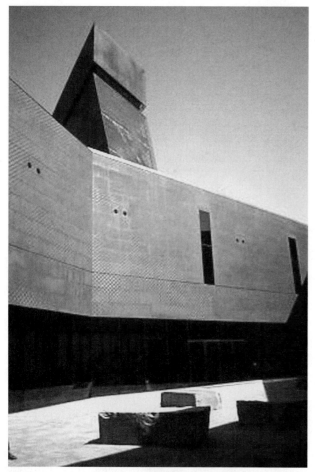

▲ **35-22.** Fine Arts Museums of San Francisco–De Young, 2005: San Francisco, California; Herzog and de Meuron.

are fixed glass so they do not open. Some windows are tinted in brown, gray, bronze, or green shades. Narrow metal moldings in neutral colors continue to define edges and shapes.

■ *Doors*. Entries may blend in with the overall design of the building to seemingly confuse visitors (Fig. 35-11, 35-13, 35-20, 35-21) or they may stand out from it to announce importance (Fig. 35-4, 35-9). Size, scale, and design of entries vary by architect. Examples may be lyrical, humorous, or somewhat bland. Usually there is one major entry that sets the stage and passage for more to come, with unobtrusive secondary entry/exits.

■ *Roofs*. Because buildings are designed as pieces of large sculpture, there may be little separation between roof and façade. Instead, roofs may meet walls to contour upward, angle downward, or diminish in appearance. They may be curved, angled, flat, pointed, or a combination of several shapes to achieve design variety (Fig. 35-5, 35-6, 35-10, 35-11, 35-16, 35-19, 35-22, 35-23). Multiple rooflines and cutouts add complexity and interaction (Fig. 35-7, 35-12,

▲ **35-23.** Hotel de Puerta America, 2006; Madrid, Spain; design by 12 international designers.

35-13, 35-21). Some designs are symmetrical, while others are asymmetrical. Often roofs integrate with the building as a visual symbol that proclaims the building's character (Fig. 35-10, 35-15, 35-17, 35-20).

▲ **35-24.** Gehry House, 1978; Santa Monica, California; Frank Gehry.

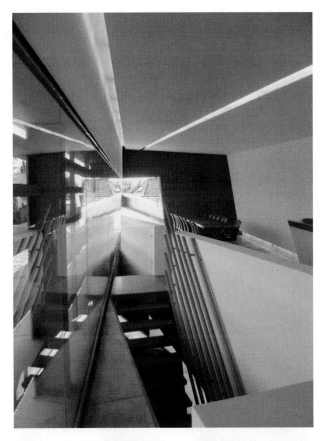

INTERIORS

Interiors by architects become the visual extension of the distinctive exterior form. There is little separation between the two because of the three-dimensional plan development. Architectural forms, materials, and colors from the outside repeat within to achieve a unified composition. Growing out of the Neo-Modernist fluid views of function, some interior spaces seem adverse to their intended function and/or the user. Discontinuous space, oblique angles, and juxtapositions of forms, shapes, sizes, and

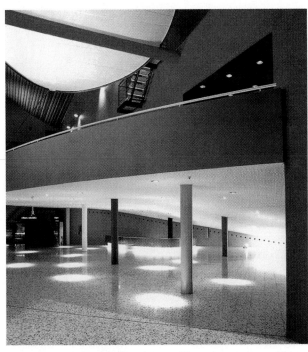

▲ **35-25.** Interiors, National Dance Theater, 1984–1987; The Hague, Netherlands; Rem Koolhaas.

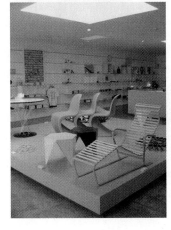

▲ **35-26.** Interiors, Vitra Furniture Design Museum, 1987–1990; Weil-am-Rhein (near Basel, Switzerland), Germany; Frank Gehry.

DESIGN SPOTLIGHT

Interiors: Guest room, Paramount Hotel, 1990, and lobby and dining area, Royalton Hotel, c. 1990–1992; New York City, New York; Philippe Starck. Located in the heart of Manhattan, both of these boutique hotels retain elements of their 19th-century classically articulated exteriors, but with modern touches, including distinctive new façade elements, signage, lighting, and handrails. The new additions, juxtaposed against the more traditional building context, offer a prelude to Starck's innovative, individualistic, and theatrical interiors. In the Paramount, the open lobby features a random placement of unusual and custom furniture in varying colors and materials, angled gray and metal stairs that widen as they ascend to the mezzanine, and elevators illuminated by different floor lights with colored gels. The guest room is accented by an enlarged headboard that replicates a small gold-framed Vermeer painting, but with thick padding behind it. Interior colors in white, gray, and black are as a backdrop to spotlight the headboard. Starck's custom-designed furniture with its unusual and distinctive forms enriches the overall character. Lighting is dramatic as well as functional, with up-lighting mounted on a tall movable storage unit to create a kinetic effect, exhibit lighting mounted on top of the gold headboard frame to spotlight it, and task lighting projecting down in a tube shape over the table desk. In the adjacent bathroom, a new conical metal sink and metal frame mirror offer distinctiveness to a basically simple white space. The interiors are so dramatic and create such lasting visual impressions that one does not fully notice the limited natural light, small-scaled spaces, or lack of some common functional features. Starck manages to cleverly conceal these defects through his inventive, dramatic, and distinctive design.

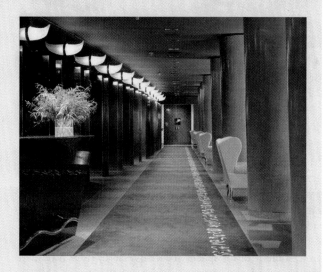

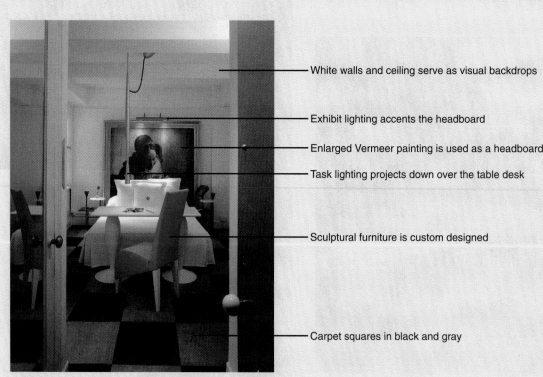

White walls and ceiling serve as visual backdrops

Exhibit lighting accents the headboard

Enlarged Vermeer painting is used as a headboard

Task lighting projects down over the table desk

Sculptural furniture is custom designed

Carpet squares in black and gray

▲ 35-27. Guest room, Paramount Hotel, and dining area, Royalton Hotel; New York City.

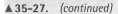

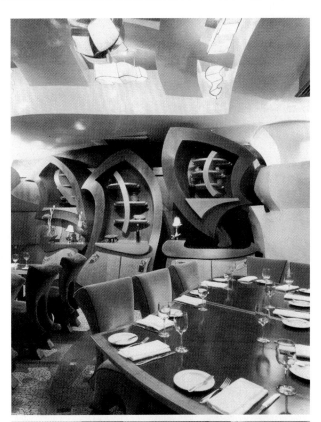

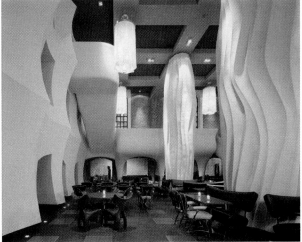

▲ **35-27.** *(continued)*

materials are prevalent. Often interiors and circulation are confusing and may exhibit inexplicable details, such as off-center lighting and columns that do not reach the floor.

Interiors by interior designers are far more limited and confined to new construction by others and the remodeling of earlier modernistic spaces. Within these existing shells, designers experiment with architectural forms, colors, materials, lighting, and furnishings as theater to create new visual images. Overall, interiors appear energetic, individualistic, unusual, and distinctive. Creative and original solutions are typical.

Public and Private Buildings

■ *Types.* Large spaces such as auditoriums (Fig. 35-34), exhibition areas (Fig. 35-26), lobbies (Fig. 35-25, 35-30, 35-32, 35-34), and airport spaces (Fig. 35-36, 35-37) are more common than others because they allow more freedom in expression. Boutique hotels or design hotels (small unique hotels) frequently hire well-known and prominent designers (Fig. 35-27, 35-28, 35-31, 35-32, 35-35).

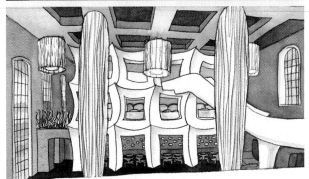

▲ **35-28.** Iridium Restaurant at Lincoln Center, 1994; New York City, New York; restaurant, lobby, and guest room at the East Hotel, 2005; Hamburg, Germany; Jordan Mozer & Associates.

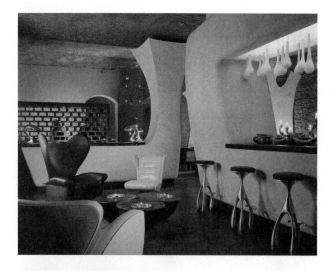

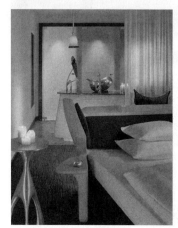

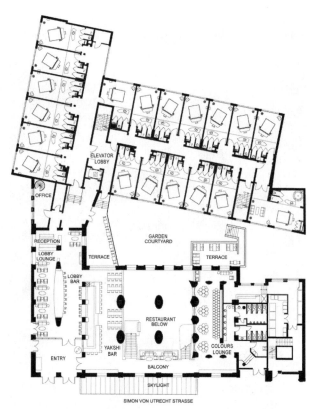

▲ **35-28.** *(continued)*

▲ **35-29.** Floor plans, East Hotel, 2005; Hamburg, Germany; Jordan Mozer & Associates.

■ *Relationships*. Architects create strong relationships between exterior and interior so that the building appears as an integrated whole. Interior designers create interiors that develop from individual units of small spaces or concepts related to the function of the interiors such as working, eating, or sleeping.

■ *Color*. White, black, and gray frame many color palettes, with accents of other colors or materials (Fig. 35-27, 35-28, 35-31, 35-35, 35-37). Neutral color schemes give some order to disordered spaces. Some designers use monochromatic colors and materials in various shades to create unity and enhance spatial scale. Others experiment with a variety of colors to create energy or contrast with structure (Fig. 35-26, 35-28, 35-36).

■ *Lighting*. Natural lighting enters from various glazed openings in the building (Fig. 35-6, 35-9, 35-10, 35-12, 35-15, 35-17, 35-19, 35-20, 35-21, 35-23, 35-33, 35-34, 35-35, 35-36, 35-37). Ongoing research on lighting, enhanced technology, and new types of lighting, such as

fiber optics, support new and different lighting designs. Architectural lighting, indirect lighting, and custom fixtures are the most important applications (Fig. 35-26, 35-33, 35-36). Designers continue to address different types of lighting including ambient, task, and mood, as well as specialized lighting for specific projects (Fig. 35-27, 35-28, 35-32, 35-38). Often lighting is unusual or creative to add drama and emphasize circulation or focal points within the interior.

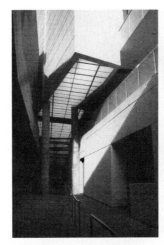
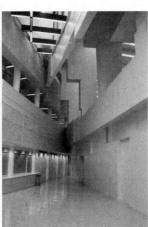

▲ **35-30.** Lobby, Aronoff Center for Design and Art, University of Cincinnati, 1996; Cincinnati, Ohio; Peter Eisenman.

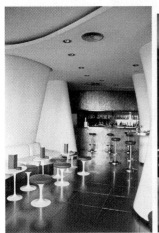
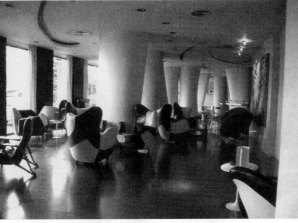

◄ **35-31.** Splash and Crash Bar, Gran Hotel Domine, c. late 1990s–2000s; Bilbao, Spain; Javier Mariscal and Fernando Salas.

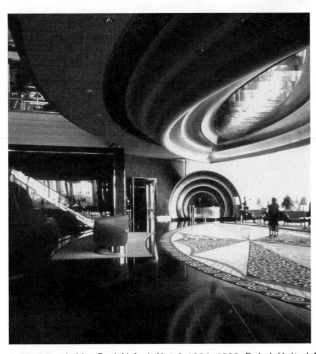
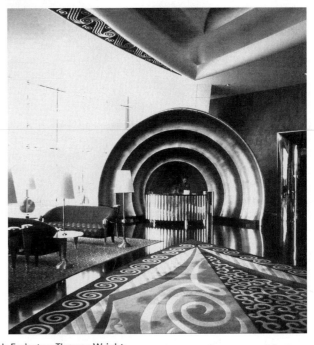

▲ **35-32.** Lobby, Burj Al Arab Hotel, 1994–1999; Dubai, United Arab Emirates; Thomas Wright.

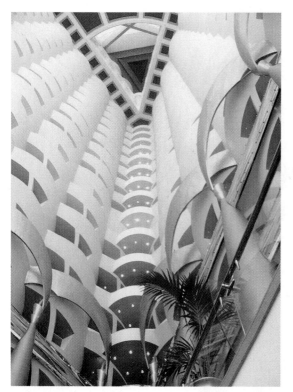

▲ **35-32.** *(continued)*

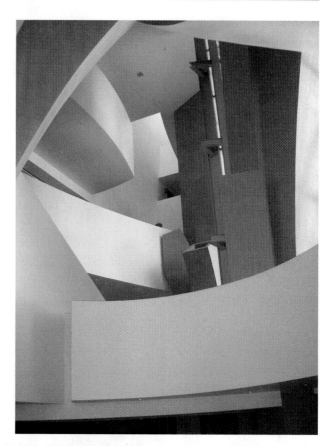

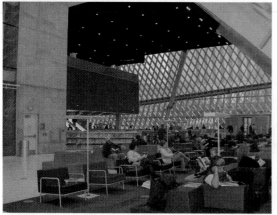

▲ **35-33.** "Living Room," Seattle Public Library, 1999–2004; Seattle, Washington; Rem Koolhaas.

▲ **35-34.** Interiors and stair carpet pattern, Walt Disney Concert Hall, 2004; Los Angeles, California; Frank Gehry.

■ *Floors.* Concrete, marble, terrazzo, and wall-to-wall carpeting in different colors and designs are the most common floor treatments (Fig. 35-27, 35-30, 35-32, 35-34, 35-35, 35-36).

■ *Walls.* Diversity in wall design and the more extensive use of interior architectural features to articulate interior space are characteristic (Fig. 35-26, 35-27, 35-28, 35-30, 35-31, 35-32, 35-34, 35-35, 35-36). Walls may be flat, angled, curved, broken, perforated, layered, or transparent.

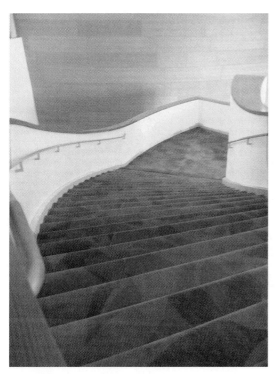

▲ **35-34.** *(continued)*

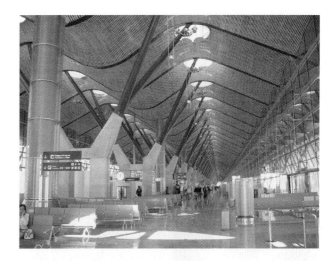

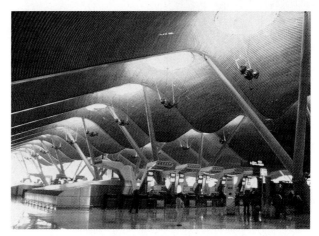

▲ **35-36.** Interiors, Barajas Airport, 1998–2006; Madrid, Spain; Richard Rogers Partnership.

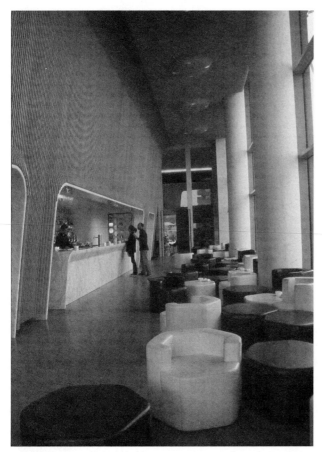

▲ **35-35.** Bar, Hotel de Puerta America, 2006; Madrid, Spain; Zaha Hadid.

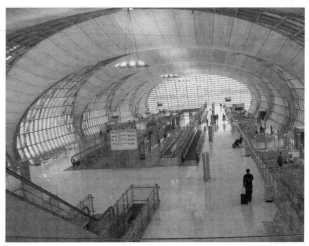

▲ **35-37.** Interiors, Bangkok Airport, 2006; Bangkok, Thailand; Murphy/Jahn Architects.

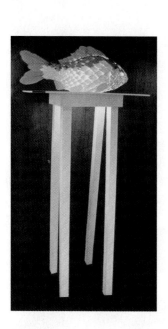

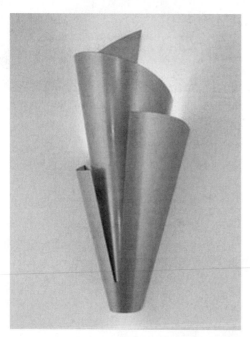

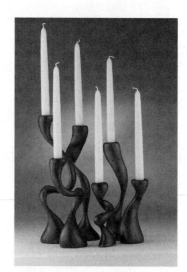

▲ **35-38.** Lighting: Fish lamp, 1990–1992, by Frank Gehry; Algue lighting (branching light), 2004, by Ronan and Erwin Bouroullec, manufactured by Vitra; Song (wall scorce), 1998, by Quotinim Song, manufactured by Artemide; candelabra and lamp, 2005–2006, by Jordan Mozer & Associates; Take (hanging lights), 2003, and Easy, 2004, by Ferruccio Laviani, manufactured by Kartell; and Titania oval hanging lamp, c. 1990, by Alberto Meda and Paolo Rizzatto, manufactured by Luceplan S.P.A.

Complicated spaces often have little architectural articulation and few details to allow the space to speak for itself. Paint colors may highlight a particular wall or walls and/or significant architectural features (Fig. 35-28, 35-32, 35-36). Wallpaper is rare. Sometimes designers use drapery as a backdrop for furniture groups or to soften walls. These are usually of plain, unpatterned, softly draping fabric.

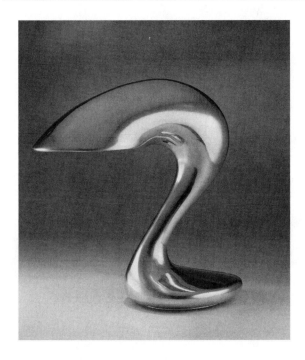

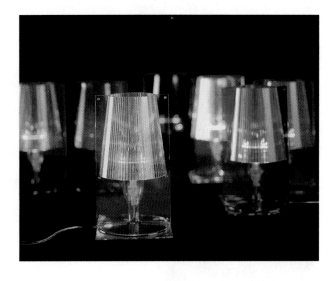

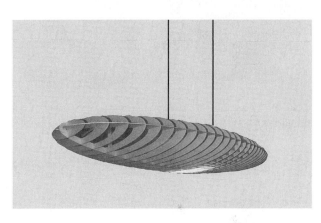

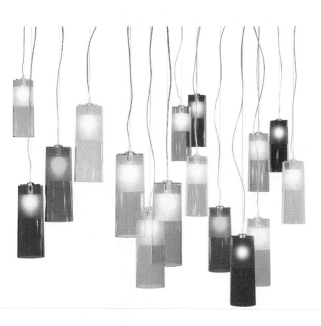

▲ 35-38. *(continued)*

■ *Window Treatments*. Most windows have no window treatments, which can interfere with the overall concept and complexity. When necessary for privacy, treatments are simple and plain, such as shades, blinds, or pinch-pleated drapery of plain fabrics in white or light neutral colors. Architectural features often protect interiors from glare.

■ *Ceilings*. Designers experiment with custom-designed ceilings that integrate lighting, have visual layering, and create interesting focal points (Fig. 35-26, 35-28, 35-34, 35-36, 35-37). Creativity and originality in design composition are common.

FURNISHINGS AND DECORATIVE ARTS

Like architecture and interiors, furniture is expressionist, artistic, sculptural, and individualistic in design. There is far less emphasis on function and ergonomics, and more on furniture as art. Movement, either physical or visual, and complexity are important design characteristics. Furniture may stand out like a piece of art in the interior or appear as an integrated unit so as not to distract from the architecture. Like architects, Neo-Modern designers challenge preconceived ideas of seating, what it should be, how it should look, and what it

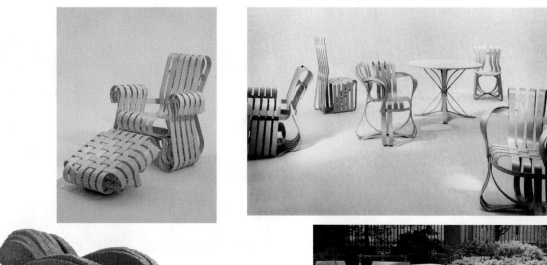

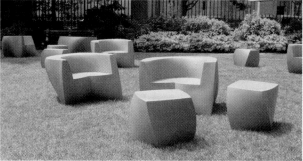

▲ **35–39.** Powerplay armchair and ottoman, 1990–1992; Red Beaver, 2005; seating, 2006; United States and Germany; Frank Gehry, for Vitra, Knoll International, and Heller.

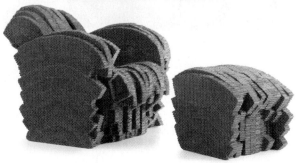

▲ **35–40.** Airos, 1992; Switzerland; Robert Wettstein and Stanislaus Kutac, manufactured by Structure Design.

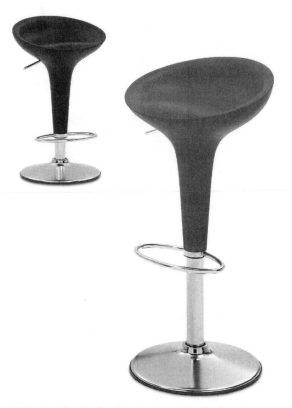

should be made of. Advances in technology, including computers and new materials, allow greater complexity in designs. As before, well-known architects and interior designers create individual pieces or furniture groups, textile collections, and decorative arts for various manufacturers. Some, such as Starck, design mass-produced objects with lower prices.

▲ **35–41.** Bombo Bar Stool, 1997; Italy; Stefano Giovannoni, manufactured by Magis.

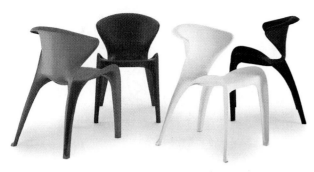

▲ **35-42.** Calla chair, 2001; Italy; William Sawaya, manufactured by Heller SLR.

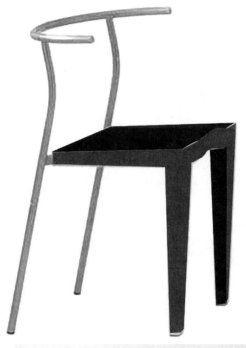

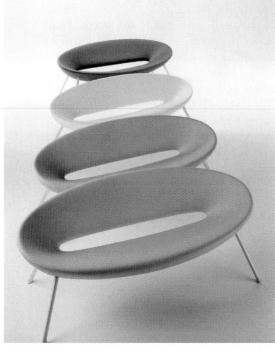

▲ **35-43.** Dr. Glob (top left), Ploof (lower left), Louis Ghost armchair (top right), Dr. No and Dr. Na, (center right), and Bubble Club chair, 2002; France; Philippe Starck, manufactured by Kartell.

▲ **35-44.** And (spiral seating), 2002; Italy; Fabio Novembre, manufactured by Cappellini.

▲ **35-45.** Chair One, 2003; Italy; Konstantin Grcic, from Magis.

Public and Private Buildings

■ *Types*. Chairs are important throughout the design development. Custom-designed furniture continues to be important in all types of spaces, but is particularly important in unique interiors (Fig. 35-27, 35-28, 35-43). Some manufacturers, such as Knoll, commission designs by well-known architects including Gehry (Fig. 35-39) and Eisenman.

■ *Distinctive Features*. Designers push the envelope and experiment with shapes, forms, and materials. Lines and contours are important features, as well as solid and void interplay (Fig. 35-40, 35-42, 35-44, 35-45, 35-46, 35-50). Complexity and fragmentation reflect architectural developments. Designers also experiment with atypical materials, such as cardboard.

■ *Relationships*. Many furniture examples relate to either the architecture and/or interior design compositions by a strong unity and harmony in the overall interpretation. However, much furniture is distinct from its environment because of unusual designs and/or because of intentional placement. There is no set formula for furniture placements and arrangements; they vary by designer.

■ *Materials*. The most prevalent materials are laminated wood, cardboard, steel, chrome, aluminum (anodized, enameled, and cast), polypropylene, polycarbonate, other plastics, molded carbon fiber, glass, and polyurethane foam. Metals and wood are often used as frames for upholstered chairs.

■ *Seating*. Chairs continue to be the most important pieces of furniture (Fig. 35-27, 35-35, 35-39, 35-40, 35-42, 35-43, 35-45, 35-46, 35-47). Designers experiment with forms and contours, but in contrast to Late Modern, they pay far less attention to ergonomics and modularity. This relates to architecture's deemphasis of function. The overall aesthetic character and uniqueness are more important than anything else. Consequently, some are comfortable, and some are not. Geometry and straight lines become asymmetry, curves, and sculptural features in Neo-Modern. Some examples have solid compositions (Fig. 35-46, 35-47), while others are more open or transparent (Fig. 35-40, 35-43, 35-45). Designers also experiment with bar stools, benches, and seating with unusual forms (Fig. 35-28, 35-41, 35-44, 35-48).

■ *Tables*. Sleek and unornamented in overall design, most tables exhibit intricate and interesting sculptural forms that relate to the general architectural design of the period (Fig. 35-27, 35-49). Some examples have pierced surfaces, curved bases, or disconnected parts. As with the architecture, separation of unusual contiguous parts to create complexity is characteristic.

DESIGN SPOTLIGHT

Furniture: Bad Tempered Chair, 2002; Creature Comfort, 1992; and Voido, 2005; England, Germany, and Italy; Ron Arad Associates, from Vitra One Off, and Magis. Defined by his innovative and unique concepts, Arad creates sculptural furniture that shows his experimentation with advanced technologies. Formed of bent and welded steel, his volumetric seating suggests large overstuffed chairs. Simple in shape and form, they dominate interior spaces because of their size, weight, materials, and visual presence. His more recent furniture designs continue these concepts, but the construction materials may be steel, injection-molded plastic, or glass and carbon fiber laminate. With the laminate, as in the Bad Tempered Chair, he is able to pierce the volume, develop more ergonomic contours, and physically and visually lighten the overall form.

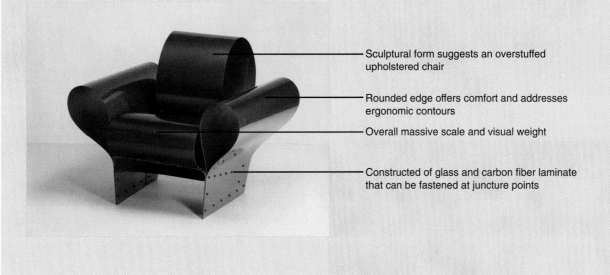

Sculptural form suggests an overstuffed upholstered chair

Rounded edge offers comfort and addresses ergonomic contours

Overall massive scale and visual weight

Constructed of glass and carbon fiber laminate that can be fastened at juncture points

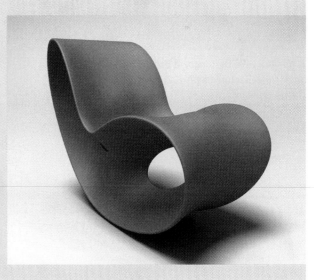

▲ **35–46.** Furniture by Ron Arad.

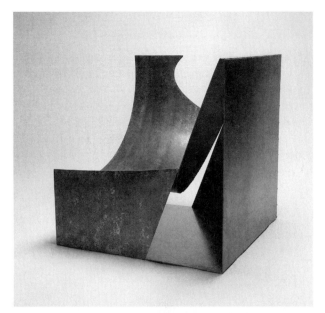

▲ **35-47.** Cube chair, 2006; United States; Stan Carroll.

▲ **35-48.** The Ordrupgaard Bench, 2005; Denmark; Zaha Hadid, manufactured by P. P. Mobler.

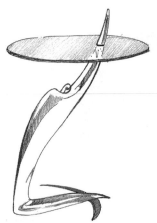

◄ **35-49.** Arcadia wings table, 1987; France; Pierangelo Caramaia, for XO.

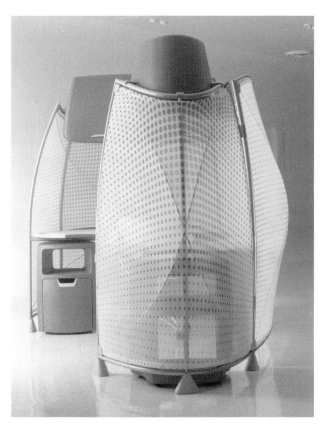

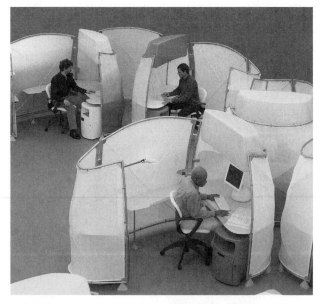

▲ **35-50.** A3 systems furniture, 2002; United States; Hani Rashid at Asymptote, manufactured by Knoll International.

■ *Storage and Furniture Systems.* Storage pieces and furniture systems can not only be functional, but they can become unique art objects within their environments (Fig. 35-50, 35-51). Characteristics from Neo-Modern architecture repeat through their curved surfaces, distinctive character, solid and void relationships, and individualistic

▲ **35–51.** Bookworm and Lovely Rita, 2006; Italy; Ron Arad, manufactured by Kartell.

▲ **35–52.** Decorative Arts: Pito Kattle (tea kettle), 1988, by Frank Gehry; Les Ministre (stand), 1996, by Philippe Starck, manufactured by Alessi; mirror, 2005–2006, by Jordan Mozer & Associates.

expression. Sometimes designs challenge the purpose of the piece so that it may look very different from what is expected.

■ *Decorative Arts*. Decorative arts objects repeat the character of Neo-Modern architecture, interiors, and furniture. They are expressionistic, sculptural, unique, and playful (Fig. 35-52). Interior designers often design individualistic pieces to support and enhance the ambiance of a particular space.

Glossary

acanthus A Mediterranean plant with thick scalloped leaves; its stylized forms highlight Greek, Roman, and later architecture, interiors, and furniture.

adaptation Designs based upon earlier buildings, interiors, and furnishings that change or exploit one or more aspects of the original, such as color; use elements in a new or different way; or combine details from other styles or periods. Simplification and abstraction are the most typical changes. The end product may closely approximate the original or bear a range of resemblances to the historical original.

adobe Sun-dried clay brick in varying sizes used to build many Spanish missions and dwellings in the southwestern United States. Spanish Colonial Revival interprets adobe in plaster or stucco.

aedicule (*aedicula*, pl.) A small motif composed of columns or pilasters supporting a pediment. Created by the Romans, it surrounds a niche, window, or door.

aisle Space flanking the nave and separated from it by the arcade in a basilica or Latin cross church.

anthemion Motif composed of the radiating clusters of stylized leaves and flowers of the honeysuckle.

anthropometrics Study of the measurements and proportions of the human body.

antimacassar Small covering or doily used to protect furniture from soiling by macassar hair oil.

***appartement* (Fr.)** A suite of rooms usually associated with one person.

***appliqué* (Fr.)** A wall sconce.

apron A horizontal support under a chair seat, tabletop, bottom frame of a case piece, or window sill; often carved, pierced, or otherwise decorated.

apse A semicircular, polygonal, or rectangular space on the eastern or altar end of a church.

arabesque Decoration composed of geometric patterns and flowing, curving lines and tendrils that develops in Hellenic Greece.

arcade A row of arches carried on columns or piers. An arcade may be open, as in a nave, or closed, as on the façade of a building.

arch In architecture, a structure composed of wedge-shaped blocks that spans an opening supported on the sides by columns or piers.

architectonic Related to or resembling aspects of architecture, such a space or structure.

architrave The horizontal member (lintel) immediately above a column.

arcuated Construction using arches.

armoire (Fr.)(*amario*, Sp.) French term for a wardrobe; a tall upright cupboard, with or without interior shelves, with a door or doors on its façade.

astragal Molding composed of a half-round portion flanked by two flat portions.

atrium Large open space, often glassed or with skylights and plants and greenery, that is derived from a large open entrance hall in Roman houses.

Aubusson A carpet with a coarse tapestry weave, made at the Aubusson factory in France established during the Middle Ages. These flat-woven, pileless rugs are characterized by open slits where colors meet.

axial plan A plan that is longitudinal or arranged along an axis.

Axminster Hand-knotted wool cut-pile carpet originating in 18th-century Axminster, England. Later, machine woven on complex looms in an unlimited number of colors.

awning window A window in which the individual panes or sashes are hinged at the top so that they open outward. It may have several panes or sashes.

baize A coarse wool or cotton fabric imitating felt that is used to protect carpet, tabletops, and bookcases.

Bakelite Resin similar to plastic available in numerous colors and patterns and used for jewelry and a variety of consumer products especially during the 1920s and 1930s.

baluster A turned or carved upright, sometimes in the form of a column, that may appear in a chair back or with other balusters in a balustrade.

balustrade A parapet or railing composed of a handrail, balusters, and base.

banquette An upholstered seat that is or appears to be built-in.

bargeboard Decorative board beneath the edge and following a gable roof; also called a vergeboard.

barrel vault A semicircular continuous vault used from ancient times to the present.

basilica Originally, a Roman hall of justice with a nave, side aisles, and a circular apse on one end, usually opposite the entrance. During the Early Christian period (3rd–7th centuries), the plan is adapted for Christian churches and becomes the typical plan.

batter Wall that is slanted for stability; usually only on one side; characteristic form in Egyptian and Egyptian Revival architecture and Egyptian Revival furniture.

battlement A parapet consisting of raised rectangular shapes (*merlons*) and openings (*crenellations*); part of early fortification techniques used decoratively later.

bay A vertical division of an exterior or interior marked by an order, pilasters, fenestration, a vaulting unit as in a nave, or roof component.

bay window An angular window that projects outward at ground level.

bed hangings Draperies intended to surround a bed for privacy, protection from drafts, and as an indication of wealth. A set of hangings includes the **head cloth** that hangs at the head of the bed; the **ceiler**, the cloth inside the tester or cornice; the **valances**, shaped or plain fabrics hanging from the tester or cornice; **bases** that are similar to today's dust ruffles; **curtains** on all four sides that completely enclosed the bed; and the **counterpoint, counterpane,** or **coverlet.**

bead molding Convex molding composed of circular or oval forms.

bifora or biforate window Arched window divided into two lights by a colonette. They are common in medieval and early Renaissance Italian buildings.

board and batten Exterior wall covering composed of boards with narrow strips applied over the joints between boards.

bombé (Fr.) Vertical swelling shape on furniture. Characteristic of French Rococo of the 18th century.

boss An applied circular or oval furniture ornament that grows out of the crossing points of ceiling ribs in Gothic; characteristic of medieval and Renaissance styles and their revivals.

Boullework (Fr.) Form of marquetry composed of tortoiseshell and brass; developed by André-Charles Boulle in the 17th century and revived later in the Neoclassical period. A thin layer of tortoiseshell and brass are glued together and shaped into complicated designs; when separated, they produce identical images of brass with a tortoiseshell ground and vice versa.

bow front A case piece with a convex front shaped like a bow or semicircle; common in the 18th century.

bracket A projecting support carrying an overhanging element; large, bold brackets beneath the roofline are a defining characteristic of Italianate or Italian Villa architecture.

brise soleil Angled panels used as sunlight regulators.

brocade Rich, heavy jacquard-woven fabric with a raised pattern that is emphasized by contrasting colors or surfaces; may have satin or twill patterns on a plain, twill, or satin background. Some have gold or silver threads.

brocatelle Fabric similar to a brocade, but its design is in higher relief, which gives a distinctive puffed appearance; the jacquard-woven design is in a satin or twill weave on a plain or satin background.

brownstone Red-brown sandstone used as a building material in the eastern United States.

Brussels carpet Looped pile wool carpet that is first woven in Brussels, Belgium, about 1710. Durable but expensive because of the amount of wool required, the weaving process limits the number of colors in the face to five. The manufacture of Brussels carpet ends in 1930. Today woven looped pile carpets are made on Wilton looms.

bull pin Open space with rows of rectangular desks and files sometimes separated by partitions. Common in offices until the 1970s introduction of systems furniture.

bun foot A type of furniture foot that is round and slightly flattened on top and bottom, resembling a bun.

bungalow Small one- or one-and-a-half-story house with a broad roof with one or two dormers and a porch. As a house type, bungalows have many variations and reflect many stylistic influences. The name is a corruption of a Hindu term that refers to a low house with veranda.

bureau plat (Fr.) A table desk that is oblong in shape with three drawers in the apron.

burl Veneer with a mottled appearance deriving from irregular growths on a tree.

buttress Mass of masonry built against a wall to strengthen it against the pressure of an arch or vault.

cabochon An oval ornament with no facets, resembling a polished stone or gem.

cabriole leg A curving form imitating an animal's leg; it curves out to a knee, down and into an ankle, and swells out again to a foot.

café curtains Half-length solid or translucent curtains used alone or with valances.

calico Originally, a printed or painted cotton fabric from India; later the term is applied to a cotton fabric printed in several colors.

canapé (Fr.) A settee or sofa.

candelabrum (candelabra, pl.) (Fr.) Multiarm candleholder usually placed on a mantel, table, or stand.

canopy Originally, in the Middle Ages, a fabric or covering hanging over a chair or bed to denote rank. Full canopies are reserved for the person of the highest rank, and lesser persons receive half or partial canopies. During the Renaissance, canopy frames become more elaborate, and eventually the term comes to its present meaning of a framework over a bed on which fabrics hang. It is also called a *tester.*

canterbury An open rack with partitions used to hold music or magazines. Introduced in the 1780s, the canterbury sometimes has drawers beneath the partitions and four short legs usually with casters.

cartouche A tablet or panel, usually oval with an ornamented frame or scrolled edges; usually contains an inscription, coat of arms, or monogram.

caryatid A female figure used as a column or furniture support.

cased glass Two or more layers of glass of different colors into which designs are cut so that base glass and layers show through.

casement window A window hung vertically and opening outward.

casements Modern, loosely woven textiles used as window treatments to block glare.

caster Small wheel with a swivel on a leg or bottom of a piece of furniture to facilitate moving the piece. Very popular in the Victorian period, casters are invented in the 16th century.

chaise (Fr.) A side chair.

chaises volantes (Fr.) Literally, flying chair. A chair intended to be moved, often with casters, appearing during the Empire period.

château (châteaux, pl.) (Fr.) A monumental, luxurious country house or castle of a French aristocrat.

chenille Thick cloth woven with chenille yarns, which are piled.

Chicago window Tripartite window with a fixed wide center glass pane flanked on one or both sides by double-hung sash windows for light and ventilation. Introduced by Louis Sullivan at the Carson, Pirie, Scott Store in Chicago, 1899–1904.

chiffonier Usually refers to a small chest or cupboard with shelves or drawers. It may sometimes refer to a small table for serving drink or food. Its name derives from *chiffonnière*, a French term for a light chest of drawers.

chimera A Greek mythological creature with the head of a lion, body of a goat, and tail of a snake.

Chinoiserie (Fr.) Chinese and pseudo-Chinese motifs that reflect European fanciful, naïve, and/or Romantic notions about China.

chintz Originally, painted or printed cotton from India, not like today's glazed and printed cottons. In Hindi, *chint* means spotted cloth; its plural, *chintes*, becomes chintz; used for clothing and furnishings in the 19th century.

choir A location for singers. In a large church, it is usually in the eastern nave or it may be on the east side of the crossing of a cruciform plan. The choir usually has stalls or seats and is partially screened.

cinquefoil Five lobed form; see also *foils*.

clapboard Weatherboarding on the exterior of a building composed of planks tapering from thick to thin to facilitate horizontal overlapping.

clerestory Windows placed high in a wall, especially near a roof.

cloak pin A metal or, later, glass medallion or rod over which drapery may be looped to hold it back from the window glass; also called a holdback.

cluster column A column with several attached or detached shafts; also called a compound column; typical of Gothic and Gothic Revival.

coffer A sunken decorative panel in a ceiling, often repeated in a grid.

colonnette A small column used decoratively or as support, such as in an arcade.

commode **(Fr.)** A low chest with drawers or doors. Introduced in the 17th century, its name comes from the French term for convenient or accommodation.

composite A type of column arising in late Roman times. The capital is composed of the two pairs of Ionic volutes and the double row of acanthus leaves of the Corinthian; the shaft, which rises from a base, may be fluted or plain.

console (Fr.) A table attached to a wall and supported only in the front by legs or a pedestal. Later, any table placed against a wall; only its front portion may be decorated.

corbel table Wall projection composed of brackets connected by round arches; characteristic of Romanesque and Romanesque Revival buildings.

Corinthian An order invented by the Greeks. Rising from a base is the slenderest of fluted shafts capped by an inverted bell-shaped capital. Two rows of eight acanthus leaves highlight the lower portion of the capital and stalks rising from them terminate in small volutes that support the abacus. The abacus

curves outward to the corners, ending in a point or chamfer. A carved rosette decorates the center; the entablature resembles that of the Ionic.

cornice Uppermost or crowning portion of a classical entablature; also an ornamental projecting molding along the upper portion of an exterior or interior wall below the roof or the ceiling, respectively.

cornucopia Decorative motif composed of an animal horn with fruit and flowers spilling from it; the horn of plenty symbolizes prosperity and abundance.

crazing Allover pattern of cracks in glass or a glaze. It may be accidental or intentional.

cresting Ornament, often pierced, atop a roof or wall.

cretonne Heavy unglazed, printed cotton common in the late 19th and early 20th centuries.

crockets Blocks of stone carved with foliage that decorate the raking angles of spires or canopies; typical of Gothic and Gothic Revival.

cross-banding A border strip of wood veneer running transversely and contrasting in color and grain to the main surface.

cross vault Two barrel vaults intersecting at right angles; also called a groin vault.

crow-step gable A gable or parapet composed of steps tapering to a single step or apex; common in the Netherlands, Germany, and Scandinavia but also in Gothic, Tudor, Elizabethan, and Jacobean England and their later revivals.

curule chair An X-shaped chair with curving legs and arms common in the Neoclassical period. Its ancestors include the Renaissance folding chair, medieval chairs of state, and the *sella curulis*, an X-shaped folding stool used by ancient Roman curules or magistrates.

cusp A projecting point formed by the intersections of curving Gothic tracery.

dado Part of a pedestal between the base and cornice in classical architecture; later, the lower portion of a wall, often decorated to separate it from the upper portion.

dais A raised platform.

damask Fabric with woven designs in contrasting shiny and dull surfaces, that is reversible. Originally made in China, it is imported into Europe through Damascus, hence its name.

dentil Molding composed of projecting rectangular or tooth-like blocks.

dhurrie Hand-woven pileless rug of cotton or wool made in India with a plain, twill, or tapestry weave.

dime novel Mass-produced short stories aimed at young people and sold in dry goods stores and other similar locations between World Wars I and II.

divan Couch intended for lounging without a back or arms, developed in the second half of the 19th century; the name is from the built-in dais covered with pillows and fabrics of Turkish origin for persons of rank.

dome A hemispherical or semielliptical convex covering over a circular, square, or polygonal space; a series of arches rotating in a circle.

Doric An order introduced by the Greeks characterized by a heavy column with fluted shaft and no base; an echinus and abacus comprise the capital and triglyphs and metopes with relief

sculpture define the frieze. Roman Doric columns are more slender than Greek ones and have a base.

dormer Window projecting through the roof.

double-hung or **sash window** Two sliding sashes or panels hold the glass and slide up and down; invented in Holland in the 1640s. Pegs are used to hold the sashes up until they are replaced by cords and counterweights.

drugget A durable wool or linen and wool fabric used to protect carpet.

earthenware Pottery or ceramics fired at low temperatures so they do not vitrify. Porous, opaque, and somewhat coarse, they are usually glazed.

ecology The study of the relationship between organisms and their environments.

egg and dart (or egg and tongue or ovolo) Molding composed of alternating oval or egg-shaped and pointed forms.

églomisé (Fr.) Painting or gilding applied to the reverse side of a piece of glass.

enfilade (Fr.) Introduced about 1650, the French system of aligning the interior doors of rooms on an axis so that when they are opened, they create a vista. Doors are placed near windows with fireplaces centered on the same wall as doors.

engaged column A column attached to a wall; vertical member that is circular in section.

entablature Part of a building above the columns; composed of architrave, frieze, and cornice.

entasis A slight swelling or outward curve of a column shaft; a Greek optical refinement, it is used to counter any inward curve and also gives the appearance of the column responding to the load it carries.

environmentalism Refers to the principles and methods for reclaiming the natural environment from the destructive effects of industrialization and humanity.

ergonomics An applied science that addresses human fit to environments. Using knowledge from design, psychology, anatomy, and physiology, ergonomics creates objects and systems that people can use comfortably, efficiently, and safely.

estípite (Sp.) A broken pilaster that is composed of stacks of square balusters and a capital that tapers toward the base. Characteristic of Spanish Baroque architecture, they appear in high-style examples of Spanish Colonial Revival.

étagère Display piece consisting of shelves, doors, and/or drawers and mirrored backs; introduced in the early 19th century, it comes into its own during Rococo Revival; also called a whatnot.

eyebrow dormer A low dormer window with a concave, convex, concave curve like an eyebrow. Unlike a regular dormer, it does not project from the roof.

fan vaulting Vaulting that resembles a fan in shape; not structural, it is characteristic of the Perpendicular Gothic and some expressions of the Gothic Revival in England.

fanlight A semicircular or semielliptical window with radiating mullions, often above a door.

fauteuil (Fr.) Chair with upholstered seat and back and open arms; or an armchair.

finial Decorative turned or carved element that terminates a post or corner and accentuates a focal point or crossing of elements.

flock paper Wallpaper with a texture created by gluing minute textile fibers to the surface. Most flocked papers imitate textiles.

fluted Shallow concave channels or grooves in a column, pilaster, chair leg, or other vertical surface.

flying buttress On an exterior, an arch or rounded form extending from the nave wall between the clerestory windows to a separate pier a short distance away. Like a regular buttress, it helps strengthen against pressure from vaults. Common on Gothic and some Gothic Revival cathedrals.

foils (Fr.) Small arc openings or lobes separated by cusps (projecting points at intersections) in Gothic tracery; *trefoils* have three lobes; *quatrefoils* have four; *cinquefoils* have five.

foliated arch An arch that is composed of small arcs or foils; it is characteristic of Islamic architecture.

four square A two-story cubical-shaped house type in the United States; common in the early 20th century.

frailero (Sp.) Rectangular arm or side chair.

French window Casement or fixed window that reaches to floor level and usually opens to a balcony or porch. Also called *French door.*

fresco paper Wallpaper with decorative borders that appear to divide the wall into vertical panels or compartments. Most centers are plain or have small repeating patterns, but some have landscapes with fountains, statues, and flowers.

fretwork Carved ornament composed of straight lines in geometric patterns; it may be open as in a chair back or in relief as on a seat rail; seen on aprons, legs, stretchers, and arms of furniture with Rococo or Chinese influence.

frieze The middle portion of a classical entablature between the architrave and cornice; also a decorated band on an interior wall below the ceiling or cornice.

gable-end house A house form in which the narrow or gabled end of the roof forms the facade.

gable roof A roof composed of two sloping sides.

gambrel roof A roof with two pitches or slopes on either side of a ridge. It is a definitive characteristic of Dutch Colonial Revival.

gingham Light- or medium-weight cotton in a plain weave. It may be a two-color check, multicolor plaid, a stripe, or a solid. Its name may be derived from *ging-gang*, a Malaysian word meaning striped.

glass curtain In the 19th century, a curtain of thin or translucent material, such as muslin, beneath panels, next to the window glass.

gondola chair A chair with a low, concave back composed of a sweeping curve that terminates at the seat; introduced in France in the mid-18th century, it is especially fashionable in French Empire.

Greek cross A church plan composed of four arms equal in length. It characterizes Byzantine and some Renaissance churches.

Greek key Motif composed of short, straight, horizontal and vertical lines at right angles to one another; also called meander or fret.

groin vault Two barrel vaults intersecting at right angles; the groins are the lines of intersection; may be called a cross vault.

grotesque Interpretations of ancient Roman ornament found in grottoes or underground excavations that begin in the last two

decades of the 15th century (Renaissance) after the discovery of Nero's Golden House in Rome; usually a fanciful ornament in paint and stucco resembling an arabesque with colorful depictions of animals, flowers, mythological creatures, and architecture.

guéridon (Fr.) A floor candlestand that may be sculptural or a small table. See also *torchère*.

hacienda (Sp.) Spanish term for a country estate.

hard paste Alternative term for true porcelain, which is made of china clay and china stone.

hieroglyphs Egyptian picture writing.

high-style Architecture, interiors, and furniture at the forefront of fashion, stylistic, or design trends, and usually associated with the aristocracy or the affluent.

hipped roof A roof composed of a single slope on all four sides. The hips are the lines of intersections.

Historicism As applied to architecture, interiors, furniture, and the visual arts, a belief system dominating the 19th century in which historical character becomes the dominant standard of value, thus producing borrowings of ideas and characteristics from past styles.

hood molding Heavy molding over a window originally designed to carry away water. Characteristic of Italianate, Renaissance Revival, and Second Empire, hood moldings may be simple moldings or pediments.

horseshoe arch Rounded or pointed arch that is narrower at the bottom like a horseshoe; the top may be round or pointed; common in Islamic architecture and found in Moorish Revival and Spanish Colonial Revival.

hôtel (Fr.) Luxurious townhouse of a French aristocrat.

incised Cut or carved ornament that is below the surface.

ingrain American term for flat-woven wool carpet with a reversible pattern. Originally made in Kidderminster, England, it is also known as a Scotch carpet.

inlay Decoration created by embedding one material into another to create a flat surface.

Ionic A Greek order with slender, fluted shaft and capital composed of two pairs of volutes or spirals, one pair on the front of the column and one pair on the back. The volutes rest on a circular echinus carved with egg and dart and bead moldings; the shallow abacus is carved also. The shaft is more slender than Doric and has a molded base. The architrave may be plain or composed of fascia and may be capped by a dentil or egg and dart moldings.

jalousie Window or door with a series of horizontal panes in a frame. The panes open outward by a hand crank and overlap each other when closed.

Japanning English and European imitations of Oriental lacquer done mostly on red and black backgrounds, but also on white, blue, yellow, and green backgrounds. Not really a lacquer, it consists of many coats of varnish. Decorations are raised and depict Chinese and pseudo-Chinese scenes and motifs in gold or silver.

Japonisme A style evolving from Japanese prints, decorative arts, and architecture that develops in late-19th- and early-20th-century Europe and North America.

jetty An upper story that overhangs a lower one in a timber frame building. First appearing in the Middle Ages, jetties appear in Gothic Revival, Queen Anne, Stick Style, and Colonial Revival in England and the United States.

kelim or **kilim** A handwoven, heavy, pileless, and reversible rug made in Turkey and Iran. Typical patterns are geometric and multicolored. The term means double-faced.

klismos A light, simple chair developed by the Greeks; it depends upon its silhouette and proportions for beauty. Four outward-curving legs support a seat of plaited leather or rushes; the back uprights continue the curve of the back legs and support a horizontal concave board at shoulder height. The *klismos* is the model for numerous Directoire, Empire, Biedermeier, English Regency, and American Empire chairs.

lacquer An opaque finish made from the sap of trees. Lacquering originates in China but also is used in Japan. Following the importation of lacquered wares, the Europeans learn to imitate or make it.

lambrequin Decorative window treatment composed of stiffened, unpleated fabric hanging from a cornice. It may be trimmed with tassels or other embellishment.

laminate Several layers of wood glued together with grains at right angles to each other; used extensively in Rococo Revival furniture for seating backs and other parts.

lampas Patterned fabric with a satin weave in which additional threads create a design in one texture on the background of another with different texture. The effect is of a two-color damask.

Latin cross Cross-shaped plan in which the three upper arms are equal in length and shorter than the lower arm. It becomes the typical plan for churches during the Romanesque period (9th–12th centuries).

lean-to A structure with a single pitched roof attached to a taller portion of a building.

linenfold Carving in wood that resembles vertical folds of cloth. Probably introduced in the 15th century by Flemish carvers, it has no architectural prototype. *Linenfold* is probably a 19th-century term. It was originally called wavy work.

lintel Horizontal member over an opening that carries the wall above it.

list carpet Carpet with strips of cloth, ingrain carpet, or selvages of fabric forming weft threads; called rag rugs in the 19th century.

lit (Fr.) Bed.

lit droit (Fr.) A French Empire bed with straight ends favored by the middle class; the headboard may be topped by a pediment.

lit en bateau (Fr.) A French Empire bed that is shaped like the prow of a boat.

loggia (It.) A porch or gallery open on one or more sides.

lozenge A diamond-shaped motif or ornament.

lyre Motif derived from a Greek musical instrument composed of two curving forms with strings between them; common in classical and neoclassical styles.

maiolica (It.) Italian tin-glazed earthenware developed in the 14th century in Valencia, Spain. It has an opaque white body with painted decoration that resembles porcelain; called *faience* in France and delft in Holland and England.

majolica Type of ceramic developed in the 1850s by Minton; decorated in lead glazes, its colors sometimes resemble Italian *maiolica*.

mansard roof A roof with two slopes on all four sides; the lower is more steeply pitched, and the upper is often not visible. The roof may have straight or curved profiles and is usually capped with cresting. Named after French architect François Mansard.

marquetry Decorative veneer pattern of wood, brass, or other materials applied to furniture.

méridienne (Fr.) A small sofa with one side higher than the other; introduced during the French Empire period and appearing again in Rococo Revival.

metope Flat slabs recessed between triglyphs in a Doric frieze; usually decorated with paintings or sculpture.

minaret Tall, slender tower or turret attached to a mosque. It has one or more projected balconies from which the faithful are called to prayer.

modillion Small bracket, usually with carving, which, in a series, supports a Corinthian or Composite cornice.

module A unit of measurement that determines the size and/or proportions of a building, interior space, furniture, or other item.

moiré Ribbed wool or silk fabric with a watered design created from uneven pressure of rollers.

monopodium (monopodia, pl.) Head and chest of a lion attached to a paw. Invented by the Romans, it is common in French Empire and English Regency.

moquette (Fr.) A machine-woven carpet in repeating patterns. Made in narrow widths, the pieces are sewn together for room-sized rugs. Alternative term for *Axminster*.

moreen A wool or mohair fabric that may be plain or embossed with a pattern of flowers or other foliage. Used for upholstery, window curtains, and bed hangings.

mortise and tenon A type of joint composed of a rectangular projection, or tenon, that is inserted into a rectangular cavity with a corresponding shape, or mortise.

mosque In Islamic architecture, a religious building for common prayer; may be used for other purposes.

multifoil arch An arch composed of a series of small arcs.

nave The center portion of a basilica or Latin cross church.

nesting tables Small tables that diminish in size so that they can slide into one another when not in use. Four nesting tables are called quartetto tables and three are called trio tables.

newel The main post or support for a stair rail.

niche-pilaster A pilaster with a shaft that has a niche with a figure or other decorative element. Characteristic of Spanish Baroque architecture, it appears in high-style examples of Spanish Colonial Revival.

obelisk An Egyptian monolithic pillar tapering to a pyramid-shaped point.

ogee arch A pointed arch composed of two curves, one convex and one concave.

onion dome Pointed bulbous forms resembling an onion in shape; not a true dome.

order In classical architecture, a column's base, shaft, and capital, and the entablature treated according to an accepted mode compose an order. The Greeks create three orders: Doric, Ionic, and Corinthian; the Romans add Tuscan and Composite.

oriel window A bay window on an upper story that is supported by brackets, corbels, or pilasters.

ormolu (Fr.) Gilded bronze ornament applied to furniture or used alone, as in a candlestick.

ottoman A small overstuffed seat without back or arms for one or more people; introduced from Turkey into England in the 18th century. By the 19th century, the form becomes circular or octagonal with deep tufting. Ottomans during this period are round with tufted backs and a potted palm or sculpture in the center.

pagoda (Ch.) A Buddhist temple in the form of a tower; usually polygonal in shape with highly ornamental roofs projecting from its many stories.

Palladian or Venetian window A tripartite window composed of two rectangular lower sections flanking a taller, arched center light; derived from the arch, column, space, and pier combinations seen in the work of Sebastiano Serlio and Andrea Palladio.

palmette A stylized palm leaf in a fan shape that originates in ancient Egypt and subsequently is used by the Greeks and Romans.

panorama Continuous painted scenes or landscapes that surround or unroll in front of viewers; popular forms of entertainment in the late 18th and 19th centuries, they usually take place in round buildings especially built to house them. In the mid-19th century, rolled panoramas traveled the country.

papier-mâché Material composed of paper pulp, resin, and glue; may be pressed into a mold to make ornament or furniture.

parabolic window Window with a parabolic shape; a vertical rounded or semipointed arch.

parapet Low retaining wall for support or protection at the edge of a roof or other structure.

pargework Plasterwork in patterns on ceilings or the exteriors of timber frame buildings; originating during the Tudor period, pargework is characteristic of English Queen Anne and Old English–style architecture.

Parian ware Unglazed or biscuit porcelain developed in England in the 1840s.

parquetry Geometric patterned wood inlay used mainly for floors.

paterae An oval or circular form with radiating lines and a rosette in the center, introduced by the ancient Greeks.

parterres (Fr.) Flat terraces near or around a building with flowers and decorative plantings.

pavilion A distinctive, prominent structure marking the ends and center of the façade of a building; characteristic of French architecture including Second Empire.

pediment In classical architecture, the triangular area formed by the cornice and sloping sides of the roof; also, a similar form over a door, window, mantel, or surmounting a case piece. Shapes include triangular, segmental (rounded), broken (open at the apex), or swan's neck (double curve).

pelmet Flat, shaped fabric treatment at the top of a window; also called a *valance*.

pendentive A triangular curving form that allows construction of a circular dome over a square or rectangular space; originates in Byzantine architecture.

peripteral A temple or building surrounded by a single row of columns called the *peristyle*.

peristyle A row of columns surrounding a temple, other building, or courtyard.

photovoltaic panels Solar cells that convert the sun's energy into electricity.

pickle finish Originally a way of treating new wood to make it look old; today pickling is a white or off-white stain.

picture window A window with a large fixed pane of glass to provide a view; some have smaller double-hung windows on either side.

pier glass A tall, narrow mirror intended to be hung on the wall or pier between windows.

pier table A table originally meant to be placed against the wall or pier between windows. It often has a large matching mirror above or attached to it.

pilaster A vertical member attached to a wall with the general form and proportions of a column, but rectangular in section.

pilotis (Fr.) Piers or colums that support and raise a building above the ground. Pilotis lighten visual weight while providing free space beneath the building. Le Corbusier introduces the concept.

pinnacle A terminating element, usually tapering to a point or knob.

piping Variation of tufting that forms a decorative ridge at the edge of a seat or back of a piece of upholstery.

plush Heavy fabric that is similar to velvet but that has a longer pile.

podium (podia, pl.) A continuous base for a building or a pedestal for a column.

porcelain Ceramic with a translucent white body made of china clay and china stone. **True** or **hard-paste** porcelain contains both ingredients, while artificial or **soft paste** porcelain lacks one of them. True porcelain originates in China.

porte cochère Porch or covered entrance that is large enough for a carriage or automobile to pass through.

portico Roofed space or porch forming the entrance or center of a façade; may be open or closed and usually has columns.

portiere (Fr.) Curtain hanging across a doorway to serve as a door, prevent drafts, or as decoration.

post and lintel See *trabeated*.

pouf or pouffe Stool with deeply tufted coil spring upholstery that is introduced from France about 1830.

presbytery The high altar in a church, it is usually raised to signify its importance.

Prince of Wales motif Motif composed of three ostrich feathers tied together at the shafts. A symbol of the heir to the British throne.

Priscilla curtains Ruffled curtains in solid or sheer fabrics gathered on rods or sometimes crossed and tied back.

puffing Decorative pleating on the edge of an upholstered seat or back.

pylon Greek word for gateway; a monumental gateway shaped like a truncated pyramid found in Egyptian and Egyptian Revival architecture.

quartetto tables See *nesting tables*.

quatrefoil Four-lobed form; see also *foils*.

quoin Cornerstone that marks the corner of a building by its difference from the wall in rustication, color, size, or material.

rail On furniture or doors, a horizontal member joining vertical posts (stiles) or framing a panel.

reeded Convex ridges next to each other that cover a surface.

reproduction Building or furniture piece that copies as exactly as possible an historic document or object within the constraints of modern technology.

ribbed vault Vault with structural or decorative projecting bands defining the lines of intersection.

rinceau A linear pattern of scrolling vines, leaves, and foliage.

rose window Circular window or motif with tracery that converges in the center like the spokes of a wheel.

rosette Circular stylized floral motif.

rustication Smooth or roughly cut blocks of stone with deeply cut joints, which give a rich textural appearance.

saber leg A quadrangular, outward-curving leg with no foot; its name comes from its resemblance to a sword or saber.

salon (Fr.) An elegant apartment or living space.

sash window See *double-hung window*.

Savonnerie Hand-knotted cut-pile carpet made at the Savonnerie Factory established in France in 1626.

scagliola Imitation marble composed of plaster or cement and marble chips.

secrétaire à abattant (Fr.) A tall desk with a drop-front writing surface and drawers or door beneath; when open, the drop front reveals small drawers and compartments.

semanier (Fr.) A tall chest with seven drawers, one for each day of the week.

serge Durable wool or worsted wool fabric in a twill weave.

serpentine An undulating or curving form; a front or top that is concave, convex, and concave.

Shagreen Leather made from sharkskin or skin of a ray fish. The rounded scales on the skin are ground to give a rough surface. Shagreen is often dyed green.

shotgun house A house type that is one room wide and several rooms deep.

sidelights Two tall, narrow windows flanking a door.

singerie (Fr.) Motif of monkeys dressed in clothing and engaged in human activities.

sofa table A tall drop-leaf table with drawers and various types of legs; used for games, sewing, and a variety of activities.

soft paste porcelain Artificial porcelain lacking one of the ingredients of true porcelain; common in England and Europe in the 18th and early 19th centuries.

spade foot A rectangular, tapering foot resembling a spade or shovel.

Spanish foot A tapering, rectangular, ribbed foot terminating in an outward-turned scroll. Originates in Spanish and Portuguese Baroque furniture during the late 17th and early 18th centuries; also known as a Portuguese foot or a paintbrush foot.

sphinx Egyptian mythological creature with a man or woman's head and body of a lion.

splat A flat, vertical member in a chair back. An important ornamental element and determinant of style, splats may be shaped, carved, pierced, or otherwise decorated.

split baluster turning A small turned element with curving side out and the flat side applied as decoration to furniture.

spoon back American term for a chair back in which the uprights curve in to fit the human body; term derives from its resemblance to a spoon bowl; common on some William and Mary chairs, but characteristic of Queen Anne; often found on Chinese chairs.

stile A vertical member that frames a back, panel, or door.

stoneware Pottery of clay and fusible stone, it vitrifies upon firing so that it becomes impervious to liquids. Glazes are applied for decoration; unlike porcelain, it is not translucent.

strapwork Ornament composed of flat, curving bands resembling leather thongs or straps; a common Northern European Mannerist motif that is popularized by pattern books.

stretcher A horizontal brace connecting furniture legs for additional support.

string The open side of a stair, beneath the steps.

stringcourse A projecting molding that may be plain or carved, and that runs horizontally on a building; it usually separates stories.

stringing A narrow band of inlay or contrasting wood veneer outlining a leg, drawer, or other element.

stucco Plaster used from antiquity and made of several ingredients; lime stuccos, classified as cements, are used on exteriors, whereas plaster stucco forms interior moldings and applied decoration.

stylization Simplification; reducing an object to its simplest form or reproducing the essence of its character.

Syrian arch A series of round arches over wider, heavier round arches.

swag Classical ornament composed of a curving form suspended between two points. The curving form, composed of flowers, fruit, or foliage and tied with ribbons, is lighter on the ends and heavier in the middle. Also, a window treatment composed of fabric draped in a semicircle; also called a *festoon*.

temple front Composed of columns and a pediment, it replicates the main façade of a temple; may be used decoratively or to form a porch or portico.

term A tapering quadrangular support capped with the bust of a human, animal, or mythical creature.

terra-cotta Glazed or unglazed fired clay used in construction and decoration; unglazed tile.

terrazzo Floor composed of small pieces of marble or granite in a concrete mixture.

tester Framework over a bed on which fabrics hang. It may fully or partially cover the bed; also called a canopy.

tête-à-tête Small S-shaped sofa in which the seats face each other, enabling the two sitters to see each other; common in Rococo Revival.

thimble foot A cylindrical tapering foot characteristic of Hepplewhite or Sheraton furniture.

tholos A circular building with columns.

toile de Jouy (Fr.) White or cream cotton, linen, or silk fabric with monochromatic engraved decoration in red, blue, green, black, or purple.

torchère (Fr.) A floor candlestand; see also *guéridon*.

trabeated Post and lintel or post and beam construction; consists of two uprights (post) supporting a horizontal member (beam or lintel).

tracery Curving, ornamental stone or wooden subdivisions in an architectural opening. Common in Gothic stained glass windows, tracery also defines Gothic Revival fenestration, wood paneling, plasterwork, ceilings, textiles, wallpapers, and furniture.

track lighting Individual lighting fixtures attached to an electrified ceiling track; fixtures can move along the track to provide light where needed or desired.

traditional Common term for buildings, interiors, furniture, or decorative arts that are derived closely or loosely from past styles, types, objects, or forms.

transept A space(s) at right angles to and crossing the nave of a church.

transfer-print A decorative technique in which an impression of the scene, pattern, or motif is made in ink from a copperplate onto transfer paper and applied to surface of the furniture or ceramic.

transitional Common term for interiors or furniture that is generally modern in style but has elements of the past often in ornament, details, or finishes.

trefoil A three-lobed form; see also *foils*.

trestle table A table composed of a flat board top supported by trestles; originally developed in the Middle Ages.

triglyph A block with three vertical divisions in a Doric frieze.

trio tables See *nesting tables*.

Tuscan A Roman column with a base and unfluted shaft; an echinus and abacus compose the capital. Architraves are simply treated, usually with moldings.

tufting An effect created when buttons placed between springs create a deep indention and excess fabric gathers into pleats beneath the buttons.

trompe l'oeil (Fr.) Literally, "fool the eye"; a photographically realistic depiction or decoration.

Tudor arch A flattened pointed or four-centered arch.

tympanium In classical architecture, the triangular space formed by the sides of the gable roof and the cornice in the pediment; it usually has relief sculpture. In churches of the middle ages, the space between the lintel and the arch in a doorway.

valance Today, a flat, shaped fabric treatment at the top of a window; also called a pelmet. In the early 19th century, complicated top treatments usually forming swags were called drapery instead of valances.

vanity Alternate, modern term for a dressing table, often with an attached mirror.

vargueño (Sp.) Furniture piece consisting of a drop-front cabinet on a base.

vault An arched covering of brick or stone; see also *barrel vault*, *groin vault*, and *cross vault*.

veneer A thin layer of wood or other material attached to another surface, usually to create a decorative effect.

Venetian blind A window treatment composed of horizontal wooden (or other materials later) slats connected by tapes that can be raised or lowered; thought to have been invented near Venice, Venetian blinds appear in the mid-18th century in Italy,

then France, England, and the United States. The method of adjusting the angle of the slats is invented in 1841.

Venetian window See *Palladian window.*

veranda A gallery or walkway beneath a shed (or single sloping) roof carried by slender columns or piers; may be on one or more sides of the house with French doors allowing access from the main rooms.

vernacular Architecture and material of common people; may reflect and simplify prevailing fashions and styles in form and material.

verre églomisé (Fr.) Decorative painting done mainly in gold, white, and blue on the reverse side of a glass panel to be used in a door, case piece, picture frame, or mirror. Fashionable during the Neoclassical period, the technique is developed by the ancient Romans.

vigas (Sp.) Large beams supporting the flat roof in Spanish, Spanish Colonial, and Spanish Colonial Revival architecture. Vigas may protrude through walls.

vitrine Originating in the 18th century, a display cabinet with glass doors. The most typical form is a small cabinet on a stand.

Vitrolite A structural, pigmented opaque glass used in buildings during the Art Deco period.

VOC Volatile organic compounds; emitted from solids or liquids, they can be hazardous to health.

volute A spiral scroll reminiscent of a ram's horn or shell, forming the capital of the Ionic order and also part of the capital in Corinthian and Composite orders.

Voussoir A wedge-shaped block that, with others, forms an arch.

wainscot chair English, American, and French rectilinear armchair with carved paneled back; evolves from a seat incorporated into wall paneling during the Gothic period. It may have panels under the arms and all four sides to the floor or only a paneled back.

wainscoting Wooden paneling for walls; derives from a Dutch term for a grade of oak used in fine interior work.

wall dormer A window that rises from the wall below and extends upward into the roof; it may also be called a lucarne.

water table A slanted projection at the base of a building.

Wilton carpet A cut-pile carpet first woven in Wilton, England, in the mid-18th century. It is made in a similar way to Brussels in that face yarns are carried in the backing when not appearing, but the number of colors may be three to six. Today woven carpets are mostly Wilton.

zapatas (Sp.) Bracket capitals found in Spanish, Spanish Colonial, and Spanish Colonial Revival architecture.

Bibliography

Architecture, Art History, Design

Agnoletto, M. *Masterpieces of Modern Architecture*. New York: Barnes & Noble Publishing, 2006.

The Art Institute of Chicago. *Chicago and New York: Architectural Interactions*. Chicago: The Art Institute of Chicago, 1984.

Asensio, Paco, ed. *The World of Contemporary Architecture*. Cologne: Könemann, 2000.

Banham, Reyner. *Theory and Design in the First Machine Age*. New York: Frederick A. Praeger, 1960.

Bergdoll, Barry. *European Architecture 1750–1890*. Oxford: Oxford University Press, 2000.

Brooks, Alfred M. *Architecture and the Allied Arts*. Indianapolis: Bobbs-Merrill, 1914.

Brownell, Charles E., Calder Loth, William M. S. Rasmussen, and Richard Guy Wilson. *The Making of Virginia Architecture*, Richmond: Virginia Museum of Fine Arts, 1992.

Building Images: Seventy Years of Photography at Hedrich Blessing. San Francisco: Chronicle Books, 2000.

Burchard, John, and Albert Bush-Brown. *The Architecture of America: A Social and Cultural History*. Boston: Little, Brown and Co., 1961.

Carley, Rachel. *The Visual Dictionary of American Domestic Architecture*. New York: Henry Holt, 1994.

Clark, Clifford Edward, Jr. *The American Family Home, 1800–1960*. Chapel Hill: University of North Carolina Press, 1986.

Colquhoun, Alan. *Modern Architecture*. New York: Oxford University Press, 2002.

Curl, James Stevens. *Oxford Dictionary of Architecture*. Oxford: Oxford University Press, 1999.

Doordan, Dennis P. *Twentieth-Century Architecture*. New York: Harry N. Abrams, 2002.

Ferguson, Russell, ed. *At the End of the Century, One Hundred Years of Architecture*. New York: Harry N. Abrams, 1998.

Fitch, James Marston. *American Building: The Historical Forces That Shaped It*. New York: Schocken Books, 1966.

Frampton, Kenneth. *Modern Architecture: A Critical History*. London: Thames and Hudson, 1992.

———— and Yukio Futagawa. *Modern Architecture 1851–1919*. New York: Rizzoli, 1983.

———— and David Larkin, eds. *American Masterworks: The Twentieth-Century House*. New York: Universe Publishing, 2002.

French, Hilary. *Architecture: A Crash Course*. New York: Watson-Guptill Publications, 1998.

Gebhard, David, and Robert Winter. *Architecture in Los Angeles: A Compleat Guide*. Salt Lake City, UT: Gibbs Smith, 1985.

Ghirardo, Diane. *Architecture After Modernism*. London: Thames and Hudson, 1996.

Giedion, Sigfried. *Space, Time and Architecture*. Cambridge, MA: Harvard University Press, 1941.

Gillon, Edmund V., Jr. *Pictorial Archive of Early Illustrations and Views of American Architecture*. Mineola, NY: Dover Publications, 1971.

Glancey, Jonathan. *The Story of Architecture*. New York: Dorling Kindersley, 2000.

————. *20th Century Architecture: The Structures That Shaped the Twentieth Century*. London: Carlton Books, 1998.

Goodyear, William Henry. *History of Art for Classes, Art Students, and Tourists in Europe*. New York: A. S. Barnes, 1889.

Gössel, Peter, and Gabriele Liuthäuser. *Architecture in the Twentieth Century*. Germany: Taschen, 1991.

Gowans, Alan. *Images of American Living: Four Centuries of Architecture and Furniture as Cultural Expression*. Philadelphia and New York: J. B. Lippincott, 1964.

————. *Styles and Types of North American Architecture: Social Function and Cultural Expression*. New York: HarperCollins Publishers, 1992.

Hamlin, Alfred D. F. *History of Architecture*. New York: Longmans, Green, 1902.

Harris, Cyril M. *Illustrated Dictionary of Historic Architecture*. New York: Dover Publications, 1977.

History of Architecture. Scranton, PA: International Textbook Company, 1924.

Hitchcock, Henry-Russell. *Architecture: Nineteenth and Twentieth Centuries*. New York: Penguin Books, 1985.

———— and Philip Johnson. *The International Style*. New York: W. W. Norton and Company, 1966.

Howe, Jeffery, ed. *The Houses We Live In: An Identification Guide to the History and Style of American Domestic Architecture*. London: PRC Publishing, 2002.

Jodidio, Philip, ed. *Architecture Now!* New York: Taschen, 2002.

Kidney, Walter C. *The Architecture of Choice: Eclecticism in America 1880–1930*. New York: George Braziller, 1974.

Kimball, Fisk, and George Edgell. *A History of Architecture*. New York: Harper and Brothers, 1918.

LeBlanc, Sydney. *The Architecture Traveler: A Guide to 250 Key 20th-Century American Buildings*. New York: W. W. Norton, 2000.

Lemoine, Bertrand. *Architecture in France, 1800–1900*. New York: Harry N. Abrams, 1998.

Lewis, Arnold. *American Country Houses of the Gilded Age*. New York: Dover Publications, 1982.

Maddex, Diane, ed. *All About Old Buildings*. Washington, DC: Preservation Press, 1985.

Matthews, Kevin. *The Great Buildings Collection*. Eugene, OR: Artifice, 1994.

McAlester, Lee, and Virginia McAlester. *A Field Guide to American Houses*. New York: Alfred A. Knopf, 1984.

McGrath, Norman. *Photographing Buildings Inside and Out*. New York: Whitney Library of Design, 1987.

Middleton, Robin, and David Watkin. *Neoclassical and 19th Century Architecture*. 2 vols. New York: Electa/Rizzoli, 1980.

Mignot, Claude. *Architecture of the Nineteenth Century in Europe*. New York: Rizzoli, 1984.

Moffett, Marian, Michael Fazio, and Lawrence Wodehouse. *Buildings Across Time: An Introduction to World Architecture*. New York: McGraw-Hill, 2004.

Morgan, William. *The Abrams Guide to American House Styles*. New York: Harry N. Abrams, 2004.

Musgrove, John, ed. *Sir Banister Fletcher's A History of Architecture*. 19th ed. London: Butterworths, 1987.

Neal, James. *Architecture: A Visual History*. New York: Barnes & Noble Books, 2004.

Norwich, John Julius, ed. *Great Architecture of the World*. New York: Da Capo Press, 1991.

Pevsner, Nikolaus. *Pioneers of Modern Design, from William Morris to Walter Gropius*. London: Penguin Books, 1991.

———. *The Sources of Modern Architecture and Design*. New York and Toronto: Oxford University Press, 1968.

The Phaidon Atlas of Contemporary World Architecture. New York: Phaidon Press, 2005.

Poppeliers, John C., and S. Allen Chambers, Jr. *What Style Is It? A Guide to American Architecture*. Hoboken, NJ: John Wiley and Sons, 2003.

Raizman, David. *History of Modern Design*. Upper Saddle River, NJ: Prentice Hall, 2004.

Reiff, Daniel D. *Houses from Books, Treatises, Pattern Books, and Catalogs in American Architecture, 1738–1950: A History and Guide*. University Park: Pennsylvania State University Press, 2000.

Rifkind, Carole. *A Field Guide to American Architecture*. New York: New American Library, 1980.

———. *A Field Guide to Contemporary American Architecture*. New York: Dutton, 1998.

Roth, Leland. *American Architecture: A History*. Boulder, CO: Westview Press, 2001.

Saunders, Ann. *The Art and Architecture of London: An Illustrated Guide*. Oxford: Phaidon Press, 1984.

Scully, Vincent. *Architecture: The Natural and the Manmade*. New York: St. Martin's Press, 1991.

Sharp, Dennis. *Twentieth-Century Architecture: A Visual History*. Victoria, Australia: Images Publishing Group, 2002.

Smith, G. E. Kidder. *Source Book of American Architecture*. New York: Princeton Architectural Press, 1996.

Smith, Herbert L., ed. *25 Years of Record Houses*. New York: McGraw-Hill, 1981.

Snodin, Michael, and John Styles. *Design and the Decorative Arts in Britain, 1500–1900*. London: Harry N. Abrams, 2001.

Sparke, Penny. *A Century of Design: Design Pioneers of the 20th Century*. Hauppauge, NY: Barron's Educational Series, 1998.

Statham, H. Heathcote. *A Short Critical History of Architecture*. London: B. T. Batsford, 1912.

Steele, James. *Architecture Today*. New York: Phaidon Press, 1997.

Stoddard, John. *A Trip Around the World*. N.p., c. 1890.

Sturgis, Russel, et al. *Sturgis' Illustrated Dictionary of Architecture and Building*. New York: Dover Publications, 1989.

Summerson, John. *Architecture in Britain, 1530–1830*. New Haven, CT: Yale University Press, 1993.

Sutro, Dirk. *San Diego Architecture*. San Diego, CA: San Diego Architectural Foundation, 2002.

Tafuri, Manfredo, and Francesco Dal Co. *Modern Architecture/1*. New York: Rizzoli, 1986.

Upton, Dell. *Architecture in the United States*. New York: Oxford University Press, 1998.

Vickers, Graham. *Key Moments in Architecture: The Evolution of the City*. New York: Da Capo Press, 1999.

Warren, Garnet, and Horace B. Cheney. *The Romance of Design*. New York: Doubleday, Page and Company, 1926.

The Visual Dictionary of Buildings. New York: Dorling Kindersley, 1992.

Watkin, David. *English Architecture*. London: Thames and Hudson, 2001.

———. *A History of Western Architecture*. 3rd ed. New York: Watson-Guptill, 2000.

Whiffen, Marcus, *American Architecture Since 1780: A Guide to the Styles*. Rev. ed. Cambridge, MA: MIT Press, 1992.

——— and Fredrick Koeper. *American Architecture*. 2 vols. Cambridge, MA: MIT Press, 1984.

Widdenhager, Von Graft. *History of Art*. N.p., 1919.

Woodbridge, Sally B. *California Architecture: Historic American Buildings Survey*. San Francisco: Chronicle Books, 1988.

Zukowsky, John, ed. *Chicago Architecture 1872–1922*. Chicago: The Art Institute of Chicago, 1987.

Interiors, Finishes, and Textiles

Abercrombie, Stanley. *A Century of Interior Design, 1900–2000: The Design, the Designers, the Products, and the Profession*. New York: Rizzoli, 2003.

Art and Design in Europe and America 1800–1900 at the Victoria and Albert Museum. London: Herbert Press, 1987.

Banham, Joanna, Sally MacDonald, and Julia Porter. *Victorian Interior Design*. New York: Crescent Books, 1991.

Beard, Geoffrey. *The National Trust Book of the English House Interior*. London: Viking, 1990.

Bristow, Ian C. *Architectural Colour in Britain, 1615–1840*. New Haven, CT: Yale University Press, 1996.

Byron, Joseph. *Photographs of New York Interiors at the Turn of the Century*. New York: Dover Publications, 1976.

Clifford, C. R. *Period Furnishings: An Encyclopedia of Historic Furniture, Decorations and Furnishings*. New York: Clifford and Lawton, 1922.

Cooper, Jeremy. *Victorian and Edwardian Décor: From the Gothic Revival to Art Nouveau*. New York: Abbeville Press, 1987.

Davidson, Marshall B., and Elizabeth Stillinger. *The American Wing at the Metropolitan Museum of Art*. New York: Metropolitan Museum of Art, 1985.

de Wolfe, Elsie. *The House in Good Taste*. New York: Century Company, 1914.

Eberlein, Harold Donaldson, Abbot McClure, and Edward Stratton Holloway. *The Practical Book of Interior Decoration*. Philadelphia: J. B. Lippincott, 1919.

Gere, Charlotte. *Nineteenth-Century Decoration: The Art of the Interior*. New York: Harry N. Abrams, 1989.

——— and Michael Whiteway. *Nineteenth Century Design: From Pugin to Mackintosh*. New York: Harry N. Abrams, 1994.

Gibbs, Jenny. *Curtains and Drapes: History, Design, Inspiration.* London: Cassell, 1994.

Gore, Alan, and Ann Gore. *The History of English Interiors.* London: Phaidon Press, 1995.

Grant, Ian, ed. *Great Interiors.* New York: E. P. Dutton, 1967.

Holloway, Edward Stratton. *The Practical Book of Furnishing the Small House and Apartment.* Philadelphia: J. B. Lippincott, 1922.

The House Beautiful Furnishing Annual 1926. Boston: Atlantic Monthly Company, 1925.

The Illustrated Dictionary of Twentieth Century Designers. New York: Mallard Press, 1991.

Jakway, Bernard C. *The Principles of Interior Decoration.* New York: Macmillan Company, 1926.

Kurtich, John, and Garret Eakin. *Interior Architecture.* New York: Van Nostrand Reinhold, 1993.

Lewis, Arnold, James Turner, and Steven McQuillin. *The Opulent Interiors of the Gilded Age.* New York: Dover Publications, 1987.

Lowe, David. *Chicago Interiors: Views of a Splendid World.* Chicago: Contemporary Books, 1979.

Malnar, Joy Monice, and Frank Vodvarka. *The Interior Dimension: A Theoretical Approach to Enclosed Space.* New York: Van Nostrand Reinhold, 1992.

Massey, Anne. *Interior Design of the Twentieth Century.* New York: Thames and Hudson, 1990.

Mayhew, Edgar deN., and Minor Myers, Jr. *A Documentary History of American Interiors from the Colonial Era to 1915.* New York: Charles Scribner's Sons, 1980.

McCorquodale, Charles. *History of the Interior.* New York: Vendome Press, 1983.

Period Rooms in the Metropolitan Museum of Art. New York: Metropolitan Museum of Art/Harry N. Abrams, 1996.

Phillips, Barty. *Fabrics and Wallpapers: Sources, Design and Inspiration.* Boston: Bulfinch Press, 1991.

Pile, John. *A History of Interior Design.* New York: John Wiley & Sons, 2005.

Praz, Mario. *An Illustrated History of Furnishing.* New York: George Braziller, 1964.

Tate, Allen, and C. Ray Smith. *Interior Design in the 20th Century.* New York: Harper and Row, 1985.

Thornton, Peter. *Authentic Décor: The Domestic Interior, 1620–1920.* New York: Random House, 1984.

Trocmé, Suzanne. *Influential Interiors.* New York: Clarkson N. Potter, 1999.

Wheeler, Candace. *Principles of Home Decoration.* New York: Doubleday, Page, 1903.

Whiton, Sherrill. *Interior Design and Decoration.* Philadelphia, New York, Toronto: J. B. Lippincott, 1974.

Furniture and Decorative Arts

Andrews, John. *Victorian and Edwardian Furniture.* Suffolk, England: Antique Collectors' Club, 1992.

Asensio, Paco, ed. *Furniture Design.* New York: teNeues, 2002.

Baker, Fiona, and Keith Baker. *20th Century Furniture.* London: Carlton Books, 2003.

Benn, R. Davis. *Style in Furniture.* New York: Longmans, Green, 1920.

Boger, Louise Ade. *The Complete Guide to Furniture Styles.* Prospect Heights, IL: Waveland Press, 1959, 1969, 1997.

Brunt, Andrew. *Phaidon Guide to Furniture.* Upper Saddle River, NJ: Prentice Hall, 1983.

Dresser, Charles. *Modern Ornamentation.* New York: American Life Foundation and Study Institute, 1976.

The Dunbar Book of Contemporary Furniture. Berne: Dunbar Furniture Corporation of Indiana, 1956.

Duncan, Alastair. *Modernism: Modernist Design, 1880–1940.* Suffolk, England: Antique Collectors' Club, 1998.

Durant, Stuart. *Ornament.* Woodstock, NY: Overlook Press, 1986.

Encyclopedia of Antiques. New York: Galahad Books, 1976.

Fiell, Charlotte, and Peter Fiell. *Design of the 20th Century.* New York: Taschen, 1999.

————. *1000 Chairs.* New York: Taschen, 2000.

Fitzgerald, Oscar P. *Four Centuries of American Furniture.* Radnor, PA: Wallace-Homestead Book Company, 1995.

Garner, Philippe. *Twentieth-Century Furniture.* New York: Van Nostrand Reinhold, 1980.

Gloag, John. *British Furniture Makers.* New York: Hastings House, n.d.

Hanks, David A., and Anne Hoy. *Design for Living: Furniture and Lighting 1950–2000.* New York: Flammarion, 2000.

———— and Donald C. Pierce. *The Virginia Carroll Crawford Collection: American Decorative Arts, 1825–1917.* Atlanta, GA: High Museum of Art, 1983.

Hayward, Helena. *World Furniture.* New York: McGraw-Hill, 1965.

The Italian Chair. Rome: Italian Institute for Foreign Trade, n.d.

Joy, Edward. *The Connoisseur Illustrated Guides: Furniture.* London: Connoisseur Cestergate House, 1972.

Lindquist, David P., and Caroline C. Warren. *Victorian Furniture.* Radnor, PA: Wallace-Homestead Book Company, 1995.

Litchfield, Frederick. *Illustrated History of Furniture.* Boston: Medici Society of America, 1922.

Lucie-Smith, Edward. *Furniture: A Concise History.* London: Thames and Hudson, 1979.

Madigan, Mary Jean, ed. *Nineteenth Century Furniture: Innovation, Revival and Reform.* New York: Roundtable Press, 1982.

Mang, Karl. *History of Modern Furniture.* New York: Harry N. Abrams, 1979.

Miller, R. Craig. *Modern Design in the Metropolitan Museum of Art 1890–1900.* New York: Metropolitan Museum of Art/Harry N. Abrams, 1990.

Morley, John. *The History of Furniture.* Boston: Little, Brown, 1999.

Payne, Christopher. *19th Century European Furniture.* Suffolk, England: Antique Collectors' Club, 1981.

Sassone, Adriana Boidi, et al. *Furniture from Rococo to Art Deco.* N.p.: Evergreen, 1988.

Sembach, Klaus-Jürgen, Gabriele Leuthäuser, Peter Gössel. *Twentieth-Century Furniture Design.* Köln, Germany: Taschen, 1991.

Sollo, John, and Nan Sollo. *American Insider's Guide to Twentieth-Century Furniture.* London: Miller's-Mitchell Beazley, 2002.

Wardropper, Ian, and Lynn Springer Roberts. *European Decorative Arts in the Art Institute of Chicago.* Chicago: The Art Institute of Chicago, 1991.

Timelines

American Film Institute's Top 100 Movie Songs. Milwaukee, WI: Hal Leonard Corp., 2004.

American Society of Interior Designers. *The History of ASID: 30 Years of Advancing the Interior Design Profession*. Washington, DC: American Society of Interior Designers 2005.

Berger, Shoshana and Grace Hawthorne. *Ready Made: How to Make (Almost) Everything*. New York: Clarkson Potter, 2005.

Booth-Clibborn, Edward, and Daniele Baroni. *The Language of Graphics*. New York: Abrams, 1980.

Contract. August 2003.

The Costco Connection. July 2003.

Cruickshank, Dan, ed. *Architecture: The Critics' Choice*. New York: Watson-Guptill Publications, 2000.

Dormer, Peter. *The Illustrated Dictionary of Twentieth Century Designers*. New York: Mallard Press, 1991.

Eames, John Douglas. *The MGM Story: The Complete History of 50 Years*. New York: Crown Publishers, 1979.

The Eyewitness Atlas of the World. New York: Dorling Kindersley Publishing, 1994.

Fellows, Will. *A Passion to Preserve: Gay Men as Keepers of Culture*. Madison, WI: The University of Madison Press, 2004.

Findling, John E., and Kimberly D. Pelle, eds. *Historical Dictionary of World's Fairs and Expositions, 1851–1988*. New York: Greenwood Press, 1990.

French, Hilary. *Architecture: A Crash Course*. New York: Watson-Guptill Publications, 1998.

Gelernter, David. *1939: The Lost World of the Fair*. New York: Avon Books, 1996.

The Great American Bathroom Book II. Salt Lake City, UT: Compact Classics, 1993.

Green, David. *The Eyewitness Atlas of the World*. New York: Dorling Kindersley Publishing, 1994.

Greer, Michael. *Inside Design*. New York: Doubleday & Co., 1962.

Hanson, Steve, and Patricia King Hanson. *Lights, Camera, Action!* Los Angeles: Los Angeles Times, 1990.

Harper's Magazine, January 2005.

Hirschhorn, Clive. *The Universal Story: The Complete Story of the Studio*. New York: Crown Publishers, 1983.

Historical Atlas and Guide. New York: Rand McNally, 1993.

Horsham, Michael. *Twenties and Thirties Style*. North Digton, MA: JG Press, 1989.

Hull, Edward. *The Wall Chart of World History*. New York: Barnes & Noble Publishing, 1995.

Jennings, Peter, and Todd Brewster. *The Century*. New York: Doubleday, 1998.

Larson, Erik. *The Devil in the White City*. New York: Vintage Books, 2003.

Lawton, Richard. *A World of Movies*. New York: Dell Publishing Co., 1974.

London Review of Books, September 11, 2003.

Lynes, Russell. *The Tastemakers*. New York: Grossett & Dunlap, 1954.

Meggs, Philip B. *A History of Graphic Design*. New York: Van Nostrand Reinhold, 1992.

Parade Magazine, November 23, 2003, and April 18, 2004.

Scarre, Chris, ed. *Smithsonian Timelines of the Ancient World*. New York: Dorling Kindersley Publishing, 1993.

Smithsonian. August 2004.

Syracuse Cultural Workers Peace Calendar, 2004.

Tambini, Michael. *The Look of the Century*. New York: DK Publishing, Inc., 1996.

The Wall Chart of World History. New York: Barnes & Noble Publishing, 1995.

Revolution

Appelbaum, Stanley. *The Chicago's World Fair of 1893*. New York: Dover Publications, 1980.

The Art Journal Illustrated: The Industry of All Nations. London: Published for the Proprietors, by George Virtue, 1851.

Barlow, Ronald S., ed. *Victorian Houseware, Hardware and Kitchenware*. Mineola, NY: Dover Publications, 1992.

Bicknell, Amos J., and Company. *Bicknell's Victorian Buildings*. New York: Dover Publications, 1979.

Blackie and Son. *The Victorian Cabinet-Maker's Assistant*. New York: Dover Publications, 1970.

Fergusson, James. *History of the Modern Styles of Architecture*, Vol. II. New York: Dodd, Mead, 1899.

Furniture. Grand Rapids, MI: 1890.

Gillon, Edmond V., Jr. *Pictoral Archive of Early Illustrations and Views of American Architecture*. New York: Dover Publications, 1971.

Greeley, William R. *The Essence of Architecture*. New York: Van Nostrand, 1927.

Hamlin, Talbot F. *The American Spirit in Architecture: The Pageant of America*. Vol. 13. New Haven, CT: Yale University Press, 1926.

Harpers Illustrated Weekly, February–March 1872, New York Public Library Image.

Hart, Harold H., ed. *Chairs Through the Ages*. Mineola, NY: Dover Publications, 1971.

Illustrated London News. Vol. XLI, July to December, 1862.

Montgomery Ward Furniture Catalog, 1897.

Palliser, George, and Charles Palliser. *Palliser's American Cottage Homes*. Bridgeport, CT: Palliser, Palliser and Company, 1878.

Sears Roebuck Catalogue. Chicago: Sears, Roebuck and Company, 1902.

Smith, Walter. *Masterpieces of the Centennial Exhibition*. Philadelphia: Gebbie and Barrie, 1876.

Tipping, H. Avray. *English Homes, Period V, Volume I*. London: Offices of Country Life, 1924.

The White City (World's Columbian Exposition catalog). Chicago: 1893.

Williams, Henry T., and Mrs. C. S. Jones. *Beautiful Homes: Or Hints in House Furnishing*. Vol. 4. Williams Household Series. London: Henry T. Williams, 1878.

Late Neoclassic

Ackermann, Rudolf. *Ackermanns's Repository of Arts*. London: R. Ackermann, 1829.

Barron, James. *Modern & Elegant Designs of Cabinet & Upholstery Furniture*. London: 1814.

Cescinsky, Herbert. *Chinese Furniture*. London: Benn Brothers, 1922.

Clute, Eugene. *The Treatment of Interiors*. New York: Pencil Points Press, 1926.

Cooper, Wendy A. *Classical Taste in America, 1800–1840*. New York: Abbeville Press Publishers, 1993.

Cornu, Paul. *Meubles et objets de goût 1796–1830*. Paris: Libraire des Arts Décoratifs, 1833.

Crook, J. Mordaunt. *The Greek Revival: Neoclassical Attitudes in British Architecture, 1760–1870*. London: John Murray, 1972.

Cross, Alfred. *History of Architecture*. London: International Correspondence School, n.d.

Deschamps, Madeleine. *Empire*. New York: Abbeville Press, 1994.

Ellwood, G. M. *English Furniture and Decoration 1680 to 1800*. Stuttgart, Germany: Julius Hoffmann, c. 1930.

Guinness, Desmond, and Julius Trousdale Sadler, Jr. *Mr. Jefferson Architect*. New York: Viking Press, 1973.

Hamlin, Talbot. *Greek Revival in America*. New York: Dover Publications, 1944.

Himmelheber, Georg. *Biedermeier, 1815–1835*. Munich: Prestel-Verlag, 1989.

Hubert, Gerard. *Malmaison*. National Museum of the Château of Malmaison: Editions de la Réunion des Musées Nationaux, 1982.

Irwin, David. *Neoclassicism*. London: Phaidon Press, 1997.

Jackson, Anna. *The V & A Guide to Period Styles*. London: Harry N. Abrams, 2002.

Kennedy, Roger G. *Greek Revival America*. New York: Stewart Tabori and Chang, 1989.

Lévy, Émile, ed. *Art et Décoration*. Paris: Librairie Centrale des Beaux-Arts, Volumes 1897–1906.

Litchfield, Frederick. *Illustrated History of Furniture*. Boston: Medici Society of America, 1922.

Lockwood, Luke Vincent. *Colonial Furniture in America*. New and enlarged ed. New York: Charles Scribner's Sons, 1913.

Morley, John. *Regency Design, 1790–1840*. New York: Harry N. Abrams, 1993.

Nye, Alvan C. *A Collection of Scale Drawings, Details, and Sketches of What Is Commonly Known as Colonial Furniture*. New York: William Helburn, 1895.

Ormsbee, Thomas H. *The Story of American Furniture*. New York: Macmillan, 1934.

Parissien, Steven. *Regency Style*. London: Phaidon Press, 1992.

Percier, Charles, and Pierre Fontaine. *Empire Stylebook of Interior Design*. New York: Dover Publications, 1991.

———. *Recueil de décorations intérieures*. Paris: Jules Didot Pine, 1827.

Pierson, William H. *American Buildings and Their Architects: The Colonial and Neoclassical Styles*. New York: Anchor Books, 1976.

Poesch, Jessie. *The Art of the Old South, Painting, Sculpture, Architecture and the Products of Craftsmen, 1560–1860*. New York: Harrison House, 1989.

The Room Beautiful: A Collection of Interior Illustrations Showing Decoration and Furniture Details of the Important Furnishing Periods. New York: Clifford and Lawton, 1915.

Shepherd, Thomas H., and James Elmes. *Metropolitan Improvements or London in the Nineteenth Century*. London: Benjamin Blom, 1968.

Smith, George. *The Cabinet Maker and Upholsterer's Guide*. London: 1826.

Speltz, Alexander. *The Styles of Ornament*. New York: Dover, 1959. Reprint of 1904 ed.

Strange, Thomas Arthur. *French Interiors, Furniture, Decoration, Woodwork & Allied Arts During the 17th and 18th Centuries*. New York: Bonanza Books, 1968.

Waissenberger, Robert, ed. *Vienna in the Biedermeier Era, 1815–1848*. London: Alpine Fine Arts Collection, 1986.

Wilkie, Angus. *Biedermeier*. New York: Abbeville Press, 1987.

Victorian Revivals

Aldrich, Megan. *Gothic Revival*. London: Phaidon Press, 1994.

———, et al. *A. W. N. Pugin, Master of Gothic Revival*. New Haven, CT: Yale University Press, 1995.

Artistic Furniture and Architectural Interiors. New York: Clifford & Lawton, 1892.

Atterbury, Paul, and Clive Wainwright. *Pugin: Gothic Passion*. New Haven, CT: Yale University Press, 1994.

Bicknell, A. J., and Company. *Detail, Cottage and Constructive Architecture*. New York: A. J. Bicknell, 1873.

Blum, Stella, ed. *Fashions and Costumes from Godey's Lady's Book*. New York: Dover Publications, 1985.

Blundell, Peter S. *The Marketplace Guide to Oak Furniture, Styles and Values*. Paducah, KY: Collector Books, 1980.

Bridgeman, Harrriet, and Elizabeth Drury, eds. *The Encyclopedia of Victoriana*, New York: Macmillian Publishing, 1975.

Carrott, Richard G. *The Egyptian Revival: Its Sources, Monuments, and Meaning, 1808–1858*. Berkeley: University of California Press, 1978.

Constock, William. *Modern Architectural Design and Detail*. New York: William T. Constock Architectural Publisher, 1881.

Cooper, Jeremy. *Victorian and Edwardian Décor*. New York: Abbeville Publishers, 1987.

Curl, James Stevens. *Victorian Architecture*. London: David & Charles, 1990.

Dixon, Roger, and Stefan Muthesius. *Victorian Architecture*. London: Thames and Hudson, 1978.

Downing, Andrew Jackson. *The Architecture of Country Houses; Including Designs for Cottages, Farm Houses, and Villas*. New York: Dover Publications, 1850. Reprint 1969.

Eastlake, Charles L. *Hints on Household Taste, the Classic Handbook of Victorian Interior Decoration*. New York: Dover Publications, 1878. Reprint 1969, 1986.

———. *A History of the Gothic Revival*. London: Longmans, Green, 1872.

Furniture for the Victorian Home, Comprising the Abridged Furniture Sections from A. J. Downing's Country Houses of 1850 and J. C. Louden's Encyclopedia of 1833. Watkins Glen, NY: American Life Foundation, 1968.

Garrett, Wendall. *Victorian America*. New York: Rizzoli, 1993.

Girouard, Mark. *Sweetness and Light: The Queen Anne Movement, 1860–1900*. Oxford, England: At the Clarendon Press, 1977.

Humbert, Jean-Marcel, Michael Pantazzi, and Christiane Ziegler. *Egyptomania: Egypt in Western Art, 1730–1930*. Ottawa, Canada: National Gallery of Canada, 1994.

Jones, Owen. *Grammar of Ornament*. New York: Van Nostrand Reinhold, 1856. Reprint 1982.

Knight, T., and Son. *Suggestions for Home Decoration*. London: T. Knight and Son, 1880.

Late Victorian Architectural Details. Watkins Glen, NY: American Life Foundation Study Institute, 1978.

Lewis, Michael. *The Gothic Revival*. London: Thames and Hudson, 2002.

Newsom, Samuel, and Joseph Newsom. *Picturesque California Homes*. San Francisco: Samuel and Joseph Newsom, 1884.

Norbury, James. *The World of Victoriana*. New York: Hamlyn Publishing Group, 1972.

Oak Furniture, Styles and Prices. Des Moines, IA: Wallace-Homestead Book Company, 1980. Illustrations from the 1897 Montgomery Ward Furniture catalog.

Pierce, Walter. *Painting and Decoration.* London: 1893.

Prignot, Eugène. *L'Architecture, L'Décoration, L'Ameublement Librarie Speciale des Arts Industriels et Décoratifs.* N.p.: 1873.

Pugin, A. Welby N. *Fifteenth and Sixteenth Century Ornaments.* Edinburgh: John Grant, 1830.

Seale, William. *The Tasteful Interlude, American Interiors Through the Camera's Eye, 1860–1917.* New York: Praeger Publishers, 1975.

Shoppell, Robert W. *Dining-Room Furniture & Decoration.* New York: Co-Operative Building Plan Association, 1883.

Sloan, Samuel. *Sloan's Homestead Architecture.* Philadelphia: J. P. Lippincott, 1861.

Stevenson, Katherine Cole. *Houses by Mail: A Guide to Houses from Sears, Roebuck and Company.* Washington, DC: Preservation Press, 1986.

Sweetman, John. *The Oriental Obsession: Islamic Inspiration in British and American Art and Achitecture, 1500–1920.* Cambridge, England: Cambridge University Press, 1988.

Talbert, B. J. *Examples of Ancient and Modern Furniture, Metal Work, Tapestries, Decorations.* Boston: James R. Osgood, 1876.

d. Verleger, Eigenthum. *Aus d. Kunstanst d. Bibl. Instit.* In Hildbhn. N.p., n.d.

Winkler, Gail Caskey, and Roger W. Moss. *Victorian Interior Decoration, American Interiors 1830–1900.* New York: Henry Holt, 1986.

Academic Historicism

Anscombe, Isabelle. *A Woman's Touch.* New York: Viking, 1984.

Appleton, Marc. *George Washington Smith: An Architect's Scrapbook.* Los Angeles: Tailwater Press, 2001.

Axelrod, Alan. *The Colonial Revival in America.* New York: W. W. Norton, 1985.

Baca, Elmo. *Romance of the Mission.* Salt Lake City, UT: Gibbs Smith Publisher, 1996.

Brooklyn Museum. *The American Renaissance, 1876–1917.* New York: Pantheon Books, 1979.

Cook, Clarance. *The House Beautiful: Essays on Beds and Tables, Stools and Candlesticks.* New York: Charles Scribner's Sons, 1878.

Cravath, James R., and Van Rensselaer Lansingh. *Practical Illumination.* New York: McGraw-Hill, 1907.

Curran, Kathleen. *The Romanesque Revival: Buildings, Landscapes, and Societies.* University Park: Pennsylvania State University Press, 2003.

Drexler, Arthur, ed. *The Architecture of the École des Beaux-Arts.* New York: Museum of Modern Art, 1977.

Edgell, George H. *American Architecture Today.* New York: Charles Scribner's Sons, 1928.

Elliott, Maud Howe, ed. *Art and Handicraft in the Women's Building of the World's Columbian Expositon.* Chicago: Rand McNally, 1894.

Floyd, Margaret Henderson. *Henry Hobson Richardson: A Genius for Architecture.* New York: Monacelli Press, 1997.

Gellner, Arrol, and Douglas Keister. *Red Tile Style: America's Spanish Revival Architecture.* New York: Viking Studio, 2002.

Hegemann, Werner, and Elbert Peets. *The American Vitruvius: An Architect's Handbook of Civic Art.* New York: 1922.

Hertz, B. Russell. *The Decoration and Furnishing of Apartments.* New York: G. P. Putnam's Sons, 1915.

I.C.S. Reference Library. *Use and Design of Lighting Fixtures.* Scranton, PA: International Textbook Company, 1909.

Jackson, Alice, and Bettina Jackson. *The Study of Interior Decoration.* Garden City, NJ: Doubleday, Doran, 1928.

Jennings, A. S. *Upholstery and Wall Coverings.* N.p., 1903.

Jordy, William H. *American Buildings and Their Architects: Progressive and Academic Ideas at the Turn of the Century.* Vol. 4. Oxford: Oxford University Press, 1972.

Lindquist, David P., and Caroline C. Warren. *Colonial Revival Furniture.* Radnor, PA: Wallace-Homestead, 1993.

May, Bridget A. "Progressivism and the Colonial Revival: The Modern Colonial House, 1900–1920," *Winterthur Portfolio* Vol. 26, No. 2/3, Summer–Autumn 1991, pp. 107–122.

McCelland, Nancy. *The Practical Book of Wall Treatments.* New York: J. P. Lippincott, 1926.

McMillian, Elizabeth. *California Colonial: The Spanish and Rancho Revival Styles.* Atglen, PA: Schiffer Publishing, 2002.

Mizner, Addison. *Florida Architecture of Addison Mizner.* New York: Dover Publications, 1992.

Monograph of the Works of McKim Mead and White 1879–1915. New York: Architectural Book Publishing, 1915–1920.

Nelson, L. H. *View of London Cities.* Portland, ME: 1905.

Nutting, Wallace. *Furniture Treasury.* 2 vols. New York: Macmillan, 1948.

O'Gorman, James F. *H. H. Richardson: Architectural Forms for an American Society.* Chicago: University of Chicago Press, 1987.

———. *Living Architecture: A Biography of H. H. Richardson.* New York: Simon and Schuster, 1997.

Platt, Frederick. *America's Gilded Age: Its Architecture and Decoration.* New York: A. S. Barnes, 1976.

Raymond, Maud Wotring. *The Architecture and Landscape Gardening of the Exhibition.* San Francisco: Paul Elder, 1915.

Renick, Roger, and Michael Trotter. *Monterey: Furnishings of California's Spanish Revival.* Atglen, PA: Shiffer Publishing, 2000.

Rhodes, William B. *The Colonial Revival.* New York: Garland Press, 1977.

Roth, Leland. *McKim, Mead, and White Architects.* New York: Harper and Row, 1983.

Saylor, Henry. *Architectural Styles for Country Houses.* New York: Robert M. McBride, 1919.

———. *Inexpensive Homes.* N.p., 1912.

Scully, Vincent J., Jr. *The Shingle Style and the Stick Style.* Rev. ed. New Haven, CT: Yale University Press, 1971.

Shackleton, Robert, and Elizabeth Shackleton. *The Quest of the Colonial.* New York: Century Company, 1913.

Shapland, H. P. *Style Schemes in Antique Furnishings.* N.p., 1909.

Smith, Jane S. *Elsie de Wolfe: A Life in the High Style.* New York: Atheneum, 1982.

Stein, Susan R., ed. *The Architecture of Richard Morris Hunt.* Chicago: University of Chicago Press, 1986.

Taylor, Lonn, and Dessa Bokides. *New Mexican Furniture, 1600–1940: The Origins, Survival, and Revival of Furniture Making in the Hispanic Southwest.* Santa Fe: Museum of New Mexico Press, 1987.

Thorne, Edward. *Decorative Draperies and Upholstery.* N.p., c. 1900.

Wallis, Frank E. *How to Know Architecture*. New York: Harper and Brothers, 1910.

Van Rensselaer, Marian Griswold. *Henry Hobson Richardson and His Works*. New York: Dover Publications, 1969.

Reforms

Adams, John D. *Arts & Crafts Lamps: How to Make Them*. Chicago: Popular Mechanics, 1911.

Anscombe, Isabelle. *Arts & Crafts Style*. New York: Rizzoli, 1991.

———— and Charlotte Gere. *Arts & Crafts in Britain and America*. New York: Van Nostrand Reinhold, 1978.

Arts and Crafts Movement. New York: Todtri Book Publishers, 2002.

Aslin, Elizabeth. *The Aesthetic Movement: Prelude to Art Nouveau*. New York: Frederick A. Praeger, 1969.

Boris, Eileen. *Art and Labor: Ruskin, Morris, and the Craftsman Ideal in America*. Philadephia: Temple University Press, 1986.

Burke, Doreen Bolger, et al. *In Pursuit of Beauty: Americans and the Aesthetic Movement*. New York: Rizzoli, 1986.

Clark, Robert Judson, ed. *The Arts and Crafts Movement in America 1876–1916*. Princeton, NJ: Princeton University Press, 1972.

Cumming, Elizabeth, and Wendy Kaplan. *The Arts and Crafts Movement*. London: Thames and Hudson, 1991.

Davey, Peter. *Arts and Crafts Architecture*. London: Phaidon Press, 1995.

Duchscherer, Paul, and Douglas, Keister. *The Bungalow: America's Arts and Crafts Home*. New York: Penguin Studio, 1995.

The Encyclopedia of Arts and Crafts: The International Arts Movement, 1850–1920. New York: E. P. Dutton, 1989.

Gere, Charlotte, and Lesley Hoskins. *The House Beautiful: Oscar Wilde and the Aesthetic Interior*. London: Geffrye Museum, 2000.

Gordon, Beverly. *Shaker Textile Arts*. Hanover, NH: University Press of New England, 1980.

Harbron, Dudley. *The Conscious Stone: The Life of Edward William Godwin*. New York: Benjamin Blom, 1971.

Johnson, A. P., and Marta K. Sironen. *Manual of the Furniture Arts and Crafts*. Grand Rapids, MI: A. P. Johnson Company, 1928.

Kaplan, Wendy. *"The Art That Is Life": The Arts and Crafts Movement in America, 1875–1920*. Boston: Little, Brown, 1987.

Kardon Janet, ed. *The Ideal Home: 1900–1920*. New York: Harry N. Abrams, 1993.

Lambourne, Lionel. *The Aesthetic Movement*. London: Phaidon Press, 1996.

Limbert Furniture. New York: Turn of the Century Editions, 1981.

Lind, Carla. *The Wright Style*. New York: Simon and Schuster, 1992.

Makinson, Randell L. *Greene and Greene*. Santa Barbara, CA: Peregrine Smith, 1979.

Mission Furniture: How to Make It, Part One. Chicago: Popular Mechanics, 1909.

Mission Furniture: How to Make It, Part Two. Chicago: Popular Mechanics, 1910.

Naylor, Gillian. *The Arts and Crafts Movement*. Cambridge, MA: MIT Press, 1971.

Nicoletta, Julie. *The Architecture of the Shakers*. Woodstock, VT: Countryman Press, 1995.

Pfeiffer, Bruce Brooks, and Gerald Nordland, eds. *Frank Lloyd Wright: In the Realm of Ideas*. Carbondale: Southern Illinois University Press, 1988.

The Radford American Homes. Chicago: Radford Architectural Company, 1903.

Richardson, Margaret. *The Craft Architects*. New York: Rizzoli International Publications, 1983.

Rieman, Timothy D., and Jean M. Burks. *The Complete Book of Shaker Furniture*. New York: Harry N. Abrams, 1993.

Rocheleau, Paul, and June Sprigg. *Shaker Built: The Form and Function of Shaker Architecture*. New York: Monacelli Press, 1994.

Rodel, Kevin P., and Jonathan Binzen. *Arts and Crafts Furniture: From Classic to Contemporary*. Newtown, CT: Taunton Press, 2003.

Roth, Leland M. *Shingle Styles: Innovation and Tradition in American Architecture, 1874–1982*. New York: Harry N. Abrams, 1999.

Scott, M. H. Baillie. *Houses and Gardens—Arts and Crafts Interiors*. Suffolk, England: Antique Collectors' Club, 1995.

Scully, Vincent J., Jr. *The Shingle Style and the Stick Style*. Rev. ed. New Haven, CT: Yale University Press, 1971.

Shea, John G. *The American Shakers and Their Furniture*. New York: Van Nostrand Reinhold, 1971.

Simpson, Duncan. *C. F. A. Vosey: An Architect of Individuality*. New York: Whitney Library of Design, 1981.

Spencer, Robin. *The Aesthetic Movement*. New York: E. P. Dutton, 1972.

Sprigg, June, and David Larkin. *Shaker Life, Work, and Art*. Boston: Houghton Mifflin Company, 1987.

Stickley, Gustav, ed. *Craftsman Bungalows*. New York: Dover Publications, 1988.

————. *Craftsman Homes, Architecture and Furnishings of the American Arts and Crafts Movement*. New York: Dover Publications, 1909.

Talbert, Bruce J. *Victorian Decorative Art*. Watkins Glen, NY: American Life Foundation, 1978.

Tinniswood, Adrian. *The Arts and Crafts House*. New York: Watson/Guptill Publications, 1999.

Watkinson, Ray. *William Morris as Designer*. New York: Reinhold Publishing, 1967.

Watt, William. *Art Furniture from Designs by E. W. Godwin*. London: B. T. Batsford, 1877.

The Work of L & J. G. Stickley. Fayetteville, NY: n.d.

Innovation

Albrecht, Donald, and Chrysanthe B. Broikos, eds. *On the Job: Design and the American Office*. New York: Princeton Architectural Press, 2000.

Amaya, Mario. *Art Nouveau*. New York: E. P. Dutton, 1966.

Blake, Fanny. *Essential Charles Rennie Mackintosh*. Bath, England: Parragon Publishing, 2001.

Boubnova, Iaroslava, Christoph Horst, Robert Fleck, John Miller, and Michel Onfray. *Vienna Secession, 1898–1998: The Century of Artistic Freedom*. Munich: Prestel, 1998.

Brandstätter, Christian. *Wiener Werkstätte: Design in Vienna, 1903–1932*. New York: Harry N. Abrams, 2003.

Crawford, Alan. *Charles Rennie Mackintosh*. London: Thames and Hudson, 1995.

De Wit, Wim., ed. *Louis Sullivan: The Function of Ornament*. New York: W. W. Norton, 1986.

Droste, Magdalena. *Bauhaus 1919–1933*. Köln, Germany: Taschen, 1990.

Duncan, Alastair. *Art Nouveau Furniture*. New York: Crown Publishers, 1982.

Fahr-Becker, Gabriele. *Wiener Werkstätte*. Köln, Germany: Taschen, 1995.

Felderer, Brigitte, Gottfried Fliedl, Otto Kapfinger, Eleonora Louis, and James Shedel. *Secession: The Vienna Secession from Temple of Art to Exhibition Hall*. Ostfildern-Ruit, Germany: Hatje, 1997.

Frazier, Nancy. *Louis Sullivan and the Chicago School*. New York: Crescent Books, 1991.

Friedman, Mildred, ed. *De Stijl: 1917–1931 Visions of Utopia*. New York: Abbeville Press, 1982.

Greenhalgh, Paul, ed. *Art Nouveau, 1890–1914*. London: V&A Publications, 2000.

Johnson, Diane Chalmers. *American Art Nouveau*. New York: Harry N. Abrams, 1981.

Kentgens-Craig, Margret. *The Bauhaus and America: First Contacts, 1919–1936*. Cambridge, MA: MIT Press, 2001.

Macleod, Robert. *Charles Rennie Mackintosh, Architect and Artist*. New York: E. P. Dutton, 1983.

Masini, Lara-Vinca. *Art Nouveau*. Secaucus, NJ: Chartwell Books, 1984.

McCoy, Esther. *Five California Architects*. Los Angeles: Hennessey and Ingalls, 1960.

McQuaid, Matilda. *Lilly Reich: Designer and Architect*. New York: Harry N. Abrams, 1996.

Overy, Paul. *De Stijl*. London: Thames and Hudson, 1991.

Rowland, Anna. *The Bauhaus Sourcebook*. New York: Van Nostrand Reinhold, 1990.

Russell, Frank. *Art Nouveau Architecture*. New York: Rizzoli, 1979.

Saliga, Pauline A., ed. *The Sky's the Limit: A Century of Chicago Skyscrapers*. New York: Rizzoli, 1990.

Schezen, Roberto. *Adolf Loos—Architecture 1903–1933*. New York: Monacelli Press, 1996.

Shimomura, Junichi. *Art Nouveau Architecture: Residential Masterpieces, 1892–1911*. San Francisco: Cadence Books, 1990.

Troy, Nancy J. *The De Stijl Environment*. Cambridge, MA: MIT Press, 1983.

Van Doesburg, Theo. *Principles of Neo-Plastic Art*. New York: Graphic Society, 1966.

Varnedoe, Kirk. *Vienna 1900, Art, Architecture & Design*. New York: Museum of Modern Art, 1986.

Vinci, John. *The Stock Exchange Trading Room*. Chicago: The Art Institute of Chicago, 1977.

Wadsworth, Ginger. *Julia Morgan: Architect of Dreams*. Minneapolis, MN: Lerner Publications Company, 1990.

Waissenberger, Robert. *Vienna Secession*. New York: Rizzoli, 1977.

Warncke, Carsten-Peter. *De Stijl 1917–1931*. Köln, Germany: Taschen, 1990.

Whitford, Frank. *Bauhaus*. London: Thames and Hudson, 1984.

Wichmann, Siegfried. *Jugendstil Art Nouveau: Floral and Functional Forms*. New York: New York Graphic Society, 1984.

Willis, Carol. *Form Follows Finance: Skyscrapers and Skylines in New York and Chicago*. New York: Princeton Architectural Press, 1995.

Wingler, Hans M. *The Bauhaus*. Cambridge, MA: MIT Press, 1979.

Modernism

Abercrombie, Stanley. *George Nelson: The Design of Modern Design*. Cambridge: MA: MIT Press, 1995.

Arwas, Victor. *Art Deco*. New York: Harry N. Abrams, 1980.

Baldwin, Billy. *Billy Baldwin Decorates*. New York: Holt, Rinehart, and Winston, 1972.

Bayer, Patricia. *Art Deco Architecture: Design, Decoration, and Detail from the Twenties and Thirties*. New York: Harry N. Abrams, 1992.

———. *Art Deco Interiors: Decoration and Design Classics of the 1920s and 1930s*. New York: Thames and Hudson, 1990.

Benton, Charlotte, Tim Benton, and Ghislaine Wood. *Art Deco, 1910–1939*. New York: Bulfinch Press, 2003.

Berry, John R. *Herman Miller: The Purpose of Design*. New York: Rizzoli, 2004.

Bony, Anne. *Furniture and Interiors of the 1960s*. Paris: Éditions Flammarion, 2004.

Bullock, Orin M., Jr. *The Restoration Manual*. Norwalk, CT: Silvermine Publishers, 1966, 1978.

Bréon, Emmanuel, and Rosalind Pepall, eds. *Ruhlmann—Genius of Art Deco*. Paris: Somogy Éditions D'Art, 2004.

Brown, Erica. *Interior Views: Design at Its Best*. New York: Viking Press, 1980.

Brunhammer, Yvonne. *Art Deco Style*. London: Academy Editions, 1983.

Calloway, Stephen. *Twentieth-Century Decoration*. New York: Rizzoli, 1988.

Carnard, Florence. *Ruhlmann: Master of Art Deco*. New York: Abrams, 1984.

Carter, Randolph, Robert Reed Cole. *Joseph Urban: Architecture, Theatre, Opera, Film*. New York: Abbeville Press, 1992.

Le Corbusier. *Towards a New Architecture*. New York: Dover Publications, 1986.

Dietsch, Deborah K. *Classic Modern: Mid-Century Modern at Home*. New York: Simon & Schuster, 2000.

Duncan, Alastair. *Art Deco*. New York: Thames and Hudson, 1988.

———. *Modernism: Modernist Design 1880–1940*. Minneapolis, MN: Norwest Corporation, 1998.

———. *Art Deco Furniture: The French Designers*. New York: Thames and Hudson, 1992.

Dunlop, Beth. *Building a Dream: The Art of Disney Architecture*. New York: Harry N. Abrams, 1996.

The Edward J. Wormley Collection. High Point, NC: Dunbar Furniture, 2003.

Eidelberg, Martin, ed. *Design 1935–1965: What Modern Was*. New York: Harry N. Abrams, 1991.

Fehrman, Cherie, and Kenneth Fehrman. *Postwar Interior Design: 1945–1960*. New York: Van Nostrand Reinhold, 1987.

Fiell, Charlotte, and Peter Fiell. *Modern Furniture Classics since 1945*. Washington, DC: AIA Press, 1991.

Fleig, Karl. *Alvar Aalto*. Basel, Germany: Birkhäuser Verlag, 1999.

Giedion, Sigfried. *Walter Gropius*. New York: Dover Publications, 1992.

Goldstein, Barbara, ed. *Arts & Architecture: The Entenza Years*. Cambridge, MA: MIT Press, 1990.

Greenberg, Cara. *Mid-Century Modern: Furniture of the 1950s*. New York: Harmony Books, 1995.

———. *Op to Pop: Furniture of the 1960s*. Boston: Little, Brown, 1999.

Hampton, Mark. *Legendary Decorators of the 20th Century*. New York: Doubleday, 1992.

Hanks, David A., and Anne Hoy. *Design for Living: Furniture and Lighting, 1950–2000: The Liliane and David M. Stewart Collection*. New York: Flammarion, 2000.

Hanks, David A., and Jennifer Toher. *Donald Deskey: Decorative Designs and Interiors*. New York: E. P. Dutton, 1987.

Hess, Alan. *The Ranch House*. New York: Harry N. Abrams, 2004.

Hillier, Bevis. *The Style of the Century*. New York: E. P. Dutton, 1983.

Hosmer, Charles B. *Presence of the Past*. New York: Putnam, 1965.

———. *Preservation Comes of Age*. Charlottesville, VA: Univ. Press of Virginia, 1981.

Isamu Noguchi. San Francisco: Chronicle Books, 1986.

Jackson, Lesley. *"Contemporary": Architecture and Interiors of the 1950s*. New York: Phaidon Press, 1994.

———. *The New Look: Design in the Fifties*. New York: Thames and Hudson, 1998.

———. *The Sixties: Decade of Design Revolution*. New York: Phaiden, 1998.

Joedicke, Jürgen. *Architecture Since 1945: Sources and Directions*. New York: Frederick A. Praeger, 1969.

Johnson, Stewart J. *American Modern, 1925–1940: Design for a New Age*. New York: Harry N. Abrams, 2000.

Khan, Hasan-Uddin. *International Style: Modernist Architecture from 1925 to 1965*. New York: Taschen, 2001.

Lahti, Louna. *Alvar Aalto*. Los Angeles: Taschen, 2004.

Lupton, Edith, ed. *The ABCs of the Bauhaus and Design Theory*. New York: The Cooper Union, 1991.

McClinton, Katharine Morrison. *Art Deco: A Guide for Collectors*. New York: Clarkson N. Potter, 1972.

Murtagh, William. *Keeping Time*. New York: Wiley, 2005.

Neuhart, John, Marilyn Neuhart, and Ray Eames. *Eames Design: The Work of the Office of Charles and Ray Eames*. New York: Harry N. Abrams, 1989.

Pardo, Vittorio Franchetti. *Le Corbusier*. New York: Grosset & Dunlap, 1971.

Piña, Leslie. *Herman Miller Office*. Atglen, PA: Schiffer Publishing, 2002.

The Radio City Music Hall Art Deco Collection. New York: Schumacher, n.d.

Reed, Peter. *Alvar Aalto: Between Humanism and Materialism*. New York: The Museum of Modern Art, 1998.

Salokorpi, Asko. *Modern Architecture in Finland*. New York: Praeger Publishers, 1970.

Schulman, Julius. *Architecture and Its Photography*. Köln, Germany: Taschen, 1998.

Seale, William. *Recreating the Historic House Interior*. Nashville, TN: American Association of State and Local History, 1979.

Sembach, Klaus-Jürgen. *Contemporary Furniture: An International Review of Modern Furniture, 1950 to the Present*. New York: Architectural Book Publishing Company, 1982.

Serraino, Pierluigi, and Julius Shulman. *Modernism Rediscovered*. Köln, Germany: Taschen, 2000.

Tinniswood, Adrian. *The Art Deco House: Avant-Garde Houses of the 1920s and 30s*. New York: Watson-Guptill, 2002.

Troy, Nancy J. *Modernism and the Decorative Arts in France*. New Haven, CT: Yale University Press, 1991.

Wilson, Kristina. *Livable Modernism: Interior Decorating and Design during the Great Depression*. New Haven, CT: Yale University Press, 2004.

With Heritage So Rich: Special Committee on Historic Preservation, United States Conference of Mayors, 1966.

Experimentation

Anargyros, Sophie. *Le Style des Annes 80: Architecture Decoration Design*. Paris: Rivages, 1986.

Bertoni, Franco. *Minimalist Architecture*. Boston: Birkhäuser, 2002.

———. *Minimalist Design*. Boston: Birkhäuser, 2004.

Blake, Peter. *Form Follows Fiasco: Why Modern Architecture Hasn't Worked*. Boston and Toronto: Little, Brown, 1977.

Collins, Michael. *Towards Post-Modernism: Decorative Arts and Design Since 1851*. New York: New York Graphic Society, 1987.

——— and Andreas Papadakis. *Post-Modern Design*. New York: Rizzoli, 1989.

De Bure, Gilles. *Ettore Sottsass Jr*. Paris: Rivages, 1987.

Edwards, Andres R. *The Sustainability Revolution: Portrait of a Paradigm Shift*. Gabriola Island, Canada: New Society Publishers, 2005.

Friedman, Mildred, ed. *Gehry Talks, Architecture + Process*. New York: Universe Publishing, 2005.

Garofalo, Francesco. *Steven Holl*. New York: Universe Publishing, 2003.

Girardo, Diane. *Architecture After Modernism*. London: Thames and Hudson, 1996.

Horn, Richard. *Memphis: Objects, Furniture, and Patterns*. Philadelphia: Running Press Book Publishers, 1985.

Italy: The New Domestic Landscape. New York: Museum of Modern Art, 1972.

Jencks, Charles. *The Language of Post-Modern Architecture*. 6th rev. ed. New York: Rizzoli, 1991.

———. *Late-Modern Architecture*. New York: Rizzoli, 1980.

———. *The New Moderns: From Late Modern to Neo-Modernism*. New York: Rizzoli, 1990.

———. *The New Paradigm in Architecture: The Language of Post-Modernism*. New Haven, CT: Yale University Press, 2002.

———, ed. *Post-Modern Classicism*. London: Architectural Design, 1980.

Klotz, Heinrich. *The History of Postmodern Architecture*. Cambridge, MA: MIT Press, 1988.

———, ed. *Revision of the Modern*. London: Architectural Design, 1985.

Kron, Joan, and Suzanne Slesin. *High-Tech: The Industrial Style and Source Book for the Home*. New York: Clarkson N. Potter, 1978.

Martinez, Antonio Riggen. *Luis Barragán*. New York: Monacelli Press, 1996.

Mastelli, Rich, and John Kelsey, eds. *Tradition in Contemporary Furniture*. Free Union, NC: Furniture Society, 2001.

McDonough, Michael, and Michael Braungart. "The NEXT Industrial Revolution." *Atlantic Monthly*, October 1998.

Meier, Richard, with introduction by Joseph Rykwert. *Richard Meier Architect*. New York: Rizzoli, 1984.

Miller, Nory. *Johnson/Burgee Architecture*. New York: Random House, 1979.

Nakashima, George. *The Soul of a Tree: A Woodworker's Reflections*. New York: Kodansha International, 1981.

Pearman, Hugh. *Contemporary World Architecture*. New York: Phaidon Press, 2002.

Portoghesi, Paolo. *After Modern Architecture*. New York: Rizzoli, 1980.

———. *Postmodern: The Architecture of the Postindustrial Society*. New York: Rizzoli, 1983.

Radice, Barbara. *Memphis*. New York: Rizzoli, 1984.

Russell, Beverly. *Architecture and Design 1970–1990: New Ideas in America*. New York: Harry N. Abrams, 1989.

———. *Women of Design: Contemporary American Interiors*. New York: Rizzoli, 1992.

Sakellaridou, Irena. *Mario Botta, Architectural Poetics*. New York: Universe Publishing, 2000.

Sottsass Associati. New York: Rizzoli, 1988.

Stang, Alanna, and Christopher Hawthorne. *The Green House: New Directions in Sustainable Architecture*. New York: Princeton Architectural Press, 2005.

Trocmé, Suzanne. *Influential Interiors: Shaping 20th Century Style through Key Interior Designers*. New York: Clarkson Potter Publishers, 1999.

Venturi, Robert. *Complexity and Contradiction in Architecture*. New York: Museum of Modern Art, 1966, 1977, 1983.

Wheeler, Karen Vogel, Peter Arnell, and Ted Bickford, eds. *Michael Graves, Buildings and Projects 1966–1981*. New York: Rizzoli, 1982.

Wines, James. *Green Architecture*. London: Taschen, 2000.

Index

(Note: Boldface page numbers indicate photographs or illustrations; italic page numbers indicate inclusive discussions.)

Goff, Bruce, 645, 741
Goldberger, Paul, 837
Goldsmith, Jonathan, 101
 Dr. John H. Matthews House, Painesville, Ohio, **101**
Goodell, Nathaniel, 190
 Albert Gallatin House (Governor's Mansion), Sacramento, California, **198–199**
Goodhue, Bertram G., 219, 347, 348, 352, 359, 644
 California Tower, New Mexico Building, and Foreign and Domestic Building, Panama-California Exposition, 356
Goodwin, Philip L., 711
Goodwin, William Archer Rutherford, 323
Goslinsky House, San Francisco, California, 454
Gothic Revival, *121–153*
Goujon, Jean, 188
Gould, Jay, 402
Gov. Henry Lippitt House, Providence, Rhode Island, 161
 entry hall and dining room, **172**
Gov. Leland Stanford House, Sacramento, California, 190
 stair hall, **204**
Governor's Mansion, Austin, Texas, 94, 95, **102**
Governor's Mansion, Jefferson City, Missouri, 190, **197**
Governor's Palace, Williamsburg, Virginia, 326, **328**, 765, 773
Gowan, James, 810
Grace Church, New York City, New York, 127
Graff, Frederick C., 95
Graham, Anderson, Probst, and White Architects, 547
Graham, Bruce, 810
 John Hancock Center, **809**
Graham, Ernest, 547
Granada Buildings, Los Angeles, California, 352
Grand Central Railroad Terminal Station, New York City, 16, **17,** 18, 296
Grandfather clocks, **335,** 340
Grand Floridian Resort and Spa, Lake Buena Vista, Florida, **253**
Grand Hotel, Scarborough, England, 190
"Grandmother's Cupboard" (Cook), in *House Beautiful,* 324
Grand Rapids Chair Company, 247
Grand Trianon, salon, **45**
The Grange restaurant, Paris, **789**
Grant-Hill-White-Bradshaw House, Athens, Georgia, 94
Grauman's Chinese Theater, Los Angeles, California, 644
Graves, Michael, 654, 840, 841, 842, 844, 846, 851, 852, 860
 architectural details, **839**
 carpets, **856**
 Denver Public Library, **848, 854, 859**
 Dolphin and Swan Hotels, **847, 853**
 Humana Building, **845**
 lighting, **855**
 photograph of, **837**
 Plaza dressing table and stool, **861**
 Portland Public Services Building, **843**
 seating, **856**
 Sunar Furniture Showrooms, **850**
 tea kettle, **861**
Gray, Eileen, 589, 645, 653, 656, 662, 668, 672
 interior and furnishings, **671**
 table, **635**
Grcic, Konstantin, seating, **834, 960**
Great Auditorium, City University of Caracas, Caracas, Venezuela, 741
Great (Bamboo) Wall House, Shuiguan-Badaling, China, **924**
Great Court at the British Museum, London, England, 871, **883**
Great Exhibition of the Works of Industry of All Nations. *See* Crystal Palace Exhibition

Great Western Hotel, London, England, **187, **190
Grecian-style couch, English Regency, British Greek Revival, **86**
Green, Calvin, 381
Green, Henry, 388
Greenacres (Harold Lloyd House), Beverly Hills California, 352
 entrance hall and dining room, **372**
Greenberg, Allan, 771, 772
 LaStrada Novissima—Presence of the Past, **841**
 Memorial Hall, **779**
Greenbriar Hotel, White Sulphur Springs, West Virginia, 297
Green design, green architecture, 900. *See also* Environmental Modern
Green dining room, Victoria and Albert Museum, South Kensington, London, **401**
Greene, Charles Sumner, 450, 454, 456, 461, 462, 464
 David B. Gamble House, **460, 471**
 Robert C. Blacker House, **475**
 Theodore Irwin House, **459**
Greene, Henry Mather, 450, 454, 456, 459, 461, 462, 464
 David B. Gamble House, **460, 471**
 Robert C. Blacker House, **475**
Greene and Greene, 465, 467, 476
 stained glass, **452**
Green-Meldrin House, Savannah, Georgia, 127
 entrance hall, **141**
Greenpeace, 898
Greenwell Goetz Associates, W. Kevin Wylie interiors, **881**
Greenwich Millennium Village, London, England, 906
Greer, Michael, 762
Grey, Elmer, 352
 Beverly Hills Hotel, **355**
Greyhound Bus Terminals, Washington, D.C., South Carolina, and Mississippi, **648**
Greystone Hotel, Miami Beach, Florida, **649**
Griffin, Percy, 326
 James W. Allison House, 330,336
Grimshaw, Nicholas, The Eden Project, **911**
Grimson, Ernest, 427, 443
 chair, **445**
Griswold House, Newport, Rhode Island, 241, **243,** 249, **254**
Gropius, Walter, 523, 552, 564, 571, 590–591, 593, 596, 616, 617, 618, 628, 629, 702, 704, 710, 711
 Bauhaus buildings, **594–595, 600–601**
 desks, **609**
 Fagus Shoe Factory, **567**
 German Pavilion, International Exposition, **603**
 Masters' Houses, Bauhaus, **598, 604**
 Municipal Employment Office, **597**
 Pan Am Building, **708**
 Walter Gropius House, **712, 723**
 Weimar Bauhaus, **600**
 Weissenhof Housing Development, **599**
Grosses Schauspielhaus, Berlin, Germany, 564
Grosvenor Hotel, London, England, **293,** 296
Grove Park Inn, Asheville, North Carolina, 454, **455**
Grove Street Cemetery Entrance, New Haven, Connecticut, 219, **221**
Gruen Associates, Pacific Design Center, **812**
Grundtvig Church, Copenhagen, Denmark, **678**
Guaranty Building, Buffalo, New York, 16, 18, 547, 552
 exterior, **548–549**
 staircases, **554**
Guggenheim, Peggy, 735
Guggenheim Museum, Bilbao, Spain, 938, 940, **943**
Guggenheim Museum, New York City, **740,** 741, 744

Guild House, Philadelphia, Pennsylvania, 840, **848**
Guild of Handicrafts, 432, 517
Guild of S. George, 423
Guilds, 424, 430
Guimard, Hector, 483, 484, 491, 498, 637
 cabinet, **513**
 Le Castel Béranger, **486–487**
 office suite, **512**
 Paris Métro stations, **491–492**
The Gumma Prefectural Museum of FineArts, Tasaki, Japan, **811**
Gunnar Birkerts and Associates, 810
Gustav Stickley Company, 474
Gwathmey, Charles, 458

H. A. C. Taylor House, Newport, Rhode Island, 326, **329**
Haas-Lilenthal House, San Francisco, California, 244
Habitat, EXPO 67, Montreal, Canada, **709,** 710
Habitat Stores, 827
Hadfield, George, 95
Hadid, Zaha, 939, 940
 Hotel de Puerta America, **955**
 Rosenthal Center for Contemporary Art, **946**
 seating, **962**
Hadley, Albert, 775
Hale House, Los Angeles, California, 244
Hall, John, 92
Hall, Nels, Kelley Engineering Center, Oregon State University, **924**
Hall, Peter, Sydney Opera House, **743**
Hall House, New York City, reception room, **231**
Hallidie Building, San Francisco, California, 547
Hamilton, G. E., 269
Hamilton, Thomas, 68
Hamilton, Walter, 399
Hamlin, T. F., 762
Hampshire House, New York City, corridor, **778**
Hampstead Garden, 429
Hancock Shaker Village, Pittsfield, Massachusetts
 Elder's Room, Main Meeting House, **387**
 Round Stone Barn, **383**
Hankar, Paul, 491
Hannaford, Samuel, 272
Hardaway-Evans-Wilson-Sledge House, Mobile, Alabama, **102**
Hardenbergh, Henry Janway, 773, 781
 Willard Hotel, **767, 781**
Hardie, James, 95
Hardwick, P. C., 187, 190
 Great Western Hotel, Paddington, London, England, **187**
Häring, Hugo, 740
Hariri and Hariri Architecture, 871
 JSM Music Studios, **886**
 master bedroom and bath, **886**
 Perry Street Loft, **886**
Harold Craig Brooks House, Marshall, Michigan, 95
Harold Washington Library Center, Chicago, Illinois, 772
Harper, Frank, 352
Harper and Brothers Building, New York City, 16
Harrison, Wallace K., 711, 772
 United Nations Secretariat Building, **705**
Hart, Russell E., Parthenon, **300**
Hartley, Jesse, 16
Harvard Shaker Village Historic District, Harvard, Massachusetts, 383
Harvard University Graduate Center, Cambridge, Massachusetts, 710
Hastings, Thomas, 296
Hastings Furniture
 Spanish upholstered bench, **374**
 tables, **375**
Hauptwache, Berlin, 56, 58
Haus am Michaelerplatz (Goldman and Salatsch Building), Vienna, Austria, 564, **566**
Hauserman Company Walls Showroom, Los Angeles and New York City, **824**

Credits for Text Illustrations

NOTE: For greater historical accuracy, some images have been slightly modified digitally from their original appearance to more accurately represent the building or object as it would have appeared upon completion or within its appropriate time frame. These actions would include removing automobiles, electrical or telephone wires, and signage that is not of the original period. Older prints and negatives have also had their foxing or spotting removed. These actions have not been taken on images obtained from museums or commercial photographers.

Ackermann, Rudolf, *Ackermanns's Repository of Arts*, London, R. Ackermann, 1829: Fig. 4-27a, 6-41e.

Adams, John D., *Arts-Crafts Lamps*, Chicago, Popular Mechanics Co., 1911: Fig. 18-41b, 18-41e.

Ian Aitken © Rough Guides: Fig. 19-13a.

Alamy: Fig. 4-13, 33-1b, 33-20, 33-34a, 33-34b, 33-34c, 33-34d, 35-1b, 35-27b, 35-27c.

Josef Albers (1888–1976) German, "Homage to the Square"/Superstock, Inc. © 1998 The Josef and Anni Albers Foundation/Artists Rights Society (ARS), New York: Fig. 24-2.

Courtesy Alessi S.p.a., Crusinalla, Italy: Fig. 35-52a, 35-52b.

Max Alexander © Dorling Kindersley: Fig. 24-17c.

Courtesy Alias: Fig. 31-45a, 31-45b, 31-45c.

© Miroslav Ambroses/GreatBuildings.com: Fig. 24-22a.

Andrews, Wayne: Fig. 12-27.

AP Wide World Photos: Fig. 26-30c.

Arcaid/Alamy: Fig. 9-25.

architectureisfun, Inc., Doug Snower, photographer: Fig. 23-9.

Architectural Association Photo Library, London: Fig. 25-30, 27-5a, 27-6, 27-13.

© Architex International: Fig. 34-42.

Artek: Fig. 27-29c, 27-29e, 27-33a, 27-33b, 27-33c.

Courtesy Artemide USA: Fig. 31-32a, 34-32c, 31-32f.

Courtesy Artemide USA: Fig. 33-38a, 33-38b, 33-38c, 33-38d, 33-38e, 35-38d.

Art Furniture Warehouse, London, n.p., 1877: Fig. 16-8, 16-32d.

The Art Institute of Chicago, gift of the Antiquarian Society through the Captial Campaign Fund: Fig 3-19.

The Art Journal Illustrated: The Industry of All Nations, London, Published for the Proprietors, by George Virtue, 1851: Fig. 1-33d, 1-42a, 8-38a, 8-38b, 8-38d, 8-38g, 8-39b, 8-39c, 8-39d, 8-41b, 8-41c, 8-41d1, 8-41d3, 8-43a1, 8-43a3, 8-44a, 8-46, 8-47b, 9-34a1, 9-34a2, 17-27d, 21-29d.

Art Resource/The New York Public Library Photographic Services: Fig. 1-38b.

© Artists Rights Society (ARS), New York/VG Bild-Kunst, Bonn: Fig. I-5, 24-17a.

© 2005 Artists Rights Society (ARS), New York/ADAGP, Paris/FLC: Fig. 25-25c.

© 2005, Artists Rights Society (ARS), New York/SOFAM, Brussels. Photo by Ch. Bastin & J. Evrard: Fig. 19-26.

Artistic Furniture and Architectural Interiors, New York, Clifford & Lawton, 1892: Fig. 9-37.

Artistic Houses, New York, Benjamin Blom, Inc., 1883, Republished 1971: Fig. 1-36h, 7-32, 7-35a, 7-35b, 9-27, 9-28, 9-29, 11-29, 12-38a, 12-38b, 16-14, 16-23, 16-25, 16-26.

Les Arts de la Maison, Paris, Editions Albert Morancé, c. 1923: Fig. 26-31a, 26-31b, 26-38b, 26-41b.

Les Arts de la Maison, Paris, Editions Albert Morancé, c.1925: Fig. 26-7a.

Les Arts de la Maison, Paris, Christian Zervos, 1926: Fig. 26-24, 26-34, 26-36a, 26-37b, 26-37c, 26-37d, 26-48.

The Asher and Adams Commercial Atlas, New York, 1870: Fig. 16-31.

Courtesy Baker Furniture: Fig. 9-42, 30-44a, 30-44b, 30-45a, 30-45b, 30-45c, 34-52.

Barlow, Ronald S (Ed.), *Victorian Houseware, Hardware and Kitchenware*, Mineola, Dover Publications, 1992: Fig. 1-2f, 1-36d, 1-42b, 1-42c, 9-40a2, 9-40a3, 9-40a4, 10-38a, 10-38b, 10-38c1.

Barron, James, *Modern & Elegant Designs of Cabinet & Upholstery Furniture*, London, n.p., 1814: Fig. 4-27b.

Bauhaus-Archiv, Berlin: Fig. 24-3.

Bauhaus-Archive, Berlin, Germany/The Bridgeman Art Library: Fig. 24-36d.

Bauhausarchiv-Museum fur Gestaltung, Berlin, Germany: Fig. 24-16b, 24-21a, 24-21b.

© Achim Bednorz, Koln: Fig. I-16.

Behrens, Peter (1868–1940). "AEG Turbine Factory." 1909. Exterior. Berlin, Germany. © 2006 ARS Artists Rights Society, NY/VG Bild-Kunst, Bonn/Erich Lessing/Art Resource, NY: Fig. 22-07.

Benn, R. Davis, *Style in Furniture*, New York, Longmans, Green, and Co., 1920: Fig. 19-43, 19-46.

The Beverly Hills Hotel, Beverly Hills, California: Fig. 14-7b.

Courtesy Beyer Blinder Bell–Tom Lee Interiors: Fig. 30-25c (Photography, Jamie Ardiles).

Bicknell, A.J. and Co., *Bicknell's Victorian Buildings*, New York, A.J. Bicknell and Co, 1887: Fig. 8-19.

Bicknell, A.J. and Co., *Detail, Cottage and Constructive Architecture*, New York, A.J. Bicknell and Co., 1873: Fig. 10-21a.

Bicknell, A.J. and Co., *Specimen Book of One Hundred Architectural Designs*, New York, A.J. Bicknell and Co., 1878: Fig. 10-10, 10-43b.

Bildarchiv Monheim GmbH/Alamy: Fig. 3-16, 24-16a, 24-16b.

Used with permission from Biltmore Estate, Asheville, North Carolina: Fig. 12-41a and b.

Blackie and Son, *The Victorian Cabinet-Maker's Assistant*, New York, Dover Publications, Inc., 1970: Fig. 8-48a.

Bloomingdale's Illustrated 1886 Catalog, New York, Dover Publications, 1988: Fig. 9-1.

Blum, Stella, *Fashions and Costumes from Godey's Lady's Book*, New York, Dover Publications, Inc., 1985: Fig. 6-1, 8-1.

Blunt, Ron/Courtesy of the National Trust for Historic Preservation: Fig. 5-31.

Erik Bohr: Fig. 24-4b.

Photos courtesy of Bradbury & Bradbury Art Wallpapers: Fig. 30-39a, 30-39b, 30-39c.

Courtesy Marcel Breuer & Associates Architects: Fig. 24-24b.

BrianKMiller.com: Fig 5-35.

The Bridgeman Art Library International: Fig. 17-31a, 17-35, 19-10a.

Private Collection/The Bridgeman Art Library: Fig. 24-15b.

Bridgeman-Giraudon: Fig. 2-19.

Alan Briere © Dorling Kindersley: Fig. 15-9.

The British Architect, London, n.p., July, 1881: Fig. 16-24.

The British Architect, London, n.p., June 20, 1884: Fig. 10-28.

Brooklyn Museum of Art, New York : Fig. 8-33 (Gift of Sarah Milligan Rand, Kate Milligan Brill, and the Dick S. Ramsay Fund, 40.930MN); 9-17; 9-30 (Gift of John D. Rockefeller, Jr. and John D. Rockefeller III, 46.43).

Bruno Mathsson International AB: Fig. 27-34a, 27-34b.

Buffalo and Erie County Historical Society: Fig. 22-21, 22-30.

Cadw. Crown Copyright: Fig. 6-35.

California Department of Parks & Recreation, Old Town San Diego State Historic Park, Roscoe E. Hazard Collection: Fig. 9-39b.

Courtesy Cappellini: Fig. 31-50, 35-44.

Carl Hanson & Son, Inc: Fig. 37-35d.

Demetrio Carrasco © Dorling Kindersley: Fig. 19-35a.

Centennial Exhibition Digital Collection, libwww.library.phila. gov: Fig. 10-4a.

Cescinsky, Herbert, *Chinese Furniture*, London, Benn Brothers, Ltd., 1922: Fig. 4-39.

Chappey, Marcel, *Le XX Salon des Artistes Decorateurs*, Paris, Vincent Freal et cie, 1930: Fig. 24-18a, 24-18b, 24-19a, 26-37f.

Richard Cheek: Fig. 12-39a.

Photograph © Richard Cheek for the Preservation Society of Newport County: Fig. 8-36, 16-13.

Clifford, Chandler R., *Period Furnishings: An Encyclopedia of Historic Furniture, Decorations, and Furnishings*, New York, Clifford and Lawton, 1911/1914: Fig. 2-1a, 2-1b, 2-44c, 5-44b, 5-45c.

Clifford, Chandler R., *Period Furnishings: An Encyclopedia of Ornament*, New York, Clifford and Lawton, 1922: Fig. 20-20.

Clute, Eugene, *The Treatment of Interiors*, New York, Pencil Points Press, 1926: Fig. 2-25a, 2-25b, 2-45, 13-3b, 14-40, 14-46, 20-28a, 26-2d, 26-40b, 26-40d, 26-42a.

© Colefax and Fowler: Fig. 30-34a (Photography: English Heritage Millar & Harris Collection), 30-34b (Photography: James Mortimer), 30-34c (Photography: English Heritage Millar & Harris Collection).

Colie & Son Catalog, n.p, n.d.: Fig. 10-39a.

Courtesy, Colorado Historical Society, F39657; F21985; F4096; F4154: Fig. 10-25a, 10-25b, 10-25c.

Constock, William, *Modern Architectural Design and Details*, New York, William T. Constock Architectural Publisher, 1881: Fig. 10-21b.

Courtesy, Contemporary Arts Center: Fig. 35-18a (Photography: Roland Halbe, 2003).

Convention and Visitors Bureau, Mitchell, South Dakota: Fig. 9-14.

Cook, Clarance, *The House Beautiful: Essays on Beds and Tables, Stools and Candlesticks*, New York, Charles Scribners Sons, 1881: Fig. 13-1, 13-2, 13-39, 13-42, 16-2, 16-22, 16-40.

Cooper-Hewitt, National Design Museum, Smithsonian Institution: Purchased for the Museum by the Advisory Council 1911-28-479, photo: Scott Hyde: Fig. 3-18a; Gift of Brighton Art Gallery and Museum 1950-59-2, photo: Scott Hyde: Fig. 4-26a.

Corbis/Bettmann: Fig. I-17, 1-7, 21-12.

Corbis Digital Stock: Fig. 14-23a.

Le Corbusier, Pavillon de l'Esprit Nouveau, International Exposition of Decorative and Modern Industrial Arts, Paris, 1925. From: Le Corbusier, "My Work," London: Architectural Press, 1960, p. 72. © 2005 Artists Rights Society (ARS), New York/ADAGP, Paris/FLC: Fig. 25-3.

Joe Cornish © Dorling Kindersley, Courtesy of Castle Howard, Yorkshire, England: Fig. 17-29.

Cornu, Paul, *Meubles et Objets de gout 1796-1830*, Paris, Librarie des Arts Decoratifs, 1833: Fig. 2-26d, 2-27c, 2-27d, 2-33, 2-35b, 2-36a, 2-36b.

Country Life Picture Library, London, England: Fig. 19-38a.

Crane, Walter, *The Basis of Design*, London, G. Bell and Sons, Ltd., 1925: Fig. 16-19c, 16-19d, 16-19e, 17-4b.

Cravath, James R. and Van Rensselaer Lansingh, *Practical Illumination*, New York, McGraw Publishing Co., 1907: Fig. 11-27, 21-22d.

The Craftsman, Syracuse, October 1903: Fig. 18-52e.

The Craftsman, Vol. 5, October 1903 – March 1904, Syracuse, 1904: Fig. 14-5, 14-6a, 14-6b, 14-19, 18-36b.

The Craftsman, Vol. 6, April 1904 – September 1904, Syracuse, 1904: Fig. 14-30a, 14-30b, 19-54b.

The Craftsman, Vol. 7, October 1904 – March 1905, Syracuse, 1905: Fig. 17-1a, 17-1b, 18-1b, 18-36c, 18-36d, 18-36e.

The Craftsman, Vol. 8, April 1905 – September 1905, Syracuse, 1905: Fig. 17-30, 18-44d, 18-44e.

The Craftsman, Syracuse, May 1907: Fig. 18-16, 18-17.

Cravath, James R., Lan Singh, Van Rensselaer, *Practical Illumination*, New York, McGraw Publishing Co., 1907: Fig. 21-22e.

Crystal Cathedral: Fig. 22-28.

Daniel & Sons, *Daniel & Sons Catalog*, n.p., 1880: Fig. 10-35.

Daniel Aubry Studio: Fig. 34-1b, 34-31a, 34-31b, 34-31c, 34-31d.

Das Interieur II, Ludwig Ables, (Ed.), Vienna, Kunstverlag Anton Schroll & Co., 1901: Fig. 20-1b, 20-14a, 20-14b, 20-19, 20-22b, 20-22c, 20-22e, 20-23b, 20-23c, 20-27a, 20-27b, 20-29, 20-30a, 20-30b, 20-30c, 20-30e, 20-30f.

Das Interieur V, Ludwig Ables, (Ed.), Vienna, Kunstverlag Anton Schroll & Co., 1904: Fig. 20-2a, 20-17c, 20-23a, 20-30d.

Das Interieur VI, Ludwig Ables, (Ed.), Vienna, Kunstverlag Anton Schroll & Co., 1905: Fig. 25-33b.

Eliza Houston Davey for the Chicago Architecture Foundation: Fig. 21-9a.

David Skinner & Son Irish Wallpapers Exclusively Through Classic Revivals, Inc., Boston, Mass.: Fig. 2-44f, 5-49c.

De Stijl – 11, 1, Leiden/Delft, 1918: Fig. 23-11, 23-12.

De Stijl – 11, 9, Leiden/Delft, 1919: Fig. 23-1.

de Wolf, Elsie, *The House in Good Taste*, New York, The Century Co., 1913: Fig 12-2, 12-35, 12-42a, 12-42b.

The Delineator, Vol. 58, New York, The Butterick Publishing Co., 1901: Fig. 21-1a.

Courtesy Design Within Reach, www.dwr.com.: Fig. 31.34.

Die Kunst XI – Monaschefte für Freie und Angewandte Kunst, Munich, F. Bruckmann, 1908: Fig. 20-8a, 20-8b, 20-24b, 27-14, 27-15.

© Dorling Kindersley: Fig. 1-4, 2-10b, 4-20e, 26d.

From the archives of Dorothy Draper & Co. Inc. New York: Fig. 30-17a, 30-17b, 30-17c.

Downing, Andrew Jackson, *The Architecture of County Houses*, New York, D. Appleton and Company, 1850: Fig. 6-18b, 6-19, 6-32, 6-46f, 7-13a, 7-13b, 7-24, 7-39, 8-43b.

Du Page Children's Museum, Doug Snower Photography: Fig. 23-9.

Courtesy Dunbar Furniture: Fig. 30-1b, 30-43b, 30-43c, 30-43d, 30-43e.

Eastlake, Charles L., *Hints on Household Taste*, London, Longmans, Green & Co., 1878: Fig. 1-2a, 1-46a, 6-37c, 6-37d, 6-38a, 6-38b, 6-39a, 6-41c, 6-43, 10-45b, 16-21.

Eastlake, Charles L., *A History of the Gothic Revival*, London, Longmans, Green & Co., 1872: Fig. 6-27.

Eberlain, Harold D., Edward Stratton Halloway, and Abott McClure, *The Practical Book on Interior Decoration*, Philadelphia, J.B. Lippincott, 1919: Fig. 2-35a, 12-48b, 12-48c.

Edgell, George H., *The American Architecture Today*, New York, Scribners Sons, 1928: Fig. 21-6a, 12-18b, 21-6a.

Edgell, George and Fiske Kimball, *A History of Architecture*, New York, Harper & Bros. Publishers, 1918: Fig. 11b.

Edifice/Adrian Forty: Fig. 25-28b.

Edward Caldwell Location Photography: Fig. 34-2f, 34-25.

Elliott, Maud Howe (Ed.), *Art and Handicraft in the Women's Building of the World's Columbian Expositon*, Chicago, Rand McNally & Co., 1894: Fig. 12-52, 12-54, 12-55.

Ellwood, G. M., *English Furniture and Decoration 1680-1800*, Stuttgart, Julius Hoffman, n.d.: Fig. 4-20c.

Encyclopéde des Metiers d'Art, Paris, Albert Morancé, 1926: Fig. 25-26, 26-44b, 26-46b, 26-47a, 26-47b, 26-49d.

Erik Jørgensen Møbelfabrik A/S: Fig. 37-35f.

Esto: 9-17, 9-26a, 14-41b, 17-41b, 26-30b, 28-22 (photography Tim Street-Porter), 28-29, 29-26, 31-1, 31-12, 31-18, 31-26a, 32-1, 32-28, 34-24.

© Esto for the Ford Foundation: Fig. 21-21.

Courtesy Eva Maddox Branded Environments: Fig. 33-26a, 33-26b (© Perkins & Will), 33-26c, 33-26d.

Exposition Internationale des Arts Décoratifs et Industriels Modernes Paris 1925, Edité Par L'Art Vivant, Pairs, Librarie La Rousse, 1929: Fig. 26-1a, 26-2a, 26-4, 26-5, 26-6, 26-23, 26-36d.

Ezra Stoller, Esto/IPNSTOCK: Fig. 26-30b, 27-22, 27-28.

Fergusson, James, *History of the Modern Styles of Architecture, Vol. II*, New York, Dodd, Mead, 1899: Fig. 1-24b, 3-6, 3-10, 6-5a, 6-7, 6-12, 6-36, 7-5a, 7-11, 10-20, 11-4, 11-6a, 11-9a.

Foto Marburg: Fig. 20-11a.

Foto Marburg/Art Resource, NY: Fig. 20-21a, 20-21b, 24-16c.

Courtesy John Reed Fox: Fig. 18-53.

Fowles, Dorothy L.: Fig. 34-5a, 34-14, 34-17a, 34-17b, 35-38i.

Courtesy Frank O. Gehry & Associates, Inc.: Fig. 35-39b.

Frankl, Paul, *New Dimension: The Decorative Arts of Today in Words & Pictures*, New York, Payson-Clarke Ltd., 1928: Fig. 22-12, 25-2d, 25-11a, 25-11b, 26-38i, 26-38j, 26-42b, 26-42c, 26-44a.

Fredericia Furniture: Fig. 33-42a, 33-42b.

Michael Freeman: Fig. 18-38b.

French Embassy: Fig. 25-7.

Frost, David and Roger Sorrell: Fig. 34-55c.

Frye, Alex Everett, *Frye's Complete Geography*, Boston, Ginn & Co., 1895: Section E Opener.

Furniture, Grand Rapids, n.p., June, 1890: Fig. 1-45a, 10-44c.

Courtesy Gaineswood Historic Site: Fig. 5-36a.

Antonio Gaudi, 1852–1926. Woodwork-Spanish-XX Century. Armchair. Walnut. About 1902–1904. 38 × 25-1/2 × 20 inches. The Metropolitan Museum of Art, Purchase, Joseph H. Hazen Foundation, Inc., Gift. (1974.107): Fig. 19-47.

Gensler Architecture: Fig. 33-1b, 33-29a (courtesy ING NY), 33-29b, 33-29c, 33-29d, 33-29e, 33-30a, 33-30b.

© J. Paul Getty Trust. Used with permission: Fig. 25-14b, 25-27b, 28-18, 28-25, 28-40a.

Getty Images: 20-21b, 26-30a.

Getty Images Inc./Berenice Abbott: Fig. 25-5.

Getty Images/De Agostini Editore Picture Library: Fig. 19-33.

Getty Images Inc./Hulton Archive Photos: Fig. 13-34a, 15-1b, 15-2, 21-9b, 27-39a.

Gillon, Edmond V. Jr., *Pictoral Archive of Early Illustrations and Views of American Architecture*, New York, Dover Publications, Inc., 1971: Fig. 1-28, 7-9a, 8-9, 10-4b.

Giraudon: Fig. 2-41a, 26-12.

Gleason, *Gleason's Pictorial Dining Room Companion*, Boston, Gleason, 1854: Fig. 8-35.

Gloag, John, *British Furniture Makers*, New York, Hastings House, n.d.: Fig 4-24b, 4-31.

Godey's Ladies Book, New York, Godey's, 1854, 1870: Fig. 7-25d, 8-40a1, 8-40a2, 8-40a5.

Good, Chris: Fig. 1-5, 1-8, 1-17, 1-29, 2-10a, 2-21, 2-27b, 2-28b, 2-37, 2-43, 3-21, 4-3, 4-15, 4-18, 4-20b, 4-23, 4-28, 4-38, 4-41, 4-42a, 4-42b, 5-40a, 5-49a, 5-49b, 6-42a, 6-49c, 8-2, 8-5, 8-7, 8-43a2, 8-48b, 9-6, 9-12, 9-38, 9-39a, 10-9, 10-15, 10-24, 11-32a, 12-18a, 12-45, 13-35, 13-37, 13-38b, 14-42, 15-12, 16-11, 17-7, 17-8, 17-23b, 19-24, 19-50, 20-6, 20-7, 20-12, 20-15, 20-16a, 20-22a, 20-22d, 20-28c, 22-4, 22-11, 23-6, 23-8, 23-10b, 23-13, 23-15a, 23-15b, 23-16, 23-19a, 23-19c, 23-20, 23-21, 24-5, 24-6, 24-12, 25-18, 25-21, 25-29, 25-32, 26-20a, 26-46a, 27-7, 27-11, 27-12, 27-17, 27-21, 27-23, 27-42, 28-7, 28-16, 28-19, 28-21, 28-37, 28-45, 28-49, 29-6, 29-17, 29-27a, 29-27b, 29-40, 30-42a, 30-42b, 31-9, 31-10a, 31-10b, 31-11b, 31-19a, 31-20, 31-26b, 31-26c, 31-26d, 31-27a, 31-27b, 31-27b, 31-31a, 31-31b, 31-42, 31-43, 32-5c, 32-8, 32-20, 32-21, 32-22a, 32-22b, 32-24, 32-26, 32-27a, 32-27b, 32-27c, 32-33a, 32-33c, 32-33d, 32-36, 32-41, 32-45, 33-7, 33-21, 33-47, 34-19, 34-20, 34-21, 34-23a, 34-23b, 34-26, 34-38a, 34-38b, 34-39, 34-40a, 34-40b, 34-46, 34-51, 35-3, 35-8, 35-40, 35-46b, 35-49.

Goodyear, William Henry, *History of Art for Classes, Art Students, and Tourists in Europe*, New York, A.S. Barnes and Co., 1889: Fig. 6-8.

Gould, Mr. & Mrs. Glen, *Period Lighting Fixtures*, New York, Dodd, Mead and Co., 1928: Fig. 1-36b.

Grand Rapids Furniture Record, Grand Rapids, n.p., 1902: Fig. 13-38a.

The Great Masters of Decorative Arts, London, The Art Journal Office, 1900: Fig. 17-2a, 17-27a.

Greeley, William R., *The Essence of Architecture*, New York, D. Van Nostrand Company, Inc., 1927: Fig. 1-6c.

Greene & Greene Archive, Huntington Library: Fig. 18-38d.

Halloway, Edward Stratton, *The Practical Book of Furnishing the Small House and Apartment*, Philadelphia and London, J.B. Lippincott Co., 1922: Fig. 7-45, 12-5.

Courtesy of Hamilton Weston Wallpapers, Ltd.: Fig. 4-26b, 4-26c, 4-26d.

Hamlin, Alfred D. F, *History of Architecture*, New York, Longmans, Green and Co., 1902: Fig. 3-9, 8-25.

Hamlin, Talbot F., The Pageant of America, Vol. 13, *The American Spirit in Architecture*, New Haven, Yale University Press, 1926: Fig. 1-24c, 12-36a.

Courtesy Fritz Hansen www.fritzhansen.com: Fig. 27-1a, 27-25a, 27-25b, 27-25c, 27-25d, 27-25e, 27-35c, 27-37a, 27-37b, 27-38a, 27-38b, 27-38c, 27-38d.

Hansen & Sørensen APS: Fig. 27-35b, 27-36a, 27-36b, 27-36d.

Hariri & Hariri – Architecture (Paul Warchol, photography): Fig. 33-35a, 33-35b, 33-35c, 33-35d, 33-35e, 33-35f.

Harpers Illustrated Weekly, February-March, 1872:Fig. 1-12e.

Hart, Harold H. (Ed.), *Chairs Through the Ages*, Mineola, Dover Publications, 1971: Fig. 1-40, 9-36c, 9-40a1, 10-37b, 10-38c2.

Harter, Jim (Ed.), *Images of World Architecture*, New York, Bonanza Books, 1990: Fig. 11-6c, 11-8a, 11-8c, 11-14.

Hartman, Sadakichi, *The Whistler Book*, Boston, L.C. Page & Co., 1910: Fig. 16-16c.

Harwood, Buie: Fig. 1-3a, 1-3d, 1-3e, 1-9, 1-15a, 1-15b, 1-24a, 1-35c, 1-35e, 1-36c, 2-13a, 2-26a, 2-26b, 2-26c, 2-28a, 3-4, 3-13, 3-18b, 3-20a, 3-23, 3-24, 4-7, 4-8a, 4-8b, 4-14a, 4-14b, 4-19, 4-20d, 4-24d, 4-26e, 4-34a, 5-4d, 5-8, 5-38a, 5-38c, 5-39a, 5-39e, 5-40b, 5-42b, 5-46a, 5-47b, 5-47c, 5-48b, 6-5a, 6-13, 6-16a, 6-16c, 6-22, 6-23a, 6-23b, 6-23c, 6-28b, 6-37a, 6-37b, 6-41b, 6-45b, 7-4, 7-5b, 7-6, 7-7, 7-8, 7-12, 7-19, 7-21, 7-23a, 7-23b, 7-23c, 7-40, 8-6b, 8-11b, 8-11c, 8-13, 8-17c, 8-39a, 8-41a, 8-44b, 8-45a, 8-47a, 8-48c, 9-10, 9-33a3, 9-33b2, 9-36d, 9-37, 9-41b, 10-5a, 10-5b, 10-11c, 10-19c, 10-36a, 10-36b, 11-2b, 11-2c, 11-2d, 11-2e, 11-3d, 11-5b, 11-7b, 11-9b, 11-17, 12-5, 12-6b, 12-7, 12-9b, 12-13, 12-14a, 12-14b, 12-15b, 12-17, 12-21a, 12-21b, 12-21c, 12-29a, 12-29b, 12-31, 12-32, 12-46a, 12-46b, 13-13, 13-16, 13-23a, 13-23b, 13-23c, 13-23d, 13-24a, 14-2a, 14-4b, 14-9a, 14-15, 14-17, 14-18, 14-23c, 14-24a, 14-24b, 14-24c, 14-35a, 14-35b, 15-8b, 15-10c, 15-10c, 15-20f, 15-22b, 15-23, 15-25b, 16-16d, 16-32b, 16-32c, 16-41b, 16-41d, 17-5, 17-6, 17-9, 17-10, 17-12, 17-13a, 17-14b, 17-15a, 17-15b, 17-15c, 17-15d, 17-16, 17-17b, 17-22, 17-31c, 17-32, 17-33a, 17-37, 17-38, 18-4a, 18-5, 18-8a, 18-19a, 18-25a, 18-27a, 18-27b, 18-41a, 18-41g, 18-43, 18-45, 18-49b, 18-50, 19-9a, 19-10b, 19-10c, 19-11a, 19-11b, 19-11c, 19-14b, 19-16a, 19-16b, 19-16c, 19-17a, 19-17b, 19-18, 19-20a, 19-20b, 19-21a, 19-21b, 19-28b, 19-35b, 19-35c, 19-44d, 19-45a, 19-45b, 19-53c, 19-53d, 20-1a, 20-2b, 20-3a, 20-5, 20-9a, 20-9c, 20-10a, 20-11a, 20-11c, 20-16b, 20-16b, 20-26a, 20-28b, 21-4c, 22-2b, 22-2c, 22-2d, 22-8a, 22-13, 22-14, 22-17a, 22-17d, 22-18, 22-20a, 22-20b, 22-29b, 23-7b, 23-7c, 12-17, 23-22,

24-4c, 24-4d, 24-9a, 24-9b, 24-9c, 24-21d, 25-17a, 25-17b, 25-17c, 25-17d, 25-28a, 25-28d, 26-13b, 26-14b, 26-45c, 26-49c, 28-34, 29-5b, 29-28c, 30-2d, 30-12a, 30-12b, 30-14a, 30-15d, 30-22b, 31-3a, 31-3b, 31-4, 31-14b, 31-15b, 31-23b, 31-25a, 31-32d, 31-48b, 31-48c, 32-11c, 32-17a, 32-25b, 32-25c, 32-29b, 32-29c, 32-40, 32-44c, 32-46c, 33-2a, 33-2b, 33-4b, 33-4c, 33-6b, 33-6c, 33-8, 33-14a, 33-14c, 33-14d, 33-15, 33-16a, 33-16b, 33-17, 33-24a, 33-32, 34-2c, 34-3c, 34-6b, 34-7b, 34-8b, 34-8c, 34-10b, 34-15b, 34-16a, 34-16c, 34-28d, 34-55a, 34-55b, 35-2a, 35-4c, 35-5a, 35-5b, 35-5c, 35-6, 35-13a, 35-18b, 35-20a, 35-20b, 35-23a, 35-23b, 35-31a, 35-31b, 35-35, 35-36b.

Courtesy Haworth, Inc.: Fig. 34-49.

Heck, J.G., and Paul Bacon, *The Complete Encyclopedia of Illustration*, New York, Park Lane/Crown Publishers, 1851/1979: Fig. 2-12.

Hegemann, Werner and Elbert Peets, *The American Vitruvius: An Architect's Handbook of Civic Art*, New York, 1922, Reissued Benjamin Blom, Inc., 1972: Fig. 2-13b, 13-6.

The Henry Francis du Pont Winterthur Museum, Inc.: Fig. 13-36, 15-22b, 15-24.

Courtesy Herman Miller, Inc.: Fig. 19-55, 20-31, 24-38, 28-28, 28-40b, 28-42a, 28-42b, 28-42d, 28-46b, 28-46c, 28-46d, 28-47a, 28-47c, 28-47d, 28-51d, 28-52a, 28-52b, 28-54, 29-1a, 29-28f, 29-29a, 29-29b, 29-29c, 29-29d, 29-33a, 29-33b, 29-33c, 29-34a, 29-39, 31-39a, 31-39b, 31-44, 31-46a, 31-46b, 31-46c, 31-46d, 33-50a (Hedrich/Blessing photography), 33-50b (Hedrich/ Blessing photography), 34-35a (Nick Merrick – Hedrich Blessing, photography), 34-35b (Nick Merrick – Hedrich Blessing, photography), 34-47, 34-54a (Hedrich/Blessing photography), 34-54b (Hedrich/Blessing photography), 34-54c (Hedrich/ Blessing photography).

Courtesy of The Hermitage: Home of President Andrew Jackson, Nashville, TN: Fig. 5-32a, 5-32b.

Hertz, B. Russell, *The Decoration and Furnishing of Apartments*, New York, G.P. Putnam's Sons, 1915: Fig. 13-41a.

Hickory Chair, Hickory, N.C.: Fig. 6-50 (Gothcik Bench), 16-42 (Country Occasional Chair).

Courtesy The Estate of David Hicks: Fig. 30-1d, 30-35c, 30-35d, 30-41.

High Museum of Art, Atlanta, Georgia; Virginia Carroll Crawford Collection: Fig. 16-38.

Hing, Allan: Fig. 4-21a, 4-21b, 27-10b, 30-18, 31-19b, 31-19c, 32-2b, 32-9b, 32-9c, 32-25d, 33-5, 33-12, 35-7a, 35-15, 35-20c, 35-22, 35-26b, 35-32a, 35-32b.

© Historical Picture Archive/CORBIS: Fig. 1-22.

History of Architecture, (Editorial Staff), Scranton, PA, International Textbook Co., 1924: Fig. 9-23a, 9-23b, 19-31b.

Hoffmann, Jr., Julius, *Der Moderne Stil*, Stuggart, Verlag von Julius Hoffman, 1890: Fig. 17-39.

Holloway, Edward Stratton, *The Practical Book of Furnishing the Small House and Apartment*, Philadelphia, J.B. Lippincott Company, 1922: Fig. 13-41b, 13-44b, 13-44c.

Holloway, Edward Stratton, *The Practical Book of Learning Decoration and Furniture*, Philadelphia, J.B. Lippincott Company, 1926: Fig. 2-30.

Holly, H.H., *Modern Dwellings*, New York, n.p, 1878: Fig. 16-19a1, 16-19a2.

Holme, Charles (Ed.), *Modern British Domestic Architecture & Decoration "The Studio"*, London, n.p., 1901: Fig. 17-11e, 17-23c, 17-23d, 17-23e.

Honoré, Edmond (Ed.), *Mobilier et Décoration-Revue Mensuelle des Arts Décoratifs Appliqués et de l'Architecture Moderne*, Paris, n.p., 1930: Fig. 26-37e.

Hope, Thomas, *Household Furniture and Interior Decoration*, London, Longman, Hurst Rees and Orme (printed by T. Bensey), c. 1807: Fig. 4-2a, 4-2b, 4-22, 4-29a, 4-29b, 4-29c, 4-30a, 4-30b, 4-33a, 4-33b, 4-33c, 4-36, 4-37a, 4-37b, 4-40.

Horta, Eugenio: Fig. 29-2c, 29-4a, 29-4b.

Hottenroth, Fredrich, *Trachten, Haus-, Feld,-, und Kriegsgeräthschaften der Völker Alter und Neuer Zeit*, Stuttgart, Verlag von Gustave Weise, 1891: Fig. 3-1, 4-1.

House and Garden, August, 1925: Fig. 13-29c.

House Beautiful, Vol. 34, #5, October, 1913: Fig. 13-17.

Reprinted by permission from *House Beautiful*, © October, 1913; October 1920; September, 1916; August, 1960: Fig. 13-33.

Tim Hursley, photographer: Fig. 6-40, 34-10a.

© Hunterian Museum and Art Gallery, University of Glasgow, Mackintosh Collection: Fig. 19-37a, 19-37b.

I.C.S. Reference Library, *Use and Design of Lighting Fixtures*, Scranton, International Textbook Company, 1909: Fig. 13-29f.

Illustrated Catalogue and Price List of Shakers' Furniture, Mount Lebanon, N.Y., R.M. Wagan & Co., c. 1880: Fig. 15-22a.

Illustrated London News, Vol. XLI, July to Dec., 1862: Fig. 1-1, 1-20b, 1-21a, 1-21b, 1-33a, 1-38a, 1-44a, 6-3a, 6-3b, 7-1, 7-26a, 7-23a, 7-44b, 8-40b, 8-41d2, 9-34b.

L'Illustration Arts Décoratifs Modernes, n.p., March 1931: Fig. 26-1b.

Interfoto, Ognan Borissov, phogographer: Fig. 19-38e.

Intérieurs au Salon Des Artistes Décorateurs 6, Paris, Charles Moreau, 1927: Fig. 26-33a, 26-33c, 26-35a, 26-35b, 26-35c.

Intérieurs Français, Paris, Editions Albert Morancé, 1924: Fig. 26-32d, 26-33b, 26-45a, 26-45b.

Courtesy InterMetro Industries: Fig. 31-48a.

International Library of Technology, Scranton, PA, International Textbook Company, 1905: Fig. 19-2b.

iStockphoto.com: Fig. 35-32c (Sue Hexham, photography).

Jackson, Alice and Bettina, *The Study of Interior Decoration,* Garden City, Doubleday, Doran & Co., Inc., 1928: Fig. 13-29d.

Jaeger, Walter, Jaeger and Ernst Cabinetmakers, Philip Beaurline, photographer: Fig. 17-40.

Heidi James/Alamy: Fig. 24-22b.

Jeffrey & Co, London, 1876: Fig. 16-19b.

Jennings, A.S., *Upholstery and Wall Coverings,* n.p., 1903: Fig. 13-30.

© Jewish Museum Berlin, Jens Ziehe, photography: Fig. 35-14a, 35-14b.

Philip Johnson: Fig. 24-24.

Kevin Jones and Associates © Dorling Kindersley: Fig. 25-9c.

Jones, Owen, *The Grammar of Ornament,* London, B. Quaritch, 1868: Fig. 9-2a, 9-2b, 9-2c.

Jordon Mozer and Associates: Fig. 35-28a, 35-28b, 35-28c, 35-28d, 35-28e, 35-29a, 35-29b, 35-38e, 35-38f, 35-52c.

Le Journal Illustré, Paris, n.p., 28, February, 1875: Fig. 8-28c.

Joseph Mills Photography: Fig. 33-48, 35-47.

Karl Andersson & Søner: Fig. 27-40b, 27-40c.

Courtesy Kartell: Fig. 30-38E, 33-46a, 33-46b, 35-38g, 35-38h, 35-42, 35-43a, 35-43b, 35-43c, 35-43d, 35-43e, 35-51a, 35-51b.

Kevin Roche John Dinkeloo & Associates, KRJDA- Livieri: Fig. 28-35.

Key Color: Fig. 25-1.

Kieran Reynolds Photography: Fig. 33-37a.

Kiesler, Frederick, *Contemporary Art Applied to the Store and its Display,* New York, Brentano's, Inc., c. 1930: Fig. 23-2b, 23-2c, 23-5, 23-10a.

Kilty, Roberta: Fig. 35-2d, 35-7b, 35-7c, 35-26a, 35-26d.

Kimball, Fisk and George Edgell, *A History of Architecture,* New York, Harper and Brothers, Publishers, 1918: Fig. 1-23, 8-12.

Courtesy Kindel Furniture Company: Fig. 30-53a, 30-53b, 30-53c, 30-53d.

Dave King © Dorling Kindersley: Fig. 5-43, 26-9b.

Dave King © Dorling Kindersley, Courtesy of The Science Museum, London: Fig. 5-39d.

Courtesy Kittinger Furniture Company, Buffalo, N.Y.: Fig. 13-46.

Knight, T. and Son, *Suggestions for Home Decoration,* London, T. Knight and Son, 1880: Fig. 10-26.

Courtesy Knoll, Inc.: Fig. 24-26, 24-27, 24-28a, 24-29, 24-30b, 24-31a, 24-31b, 25-38, 28-1, 28-31a, 28-31b, 28-31c, 28-31d, 28-31e, 28-31f, 28-33, 28-41a, 28-44a, 28-44b, 28-48a, 28-48b, 28-48c, 28-48d, 28-50, 29-1b, 29-31, 29-36, 29-37, 29-38, 31-35, 31-37a, 31-37b, 31-38, 32-39b, 35-39a, 35-50a, 35-50b.

Courtesy of Lansdowne, Natchez, MS: Fig. 8-34.

Lebrecht Music and Arts Photo Library: Fig. 2-11b, 8-11a.

Leixner, Othmar, *Einführung in Die Architektur,* Vienna, Franz Deuticke, 1919: Fig. 2-14b, 2-18a, 3-2a, 3-2b, 3-7, 3-11, 3-12, 11-5a, 11-6b, 11-22, 11-25, 20-9b.

Lévy, Albert (Ed.), *L'Art Décoratif Français,* Paris, n.p., 1925: Fig. 26-36b, 26-36c, 26-37a, 26-38c, 26-38d, 26-38e, 26-40c, 26-41a, 26-49a.

Lévy, Albert (Ed.), *Exposition des Art Décoratifs Paris 1918-1925 la Ferronnerie,* Paris, Librairie Centrale des Beaux-Arts, 1926: Fig. 26-2b, 26-2c.

Lévy, Émile (Ed.), *Art et Décoration,* Paris, Librairie Centrale des Beaux-Arts, Volumes 1894-1908, 1914, 1920, 1921, 1923: Fig. 2-39, 2-40, 2-42, 2-44d, 2-44e, 17-17c, 19-1, 19-2a, 19-3, 19-4, 19-5e, 19-7, 19-8a, 19-8b, 19-8c, 19-14a, 19-15, 19-19a, 19-19b, 19-27, 19-31a, 19-32, 19-34, 19-36, 19-39a, 19-39b, 19-39c, 19-39d, 19-39e, 19-39f, 19-41a, 19-41b, 19-41c, 19-41d, 19-41e, 19-44a, 19-44b, 19-44c, 19-49, 19-53a, 19-53b, 19-54a, 26-2f, 26-32a, 26-32b, 23-32c, 26-38f, 26-41c, 27-27.

Courtesy of the Library of Congress: Fig. 21-20.

Courtesy of the Library of Congress, American Memory: Fig. 5-1, 8-42, 16-41a, 16-41c, 21-5, 21-14c, 21-26b, 21-27a, 21-27d, 31-8b, Section A Opener, Section C Opener, Section F Opener.

Courtesy of the Library of Congress, Prints and Photographs Division: Fig. 1-11, 1-26, 1-30 (photography by Carol M. Highsmith), 2-8, 2-14a, 2-15,

3-5, 4-10, 6-6a, 6-10, 8-28a, 8-28b, 9-22, 9-36b, 10-1a, 10-1b, 10-1c, 12-8a, 12-11, 12-11, 12-12, 12-34a, 16-1, 18-1a, 19-6a, 21-1b, 21-26c, 22-1, 26-9a, 26-8c (photography by Carol M. Highsmith), 26-16a (photography by Carol M. Highsmith), 28-51b, 30-1c, 30-16b, 30-16c, 30-21a, 30-21b (photograph by Carol M. Highsmith), 30-21c (photography by Carol M. Highsmith), 30-33a, 30-33b, 30-38d, 30-38e, 31-13b, 35-16a (photography by Carol M. Highsmith), 35-16b (photography by Carol M. Highsmith), 35-21a (photography by Carol M. Highsmith).

Courtesy of the Library of Congress, Prints and Photographs Division, Historic American Buildings Survey: Fig. 1-2b, 1-2e, 1-3b, 1-12a, 1-12b, 1-12c, 1-12d, 1-13a, 1-13b, 1-32, 1-33c, 1-35a, 1-35b, 1-35d, 1-36e, 1-43, 4-17, 5-2a, 5-2b, 5-2c, 5-3a, 5-3b, 5-3c, 5-4a, 5-4b, 5-4c, 5-5, 5-6, 5-7, 5-9, 5-10, 5-11a, 5-12, 5-13, 5-14, 5-15, 5-16, 5-17, 5-18, 5-19, 5-20, 5-21, 5-22, 5-24, 5-25a, 5-25b, 5-26a, 5-26b, 5-26c, 5-26d, 5-27a, 5-27b, 5-29, 5-30a, 5-30b, 5-33, 5-34, 5-36b, 5-37, 5-38b, 5-39f, 6-15, 6-16b, 6-17, 6-18a, 6-20b, 6-20c, 6-21, 6-25, 6-29a, 6-29c, 6-31, 6-33, 6-34b, 6-34c, 6-34d, 6-39d, 6-42c, 6-45c, 7-3a, 7-3b, 7-3c, 7-9b, 7-10, 7-14, 7-15, 7-16, 7-18b, 7-18c, 7-18d, 7-25a, 7-26b, 7-26c, 7-26d, 7-26e, 7-28, 7-29a, 7-29b, 7-31a, 7-31b, 7-31c, 7-33a, 7-33b, 7-33c, 7-34a, 7-34b, 7-34c, 7-41, 7-43b, 8-3a, 8-3b, 8-3c, 8-4a, 8-4b, 8-4c, 8-8, 8-10, 8-14a, 8-14b, 8-14c, 8-15b, 8-16, 8-17a, 8-17b, 8-18, 8-20, 8-22, 8-23, 8-24, 8-27, 8-29a, 8-29b, 8-30, 8-31, 8-32, 8-37, 8-47c, 8-49a, 9-3a, 9-3c, 9-4a, 9-4b, 9-8, 9-9, 9-15b, 9-16, 9-19, 9-20, 9-21b, 9-24a, 9-24b, 9-26b, 9-26c, 9-26d, 10-2b, 10-6, 10-8b, 10-11a, 10-11b, 10-11c, 10-12a, 10-12b, 10-13a, 10-13b, 10-14, 10-16a, 10-16b, 10-17b, 10-18b, 10-18c, 10-19a, 10-19b, 10-21c, 10-23, 10-29a, 10-29b, 10-30a, 10-30b, 10-31a, 10-32a, 10-36c, 10-43a, 11-2a, 11-2f, 11-3b, 11-3c, 11-7a, 11-7c, 11-9c, 11-12a, 11-12b, 11-13, 11-18, 11-19a, 11-19b, 11-20, 11-26, 11-28a, 11-28b, 11-30, 11-31a, 11-31b, 12-3b, 12-3c, 12-3d, 12-3e, 12-3f, 12-4a, 12-4b, 12-15a, 12-19b, 12-19c, 12-20, 12-22, 12-23, 12-34a, 12-25, 12-26a, 12-33a, 12-33b, 12-34c, 12-34d, 12-36a, 12-37a, 12-37b, 12-37c, 12-38c, 12-38d, 12-40a, 12-40b, 12-43a, 12-44a, 12-44b, 12-47, 12-48e, 13-4, 13-7, 13-8, 13-10a, 13-10b, 13-14, 13-20, 13-22b, 13-23a, 13-26, 13-27a, 13-27b, 14-2c, 14-2d, 14-3a, 14-4a, 14-4c, 14-11, 14-12, 14-13a, 14-13b, 14-20a, 14-22a, 14-22b, 14-25a, 14-25b, 14-31a, 14-31b, 14-31c, 14-32a, 14-32b, 14-32c, 14-38a, 14-38b, 14-41a, 14-41c, 14-41d, 15-4, 15-5a, 15-5b, 15-6a, 15-6c, 15-7, 15-8a, 15-10a, 15-11, 15-13, 15-14, 15-15, 15-16a, 15-16b, 15-16c, 15-16d, 15-16e, 15-17a, 15-17b, 15-17c, 15-18, 15-20b, 16-9b, 16-15, 18-2c, 18-2d, 18-3a, 18-4b, 18-10a, 18-10b, 18-11b, 18-12, 18-13, 18-14a, 18-14b, 18-18, 18-19b, 18-20, 18-22, 18-29b, 18-29c, 18-32a, 18-32b, 18-32c, 18-33a, 18-33b, 18-34a, 18-34b, 18-35a, 18-35b, 18-38c, 18-39, 18-40, 18-41f, 18-42, 21-2b, 21-2d, 21-3a, 21-3b, 21-3c, 21-3d, 21-7, 21-8a, 21-8b, 21-8c, 21-8d, 21-8d, 21-10a, 21-10b, 21-10c, 21-13, 21-14a, 21-14b, 21-16a, 21-16b, 21-17a, 21-18a, 21-18c, 21-19b, 21-22a, 21-22b, 21-22c, 21-23c, 21-23d, 21-24a, 21-24b, 21-24c, 21-25a (Courtesy Chicago Historical Society), 21-25b, 21-25d, 21-26a, 21-27b, 21-27c, 22-2e, 22-6, 22-9a, 22-9c, 22-15a, 22-16a, 22-16b, 22-22a, 22-22b, 22-22c, 25-2b, 25-2c, 25-2e, 25-6a, 25-6b, 25-10a, 25-10b, 25-14a, 25-15, 25-24a, 25-24b, 25-27a, 26-3a, 26-3b, 26-3c, 26-3d, 26-8a, 26-10a, 26-10b, 26-13a, 26-14a, 26-14c, 26-15a, 26-15b, 26-16b, 26-17b, 26-17c, 26-20d, 26-26a, 26-26b, 26-27a, 26-27c, 26-27d, 28-2d, 28-2e, 28-15a, 28-15b, 28-17a, 28-17b, 28-24b, 28-36a, 28-36b, 28-36c, 28-36d, 29-2a, 29-2b, 29-3c, 29-9a, 29-16b, 29-21a, 29-25a, 29-25b, 29-25c, 29-25d, 29-32b, 30-8a, 30-23a, 30-23b, 30-25a, 30-25b, 30-26, 30-36a, 30-36b, 30-36c.

Courtesy of the Library of Congress, Prints and Photographs Division, Historic American Engineering Record: Fig 1-6a, 1-6b, 16-5.

Lichtfield, Frederick, *Illustrated History of Furniture,* Boston, The Medici Society of America, Inc., 1922: Fig. 7-2, 7-38a, 7-42, 13-40.

Charles P. Limbert Co. Catalog: Fig. 18-48.

Lipe, Melissa M.: Fig. 29-15.

Courtesy of Lyndhurst, a National Trust Historic Site: Fig. 6-20a (photograph by Carol M. Highsmith), 6-34a (photography by Carol M. Highsmith).

Lockwood, Luke Vincent, *Colonial Furniture in America,* new and enlarged edition, New York, Charles Scribners Sons, 1913: Fig. 5-45a, 5-46b, 5-47a.

Courtesy of the Frances Loeb Library, Graduate School of Design, Harvard University: Fig. 11-11.

Los Angeles Architectural Club Year Book, Third Exhibition, Los Angeles, Architectural League of the Pacific Coast, February 23 – March 15, 1912: Fig. 14-7a.

Los Angeles Public Library: Fig. 26-8b (Herald Examiner Collection), 35-1a (Security Pacific Collection), 35-24 (Security Pacific Collection, Marvin Rand, photography).

Louis Poulsen Lighting, Inc.: Fig. 27-29d.

David Lyons © Dorling Kindersley: Fig. 15-16d.

David Lyons © Dorling Kindersley, Courtesy of the Art Complex Museum, Duxbury, Massachusetts: Fig. 15-25.

David Lyons © Dorling Kindersley, Courtesy of Fruitlands Museums, Sudbury, Massachusetts: Fig. 15-26.

Courtesy Magis SPA: Fig. 33-44, 35-41, 35-45, 35-46c.

Courtesy Maharam: 33-52.

May, Bridget: Fig. 6-6b, 6-6c, 6-6d, 12-8b, 12-8c, 12-14c, 30-10a, 30-10b, 30-10c, 30-10d, 13-24a, 13-24b, 30-55, 33-13b.

McCelland, Nancy, *The Practical Book of Wall Treatments*, New York, J.P Lippencott Co., 1926: Fig. 13-34a, 13-34b, 30-32a.

McDonough, Wisley & Co. Catalog, Chicago, 1878: Fig. 7-37a, 7-37b.

Courtesy McGuire Furniture and Orlando Diaz-Azcuy: Fig. 34-53.

Mekus Johnson, Inc.: Fig. 33-25a (Steve Hall, Hedrich Blessing, photographer), 33-25b (Doug Snower, photographer), 33-25c (Jon Miller, Hedrich Blessing, photographer).

Memphis Milano: Fig. 32-32a, 32-37, 32-38, 32-43, 32-46b.

The Metropolitan Museum of Art, Gift of Josephine M. Fiala, 1968. (68.133.7): Fig. 7-27.

The Metropolitan Museum of Art, Purchase, Edgar Kaufmann, Jr. Gift, 1973, and Bequest of Collis P. Huntington, by exchange, 1973 (1973.154.1-3). Photograph by Mark Darley. Photograph © 1983 The Metropolitan Museum of Art: Fig. 26-40a.

The Metropolitan Museum of Art, photograph, all rights reserved, The Metropolitan Museum of Art: Fig. 5-28, 5-41, 8-45b, 22-19, 22-23, 26-29.

© Judith Miller/Dorling Kindersley/Bonhams: Fig. 23-19b.

© Judith Miller/Dorling Kindersley/Caroline de Kerangal: Fig. 4-32.

© Judith Miller/Dorling Kindersley/China Search: Fig. 27-2e.

© Judith Miller/Dorling Kindersley/Decodame.com: Fig. 26-49b.

© Judith Miller/Dorling Kindersley/Freeman's: Fig. 15-22c, 15-27, 18-44a, 18-52d, 25-34a, 25-34b, 27-29b, 27-35g, 27-39b.

© Judith Miller/Dorling Kindersley/Legacy: Fig. 18-52c.

© Judith Miller/Dorling Kindersley/Lyon and Turnbull Ltd: Fig. 3-20b, 9-40d, 16-3, 25-35.

© Judith Miller/Dorling Kindersley/Mum Had That: Fig. 27-41a, 27-41b.

© Judith Miller/Dorling Kindersley/Nigel Benson: Fig. 27-41c.

© Judith Miller/Dorling Kindersley/Pook and Pook: Fig. 5-42a.

© Judith Miller/Dorling Kindersley/The Silver Fund: Fig. 27-29a.

© Judith Miller/Dorling Kindersley/Sloan's: Fig. 2-27a, 5-39b, 5-39c, 19-40b, 19-40c.

© Judith Miller/Dorling Kindersley/Wallis and Wallis: Fig. I-8, 1-41, 1-44b, 18-52b.

© Judith Miller/Dorling Kindersley/Woolley and Wallis: Fig. 4-34b, 16-32a, 18-52a.

Mira.com/Terry Smith: Fig. 12-6a.

Mission Furniture – How to Make It – Part One, Chicago, Popular Mechanics Co., 1909: Fig. 18-47b.

Piet Mondrian, (1872–1944), Composition with Red, Blue and Yellow, 1930. 51 × 51 cm. Oil on canvas, 18 1/8 × 18 1/8" Photo: Giraudon/Art Resource © 2004 Mondrian/Holtzman Trust. c/o hcr@hcrinternational.com: Fig. 23-2a.

Monograph of the Works of McKim Mead & White 1879-1915, The, New York, The Architectural Book Publishing Co., 1915-1920: Fig. 13-9.

Montgomery Ward Furniture Catalog, 1897: Fig. 1-46b, 10-42a, 10-44a.

Michael Moran © Dorling Kindersley: Fig. 12-24b, 26-18a.

Pam Morgan: Fig. 9-14.

Museé National d'Art Moderne, Paris: Fig. 24-1.

Museum of the City of New York: Fig. 1-31a, 1-31b, 1-39; The Byron Collection 9-31, 9-32, 16-28.

The Museum of Modern Art/Licensed by Scala-Art Resource, NY. Gift of Cafe Nicholson: Fig. 19-48b.

The Museum of Modern Art/Licensed by Scala-Art Resource, NY: Fig. 24-4a.

The Museum of Modern Art, *What is Modern Design?*, New York, 1950: Section G Opener.

National Archives and Records Administration: Fig. 21-26f.

National Trust for Historic Preservation: Fig. 5-48c.

National Park Service: Fig. 18-6a, 18-6b, 18-29a (J.P. Clum Lantern, photographer).

The Natural History Museum, London: Fig. 11-8b, 11-23.

Needlecraft: Artistic and Practical, New York, The Butterick Publishing Company, 1890: Fig. 16-18a, 16-18b, 16-20b, 16-20c, 16-33a, 16-33b.

Nelson, L.H., *View of London Cities*, Portland, ME, 1905: Fig. 11-16.

The Netherlands Information Bureau: Fig. 22-3.

Neue Arbeiten der Bauhauswerkstätten, Munich, Albert Langen Verlag, 1925: Fig. 24-15a, 24-21c, 24-23a1, 24-23a2, 24-23e, 24-25a, 24-25b, 24-32, 24-33a, 24-33b, 24-34a, 24-34b, 24-36a, 24-36b, 24-36c, 24-36e, 24-37a, 34-37b.

Neuhaus, Eugen, *The San Diego Garden Fair*, San Francisco, Paul Elder and Co., 1916: Fig. 14-1, 14-9b.

The New England Magazine, Vo. 7, Issue 5, January 1890: Fig. 11-1.

Newcomb, Rexford, *The Spanish House for America*, Philadelphia, J.B. Lippincott Co., 1927: Fig. 14-3c, 14-20b, 14-20c, 14-21, 14-36, 14-39, 14-43, 14-44, 14-45.

Newsom, Samuel and Joseph, *Picturesque California Homes*, San Francisco, Samuel and Joseph Newsom, 1884: Fig. 7-18e, 7-18f.

New York Convention & Visitors Bureau: Fig. 24-14.

© NTPL/Nadia Mackenzie: Fig. 17-19.

Nye, Alvan C., *A Collection of Scale Drawings, Details, and Sketches of What is Commonly Known as Colonial Furniture*, New York, William Helburn, 1895: Fig. 5-44a.

© Oesterreich Werbung (Austrian National Tourist Office): Fig. 3-15, 3-18c.

Oilcloths & Linoleum, Boston, John H. Pray & Sons, 1906: Fig. 10-31b.

Omni-Photo Communications, Inc./Marit Nieuwland: Fig. 27-31.

Ormsbee, Thomas H., *The Story of American Furniture*, New York, The Macmillan Co, 1934: Fig. 5-48a.

Ouradnik Studio: Fig. 21-19a.

Richard Payne: Fig. I-12.

Photolibrary, Glasgow Museums, Glasgow, Scotland: Fig. 19-29.

Picture Desk, Inc./Kobal Collection/Dagli Orti: Fig. 2-20b, 19-28a.

Picture Desk, Inc./Kobal Collection/Nicolas Sapieha: Fig. 24-7b.

PP Møbler/Brayton International: Fig. 27-1b, 27-35a, 27-35b, 37-35c, 27-35e.

Peter Paige Photography: Fig. 26-39.

Palecek: Fig. 34-50a, 34-50b.

Palliser, George and Charles, *Palliser's American Cottage Homes*, Bridgeport, Palliser, Palliser & Co., 1878: Fig. 1-2g, 1-18, 1-33i, 1-34c, 10-32c.

Palliser, George and Charles, *American Victorian Cottage Homes*, Bridgeport, Palliser, Palliser & Co., 1878: Fig. 10-2a, 10-2c, 10-18a, 10-32b.

Pencil Points, New York, The Pencil Points Press, Jan. 1–Sept., 1930: Fig. 13-19, 14-26, 25-8a, 25-8b, 25-19, 25-20.

Pennell, E. R., *The Life of James McNeill Whistler*, Philadelphia, J.B. Lippincott, 1911: Fig. 16-16a.

Percier, C. et P.F.L. Fontaine, *Recueil de Decorations Interieures*, Paris, Jules Didot Pine, 1827: Fig 2-3, 2-4, 2-6a, 2-16, 2-17, 2-20a, 2-23, 2-31, 2-34, 2-38, 2-41b.

Peterson's Magazine, Philadelphia, 1887: Fig. 16-20a.

Paul Petrie: Fig. 27-3b, 27-10a, 27-10c, 27-10d, 27-18, 27-20b.

Photofest, Inc.: Fig. 26-28.

Pierce, Walter, *Painting & Decoration*, London, n.p., 1893: Fig. 10-33.

© Sergio Pitamitz/Alamy: Fig. 22-19.

Courtesy Poltronova SRI: Fig. 32-41b.

POPPERFOTO/Alamy: Fig. 6-26.

John Portman & Associates, Inc.: Fig. 31-22a, 31-22b.

Practical Handbook on Cutting and Draperies, n.p., 1890: Fig. 10-34.

Prignot, Eugène, *L'Architecture, L'Décoration, L'Ameublement Libraire Speciale des Arts Industriels et Decoratifs*, n.p., 1873: Fig. 3-3b.

Pugin, A. Welby, *Fifteenth and Sixteenth Century Ornaments*, Edinburgh, John Grant, 1830: Fig. 6-2a, 6-2b, 6-39b, 6-39c, 6-41a, 6-42b, 6-42c, 6-44a, 6-44b, 6-45a, 6-46a, 6-46b, 6-46c, 6-46e, 6-49a, 6-49b.

Courtesy of May Frances Ramsey: Fig. 19-5a. 19-5c, 19-22b, 34-13a, 34-13b, 34-13c, 34-34a, 34-34b, 34-34c.

Rob Reichenfeld © Dorling Kindersley: Fig. 8-15a.

Rhode Island Economic Development Corporation: Fig. 12-39b.

Gerrit Rietveld (1888–1964). First floor, 1987, view of the stairwell/landing and the living-dining area. In the foreground is the Red and Blue chair. Rietveld Schroderhlis, 1924, Utrecht, The Netherlands. c/o Stichting Beeldrecht, Anstelveen. Collection: Centraal Museum Utrecht/Rietveld-Schroder Archive. Photo: Ernst Moritz, The Hague. © 2005 Artists Rights Society (ARS), New York/Beeldrecht, Amsterdam: Fig. 23-14.

Gerrit Rietveld (1888–1964) "The Red Blue Chair," 1917. Cassina USA, Inc. © 2008 ARS Artists Rights Society, NY: Fig. 23-18.

Archives of Ricardo Bofill Taller de Arquitectura: Fig. 30-27a, 30-27b.

Richards, Charles R., *Art in Industry*, New York, Macmillan, 1929: Fig. 13-43, 26-43.

© Rion Rizzo/Creative Sources Photography: Fig. 30-28a, 30-28b, 33-37b.

Courtesy Rita St. Clair Associates, Inc.: Fig. 30-24a, 30-24b, 30-24c, 30-24d.

Ritter-Antik, New York: Fig. 3-20c.

Robert Harding/Ellen Rooney: Fig. 19-19b.

Robert Harding/Simon Harris: Fig. 12-19.

© Robert Harding World Imagery/CORBIS All Rights Reserved: Fig. 13-7.

Robertson, Howard and F.R. Yerbury (Ed.), *Examples of Modern French Architecture*, New York, Scribner's Sons, 1928: Fig. 22-25, 25-9a, 25-9b, 25-12a, 25-12b, 25-13a, 25-13b, 25-25b, 25-37, 26-2e, 26-7b, 26-7c, 26-19a, 26-19b, 26-19c, 26-19d, 26-25a, 26-25b, 26-25c.

Paul Rocheleau: Fig. 15-21.

The Room Beautiful, New York, Clifford & Lawton, 1915: Fig. 2-24, 2-29, 3-17, 6-30, 13-3a, 26-22.

Royal Institute of British Architects Library of Photographs Collection: Fig. 17-23a, 25-4.

Royal Pavilion Libraries and Museums, Brighton, England, U.K.: Fig. 4-24c.

Courtesy John Saladino, Saladino Group: Fig. 30-37a, 30-37b, 30-48a, 30-48b.

Sanderson Wallpapers: Fig. 17-27g.

Courtesy Sargert Design Associates – sargertdesign.com: Fig. 34-36a, 34-36b, 34-36c, 34-36d.

Kim Sayer © Dorling Kindersley: Fig. 12-16.

Saylor, Henry, *Architectural Styles for Country Houses*, New York, Robert M. McBride & Co., 1919: Fig. 13-22c, 17-13b.

Saylor, Henry, *Inexpensive Homes*, n.p., 1912: Fig. 13-15.

© San Diego Historical Society: Fig. 10-7a, 10-17a, 16-27.

Courtesy Sawaya and Moroni: Fig. 33-39.

Courtesy Scalamandré: Fig. 30-40.

J. Schoolbred and Co. Catalog, England, n.p., 1889: Fig. 10-42c.

Scribner's Monthly, 22, No. 3, New York, July 1881: Fig. 16-9a.

Sears Roebuck Catalogue, Chicago 1902: Fig. 1-33h, 1-34a, 1-34b, 1-42d, 1-42e, 1-45b, 1-46c, 10-39b, 10-41a, 10-41b, 10-42b, 10-44b, 10-45a, 21-29a, 21-29b, 21-29e.

Sears, Roebuck and Co., Chicago, 1918: Fig. 5-23.

Sears, Roebuck and Co.: Fig. 12-28a, 12-28b, 13-21a, 13-21b, 18-26a, 18-26b.

Shackleton, Robert and Elizabeth, *The Quest of the Colonial*, New York, The Century Company, 1913: Fig. 5-44c, 5-45b.

Shapland, H.P., *Style Schemes in Antique Furnishings*, n.p., 1909: Fig. 13-31.

© Shelburne Museum, Shelburne, Vermont: Fig. 13-25.

Shepherd, T and James Elmes, *Metropolitan Improvements or London in the Nineteenth Century*, London, Jones & Co., Benjamin Blom, Inc., 1827: Fig. 4-4, 4-5, 4-6, 4-12a, 4-12b, 4-12c, 4-12d, 9-7.

Sherman, Curt: Fig. 1-3c, 1-14, 1-19, 1-25, 1-27, 1-34d, 1-34e, 1-37, 3-18d, 4-16, 4-20a, 4-24a, 4-25b, 4-25c, 4-25d, 4-25e, 5-11b, 6-4, 6-11a, 6-11b, 6-14a, 6-14b, 6-14c, 6-24, 6-28a, 6-29b, 6-41d, 7-18a, 7-22, 8-21, 8-26, 9-11, 9-15a, 9-18, 9-21a, 9-35, 10-7b, 10-8a, 10-11a, 10-16c, 10-17c, 10-19d, 10-22, 10-37c, 10-44d, 11-15, 11-21, 11-32b, 12-15c, 12-26b, 12-29c, 12-30, 12-34b, 13-24c, 14-3b, 14-10a, 14-10b, 14-14a, 14-14b, 14-16, 14-23b, 14-23d, 14-27a, 14-27b, 14-27c, 14-27d, 14-27e, 14-28, 14-29a, 14-29b, 14-33a, 14-33b, 14-33c, 14-33d, 14-33e, 14-34a, 14-34b, 14-34c, 14-34d, 14-35c, 15-3, 15-20a, 15-20c, 15-20d, 15-20e, 16-4, 16-6, 16-16e, 17-27b, 17-27e, 17-27f, 18-2a, 18-2b, 18-3b, 18-3c, 18-7a, 18-7b, 18-7c, 18-8b, 18-9a, 18-9b, 18-9c, 18-11a, 18-15a, 18-15b, 18-21a, 18-21b, 18-21c, 18-23a, 18-23b, 18-25b, 18-25c, 18-25d, 18-28, 18-30, 18-31a, 18-31b, 18-31c, 18-31d, 18-41c, 18-42, 18-47a, 18-49a, 19-5b, 19-5d, 19-12a, 19-12b, 19-12c, 19-13b, 19-13c, 19-22a, 19-22c, 19-23b, 19-23c, 19-25, 20-2e, 20-4, 20-13, 20-25, 21-2a, 21-2c, 21-4a, 21-4b, 21-6b, 21-6c, 21-12, 21-15, 21-17b, 21-17c, 21-18b, 21-23a, 21-23b, 21-25c, 21-28, 21-30, 22-2a, 22-5a, 22-5b, 22-9b, 22-15b, 22-17b, 22-17c, 22-17e, 22-27a, 22-27b, 23-3, 24-13, 25-2a, 25-2f, 25-6c, 25-14c, 25-14d, 25-22, 25-31, 25-33a, 25-33b, 25-36, 26-3e, 26-11a, 26-11b, 26-18b, 26-18c, 26-20b, 26-20c, 26-21, 26-27b, 27-2a, 27-2b, 27-2c, 27-2d, 27-3a, 27-4a, 27-4b, 27-9a, 27-9b, 27-19, 27-20a, 27-26a, 27-26b, 27-30a, 27-30b, 27-30c, 27-32, 27-36c, 27-40a, 28-2a, 28-2b, 28-2c, 28-8, 28-9b, 28-12a, 28-12b, 28-12c, 28-13c, 28-14a, 28-14b, 28-42c, 28-42e, 28-42f, 28-47b, 29-3a, 29-3b, 29-7, 29-8a, 29-11a, 29-12b, 29-14a, 29-14b, 29-20, 29-21b, 29-22a, 29-22b, 29-24b, 29-29e, 29-29f, 30-2a, 30-2b, 30-2c, 30-4b, 30-4d, 30-6b, 30-6c, 30-7, 30-11a, 30-11b, 30-13a, 30-13c, 30-14e, 30-15a, 30-15b, 30-15c, 30-23c, 30-23d, 30-38a, 30-38c, 30-38f, 30-43a, 30-51b, 31-2a, 31-2b, 31-2c, 31-2d, 31-2e, 31-5b, 31-6, 31-7, 31-8a, 31-11a, 31-11c, 31-13a, 31-16a, 31-16b, 31-16c, 31-17a, 31-17b, 31-21, 31-22c, 31-23a, 31-25b, 31-28a, 31-28b, 31-36, 31-49a, 31-49b, 31-51, 32-2a, 32-2c, 32-2d, 32-2d, 32-2e, 32-2f, 32-3a, 32-5a, 32-5b, 32-5d, 32-5e, 32-6a, 32-6b, 32-7b, 32-7c, 32-11b, 32-12a, 32-12b, 32-13a, 32-13b, 32-14a, 32-14b, 32-14c, 32-15a, 32-15b, 32-15c, 32-16, 32-17b, 32-23, 32-25a, 32-29a, 32-30a, 32-30b, 32-30c, 32-31a, 32-31b, 32-31c, 32-31d, 32-31d, 32-32c, 32-33b, 32-34a, 32-34b, 32-35, 32-42a, 32-42b, 32-42c, 33-2c, 33-2d, 33-2e, 33-3a, 33-3b, 33-4a, 33-9a, 33-10a, 33-10b, 33-10c, 33-11a, 33-11b, 33-11c, 33-11d, 33-14a, 33-14b, 33-18, 33-19a, 33-19b, 33-22a, 33-22b, 33-22c, 33-24b, 33-31, 33-38g, 34-2a, 34-2b, 34-2d, 34-2e, 34-3a, 34-3b, 34-4a, 34-4b, 34-4c, 34-5b, 34-5c, 34-6a, 34-7a, 34-7c, 34-9a, 34-9b, 34-11a, 34-11b, 34-15a, 34-15b, 34-15c, 34-15d, 34-16b, 34-18, 34-22a, 34-22b, 34-30a, 34-30b, 34-32a, 34-32b, 34-32c, 34-33a, 34-33b, 34-33c, 34-44a, 34-45b, 34-45c, 34-45e, 34-55c, 34-55d, 34-55e, 35-2b, 35-2c, 35-2d, 35-9a, 35-9b, 35-9c, 35-9d, 35-10a, 35-10b, 35-11, 35-12, 35-19a, 35-19b, 35-21b, 35-21c, 35-30a, 35-30b, 35-30c, 35-33a, 35-33b, 35-34a, 35-34b, 35-34c, 35-37, 35-38a, 35-39d.

Shoppell, Robert W, *Dining-Room Furniture & Decoration*, New York, The Co-Operative Building Plan Association, 1883: Fig. 10-27, 16-19a3, 16-19a4.

Sloan, Samuel, *Sloan's Homestead Architecture*, Philadelphia, J.P. Lippincott & Co., 1861: Fig. 7-23d.

Courtesy Smith & Hawken: Fig. 17-41, 34-48.

Smith, G, *Cabinetmaker & Upholstery Guide*, London, n.p., 1826: Fig. 4-27c.

Smith, Walter, *Masterpieces of the Centennial Exhibition*, Philadelphia, Gebbie & Barrie, 1876: Fig. 1-2c, 1-2d, 1-33b, 1-36f, 1-36g, 7-38b, 7-38c, 7-38d, 7-43a, 7-43c, 7-44a, 9-33a1, 9-33a2, 9-33b1, 9-34a3, 9-34a4, 9-36a, 9-41a, 12-43b, 12-43c, 12-48a, 12-48d, 12-48f, 12-51, 13-45, 16-3a, 16-35, 16-39a, 16-39b, 19-48a.

Smithsonian American Art Museum: Fig. 26-50 (Gift of Eleanor T. and Samuel J. Rosenfeld), 30-49 (Gift of Jacob Cress), 34-43b (Gift of Lloyd E. Herman, founding director and director emeritus of the Renwick Gallery (1971-1986)), 34-45a (Gift of Alfreda and Sam Maloof in honor of Michael W. Monroe, curator-in-charge, Renwick Gallery (1986-1995)), 34-45d (Gift of Sam and Alfreda Maloof).

Smithsonian Freer Gallery of Art and Arthur M. Sackler Gallery: Fig. 16-16b.

Frits Solvang © Dorling Kindersley: Fig. 27-8.

Courtesy Southern Accents and Henry Sprott Long and Associates, Photographer Tria Giovan: Fig. 17-18.

Speltz, Alexander, *The Styles of Ornament*, 1904: Fig. 2-6b, 2-18a.

Spires & Ponds Catalog, London, 1903: Fig. 21-29c.

Irene Springer, Pearson Education/PH: Fig. 1-47.

Courtesy Staffelbach Design Associates: Fig. 31-33, 33-33a, 33-33b, 33-33c, 33-33d.

Statham, H. Heathcote, *A Short Critical History of Architecture*, London, B.T. Batsford, 1912: Fig 3-8, 4-9, 4-11.

Courtesy Steelcase Inc., Grand Rapids, MI: Fig. 18-37a, 18-37c, 18-37d, 29-32a, 31-47a, 31-47b, 31-47c.

L. & J.G. Stickley, Inc.: Fig. 30-50a, 30-50b, 30-52a, 30-52b.

The Work of J.G. Stickley, Fogetteville, NY, n.d.: Fig. 18-51a, 18-51b.

Stickley, Gustav, *Craftsman Homes*, New York, The Craftsman Publishing Co., 1909: Fig. 18-36a, 18-44b, 18-44c.

Strange, Thomas Arthur, *French Interiors, Furniture, Decoration, Woodwork & Allied Arts*, n.p., 1903: Fig. 2-5, 2-22, 2-27e, 2-32.

Stoddard, John Lawson, *A Trip Around the World*, c.1890: Fig. 2-9, 3-3, 6-9, 6-11, 8-6a, 12-10.

Stuart, F.P., *F.P. Stuart Catalog*, n.p., 1900: Fig. 10-37a.

The Studio, London, The Studio, 1911: Fig. 40b.

The Studio, an Illustrated Magazine of Fine and Applied Art, Vol. I, No. 6, London, The Studio, 1893: Fig. 17-20, 17-33b.

The Studio, an Illustrated Magazine of Fine and Applied Art, Vol. II, No. 7, London, The Studio, 1899: Fig. 17-2b.

The Studio, an Illustrated Magazine of Fine and Applied Art, Vol. V, No. 25, New York, The Studio, 1895: Fig. 17-14a, 17-14c.

The Studio, an Illustrated Magazine of Fine and Applied Art, Vol. 6, New York, The Studio, 1899: Fig. 17-3, 17-21a, 17-21b.

The Studio, an Illustrated Magazine of Fine and Applied Art, Vol. 7, New York, The Studio, 1899: Fig. 17-11a, 17-11c, 17-11d, 17-28a, 17-34.

The Studio, an Illustrated Magazine of Fine and Applied Art, Vol. 9, New York, The Studio, 1900: Fig. 17-3, 17-28c, 17-28d, 17-36b.

The Studio, an Illustrated Magazine of Fine and Applied Art, Vol. 10, New York, The Studio, 1900: Fig. 17-26a.

The Studio, an Illustrated Magazine of Fine and Applied Art, Vol. 11, New York, The Studio, 1900: Fig. 17-24a.

The Studio, an Illustrated Magazine of Fine and Applied Art, Vol. 12, New York, The Studio, 1900: Fig. 20-17b.

The Studio, an Illustrated Magazine of Fine and Applied Art, Vol. 20, London, August 15, 1900, No. 89, p. 140: Fig. 19-6b.

The Studio Yearbook of Decorative Arts, London, The Studio, 1906: Fig. 17-26b, 17-26c, 17-26d, 17-26e, 17-26f, 17-26g, 17-28b, 17-28e.

The Studio Yearbook of Decorative Arts, London, The Studio, 1908: Fig. 17-17a, 17-24b, 17-28f.

The Studio Yearbook of Decorative Arts, London, The Studio, 1909: Fig. 9-40c, 20-24c, 20-24d, 22-26, 22-29a.